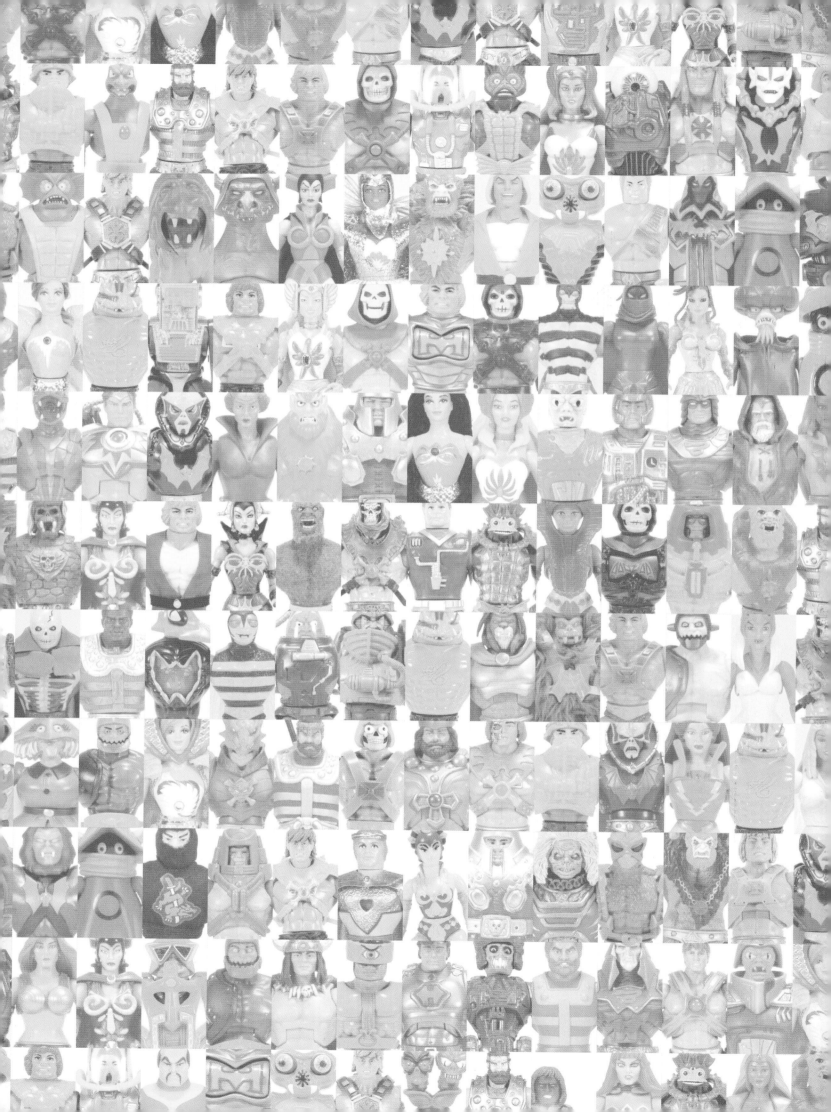

THE TOYS OF

HE-MAN AND THE MASTERS OF THE UNIVERSE

DARK HORSE BOOKS

President and Publisher
MIKE RICHARDSON

Editor
IAN TUCKER

Associate Editor
BRETT ISRAEL

Designer
ERIC MARSHALL

Digital Art Technician
ADAM PRUETT

NEIL HANKERSON Executive Vice President **TOM WEDDLE** Chief Financial Officer **RANDY STRADLEY** Vice President of Publishing **NICK MCWHORTER** Chief Business Development Officer **DALE LAFOUNTAIN** Chief Information Officer **MATT PARKINSON** Vice President of Marketing **VANESSA TODD-HOLMES** Vice President of Production and Scheduling **MARK BERNARDI** Vice President of Book Trade and Digital Sales **KEN LIZZI** General Counsel **DAVE MARSHALL** Editor in Chief **DAVEY ESTRADA** Editorial Director **CHRIS WARNER** Senior Books Editor **CARY GRAZZINI** Director of Specialty Projects **LIA RIBACCHI** Art Director **MATT DRYER** Director of Digital Art and Prepress **MICHAEL GOMBOS** Senior Director of Licensed Publications **KARI YADRO** Director of Custom Programs **KARI TORSON** Director of International Licensing **SEAN BRICE** Director of Trade Sales

THE TOYS OF HE-MAN AND THE MASTERS OF THE UNIVERSE®

Published by Dark Horse Books
A division of Dark Horse Comics LLC
10956 SE Main Street
Milwaukie, OR 97222

DarkHorse.com

First edition: April 2021
Hardcover ISBN 978-1-50672-047-0
Ebook ISBN (part 1): 978-1-50672-055-5
Ebook ISBN (part 2): 978-1-50672-514-7

1 3 5 7 9 10 8 6 4 2
Printed in Korea

CREDITS

PROJECT LEAD
Dan Eardley

PROJECT ADVISEMENT AND COORDINATION
Val Staples

ENTRIES & ARTICLES
Dan Eardley, Darah Herron, Adam McCombs

ADDITIONAL ENTRIES & ARTICLES
Curtis Tone, James Reid, Christa Van Fleet, Rodrigo De Orduña

TRADEMARK TIMELINES, FACTOIDS & INTERVIEWS
Adam McCombs

ADDITIONAL DESIGN ELEMENTS
Tom Bryski

MAIN PHOTOGRAPHY
Dan Eardley, Val Staples, Peter Wilura

ADDITIONAL PHOTOGRAPHY
Frederic Oudoul, Christina Eardley, Joe Teague, David Fowler, C. Drew, Aaron Eiland, Gazzi Gianluca, Philipp Leonard Gloth, Jeff Louis, Nick Murray, Carsten de Muynck, Mike Petruk, Brian Charles Rooney, Frank Scuderi

PHOTO RESTORATION
Daniel Quintero, Val Staples

ADDITIONAL RESTORATION
Nathan Blu, Kyle Wolfe, Santiago Salvador, Leanne Hannah, Roberto Migeul Alban, Jose Rafael Hoffman

MAIN PROOFREADERS
Aidan Cross, Danielle Gelehrter

ADDITIONAL PROOFREADERS
Darah Herron, Jonathan Leonard, Adam McCombs, Joe Teague, Curtis Tone, Crista Van Fleet

SPECIAL THANKS

Tim Beers, Daniel Benedict, Ted Biaselli, Thomas Brandt, Justin Curry, Joe DiLeo, Bob Feller, Darren Fowler, Gary Gefter, Ramy Ghassemi, Cary Grazzini, Eddie Hernandez, Darah Herron, Andrew Kistner, Rodney Langford, John Mansour, John McReynolds, Nick McWhorter, John Medaglia, Joseph Norstedt, Jeremy Peerboom, Michael Reithmeier, Brent Scarano, Brock Snyder, Eric Spikes, Jeff Vlcan

TABLE OF CONTENTS

FOREWORD

COOL TOYS!

If you were to mention He-Man to my mom today, she would gleefully tell you how I would regularly run around the house with a yellow, plastic Sword of Power toy tucked into the back of my shirt—excitedly reaching back to grab it, hold it up to the sky, and shout "By the Power of Grayskull!"

She loves telling that story, always wearing the type of smile only seen on a parent recalling the youth of their children. And truth be told, I always love hearing that story. Masters of the Universe had such a huge impact on me as a kid. I may have been young, but I fondly remember He-Man, Skeletor, and the colorful cast of characters being everywhere. They were all around me, and their adventures dominated my every thought. But it wasn't just me. Many kids experienced this same phenomenon. And it all started with a line of toys.

Mattel's *Masters of the Universe* toy line was something truly unique. The toys were much bigger than most action figures of the time, which instantly gave them a larger than life feel. The line beautifully mashed together fantasy elements with science fiction. You could have wizards and warriors, robots and vampires, skunks and dudes wearing elephant masks. It was weird, wonderful, inspired, and totally insane—and that is exactly what made this toy line so special!

But this was only the beginning of the adventure. Soon we were introduced to He-Man's twin sister She-Ra, and with that introduction came a whole new batch of toys ready to inspire imaginations and even engage a new audience. A gorgeous combination of fashion dolls and action figures, you could choose to defend the Crystal Castle and fly into battle on a winged Pegasus or check out some Fantastic Fashions while relaxing near the Crystal Falls.

He-Man would eventually go on to meet new friends and battle evil Space Mutants on a new adventure. He would go through a highly detailed, story-driven redesign to try and attract new fans, and ultimately reinvent and expand upon everything that made *Masters of the Universe* so great for fans.

For over three decades we've seen He-Man, She-Ra, Hordak, Skeletor, and all of the amazingly creative characters that we've grown to adore grace both the physical and virtual toy aisles. It's a testament to how impactful these toys were—and still are. No matter which version was *your* version.

My hope is that this book, with its collection of images spanning the entire life cycle of officially released *Masters of the Universe* and *Princess of Power* toys, will not only act as a way to catalog and document these amazing releases—but also spark that wonderful nostalgic feeling of what these toys meant to you as a kid. Maybe you'll be reminded of items you had completely forgotten you once had in your toy box, or be introduced to something brand-new to hunt down and add to your current collection.

And perhaps you'll have a smile and a laugh while recalling your very own yellow, plastic Sword of Power memory.

"PIXEL DAN" EARDLEY
Project Lead & Writer

GUIDE TO CONTENT

When the Most Powerful Man in the Universe hit the toy aisles in 1982, few could have imagined this toy would stand the test of time. But here we are, decades later, looking back at an epic history of some of the world's best action figures and accessories.

Assembling a guide for Masters of the Universe and Princess of Power did not come without its challenges. There was so much to show and narrowing it down was difficult. Ultimately, we decided upon a handful of key factors that would go on to dictate what content would embody this guide. The first was that this book would represent the main action figure lines of the past. After that, the focus was given to the 5.5" product. And then, to make it more specific, these toys had to be produced by Mattel. In addition, our goal was to present the collectibles that you would find in that action figure line's section of the toy aisle – that is, when it was not an online product.

This came with a couple of exceptions. The 2008 Masters of the Universe Classics line scaled up the vintage 5.5" figures to 7." In addition, a license was granted to a popular independent company called Super7 to continue MOTU Classics, starting in 2017. Beyond that, we avoided spin-off lines of other sizes and styles, no matter if they were licensed or produced by Mattel. As fantastic as these additional lines are, it is hard to imagine adding more content to this already massive book!

The toy lines printed in this archive, mainly the earliest ones, saw production in many different countries. This resulted in multiple variations in the colors and sometimes the molded details on the figures. While we would have loved to cover that in this guide, the sheer magnitude of international variations could have tripled or even quadrupled the size of this book.

Therefore, we focused on product that was released chiefly in the United States. But, if you own some of the USA figures cataloged here, you may notice subtle differences in your figures versus the ones presented here. And that is typically because of the disparities between factories, or during production over time in the same factory. In the 80s, Mattel had its toy product produced in multiple countries. This resulted in slight color shifts, and even slightly different casting molds for the body parts, depending on which factory was producing the product. While the number of factories narrowed as the years have passed, the toys from the 80s are known to have a plethora of variations, ranging from the obvious to the extremely minute.

That brings us to the packaging. On this, we targeted United States packages which primarily featured English text. There are instances where some figures were only released outside of the USA and, as a result, had multiple languages used on the card or box. However, much like the production on the figures, the USA packaging also had numerous discrepancies depending on the country of origin or the release date. In fact, some of the figures of the MOTU line from the 80s were reissued multiple times and were marked with what is called a G-code on the back to indicate its release generation. When possible, we have used G1 releases in the guide. Depending on the generation, the packaging may have had a change in art or information on the back, which is not represented here.

Even with our intent to present a specific theme, there are still variants we could not ignore. These are differences that, over the years, have become some of the most popular variants sought after by fans. They are typically identified by a distinct change in paint application or a difference in the molds used to cast the figure's body parts. We cover a selection of these figures throughout the book.

Once we selected the toys to photograph, our goal was to provide you with images that were as close as possible to when the toys were first released. Due to how some of the product has aged over time, photo restoration was required. So, while we you see a pristine representation, it is important to note that it is becoming increasingly difficult to find some of the older releases in the condition seen in our images. If you are a collector, one must expect the natural aging that can occur with some plastics and paints.

Even with the specific direction taken, we are confident that you will find a wealth of information within this guide. And if you want more, Dark Horse has already published many extraordinary books about Masters of the Universe and Princess of Power that have archived many things from the history of these brands. But for now, we leave you to dive into the depths of what constitutes the amazing toy lines that have helped define the rich history of He-Man and She-Ra!

CHAPTER 1

MASTERS OF THE UNIVERSE
(1982)

ASTRO LION
HEROIC LION WITH AMAZING BRUTE STRENGTH!

First released 1986 • Member of the Heroic Meteorbs

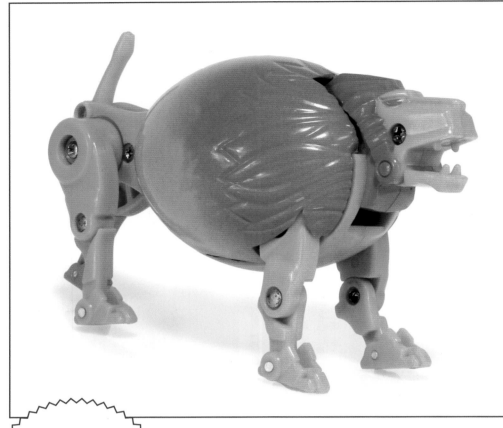

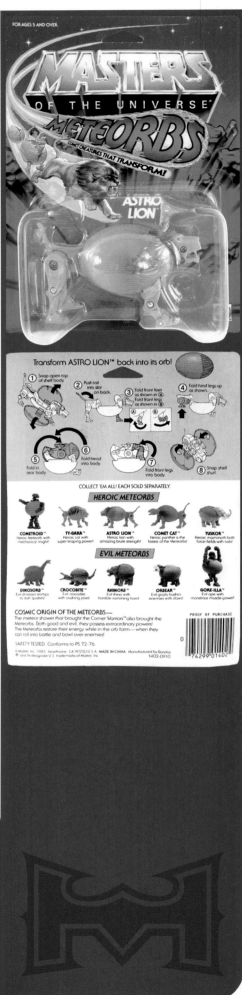

The Meteorbs are meteor rocks that have the ability to transform into animals and robots.

These egg-shaped transforming toys were originally released in Japan by Bandai under the name "Tamagoras." They were brought to the US by Mattel and released as characters in the Masters of the Universe line of action figures. This was Mattel's attempt to add the popular transforming toy mechanism seen in other lines, such as Transformers.

The transformation from meteor to animal is a fairly simple mechanism, usually not requiring instructions. By simply popping open the toy you can easily fold out the legs and head to complete the transformation.

Astro Lion features a yellow-orange coloration and when fully transformed looks like a robotic or alien lion-type animal. Minimal articulation can be found in the legs, allowing for a small amount of posability.

The Meteorbs at times feel out of place among the many action figures found within Masters of the Universe, but somehow they still fit within the combination of magic and science fiction that allowed the toy line to incorporate so many widely differing designs.

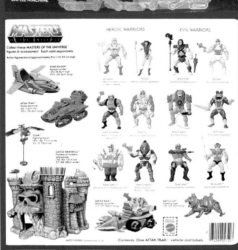

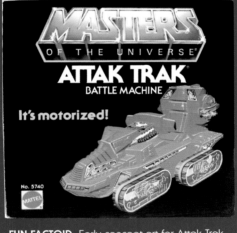

ATTAK TRAK
BATTLE MACHINE

First released 1983 • Vehicle of the Heroic Warriors

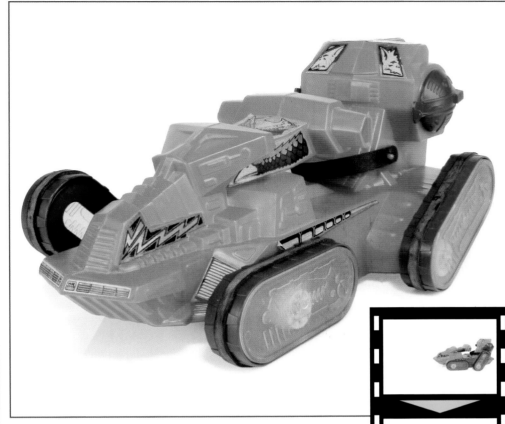

Created for the Heroic Warriors, the Attak Trak is a bright red tank-like vehicle made to carry one action figure. The vehicle is covered in decals to give the design some variety and includes rotating blue laser cannons on the back.

The Attak Trak is a motorized vehicle that utilizes C batteries. When powered on, the individual treads flip and flop end over end, moving the vehicle forward toward the enemy!

The exact same rotating-tread gimmick was also utilized the same year for the All-Terrain Vehicle in another Mattel toy line called Big Jim. This is not the only time Mattel repurposed parts between the two toy lines.

FUN FACTOID: Early concept art for Attak Trak (designed by Ted Mayer) featured a canopy. The canopy was dropped on the toy, but used in the Monogram Attak Trak model.

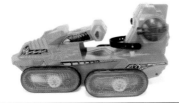

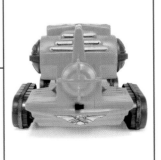

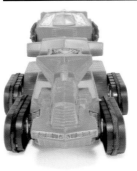

BASHASAURUS
HEROIC COMBAT VEHICLE

First released 1985 • Vehicle of the Heroic Warriors

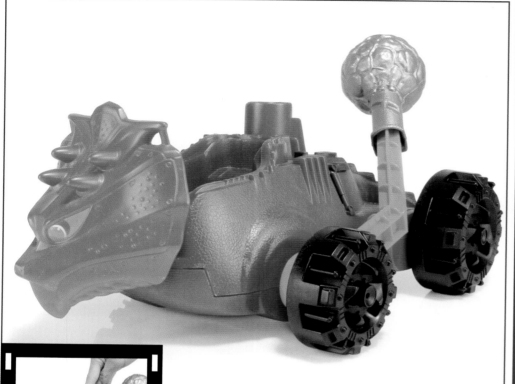

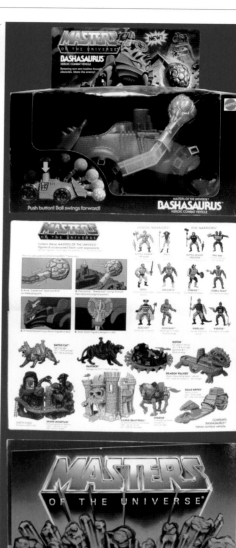

Push button! Ball swings forward!

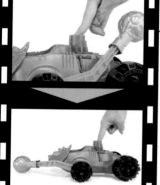

The heroic Bashasaurus is a vehicle with a really fun action feature. The bright red tank has a battering ram head on the front that resembles a triceratops-like dinosaur, leading to the vehicle's name.

This head can also be used to pin down enemies by tilting forward. This works great in tandem with the large telescoping arm topped with the Basher Ball!

By pressing a button on the rear of the Bashasaurus, the arm smashes the Basher Ball down onto the Evil Warriors or any obstacle that gets in the way!

FUN FACTOID: The early working name for Bashasaurus was "Ball Buster," and it was originally intended for the Evil Warriors.

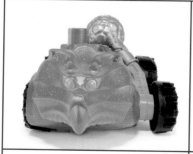

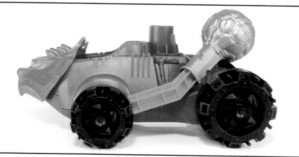

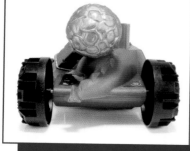

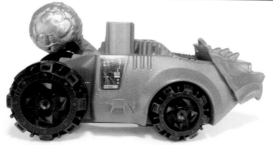

BATTLE ARMOR HE-MAN
MOST POWERFUL MAN IN THE UNIVERSE

First released 1984 • Member of the Heroic Warriors

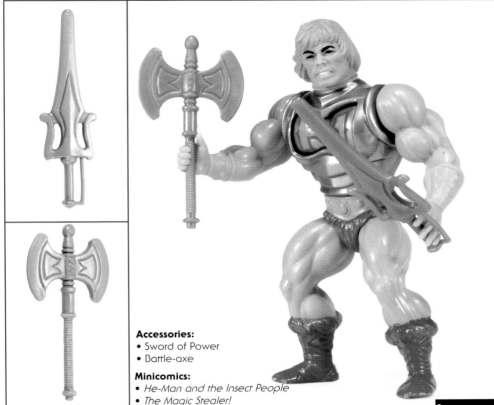

Accessories:
- Sword of Power
- Battle-axe

Minicomics:
- *He-Man and the Insect People*
- *The Magic Stealer!*

This is the first of several variations on our main hero released in the original Masters of the Universe toy line. It was a great way for Mattel to refresh the character with a slightly new look, allowing them to keep the main character on store shelves while simultaneously enticing kids to buy another He-Man action figure.

Many parts of the figure still looked just like the original He-Man, with the same recognizable look to the head, arms, legs, and weapons. This time around, however, his torso featured a brand-new sculpt in his battle armor that contained a very fun new action feature. This mechanism allowed the armor to show various levels of damage while doing battle with the bad guys.

The chest features a rotating drum with three damage indicators: clean, one slash, and two slashes. The drum was spring-loaded, and by pressing on the chest with your finger or the weapon of an enemy, He-Man's chest plate would snap to the next setting to show the battle damage. After rolling all the way to the final setting of two slashes, you can easily repair the damage by rolling it back up to the clean setting.

This action feature functions incredibly well. While He-Man and the matching Battle Armor Skeletor are probably some of the most popular action figures to utilize it, Mattel has used this action feature many times over the years. For example, just a year later, in 1985, the feature was incorporated into the Hot Wheels line under the name "Crack Ups."

FUN FACTOID: Mattel designers Ted Mayer, Martin Arriola, Ronald MacBain and Tony Rhodes all made contributions to Battle Armor He-Man's design.

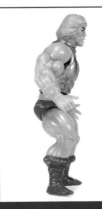

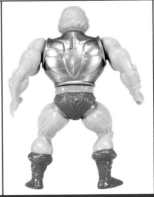

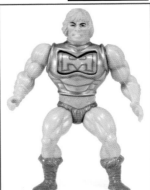

BATTLE ARMOR SKELETOR
EVIL LORD OF DESTRUCTION

First released 1984 • Member of the Evil Warriors

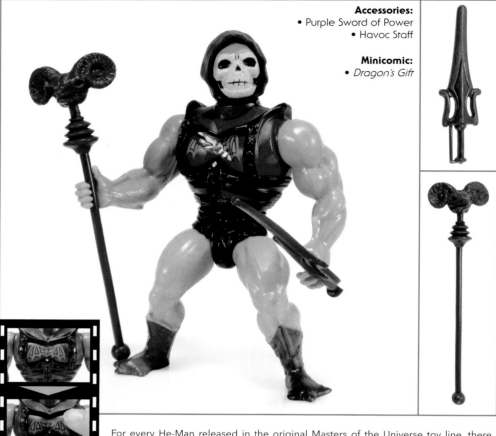

Accessories:
• Purple Sword of Power
• Havoc Staff

Minicomic:
• *Dragon's Gift*

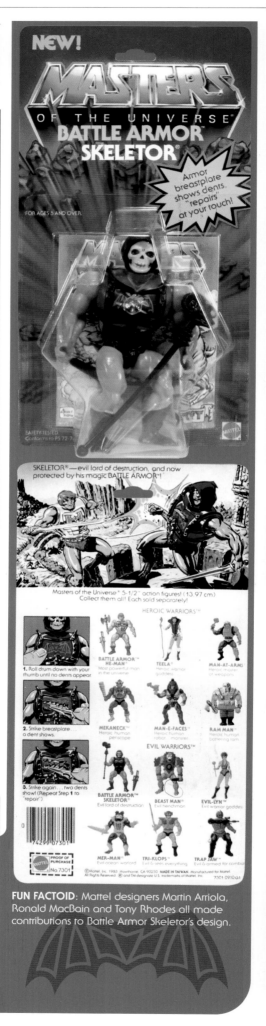

MASTERS OF THE UNIVERSE
BATTLE ARMOR SKELETOR

Armor breastplate shows dents, "repairs" at your touch!

FOR AGES 5 AND OVER.

SAFETY-TESTED Conforms to PS 72-7

SKELETOR® —evil lord of destruction, and now protected by his magic BATTLE ARMOR™!

Masters of the Universe™ 5-1/2" action figures! (13.97 cm) Collect them all! Each sold separately!

HEROIC WARRIORS™

1. Roll drum down with your thumb until no dents appear.

BATTLE ARMOR HE-MAN™ Most powerful man in the universe

TEELA™ Heroic warrior goddess

MAN-AT-ARMS™ Heroic master of weapons

2. Strike breastplate... a dent shows.

MEKANECK™ Heroic human periscope

MAN-E-FACES™ Heroic human robot monster

RAM MAN™ Heroic human battering ram

EVIL WARRIORS™

3. Strike again... two dents show! (Repeat Step 1 to "repair")

BATTLE ARMOR SKELETOR™ Evil lord of destruction

BEAST MAN™ Evil henchman

EVIL-LYN™ Evil warrior goddess

MER-MAN™ Evil ocean warlord

TRI-KLOPS™ Evil & sees everything

TRAP JAW™ Evil & armed for combat

Mattel, Inc. 1983. Hawthorne, CA 90250. MADE IN TAIWAN. Manufactured for Mattel. All Rights Reserved. ® and TM designate U.S. trademarks of Mattel, Inc.
7301 0910 G1

MATTEL PROOF OF PURCHASE No.7301

74299 07301

For every He-Man released in the original Masters of the Universe toy line, there was an accompanying Skeletor. Joining Battle Armor He-Man as the first of several variations was Battle Armor Skeletor. This was a great way for Mattel to keep the main characters on toy shelves while also adding exciting gimmicks to keep kids wanting each new release.

Much like Battle Armor He-Man, Battle Armor Skeletor still matches the original release very closely, except for his torso, which features a brand-new sculpt. This battle armor contained a mechanism that allowed the armor to show various levels of damage while doing battle with the good guys.

The chest features a rotating drum with three damage indicators: clean, one slash, and two slashes. The drum was spring-loaded, and by pressing on the chest with your finger or smashing it with He-Man's Sword of Power, Skeletor's chest plate would snap to the next setting to show battle damage. After rolling all the way to the final setting of two slashes, you can easily repair the damage by rolling it back up to the clean setting.

Along with Battle Armor He-Man, Battle Armor Skeletor's great-looking new armor with its fun action feature made for a figure that was much more than just a rehash of the original action figure.

FUN FACTOID: Mattel designers Martin Arriola, Ronald MacBain and Tony Rhodes all made contributions to Battle Armor Skeletor's design.

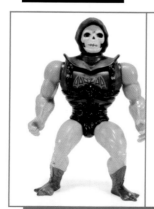
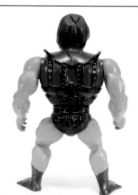

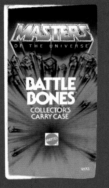

BATTLE BONES
COLLECTOR'S CARRY CASE

First released 1985 • Transport of the Heroic Warriors

Battle Bones is a really creative way to make a carry case for your Masters of the Universe action figures that also doubles as a large beast that you can use in battle!

The large creature is made to look like the living skeleton of a large dinosaur or dragon. The rib bones are made so that they can clamp snugly around a basic action figure's waist. There are six clamps on either side, allowing you to hold twelve different figures! There are even two loops worked into the beast's spine that work as a handle to carry around your holstered figures!

Battle Bones's mouth can open and close. This not only works as a great articulation point for playing with him as a beast, but you can also store all of your action figure weapons and accessories inside.

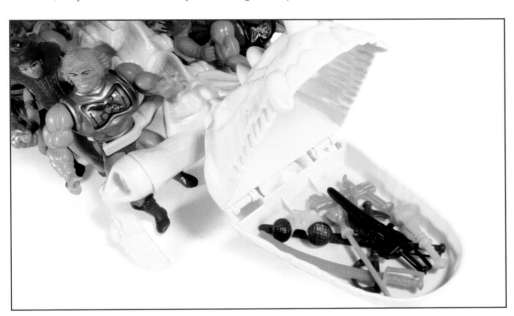

FUN FACTOIDS:
- *Mystery Science Theater 3000* created "Demon Dogs" props by repainting a few Battle Bones toys.
- An early suggested name for Battle Bones was "Dem Bones."

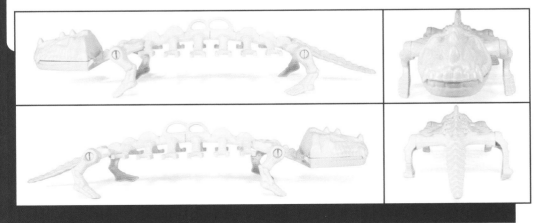

BATTLE CAT
FIGHTING TIGER

First released 1982 • Steed of the Heroic Warriors

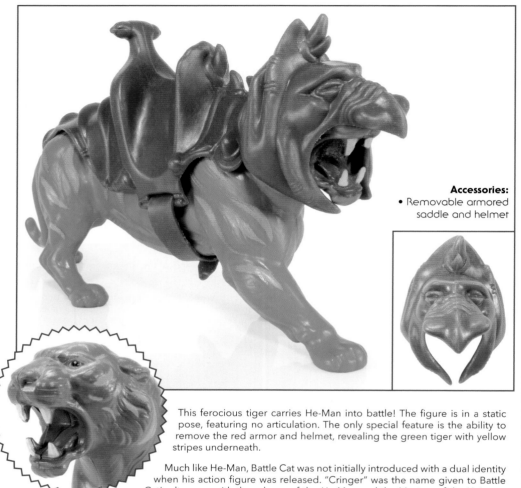

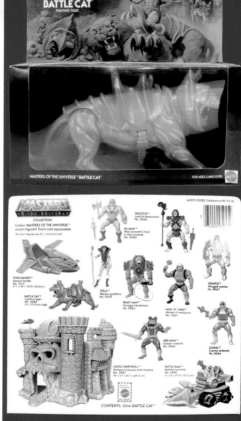

Accessories:
• Removable armored saddle and helmet

This ferocious tiger carries He-Man into battle! The figure is in a static pose, featuring no articulation. The only special feature is the ability to remove the red armor and helmet, revealing the green tiger with yellow stripes underneath.

Much like He-Man, Battle Cat was not initially introduced with a dual identity when his action figure was released. "Cringer" was the name given to Battle Cat's alter ego with the release of the *He-Man and the Masters of the Universe* animated series by Filmation. While this was not the original intention, removing the armor to turn Battle Cat into Cringer became a very common way for kids to play with the toy after the rise in popularity of the cartoon.

The figure stands around five inches tall, making him very out of scale with the five-and-a-half-inch humanoid figures in the line. This is because the mold for Battle Cat was originally used during the 1970s for a few of Mattel's twelve-inch action figure lines: once as a normal orange tiger for their 1976 Big Jim line, and again as a black jungle cat for their 1977 Tarzan line. To explain why Battle Cat was so oversized, Mattel created the saddle and the idea that he was a steed for He-Man.

An extremely rare version of Battle Cat was produced that matches the original hand-painted prototypes, featuring yellow stripes on the tail and orange paint around the mouth. This is thought to be the earliest release and is so hard to come by that only a few examples are known to exist in personal collections.

FUN FACTOID: Battle Cat's body was reused from an existing mold that had been used for Mattel's 1976 Big Jim on the Tiger Trail, and the 1977 gift set Tarzan and the Jungle Cat where the cat was in scale with ten-to-twelve-inch figures.

VARIANT

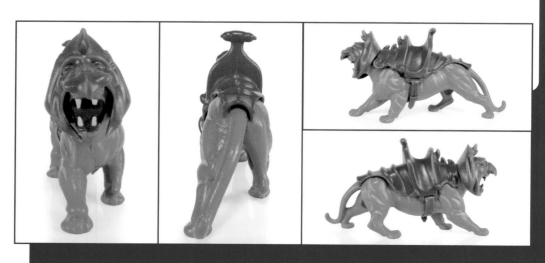

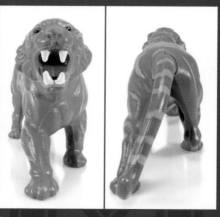

This extremely rare early version of Battle cat features painted stripes on his tail and yellow deco around his mouth.

FUN FACTOID: The decals used on the Battle Ram were created by Mark Taylor's wife, Rebecca Salari Taylor. Earlier versions used on the prototype were created by Mark Taylor.

BATTLE RAM
MOBILE LAUNCHER

First released 1982 • Transport of the Heroic Warriors

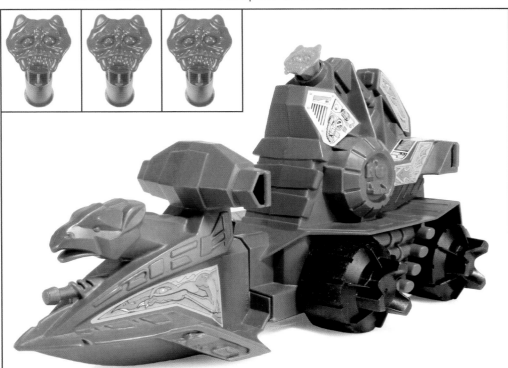

Accessories:
• Three missiles

Released with the launch of the Masters of the Universe toy line, the heroic vehicle known as the Battle Ram is an all-around classic. The design of the vehicle perfectly depicts the overall MOTU aesthetic, with a marriage of barbarian and gothic designs with futuristic technology.

A cannon on the back half can fire large red missiles with the press of a lever via a spring-loaded mechanism. The missiles themselves have a distinctive look, because instead of being just plain, ordinary-shaped projectiles, they feature large gargoyle faces on the front.

The front half of the vehicle is where your action figure can sit and features a griffin sculpt. This part of the vehicle has the ability to separate from the back, creating the Sky Sled—a smaller hovering vehicle.

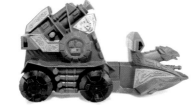

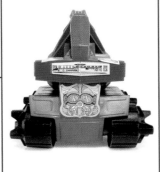

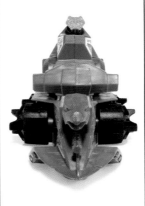

INTERVIEW WITH
TED MAYER

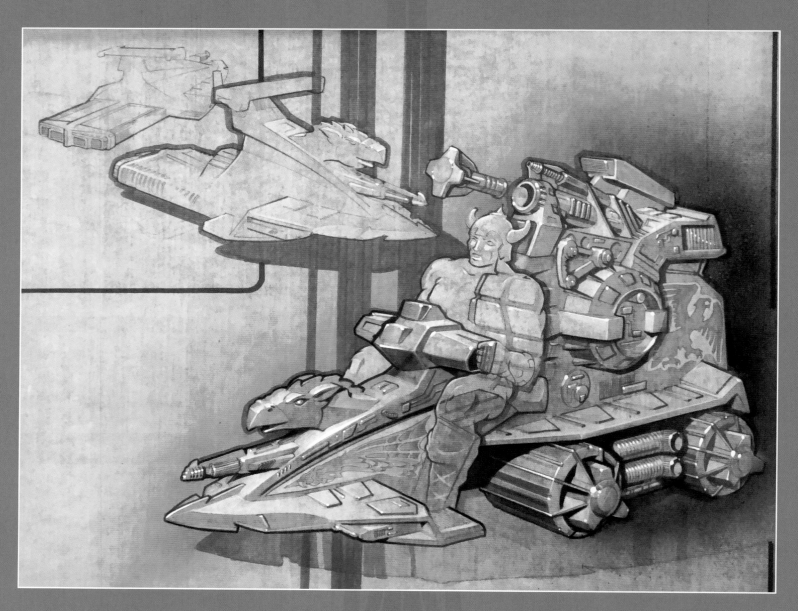

How did you get into the design business?

I originally worked in the aircraft industry, then went on to study illustration. I went back to school to study automotive design, but after graduation, I eventually got the job with Mattel. I loved working there. So many talented people of all kinds, painters, sculptors, etc. That's where I met Mark Taylor. We had cubicles next to each other. We found we had so many things in common. To this day he is my best friend. We see each other often. Mark was/is such a wonderful classic illustrator.

How did you come to work on the Masters of the Universe toy line at Mattel? Can you talk a little bit about how it started and what your involvement was early on?

The two design sections at Mattel were divided in two departments. There was Preliminary Design that was supposed to come up with ideas for toys, and Visual Design that actually did the design work (visualization). I was in Visual Design. We had about twenty designers, so each designer had many projects that we managed.

He-Man came about because Mattel had turned down Star Wars, and was desperate to come out with an action figure line to rival [Kenner's] Star Wars line.

Mark (who was a comic book maniac, and constantly sketching in his sketch book) was asked by a marketing person, who saw some of his sketches, to come up with something he could present. This was because prelim could not come up with anything. He presented the "Torak" drawing. It was accepted to go to the next stage . . . [Roger Sweet] was selected to help Mark with the final presentation.

Mark did all the sketches of the various characters . . . for the big presentation. Meanwhile Mark and I had five to six other projects we were working on.

When the go ahead was given to go to production, Roger was out of it and it moved into Visual Design. It was then that I was asked to come in and help Mark. We split the design chores up. Mark would do the figures, and I would do the vehicles, and we both would do the weapons and accessories that went with Castle Grayskull, including all the artwork for the decal sheets.

Tell me a bit about how you went about designing the Battle Ram. What influenced you at the time? Were there any challenges in designing it?

It's been a long time to remember what I was thinking! As I mentioned, all the visual designers were grouped together in a big bullpen. All the guys were either into cars or planes. We used to go to air shows, car concours and hot rod shows as a group — a lot of testosterone going round.

So the six big fat wheels, multiple exhaust pipes, Recaro-type seat, came out of that. Also recently coming out of working on Star Wars, I added all the surface detail that we put on all the vehicles. Added to that we wanted a shoot-out rocket. Mattel had just been sued over the missiles on the Battlestar Galactica vehicle, so they did not want a shooter. I had to design a missile that was big enough that would not choke a kid and would pass the safety department. And of course it had to be really, really bad ass!

. . . I was assigned my own model maker (Jim Openshaw), and we worked to make my sketch come to life.

I think the two vehicles in one, was an idea both Mark and I came up with, while discussing the whole line. Mark and I worked closely together; we sat next to each other and had a lot of fun. Jim eventually did all the tooling models for production.

Up until He-Man, all the figures, Big Jim and others had vertical hinge points at 90 degrees. Well Mark thought, why can't we just angle it? Mark wanted the arms to swing across the chest. So I went back and did a sketch and we showed the engineers that to prove it could be done.

What was your design process on the Wind Raider? What influenced you?

Just a lot of sketching with input from Mark.

Was the Wind Raider meant to be something of a seaplane? It looks a bit like a flying boat.

Yes, it was loosely based on a seaplane, but the dominant thing was the big engines so it could skim across the water and also take off and fly. We added the anchor later as we needed an action feature. The front monster was later changed to resemble a crocodile. Jim also did the models and tooling patterns on the Wind Raider.

Did you also create the stickers for the vehicles you designed? They featured some interesting creature designs.

Mark did the stickers based on the shapes I gave him. His wife Rebecca, who is a graphic designer, did the final art.

Can you talk about how you went about designing the Attak Trak? What influenced you at the time? I notice it originally had a canopy that was dropped from the final toy (but was included in a Monogram model kit version of the vehicle).

It started out as a mechanical toy submission that Mattel bought from an outside inventor. It was given to me, to make into a He-Man vehicle. I did about four different design directions, of which they picked one.

The canopy was dropped because it costed out quite high, so they looked at dropping as many extras as possible. By this time I was also doing all the control drawings, so when they went to the engineers, things were final.

Can you tell me a little about some of the other concept vehicles for Masters of the Universe that you have on your website? I see there is a green vehicle with a yellow bird head that drops down to reveal a disc shooting mechanism. What's the story behind that?

Marketing would try to bring back old concepts, because they didn't have to do any new engineering development on it, they could just do and incorporate it into the line. They may have had the patent on it and that would have made it easier too.

I was asked to design a He-Man vehicle with this feature. That's the vehicle I presented. I remember that I was always trying to come up with different types of illustrations. On this one I did the line drawing and had a cell made of it, then colored a background. The cell line drawing was then an overlay, just like animation.

It looks like you also designed the Jet Sled vehicle, which got released in 1986. Can you talk a bit about that one?

Mark left after the first year of He-Man . . . Mattel decided to reorganize, and combine Prelim and Visual Design.

At that time the Intellivision video game started to take off. I was promoted to design director and selected to be in charge of that division. That was when Roger was chosen to head up the He-Man group.

They closed that [Intellivision], and I was out of a job! Because I knew so many people there, Mattel offered me a job - in the He-Man group, under Roger! It was at that time I designed the other vehicles.

By this time there were about five other designers in this group. We would have group concept meetings, and out of those came the ideas for new figures and vehicles. That's when I also started to do the figures.

Did you also design the Talon Fighter vehicle (a yellow/blue/red bird-shaped vehicle that perched on top of Point Dread)?

Yes, that was just something that came out when I was doing the Eternia Sketch.

Can you talk a bit about how Castle Grayskull came into existence?

Mark did the original sketch. That was then sent to the sculpting department . . . There was competition between engineering, sculpting and design. What would happen is we would get the drawings, in this case Mark's Castle Grayskull drawing. Once it was accepted by marketing, we sent the drawings to sculpting to sculpt it, and it came back like Windsor Castle, all straight walls and square corners and turrets. Mattel had a great sculpting department, but they wanted to put their two cents in. We sent it back and it came back almost the same but modified, and that's when Mark said we should have a go.

Somehow Mark persuaded the powers in charge to let him sculpt it. The sculpting department was pissed! Mark set up a board in his office and with a bunch of Chevaler sculpting clay, set about modeling it. I took turns helping him, even my nine year old son had a go. When that was finished it went back to sculpting for molding and engineering.

It looks like you came up with or at least worked on quite a few figure designs, some of which became toys (Snout Spout, King Hiss, Hordak, Leech, etc.). What was your favorite figure design?

I worked on a lot of figures after I came back. I guess my favorite was Brainiac, but I don't know if that was ever made. [Editor's note: it was never produced.]

Can you talk a bit about your work on the Eternia play set?

I was given the project to design a play set that would dwarf Grayskull. I just stood at my drawing board and started sketching. I remember for some reason that I wanted to do a big drawing. It came out at 40" x 40."

Everyone liked the design, and it was decided, by someone, to do a size mock-up. I left Mattel around that time so I never knew until recently, that they actually produced it.

What is your fondest memory of working on the Masters of the Universe toy line?

Just a lot of fun. It was a great learning experience because there were so many talented people to learn stuff from.

If you could design a new vehicle or figure or play set for He-Man, what would it be?

That I would have to think about. It's been a long time since I was involved in that area. The things that I see being done by some of the up and coming generation are terrific, and I think they could do a better job than I!

What are some highlights of your career after you left Mattel?

I left Mattel to work for LJN Toys in New York. I ended up being VP in charge of design for the whole product line. We moved the design department back to California, and I hired Mark back to work for me. That was a great experience.

After that, Universal pictures bought out LJN. Later Mark again got hired as VP of Design for Playmates Toys. He then asked me to come work for him on the TMNT line where I designed a bunch of stuff. That was fun too!

I am still designing for other toy companies, and still enjoy it.

BEAM-BLASTER & ARTILLERAY

First released 1987 • Accessory of the Heroic Warriors

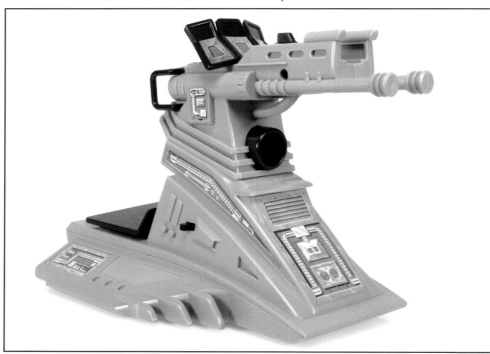

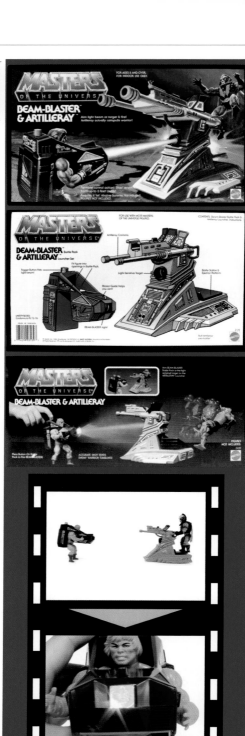

Beam-Blaster and Artilleray is a unique package that gives you large weapons for both your Heroic and Evil Warriors! This set features "remote control" blast action that is powered by AA batteries.

The Beam Blaster is a large laser cannon harness that can fit over most of your standard action figures. The Artilleray is a large double-barrel cannon with a base for warriors to stand on.

By pressing the large orange button on the back of the Beam Blaster, an infrared signal is emitted. If this signal connects with the Artilleray, a spring-loaded platform is released and the action figure standing on it is sent flying off!

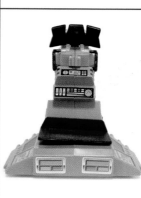

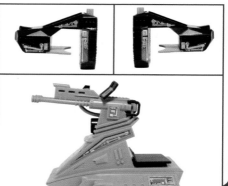

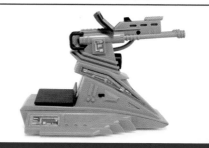

BEAST MAN
SAVAGE HENCHMAN!

First released 1982 • Member of the Evil Warriors

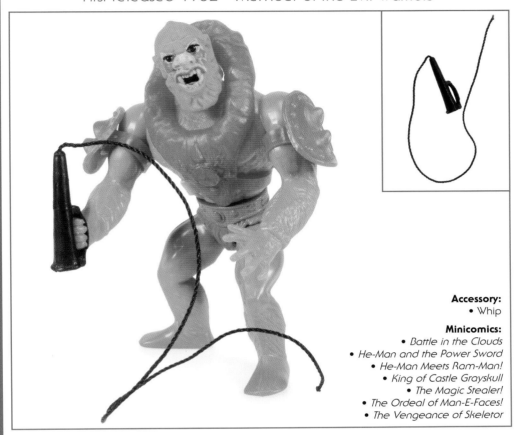

Accessory:
• Whip

Minicomics:
• Battle in the Clouds
• He-Man and the Power Sword
• He-Man Meets Ram-Man!
• King of Castle Grayskull
• The Magic Stealer!
• The Ordeal of Man-E-Faces!
• The Vengeance of Skeletor

This evil underling of Skeletor was one of the very first figures released in the original wave of figures. The character features a very bright orange sculpted-fur body with an ape-like look to his design. As a result, Beast Man was given a completely unique body type that would go on to be reused for other characters, such as Stratos and Moss Man.

Beast Man's figure includes the familiar spring-loaded "power punch" action feature that was very common throughout the line. By turning the figure's waist while holding his arm, the figure would quickly snap back into place once let go, to deliver the punch. This also worked well with Beast Man's included whip accessory, making it look as though he was using the weapon against his foes.

The whip accessory itself is another classic example of Mattel recycling a preexisting piece from one of their other toy lines. This whip was originally included with their 1976 The Whip action figure from the Big Jim toy line. This weapon featured a plastic handle with a long piece of black string for the whip. Since it was originally designed for a twelve-inch-tall action figure, it was technically too big for Beast Man. As a result, the figure has to hold it by the hand guard. Interestingly, Beast Man has an unpainted spiked knuckle duster weapon sculpted on his right hand. This reappears on the Stratos figure, since he uses the same arm as Beast Man.

Beast Man himself was almost the result of more Mattel recycling. Early designs for the character show the potential reuse of the 1974 Big Jim Jungle Adventure Gorilla. This would have made Beast Man a much larger action figure. Ultimately the decision was made to make Beast Man a figure that fit the size of the rest of the basic Masters of the Universe figures.

EIGHT-BACK

TWELVE-BACK

FUN FACTOID: The earliest known prototype for Beast Man has huge spikes along his chest armor, large golden bracers, and a large belt with a compass-like design on it. That design would later be moved to Beast Man's chest armor.

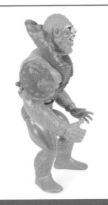
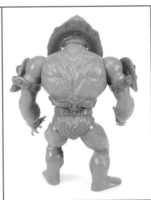
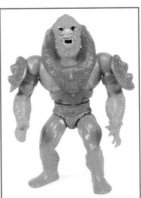

BIONATOPS
HEROIC BIONIC DINOSAUR

First released 1987 • Steed of the Heroic Warriors

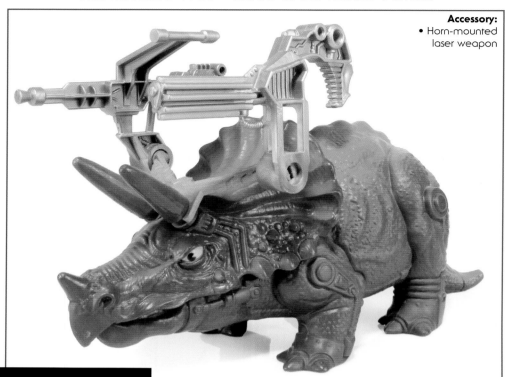

Accessory:
• Horn-mounted laser weapon

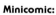

Minicomic:
• *Powers of Grayskull: The Legend Begins!*

Masters of the Universe includes a little bit of everything: swords, sorcery, technology . . . it's all here. So when the line was nearing the end of its shelf life and Mattel wanted to inject something new and exciting, they tapped into a classic theme that kids are always guaranteed to love: dinosaurs!

Bionatops is a heroic dinosaur, intended as a steed for He-Man or any of his allies. Unlike Battle Cat, this triceratops does not include a saddle for heroes to mount. Instead, the figures just rest on the dino's head between his horns, which admittedly is a little awkward and not the most stable seat.

Like any good dinosaur toy, Bionatops also features a hinge joint at his jaw, allowing you to open and close his mouth by pushing on the crown on his head. Aside from this joint, the dinosaur is otherwise in a static pose.

The sculpt is interesting, meshing the prehistoric beast with technology by adding bionic-looking pieces. Mounted to his back is a large gray laser that He-Man can hold on to while riding.

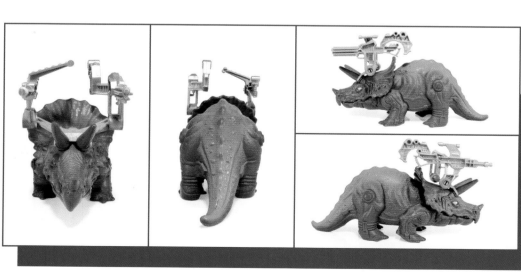

FUN FACTOID: David Wolfram's Bionatops concept art featured a gold gun rather than the silver one that came with the toy.

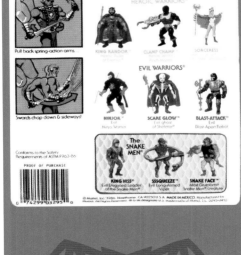

BLADE
EVIL MASTER OF SWORDS

First released 1987 • Member of the Evil Warriors

Accessories:
• Two swords

Minicomics:
• *The Cosmic Key*
• *The Powers of Grayskull: The Legend Begins!*

Blade is one of three figures released based on the *Masters of the Universe* motion picture. Mattel wanted new characters introduced into the film for the sole purpose of releasing these new characters as toys in the already successful toy line.

While the figure does not feature an accurate actor likeness, it does benefit from being one of the action figures with a completely unique sculpt with no shared parts. The upper body has the armor sculpted on, instead of the typical removable armor found on most other characters. The legs are also straighter, unlike the "battle-ready" squat pose of most of the other figures. Blade is overall thinner and less muscular.

Blade's figure includes the waist-twisting "power punch" action feature. In addition, his arms are also spring loaded at the shoulders. When you raise the figure's arms and let go, they quickly come snapping downward, mimicking a sword-swinging action.

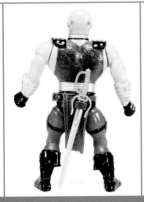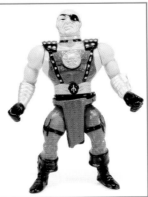

BLAST-ATTAK
EVIL BLAST-APART ROBOTIC WARRIOR

First released 1987 • Member of the Evil Warriors

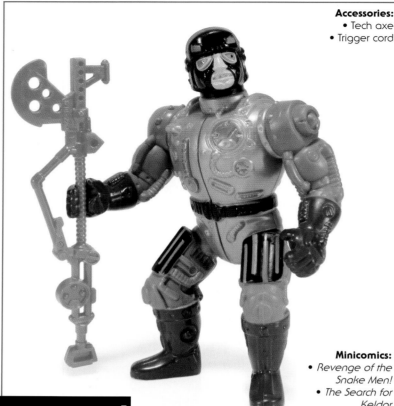

Accessories:
• Tech axe
• Trigger cord

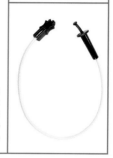

Minicomics:
• *Revenge of the Snake Men!*
• *The Search for Keldor*

Blast-Attak is one of the unique figures in the line. The package touts that "he flies apart," alluding to the fact that as a character, he is a robotic ticking time bomb who blows himself up to attack his enemies.

To achieve this exploding action feature, the figure's construction is very different from what is typical for Masters of the Universe. The figure is composed of two halves that fit together. To blow him apart, there is an included trigger cord that plugs into the figure's back. By pressing the button on the plunger at the end of the cord, a spring-loaded mechanism is triggered that blasts the two halves of the figure apart.

This action feature has been reused outside of the Masters of the Universe toy line by Mattel, with the exact same trigger cord accessory first being included with Mattel's 1986 Fort Kerium play set from their Bravestarr line of figures.

While Blast-Attak's packaging lists him as one of Skeletor's Evil Warriors, his included minicomic *Revenge of the Snake-Men* presented him as a creation of King Hiss, and thus affiliated with the Snake Men. This is an unusual allegiance for the character, since he has neither a snake-like appearance nor Snake Men markings like other members of the team. Other media depictions of the character during this time maintained his status as one of Skeletor's warriors.

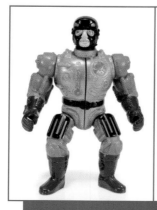

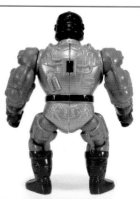

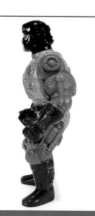

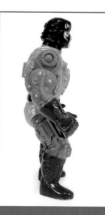

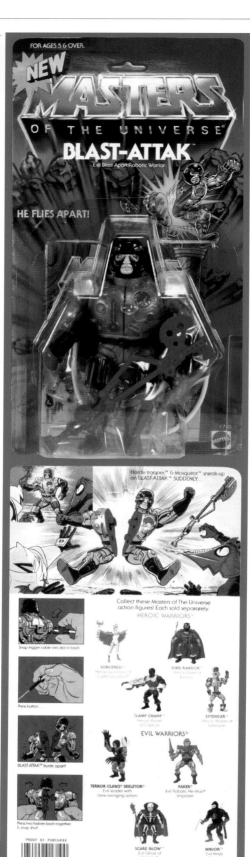

FUN FACTOID: A 1985 concept drawing by Mark Jones shows the character with a human face and a red-and-silver costume. The idea for a walking time bomb character in Masters of the Universe seems to have originated with Mark Taylor.

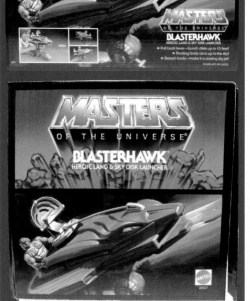

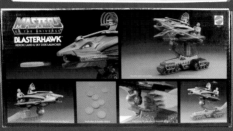

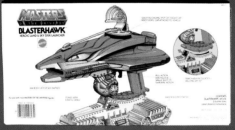

FUN FACTOID: Blasterhawk appears briefly in the background of the 1988 film *Big*.

BLASTERHAWK
HEROIC LAND & SKY DISK LAUNCHER

First released 1986 • Vehicle of the Heroic Warriors

Accessories:
• Eight disks

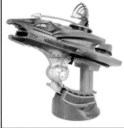

Blasterhawk also connects to the gun base from the Eternia play set!

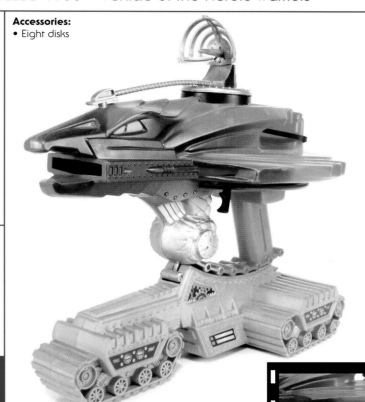

The heroic Blasterhawk is a disk-shooting vehicle. It is uniquely designed so that the shape of the vehicle is more like a kid-sized gun, allowing the user to hold it in their hand to fire the disks.

Blasterhawk has a base with sculpted tank treads, to which it can be attached to form a ground vehicle. It has a unique attachment point that allows you to aim the Blasterhawk upwards or downwards for firing. You can then detach it from this base for "in-flight" attacks.

8 disks are included, and can be loaded into the top by removing the radar dish. Single shot or rapid fire is possible. When launched, the disks fly out of the mouth-shaped opening in the front and spin through the air.

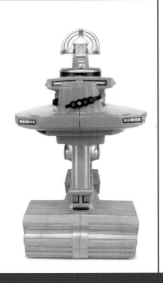

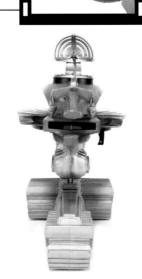

BUZZ-OFF
HEROIC SPY IN THE SKY

First released 1984 • Member of the Heroic Warriors

Minicomics:
• He-Man and the Insect People
• He-Man Meets Ram-Man!

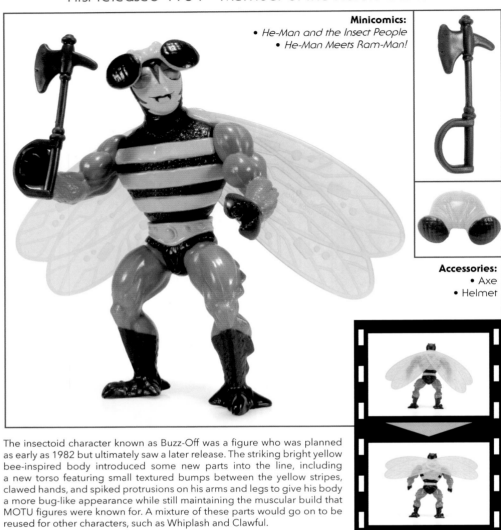

Accessories:
• Axe
• Helmet

The insectoid character known as Buzz-Off was a figure who was planned as early as 1982 but ultimately saw a later release. The striking bright yellow bee-inspired body introduced some new parts into the line, including a new torso featuring small textured bumps between the yellow stripes, clawed hands, and spiked protrusions on his arms and legs to give his body a more bug-like appearance while still maintaining the muscular build that MOTU figures were known for. A mixture of these parts would go on to be reused for other characters, such as Whiplash and Clawful.

Buzz-Off is notable for having a face sculpt that features a happy smile. His large bug eyes are painted a metallic blue-green color, which is meant to mimic the natural shine of a bee's eyes. Interestingly, his helmet also features a separate pair of eyes sculpted in brown, which does look a bit odd. The helmet is also a little large and loose fitting, so it tends to easily fall off the figure when worn.

The biggest standout of this figure is Buzz-Off's tech-inspired wings. These wings are molded in a translucent yellow plastic and feature a very distinctive sculpt, making them look as though they are cybernetically enhanced. They are attached to his back via a small peg in the center, allowing you to pose the wings up for flight, or down for standing. Buzz-Off also features the familiar "power punch" action feature found on many figures in the line. The clawed hands are very striking, but pose a problem when trying to hold the figure's included axe weapon. To remedy this, Mattel designed a loop on the handle that is meant to fit over the claw, allowing Buzz-Off to hold his weapon for battle. However, even with this addition, the axe has a hard time staying put on the oddly shaped claws.

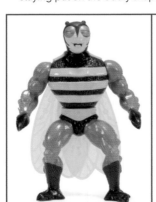 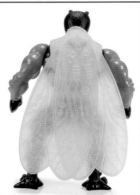 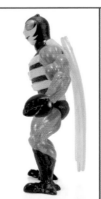 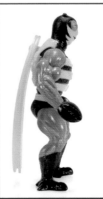

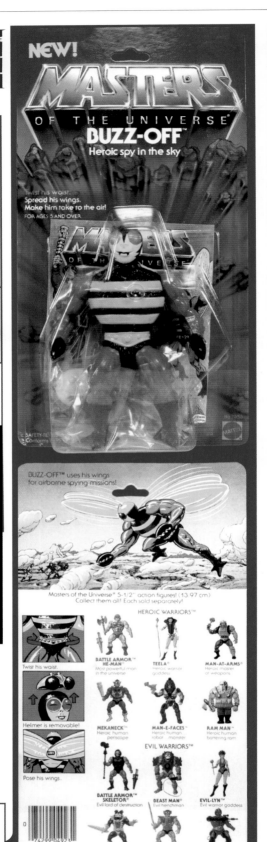

FUN FACTOIDS:
• Designed by Colin Bailey, an early prototype for Buzz-Off had a He-Man head (with brown hair) and a removable insectoid helmet.
• Buzz-Off's early working names were Wasp Man and Bug-Off.

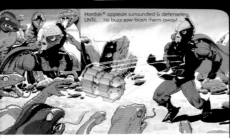

BUZZ-SAW HORDAK
RUTHLESS LEADER WITH BLASTER BLADE

First released 1987 • Member of the Evil Horde

Minicomic:
• *Enter...Buzz-Saw Hordak!*

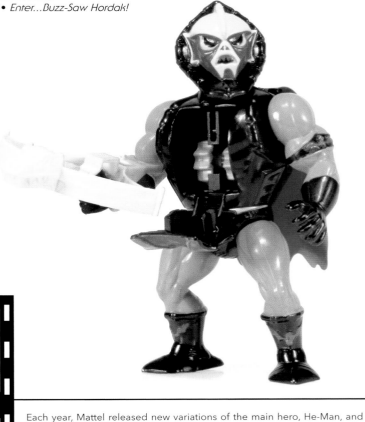

Accessories:
• Crossbow
• Blaster blade

Each year, Mattel released new variations of the main hero, He-Man, and the main villain, Skeletor. After Hordak was introduced as the leader of a new evil faction (and archnemesis of She-Ra), Mattel followed this pattern by also releasing new variations of Hordak for the remaining years. Enter, Buzz-Saw Hordak!

Unlike many of the other variations, that were notably different visually, at first glance Buzz-Saw Hordak does not look any different from the standard Hordak action figure. The color scheme is still the same—gray and black, with a bright red Horde bat emblem on his armor. However, with closer inspection, you'll notice that his torso is slightly larger than normal and shaped a bit differently.

This is because the new action feature is housed here. The construction of the figure is different from the standard figure as a result. The torso and pelvis piece are part of the same sculpt, which means there is no waist-twisting feature. The inside of the torso is hollowed out, as it stores his Blaster Blade projectile, as well as a firing mechanism to launch it out.

To activate this feature, there is a lever on Hordak's back, cleverly disguised by his red cape. Pulling this lever downward with your thumb will pop open a hidden door on Hordak's chest, revealing the Blaster Blade. Pulling the lever down a second time will then launch the Blade from his chest. The force of the launch is quite impressive, and if you have the figure standing on a flat, hard surface, the Blaster Blade will roll across it!

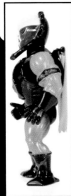

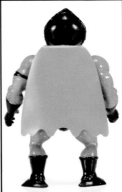

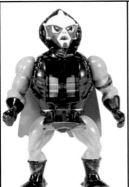

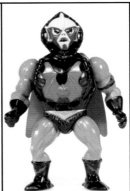

CASTLE GRAYSKULL
FORTRESS OF MYSTERY AND POWER

First released 1982 • Fortress of the Heroic Warriors

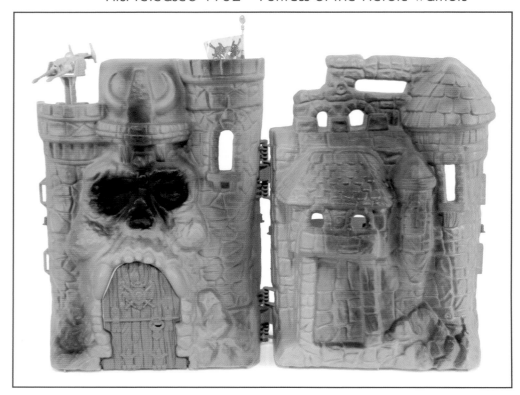

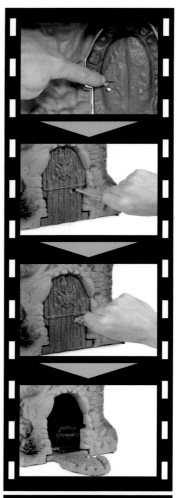

Launching with the Masters of the Universe toy line in 1982 was its most important play set: the mysterious Castle Grayskull. This green-bricked ancient castle with the ominous skull face was designed to be the point of struggle between the forces of good and evil. From a marketing standpoint, creating one play set that could work for either the good guys or the bad guys was quite ingenious! And the imposing design is remarkable. It looks like it could belong to Skeletor . . . it practically has his face on it! But fans knew the score. Castle Grayskull housed powerful secrets that the heroes needed to protect and the villains wanted to steal!

This story is worked right into the play set itself! It all starts at the Jawbridge. There is a small slot on the front where a figure can unlock the door. In order to do this, a character needs to obtain both halves of the Sword of Power (He-Man's and Skeletor's combined) to essentially create the key to Castle Grayskull. You can use the sword (or anything that fits in the slot, really) to slide the lock up so the Jawbridge can be lowered.

Inside you find a series of gadgets and traps awaiting unwanted visitors! Among the wild accessories found within are a weapons rack, complete with nine different weapons, such as a spear, an axe, a few blasters, a club, and even a shield. Some of the weapons that debuted here would end up being recolored and given to other figures later on in the toy line. There is a spinning training device of some sort. It looks like it's supposed to be an object that He-Man might punch and then dodge to train for battle against the Evil Warriors. There's also a ladder than can be positioned wherever you wish, allowing figures to climb up to the second level, or even to the towers.

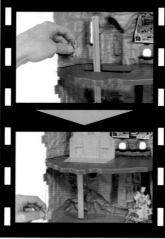

An elevator is also included. By pulling on a small gargoyle at the top of the elevator, a string will work as a pulley system to lift the elevator up to the second level. There are also some cardboard cutouts used to help decorate the interior. Next to the elevator is a series of screens that shows many colorful scenes from around Eternia and out in space. There's also the robot armor, which looks similar to a suit of armor you might see inside a medieval castle, but with a much more futuristic flair.

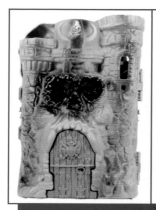 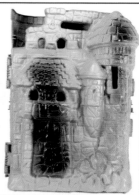 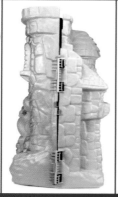 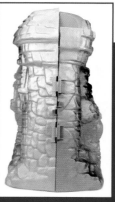

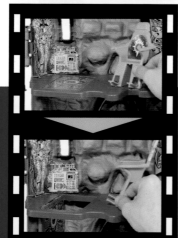

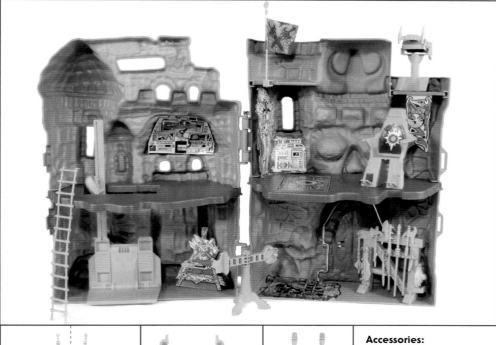

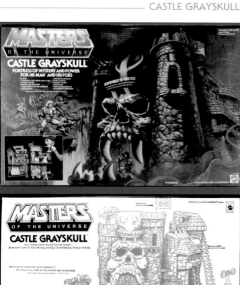

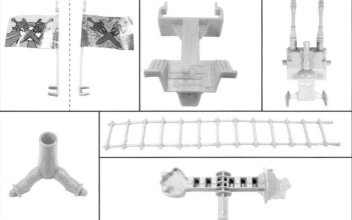

Accessories:
- Flag
- Laser cannon
- Ladder
- Combat training device
- 2 Halberds
- Spear
- Rifle
- Blaster
- Axe
- Sword
- Club
- Shield
- Weapons Rack

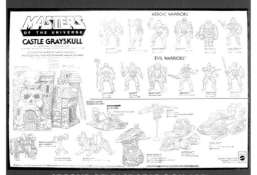

FIRST RELEASE REAR BOX ART

SECOND RELEASE REAR BOX ART

FUN FACTOIDS:
- The original prototype had a secret back door entrance, which was cut from the final toy.
- A play mat with a moat design was created for the castle but cut from the final product.

On the second level on the right side is a throne that sits in front of a unique rug on the floor. If a figure is standing on this rug, you can turn the throne to reveal that the rug is actually a trapdoor! This will send your figure falling to the lower level, where they will land on top of one of the most memorable stickers inside: the dungeon grate! Even though this is not a sculpted piece, there is so much going on with the artwork on this sticker that it is enjoyable enough just to stare at it for long periods of time, studying all the weird creatures attempting to escape!

The towers even featured small platforms. One tower has a large laser cannon that can be used to fire down at approaching enemies. There's not a lot of room to stand a figure here, however. And then there's the flag. This has a unique feature where each side of the flag is meant to represent either the heroes or the villains. Flipping this flag is supposed to mark who currently has control over the castle!

There's quite a lot going on here. Fun play features, a ton of accessories, and a great look. There have been a lot of wonderful play sets released from the many toy lines out there, but it's hard to think of any that are as iconic as Castle Grayskull.

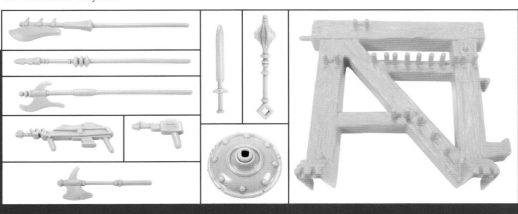

CLAMP CHAMP
HEROIC MASTER OF CAPTURE

First released 1987 • Member of the Heroic Warriors

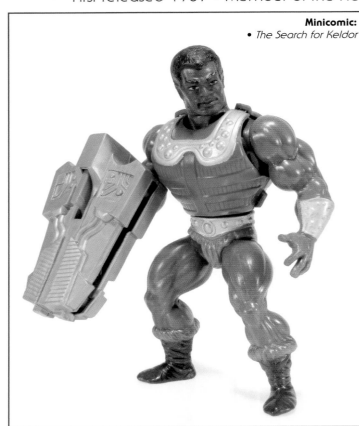

Minicomic:
• *The Search for Keldor*

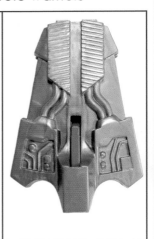

Accessory:
• Power pincer

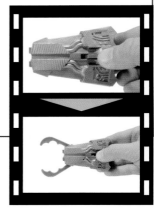

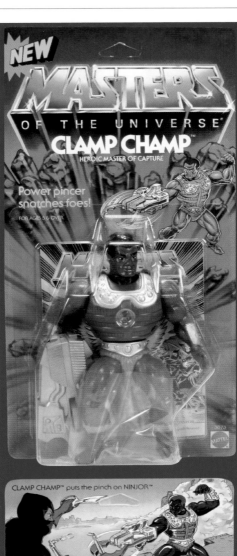

CLAMP CHAMP™ puts the pinch on NINJOR™

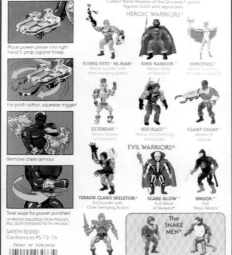

At this point in the line, many of the new figures being released were getting newly sculpted pieces, since Mattel's budget had improved. Clamp Champ, however, is one of the few later figures that follows the original formula of parts reuse, utilizing He-Man's entire body and a modified Fisto armor, with the head sculpt being the only truly new piece on the figure.

However, what he lacks in regard to newly sculpted pieces, he makes up for with paint details. Clamp Champ features more paint deco than many of the early figures, including He-Man himself. Two-tone boots and fully painted wrist bracers really make him stand out a little more. The bright blue, silver, and red all complement each other well to make for a distinctive new character that feels very "original MOTU."

While Clamp Champ features the familiar "power punch" action feature, the true charm here lies in his fun Power Pincer weapon. This oversized hunk of plastic, which somewhat resembles a mechanical shield, has a small handle that fits in the figure's right hand and a small lever on the top. By pressing this lever, two large red claws come quickly snapping forward to grab on to anything or anyone who gets in his way. This claw-pinching action feature works remarkably well and is incredibly satisfying to play with. It's easy to find yourself using Clamp Champ to just grab on to all your other action figures and tossing them around your make-believe battlefield.

While Black characters had appeared in the *He-Man and the Masters of the Universe* cartoon series earlier, Clamp Champ marks the first black character to get an action figure in the toy line.

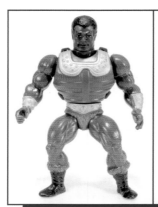

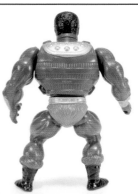

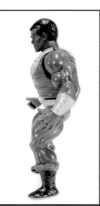

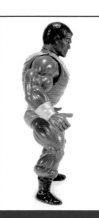

CLAWFUL
WARRIOR WITH THE GRIP OF EVIL!

First released 1984 • Member of the Evil Warriors

Accessory:
• Mace

Minicomic:
• *The Clash of Arms*

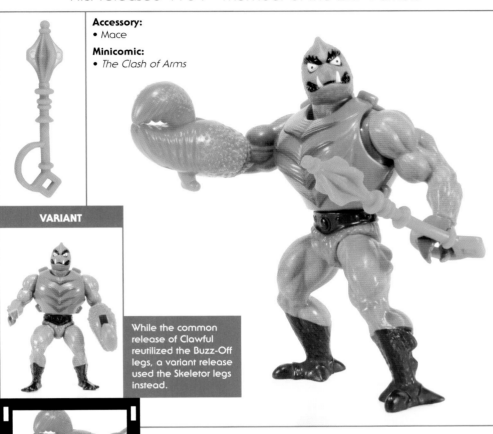

VARIANT

While the common release of Clawful reutilized the Buzz-Off legs, a variant release used the Skeletor legs instead.

Many of the early figures in the line were characters that were some sort of half-human, half-animal hybrid. Clawful is one of the more striking of these early releases, with a bright red crab-like look that really makes him stand out.

Clawful's figure shares parts with figures like Buzz-Off and Whiplash, specifically his monster-like legs with the jagged ridges on the sides and the oversized clawed feet. While this is the common look for Clawful, it's worth noting that there is a variation that instead uses the same legs seen on the Skeletor action figure. This version is more obscure than the one with the Buzz-Off legs, so it is thought to be an early release before the change was made.

Clawful also has Buzz-Off's arms, but the right hand is replaced with a large red crab claw. This claw houses an action feature in which, by pressing the lever on the underside, Clawful's claw can open and snap shut. This allows him to grab on to the arms or weapons of other action figures.

Clawful's weapon is a green version of the same mace that was included with the Castle Grayskull play set, with one unique difference. Like what was done with Buzz-Off's axe, a loop was added to the handle so that it can be clipped over Clawful's unique clawed hand. Also like with Buzz-Off's axe, this still tends to fall off the hand easily.

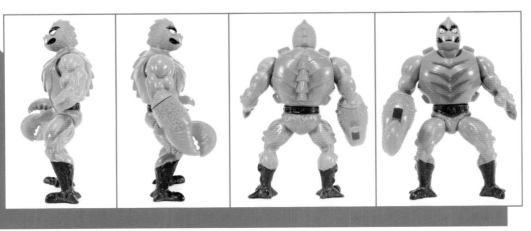

CLIFF CLIMBER POWER GEAR
MOTORIZED MOUNTAIN BATTLE EQUIPMENT

First released 1987 • Accessory of the Heroic Warriors

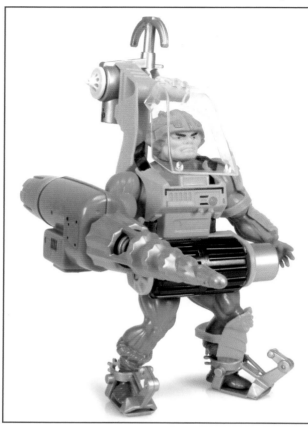

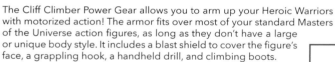

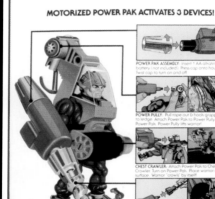
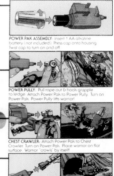

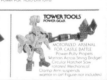

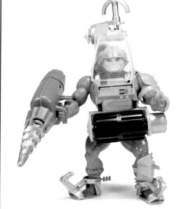

The Cliff Climber Power Gear allows you to arm up your Heroic Warriors with motorized action! The armor fits over most of your standard Masters of the Universe action figures, as long as they don't have a large or unique body style. It includes a blast shield to cover the figure's face, a grappling hook, a handheld drill, and climbing boots.

The set includes a small motor that requires one AA battery. This motor can be plugged into three different areas on the Power Gear, triggering different action features. The drill can be plugged on to the front and used as a handheld tool, with the drill bit spinning when held. You can also plug the motor into the back, which moves the large roller on the front and allows your figure to roll across the floor.

The most fun feature just might be the grappling hook. You can attach this hook to a high point, such as the tower of Castle Grayskull. By plugging the motor into the top of the Power Gear and turning it on, the motor will retract the grappling rope, causing your figure to climb upward!

FUN FACTOID: The motors are interchangeable between the "Motorized Battle Equipment."

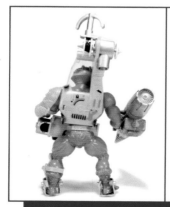
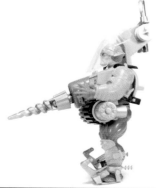
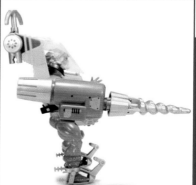

MASTERS OF THE UNIVERSE **Meteorbs**

...creatures that transform!

COMET CAT

Transform COMET CAT™ back into its orb!

① Snap open top of shell body.
② Push tail into slot on back.
③ Fold front feet as shown in Ⓐ. Fold front legs as shown in Ⓑ.
④ Fold hind legs up as shown.
⑤ Fold in rear body.
⑥ Fold head into body.
⑦ Fold front legs into body.
⑧ Snap shell shut!

COLLECT 'EM ALL! EACH SOLD SEPARATELY

HEROIC METEORBS

COMETROID™
Heroic Meteorb with mechanical might!

TY-GRRR™
Heroic cat with super-leaping power!

ASTRO LION™
Heroic lion with amazing brute strength!

COMET CAT™
Heroic panther is the fastest of the Meteorbs!

TUSKOR™
Heroic mammoth busts force-fields with tusks!

EVIL METEORBS

DINOSORB™
Evil dinosaur stomps to eart quakes!

CROCOBITE™
Evil crocodile with crushing jaws!

RHINORB™
Evil rhino with horrible ramming horn!

ORBEAR™
Evil grizzly bashes enemies with claws!

GORE-ILLA™
Evil ape with monstrous muscle power!

COSMIC ORIGIN OF THE METEORBS—
The meteor shower that brought the Comet Warriors™ also brought the Meteorbs. Both good and evil, they possess extraordinary powers! The Meteorbs restore their energy while in the orb form—when they can roll into battle and bowl over enemies!

PROOF OF PURCHASE

74299 01407

FUN FACTOID: Meteorbs were originally Bandai Tamagoras. Mattel acquired the license to release the toys under the Masters of the Universe Meteorbs name, similar to how Hasbro acquired the rights to produce Takara's Diaclone and Microman lines under the Transformers name.

COMET CAT
HEROIC PANTHER IS THE FASTEST OF THE METEORBS!

First released 1986 • Member of the Heroic Meteorbs

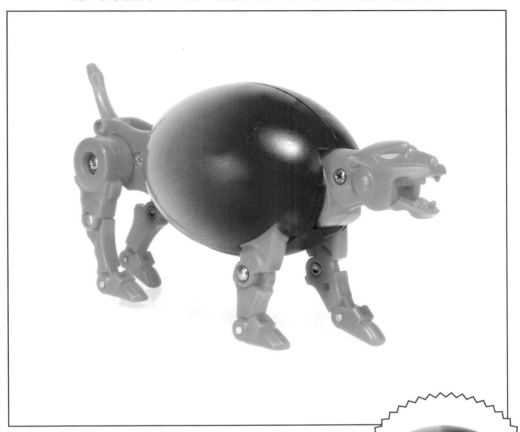

The Meteorbs are egg-shaped meteor rocks that can transform into animals and robots.

These transforming toys were originally released in Japan by Bandai under the name "Tamagoras." They were brought to the US by Mattel and released as characters in the Masters of the Universe line of action figures. This was Mattel's attempt to add the popular transforming toy mechanism seen in other lines, such as Transformers.

The transformation from meteor to animal is a fairly simple mechanism, usually not requiring instructions. By simply popping open the toy, you can easily fold out the legs and head to complete the transformation.

Comet Cat features a red coloration, and when fully transformed looks like a robotic panther. Minimal articulation can be found in the legs, allowing for a small amount of posability.

The Meteorbs at times feel out of place among the many action figures found within Masters of the Universe, but somehow they still fit within the combination of magic and science fiction that allowed the toy line to incorporate so many widely differing designs.

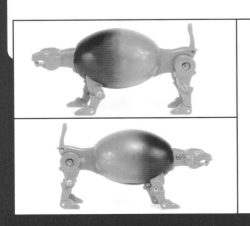

COMETROID
HEROIC METEORB WITH MECHANICAL MIGHT!

First released 1986 • Member of the Heroic Meteorbs

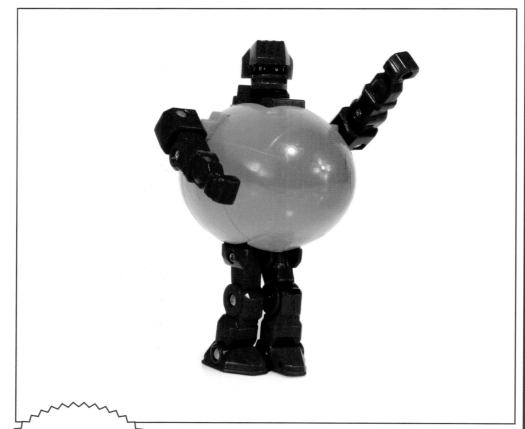

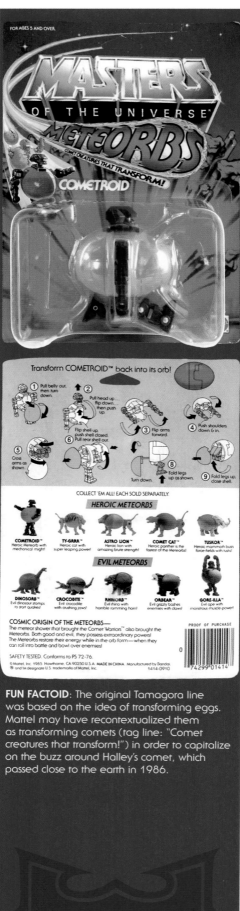

The Meteorbs are meteor rocks that can transform into animals and robots.

These transforming toys were originally released in Japan by Bandai under the name "Tamagoras." They were brought to the US by Mattel and released as characters in the Masters of the Universe line of action figures. This was Mattel's attempt to add the popular transforming toy mechanism seen in other lines, such as Transformers.

The transformation from meteor to animal is a fairly simple mechanism, usually not requiring instructions. By simply popping open the egg-shaped toy, you can easily fold out the legs and head to complete the transformation.

Cometroid is unique among the rest of the Meteorbs, as he looks much more like a classic robot than a robotic animal. Once transformed, his body features an orange-colored egg-shaped torso with blue arms, legs, and robotic head. A small amount of articulation allows you to pose the legs and arms.

The Meteorbs at times feel out of place among the many action figures found within Masters of the Universe, but somehow they still fit within the combination of magic and science fiction that allowed the toy line to incorporate so many widely differing designs.

FUN FACTOID: The original Tamagora line was based on the idea of transforming eggs. Mattel may have recontextualized them as transforming comets (tag line: "Comet creatures that transform!") in order to capitalize on the buzz around Halley's comet, which passed close to the earth in 1986.

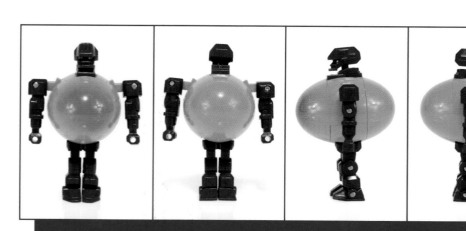

CROCOBITE
EVIL CROCODILE WITH CRUSHING JAWS!

First released 1986 • Member of the Evil Meteorbs

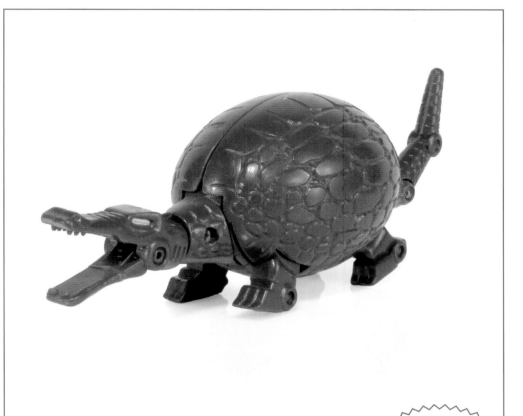

MASTERS OF THE UNIVERSE METEORBS
CREATURES THAT TRANSFORM!

CROCOBITE

FOR AGES 5 AND OVER.

Transform CROCOBITE™ back into its orb!

① Pull shell halves apart.
② Fold head into body.
③ Fold tail up. Push tip of tail up. Fold tail down.
④ Bend bottom of rear leg back as shown.
⑤ Fold legs into body.
⑥ Snap shell shut.

COLLECT 'EM ALL! EACH SOLD SEPARATELY

HEROIC METEORBS

COMETROID™ — Heroic Meteorb with mechanical might!
TY-GRRR™ — Heroic cat with super leaping power!
ASTRO LION™ — Heroic lion with amazing brute strength!
COMET CAT™ — Heroic panther is the fastest of the Meteorbs!
TUSKOR™ — Heroic mammoth bush force-fields with tusks!

EVIL METEORBS

DINOSORB™ — Evil dinosaur stomps to start quakes!
CROCOBITE™ — Evil crocodile with crushing jaws!
RHINORB™ — Evil rhino with horrible ramming horn!
ORBEAR™ — Evil grizzly bashes enemies with claws!
GORE-ILLA™ — Evil ape with monstrous muscle-power!

COSMIC ORIGIN OF THE METEORBS—
The meteor shower that brought the Comet Warrior™ also brought the Meteorbs. Both good and evil, they possess extraordinary powers! The Meteorbs restore their energy while in the orb form — when they can roll into battle and bowl over enemies!

PROOF OF PURCHASE

SAFETY TESTED: Conforms to PS 72-76
© Mattel, Inc. 1985. Hawthorne, CA 90250 U.S.A. MADE IN CHINA. Manufactured by Bandai ® and its designation U.S. trademarks of Mattel, Inc.
74299 01410
1410-0910

The Meteorbs are meteor rocks that can transform into animals and robots.

These transforming toys were originally released in Japan by Bandai under the name "Tamagoras." They were brought to the US by Mattel and released as characters in the Masters of the Universe line of action figures. This was Mattel's attempt to add the popular transforming toy mechanism seen in other lines, such as Transformers.

The transformation from meteor to animal is a simple mechanism, usually not requiring instructions. By simply popping open the toy, you can easily fold out the legs and head to complete the transformation.

Crocobite's egg-shaped body features a scaly sculpt. Once transformed, he takes on the shape of an alligator with an articulated jaw, allowing him to bite. According to the appearance of the Meteorbs in Star Comics, Crocobite appears to be the leader of the Evil Meteorbs faction.

The Meteorbs at times feel out of place among the many action figures found within Masters of the Universe, but somehow they still fit within the combination of magic and science fiction that allowed the toy line to incorporate so many widely differing designs.

DINOSORB
EVIL DINOSAUR WHO STOMPS TO START QUAKES!

First released 1986 • Member of the Evil Meteorbs

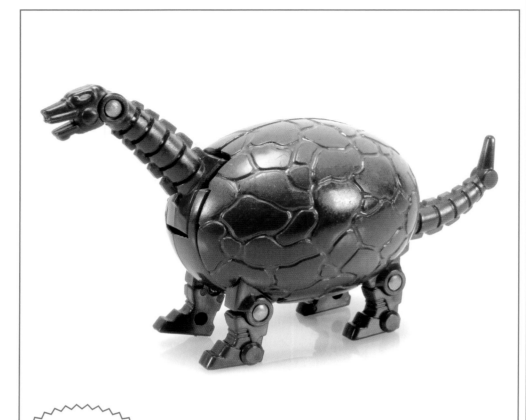

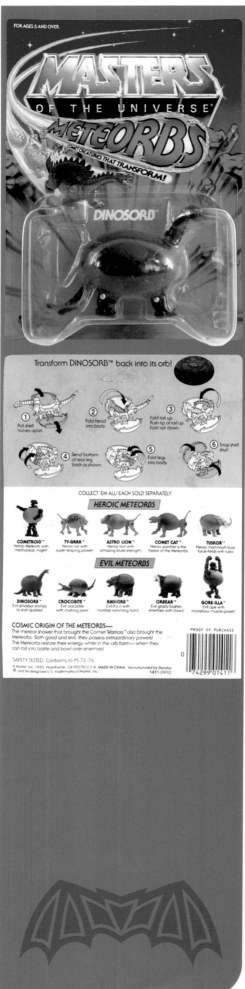

Transform DINOSORB™ back into its orb!

① Pull shell halves apart. ② Fold head into body. ③ Fold tail up. Push tip of tail up. Fold tail down.

④ Bend bottom of rear leg back as shown. ⑤ Fold legs into body. ⑥ Snap shell shut.

COLLECT 'EM ALL! EACH SOLD SEPARATELY.

HEROIC METEORBS

COMETROID™ Heroic Meteorb with mechanical might! TY-GRRR™ Heroic car with super leaping power! ASTRO LION™ Heroic lion with amazing brute strength! COMET CAT™ Heroic panther is the fastest of the Meteorbs! TUSKOR™ Heroic mammoth busts force-fields with tusks!

EVIL METEORBS

DINOSORB™ Evil dinosaur stomps to start quakes! CROCOBITE™ Evil crocodile with crushing jaws! RHIORB™ Evil rhino with horrible ramming horn! ORBEAR™ Evil grizzly bashes enemies with claws! GORE-ILLA™ Evil ape with monstrous muscle-power!

COSMIC ORIGIN OF THE METEORBS—
The meteor shower that brought the Comet Warriors™ also brought the Meteorbs. Both good and evil, they possess extraordinary powers! The Meteorbs restore their energy while in the orb form—when they can roll into battle and bowl over enemies!

SAFETY TESTED. Conforms to PS 72-76.

© Mattel, Inc. 1985. Hawthorne, CA 90250 U.S.A. MADE IN CHINA. Manufactured by Bandai. ® and ™ designate U.S. trademarks of Mattel, Inc.

The Meteorbs are meteor rocks that can transform into animals and robots.

These transforming toys were originally released in Japan by Bandai under the name "Tamagoras." They were brought to the US by Mattel and released as characters in the Masters of the Universe line of action figures. This was Mattel's attempt to add the popular transforming toy mechanism seen in other lines, such as Transformers.

The transformation from meteor to animal is a fairly simple mechanism, usually not requiring instructions. By simply popping open the toy, you can easily fold out the legs and head to complete the transformation.

Dinosorb is the one dinosaur-themed Meteorb. His purple-colored, egg-shaped body features a scaly sculpt. When transformed, Dinosorb has a long neck with an articulated head, a long tail that moves up and down, and short articulated legs.

The Meteorbs at times feel out of place among the many action figures found within Masters of the Universe, but somehow they still fit within the combination of magic and science fiction that allowed the toy line to incorporate so many widely differing designs.

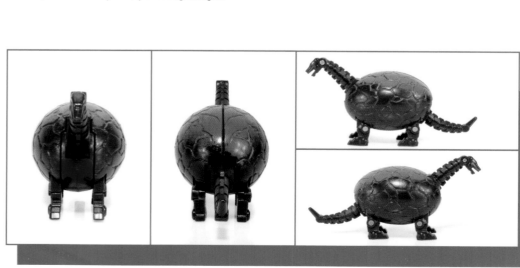

DRAGON BLASTER SKELETOR
EVIL LEADER & HIS DREADFUL DRAGON WITH "PARALYZING" SPRAY!

First released 1985 • Member of the Evil Warriors

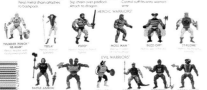

FUN FACTOID: An early concept for this figure called "Smoke and Chains Skeletor" shot out puffs of talcum powder as "smoke." However the "smoke" turned out to be very flammable, so the idea was dropped and the toy was redesigned to shoot water.

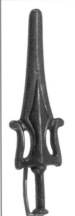
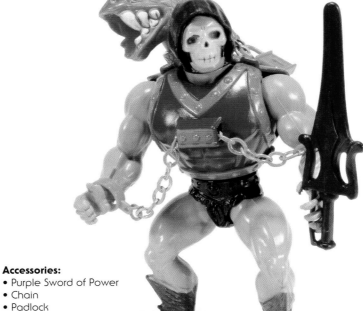

Accessories:
• Purple Sword of Power
• Chain
• Padlock
• Removable armor with dragon on back

Minicomic:
• *Skeletor's Dragon*

Dragon Blaster Skeletor is one of the "deluxe" releases, packaged on a larger card back and set at a higher price point. The figure includes extra accessories with a bigger, bulkier feel that make him feel worthy of that "deluxe" title.

The main feature here is Skeletor's pet dragon attached to his back. The rear of Skeletor's armor was sculpted so it looks like a small reddish-purple dragon that clung to the figure's back. A metal chain drapes from the collar around the dragon's neck, hooks to the front of Skeletor's armor, and links to Skeletor's wrist, making it look like a leash to keep the dragon from scurrying away. The dragon features a "paralyzing" spray action feature. The head of the dragon is removable, allowing you to fill the body with water. Once the head is back in place, pumping the head down causes the water to spray out of the dragon's mouth in the form of a light mist. This action feature is much like the one seen on Kobra Khan.

While the Skeletor figure's sculpt looks mostly similar to past releases, there is one major difference in that the figure's feet are much larger. This is to keep the figure better balanced for standing, since he now has a very top-heavy dragon attached to his back.

There is a noticeable paint difference sometimes found with the face, depending on what country the figure was manufactured in. While some releases feature a paint deco reminiscent of earlier Skeletor figures, with the yellow face and a green pattern around the outside, there are some versions that feature a very noticeable, more M-shaped pattern on the green parts of his face.

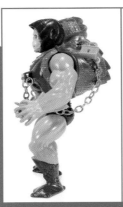
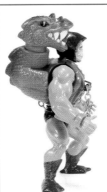

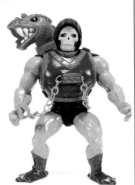

DRAGON WALKER
SIDEWINDING BEAST/VEHICLE

First released 1984 • Vehicle of the Heroic Warriors

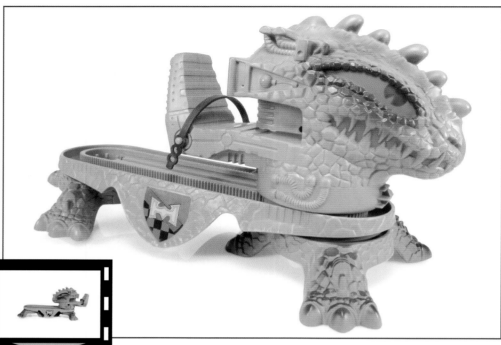

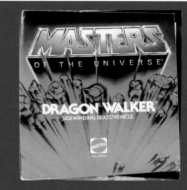

This battery-powered heroic vehicle has a pretty incredible action feature! The dragon shaped head has a seat for your action figures. The head rests on a long track, which in turn rests on legs. It's a very distinctive design that really fits right in with the look of Masters of the Universe.

Once powered on, the dragon vehicle drives forward on the track. Once it gets to the end of the track, the track section swivels around so that the section of the track that was behind the dragon is now in front of him. The dragon vehicle then continues along the track. This repeats, essentially creating a never-ending track. This allows your figures to cover quite a bit of distance!

The Dragon Walker seems a bit impractical when thinking about it in terms of an actual vehicle that the warriors would drive into battle. But it definitely makes for a fun toy gimmick! Dragon Walker is one of the most memorable vehicles from the original toy line.

FUN FACTOID: An early concept drawing by Ed Watts had the figures standing on a platform within the vehicle's head, rather than sitting.

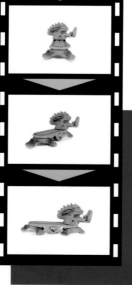

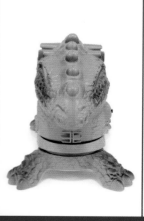

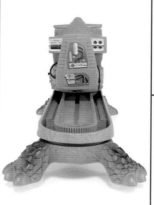

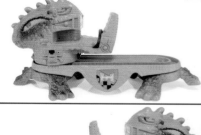

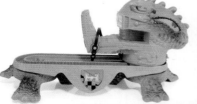

DRAGSTOR
TRANSFORMING EVIL WARRIOR VEHICLE

First released 1986 • Member of the Evil Horde

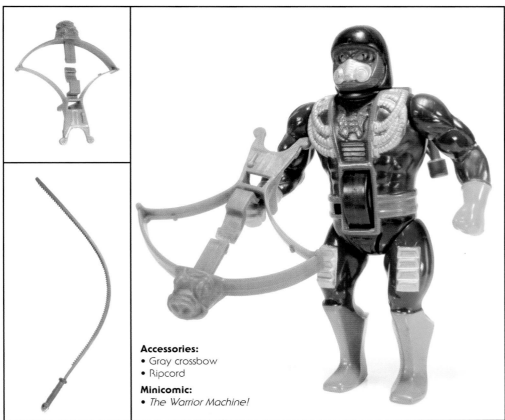

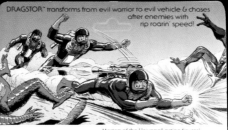

Accessories:
• Gray crossbow
• Ripcord

Minicomic:
• *The Warrior Machine!*

Dragstor was introduced as the Evil Horde hunter who transforms into a pursuit machine! It's quite possible that the introduction of a figure into the line whose action feature was transformation into a vehicle was an attempt by Mattel to cash in on the popularity of Hasbro's Transformers, which was heavy competition at the time.

Although the packaging touts that the figure "transforms," there's very little, if any, actual transformation involved. The figure features a large wheel embedded in his torso, with a slot for the ripcord off to the side. By folding the figure's arms upward—the extent of his "transformation"—and laying him down face first on a smooth surface, you can prepare the figure to act as a vehicle. Rapidly pulling the ripcord from the slot will spin the wheel and send the figure zooming across the surface.

Such a unique action feature for this figure resulted in an entirely new sculpt with no reused parts from any other figure. His slender body is far less muscular and less barbarian in nature. Dragstor is definitely imbued with the more tech-heavy theme the Horde was known for, specifically in the *She-Ra: Princess of Power* animated series, despite the fact that he never appeared in the show.

FUN FACTOID: Dragstor (working name: "Engine Man") was designed by Ed Watts. His early concept art featured a reptilian-looking helmet and wheels on his elbows and knees. These details found their way into the minicomic *The Warrior Machine.*

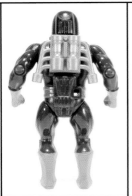
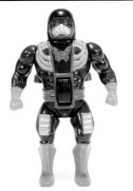

ETERNIA
THE ULTIMATE BATTLEGROUND!

First released 1986 • Fortress of the Heroic Warriors

Minicomic:
• *The Ultimate Battleground!*

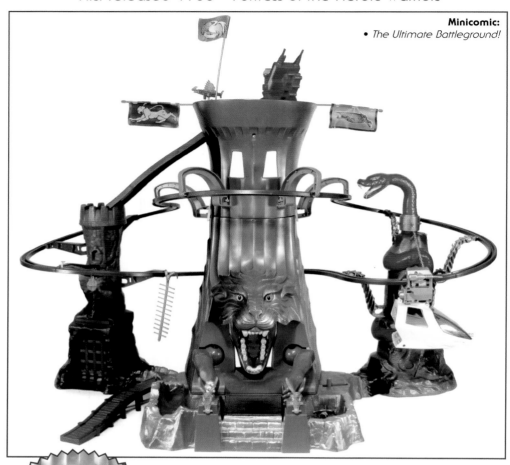

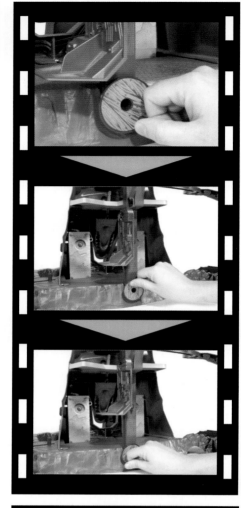

The Eternia Play set is the largest toy Mattel produced for the Masters of the Universe toy line. It features three large towers connected with a monorail track and multiple vehicles that can run along that track!

The Central Tower is the largest portion of the play set, measuring over thirty inches in height! It features four floors on the inside for plenty of room to store or play with your figures. You'll also find a command console inside and a red laser cannon that sits on top. An elevator can be manually moved between the levels.

The base of this tower looks like a moat. The moat is accomplished via a sticker with some great artwork and features quite a few unique creatures for added atmosphere! The lower portion of the Central Tower looks like the face of a blue lion. This lion works as a trap, as the two arms on either side of the face can be used to grab on to figures and trap them in the lion's mouth! You can also control this mouth piece from the inside. Closing the mouth lowers a drawbridge over the moat for figures to cross.

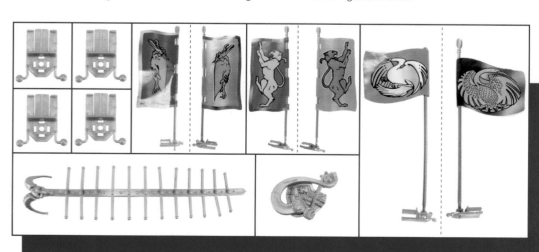

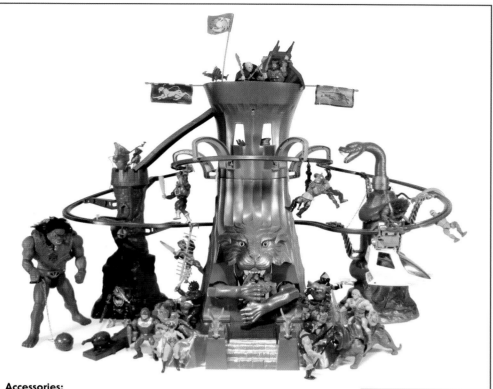

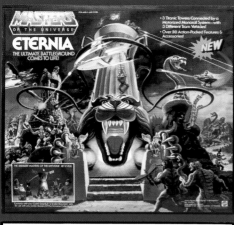

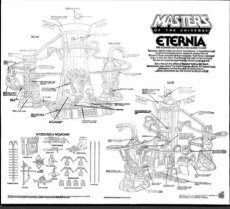

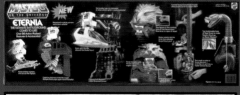

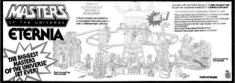

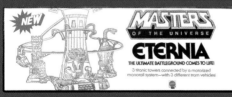

Accessories:

- Four spear & weapon clip mounts
- Three flag spears & flags
- Grappling ladder
- Star launcher
- Weapons rack
- Sword rifle
- Long bow
- Moat ray
- Dart launcher
- Rocket launcher
- Four grappling hooks
- Laser Crossbow
- Track trigger

There are a ton of fun additional details worked into the sculpt of this base. There are two gargoyles sitting near the front. One of those is hollowed out and can be moved to reveal a hidden compartment. All along the outside you can see the shape of several recognizable weapons, such as a bunch of the Castle Grayskull weapons and even He-Man's sword!

FUN FACTOID: Eternia was originally designed by Ted Mayer. One early version of it had three towers with three different animal heads on it, and a set of tracks that went along the ground rather than suspended in the air.

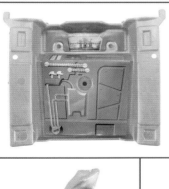

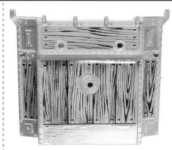

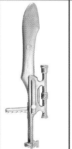

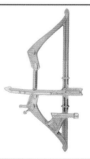

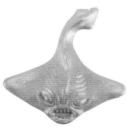

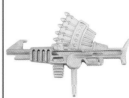

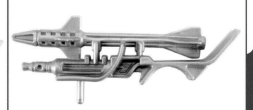

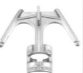

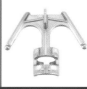

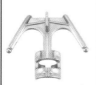

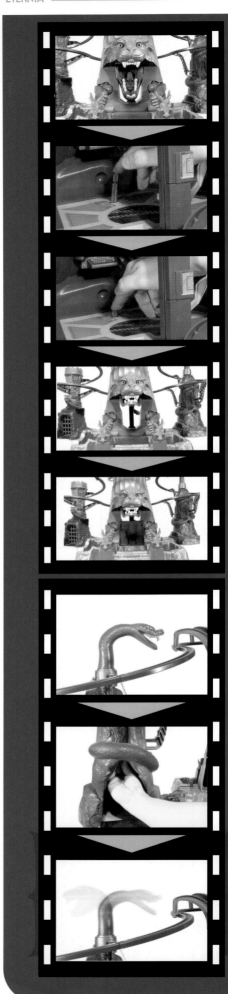

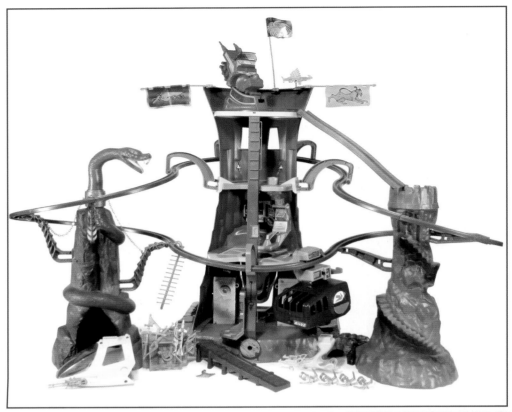

The Grayskull Tower is designed with the familiar green brick design of Castle Grayskull. The main action feature in this tower is the prison gate. This gate has a chain that is attached to a ball. This ball can be snapped on to one of the monorail supports. When a vehicle comes by this portion of the track, the ball is released and falls, causing the gate to slam shut, trapping a foe inside the cell!

The Viper Tower is meant to resemble Snake Mountain. The snake head on the top can telescope out of the tower and can be swiveled around.

As mentioned, there are three different vehicles that can run along the monorail: the Jet Pak Fighter, the Battle Tram, and the Sky Cage! The Sky Cage is the most memorable of the three. When the red tab on top of the cage is moved while it is running along the track, the bottom of the cage opens and drops the figure within to the ground below!

The Eternia Play set was released towards the end of the line and was set at a high price point. It is believed that because of this, there weren't many sold, resulting in not as many being made as other play sets in the line. This has resulted in the play set being a bit harder to come by these days. Couple that with the fact that there are so many accessories that can easily be lost. The monorail tracks are also notoriously brittle, so it's very hard to find one without broken tracks. If you ever have the chance to play with one that is complete and in working order, it's an incredibly fun and impressive toy!

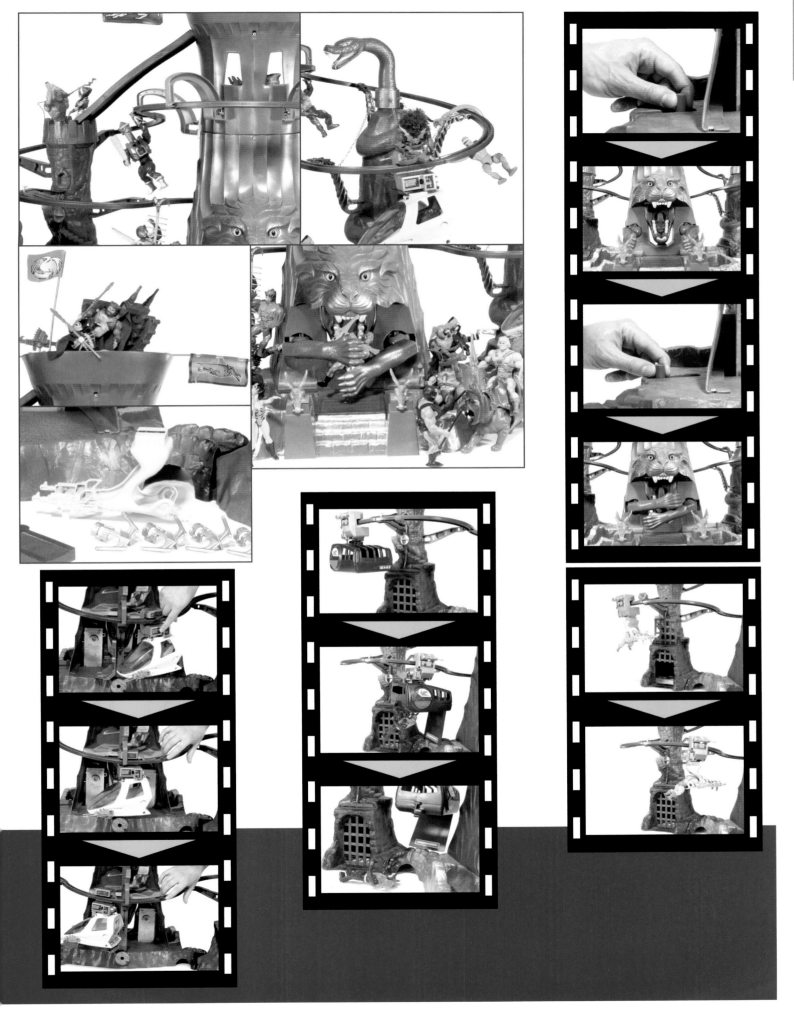

EVIL-LYN
EVIL WARRIOR GODDESS

First released 1983 • Member of the Evil Warriors

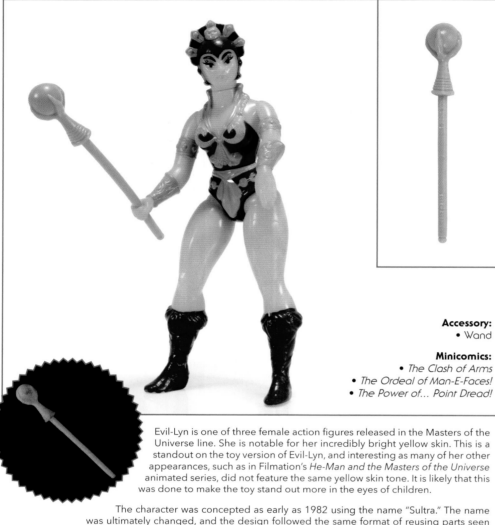

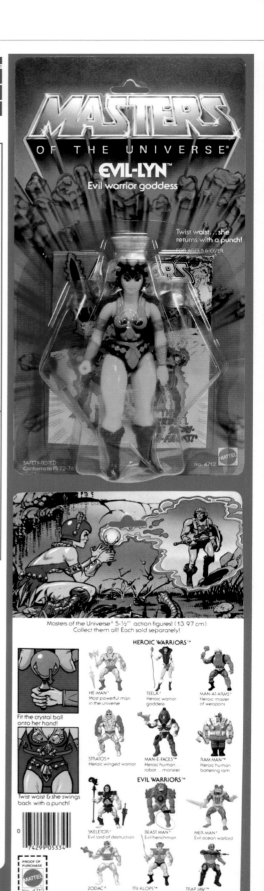

Accessory:
• Wand

Minicomics:
• *The Clash of Arms*
• *The Ordeal of Man-E-Faces!*
• *The Power of… Point Dread!*

Evil-Lyn is one of three female action figures released in the Masters of the Universe line. She is notable for her incredibly bright yellow skin. This is a standout on the toy version of Evil-Lyn, and interesting as many of her other appearances, such as in Filmation's *He-Man and the Masters of the Universe* animated series, did not feature the same yellow skin tone. It is likely that this was done to make the toy stand out more in the eyes of children.

The character was concepted as early as 1982 using the name "Sultra." The name was ultimately changed, and the design followed the same format of reusing parts seen throughout many of the early releases. The entire figure, except for the head, utilizes the Teela sculpt, minus the snake armor included with the Teela figure.

Evil-Lyn's included staff accessory was originally intended to be a much shorter wand accessory, but was later changed to the longer staff to avoid a choking hazard for young kids. The wand is molded in glow-in-the-dark blue plastic. Interestingly, the packaging for the figure does not even mention this glow-in-the-dark feature. Instead, it only mentions the waist-twisting "Power Punch," an action feature found on many figures in the line.

While not presented in any of the minicomic stories until 1984, Evil-Lyn ultimately became a very important character in many MOTU stories, often portrayed as Skeletor's second in command.

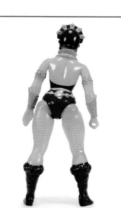
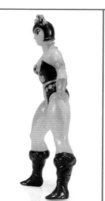
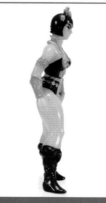

EXTENDAR
HEROIC MASTER OF EXTENSION

First released 1986 • Member of the Heroic Warriors

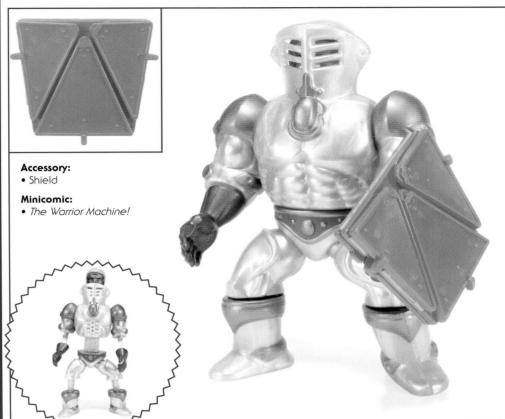

Accessory:
• Shield

Minicomic:
• *The Warrior Machine!*

Often referred to as the Heroic "Tower of Power," Extendar appears to be a normal knight in silver armor. Beneath this armor, however, he is a cyborg warrior with the ability to extend to great heights.

The figure's extending feature works extremely well. His torso extends by pulling his upper body, his arms extend by pulling his arms, his legs extend by pulling his feet, and his neck extends by pulling his head. The parts all lock in place nicely while extended, changing your five-and-a-half-inch action figure to an eight inch action figure!

Because his body must house all these extending limbs when shrunk down to his normal size, Extendar's body is very bulky in relation to the other action figures in the line. Making him a knight in armor was a very clever way to explain this bulk. His armor is molded in a swirled, pearlized white plastic, giving it a very nice natural shine. The rest of the figure is accented in gold. Because of the plastic used, the gold color has been known to turn sort of a turquoise or green with age.

Extendar's red shield is unique, as it includes its own extending feature. Starting off in a square shape clipped to his arm, panels can be opened to make the shield larger, to help protect his elongated body.

The sculpted details on the extended parts are quite intricate, looking like a series of circuitry, showing the cyborg under the armor. There's also an odd Easter egg in the sculpt. If you look at the back of Extendar's neck while extended, there's a peace sign worked into the sculpt of his circuitry.

FUN FACTOID: In an early Extendar concept design by Ted Mayer, the figure sports a bright red and orange costume. The final design was done by John Hollis.

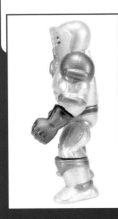

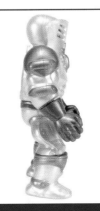

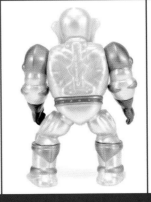

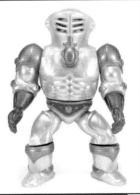

FAKER
EVIL ROBOT OF SKELETOR!

First released 1983 • Member of the Evil Warriors

Accessory:
• Orange Sword of Power

Minicomics:
• *He-Man Meets Ram-Man!*
• *King of Castle Grayskull*
• *The Ordeal of Man-E-Faces!*
• *The Vengeance of Skeletor*

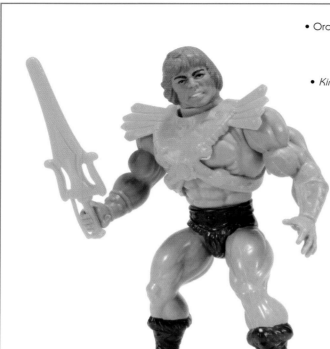

VARIANT

Earlier versions of Faker had a soft head and reused He-Man's legs. Later releases had a hard head and had larger feet.

The idea of an evil or mirror version of the main hero is a concept seen across all forms of media. It's an easy way to introduce a new villain. In the case of Faker here, the figure is essentially a blue He-Man with bright orange Skeletor armor and sword. And that's it! It's a simple repaint with no new sculpted pieces, making this a cheap but effective new character.

Regardless of the simple parts reuse, Faker has garnered a bit of a cult following over the years. Fans seem to love this character. The bright blue and orange colors really stand out, making this character quite eye catching and very appealing.

The only thing that really stands out as something different on this figure is the small "control panel" sticker found on the figure's chest, under his armor. The figure retains the same waist-twisting "power punch" action feature seen in He-Man and many other figures. By turning the figure's waist while holding his arm, the figure would quickly snap back into place once the arm was released.

Faker got a reissue later in the toy line's life, in 1987. The second version has larger feet and a hard, solid head, while the original release from 1983 had a soft head.

One of the most sought-after variants of Faker is the Leo Toys version released in India. This variation includes all of Skeletor's armor, not just the chest harness, as well as Skeletor's Havoc Staff molded in either orange or pink plastic. The pink plastic is more representative of the way Faker appeared on the box art. Leo Faker also has a little black mask painted over his eyes, really making him stand out from the standard US release.

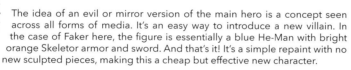

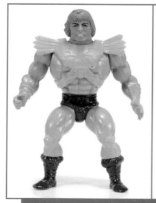

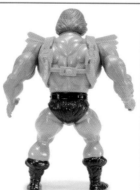

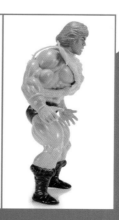

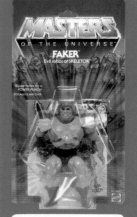

EIGHT-BACK

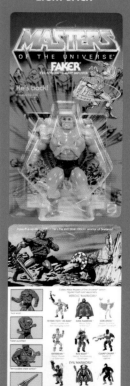

TWELVE-BACK

FUN FACTOID: Most versions of Faker use He-Man's head and body (with blue skin) and Skeletor's armor in orange. A rare Taiwan variant was released with Skeletor arms. A version made in India by Leo Toys featured Skeletor's belt accessory and Havoc Staff, and had black paint around his eyes.

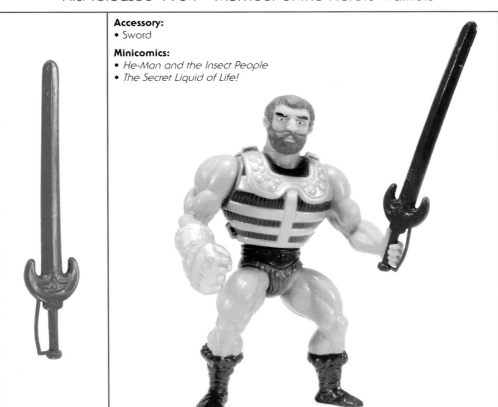

FISTO
HEROIC HAND-TO-HAND FIGHTER

First released 1984 • Member of the Heroic Warriors

Accessory:
• Sword

Minicomics:
• *He-Man and the Insect People*
• *The Secret Liquid of Life!*

Fisto, and his evil counterpart Jitsu, introduced the gimmick of having enlarged hands that can deliver a punch or chop via the use of a spring-loaded right arm. It is a really popular feature that functions very well. In the case of Fisto, by pulling his arm back and releasing it, Fisto's giant silver fist comes crashing forward. If you instead pull the arm upwards, Fisto's fist comes slamming downward!

The figure also retains the waist-twisting "power punch" feature, meaning you can also make him swing his punch from side to side with the spring-loaded waist! This allowed for many different ways of punching through foes with Fisto's iconic giant metal gauntlet. The packaging even touted this, saying Fisto could "throw hooks, uppercuts, and straight punches!"

While Fisto's body is based around the same basic buck used for He-Man, it's worth noting that the sculpt of the chest had to be slightly increased in order to make room for the spring-loaded mechanism for his arm. Also, the left hand was given a gripping hand instead of the usual open palm found on most of the figures' left arms. This was so he could hold on to his included sword access'y, which was a reused Tri-Klops sword cast in purple.

FLYING FISTS HE-MAN
HEROIC LEADER WITH THE ARM SWINGING ACTION!

First released 1986 • Member of the Heroic Warriors

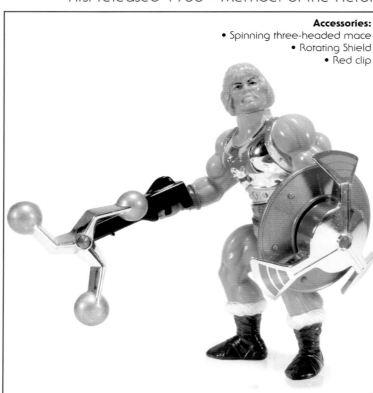

Accessories:
- Spinning three-headed mace
- Rotating Shield
- Red clip

Minicomic:
- *The Flying Fists of Power!*

Continuing the tradition of releasing new variations of the main characters over the course of the line, Flying Fists He-Man is the fourth He-Man released in the line. This version was released on the "deluxe" card back and featured shiny vac-metalized chest armor and several weapons that played into his waist-twisting action feature.

Using the small thumb grip sculpted on the figure's back, you can swivel the figure back and forth at the waist. Doing so causes the figure's arms to move up and down, thus flailing his weapons. The mace clipped on to one hand features a spinning head that rotates as a result of the motion of the arms. The shield features a similar spinning blade on the outside, also rotating while the arms swing.

The shiny armor is part of the upper body's sculpt, rather than being removable armor, as is often found on Masters of the Universe figures. To make room for the weapon-swinging feature, He-Man's body is a bit more slender than his other figures.

The vac-metal armor really makes the figure stand out and appear special. The belt at the bottom of the armor and the cuffs around the arms are painted gold, but over the years many of the figures have lost this gold paint, sometimes making the armor appear entirely silver.

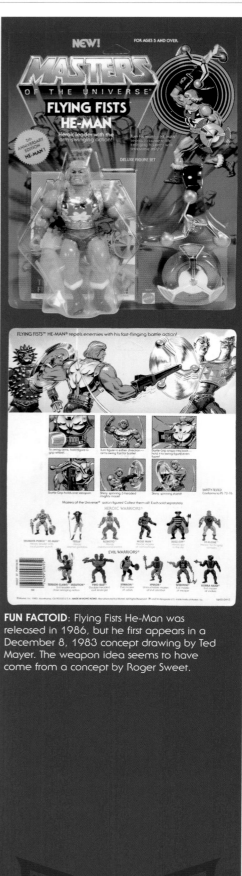

FUN FACTOID: Flying Fists He-Man was released in 1986, but he first appears in a December 8, 1983 concept drawing by Ted Mayer. The weapon idea seems to have come from a concept by Roger Sweet.

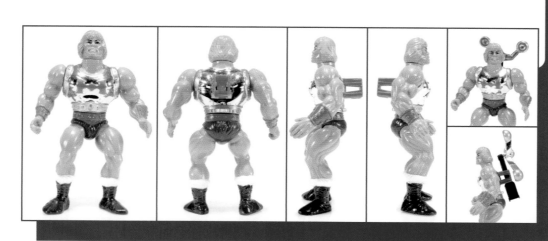

FRIGHT FIGHTER
EVIL DRAGONFLY ATTACK VEHICLE

First released 1986 • Vehicle of the Evil Warriors

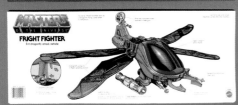

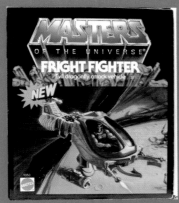

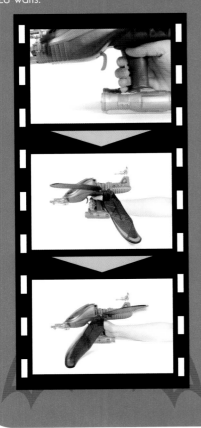

FUN FACTOID: Fright Fighter's early working name was "Dragon Fly." The name "Fright Fighter" came from another concept aircraft that was never produced. Both were designed by Ed Watts.

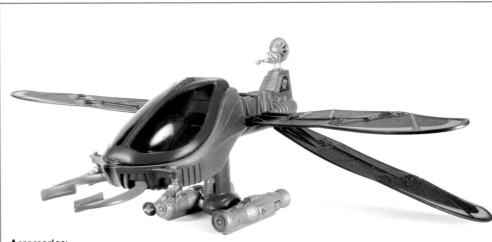

Accessories:
- Two cannons
- Radar dish

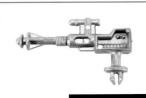

The evil Fright Fighter is a flying contraption that is designed to resemble a dragonfly. It is bright purple and blue in color with four large wings extending from the sides. The canopy that opens up to house the figure inside is bulbous, almost looking like insect eyes.

A trigger on the handle can be repeatedly pushed to flap the wings. The wings move opposite of one another on each side, which looks very striking when the trigger is rapidly pressed.

A second trigger opens and closes the large pincers on the front. These can be used to scoop up your Heroic Warriors and drop them to their doom!

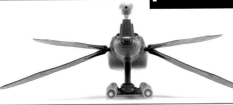

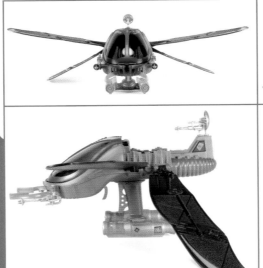

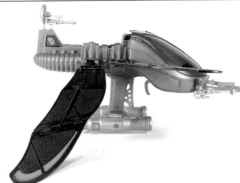

FRIGHT ZONE
TRAP-FILLED STRONGHOLD OF TERROR!

First released 1985 • Lair of the Evil Horde

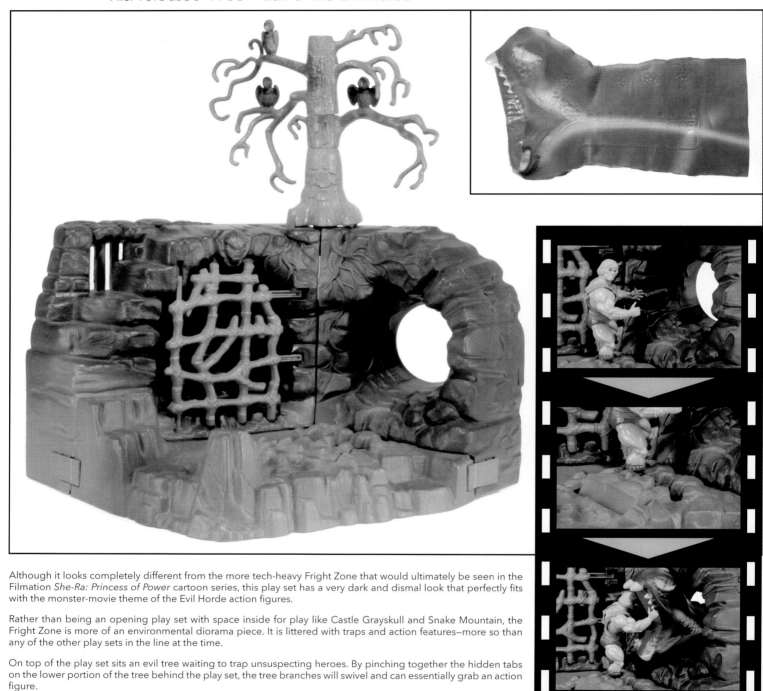

Although it looks completely different from the more tech-heavy Fright Zone that would ultimately be seen in the Filmation *She-Ra: Princess of Power* cartoon series, this play set has a very dark and dismal look that perfectly fits with the monster-movie theme of the Evil Horde action figures.

Rather than being an opening play set with space inside for play like Castle Grayskull and Snake Mountain, the Fright Zone is more of an environmental diorama piece. It is littered with traps and action features—more so than any of the other play sets in the line at the time.

On top of the play set sits an evil tree waiting to trap unsuspecting heroes. By pinching together the hidden tabs on the lower portion of the tree behind the play set, the tree branches will swivel and can essentially grab an action figure.

On the main level, there is a large cage door with a shallow cave directly behind it. You can unlatch this cage door by hitting the switch on the top, near the tree. This is a perfect little jail cell for Hordak to lock away any heroes he catches in his traps!

Directly in front of this cage is a section of rocks on the ground that blends in with the rest of the play set, but when a figure steps on it, it clamps on to the figure's leg, locking them in place.

And finally, there is an included hand puppet that kids can wear to manipulate a large serpent-like creature! This creature can be fed directly through a hole on the back of the play set. You can grab heroes with the jaws of the serpent and drag them back into his den . . . perhaps for a feast!

At first glance it feels like a much smaller play set than most of the others in the line, but it packs in a ton of really fun play features.

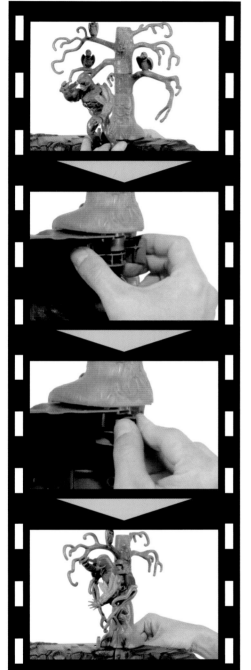

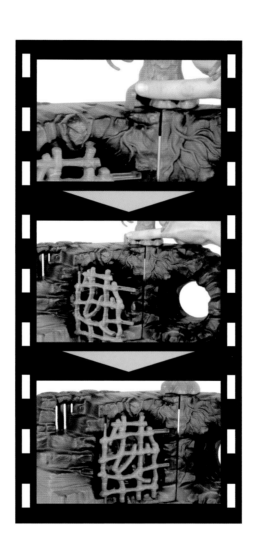

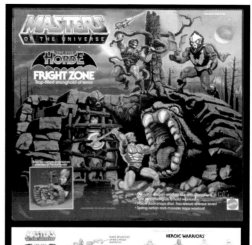

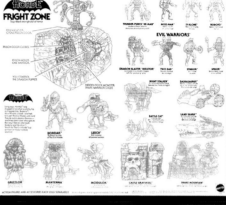

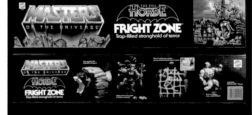

FUN FACTOIDS:

• According to patent filings, Robert W. Atwood invented the Fright Zone's action features.

• An early working name for the play set that would eventually become the Fright Zone was "Masters Villain Play set." It predates the Evil Horde and was probably intended for the Evil Warriors. The early concept was illustrated by Ed Watts.

GORE-ILLA
EVIL APE WITH MONSTROUS MUSCLE-POWER!

First released 1986 • Member of the Evil Meteorbs

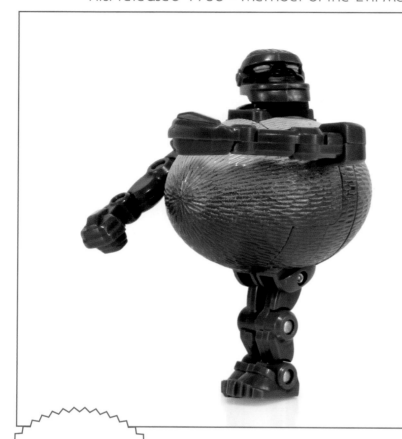

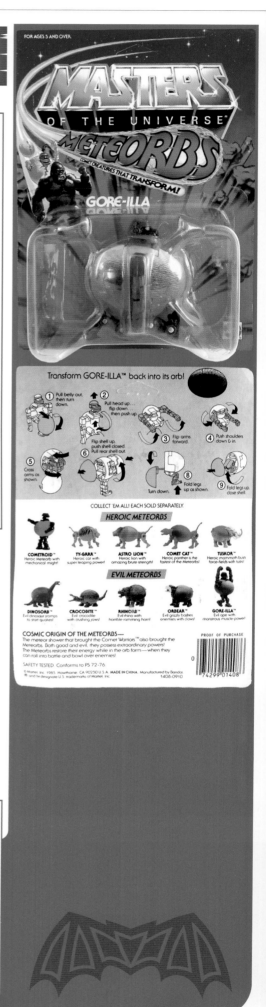

The Meteorbs are meteor rocks that can transform into animals and robots.

These transforming toys were originally released in Japan by Bandai under the name "Tamagoras." They were brought to the US by Mattel and released as characters in the Masters of the Universe line of action figures. This was Mattel's attempt to add the popular transforming toy mechanism seen in other lines, such as Transformers.

The transformation from meteor to animal is a fairly simple mechanism, usually not requiring instructions. By simply popping open the egg-shaped toy you can easily fold out the legs and head to complete the transformation.

Gore-Illa is brown and white in color, with lines sculpted on his torso that give him a hairy appearance. He transforms into an upright robotic gorilla. Much like Crocobite, Gore-illa's appearance in the Star comics suggests that he also might be the leader of the Evil Meteorbs. It is not made clear which of them is intended to be the actual leader.

The Meteorbs at times feel out of place among the many action figures found within Masters of the Universe, but somehow they still fit within the combination of magic and science fiction that allowed the toy line to incorporate so many widely differing designs.

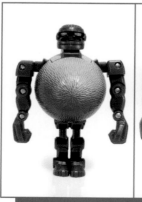 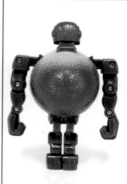 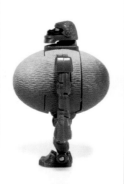 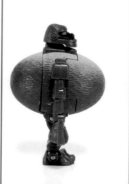

GRIZZLOR
HAIRY HECHMAN OF THE EVIL HORDE

First released 1985 • Member of the Evil Horde

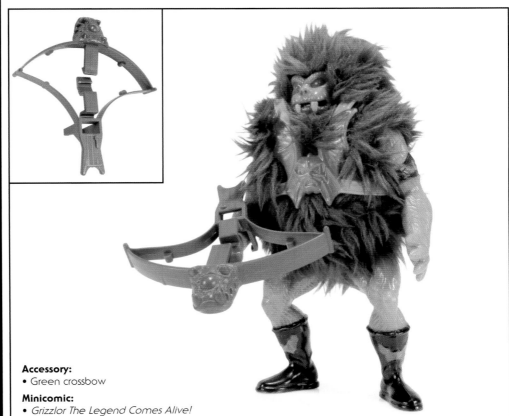

Accessory:
• Green crossbow

Minicomic:
• *Grizzlor The Legend Comes Alive!*

VARIANT

A more obscure variant features a dark brown colored face.

One of the original members of the Evil Horde, Grizzlor fits the theme of being based around a movie-monster motif. The standout feature on the figure is his fluffy, fur-covered body. The fur was fitted over a unique body piece with no sculpted muscles. As a result of this, the figure does not feature waist articulation.

Grizzlor's figure comes with a green version of the Evil Horde crossbow. This weapon is included with most of the Evil Horde action figures, appearing in different colors and with different sculpts on the faces of the crossbows. The crossbow has a pseudo firing mechanism. There is a small latch in the center of the crossbow allowing you to hook the front of the weapon to the handle. By giving a light press on the top of the latch, it will unhook and slightly spring forward.

There are two major versions of Grizzlor. The more common figure has a lighter brown skin tone on his face and arms. A rarer version features dark brown arms and a dark brown, almost black, skin tone on the face. This darker one is actually more representative of early designs for the character.

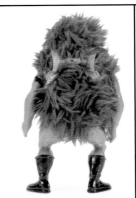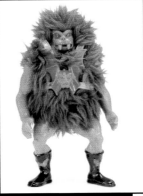

FUN FACTOIDS:
• The rare variant with a darkly colored face echoes the color scheme in concept art by Ted Mayer.
• Grizzlor appears briefly in the background of the 1987 film *The Princess Bride*.

INTERVIEW WITH
MARK & REBECCA TAYLOR

Mark and his wife Rebecca were gracious enough to answer some of my questions about the origins of these characters, and the process of bringing them to life.

Thank you both so much for agreeing to answer my questions. I recently interviewed Ted Mayer and Rudy Obrero. It's a thrill and an honor to also be able to interview you now!

Mark Taylor: Adam, thank you for your interest, both Ted and Rudy are my friends as well as excellent designers. It was a pleasure to work with them on He-Man. I do not call the brand MOTU because that was just a Mattel marketing and management concept. "Masters of the Universe" also helped them separate it from a potential lawsuit with the Conan property owners . . .

You were originally hired by Mattel to work on packaging. How did you come to be the designer for He-Man?

Mark: At the age of eleven I was a compulsive reader and drawer, I love story telling and adventure, influenced by Hal Foster's beautiful strip and Burroughs and Howard's books. I started telling my own heroic story.

I went to Art Center, Cal State and worked for the US Navy (Combat Illustrator). Then through a friend I found out there was an opening at Mattel in the Visual Development group. They were a very talented "bullpen" who were responsible for the appearance of the product which included packaging but also the products' labels, color, details and early engineering drawings. This was a perfect fit for me, and I was promptly assigned to work on the Barbie product, which was an honor because Barbie has always been Mattel's cash cow.

He-Man and Skeletor seem very primordial and archetypal to me. He-Man is the embodiment of life and vitality; Skeletor is the embodiment of death and decay. When you were designing these characters, was any of that running through your head?

Mark: He-Man's original name was Torak, Hero of Prehistory. He was the defender of the weak and righteous and foe of bullies and villains. This powerful hero needed a worthy adversary who embodied evil and sorcery on every level.

Skeletor was influenced by many literary sources but visually by a carnival scare ride with a skeleton-like figure that dropped down and rattled (turned out to be a real mummified outlaw); also a lot of Mexican Day of the Dead art and sculpting. Skeletor had to be powerful in his own right and believe completely in his cause as much as Torak (He-Man).

The battle was set, a righteous hero mounted on a giant Battle Cat versus a nefarious villain imbued with mystical evil powers. The clash of arms could be heard to the ends of the earth.

So He-Man originated with your Torak character, which I believe you had been working on since the 1950s. Did Skeletor originate from that same time?

Mark: Absolutely. Skeletor evolved simultaneously with Torak. It had to be this way. They were the yin and yang, the reason for being, opposites to battle forever.

As far as I can tell, Stratos was originally supposed to be an evil warrior (correct me if I'm wrong!), but then he was released as a heroic warrior. Were there any other characters who ended up switching sides?

Mark: Yes many, the early figures that switched sides were, Beast Man, Teela, Stratos, Man-E-Faces and Ram Man. It was a money thing, we had to release the figures, vehicles, play sets and accessories in waves to pay for the tooling and advertising. Mattel did not really believe in the line until after Castle Grayskull was a big hit . . .

Can you talk about your working relationship with Ted Mayer on the Masters of the Universe toy line?

Mark: Ted is an industrial designer, I am a designer/illustrator. I sketched out the line but needed help with the vehicles. I requested Ted and he did a great job. It was important that the figure controlling the vehicle be very visual, we didn't have a movie to explain and promote our product like Star Wars did.

How did you come to hire Rudy Obrero to do paintings for the packaging artwork? Can you speak a little bit about your experience working with him?

Mark: He was the only guy who could paint like Frank Frazetta, he was great to work with. Always came back with more and better than I expected. He would do great stuff from very little reference material. We were turning out stuff like crazy fast. It was like we were joined at the imagination.

Mattel took quite a risk in producing your designs that were not based on any previous intellectual property. It was a risk that obviously paid off. Do you think toy companies today are more hesitant to take those kinds of risks?

Mark: Mattel took no chances at first. Ray Wagner, President of Mattel at that time, laid his reputation on the line and went against everyone else to give Masters a lift off . . . I was there with He-Man, Teela, Beast Man, Battle Cat and Skeletor. The kids tried to steal the prototypes after the testing. We had a hit.

A lot of characters went through color changes as they went through development (either to themselves or their costumes or both). Examples include Beast Man, Mer-Man, Teela and Ram Man. What was driving those changes?

Mark: Sorry to admit it, but cost . . . Also there was a conscious effort to avoid anything that resembled Star Wars or Conan in any way.

Mer-Man went through quite a few changes from B-sheet to final toy. What was behind the changes to his design, particularly the changes to his face?

Mark: Mer-Man tested the lowest. Tony Guerrero the great sculptor and I chased the negative child test comments until we finally realized the marketeers were just messing with us and then we went with what we had. Mer-Man was the weakest but people who like him really like him (I based him on Bernie Wrightson's Swamp Thing).

There is a character you designed who fans refer to now as Demo-Man. Do you see him as an early incarnation of Skeletor or Beast Man?

Mark: No, he was a separate concept that I was too busy to exploit. I was working until the sun came up and the Mattel building was empty. I was pretty much running on fumes . . .

You designed the armor and helmet for Battle Cat as a way to reuse the Big Jim tiger. Can you talk a little bit about that design? The helmet design is quite striking, like some mythical beast.

Mark: I had used the Cat on the Tarzan line, I liked the sculpt but the 5.30" He Man figures wouldn't ride on him and I wanted him to ride on a huge cat. Nobody messes with a guy riding a huge armored cat! I had seen a guy ride a regular tiger in the circus and wow!

The colors green and orange seem to be pretty prominent on those early toys (Battle Cat, Man-At-Arms, Wind Raider). Is there a story behind that color scheme?

Mark: Not just a story but a lot of work and fighting, those colors were not very common in action toys. They pop but looked somewhat alien . . .

Did you have an origin story in mind when you designed Man-E-Faces? How about Ram Man?

Mark: Yes, but no one was interested, they wanted to ship it out immediately to animators and movie producers, you know "professionals." I designed him to have a different and interesting feature besides a twist waist. All the answers to my original story are in clues in Castle Grayskull, where they should be like a puzzle.

Teela and the Sorceress/Goddess (the one with the snake armor) were originally separate characters. Whose decision was it to combine them into a single action figure? How did you feel about that? Did you intend the Sorceress character to be a hero or a villain?

Mark: She was actually supposed to be a changeling but the comic book guys had a hard time with that . . . She was intended to be like a spy and play both sides with some magic . . .

In the first couple of years of the toy line, all of the vehicles seem to be geared toward the good guys. Why was that?

Mark: Don't forget Skeletor used magic, but He-Man never did. Skeletor could animate anything and go anywhere. In my mind that was one of the main differences between the main characters and their followers.

The late Tony Guerrero sculpted a lot of the early He-Man figures. Can you talk a little bit about what it was like to work with him?

Mark: Tony was a great artist and a really nice man and it was my honor to work with him. I also worked on another project, TMNT with a nice and super talented guy named Scott Hensey. Working with both of these sculptors allowed me to break custom by adding a step to the development process. On the He-Man line we did a "looks like beauty" sculpt, non articulated from my "B" sheet (design sketch) for testing and sales and until we got the first shots from China. This was Tony's idea and without this extra step, the confidence in this "weird" concept wouldn't have happened. I repeated this process with the Turtles.

These toys were a surprise, runaway success. What is it about He-Man that made it so successful, do you think?

Mark: Everybody pushes us little guys around, we secretly want to strike back at all the bullies. We need to feel like we can make things better and are willing to fight to do it. With He-Man we have the power! We have a chance. I feel that the basic concept of courage cannot be taught, it can only be shown.

What did you envision for Zodac when you designed him? What were his abilities and where did he fit in to the MOTU universe?

Mark: Zodac was all about flying. He was the air wing. I was influenced by Flash Gordon and the flying Vikings. Skeletor could animate anything and go anywhere. In my mind that was one of the main differences between the main characters and their followers.

Castle Grayskull is probably the greatest play set ever made, and I understand that you sculpted most of it yourself? What was that process like? What does Castle Grayskull mean to you?

Mark: Yes I did because Tony was busy with the figures and the other sculptors kept making it too architectural. I wanted the castle to be organic, coming to life to tell its story. I made a wood armature and sculpted it in green clay. Ted helped with the plaster mold and vacuum forming, Rebecca did the labels. Marketing (now everyone wants in on the game) wanted it to retail for twenty nine dollars. The imaginative user applied labels themselves to offset the lack of interior walls. Toys 'R' Us sold all they could get for fifty dollars which was quite a mark up.

Rebecca, I understand you worked on the stickers and cardboard inserts used in Castle Grayskull. The style ranges from regal to almost psychedelic. What did you have in mind when you were working on that project?

Rebecca: The only chance Mark had to tell the story was with the castle. He always said, "all the answers are in Castle Grayskull," which is quite a different direction than it eventually went. Once the president of Mattel Ray Wagner chose to go with it, everything moved at such a high velocity because he wanted it and no one else understood it.

Mark asked me to combine classic icons along with futuristic ones because he was going against Star Wars and after all it was a "warrior-type" premise that had to somehow be more than Conan, Tarzan etc.

Mark had sketches in ancient sketchbooks which I took and redesigned stickers from. I did the designing, drawing, inking and coloring, that includes labels for vehicles as well as directed by and revised by Mark. Just like every label job, I was given areas that I had to fit. Because everything was going so fast, sometimes those areas would change shape and would have to be redrawn on the fly. In those cases Mark was redrawing my stuff because he was hands on with the castle. Because we've worked together for decades, we speak in brain waves.

I think the reason they are perceived as "psychedelic" is because Mark said, "We're already going somewhere no one else has so don't render the labels in the normal hard edged graphic way. I used Dr. Martin's Dyes and let the colors run and wash into the line art. I think it went through because it was so fast and still no one really "got it." . . .

The innovation on those labels happened because Mark was approving and

controlling this project and I knew what he wanted. I've done many labels for other toy companies and no one has ever asked me for "something really different" and yet these were a big hit.

I was always disappointed that the Mylar printed moat that surrounded the castle was costed out.

Was Errol McCarthy responsible for creating the cross-sell artwork on the back of the packaging?

Mark: In the beginning it was someone else and then Errol came in.

MOTU differs a bit from traditional sword and sorcery in that it includes laser guns and flying vehicles. What was behind the inclusion of science fiction with barbarian elements?

Mark: I never wanted it to be traditional. If I was still working on it I probably would have added zombies, aliens and time travel. Why not?

Often in the process from b-sheet to prototype to finished toy, there are a lot design changes. Which finished toy were you most pleased with? Which one do you feel didn't live up to its potential?

Mark: Castle Grayskull was the best and most innovative, Mer-Man left me a little unsatisfied.

In a nutshell, what is your vision for Eternia? What kind of place is it?

Mark: . . . I imagined that world to be like a nightmare that you can modify as you go. Always about hope.

In public appearances you often talk about Joseph Campbell and the hero's journey. What has been your personal hero's journey?

Mark: My wife Rebecca epitomizes attaining a fulfilling goal, she is my Nirvana. My life is filled with beauty and love, I wish everyone could be as lucky as I.

Are you both still actively involved in creating artwork? What kinds of projects are you passionate about now?

Mark: I am writing the original prequel to He-Man based on the original Torak. Also an autobiography about my life in the toy biz. I am fascinated by computer 3D design but it is very non-intuitive for me. I still love to read and watch movies, I wish I had the resources to make one.

Rebecca: I work on digital art because it is so easy to create my style of graphic art which is strongly based on shapes and color. It is so exciting to me to be able to have such a magnificent palette and to be able to experiment with unlimited color combinations with a couple of keystrokes.

Collect these **MASTERS OF THE UNIVERSE**® figures and accessories! Each sold separately.

ZODAC®
Cosmic Enforcer

STRATOS™
Winged Warrior

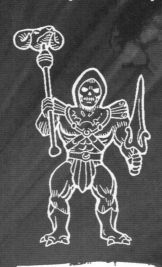

SKELETOR®
Lord of Destruction

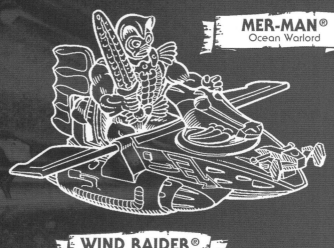

MER-MAN®
Ocean Warlord

WIND RAIDER®
Assault lander

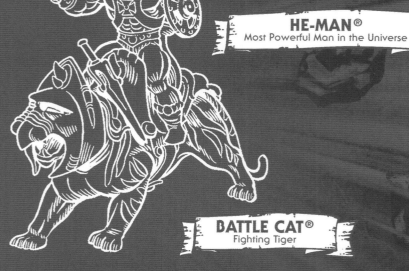

HE-MAN®
Most Powerful Man in the Universe

MAN-AT-ARMS®
Master of weapons

BATTLE CAT®
Fighting Tiger

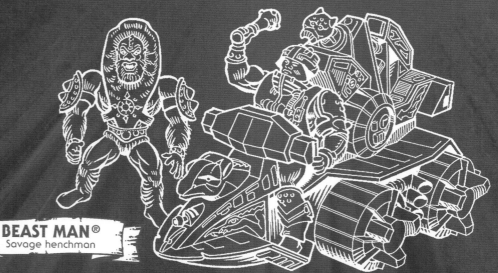

BEAST MAN®
Savage henchman

BATTLE RAM™
Mobile launcher

TEELA®
Warrior Goddess

GWILDOR
HEROIC CREATOR OF THE COSMIC KEY

First released 1987 • Member of the Heroic Warriors

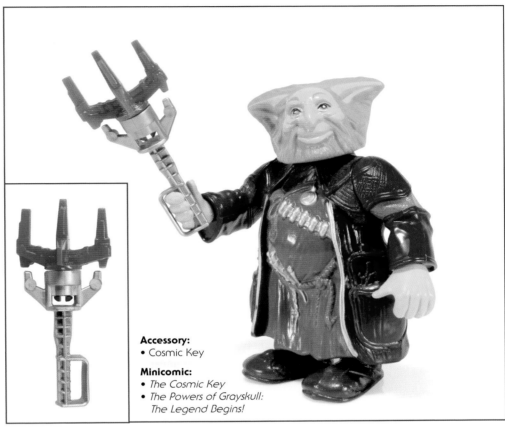

Accessory:
• Cosmic Key

Minicomic:
• *The Cosmic Key*
• *The Powers of Grayskull: The Legend Begins!*

Gwildor is one of three brand-new characters created for the 1987 *Masters of the Universe* motion picture who received an action figure in the toy line. He is the creator of the Cosmic Key, which drove the plot in the film.

The figure comes with a toy version of the Cosmic Key. Its appearance is completely different from its movie equivalent, but it does allow the user to spin the top, thus re-creating the spinning motion of the activated key from the film. It was given a handle on the end so that the Gwildor figure could hold it.

The figure itself has a unique look, with an entirely new sculpt that does not reuse parts from any other figure. Since the character is dwarf-like, the figure is much shorter than the standard figures. It also has some unique articulation, with swiveling wrists and feet—movement not typically found across the majority of the figures in the line. This articulation was touted as one of his features on the figure's packaging.

FUN FACTOID: An early Gwildor concept design had white hair and a long white Fu Manchu moustache.

HE-MAN
MOST POWERFUL MAN IN THE UNIVERSE!

First released 1982 • Member of the Heroic Warriors

Accessories:
• Shield
• Sword
• Axe

Minicomics:
• *Battle in the Clouds*
• *He-Man and the Insect People*
• *He-Man and the Power Sword*
• *He-Man Meets Ram-Man!*
• *King of Castle Grayskull*
• *The Magic Stealer!*
• *The Menace of Trap Jaw!*
• *The Vengeance of Skeletor*

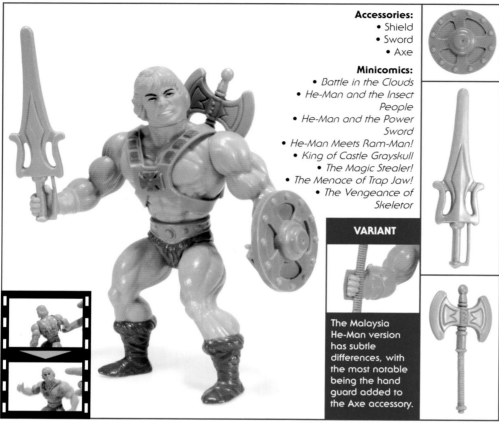

VARIANT

The Malaysia He-Man version has subtle differences, with the most notable being the hand guard added to the Axe accessory.

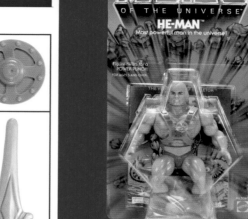

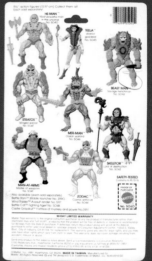

EIGHT-BACK

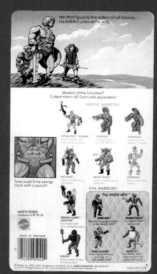

TWELVE-BACK

The main hero of Masters of the Universe, He-Man was unlike any other action figure commonly found in stores in the early 1980s. While the four-inch action figure was becoming more and more the norm thanks to the success of Kenner's Star Wars and Hasbro's G.I. Joe, He-Man stood a whopping five and a half inches tall with a superhero-like body covered in hulking muscles, and battle-ready squatting legs. He was purposely made to look bigger and stronger than all of the other toys in an effort to grab attention. The design of this figure would set the stage for the entire line, with many of the figures released in the line over the next five years reusing the same basic body design.

Aside from including removable armor and multiple weapons, He-Man also featured a spring mechanism in his waist. By turning the figure's waist while holding his arm, the figure would quickly snap back to place once the arm was let go—delivering a "power punch" to his foes! This "power punch" action feature is the most common in the line, recycled for many of the various figures released.

The included Sword of Power accessory almost looks like it's held backward in his hand, due to the way it was made. As a result, a lot of kids posed He-Man holding the sword in his open hand, using the hand guard to keep the sword clipped on with the handle actually being on the outside of his hand. As a result, it's not uncommon to find loose swords on the aftermarket with broken hand guards. The sword also has a unique feature, in which it is technically only half of the full Sword of Power. The purple version that comes with his archnemesis Skeletor has the ability to fit together with He-Man's, creating the full Sword of Power. This is a direct tie-in to the story found in the included minicomics.

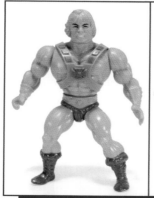
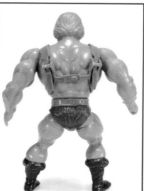
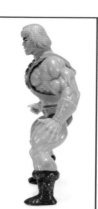
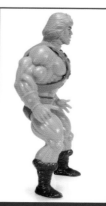

FUN FACTOIDS:
• He-Man was not originally going to come with a sword, but a split sword was proposed by marketing for a commercial, and He-Man's Sword of Power was born.
• In one early marketing concept, He-Man was going to be Skeletor's son.

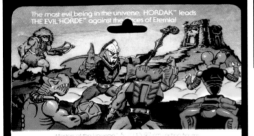

HORDAK
RUTHLESS LEADER OF THE EVIL HORDE

First released 1985 • Member of the Evil Horde

Accessories:
- White crossbow
- Bat shield

Minicomic:
- *Hordak—The Ruthless Leader's Revenge!*

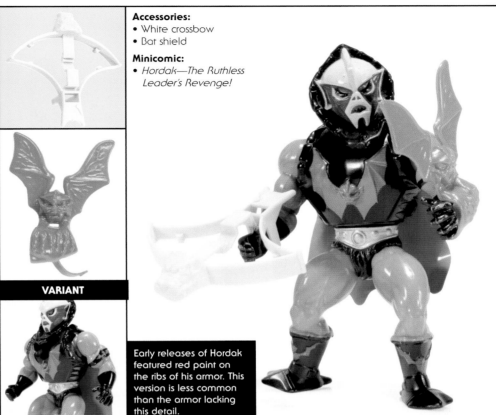

VARIANT

Early releases of Hordak featured red paint on the ribs of his armor. This version is less common than the armor lacking this detail.

The Evil Horde was introduced to the MOTU line in 1985 as a second evil threat to He-Man and Eternia. Hordak, the leader of this new faction, appeared as the main antagonist in Filmation's new spinoff series, *She-Ra: Princess of Power*. Hordak appears to have been a joint creation between the animation studio and Mattel.

Although part of the *She-Ra* cartoon, Hordak and the rest of the Evil Horde were marketed as the enemies of He-Man and Skeletor in the action figure aisles. The toy versions of the Evil Horde had a monster-movie aesthetic to their designs. While his skin was bright blue in his animated appearance, the toy version of Hordak was a much grimmer gray and black in color. The bright red bat emblazoned upon his armor was the symbol of the Horde, appearing on most of the Horde action figures. The color scheme and bat imagery evoke the feel of a vampire.

Hordak's figure includes the waist-twisting "power punch" action feature found on many figures in the line. By turning the figure's waist while holding his arm, the figure would quickly snap back into place once the arm was let go. He is also packaged with a white version of the Horde crossbow, found as an accessory with most of the Evil Horde action figures.

There are two notable paint variations of Hordak. On some releases, the ribs of Hordak's armor are painted red. The more common release seems to be the version on which the ribs of the armor were left unpainted. In addition, there is also an extremely rare paint variation in which Hordak's face is painted a bright white instead of the more common cream color. This version seems to have only been produced in Mexico, and is quite hard to come by."

FUN FACTOID: Mattel and Filmation worked in tandem to develop Hordak, going through many iterations of the character before arriving at finalized designs for the toy and cartoon looks.

HORDE TROOPER
EVIL HORDE 'COLLAPSING' ROBOT

First released 1986 • Member of the Evil Horde

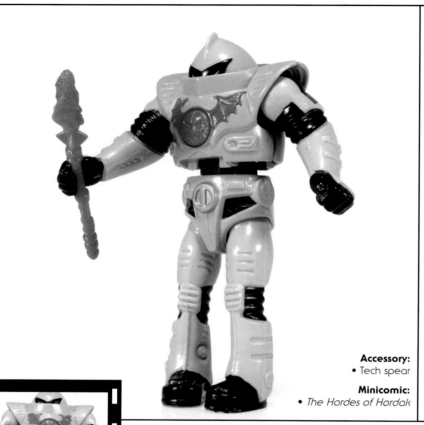

Accessory:
• Tech spear

Minicomic:
• *The Hordes of Hordak*

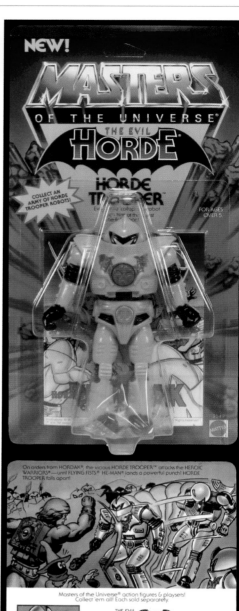

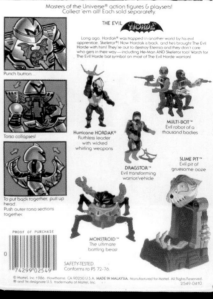

The Horde Troopers are the evil foot soldiers of the Horde Empire, first appearing in the *She-Ra: Princess of Power* animated series before they received an action figure in the Masters of the Universe toy line. Since there were many of these faceless, robotic soldiers in the cartoon, the idea was that kids could build an entire army of these in action figure form. The packaging even pushed for multiple purchases, with a burst of text spouting, "Collect an army of Horde Trooper Robots!"

The trooper has a unique body sculpt unlike any other figure in the line. He is far less muscular, and features straight arms and legs instead of the usual "battle ready" posed limbs. This gives him a unique robotic look much like what we saw in the cartoon and plays into his collapsing action feature.

There is a small button positioned in the center of the Horde bat emblem on the figure's chest, which acts as a sort of target for your He-Man or other heroic action figures to punch. When this button is pressed, the chest armor pops apart in the center, revealing a red robot body underneath that flops forward. He is easily put back together, by simply lifting the head and pressing together the two halves of his torso. The action feature proved popular despite being admittedly a bit wonky.

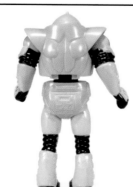

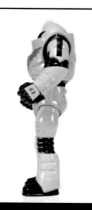

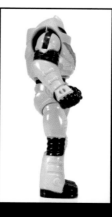

FUN FACTOID: An early Horde Trooper prototype featured repainted Sy-Klone arms and Mantenna legs.

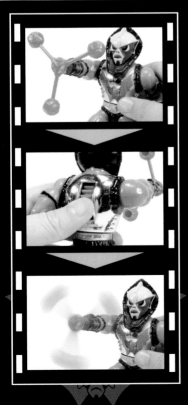

HURRICANE HORDAK
RUTHLESS LEADER WITH WICKED WHIRLING WEAPONS!

First released 1986 • Member of the Evil Horde

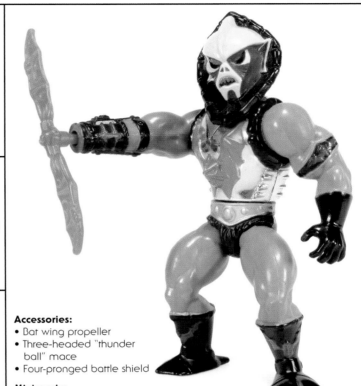

Accessories:
- Bat wing propeller
- Three-headed "thunder ball" mace
- Four-pronged battle shield

Minicomic:
- *Between a Rock and a Hard Place!*

Much like He-Man and Skeletor, Hordak received a few variations throughout the life of the line. Hurricane Hordak was the second version released and is probably the most visually striking of the group.

Like Flying Fists He-Man, Hurricane Hordak is a deluxe figure that sports a shiny vac-metalized torso. Because of this and his built-in action feature, the figure does not include removable armor. Instead, the armor is part of the construction of his upper body and gives him an overall thinner look than the other two Hordak figures in the line.

This version also features a robotic arm that resembles the arm cannon Hordak often used in the *She-Ra: Princess of Power* animated series. This gave fans of the cartoon a Hordak figure that was closer to what they were used to seeing on TV.

Hurricane Hordak's robot arm included three different weapons that could be attached. Each of these three weapons was designed specifically for the included "hurricane" action feature. Once attached, you could spin the weapon by turning the large red dial on Hordak's back.

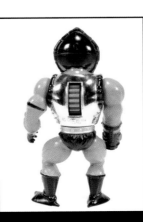
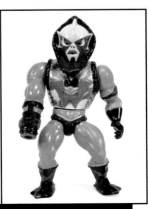

JET SLED
HEROIC ROCKET SLED & JETPACK

First released 1986 • Vehicle of the Heroic Warriors

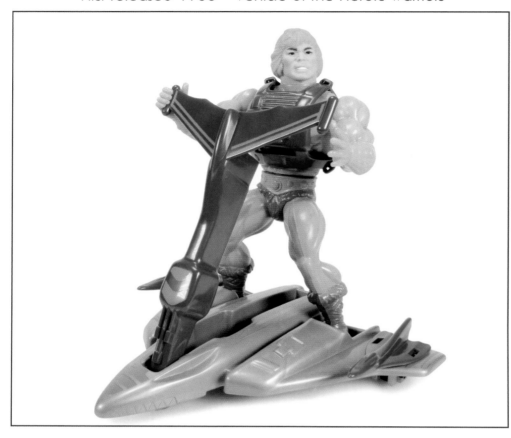

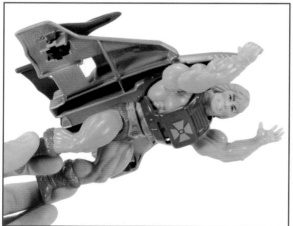

The heroic Jet Sled is two vehicles in one! Special armor is included, which will fit on most of your standard Masters of the Universe action figures, as long as they don't have large or unique body designs.

In hover-race position, your action figure can stand on top and hold on to the handles, riding it around like a hovering vehicle. The handle can then fold down, and the Jet Sled can clip to the back of the armor to change it into a jetpack so your hero can take flight!

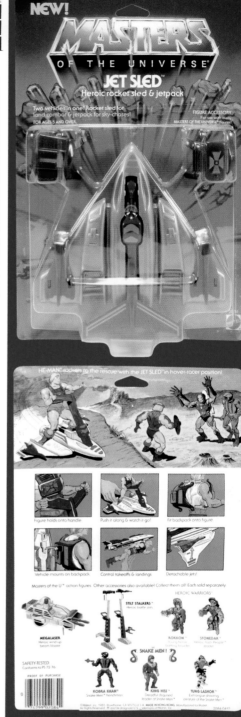

FUN FACTOID: An early concept for Jet Sled, designed by Ted Mayer, had a green and yellow color scheme.

JITSU uses his chopping power to get his evil way!

Masters of the Universe™ 5-1/2" action figures! (13.97 cm.)
Collect them all! Each sold separately!

HEROIC WARRIORS™

Twist! His wrist turns!

BATTLE ARMOR™ HE-MAN™

TEELA™

MAN-AT-ARMS™

Make his arm slash up or down, side-to-side!

MEKANECK™

MAN-E-FACES™

BUZZ-OFF™

Breastplate is removable!

EVIL WARRIORS™

BATTLE ARMOR SKELETOR™

BEAST MAN™

EVIL-LYN™

MER-MAN™

TRI-KLOPS™

WHIPLASH™

FUN FACTOIDS:
- An early prototype of Jitsu featured Skeletor's legs, but the final figure used He-Man's legs.
- Jitsu's early working name was "Chopper."
- Jitsu was created by Mattel designer Colin Bailey.

JITSU
EVIL MASTER OF MARTIAL ARTS

First released 1984 • Member of the Evil Warriors

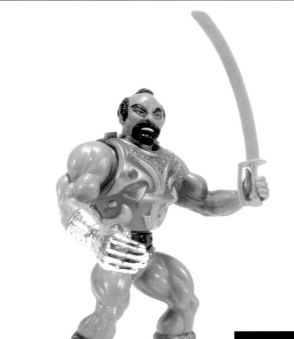

Accessory:
- Samurai sword

Minicomics:
- *The Clash of Arms*
- *The Secret Liquid of Life!*

Jitsu is the evil counterpart to the heroic Fisto, complete with the same spring-loaded action feature arm and enlarged right hand. Unlike the giant silver fist found on Fisto; however, Jitsu's enlarged hand takes the form of a shiny gold chopping hand.

Jitsu is a mixture of reused and original parts, utilizing the same legs from He-Man and the similar reshaped torso seen on Fisto to house his spring-loaded action feature. The head sculpt and armor are brand-new for this figure.

Jitsu's right arm can deliver a quick chop when the arm is pulled up and released or can deliver an uppercut-type blow when pushed back and released. His figure also includes the familiar waist-twisting "power punch" feature, meaning he can also swing from side to side. This is all touted on the back of his packaging, which states, "Make his arm slash up or down, side-to-side!"

He is also packaged with a brand-new samurai sword weapon that can be held in his left hand. The hand guard is molded on the wrong side of the sword, causing it to fit a bit awkwardly in Jitsu's hand.

Early in development, Jitsu was given the working name "Chopper." He featured in an early episode of the *He-Man and the Masters of the Universe* cartoon, in which his name was not mentioned, but the script alluded to him as Chopper.

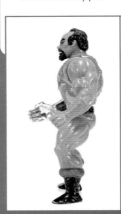
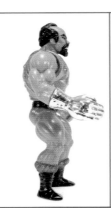
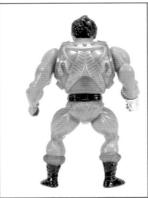
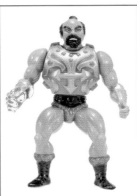

KING HISS
DREADFUL DISGUISED LEADER OF THE SNAKE MEN
First released 1986 • Member of the Snake Men

Accessories:
• Snake staff
• Shield
• Clip-on disguise

Minicomic:
• *King of the Snake Men!*

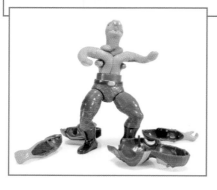

1986 introduced a third evil faction for He-Man and the Heroic Warriors to battle against, in the form of The Snake Men. As the leader of this evil group, King Hiss looks like an unassuming human. But underneath his skin lies a body of slithering snakes!

The human arms are clipped over smaller arms that are shaped like snakes, with snake heads instead of hands. The torso works like many of the hard pieces of armor found on other figures in the line, with the difference that it also covers the figure's head to disguise him as a human. By popping this armor apart down the center, you can remove the disguise to reveal a large snake head with an open mouth, and a body composed of even more snakes.

The legs themselves are sculpted in the human form and do not have a transforming feature like his upper body. The overall feature is quite effective, and the disguise pieces do a pretty good job of staying attached to the figure when clipped on.

Because of his unique action feature, King Hiss is an entirely new sculpt, sharing no parts with any other figure. He comes packaged with a green staff with a snake wrapped around it, an accessory that was released with other Snake Men figures in various colors.

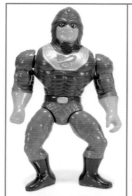 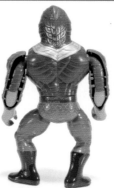 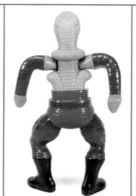

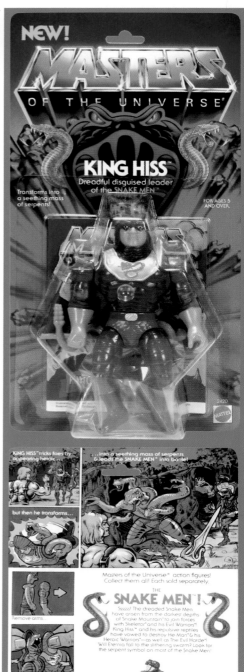

FUN FACTOID: Early concept art by Ted Mayer for King Hiss did not give the character a human disguise, but rather a monstrous exterior covering a mass of writhing snakes underneath.

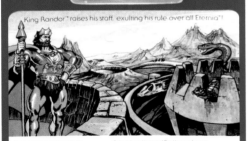

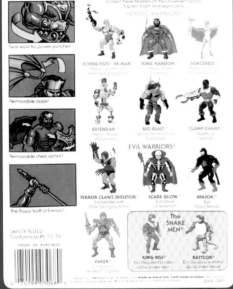

KING RANDOR
HEROIC RULER OF ETERNIA

First released 1987 • Member of the Heroic Warriors

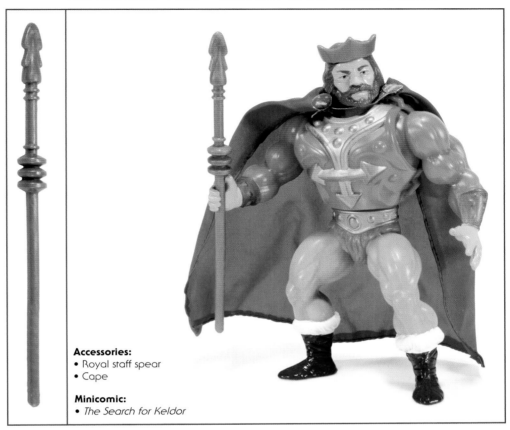

Accessories:
• Royal staff spear
• Cape

Minicomic:
• *The Search for Keldor*

The king of Eternia and father to Prince Adam / He-Man, Randor appeared in media long before he finally received his very own action figure in 1987. While he appeared in many comic stories, King Randor was most fleshed out as a character in Filmation's *He-Man and the Masters of the Universe* cartoon series. This is no doubt the medium via which most kids were introduced to the character, and thus the image they had of him in their minds.

Most Mattel minicomics prior to the toy's release had depicted Randor as an elderly, white-haired king. But the toy version's appearance is more in line with the Randor featured in the cartoon, with a younger, brown-haired appearance. However, he is presented in much more "battle ready" attire than the cartoon ever showed him with. Instead of robes and slippers, the King Randor action figure is wearing armor and boots and comes equipped with a spear weapon. This was likely done to enable the figure to feel more exciting, thus rendering it something kids would enjoy playing with. The minicomics that followed the toy's release also redefined the character's nature somewhat, portraying him as a warrior king who would gladly rush into battle, as opposed to the older and less physically imposing character of prior depictions. This reworking of the character would carry through to later iterations of MOTU.

The figure itself is mostly a reuse of parts, utilizing the standard body found on many figures in the line and a repainted version of Jitsu's armor. The head is all new, featuring a king's crown atop his head. The figure is also unique in that it features a removable cloth cape, made from a shimmery blue material to add to the overall regal feel.

FUN FACTOID: In a television promotion, King Randor was offered as a free gift when you sent in three proofs of purchase from other Masters of the Universe figures.

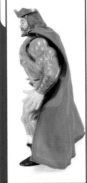 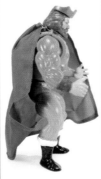 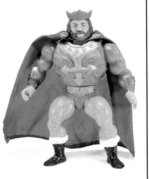

KOBRA KHAN
EVIL MASTERS OF SNAKES

First released 1984 • Member of the Evil Warriors

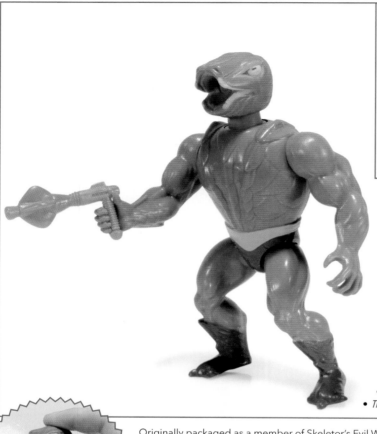

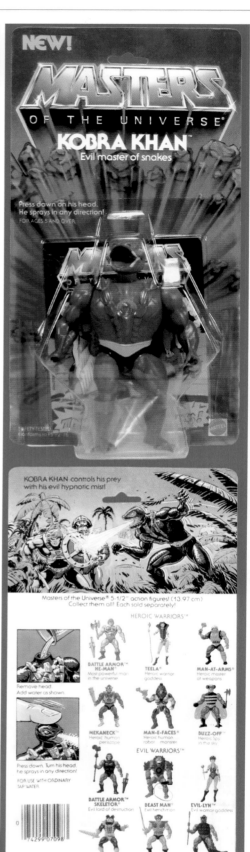

Accessory:
• Laser pistol

Minicomics:
• *Double-Edged Sword*
• *The Secret Liquid of Life!*

Originally packaged as a member of Skeletor's Evil Warriors, Kobra Khan was later retconned as a member of the Snake Men following their introduction into the line in 1986, with his tag line changed to "Evil henchman of The Snake Men!" In the minicomics, this is explained when Kobra Khan is instructed by Skeletor to work as a spy within the ranks of the Snake Men.

The figure reuses the monster-like arms and legs from Skeletor, and includes an orange-red version of Zodac's laser pistol for a weapon. The head and torso are brand-new. To accommodate his "venom"-spraying action feature, the figure has a hollowed-out chest and therefore lacks the usual waist twist found on most other figures in the Masters of the Universe line.

The water spray action feature is incredibly functional and became highly popular. By removing Kobra Khan's head, you can fill the torso up with water. The head has a pump on the bottom that fits into the torso. When the head is pressed down, water is pumped through and sprayed out of the mouth in the form of a mist.

There is an interesting paint variation that was released by Top Toys in Argentina. Usually referred to as "Camo Khan," Kobra Khan Camuflado has a unique dark green and black camouflage paint deco, gold boots, and, somewhat oddly, Buzz-Off's clawed arms. He also comes with Clawful's green mace and has the Snake Men logo painted on his chest. Since this version is so drastically different and was only released outside of the US, it is highly sought after by collectors today.

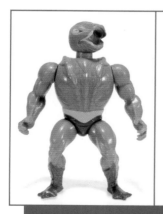

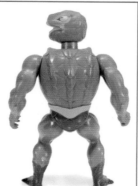

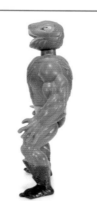

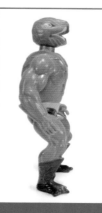

FUN FACTOID: Early concept art by Roger Sweet portrayed the character as a human wearing a snake costume.

LAND SHARK
EVIL MONSTER/VEHICLE

First released 1985 • Vehicle of the Evil Warriors

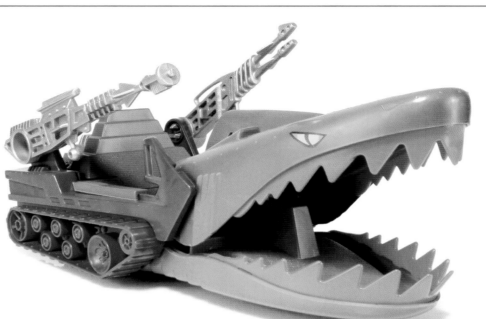

A giant evil tank that looks like a chomping shark!

This pink-and-blue vehicle has a seat behind the shark head for your Evil Warriors to sit on. Two large laser cannons are mounted to the back.

When pushing the vehicle forward, the wheels on the bottom trigger the shark mouth to chomp open and closed. The faster the vehicle moves, the faster the chomping action! There is also a small button on the control panel that, when pushed, will open the mouth when the vehicle is not moving. It's perfect for chewing down on one of your heroic action figures!

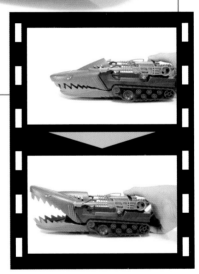

FUN FACTOIDS:
- Otto L. Gabler and Ronald L. Torres invented Land Shark's chomping mechanism, according to Mattel's patent filing.
- The idea for Land Shark came from Roger Sweet, and Ed Watts created the visual design for the vehicle.

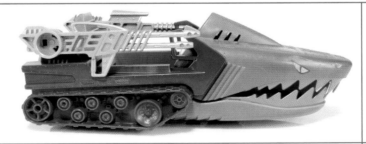

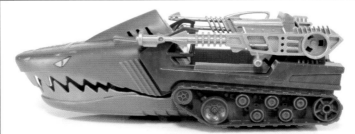

LASER BOLT
HEROIC ROAD ROCKET

First released 1986 • Vehicle of the Heroic Warriors

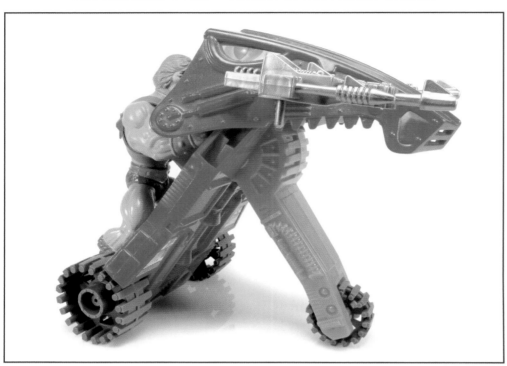

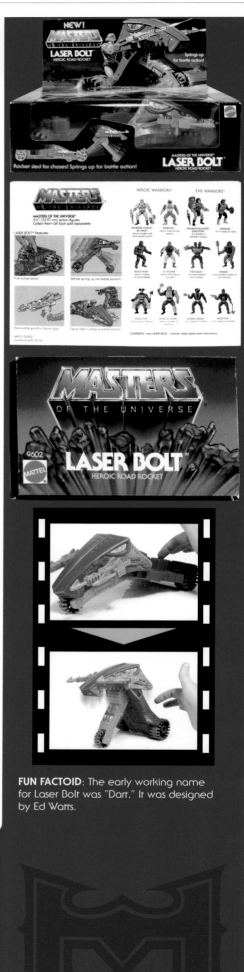

The heroic Laser Bolt vehicle is a bit like a three-wheeled motorcycle. There are two large cannons mounted to the front. Your action figure lies down face forward on it, with the feet positioned in slots and arms extended forward. The sculpt under the figure has what looks like a little visor screen. This helps explain how the hero can see where he or she is driving.

By pressing the small button on the back, the Laser Bolt springs upright into a standing position. Now that it has been transformed into a stationary battle station, your Heroic Warriors can use it for cover while blasting at the foes!

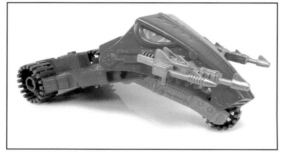

FUN FACTOID: The early working name for Laser Bolt was "Dart." It was designed by Ed Watts.

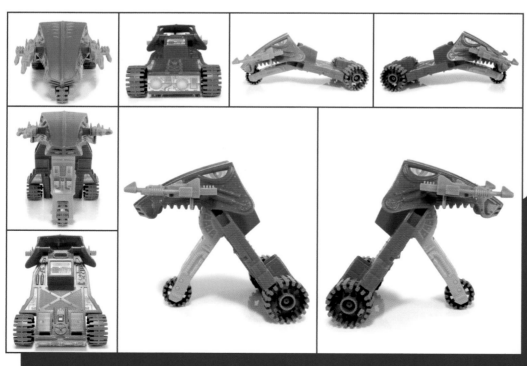

LASER-LIGHT SKELETOR
EVIL MASTER OF LIGHT ENERGY

First released 1988 • Member of the Evil Warriors

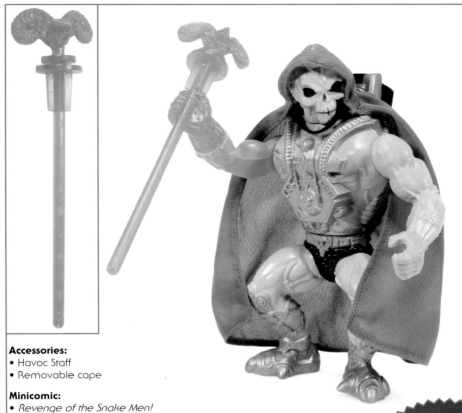

Accessories:
- Havoc Staff
- Removable cape

Minicomic:
- *Revenge of the Snake Men!*

The final variations of our main hero and villain, Laser-Light Skeletor and Laser Power He-Man, are among some of the rarest figures in the line, since they were only released in Europe.

Laser-Light Skeletor has a completely new sculpt and a drastically new look. This version has a very biomechanical look to it, with armor that seems to be fused to his skin. His head sculpt is all-new and features a removable cloth cape and hood. For the first time we can pull back Skeletor's purple hood and get a look at the back of his head, where we see the sculpt of several wires. The overall futuristic, semicyborg look seems to be a step in the direction of the 1989 He-Man line, in which Skeletor has many of these same attributes.

Laser-Light Skeletor's armor has a slim, black removable "Power Pack," allowing you to insert a AA battery to power his light-up action feature. This differs from Laser Power He-Man's much larger removable backpack, which was used to house the electronics for that figure. Skeletor's wiring runs internally, instead of being exposed like He-Man's. He features a translucent red right hand that can hold on to his Havoc Staff, also molded in translucent red. When raising Skeletor's right arm, the light-up feature is triggered. Bright lights shine from his red hand, which then illuminates the Havoc Staff via light piping. The staff does not light up nearly as brightly as his hand, but it is still a highly effective feature. In addition, Laser-Light Skeletor's eyes light up a bright red, giving him a very evil and menacing look. Due to these exciting features, this rare figure has become highly sought-after by collectors.

FUN FACTOIDS:
- The early working name for Laser-Light Skeletor was "Bio-Mechazoid Skeletor." Designed by David Wolfram, it was influenced by H. R. Giger and the novel *Neuromancer*.
- Figures made in Spain had a shorter cloak than those made in Italy.

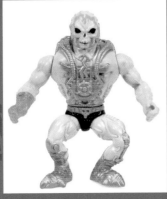

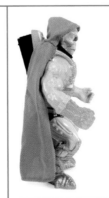

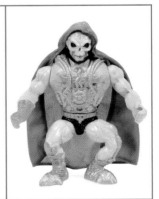

LASER POWER HE-MAN
HEROIC MASTER OF LIGHT ENERGY

First released 1988 • Member of the Heroic Warriors

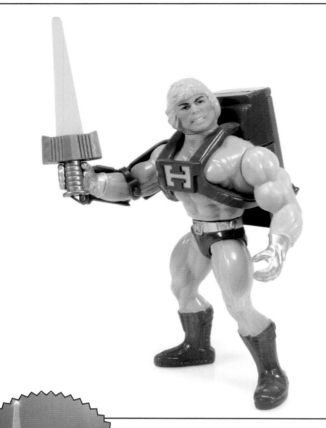

VARIANT

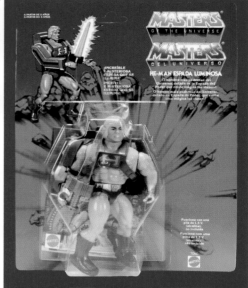

Accessories:
• Laser sword
• Arm armor
• Backpack

Minicomics:
• Enter...Buzz-Saw Hordak!
• Revenge of the Snake Men!

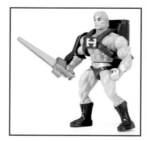

The final variations of our main hero and villain, Laser Power He-Man and Laser-Light Skeletor, are among some of the rarest figures in the line, since they were only released in Europe.

Laser Power He-Man has an entirely new sculpt that features quite a drastic change to his outfit. He appears almost futuristic, with silver gloves and padded boots. The figure seems to bridge the gap between the original Masters of the Universe toy line and the 1989 He-Man toy line, which finds our hero in space.

The figure's gimmick lies in the laser sword. The oversized backpack on Laser Power He-Man's back houses a AA battery. Wires extend from the pack and into the bottom of the laser sword. When He-Man's sword is raised by lifting his arm, the sword illuminates via a light inside the clear yellow blade.

Laser Power He-Man is also notable for having a variant head sculpt. The Spanish release has the standard 1982 He-Man head used for all previous versions. However, the Italian release's head has shorter hair and is often referred to by fans as the "Dolph head," due to its resemblance to actor Dolph Lundgren, who portrayed He-Man in the 1987 motion picture. This was the first time He-Man's look was changed so drastically in the entirety of the line.

FUN FACTOID: An early Laser Power He-Man prototype featured a green crystal on the backpack. Originally he was going to be a part of a line of crystal-powered toys, potentially as part of a live-action television show.

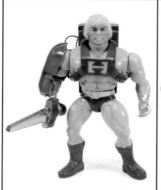

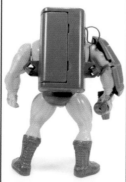

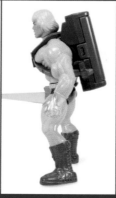

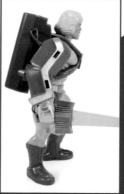

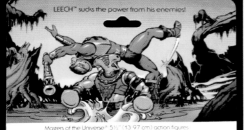

LEECH
EVIL MASTER OF POWER SUCTION

First released 1985 • Member of the Evil Horde

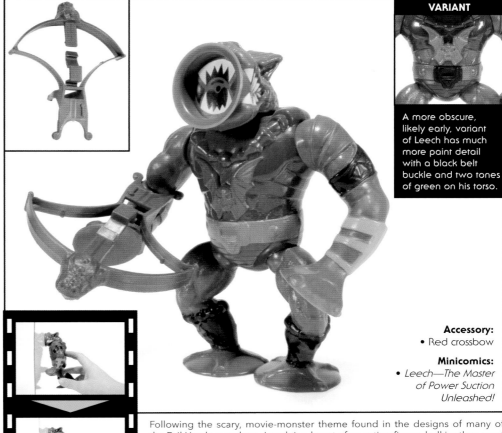

VARIANT

A more obscure, likely early, variant of Leech has much more paint detail with a black belt buckle and two tones of green on his torso.

Accessory:
• Red crossbow

Minicomics:
• *Leech—The Master of Power Suction Unleashed!*

Following the scary, movie-monster theme found in the designs of many of the Evil Horde members, Leech is a beast of an action figure, bulkier than most figures in Masters of the Universe. The figure shares no parts with any other figure in the line and features sharp teeth and large suction cup–shaped hands and feet.

The figure's gimmick lies in the suction cups. The hands are made of softer plastic, allowing the figure to cling to smooth surfaces. But the suction of his hands tends to be rather weak. However, the suction feature at the end of the figure's mouth is much more effective. The suction cup on the end of Leech's mouth has a small hole in it, with a tube that leads down to a bladder housed inside the figure. By pressing a button on Leech's back, a vacuum can be created in the bladder, allowing Leech to cling to smooth surfaces with his mouth.

Leech is also packaged with a dark red version of the Horde crossbow, a weapon that is included with many of the Evil Horde action figures, but it has a different head sculpt. This can clip over Leech's wrist and has the same "firing" mechanism as the other crossbows. There is a small latch in the center of the crossbow, allowing you to hook the front of the crossbow to the handle. Giving a light press on the top of the latch will cause it to unhook and slightly spring forward.

Leech has a notable paint variation with a black belt buckle and a light green stomach. This more closely matches the cross-sell artwork on the packaging, and is thought to be the early release of the figure. The more common release, and likely a running change, has Leech's entire torso painted the same color—dark green—and has no black paint on the belt buckle.

FUN FACTOID: There are several production variants for Leech, the most notable being the version with a black belt buckle and light green abs. This is likely the first release version of Leech, as it is closest to the cross-sell artwork and the prototype figure that the artwork was based on.

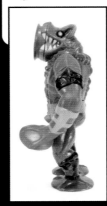

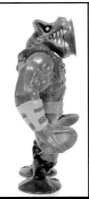

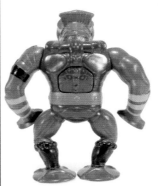

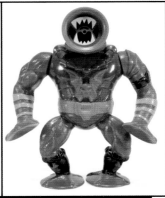

MAN-AT-ARMS
HEROIC MASTER OF WEAPONS!

First released 1982 • Member of the Heroic Warriors

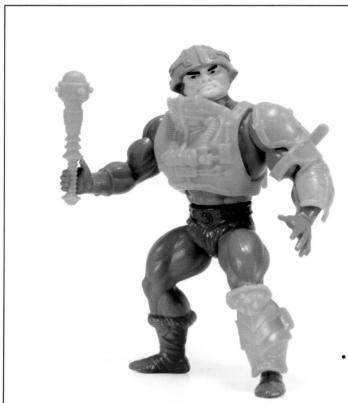

Accessories:
- Mace
- Removable arm and leg armor

Minicomics:
- *Battle in the Clouds*
- *He-Man and the Power Sword*
- *He-Man Meets Ram-Man!*
- *King of Castle Grayskull*
- *The Ordeal of Man-E-Faces!*
- *The Vengeance of Skeletor*

VARIANT

The original eight-back release of Man-at-Arms has two red dots on his helmet. This detail was left unpainted on future releases.

A perfect example of the Masters of the Universe mythology's fusion of barbarian warriors and technology, Man-At-Arms is the most "tech-heavy" of the first wave of figures released. His design resembles a futuristic Spanish conquistador, with his armor and helmet covered in sculpted hoses and cables.

The body of the figure is the standard He-Man torso, arms, and legs, with the interesting decision to cast the arms, including the wrist bracers and hands, in a solid green plastic with no paint details, as if he is wearing a full-body suit under his orange armor. An often overlooked observation: the back of Man-At-Arms's head shows hair sculpted under the helmet, but it is painted the same blue color as the helmet, so it is hard to notice.

The figure is noticeably lacking the mustache that Man-At-Arms is known for, thanks to his appearance in the *He-Man and the Masters of the Universe* cartoon series. The mustache was an addition by Filmation in an effort to make him look older, and more like a father figure. This look became iconic for the character, so many fans find it can feel odd to look back at his original action figure and see his clean-shaven face.

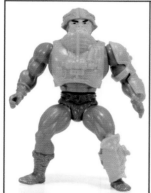

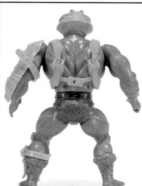

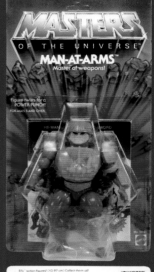

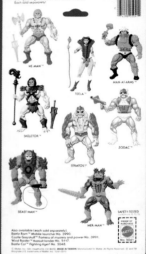

EIGHT-BACK

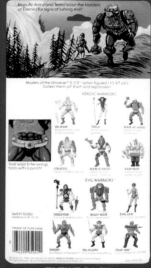

TWELVE-BACK

FUN FACTOIDS:
- One early working name for Man-At-Arms was Arms Man.
- Early releases of Man-At-Arms have red dots on the helmet, while subsequent releases omitted this detail.

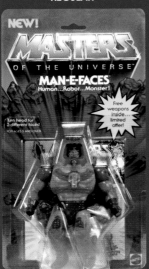

REGULAR

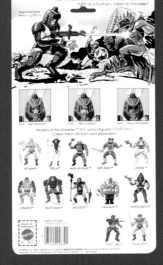

(MAN-E-WEAPONS)

MAN-E-FACES
HEROIC HUMAN...ROBOT...MONSTER!

First released 1983 • Member of the Heroic Warriors

Accessory:
• Laser pistol

Minicomics:
• *He-Man Meets Ram-Man!*
• *The Ordeal of Man-E-Faces!*
• *Siege of Avion*

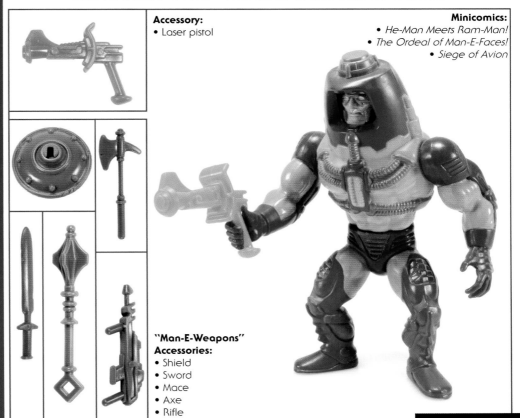

"Man-E-Weapons"
Accessories:
• Shield
• Sword
• Mace
• Axe
• Rifle

Man-E-Faces is the first real departure from the basic look of Masters of the Universe figures. He has the most tech-heavy design of any of the figures that came in the first few waves. All pieces used for Man-E-Faces are unique, aside from the legs, which are shared with Trap Jaw (released the same year) and Roboto (released later in the line).

While Man-E-Faces has the same "battle ready" squat pose, his legs appear too short for his body. This is because his torso was elongated in order to fit his face-changing action feature. The head features a drum inside with three face sculpts—a human face, a robot face, and a green monster face. By turning the dial on top of his head, you can easily rotate the face drum and display the figure with the face of your choice.

Even with the new body sculpt, Man-E-Faces' figure still includes the standard waist-twisting "power punch" action feature. By rotating his upper body and letting go, the spring-loaded mechanism will cause him to snap back into place to deliver a punch to his foes.

There were a couple of different releases for Man-E-Faces. The standard release included a reddish-orange laser pistol accessory. There was also a more deluxe release, now referred to by fans as "Man-E-Weapons," that included five bonus weapons from the Castle Grayskull play set molded in maroon plastic.

FUN FACTOIDS:
• Man-E-Faces' blaster weapon was later reused as a tail gun in the Voltron line.
• Man-E-Faces' blaster weapon was also used as the blaster for the highly collectable Deathlor from the Speclatron toy line.
• Early working names for Man-E-Faces include "Multi Face" and "Maska-Ra."

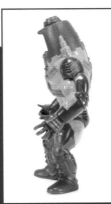
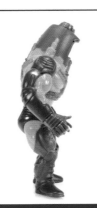
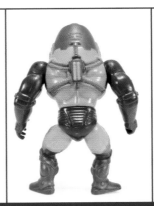
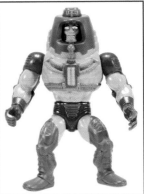

MANTENNA
EVIL SPY WITH THE POP-OUT EYES

First released 1985 • Member of the Evil Horde

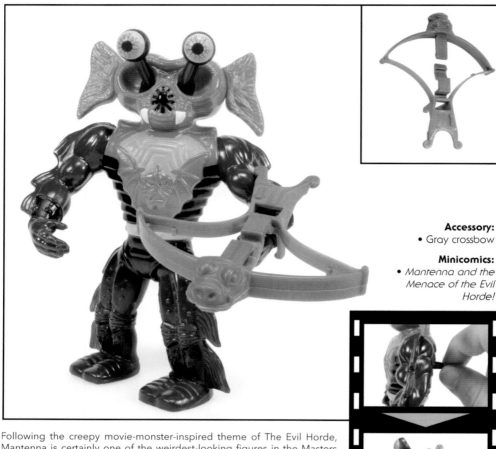

Accessory:
• Gray crossbow

Minicomics:
• *Mantenna and the Menace of the Evil Horde!*

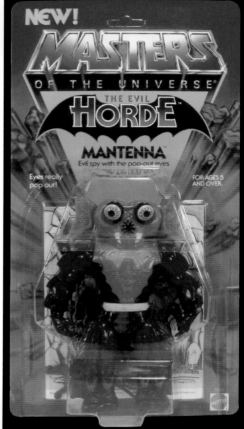

Following the creepy movie-monster-inspired theme of The Evil Horde, Mantenna is certainly one of the weirdest-looking figures in the Masters of the Universe line. As the Horde spy, he features an oversized head with large radar-dish-like ears and round bug-out eyes.

There is a small lever protruding from the figure's back. By lifting the lever upward, Mantenna's eyes extend from within his head. Lowering the lever brings the eyes back into his eye sockets. This action feature certainly adds to the overall weird look of the character.

Mantenna is a brightly colored member of the Horde, featuring a prominent blue-and-red color scheme. An interesting bit of sculpted detail can be found in his legs. If you look closely, you'll notice that Mantenna actually has four skinny legs. It is easy to miss this detail, because the legs have been fused together and only function on the figure as two legs.

Mantenna is also packaged with a gray version of the Horde crossbow. This version of the Evil Horde crossbow was reused with Dragstor. There is a small latch in the center of the crossbow, allowing you to hook the front of the weapon to the handle. By giving a light press on the top of the latch the weapon will unhook and slightly spring forward.

There is a paint variation on the figure where the area around the Horde bat's head on its chest is painted orange instead of red. However, this version is lacking the red paint on the bat emblems on the shin guards.

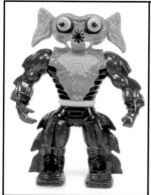
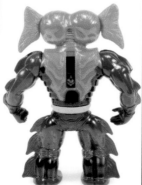

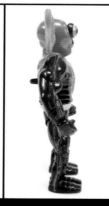

FUN FACTOID: Designed by Ted Mayer, Mantenna's early working names were "Sensor" (also a working name for Zodac) and "Raydor." All of his names are puns on devices used to sense things from a distance—hence his large pop-out eyes and oversized ears.

MANTISAUR
EVIL INSECTOID STEED

First released 1986 • Steed of the Evil Horde

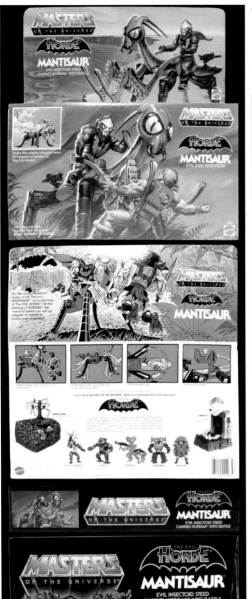

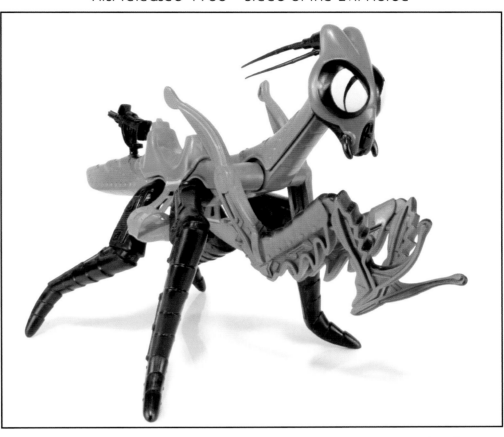

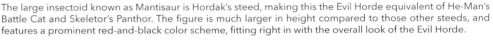

FUN FACTOID: Early working names for Mantisaur include "Mantoid" and "Mantor."

The large insectoid known as Mantisaur is Hordak's steed, making this the Evil Horde equivalent of He-Man's Battle Cat and Skeletor's Panthor. The figure is much larger in height compared to those other steeds, and features a prominent red-and-black color scheme, fitting right in with the overall look of the Evil Horde.

The removable saddle strapped to Mantisaur allows Hordak, or any other figure of your choice, to ride on the creature's back. There is also a gun mounted behind the saddle that can be rotated.

Mantisaur's front arms are shaped so they can hook under the arms of your Masters of the Universe action figures. By pushing down on the backs of the arms, which are shaped like levers, you can make Mantisaur pick up action figures, to mimic the way an actual praying mantis picks things up to feed on.

The design and colors used on Mantisaur's head, specifically his bulging eyes, are very reminiscent of the design of Mosquitor, making this an ideal steed to use for the Evil Energy-Draining Insectoid of the Evil Horde as well.

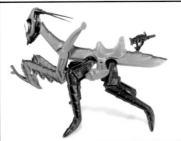

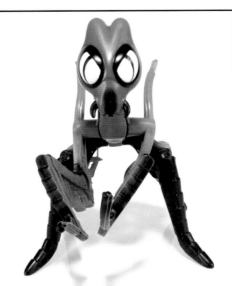

MEGALASER
HEROIC WIND-UP BEAM BLASTER

First released 1986 • Accessory of the Heroic Warriors

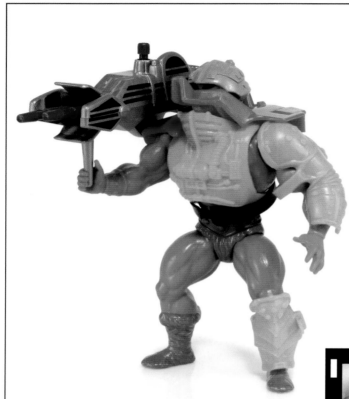

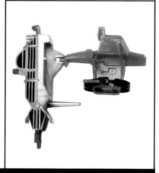

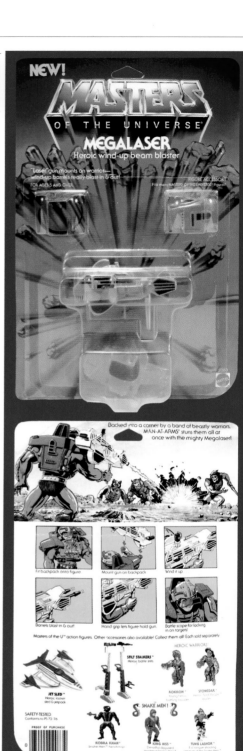

The Megalaser is a large weapon attachment that can be worn by your Heroic Warrior action figures. The armor attaches to most basic action figures with the included belt. As long as the figure does not have an oversized or unique body sculpt, the Megalaser armor should fit.

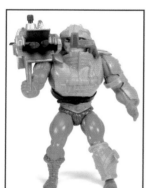

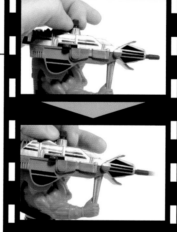

Mounted to the shoulder of the included armor is the large Megalaser weapon. There is a handle on the front that your action figure can grip on to. A red scope extends from the other side of the back armor and covers the figure's left eye to help lock on to targets.

The wind-up mechanism causes two laser cannon barrels to move in and out, making it look like the cannon is blasting at foes!

FUN FACTOID: Megalaser was designed by Ted Mayer.

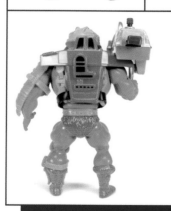

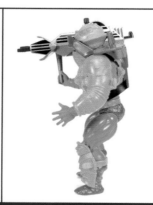

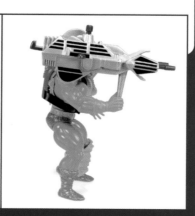

MEGATOR
EVIL GIANT DESTROYER

First released 1988 • Member of the Evil Warriors

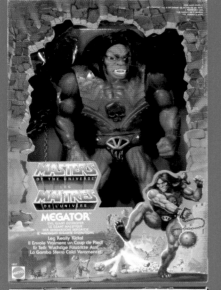

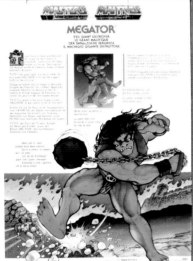

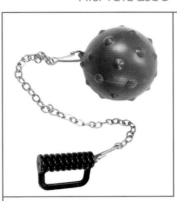

Accessories:
• Spiked ball and chain

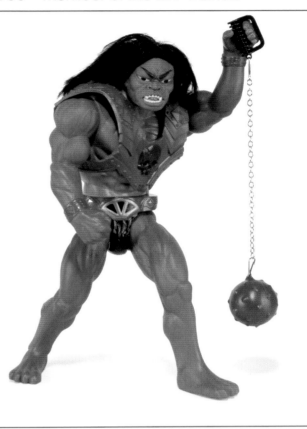

The giants Megator and Tytus are some of the rarest figures in the Masters of the Universe line, since they were only released in Europe. They were designed to be part of the spinoff Powers of Grayskull line, which was intended as the follow-up to Masters of the Universe. While the Powers of Grayskull line never actually got off the ground, Tytus and Megator were still released, primarily in Italy, but with the new Powers of Grayskull logos replaced on their packaging by the regular Masters of the Universe logo. Regardless, the artwork still gives us a glimpse of He-Ro, the character who was intended as the protagonist in the Powers of Grayskull line.

Megator stands a massive fifteen inches tall, towering over the regular five-and-a-half-inch action figures in the line. This evil giant has a hideous, ogre-like look, with green skin and a face only a mother could love. Both giants also feature rooted hair, something not found anywhere else in the Masters of the Universe line.

Megator has a spring-loaded right leg for a "real" kicking action feature. By pulling his leg backwards and letting go, the leg quickly snaps back into place, allowing the evil giant to punt-kick the tiny Heroic Warriors!

FUN FACTOID: Megator was inspired by an early Mark Taylor sketch, which was itself based on another Mark Taylor concept design known as Demo Man. Alan Tyler developed the figure further into Megator.

 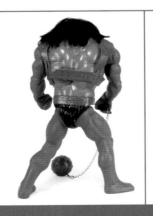 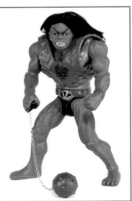

MEKANECK
HEROIC HUMAN PERISCOPE!

First released 1984 • Member of the Heroic Warriors

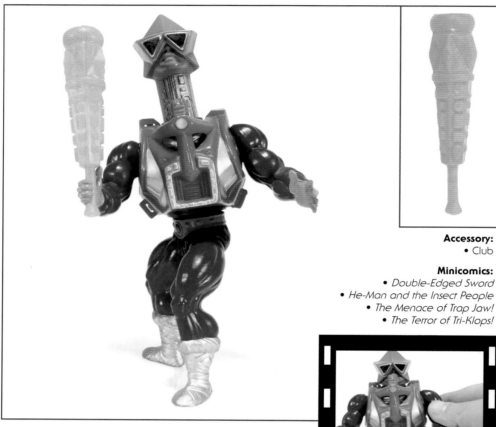

Accessory:
• Club

Minicomics:
• Double-Edged Sword
• He-Man and the Insect People
• The Menace of Trap Jaw!
• The Terror of Tri-Klops!

With his periscopic neck imbuing him with the power of long-range viewing, Mekaneck is the heroic spy of the Masters of the Universe toy line. In fact, his early working name during development was "Spy Man."

Mekaneck's figure reuses the He-Man body, but comes with unique clamshell armor, an original head design, and a brand-new weapon. Of course, the torso was reworked slightly to fit Mekaneck's action feature. The periscopic neck works by twisting the figure's waist. Doing so extends the neck upwards, revealing a silver mechanical-looking neck with lots of sculpted details. Twisting his waist back lowers the neck and head back down to normal position.

This action feature does work well, but as a result Mekaneck's neck can only be extended when his body is awkwardly twisted, which can have an odd effect during play or when trying to display him on a shelf.

Mekaneck's armor and helmet design are both very bulky and angular, giving him a unique look. Like Man-At-Arms and Man-E-Faces before him, he is another early character that steered the designs in a more sci-fi direction.

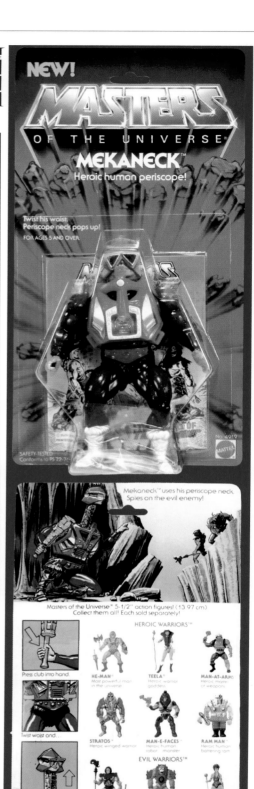

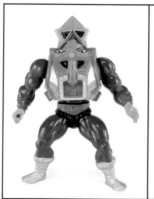

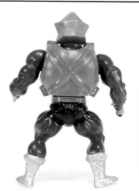

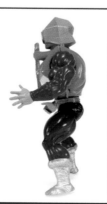

MER-MAN
OCEAN WARLORD!

First released 1982 • Member of the Evil Warriors

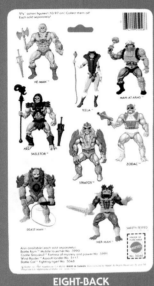

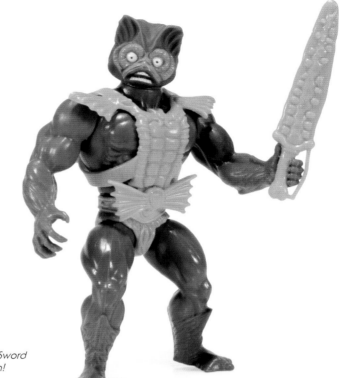

Accessory:
• Sword

Minicomics:
• *Battle in the Clouds*
• *He-Man and the Power Sword*
• *He-Man Meets Ram-Man!*
• *King of Castle Grayskull*
• *The Vengeance of Skeletor*

One of the earliest Evil Warriors released, Mer-Man is one of the more prominent henchmen of Skeletor, alongside Beast Man.

The figure reuses Skeletor's body with the finned arms and monster-like feet. He has a new head sculpt and a unique piece of armor that has a coral-like appearance. Interestingly, Mer-Man's design, specifically his head sculpt, is one that is drastically different from the cross-sell artwork found on the figure's packaging.

Like many of the figures in the early releases, Mer-Man's figure includes the waist-twisting "power punch" action feature. When you rotate his upper body and let go, the spring-loaded mechanism will cause him to snap back into place to deliver a punch to his foes.

Mer-Man's sword is always a memorable accessory, as many fans tend to humorously relate it to corn on the cob. The sculpt is likely supposed to give the impression the weapon is made from coral or the rostrum of a sawfish.

VARIANT

Later releases of Mer-Man left the belt unpainted, making it the same orange color as his trunks.

FUN FACTOIDS:
• Mer-Man's design was inspired by Bernie Wrightson's Swamp Thing.
• Mer-Man tested poorly with children, and was almost dropped from the line.
• An early working name for the character was "Sea Man."

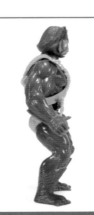

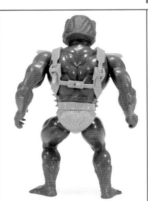

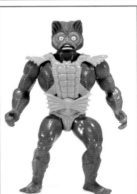

MARK ELLIS

Can you tell me a little bit about your early career and how you came to work at Mattel?

I went to University of Minnesota, and after that got my MBA at Wharton. I started my business career at General Mills in the marketing department. I spent five or six years at General Mills, and then I worked for Schaper Toys. In my second year at Schaper Toys I was approached by Mattel, who were trying to find somebody who knew something about toys, but more importantly had experience in how to develop a national product from scratch. This was 1980. Historically, toys were developed by an inventor or in-house inventors in the company. They would say, here's a doll that does this, or, here's a vehicle that does that. Or more importantly for male action figures, here's a movie that can be licensed so kids will want to relive the movie experience, so they will buy the figures and relive the experience of the film with their figures.

Mattel at that point wanted to develop a male action figure line that didn't come from a license from a cartoon or a movie or something that already existed. They hired me as Director of Marketing primarily to develop a new male action figure line.

Just to put the tape on rewind, in 1975 the toy industry for male action figures changed when the Six Million Dollar Man was introduced. That wiped out the generic figures of the day, which were G.I. Joe and Big Jim. Mattel had already tried to do what Kenner had done with Star Wars. They tried it with a series of films—*Clash of the Titans*, *Megaforce*, etc. The movies would open and close in spring, and Mattel would have spent $500,000 for licensing rights and $500,000 for tooling. Come November no one remembered the film and they just sat there on the shelves. The thought of Ray Wagner (the president of Mattel at the time) was that they needed to develop their own male action figure line from scratch.

They needed someone who could direct the development of this new male action line who already had developed products for nationwide production. My primary assignment was to set about developing what it takes to make a successful male action line. At the end of the day He-Man was successful because we paid attention to the right details. We did theme research. What's this going to be about—is it going to be space or military? More importantly, we did an evaluation of past major line introductions at Mattel and what made them successful or unsuccessful. We found that you can't introduce a male line without vehicles, and you need enough characters that people can play different roles and start a collection. They have to be collectible.

From that analysis, I knew we should have eight figures, two vehicles, and a play set. And the play set was critical because we needed a backdrop to set the tone of a commercial. We had to have an environment, a diorama to present the characters. To do that it had to be part of a line, legally.

Another aspect of the research that we did was how kids play with male action figure lines and what the features are that they want. One aspect of the research that was answered was that when a little boy picks up a male action figure, the first thing he says is, "What's it do?" To be successful, the figure has to do something. In contrast to Star Wars, our figures didn't just stand there, they did something. We developed the power action waist—able to twist and to hit things over—to make our figure stand out and answer that basic question.

It was very clear in watching our researcher deal with five-year-old boys, when a little boy is playing with these figures, any figure, what you hear coming from his mouth is the same things that he heard coming from his mother earlier in the day. "You do that because I tell you to do it." Little boys want to have power, just like (from their point of view) their mom has all the power.

We did theme research. One of the themes was Frank Frazetta–style barbarians, and the theme was power. Frazetta characters were very muscular. We accentuated that and put it into the marketing. Kids were saying they wanted power. Incidentally that led to the Sword of Power, that He-Man and Skeletor had.

Another aspect of the research that came out was that at five years old, the point of view is either you're good or you're bad. On a grown-up show like *NYPD Blue*, there were some cops who were not good, and some bad guys who were better than the cops. But for kids it's just black and white.

At my office in Mattel, I had an organization chart. Man-At-Arms reports to He-Man. You need to know who reports to who and what powers do

they have. It's clear, there's no ambiguity. When you're starting from scratch, these are important elements to have. By virtue of the fact that we had paid attention to all these details, that's what came out in all our subsequent efforts, that's why it was as successful as it was.

What about the name, "Masters of the Universe?"

It wasn't "Masters of the Universe" during the development of the line. After the theme research pointed to the barbarian style, the line acquired the name "Power Lords." That was its name until the very last minute. Glenn Hastings, the toy company president at the time, was adamant that the name Power Lords was inappropriate. He insisted on changing it and at the last second, we changed the line to Masters of the Universe.

I thought it was very interesting, shortly after Toy Fair, that Revell came out with a line of male figures called Power Lords. Clearly Revell knew about the research we had done. They copied a few of the things, but crucially, not all of them, and they weren't at all successful.

We showed our new line to large customers at our headquarters and later at Pre-Toy Fair in Scottsdale. At the end of my presentation for the line I got questions about, "What are you doing to tie it into another company so your marketing effort isn't just advertising?" They didn't want to get stuck with unsold inventory. Out of the blue, I said, "Didn't I tell you about the comic books?"

So then you had to make the comic books?

I got appointments at DC and Marvel. At DC I sat down and talked to the head of advertising. I said, "I want to buy ten pages of ads across your entire line." This guy looks at me and says, "Can I see your business card again?" I said "There is a small catch. I want you to do a comic book line having to do with this figure," and I pulled out a prototype He-Man figure. And the guy goes, "No . . . we're only in charge of advertising, but I can give you a great deal for the ads."

So I said, "You're not understanding where I'm coming from. I'm going to offer the same thing to Marvel. If I were you I'd go to your publisher's office right now so you don't get fired."

He went and got the publisher. Just then the editor came by and said it was a great figure, we should do a comic on this. That settled it. They did the first comic book miniseries.

In two weeks when Toys"R"Us came along, I had the comic book cover ready. When I had finished my presentation, my grand ending was "And here is the comic that DC is doing on this figure line." The Toys"R"Us buyer said, "The kids are five, they can't read, so what's a comic book going to do?" I responded, "Did I tell you about the three one-hour TV specials we are doing?" My brand group watching in the back did the eye roll, as of course I was making this up.

I went to Bill Hanna. He was the most famous cartoon guy I knew of. The first question from one of his executives was, "Well, Mr. Ellis, how many cut lines are you expecting on your character?" You really can't bullshit an answer if you have no idea what the question is about. So I just sat there looking stupid. So she finally said, "We do Casper, he's cheap to animate because he's just a tent. If your character has six-pack abs, and you have six cut lines to show his muscles, that is more than twice the expense of a Casper cel." They realized I couldn't find my butt with both hands. I didn't know what cut lines were.

So I go back to the office and make an appointment with Lou Scheimer at Filmation. I went out to the Valley and after talking to him for five minutes I said, "I'm looking for three or four cut lines." I wanted him to know that I was an "expert" or at least not as dumb as I was with Hanna Barbera. Lou, to his credit, asked me if we bought spot television in addition to network ads. I said, "Yes, we have a huge spot budget."

Lou asked that question about whether we bought spot TV because he had the idea of using our spot budget to help him sell this new *He-Man* cartoon. Rather than just try to convince a station to pick up the cartoon, he would be able to go in and say, "If you buy this cartoon, I can get your station more advertising revenue from Mattel." Because we combined the cartoon with our ad budget, we got great clearances. The cartoon that Filmation did was very good. So it got excellent ratings as well.

Do you think the Filmation show increased He-Man's sales?

We were already selling more than we could produce, so it was hard to tell. But in retrospect, I think the cartoon made Masters of the Universe an icon. My thought was to introduce it with comic books to get the story out. Then we would introduce the TV show. That kicked it as it was peaking to get a new audience, and then a year after that the plan was to do a movie.

A couple of thoughts: what makes an interesting cartoon is totally different from what made Masters of the Universe figures popular. We (Mattel) were focused on power and to keep all of our figures true to the various elements of research we had done. In animation or cartoons, an important aspect of doing a kids' show is to have comic relief. That was the last thing Mattel wanted but it was vital to the cartoon show. Thus Filmation added characters like Orko because they knew how to make a successful cartoon.

Oh, one thing I didn't mention about our research. There's a strong desire for kids to collect. Once they start with one figure or car or whatever, they want the whole collection. We could tell what sales will be by monitoring sales of He-Man and Skeletor. If they bought He-Man and Skeletor, we knew they would get another four point five figures over the next four to six months because they would want more figures to play with. So the idea was to get kids to start a collection and then make sure the additional vehicles and figures would be available for them to complete their collection. The way I looked at it, the TV show was about getting a new audience. Same with the movie—start a new audience of younger kids. Once the new fan bought He-Man or Skeletor, he was on track to buy the rest of the figures in the line, the vehicles, and the play sets, if he begged enough.

You mentioned you wanted to do the movie right after the TV show. Of course the movie didn't come out until much later—four years after the cartoon debuted.

I wanted the movie to come out two years after the cartoon. But when I walked in and talked to some of these movie guys, that's when I realized I was out of my element. A two-year planning horizon for that sort of project was totally unrealistic. I sat down with a couple of major producers of movies. One guy said, "Okay, listen, you put five million cash in, and I put five million equivalent in and I get international rights." And he stuck his hand out like he wanted to do the deal right there. I left Mattel to be the International President of Ideal Toys before serious work started on the movie. I was there to get it started, but it was others who carried that ball forward.

I was involved in getting a producer for the Masters movie. The guy who sold us that he knew how to produce a movie that fit our budget was Ed Pressman. He came into the Mattel conference room and said, "For your budget, you can't afford to do the film on Eternia. But you've got to start the film on Eternia to establish this as the real Masters of the Universe movie. Whole thing set. The real success of this film will be how good of a segue you can come up with in the first ten minutes to get the action from Eternia to Earth, where you can film the rest of the movie and be on budget." So with that understanding he got the go-ahead to start the movie. As you mention, it ended up taking a lot longer than I had expected, but that it got done at all was actually quite remarkable.

Early artwork for He-Man had him depicted with a Viking helmet. Why did that get dropped?

We did theme research, and that theme research had three different things: space, military, and, loosely phrased, Frank Frazetta. The first sketches were for the research as to what theme we should do, and those had really nothing to do with Masters of the Universe, they were to do with deciding our themes. I believe the sketches you refer to were not production sketches, but rather something used for the theme research.

And then there's He-Man's hair color. There's the famous story about He-Man's hair being changed to blond to look more like a Mattel executive?

Right, my boss was Tom Kalinske, and he had blond hair. The prototype had brown hair. Pay attention, all of the people reading this. In corporate America, make the hero have the same color hair as your boss.

The B-sheet art for He-Man and Skeletor didn't include the split Sword of Power. Was it added fairly late in the process prior to production?

The real story, which I don't think anybody's ever published, is that our advertising guy was enamored with *Star Wars* and wanted the story line to have something to do with brothers. I thought that was too much of a knock-off of the Luke/Vader father relationship. But the engineering was already done to have the swords work together to open Grayskull. So I left that in the line but we never developed the story behind it.

There were originally going to be two female figures released in 1982—one with cobra armor (Sorceress) and one without (Teela). They were eventually combined into the same figure and released as Teela. Can you talk about why that happened?

Thinking about the line in the eleventh hour, the president was screwing around with our name. We sat down with the whole brand group and they asked: are girls going to play with this? It didn't have hair play or costume play, which were the hallmarks of dolls. At the end, we decided to keep eight figures but only do one female and seven guys. Later on we got the usage research, after the first four or five months of Masters being introduced. We figured out that thirty to forty percent of the kids playing with it were girls! That was an astounding figure and it showed we made a mistake in our original line makeup.

When were the first figures released?

Toy Fair was in January or February [of 1982]. I do know we were very careful on our first shipment. I explained this idea of kids would buy He-Man or Skeletor and then buy secondary figures. So we had to be very careful with our assortments. It was all about keeping He-Man and Skeletor on the shelf. Nobody started with any of those other characters.

I remember at the end of the first year we had merchandisers, an army of people at the toy stores that took out slow-selling ones and put He-Man and Skeletor back on the shelf. The first year was handled very well. I would say the demise of the line had a great deal to do with the loss of that thinking. We had all these orders, so for a twenty-four-pack of assorted figures, it was up to us what the assortment was. We had a ton of these tertiary characters, so we put a ton in. But they wouldn't sell.

Not keeping the discipline of the makeup of the assortments and making sure the right mix of product was on the shelf was just a giant shotgun to the foot. More than anything that's what caused the demise of the line, in my opinion.

The toy commercials were pretty memorable. Did you have a hand in those?

I remember the very first meeting with the advertising agency and I said, "I want a Gregorian chant going underneath this whole thing." That established the tone. I was trying to impress them to go as far as they could with the theme. It was very important. Kids didn't know about this line, so we relied on our commercial to show what the whole thing was about. We had Castle Grayskull as the diorama to convey the theme and the power.

How did you guys come up with the character names?

I can tell you we did a great deal of research at Tequila Willie's at Manhattan Beach. Our brand group would meet there and discuss alternative figures. I'm not suggesting that's the research we did. But throughout the line there's some incredibly poor puns that if you had some margaritas you might come up with.

Do you think MOTU could ever work again as a toy line primarily marketed to young kids? Or has its day come and gone?

There's a probability. I can tell you that to my knowledge nobody went through and researched all of the elements required to be a success as thoroughly as we did. In looking at subsequent introductions by other companies, I found they forgot about the collection, that there's an innate desire among people to start collections. There's ways of starting that process. They would ignore that, or they forgot the context, they forgot the diorama, what's the backdrop, how do you simulate the action. You have to research it and figure out all the elements.

I noticed that Janice Varney-Hamlin, I think it was on Barbie in *The Toys That Made Us*. She was explaining how She-Ra got over to the girls' side rather than the boys' side. It was the first time ever that boys' toys outsold girls' toys. They were pissed about that. We actually outsold all of the girls' toys, including dolls.

What are you most proud of from your time on the He-Man brand?

There was a series of talented people at Mattel, artists that did varying things that combined to make this a wonderful product. Starting out with Mark Taylor's characters. The sculptor Tony Guerrero . . . those guys made it come to life. So you have to hand it to them. Paul Cleveland was the guy who came up with the battle action waist. It seems like a throwaway, but it was really a key element to answer the question of "What does it do?" It was so simple. The most unheralded innovation was our packaging. The Masters logo on the card. The blister wasn't just square, it was shaped and angular. That was really cool. The logo to this day, that was the first time the blue logo with lines shooting out was done. I see that style in all kinds of other things. In every package was a small pack of sword and shields. Every package. I was talking about the research before. You have to get everything right. I found out in the girls' research that the little combs that they include with Barbie are valued as much as the toy itself. I made sure to include a lot of little stuff to give away with the figures, which added to the value. I think my most significant contribution was that I made sure we included all of those lessons learned from our research and analysis.

MODULOK
EVIL BEAST OF A THOUSAND BODIES

First released 1985 • Member of the Evil Horde

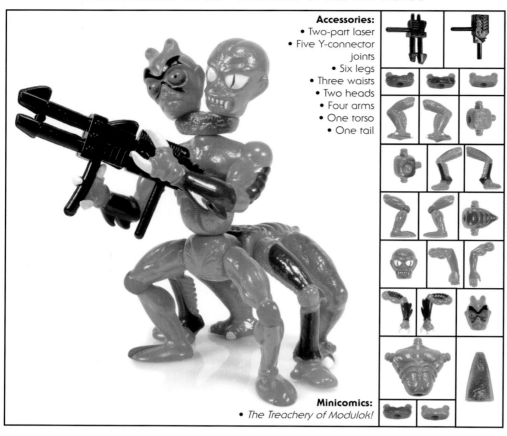

Accessories:
- Two-part laser
- Five Y-connector joints
- Six legs
- Three waists
- Two heads
- Four arms
- One torso
- One tail

Minicomics:
- *The Treachery of Modulok!*

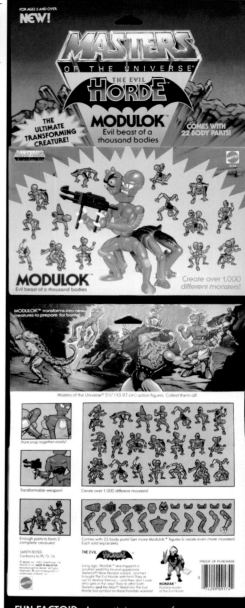

Modulok is the Evil Horde's shape-shifting creature! This deluxe figure came packaged inside of a box instead of on the usual blister card like the standard action figures. This is because Modulok has an exciting and (at the time) unique action feature that allows you to mix and match all of his parts to create whatever kind of monster you want!

The box contains twenty-four pieces in total, including his connecting guns, allowing you enough pieces to build two separate beasts if you wish to. Or, you can combine all twenty-four parts to make one large, hideous creature! With two heads, six different legs, and four different arms, fans had a lot of fun creating different-looking versions of this character. Whether you want him to have a simple shape with one head, two arms, and two legs, or want to go wild and give him both heads, all six legs, and four arms, the possibilities are all there!

It's no surprise that this figure has completely new pieces and no shared parts with any other figures. Modulok is much slimmer, and his parts have an almost insect-like appearance.

A second figure released in a later wave—Multi-Bot—would share this same mix-and-match action feature. You can even combine Modulok and Multi-Bot together to create a large mismatched creature! In various pieces of art, this mismatched character has actually been given a name. Sometimes he is referred to as "Megabeast," like on the poster art for Eternia. At other times, he is referred to as "Mega-Monster," like in the instruction sheet for Multi-Bot. There doesn't appear to be one standard way to build this creature.

FUN FACTOID: Argentinian manufacturer Top Toys produced a version of Modulok that was packaged on the standard-sized blister card. Since there was no such card set up for Modulok, Top Toys reused the card back from Kobra Khan. The figure itself came with green limbs and is highly sought after today.

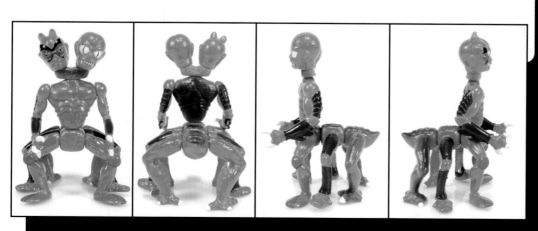

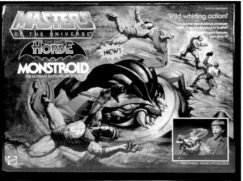

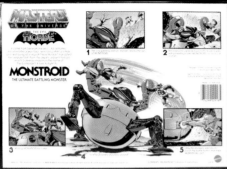

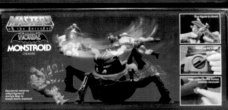

MONSTROID
THE ULTIMATE BATTLING MONSTER

First released 1986 • Monster of the Evil Horde

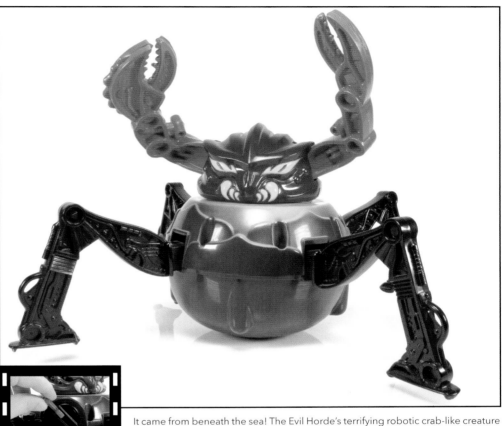

It came from beneath the sea! The Evil Horde's terrifying robotic crab-like creature is a massive beast that whirls and twirls your heroic action figures, while also knocking over any other figures who come close enough to try to stop him!

The creature has two crab-like claws extending from his head that can grab on to the limbs of any of your Masters of the Universe figures. The lower body is a large bulb-like structure with four legs. After he is wound up, Monstroid begins to spin quickly while also rolling around on his lower body. But there is a button on the beast's body that you can press to stop his spinning destruction. This way, you can use He-Man or any of your other figures to stop him with a punch!

FUN FACTOID: The animated *He-Man and She-Ra Christmas Special* featured several giant robots called Monstroids; however, they looked nothing like the Mattel toy.

MOSQUITOR
EVIL ENERGY-DRAINING INSECTOID
First released 1987 • Member of the Evil Horde

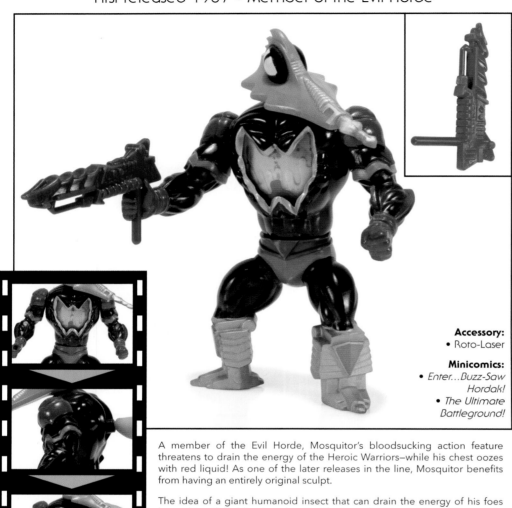

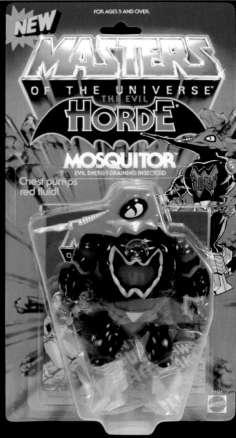

Accessory:
• Roto-Laser

Minicomics:
• *Enter...Buzz-Saw Hordak!*
• *The Ultimate Battleground!*

A member of the Evil Horde, Mosquitor's bloodsucking action feature threatens to drain the energy of the Heroic Warriors—while his chest oozes with red liquid! As one of the later releases in the line, Mosquitor benefits from having an entirely original sculpt.

The idea of a giant humanoid insect that can drain the energy of his foes by sucking their blood evokes that feeling of a late-night monster movie, making him a perfect fit for the horror-themed Evil Horde faction. The blood pumping action feature is one of the coolest used in the line and is a bit of a Mattel classic. By pumping the button on his back, red liquid begins to flow through the window on his chest, simulating the absorption of "energy" or "blood" from his victims. The same red liquid just recycles through as you are pumping the button, and remarkably, even after thirty years most of these figures still retain this feature in working order.

The same blood-pumping action feature also appeared on previous Mattel toys, such as Pulsar: The Ultimate Man of Adventure in 1976 and Gre-Gory, Big, Bad Vampire Bat, in 1979.

Mosquitor is often found with either an unpainted or a silver-painted belt buckle. There is also a rare version known as "Black Blood Mosquitor" released by Top Toys in Argentina, with other paint variations and liquid in his chest that is black in color. The pumping feature is also known to be nonfunctional on this version, though it is unconfirmed if that was intended or if the figures that exist are not in working order.

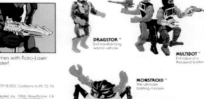

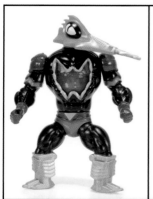

FUN FACTOIDS:
• Some Top Toys–produced versions of Mosquitor have black "blood." This was apparently used when the factory ran out of red.
• The Mosquitor sold in Spain came with a blue gun rather than a purple one.

MOSS MAN
HEROIC SPY & MASTER OF CAMOUFLAGE
First released 1985 • Member of the Heroic Warriors

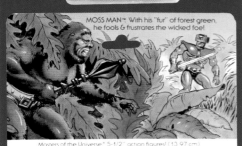

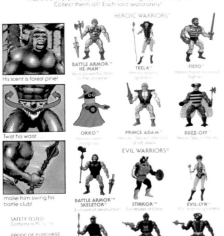

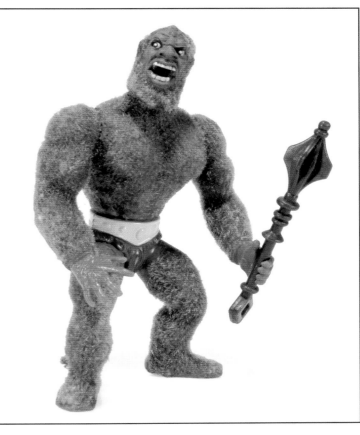

Accessory:
• Club

Minicomics:
• *The Secret Liquid of Life!*
• *The Strench of Evil!*

Much like Mekaneck before him, Moss Man was characterized as being a spy for the Heroic Warriors because of his ability to blend in with his surroundings.

The figure reuses the Beast Man body completely, down to the head sculpt. In an effort to make the Beast Man face look a little less angry, Mattel opted to paint the eyes looking off to the side. They also painted black over the fangs sculpted in his mouth, causing them to blend in to the open part of his mouth, giving his teeth a more natural appearance as opposed to monstrous.

The big difference here is that the figure is flocked, giving him a rough, turf-like feel. To go along with this, Moss Man's unique action features is his pine-fresh smell! Mattel mixed a pine scent in with the figure's plastic. As soon as you ripped this figure off the card back, your home would instantly smell like a Christmas tree. While not quite as powerful after a time, Moss Man figures do still retain a hint of that pine smell even today.

Continuing the parts reuse, Moss Man's weapon is the Castle Grayskull weapons rack club molded in a brown plastic. The figure also retains the same waist-twisting "power punch" action feature. By rotating his upper body and letting go, the spring-loaded mechanism will cause him to snap back into place to deliver a punch to his foes.

FUN FACTOID: It's likely that both Moss Man and Stinkor were among the first new figures to be released in 1985. Their cross-sell artwork shows up first on the back of vehicle packaging, along with the figures released from 1982-1984.

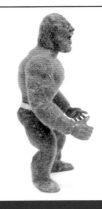
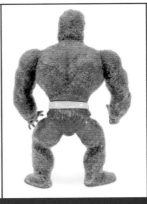
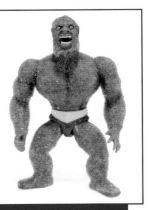

MULTI-BOT
EVIL ROBOT OF A THOUSAND BODIES

First released 1986 • Member of the Evil Horde

Accessories:
- Five Y-connector pins
- Six legs
- Two torsos
- Three waists
- Two heads
- Four arms
- Two-part laser

Minicomic:
- *The Menace of Multi-Bot!*

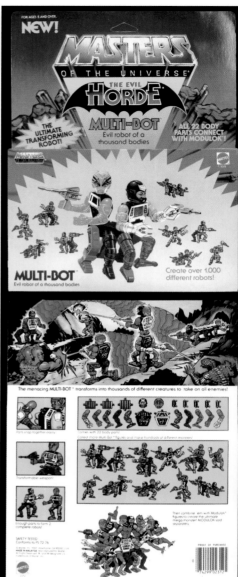

Much like Modulok before him, Multi-Bot is a member of the Evil Horde with a fun mix-and-match feature allowing you to combine multiple parts to create many different-looking robotic creatures! Multi-Bot came packaged inside of a box instead of on the usual blister card like the standard action figures. The box includes twenty-four total pieces, counting his connecting lasers, allowing you enough pieces to build two separate robots if you wish. Or, you can combine all twenty-four parts to make one large robot with multiple heads and limbs. The box touts that there are a thousand possibilities!

Again like Modulok, this figure has completely new pieces and no shared parts with any other figures. His joints are the same design as Modulok's. This means you can share parts between the two figures if you desire. In various pieces of art, this mismatched character has actually been given a name. Sometimes he is referred to as "Megabeast," like on the poster art for Eternia. He's also referred to as "Mega-Monster" in the instruction sheet for Multi-Bot. There doesn't appear to be one standard way to build this creature.

FUN FACTOID: An early working name for Multi-Bot was "Modular Man." The concept was created by Roger Sweet and designed by Ted Mayer.

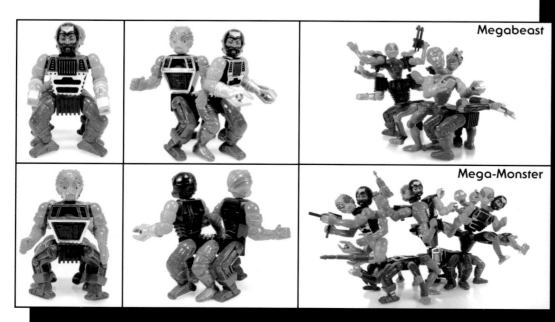

Megabeast

Mega-Monster

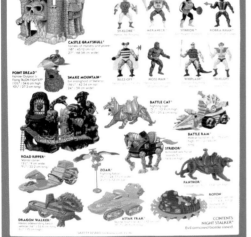

NIGHT STALKER
EVIL ARMORED BATTLE STEED!

First released 1985 • Steed of the Evil Warriors

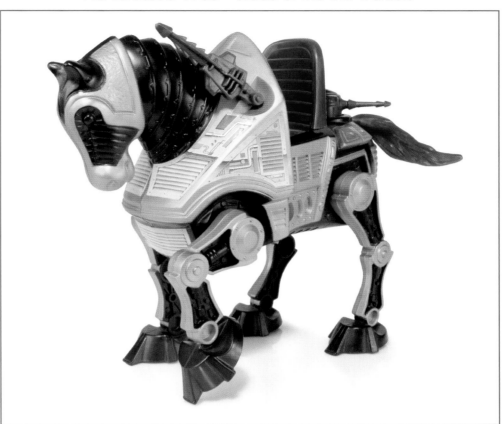

Night Stalker is a repainted release, essentially a reissue of Stridor from the year before, but in a new color scheme and made for the Evil Warriors. This is like how Panthor is simply an evil version of Battle Cat.

Night Stalker is lacking the helmet that appears on Stridor. He also has a completely new set of stickers. This design choice does a pretty good job of making him look like a different character.

The horse is made to look mechanical in design. Rather than a saddle on his back for figures to mount, he has a cockpit for the figures to sit inside, with their legs fitting into the body of the horse. There is a gun mounted behind the cockpit that can be swiveled, and two guns sit on either side of his neck. These guns can also be moved up or down. Even though his appearance suggests otherwise, Night Stalker does not have any articulation whatsoever. His legs look like they should move, but instead are molded in a static pose, much like Battle Cat and Panthor before him. While he was released without a helmet in most markets, a version of Night Stalker with a purple Stridor helmet was released in Venezuela, Brazil, and France.

While Skeletor is depicted as Night Stalker's rider on the box art, there was also a gift set released that included a Jitsu figure. Because of this, many fans consider Jitsu to be Night Stalker's regular rider.

FUN FACTOID: Night Stalker is the only evil vehicle or steed in the vintage Masters of the Universe line to be packaged with a figure other than Skeletor or Battle Armor Skeletor.

NINJOR
EVIL NINJA WARRIOR

First released 1987 • Member of the Evil Warriors

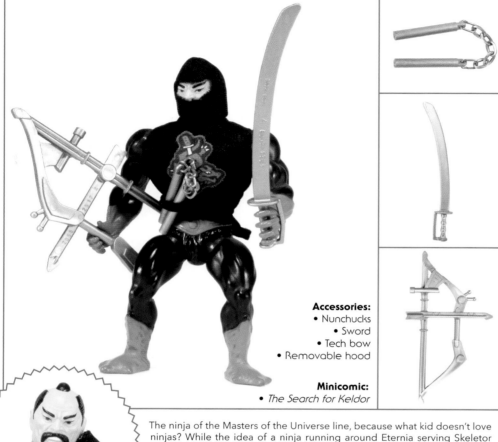

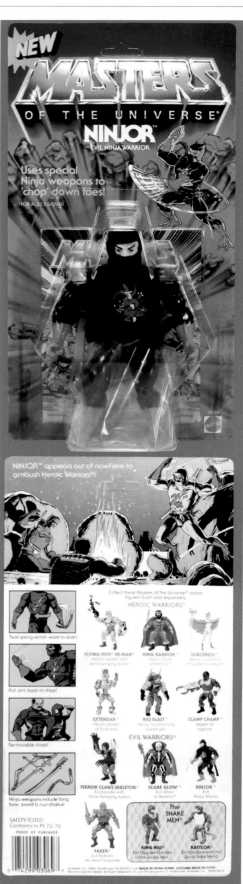

Accessories:
- Nunchucks
- Sword
- Tech bow
- Removable hood

Minicomic:
- *The Search for Keldor*

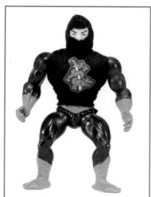

The ninja of the Masters of the Universe line, because what kid doesn't love ninjas? While the idea of a ninja running around Eternia serving Skeletor does seem a bit out of place, when designing Ninjor the design team took the look of a ninja and MOTU-ified it.

The figure reuses Skeletor's body, thus giving him monster-like arms and legs, making him seem slightly less human. Also, since he's part of the Masters of the Universe line, he has the same bulky, muscular body as most of the other characters—something you wouldn't typically picture when thinking of a ninja.

Ninjor has a cloth tunic and hood instead of the usual plastic armor found on most of the other figures. This could of course be removed, giving toy buyers the interesting feature of being able to pull back his hood to reveal his face hidden underneath.

Ninjor's figure is packaged with several weapons for accessories, including a very high tech-looking bow (reused from the Eternia play set), a ninja sword(reused from Jitsu), and a pair of nunchakus with a real metal chain.

The figure also has a few spring-loaded action features, allowing him to pull off some martial arts–type moves on his foes. The waist-twist "power punch" feature is here, allowing you to twist his waist and release, snapping the figure back quickly to deliver a punch. Much like Fisto and Jitsu, he also has a spring-loaded feature in his right arm. By lifting the arm, Ninjor can "chop" downward, or swing his sword and nunchakus.

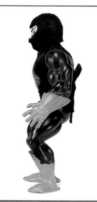

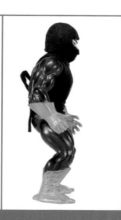

FUN FACTOID: The prototype head sculpt for Ninjor looked too much like actor Lee Van Cleef and had to be resculpted.

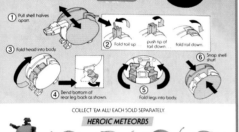

ORBEAR
EVIL GRIZZLY BASHES ENEMIES WITH CLAWS!

First released 1986 • Member of the Evil Meteorbs

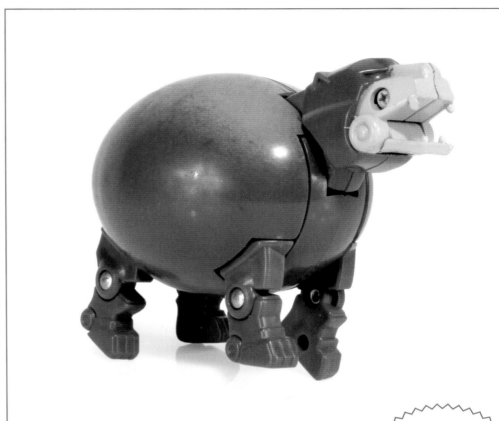

The Meteorbs are meteor rocks that can transform into animals and robots.

These transforming toys were originally released in Japan by Bandai under the name "Tamagoras." They were brought to the US by Mattel and released as characters in the Masters of the Universe line of action figures. This was Mattel's attempt to add the popular transforming toy mechanism seen in other lines, such as Transformers.

The transformation from meteor to animal is a fairly simple mechanism, usually not requiring instructions. By simply popping open the egg-shaped toy you can easily fold out the legs and head to complete the transformation.

Orbear is mostly brown in color, transforming into a grizzly bear down on all fours. He features very little articulation outside of the transforming action feature.

The Meteorbs at times feel out of place among the many action figures found within Masters of the Universe, but somehow they still fit within the combination of magic and science fiction that allowed the toy line to incorporate so many widely differing designs.

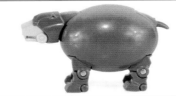
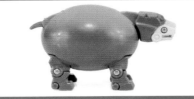

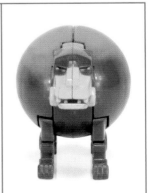

ORKO
HEROIC COURT MAGICIAN

First released 1984 • Member of the Heroic Warriors

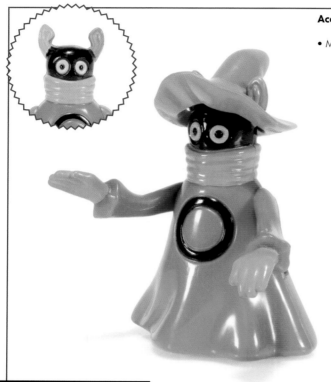

Accessories:
• Ripcord
• Magic trick

Minicomic:
• *Slave City!*

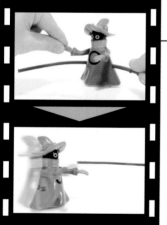

Orko, the little Trollan magician, was made popular by Filmation's *He-Man and the Masters of the Universe* cartoon series. Due to the success of the show, Mattel decided to bring Orko into the toy line in 1984.

Because he is based on the animated character, Orko has a very different look from most of the figures found in Masters of the Universe. This short character features an oversized, removable hat, posable arms, and a long robe with no legs.

Orko's action feature is triggered by inserting the included ripcord. Once it's quickly pulled, a small metal rod on the bottom of the figure would spin, causing Orko to wildly run around in circles on a smooth surface. In the cartoon, Orko levitated, so this action feature was a way to try to mimic his wild flight patterns seen in the show.

His figure is also packaged with a magic trick accessory, consisting of small plastic coins with stickers depicting both Evil and Heroic Warriors. This was a simple trick similar to those found in cheap magic trick sets at toy stores, in which Orko "magically" changes the Evil Warrior coins to Heroic Warriors by use of a secret compartment in the cap.

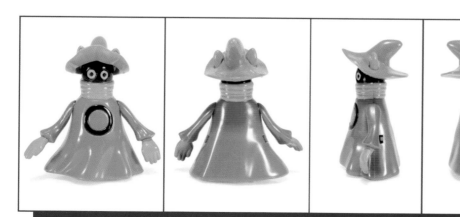

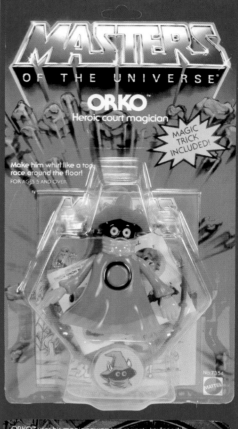

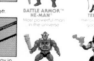
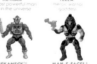
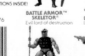

FUN FACTOIDS:
• Orko was the only vintage Masters of the Universe figure to have a Filmation copyright stamped on it.
• The early version of Orko, named Gorpo, wore a costume that was blue rather than orange and magenta. He also had a Caucasian skin tone.

PANTHOR
SAVAGE CAT

First released 1983 • Steed of the Evil Warriors

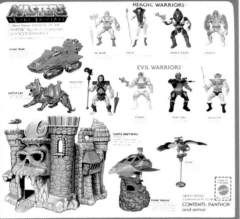

Accessory:
• Removable saddle

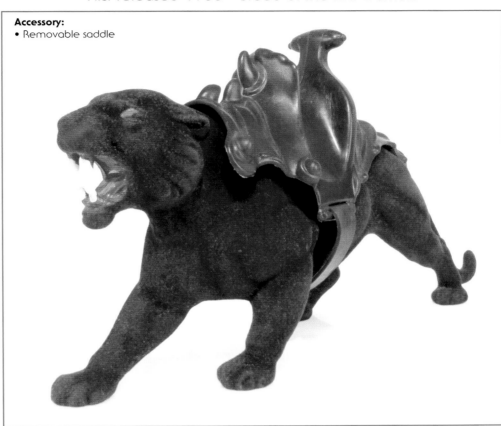

FUN FACTOID: Panthor was based on Battle Cat, but with short "fur" and no helmet. Panthor's color scheme was chosen by Mattel designer Martin Arriola. Some early depictions of the character gave the cat black fur and purple armor.

Skeletor's savage steed and the evil counterpart to Battle Cat, Panthor clearly recycles the same mold used for He-Man's steed, released the prior year.

Battle Cat was not the first time Mattel reused this exact same cat sculpt. It was first used during the 1970s for a few of Mattel's twelve-inch action figure lines: once as a normal orange tiger for their 1976 Big Jim line, and again as a black jungle cat for their 1977 Tarzan line. Just like with Battle Cat, this makes Panthor larger in scale when compared to the five-and-a-half-inch Masters of the Universe action figures, and works perfectly when he is presented as a large steed for Skeletor to ride.

While utilizing the same sculpt as Battle Cat, Mattel did a good job of making Panthor look like a completely different feline character. He is given the same saddle armor as Battle Cat but molded in green, and he lacks the signature Battle Cat helmet. He is colored a deep purple, giving him a colorful appearance very unlike any real-world feline. To make Panthor a little more exciting and to help him stand out on his own, Panthor is fully flocked, giving him a slightly fuzzy texture. As with any toys, years of play could possibly cause some Panthor figures to lose a little fur. Yet this flocking undoubtly enabled kids to love Panthor much more than if he had been simply "a purple Battle Cat."

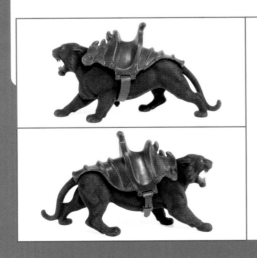

POINT DREAD
& TALON FIGHTER

First released 1983 • Outpost of the Heroic Warriors

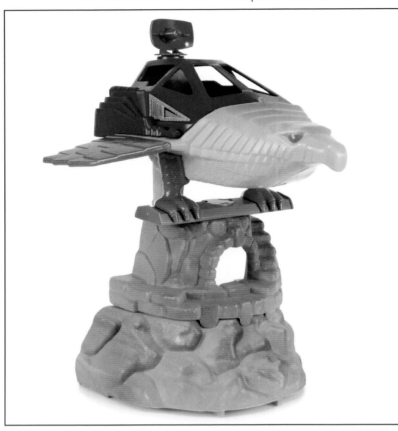

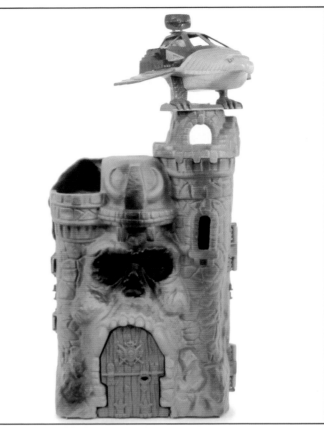

Point Dread and the Talon Fighter is touted as being three toys in one due to the multiple modes of play.

The Talon Fighter is a large flying vehicle that is designed to look like an eagle or a hawk. It is brightly colored, featuring an orange-and-blue color scheme with a radar dish on the top and an opening canopy. The interior is roomy, allowing you to fit two figures inside. Stickers adorn the cockpit to look like controls and various tools and weapons. The landing gears are shaped like talons, and a handle on the bottom allows kids to grip it and easily zoom the ship around.

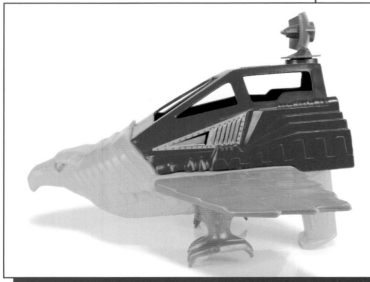

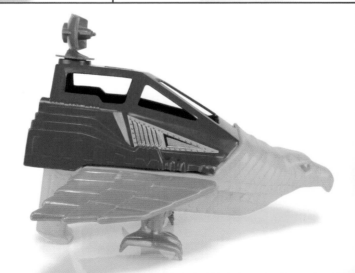

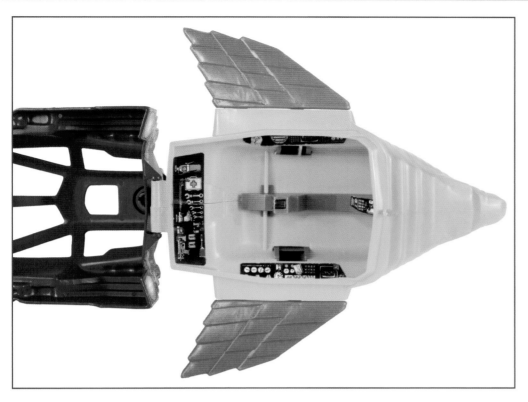

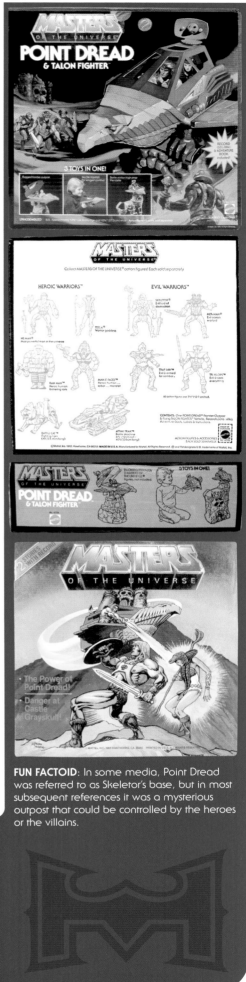

The frontier outpost known as Point Dread is very similar in design and color to the Castle Grayskull play set. It's an empty shell with a rocky structure on the outside. The top portion has a small sculpted staircase leading up to a perch that the Talon Fighter can sit atop. The inside has a small cardboard insert that works as a control panel and screen for your figures.

The top portion of Point Dread can actually be detached from the base and attached to the top tower of the Castle Grayskull play set, extending the tower and allowing the Talon Fighter to sit atop the castle. It's a really fun play feature that adds a bit of new excitement to the existing castle!

Point Dread & Talon Fighter was also packaged with its own record and storybook: *The Power of Point Dread!*

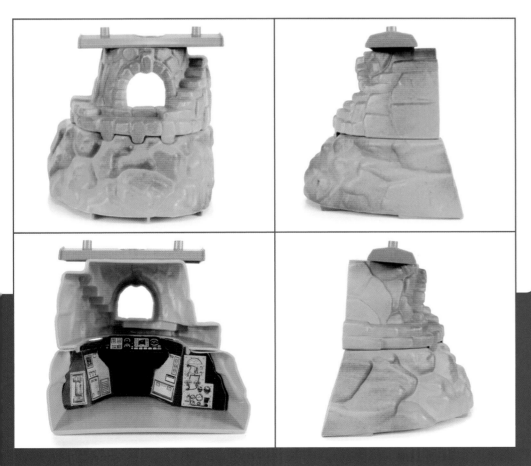

FUN FACTOID: In some media, Point Dread was referred to as Skeletor's base, but in most subsequent references it was a mysterious outpost that could be controlled by the heroes or the villains.

PRINCE ADAM
HEROIC "SECRET IDENTITY" OF HE-MAN

First released 1984 • Member of the Heroic Warriors

Accessory:
• Magenta Sword of Power

Minicomics:
• *He-Man and the Insect People*
• *The Menace of Trap Jaw!*

Even though he appeared in the DC comics prior to the release of the show, the Filmation *He-Man and the Masters of the Universe* cartoon certainly popularized the idea of Prince Adam being the alter ego and secret identity of He-Man, and made it standard canon for the remainder of the original toy line and beyond.

Because of this, Mattel introduced a Prince Adam action figure. Much like in the cartoon itself, the Prince Adam action figure was just He-Man in different clothes. The He-Man figure was repainted, this time with his torso and arms painted white as if he were wearing a shirt, and his legs painted a light purple as if he were wearing pants.

The colors used on the figure very much matched the appearance of the character in the Filmation cartoon, with the exception that his vest was changed to a dark maroon instead of the light pink he was seen sporting in the show. Prince Adam is the very first action figure in the line to be given cloth clothing elements with his vest and his elastic belt.

Prince Adam also comes with the same Sword of Power accessory, molded in a maroon plastic instead of the usual gray found on the He-Man figure. He also retains the waist-twisting "power punch" action feature, although it's up to the user to decide whether Prince Adam's punch is as powerful as He-Man's. By twisting the figure at his waist and releasing, the figure will quickly snap back to place, allowing him to deliver a punch to his foes.

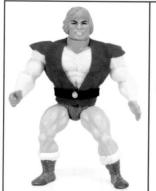

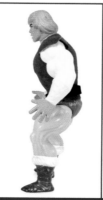
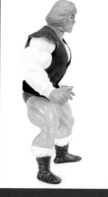

FUN FACTOID: Prince Adam went through many different design changes before his final toy design. An early design by Mark Taylor had him wearing a flamboyant brimmed hat. Later designs would depict him with a red vest and sometimes a red shirt.

 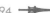

RAM MAN
HUMAN BATTERING RAM!

First released 1983 • Member of the Heroic Warriors

Accessory:
• Axe

Minicomics:
• *He-Man Meets Ram-Man!*
• *The Secret Liquid of Life!*

Released in the second wave of the Masters of the Universe toy line, Ram Man is a departure from the standard body design used for most of the figures in the line. He's also the first figure whose unique parts were never reused for another figure. The figure is short and stout, with a heavy focus on his battering ram action feature. The figure's legs are fused together, and do not individually articulate. In fact, his overall articulation is extremely limited due to his design, meaning the only things you can actually move on the figure are his arms.

The figure features a spring-loaded leg mechanism. By pressing the torso down, the legs lock in place inside the figure's body. A small button is located on the back of his foot. Pressing the button will trigger the spring, popping the upper body back to make the figure a human battering ram that can be used to knock over other figures.

The figure that was released in stores looks noticeably different from the figure that was pictured on the back of the toy packages. The final figure was a red and green in color, but in all of the cross-sell art Ram Man is shown wearing an orange tunic and red pants.

FUN FACTOIDS:
• Ram Man had at least two early working names: "Hercule" and "Jumping Jack Flash."
• The first prototype was colored red and orange, which were the colors from the "Jumping Jack Flash" character.

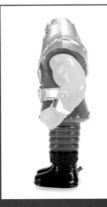

RATTLOR
EVIL SNAKE MEN CREATURE WITH THE QUICK-STRIKE HEAD
First released 1986 • Member of the Snake Men

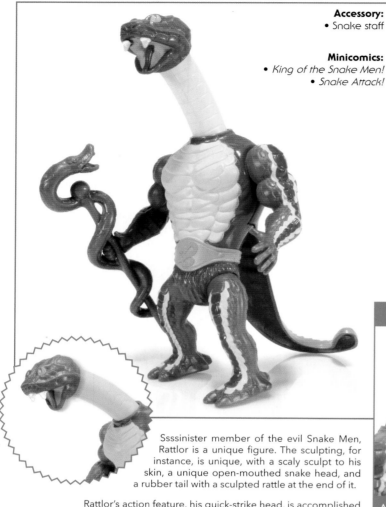

Accessory:
• Snake staff

Minicomics:
• *King of the Snake Men!*
• *Snake Attack!*

Ssssinister member of the evil Snake Men, Rattlor is a unique figure. The sculpting, for instance, is unique, with a scaly sculpt to his skin, a unique open-mouthed snake head, and a rubber tail with a sculpted rattle at the end of it.

Rattlor's action feature, his quick-strike head, is accomplished with the figure having an elongated, spring-loaded neck that can be pressed down inside the figure's body. A small button is on his back, hidden underneath the rubber tail. By pressing this button, the spring mechanism is triggered and the neck quickly shoots forward, giving the effect of a snake lunging forward to strike at its prey.

VARIANT

A less common variant of Rattlor has his neck the same red color as the rest of his body. Interestingly, this matches the card back artwork.

In order to accommodate the long neck within the body, Rattlor's torso had to be quite large when compared to other Masters of the Universe figures. This causes his legs to appear quite short and stumpy. The figure also had a few pieces of loose plastic inside that would rattle around when you shook the figure. This is his "battle rattle," as the package calls it: a way to re-create the warning a rattlesnake gives by shaking its tail just before a strike.

There is a notable variation of Rattlor. The more common release sees the figure with a bright yellow neck. However, there are some releases where the neck is the same color red as the rest of the figure.

FUN FACTOID: Rattlor started life as a Roger Sweet concept, with a yellow-and-green color scheme. Rattlor would have reused Buzz-Off's legs and Skeletor's arms, just like Whiplash. The final toy, however, has a unique body sculpt and was designed by John Hollis.

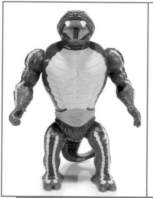
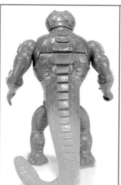
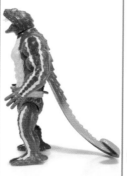
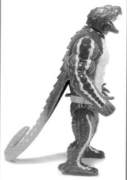

RHINORB
EVIL RHINO WITH HORRIBLE RAMMING HORN!

First released 1986 • Member of the Evil Meteorbs

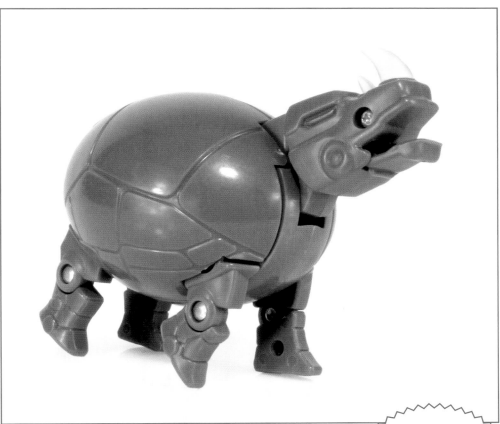

The Meteorbs are meteor rocks that can transform into animals and robots.

These transforming toys were originally released in Japan by Bandai under the name "Tamagoras." They were brought to the US by Mattel and released as characters in the Masters of the Universe line of action figures. This was Mattel's attempt to add the popular transforming toy mechanism seen in other lines, such as Transformers.

The transformation from meteor to animal is a fairly simple mechanism, usually not requiring instructions. By simply popping open the egg-shaped toy you can easily fold out the legs and head to complete the transformation.

Rhinorb's gray body has a unique sculpted scale-like pattern. Once transformed, he features a robotic rhino-shaped head complete with horn and bright red eyes. In some media, such as comic book appearances, Rhinorb could be seen shooting lasers from his eyes, hence the red color on the toy.

The Meteorbs at times feel out of place among the many action figures found within Masters of the Universe, but somehow still fit within the combination of magic and science fiction that allowed the toy line to incorporate so many widely differing designs.

RIO BLAST
HEROIC TRANSFORMING GUNSLINGER

First released 1986 • Member of the Heroic Warriors

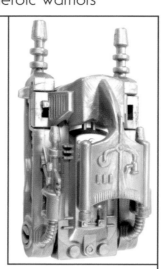

Accessory:
• Blasterpak

Minicomic:
• *The Fastest Draw in the Universe!*

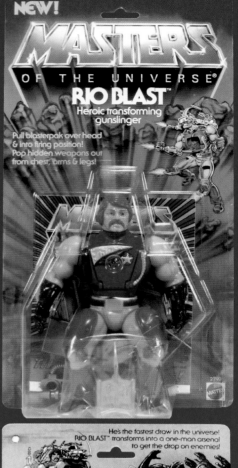

MASTERS OF THE UNIVERSE®
RIO BLAST™
Heroic transforming gunslinger

Pull blasterpak over head & into firing position! Pop hidden weapons out from chest, arms & legs!

He's the fastest draw in the universe! RIO BLAST™ transforms into a one-man arsenal to get the drop on enemies!

Masters of the Universe® action figures! Collect them all! Each sold separately.

Heroic Warrior Rio Blast has the appearance of a futuristic cowboy with an arsenal of blasters hidden all over his body, including inside of his chest! His look has a very Wild West vibe, especially with his handlebar mustache and hairstyle. However, there is also an abundance of futuristic technology in the character's look, with the laser blasters in place of classic six-shooters, and what appear to be cybernetic enhancements attached to him.

All of his blasters can be revealed. The blasters attached to the palms of his hands can be rotated forward. The brown patches on his thighs can be folded forward, revealing hidden blasters within. You can even pull his chest flap forward, revealing a larger laser blaster that was hidden inside of his chest cavity.

If that's not enough firepower for you, his blasterpak accessory also has the ability to fold forward over his head, revealing four more blasters and placing goggles over his eyes. Now with nine blasters, Rio-Blast is a one-man army ready to take on the forces of evil!

Rio Blast is a character who often gets labeled as being out of place among the heavy swords and sorcery theme of the Masters of the Universe toy line; however, technology has been a big part of the line from the very beginning. A cowboy is definitely a more American piece of history, and therefore could certainly be considered out of place on the planet of Eternia, but this was still a unique merging of an old theme and futuristic technology, that made for a fun action figure.

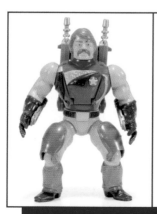
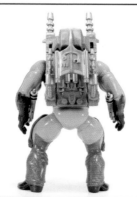
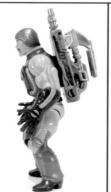

FUN FACTOID: An early concept for Rio Blast by Ed Watts had the working name "Fire Power Man." The character was not western-themed, but he did have a mustache and was intended to be a villain. The She-Ra character Colonel Blast was based on Fire Power Man.

ROAD RIPPER
WARRIOR CARRIER

First released 1984 • Vehicle of the Heroic Warriors

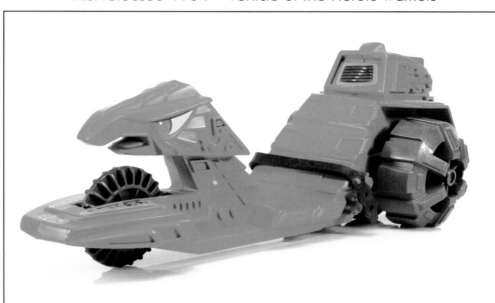

FUN FACTOIDS:
- An early working name for the Road Ripper was the "Tri-Trak."
- Early concept art for the Road Ripper showed a black-and-red color scheme.

The Road Ripper is a heroic three-wheeled motorcycle with a dragon theme in the design. It is a bright green in color with a very detailed sculpt. A few brightly colored stickers also help add to the overall detail and look.

The name is a clever play on words relating to the vehicle's action feature. It came packaged with a long red ripcord accessory. Placing the ripcord in the slot on the vehicle and then quickly removing it would leave a heavy rubber wheel hidden on the underside rapidly spinning, sending the vehicle speeding away across the floor!

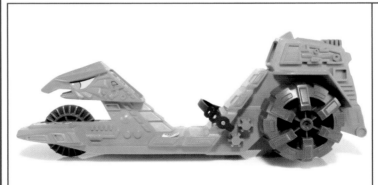

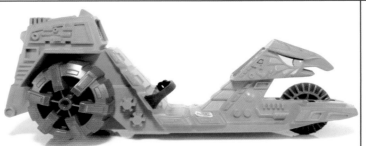

ROBOTO
HEROIC MECHANICAL WARRIOR

First released 1985 • Member of the Heroic Warriors

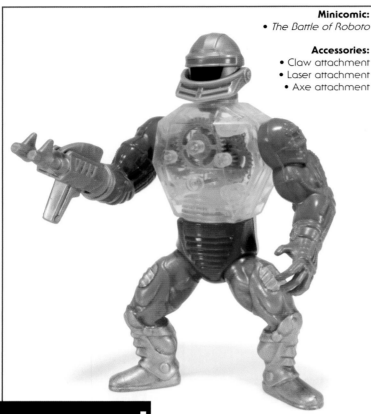

Minicomic:
• *The Battle of Roboto*

Accessories:
• Claw attachment
• Laser attachment
• Axe attachment

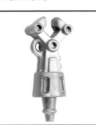
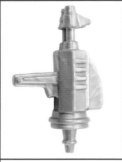
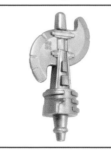

Roboto is one of the characters who really enhanced the futuristic sci-fi feel to the line. He is bright and colorful and features some unique pieces while still retaining the classic build of a standard Masters of the Universe action figure.

This figure's main standout is the translucent torso, allowing you to see the colorful gears that make up Roboto's innards. Instead of the typical spring-loaded "power punch" action feature, turning Roboto's waist triggers the gears inside to turn and the mouth piece on his head to move up and down.

Because of the action feature, Roboto's head cannot turn, but it is unique looking and very striking. The arms feature wires sculpted into the muscles to give him a more robotic feel. The legs are the only reused part, the mold having previously been used for Trap Jaw and Man-E-Faces.

Also, in similar fashion to Trap Jaw, Roboto has an interchangeable right hand. This allows you to swap between a laser, an axe, and a robotic claw. There is a lot of play value crammed into this one figure!

Of note, the figure's boots and thigh pieces are supposed to be a shiny silver in color; however, over time deterioration in the plastic can cause the silver to turn a pinkish color.

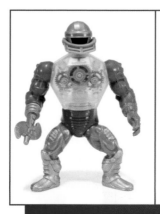
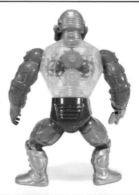
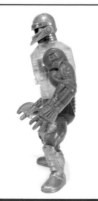
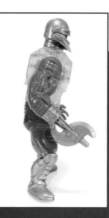

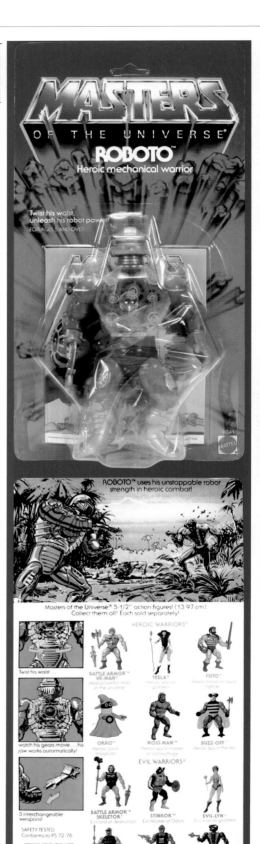

FUN FACTOID: Roboto was loosely based on a concept by Ted Mayer called "Transparent Man."

ROKKON
YOUNG HEROIC BATTLING BOULDER

First released 1986 • Member of the Heroic Warriors

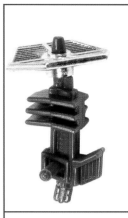

Accessory:
• Laser

Minicomic:
• *Rock People to the Rescue!*

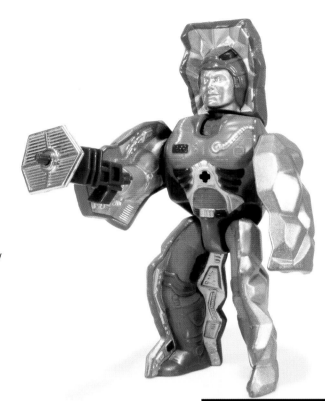

The Comet Warriors Rokkon and Stonedar were Mattel's way of incorporating a transforming action feature into the Masters of the Universe toy line to compete with the popular Transformers toy line from Hasbro. This action feature would be included again with the Meteorbs in 1987.

The unique design means that Rokkon is a fully original figure with no shared parts. The articulation also functions much differently from all other figures in the toy line, as the joints are designed specifically with the transformation in mind. It's a simple mechanism—essentially by folding the figure forward at the neck, arms, and legs, Rokkon folds into a blue-and-silver rock.

Rokkon includes one accessory in the form of a laser gun that has a unique chromed satellite-dish shape on the front. This blaster has two pegs: one on the side and one on the back. The peg on the side can plug into the socket on the figure's hand, allowing him to hold it for battle. The peg on the back plugs into the socket in the figure's chest. While it's not uncommon to see the Comet Warriors displayed with their laser guns plugged into their chests, the real purpose of the chest peg is so that the laser gun can be hidden within the rock formation when the figures are transformed.

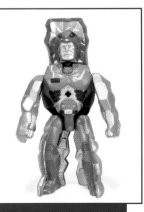

FUN FACTOID: Rokkon was initially packaged on a card that called him the "Young heroic battling boulder." The front of the card read, "Invincible boulder transforms into master of defense!" However, on subsequent versions, Rokkon was called a "Young heroic comet warrior" and the front of the revised card read "Invincible meteor transforms into mighty warrior." The change may have been made to capitalize on Halley's comet, which passed close to the earth in 1986.

ROTAR
Heroic master of hyper-spin

First released 1987 • Member of the Heroic Warriors

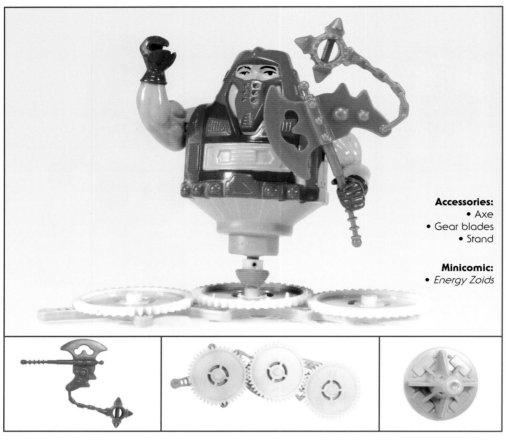

Accessories:
- Axe
- Gear blades
- Stand

Minicomic:
- *Energy Zoids*

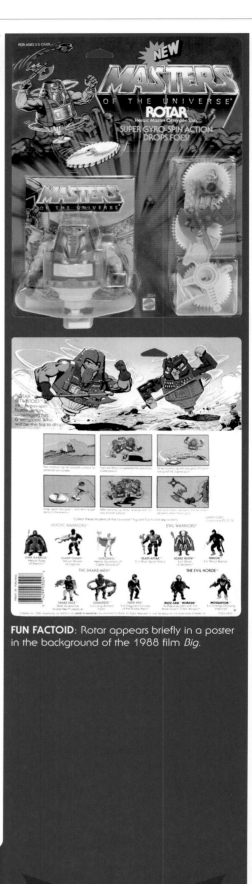

FUN FACTOID: Rotar appears briefly in a poster in the background of the 1988 film *Big*.

The Energy Zoids Rotar and Twistoid were an odd combination: half-action figure, half-revving top toy. The revving top function comes straight out of a classic Mattel toy known as the Wizzzer, a gyrostat top toy that was first released in 1969. By gripping the figure at the top and revving the bearing on a smooth surface, you can create a high-speed top spin that allows the figure to spin and remain standing for a lengthy amount of time.

The arms are the only articulated joints on the figure, and they are loose enough that when the figure is spinning the arms fly upward. This is so you can send your Energy Zoids into a spinning battle with each other or barreling over any standing foe that might be in their path!

The included accessories also worked into the spinning top action feature. One accessory resembles a large sword with three gears attached. Although it looks like a sword, it's a bit too large for Rotar to hold. Instead, when Rotar's spinning action is revved up, you can balance him on top of one of the gears. His spin will cause all three of these gears to spin, almost like saw blades.

Rotar also comes with a small stand, specifically designed to balance Rotar on top of while spinning.

Interestingly, Mattel was also working on a vehicle specifically for Rotar called the Gyrattacker. This vehicle was intended to launch Rotar and Twistoid into combat. While the vehicle appeared in the art found within the minicomic *Energy Zoids*, the Masters of the Universe toy line was canceled before the Gyrattacker toy could be produced.

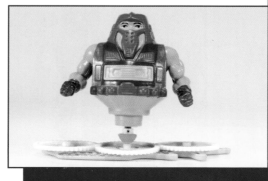
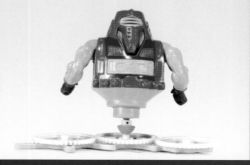

ROTON
EVIL ASSAULT VEHICLE!

First released 1984 • Vehicle of the Evil Warriors

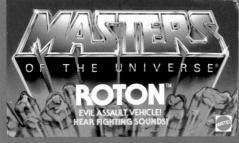

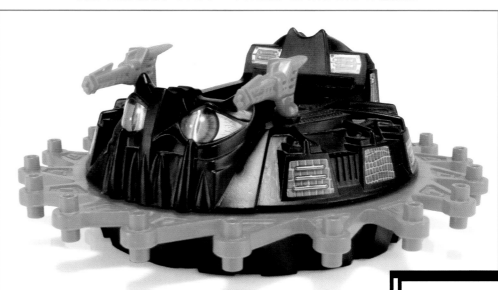

FUN FACTOIDS:
- The Roton was originally envisioned as a vehicle for the Heroic Warriors.
- Early concept art by Ed Watts showed the Roton with a red-and-white color scheme and a different design on the face.
- Monogram also released Roton as a model kit.

The Roton was originally conceived as a heroic vehicle, but up until this point there had not yet been a vehicle released specifically for the Evil Warriors. This might be why the decision was made to slightly alter the Roton's design and make it an evil assault vehicle.

The round, compact vehicle features a seat right in the center, flanked by twin red lasers that can swivel from side to side. The front has a monstrous face with bright red eyes, a look accomplished with the help of stickers.

By pushing the vehicle forward, the wheels on the underside will turn the internal gears, causing the red saw blade to rotate around the outside of the vehicle while making a loud clicking sound. The Roton was originally intended to be a ground vehicle, as you can see in the original box art. But the rotating blade made it look as if it might be a flying vehicle, which is likely why it was portrayed as such in many art pieces as well as many story media.

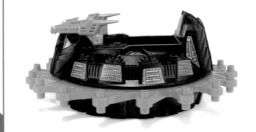

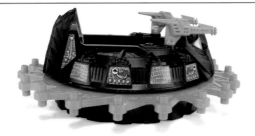

SAUROD
EVIL 'SPARK-SHOOTING' REPTILE

First released 1987 • Member of the Evil Warriors

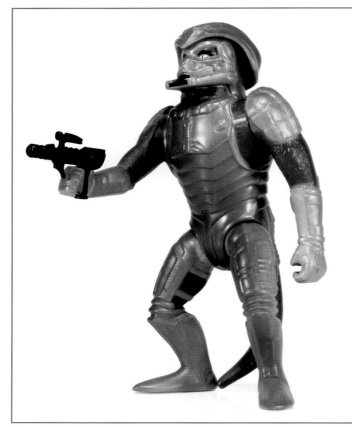

Accessory:
• Laser pistol

Minicomic:
• *The Cosmic Key*

Saurod is one of three brand-new characters created specifically for the 1987 *Masters of the Universe* live-action movie that received an action figure in the toy line.

The figure features the ability to shoot real sparks out of his mouth to simulate a laser shot—a power that Saurod did not possess in the movie. This sparking action feature has been found on many classic toys. It is achieved by repeatedly pushing the lever on Saurod's back. Inside the figure's torso, this spins a metal wheel that rubs against a piece of flint, causing sparks to emit from the open mouth. It's not unlike the mechanism found inside a cigarette lighter.

Like the other movie figures, Saurod has a unique sculpt, sharing no parts with any other figure in the line. Because of his unique action feature, his torso is hollowed out and he does not have the ability to turn his waist or head. He does have the addition of a tail, which can be swiveled.

The hollow plastic of Saurod's chest could also become quite brittle over the years, making it common to find Saurod action figures with cracked or broken bodies.

Saurod's spark-spitting action feature of course can be dangerous. Mattel did have some controversy with a similar sparking feature in their Barbie line of dolls in the early 1990s, after it was shown to have the ability to cause clothes to catch on fire if the user was not careful. As a result, this is not a common action feature found on toys any longer.

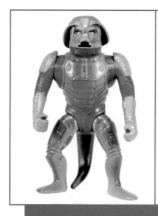
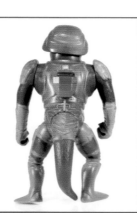
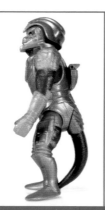
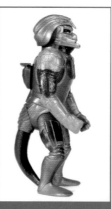

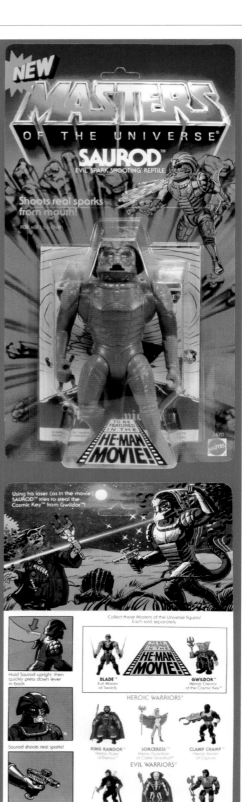

SCARE GLOW
EVIL GHOST OF SKELETOR

First released 1987 • Member of the Evil Warriors

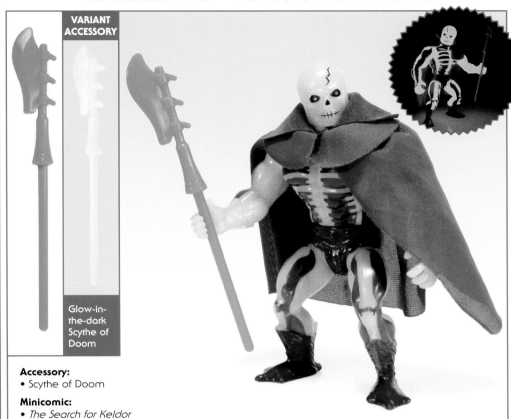

VARIANT ACCESSORY

Glow-in-the-dark Scythe of Doom

Accessory:
• Scythe of Doom

Minicomic:
• *The Search for Keldor*

Living up to the trend of gimmicks in Masters of the Universe toys, Scare Glow delivers the classic glow-in-the-dark action feature. While a few other items in the line have used the glow-in-the-dark feature, such as Evil-Lyn's wand and the Warrior's ring that came with Trap Jaw and Tri-Klops, Scare Glow is the first full action figure that glows entirely.

Scare Glow utilizes Skeletor's body, albeit with slightly bigger feet than the original Skeletor release. The body features a painted-on skeleton, with black on top of the white glow-in-the-dark plastic. He also features a purple cloth cape. This is one of the few instances in the line where a cloth accessory was included—King Randor and Prince Adam being other examples. Scare Glow still retains the waist-twisting "power punch" action feature that we've seen on so many other action figures in this line. By twisting the figure at his waist and releasing, Scare Glow's upper body quickly snaps back to deliver a punch to his foes.

With the moniker of "Evil Ghost of Skeletor" used on the packaging, fans have often speculated whether Scare Glow was just a ghost character working for Skeletor or Skeletor's literal ghost. However, the included minicomic *The Search for Keldor* shows Skeletor summoning Scare Glow "from time and space" and commanding him as his henchman. In addition, Mattel employees recalled Scare Glow being intended as just another minion of Skeletor.

The included Scythe of Doom accessory is the same scythe released with the Castle Grayskull play set. There are two variations packaged with Scare Glow: one that is bright green, and another that is the same glow-in-the-dark white plastic as the figure. The latter version is scarcer.

FUN FACTOID: The included Scythe of Doom accessory is the same scythe released with the Castle Grayskull play set. A glow-in-the-dark white plastic variant exists, but is scarcer than the green version.

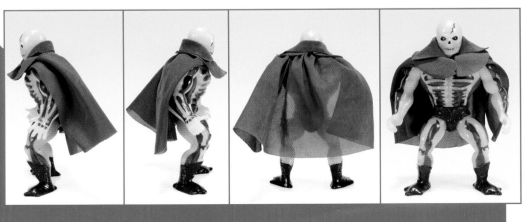

SCREEECH
BARBARIAN BIRD

First released 1983 • Beast of the Evil Warriors

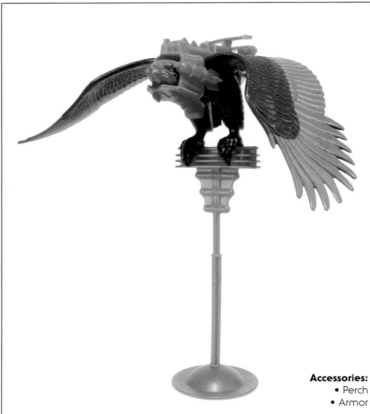

Accessories:
- Perch
- Armor

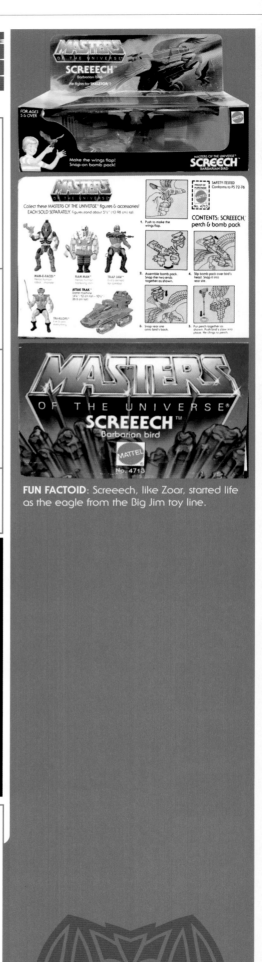

FUN FACTOID: Screeech, like Zoar, started life as the eagle from the Big Jim toy line.

Screeech is the evil counterpart of the heroic Zoar, much in the way Panthor is to Battle Cat. The large bird is colored two shades of purple, giving a relatively matching uniform look to the trio of Skeletor, Panthor, and Screeech.

Screeech features a button on his back underneath the softer plastic used for his wings. When this button is pressed, Screeech flaps his wings. Screeech also includes removable red armor and a red perch, both of which are the same ones included with Zoar.

In another similarity to Battle Cat and Panthor, the mold used for both Zoar and Screeech originated as an eagle in Mattel's 1972 Big Jim toy line.

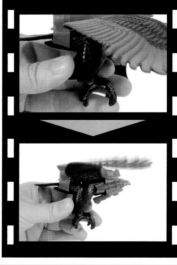

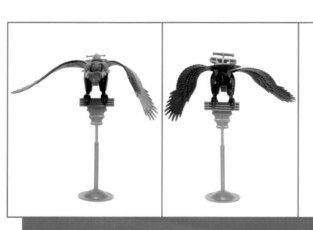

INTERVIEW WITH
RUDY OBRERO

Growing up, were there any artists you admired and wanted to emulate?

I grew up reading comic books by the tons. I thought the DC and Marvel comics were well drawn. I thought the best-drawn comics were the classics, like Edgar Rice Burroughs' Tarzan series.

How did you become a professional illustrator?

Long story short—I didn't start drawing till I was nineteen years old. At the time I was in the Air Force stationed on Guam in the middle of the Pacific Ocean. Trying to fight boredom from being on a tiny island I went to the base hobby store and bought some drawing materials. Just before I got out of the Air Force I was stationed in Riverside, California, where by chance I ran into the art director of Capitol Records. I had no idea there was a whole field of art that was not involved with gallery or fine art. I asked him, "How do I become an art director?" He told me to check out a couple of art schools in Los Angeles. So I go to speak with a counselor at the Art Center College of Design—and he turns out to be from, of all places, Guam. He was very helpful to me because we bonded talking over Guamanian good times. From there I chose illustration as a major and the rest is history.

What are some of the highlights of your career before you got involved with Masters of the Universe?

I worked on movie posters for most of my career. I did the poster for James Bond—Never Say Never Again. I have painted so many projects. Every once in a while someone sends me an image of an old poster that I did that my memory barely recognizes.

How did you get involved in the Masters of the Universe toy line?

I was painting a lot of car races, crashes, and explosions for action movies. So someone from Mattel asked me to do Barbie's Star 'Vette. Soon after I got a call from Mark Taylor to do some "Frazetti" (his words) type of packaging. It was like, let's not totally do Frazetta, but sorta like maybe "Frazetti." That's how it began. I started with Mark, then it became a string of other art directors. Mark was the most enthusiastic and the most fun to work with, as he gave me a ton of leeway creatively.

Was the Battle Cat packaging illustration your first project for MOTU?

Yes, it was. I intended to create something I would love to have for myself! The kid in me came out on that one. I think I was growling while drawing it.

For your He-Man/Battle Cat gift set packaging illustration, there is famously a scene depicting Skeletor and Beast Man riding Battle Cats. Was it the case that there was no established idea that Battle Cat was a unique character at the time?

Ha ha, yeah, I didn't get the memo or the story line. I thought that Battle Cat was what everybody would be riding. Like horses, right? I think Mark would've told me if he had known the story. My guess is there was no story yet.

What was your intention and inspiration behind your Battle Ram illustration? I also notice there is a barbarian figure with a horned helmet in the background, near Skeletor . . .

I could stretch the Battle Ram to make it look more rakish and powerful. The guy with the horned helmet was just a made-up filler guy. Again, "Frazetti."

In both your Battle Ram and Castle Grayskull illustrations you included flying enemy vehicles that look a bit like the front end of the Battle Ram, but with downward-curved wings.

My friends from high school keep telling me that I was forever drawing air battles in the margins of my homework. So I guess unconsciously I just need to see air combat! I was born shortly after World War II in Hawaii. I grew up just outside of Pearl Harbor. We still could find shell casings from the air war on the ground where I played. I kept imagining what it would've been like watching the attack on Pearl Harbor. Maybe this explains it!

The original Castle Grayskull box illustration is probably your most beloved piece for MOTU. Can you talk about how you went about composing the scene?

Well, as an illustrator I have to work around layout constraints. What's left is where I get to put things in. Again, the fun aspect of this project is I got to do stuff the way I like it . . . I really had fun doing this one.

You did two illustrations for the Wind Raider—one for the standalone vehicle and one for the gift set that came with He-Man. Which is your favorite and why?

The first one is my favorite, it's more action packed. Funny there's an air battle here too. And the second one has the castle cannon shooting at He-Man. Jesus, air battles really were an obsession.

You've mentioned in previous interviews that your Attak Trak illustration was the most challenging piece. Can you talk a bit about why that was?

I started to think the art direction came from a committee, seemed as though everyone in Mattel wanted in on package art because of its success as a toy line. These pieces were done in oil paint, so changes were a pain to do.

Your Skeletor/Screeech illustration features some of the same kinds of craggy fissure edges seen in the Castle Grayskull, Battle Ram, and Zoar packaging illustrations, with a suggestion that there is lava flowing at the bottom in each of them. Was this your personal vision for the landscape of Eternia?

If you've ever seen the caldera in Kilauea Volcano in Hawaii, you will feel like you're on a totally different planet. It just overwhelms you with a sense of danger.

You've done a lot of illustration work for the modern MOTU Classics line. What's your favorite piece that you've done for the Classics line?

I love the castle again. The challenge coming from all the characters that had to be in the image.

SCUBATTACK POWER GEAR
MOTORIZED UNDERWATER BATTLE PAK

First released 1987 • Accessory of the Evil Warriors

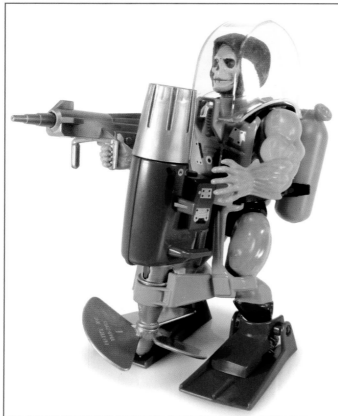

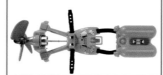

The underwater battle pack known as Scubattack is one of three motorized Power Gear releases in the original toy line.

The set includes a pair of flippers and armor complete with a clear dome that should fit on most of your standard Masters of the Universe action figures. An included hydrocannon can be held by your figure and features a squeeze bulb on the back. This allows the cannon to suck up and then spray water.

The motorized Power Pak is the same one that is also included with the Cliff Climber and Tower Tools, only made in blue plastic this time. It takes one AA battery. This can be plugged into the large propeller and plugged onto the front of the armor. Once turned on, the gears of the Power Pak line up with the propeller, causing it to quickly spin. This allows your action figure to swim in real water!

FUN FACTOID:
Unlike the other two motorized battle gear releases, the propeller is the only action feature powered by the Power Pak.

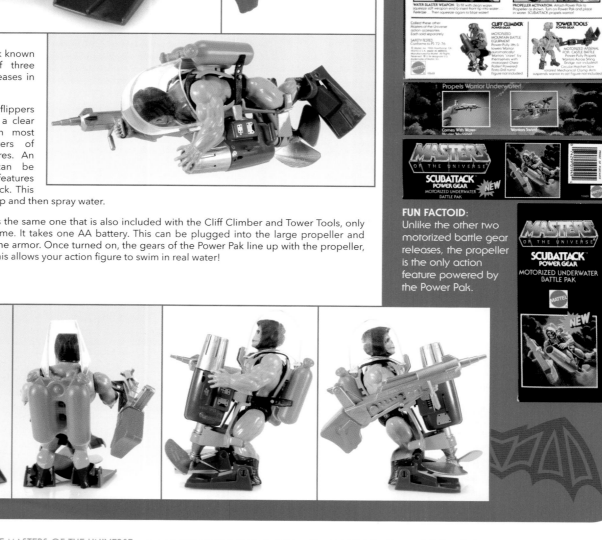

EIGHT-BACK

TWELVE-BACK

FUN FACTOID: Skeletor was inspired by Mexican Day of the Dead artwork and by the mummified corpse of outlaw Elmer McCurdy. As a child, designer Mark Taylor encountered the corpse when he visited the Pike amusement park in Long Beach, California, where it was being used in a scary funhouse exhibition.

SKELETOR
LORD OF DESTRUCTION!

First released 1982 • Member of the Evil Warriors

Accessories:
• Havoc Staff
• Purple Sword of Power

Minicomics:
• *Battle in the Clouds*
• *He-Man and the Power Sword*
• *He-Man Meets Ram-Man!*
• *King of Castle Grayskull*
• *The Ordeal of Man-E-Faces!*
• *The Power of... Point Dread!*
• *Siege of Avion*
• *The Vengeance of Skeletor*

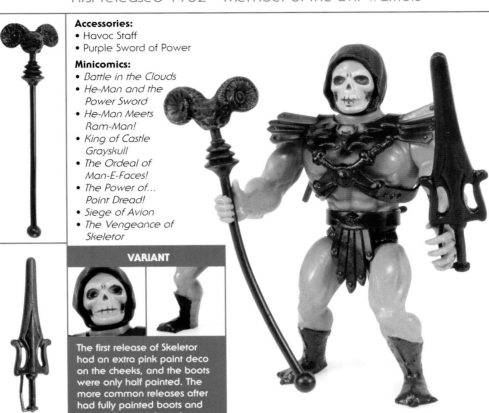

VARIANT

The first release of Skeletor had an extra pink paint deco on the cheeks, and the boots were only half painted. The more common releases after had fully painted boots and lacked the extra face deco.

Skeletor, the main villain of the Masters of the Universe toy line, would go on to become one of the most iconic villains of the eighties. Skeletor's figure utilizes the same muscular body found on He-Man, but has some new details that would be used on many villain figures to follow. His forearms have a finned design, and his left hand is wide open with spaced, clawed fingers. His boots look scaly and organic, with three pointed toes to give him a more demonic look.

Skeletor also featured a spring mechanism in his waist. By turning the figure's waist while holding his arm, the figure would quickly snap back into place once let go—delivering a "power punch" to He-Man and the Heroic Warriors!

Skeletor's included Havoc Staff is probably his most preferred accessory, since it went on to be his main weapon in the Filmation cartoon series. It can be held in his right hand, which is the only hand made to grip weapons. Since his left hand is molded open, many fans would often clip his sword's hand guard over the fingers. As a result, it's not uncommon to find these swords with broken hand guards.

Much like with He-Man, Skeletor's Sword of Power accessory also has a unique feature in which it is technically only half of the full Sword of Power. The gray version that comes with He-Man has the ability to fit together with Skeletor's, creating the full Sword of Power. This is a direct tie-in to the story found in the included minicomics.

Early releases have a paint error on Skeletor's skull which resulted in him having an orangish-pink color on his cheeks. Other early releases have only the front half of his boots painted to indicate shin guards, later changed to be full boots. The same early releases also had a purple loincloth, later changed to black.

 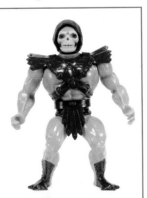

SLIME PIT
EVIL PIT OF GRUESOME OOZE

First released 1986 • Lair of the Evil Horde

Minicomic:
• *Escape from the Slime Pit!*

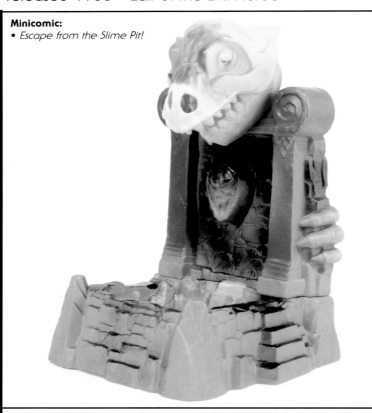

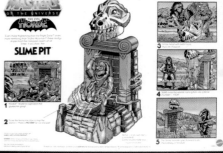

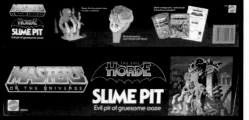

Mattel and slime go hand in hand, so it was only a matter of time before they brought their sticky ooze to the Masters of the Universe toy line! The Mattel Slime logo, which has been used since the 1970s, even appears on the Slime Pit's box!

Mattel's Slime compound debuted in 1976, and Mattel has one of the all-time best recipes for the gooey stuff! The consistency causes it to ooze perfectly, but still hold together very well due to its sticky nature. The Evil Horde slime came inside of a red can with Hordak's face on the lid. It had a distinct smell, which is probably remembered by anyone who had the Slime as a child!

The Slime Pit has a skull of a dinosaur at the top, hanging over the pit. A figure can be placed in the pit and held in place by a dinosaur hand attached to the base. A small cover can then be removed from the skull so it can be filled with Evil Horde Slime! Once filled, tilting the skull forward causes the Slime to ooze from the mouth, slowly covering the trapped action figure below. It is amazingly satisfying to watch a figure get coated in green goo! Just make sure you follow the instructions and avoid using any figure that has flock or fur! That Slime compound washes off most figures easily, but could get stuck to poor Grizzlor, Moss Man, or Panthor!

Mattel also sold vats of Slime individually, so you could keep your Slime Pit fully stocked. These were in the same red cans, but they had a wrapper on them with artwork of Beast Man being covered in Slime!

FUN FACTOIDS:
• An early concept for the Slime Pit by Ted Mayer featured a wolf-like head rather than a reptilian skull.
• The Slime Pit was slated to be rereleased in Mattel's 1992 King Arthur and the Knights of Justice toy line. However, the line ended before the Slime Pit was released.
• Mattel also sold vats of Slime individually, so you could keep your Slime Pit fully stocked. These were in the same red cans, but they had a wrapper on them with artwork of Beast Man being covered in slime!

SNAKE FACE
MOST GRUESOME OF THE SNAKE MEN WARRIORS

First released 1987 • Member of the Snake Men

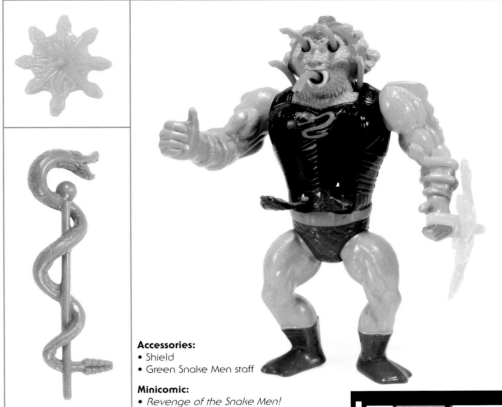

Accessories:
- Shield
- Green Snake Men staff

Minicomic:
- *Revenge of the Snake Men!*

Filling out the ranks of the evil Snake Men, Snake Face is very similar to the mythological Gorgon creature in design and action feature. He features a snake-popping action feature, which is meant to imitate his power of turning Heroic Warriors into stone.

By lifting a lever on the figure's back, small red snakes pop out of the figure's eye sockets and mouth. Two more large snakes also fold down from hidden cavities on his chest. Because of the mechanism to trigger this feature within his torso, the figure does not feature any waist or neck articulation. The torso is also elongated to fit the mechanism inside, giving the illusion that Snake Face's legs are a bit too short.

His unique action feature also means that he is a completely new sculpt, sharing no parts with any other figure in the line. His helmet has small sculpted green snakes that appear to be part of his head and popping through his helmet. His arms even have little snakes wrapped around his forearms as part of the figure's sculpt, though they are not individually painted.

Snake Face is packaged with the usual snake staff that comes with most of the Snake Men figures, this time made of a green plastic. He also has a unique accessory in the form of a bright green shield with a snake design that seems to match nicely with the snakes found on his head.

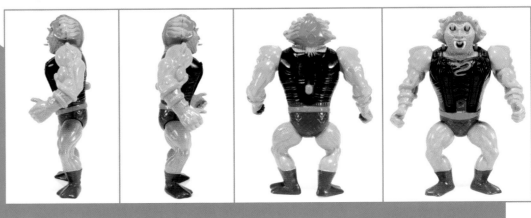

FUN FACTOID: The early working name for Snake Face was Medusa Man.

SNAKE MOUNTAIN
EVIL STRONGHOLD OF SKELETOR

First released 1984 • Lair of the Evil Warriors

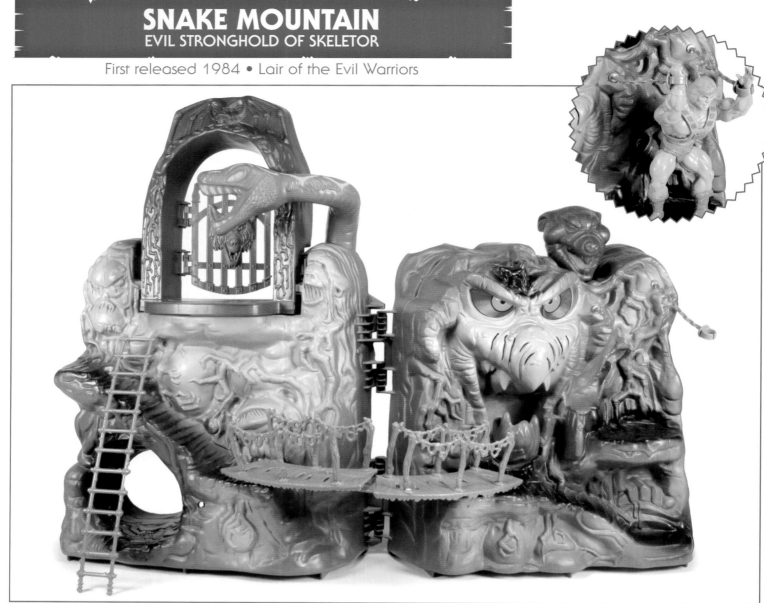

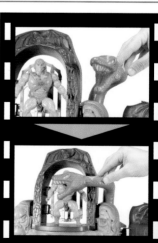

In the Filmation cartoon series, Skeletor's Snake Mountain was two pointed peaks with a large snake structure wrapped around one and a waterfall of lava flowing between them. The Snake Mountain toy looked quite a bit different from this. This is likely because Mattel opted to reuse an idea for a jungle-themed play set that they had not released.

The end result gave us a purple mountain structure with a large green snake on the upper left and a striking demon face on the right. This play set folded open much in the same way as Castle Grayskull before it. A small bridge connected the two halves together, though it's worth noting that the bridge is so small you must turn the action figures sideways in order to make them walk across.

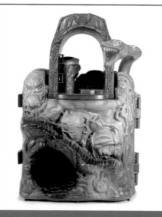

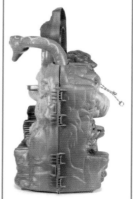

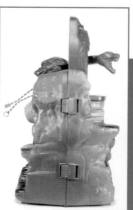

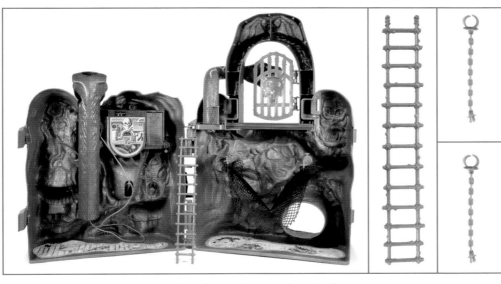

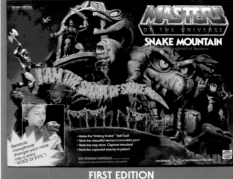

FIRST EDITION

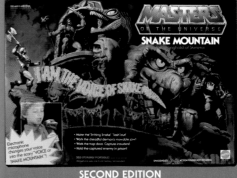

SECOND EDITION

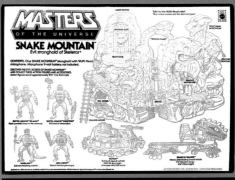

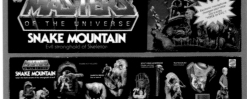

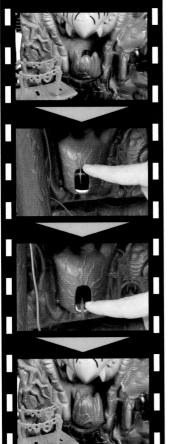

The demon face on the right has a mouth that can be manipulated via a lever on the inside. The gray wolf head sitting just above it is a removable echo microphone. This is battery powered, giving kids a slight voice change via the echo. The idea here is that when you speak through this echo microphone, you are the voice of Snake Mountain. This goes with the option to move the mouth of the demon, to make it look as if he is speaking.

On the side of the demon face is a small ledge with a pair of shackles above. These shackles can be attached to a figure's wrists to trap them as prisoners. These are notoriously fragile and were known to break, even when the play set was new. As a result, play sets are often found with broken shackle chains today.

Up near the green snake is a platform with an opening gate. You can stand a figure up here, and "scare" it by rotating the giant snake toward them! A small lever on the underside of the platform will release a trapdoor, sending your figure falling down to be caught in a net on the inside!

The inside of this play set is quite bare when compared to Castle Grayskull. Aside from the aforementioned microphone and net, the only other things you'll find inside are some stickers on the floor. The stickers feature artwork with some bizarre-looking creatures on them!

The overall sculpt and look is very striking, all things considered. The details worked into the front with the twisting and turning roots and the weird demonic faces give the play set an aura of fear!

Accessories:
• Ladder
• Two chains
• Net

FUN FACTOIDS:
• The Snake Mountain play set was not based on the lair from the Filmation cartoon version, but on an abandoned jungle play set concept that was repurposed as Snake Mountain.
• Some Snake Mountain boxes featured the phrase "I am the voice of Snake Mountain" on the front. Others read "I am the spirit of Snake Mountain."

SNOUT SPOUT
HEROIC WATER-BLASTING FIREFIGHTER

First released 1986 • Member of the Heroic Warriors

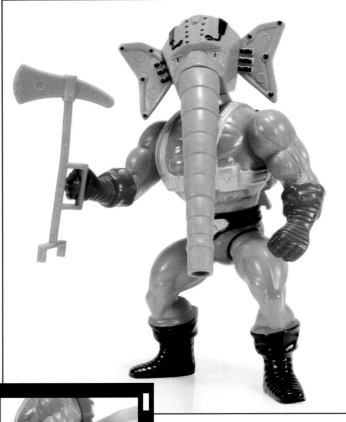

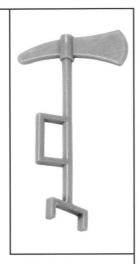

Accessory:
• Fireman's Axe

Minicomic:
• *Eye of the Storm*

Probably one of the weirdest-looking characters in the line, Snout Spout is a humanoid with a cybernetic elephant head who happens to be an Eternian firefighter.

The figure is unique, made up of entirely new parts not shared with any other figure. His outfit almost has a streamlined, futuristic look to it, as opposed to the more barbarian features of most of the line's characters.

The head is an oversized robotic elephant head, with yellow eyes that seem to have a sad expression due to the way they droop to the side. The trunk portion is made of a softer, more pliable plastic that allows you to flex it up and down. This plays into the water-squirting action feature.

There is a backpack as part of the torso sculpt. This pack has a small opening that allows you to fill it with water. When you pump the button on his back, Snout Spout shoots a stream of water out of his spout. The action feature works much like a classic water gun toy.

Snout Spout comes packaged with a fireman's axe as an accessory. This axe has a small handle that fits in his open right hand. There is also a fork on the bottom of the axe. By holding the axe upside down, you can use that fork to move Snout Spout's trunk, allowing you to aim his water shots.

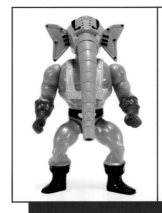

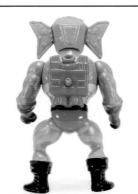

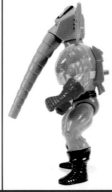

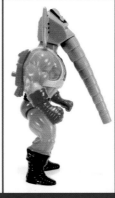

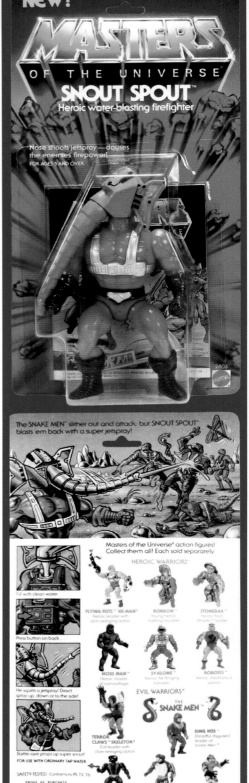

FUN FACTOID: An early working name for Snout Spout was "Hose Nose."

SORCERESS
HEROIC GUARDIAN OF CASTLE GRAYSKULL

First released 1987 • Member of the Heroic Warriors

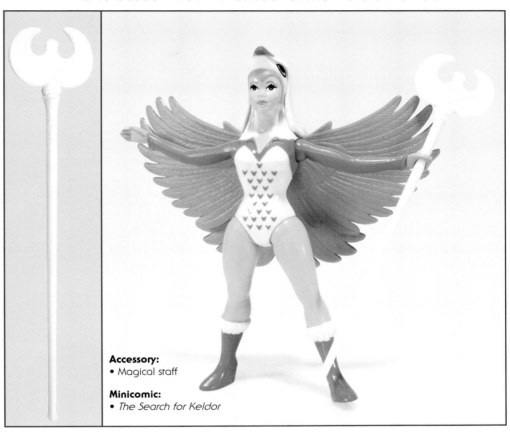

Accessory:
• Magical staff

Minicomic:
• *The Search for Keldor*

The third and final female figure to be released in the original Masters of the Universe toy line, the Sorceress was a pivotal character in the Filmation animated series who finally got her own toy in 1987.

The figure's appearance was very close to how the character appeared in the cartoon, tying her directly to Zoar with the orange-and-blue falcon design in her costume. Because of this, the figure is made entirely of new parts, instead of reusing the same body that was used for both Teela and Evil-Lyn.

The Sorceress has the ability to raise her arms horizontally, unlike most of the other figures in the line. This is because she was given ball-jointed shoulders, allowing her to raise her arms as if she is raising her wings. This plays into her action feature. The wings are spring-loaded. By pushing the wings down, they lock in place. Pressing the tail feature button then causes the wings to pop up at her sides.

Because of this spring-loaded action feature attached to her back, the Sorceress does not feature any articulation at her neck or at her waist.

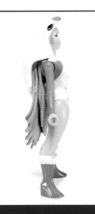

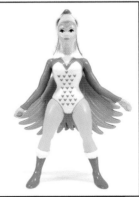

FUN FACTOID: The first Sorceress concept was designed by Mark Taylor, but the character was merged with Teela. Subsequent versions of the Sorceress character were developed, one of them featuring purple skin. The version that appeared in the Filmation *He-Man* cartoon in 1983 is what the 1987 action figure was based on.

SPIKOR
UNTOUCHABLE MASTER OF EVIL COMBAT

First released 1985 • Member of the Evil Warriors

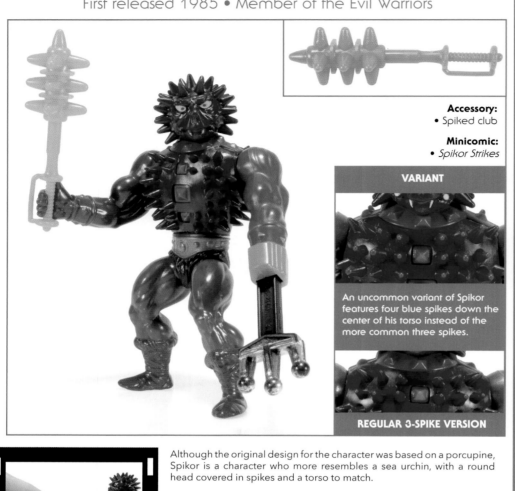

Accessory:
• Spiked club

Minicomic:
• *Spikor Strikes*

VARIANT

An uncommon variant of Spikor features four blue spikes down the center of his torso instead of the more common three spikes.

REGULAR 3-SPIKE VERSION

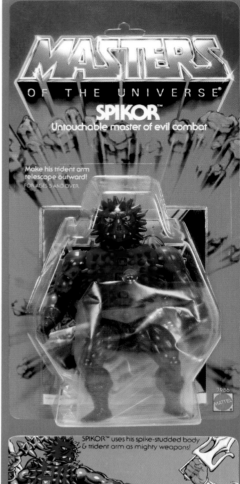

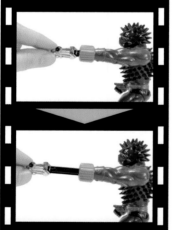

Although the original design for the character was based on a porcupine, Spikor is a character who more resembles a sea urchin, with a round head covered in spikes and a torso to match.

The figure utilizes a body found on many figures in the line, with a few differences to achieve his unique look. The torso is smooth, without the muscular details, with softer plastic spikes covering it. The head is made of the same softer rubber, ensuring that the spikes are not sharp and therefore could not cause any accidental injury to kids.

The left arm is molded straight as opposed to the usual bent arm. Instead of a hand, Spikor has a trident with rounded prongs. The trident has the ability to extend and retract from the arm. This also plays into the spring-loaded "power punch" action feature. Much like many MOTU figures, you can turn the figure at the waist and release to make the figure quickly snap back to deliver a punch. However with Spikor, this will also make the trident hand shoot out.

To add even more spikes, Spikor comes packaged with a large spiked club that he can hold in his right hand.

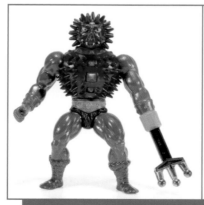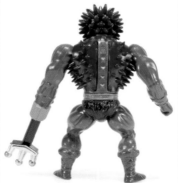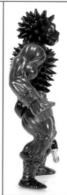

FUN FACTOID: An early Spikor design by Roger Sweet shows the character with a brown color scheme, giving the character more of a porcupine look.

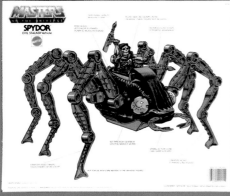

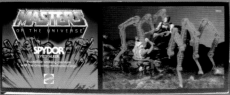

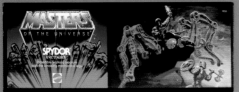

FUN FACTOIDS:
- Mattel engineer Mike McKittrick worked on both Eternia and Spydor.
- An early and similar concept by Ed Watts had the working name of "Masters Spider Attack Vehicle."

SPYDOR
EVIL STALKER

First released 1985 • Vehicle of the Evil Warriors

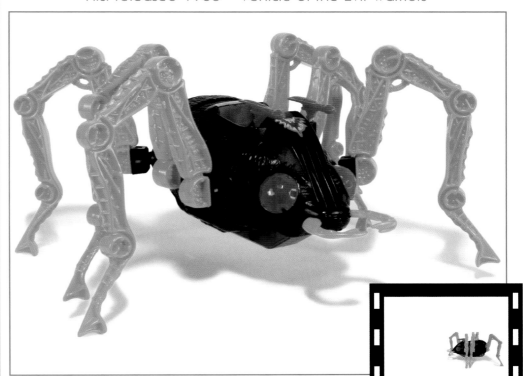

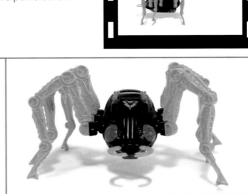

This large mechanical-looking spider is quite a fearsome vehicle for the Evil Warriors! If you suffer from arachnophobia, you might want to steer clear of this one!

Your Masters of the Universe action figure can ride on the creature's back in the cockpit. Two rotating laser guns are mounted on top. The front has two spring-loaded pincers, allowing Spydor to pick up and carry any heroic action figure that gets in the way!

Powered by two C batteries, the vehicle has a switch on the back that will activate Spydor's forward or backward walking action. The legs move very realistically, and the creature walks incredibly well across smooth surfaces. It's quite a menacing vehicle, to be sure.

A fun little bonus feature can be found on the underside, where the gearbox is transparent so you can watch it work when the legs are powered on!

SSSQUEEZE
EVIL LONG-ARMED VIPER

First released 1987 • Member of the Snake Men

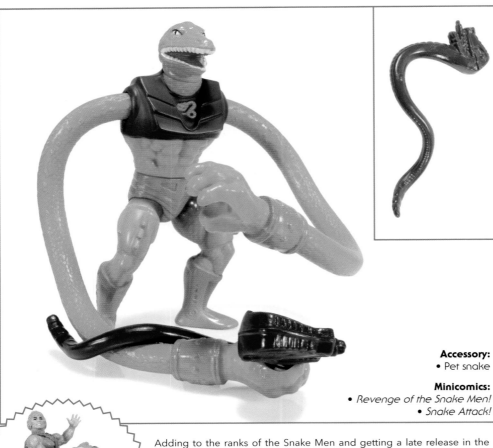

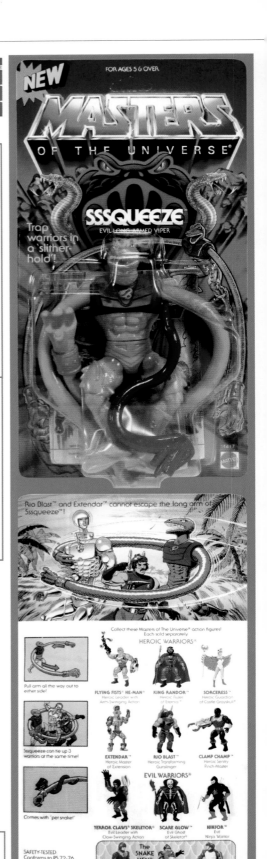

Accessory:
• Pet snake

Minicomics:
• *Revenge of the Snake Men!*
• *Snake Attack!*

Adding to the ranks of the Snake Men and getting a late release in the line, Sssqueeze is one of those oddballs who almost look out of place among the rest of the Masters of the Universe toy line because he is so different. He does not even look particularly like a snake—his head, with its long snout and mouth full of teeth, has more of a dinosaur or alligator look to it.

His extra-long arms are more snake-like than his head. They are made of a flexible rubber with an internal wire that allowed them to bend and retain their position. His flexible arm may also be pulled through the upper body making one side shorter or longer. This could be used to wrap up and trap foes much in the way a snake constricts its prey.

Sssqueeze also includes the typical spring-loaded waist, but because his arms are so long and awkward, the spring-back is a bit too slow to pull off an effective "Power Punch."

His only accessory is a strange little purple snake referred to on the packaging as his "pet snake." This is made of a slightly pliable plastic and is shaped in such a way that it can be wrapped around Sssqueeze's arm.

FUN FACTOID: Sssqueeze's early working name was "Tanglor." He was referred to by that name in the *Revenge of the Snake Men!* minicomic.

MASTERS
OF THE UNIVERSE
STILT STALKERS
Heroic battle stilts

Telescoping stilts for stalking foes on the
battlefield & "blasting" 'em from above!
FOR AGES 5 AND OVER.

FIGURE ACCESSORY

HE-MAN™ uses his telescoping STILT STALKERS™ to get
on top of the battle & strike down
enemies from above!

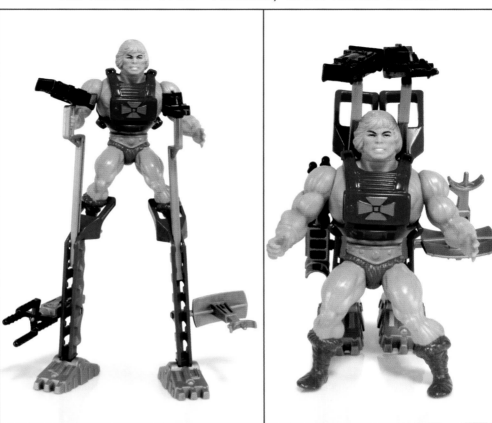

STILT STALKERS
HEROIC BATTLE STILTS

First released 1986 • Accessory of the Heroic Warriors

Telescoping stilts for stalking foes on the battlefield and "blasting" 'em from above!

Exactly as it sounds, this accessory set includes a pair of stilts that can attach to the feet of most basic Masters of the Universe action figures. They have a telescoping feature, allowing them to raise the figure up higher.

Also included is special body armor that can also be attached to most basic action figures. The top portion of the stilts has handles for the figure with mounted guns. An additional gun and radar dish are attached to the lower portion of the stilts, allowing the heroes to blast the villains from up high and down low!

FUN FACTOID: Stilt Stalkers was designed by Ted Mayer.

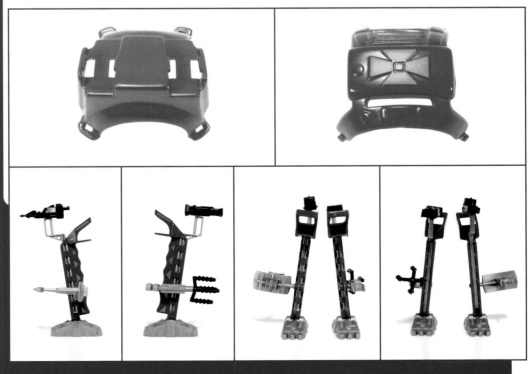

STINKOR
EVIL MASTER OF ODORS

First released 1985 • Member of the Evil Warriors

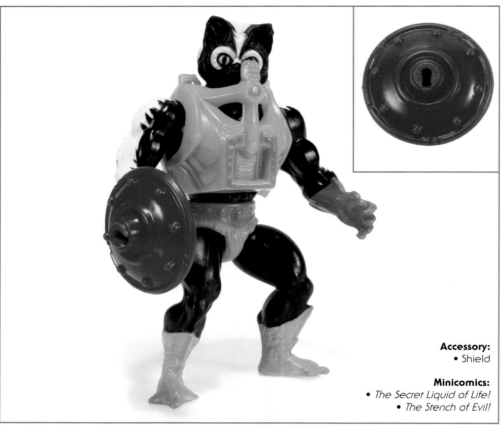

Accessory:
• Shield

Minicomics:
• *The Secret Liquid of Life!*
• *The Stench of Evil!*

Stinkor, a humanoid skunk, was one of several characters who were made up entirely of preexisting parts. He is a repaint of Mer-Man wearing Mekaneck's armor recolored in orange.

Stinkor was marketed as the evil counterpart to Moss Man. While that figure has a pine-scent, Stinkor has what is supposed to be a bad smell. However, while many might remember Stinkor smelling awful like a real skunk, in reality the smell was a type of patchouli that was mixed in with the figure's plastic. The smell was quite potent once the figure was out of the packaging. Even after all of these years, you can still smell it when taking a whiff of the figure.

Stinkor's only accessory is a blue shield. It's the same shield that was included with the weapons rack inside the Castle Grayskull play set, just molded in blue. He also includes the spring-loaded "power punch" action feature found on Mer-Man and many other figures in the line.

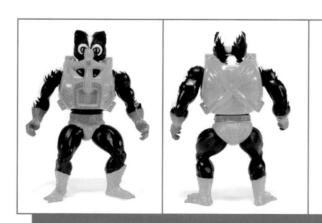

FUN FACTOID: Stinkor was originally going to reuse Beast Man's body. This look made it into Stinkor's cross-sell artwork and minicomic. The toy itself ended up reusing Mer-Man's head and body.

MASTERS
OF THE UNIVERSE
STONEDAR
Heroic leader of the Rock People

Invincible boulder transforms into mighty warrior!

FOR AGES 5 AND OVER

When the Rock People are in danger, STONEDAR transforms into his boulder form to drive back the enemy!

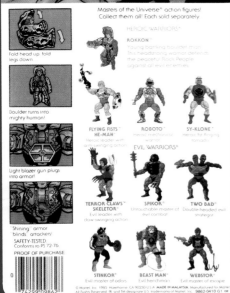

Masters of the Universe® action figures! Collect them all! Each sold separately

HEROIC WARRIORS

ROKKON
Young roaming boulder that the headstrong warrior defends the peaceful Rock People against all evil enemies!

FLYING FISTS HE-MAN
Heroic leader with arm-swinging action!

ROBOTO
Heroic mechanical warrior

SY-KLONE
Heroic fly-fighting tornado

EVIL WARRIORS

TERROR CLAWS SKELETOR
Evil leader with claw-swinging action!

SPIKOR
Untouchable master of evil combat

TWO BAD
Double-headed evil strategist

STINKOR
Evil master of odors

BEAST MAN
Evil henchman

WEBSTOR
Evil master of escape

SAFETY-TESTED
Conforms to PS 72-76
PROOF OF PURCHASE

FUN FACTOIDS:
- Stonedar was sculpted by Steve Varner, a former business partner of Eddy Mosqueda and an outside vendor at the time.
- Both Ted Mayer and Roger Sweet are listed as inventors on the patent application, which was filed January 14, 1986.

STONEDAR
HEROIC LEADER OF THE ROCK PEOPLE

First released 1986 • Member of the Heroic Warriors

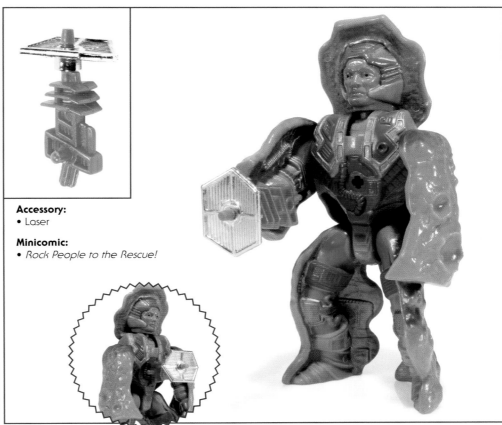

Accessory:
- Laser

Minicomic:
- *Rock People to the Rescue!*

The Comet Warriors Stonedar and Rokkon were Mattel's way of incorporating a transforming action feature into the Masters of the Universe toy line to compete with the popular Transformers toy line from Hasbro. This action feature would be included again with the Meteorbs in 1987.

The unique design means that Stonedar is a fully original figure with no shared parts. The articulation also functions much differently from all other figures in the toy line, as the joints are designed specifically with the transformation in mind. It's a simple mechanism—essentially by folding the figure forward at the neck, arms, and legs, Stonedar folds into a blue-and-silver colored rock.

Stonedar includes one accessory in the form of a laser gun that has a unique, chromed satellite-dish shape on the front. This blaster has two pegs: one on the side and one on the back. The peg on the side can plug into the socket on the figure's hand, allowing him to hold it for battle. The peg on the back plugs into the socket in the figure's chest. While it's not uncommon to see the Comet Warriors displayed with their laser guns plugged into their chests, the real purpose of the chest peg is so that the laser gun can be hidden within the rock formation when the figures are transformed.

STRATOS
WINGED WARRIOR!

First released 1982 • Member of the Heroic Warriors

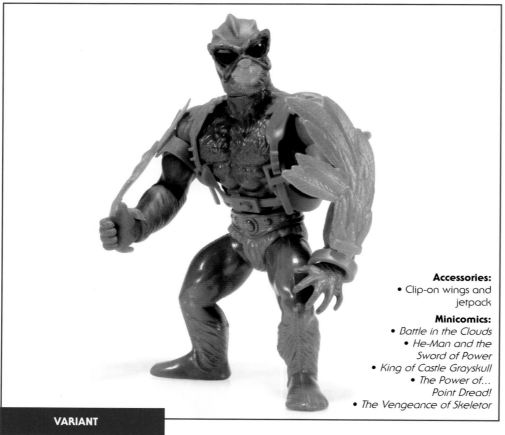

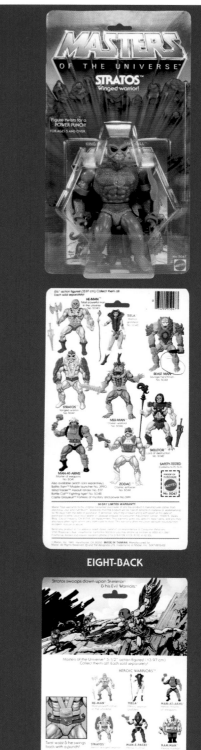

EIGHT-BACK

TWELVE-BACK

Accessories:
• Clip-on wings and jetpack

Minicomics:
• *Battle in the Clouds*
• *He-Man and the Sword of Power*
• *King of Castle Grayskull*
• *The Power of... Point Dread!*
• *The Vengeance of Skeletor*

VARIANT

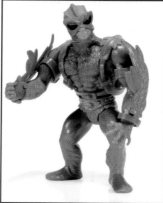

Later releases of Stratos swapped the colors of his wings and jetpack.

One of the original eight figures released, the heroic Stratos reuses most of the components that were made for Beast Man. The sculpted-fur body combined with the new feathered wing accessories create a sort of ape / bird man hybrid.

Along with the torso, arms, and legs all being reused from Beast Man, so are the straps wrapped around the figure's biceps. However, they are now used to keep Stratos's wings attached to his arms. Aside from these wings and the jetpack armor, Stratos does not include any other accessories, meaning he does not have a weapon of any kind.

The figure has been released with two color variations on his accessories. One includes a pair of red wings and a blue jetpack. The alternate version came with the colors flipped, giving us a Stratos with blue wings and a red jetpack. The figure was typically seen with a gray beard and blue goggles. However, there is a notable variation that switches these colors, giving Stratos a blue beard and gray goggles.

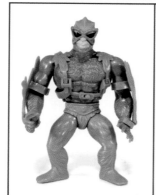

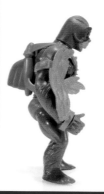

FUN FACTOIDS:
• Stratos's early working names were "Bird Man" and "Wing Man."
• Although Stratos reused Beast Man's body, his prototype reused only Beast Man's legs and arms. His chest was borrowed from He-Man.

STRIDOR
HEROIC ARMORED WAR HORSE

First released 1984 • Steed of the Heroic Warriors

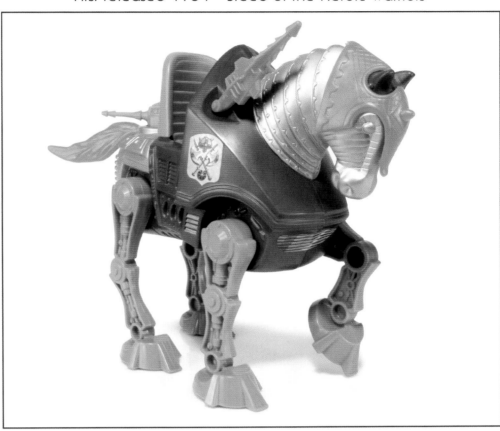

Stridor is a robotic steed for the heroes to ride into battle! Is he a creature? Is he a vehicle? That's up to you!

The horse is made to look mechanical in design. Rather than a saddle on his back for a figure to mount, he has a cockpit that a figure can sit inside, with their legs fitting into the body of the horse. There is a laser turret mounted behind the cockpit that can be swiveled, and two laser guns sit on either side of his neck that can also be moved up or down.

The orange, brown, and silver mechanical-looking horse is adorned with a few stickers depicting a control panel and a small shield with the images of a helmet and a pair of battle-axes. Stridor also includes a removable orange helmet with a slot in the top for his ears.

Even though he looks like he should be mobile, Stridor does not have any articulation whatsoever. His legs look like they should move, but rather they are molded in a static pose much like Battle Cat and Panthor before him.

While He-Man is depicted as Stridor's rider on the box art, there was also a gift set released that included a Fisto figure. Because of this, many fans consider Fisto to be Stridor's regular rider, and he was depicted as such in numerous comics and storybooks.

FUN FACTOIDS:
- According to Martin Arriola, Stridor was created by Mattel designer Colin Bailey.
- Stridor is the only heroic vehicle or steed in the vintage Masters of the Universe line to be packaged with a figure other than He-Man or Battle Armor He-Man.

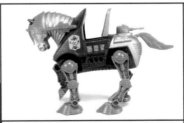

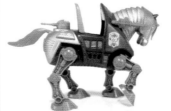

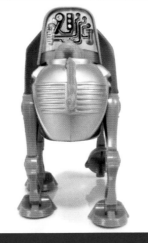

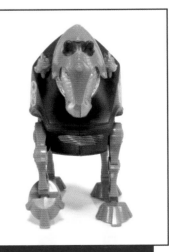

SY-KLONE
HEROIC FIST-FLINGING TORNADO

First released 1985 • Member of the Heroic Warriors

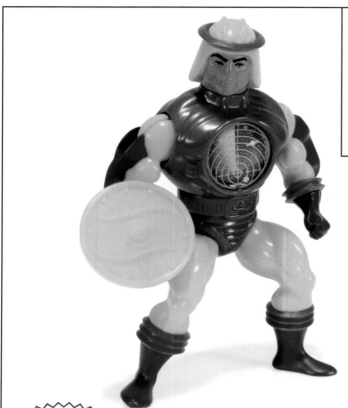

Accessory:
• Shield

Minicomic:
• *Spikor Strikes*

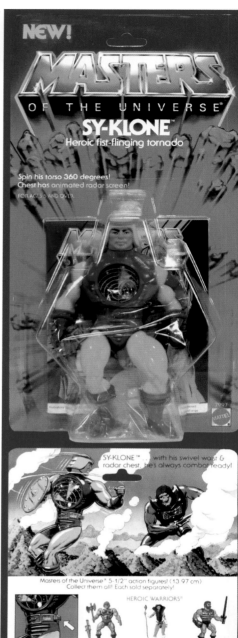

The heroic human tornado known as Sy-Klone is one of the characters in the line that leans more toward science fiction than fantasy. His uniform has a streamlined look with a space theme. His red belt has a ringed Saturn-like planet on the buckle, and around his forearms and boots are similar red rings. His chest features a star-filled radar screen. This screen is a lenticular sticker. Looking at it from different angles makes it appear as if the radar is moving about the screen.

The figure features all-new parts that are not shared with any other figure. He is also one of the few figures in the original toy line that feature ball-jointed shoulders. These joints are loose, which allows Sy-Klone's arms to fly up to his sides when using his spinning action feature.

The spin is triggered by spinning the small dial located on the back of Sy-Klone's belt. By turning this dial with your thumb, the upper body rapidly spins 360 degrees, with his fists whipping around for a tornado punch!

The only accessory included is a yellow shield that can clip to Sy-Klone's wrist. Although it's just a shield, its disk-like shape allows it to act as a weapon when Sy-Klone is in full tornado spin.

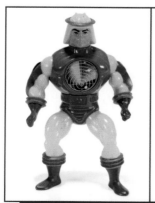
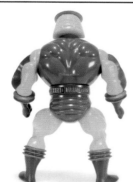
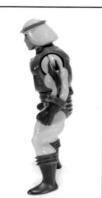
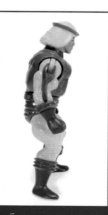

FUN FACTOIDS:
• The early working name for Sy-Klone was "Tornado."
• Sy-Klone was the first Masters of the Universe figure with the ability to raise his arms at his sides.

TEELA
WARRIOR GODDESS!

First released 1982 • Member of the Heroic Warriors

EIGHT-BACK

TWELVE-BACK

FUN FACTOID: Teela is a design amalgamation of two separate Mark Taylor characters, "Female Warrior" and "Sorceress." Mattel's marketing group didn't think there was enough demand for two female action figures in one year, prompting the two characters to be combined. It later turned out that thirty to forty percent of the children playing with Masters of the Universe toys were girls.

VARIANT

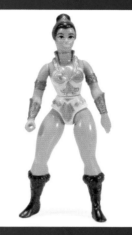

There were a lot of paint inconsistencies with Teela. Later releases sometimes had dark brown hair and boots instead of the more reddish brown.

Accessories:
• Snake staff
• Shield

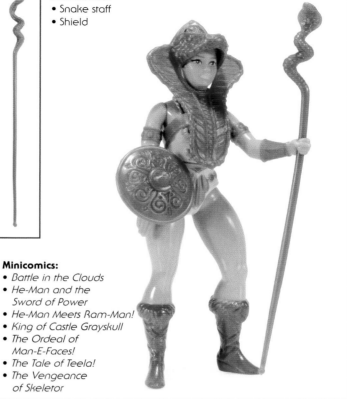

Minicomics:
• Battle in the Clouds
• He-Man and the
 Sword of Power
• He-Man Meets Ram-Man!
• King of Castle Grayskull
• The Ordeal of
 Man-E-Faces!
• The Tale of Teela!
• The Vengeance
 of Skeletor

Teela is one of only three female action figures in the original Masters of the Universe toy line. Originally, she was referred to as a goddess, a role that was later filled by the Sorceress. This is indicated by the wording on her packaging and some of the early minicomics.

The figure includes removable snake armor and a snake staff as her accessories. In one of the early minicomics The Tale of Teela!, we see Skeletor make a clone of the Goddess to take her as his bride. This almost seems to set up the action figure as having dual identities: with the snake armor and staff, you have the Goddess. Remove the armor, and you have the warrior known as Teela.

The action figure also includes the same "power punch" waist twisting action feature found on many of the original Masters of the Universe toys. By twisting her waist and letting go, her upper body quickly snaps back into place, allowing her to deliver a powerful strike to her foes!

There were many inconsistencies with the way the paint was applied to Teela, depending on what country the figure was produced in, resulting in several slight variations to the look of the figure's face. In addition, later versions of Teela sometimes had darker brown used for the boots and hair, with lighter red used for the accessories.

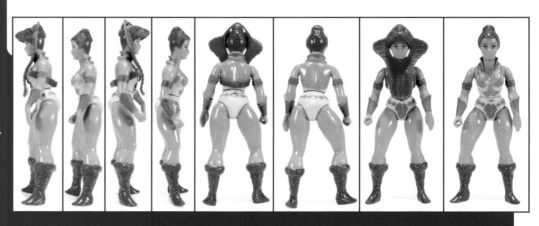

TERROR CLAWS SKELETOR
EVIL LEADER WITH THE CLAW-SWINGING ACTION!

First released 1986 • Member of the Evil Warriors

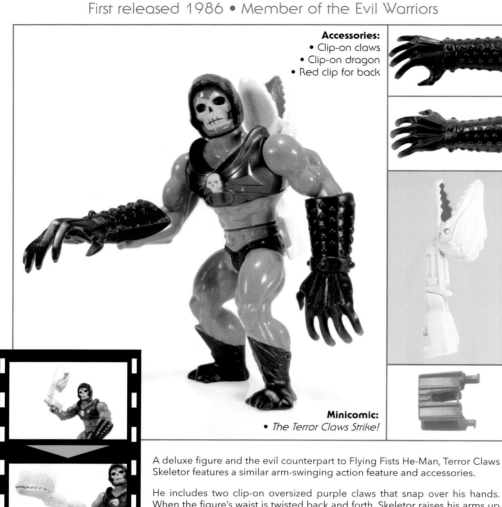

Accessories:
• Clip-on claws
• Clip-on dragon
• Red clip for back

Minicomic:
• *The Terror Claws Strike!*

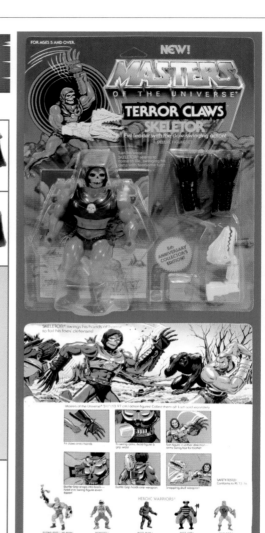

A deluxe figure and the evil counterpart to Flying Fists He-Man, Terror Claws Skeletor features a similar arm-swinging action feature and accessories.

He includes two clip-on oversized purple claws that snap over his hands. When the figure's waist is twisted back and forth, Skeletor raises his arms up and down opposite each other in a slashing motion. In place of one of the claws, you can also attach the white dragon accessory. This dragon whips up and down, causing the jaw of the dragon to open up and snap shut.

The small red clip can be placed on Skeletor's back. This is a dual-purpose accessory, allowing you to store his dragon on his back but also allowing you to easily grip the figure with your fingers to twist his torso from side to side.

There is a notable variation of this figure that includes a dragon accessory with an unpainted mouth.

FUN FACTOID: Terror Claws Skeletor's costume seems to have been influenced by an early, discarded Man-E-Faces design by Mark Taylor. An early concept version of the figure by Roger Sweer featured armor more reminiscent of Battle Armor Skeletor.

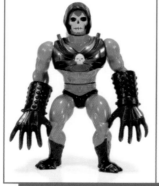 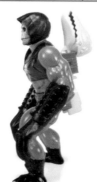 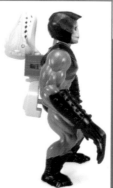

THUNDER PUNCH HE-MAN
LEADER OF THE HEROIC WARRIORS NOW PACKS A LOUD POWER PUNCH!

First released 1985 • Member of the Heroic Warriors

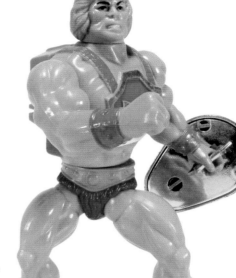

Accessories:
- Translucent yellow Sword of Power
- Shield
- Thunder punch ammo caps

Minicomic:
- The Treachery of Modulok!

FUN FACTOID: Larry H. Renger and Mike T. McKittrick invented Thunder Punch He-Man's action feature, according to Mattel's patent filing.

A deluxe release and one of the more popular variations of our main hero, Thunder Punch He-Man takes the idea of the "power punch" action feature and totally amps it up to the max!

The torso on this figure is a bit bulkier than the standard figure since it houses a cap-popping action feature. Included with the figure are a few red caps exactly like the type you would find for a toy cap gun. This is because Thunder Punch He-Man's action feature is much like the mechanism found within those toy guns!

The red backpack opens on his back, revealing the metal drum where you plug the red caps. Once the cap is loaded and the backpack is closed, turn He-Man's waist and let go. The torso quickly snaps back to deliver a punch, much like many standard figures in the line. But this time the figure will deliver a loud pop from the cap in his back! You can then turn the small dial on his back to line up the next cap to repeat the feature again!

The figure also includes two accessories in the form of a uniquely colored Sword of Power and a shiny silver shield. Since He-Man's right hand is a closed fist for his punch, he can only hold one at a time. To get around this, there's a slot on the front of the shield that can store the sword. It can also be used to store the red caps.

While Mattel released their own carded "Thunder Punch Ammo," you could buy any red caps used for toy guns to reload Thunder Punch He-Man when needed.

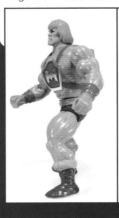
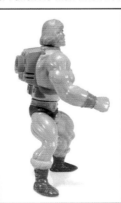
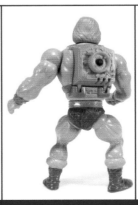
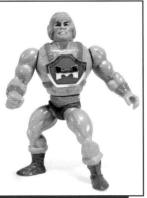

TOWER TOOLS POWER GEAR
MOTORIZED FOR CASTLE BATTLES

First released 1987 • Accessory of the Heroic Warriors

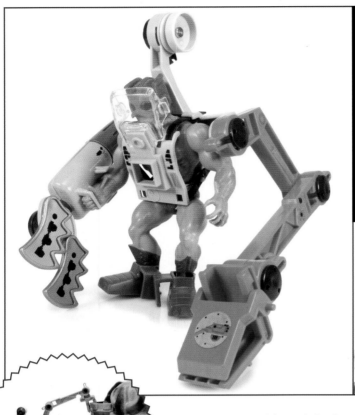

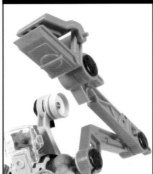

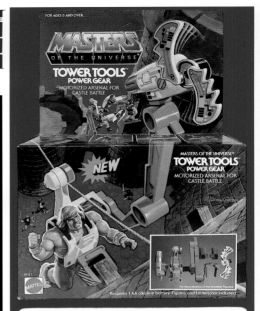

FOR AGES 5 AND OVER

MASTERS OF THE UNIVERSE

TOWER TOOLS POWER GEAR
MOTORIZED ARSENAL FOR CASTLE BATTLE

MASTERS OF THE UNIVERSE®

NEW

TOWER TOOLS POWER GEAR
MOTORIZED ARSENAL FOR CASTLE BATTLE

Requires 1 AA alkaline battery. Figures and battery not included.

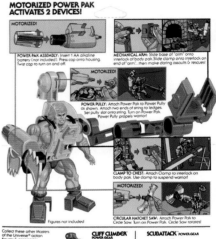

MOTORIZED POWER PAK ACTIVATES 2 DEVICES!

MOTORIZED!

POWER PAK ASSEMBLY: Insert 1 AA alkaline battery (not included). Press cap onto housing. Twist cap to turn on and off.

MECHANICAL ARM: Slide base of "arm" onto interlock of body pak. Slide clamp onto interlock on end of "arm"...then make daring assaults & rescues!

MOTORIZED!

POWER PULLY: Attach Power Pak to Power Pully as shown. Attach two ends of string to ledges. Set pully slot onto string. Turn on Power Pak. Power Pully propels warrior!

CLAMP TO CHEST: Attach Clamp to interlock on body pak. Use clamp to suspend warrior!

MOTORIZED!

CIRCULAR HATCHET SAW: Attach Power Pak to Circle Saw. Turn on Power Pak. Circle Saw rotates!

Figures not included

Collect these other Masters of the Universe® action figures & accessories. Each sold separately.

SAFETY-TESTED. Conforms to P.S. 72-76.

© Mattel, Inc. 1986 Hawthorne, CA 90250 U.S.A. All Rights Reserved. Manufactured for Mattel. MADE IN MEXICO. ® & ™ designate U.S. trademarks of Mattel, Inc.

© 1987

CLIFF CLIMBER POWER GEAR
MOTORIZED MOUNTAIN BATTLE EQUIPMENT
Power-Pully Lifts & Lowers Warrior! Warriors "Crawl" By Themselves With Motorized Chest Crawler Power-Charged Roto-Drill Turns! Figures not included

SCUBATTACK POWER GEAR
MOTORIZED UNDERWATER BATTLE PAK
Motorized Hydro-Peller Propels Warrior Underwater! Water-Blaster Weapon Shoots Water! Figure not included

This motorized arsenal for castle battle is one of three Power Gear packs released in the line.

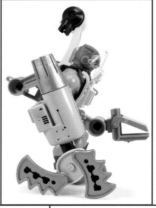

Included are a pair of boots and a large armor piece that should fit on most of your standard Masters of the Universe action figures. It includes a clear face shield that fits over the head and a large articulated orange arm extending from the left side. This arm has a clamp at the end of it that can be used to clamp to a table or shelf or a piece of Castle Grayskull to make it look as though your figure is scaling a large structure. The clamp does a great job of keeping the figure balanced. The clamp can also be removed from the arm and instead plugged into the front of the included armor if you'd rather clip the figure directly onto something.

The motorized Power Pak requires one AA battery to work. You can plug this into the included saw blade and then place this into the hand of your figure. Once turned on, the saw blade spins in a circular motion. You can also attach the Power Pak into the upper portion of the arm. This will spin the pulley wheel on top, allowing your figure to zip along the included piece of string to get over large gaps!

FUN FACTOID:
The box art features an error. He-Man is featured using Tower Tools yet Prince Adam can be seen on the ground below.

MARK DICAMILLO

When did you start at Mattel, and how did your involvement with He-Man start?

I started at Mattel Electronics as a hardware engineer from 1982 to 1983, where I worked on the Intellivision II music keyboard attachment . . . I came back to Mattel in 1985 as senior engineer in boys' toys. After that I moved to design and became the male action design manager. While running design, I worked on a number of male action brands including the New Adventures of He-Man. Later, I became the director of marketing for boys' toys, building brands like the New Adventures of He-Man . . . While heading up male action design, my group worked on an abortive attempt to create a new version of He-Man that was to be based on a weekly live-action TV show. The result of this was a series of character and vehicle concepts that could be created and built in the real world, using real actors in costume and real working vehicles. All of the costumes and any visual effects had to fit inside episodic TV budgets. The TV show funding backers were never able to put the whole deal together, so the toy concepts were packed up and put away.

When Lindsey Williams took over as president of Mattel International, he tasked my team with coming up with a new version of He-Man that was better targeted at the European/international market. A couple of the key parameters were to provide a more modern theme to combat the success of Star Wars and other male action lines, and to make the figures a bit smaller so that play sets and vehicles would better fit inside smaller international homes.

Shortly after starting on this new design project, Jill Barad and I traveled to Tokyo for an inventor sweep for new toy concepts. On this trip we met with one inventor studio named Sente. They had developed a number of male action toy features, as well as an electronic karate glove that made sounds when you punched with it. That night I went back to my hotel room and sketched a sword that incorporated the electronic sounds of the Sente karate glove, and He-Man's Sword of Power was born. Jill flew back to the States, and I stayed on in Tokyo for another week working with Sente to refine the concept further and to build some prototypes.

Upon my subsequent return to the US, we took out the old TV live-action concept drawings and began adapting them to incorporate International's requested modern and smaller look, along with some of the Sente features. We needed a story line to go along with the concepts when we first presented them to Mattel's management design review committee in conference room 3B. So, Dave Wolfram and I spent several days writing out the backstory for the new He-Man line, including Dave's drawing a map of the new solar system setting. Many of our character and place names were incorporated into the final animated TV series produced by Jetlag.

In a final showdown before the New Adventures of He-Man was greenlighted, I was summoned to a management offsite meeting, with then chairman and CEO John Amerman, Jill Barad, and Lindsey Williams. The struggle was between Jill wanting figures with demonstrable action features that would play well on US TV commercials, and Lindsey's desire to have smaller-sized figures that would cost less and thereby fit European homes and budgets. In the end it was agreed to try to keep the size smaller for Lindsey, but squeeze in the action features for Jill. This gave us the green light, but did not win many friends in the engineering department.

We also got the green light to move forward with the first major He-Man child-sized toy, the Sword of Power. The Sword of Power went on to generate over $30 million in sales, making it almost its own brand. The electronic sounds allowed children to role-play, becoming He-Man themselves, and the motion-detecting circuitry allowed children to cut through invisible barriers and foes with every swing. The Sword of Power was so break-frame for its time that it spawned other themed child-sized toys like Ghostbusters backpacks from Hasbro / Kenner.

Richard Fukutaki was responsible for the marketing of the New Adventures brand launch. After I moved from running design to boys' marketing, I took over marketing for the New Adventures line, and introduced the companion Skeletor Skull Staff electronic role-play toy.

You mentioned that Mattel was looking at a live-action TV show. Do you recall a concept about glowing crystals that would power various weapons? I've heard that Laser-Light Skeletor and Laser Power He-Man were a result of that concept, which was never developed further.

Yes, we looked at a number of themes for live action. Some of the Laser Power stuff came over from BraveStarr and Captain Power.

Regarding your work on the child-sized Sword of Power and Skull Staff, the advertisements for those toys were pretty great, featuring live actors wearing some very nicely made He-Man and Skeletor costumes. Can you talk about that?

The commercials were definitely a hit. Using green screen and rotoscoping, which was pretty breakthrough for that time. Originally Deron McBee, who was Malibu on the *American Gladiators*, was to play the part of He-Man, but that did not work out for this commercial.

You put together a design for the 1989 New Adventures Skeletor based on Laser-Light Skeletor, with some changes. Can you talk about that process?

The New Adventures Skeletor borrowed from a number of influences, including Laser-Light. My team and I did dozens of sketches for each of the characters. Ultimately it was Wolfram and myself that did the final details on the design.

Do you recall any New Adventures toy designs that never made it into production?

As with any toy line there were probably hundreds of toy concepts that never saw the light of day. I remember we did a whole series of vehicle studies, again based on customizing real-world vehicles so that they could appear onscreen in live action TV. We had a sort of ATV as well as a hover sled. None made it through the mill though.

Saleswise, how did the New Adventures line perform compared to expectations?

Overall, the New Adventures line never came close to capturing the sales success of the original Masters. It had decent success in Europe to start, but that was to be expected given the amount of influence the international team had in directing the toy line's development. The one bright spot was He-Man's Sword of Power, which became one of the highest-selling child-sized accessories of all time, and spawned a new trend in electronic child-sized accessories.

TRAP JAW
EVIL & ARMED FOR COMBAT

First released 1983 • Member of the Evil Warriors

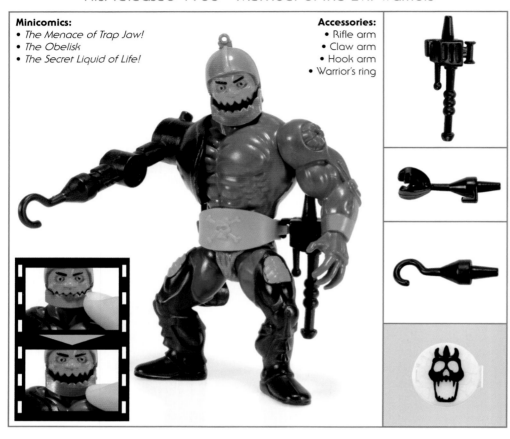

Minicomics:
- *The Menace of Trap Jaw!*
- *The Obelisk*
- *The Secret Liquid of Life!*

Accessories:
- Rifle arm
- Claw arm
- Hook arm
- Warrior's ring

Depicted as an escaped criminal in early minicomics, Trap Jaw has a futuristic pirate design. His bright green belt has a skull and crossbones design, and his signature mechanical arm almost feels like a tech version of the classic wooden peg leg or the hook for a hand.

He features three interchangeable attachments for the arm: a laser rifle, a hook, and a claw. These weapons also have small hooks on them, allowing you to store them on the loops of his green belt when not in use.

Trap Jaw has two more unique features in addition to his bionic arm. His jagged jaw is articulated, allowing you to open and close his mouth for chomping action. He also has a small loop on the top of his helmet. By running a piece of string through this loop, Trap Jaw can rappel into battle with his helmet as if he's riding on a zip-line.

While the right arm itself is a unique piece made for Trap Jaw, the figure also utilizes some reused parts. His legs are fully reused from Man-E-Faces, and they would go on to be used again for Roboto.

Earlier versions of Trap Jaw came packaged with a Warrior's ring. This glow-in-the-dark plastic ring is made to fit a child's fingers and can open to reveal a hidden compartment featuring the Masters logo.

Trap Jaw owes some of his signature looks to a figure named Iron Jaw that Mattel designed for their Big Jim toy line. This figure has the same jaw action feature, as well as a mechanical arm with interchangeable attachments.

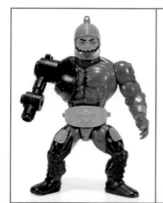
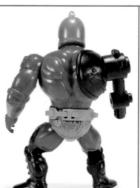
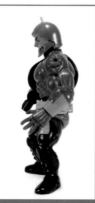
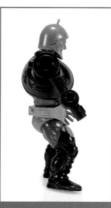

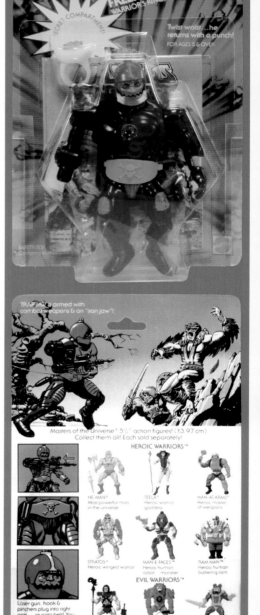

FUN FACTOIDS:
- Trap Jaw's early working title was "X-Man."
- Early concept art by Colin Bailey indicated that Trap Jaw would have included a mechanical hand and a hairy chest.

NEW!

MASTERS
OF THE UNIVERSE®
TRI-KLOPS™
Evil & sees everything

FUN FACTOID: Tri-Klops was designed by Roger Sweet. An early prototype featured at least one green eye, but the final toy had two red eyes and one blue one.

TRI-KLOPS
EVIL AND SEES EVERYTHING

First released 1983 • Member of the Evil Warriors

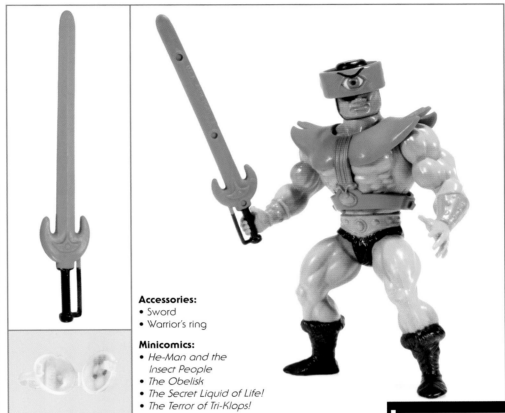

Accessories:
- Sword
- Warrior's ring

Minicomics:
- *He-Man and the Insect People*
- *The Obelisk*
- *The Secret Liquid of Life!*
- *The Terror of Tri-Klops!*

The evil Tri-Klops is a fun take on the Cyclops character, with a spinning helmet action feature allowing you to switch between three mechanical eyes.

The helmet is a simple disk-shaped piece that easily rotates on a peg. This allows you to rotate to display one of three eyes: a blue eye, a red eye, and a very angry-looking deep red eye.

The figure reuses the standard He-Man body with some extra paint details. Specifically, the arm bracers are painted orange, whereas these are typically left unpainted on He-Man and many other figures that use these arms. He also retains the standard "power punch" action feature. By turning the figure at the waist and releasing, the torso will quickly snap back to deliver a powerful blow to his enemies.

Earlier versions of Tri-Klops came packaged with a Warrior's ring. This glow-in-the-dark plastic ring is made to fit a child's fingers and can open up to reveal a hidden compartment featuring the Masters logo.

There are known variations of Tri-Klops where the face sculpt is slightly different. The scowl is sometimes more pronounced, and his nose appears flatter.

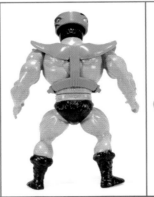

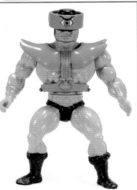

TUNG LASHOR
EVIL TONGUE-SHOOTING SNAKE MEN CREATURE
First released 1986 • Member of the Snake Men

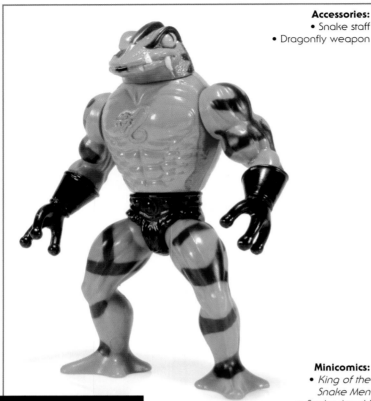

Accessories:
• Snake staff
• Dragonfly weapon

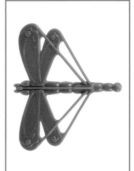

Minicomics:
• *King of the Snake Men*
• *Snake Attack!*

Tung Lashor was released as part of the first wave of Snake Men figures. He is a distinctive figure, but, going from the look of him, his allegiance to King Hiss feels a bit forced.

The overall design of Tung Lashor is closer to a poison-dart frog than snake. He features brand-new parts not shared with any other figure, including three-fingered hands that are shaped very much like those of a tree frog. His body is brightly colored with stripe-like markings on his back (some versions were lacking this paint application), arms, and legs. He does feature the Snake Men logo sculpted on his chest, proving his allegiance.

His action feature is triggered by a wheel on his back. By rolling the wheel up and down, Tung Lashor's multicolored tongue will dart in and out of his mouth. It is forked like a snake's tongue, but a darting tongue could still work for a frog as well.

For his accessories, he features the typical snake staff found with other members of the Snake Men faction, this time made of a deep purple plastic. He also has a unique dragonfly accessory—just another thing that adds to the confusion of making him feel more like a frog.

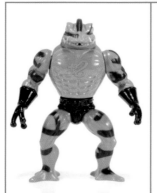

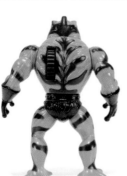

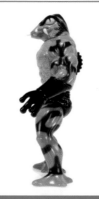

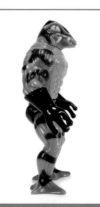

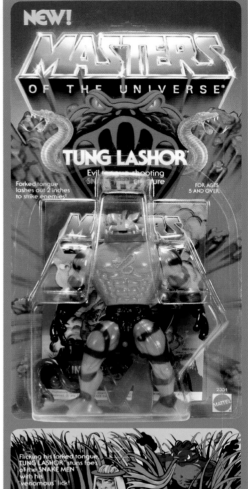

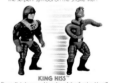

FUN FACTOID: An early Tung Lashor concept by Ted Mayer gave the character red skin and an imp-like face. The final toy was totally redesigned, but the red-skinned version was used as a basis for Tung Lashor's Filmation look.

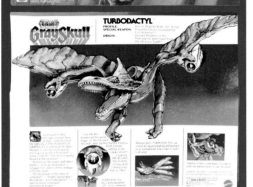

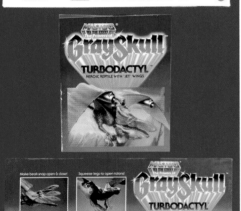

TURBODACTYL
HEROIC REPTILE WITH "JET" WINGS

First released 1987 • Steed of the Heroic Warriors

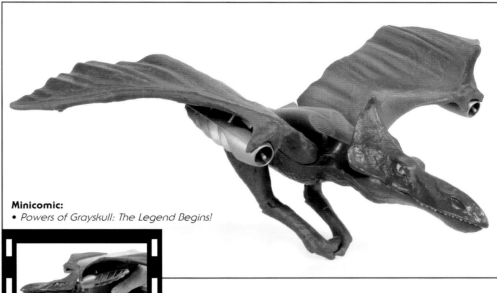

Minicomic:
• *Powers of Grayskull: The Legend Begins!*

Masters of the Universe includes a little bit of everything: swords, sorcery, technology . . . it's all here. So when the line was nearing the end of its shelf life and Mattel wanted to inject something new and exciting, they tapped into a classic theme that kids are always guaranteed to love: dinosaurs!

Turbodactyl is a heroic dinosaur, intended to be the first flying animal in the new Powers of Grayskull line that was conceived as a follow-up to the original Masters of the Universe toy line. Instead, he ended up being one of the final releases in the Masters of the Universe line itself.

The sculpt is interesting, meshing the prehistoric beast with technology by adding bionic-looking pieces. Jet engines are mounted to the underside of his wings. His claws can open and close, allowing you to pick up your Evil Warriors and then drop them. And just like any good dinosaur toy, the mouth can also open and close for chomping action!

FUN FACTOID: Turbodactyl's box art (illustrated by Warren Hile) features the planned but never released character He-Ro. The toy was designed by Mark Jones.

TUSKOR
HEROIC MAMMOTH BUSTS FORCE-FIELDS WITH TUSKS!

First released 1986 • Member of the Heroic Meteorbs

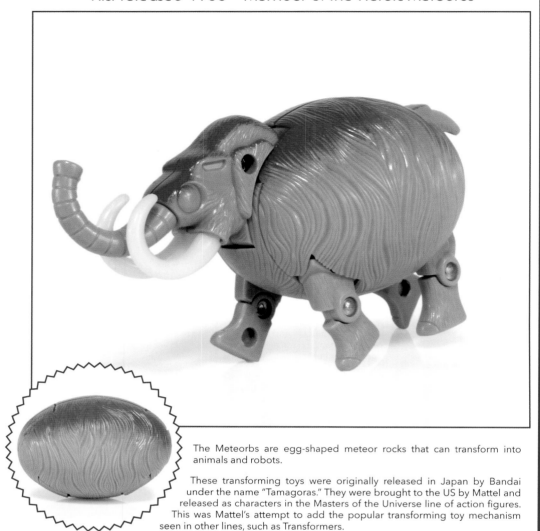

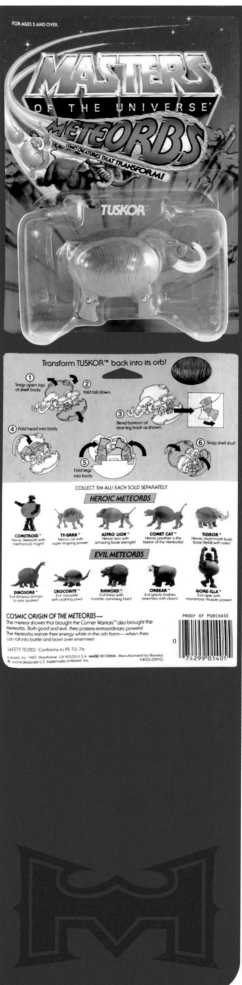

The Meteorbs are egg-shaped meteor rocks that can transform into animals and robots.

These transforming toys were originally released in Japan by Bandai under the name "Tamagoras." They were brought to the US by Mattel and released as characters in the Masters of the Universe line of action figures. This was Mattel's attempt to add the popular transforming toy mechanism seen in other lines, such as Transformers.

The transformation from meteor to animal is a simple mechanism, usually not requiring instructions. By simply popping open the toy you can easily fold out the legs and head to complete the transformation.

Tuskor is a unique member of the group. His egg-shaped body is sculpted to look as though it is covered in fur like a prehistoric woolly mammoth. He features a large mastodon head with a swiveling trunk and two large tusks on either side. He also features articulation at the knees of his short legs.

The Meteorbs at times feel out of place among the many action figures found within Masters of the Universe, but somehow still fit within the combination of magic and science fiction that allowed the toy line to incorporate so many widely differing designs.

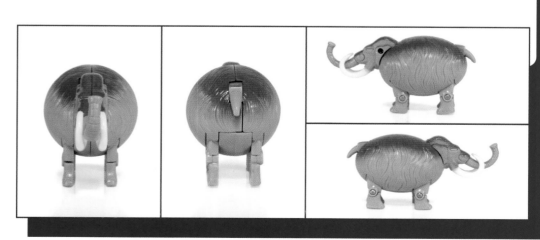

TWISTOID
EVIL SPEED-TWISTING ROBOT

First released 1987 • Member of the Evil Warriors

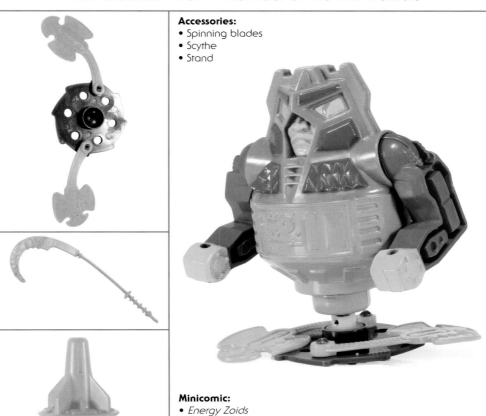

Accessories:
- Spinning blades
- Scythe
- Stand

Minicomic:
- *Energy Zoids*

The Energy Zoids Twistoid and Rotar were an odd combination: half-action figure, half-revving top toy. The revving top function comes straight out of a classic Mattel toy known as the Wizzzer, a gyrostat top toy that was first released in 1969. By gripping the figure at the top and revving the bearing on a smooth surface, you can create a high-speed top spin that allows the figure to spin and remain standing for a lengthy amount of time.

The arms are the only articulated joints on the figure, and they are loose enough that when the figure is spinning, the arms fly upward. This is so you can send your Energy Zoids into a spinning battle with each other or barreling over any standing foe that might be in their path!

The included accessories also worked into the top-spin action feature. The spinning blades accessory has an indent made to fit the revving top portion of Twistoid. By placing him inside while revved up, the blade spins with the figure while the articulated orange blades flail about.

Interestingly, Mattel was also working on a vehicle specifically for Rotar called the Gyrattacker. This vehicle was intended to launch Rotar and Twistoid into combat. While the vehicle did appear in the art found within the included minicomic *Energy Zoids*, the Masters of the Universe toy line was canceled before the Gyrattacker toy could be produced.

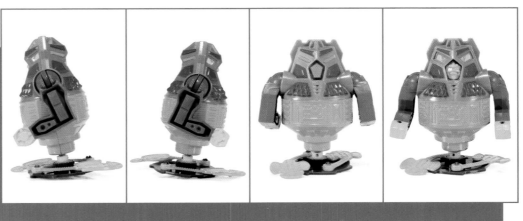

TWO BAD
DOUBLE-HEADED EVIL STRATEGIST

First released 1985 • Member of the Evil Warriors

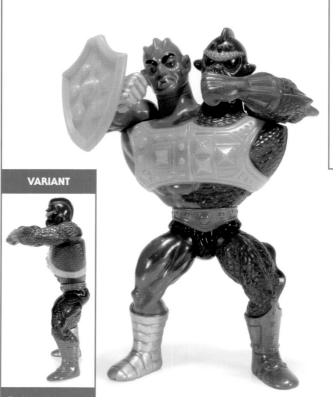

VARIANT

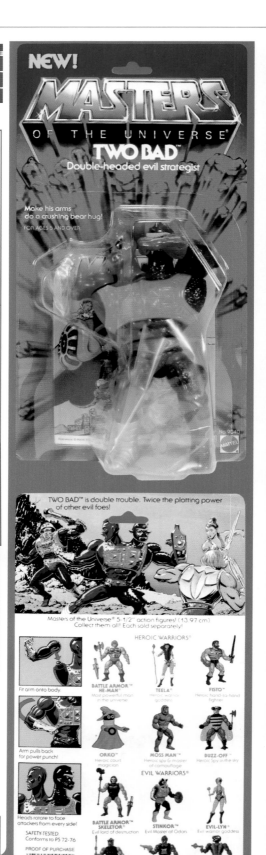

Accessory:
• Shield

Minicomic:
• *The Battle of Roboto*

Earlier releases of Two Bad had a larger, rounded back. This was changed to a flat back, likely to save on production costs.

Two heads may be better than one in most cases, but Two Bad's two heads rarely get along. Two heads do, however, make for a fun action figure!

Aside from the standard crotch piece, Two Bad features all-new parts. This includes a larger torso that is much wider than the other figures to fit the two heads on top. The arms are also placed up on top of the torso rather than on the sides like a normal figure.

These arms play into the figure's action feature. They are spring-loaded at the shoulders. If you pull the arms outward and release, the arms come flying forward. In addition, because of their high placement you can easily make Two Bad punch himself in the opposite face. This plays right into the idea that the heads rarely get along, and even if it's not the primarily promoted action feature, everyone seems to remember making their Two Bad figure punch himself.

There are two notable variations of Two Bad. The original release had a more full, rounded torso. A design change flattened the back, likely to save the amount of plastic used for production. This flat-back version seems to be the most common version.

FUN FACTOID: Two Bad's early working name was "Schizo." Designed by Roger Sweet, the character was originally envisioned as having one good half and one evil half.

TY-GRRR
HEROIC CAT WITH SUPER LEAPING POWER!

First released 1986 • Member of the Heroic Meteorbs

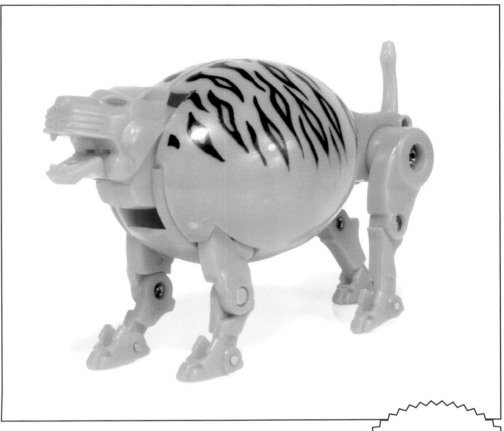

The Meteorbs are meteor rocks that can transform into animals and robots.

These transforming toys were originally released in Japan by Bandai under the name "Tamagoras." They were brought to the US by Mattel and released as characters in the Masters of the Universe line of action figures. This was Mattel's attempt to add the popular transforming toy mechanism seen in other lines, such as Transformers.

The transformation from meteor to animal is a simple mechanism, usually not requiring instructions. By simply popping open the toy you can easily fold out the legs and head to complete the transformation.

Ty-Grrr is orange in color with tiger stripes found on his egg-shaped body. The transformation is simple. By popping the egg in half you can easily fold out the figure's head, front legs, and hind legs with tail. Once fully transformed, Ty-Grrr resembles a tiger, as you might expect from his name.

The Meteorbs at times feel out of place among the many action figures found within Masters of the Universe, but, somehow, they still fit within the combination of magic and science fiction that allowed the toy line to incorporate so many widely differing designs.

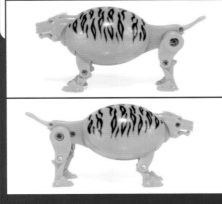

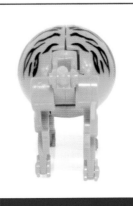

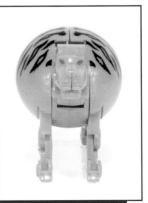

TYRANTISAURUS REX
MOST TERRIFYING DINOSAUR IN THE LAND OF PRETERNIA

First released 1987 • Steed of the Snake Men

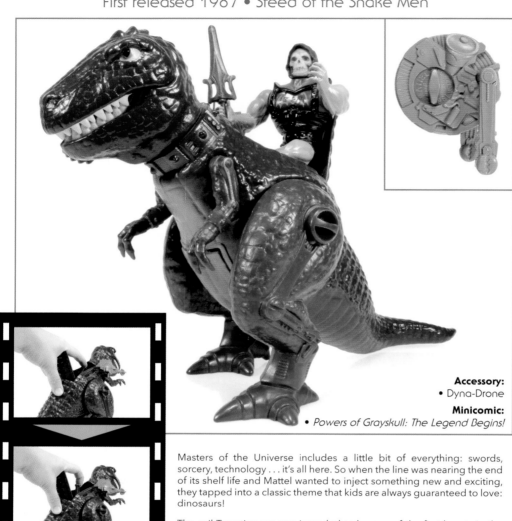

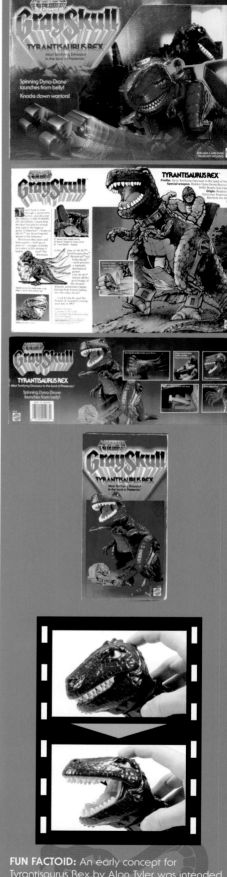

Accessory:
• Dyna-Drone

Minicomic:
• *Powers of Grayskull: The Legend Begins!*

Masters of the Universe includes a little bit of everything: swords, sorcery, technology . . . it's all here. So when the line was nearing the end of its shelf life and Mattel wanted to inject something new and exciting, they tapped into a classic theme that kids are always guaranteed to love: dinosaurs!

The evil Tyrantisaurus was intended to be one of the first beasts in the Powers of Grayskull line that was intended to follow the original Masters of the Universe toy line. Instead, he ended up being one of the final releases in the Masters of the Universe line itself.

The sculpt meshes the prehistoric beast with technology by adding bionic-looking pieces. A large laser cannon is mounted at his side. A seat can open up on the dino's back, allowing Skeletor or any of your Evil Warriors to mount it. It should be noted that, due to the design, the side mounted cannon often broke, making unbroken ones hard to find.

The Dyna-Drone is a unique little wind-up buzz saw weapon. Once you wind this up, you can place it into a trapdoor in Tyrantisaurus's belly. When you pull the door open, the Dyna-Drone comes flying out and quickly rolls across the floor, bowling over any Heroic Warrior in the way!

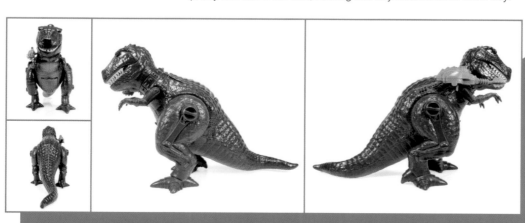

FUN FACTOID: An early concept for Tyrantisaurus Rex by Alan Tyler was intended for the Heroic Warriors and featured an organic "pet" accessory. The final design by David Wolfram was much more mechanical and featured a robotic accessory.

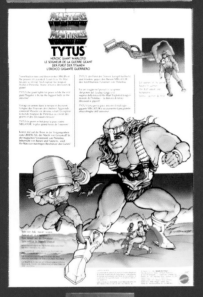

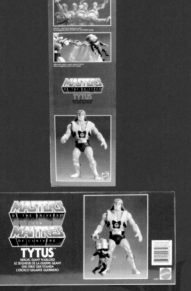

TYTUS
HEROIC GIANT WARLORD

First released 1988 • Member of the Heroic Warriors

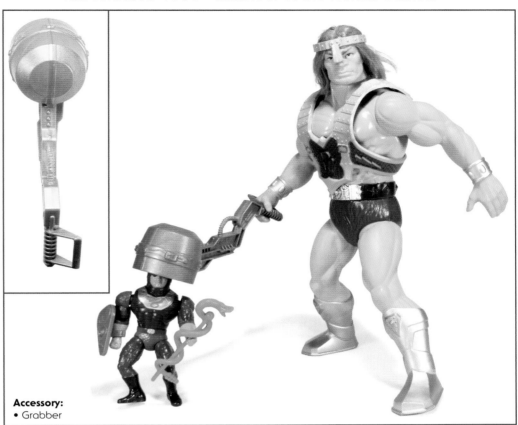

Accessory:
• Grabber

The giants Tytus and Megator are some of the rarest figures in the Masters of the Universe line, since they were only released in Europe. They were designed to be part of the spinoff Powers of Grayskull line that was intended to be the follow-up to Masters of the Universe. When the Powers of Grayskull line never actually got off the ground, Tytus and Megator were still released, primarily in Italy, but with the new Powers of Grayskull logos replaced on their packaging by the regular Masters of the Universe logo. Regardless, the artwork still gives us a glimpse of He-Ro, the character who was intended to be the protagonist in Powers of Grayskull.

Tytus stands a massive fifteen inches tall, towering over the regular five-and-a-half-inch action figures in the line. This heroic giant has an outfit very similar to the more barbarian-style figures in the basic line. He features rooted hair, something not found anywhere else in the Masters of the Universe line, with the exception of his evil counterpart, Megator.

Tytus has a really odd-looking weapon that is designed to grab on to the smaller five-and-a-half-inch action figures. The underside is made of a softer plastic, allowing it to easily grab onto the figures by lowering it over their heads. Twisting Tytus's waist lifts his arm—thus lifting his foes into the air with his grabber weapon!

FUN FACTOID: Tytus' original design by Alan Tyler featured a mace and a claw weapon. The final figure capture weapon was designed by David Wolfram.

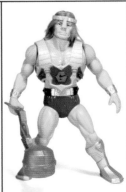

WEAPONS PAK
ARMS & ARMOR FOR YOUR MASTERS OF THE UNIVERSE FIGURES

First released 1984

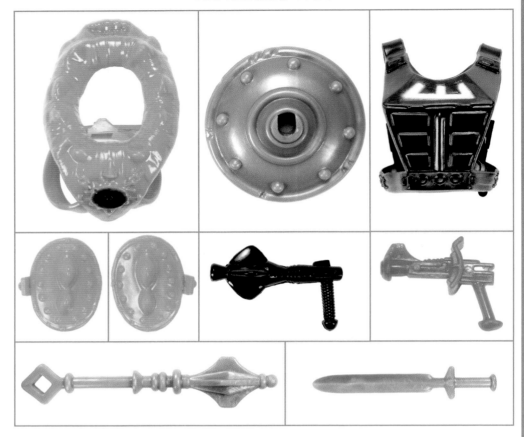

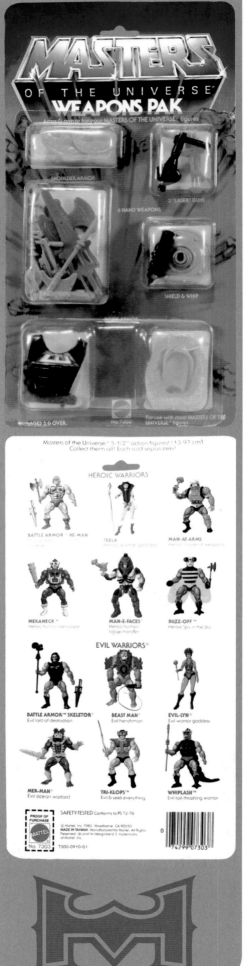

This accessory pack was a creative way to reuse several pieces and give kids either replacement pieces for lost weapons and armor or new pieces to change up their favorite figures!

This set gives you the following pieces: Beast Man's whip; Beast Man's armor and armbands in yellow; Zodac's laser pistol and armor in black; He-Man's sword and axe in bright blue; Man-E-Faces' blaster; and the Castle Grayskull rifle, shield, sword, axe, and mace, all in gray.

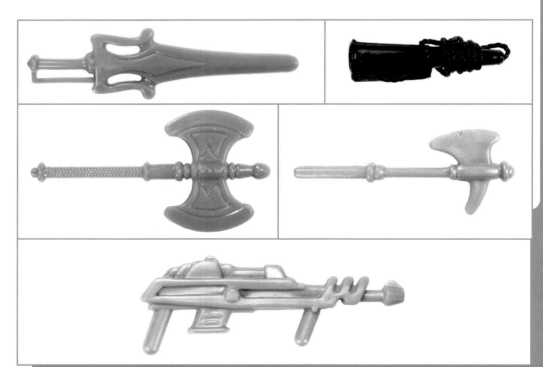

WEBSTOR
EVIL MASTER OF ESCAPE

First released 1984 • Member of the Evil Warriors

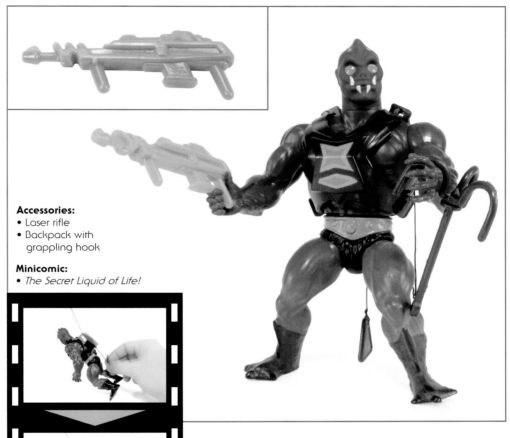

Accessories:
- Laser rifle
- Backpack with grappling hook

Minicomic:
- *The Secret Liquid of Life!*

With multiple eyes on his head and a black widow emblem emblazoned upon his armor, Webstor is meant to be a spider-like character. However, those two details and his climbing action feature are really the only things that make him feel spider-like. He really doesn't look much like an actual spider.

Aside from his unique action feature, Webstor features a lot of reused parts. The body is the same as that used for Skeletor and many of the Evil Warriors. His orange laser rifle is the same one that comes with the Castle Grayskull weapons rack, just in a different color. And while his grappling hook is brand-new to the Masters of the Universe toy line, it's another instance where Mattel reused a piece from their older Big Jim toy line. It was originally included with the Big Jim Pirate Boat!

The action feature is a lot of fun. The backpack has a complicated internal pulley system. A small string attaches to the grappling hook from the top of the pack. The string coming from the bottom of the pack has a small pull tab. By attaching the grappling hook to a precipice, such as Castle Grayskull's tower, you can make Webstor ascend the tower via the string by pulling the tab downward. The pulley system inside works very well, sending the figure up and down the string. However, since the string is so small, it was not uncommon for it to get tangled internally after a lot of play, causing the climbing feature to stop functioning properly.

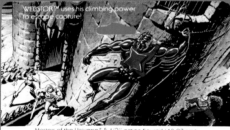
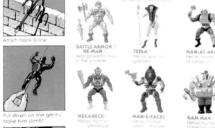

FUN FACTOIDS:
- Early concept art by Roger Sweet had the figure's string passing through its body rather than through a backpack.
- Webstor's early working name was "Black Widow."
- A variant of Webstor came with a blue laser rifle.

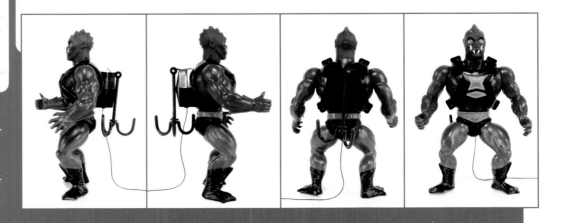

WHIPLASH
EVIL TAIL-THRASHING WARRIOR
First released 1984 • Member of the Evil Warriors

Minicomics:
- *He-Man Meets Ram-Man!*
- *The Secret Liquid of Life!*

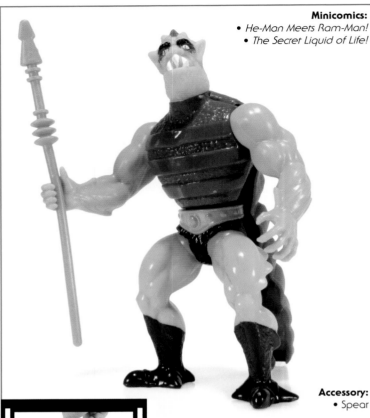

Accessory:
- Spear

Whiplash is one of the early figures in the Masters of the Universe line, following a distinct animal theme. With gator-like features, Whiplash has a green color scheme with a scaly sculpted head and a signature long tail coming off his back.

The figure does feature a lot of reused parts. The arms are the same ones originally used for Skeletor and many other Evil Warriors. The legs and torso are the same ones originally used for Buzz-Off. This time around, the stripes on the chest are all just the same shade of green to make it look more reptilian. His weapon is the same spear from the Castle Grayskull weapons rack, this time made in bright orange plastic.

The feature that makes him stand out is the long scaly tail that extends from his back. It's made of a much softer plastic, giving it a squishy, rubber-like feeling. It covers his entire back to give him the look of a scaly alligator. He has the same waist-twisting "power punch" action feature as many figures, but this time it's promoted as being a tail-whipping feature. By twisting his torso and releasing, it quickly snaps back, making it appear that he is swinging his tail for battle. His thrashing tail can be used to knock over other figures.

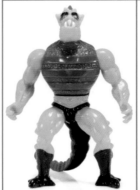 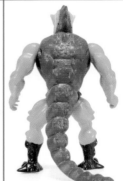 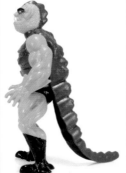 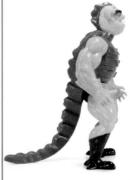

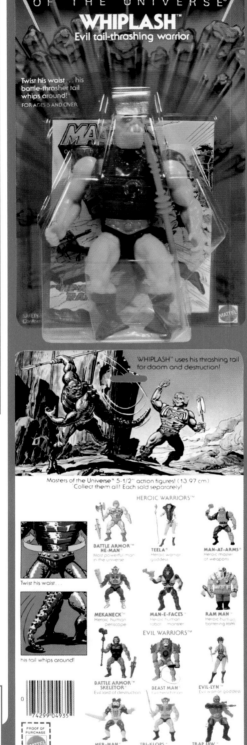

FUN FACTOIDS:
- Whiplash's early working name was "Lizard Man."
- Whiplash's early concept art, created by Colin Bailey, featured much more prominent spines as well as yellow legs.

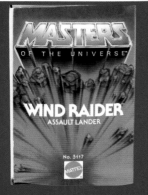

WIND RAIDER
ASSAULT LANDER

First released 1982 • Vehicle of the Heroic Warriors

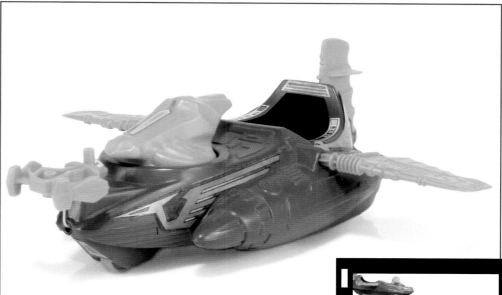

The Wind Raider was one of the very first vehicles released in the Masters of the Universe toy line, and would become a somewhat prominent one for He-Man and the Heroic Warriors. It was often featured heavily in story media, notably in the minicomics and in the Filmation cartoon series.

It's a smaller vehicle, meant to be a single-rider flying vehicle. The design is quite striking, featuring a dark green color with orange wings and a large alligator-type design on the front. The wings on the sides can rotate, and small wheels hidden on the underside allow kids to push the vehicle across the floor.

The most fun feature has to be the grappling hook and winch! The small hook can be removed from the peg on the front of the Wind Raider, and can be extended a decent distance. By lifting up and turning the alligator head on the front, you can then wind up the attached string and bring the grappling hook back to the vehicle!

FUN FACTOIDS:
- The Wind Raider's anchor was added in later, as it was felt that the toy needed some kind of action feature.
- In an early prototype, sculpted by Jim Openshaw, the figurehead on the vehicle was a much taller dragon design. In revised versions the figurehead was changed to resemble a stylized alligator head.

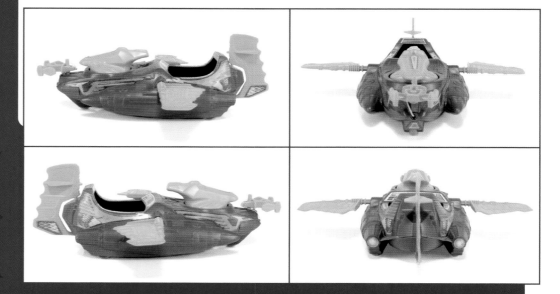

ZOAR
FIGHTING FALCON

First released 1983 • Beast of the Heroic Warriors

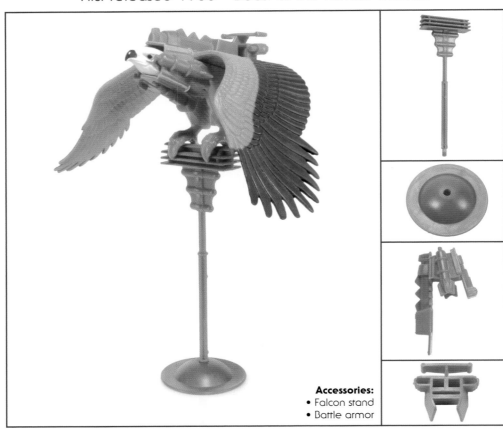

Accessories:
• Falcon stand
• Battle armor

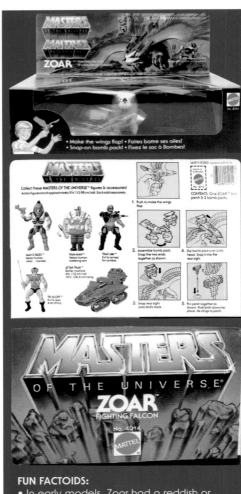

FUN FACTOIDS:
• In early models, Zoar had a reddish or orange paint scheme. The final figure had an orange, blue and white color scheme.
• The colors for Zoar were chosen by Mattel designer Martin Arriola.

Zoar was originally depicted as a male fighting falcon who fights alongside He-Man. He was meant to be another animal companion alongside Battle Cat. Upon the release of the popular cartoon series from Filmation, Zoar was altered significantly, now depicted as the falcon form of the Sorceress of Grayskull.

The large bird is a very bright orange color with prominent blue and white markings. Zoar features a button on the back of his leg, underneath the softer plastic used for his wings. When this button is pressed, Zoar flaps his wings. Zoar also includes removable red armor and a red perch, both of which are the same ones included with Screeech.

In another similarity to Battle Cat and Panthor, the mold used for both Zoar and Screeech originated as an eagle in Mattel's 1972 Big Jim toy line.

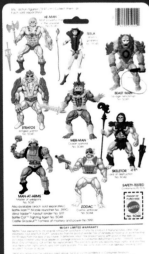

EIGHT-BACK

TWELVE-BACK

ZODAC
COSMIC ENFORCER

First released 1982 • Member of the Heroic Warriors

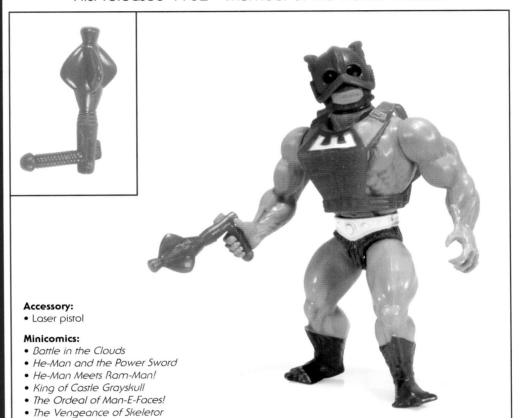

Accessory:
• Laser pistol

Minicomics:
• Battle in the Clouds
• He-Man and the Power Sword
• He-Man Meets Ram-Man!
• King of Castle Grayskull
• The Ordeal of Man-E-Faces!
• The Vengeance of Skeletor

Zodac is a character with a bit of a confusing backstory. His original card back referred to him as a "Cosmic Enforcer," which was originally intended by Mattel to signify a sort of bounty hunter for the world of MOTU. His second card back then distinctly referred to him as "evil." This was quickly changed, however, and he was ultimately presented as more of a neutral cosmic character who maintains balance between good and evil. It's pretty obvious Mattel was not quite clear on the direction of this character upon his release.

Zodac is a really unusual-looking action figure as well. He was a late addition to the original wave of eight action figures, which might explain why he is such a weird mixture of existing parts. His arms and legs are the same demonic-looking ones used for Skeletor and many Evil Warriors. His chest is the furry Beast Man chest, which is weird, since he has a humanoid look with a tan skin tone. It makes the character look as though he has an abnormally hairy chest and back.

Zodac has a very space-age look to his overall design, which fits in with the original concept of a cosmic bounty hunter. He has a unique laser pistol, which would later be reused for Kobra Khan. An interesting detail in the figure's sculpt can be found on the straps of his futuristic armor. There are small bullets sculpted on, bandoleer-style. Since he has a laser pistol, it's interesting to think that these might be laser bullets of some sort. This again really fits in with that original bounty hunter concept.

FUN FACTOIDS:
• Zodac was designed last out of the original eight figures, after the characters of Teela and Sorceress were combined into one figure.
• Zodac's original working name was "Sensor."

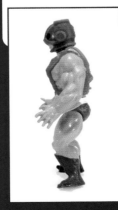
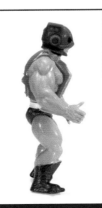
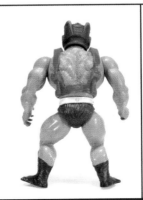
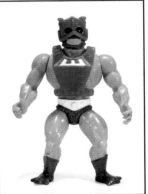

MASTERS OF THE UNIVERSE GIFT SETS by Dan Eardley

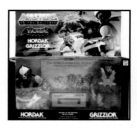

In addition to the standard releases in the original Masters of the Universe toy line, there were also a number of gift set releases. These gift sets typically paired up various single releases in new packaging, allowing customers to get a bit more bang for their buck. Some of these gift sets came in the form of action figure three-packs. Each gift set contained three previously released Masters of the Universe action figures now packaged together in a window box displaying the toy line logo and the character names across the front. Many times, these contained three basic figures, such as Man-At-Arms, Battle Armor He-Man, and Man-E-Faces. But sometimes that third figure was one of the cats, like in the Battle for Eternia set that contained Skeletor, Man-E-Faces, and Panthor.

There were also two-packs, coming in several varieties. The most common are the window box sets featuring He-Man with Battle Cat, and Skeletor with Panthor. Many of these two-packs are known for the amazing new artwork that did not appear on any other package in the line. He-Man with Jet Sled, Hordak with Mantisaur, and Skeletor with Screeech are a few examples of three-packs with unique artwork not seen anywhere else. The Hordak and Grizzlor two-pack even included a storybook and cassette tape.

But some two-packs had much more basic packaging. Such was the case with the JC Penney exclusive sets. These two-packs, featuring combinations such as Man-E-Faces with Faker and Jitsu with Clawful, were mail order gift sets. As a result, the figures were placed inside of plain brown shipper boxes with simple illustrations of the characters on the outside. They aren't as striking as the sets mentioned previously, but with the popularity of JC Penney's holiday catalogs, it's likely many of these found their way under many Christmas trees during the holidays.

There were numerous gift sets released throughout the original toy line's run, both domestically and internationally. As a result, they are hard to keep track of. It's also quite rare to find these gift sets still sealed, making them extremely collectible and highly sought after by fans. Aside from the scarcity of many of the gift sets, the unique packaging with gorgeous artwork featured on some make for showpieces on any collector's shelf.

THE MYSTERY OF SAVAGE HE-MAN by Val Staples

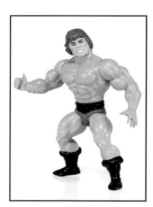

If there is one figure that has long puzzled He-Man fans, it is Savage He-Man (AKA: Wonder Bread He-Man). And for over twenty years, fans have pondered the history of this toy.

This figure is regarded as one of the gems of any He-Man collection. But the figure has a problem in that is no one knows exactly where it originated. Theories of its genesis range from it being a mail-in figure, to a store give-away, to promotional offers. Many of those who had this figure from a young age often have a different account of how it came to be in their collection.

The whole thing kicked off in the early days of the internet thanks to Alex Bickmore's Super Toy Archive (toyarchive.com). Part of the collection of one David Schickedan, this figure is depicted with brown hair, brown trunks, black boots, and a black belt. It was also shown wearing black Zodac armor and brandishing a maroon Castle Grayskull mace. It was stated this was part of a mail-in Wonder Bread promotion. Once Lee's Action Figure News & Toy Review magazine, a popular action figure magazine at the time, printed information about this figure then the legend of Wonder Bread He-Man took off!

In the early days of the internet, many fans had not even seen the later USA releases of the toy line. And the number of gift sets was unquantified. So, this figure being an unknown mail-away seemed plausible. In addition, many fans were unfamiliar with its weapons depicted on Super Toy Archive.

It did not take long for fans to realize the black Zodac armor came from Mattel's vintage accessory pack. And then a packaged promotional version of Man-E-Faces surfaced (now referred to as "Man-E-Weapons") that contained five of the Castle Grayskull weapons that were cast in a maroon color, including the mace.

When 2000 rolled around, two prominent collectors Darren Fowler and David Fowler purchased on eBay the only known packaged sample. It came with no armor, a maroon sword, and maroon axe, all of which differed from the image on Toy Archive. In addition, it included a Mattel Buy-3-Get-1-Free coupon that was supposed to be how the figure was offered. But it was odd that it came packaged with the very coupon that would have been mailed to claim the figure. The bag it came in was also questionable, as it was not the typical sealed polybag one would expect from a factory. As a result, the mystery only deepened.

Soon after in 2001, Mattel started to produce a Commemorative line that re-released some of the vintage Masters of the Universe figures. Working with He-Man.Org, Mattel polled fans about their favorite figures, cartoon episodes, and more. During this polling, Mattel shared with He-Man.Org that they planned to release a Commemorative Wonder Bread He-Man due to the hype and mystique surrounding the figure. But Mattel cancelled plans for the release because they could find no prior deal with Wonder Bread in their archives for a mail-in promotional figure. It turned out the Wonder Bread promotion previously attached to the figure was instead a 1985 / 1986 mail-in for a trading card set which was a far cry from being an action figure.

Realizing the figure never came from Wonder Bread, and all the accessories were now accounted for from other sources, fans were left with an armorless, weaponless figure of unknown origin. In order to disassociate from the Wonder Bread promotion, fans went on to call the figure "Savage He-Man" because of his resemblance to the armorless, weaponless He-Man depicted in the very first minicomic where the story was more "savage" and that preceded the Filmation cartoon.

One thing for certain is that the brown-haired figure is legitimate. It was produced with the same materials and methods of vintage He-Man figures that could have only come from a factory. Customizers of that time did not have the ability to replicate a figure to match the eighties releases from Mattel. And as the years have passed, many legitimate samples of the figure have surfaced on the aftermarket and in private collections.

In a 2007 / 2008 attempt to cast a net for information, Mattel, ToyFare magazine, and He-Man.Org all teamed up to try and resolve the mystery once and for all. All three put a call out to the public for any information on the figure that may help to discover its roots. Unfortunately, nothing surfaced.

Trying again in 2019, we spoke to Mark Ellis, former Director of Marketing for Male Action Toys who oversaw Masters of the Universe, and showed him all the current evidence. Mark revealed the original test sample of He-Man from the factory had brown hair. But that test sample would have had an earlier torso sculpt that ended up being corrected for figures released later in 1982. The mysterious brown-haired figure has the corrected torso. With the test sample theory dead, fans are left wondering how this figure came to be. There are many unproven theories at this point. One popular idea is this may have been an early test run for the 1983 Faker, where the colors ended up being too close to He-Man and were altered further to the blue Faker we all know for the official release.

In addition, internal letters at Mattel revealed that a 1983 Buy-3-Get-1-Free offer that appeared to be tied to Meijer Thrifty Acres (now known just as Meijer) led to an unhappy customer. The customer, a mother whose son was a fan of He-Man, wrote to Mattel about receiving an oddly colored He-Man with no armor or accessories. Both her and her son were displeased with this bland "special edition" figure. Mattel noted in a response that the offer did not specify what would be sent nor that it would be a "special edition" item. In 1983, Meijer Thrifty Acres had a string of stores in Michigan and had just entered the Ohio marketplace. If Mattel coordinated with Thrifty Acres to offer a special mail-in incentive, it is possible a test-run that resulted in a brown-haired He-Man may have been used to satisfy the promotional needs of this smaller, regional account. But no one knows for certain, and any number of possibilities remain.

Mattel went on to pay homage to the figure in 2010 with the release of the Masters of the Universe Classics Wun-Dar figure, which played off the original Wonder Bread origin rumors. But today, the exact origin of this figure remains a mystery. And while not being an official release on record, Savage He-Man is one of the most coveted vintage Masters of the Universe toys. Often sold as customs or bootlegs, finding a legitimate version is proving harder as time passes. So, if you can find one that is real, you will have a special item for your collection!

A WORLD OF VARIANTS by James Reid and Rodrigo De Orduña

Playing with toys as a child, you don't pay much attention to where they came from—but as an adult, you start to notice certain differences between figures. For instance, why is the belt color on one Man-At-Arms figure different from another, and why does one have red-painted dots on the helmet? It turns out one is marked "Made in Malaysia" and the other "Made in Taiwan." And why does one Skeletor have half-painted boots instead of fully painted like the others?

Welcome to the world of Masters of the Universe variants. At least sixteen different countries have been confirmed to have had factories that produced toys for the line, and the output of each particular factory often differed significantly from that of the others.

A total of seventy-two individual figures from 1982 to 1988, including four European exclusive releases (the two giants and two Laser figures) were created for the Masters of the Universe toy line. Every figure, bar one, was made in at least two different factories. This one exception was the giant Megator, which was only released in Italy. No factory produced every single figure, and neither is there any consistency in which factories produced which figures, or which they continued to produce as the line progressed through the years. According to Mattel, no production records were kept from this time period, so our knowledge of which factories produced which figures is entirely down to the research of intrepid collectors.

While Mattel ceased production on the MOTU line altogether in 1988, other companies with the license to produce MOTU, such as Top Toys in Argentina and Leo in India, continued well into the nineties. Some of these figures moved even further away from the Mattel standard paint applications, and this is arguably where some of the best and rarest variants came from.

Along with the figures, many vehicles, play sets, and other accessories were made in the same factories. The only known factory that did not produce any figures was in Australia, where a few of the larger items, such as Castle Grayskull, Snake Mountain, and Battle Bones, were manufactured for local sales.

TYPES OF VARIANTS

Variants can be classified into four categories:

- Deliberate production changes within the same factory
- Production differences between multiple factories, e.g. Malaysia, Taiwan, and Mexico
- International production for release only in a specific country, e.g. Rotoplast, Leo, Top Toys
- Production errors, e.g. factory errors that were released in significant numbers

GEOGRAPHICAL DIFFERENCES

MATTEL STANDARD

Mattel Standard figures were produced for export. These were sold in the US, Canadian, and Australian markets, while European countries such as Spain, France, Italy, and Greece contributed to manufacture for release in Europe.

The factories in Mexico, the USA, Malaysia, Taiwan, Hong Kong, and China are considered the Mattel Standard. Although there are variations among these, they are not considered international variants. There are nevertheless differences between these countries, and even production changes within the same factories. Let us look at each individual country to gain a greater perspective:

Taiwan. The very first MOTU figure releases came from Taiwan. The original eight figures, known as „eight-backs," all had slight differences when they were re-released. This usually amounted to a change in paint application and armor strap length. They were rereleased with 1982 markings, along with other figures which were added to production over the years.

Mexico/USA. Figures made in Mexico came from the Mabamex factory located in Tijuana, and their accessories were made in the US. Only two figures are known to have been made in the USA—a 1982-marked He-Man, and a 1983-marked Battle Armor Skeletor. The rest all came from Mexico.

Malaysia. Another major supplier was Malaysia. These figures differed from the Taiwan products in that some of them were produced with hard heads. These were often released on Euro cards.

Hong Kong/China. It appears that Hong Kong and China had very similar, if not the same production. The only figures marked "China" were the Commemorative series rel,eased in the year 2000. No vintage figures were marked "China," and only a few were ever marked "Hong Kong," with cards initially stating, "Made in Hong Kong." Later releases included a sticker over the top of this, stating "Made in China." Eventually cards were printed that themselves read "Made in China." Whether this was due to a political issue of the time, or whether there were in fact two separate factories, is unclear. Mattel has no archived records of which factories they used, so we can only go by the information from carded evidence. Comparative analysis between several mint-on-card copies of the same figure from both China and Hong Kong reveals small differences, but whether these are production changes within a single factory or differences due to being made in a different factory, is uncertain. It is most likely that Hong Kong and China did indeed have separate production factories. This is implied by the fact that some cards state outright, "Figure made in China, Accessories made in Hong Kong." It is quite possible that the two factories worked together, and excess Hong Kong cards were used by the Chinese factory, with sticker in place. As another interesting piece of MOTU history, the Meteorb figures were made in Macau, which is now back under control of China, much like Hong Kong.

Japan. While Japan was not a site of manufacture for MOTU figures, it did see a very limited set of figures by Takara. These were simply regular Taiwan carded figures, with a Takara sticker on the back. These were intended to be released by Ma-Ba, a deal between Mattel and Bandai, and several boxed examples were created with unique artwork. This deal did not mint-on-card, and the figures were never released.

EUROPEAN PRODUCTION

While many figures sold in European countries were simply Taiwan, Malaysia, or Hong Kong figures on Euro cards, several European countries were involved in production:

France (37). There were two French factories in operation, which made all figures from series 1-4, excluding Teela and Evil-Lyn. French-produced figures featured paint apps that were slightly different from the Mattel Standard. Some of the stranger oddities included the rare super series, the rubber boot variations and the clear leg band variants. Most of these figures are marked "Made in France"; however, it appears that excess parts from Taiwan were used for some French figures. There are several types of French cards, with the yellow-border card being the most well

Musclor from France

known. It should be noted that not all figures packaged on French cards were themselves made in France. It is possible that the many French variations are due to multiple factories making the same figures.

Spain (67). No country produced every single MOTU figure, but Spain did come close—producing all figures except Ninjor, Faker, the Sorceress and the giants Tytus and Megator. Only a few figures produced in Spain are marked with the country of origin (COO), and they often used molds from other countries. However, all figures packaged on a "Masters del Universo" card are made in Spain, regardless of what their COO molds say. Many variants came from Spain and some of these are extremely rare and hard to find. Many of them use the clear leg bands, and there are multiple Spanish variations of the same figures. Spain also produced its own variants of the two Laser figures. The first Spanish wave was packaged on Congost-marked cards, whereas future waves omitted the Congost logo, although Congost is thought to have been responsible for the entire "Masters del Universo" Universo run.

Italy (13). While only a handful of figures on Euro cards were produced here, four major additions to the MOTU line came from Italy. These are the giants Megator and Tytus in 1987, and Laser-Light Skeletor and Laser Power He-Man in 1988. The other figures produced in Italy are Blast-Attak, Mosquitor, Blade, Gwildor, Battle Armor He-Man, Sorceress, Saurod, Ninjor, and Scare Glow. Some of these used clear leg bands, and the figures themselves have subtle differences when directly compared to standards of Hong Kong or Mexico.

Greece (2). Greece has only been confirmed to have produced two figures: Skeletor and Terror Claws Skeletor. The regular Skeletor figure is actually marked "Spain," and has very soft and translucent accessories, using the clear leg bands. Terror Claws Skeletor also has an unchromed matte pink finish.

INTERNATIONAL PRODUCTION

Licensing deals with local manufacturers were the cause of many variations in the Masters of the Universe line.

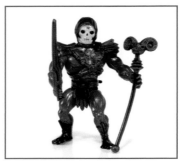
Skeletor (Leo Release)

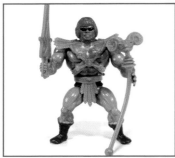
Faker (Leo Release)

India LEO (31). Leo was a licensing deal between Blowplast and Mattel to manufacture and release MOTU in the Indian market. Leo continued to produce MOTU toys in India well into the nineties, creating some of the most interesting, rare, and now valuable variants. These include the most well-known variant of all, which is considered the crown jewel among collectors: Leo Faker. Most Leo figures and accessories are marked "India," which is useful for their identification. Leo packaged the figures on regular cards to begin with, and New Adventures of He-Man cards towards the end of their run.

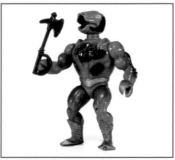
"Camo Khan" (Top Toys Release)

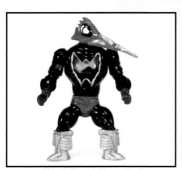
"Black Blood Mosquitor" (Top Toys Release)

Argentina: Top Toys (39). Top Toys had the license to manufacture and release MOTU in Argentina. Initially most Argentinian figures stuck close to the Mattel Standard, but standout variations were created along the line. Kobra Khan Camuflado ("Camo Khan") was almost an entirely new creation, and the Argentinian Modulok was given green limbs. As time went on—and presumably to cut costs—figures moved further away from the Mattel Standard. Accessories and paint apps continued to change as Top Toys reissued figures well into the nineties. These reissued figures have unique leg sculpts, while the muscles are more defined. Top Toys used molds from other factories, erasing the names of the origin countries. The only figure to have an Argentina COO stamp is Trap Jaw.

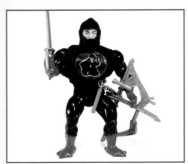
Ninjor (Rotoplast Release)

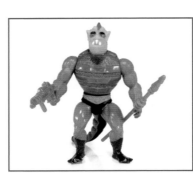
Whiplash (Rotoplast Release)

Venezuela: Rotoplast (25). Rotoplast was the company that manufactured and distributed MOTU in Venezuela. Some Rotoplast figures used a soft bendable rubber material for the arms and accessories. Many of the figures which came from Venezuela were variations from the Mattel Standard. While the Rotoplast-released Battle Bones and Blasterhawk had a "Made in Venezuela" stamp, no figures were ever marked with COO Venezuela. Instead, Rotoplast used molds from Spain and other countries, erasing the molds' COO, or sometimes leaving the original COO in place.

Brazil: Estrela (18). Estrela is the only company besides Mattel to have its name printed on the MOTU figures. The Estrela figures were made for the Brazilian market. Figure names were localized. While most of the figures themselves were close to Mattel's standard paint applications, Estrela did produce a standout version of Mer-Man. Renamed "Aquatico," he was packaged with entirely orange accessories.

Mexico: Aurimat (28). Masters of the Universe was also released locally in Mexico. The license was given to Aurimat, an alliance between Auriga and Mattel, and the line was renamed "Los Amos del Universo." Figures manufactured by Aurimat are different from those made in Mexico by Mabamex. They became known as the Los Amos variants and came packaged in boxes. Molds are known to have come from Mexico, Malaysia, Hong Kong, Taiwan, and France, so only a limited number were marked "Mexico." There are many rare and interesting variations in the Aurimat collection.

Roton (Aurimat Release)

There are still many other rumored variants, but it is the research done by collectors and shared with the community that has made it possible to confirm true factory-made variations, and made the hunt for variants possible. The quest for variants can be addictive but very fun, and the most ardent of collectors have close to a thousand figure variations in their collections. Does anyone have them all? It is doubtful, but worth a try!

MASTERS OF THE UNIVERSE

TIMELINE COLOR KEY

- ◯ Drawing/Sketch
- ◯ Trademark
- ◯ Documentation
- ◯ First Use in Commerce
- ◯ Copyright
- ◯ Concept
- ⬤ Patent
- ◯ Milestone

1979

08/15/1979 • Category Management memo

1979 • First Castle Grayskull sketch, by Mark Taylor

1979 • Torak (very early He-Man) sketch, by Mark Taylor

1980

05/22/1980 • Fantasy Make Believe idea disclosure form

06/11/1980 • Male Action Figure attributes list

09/08/1980 • Figure Attributes list

09/21/1980 • Space/Monster/Fantasy Figures budgeted hours form

11/03/1980 • Megaton Man project request form

12/30/1980 • He-Man Characters & Accessories idea disclosure form

1981

01/23/1981 • Drawing by Colin Bailey depicting Mark Taylor working on He-Man project

03/30/1981 • De-Man (Skeletor) concept, by Mark Taylor

04/01/1981 • Man-At-Arms concept, by Mark Taylor

04/02/1981 • Tree Man (Beast Man) concept, by Mark Taylor

04/06/1981 • He-Man (tan boots) concept, by Mark Taylor

04/07/1981 • Battle Ram (tank treads version) concept, by Ted Mayer

05/03/1981 • He-Man (red/yellow boots) concept, by Mark Taylor

05/28/1981 • Female Warrior (Teela) concept, by Mark Taylor

05/28/1981 • Battle Ram control drawing, by Ted Mayer

06/03/1981 • Sorceress concept, by Mark Taylor

06/05/1981 • Battle Chariot concept, by Ted Mayer

07/14/1981 • Memorandum discussing Mattel's presentation of He-Man to Toys"R"Us

08/10/1981 • Attak Trak mechanism patent filed (non-Mattel)

09/16/1981 • Mer-Man sword design concept, by Mark Taylor

09/30/1981 • "Proprietary Line Concepts" document

11/28/1981 • King of Castle Grayskull published per copyright records

11/28/1981 • He-Man and the Power Sword published per copyright records

11/28/1981 • The Vengeance of Skeletor published per copyright records

12/08/1981 • He-Man first use in commerce

12/08/1981 • Battle Cat first use in commerce

12/08/1981 • Battle Ram first use in commerce

12/08/1981 • Beast Man first use in commerce

12/08/1981 • Man-At-Arms first use in commerce

12/08/1981 • Teela first use in commerce

12/08/1981 • Mer-Man first use in commerce

12/08/1981 • Stratos first use in commerce

12/08/1981 • Wind Raider first use in commerce

12/08/1981 • Zodac first use in commerce

12/08/1981 • Masters of the Universe first use in commerce

12/14/1981 • Battle Cat trademarked

12/14/1981 • Teela trademarked

12/14/1981 • Man-At-Arms trademarked

12/14/1981 • Stratos trademarked

12/14/1981 • Wind Raider trademarked

12/14/1981 • Battle Ram trademarked

12/14/1981 • Beast Man trademarked

12/14/1981 • Mer-Man trademarked

12/14/1981 • Zodac trademarked

12/14/1981 • Masters of the Universe trademarked

12/21/1981 • Battle Cat trademarked

12/21/1981 • Castle Grayskull Trap Door patent filed

12/28/1981 • Skeletor first use in commerce

12/28/1981 • Castle Grayskull first use in commerce

1981 • Bird Man (Stratos) concept, by Mark Taylor

1981 • Mer-Man concept, by Mark Taylor

1981 • Castle Grayskull concept, by Mark Taylor

1981 • Battle Cat concept, by Mark Taylor

1981 • Sensor (Zodac) concept, by Mark Taylor

1981 • Battle Tester/Combat Trainer concept, by Mark Taylor

1981 • Heroic Figure (He-Man) concept, by Mark Taylor

1981 • Heroic Figure (He-Man) battles plant monster concept, by Mark Taylor

1982

01/15/1982 • Castle Grayskull trademarked

01/15/1982 • Skeletor trademarked

02/17/1982 • Mattel introduces new "Masters of the Universe" toy line at Toy Fair

03/01/1982 • Earliest purchase date for MOTU toys in rebate offer

03/04/1982 • Attak Trak control drawing, by Ted Mayer

03/23/1982 • Attak Trak concept, by Ted Mayer

05/21/1982 • Trap Jaw concept, by Colin Bailey

07/1982 • Wasp Man (Buzz-Off) concept, by Colin Bailey

07/1982 • Lizard Man (Whiplash) concept, by Colin Bailey

09/21/1982 • Zoar first use in commerce

09/21/1982 • Ram Man first use in commerce

09/21/1982 • Man-E-Faces first use in commerce

09/21/1982 • Trap Jaw first use in commerce

09/21/1982 • Attak Trak first use in commerce

09/21/1982 • Point Dread & Talon Fighter first use in commerce

09/27/1982 • Attak Trak trademarked

09/27/1982 • Man-E-Faces trademarked

09/27/1982 • Point Dread & The Talon Fighter trademarked

09/27/1982 • Ram Man trademarked

09/27/1982 • Trap Jaw trademarked

09/27/1982 • Zoar trademarked

10/05/1982 • Sultra (Evil-Lyn) concept, by Colin Bailey

10/25/1982 • Castle Grayskull copyrighted

10/26/1982 • Teela copyrighted

11/04/1982 • Battle Ram copyrighted

11/04/1982 • Beast Man copyrighted

11/04/1982 • He-Man copyrighted

11/04/1982 • Man-At-Arms copyrighted

11/04/1982 • Mer-Man copyrighted

11/04/1982 • Skeletor copyrighted

11/04/1982 • Stratos copyrighted

11/04/1982 • Wind Raider copyrighted

11/04/1982 • Zodac copyright registered

11/22/1982 • Tri-Klops first use in commerce

12/07/1982 • King of Castle Grayskull copyrighted

12/08/1982 • He-Man and the Power Sword copyrighted

12/10/1982 • Tri-Klops trademarked

12/28/1982 • The Vengeance of Skeletor copyrighted

1982 • Ram Man concept, by Mark Taylor

1982 • Man-E-Faces concept, by Mark Taylor

1983

01/11/1983 • Evil-Lyn first use in commerce

01/21/1983 • Evil-Lyn trademarked

01/21/1983 • Heroic Warriors trademarked

01/21/1983 • Evil Warriors trademarked

Continued on next page . . .

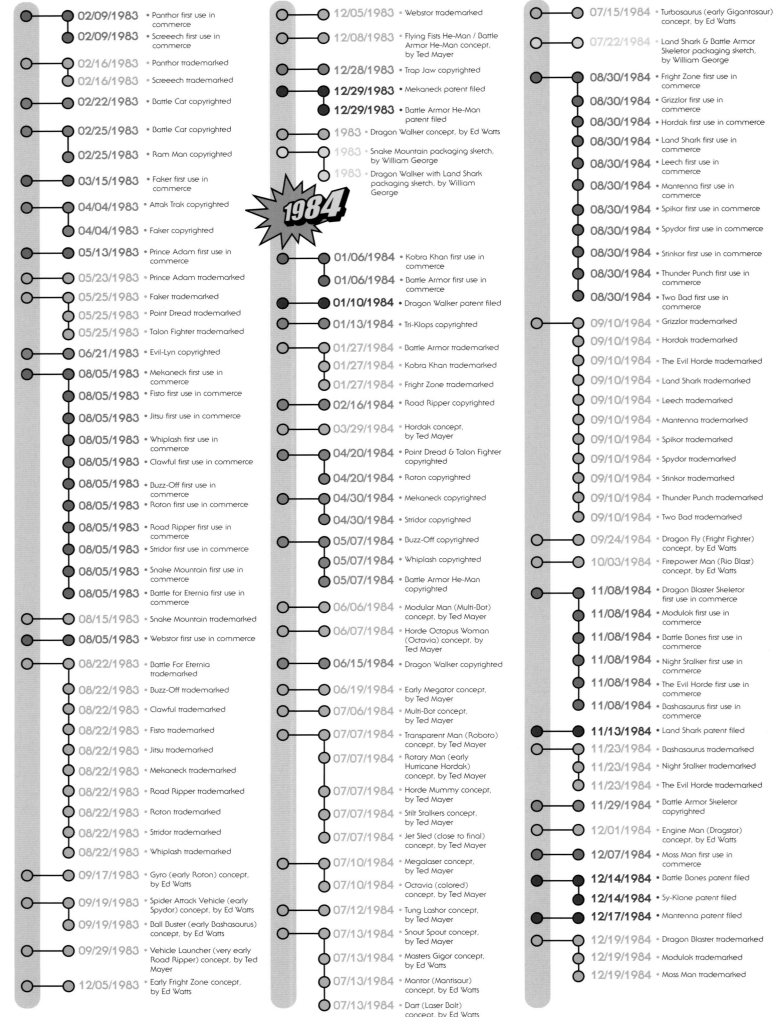

1984



- 02/09/1983 • Panthor first use in commerce
- 02/09/1983 • Screeech first use in commerce
- 02/16/1983 • Panthor trademarked
- 02/16/1983 • Screeech trademarked
- 02/22/1983 • Battle Cat copyrighted
- 02/25/1983 • Battle Cat copyrighted
- 02/25/1983 • Ram Man copyrighted
- 03/15/1983 • Faker first use in commerce
- 04/04/1983 • Attak Trak copyrighted
- 04/04/1983 • Faker copyrighted
- 05/13/1983 • Prince Adam first use in commerce
- 05/23/1983 • Prince Adam trademarked
- 05/25/1983 • Faker trademarked
- 05/25/1983 • Point Dread trademarked
- 05/25/1983 • Talon Fighter trademarked
- 06/21/1983 • Evil-Lyn copyrighted
- 08/05/1983 • Mekaneck first use in commerce
- 08/05/1983 • Fisto first use in commerce
- 08/05/1983 • Jitsu first use in commerce
- 08/05/1983 • Whiplash first use in commerce
- 08/05/1983 • Clawful first use in commerce
- 08/05/1983 • Buzz-Off first use in commerce
- 08/05/1983 • Roton first use in commerce
- 08/05/1983 • Road Ripper first use in commerce
- 08/05/1983 • Stridor first use in commerce
- 08/05/1983 • Snake Mountain first use in commerce
- 08/05/1983 • Battle for Eternia first use in commerce
- 08/15/1983 • Snake Mountain trademarked
- 08/05/1983 • Webstor first use in commerce
- 08/22/1983 • Battle For Eternia trademarked
- 08/22/1983 • Buzz-Off trademarked
- 08/22/1983 • Clawful trademarked
- 08/22/1983 • Fisto trademarked
- 08/22/1983 • Jitsu trademarked
- 08/22/1983 • Mekaneck trademarked
- 08/22/1983 • Road Ripper trademarked
- 08/22/1983 • Roton trademarked
- 08/22/1983 • Stridor trademarked
- 08/22/1983 • Whiplash trademarked
- 09/17/1983 • Gyro (early Roton) concept, by Ed Watts
- 09/19/1983 • Spider Attack Vehicle (early Spydor) concept, by Ed Watts
- 09/19/1983 • Ball Buster (early Bashasaurus) concept, by Ed Watts
- 09/29/1983 • Vehicle Launcher (very early Road Ripper) concept, by Ted Mayer
- 12/05/1983 • Early Fright Zone concept, by Ed Watts



- 12/05/1983 • Webstor trademarked
- 12/08/1983 • Flying Fists He-Man / Battle Armor He-Man concept, by Ted Mayer
- 12/28/1983 • Trap Jaw copyrighted
- 12/29/1983 • Mekaneck patent filed
- 12/29/1983 • Battle Armor He-Man patent filed
- 1983 • Dragon Walker concept, by Ed Watts
- 1983 • Snake Mountain packaging sketch, by William George
- 1983 • Dragon Walker with Land Shark packaging sketch, by William George
- 01/06/1984 • Kobra Khan first use in commerce
- 01/06/1984 • Battle Armor first use in commerce
- 01/10/1984 • Dragon Walker patent filed
- 01/13/1984 • Tri-Klops copyrighted
- 01/27/1984 • Battle Armor trademarked
- 01/27/1984 • Kobra Khan trademarked
- 01/27/1984 • Fright Zone trademarked
- 02/16/1984 • Road Ripper copyrighted
- 03/29/1984 • Hordak concept, by Ted Mayer
- 04/20/1984 • Point Dread & Talon Fighter copyrighted
- 04/20/1984 • Roton copyrighted
- 04/30/1984 • Mekaneck copyrighted
- 04/30/1984 • Stridor copyrighted
- 05/07/1984 • Buzz-Off copyrighted
- 05/07/1984 • Whiplash copyrighted
- 05/07/1984 • Battle Armor He-Man copyrighted
- 06/06/1984 • Modular Man (Multi-Bot) concept, by Ted Mayer
- 06/07/1984 • Horde Octopus Woman (Octavia) concept, by Ted Mayer
- 06/15/1984 • Dragon Walker copyrighted
- 06/19/1984 • Early Megator concept, by Ted Mayer
- 07/06/1984 • Multi-Bot concept, by Ted Mayer
- 07/07/1984 • Transparent Man (Roboto) concept, by Ted Mayer
- 07/07/1984 • Rotary Man (early Hurricane Hordak) concept, by Ted Mayer
- 07/07/1984 • Horde Mummy concept, by Ted Mayer
- 07/07/1984 • Stilt Stalkers concept, by Ted Mayer
- 07/07/1984 • Jet Sled (close to final) concept, by Ted Mayer
- 07/10/1984 • Megalaser concept, by Ted Mayer
- 07/10/1984 • Octavia (colored) concept, by Ted Mayer
- 07/12/1984 • Tung Lashor concept, by Ted Mayer
- 07/13/1984 • Snout Spout concept, by Ted Mayer
- 07/13/1984 • Masters Gigor concept, by Ed Watts
- 07/13/1984 • Mantor (Mantisaur) concept, by Ed Watts
- 07/13/1984 • Dart (Laser Bolt) concept, by Ed Watts



- 07/15/1984 • Turbosaurus (early Gigantosaur) concept, by Ed Watts
- 07/22/1984 • Land Shark & Battle Armor Skeletor packaging sketch, by William George
- 08/30/1984 • Fright Zone first use in commerce
- 08/30/1984 • Grizzlor first use in commerce
- 08/30/1984 • Hordak first use in commerce
- 08/30/1984 • Land Shark first use in commerce
- 08/30/1984 • Leech first use in commerce
- 08/30/1984 • Mantenna first use in commerce
- 08/30/1984 • Spikor first use in commerce
- 08/30/1984 • Spydor first use in commerce
- 08/30/1984 • Stinkor first use in commerce
- 08/30/1984 • Thunder Punch first use in commerce
- 08/30/1984 • Two Bad first use in commerce
- 09/10/1984 • Grizzlor trademarked
- 09/10/1984 • Hordak trademarked
- 09/10/1984 • The Evil Horde trademarked
- 09/10/1984 • Land Shark trademarked
- 09/10/1984 • Leech trademarked
- 09/10/1984 • Mantenna trademarked
- 09/10/1984 • Spikor trademarked
- 09/10/1984 • Spydor trademarked
- 09/10/1984 • Stinkor trademarked
- 09/10/1984 • Thunder Punch trademarked
- 09/10/1984 • Two Bad trademarked
- 09/24/1984 • Dragon Fly (Fright Fighter) concept, by Ed Watts
- 10/03/1984 • Firepower Man (Rio Blast) concept, by Ed Watts
- 11/08/1984 • Dragon Blaster Skeletor first use in commerce
- 11/08/1984 • Modulok first use in commerce
- 11/08/1984 • Battle Bones first use in commerce
- 11/08/1984 • Night Stalker first use in commerce
- 11/08/1984 • The Evil Horde first use in commerce
- 11/08/1984 • Bashasaurus first use in commerce
- 11/13/1984 • Land Shark patent filed
- 11/23/1984 • Bashasaurus trademarked
- 11/23/1984 • Night Stalker trademarked
- 11/23/1984 • The Evil Horde trademarked
- 11/29/1984 • Battle Armor Skeletor copyrighted
- 12/01/1984 • Engine Man (Dragstor) concept, by Ed Watts
- 12/07/1984 • Moss Man first use in commerce
- 12/14/1984 • Battle Bones patent filed
- 12/14/1984 • Sy-Klone patent filed
- 12/17/1984 • Mantenna patent filed
- 12/19/1984 • Dragon Blaster trademarked
- 12/19/1984 • Modulok trademarked
- 12/19/1984 • Moss Man trademarked

12/24/1984 • Two Bad patent filed

12/24/1984 • Jitsu copyrighted

12/24/1984 • Kobra Khan copyrighted

12/24/1984 • Clawful copyrighted

12/24/1984 • Webstor copyrighted

12/28/1984 • Battle Bones trademarked

1984 • Mantisaur concept variations for "New Ventures"

1984 • Battle Armor Skeletor & Panthor packaging sketch, by William George

1984 • Dragon Blaster Skeletor packaging sketch, by William George

1985

01/03/1985 • Roboto patent filed

01/03/1985 • Thunder Punch He-Man patent filed

01/04/1985 • Bashasaurus patent filed

01/31/1985 • Snake Mountain copyrighted

02/05/1985 • Wolf head Eternia concept, by Ted Mayer

02/25/1985 • Battle Bones copyrighted

02/26/1985 • Early Blast Attak concept, by Mark Jones

03/29/1985 • Seaman (Scubattack) concept, by Alan Tyler

04/05/1985 • Fright Zone puppet tooling method patent filed

04/18/1985 • Heroic Giant (Tytus) concept, by Alan Tyler

04/22/1985 • Fisto copyrighted

05/22/1985 • Land Shark copyrighted

05/22/1985 • Bashasaurus copyrighted

05/22/1985 • Roboto copyrighted

05/22/1985 • Two Bad copyrighted

05/30/1985 • Flying Fists He-Man first use in commerce

05/30/1985 • Laser Bolt first use in commerce

05/30/1985 • Rattlor first use in commerce

05/30/1985 • Rokkon first use in commerce

05/30/1985 • Stonedar first use in commerce

05/30/1985 • Sy-Klone first use in commerce

05/30/1985 • Terror Claws Skeletor first use in commerce

05/30/1985 • Tung Lashor first use in commerce

06/14/1985 • Laser Bolt trademarked

06/14/1985 • Terror Claws trademarked

06/15/1985 • Gyrattacker concept, by Ted Mayer

06/17/1985 • Flying Fists trademarked

06/17/1985 • Rattlor trademarked

06/17/1985 • Rokkon trademarked

06/17/1985 • Stonedar trademarked

06/17/1985 • Sy-Klone trademarked

06/17/1985 • Tung Lashor trademarked

06/17/1985 • Slime Pit trademarked

06/24/1985 • Slime Pit trademarked

07/08/1985 • Spydor patent filed

09/04/1985 • Triceratops (very early Bionatops) concept, by Mark Jones

09/04/1985 • Turbodactyl concept, by Mark Jones

09/13/1985 • Laser Bolt patent filed

09/16/1985 • Secrets of Grayskull "New Notes" document (Grayskull Tower, King Hiss, etc.)

09/22/1985 • Early Jet Sled concept, by Ted Mayer

09/25/1985 • Horde Trooper patent filed

09/27/1985 • King Hiss patent filed

09/27/1985 • Megalaser patent filed

10/04/1985 • Fright Zone patent filed

10/10/1985 • Grizzlor copyrighted

10/10/1985 • Mantenna copyrighted

10/10/1985 • Moss Man copyrighted

10/10/1985 • Spikor copyrighted

10/10/1985 • Spydor copyrighted

10/10/1985 • Sy-Klone copyrighted

10/10/1985 • Thunder Punch He-Man copyrighted

10/11/1985 • Hurricane Hordak patent filed

10/16/1985 • Modulok copyrighted

10/17/1985 • Secrets of Grayskull Preliminary Story Background (Eternia, King Hiss, etc.)

11/04/1985 • Medusa-Man (Snake Face) concept, by David Wolfram

11/06/1985 • Snake Men first use in commerce

11/06/1985 • Snout Spout first use in commerce

11/06/1985 • Multi-Bot first use in commerce

11/06/1985 • Horde Trooper first use in commerce

11/06/1985 • Mantisaur first use in commerce

11/12/1985 • Horde Trooper trademarked

11/12/1985 • Mantisaur trademarked

11/12/1985 • Multi-Bot trademarked

11/12/1985 • Snake Men trademarked

11/12/1985 • Snout Spout trademarked

11/12/1985 • Leech copyright registered

11/21/1985 • Tyrantisaurus concept, by David Wolfram

11/22/1985 • Blasterhawk first use in commerce

11/25/1985 • Laser Bolt copyrighted

11/25/1985 • Hordak copyrighted

11/25/1985 • Fright Zone copyrighted

11/26/1985 • Crack-Pot (Blast-Attak) concept, by Richard Lepik

12/09/1985 • Rio Blast first use in commerce

12/09/1985 • Extendar first use in commerce

12/12/1985 • Blasterhawk trademarked

12/16/1985 • Evil Giant (Megator) concept, by Alan Tyler

1985 • "The Slime Pit" finished painting, by William George

1985 • Hurricane Hordak pencils, by William George

1985 • Flying Fists He-Man pencils, by William George

1986

01/09/1986 • Extendar trademarked

01/09/1986 • Rio Blast trademarked

01/14/1986 • Rokkon/Stonedar patent filed

01/15/1986 • Triceratops (Bionatops) concept, by David Wolfram

02/11/1986 • Rokkon copyrighted

02/11/1986 • Stonedar copyrighted

03/07/1986 • Fright Fighter first use in commerce

03/07/1986 • Stilt Stalkers first use in commerce

03/15/1986 • Comet Warriors trademarked

03/21/1986 • Battle for Eternia (game) trademarked

03/21/1986 • Fright Fighter trademarked

03/24/1986 • Stilt Stalker trademarked

04/07/1986 • Eternia first use in commerce

04/07/1986 • Jet Sled first use in commerce

05/12/1986 • Flying Fists He-Man copyrighted

05/12/1986 • Rattlor copyrighted

05/12/1986 • Tung Lashor copyrighted

05/12/1986 • Mantisaur copyrighted

05/16/1986 • Monstroid first use in commerce

05/19/1986 • Terror Claws Skeletor copyrighted

05/28/1986 • Snout Spout copyrighted

05/28/1986 • Dragstor copyrighted

06/05/1986 • Sorceress first use in commerce

06/05/1986 • Mosquitor first use in commerce

06/05/1986 • Buzz-Saw Hordak first use in commerce

06/09/1986 • Tower Tools / Cliff Climber / Scubattack mechanism patent filed

06/20/1986 • Gwildor concept, by Alan Tyler (based on movie designs)

06/23/1986 • Rotar / Twistoid patent filed

06/23/1986 • Eternia trademarked

06/23/1986 • Grayskull (He-Ro early name) trademarked (canceled)

06/23/1986 • Jet Sled trademarked

06/23/1986 • Monstroid trademarked

06/23/1986 • Buzz-Saw trademarked

06/23/1986 • Mosquitor trademarked

06/23/1986 • Sorceress trademarked

06/23/1986 • Meteorbs trademarked

06/23/1986 • Cometroid trademarked

06/23/1986 • Ty-Grrr trademarked

Continued on next page . . .

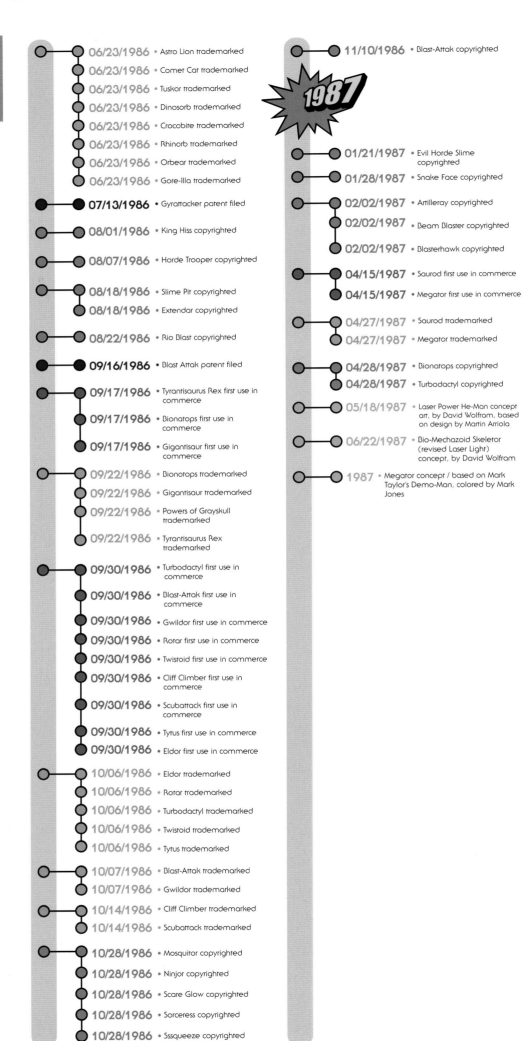

06/23/1986 • Astro Lion trademarked

06/23/1986 • Comet Cat trademarked

06/23/1986 • Tuskor trademarked

06/23/1986 • Dinosorb trademarked

06/23/1986 • Crocobite trademarked

06/23/1986 • Rhinorb trademarked

06/23/1986 • Orbear trademarked

06/23/1986 • Gore-Illa trademarked

07/13/1986 • Gyrattacker patent filed

08/01/1986 • King Hiss copyrighted

08/07/1986 • Horde Trooper copyrighted

08/18/1986 • Slime Pit copyrighted

08/18/1986 • Extendar copyrighted

08/22/1986 • Rio Blast copyrighted

09/16/1986 • Blast Attak patent filed

09/17/1986 • Tyrantisaurus Rex first use in commerce

09/17/1986 • Bionatops first use in commerce

09/17/1986 • Gigantisaur first use in commerce

09/22/1986 • Bionotops trademarked

09/22/1986 • Gigantisaur trademarked

09/22/1986 • Powers of Grayskull trademarked

09/22/1986 • Tyrantisaurus Rex trademarked

09/30/1986 • Turbodactyl first use in commerce

09/30/1986 • Blast-Attak first use in commerce

09/30/1986 • Gwildor first use in commerce

09/30/1986 • Rotar first use in commerce

09/30/1986 • Twistoid first use in commerce

09/30/1986 • Cliff Climber first use in commerce

09/30/1986 • Scubattack first use in commerce

09/30/1986 • Tytus first use in commerce

09/30/1986 • Eldor first use in commerce

10/06/1986 • Eldor trademarked

10/06/1986 • Rotar trademarked

10/06/1986 • Turbodactyl trademarked

10/06/1986 • Twistoid trademarked

10/06/1986 • Tytus trademarked

10/07/1986 • Blast-Attak trademarked

10/07/1986 • Gwildor trademarked

10/14/1986 • Cliff Climber trademarked

10/14/1986 • Scubattack trademarked

10/28/1986 • Mosquitor copyrighted

10/28/1986 • Ninjor copyrighted

10/28/1986 • Scare Glow copyrighted

10/28/1986 • Sorceress copyrighted

10/28/1986 • Sssqueeze copyrighted

11/10/1986 • Blast-Attak copyrighted

1987

01/21/1987 • Evil Horde Slime copyrighted

01/28/1987 • Snake Face copyrighted

02/02/1987 • Artilleray copyrighted

02/02/1987 • Beam Blaster copyrighted

02/02/1987 • Blasterhawk copyrighted

04/15/1987 • Saurod first use in commerce

04/15/1987 • Megator first use in commerce

04/27/1987 • Saurod trademarked

04/27/1987 • Megator trademarked

04/28/1987 • Bionatops copyrighted

04/28/1987 • Turbodactyl copyrighted

05/18/1987 • Laser Power He-Man concept art, by David Wolfram, based on design by Martin Arriola

06/22/1987 • Bio-Mechazoid Skeletor (revised Laser Light) concept, by David Wolfram

1987 • Megator concept / based on Mark Taylor's Demo-Man, colored by Mark Jones

CHAPTER 2

PRINCESS OF POWER (1985)

ANGELLA
ANGELIC WINGED GUIDE!

First released 1985 • Member of the Great Rebellion

Accessories:
- Wings
- Comb
- Pantaloons

Minicomic:
- *Journey to Mizar*

Angella features a lot of pink—more so than in the Filmation cartoon! She comes with hard plastic wings which "flap" as you press the halo-shaped lever. They fit into her back with two pegs and she is the first to feature the two-pronged backpack style. It was an exciting feature, since you could hold the doll by the winged backpack and really simulate her flying! Angella and Catra come with the same comic, which features both of them prominently.

Her pantaloons are unique in the Princess of Power toy line—no other figure wears removable pants. She features a clear embedded jewel in her bodice. Though she was a blond in the Filmation cartoon, she has lovely, rooted light brown hair, styled simply in a slightly-to-the-side ponytail to allow for her wings.

Notable variations: Angella can be found with a clear, a light blue, or a very dark blue jewel in her bodice, and also with blond or light-brown hair or a combination of both, depending on the country of origin. Her pantaloons vary quite a bit: the prism sticker can be a very dark pink or very light pink, the waistband is either an iridescent crystal fabric or silver, and the translucent pink fabric can be patterned, lightly or heavily pleated, or plain. Her wings are usually a very light pink plastic, but can also be found a bit darker as well. Her makeup and head shape also change depending on the country in which she was produced.

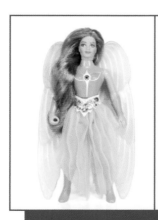

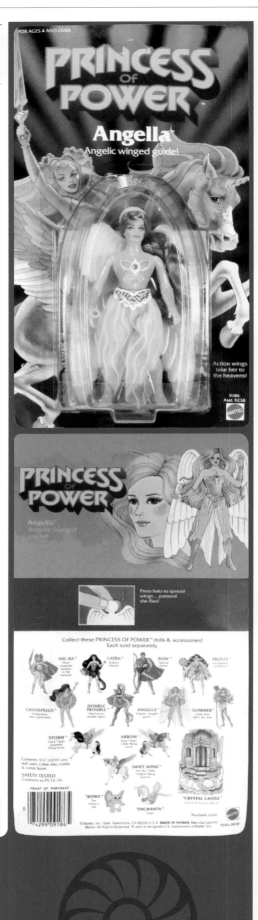

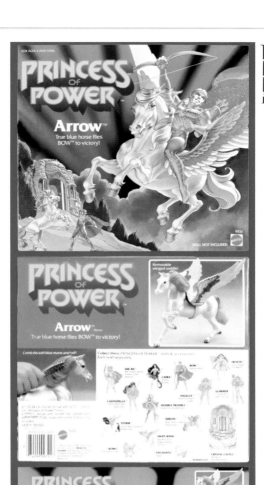

ARROW
TRUE BLUE HORSE FLIES BOW TO VICTORY!

First released 1985 • Steed of the Great Rebellion

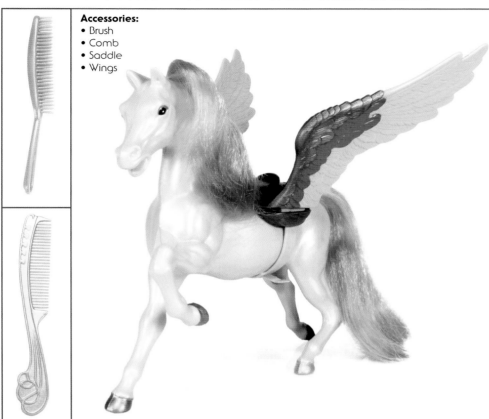

Accessories:
• Brush
• Comb
• Saddle
• Wings

Arrow makes an appearance in the Filmation cartoon, but you'd never recognize him! Though his gender is consistent, his coloring is not even close! Not only does the toy version of Arrow have wings, he is also a lovely shade of blue. He has rooted pale blue hair and the instructions detail ways to style his mane and tail.

His wings fit into notches in the saddle and fasten under the belly. This seems like a decent design, yet the wings have a tendency to slip during play. Arrow has black eyes and gold hooves, and his wings are embellished with gold and bright red paint.

Notable variations: Arrow's saddle can be found in either a bright gold or a dark greenish-gold plastic. The gold on his wings and hooves is sometimes those colors or even more brassy. Depending on the country of origin, Arrow's hair can be a more vivid blue.

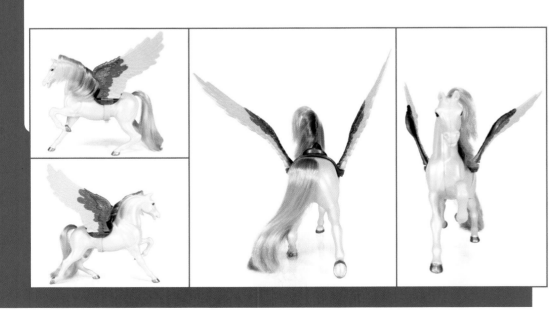

BLUE LIGHTNING
FANCY GOWN! SHIELD HIDES "LIGHTNING BOLT!"

First released 1987 • Accessory of the Great Rebellion

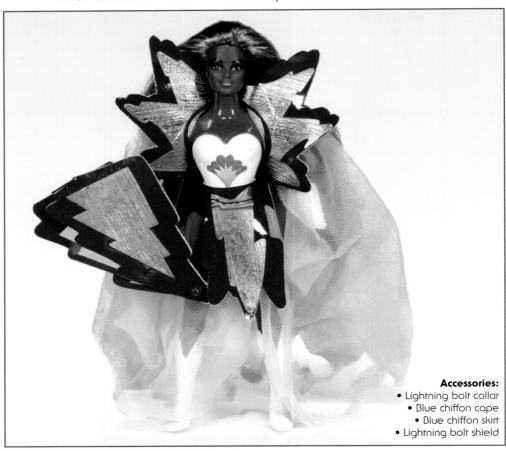

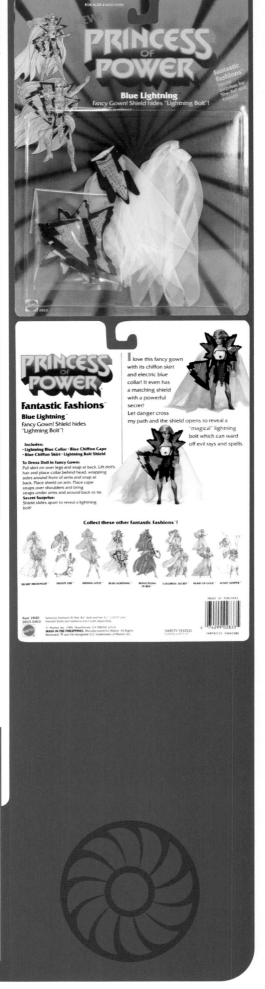

Accessories:
- Lightning bolt collar
- Blue chiffon cape
- Blue chiffon skirt
- Lightning bolt shield

Not surprisingly, Blue Lightning features a lot of blue! Gauzy, pale blue fabric makes up the cape and skirt and dark blue vinyl is used for the belt, collar, and shield. Large, blue prism stickers adorn the vinyl. The shield has a flap that slides out to show a bright yellow sticker in the shape of a lightning bolt.

The packaging gives instructions for dressing the figure, and states the Secret Surprise as: "Shield slides apart to reveal a lightning bolt!" It also says the "magical" lightning bolt can ward off evil rays and spells. Due to its color, this fashion displays nicely on She-Ra, Netossa, and Frosta.

This fashion was not widely produced before the Princess of Power toy line was canceled, making it quite rare to find either carded or loose. The only notable variation comes from the style of prism sticker: some have the standard geometric pattern, while others look more like brushed steel. None of the stickers are stitched in place, causing some shifting in placement to occur.

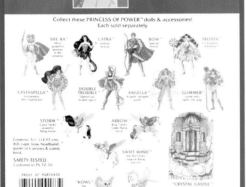

BOW
SPECIAL FRIEND WHO HELPS SHE-RA!
First released 1985 • Member of the Great Rebellion

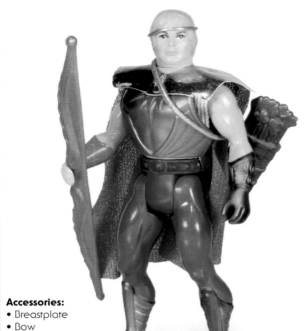

Accessories:
- Breastplate
- Bow
- Quiver of arrows
- Headband
- Cape

Minicomics:
- *The Hidden Symbols Mystery*
- *Journey to Mizar*

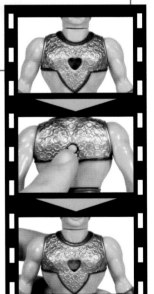

Bow has quite a few accessories for a first-wave figure. His weapons aren't functional, but they are decent representations. His special feature is that you can make his heart beat by pressing a button on his back. The heart is visible through a small, clear window on his chest. Bow is the only male figure produced and does not feature rooted hair or a jewel. Bow and Kowl come with the same comic, which features both of them prominently.

Being the only male figure means he has his own unique sculpt. Possibly Mattel was afraid too many male characters would not be popular with the majority of Princess of Power collectors, but as the one male in the line, Bow is made well. He stands out with his gold accent paint and sparkly red cape.

There are not very many variations for Bow, but his paint application can vary based on country of origin: sometimes his hair is brown and other times it appears to have more of a blond shade.

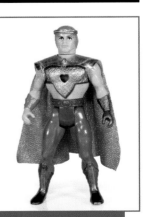

BUBBLE POWER SHE-RA
THE MOST POWERFUL WOMAN IN THE UNIVERSE!

First released 1987 • Member of the Great Rebellion

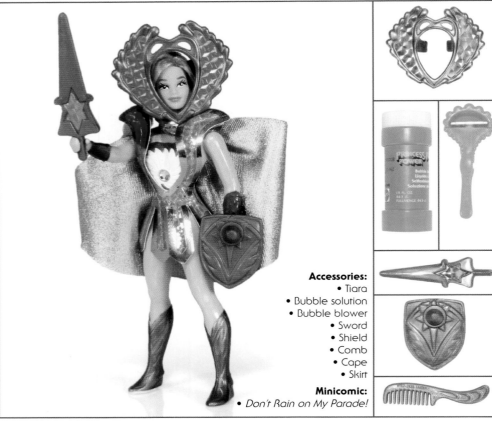

Accessories:
- Tiara
- Bubble solution
- Bubble blower
- Sword
- Shield
- Comb
- Cape
- Skirt

Minicomic:
- *Don't Rain on My Parade!*

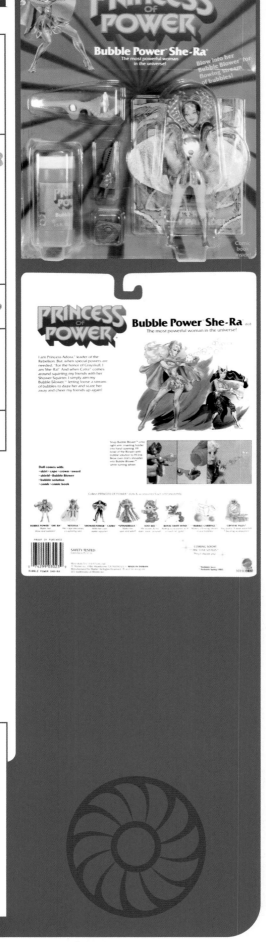

Bubble Power She-Ra is the third and final incarnation of the Most Powerful Woman in the Universe. She uses the same sculpt as Starburst She-Ra, with the exception of a notch in her shoulder where her bubble gun can rest. Her arms do not move together like Starburst She-Ra's, either, making her fairly easy to distinguish even without accessories. Her unique weapon is her bubble blower, which can be filled with bubble solution and blown into while spinning the white wheel. This "attack" is meant to daze and scare Catra away while cheering her friends up.

Her short cape is bright gold, adorned with a dark pink prism sticker on the collar. Bubble Power She-Ra does not have a gauzy white skirt like her other incarnations, wearing instead an armored skirt with two panels rising up on either side, and lots of dark pink prism stickers. Her mask and sword feature the same stickers and are made from a dark gold plastic. Her matching shield uses the same mold as her predecessors and her bodice features the same clear jewel. She has rooted blond hair styled in the same way as Starburst She-Ra: two twisted ponytails with a single small ponytail over them.

Because the Princess of Power toy line was canceled halfway through the release of the third series, there were not many Bubble Power She-Ra figures produced, making them quite rare to find today.

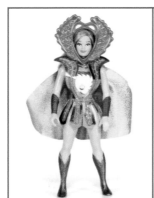 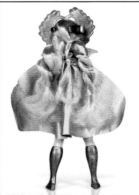 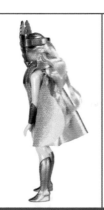

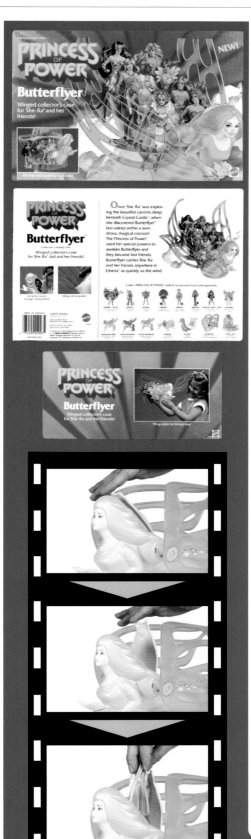

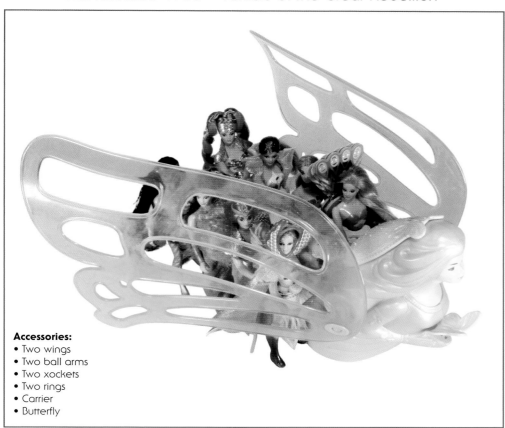

BUTTERFLYER
WINGED COLLECTOR'S CASE FOR SHE-RA AND HER FRIENDS!

First released 1986 • Vehicle of the Great Rebellion

Accessories:
- Two wings
- Two ball arms
- Two xockets
- Two rings
- Carrier
- Butterfly

Butterflyer is the only toy produced in the Princess of Power series that is meant to be used as a carrying case for the figures. Like Battle Bones in the MOTU line, it functions as both a collector case and a vehicle. Butterflyer has a compartment to store accessories and the figures can be clipped into the carrier. She can hold eight figures this way, and her wings pivot to latch around two pegs extending out from the carrier piece. The top of the wings can be used as a handle for easy transport.

The instructions detail how to put this unusual character together. The story on the back of the box for Butterflyer explains that she is not just a vehicle, but also a living being who had been in a magical cocoon until She-Ra found her and used her special powers to awaken her. When fully assembled, Butterflyer holds a small butterfly between her hands.

Her wings can be a bit delicate, making this character a little difficult to incorporate into play, but it is an effective way to keep figures together and keep track of their many accessories!

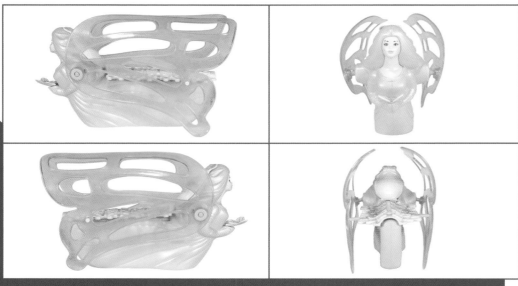

CASTASPELLA
ENCHANTRESS WHO HYPNOTIZES!

First released 1985 • Member of the Great Rebellion

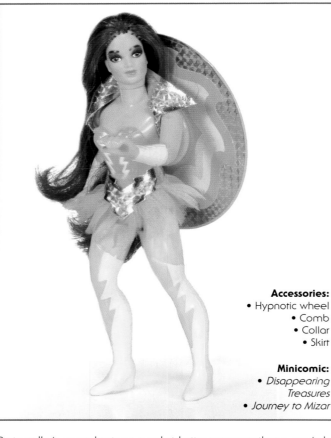

Accessories:
- Hypnotic wheel
- Comb
- Collar
- Skirt

Minicomic:
- *Disappearing Treasures*
- *Journey to Mizar*

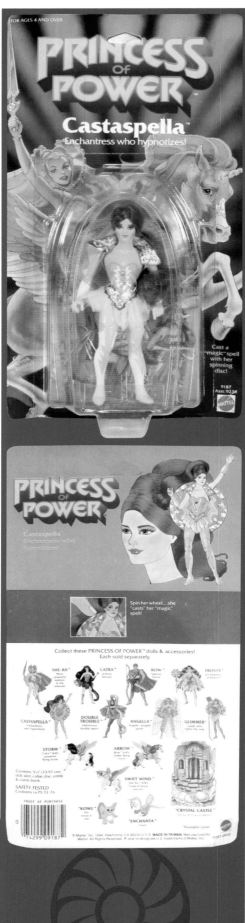

Castaspella is an enchantress, so what better accessory than a magic hypnotic wheel? This wheel fits into her back using a single peg and you can spin the disk to "enchant" her enemies. The sticker on her wheel is a yellow prism with orange and yellow spirals. She is the first figure to have her right hand not fully closed. (This is an improvement over the completely closed hand, since some of the figures' weapons were difficult to thread through.) Her other hand also held a new pose: one finger extended with the others curled inward. Castaspella and Glimmer come with the same comic, which features both of them prominently.

Her skirt is made from translucent yellow fabric made to look like tiny strips or petals. Her collar uses a prism sticker over the shiny gold fabric. Her embedded bodice jewel is orange. She has dark, reddish-brown rooted hair styled in a simple, slightly-to-the-side ponytail. Unlike most other figures, she was sculpted to wear boots well above the knee. Only a couple of other figures share this feature: Frosta and Entrapta. In fact, Entrapta is based entirely on Castaspella's mold!

Castaspella's boots are the most unusual of all the variations in the Princess of Power line. They are sculpted to show a lightning bolt down the front, but it seems as though the designers were unsure of the best way to use this design. On some versions, the bolt is painted solid to blend into the boot, others have her legs appearing to be wearing tights and the bolts are tights-colored, and others have her legs appearing not to be wearing tights and the bolts are skin-colored. Hilariously, you can sometimes find a mixture of these different bolt and color designs on the same figure! Castaspella's makeup, head shape, and prism stickers all vary from country to country. She also came with an orange, yellow, or white jewel in her bodice.

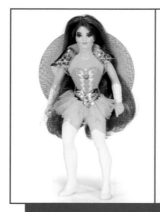

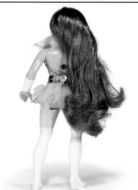

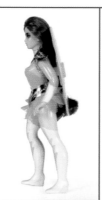

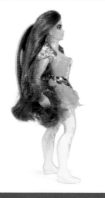

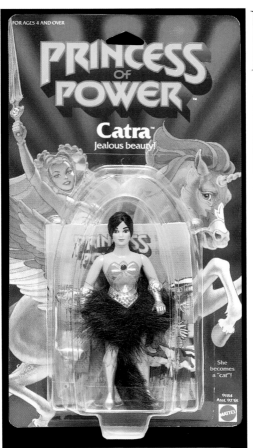

CATRA
JEALOUS BEAUTY!

First released 1985 • Member of the Evil Horde

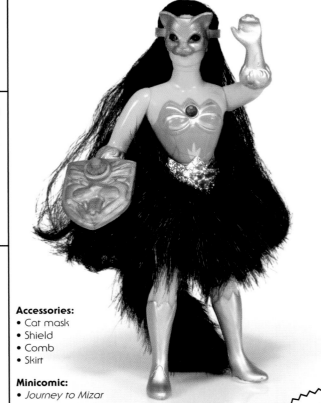

Accessories:
- Cat mask
- Shield
- Comb
- Skirt

Minicomic:
- *Journey to Mizar*

Catra was made to be the primary villain in the toy line. In fact, in the first wave of characters, she's the *only* villain! The Filmation cartoon reveals Catra's ability to transform into a cat. The transformation in the toy form occurs as follows: "Put on mask . . . she's a cat! Scratching action waist!" As described, Catra's figure features an "action waist." The action waist was a simple idea: twisting her torso and letting go would result in her springing back to "scratch" her foes. The 'action waist' is featured in many of the first-wave figures. Catra and Angella come with the same comic, which features both of them prominently.

Catra's skirt is made of black fur and includes a tail. Instead of gauntlets, she was sculpted to include gloves with cuffs intended to look as though they are made of fur. She is accented with silver paint for her gloves and boots and has an embedded red jewel in her bodice. She has black, rooted hair styled in a simple ponytail.

Catra is a beautiful villain, displaying one of the more beautiful faces in the toy line due to the detail of her makeup, and no one else sports that lovely shade of green eye shadow!

Catra can be found with either a red or dark pink jewel in her bodice. In some countries, she was given a silver sword which used the same mold as She-Ra's but did not have a jewel. Her skirt's prism sticker varies a lot as well: they can be dark or light pink, some are sewn on, and some are just stickers. The skirt material's texture varies as well: some of them are quite coarse and a bit shaggy, others are sleek and soft. Catra's head shape varies from country to country, as does her makeup, but all of them have that vibrant green eye shadow!

CLAWDEEN
GLAMOROUS CAT CARRIES CATRA TO ADVENTURE!
First released 1986 • Steed of the Evil Horde

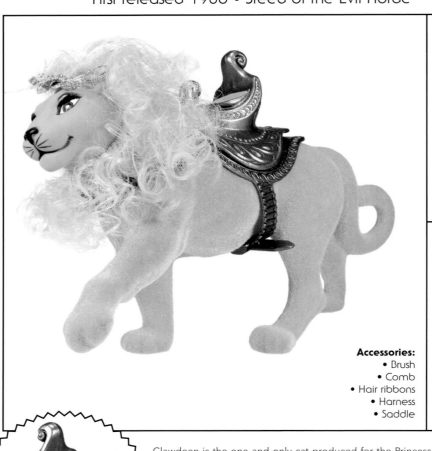

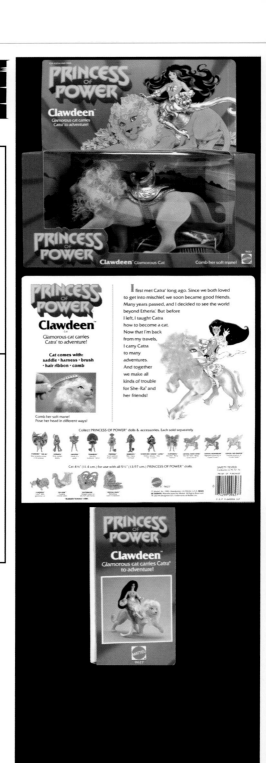

Accessories:
- Brush
- Comb
- Hair ribbons
- Harness
- Saddle

Clawdeen is the one and only cat produced for the Princess of Power toy line. She is flocked with pink and has curly pink rooted hair. Using a different mold from the He-Man cats, she has a closed mouth and a more slender frame. The box for Clawdeen lets us know that at least in Mattel's version of the story, she is responsible for teaching Catra how to transform into a cat. Her most notable feature is her eyes: they are clear jewels!

Clawdeen's harness and saddle are two pieces that fit together to make up her complete gear. It attaches securely under her belly and around her neck. The saddle part fits a figure securely as well, much more so than the other steeds. The figure kind of "snaps" into place. Clawdeen's features are accented with green eye shadow and black nose, mouth, and whiskers.

Clawdeen is pretty uniform in production, but some countries give her a much brighter green paint around her eyes and a slightly darker pink flocking.

COLORFUL SECRET
RAINBOW DRESS! HIDDEN SECRET SWORD!

First released 1987 • Accessory of the Great Rebellion

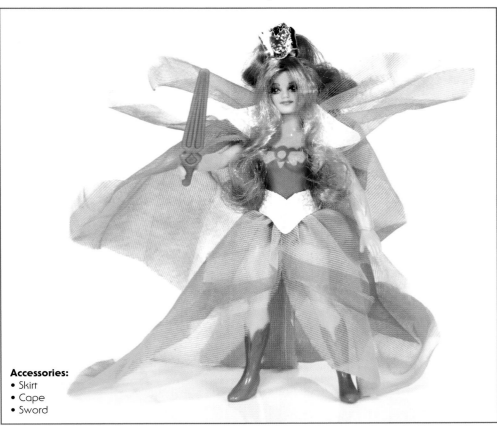

Accessories:
- Skirt
- Cape
- Sword

Colorful Secret is another gown-style fashion. This one comes with a sparkling collar (on the cape) and belt (on the skirt). There are no prism stickers on this fashion, putting it in the minority. The sword is a light golden brown color and there is no jewel.

The packaging reveals the Secret Surprise: a sword can be hidden behind the figure's back, to be pulled out on a moment's notice. She-Ra is always ready to stand up to Catra, even in a fancy dress. Due to its variety of color, this fashion displays nicely on nearly all of the figures.

This fashion was not widely produced before the Princess of Power toy line was canceled, making it quite rare to find either carded or loose. The only notable variation comes from the texture and color of the fabric; some are quite soft with pale colors and others have a rougher feel with much brighter colors.

CRYSTAL CASTLE
SHIMMERING CASTLE OF FANTASY AND FUN FOR SHE-RA AND HER FRIENDS!

First released 1985 • Fortress of the Great Rebellion

Accessories:
- Plush rug
- Castle flag
- "Mirrored" vanity
- Clothes stand
- Canopy bed
- Pillow
- Bedspread
- Fireplace
- Treasure chest of "jewels"
- Table with map of Etheria
- Two chairs

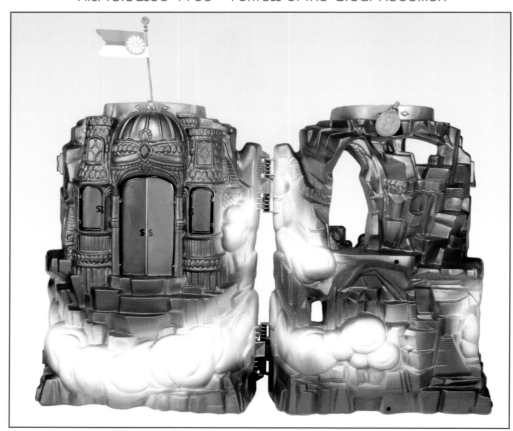

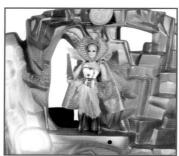

The first play set in this toy line, the Crystal Castle is the ultimate lair. Though it looks nothing like the Filmation cartoon's version, this pale pink paradise is perfect for She-Ra and her friends. The furniture is mostly a pastel sea green but there are a few pieces in translucent dark blue. Embellished with a decorative sticker, the throne has a place to fit She-Ra's shield and works like an elevator, using a string and a "key," so She-Ra can access the top, middle, and bottom. The castle comes equipped with a table with a map sticker and chairs; a canopy bed with a sponge mattress covered in purple silky fabric, curtains with butterfly clips, and a pillow; a hearth with a fire screen, fire sticker, and a furry purple rug; a dresser with a mirror sticker; a treasure chest with a false bottom which has room to hold accessories; a clothes tree (or armor stand) which can hold a sword and shield; a chandelier; and lastly, a flag that can clip to the castle in multiple places. The Crystal Castle features two floors, balconies, doors, windows, and a 'secret' entrance, which is just a hole in the side large enough for a figure to fit through, keeping consistent with She-Ra's need to keep her identity a mystery.

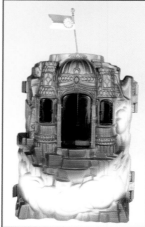
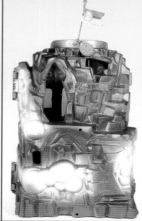

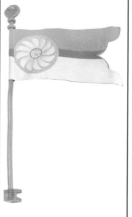

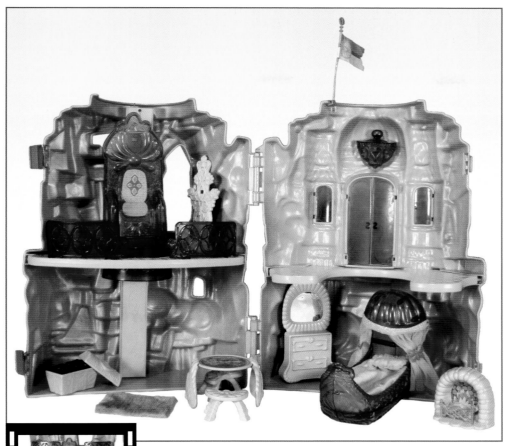

This castle can be closed and latched, keeping everything together, though there is no handle and enough large holes that it is not designed to be transported easily. The castle is painted pink with white clouds at the base, keeping in line with the Filmation story, in which her castle is located above the clouds. Accented with a healthy amount of gold paint, the Crystal Castle has quite an impressive appearance. The dark, translucent blue of the windows and doors also adds a nice touch.

There are a few variations in this play set. Sometimes the top of the curtains will be a plain pink border, as opposed to the more common iridescent version. Some of the map stickers are missing the black ink layer and are therefore missing the labeling that identifies the areas on the map. Depending on the country of origin, the curtains could be white with a gold top border and the rug and mattress cover could be pink. The pillow could also come with a larger white lace edging instead of the more common small translucent pink ruffles.

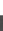

CRYSTAL FALLS
REFRESHING WATER WONDERLAND FOR SHE-RA AND HER FRIENDS!

First released 1986 • Location of the Great Rebellion

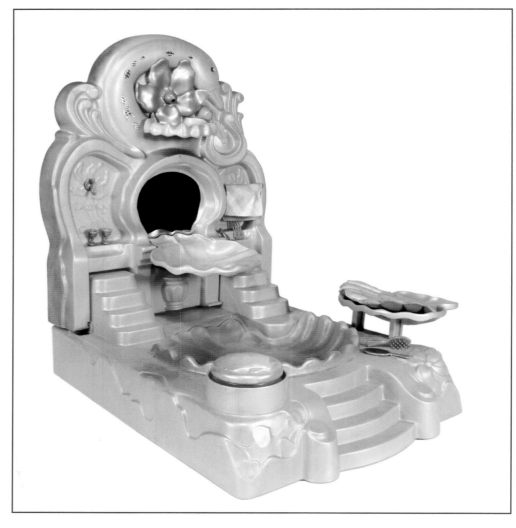

Accessories:

- Two water goblets
- Shell cushion
- Towel
- Hairbrush
- Hand mirror
- Hair comb
- Perfume bottle

The second and final play set, the Crystal Falls is a relaxing retreat for She-Ra and her friends. Dusted with a golden paint for accent, the play set can also be adorned with a few small prism stickers to look like jewels along the swan's head at the top. The towel and cushion are a matching set with their striped, colorful fabric. When assembled properly, the Crystal Falls will pump water out of the top orchid when the pump is pressed, spilling water over the small shell, to the larger shell, to the largest shell at the bottom, which drains back into the system to be pumped through all over again. There are three levels for the figures to occupy and many can fit on this play set at once. This set comes with several small pieces all made from the same golden plastic. The box indicates that the waters of the Crystal Falls are magical, but doesn't tell us all this water can do, other than to refresh visitors, leaving the creative play up to the child.

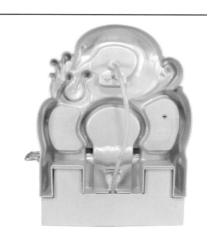

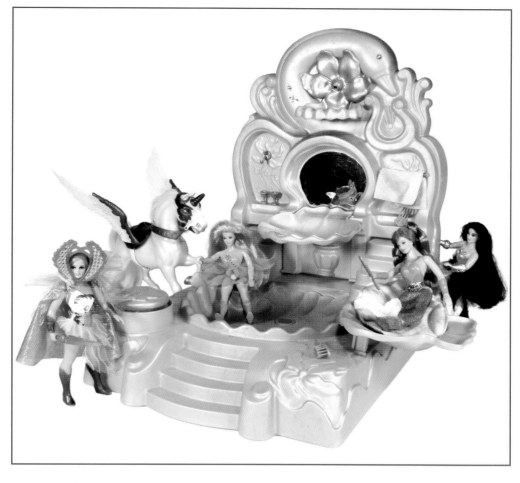

Because all of the accessories for this play set fit in the bottom shell, this play set can be folded up for easy transport and storage. Everything on this play set was made specifically for it—there are no reused pieces from any other toy in the Princess of Power toy line. The purple of the orchid, aqua of the shells, and pink of the play set itself are all brought together by the pattern of the fabrics, giving this set a striking appearance.

The one drawback from this lovely set has to do with the accessories; they are quite small and plentiful! They can be very difficult to keep track of, making this play set unusual to find complete once it's been opened.

CRYSTAL MOONBEAM
WINGED STALLION PROTECTS CRYSTAL CASTLE AT NIGHT!

First released 1986 • Steed of the Great Rebellion

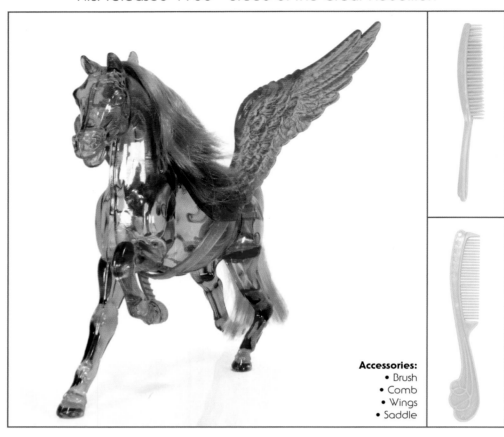

Accessories:
- Brush
- Comb
- Wings
- Saddle

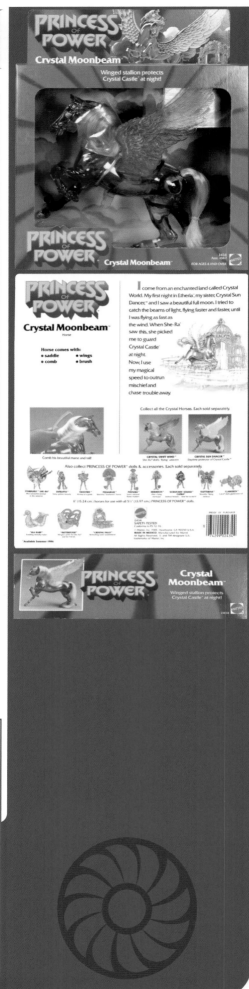

Crystal Moonbeam makes only a brief appearance in the Filmation cartoon, but his box tells us he is the brother of Crystal Sun Dancer and the protector of the Crystal Castle at night. He also has a special skill of magical speed! His body is a lovely translucent purple which shows off his interior structure. He has rooted blue hair and translucent blue wings and saddle. Due to his coloration, he is a perfect match for Peekablue and they were sometimes packaged together as a gift set.

His wings fit into notches in the saddle and fasten under the belly. This design is very similar to the first series of horses, but the straps on the wings have been adjusted to a new angle to help keep them in place. Unfortunately, the material the wings and saddle are made from has a tendency to break down somewhat over time, making them slightly sticky to the touch. Crystal Moonbeam has bright pink eyes, but his hooves and wings are not embellished with any paint.

Though you can find Crystal Moonbeam with a greenish tint to his wings and saddle, these are likely just discolorations that have happened over time and are not true variants. His body can also appear as a pinkish gray due to the original purple fading over time.

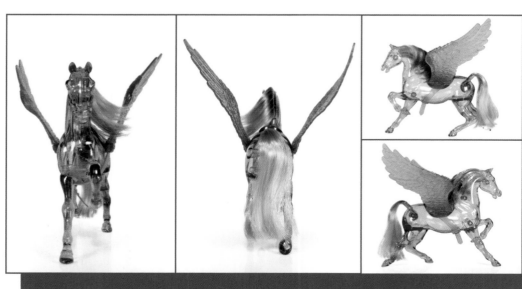

PRINCESS OF POWER

CRYSTAL SUN DANCER
LOVELY WINGED PROTECTOR OF CRYSTAL CASTLE BY DAY!

First released 1986 • Steed of the Great Rebellion

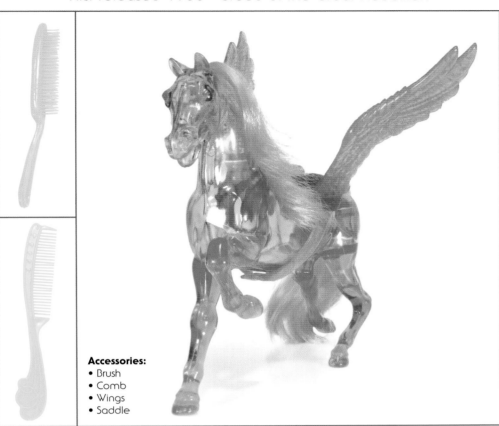

Accessories:
- Brush
- Comb
- Wings
- Saddle

Crystal Sun Dancer makes only a brief appearance in the Filmation cartoon, but her box tells us she is the sister of Crystal Moonbeam and the protector of the Crystal Castle by day. She also has a special skill of jumping! Her body is a lovely translucent coral which shows off her interior structure. She has rooted yellow hair and translucent yellow wings and saddle. Due to her coloration, she is a perfect match for SweetBee and they were sometimes packaged together as a gift set.

Her wings fit into notches in the saddle and fasten under the belly. This design is very similar to the first series of horses, but the straps on the wings have been adjusted to a new angle to help keep them in place. Unfortunately, the material the wings and saddle are made from has a tendency to break down somewhat over time, making them slightly sticky to the touch. Crystal Sun Dancer has bright pink eyes, but her hooves and wings are not embellished with any paint.

Though you can find Crystal Sun Dancer with very pale wings and saddle, these are likely just discolorations that have happened over time and are not true variants. Her body can also appear as a pastel orange due to the original bright coral color fading over time.

CRYSTAL SWIFT WIND
MAGNIFICENT CRYSTAL UNICORN "FLIES" SHE-RA TO ADVENTURE!

First released 1986 • Steed of the Great Rebellion

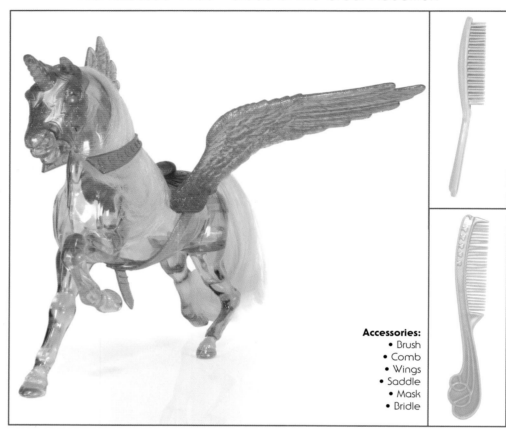

Accessories:
- Brush
- Comb
- Wings
- Saddle
- Mask
- Bridle

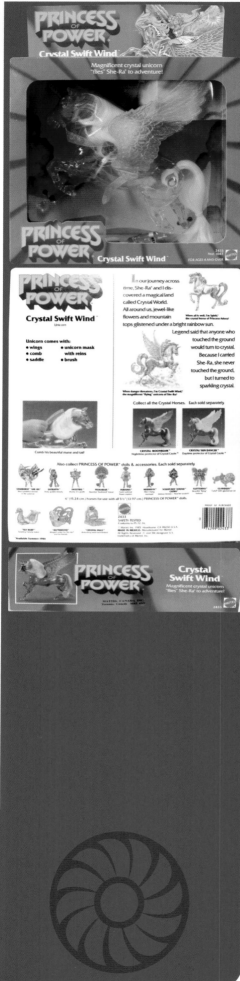

Crystal Swift Wind is meant to be two horses in one: Spirit for Adora and Crystal Swift Wind for Starburst She-Ra. His transformation is a simple one: just add the wings and mask to make him Crystal Swift Wind. You read that correctly: Crystal Swift Wind is male, as opposed to Swift Wind, who was marketed as female. The instructions detail ways to style his mane and tail. The comb and brush set that comes with all of the horses can also be found packaged with Barbie.

Crystal Swift Wind's origin story is given in the minicomic that comes with Starburst She-Ra, entitled *Across the Crystal Light Barrier*. He and She-Ra traveled to a magical world named Crystal World. Anything that touched the ground turned to crystal; he was transformed when he landed and She-Ra remained on his back.

His wings fit into notches in the saddle and fasten under the belly. This design is very similar to the first series of horses, but the straps on the wings have been adjusted to a new angle to help keep them in place. Unfortunately, the material the wings, saddle, mask, and reins are made from has a tendency to break down and become sticky. Though you can find Crystal Swift Wind with an almost colorless body, this is likely just discoloration due to fading over time and is not a true variant.

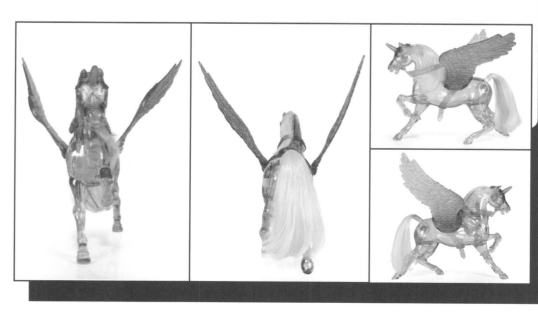

DEEP BLUE SECRET
OCEAN BLUE OUTFIT WITH A SECRET MAP OF THE SEA!

First released 1986 • Accessory of the Great Rebellion

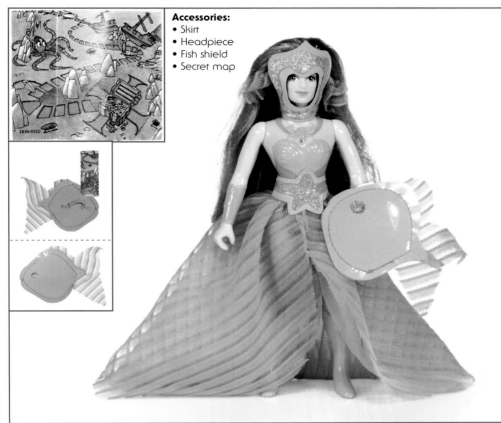

Accessories:
- Skirt
- Headpiece
- Fish shield
- Secret map

Guess what! I have a secret map. A map of the world below the sea that leads to buried treasure! And if you promise not to tell a soul, I'll show you where the map is hidden. See, right here behind the blue fish shield that matches my beautiful blue gown! Now come with me in search of the secrets of the sea!

Deep Blue Secret is quite dressy. It features glittery, yellow prism stickers and a long sash coming from the headpiece which wraps around the face to snap closed in the back. The skirt is long, flowing all the way to the ground. Shaped to look like a round, flat fish, the shield is made from an aqua blue vinyl and holds the secret!

The packaging gives instructions for dressing the figure, and states the Secret Surprise as: "Remove map from the fish shield pocket and discover the deep blue secrets of the sea!" Since we are not told what those secrets are, the child is encouraged to use imagination during play. The map that is included in this fashion is the same one that comes with Secret Messenger. Due to its color, this fashion displays nicely on She-Ra, Mermista, and Peekablue.

Being among the first series of fashions makes this one easier to find, though the map can be difficult to locate if the set is found loose.

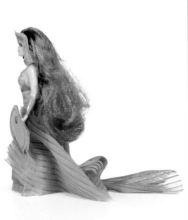
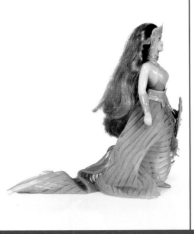

DOUBLE TROUBLE
GLAMOROUS DOUBLE AGENT!

First released 1985 • Member of the Great Rebellion

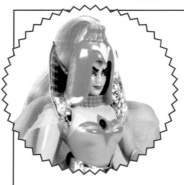

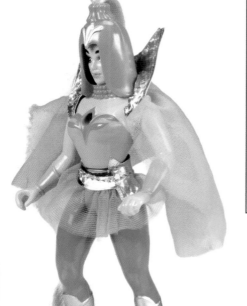

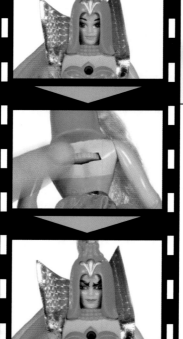

Accessories:
- Comb
- Cape
- Skirt

Minicomics:
- *Adventure of the Blue Diamond*
- *Journey to Mizar*

Double Trouble is uniquely designed for the Princess of Power toys, featuring a face that can switch from friend to foe using a dial on her back. Due to this design, her hair is restricted to a thin ponytail coming from the top of her helmet, but it makes up in length what it lacks in quantity! Only one other figure had hair that long: Entrapta.

Her clothing is made from a sheer green fabric with gold details, which is interesting since her paint embellishments use silver. She features an emerald green jewel in her bodice and an open right hand. Her boot design we'll see again on SweetBee.

Depending on the country of origin, Double Trouble can appear to be wearing a yellowish shirt under her painted green bodice; however, this is just poorly matched skin-tone paint. There are a few variations with her prism stickers, as some are sewn in place and others are just a sticker, depending on where she was produced.

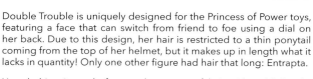

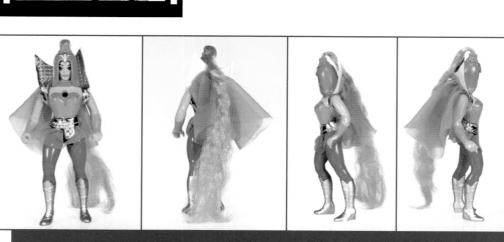

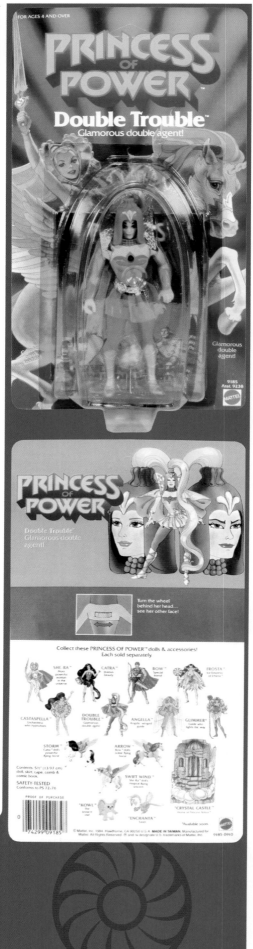

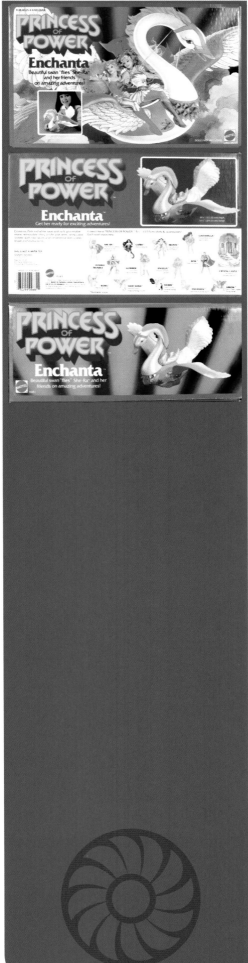

ENCHANTA
BEAUTIFUL SWAN "FLIES" SHE-RA AND HER FRIENDS ON AMAZING ADVENTURES!

First released 1985 • Steed of the Great Rebellion

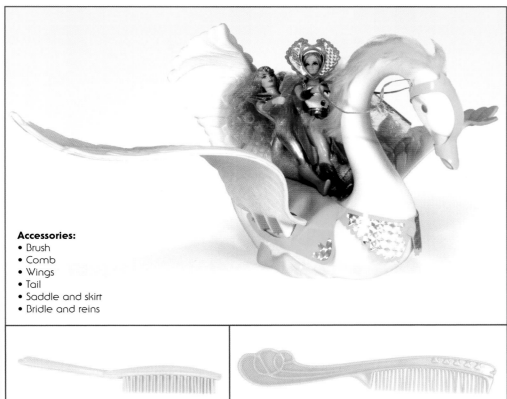

Accessories:
- Brush
- Comb
- Wings
- Tail
- Saddle and skirt
- Bridle and reins

Enchanta is the first toy intended to carry more than one figure. Her pink mane is fluffy and marketed as "groomable." The comb and brush set she comes with can also be found packaged with Barbie. The instructions show details on how to fasten her harness and saddle, which is helpful, since the front closure is a little unusual.

Her wings and tail fit securely into notches in her body. The saddle skirt fits around her wings and is accented with prism stickers. When fully assembled, Enchanta is quite a large steed due to her impressive wingspan. Her body is a light, pearly white with lavender paint and her wings are white accented with a painted pink gradient.

Depending on the country of production, Enchanta's saddle may be pink instead of her standard silver, while her wings will sometimes be painted a darker pink gradation, and the directions sometimes indicate a different closure for the front of the skirt.

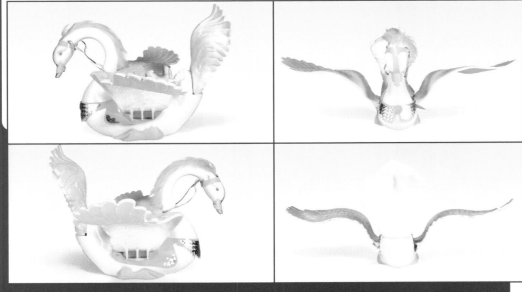

ENTRAPTA
TRICKY GOLDEN BEAUTY!

First released 1986 • Member of the Evil Horde

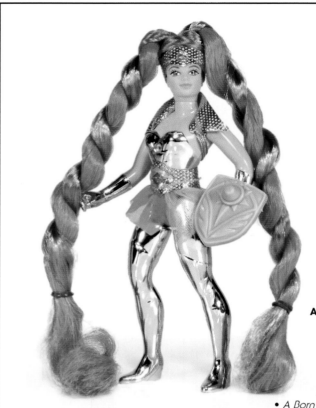

Accessories:
- Comb
- Shield
- Crown
- Collar
- Skirt

Minicomic:
- *A Born Champion*

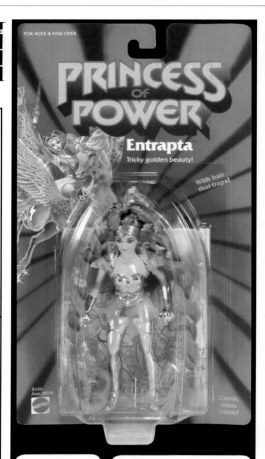

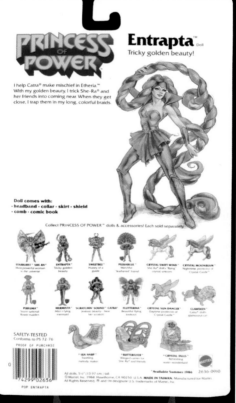

Entrapta is one of only two figures in the second series which reuses a sculpt from the first series. In this case, she is a complete replica of Castaspella, though she is made from a very different material. It is inflexible and metallic in color, with her skin being the part that is painted on. Her incredibly long and dual-colored hair is twisted into two long "ropes," giving her the ability to use it as a way to entangle her enemies. She is the only figure to have rooted hair this length, since Double Trouble's tiny ponytail wasn't a full-rooted scalp. Entrapta is the only villain other than the three Catra figures in the entire Princess of Power line. Entrapta and SweetBee come with the same comic, which features both of them prominently. Entrapta's hair is a fun variation from the rest of the figures. Because of its length, it can be styled more elaborately during play.

Entrapta's body is completely rigid and metallic, which really makes this figure stand out in a tactile way as well as visually. She comes with a purple comb and shield, which use the same mold as She-Ra's, even though she is a villain. Entrapta's crown can be found with a very pale purple dot, sometimes so pale that it almost looks silver, instead of the standard dark pink one. Her metallic color will sometimes appear more silvery than gold, though this could be due to fading and not a true variation.

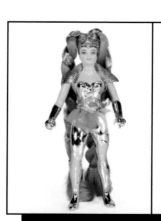
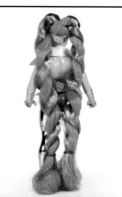
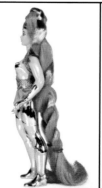
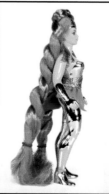

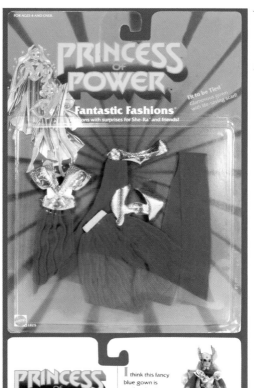

FIT TO BE TIED
GLAMOROUS GOWN WITH LIFE-SAVING SCARF!
First released 1986 • Accessory of the Great Rebellion

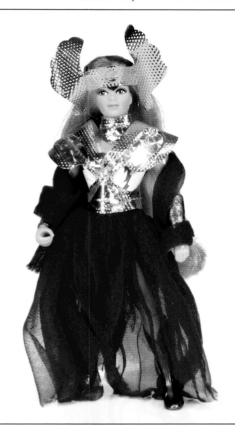

Accessories:
- Skirt
- Headpiece
- Sparkly vest
- Choker with chiffon train
- Scarf

Fit to be Tied is a gown-style fashion meant for special occasions. The golden vest is adorned with a large pink prism sticker and has special flaps to hold the scarf in place. The headdress and choker also have a small pink prism sticker and are made from a dark blue chiffon fabric.

The packaging gives instructions for dressing the figure and states the Secret Surprise as: "Gently pull scarf from vest and use to make rescues!" It also indicates that She-Ra is willing to use her life-saving rope scarf for whomever is in trouble, even Catra! With the headdress resembling She-Ra's original headpiece so closely, it is difficult to imagine the other figures wearing this, unless they were in disguise as She-Ra. Due to its color, this fashion displays nicely on She-Ra, Frosta, Peekablue, and Netossa.

Being among the first series of fashions makes this one easier to find. The headdress is a bit fragile and can be difficult to find in good condition if it is found loose.

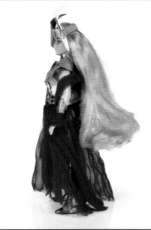
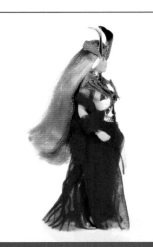

PRINCESS OF POWER

FLIGHT OF FANCY
PRETTY PANTALOONS PLUS MAGICAL SWORD AND WINGED SHIELD!

First released 1986 • Accessory of the Great Rebellion

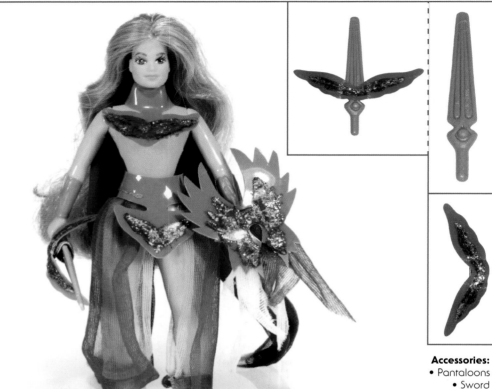

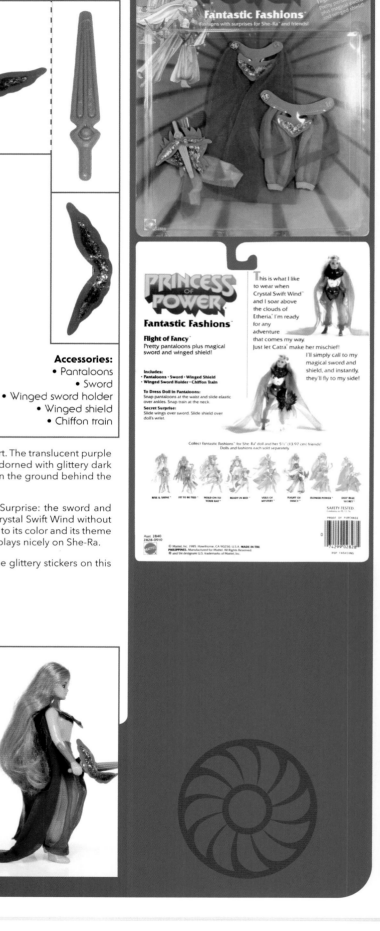

Accessories:
- Pantaloons
- Sword
- Winged sword holder
- Winged shield
- Chiffon train

Flight of Fancy is one of only two fashions to use a pantaloon design rather than a skirt. The translucent purple fabric uses a shiny purple vinyl material for the shield, collar, and waistband and is adorned with glittery dark orange stickers. The collar has a double train of chiffon fabric long enough to trail on the ground behind the figure wearing it.

The packaging gives instructions for dressing the figure, and indicates the Secret Surprise: the sword and shield are winged and can fly! While She-Ra is wearing this fashion, she can fly on Crystal Swift Wind without worry, because if Catra shows up, her magical sword and shield will fly to her aid. Due to its color and its theme of flying, this fashion seems like it was actually designed for Flutterina, but it also displays nicely on She-Ra.

Being among the first series of fashions makes this one easier to find. Sometimes the glittery stickers on this fashion can fade and/or bleed into the purple vinyl over time.

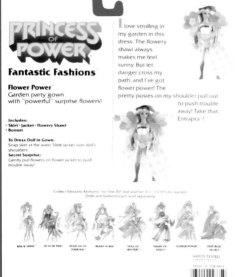

FLOWER POWER
GARDEN PARTY GOWN WITH "POWERFUL" SURPRISE FLOWERS!

First released 1986 • Accessory of the Great Rebellion

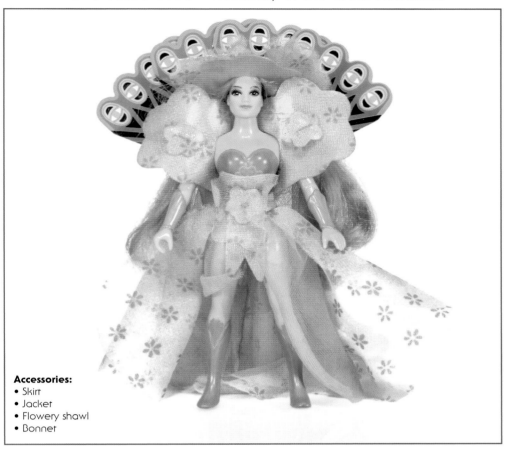

Accessories:
- Skirt
- Jacket
- Flowery shawl
- Bonnet

Flower Power's theme is quite evident: the bonnet, jacket, and skirt all have the same large flower shapes, and the skirt has a small green flower pattern. The stiff parts of this outfit have an iridescent sheen to them.

The packaging gives instructions for dressing the figure, and reveals the Secret Surprise: the two flowers on her jacket can be pulled outward to push trouble away! Though dressing up in this gown might seem to leave She-Ra defenseless, her flower jacket provides a defensive response to an attack by any troublemakers. Due to its color and its theme of flowers, this fashion seems like it was actually designed for Perfuma, but it also displays nicely on She-Ra, Double Trouble, and Peekablue.

Being among the first series of fashions makes this one easier to find. The hat can be more troublesome to find with this fashion out of the packaging, since it does not fasten to the figure in any way but merely rests on the figure's head.

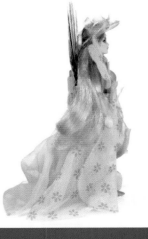

FLUTTERINA
BEAUTIFUL LOOKOUT "FLIES" WITH FLUTTERING WINGS!

First released 1986 • Member of the Great Rebellion

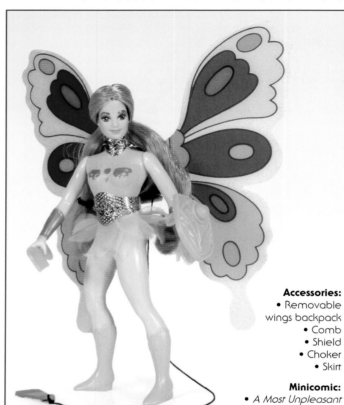

Accessories:
- Removable wings backpack
- Comb
- Shield
- Choker
- Skirt

Minicomic:
- *A Most Unpleasant Present*

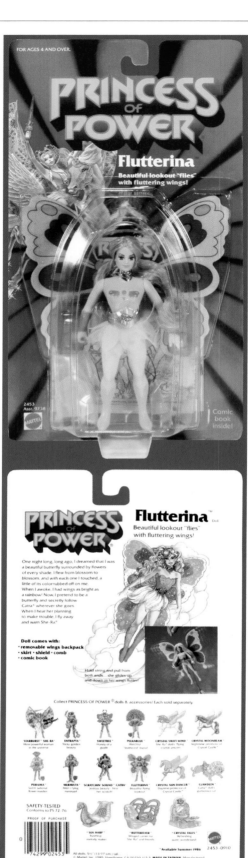

FOR AGES 4 AND OVER.

PRINCESS OF POWER

Flutterina

Beautiful lookout "flies" with fluttering wings!

2453
Asst. 9738

Comic book inside!

Flutterina uses a new sculpt that includes swivel-head articulation. This mold will be completely reused in the third series for Spinnerella. Flutterina's gimmick is her ability to "fly" with her winged backpack, which used two pegs to fit into her back. When the string is pulled (in either direction) it causes her wings to flutter. Flutterina and Perfuma come with the same comic, which features both of them prominently.

Flutterina's skirt is made from a purple chiffon fabric with a gold belt and glittery purple sticker. Her collar uses the same gold and purple components. She comes with an orange comb and shield, which use the same mold as She-Ra's. Her rooted purple hair comes styled in a split ponytail, clearing the way to attach her backpack for use during play.

The only notable variation for Flutterina is the gold material used on her skirt and choker. Some figures come with the gold as a smooth fabric and others come with dimpled fabric.

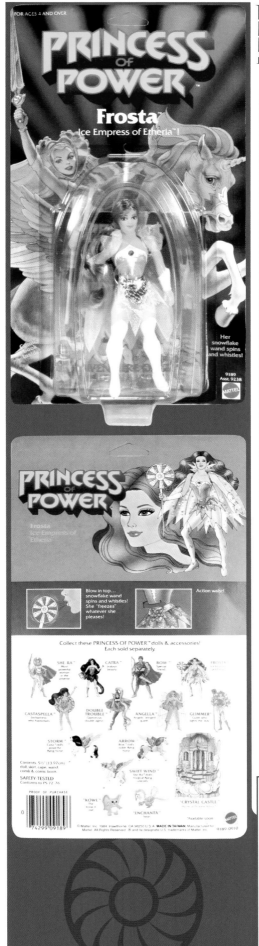

FROSTA
ICE EMPRESS OF ETHERIA!

First released 1985 • Member of the Great Rebellion

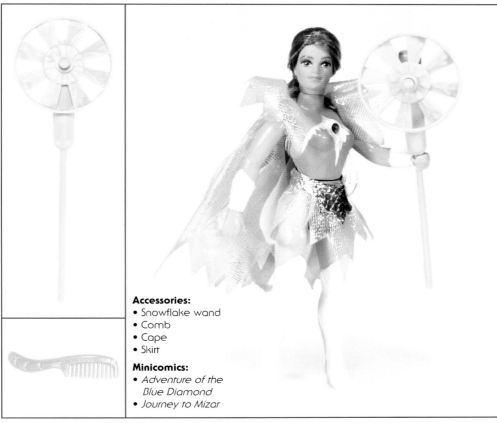

Accessories:
• Snowflake wand
• Comb
• Cape
• Skirt

Minicomics:
• *Adventure of the Blue Diamond*
• *Journey to Mizar*

When you blow into Frosta's wand, it makes a whistling sound and the snowflake spins. This did not work very well in practice but was an interesting feature to work into the character, since the Filmation cartoon reveals Frosta's ability to freeze things and create snow. Frosta also features an "action waist." The action waist was a simple idea: twisting her torso and letting go would result in her springing back to attack her foes. The 'action waist' is featured in many of the first-wave figures. Frosta and Double Trouble come with the same comic, which features both of them prominently.

Her skirt and cape are made of an iridescent, crinkly fabric. Her cape is lined with a soft, translucent blue fabric as well. Her clothing shimmers beautifully and conveys the idea of ice. Unlike most other figures, she was sculpted to wear boots well above the knee. Only a couple of other figures share this feature: Castaspella and Entrapta. Frosta's mold is not reused in any of the other Princess of Power figures, making her quite unique. Her embedded bodice jewel is blue. She has blue, rooted hair styled in a simple, single ponytail.

Frosta can be found with a blue, teal, or white jewel in her bodice. In some countries, her hair is a light, pastel blue, while in others she has blond streaks. The fabric for her cape and skirt will sometimes be made with a white, net-like fabric, and some countries used white plastic for her wand instead of light blue. Frosta's makeup and head shape also vary from country to country.

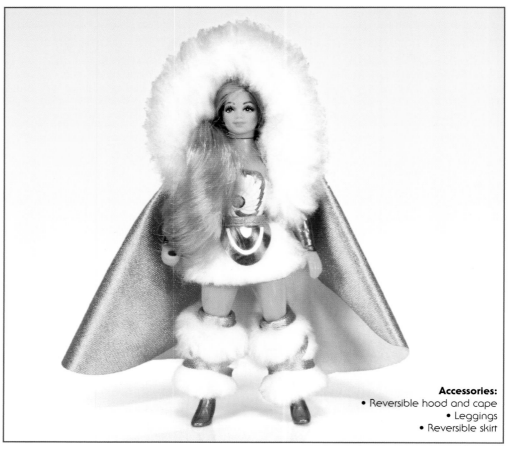

FROSTY FUR
GOLDEN COAT! FLUFFY FURRY DISGUISE!

First released 1987 • Accessory of the Great Rebellion

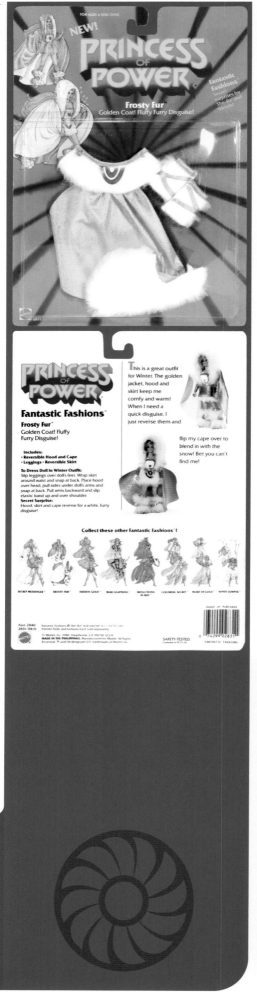

Accessories:
- Reversible hood and cape
- Leggings
- Reversible skirt

Frosty Fur is a gorgeous gold and white fashion suitable for chilly climates. This one comes with very furry accessories, literally from head to toe! There are no prism stickers on this fashion, putting it in the minority. Because this fashion uses a reversible feature, it's more like two fashions in one.

The packaging reveals the Secret Surprise: the fashion can be worn inside out in snowy climates to completely blend into the snow for a perfect disguise. When worn the other way, the shiny gold fabric displays beautifully. Due to its color scheme, this fashion works the best for She-Ra, Starburst She-Ra, or Bubble Power She-Ra.

This fashion was not widely produced before the Princess of Power toy line was canceled, making it quite rare to find either carded or loose.

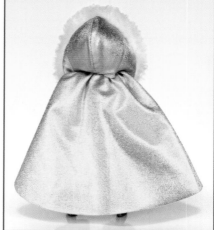
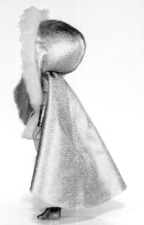
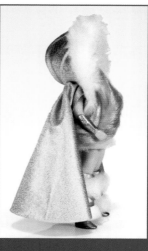

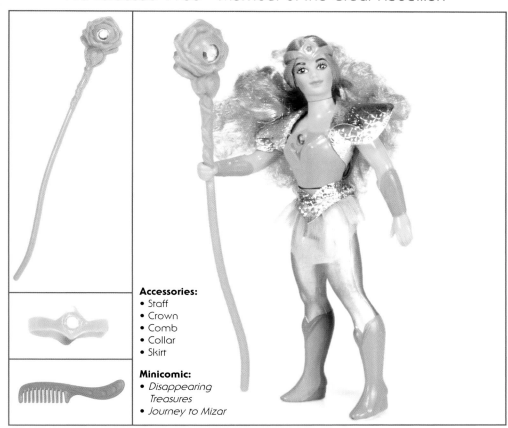

GLIMMER
THE GUIDE WHO LIGHTS THE WAY!

First released 1985 • Member of the Great Rebellion

Accessories:
- Staff
- Crown
- Comb
- Collar
- Skirt

Minicomic:
- *Disappearing Treasures*
- *Journey to Mizar*

PRINCESS OF POWER

Glimmer is the first figure to showcase very curly hair. She looks quite a bit different from her Filmation counterpart and comes with glow-in-the-dark accessories—also a pretty rare feature for the Princess of Power toys, showing up in only one other figure, SweetBee. Glimmer and Castaspella come with the same comic, which features both of them prominently.

Her collar is a unique clothing piece—its pattern does not repeat. She features a very light pink embedded jewel in her bodice, staff, and crown. Though her orchid-colored hair is incredibly curly, it is technically the same length as the other figures and it comes styled in a single large ponytail.

Glimmer can be found with either a clear jewel or a light pink jewel in her bodice, staff, and crown. Her hair is almost always orchid-colored but can be found as more of a true purple or a dark purple, depending on her country of origin. Her staff and crown are usually a dark pink but can be found looking a bit more purple, and her crown can sometimes be a very pale pink. Her skirt and collar use a silver material that can be smooth or textured, and they both use prism stickers with even more variations!

 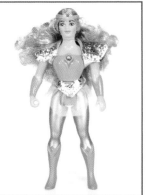

HEART OF GOLD
LILAC & GLITTER! HEART GIVES A SIGNAL!

First released 1987 • Accessory of the Great Rebellion

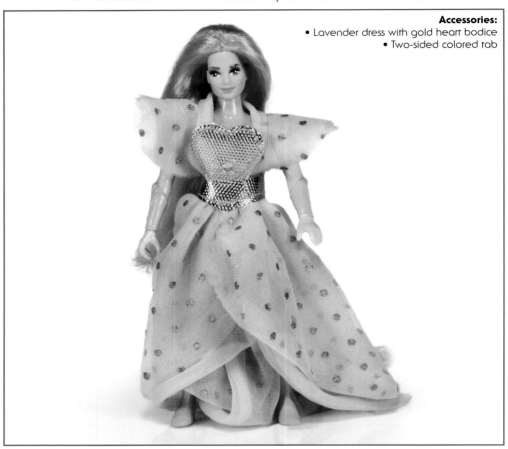

Accessories:
- Lavender dress with gold heart bodice
- Two-sided colored tab

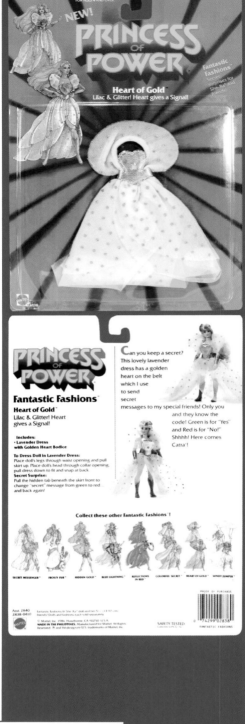

Heart of Gold is another gown-style fashion. It is a one-piece dress with attached collar and is accented with a golden bodice and gold glitter dots on the dress. There are no prism stickers on this fashion, putting it in the minority. The bodice has a small clear plastic window.

The packaging reveals the Secret Surprise: a hidden tab can be seen through the window of the bodice to send a secret message. It can reveal either a green or a red circle to mean yes or no, respectively. She-Ra is always able to send out a message to friends who know the code. Due to its color, this fashion displays nicely on She-Ra, Glimmer, and Flutterina.

This fashion was not widely produced before the Princess of Power toy line was canceled, making it quite rare to find either carded or loose. The tiny tab insert can be especially difficult to find loose.

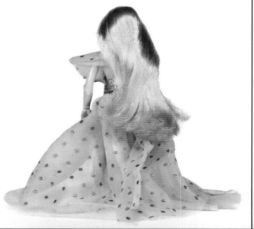
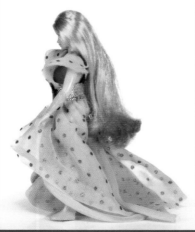
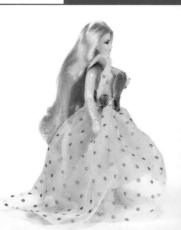

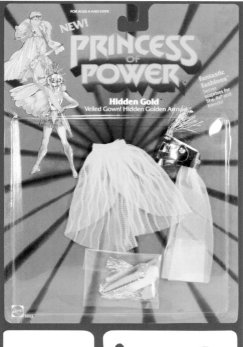

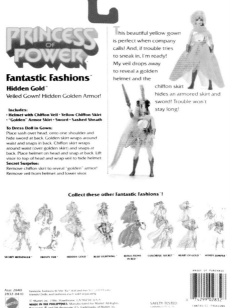

HIDDEN GOLD
VEILED GOWN! HIDDEN GOLDEN ARMOR!

First released 1987 • Accessory of the Great Rebellion

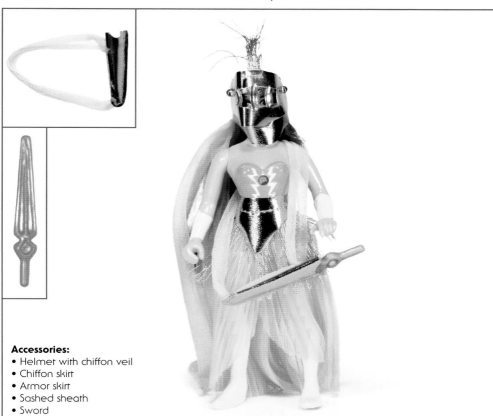

Accessories:
- Helmet with chiffon veil
- Chiffon skirt
- Armor skirt
- Sashed sheath
- Sword

Hidden Gold makes the wearer ready for anything! It is a dressy gown and armor all in one. It features flowing yellow chiffon fabric and a shiny golden helmet and skirt. The chiffon skirt and veil completely cover the golden armor.

The packaging gives instructions for dressing the figure, and states the Secret Surprise as: "Remove chiffon skirt to reveal 'golden' armor! Remove veil from helmet and lower visor." She-Ra can never be caught unaware in this fashion. Not only does she have protective armor, but she also has a hidden sheath with a sword at hand. Due to its color, this fashion displays nicely on She-Ra, SweetBee, and Castaspella.

This fashion was not widely produced before the Princess of Power toy line was canceled, making it quite rare to find either carded or loose. Because there are quite a few pieces to this outfit, it can be difficult to find complete if loose.

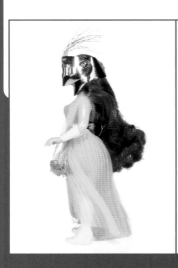

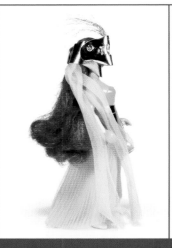

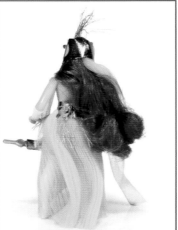

HOLD ON TO YOUR HAT
PRETTY HAT BECOMES A SECRET SHIELD!

First released 1986 • Accessory of the Great Rebellion

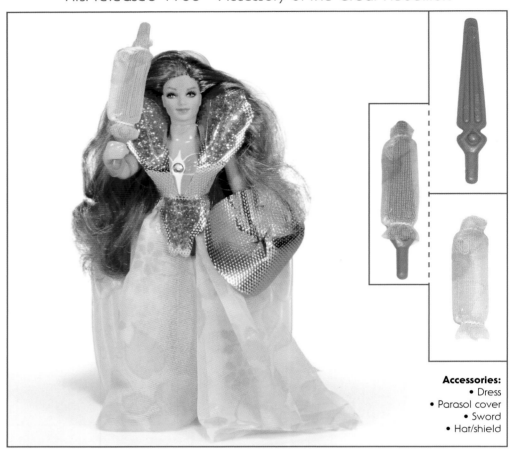

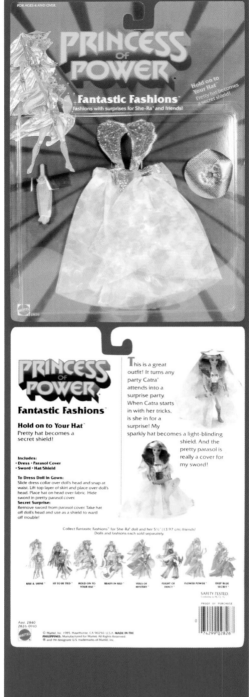

Accessories:
• Dress
• Parasol cover
• Sword
• Hat/shield

Hold On to Your Hat is a dressy fashion. It features a long, flowing skirt adorned with glittery stickers and a golden collar and belt. The hat / shield is also made of shiny gold vinyl. The parasol cover is made from the same fabric as the dress . . . disguising the secret!

The packaging gives instructions for dressing the figure, and discloses the Secret Surprise: the parasol cover can be removed to reveal a sword, and the hat becomes a shield! The shield is meant to blind attackers due to its sheen. Because of its color, this fashion displays nicely on She-Ra, Angella, and even Entrapta!

Being among the first series of fashions makes this one easier to find, though the parasol and sword can be difficult to locate if the set is found loose.

KOWL
THE KNOW-IT-OWL!

First released 1985 • Member of the Great Rebellion

Minicomic:

• *The Hidden Symbols Mystery*

Kowl has the least going for him as a figure, but he does come with an interesting Magic 8 Ball-style mechanism: lift his belly flap to reveal either red, green, or yellow. The packaging invited the user to ask a question before lifting the flap, and the color would signify the answer—green for yes, yellow for maybe, and red for no. Kowl and Bow come with the same comic, which features both of them prominently.

Kowl is a lightly flocked figure and does not come with any accessories. He is only somewhat posable due to his sculpt, though his tail surprisingly rotates.

Notable variations: There are not very many variations for Kowl, but he can also be found without the flocking based on country of origin.

INTERVIEW WITH
JANICE VARNEY-HAMLIN

You were director of worldwide marketing for fashion dolls at Mattel during the 1980s. What did the role entail?

It was everything, actually, the way Mattel was set up. The way we were organized, project management reported directly to marketing, and we had corresponding members of cost accounting, packaging, and legal. The people on my team were responsible for those aspects of the brand. It was sort of a category management role.

Can you tell me how the Princess of Power line started and what your role was in it?

It's interesting because when I first started at Mattel I was part time, and still in college. I ended up finally getting in there full time, and I reported to a guy named Jack Beuttell. He came from a P&G background and funded an attitudes and usage study for Barbie. So we learned about the brand and what Barbie could do. One of the gaps was that Barbie couldn't be an action hero, a mom, or a fantasy doll. We looked for opportunities to grow flanker brands. Competition always came for Barbie, but never lasted. When it left it created a vacuum in the market, and we would create more products and suck up all those dollars.

Did you look to He-Man for ideas to create this flanker brand?

Barbie had plateaued—she stayed at less than $100 million for years. That's why we fielded the study. Jill Barad was there. We couldn't quite get a line going because we couldn't get it past buyers, because buyers didn't believe that little girls would buy it.

We tried to do it on our own first, outside of He-Man. Then we determined we wanted to take a second attempt a few years later because there was a belief we should operate from strength, and what was our strongest action brand? It was He-Man.

The boys' side of things developed She-Ra, but she was underwhelming. So then the girls' marketing side took over and it was quite a political battle from there. We did a lot of research on it and came up with this character, this female doll. We came up with She-Ra as a way to tie in with He-Man. We gave her a war cry and transformation powers just like He-Man had. The important thing with She-Ra was that she not only had to look beautiful, but also be beautiful within.

I've heard that a big proportion of the kids who played with He-Man were girls? Did that drive the creation of the She-Ra line?

No, didn't drive it. We already had the research that said girls were interested in this type of thing. It just reinforced what we already knew.

How successful was She-Ra compared to Barbie and He-Man?

She performed like a flanker brand. She was important because her job was to create and deliver on new play patterns for girls. We didn't expect her to outperform He-Man or Barbie. It was a nice flanker brand for girls to do role play and hair play. The sales volume didn't compare but we were pleasantly surprised with how well she performed.

All the female characters had to have fashion play and hair play elements, as well as some kind of feature. Catra had a claw, She-Ra had a costume change and a sword. Even She-Ra's horse had a transformation capability.

I've heard that early models for She-Ra were based on Teela. Is that true?

Yes. The misstep there was Teela was part of He-Man's world, which was rightful, but she had no characteristic features that appealed to traditional doll play, like rooted hair and clothing. She also lacked the transformation, the traditional world of role play. When She-Ra transformed she became superpowerful. She was empowered and she empowered others.

The marketing behind the He-Man line was all about empowerment for young kids, who often felt powerless in their relationships with adults: "I have the power." What was the driving theme behind She-Ra?

I think it was empowerment, and also making the world a better place for those around her. She took care of animals and people. She was a nurturer.

To your earlier point, Barbie wasn't either of those things.

Exactly. I was a lit major, there was this literary book called *Bulfinch's Mythology*. It covers archetypes through Roman and Greek mythology. A lot of our characters were modeled after those gods and goddesses, like Athena and Venus. Those were the inspirations. Even She-Ra herself looks like what you might imagine Athena to look like. That or Venus.

The original renderings for She-Ra had red hair, but it didn't test well for little girls.

In many ways She-Ra was ahead of her time and served as a strong, action-oriented role model for young girls. How do you think She-Ra fits into the world of today?

I think she's a good fit. I think she fits right in. I'm completely amazed with how mesmerizing she was. She has really maintained her original characteristics and inspiration. It's classic. Just like the mythical characters we emulated.

She stands for a lot of goodness. We took great strides to make sure that happened. Even in the research we did, we discovered that it was really important to young girls that She-Ra was a good person and did the right thing.

Every generation has notions of violence. That was played back to us by kids. Even with her enemies like Catra, she may try to scratch you or be mean to you. But little girls would still feel Catra should be forgiven. It was never a fight to the death.

Do you have any fun stories from your time on the brand?

When we did the press event in New York, we hired a model who rode on a white horse down the middle of the street; she actually rode bareback down the street with her entourage of people dressed as the characters. We went to a hotel, and Andy Warhol showed up at the press event. He invited us to his club for the evening. He thought it was the most amazing thing, and he loved the costumes. Apparently he had read about the press event that day and just showed up.

What was your personal favorite character?

I would say She-Ra was my number one and Catra was my number two. Actually, I would say probably her horse as well. She-Ra, Swift Wind, and Catra, in that order.

It was really a fun line to work on because you're making this stuff up in your head. There was another person I worked with, Cathy Larson, who was incredibly creative. I just really liked working with her. We came up with all these things. She was in the sales department, and I brought her in halfway through. We would just make up the story line and characters.

With something like She-Ra, you get to swing out creatively. With Barbie there were a lot of guidelines and standards. We had some pretty fun meetings about She-Ra. Going from Barbie meetings to these She-Ra meetings, it was a totally different attitude, more creative and more fun.

What about the Evil Horde? How did that come into the picture?

We were great toy designers, but that did not mean we could produce a great TV series. There were certain things we didn't get about the entertainment industry. One of the areas to bridge the gap between He-Man's and She-Ra's world was to infiltrate characters that weren't in our product line. When story lines from the cartoon came back, they were completely different from storybooks we were developing at Mattel. We had to make the two come together. We didn't want three different story lines for the same thing. That was one of the things, to have to cross over characters that appeared in both places.

There was a lot of resistance to that, more on the boys' side. They had more restrictions too, and we were more or less an open book.

What can you tell me about the She-Ra cartoon?

We knew there had to be an animated series for the brand. There weren't a lot of strong female characters in cartoons at the time that had these abilities. Maybe a few, like Supergirl and Wonder Woman, were predecessors. But in terms of integrating her into He-Man's world, it was really important. We lucked out, we met with Lou Scheimer at Filmation.

So how did the She-Ra line come to an end?

There were two different challenges. First, She-Ra sales were slowing. The second problem was we shipped too much product into the marketplace. This was over my pay grade, but we would ship product based on what retail would buy, not on what would sell through. That creates a problem going to next year. If there's too much inventory left over, it creates the sense that the toy line isn't successful. At the end of year two that happened. Something similar happened in He-Man—they overproliferated characters that didn't even make sense.

What did you do after She-Ra ended?

I went and worked on other products because I was able to grow the Barbie business. It had been stagnant for twelve years. Jack Beuttell and I were able to introduce secondary dolls, more new dolls each year, to create synergy and new roles for Barbie. For example, we put out Golden Dreams Barbie, with a golden convertible, coordinated outfit, golden make-up, and we would advertise everything in one commercial. That created a halo effect which would sell the whole thing. Jack came up with that, and after he left I continued it.

If you could do She-Ra, how would you approach it this time?

I'd make her more modern. Her powers would have to do with AI and virtual reality. She would be in the modern era. I would retain certain aspects of her. It would be traditional but also embrace technology in an exciting way and in a global way. It would be incredibly inclusive with world cultures.

Anything else?

I think She-Ra's a classic. I used to think, "Why do people want to talk about this?" It's because She-Ra is an empowered, self-confident woman. She empowers other people to be confident and do the right thing. One thousand years from now that will still be an important characteristic to have. Regardless of your background, do the right thing. I hope that's what she stands for; that's what she was designed to do.

LOO-KEE
HIDES AND "SEES" ALL IN ETHERIA!

First released 1987 • Member of the Great Rebellion

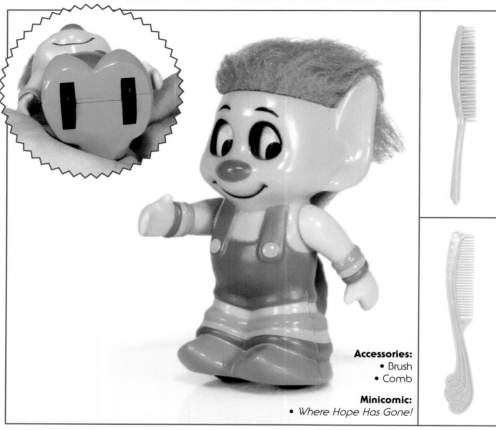

Accessories:
• Brush
• Comb

Minicomic:
• *Where Hope Has Gone!*

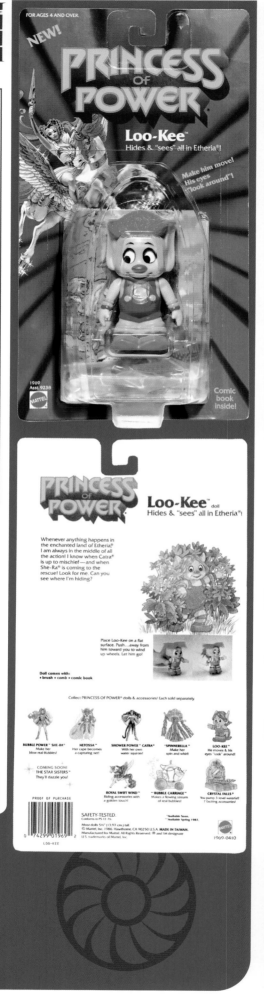

Loo-Kee comes with an interesting mechanism: pull him back and let him go, and he will roll across a flat surface while his eyes look left and right. His hair is made of the same fluffy stuff as Enchanta's, but Loo-Kee's is much longer and bright blue. Loo-Kee, Spinnerella, and Netossa come with the same comic, which features all of them prominently.

Though he is meant to be an excellent hider in the Filmation cartoon, this toy version is large enough to make this a bit of a challenge during play! Loo-Kee is articulated in his arms, but is otherwise not posable. His brush and comb can be used to keep his hair untangled, but since his hair is fluffy, it isn't really meant to be styled.

Because Loo-Kee was not widely produced before the Princess of Power toy line was canceled, he is quite rare to find either carded or loose.

MERMISTA
MIST-I-FYING MERMAID!

First released 1986 • Member of the Great Rebellion

Accessories:
- Shell backpack
- Shield
- Comb
- Tail

Minicomic:
- *A Fishy Business!*

Mermista uses a new and unique sculpt that includes swivel-head articulation and a sculpted necklace. Her ability is her shell backpack, which can be filled with water to be squirted through a hole in her back and out of her necklace. She is the first figure in the series to use water, and it can be hard not to want to take this figure to the pool! Mermista and Peekablue come with the same comic, which features both of them prominently.

Mermista's tail is a fun variation from the rest of the figures with their skirts and dresses. Her tail is shiny silver embellished with a silver waistband and fins and green prism stickers. Because the tail pushes her feet together, she is somewhat bowlegged when it is removed. She comes with a sea green comb and shield, which use the same mold as those packaged with She-Ra. Her rooted blue hair comes styled in two lopsided, hair-covered ponytails (one of the more complicated designs), clearing the way to attach her backpack for use during play.

Notable variations: There are not many variations of Mermista, but sometimes her tail will be made of fabric with a silvery-blue tint.

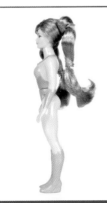

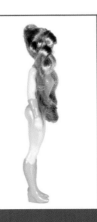

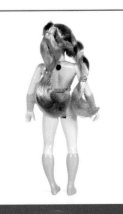

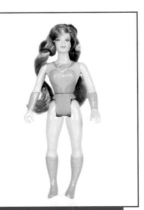

NETOSSA
CAPTIVATING BEAUTY!

First released 1987 • Member of the Great Rebellion

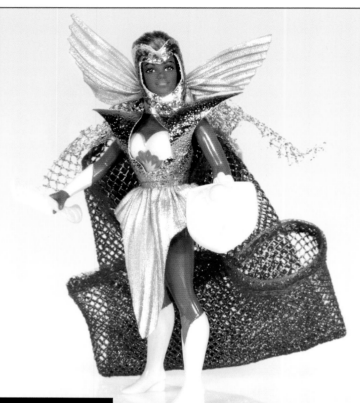

Accessories:
- Shield
- Comb
- Skirt with bodice
- Cape
- Headdress

Minicomic:
- *Where Hope Has Gone!*

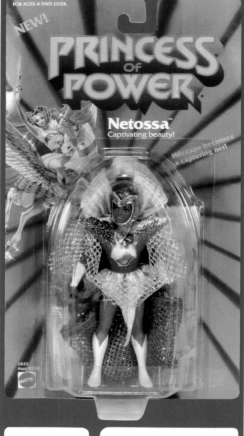

Netossa uses the same sculpt as Peekablue and is the only Black figure in the entire Princess of Power toy line. Netossa's gimmick is her cape, which can transform into a net to catch her opponents. It has a string running through the hem so that when it is pulled, the cape will close into a bag which can then be tied shut. Netossa and Spinnerella come with the same comic, which features both of them prominently.

Netossa's skirt is made from a shiny silver fabric, but the bodice is glittery blue. Her cape/net is made with a blue-and-silver woven fabric. She comes with a white comb and shield, which use the same mold as those of She-Ra. Her rooted blue hair comes styled in a simple ponytail.

This figure was not widely produced before the Princess of Power toy line was canceled, making it quite rare to find either carded or loose.

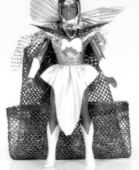
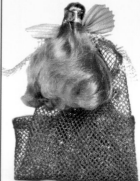
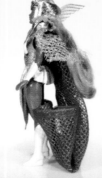
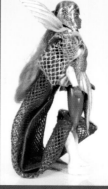

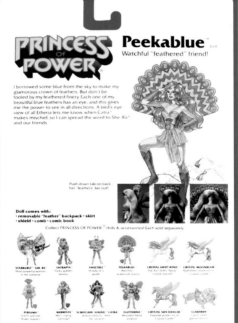

PEEKABLUE
WATCHFUL "FEATHERED" FRIEND!

First released 1986 • Member of the Great Rebellion

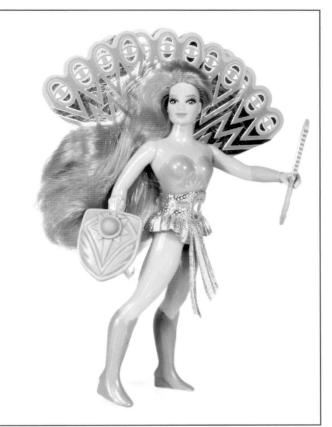

Accessories:
- Feather backpack
- Comb
- Shield
- Skirt

Minicomic:
- A Fishy Business!

Peekablue uses a new sculpt that includes swivel-head articulation. This mold will be reused in the third series for Netossa. Peekablue's ability is her stunning shiny gold-feathered backpack, which uses two pegs to fit into her back. It has a sliding lever that opens and closes her feathers like a fan. The design for the feathers includes "eyes" which help her scout for She-Ra. Peekablue and Mermista come with the same comic, which features both of them prominently.

Peekablue's skirt is made from a shiny gold fabric accented with an eye resembling those on her backpack. She comes with a blue comb and shield, which use the same mold as She-Ra's. Her rooted green hair comes styled in a split ponytail, clearing the way to attach her backpack for use during play.

There are not many variations of Peekablue, but some countries seemed to be more precise with the application of the orange paint on her boots and bodice.

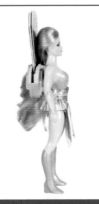

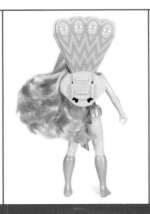

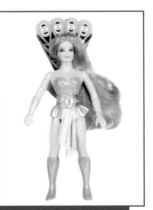

PERFUMA
SCENT-SATIONAL FLOWER MAIDEN!

First released 1986 • Member of the Great Rebellion

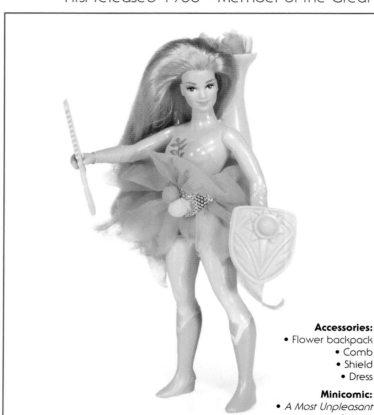

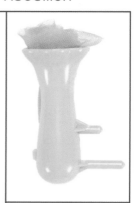

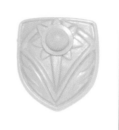

Accessories:
- Flower backpack
- Comb
- Shield
- Dress

Minicomic:
- *A Most Unpleasant Present*

Perfuma uses a new and unique sculpt that includes swivel-head articulation. Her ability is her blooming flower backpack, which uses two pegs to fit into her back. It has a sliding lever that causes her flower to bloom. This action was meant as a defense: as enemies "catch a whiff of her perfume," they fall asleep! Perfuma and Flutterina come with the same comic, which features both of them prominently.

Perfuma's dress is made from translucent pink fabric embellished with two tiny flowers on her golden belt. She comes with a spring green comb and shield, which use the same mold as She-Ra. Her rooted blond hair comes styled in two lopsided hair-covered ponytails (one of the more complicated designs), clearing the way to attach her backpack for use during play.

There are not many variations of Perfuma, but sometimes the flowers on her dress will be pink and green instead of pink and yellow.

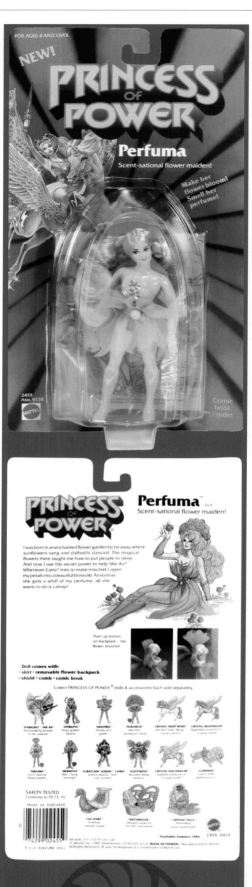

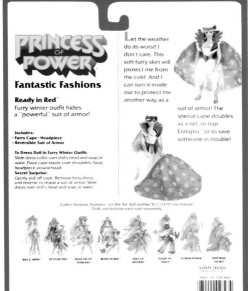

PRINCESS OF POWER

Fantastic Fashions

Fashions with surprises for She-Ra and friends!

Ready in Red
Furry winter outfit
hides a "powerful"
suit of armor!

Includes:
• Furry Cape • Headpiece
• Reversible Suit of Armor

To Dress Doll in Furry Winter Outfit:
Slide dress collar over doll's head and snap at waist. Place cape elastic over shoulders. Snap headpiece around head.

Secret Surprise:
Gently pull off cape. Remove furry dress and reverse to reveal a suit of armor. Slide dress over doll's head and snap at waist.

Let the weather do its worst! I don't care. This soft furry skirt will protect me from the cold. And I can turn it inside out to protect me another way, as a suit of armor! The special cape doubles as a net, to trap Entrapta, or to save someone in trouble!

Collect Fantastic Fashions™ for She-Ra® doll and her 5½" (13.97 cm) friends! Dolls and fashions each sold separately.

READY IN RED
FURRY WINTER OUTFIT HIDES A "POWERFUL" SUIT OF ARMOR!

First released 1986 • Accessory of the Great Rebellion

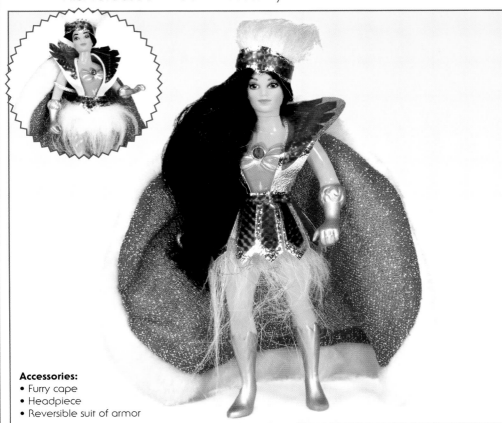

Accessories:
• Furry cape
• Headpiece
• Reversible suit of armor

Ready in Red is an armor-style fashion meant for battle in any weather. The armor dress and headpiece are adorned with large red prism stickers and use white fur. The cape is made from a glittery red fabric and bordered with a soft white fur.

The packaging gives instructions for dressing the figure and states the Secret Surprise as: "Gently pull off cape. Remove furry dress and reverse to reveal a suit of armor." It also indicates that She-Ra is able to use her cape as a net to trap Entrapta or save someone in trouble! Due to its color, this fashion displays nicely on She-Ra and Catra.

The actual fashion differs a bit from the images on the packaging, which show a large silver snowflake design on the cape. The fashion can be found with a red prism sticker on both sides of the collar part of the dress, but many times it is only on the armor side and is absent on the furry side. Being among the first series of fashions makes this one easier to find.

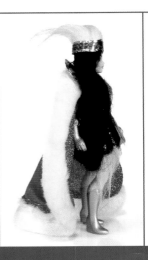

REFLECTIONS IN RED
RUBY RED CROWN! SHIELD BECOMES "MIRROR"!

First released 1987 • Accessory of the Great Rebellion

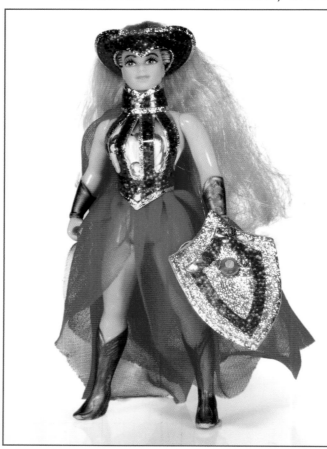

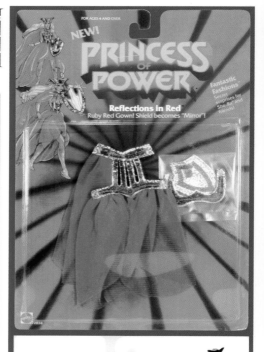

Accessories:
- Matching shield
- Dress with collar
- Royal crown

Reflections in Red is an armor-style fashion meant for battle. The dress and headdress use a silvery-lined vinyl adorned with red prism stickers. The skirt and cape are a vibrant red chiffon. Because the shield is meant to be double sided, there is no armband, instead relying on an open space in the top to fit over the figure's arm.

The packaging gives instructions for dressing the figure, and reveals the Secret Surprise: turn her shield around to become a mirror. This shield is meant to reflect evil rays or "cat-like glances" from Catra. However, due to its color, this fashion displays nicely on Catra . . . and She-Ra, too.

This fashion was not widely produced before the Princess of Power toy line was canceled, making it quite rare to find either carded or loose.

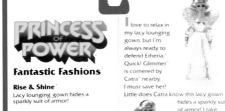

PRINCESS OF POWER
Fantastic Fashions*
Fashions with surprises for She-Ra* and friends!

PRINCESS OF POWER
Fantastic Fashions

Rise & Shine
Lacy lounging gown hides a sparkly suit of armor!

Includes:
- Bedjacket • Skirt
- Sparkly Suit of Armor

To Dress Doll in Lounging Outfit:
Slide sparkly suit of armor over doll's head and snap at waist. Slide bedjacket over shoulders. Tie skirt at waist.

Secret Surprise:
Gently pull off bedjacket. Untie skirt.

"I love to relax in my lacy lounging gown, but I'm always ready to defend Etheria.' Quick! Glimmer' is cornered by Catra' nearby. I must save her!

Little does Catra know this lacy gown hides a sparkly suit of armor! I take off my robe and it's She-Ra' to the rescue! Watch out, Catra, here I come!"

Collect Fantastic Fashions* for She-Ra* doll and her 5½" (13.97 cm) friends! Dolls and fashions each sold separately.

SAFETY TESTED

RISE & SHINE
LACY LOUNGING GOWN HIDES A SPARKLY SUIT OF ARMOR!
First released 1986 • Accessory of the Great Rebellion

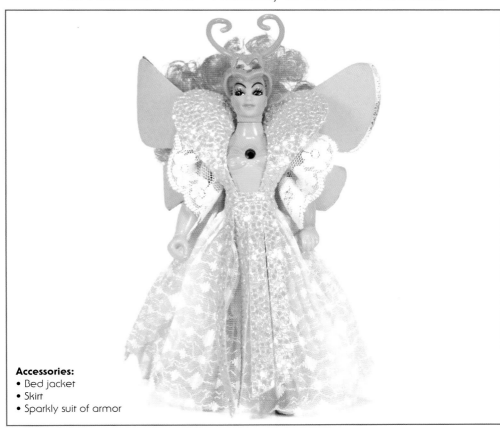

Accessories:
- Bed jacket
- Skirt
- Sparkly suit of armor

Rise & Shine is an interesting combination of sleepwear and battle armor. The skirt and bed jacket parts are made of a lacy white fabric and the armor is made from a stiff sparkling pink material without prism stickers.

The packaging gives instructions for dressing the figure, and reveals the Secret Surprise: the skirt and jacket can be removed to reveal a suit of armor! Though dressing for bed might seem to leave She-Ra defenseless, she is always prepared for Catra. Due to its color, this fashion displays nicely on She-Ra, Angella, SweetBee, and Scratchin' Sound Catra.

Being among the first series of fashions makes this one easier to find. Because there aren't too many little pieces and nothing is fragile, this fashion holds up well to play.

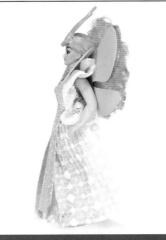

ROYAL SWIFT WIND
MIGHTY "FLYING" UNICORN CARRIES SHE-RA TO ADVENTURE!

First released 1987 • Steed of the Great Rebellion

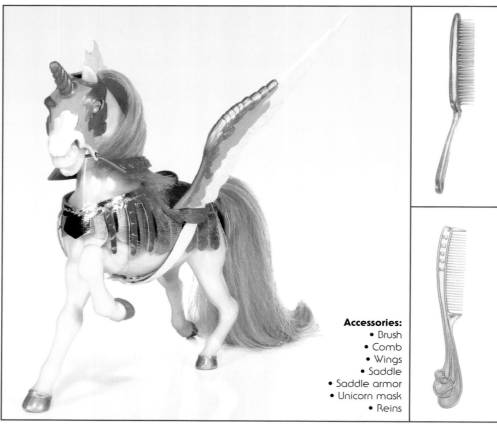

Accessories:
- Brush
- Comb
- Wings
- Saddle
- Saddle armor
- Unicorn mask
- Reins

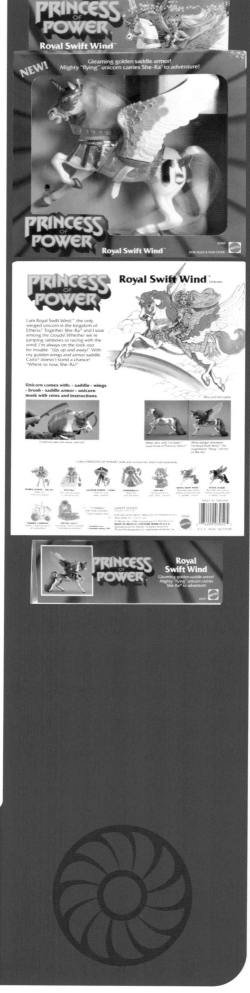

Royal Swift Wind is meant to be two horses in one: Spirit for Adora and Royal Swift Wind for Bubble Power She-Ra. His transformation is a simple one: just add the wings, mask, and armor to make him Royal Swift Wind. Though the original first-series Swift Wind was female, Royal Swift Wind is male, like Crystal Swift Wind. Fitting securely around his neck and tail, the saddle armor is made with shiny gold fabric accented with dark pink prism stickers. The instructions detail ways to style his mane and tail. The comb and brush set that comes with all of the horses can also be found packaged with Barbie.

Royal Swift Wind has a pearly white body accented with gold hooves and blue eyes enhanced with gold detailing. Adorned with a golden hair cuff, his tail is much longer than previous versions. His saddle and mask are made from the same gold plastic and his wings are white plastic with gold and dark pink paint. Royal Swift Wind's hair is dark pink with lighter pink streaks.

His wings fit into notches in the saddle and fasten under the belly. This toy uses the same design as the second series of horses.

Royal Swift Wind can sometimes be found with light pink hair instead of the dark pink with light streaks. This is a true variant, a rarity among the third series.

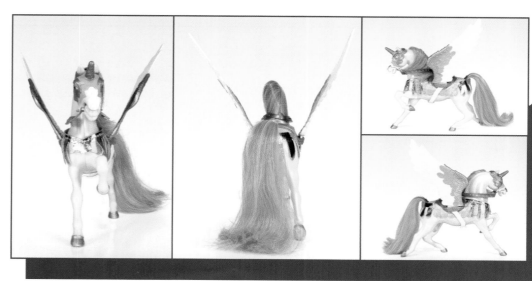

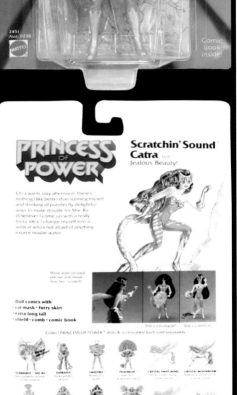

SCRATCHIN' SOUND CATRA
JEALOUS BEAUTY!

First released 1986 • Member of the Evil Horde

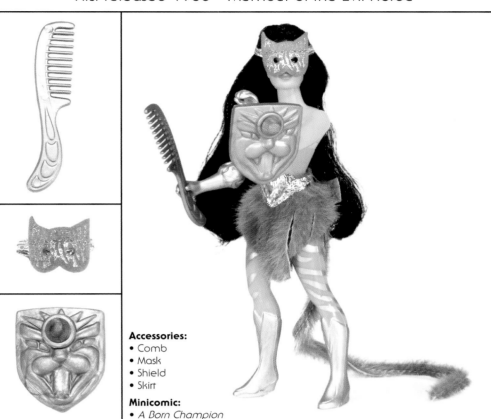

Accessories:
- Comb
- Mask
- Shield
- Skirt

Minicomic:
- *A Born Champion*

Scratchin' Sound Catra utilizes an updated sculpt to feature swivel-head articulation. Using the lever on her back will raise and lower her arm with the curled fingers. This results in a scratching sound, hence her name! (This sculpt is reused identically in the final series, except for the scratching motion.) Her furry tail is fixed to her figure and is not intended to be removed. Scratchin' Sound Catra, Entrapta, and SweetBee come with the same comic, which features all of them prominently.

Instead of hard plastic, her mask is made with silver-embellished red fabric with an elastic strap. Her skirt has the same sort of furry feel as her tail, matching it in color as well. She comes with a gray comb and cat-faced shield—the same as first-series Catra. She has a pink jewel in her bodice and is accented with shiny silver paint. Her rooted black hair comes styled in a single side ponytail, keeping the lever in her back free to use during play.

Notable variations: Scratchin' Sound Catra can be found with either a light or dark gray furry skirt and tail. Her paint will sometimes be a vibrant pink, as opposed to the more common light pink. She can also be found with a red jewel instead of pink.

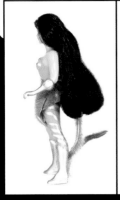
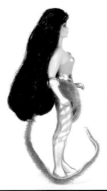
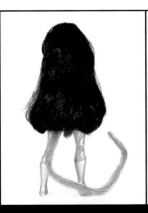
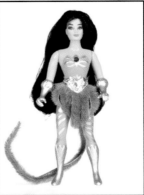

SEA HARP
MUSICAL SEA HORSE CARRIES SHE-RA AND HER FRIENDS TO ADVENTURE!

First released 1986 • Steed of the Great Rebellion

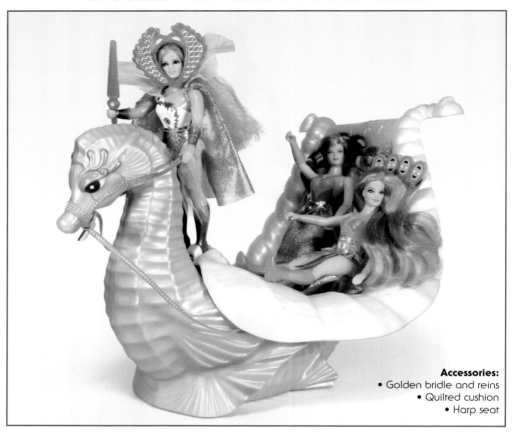

Accessories:
• Golden bridle and reins
• Quilted cushion
• Harp seat

Sea Harp is meant to carry a few figures over water, as opposed to Enchanta, who carries many through the air. She is not articulated in any way, but does have a musical harp designed to be heard throughout Etheria. The instructions show how to assemble the few accessories and how to operate the harp.

Her harp seat fits securely in the body base and has notches designed to hold a figure's feet. The cushion is made from a thin quilted sponge-like golden material. The harp feature is not as musical as her description implies, but does make noise, nonetheless. Her body is a beautiful aqua blue plastic dusted with gold paint and her eyes are blue accented with gold and pink. The harp seat is a light pink plastic with a blue harp handle.

Sea Harp is a sturdy carrier but her bridle and reins are a bit on the fragile side, making the toy difficult to find in good condition unless boxed.

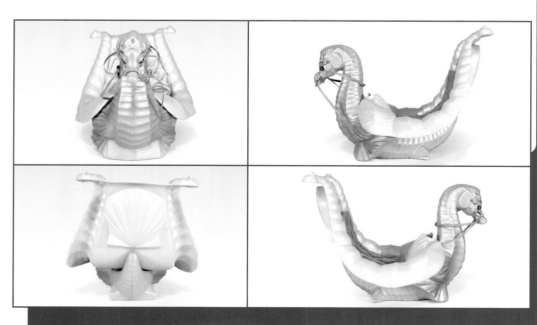

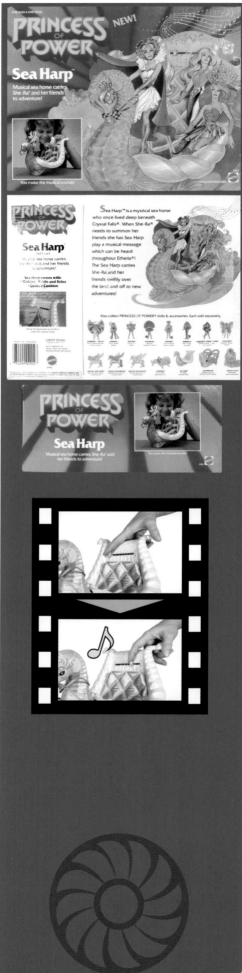

SECRET MESSENGER
ELEGANT RIDING GEAR! HIDDEN TREASURE MAP!

First released 1987 • Accessory of the Great Rebellion

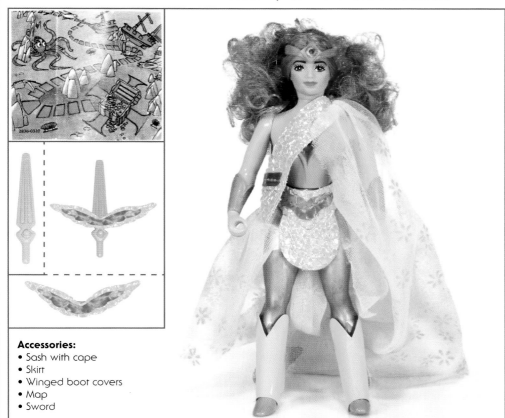

Accessories:
- Sash with cape
- Skirt
- Winged boot covers
- Map
- Sword

Secret Messenger is an unusual fashion—one of only two to use boot covers. These boots are made from a shiny pink vinyl and are accented with prism stickers on the wings. The sash, belt, and boot wings of this outfit are made with the same sparkly pink material that Rise & Shine uses. This time, however, it is accented with dark pink prism stickers. The map is the same one used in Deep Blue Secret. Her sword is a light golden brown color and there is no jewel.

The packaging reveals the Secret Surprise: "Gently pull sash to the side to reveal hidden pocket with map!" There is also a strap on the sash where the sword fits when not being held by the figure. Due to its color and theme of flying, this fashion displays nicely on Angella, but She-Ra also wears it well.

This fashion was not widely produced before the Princess of Power toy line was canceled, making it quite rare to find either carded or loose. The map and sword are particularly difficult to find with this fashion when it is loose.

PRINCESS OF POWER

PRINCESS OF POWER

SHE-RA
PRINCESS ADORA BECOMES SHE-RA, MOST POWERFUL WOMAN IN THE UNIVERSE!

First released 1985 • Member of the Great Rebellion

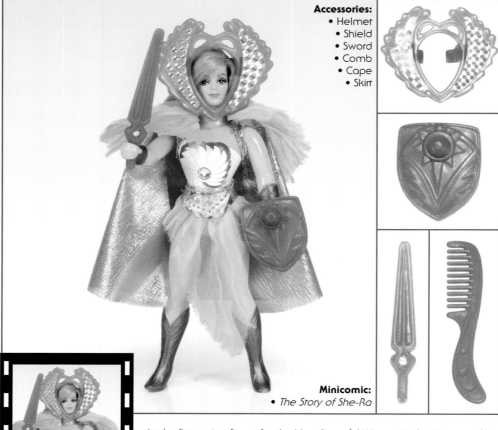

Accessories:
- Helmet
- Shield
- Sword
- Comb
- Cape
- Skirt

Minicomic:
- *The Story of She-Ra*

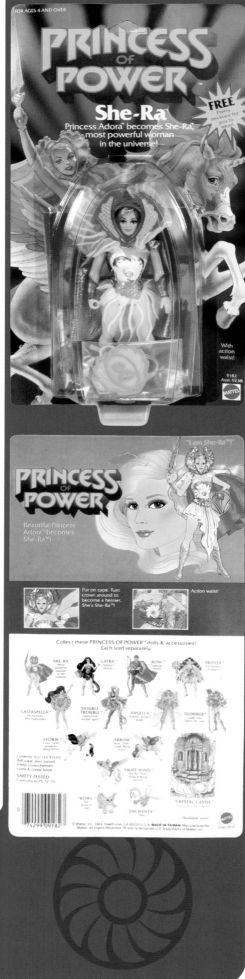

As the first action figure for the Most Powerful Woman in the Universe, this toy represented both Princess Adora and She-Ra—a difficult task! Though the Adora form looks nothing like the Filmation design, the She-Ra representation was not too far a stretch. She-Ra features an "action waist" where twisting her torso and letting go would result in her springing back to strike her foes. Her cape is made from a shiny iridescent red, her skirt and mask include prism stickers, her sword and bodice each hold a clear jewel, and gold paint accentuates her boots and gauntlets. She has blond, rooted hair styled in a simple ponytail, making her an interesting combination of fashion doll and action figure.

She-Ra was the "first of the first" for durable female action figures and inspired so many young girls, whether they were more into the clothing and hair accessories or the weapons and action!

This figure was produced in many different countries, resulting in many variations of the makeup paint and the type of prism stickers used, along with the methods of attaching them. A few countries made a different sword mold for She-Ra, ones that look closer to Bubble Power She-Ra's sword. Also, many countries had different patterns for the skirt fabric, ranging from pleated to having wavy, opaque lines running through the fabric. The capes were also prone to variations. Even the figure's head had numerous differences, from soft to hard plastic, plain or detailed makeup, and streaks of highlights in the hair.

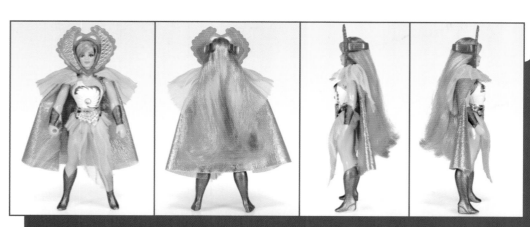

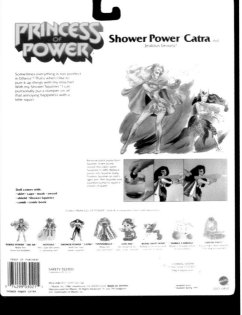

SHOWER POWER CATRA
JEALOUS BEAUTY!

First released 1987 • Member of the Evil Horde

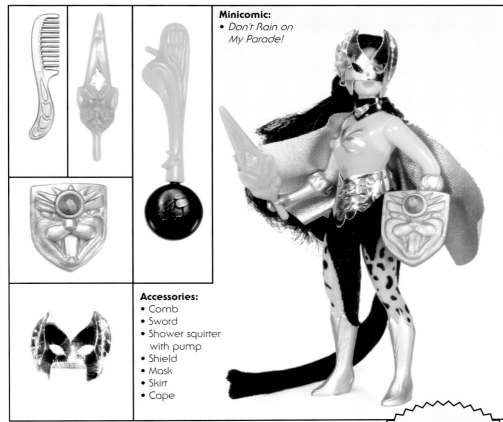

Minicomic:
• *Don't Rain on My Parade!*

Accessories:
• Comb
• Sword
• Shower squirter with pump
• Shield
• Mask
• Skirt
• Cape

Shower Power Catra is the third and final incarnation of the Princess of Power's most prominent villain. She uses the same sculpt as Scratchin' Sound Catra, with the exception of a notch in her shoulder where her squirter rests, and she does not have the scratching-feature lever in her back. Her unique weapons are her cat-themed sword and her Shower Squirter, which comes with a small black pump that can be filled with water and squeezed through the squirter. This "attack" is intended to put a dampener on She-Ra's festivities.

Her short cape is bright silver, adorned with a light pink prism sticker on the collar. Her mask and belt are made from the same shiny silver material and are adorned with more light pink prism stickers. Her skirt and tail use the same silky black fabric. Her shield uses the same mold as her predecessors', and her bodice features a pink jewel. She has rooted black hair styled in the same side ponytail as Scratchin' Sound Catra.

Because the Princess of Power toy line was canceled halfway through the release of the third series, there were not many Shower Power Catra figures produced, making them quite rare to find today.

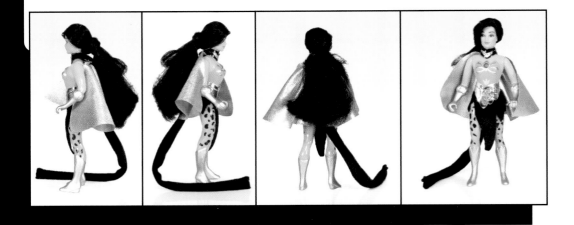

PRINCESS OF POWER

SILVER STORM
SILVER STORM "FLIES" CATRA TO MISCHIEVOUS ADVENTURES!

First released 1987 • Steed of the Evil Horde

PRINCESS OF POWER

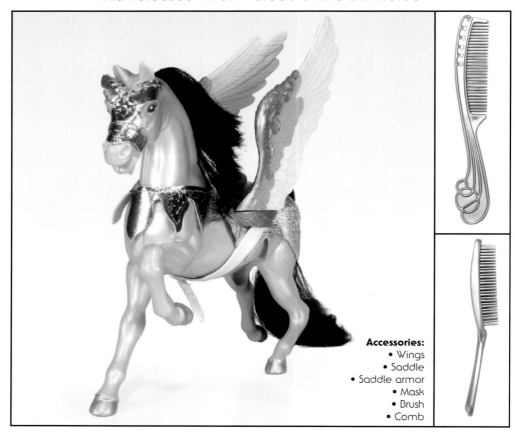

Accessories:
- Wings
- Saddle
- Saddle armor
- Mask
- Brush
- Comb

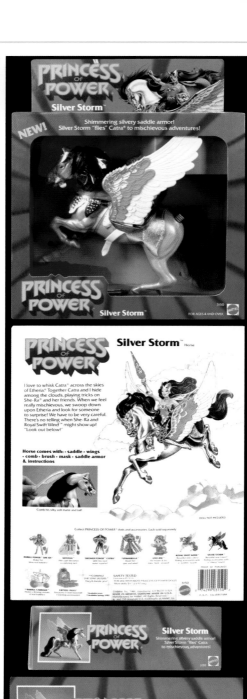

Though the original Storm was female, Silver Storm is male. He seems to enjoy helping Catra cause mischief by playing tricks together on She-Ra and her friends. His mask is a silver fabric with light pink prism stickers. Fitting securely around his neck and tail, the saddle armor is made with the same silver fabric and prism stickers. The instructions detail ways to style his mane and tail. The comb and brush set that comes with all of the horses can also be found packaged with Barbie.

Silver Storm has a pearly light gray body accented with silver hooves and black eyes. Adorned with a silver hair cuff, his tail is much longer than previous versions. His saddle is made from silver plastic and his wings are white plastic with silver and dark pink paint. Silver Storm's hair is solid black.

His wings fit into notches in the saddle and fasten under the belly. This toy uses the same design as the second series of horses.

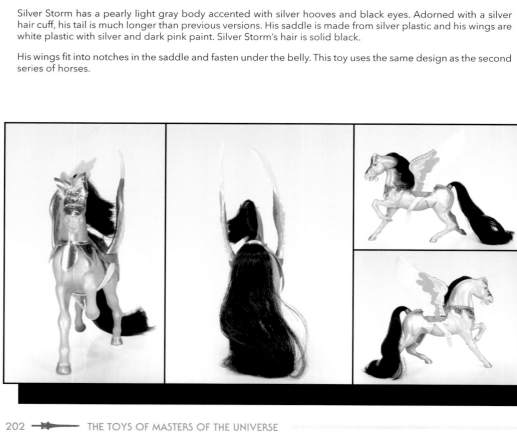

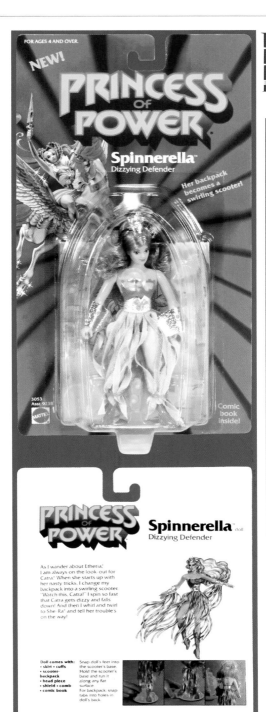

SPINNERELLA
DIZZYING DEFENDER

First released 1987 • Member of the Great Rebellion

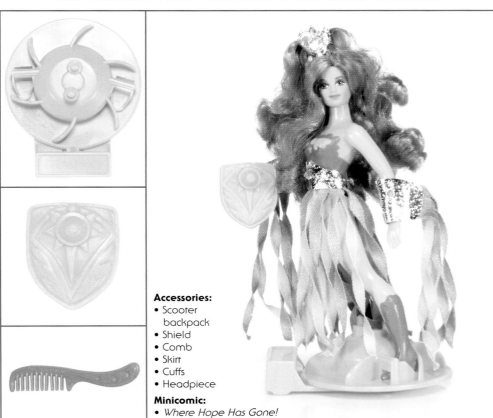

Accessories:
- Scooter backpack
- Shield
- Comb
- Skirt
- Cuffs
- Headpiece

Minicomic:
- *Where Hope Has Gone!*

Spinnerella uses the same entire sculpt as Flutterina. Spinnerella's gimmick is her spinning scooter, which her feet fit securely into. When rolled across a flat surface, it causes the figure to spin, and when not in use it snaps into Spinnerella's back. Netossa and Spinnerella come with the same comic, which features both of them prominently.

Spinnerella's skirt and arm cuffs are made from alternating purple and blue twisted fabric strips. The cuffs, belt, and headpiece are made from a shiny silver material, the latter two being adorned with a light pink prism sticker. Her curly pink and purple hair comes styled with a small top ponytail going through the headpiece, while the rest is pulled back into a second curly ponytail.

While the later Princess of Power releases tend to be rare, Spinnerella is exceedingly scarce. Even loose figures sell for hundreds of dollars on the aftermarket.

STARBURST SHE-RA
The most powerful woman in the universe!

First released 1986 • Member of the Great Rebellion

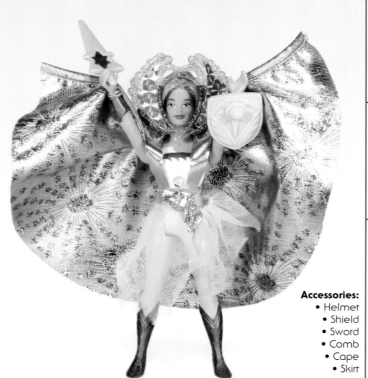

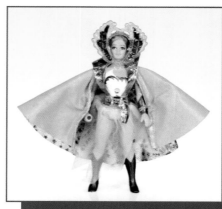

Accessories:
- Helmet
- Shield
- Sword
- Comb
- Cape
- Skirt

Minicomic:
- *Across the Crystal Light Barrier*

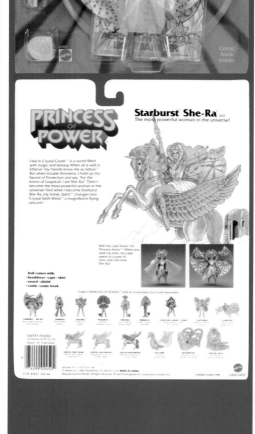

The first of the second series of Princess of Power figures, Starburst She-Ra has a brand-new sculpt and a new swivel head, an upgrade from the first-series figure, whose neck articulation could only move from side to side. Starburst She-Ra has arms that raise together so as to show off her shiny cape, intended to dazzle her enemies. Her face is thinner than the first-series version and the painted makeup has improved her appearance.

Her cape is pink on one side and shiny on the other, embellished with firework starbursts. The cape is attached to a gold belt-and-collar combo with glittery pink stickers. Made of translucent white fabric, her skirt fits under the cape's belt. Featuring pink prism stickers, her mask is cast in a clear glittery hard plastic. Her sword and shield are made from the same pink plastic, but instead of a jewel, her sword also includes yet another pink prism sticker. The clear jewel in her bodice is identical to the first-series She-Ra, and only about half of the second-series figures have a gem at all. Gold paint accentuates her boots and gauntlets, making this figure quite shiny! She has rooted blond hair styled in two twisted ponytails with a single small ponytail over those.

Notable variations: The most obvious variation of this figure is the figure itself. Some Starburst She-Ra figures are identical to the first-series She-Ra figures, except for the arm-raising motion. Only by lifting her arms can you tell if she is truly a Starburst version or not. There are also variations in the color of her cape: you can find both dark and light pink varieties.

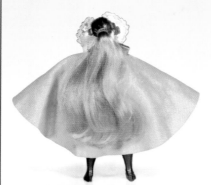

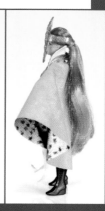

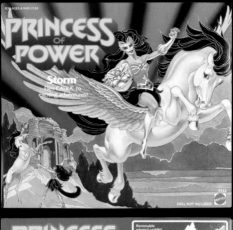

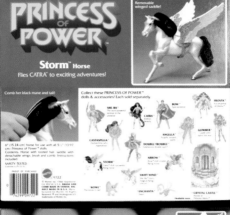

STORM
Flies CATRA to exciting adventures!

First released 1985 • Steed of the Evil Horde

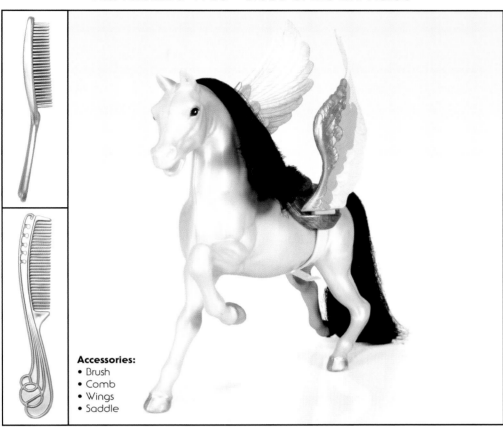

Accessories:
- Brush
- Comb
- Wings
- Saddle

Although Storm was not present in the Filmation cartoon, her corresponding colors guarantee there's no mistaking that she belongs with Catra. Storm is a complete duplicate of Swift Wind in everything but color and the omission of a mask and reins. She has rooted black hair and the instructions detail ways to style her mane and tail.

Her wings fit into notches in the saddle and fasten under the belly. This seems like a decent design, yet the wings have a tendency to slip during play. Storm's body is a light gray with silver hooves and black eyes and her wings are white plastic accented with pink and silver paint.

Notable variations: Storm's saddle can be found in either a flat gray or a shiny silver plastic. The pink on her wings is sometimes very bright but can also be more of a muted coral color.

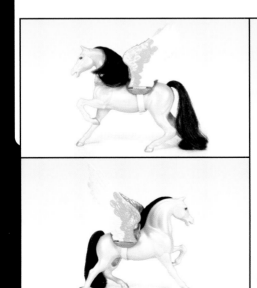

SWEETBEE
HONEY OF A GUIDE!

First released 1986 • Member of the Great Rebellion

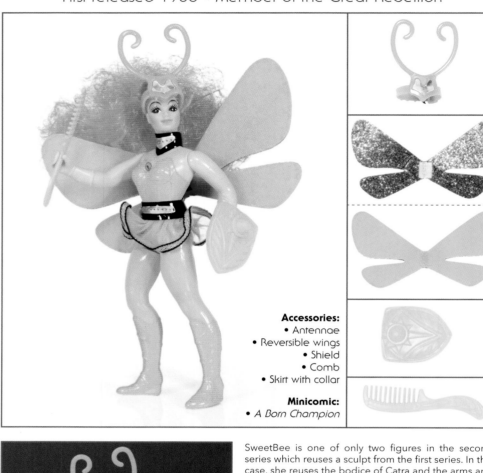

Accessories:
- Antennae
- Reversible wings
- Shield
- Comb
- Skirt with collar

Minicomic:
- *A Born Champion*

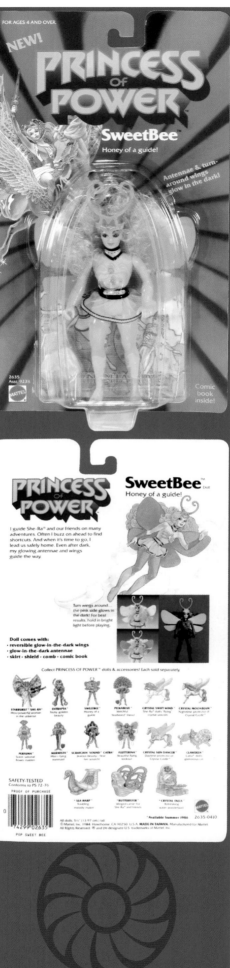

SweetBee is one of only two figures in the second series which reuses a sculpt from the first series. In this case, she reuses the bodice of Catra and the arms and boots of Double Trouble. SweetBee's bright yellow hair is in the same style as Glimmer's: a very curly ponytail. SweetBee and Entrapta come with the same comic, which features both of them prominently.

SweetBee's antennae and the pink side of her wings glow in the dark, giving her even more in common with Glimmer. Her antennae, skirt, and collar are accented with yellow prism stickers. She comes with a yellow comb and shield, which use the same mold as She-Ra's.

SweetBee has only one notable variation: her jewel can be either brown or yellow.

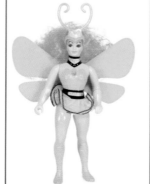

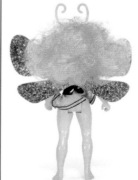

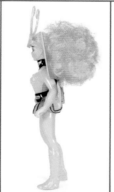

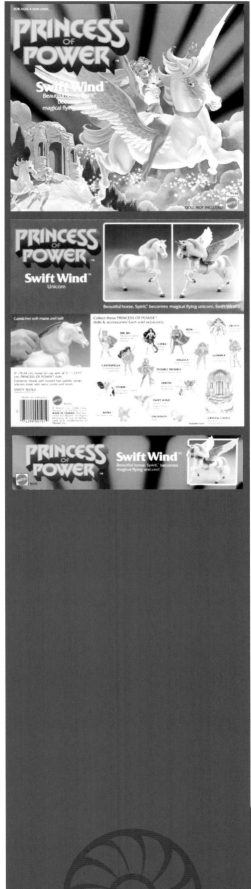

SWIFT WIND
BEAUTIFUL HORSE, SPIRIT, BECOMES MAGICAL FLYING UNICORN!

First released 1985 • Steed of the Great Rebellion

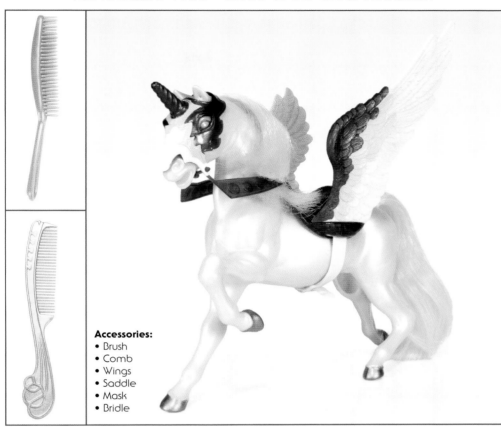

Accessories:
- Brush
- Comb
- Wings
- Saddle
- Mask
- Bridle

Swift Wind is meant to be two horses in one: Spirit for Adora and Swift Wind for She-Ra. Her transformation is a simple one: just add the wings and mask to make her Swift Wind. You read that correctly: Swift Wind in toy form is female, as opposed to Filmation's male steed. Swift Wind has rooted pink hair and the instructions detail ways to style her mane and tail. The comb and brush set that comes with all of these horses can also be found packaged with Barbie.

Her wings fit into notches in the saddle and fasten under the belly. This seems like a decent design, yet the wings have a tendency to slip during play. Swift Wind is embellished with shiny gold paint and blue eyes. Her body is a light, pearly pink with gold hooves, and her wings are white plastic with bright pink and gold paint.

Swift Wind's saddle, mask, and bridle can all be found in either a bright gold or a dark greenish-gold plastic. The gold on her wings and hooves is sometimes those colors or even more brassy.

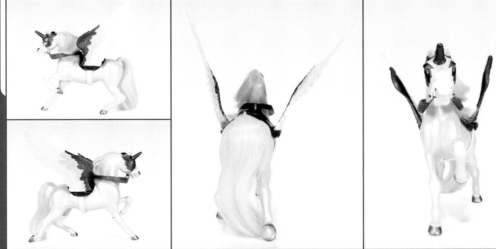

VEILS OF MYSTERY
LAYERS OF VEILS HIDE A SECRET SWORD!

First released 1986 • Accessory of the Great Rebellion

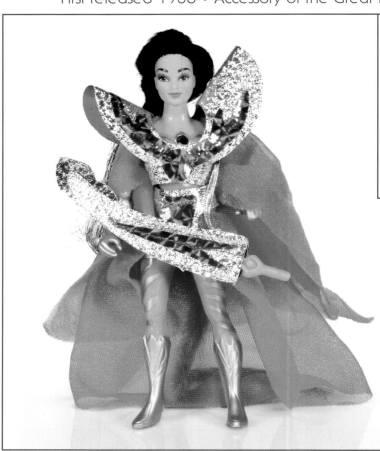

Accessories:
- Sheath
- Sword
- Skirt
- Vest
- Cape

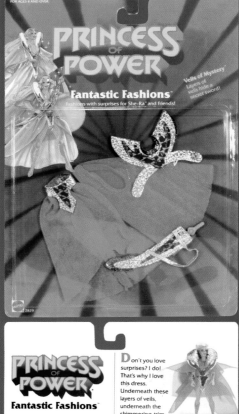

PRINCESS OF POWER
Fantastic Fashions

Veils of Mystery
Layers of veils hide a secret sword!

D on't you love surprises? I do! That's why I love this dress. Underneath these layers of veils, underneath the shimmering trim, is a special secret sword. So when trouble tries to take me by surprise, I can surprise it in return!

Veils of Mystery is a layered dressy fashion. The translucent dark pink and red fabric is matched with dimpled silver material for the vest, belt, and sword sheath, which are adorned with very dark pink prism stickers. The sword is made of purple plastic.

The packaging gives instructions for dressing the figure, and indicates the Secret Surprise: the multiple layers conceal the sword and sheath! While She-Ra is wearing this fashion, she is always ready for adventure, even if it catches her by surprise. Due to its color, this fashion displays nicely on She-Ra, Entrapta, and Scratchin' Sound Catra.

Being among the first series of fashions makes this one easier to find. The sword can be difficult to find loose.

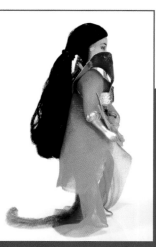

WINDY JUMPER
CHIFFON HAT! VEIL BECOMES WIND SAIL!

First released 1987 • Accessory of the Great Rebellion

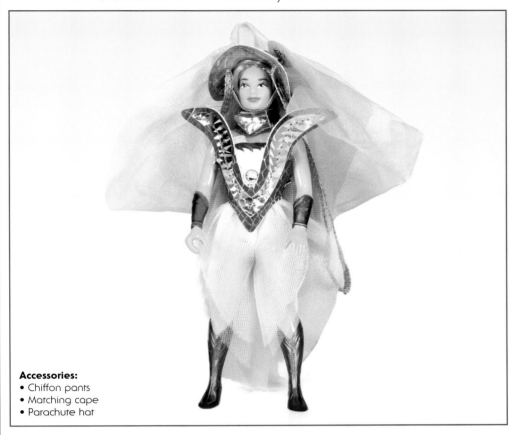

Accessories:
- Chiffon pants
- Matching cape
- Parachute hat

Windy Jumper is one of only two fashions to use a pantaloons design instead of a skirt. This one comes with white chiffon pants and parachute, and the hat and bodice are a brown reptile-like material adorned with golden prism stickers.

The packaging reveals the Secret Surprise: gently pull the veil, bringing the straps through the hat, and the veil becomes a wind sail! This fashion helps She-Ra jump into action when she spots trouble while high up in the Crystal Castle. Due to its color scheme, this fashion works the best for She-Ra, Starburst She-Ra, or Bubble Power She-Ra.

This fashion was not widely produced before the Princess of Power toy line was canceled, making it quite rare to find either carded or loose.

PRINCESS OF POWER INTERNATIONAL VARIANTS
by Christa Van Fleet and Darah Herron

With most popular toy companies, products from their lines are sold and manufactured internationally. Mattel's Princess of Power (POP) line was no exception. While it never quite attained the popularity of the Masters of the Universe (MOTU) line, the POP line proved reasonably popular during its run. The MOTU line was sold and produced in many different countries, and it made sense that the POP line would follow suit. While there is an abundance of information available on the regular releases, relatively little is known about the international variants. Even now information is scarce and is only found in a few places if you search hard enough.

Besides the regular Mattel Standard releases, which were made in either Taiwan or China, there were five other countries that produced the Princess of Power line during its run. These were France, Spain, Mexico, Venezuela, and Brazil. While there were only a few POP figures made in France, they are clearly marked as such. Unfortunately, the other international countries have no stamps on the figures to mark them. Most figures either have no country of origin stamp, or they are just marked "Taiwan" or "China." This is most likely because they were made using the same molds as the regular releases. Although the country stamps are not helpful in this regard, the figures from four of these other countries can be identified by sight. These variants occasionally show up on eBay and they are not listed as such, but once you know how to identify them you can usually pick them out right away.

The horses and the castle from the first series were also manufactured internationally (although Arrow was often excluded). There are two ways to establish whether a POP horse is a variant. First, the saddle straps will always pull forward on the belly of the horse, whereas the regular releases have straps that wrap straight around the belly. Second, the horses will also have a country or manufacturer stamp inside the left, back leg. These stamps will also appear on each piece of gear. With the castle, all the molds and accessories in the international variants are the same as the original release, but the fabrics may differ in color and texture. Each plastic piece will have either the country or the manufacturer's stamp.

PRINCESS OF POWER GIFT SETS

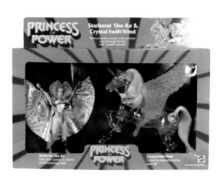

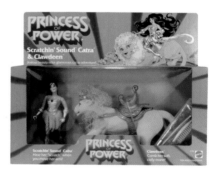

Just like He-Man and the Masters of the Universe, the Princess of Power toys would also offer gift sets. Each gift set featured a figure and matching steed. The exception to this arrangement is the Defenders of Good, which showcased no steeds and three figures: She-Ra, SweetBee, and Perfuma. Only two steeds were not represented as a gift pack: Royal Swift Wind and Silver Storm, due to the toy line being canceled halfway through the third year.

The early releases were in closed boxes with a small, clear plastic window to see the figure but not the steed inside. The back of the box shows photos of the toys included. The later series featured a box with a large plastic window to see both the figure and steed inside. The back includes artwork and bios designed specifically for this packaging arrangement. Each set contained all the same accessories and instructions or comic book as if they'd been packaged individually.

Defenders of Good also included unique artwork for its packaging, and interestingly the bios are similar but not the same as the individual carded figures' bios. The other anomaly with this set is that it appears that there was some sort of mistake on the packaging late in the process. As a result, Perfuma's name is added as a sticker on the front, meaning the name was originally wrong, misspelled, or omitted entirely (We're not willing to pull the sticker off to find out). The box also states that it comes with a comic book for She-Ra but does not indicate if there's one for SweetBee or Perfuma.

Not many of these gift sets exist, and they can be very hard to find. This is probably because each character and steed featured in the sets had already been released on their own. Therefore, many fans already owned the toys and did not need to repurchase a set, resulting in limited runs of the gift sets. Regardless, they were a great way to get a friend into She-Ra, as they made great birthday presents which might have encouraged that friend to buy even more!

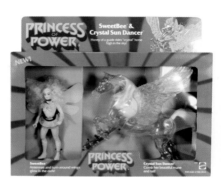

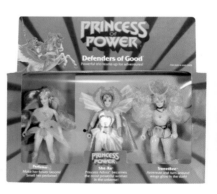

GEOGRAPHICAL DIFFERENCES by Name

Let's now take a look at each individual country of manufacture to better examine the differences.

France. The figures made in France were manufactured by Mattel. These are the only ones that may not be identifiable right away. To confirm for sure, you usually need to check for the France stamp on their backs. From the first series of figures, Mattel's French factory produced She-Ra and Catra, but these look very much like the regular Mattel Standard releases. Most times the French variant of Catra can be identified by her pink gemstone. However, some Catra figures were given a red gemstone, so this is not always a reliable way to tell. From the second wave of figures, Scratchin' Sound Catra, Peekablue, and Flutterina were produced in France. These versions have some slight differences in body paint color, but that is where it ends. The horses from the first and second series were also produced there. The first-series horses do not differ much from their regular counterparts, but you can identify their country of origin by looking inside the back, left leg and accessories. The second-series horses are also close to the regular releases, except that Crystal Swift Wind's gear and wings are less gold and somewhat grayish. All three horses have the France stamp on the inside of their legs and it shows through the plastic clearly. The packaging will have the regular Princess of Power logo on the front, but also the French-language version, "La Princesse du Pouvoir." All the regular figures will also be in the same packaging, but on the back it will clearly state, "Made in Taiwan."

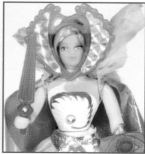

She-Ra (Spain Release)

Spain. The Spanish figures were produced by Mattel under the title "She-Ra y el Reino Magico." This translates as "She-Ra and the Magic Kingdom." If you have one of these figures in that packaging it is definitely Spanish. The packages are dated 1986, so that is probably close to when they were produced and made available. Only the first series of figures was made by the Spanish factory and Castaspella was excluded from production. Facially, these figures are quite different. The plastic of their heads can sometimes become a bit darker, so it doesn't quite match with the coloring of the body. Glimmer and Frosta have very vibrant-colored hair compared to their standard counterparts. Angella is the loveliest of the set, but She-Ra is quite pretty as well. Frosta and Glimmer both have odd, surprised expressions which can be quite amusing. The accessories are pretty much the same, but the fabrics and decals do have some very slight differences.

Oddly, the packaging for the horses states, "Made and printed in Spain." The horses themselves, though, are clearly marked "France" on the inside of the legs, as is all their gear. These appear to completely match the French releases, so they were most likely imported and placed in Spanish packaging.

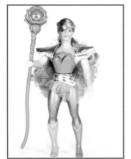
Glimmer (Mexico Release)

Mexico. The Mexican figures were produced by Aurimat under license of Mattel. The date on the packages is 1984, but they may have been produced a bit later, as the artwork featured on the packaging is from the second series. Figures were released in boxes instead of cards, with the front featuring Starburst She-Ra. The title on the box is "Princesas del Poder." The back features the normal artwork for the characters. Only part of the first series was produced in Mexico, and Double Trouble, Castaspella, and Kowl were not part of the set. The Mexican figures usually have lovely faces. Unfortunately, the plastic tends to break down and become discolored. The heads are usually a different color from the rest of the body. The plastic of the arms and legs has a tendency to develop white splotches or become all white. To find one without this discoloration is pretty rare. The accessories are the same for the most part. The biggest difference is that Catra was given a silver sword and her cat-faced shield was replaced by the normal starburst design. Swift Wind and Storm were also produced under Aurimat, but Arrow was excluded. Angella, Glimmer, and Frosta are the most common of the Mexican figures. They turn up on eBay on a regular basis. She-Ra, Catra, and Bow are usually the most difficult to find. Please note, all three series of horses were made in Mexico, but these were regular Mattel Standard releases, not produced by Aurimat.

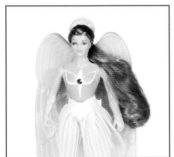
Angella (Mexico Release)

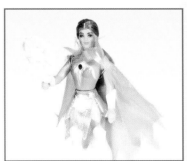
Frosta (Mexico Release)

Venezuela. The most interesting of the international variants were made in Venezuela by Rotoplast under license of Mattel. There are no dates on the packages, but it has been said that they were released in 1990. All human characters from the first wave were produced in Venezuela. The only toy from the second season produced here was Clawdeen. The Venezuelan versions of She-Ra and the others have more prominent eye makeup than the figures from any other countries. The clothing fabric is different as well. She-Ra and Frosta have clothing that has a soft layer and a netted layer, unlike the rest of their counterparts, who usually have pearly capes and skirts. The other pieces, such as the waistbands and the shoulder armor, are thicker and much shinier with huge snaps. Rather than the normal prism decals, She-Ra and Castaspella have metallic decals. The accessories are all fairly normal, with a couple of exceptions. The differences are that She-Ra has a gold sword in the Starburst mold with a gem, and Catra has a shield with the starburst design like the Mexican variant. Kowl is an interesting figure as he was released with no

Bow (Venezuela Release)

Frosta (Venezuela Release)

She-Ra (Venezuela Release)

Angella (Venezuela Release)

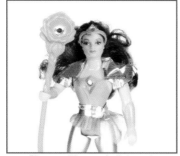
Glimmer (Venezuela Release)

flocking. What is most amusing is that Rotoplast seems to have made variants of the variants. One of these is Glimmer, who can be found with lilac-colored hair, but was also released with dark purple hair. Frosta can be found with a beautiful ice blue hair color and also with more of a pale aqua. Was this because the factory ran out of certain colors? It is possible, as other South American factories have been known to use different parts on their toys when supplies run low. As another example, there is a Rotoplast Frosta who has Castaspella's arms. This is just another reason why these figures are unique. It is very rare to find any of the figures mint on card, but they were all released in second-series packaging featuring Starburst She-Ra on the front of the card. The backs of the cards feature photos of the prototype figures rather than artwork. The animals and castle were all released in the regular series in boxes with artwork. Of all the Swift Wind variants, this one is the most different. The mane and tail are more of a peach color rather than the normal pink. Just the way it looks sets him apart from the other versions. Storm is, of course, the same as usual.

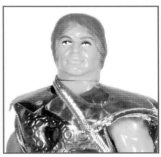
Bow (Brazil Release)

Brazil. The final set of variants were the Brazilian ones, produced by Estrela under license of Mattel. These have no dates on the packaging, but it is most likely that they were produced in the late eighties. Glimmer, Frosta, and Castaspella were excluded from production. The faces of the figures are a bit different and appear wider and flatter than other versions. They resemble the face of the Chinese-produced Starburst She-Ra. The accessories differ quite a bit. The fabrics are a bit more intricate in design. She-Ra's red cape can either be regular fabric or the normal pearly fabric. She-Ra's and Angella's clothing typically has a zigzag pattern but also occasionally has other patterns. She-Ra figures, for instance, have also been found with a floral pattern like a doily. Their outfits have no snaps; the gold and silver pieces of the capes and skirts are made to hook. Unfortunately, this usually causes tearing. Like the Venezuelan version, She-Ra also has a gold starburst-mold sword with gem. Swift Wind and Storm were also part of the series. Their bodies are not pearly, but more of a solid color. The castle has the same molds and accessories, but the colors of the floors and accessories are much brighter. Each piece is stamped "Estrela." The fabrics are different, and the bed has a yellow prism border around the canopy. Catra and Kowl both came with comics unique to this country. The titles, translated, are "She-Ra and the Evil Eye" and "Kowl and the Volcanic Ray." The Brazilian packaging features the normal first-series artwork but has the Estrela logo.

Even after all this time, there is probably still much more we can learn about these wonderful international variants. With the rise in popularity of the vintage POP series in the light of the MOTU Classics line, chances are that more information will come to light in the future. For now, hopefully the details presented here will help collectors in their searches for the fun and interesting international variants.

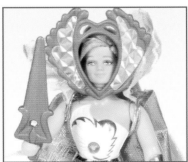
She-Ra (Brazil Release)

TIMELINE COLOR KEY

○ Trademark ○ Copyright

● First Use in Commerce ○ Concept

08/30/1984 • Angella first use in commerce
08/30/1984 • Castaspella first use in commerce
08/30/1984 • Catra first use in commerce
08/30/1984 • Double Trouble first use in commerce
08/30/1984 • Frosta first use in commerce
08/30/1984 • Kowl first use in commerce
08/30/1984 • Princess Adora first use in commerce
08/30/1984 • Swift Wind first use in commerce
09/10/1984 • Castaspella trademarked
09/10/1984 • Catra trademarked
09/10/1984 • Double Trouble trademarked
09/10/1984 • Kowl trademarked
09/10/1984 • Princess Adora trademarked
09/10/1984 • Swift Wind trademarked
09/12/1984 • She-Ra first use in commerce
09/12/1984 • Angella trademarked
09/13/1984 • Castaspella trademarked
10/23/1984 • She-Ra trademarked

01/23/1985 • Arrow first use in commerce
01/23/1985 • Crystal Castle first use in commerce
01/23/1985 • Enchanta first use in commerce
01/28/1985 • Arrow trademarked
01/28/1985 • Crystal Castle trademarked
01/28/1985 • Enchanta trademarked
03/08/1985 • She-Ra copyrighted
04/05/1985 • Catra copyrighted
04/05/1985 • Angella copyrighted
04/29/1985 • Swift Wind copyrighted
04/29/1985 • Glimmer copyrighted
05/16/1985 • Bow copyrighted
05/29/1985 • Princess of Power, She-Ra copyrighted
05/30/1985 • Clawdeen first use in commerce
05/30/1985 • Crystal Falls first use in commerce
05/30/1985 • Flutterina first use in commerce
05/30/1985 • Mermista first use in commerce

05/30/1985 • Peekablue first use in commerce
05/30/1985 • Perfuma first use in commerce
06/17/1985 • Clawdeen trademarked
06/17/1985 • Crystal Falls trademarked
06/17/1985 • Flutterina trademarked
06/17/1985 • Mermista trademarked
06/17/1985 • Peekablue trademarked
06/17/1985 • Perfuma trademarked
10/10/1985 • Crystal Castle copyrighted
11/06/1985 • Crystal Moonbeam first use in commerce
11/06/1985 • Crystal Sun Dancer first use in commerce
11/06/1985 • Crystal Swift Wind first use in commerce
11/06/1985 • Entrapta first use in commerce
11/06/1985 • Sweet Bee first use in commerce
11/12/1985 • Crystal Moonbeam trademarked
11/12/1985 • Crystal Sun Dancer trademarked
11/12/1985 • Entrapta trademarked
11/12/1985 • Sweet Bee trademarked
11/22/1985 • Double Trouble copyrighted
11/29/1985 • Enchantra (Enchanta) copyrighted
12/02/1985 • Kowl copyrighted
12/02/1985 • Castaspella copyrighted
12/31/1985 • Scratchin' Sound first use in commerce

01/13/1986 • Scratchin' Sound trademarked
02/07/1986 • Crystal Swift Wind trademarked
02/14/1986 • Sea Harp first use in commerce
02/28/1986 • Sea Harp trademarked
03/07/1986 • Fit to Be Tied first use in commerce
03/07/1986 • Fantastic Fashions first use in commerce
03/07/1986 • Flight of Fancy first use in commerce
03/07/1986 • Butterflyer first use in commerce
03/07/1986 • Deep Blue Secret first use in commerce
03/07/1986 • Flower Power first use in commerce
03/07/1986 • Hold On to Your Hat first use in commerce
03/07/1986 • Ready in Red first use in commerce
03/07/1986 • Rise & Shine first use in commerce
03/07/1986 • Veils of Mystery first use in commerce
03/14/1986 • Flight of Fancy trademarked
03/17/1986 • Fit to Be Tied trademarked
03/17/1986 • Fantastic Fashions trademarked
03/17/1986 • Flower Power trademarked
03/17/1986 • Butterflyer trademarked
03/17/1986 • Deep Blue Secret trademarked
03/17/1986 • Hold On to Your Hat trademarked
03/17/1986 • Ready in Red trademarked

03/17/1986 • Rise & Shine trademarked
03/17/1986 • Veils of Mystery trademarked
05/28/1986 • Clawdeen copyrighted
05/28/1986 • Flutterina copyrighted
05/28/1986 • Peekablue copyrighted
06/05/1986 • Blue Lightning first use in commerce
06/05/1986 • Colorful Secret first use in commerce
06/05/1986 • Frosty Fur first use in commerce
06/05/1986 • Heart of Gold first use in commerce
06/05/1986 • Hidden Gold first use in commerce
06/05/1986 • Reflections In Red first use in commerce
06/05/1986 • Secret Messenger first use in commerce
06/05/1986 • Windy Jumper first use in commerce
06/23/1986 • Blue Lightning trademarked
06/23/1986 • Colorful Secret trademarked
06/23/1986 • Frosty Fur trademarked
06/23/1986 • Heart of Gold trademarked
06/23/1986 • Hidden Gold trademarked
06/23/1986 • Reflections In Red trademarked
06/23/1986 • Secret Messenger trademarked
06/23/1986 • Windy Jumper trademarked
09/17/1986 • Bubble Power first use in commerce
09/17/1986 • Shower Power first use in commerce
09/22/1986 • Bubble Power trademarked
09/30/1986 • Loo-Kee first use in commerce
09/30/1986 • Netossa first use in commerce
09/30/1986 • Royal Swift Wind first use in commerce
09/30/1986 • Silver Storm first use in commerce
09/30/1986 • Spinnerella first use in commerce
09/30/1986 • Tallstar first use in commerce
10/06/1986 • Loo-Kee trademarked
10/06/1986 • Netossa trademarked
10/06/1986 • Royal Swift Wind trademarked
10/06/1986 • Spinnerella trademarked
10/06/1986 • Jewelstar trademarked
10/06/1986 • Tallstar trademarked
10/06/1986 • Glory Bird trademarked
11/17/1986 • Shower Power trademarked
11/17/1986 • Silver Storm trademarked

1987

02/09/1987 • Jewelstar packaging mockup
02/09/1987 • Starla packaging mockup
02/09/1987 • Tallstar packaging mockup
02/27/1987 • Glory Bird packaging mockup

Notes:
• Glimmer trademark: there is an earlier Mattel use that predates POP, and it was probably reused
• Starla trademark: there is an earlier Mattel use that predates POP, and it was probably reused
• Starburst She-Ra Trademark found, but there is a 1970s trademark for Starburst Stunt Team
• Storm trademark not found; the word was probably too generic

CHAPTER 3

HE-MAN (1989)

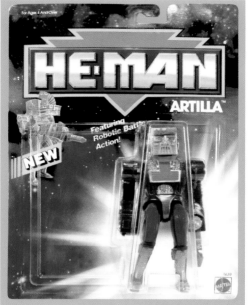

FUN FACTOID: Several figures in the He-Man toy line had different names for their foreign releases. Outside of the US, Artilla is known as "Weaponstronic."

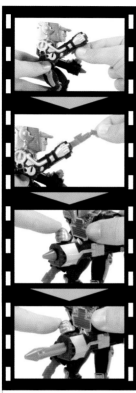

ARTILLA

First released 1991 • Member of the Galactic Guardians

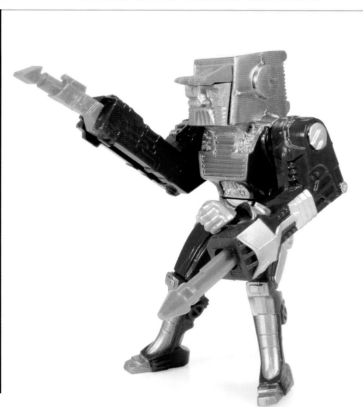

The heroic Artilla is a protocol android reprogrammed for robotic battle against the Evil Mutants!

The figure has a blocky feel to its overall design, yet somehow simultaneously still captures that more slender build seen on most of the New Adventures action figures. His head is square in shape, while his torso is boxy with oversized rectangular arms. His legs do have a robotic feel to their sculpt, but they are still slender and very humanoid, meaning they almost don't match his upper body.

While Artilla does still feature the typical pelvic and knee articulation, it's worth noting that his legs are sculpted in a wide battle stance. This wasn't done too often in this particular line of figures. It was most likely done with Artilla to keep him better balanced, since his upper body is shaped so oddly.

He does not include any accessories but has many strange spring-loaded action features. By pressing a button on the back of his head, his face springs forward in an awkward head butt. This reveals his "infrared power probes" that can be lifted up on top of his face circuitry. A red hyper-blaster can be flipped out of his right arm, while his left arm has a heat-seeking missile that springs forward, though it doesn't actually launch out of his arm.

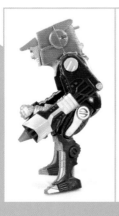

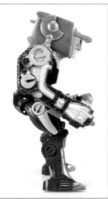

ASTROSUB

First released 1989 • Vehicle of the Galactic Guardians

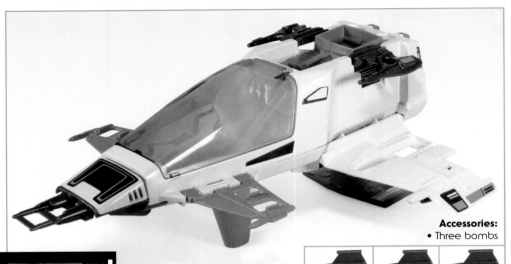

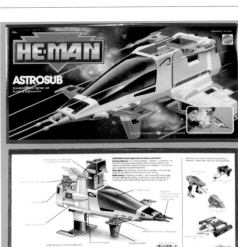

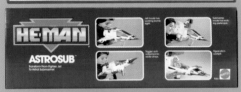

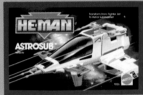

Accessories:
• Three bombs

The Astrosub is the main aerial vehicle of the heroic Galactic Guardians. As the name implies, the vehicle is supposed to double as both a fighter jet and an underwater craft, although the toy is not actually promoted as being usable in water.

Two handles positioned on the bottom allow you to hold on to the ship for pretend flight. They also work as stands to display the ship. The opening cockpit holds one action figure inside. The smaller wings on the front, larger wings on the back, and laser cannons up top all have the ability to fold up and down, which is part of the transformation between ship and sub.

Three bombs are included with the ship. A small clip on the underside can hold on to one bomb. By pressing the trigger conveniently placed on the back handle, the bomb is released and drops to the ground. You can also store the two additional bombs on the underside of the wings.

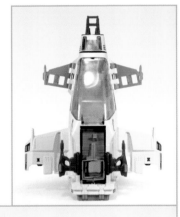

The main play feature is the working periscope. By raising the periscope up and locking it in place, you can look in through the back of the ship to target the foes! It doesn't really give you an accurate aim, especially for the bomb drop. But it's a fun feature nonetheless.

FUN FACTOID: The Astrosub is one of the vehicles in the line that feature a modular connector on the bottom, allowing it to be docked onto the Starship Eternia or even the Terroclaw.

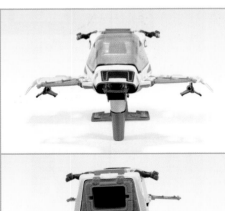

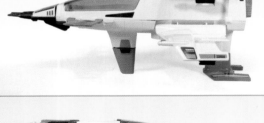

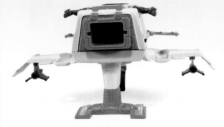

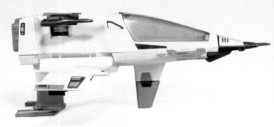

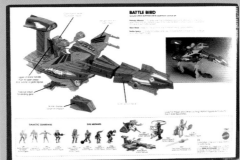

FUN FACTOID: The Battle Bird is known for being hard to come by. It's also notorious for breakage due to the brittle plastic that was used. This breakage may contribute to the vehicle's scarcity.

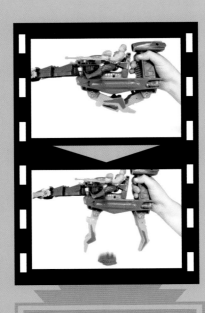

BATTLE BIRD

First released 1991 • Vehicle of the Galactic Guardians

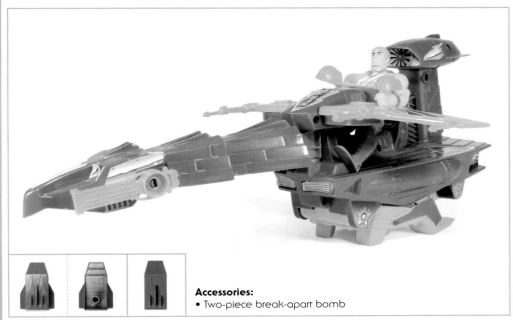

Accessories:
• Two-piece break-apart bomb

The heroic Battle Bird vehicle is described as a ground-strike skimmercraft and supersonic pursuit jet.

Like we've seen on other vehicles in this line, the back of the Battle Bird is shaped like a handle, allowing you to "glide" the ship over the battlefield for attack!

The design of this one is actually quite striking. It's very colorful, using bright blue and orange colors. There's even a large sticker on the top featuring the He-Man logo from the toy packaging so that everyone will know who's coming to get them!

The front of the ship is shaped like the head of a bird. The "scan-action" neck is articulated in three places, allowing the bird to look both left and right. This is supposed to be a feature of the ship that allows the rider to scan for enemies.

A trigger placed on the handle will open the claws on the bottom of the ship. This has multiple uses. You can actually land the vehicle with the claws down, making it look like a bird standing on its legs. It can also be used to grab figures and carry them away.

There is also a bomb included that can be placed inside the closed claws. This way when you pull that trigger while in flight, the bomb will drop from the claws and break apart into two pieces when it hits the ground!

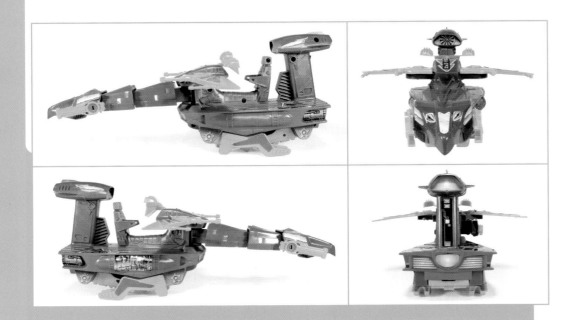

BATTLE BLADE SKELETOR

First released 1992 • Member of the Space Mutants

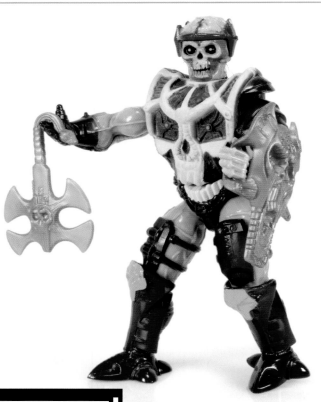

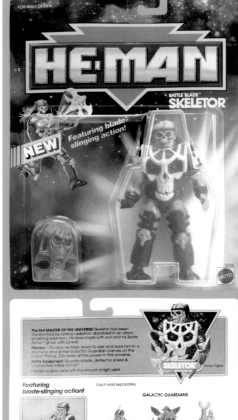

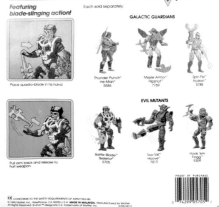

Accessories:
• Quadro-blade throwing axe
• Deflector shield

Battle Blade Skeletor is the third and final variation of the main enemy in the He-Man toy line. Like many of these figures near the end, he is much bulkier than earlier releases, making him feel a little more in line with the more muscular figures from the original Masters of the Universe toy line.

The color scheme is very familiar, featuring bright blue skin, deep purple armor bits, and a yellow-and-green skull face. This is another area which causes him to seem more connected to the original toy line. There are some unique and even odd choices for his new armor.

The figure is wearing a sort of purple headband or tiara around his head. The bit that is particularly weird is on the back, where for the first time ever, Skeletor features rooted black hair! It's certainly jarring to see Skeletor with hair, and it's not really clear if it's just part of that headband or if it's actually sprouting from his scalp.

His skull-faced "luminactive" armor is not only distinctive, but it also glows in the dark! It works quite well, and gives the appearance of a giant, floating skull coming at you in the pitch black.

Battle Blade Skeletor also features blade-slinging action! The quadro-blade accessory balances in the figure's open right hand by the curled piece on the bottom. By pulling his arm back and releasing, the spring-loaded arm shoots forward and launches the quadro-blade into the air!

FUN FACTOID: Battle Blade Skeletor was supposed to have much rattier hair, but he was given straight hair instead because Mattel's engineers had more experience with that from their work on Barbie.

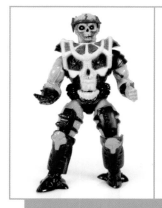

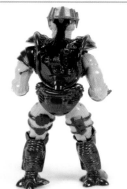

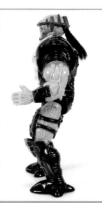

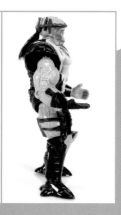

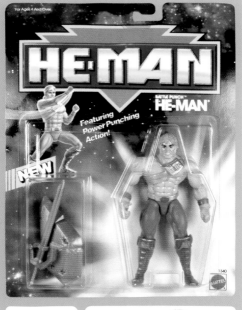

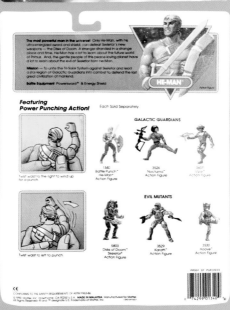

FUN FACTOID: Battle Punch He-Man was based on a design by Mark Taylor.

BATTLE PUNCH HE-MAN

First released 1990 • Member of the Galactic Guardians

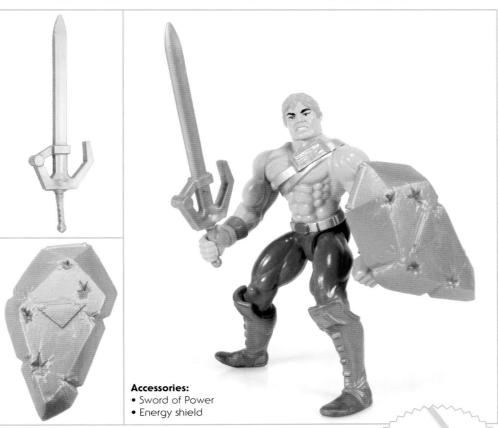

Accessories:
- Sword of Power
- Energy shield

This has got to be one of the strangest He-Man action figures ever, due to both his look and his wacky articulation!

The overall look of the figure is very similar to the first He-Man release in this line, still wearing the blue pants and similar boots. The overall design is starting to get a little more muscular, a direction that you will see continue with many of the later-released action figures. The musclebound physique of this particular figure could be said to be a little excessive though—his abs are a little out of control.

The Sword of Power has been redesigned for this figure. It has a new shape and is this time made out of a gold plastic instead of the translucent yellow seen on the first release. It's also much larger, almost comically oversized for the figure. The shield is also large, but has interesting nicks and dings, making it look like it has been through some tough battles.

While he doesn't have a traditional action feature, Battle Punch He-Man is known for his odd new articulation. The first new addition is a wrist swivel. This allows He-Man to realistically hold the Sword of Power up over his head. It's a very effective new joint that fits so well with the character.

The other joint is not quite as neat. There is a diagonal swivel joint across his chest that is meant to allow He-Man to follow through with a punching motion. The downside is that it's completely unrealistic, and twisting him makes it look as though his body has been cut in half.

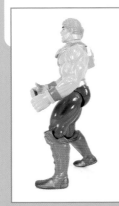
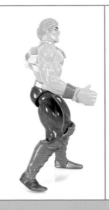
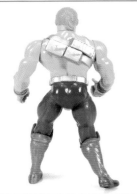
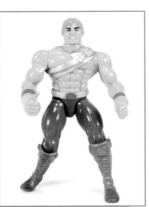

BOLAJET

First released 1989 • Vehicle of the Galactic Guardians

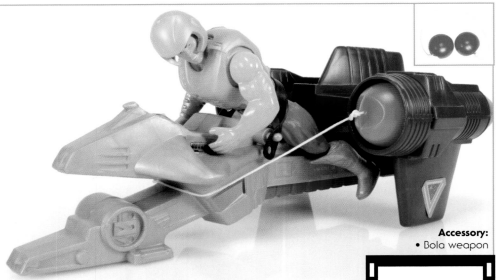

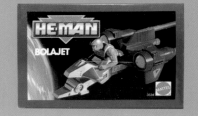

Accessory:
• Bola weapon

The Bolajet is described as a low-altitude reconnaissance vehicle made for patrolling and protecting Primus, with the ability to engage in close-range battle.

He-Man or any of your Galactic Guardians sit on the Bolajet much like you would sit on the seat of a motorcycle. Like many of the vehicles in this line, there is a handle that can fold down, allowing you to easily "fly" the vehicle around.

The main action feature is the firing bola weapon. The two red bolas fit into the cannons on the back end of the ship, with the string stretched around a small notch at the front. Pulling the red plunger on the back will prep the cannons for fire. This is another moment where the handle comes in handy, as it allows you to hold and aim the Bolajet almost like a gun.

If you press down on the red plunger on the back, the cannons launch simultaneously, hurling the bola weapon forward at an enemy action figure. Gravity then does its thing, as the bolas wrap around the figure—trapping him in place! The feature works rather well and is quite satisfying to pull off!

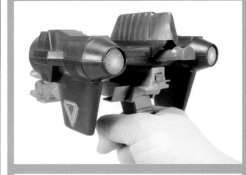

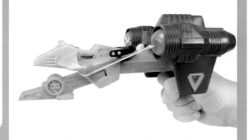

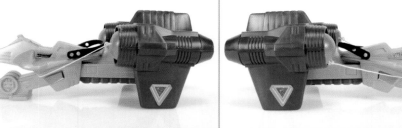

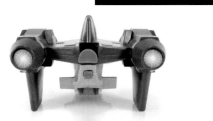

HE-MAN

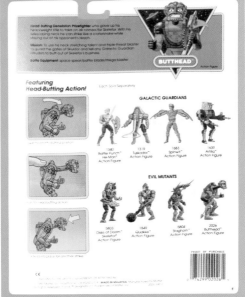

FUN FACTOID: Butthead was designed by Mark Taylor, who also designed the original 1982 He-Man and Skeletor figures, among many others.

BUTTHEAD

First released 1991 • Member of the Space Mutants

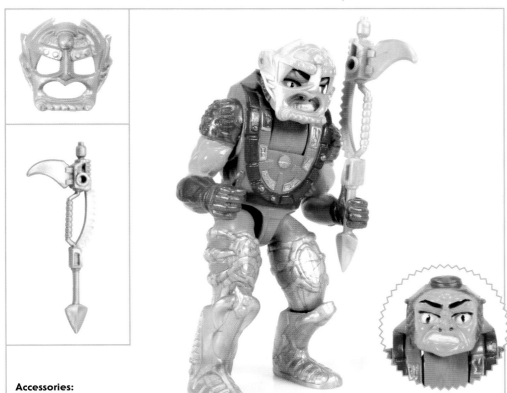

Accessories:
- Mask
- Space spear

While all of the Evil Mutants are quite bizarre looking, Butthead might be one of the weirdest. He also has the most unfortunate name.

Most of the bad guys in the line stick to the same slender proportions. However Butthead almost looks like a cartoon character in design. He has a hunched torso and a rounded head with large eyes and mouth that look almost animated in nature. His color palette is also all over the place, with orange skin, copper gloves, silver boots, and a neon green bodysuit. He's an odd one, that's for certain.

As you might have guessed from his name, his action feature is a spring-loaded head butt! By pressing the button on his back, Butthead's head butts forward, knocking over his foes! There is also an interesting ball joint at the neck that you can move by pivoting the larger area on his back with your thumb.

Many of the figures within this line feature weapons that are designed to be held in various ways, effectively making them act as multiple weapons in one. Butthead's included accessory can be held so that it functions as a Space Spear. Flip it upside down and it suddenly becomes a Battle Blade! Or flip it more horizontally, and he now has a Mega Blaster!

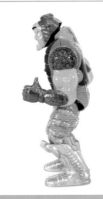

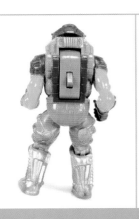

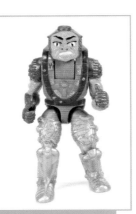

DISKS OF DOOM SKELETOR

First released 1990 • Member of the Space Mutants

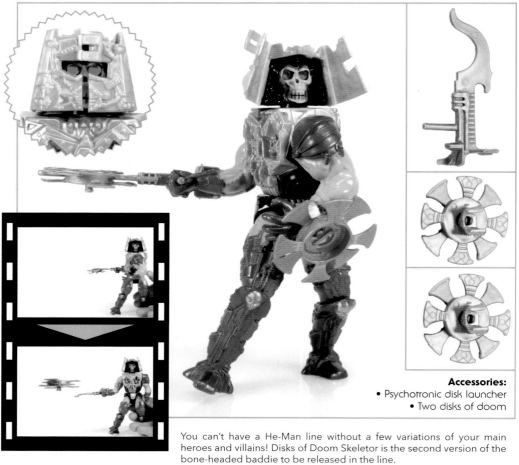

Accessories:
• Psychotronic disk launcher
• Two disks of doom

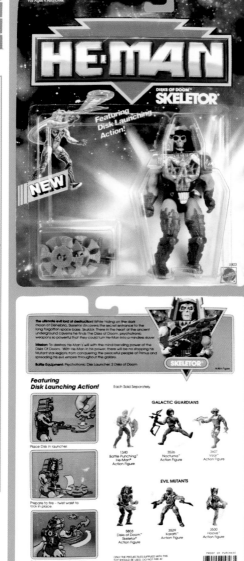

You can't have a He-Man line without a few variations of your main heroes and villains! Disks of Doom Skeletor is the second version of the bone-headed baddie to be released in the line.

His overall build is very similar to the first figure released, with the same slender frame. However, you can see Mattel making some transitions with his appearance that give him more of a vintage MOTU feel. Specifically, the bone face is now a bright yellow and green in color, with glowing red eyes. The shape also feels a bit more like the classic figure many of us grew up with in the 1980s.

And when I say glowing eyes, it's meant literally! There is a light-piping action feature. When a light source is directly above Skeletor's head, the light shines through and makes his eyes appear to glow a bright red. It's a really fun action feature that works incredibly well.

His new armor has an odd box-shaped helmet over his head that includes two flaps that can close over his face, almost like a space-age knight's helmet. It's designed a little strangely, as you have to bend the plastic hinges in order to close the flaps. It leaves a permanent crease in the plastic, and it also doesn't latch closed very well.

Disks of Doom Skeletor's main action feature makes use of the Psychotronic disk launcher held in his right hand. He has a spring-loaded waist that locks in place when his body is twisted. By placing a disk in the launcher and then pressing the button on the side of the figure, Skeletor quickly lunges forward, flinging the bladed Disk of Doom at his enemies!

FUN FACTOID: The design for Disks of Doom Skeletor, particularly in the helmet and chest armor, was a reworked version of an earlier "Space Pirate" character designed by David Wolfram.

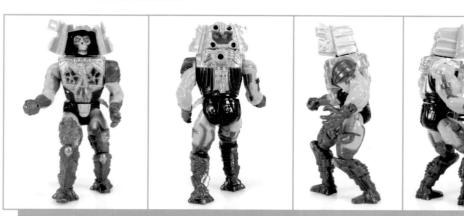

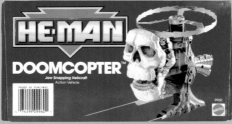

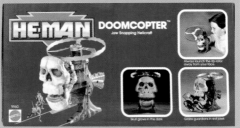

DOOMCOPTER

First released 1991 • Vehicle of the Space Mutants

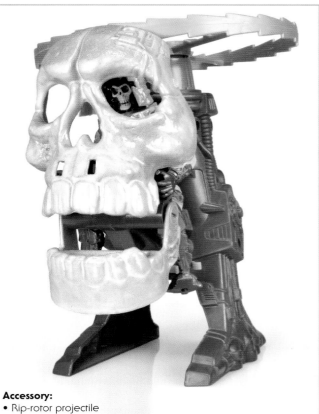

Accessory:
• Rip-rotor projectile

Skeletor might just be obsessed with his own skull-face seeing as he likes to wear it on his own armor and even design his vehicles with it! The Doomcopter is an odd-shaped helicopter-like vehicle, featuring a massive skull design on the front that also acts a shield for Skeletor riding within!

Like many of the vehicles in the He-Man toy line, the Doomcopter features a handle on the back that allows you to "fly" it around. There are two triggers on this handle. One of them launches the bladed propeller right off the copter in a fast-spinning motion, ready to plow over any Galactic Guardians that get in the way!

The other trigger operates the mouth of the skull on the front of the Doomcopter! This chomping motion can be used to "eat" enemy action figures, or perhaps to make the Doomcopter speak (using your own menacing voice, of course!).

If that skull face on the front wasn't enough fun on its own, it also glows in the dark!

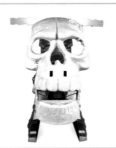

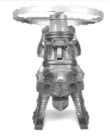

FLIPSHOT

First released 1989 • Member of the Galactic Guardians

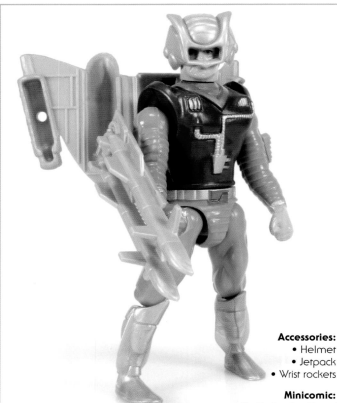

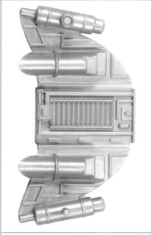

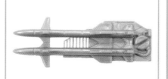

Accessories:
- Helmet
- Jetpack
- Wrist rockets

Minicomic:
- *Battle for the Crystal*

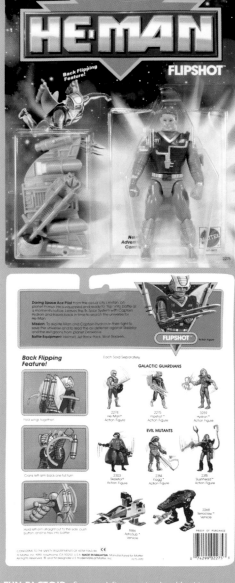

The daring space ace pilot Flipshot is one of He-Man's main allies.

Like many of the Galactic Guardians, Flipshot is humanoid. The heroes in this line are much less weird and surreal than the heroes found in the original Masters of the Universe toy line. This was likely done to better distinguish them from the Evil Space Mutants, which are considerably weirder and thus a lot more popular with fans!

Flipshot features a blue-and-silver color scheme. He has a removable silver helmet with a cutout visor section that fits over his eyes. He also comes with a jetpack with wings molded in the same silver color that can be clipped to his back, and a pair of wrist rockets that clip to his arm.

The action feature on Flipshot perfectly fits with the character's name. The first step to prepare him for action is to fold the wings of his Jetpack together. There are no articulated hinges on the wings, so folding them will unfortunately permanently crease the plastic. The wings can then be clipped together, making them more compact. You can then wind up his left arm. Once wound, hold the arm straight out with your thumb and index finger and then press the button. Flipshot will begin flipping forward, ready to flip-kick the enemy!

FUN FACTOID: Several figures in the He-Man toy line were given completely different names for their foreign releases. Outside of the US, Flipshot is known as "Icarius."

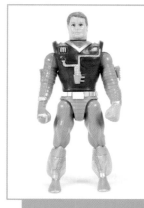

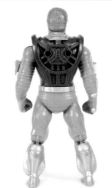

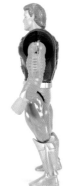

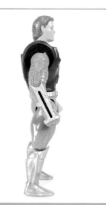

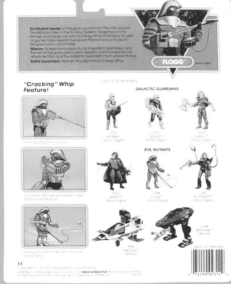

FLOGG

First released 1989 • Member of the Space Mutants

Accessories:
• Energy whip
• Chest armor
• Helmet

Minicomic:
• *The Revenge of Skeletor*

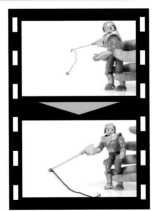

FUN FACTOID: Several figures in the He-Man toy line had alternate names for their foreign releases. Outside of the US, Flogg is known as "Brakk."

The Evil Mutant leader of the goon squad! Or at least he was the leader until Skeletor showed up!

While the artwork on the packaging shows Flogg wearing a red outfit with golden armor bits, the actual toy replaces the gold with a more silver color for the armor and weapon. The chest armor is removable and can easily be clipped onto the figure by fitting it over his head. The helmet is also a removable accessory and locks firmly on top of his odd-shaped purple head.

Flogg is another Space Mutant who has a bit of a cartoonish look to his face, with his large eyes almost bugging out of his head.

His "energy whip" accessory can be clipped on to his right hand and features a real piece of string with a plastic bit at the end for weight. By rotating Flogg's torso from side to side, the figure lashes his energy whip back and forth!

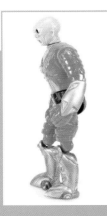
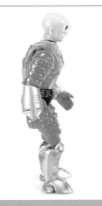

HE-MAN

First released 1989 • Member of the Galactic Guardians

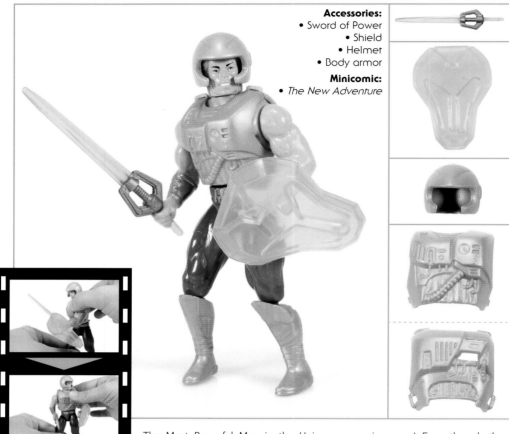

Accessories:
- Sword of Power
- Shield
- Helmet
- Body armor

Minicomic:
- *The New Adventure*

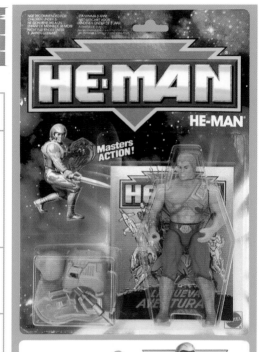

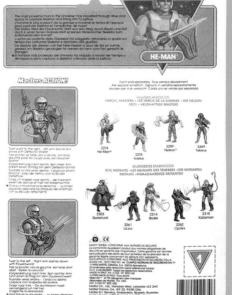

The Most Powerful Man in the Universe, now in space! Even though the original Masters of the Universe toy line did a great job of working in futuristic technology, this new line of toys completely does away with the barbarian swords-and-sorcery aspects to fully focus on the futuristic aesthetic. He-Man is drastically different looking in this new series. He has traded in his furry loincloth and boots for a pair of bright blue pants and golden boots. He also features golden body armor that can be clipped on to the torso, and a removable golden helmet.

The body shape is also quite a departure from the original incarnation of the character. Where the vintage Masters of the Universe action figures had muscular bodies and squat legs, this new He-Man is much more in line with other toys that were on the shelf at the time. He has lost a lot of muscle mass, now featuring a more slender build. And for the first time ever, He-Man can bend his knees!

The long pageboy haircut is now pulled back into a ponytail, although the sculpt of the figure makes it look like his hair is now much shorter. But while much of the figure looks considerably different, a really effective design element sees He-Man's face looking just like the face on the vintage action figure.

This time around, the Sword of Power also has a more futuristic look to it, with a golden handle and a translucent yellow-green blade that makes it look more like a laser sword. He-Man's new shield is made of the same translucent material. When he's twisted at the waist, He-Man's arms move up and down opposite each other to create a sword-slashing action!

FUN FACTOID: The reason why He-Man and other New Adventures figures were smaller than previous Masters of the Universe figures was because Mattel wanted the figures and play sets to fit better into the smaller homes typical in the international market.

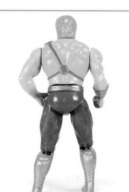

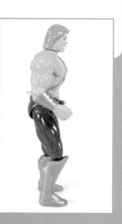

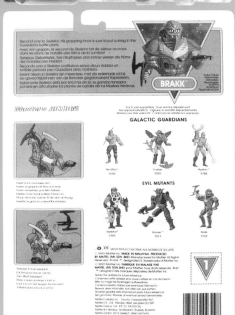

HOOK EM FLOGG

First released 1992 • Member of the Space Mutants

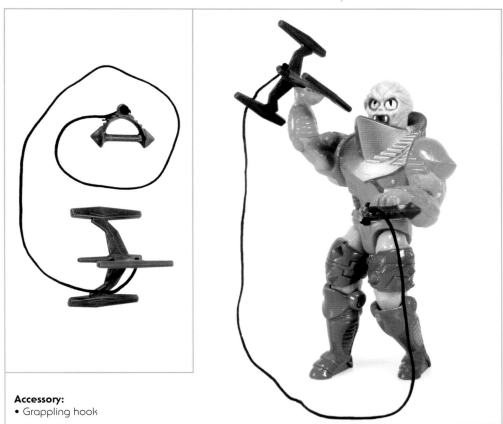

Accessory:
• Grappling hook

HE-MAN

Second to only Skeletor, his grappling hook is sure to put a snag in the Guardians' battle plans!

This variation of one of the main villains was released towards the end of the He-Man toy line. Like many of the figures in this final wave, Flogg has been beefed up quite a bit from his first release. This was likely done as a way to make the figures feel a bit more in line with the original Masters of the Universe toy line, since they had felt so drastically different at the start.

The new sculpt is quite an improvement over the first release of Flogg. The face sculpt looks a lot more sinister this time around, and less cartoonish. His armor is very similar to what was seen on his first figure, but is sculpted with a bit more detail and better paint deco. The armor is also not removable this time around.

Flogg's grappling hook accessory has a real piece of string connected to a handle that can be gripped with his left hand. The hook itself then rests in the closed right hand. When his right arm is raised and then released, the arm springs forward and launches the grappling hook while Flogg keeps hold of the handle in his left hand.

Like many of the figures in the final wave, Hook Em Flogg is a bit scarce and is one of the more sought-after figures in the He-Man toy line.

FUN FACTOID: Several figures were given alternate names for their foreign releases. Hook Em Flogg is known as "Hook Em Brakk" outside of the US.

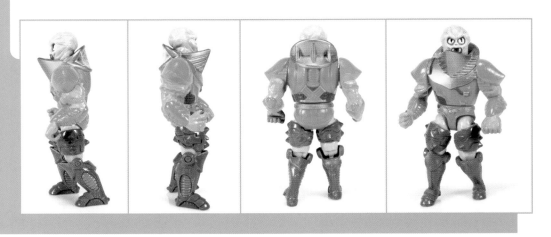

HOOVE

First released 1990 • Member of the Space Mutants

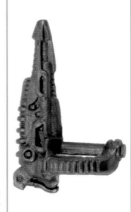

Accessories:
- Removable helmet
- Hyper-byte blaster

The stubborn, mule-minded Mutant with a mean temper and an even meaner battle kick!

Hoove is another odd-looking villain who looks as though his body is mostly cybernetic or robotic in nature. He's mostly gold and bronze in color, but has a bright green head with a deranged toothy smile!

Because of his unique action feature, Hoove's legs are set unnaturally far apart from each other, but this can also be explained by the seemingly robotic nature of his body. His right leg is weighted, and when his torso is tilted back, the right leg quickly flings forward to deliver a powerful battle kick! When his torso is tilted forward, the leg flings back to deliver a mule kick!

There are often some balance issues with Hoove because of his action feature. His upper body has a tendency to fall forward or backward when attempting to stand him up, especially if the action feature has worn out over years of use.

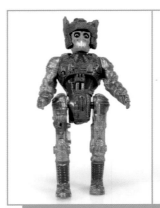

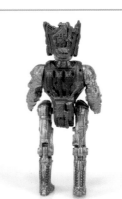

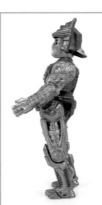

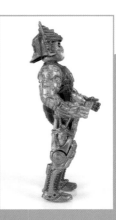

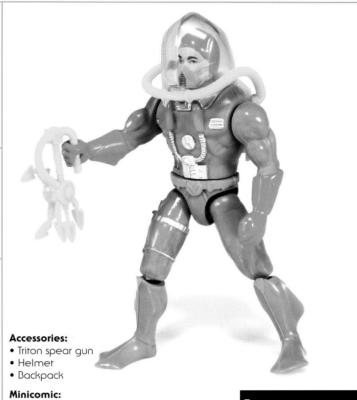

HYDRON

First released 1989 • Member of the Galactic Guardians

Accessories:
- Triton spear gun
- Helmet
- Backpack

Minicomic:
- *Battle for the Crystal*

The gallant spacesea commander who is described as coming from the Guardian Sea to lead the underwater defense against Skeletor!

Hydron may seem slightly odd for wearing scuba gear in space battles, but at least the description on his packaging specifies clearly that his main purpose is to take charge of underwater defense!

The figure includes a removable clear scuba dome that can fit over the figure's head. There is also an included oxygen tank backpack that clips on the figure's back. You can then bend the plastic hoses forward and attach the breathing apparatus to the front of the helmet. Unfortunately the hoses are not made of a softer plastic, and are actually quite brittle. As a result, it's not uncommon to find a Hydron figure with broken hoses on the backpack.

His Triton spear gun is an interestingly designed accessory that can be held with the points facing either upward or downward. When he grips it so they are pointing down, it plays perfectly into his arm-flailing action feature.

The arms can be wound up clockwise. Once properly wound, a quick turn of the waist will send them rapidly unwinding to create a "swimming" motion. If he is holding his Triton spear, it also works as a vicious attack!

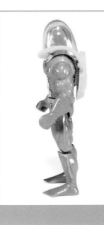

KARATTI

First released 1990 • Member of the Space Mutants

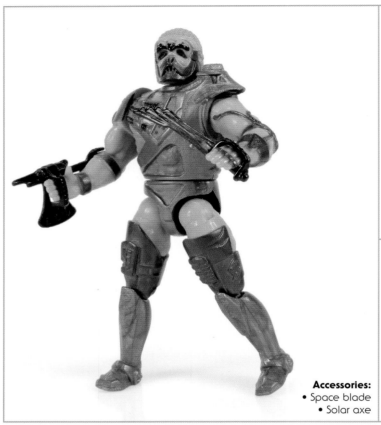

Accessories:
• Space blade
• Solar axe

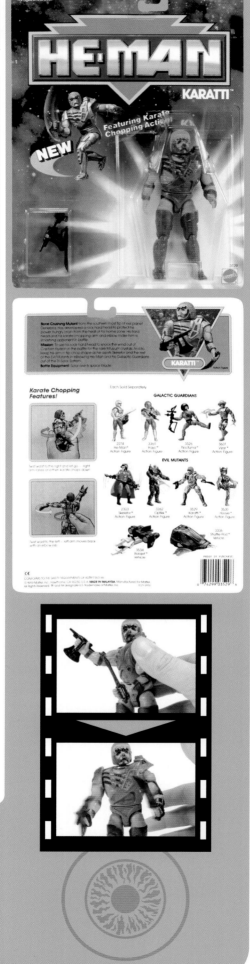

Karatti is described as a bone-crushing Mutant who has developed a rock-hard head to protect his power-hungry brain!

With neon green skin, hints of purple and red, and a gold set of armor, Karatti is one of the more interesting looking Evil Mutants in the line. With his face mask and dreadlock-like hair, it is easy to see that he might have been inspired by a certain Predator from the science-fiction world.

He has two unique weapons. The Space Blade is just a short sword in black plastic that can be held in his left hand. The other is the Solar Axe. This weapon clips on the right wrist, and looks as though it might also double as a laser blaster!

As you can deduce from his name, Karatti's action feature sees him delivering martial-arts-type moves. Twisting his waist to the right and letting go will cause his right arm to lift and then karate chop downward! This is extra effective if he is wielding his Solar Axe. When you twist his waist to the left, his left arm swings backward with an elbow jab!

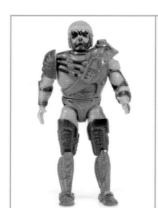

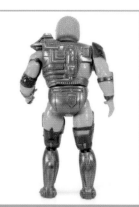

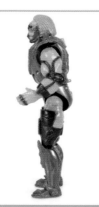

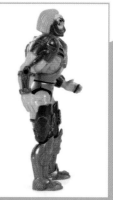

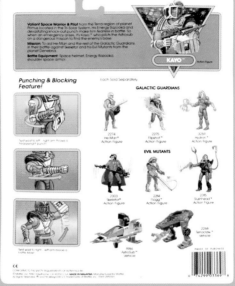

KAYO

First released 1990 • Member of the Galactic Guardians

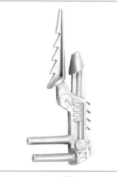

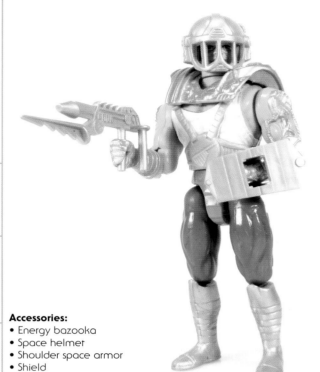

Accessories:
- Energy bazooka
- Space helmet
- Shoulder space armor
- Shield

Minicomic:
- *Battle for the Crystal*

The valiant space warrior and pilot known as Kayo is a fearless Galactic Guardian with a knockout punch!

Kayo has a really interesting look going on with his uniform. He's wearing a white tank top, red trunks, and blue pants. Over that he has a removable space helmet and space armor that sort of resembles an American football helmet and pads. He looks more like he's training for some sort of space sport rather than fighting off Skeletor and his goons.

Sculpted on to both arms are what look like cybernetic attachments. He is described as having a knockout punch, so we can gather that he has been cybernetically enhanced somehow. He has an energy bazooka that can be held in his right hand, and a shield that clips onto his left wrist.

To play up on the cybernetic sculpting, Kayo's action feature is based on his ability to deliver a powerful punch. By twisting his waist to the left, his right arm throws a heavyweight punch! By twisting his waist the opposite direction, Kayo raises his shield on his left arm to block the blows of the enemy!

FUN FACTOID: Several figures in this line had alternate names for their foreign releases. Kayo is known as "Tatarus" outside of the US.

LIZORR

First released 1990 • Member of the Space Mutants

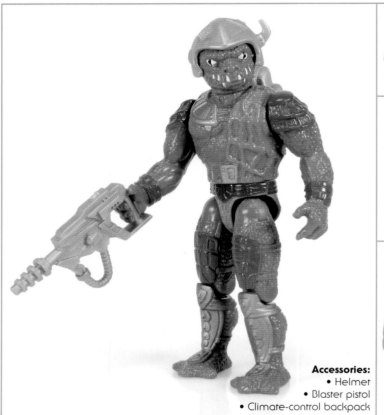

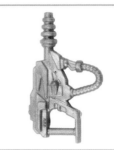

Accessories:
- Helmet
- Blaster pistol
- Climate-control backpack

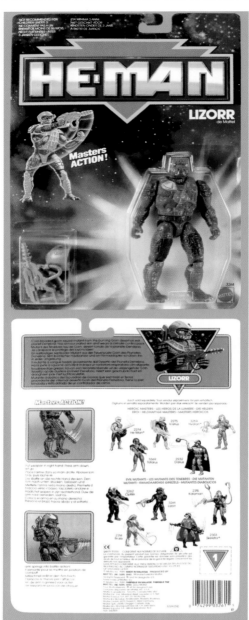

The cold-blooded goon squad Mutant is described as having armor-plated skin and wears a climate-control backpack since he is used to the heat.

Lizorr has such a classic sci-fi space creature look to him—giant green lizard person wearing golden armor. His color palette and look easily makes you think of classic creatures such as the Gorn from *Star Trek*. Another fun piece of sculpting is the shape of his feet—the three-toed look feels very much like what many of the villains had during the original Masters of the Universe toy line.

Aside from his clip-on climate-control backpack and removable helmet, Lizorr also includes a blaster pistol that can be held in his right hand. He has a spring-loaded arm that, when lowered and released, quickly flies back up, making it look as though he has drawn his weapon for attack. It's not the most exciting feature, all things considered. But the packaging refers to it as his "Masters Action!"

FUN FACTOID: Lizorr's original B-sheet design by David Wolfram specified color-changing skin, like a chameleon. The feature was not incorporated into the figure.

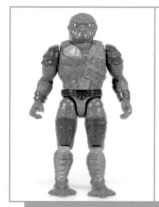

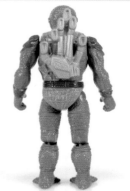

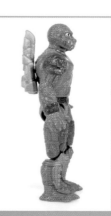

FUN FACTOID: Outside of the US, Missile Armor Flipshot is known as "Missile Armor Icarius."

MISSILE ARMOR FLIPSHOT

First released 1992 • Member of the Galactic Guardians

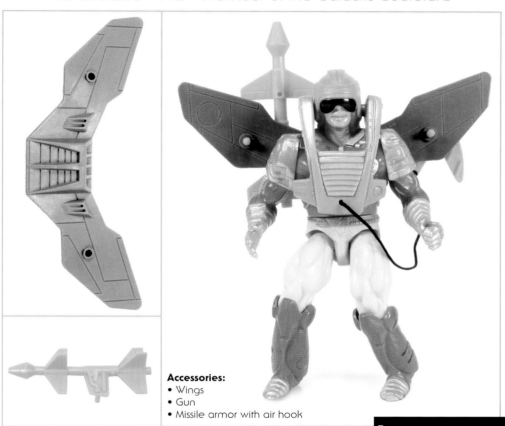

Accessories:
- Wings
- Gun
- Missile armor with air hook

This final wave continued the trend of offering new variations of already existing characters, while at the same time beefing them up to make them feel a lot chunkier than the earlier incarnations. This was likely done as an attempt to make them feel more in line with the original Masters of the Universe toy line.

Missile Armor Flipshot has a truly bizarre color palette. Tan pants with army green boots, a bright red shirt, neon orange helmet, and bright pink accessories! The colors seriously clash on this guy, and it really makes you wonder what the deciding factor was that made Mattel choose these specific colors.

Flipshot is once again wearing a jetpack with wings, but with a completely new design this time around. There are two holes on either side of the figure that allow you to clip the bright pink gun and air hook to the wings for storage.

The air hook is connected to the front of the armor via a real piece of string. The front part of the armor has a spring-loaded joint. By pulling the air hook backward above the figure's head, it lifts the armor. Releasing this will cause the armor to snap down, launching the hook forward!

Since this figure had such a limited release at the tail end of the toy line, Missile Armor Flipshot is one of the rarest and most sought-after figures.

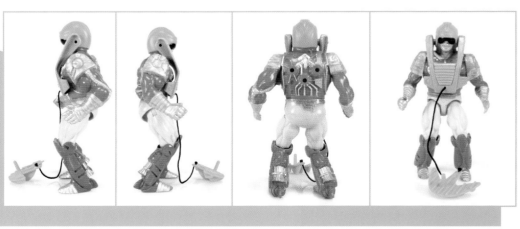

NOCTURNA

First released 1990 • Member of the Galactic Guardians

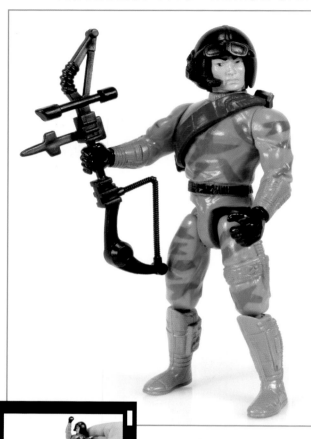

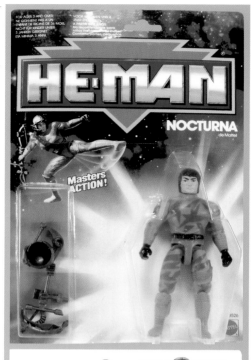

Accessories:
- Laser bow
- Helmet
- Snap-on bandoleer

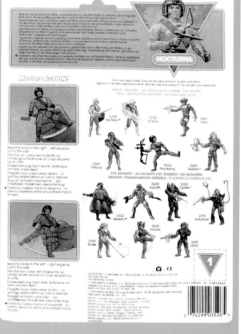

Known as the martial arts warrior of the Galactic Guardians, Nocturna has the ability to deliver a power side kick to his foes!

Like many of the Galactic Guardians, Nocturna is a humanoid who unfortunately is often seen as being a bit boring when it comes to his overall look. He's wearing a camouflaged bodysuit in the wild colors of purple and light blue, almost as if he's trying to blend in with Skeletor. Since he's a martial artist, it's easy to gather that his uniform is ninja-inspired, especially when there were so many neon-colored ninja toys in the 1990s.

He also features a removable helmet with goggles and a microphone attached. It does not seem to particularly match the rest of Nocturna's uniform. To top off his accessories, he includes a laser bow that can be held in either hand. Like many toys of the era, he cannot hold the bow properly with two hands, as they do not articulate the right way to make that work.

As you have probably guessed, his action feature is all about his swift side kicks! By tilting his body to the left, he quickly raises his right leg out to the side to deliver a side kick to his foes! Tilting his body to the right will cause the opposite leg to kick!

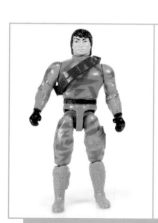

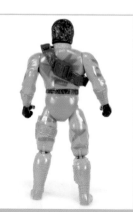

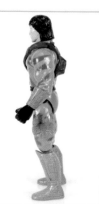

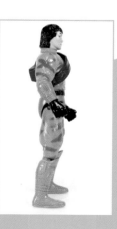

OPTIKK

First released 1990 • Member of the Space Mutants

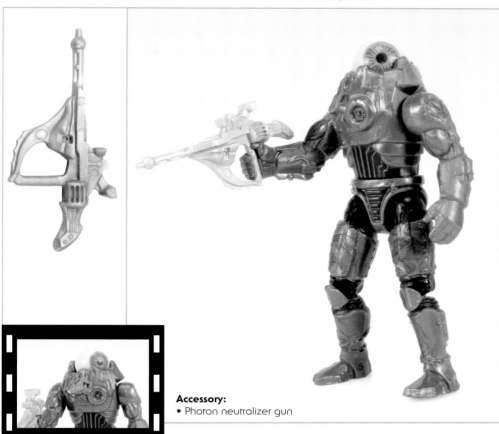

Accessory:
• Photon neutralizer gun

Known as one of the meanest Mutants in the Tri-Solar System, Optikk is described as having a spyball eyeball that sees through almost anything!

Optikk is widely considered by fans to be one of the best figures released in the He-Man toy line. His body is almost robotic in appearance, and his head is just a giant eyeball. It's easy to see the appeal; how can you hate a toy that has an eyeball for a head?

A small wheel on the figure's back allows you to use your thumb to make the eye rotate left and right to spy on the heroes! He also features the quick-draw action found on a few figures in the line. Place the photon neutralizer gun in Optikk's hand, and then press his arm downward. Releasing the arm sends it shooting back up, ready to fire!

FUN FACTOIDS:
• Optikk's leg design came from an earlier unused "Space Pirate" drawing by David Wolfram.
• Optikk's eye tampograph was reused from Mattel's Boglins Dwork figure, originally released in 1987.

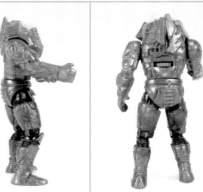

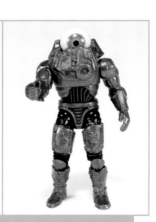

NORDOR

First released 1990 • Lair of the Space Mutants

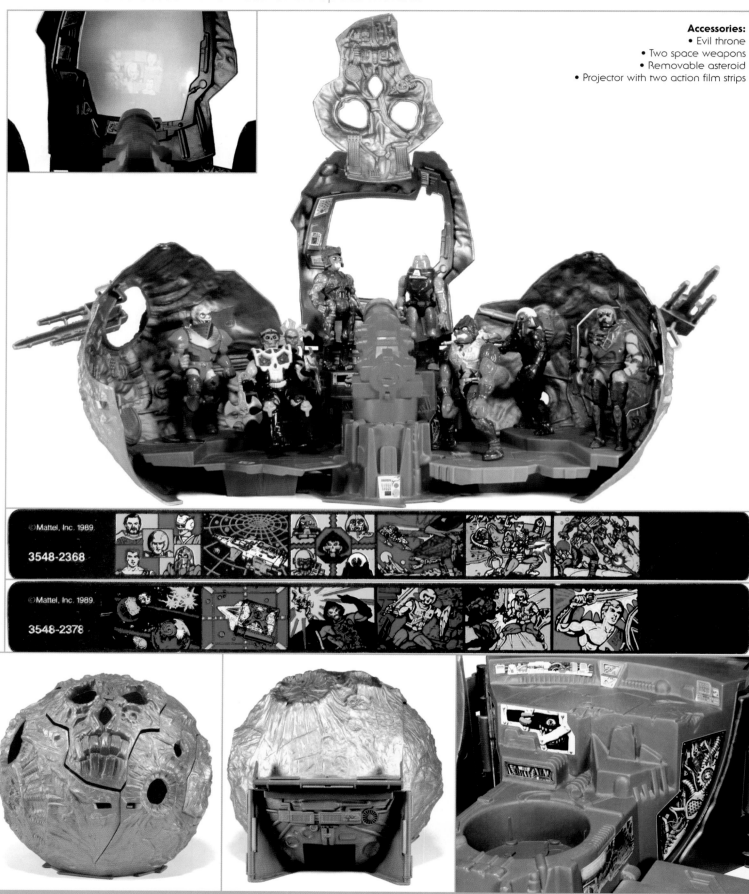

Accessories:
- Evil throne
- Two space weapons
- Removable asteroid
- Projector with two action film strips

©Mattel, Inc. 1989.
3548-2368

©Mattel, Inc. 1989.
3548-2378

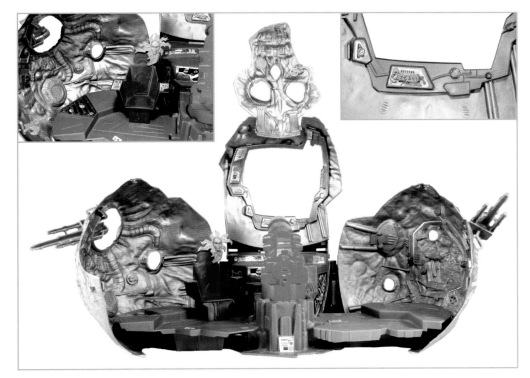

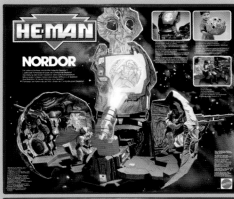

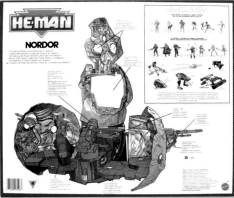

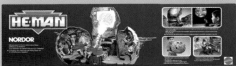

The evil asteroid fortress and battle base for Skeletor known as Nordor is an incredibly well-designed and very fun play set!

Following in the footsteps of the amazing play sets from the original Masters of the Universe toy line like Castle Grayskull and Snake Mountain, Nordor has the ability to be folded open or closed for two different methods of play!

When folded up, Nordor looks like a round, purple asteroid with a skull face in the center. The paint deco looks particularly effective, as the base color is silver with a deep purple overspray, which really makes this feel like it belongs to Skeletor. There are craters all around the play set that serve as openings allowing you to peer inside, with two of those craters serving as the menacing eyes of the skull face on the front. Two large "space weapon" lasers are included, and can be clipped to any of the craters to arm the asteroid fortress for battle.

The asteroid easily folds open by lifting the skull-shaped piece upward, and lifting the two sides outward. The inside looks like the command bridge of a space station, complete with an evil throne for Skeletor to sit on! This throne can be placed anywhere within the play set and serves as the first time any of the toy play sets gave us a throne specifically designed for the Lord of Destruction!

Small decals are placed all around the inside to give life to the control panels and various screens. There's even a small dungeon grate decal on the floor with the hands of various creatures grabbing on to the bars. This is a great nod to the dungeon grate decal from the original Castle Grayskull play set, albeit not quite as colorful. But still fun!

The primary play feature is the projector in the center of the play set. With the help of a few batteries and the included film strips, you can project images of He-Man and his allies up on the large white screen within the play set, making it look as though Skeletor is monitoring his foes! The projector can also be removed from the play set in case you want to project these scenes on the walls of your bedroom. It's an incredibly fun action feature that works wonderfully!

With an exciting design, fun features, and plenty of space to cram Skeletor and all of the Evil Mutants inside, Nordor is easily one of the highlights of the entire He-Man toy line!

FUN FACTOIDS:
- Nordor was nicknamed "the Galactic Gallstone" by Mattel's design team.
- Nordor was initially designed by Dave McElroy but completed by David Wolfram. Wolfram was unsatisfied with the sculpt by the assigned sculptor, so at the last minute he added more details to the clay sculpt, including fissures and cracks. On the bottom of the play set are some cracks that spell out Wolfram's initials—DW.

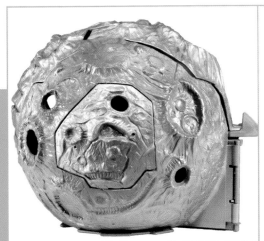

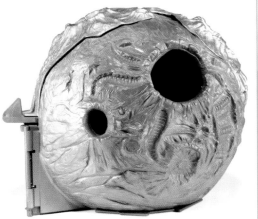

INTERVIEW WITH
DAVID WOLFRAM

Did you design Battle Blade Skeletor for the 1989 He-Man line?

Nice to see that people are still interested in this stuff! Yes, I did design Battle Blade [Skeletor]. In fact I may have a copy of the original sketch. I don't want to get too involved . . . but the skull armor was something that came out of brainstorms for new MOTU segments. One of my proposals was mutant space pirates, with many of them wearing variants of skull armor. Once we started working on the new line, I adopted that for the Skeletors that I designed. The hair on BB was supposed to be a lot gnarlier, but we had to work with someone from the Barbie group who couldn't give me what I was looking for—they only did pretty. If you have any other burning questions, fire away!

What's the story behind Laser-Light Skeletor and Laser Power He-Man? Skeletor especially is radically different from previous versions, covered with wires and implants, with a very different and creepy face. What was inspiring that look?

While MOTU was tanking domestically, it was still going strong internationally, which was a year behind in the product cycle. This was done to have something new for that market. LISA (the light transmitting plastic) was a fairly new "shiny toy" for the designers at the time, so that was the hook for that segment. I think Martin [Arriola] did the final He-Man design. I frankly don't remember for what purpose I did that awful He-Man illustration, but I'm sure that it was after the fact (and most likely rushed), and I'm sorry that it has survived.

I did the design for Skeletor. My working name was "Bio-Mechazoid Skeletor," and it was inspired by influences like Giger and the Gibson novel *Neuromancer*. Sadly, like many of our products of the time, engineering dictated what we had to design around, and in this case it was a huge battery box. Try as we might to design around it, it made the torso oversized, so to compensate, we had to give the legs a little more bend, leading to our new working name: "Take a Dump Skeletor."

How did you come to work on the original Masters of the Universe line at Mattel?

I was in my last term at Art Center College of Design, and had a fairly light schedule, so I checked into freelance opportunities offered through the job placement department at AC (I can't remember exactly what they were called), and saw an opportunity to work on a project for Mattel.

I went to Mattel, and met with Martin Arriola to discuss the project, which happened to be a dinosaur project for MOTU. Coincidentally, at my drawing board I had a small black-and-white TV, and as I was working on my school projects, I would always watch the afternoon MOTU cartoons, so I knew the property, plus I had a lifelong interest in dinosaurs, so I jumped at the

opportunity. I worked on this project on a freelance basis until graduation, then I started working in-house at Mattel as a temp, which is the backdoor way that many people end up working there. Shortly thereafter, I was hired full time. I ended up staying for twenty-two years, and worked on four different He-Man lines while I was there. Martin and I were not the prototypical Mattel designers, coming from an illustration, not product design background, which ended up being a nice niche in dealing with characters and story line–driven products.

Early on, Martin told me all that I needed to know about product design is understanding how parts come out of a tool, which ended up being true for the most part.

Correct me if I'm wrong. From the original MOTU line, you designed Laser Power He-Man, Laser-Light Skeletor, Mosquitor, and Tyrantisaurus Rex. Is that right? What am I leaving out?

To set the record straight, I worked as the primary designer on Tyrantisaurus, Bionatops, Snake Face, Ninjor, King Randor, Scare Glow, Clamp Champ, and Laser-Light Skeletor. I also was the designer on Gigantisaur, which actually went through three different iterations. Additionally, I worked on bits and pieces of other items, like designing the weapon for the heroic giant [Tytus], the revised drawing and weapon for Mosquitor (that you credited me for). I did a little bit on Eternia (but I can't remember what), the movie characters, etc.

I've been trying to put together a list of all the New Adventures toys that you designed or contributed to. Here's what I've put together so far: 1989 Skeletor, Disks of Doom Skeletor, Battle Blade Skeletor, Doomcopter, Optikk, Hoove, Sagitar, Nordor. I've heard you did most of the other evil characters.

I guess you can add Slush Head (my name Kalamarr), Quakke, The guy with the whip [Flogg], Lizorr, Butthead (from a Mark Taylor concept), Staghorn (From a Dave McElroy concept), and I'm sure a few more. The evil characters were always the most fun to design.

Laser-Light Skeletor seems to have been the predecessor to the 1989 New Adventures Skeletor design—many of the details are quite similar, albeit with a differently colored costume, plus a helmet. Can you talk about that evolution?

Laser-Light Skeletor and the corresponding He-Man were both done for the international markets. The domestic MOTU line was essentially dead after 1986 (or *maybe* 1987, it is hard to remember precisely). Pre-Toy Fair, which was a Mattel-only event held in August in Scottsdale for many years . . . I remember the marketing person saying that no domestic buyers even wanted to go in the gallery.

However, the international markets were a couple of years behind in their product cycle, so they wanted a few pieces of new news. It just so happens that one of the new MOTU segments we had been looking at was a "Power Crystal" segment with crystals "powering" vehicles, interacting with play sets, etc. The He-Man and Skeletor were borrowed from that segment.

In one of my concept drawings, for Bio-Mechazoid Skeletor . . . I started to use the mutated biomechanical detail. I don't know why, but it looks like the staff was drawn by Martin Arriola, and added.

The first Skeletor of the New Adventures was designed by Mark DiCamillo, who had just become the group manager, replacing Roger Sweet, after a particularly acrimonious meeting. Mark adopted the styling from Laser-Light, since it really hadn't been seen in the US, and everybody seemed to like it.

Regarding the first version of New Adventures Skeletor, there was some concept art (drawn by you) included in the Dark Horse Art of He-Man book. I assume then that Mark DiCamillo put a slight redesign together based on your Laser-Light design, and then you drew up a final version?

Always interesting to see something I've done, and completely forgotten about! I would say your thoughts are pretty much what happened. We probably needed to have a consistent look to the presentation boards.

You mentioned that Battle Blade Skeletor's armor came from your proposed subline of mutant space pirates. I assume that Disks of Doom Skeletor comes from the same pool of designs. Can you talk about that figure? I love the "glowing" eyes feature on that one.

That was one of my favorite figures in that line. Mattel was very gun shy (no pun intended) about using projectiles. By using the disks, we got around all the safety concerns. I also liked that a child could cock the figure, and then launch the disk using the trigger. It also gave me the opportunity to use the styling that I had been playing around with, and as a twofer I also got the LISA glowing eyes.

Regarding Scare Glow, I've always thought that was a pretty ingenious concept, despite the fact that it reused mostly existing parts. Did any concept art survive for that? What inspired you there?

Early on in my Mattel career, I was given the task to do four figures using minimal new tooling. They were Scareglow Skeletor, King Randor, Ninjor, and Clamp Champ. The four characters had already been conceived of and the concepts sold in, so all I had to do was to make it happen.

Part of that was going through the tooling banks to find parts to add to the appearance of the figures. I did get new tooling for Clamp Champ's weapon, and for four heads. Hal Faulkner, one of our good outside sculpting vendors, sculpted the heads.

Ninjor was a dead ringer for Lee Van Cleef, who had done some karate or kung fu-based show around that time, so we had to change that.

Scare Glow was the first Skeletor without a molded hood, and the paint scheme was pretty easy to figure out. It had a fair amount of luminescence, so I was pretty happy with it, and I got to learn how to work with soft goods for the first time. There is an adage in the toy industry that "once you add glow in the dark, it's a pretty good clue that the line is dead," and it pretty much was.

When you mentioned Scare Glow, you referred to him as Scareglow Skeletor. Was he considered a Skeletor variant, then? There has been some debate among fans about that for many years.

As I mentioned before, the concept was presold, I just executed. In my mind, it was never actually Skeletor, but some ghostly construct that used his likeness, and as I recall on the back of the package or somewhere else, that was supported.

[Note: In the 1987 style guide it says: "Skeletor conjured up this spirit in his own image to frighten travelers on the pathways of Eternia. Scare Glow is invisible during the daylight, but glows at night."]

About Skeletor: As I previously stated, I was a student at Art Center (1982-85) before I started working at Mattel. Sometime early on, one of my fellow students brought in a Skeletor figure, and I thought it was brilliantly conceived. I had read at one point about Jungian symbology, and the skull motif is used commonly, as in warnings for poisons, etc., to connote death or danger, something even a small child could imagine as the ultimate manifestation of evil. I think right about that time I started watching the show while at home working on my projects, which definitely helped me hit the ground running at Mattel.

For Lizorr (a.k.a. Lizard Warrior), you wrote on the concept drawing that he would have color-changing skin. I assume the idea was to use similar material that was used in some of the G.I. Joe figures like Zartan, that would change with exposure to light or heat? The actual figure didn't have that. Was it cut for cost reasons?

That was an early prelim sketch. Cost probably knocked that thought out real soon.

Tharkus [Sagitar] was designed to be an equine homage to Edgar Rice Burroughs's Barsoomian Tharks, but unfortunately the sculptor assigned was primarily a preschool sculptor, and after some bad engineering moves it sort of moved down a different path than I envisioned.

Even though I didn't design [the Darius figure] he was supposed to swing a big battle mace. It worked great in preliminary models, which used metal gears, but once the gears were molded in ABS plastic they would bind up and freeze. No amount of coaxing from engineering could change that, so even though it was fully tooled up, the toy was dropped.

Oddly enough, one original that I did hang on to, probably since it wasn't product related, was the drawing I did defining the New Adventures world. Mark DiCamillo and I sat down for a few hours brainstorming, and then I drew something up which was sent to the writers and animators for the show.

I also have another Skeletor image that apparently never went anywhere and MOTU mutant space pirate sketches that showed the skull-themed pirate armor that ended up in Disks of Doom Skeletor.

Note that much of the leg designs [in the unused Space Pirate concept] were eventually used for Optikk, while the upper body and helmet were used on Disks of Doom Skeletor.

Doomcopter is a fascinating vehicle. I assume the Giger influence is at play there again? It seems like the line started off with some very typical Star Trek–type vehicles (like the Shuttle Pod, Starship Eternia, etc.), but then the next vehicles were much wilder (for example, Doomcopter and Battle Bird). Was there a conscious effort to shift the tone?

Lots of Giger influence there. I have one partial sketch where you can see on it as well as Nordor that the skull motif is an important design element. I really didn't do a lot of vehicles. I did an early sketch of a walking tank-like vehicle which ended up becoming Terrorclaw and the Shuttle Pod. The vehicles ended up being designed by three different people: Dave McElroy, Steve Fouke, and Miller Johnson. Oh, and the Starship was designed by Terry Choi.

Optikk is, I think, probably most people's favorite figure from the New Adventures of He-Man line. Can you talk a bit about your process with him? He's a very sharp looking-design, head to toe in a dark metallic brass color, and that creepy giant eye peering out from the suit.

It was always one of my favorites. He was originally something that I did for a MOTU theme testing board, and he made it into the first wave of evil New Adventures figures.

As designers, we had been asking for quite a while for some nice molded metallics, and we finally got them. I know I used a lot of that dark bronze and copper over the next few years. We actually had a fairly limited palette to work from based on the Munsell color system, and unfortunately many of the colors were too "pretty" for my design aesthetic, so I ended up using the same colors over and over again. To get any new colors into the system took forever, and took an act of Congress. Later, as we started working on more licensed properties where we had to use specific colors from a style guide, that system was abandoned.

In the early sketch of Optikk, the thought was that his eye would be removable and go into the forks of the staff. We were looking at making the eye like the compasses that went on car dashboards at that time, but I imagine that approach ended up being too expensive, so we went with the simpler execution. The eye tampo design was the same one that I had designed and used on Boglins, another Mattel creature line from that time.

I had no idea Optikk's eye design came from Boglins! What other lines did you work on at Mattel that weren't He-Man related?

Over my Mattel career I worked on most action figure and boys' entertainment lines. I was a designer for eleven years, and then I managed the boy's entertainment design group for another eleven. One of my favorite early lines was Skateboard Gang, it was a cute skateboard-themed line based on a Hot Wheels X-V racer chassis. You could rev them up and the flywheel would let you do all kinds of tricks. Often I was called in to give "personality" to lines that needed a boost, like Food Fighters.

Boglins, Captain Power, Computer Warriors, Mad Scientist, and Hook were all lines I worked on at the old Hawthorne Location. When we moved to El Segundo, I worked on Last Action Hero, The Flintstones, Street Sharks, and Judge Dredd, among others. Sadly, upper management at Mattel at that time had our group chase lame ideas from the outside that ultimately didn't go anywhere. We had a two-year stretch where our group didn't generate any product that went to market . . . And how could I forget Max Steel? Not so big here, but *huge* in Latin America.

We got some good licenses with Disney/Pixar, Nickelodeon, and Warner Bros., which led to Toy Story, Hercules, Atlantis, Spongebob, Batman, Superman, Justice League Unlimited, and others. One of my all-time favorite Mattel lines was the Rock 'Em Sock 'Em construction line. The name never fit but the toys and the construction system were great. Unfortunately, without any entertainment, the line only sold when it was highly advertised, and was eventually dropped. We also had great success with Yu-Gi-Oh. We set a Mattel record for getting toys to market in five months. Our Duel Disk Launcher was Mattel's Toy of the Year in 2005.

By the way, we also worked on the 2002 He-Man reboot. It was great having the Horsemen onboard for the project. For a number of years, I managed what they worked on for Mattel. I read your interview with Martin, and I also wasn't a fan of that quasi-anime look that we had to go with, but in a big corporation we were only foot soldiers.

I'm going to go on record that I think one of the main reasons the line failed was that Marketing ignored what made MOTU successful: it was having so many diverse characters, and keeping He-Man and Skeletor in relatively short supply, so kids would have to keep on going back to the store to get the "popular" figures. Their idea was to make He-Man "Batman" and have multiple variations of He-Man, and also to have the assortments heavily weighted with He-Man. That strategy did not work, and the retailers' shelves quickly got clogged up with He-Man figures, and once retailers can't move product, your line is in trouble. I had a number of not-so-pleasant conversations with the director of marketing, to no avail.

In addition to a very busy and intense product cycle, we did some major pitches which were fun because we didn't have to worry about cost or production issues, and we could be very creative. Among the more memorable were *Star Wars* (we did the presentation at Skywalker Ranch!), *Cars*, and Harry Potter (my big contribution was creating a five-foot-tall Hogwarts that was made of three separate play sets).

A lot of the best products I worked on over the years never made it to market, but that is just the nature of the business. Every product line conjures up a million anecdotal memories, which are fun to think about, but I have no interest in writing a book.

You mentioned earlier that you worked on four different He-Man lines at Mattel. So that would be the original line, New Adventures, 200X, and then what else?

You left out the 2000 MOTU retro relaunch. We had a big plexiglass showcase in our area that we brought over from the old Hawthorne offices full of most of the MOTU line. Unfortunately, we had a big skylight over our area, and many of the figures after being exposed to sunlight every day started to deteriorate, mostly due to the plasticizer leaching out of the PVC. All the original MOTU tools had long been destroyed, so I had to find mint figures on eBay that we could tear apart and cast to make new tools to re-create the original MOTU figures. The only change we made was to put a little ridge on the bottom of the feet so collectors would know that they were re-creations. I was really pleased with how well they came out, and the fact that they did well was the impetus to start working on a new line.

The 2000 Commemorative line was great. I remember walking into Toys"R"Us and my jaw hitting the floor when I saw all the He-Man figures. I hadn't really thought about He-Man since the 80s. Of course I walked out of there with a five-pack. Quite a few different figures were sold in that line, although noticeably missing some key characters like Ram Man, Man-E-Faces, Orko, etc. I assume Mattel wanted to focus on figures that had a lot of shared tooling? Were there Commemorative figures that were planned but never released?

No. We carefully plotted out where we could maximize on the shared tooling. The production runs were low, and Mattel's tooling was expensive, so we didn't have the luxury of doing characters that didn't share tooling, like Ram Man or Orko. It wasn't intended as a big moneymaker, but at the same time, it is hard to justify doing anything from a corporate standpoint that doesn't contribute something to the bottom line. The whole line was designed as a one-off, including the five- and ten-packs, with no thought of any subsequent waves. In retrospect, the only other figure that I wish

we had, and could have done, was Battle Cat and Panthor. [Note: Battle Cat and Panthor were actually released in gift sets with He-Man and Skeletor, respectively.]

There seem to have been several different artists who did the artwork on the front and back of the figure, vehicle, and play set packaging for New Adventures. Do you happen to remember who they were?

That is one area that I can't help you with. I had my favorites, like Bill George, and I know a friend, Errol McCarthy, did some of the backs, but for me, the package was what it was, and hopefully displayed the product as well as possible. I did have run-ins with packaging people from time to time, where I thought the overall look of the packaging didn't represent what we were trying to do with the product, but not on any of the He-Man lines.

After twenty-two years at Mattel, what came next for you? I see on your website that you currently do a lot of fine art, focusing on outdoor subjects. Who are your influences, artistically?

After getting "whacked" along with a number of other senior Mattel people in a major management change, I started doing fine art. I was only two years away from when I planned to retire, and really didn't have the need or desire to go back to work. The very first time I went painting plein air (on location) was with Martin Arriola. I work mostly in oils and pastels. My website is mostly landscapes, by design for "branding" reasons; however, I do other, more experimental, art as well.

I am on the executive board of a number of art organizations, and have a studio in an art co-op in Old Torrance which I helped found, where I also teach. Art keeps me pretty busy, and it is a great excuse to travel. For this year and next I am leading painting workshops in France.

As far as my influences are concerned, I have many: Kim Lordier is probably my favorite pastelist, but I have taken workshops with, and become friends with, many of the top artists in the country. This weekend I am doing an advanced mentoring workshop with Richard McKinley, another of my favorites. In fact, he was the one who suggested I do the France workshop.

Hoove's early concept art was included in the Dark Horse book. In this version he actually has metallic hooves, and a very different color scheme compared to the final toy, which was all in copper and bronze (and no hooves). What's the story behind the changes? Did it have to do with the color limitations you mentioned earlier?

Wow! You've got me there!!! I guess I have forgotten over the years. I can tell it is Hoove, because there is a gun mounted on the leg that would kick up, but other than that I can't remember why the look changed. And yes, the molded copper and bronze were among my go-to evil colors.

You mentioned you did the revised drawing for Mosquitor—did someone else take a first crack at designing it then? Also, who designed Laser Power He-Man?

I think Pat Dunn did the first Mosquitor design, and I'm pretty sure that Martin Arriola would have done the [Laser Power] He-Man, maybe with some influence from Dave McElroy.

How did Mattel decide on what themes to go for in a given year? For instance, in 1987 Mattel did the three dinosaur figures, of which you designed Tyrantisaurus Rex. Were dinosaurs particularly popular that year? How much of it was market research and how much of it was guesswork, I guess is what I'm asking.

I came to the party relatively late, so I don't have a lot of insight into how the Pre-Eternia theme came about. I think that Marketing and the powers that be at Mattel were hoping for new entertainment to support that theme that didn't happen. There were also a couple of characters that didn't come out, which made the Grayskull theme even more of an outlier. They were He-Ro and Eldor. John Hollis worked on both of those. Eldor had a book, based on a simple magic trick prop. I ended up working on real holographs of the dinosaurs and Pre-Eternia that went inside the book. FYI, I also designed Bionatops.

I've heard that [Gigantisaur] has something of a storied history. Were you the main designer on that? That one showed up in the 1987 Mattel catalog, but of course was never released. Could you share some of the background on that?

Yes, I was the designer on the many iterations. When it was first shown to me, there was a beautiful, but totally unrealistic, painting by Ed Watts . . . and a white prototype model that was submitted by a well-known outside toy invention company.

My first boards (especially the side view) show the reality of what I had to work with. One of the big visual issues is that the feet had to be huge to

extend past the center of gravity. Ed's (a great guy, by the way, who went way too soon, and not in a way I would want to go) drawing hinted at this voluminous interior, when in fact, because of the cockpit, it could only hold one figure.

There was also a figure that was supposed to hide in the tail section, but in the model it looked like the dinosaur was taking a dump! There were lots of meetings when marketing and management were forced to confront the reality of this turkey-like bastardization rather than the seductive drawing. I was given the go-ahead to take some of the elements of the old model, and another provision was that it had to swallow a figure.

I did a lot of work with foam and clay to work out a better proportioned creature, and the engineer that I worked with, Ben Guerrero (Tony the sculptor's brother), came up with the idea of marrying the tail with the part of the body with the rear legs to create a tripod, which eliminated the need for gigantic feet to let it stand up. It not only stood up, it shot up, because Ben used a very strong spring. Of course, after all that it went to Pre-Toy Fair, where the line was for all intents and purposes dead domestically.

As I was thinking about Ed Watts, I flashed on a fundraiser idea my design group had to help raise money to help with his medical expenses. As you probably know, the Four Horsemen sculpted their figures very large—at least twelve inches tall. I had them cast up six figures. I remember He-Man, Skeletor, Trap Jaw, for sure, and I'm pretty sure there was a Mer-Man, too. I'm pretty sure we had six altogether. Each member of the group, including myself, took a figure, created a base, and did a tricked-out version of that character. The figures were then auctioned off to fans (I'm not sure if it was through eBay, or if it was done some other way). Anyway, we ended up making something like $15,000 to give to Ed's family. We also had a little internal competition, and my cadaverous Trap Jaw won. Stupidly, we didn't take good pictures of them, but I think at the time we used He-Man.org to promote them. If you ever come across any of those pics I'd love to see them.

You talked before about figures like King Randor, Scare Glow, Clamp Champ, and Ninjor, for which you were given very minimal new tooling to work with, for the most part just new heads. But you also did Snake Face (great drawing, by the way), which is of course all-new tooling except for the staff he came with. It seems like for some figures they would go all out on new tooling, and others they would provide very little new tooling—kind of feast or famine. Why was that?

I guess they were still trying to make some money, partly by not spending as much on tooling, but still having new characters to launch to keep the trade happy. Outside of the movie figures, Snake Face (or Medusa Man) was one of the last newly tooled MOTU figures. Again, the preliminary concept sketch showed all these gnarly fully sculpted snakes coming out from everywhere, when the reality forced on me from engineering was they had to use nylon that couldn't be detailed.

Any stories about the Nordor play set?

A lot of projects had nicknames. Nordor's was "the Galactic Gallstone." The original model was conceived of and sold in by Dave McElroy. It was up to me to make it happen. I wasn't in love with the projector, but that was what was sold in initially.

The interior parts went together pretty well. The exterior sculpting was a different matter. The sculptor assigned to the project was much more suited to preschool toys and smooth dolls' heads. Fortunately for me, the project was being sculpted in hard clay, rather than wax. No matter how much direction I gave him, he just couldn't get beyond mushy. Finally right before the date it was to be turned over to engineering for casting, Martin Arriola suggested that I should take matters in my own hands. So, right before it was set to go, I came in on the weekend, stole it out of his office, and spent at least one day adding fissures and other details. It's funny, but nobody from sculpting ever said a thing. If you look on the bottom side, you can see some cracks that look suspiciously like the letters "DW."

You mentioned you did some work on the giant Tytus's weapon, as well as some work on the movie figures. Can you talk about those projects?

Regarding the Tytus weapon: A lot of the time, the preliminary design group would "hand wave" their way through presentations, leaving the more practical aspect of how something would work to the final design group. This was a classic example. At the product conference to get the approval to go ahead on the project, Larry Renger was demonstrating the feature for Tytus. He had something that resembled a claw, and said it would trap a figure. Of course, in its configuration he had to literally wrap the fingers around it while saying that in the final toy it would work differently.

After it was dumped on me, it was pretty apparent that no claw-like accessory would work, due to the difference in configuration of the many figures, and also that anytime you tried to wrap something around a figure, it would just knock it over. For the most part, the one consistency was in the head area, which also coincided with the arc of the downward swing from the giant. I started thinking about ways of trapping things, and the "lobster trap" seemed like the best way to go, and it ended up working out pretty well.

I believe you've covered everything you worked on for the New Adventures line. Are there any other stories about the New Adventures toys you didn't work on that you remember?

Regarding the other things, nothing new comes to mind.

David, thanks once again for the fascinating information. I really appreciate you taking so much time to share this with me!

This has been fun, and has dredged up a lot of old memories.

POWERSWORD

First released 1989 • Accessory of the Galactic Guardians

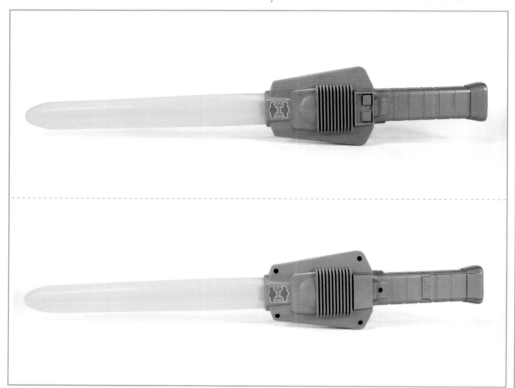

While there were many role-play toys released alongside the original Masters of the Universe toy line, this He-Man Powersword is the very first one produced by Mattel as an official part of their toy line!

This child-sized replica of the brand-new version of the Sword of Power is powered by four AA batteries. There are a few buttons located on the front and the side of the handle, all of which trigger various special effects.

Pressing each of these buttons will create various laser and thunder sound effects, and it even features a flashing light-up blade! The most fun to be had is with the swing-activated blade. By swinging the sword around for battle, it actually makes noises as if it's clashing with the weapon of your foe while the blade flashes with electrifying light!

FUN FACTOID: The role-play New Adventures Powersword toy was designed and developed by Marc DiCamillo, with sounds from a karate glove by Japanese invention studio Sente.

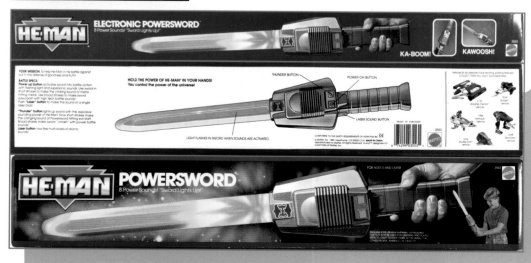

QUAKKE

First released 1991 • Member of the Space Mutants

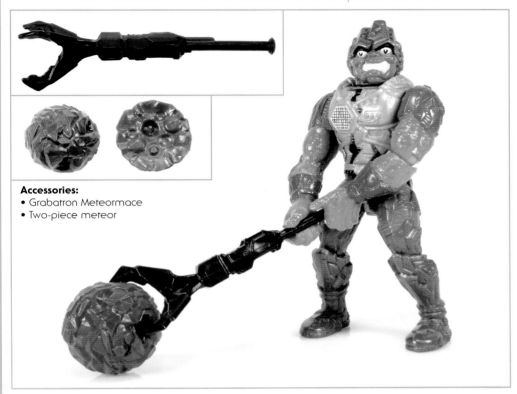

Accessories:
- Grabatron Meteormace
- Two-piece meteor

Meteor-smashing Mutant with orders to shatter the good guys!

Quakke is another of the goofy-looking Mutant action figures, with eyes bugging out of his head and an odd, cheesy smile on his face. He's also a bit bulkier than most of the other Mutants released at this time, but that was likely done to incorporate his unique earthquake action feature.

His included Grabatron mace clips on to the small meteor accessory also included. His hands are molded in such a way that he holds on to this mace with both hands—a rare feat with many figures of the era. However, his hands are pretty much stuck in this pose, making him look a bit awkward when he's not holding his weapon.

If you press the lever on his back and release it, Quakke lifts the Grabatron mace over his head, then slams it to the ground—shattering the meteor into two pieces on impact! The idea here is that he creates large earthquakes. The action feature works really well, and is actually quite fun! You could also cause some serious damage to foes by having Quakke bash them over the head!

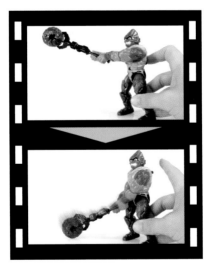

 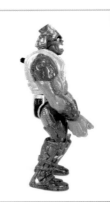 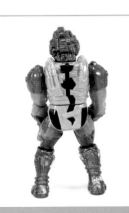 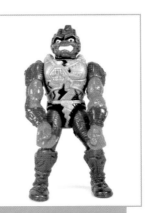

ROCKETDISC POWER PACK

First released 1989 • Accessory of the Galactic Guardians

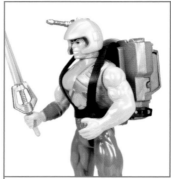

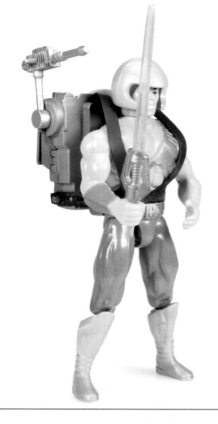

Accessories:
• Three disks

He-Man's Rocketdisc Power Pack is an accessory for your action figures that allows them to armor up and shoot projectile disks at their foes!

A rubber harness on the front wraps around the figure's torso and straps the Rocketdisc Power Pack to the figure's back. An attached laser can also fold over He-Man's shoulder for additional support in the fight against evil!

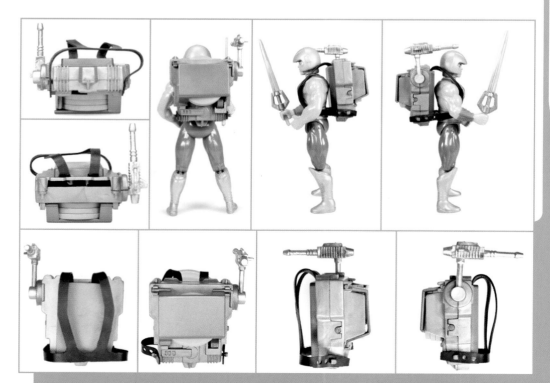

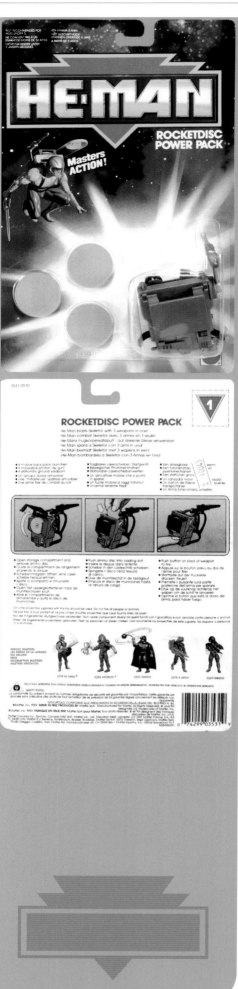

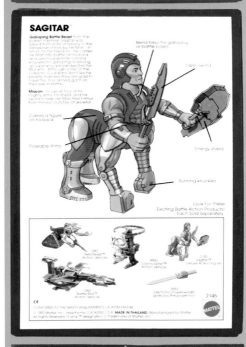

SAGITAR

First released 1991 • Member of the Galactic Guardians

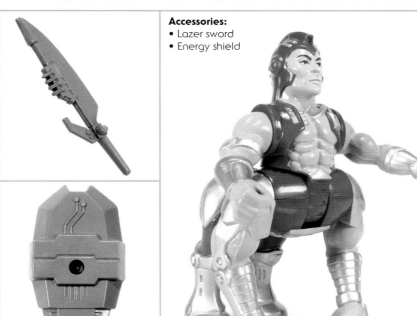

Accessories:
• Lazer sword
• Energy shield

The galloping battle beast Sagitar is the only figure in the He-Man toy line with the distinction of being a deluxe action figure.

There are two different ways you can display Sagitar. In his beast mode, Sagitar is a centaur-like creature with his lower pair of arms acting as his front legs. In this mode, your other Galactic Guardians can ride on his back, although there is really nothing that holds them in place, and balance is at times an issue.

A joint in the torso allows you to fold Sagitar upward, shifting him from a centaur to a four-armed man. Once standing upright, he towers over all other figures in the line at a massive ten inches in height! His arms can move forward and backward, but he's pretty limited in articulation overall. His head doesn't turn at all.

He includes a Lazer Sword and an energy shield, both made of a gray plastic. These can be held in any of his four hands, allowing you to mix and match how you want the accessories displayed.

Steeds for other figures to mount and ride have been a common theme since the original Masters of the Universe toy line. Sagitar is a unique way to incorporate both the idea of a steed and a new heroic warrior all in one!

 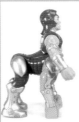 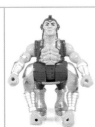

 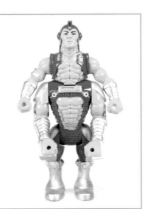

FUN FACTOID: Outside the US, Sagitar was known by his early working name, "Tharkus." The designer, David Wolfram, says that Sagitar's look was inspired by the Barsoomian Tharks in Edgar Rice Burroughs's John Carter series. Tharkus was supposed to have a horse head as well as horse hooves.

HE-MAN

SHUTTLE POD

First released 1989 • Vehicle of the Space Mutants

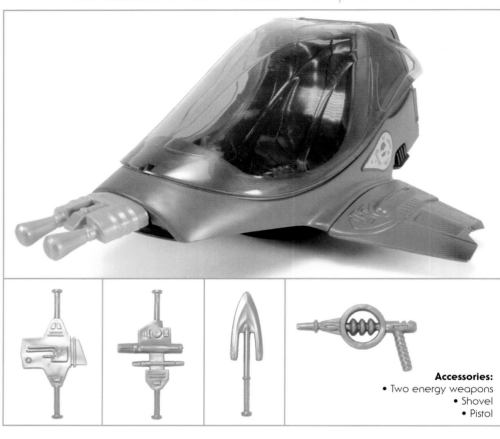

Accessories:
- Two energy weapons
- Shovel
- Pistol

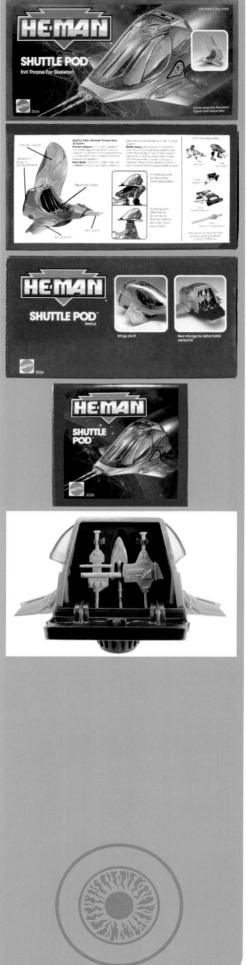

The sleek single-man craft might be small, but it packs quite a bit of play value!

The opening canopy reveals a single-seater cockpit ready to accommodate Skeletor or any of the Evil Mutants for attack! The front features twin guns to fire on foes.

The back hatch of the Shuttle Pod opens to reveal a weapons rack, which is a fun nod to the vintage Castle Grayskull toy. This rack houses four included weapons: a shovel, a pistol, and two "energy weapons." These energy weapons are unique in that they are designed specifically with Skeletor's hand placement in mind, making it so that he is the only figure in the line that can properly hold them.

The modular landing gear on the bottom is one of the most effective play features. This is seen on several of the vehicles in the He-Man line, meaning that many of them can interact. The Shuttle Pod is able to attach to the Terrapod vehicle or even land on Starship Eternia for boarding and attack!

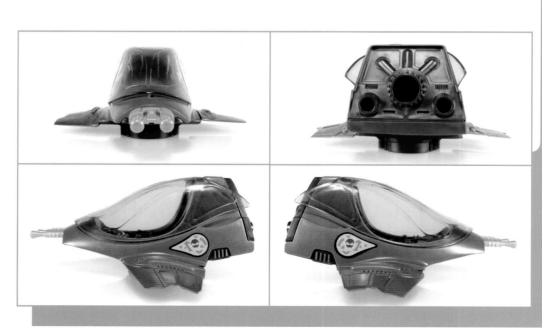

VARIANT

SKELETOR

First released 1989 • Member of the Space Mutants

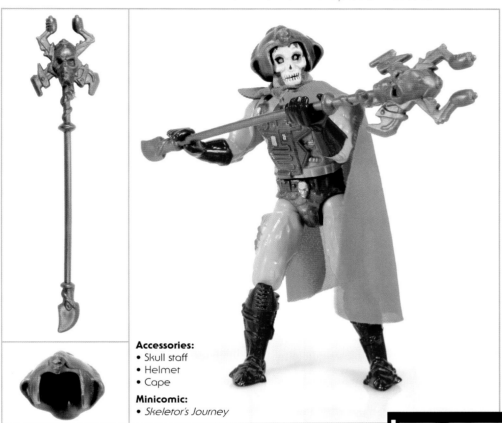

Accessories:
- Skull staff
- Helmet
- Cape

Minicomic:
- *Skeletor's Journey*

Described as a bionic blend of the ultimate evil who escaped Eternia to begin a new reign of terror to enslave the future! Like He-Man, Skeletor was given a pretty drastic overhaul for this new story. The early figures included minicomics to tell the story of He-Man and Skeletor leaving Eternia to continue their battle in the future. In this story, Skeletor was badly damaged after witnessing Prince Adam transform into He-Man, thus leaving Skeletor to implant cybernetic parts to repair his broken body.

This explains the new look for the character, and you can see all sorts of cybernetic bits and wires worked into the sculpt. The removable helmet is a neat touch, revealing wires attached to the back of his head. The figure has a slenderer design than the original version from the Masters of the Universe toy line. He also has a cloth cape this time around, removable much like the included helmet.

Instead of the ram-skulled Havoc Staff, Skeletor now comes with a brand-new Skull Staff. His arms are molded so that Skeletor holds the staff across his body. And when you twist Skeletor's waist, he lifts his arms up and down to block and battle foes with his staff!

While most releases include a cape that is a light magenta in color, there are some that come with a cape that is a deep purple in color. The purple cape isn't the most common release, but it does seem to suit the character more as it recalls the colors of the original figure from the Masters of the Universe toy line.

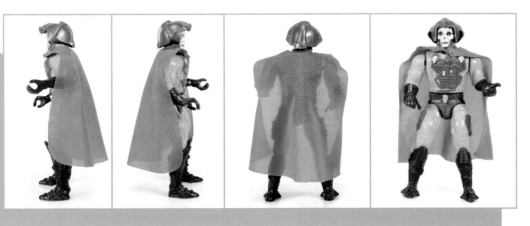

SKELETOR SKULL STAFF

First released 1991 • Accessory of the Space Mutants

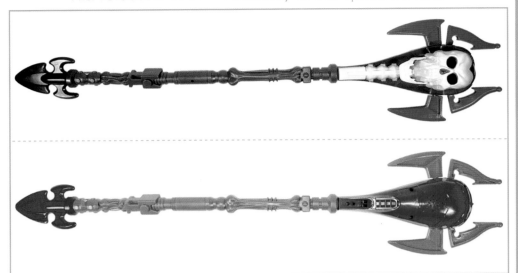

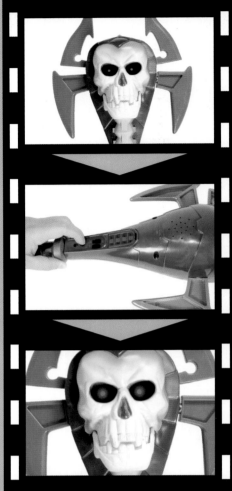

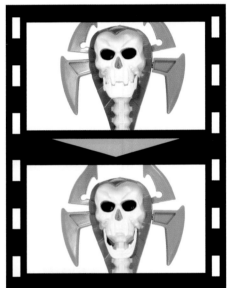

While there were many role-play weapons released alongside the original Masters of the Universe toy line, this is the first time Mattel officially released their own kid-sized version of Skeletor's staff!

The staff is three feet long and features a variety of button- and motion-activated sound effects and lights powered by a 9 V battery. Swinging the staff around gives off fun whoosh noises, as well as rumbling thunder and explosions!

The staff even features Skeletor's sinister laugh, along with light-up red eyes on the skull! The jaw is also loosely jointed, so swinging the staff will causes the jaw to snap open and closed.

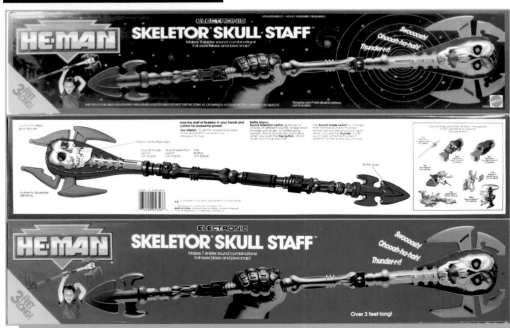

SLUSH HEAD

First released 1989 • Member of the Space Mutants

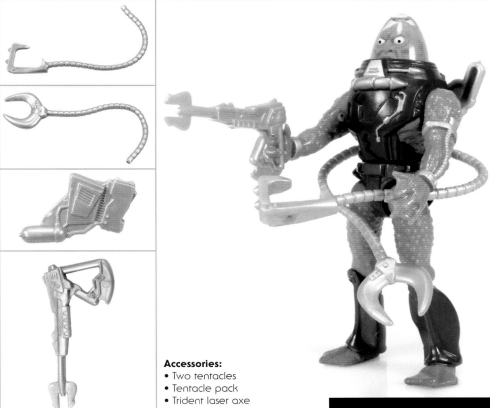

Accessories:
- Two tentacles
- Tentacle pack
- Trident laser axe

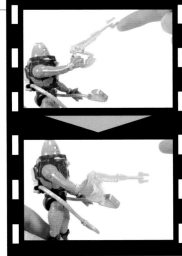

Evil Mutant moron and goon squad member with suckers on his arms and water on his brain!

Slush Head is most notable for the dome over his head. It is filled with a clear liquid that seems to magnify the ugly face within. The water is sealed inside and not removable, though it is possible to find figures whose water has leaked out over the years.

His back features a tentacle pack with two mechanical tentacles attached. These can articulate forward in front of the figure, and feature claws on the end for grabbing on to his enemies! By raising his right arm and releasing, his handheld weapon comes smashing down on the trapped foe!

Slush Head's trident laser axe is a unique weapon that can be held two different ways, acting as both a laser gun and an axe.

FUN FACTOID: Several figures in the line were given alternate names for their foreign releases. Outside of the US, Slush Head is known as "Kalamarr."

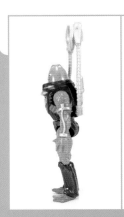
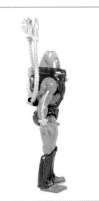
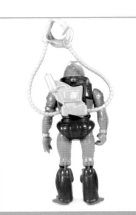
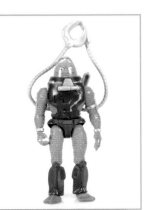

SPIN FIST HYDRON

First released 1992 • Member of the Galactic Guardians

Accessories:
• Triton Spear Gun
• Helmet

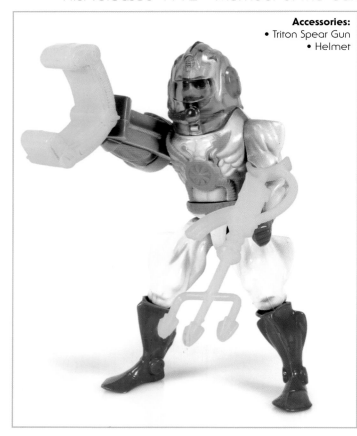

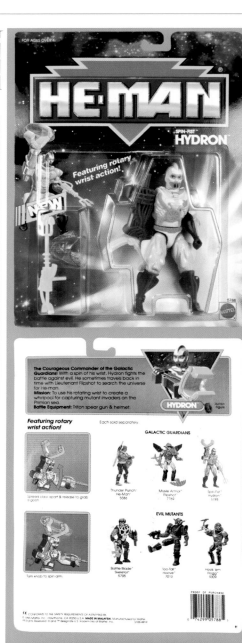

This final wave continued the trend of offering new variations of already existing characters, while at the same time beefing them up to make them a lot chunkier than the earlier incarnations. This was likely done as an attempt to make them feel more inline with the original Masters of the Universe toy line.

Aside from the chunkier body design, Spin Fist Hydron has a new color palette featuring a gray bodysuit with near-neon blue boots and gloves, with neon orange and yellow colors seen on the accessories and suit designs. He also features a bright, translucent green dome helmet that can be removed.

While he has a Triton spear gun that can be held in his left hand, his right hand is unique. The arm itself is actually a molded hand-clamp accessory. The bottom of it has a molded arm to make it look as if he is holding on to a large weapon; the clamp itself works as the figure's hand. This is done to house the claw-twisting action feature!

The clamp is large enough to be able to grab most of the Evil Mutant action figures. Once clamped on, Hydron can lift the figures above his head and then spin them by simply twisting the knob on his shoulder! It works well, but it's an odd action feature, for sure.

Since this figure had such a limited release at the tail end of the toy line, Spin Fist Hydron is one of the rarest and most sought-after figures.

 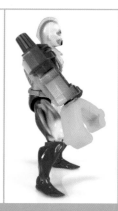

SPINWIT

First released 1991 • Member of the Galactic Guardians

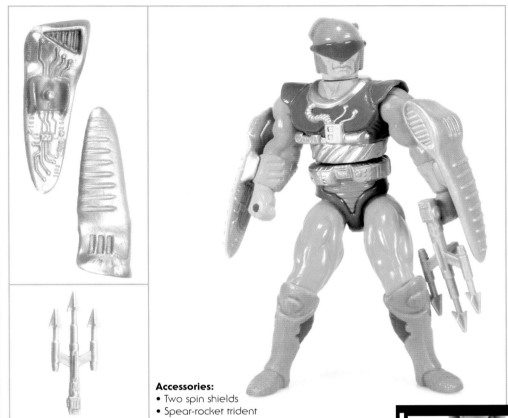

Accessories:
• Two spin shields
• Spear-rocket trident

Spinwit uses his amazing tornado spin to help the intergalactic forces of good fight the evil Skeletor!

It's easy to look at Spinwit and relate him to the classic Masters of the Universe character Sy-Klone. Their names are similar, as are their powers. Although Spinwit has a similar spinning feature, it is performed slightly differently.

He includes two clip-on shields that attach to his wrists. These act as blades for his spinning action feature. To prepare, you must wind Spinwit at the waist. Once fully wound, he should lock in place. Once you press the button on the back of the figure, Spinwit quickly unwinds, sending his torso spinning. Much like the aforementioned Sy-Klone, Spinwit's arm joints are loose, allowing his arms to rise out to his sides while spinning.

He also comes with a spear-rocket trident weapon that can be held in his hands. It's interesting to note that Mattel swiped this weapon from another toy line of theirs. This was included with the figure Col. Stingray Johnson from the Captain Power toy line.

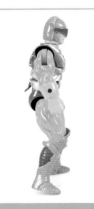

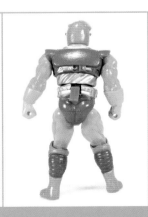

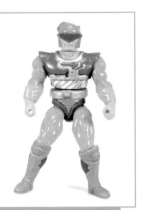

STAGHORN

First released 1991 • Member of the Space Mutants

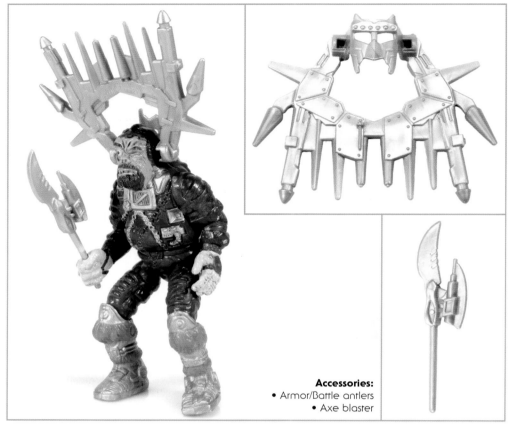

Accessories:
• Armor/Battle antlers
• Axe blaster

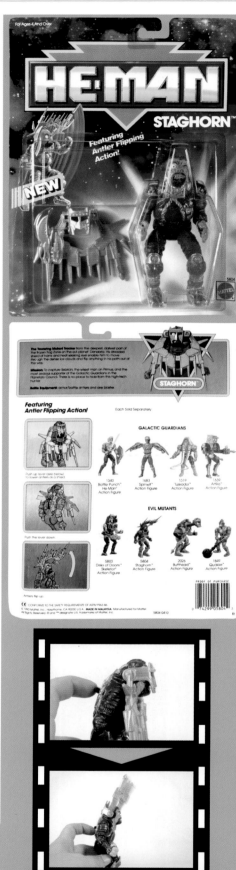

The towering Mutant tracker Staghorn is known for his dreaded shield of horns and his heat-seeking eye.

The designs of the Evil Mutants are among the most striking but also the most bizarre. Staghorn is one of those figures that has a comical, more cartoonish, look to him. He's a portly fellow with a large head decorated with a scruffy beard and a large unibrow. One eye is squinting shut, while the other is large and seemingly popping out of his head. This is meant to represent his "heat-seeking" ability mentioned on the back of the packaging.

He has a unique set of horned, mechanical antlers that attach to his head. There is a lever on the back that moves the antlers up and down. When the lever is in the up position, the antlers fold down over the figure, working as a set of armor that covers most of Staghorn's front to protect him from damage.

Quickly pressing the lever downwards will swiftly fling the armor upwards, flipping any enemy figures out of the way as if Staghorn is using them as a real pair of antlers. The armor itself is an odd design that just adds to the overall weirdness of the character's design, but the feature itself is admittedly fun and satisfying to pull off.

In addition to the armor turned antlers, Staghorn also comes with an Axe Blaster accessory that can be held in his right hand. Many of the weapon designs in the He-Man line are intended for dual purpose. Exactly as the name describes, there is a blaster on the underside of the axe blade. Presumably Staghorn would be able to fire blasts from his axe, or use it for up-close combat as a blade!

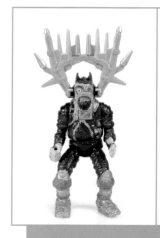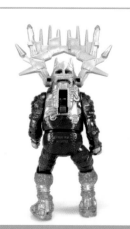

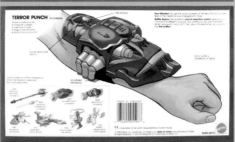

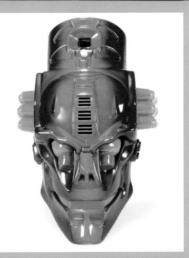

TERROR PUNCH

First released 1992 • Accessory of the Space Mutants

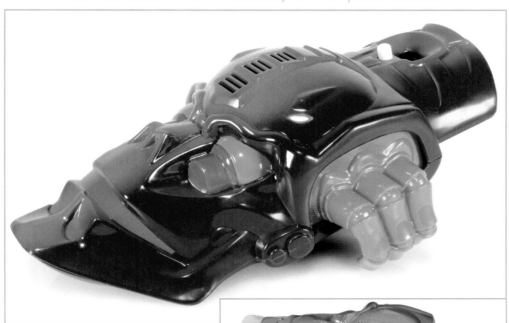

The Terror Punch is the evil equivalent to the Thunder Punch role-play item. A strap on the bottom allows you to attach this electronic device to your wrist, and it features both motion-activated and button-activated sound effects!

The design features a bright purple-and-red color scheme, and is meant to resemble a Denebrian Pit Beast, as stated on the box.

The Terror Punch has the ability to make four sounds, including a Gargoyle Grumble, a Laser Zap, a Mega Clash, and a Bug Gun "Ka-Booommm!" The two-position sound selection switch allows you to choose between the four different sounds. Two of the battle sounds are activated when you punch your arm! The other two sounds are activated at the push of a button.

It's a really fun role-play item that works rather well. The motion-activated play among all of the role-play weapons in this line makes for a lot of fun, especially when paired up together!

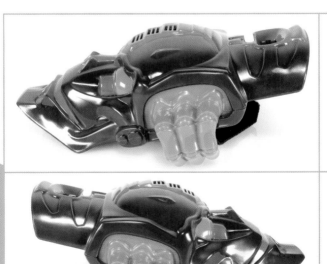

STARSHIP ETERNIA

First released 1989 • Vehicle of the Galactic Guardians

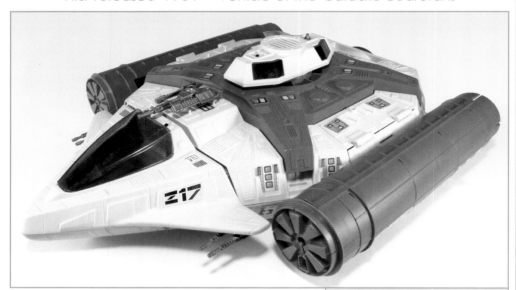

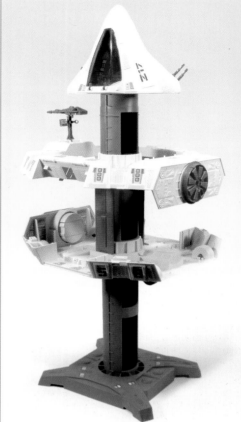

The starship named after the legendary planet Eternia was used by Flipshot and Hydron to travel back in time to locate the hero known as He-Man. The story found within the minicomics that came with the figures tells us that, due to a confrontation with the evil Skeletor, who was once again plotting to steal the Power of Grayskull, the castle's power was transferred to Starship Eternia. The legendary power is now housed within the starship, as He-Man and Skeletor are both brought to the future with it!

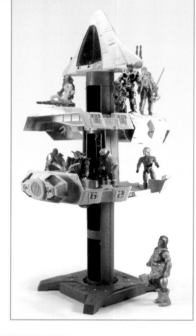

Starship Eternia is the flagship play set of the He-Man toy line. At first glance this may look like a simple futuristic starship toy and not much else, but that's where first impressions are quite wrong. The entire ship plays up the modular connectivity we've seen on a few of the other vehicles released in this line. The ship has the ability to be taken apart and reassembled in multiple formats! The back of the box touts that it can be transformed into twelve different action modes. Admittedly, some of these look rather like a hodgepodge. But the reality is that you can piece the parts together in many different formats not even shown on the box, making the play value of this set quite unmatched!

Among the different action modes shown on the box, we have Starship mode, which is the standard ship mode as the vehicle appears in both the comics and animated series. This includes an opening cockpit on the front for a figure to pilot, rotating blaster cannons, and even lights and sounds!

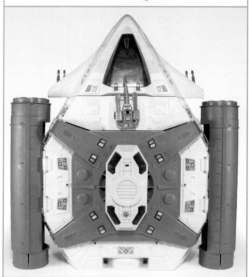

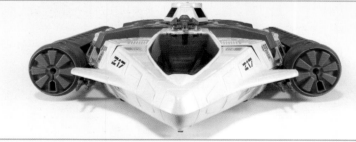

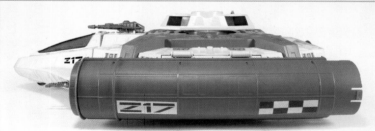

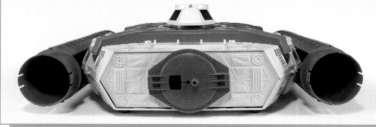

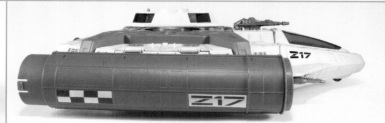

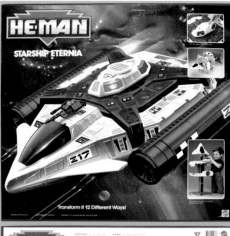

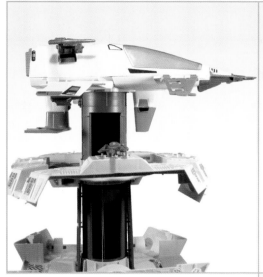

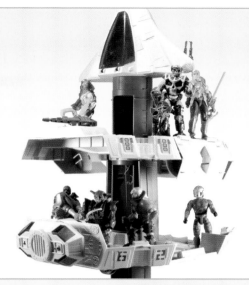

The Ground Base Command mode is probably the second most common way collectors would choose to display the play set. In this mode, the ship is opened up and standing upright much like a tower. There are plenty of platforms to load the base up with figures, and a string-drawn elevator shaft allows you to move the figures from level to level.

Other action modes shown on the box include Space Station, Deep Space Probe, Communication Satellite, and Docking Pad. These are mostly just a collection of images to show you some of the ways you can reassemble the parts. Your creativity and imagination can really drive just how much fun you can have with this particular play set.

One of the most fun features across all of the vehicles in the He-Man line is the modular connectivity between them! Ships such as the Astrosub and the Shuttle Pod have matching docking ports on the bottom. This not only allows them to interact with other vehicles in the line, such as the Terroclaw, but they can also be docked on Starship Eternia! The port on the bottom of those ships can fit on the blue tube connector piece. That means the heroes can dock the Astrosub, or Skeletor can dock the Shuttle Pod for an invasion!

As mentioned above, the play value is pretty spectacular here. The vehicles and play sets are a part of the He-Man toy line that were really done right.

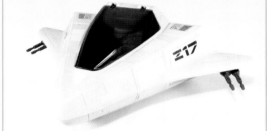

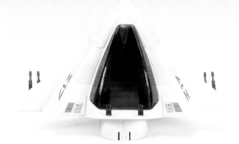

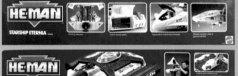

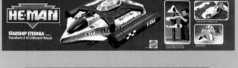

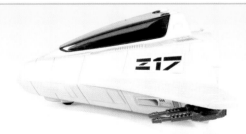

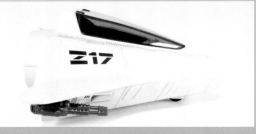

TERROCLAW

First released 1989 • Vehicle of the Space Mutants

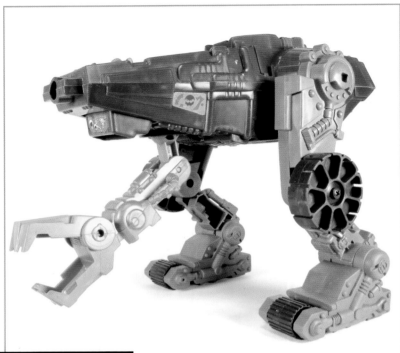

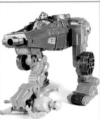

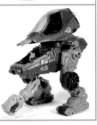

The evil Terroclaw vehicle is three attack tanks in one! This two-legged mech-like vehicle for Skeletor's evil forces features a cockpit on the top portion to seat one figure, and has a decent amount of articulation, allowing it to be transformed into various battle modes.

The Terroclaw can stand to stalk the enemy in two different positions—with the body horizontal or with the body standing upright. Or if you wish, the Terroclaw can kneel down to roll more like a tank via small wheels. A large claw hangs down from the body and can be controlled by a small joystick from within the cockpit. You can even open and close the claw for grabbing action!

A trapdoor is hidden on the underside of the cockpit, allowing figures an easy escape. The Terroclaw also utilizes the same connectivity feature seen on many of the vehicles and play sets in the line. The Shuttle Pod is able to dock on top in two different positions, adding another pilot and making the vehicle even more fierce!

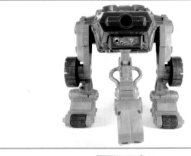

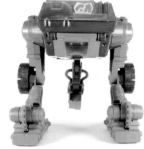

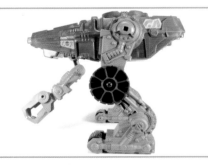

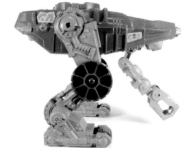

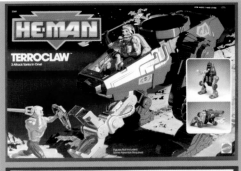

FUN FACTOID: Outside of the US, the Terroclaw is known as the "Terrapod."

HE-MAN

TERROTREAD

First released 1991 • Vehicle of the Space Mutants

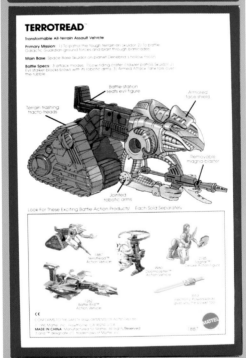

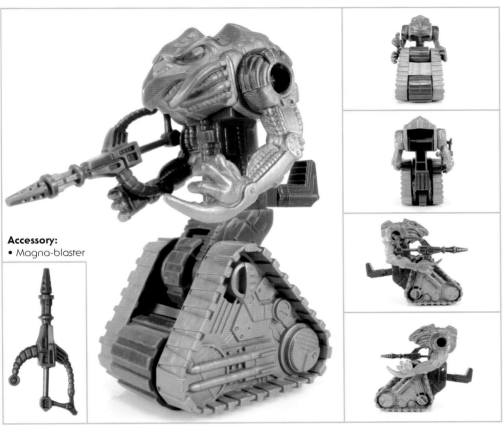

Accessory:
• Magna-blaster

The transformable all-terrain assault vehicle is designed for Skeletor or any of the Evil Mutants to patrol tough terrain and battle against the Galactic Guardians!

The really unique design looks almost robotic, featuring a base that is designed to look like tank treads. It's worth noting that these are not real treads, as they are a solid plastic sculpt and house a few plastic wheels inside to allow the vehicle to roll. A bird-like face shield with movable robotic arms holds on to a magna-blaster, which you can remove if you desire. Behind this shield is the battle station seat for your figure to sit on. This is a bit awkward, as the small seat leaves the figure unbalanced.

The gimmick is that there are three modes that can be achieved simply by moving the top portion up or down. With the robotic body pulled all the way forward in the lowest setting, low-riding terrain tracking mode is achieved. You can stand the Terrotread upright for high-mounted armored assault, though in this mode you can't really seat a figure on it. Or you can pull the body backward for armed attack tank mode. The transformations are simple, but the design is still very fun!

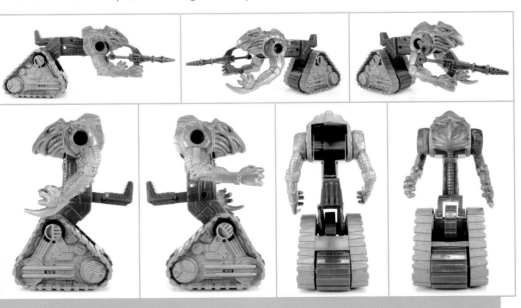

THUNDER PUNCH

First released 1992 • Accessory of the Galactic Guardians

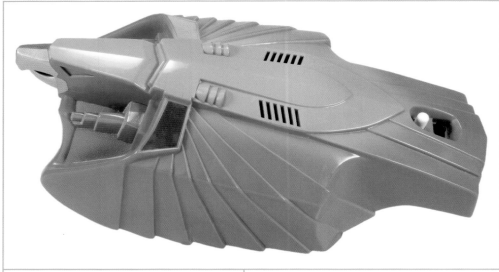

The heroic counterpart to the Terror Punch role-play item, this wearable wrist guard features four motion-activated and button-activated sound effects!

The design is bright blue in color and is meant to resemble He-Man's Battle Bird vehicle! In a fun bit of synergy, the Thunder Punch He-Man action figure can also be seen wearing this exact item on his wrist in the figure's sculpt!

The two-position sound selection switch allows you to choose between the four sound effects. Two of these sound effects are achieved by punching your fist! The other two are button activated. The four sound effects include a Battle Screech, a Photon Blast, a Jumbo Jab, and a Sledgehammer Punch!

It's another really fun role-play item that works quite well. The motion-activated play among all of the role-play weapons in this line makes for a lot of fun, especially when paired up together!

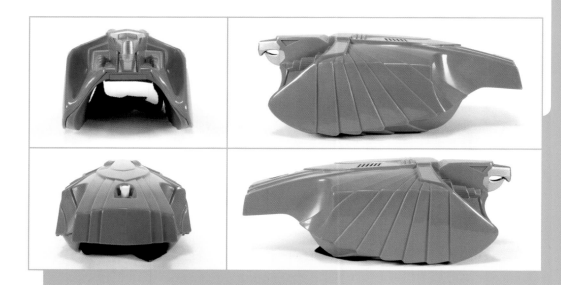

THUNDER PUNCH HE-MAN

First released 1992 • Member of the Galactic Guardians

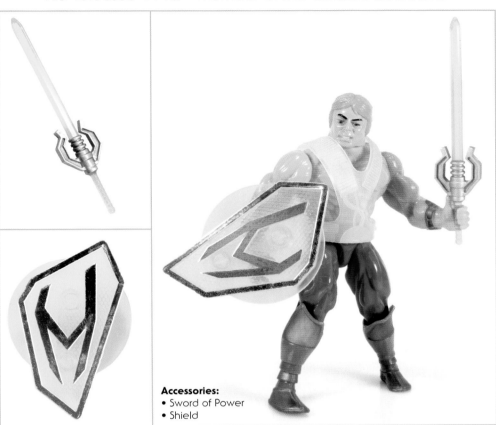

Accessories:
• Sword of Power
• Shield

This was the final variation of the main hero released. He follows the trend of all of the figures in the final wave by being quite beefed up in stature compared to the first-wave figures. As a result, this makes him feel a little closer to the original He-Man from Mattel's Masters of the Universe toy line.

Although he has the name of a variant from the original Masters of the Universe line, he does not really share the look or the same action feature. This time around He-Man is sporting a power harness that is made of a translucent yellow plastic, almost giving it a laser-like appearance much like his Sword of Power. The sword itself and the shield are also slightly redesigned from the other versions of He-Man in this line.

While he doesn't have the pop caps that made the original Thunder Punch He-Man famous, you can turn his waist and release He-Man to deliver a Thunder Punch! That's right, the classic spring-loaded "power punch" action feature returns with this figure!

Another interesting piece of sculpting is located on the figure's right hand, where you can see He-Man wearing the bird-shaped "Thunder Punch" gauntlet that kids could also buy as a role-play toy. This is great synergy for the line, and a wonderful effort to get kids to want to buy the same weaponry for themselves that they see on their He-Man action figure.

With the beefed-up look and the classic-style action feature, Thunder Punch He-Man could justifiably be considered the best version of the character released in the New Adventures toy line. Unfortunately, this figure was released at the very end, when sales were already at their lowest.

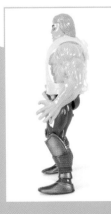
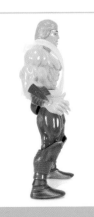
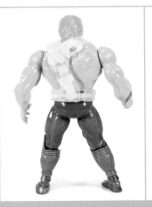
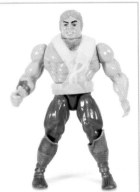

TOO-TALL HOOVE

First released 1992 • Member of the Space Mutants

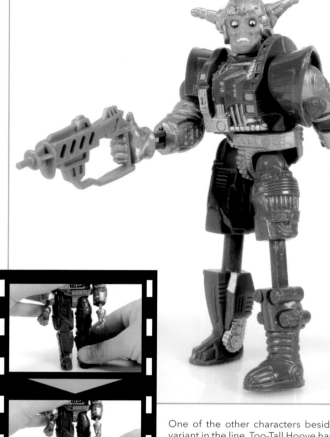

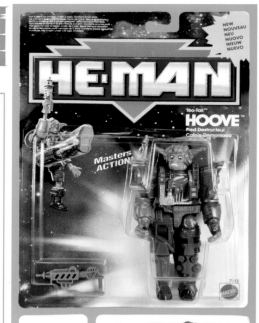

Accessory:
• Gun

One of the other characters besides He-Man and Skeletor who got a variant in the line, Too-Tall Hoove has a completely different look for 1992 with a brand-new action feature. Like all of the figures in this final wave, Too-Tall Hoove is much chunkier than his earlier release. This was likely an effort to make the New Adventures figures feel more like the beefier figures from the original Masters of the Universe toy line.

Hoove's new look is quite a bit different from his earlier release, almost making him look like an entirely different character. He is now sporting a nonremovable helmet with horns sticking out of either side. His body is much larger compared to the very skinny build of his original figure and now features a blue color palette with golden accents.

Part of the reason Hoove is much larger this time around is because his body needs to house his action feature. In similar fashion to Extendar from the original Masters of the Universe toy line, you can extend Too-Tall Hoove's legs at the boot cut and arms at the wrist, making the character appear to grow taller.

As is the case with several of the figures released as part of the 1992 wave, Too-Tall Hoove is quite hard to come by, likely because sales were so poor when he was initially released. As a result, he has become one of the more expensive and most sought-after variants in the entire lineup.

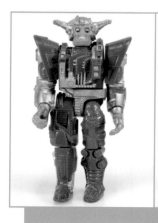
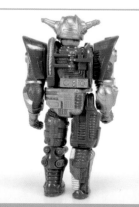
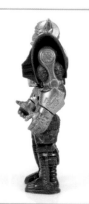
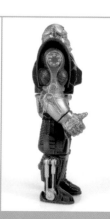

TURBO TORMENTOR

First released 1989 • Accessory of the Space Mutants

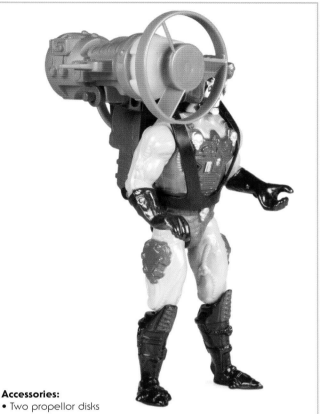

Accessories:
• Two propellor disks

TURBO TORMENTOR

The Turbo Tormentor is an accessory pack weapon that is meant to be strapped on to Skeletor or any of your Evil Mutants to give them some extra firepower against the heroes!

A rubber harness straps around the torso of your chosen action figure and connects to the Turbo Tormentor cannon. The cannon portion is attached to the backpack, and can articulate over the figure's shoulder, allowing you to fire straight ahead or slightly upwards for ranged attacks!

The propeller disks attach to the cannon and spin forward when they are fired off! You can also store two propeller disks on the backpack.

This accessory pack was only released in Europe, making it a bit harder to track down.

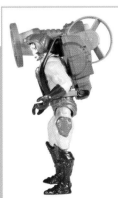

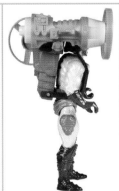

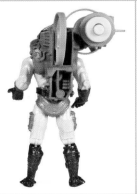

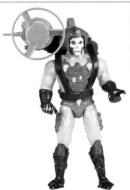

TUSKADOR

First released 1991 • Member of the Galactic Guardians

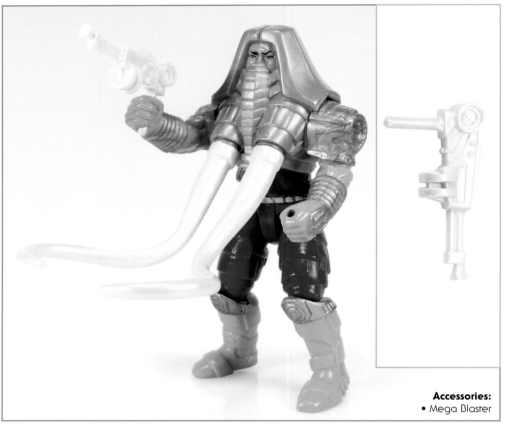

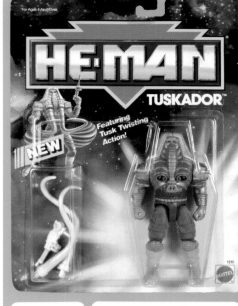

Accessories:
• Mega Blaster

While many of the Galactic Guardians action figures admittedly seem a little simple in design, Tuskador here feels very Masters of the Universe! His design is much chunkier, with the theme of a tusked mastodon in his armor!

The helmet over his head evokes a bit of Ram Man in that it appears it could be used to bash into objects or foes. The armor is a slightly shiny gold in color, while his body armor is a deep blue. The colors are quite eye catching.

The standout feature in his design is the long, pearl-white tusks extending from the front of his helmet. These tusks are part of his Masters action feature. A small lever on the back of his head allows the curved tusks to rotate inward, allowing Tuskador to trap an Evil Mutant in the grip of his tusks!

If the tusks aren't enough, he also includes a Mega Blaster made out of the same pearlized white plastic of his tusks that can be held in either hand.

It's a very cool design with a really fun action feature, making Tuskador one of the most creative Galactic Guardians in the He-Man toy line!

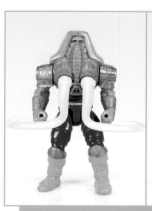
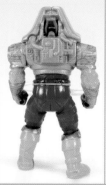
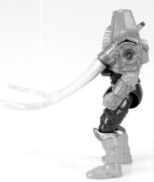
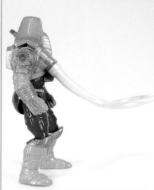
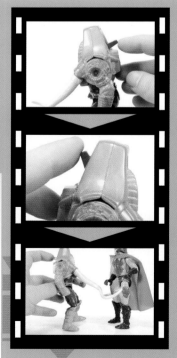

VIZAR

First released 1990 • Member of the Galactic Guardians

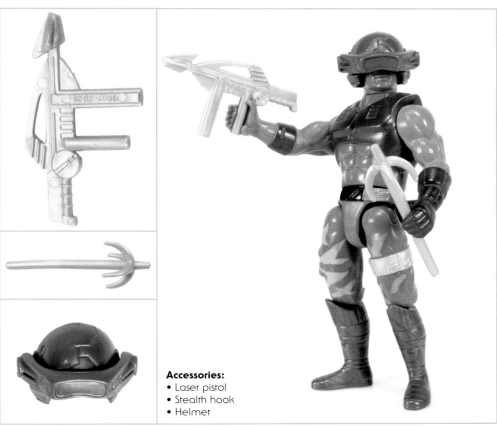

Accessories:
- Laser pistol
- Stealth hook
- Helmet

A brilliant surveillance officer, Vizar has the skills and the training to help He-Man gather information from behind enemy lines!

This figure's design includes futuristic-looking armor on his torso and his left hand, giving him a sort of humanoid and technologically enhanced hybrid look. His pants also have a unique camouflage design.

His most notable accessory and the part of his outfit that makes him stand out most is his removable helmet. This features a visor that can be lowered over the figure's eyes—exactly where his name comes from.

His action feature comes straight out of the original Masters of the Universe toy line! If you twist his waist and let go, the figure snaps back in place to deliver a powerful punch!

Like most of the figures in the He-Man toy line, Vizar comes with his own unique laser pistol. He also comes with a second weapon in the form of his Stealth Hook. This is likely to play up on the idea that he works reconnaissance missions, although with no string included or even a place to attach your own, Vizar can't really do much other than hold it.

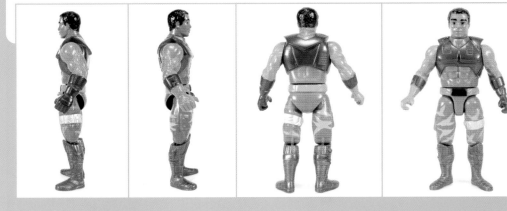

NEW ADVENTURES INTERNATIONAL VARIANTS
by Dan Eardley

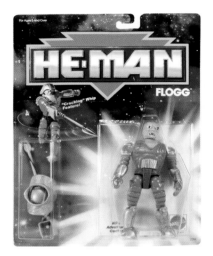

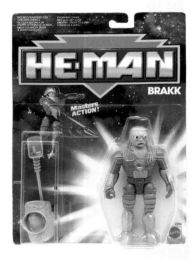

The lower interest in the He-Man line, often referred to as "The New Adventures of He-Man" due to the title of the corresponding cartoon series, persists today. With fewer collectors, the 1989 He-Man toy line is still a bit of a mystery to many people, and it's likely that there are variants yet to be discovered. But, since the line was released internationally, we do know of a few notable releases worth discussing.

You may have noticed while looking through this very book that many characters in the 1989 He-Man toy line have multiple names. That's because several characters were known by completely different names on the international market. For example, the villain known as "Flogg" in the United States is known as "Brakk" internationally.

Many of the US names definitely seem to be a little more toyetic, tying into the look or action feature of the figure. For example, Slush Head is an alien whose head is submerged in a water-filled dome. This certainly seems to follow the naming conventions of the original toy line. But internationally, Slush Head is known as "Kalamarr." The international names almost have more of a science-fiction movie feel.

Some of these characters can only be found on single-release cards which feature their international names. Slush Head, again, is a great example. In the US, he can be found in a bonus figure two-pack with He-Man, and the Slush Head name appears on the package. But if you want to get him single carded, you'll only find him labeled as Kalamarr.

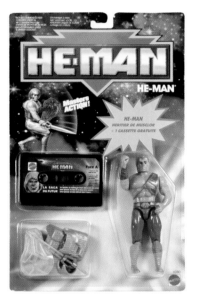

Now, if you're looking for something a little more unique, then you'll want to turn your attention to the gift sets. One of the more notable international gift set releases features He-Man packaged with a cassette tape that tells the story of his new adventure.

Perhaps some of the most interesting figures featuring the He-Man packaging were released in India by Leo Toys. Leo Toys officially distributed Masters of the Universe action figures and produced many interesting color variations for the vintage toy line, but an odd thing happened around 1990. Leo began releasing figures from the vintage Masters of the Universe toy line on card backs that were shaped like the ones from the original toy line, but with the logo and color scheme from the 1989 He-Man toy line's packaging!

This led to some strange figure releases. Seeing the original-style Prince Adam and Skeletor on card backs featuring New Adventures artwork is certainly jarring for longtime fans of the franchise. In addition, several New Adventures figures also got released on these same card backs right alongside the vintage figures. It's as if Leo Toys was the bridge between the two toy lines that many fans were hoping for.

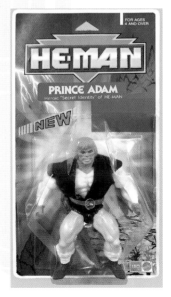

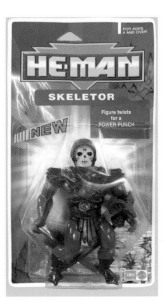

TIMELINE COLOR KEY

○ Trademark ○ Copyright
● First Use in Commerce ○ Concept

05/18/1987 • Optikk concept, by David Wolfram

05/21/1987 • Eyeyik (Optikk) revised concept, by David Wolfram

09/08/1987 • Powersword role-play concept

04/08/1988 • Tri-Solar System illustration, by David Wolfram

04/24/1988 • He-Man concept, by Martin Arriola

04/25/1988 • Skeletor concept, by David Wolfram

04/25/1988 • Hoove concept, by David Wolfram

05/09/1988 • Evil Spheroid (early Nordor) concept, by Dave McElroy

09/21/1988 • Nordor concept, by David Wolfram

11/30/1988 • Astrosub first use in commerce

11/30/1988 • Bolajet first use in commerce

11/30/1988 • Flogg first use in commerce

11/30/1988 • Powersword first use in commerce

11/30/1988 • Slush Head first use in commerce

11/30/1988 • Starship Eternia first use in commerce

11/30/1988 • Terroclaw first use in commerce

12/12/1988 • Astrosub trademarked

12/12/1988 • Bolajet trademarked

12/12/1988 • Flogg trademarked

12/12/1988 • Slush Head trademarked

12/12/1988 • Powersword trademarked

12/12/1988 • Starship Eternia trademarked

12/12/1988 • Terroclaw trademarked

1989

01/24/1989 • Tharkus (Sagitar) concept, by David Wolfram

02/08/1989 • Flipshot first use in commerce

02/08/1989 • Hydron first use in commerce

03/13/1989 • Flipshot trademarked

03/13/1989 • Hydron trademarked

04/18/1989 • Shuttle Pod first use in commerce

04/18/1989 • Kayo first use in commerce

04/18/1989 • Optikk first use in commerce

04/24/1989 • Kayo trademarked

04/24/1989 • Optikk trademarked

04/24/1989 • Shuttle Pod trademarked

05/31/1989 • Butthead concept, by David Wolfram, based on design by Mark Taylor

07/19/1989 • He-Man copyrighted

07/19/1989 • He-Man electronic powersword copyrighted

07/19/1989 • Slush Head copyrighted

07/28/1989 • Skeletor copyrighted

07/31/1989 • Flipshot copyrighted

07/31/1989 • Optikk copyrighted

08/04/1989 • Flogg copyrighted

08/22/1989 • Quakke concept, by David Wolfram

08/25/1989 • Hydron copyrighted

10/17/1989 • Kayo copyrighted

11/16/1989 • Artilla trademarked

11/16/1989 • Battle Bird trademarked

11/16/1989 • Battle Punch trademarked

11/16/1989 • Disks of Doom trademarked

11/16/1989 • Hoove trademarked

11/16/1989 • Karatti trademarked

11/16/1989 • Nocturna trademarked

11/16/1989 • Quakke trademarked

11/16/1989 • Sagitar trademarked

11/16/1989 • Spinwit trademarked

11/16/1989 • Staghorn trademarked

11/16/1989 • Terrotread trademarked

11/16/1989 • Tuskador trademarked

11/16/1989 • Vizar trademarked

12/12/1989 • Hoove copyrighted

12/26/1989 • Nocturna copyrighted

12/27/1989 • Karatti copyrighted

02/02/1990 • Doomcopter trademarked

02/16/1990 • Vizar copyrighted

02/21/1990 • He-Man (toy weapon) first use in commerce

03/22/1990 • Terror Punch trademarked

03/26/1990 • He-Man (play set) trademarked

03/26/1990 • Thunder Punch (sound effect toy) trademarked

03/26/1990 • Butthead trademarked

03/26/1990 • Skull Staff trademarked

03/28/1990 • He-Man (toy weapon) trademarked

03/31/1990 • Disks of Doom first use in commerce

05/24/1990 • Battle Punch first use in commerce

06/14/1990 • Battle Punch He-Man copyrighted

06/14/1990 • Disks of Doom Skeletor copyrighted

06/14/1990 • Staghorn copyrighted

06/18/1990 • Battle Blade trademarked

06/18/1990 • Spin Fist trademarked

07/09/1990 • Spinwit copyrighted

07/09/1990 • Butthead copyrighted

07/09/1990 • Weaponstronic (Artilla) copyrighted

07/16/1990 • Hook 'Em Flogg trademarked

07/16/1990 • Too-Tall trademarked

09/04/1990 • Skull Staff first use in commerce

09/17/1990 • Terror Punch first use in commerce

11/20/1990 • Battle Blade first use in commerce

09/14/1990 • Earthquake (Quakke) copyrighted

09/27/1990 • Skeletor skull staff copyrighted

10/19/1990 • Thunder Punch (sound effect toy) first use in commerce

1991

09/09/1991 • Too-Tall first use in commerce

1992

03/16/1992 • Battle Blade trademarked again

HE-MAN

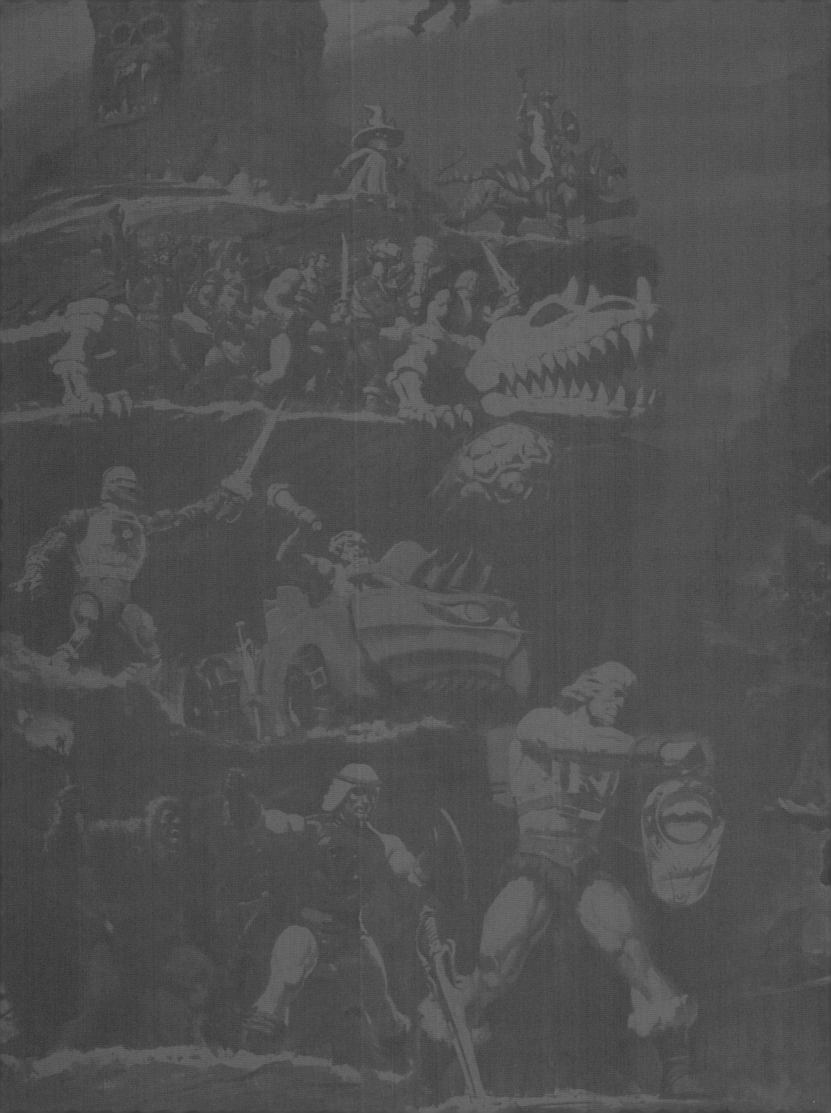

CHAPTER 4

Masters of the Universe Commemorative (2000)

WAVE ONE

First released 2000

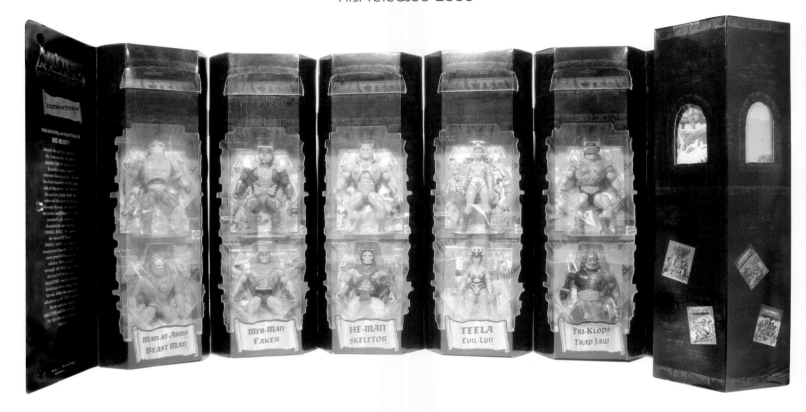

Man-At-Arms / Beast Man · Mer-Man / Faker · He-Man / Skeletor · Teela / Evil-Lyn · Tri-Klops / Trap Jaw

In 2000, Mattel released a new Commemorative Masters of the Universe series of action figures, intended to touch on the nostalgia of their popular 1980s toy line.

This line targeted toy collectors specifically. Each figure looks exactly like its 1980s counterpart and even comes packaged in the same style of blister card packaging. However, each figure is now housed inside of a large window box that makes it feel extra collectible. On the back of each box is an image of the figure's card back, printed with a shiny holo-foil look.

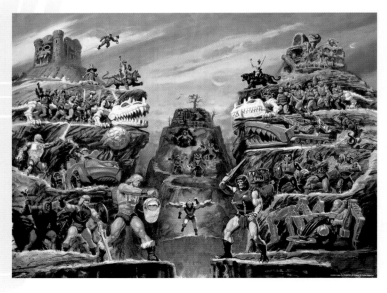

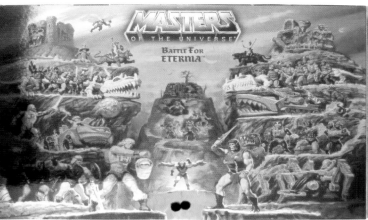

Within that box, the original-style blister card is marked "REPLICA" in an effort to deter the ability to pass this off as a carded original. Also found within the package is a reprint of the original minicomics that came with the action figures. These reprints are also marked "REPLICA."

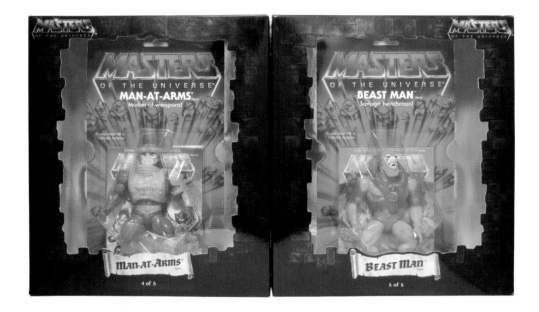

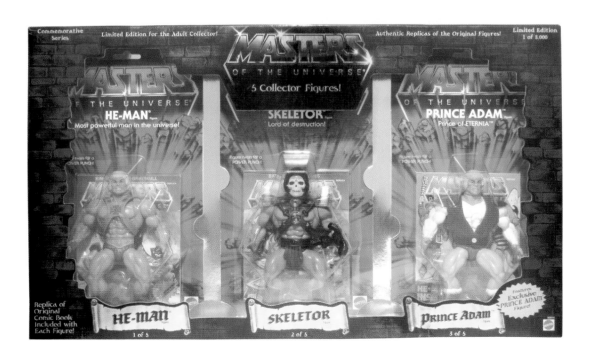

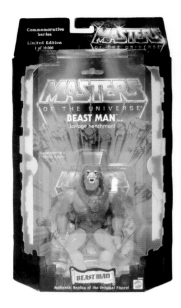

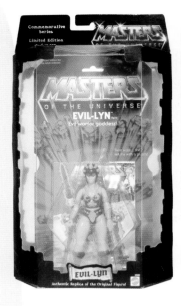

Since the original molds were long gone, Mattel couldn't just put the original figures back into production for these releases. Instead, Mattel had to get ahold of the original toys and make brand-new molds by casting the existing action figures. As a result, some of the figures in this Commemorative line have details that are slightly dulled when compared to the originals. And in some cases, the proportions seem a little off. He-Man is noticeably different if you look at his head sculpt compared to the original release from the 1980s. Nevertheless, they look pretty close and are still solid action figures that pay tribute to the original releases.

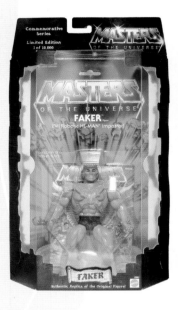

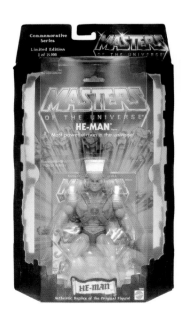

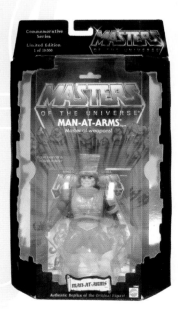

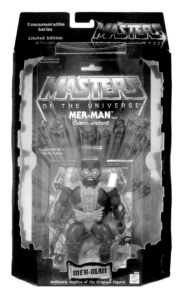

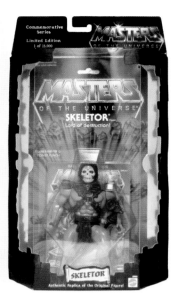

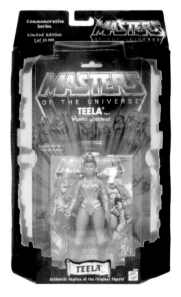

While the figures are pretty similar to the original releases, there are some differences worth noting. Trap Jaw was produced without his hook attachment, Evil-Lyn's wand is not made of glow-in-the-dark plastic, and Faker is missing his chest sticker.

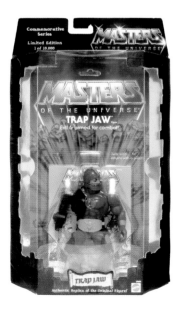

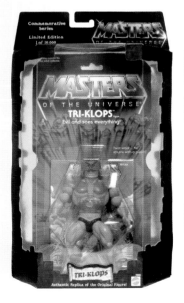

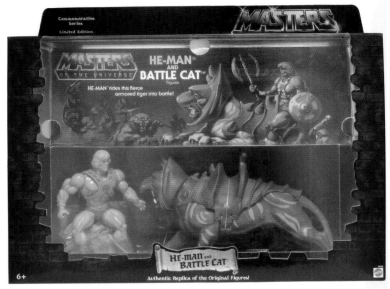

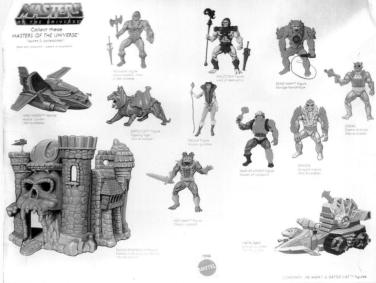

There were sixteen single carded figures reissued in the Commemorative series. Each figure was limited to ten thousand units, with the exception of both He-Man and Skeletor, who were limited to fifteen thousand units each. There were also several gift sets produced. Battle Cat was released with He-Man, and Panthor was released with Skeletor. There are also two different five-Packs, one of which included an exclusive Moss Man and the other with an exclusive Prince Adam. And the massive Legends of Eternia ten-pack, sold exclusively through JC Penney stores, includes ten figures in a special Castle Grayskull–themed box.

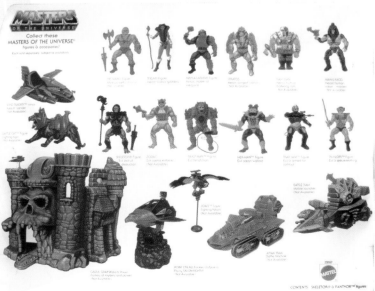

WAVE TWO

First released 2001

THE HISTORY and MYSTERY OF HE-MAN®!

Beyond the farthest galaxies of the universe lies the planet Eternia™. Half of Eternia is a beautiful utopia where everyone lives in peace. All evil has been banished to the dark side of the planet, far beyond the ancient Mystic Wall. But when evil threatens to break through the wall, the powerful Sorceress and Keeper of Castle Grayskull® calls upon one champion to save Eternia—PRINCE ADAM™. By raising the Sword Of Power, PRINCE ADAM is magically transformed into HE-MAN, the most powerful man in the universe. With amazing strength, HE-MAN must stop the lord of destruction, SKELETOR®, and his sinister henchmen from conquering Eternia. Relive the awesome adventure as HE-MAN and his heroic warriors battle SKELETOR and his evil warriors for the ultimate survival of Eternia!

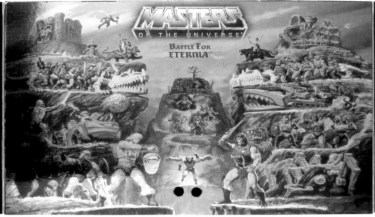

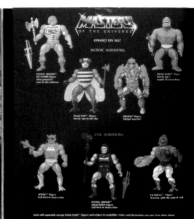

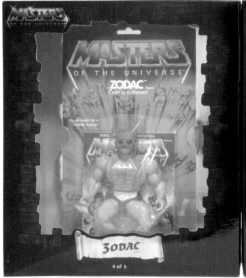

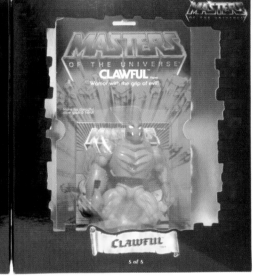

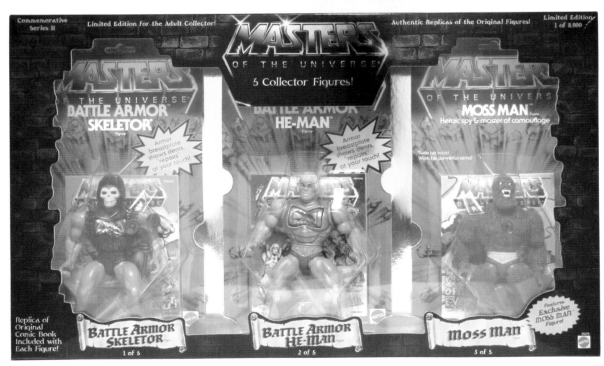

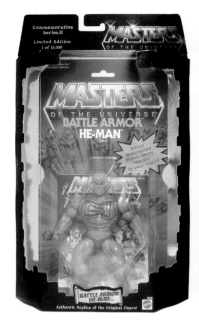

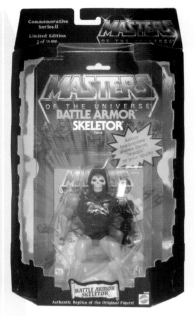

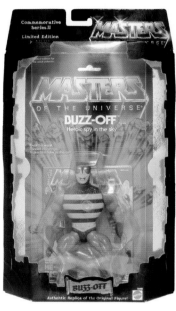

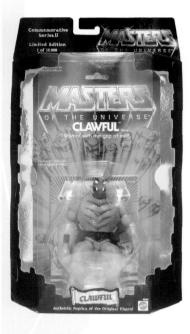

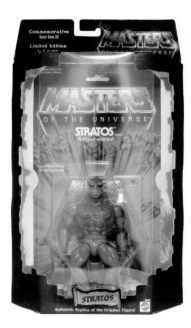

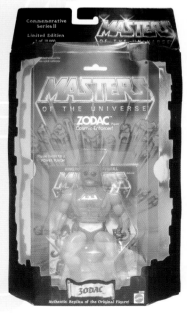

CHAPTER 5

Masters of the Universe (2002)

ATTACK SQUID

First released 2003 • Vehicle of the Evil Warriors

Accessories:
• Two cannons
• Two missiles
• Four tentacles

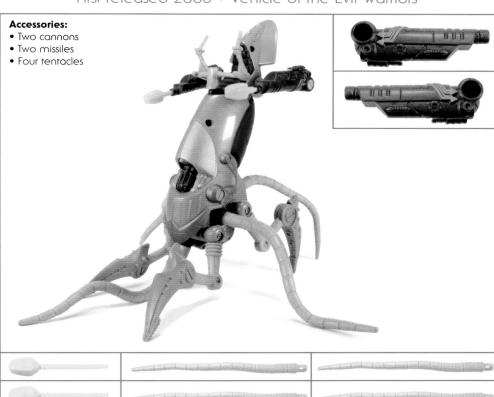

Skeletor's Attack Squid was among the first vehicles released for this new Masters of the Universe series. While the figures themselves featured sculpts from toy sculptors the Four Horsemen, the vehicles were all designed in-house at Mattel. As a result, the aesthetics sometimes didn't completely match between the figures and their transports. But that's not to say they are bad toys.

The Attack Squid follows a classic Masters of the Universe theme by being designed after an animal. It features four tentacles as well as four-bladed legs, almost making it look like a squid / crab hybrid. Rolling the vehicle forward causes the tentacles and legs to move up and down, making it look as if it's crawling.

Skeletor sits atop the creature, with handlebars positioned in front for the figure to hold on to. Admittedly, Skeletor almost appears too big for the Attack Squid. The vehicle is likely a bit undersized to maintain a certain price point in the toy aisles. Topping it all is a signature action feature of the 2002 Masters of the Universe toy line: two spring-loaded rocket-firing missiles! You're going to see a lot of those in this line.

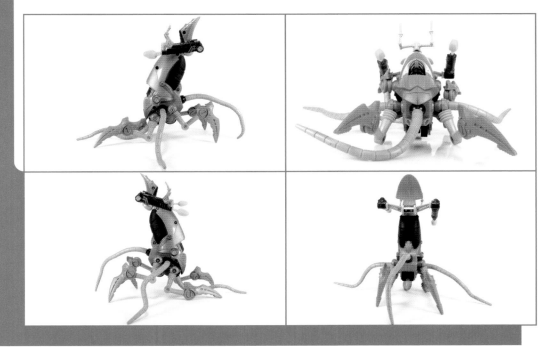

BASHIN' BEETLE

First released 2002 • Vehicle of the Heroic Warriors

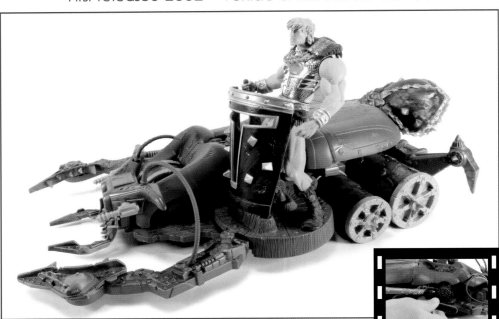

The design of the Bashin' Beetle harks back to a vintage Masters of the Universe vehicle known as the Bashasaurus. While it has a similar action feature, this time around the vehicle is insect-themed with an overall grittier look to the design.

An action figure stands behind a shield, chariot-style, to operate the vehicle. The sculpt is quite intricate here, with a lot of little wires, bolts, and circuitry worked into the design. The design is a bit of a hodgepodge, almost as if you can imagine this is something that Man-At-Arms actually built for battle.

There are quite a few play features on this one. A button on the back of the Bashin' Beetle will bash the front spiked plate forward to knock over your foes! The beetle wings on the back can be lifted to be used as shields. A small lever on the back is used to close the pincers in the front. This is used to trap any enemy that gets in the way. Once you have them properly trapped, the real fun happens!

By turning the lever on the side, a large boulder arm comes crashing down, bashing the villains as they are trapped by the pincers! The play features all function wonderfully, making this vehicle not only effective in appearance but also very fun to play with!

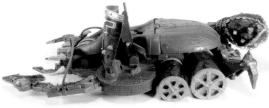

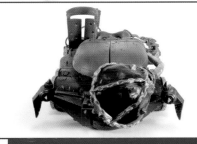

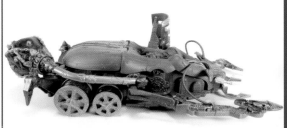

MOTU 2002

BATTLE ARMOR HE-MAN

First released 2003 • Member of the Heroic Warriors

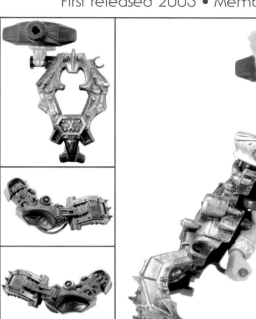

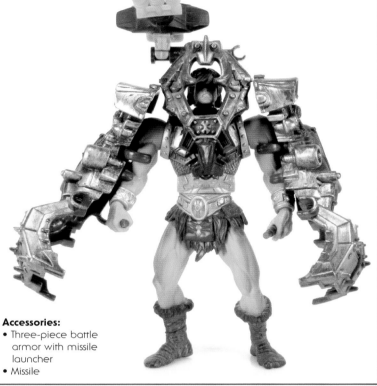

Accessories:
- Three-piece battle armor with missile launcher
- Missile

Battle Armor He-Man was the name of a classic variant of our main hero from the 80s toy line. But make no mistake—this new Battle Armor He-Man has little in common with the vintage release. Instead, it features an entirely new design for the battle armor which seems much more high tech.

Two large robot-like claws can be clipped on the sides of He-Man's arms, with small levers fitting into his hands. Two clips on top of his shoulders are intended for the overhead armor piece to snap on to. This piece resembles a large face shield with a scope and a missile launcher branching off the top. And of course, the missile launcher contains a spring-loaded mechanism allowing you to fire a bright orange missile.

The overall design feels more like a mech suit than actual battle armor, but Eternia has always featured a mix of sorcery and technology!

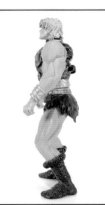
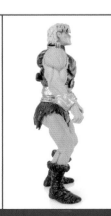
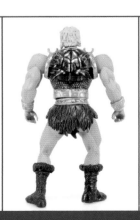
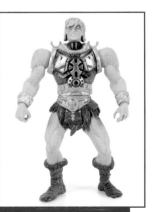

BATTLE ARMOR SKELETOR

First released 2003 • Member of the Evil Warriors

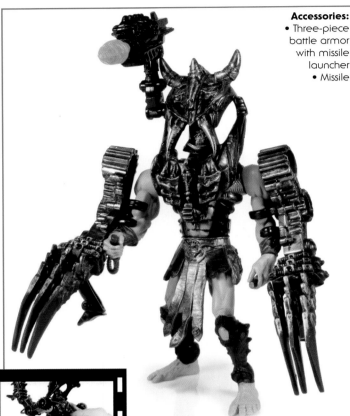

Accessories:
• Three-piece battle armor with missile launcher
• Missile

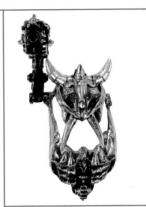

Much like in the vintage Masters of the Universe toy line, for every He-Man release in this line there is a corresponding Skeletor release. Often, their variants even have the same name, as is the case with Battle Armor Skeletor here.

As with He-Man, this version has little in common with the much-loved Battle Armor Skeletor figure from the original toy line. Instead, this Skeletor variant features similar mech-suit-like attachments in the form of giant robotic claws that can clip on to the sides of his arms. Small clips on the shoulders of his unique, metallic green armor are meant to clip on the head armor. This piece is in the shape of a large dragon with a metallic green paint deco.

The giant claws on this one almost make this figure feel more like an updated version of another classic Skeletor variant from the original line: Terror Claws Skeletor.

And of course, the figure could not be made complete without his own spring-loaded missile launcher to blast back at He-Man!

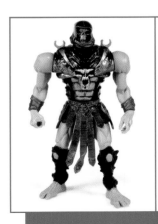

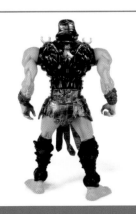

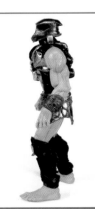

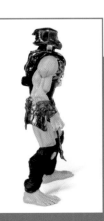

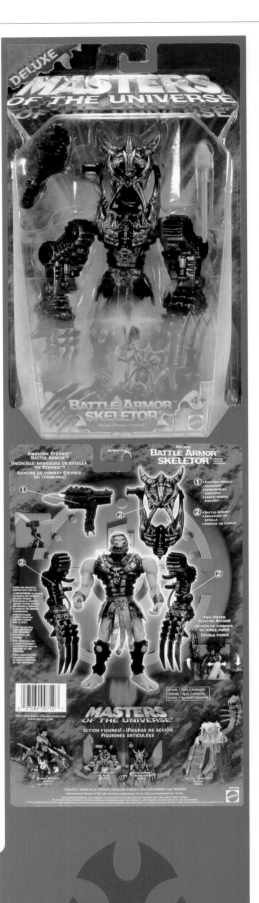

MOTU 2002

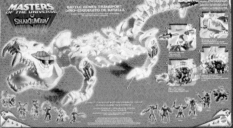

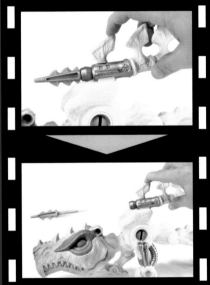

BATTLE BONES TRANSPORT

First released 2003 • Vehicle of the Heroic Warriors

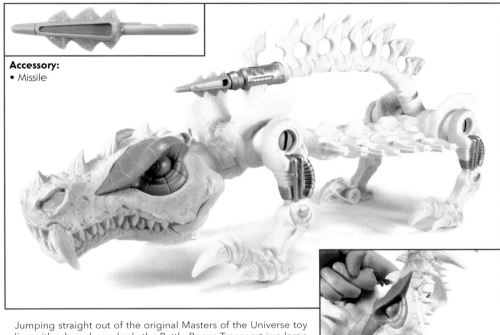

Accessory:
• Missile

Jumping straight out of the original Masters of the Universe toy line with a brand-new look, the Battle Bones Transport is a large skeletal dragon or dinosaur that also doubles as a carry case for your action figures!

While the design on this one is a little different from the original release, the way it works is exactly the same. The rib bones are designed to snap around the waist of your action figures. The tail is curved upward and attached to the front, turning into a makeshift handle that allows you to transport your figures!

The original Battle Bones was known to be made of a brittle plastic, and thus easy to break. This new version feels much sturdier. It also has the addition of articulation in the legs. The mouth can still open, also working as a place to store the accessories of your figures. And when you're not using it as a carry case, you can press a small button to unlatch the tail and fold it backward. These additions make Battle Bones feel like more than just a simple carry case! He can also be used as a large beast to fight your action figures!

Mattel even gave him a spring-loaded missile launcher at the tip of his tail—just to make him fit in with the rest of this line!

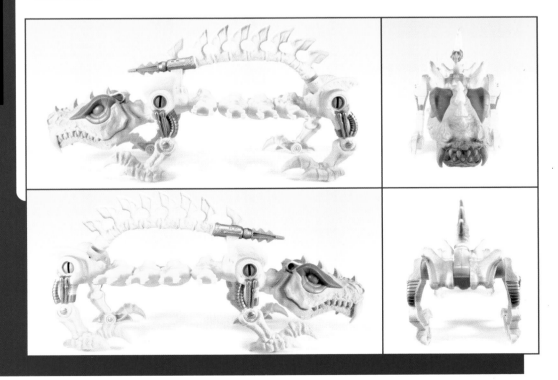

BATTLE CAT

First released 2002 • Steed of the Heroic Warriors

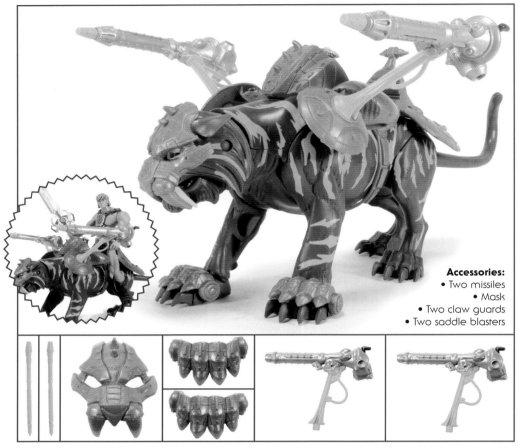

Accessories:
- Two missiles
- Mask
- Two claw guards
- Two saddle blasters

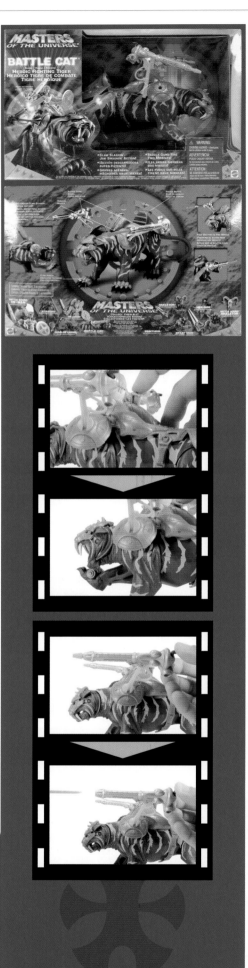

The Heroic Fighting Tiger and He-Man's best friend returns with an updated look! This fierce new look gives Battle Cat a scruffier appearance around his head and large saber teeth—giving him more of a saber-toothed tiger vibe.

The new helmet still maintains the rust red color of the original release, but the shape is much smaller. Instead of covering the entire head, it now just clips on to the front of his face, and even extends downward to cover his new long teeth. Small armor pieces are also included to clip on the front paws.

Instead of being a solid, unarticulated sculpt like the original Battle Cat action figure, we now get articulation in the legs. In addition, an action feature was included. Pressing a button on his back causes one of his paws to raise forward in a slash and results in a chomping action with his mouth!

He-Man can still mount Battle Cat via the included saddle. One of the odd additions this time around is that of large spring-loaded missile launchers that jut out of the sides of his saddle. While many of the toys in this line featured this rocket-firing gimmick, these do seem out of place on a character such as Battle Cat. Luckily, these are easily removable if you are not into them.

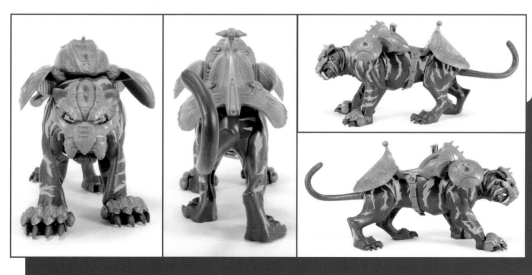

MOTU 2002

BATTLE FIST

First released 2003 • Member of the Heroic Warriors

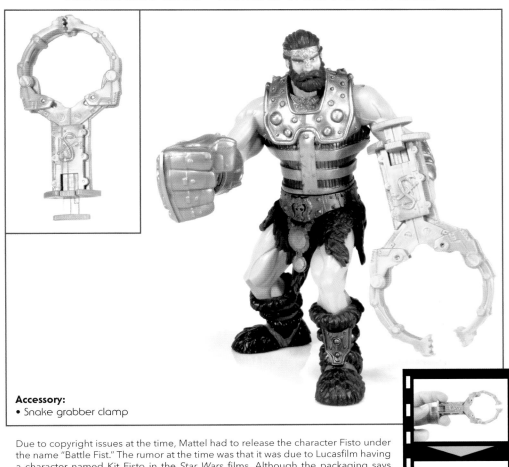

Accessory:
• Snake grabber clamp

Due to copyright issues at the time, Mattel had to release the character Fisto under the name "Battle Fist." The rumor at the time was that it was due to Lucasfilm having a character named Kit Fisto in the *Star Wars* films. Although the packaging says Battle Fist, fans still refer to this figure by his original name.

Much like many of the weapons in this series, Fisto's signature armored fist is even more oversized than usual. It also features a new action feature. By pressing a small button, the spring-loaded fist pops forward to deliver a powerful punch!

The figure reuses the base body and legs from the Ice Armor He-Man variant, giving Fisto the wider stance. This works well for the new design of the character, matching up with new parts, like the loincloth, armor, and beautiful head sculpt, to make him stand on his own.

Since Fisto was released as part of the "Masters of the Universe vs. the Snake Men" rebranding, he was given an accessory that doesn't quite fit the character. This clamp accessory features the anti–Snake Men logo and has a button on the back to open and close the prongs. The idea was to give him a tool to fight off the Snake Men; however, many fans were unhappy with this weapon's inclusion, as it replaced Fisto's classic sword as the pack-in accessory.

Being released near the end of the line, Fisto was one of the harder-to-find figures due to the poor distribution of the Snake Men waves. There is also a chase variant featuring a slightly different paint deco that is even more difficult to locate, remaining one of the rarer variants today.

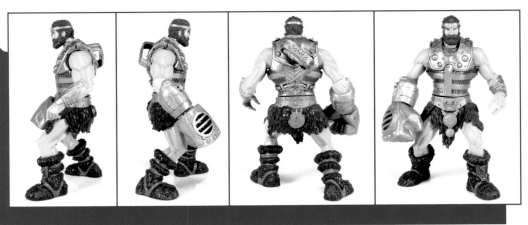

BATTLE GLOVE MAN-AT-ARMS

First released 2003 • Member of the Heroic Warriors

Accessories:
- Axe
- Missile
- Battle glove

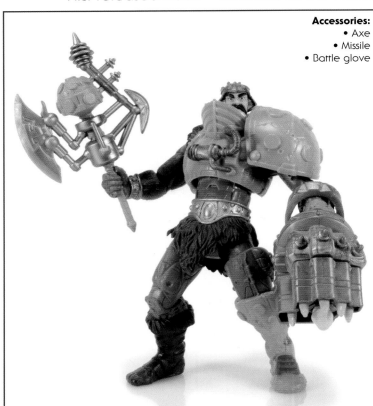

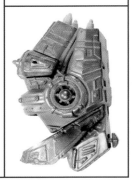

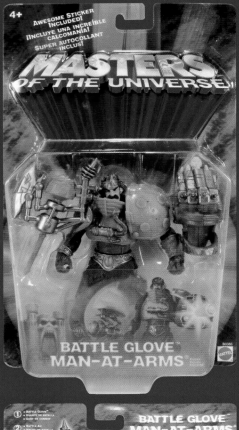

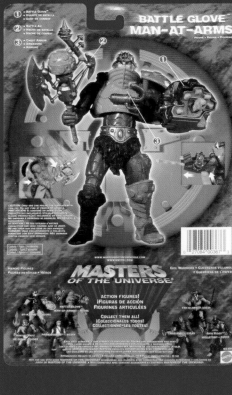

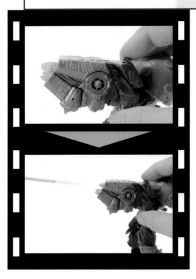

Man-At-Arms is one of the many characters in this series who got several different variants to keep the character on store shelves. The Battle Glove variant doesn't add a ton of new stuff. The overall design of the figure looks much the same as the original release. While many variants had different colors in the paint deco, Battle Glove Man-At-Arms features the same standard look to his uniform.

His signature club has a new addition in the form of a stylized axe attachment that is now connected to it. It can be held in the right hand, which features a slashing action feature by pressing a button on the figure's back.

The battle glove accessory is a modified version of the arm cannon that was included with the standard Man-At-Arms release. Much like that original release, this new battle glove still fits over the figure's left hand and has a button on the top to trigger the spring-loaded missile being fired.

While it doesn't stand out much from the original release, if you were someone who missed that first figure this was a great way to add Man-At-Arms to your collection at the time!

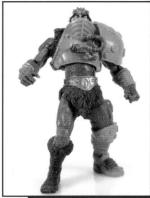

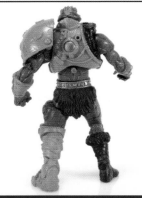

MOTU 2002

BATTLE HAWK

First released 2002 • Vehicle of the Heroic Warriors

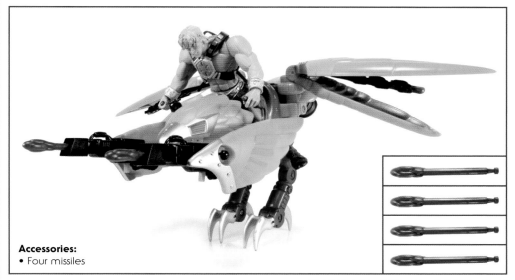

Accessories:
• Four missiles

Following the animal theme found in many of the vehicles, the Battle Hawk is a heroic jet styled to look like an orange hawk.

He-Man or almost any of your heroic action figures can mount the Battle Hawk, complete with control sticks for the figure to grip on to. Moving the control sticks up for the figure moves the front feathers forward. These contain fold-out missile launchers, complete with that spring-loaded rocket-firing action feature seen on many toys in this line.

The legs of the bird act as landing gear but can also be folded backward when in flight. Pressing down on the tail feather causes the wings to fold forward and open, revealing small blasters inside and getting the Battle Hawk ready for flight!

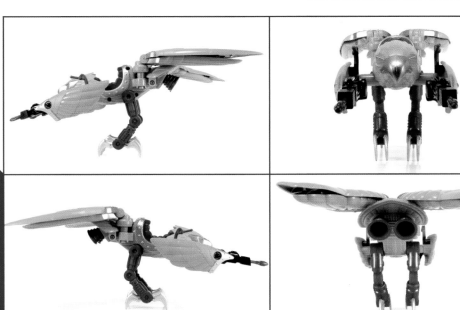

BATTLE RAM CHARIOT

First released 2002 • Vehicle of the Evil Warriors

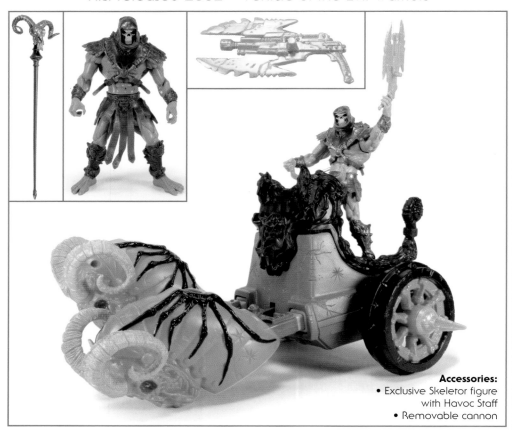

Accessories:
• Exclusive Skeletor figure
with Havoc Staff
• Removable cannon

Skeletor's all-terrain Battle Ram Chariot is a vehicle fit for the Evil Lord of Destruction!

The chariot features two large red wheels with golden spikes on the chariot portion and is pulled by two bright red ram skulls! Pushing the chariot forward triggers a galloping effect, moving the ram skulls up and down to mimic the gallop of a horse pulling the ride!

The chariot portion has a foot peg for Skeletor to stand on as he's charging into battle. It also has an extending plank off the back, allowing another villain to hitch a ride!

The included Skeletor action figure is the same sculpt as the standard release, with a few notable differences. This time around, the action feature is missing. Therefore, the articulation in the arms is not at all hindered, and the button is missing from his back. The paint deco is also a lot brighter. His bone face is lacking the black wash and has a bright yellow-and-green paint scheme that harks back to the vintage Skeletor action figure.

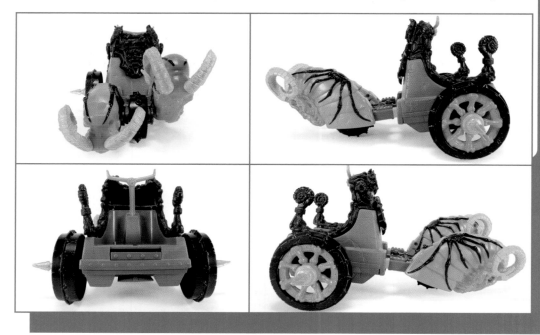

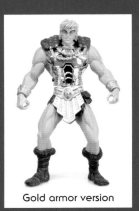

BATTLE SOUND HE-MAN

First released 2002 • Member of the Heroic Warriors

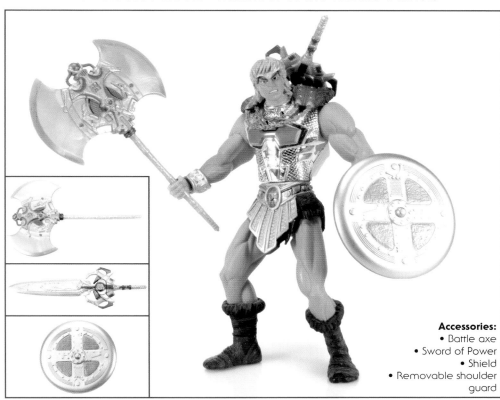

Accessories:
• Battle axe
• Sword of Power
• Shield
• Removable shoulder guard

The first deluxe variation of the main hero from this series, Battle Sound He-Man was a favorite when he was first released. He really felt like the spiritual successor to the original Battle Armor He-Man figure from the vintage toy line. Much like that one, this new figure is wearing silver body armor and even has a similar stylized orange *H* symbol on his chest.

The armor is vac metalized, giving it a very sleek metallic shine. The accessories included are the same ones from the standard He-Man release, but he does have the addition of sculpted furry shoulder armor that has a holster for the sword or axe.

The figure has a small button on his side that, when pressed, triggers his action sound. The voice of John Erwin, He-Man's voice actor in the original Filmation cartoon series, belts out the famous "I have the Power!" catch phrase followed by an action sound!

It's worth noting that there are multiple variations of this figure. A version with golden vac-metalized armor also hit store shelves shortly after the silver one was released. Eventually there was a running change that replaced the "I have the power!" voice clip with voice actor Cam Clarke, voice of He-Man in the 2002 cartoon series by Mike Young Productions. This makes four total variations that can be found, though it does not appear that any of these are any harder to find than the others.

This figure also came packaged with a VHS tape containing an episode of the original *He-Man* cartoon series.

Gold armor version

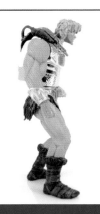

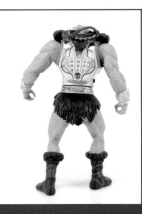

BATTLE SOUND SKELETOR

First released 2002 • Member of the Evil Warriors

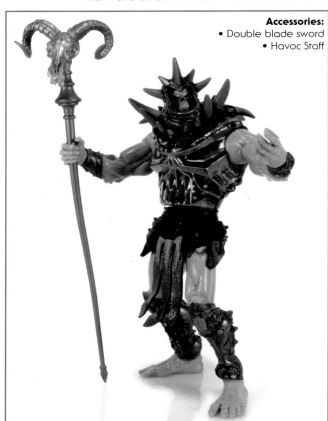

Accessories:
- Double blade sword
- Havoc Staff

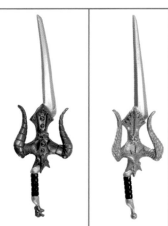

This figure was released alongside Battle Sound He-Man as the first set of deluxe variations of the main characters in the line. While Battle Sound He-Man felt like an update of the original Battle Armor He-Man, Battle Sound Skeletor has a completely new look.

The weapons themselves are the same ones that were included with the basic figure, but Skeletor's design is quite different. As with Battle Sound He-Man, Skeletor's armor is vac-metalized. It's a deep red in color, featuring a skull face in the sculpt. Large spikes rest upon Skeletor's head as well as around his neckline on his shoulders. It's quite a fierce look for the villain!

A small button on the figure's side activates sound effects when pressed. The voice of Alan Oppenheimer, voice of Skeletor in the original animated series, exclaims, "Eternia will be mine!" followed by the sound of swords clashing. It's quite thrilling to hear that classic voice, and pairing that with the menacing armor makes this one of the most popular Skeletor variations in the line.

Like with Battle Sound He-Man, Battle Sound Skeletor also came packaged with a VHS tape featuring an episode of the original Filmation *He-Man and the Masters of the Universe* series.

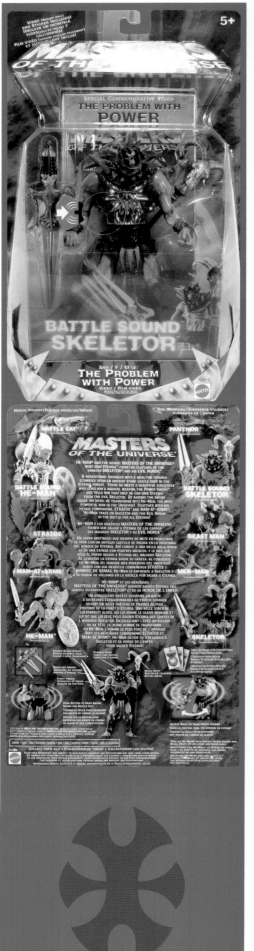

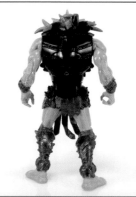

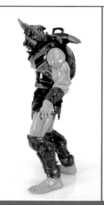

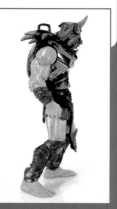

MOTU 2002

BATTLE STATION

First released 2003 • Location of the Heroic Warriors

Accessories:
- Missile cannon
- Three missiles
- Castle Grayskull clip
- Flag
- Boulder
- Catapult
- Battering ram

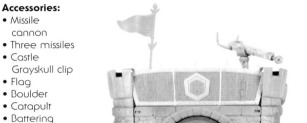

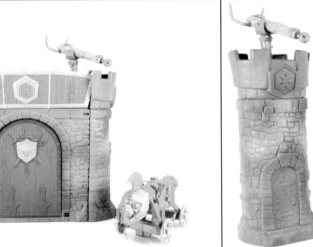

Done in the same green brick style as Castle Grayskull, the Battle Station is a small stand-alone play set that can also double as an add-on to the Castle Grayskull play set.

On its own, it resembles a stronghold complete with a gate styled similarly to the Jawbridge of Castle Grayskull. There's really not much on the inside, but there is a platform on the top that features a removable flag and a spring-loaded missile cannon to fire at approaching enemies below.

Several fun accessories are included that are specifically designed to storm the Battle Station. The battering ram accessory features a skull head on the front and wheels to roll it into position. At the press of a button, the spring-loaded battering ram launches forward and knocks down the gate upon impact.

The catapult includes a boulder that can be loaded in. Pressing a button releases the catapult, launching the boulder at the Battle Station. If the boulder hits the top portion, the wall will be knocked down, hitting any figure that may be standing atop the stronghold!

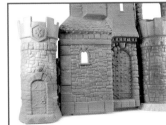

The Battle Station is also modular, with the ability to remove the two towers on either end and combine them together to make a solid tower—changing up the overall look of the Battle Station. In addition, a separate piece is included that will allow you to attach the Battle Station to the side of Castle Grayskull. Admittedly, this is a bit awkward, as it has to attach to the side wall, effectively making the Battle Station the back of Castle Grayskull, which really doesn't fit too well.

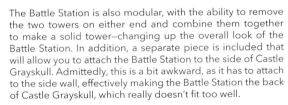

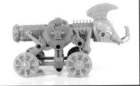

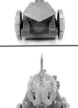

BATTLE TANK

First released 2002 • Vehicle of the Heroic Warriors

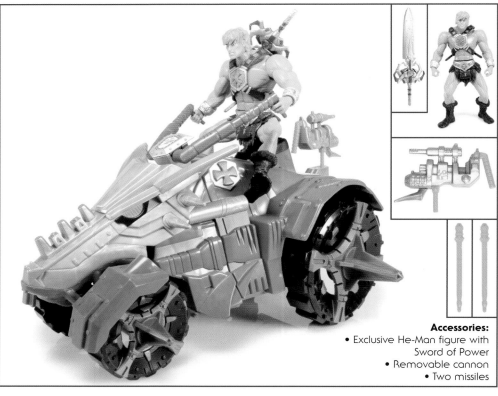

Accessories:
• Exclusive He-Man figure with Sword of Power
• Removable cannon
• Two missiles

He-Man's Attack Vehicle, the Battle Tank, is a four-wheeled all-terrain vehicle. The design is almost reminiscent of the classic Battle Ram vehicle from the vintage Masters of the Universe line, even utilizing a similar dark blue color scheme.

The big difference in the design is with the large silver wolf head adorning the front of the vehicle. Just behind that is a seat and a pair of handlebars for He-Man or any of your Heroic Warriors to mount the vehicle. A large detachable cannon sprouts from the back to blast at enemies that may be approaching on the rear. Unlike many of the cannons in this line, this one does not fire rockets. However, there are two hidden missile-launching cannons on the sides!

By pressing the lever on the back of the Battle Tank, the side missile launchers are exposed, popping down to the sides of the tank. Pushing down on this lever also fires the large wolf head forward, turning the Battle Tank into a rolling battering ram to mow over the villains in your way!

A He-Man action figure was also packed with the vehicle. He's not much different than the single released figure, albeit with a slightly lighter paint deco on the hair. His Sword of Power is included, but he does not come with the battle axe or shield.

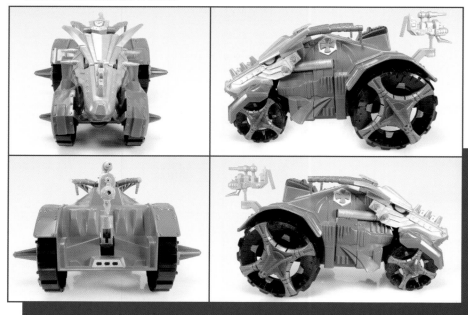

MOTU 2002

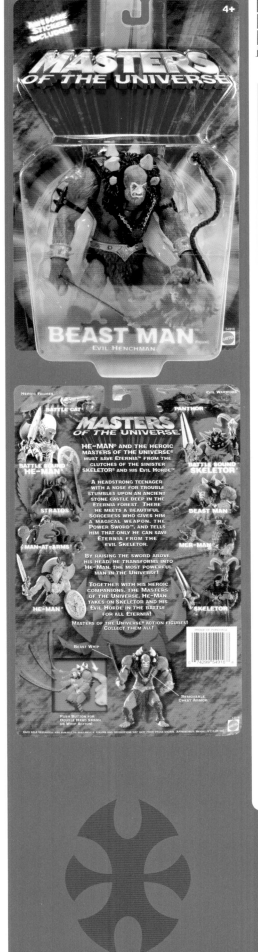

BEAST MAN

First released 2002 • Member of the Evil Warriors

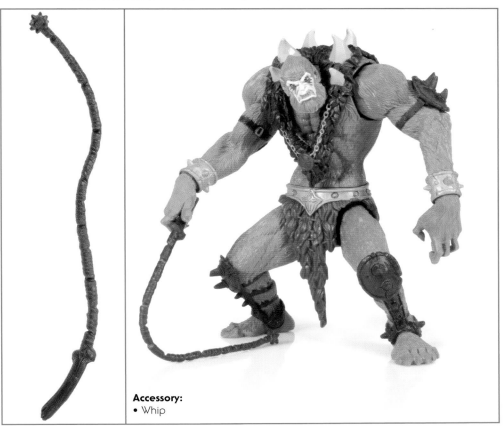

Accessory:
• Whip

Probably the most famous henchman of Skeletor, Beast Man is reintroduced in this new toy line with a brand-new, updated look.

This time around, he is much larger in stature with a more ape-like appearance. While the vintage Beast Man figure is ape-like in appearance, the ape proportions are more pronounced in this new incarnation. He has a large hunched back and huge clawed feet. While all of the figures in this line stand roughly six inches tall, Beast Man is much chunkier and bulkier because of his larger body design, making him look quite menacing when opposing the heroes.

The figures were much more articulated in this new line. Beast Man has joints at his neck, shoulders, wrists, waist, and hips, allowing for more posing options than with the original figures released in the 1980s.

Beast Man comes packaged with his classic whip as an accessory. This time, instead of being made out of a real piece of string, the whip is sculpted and molded out of a pliable plastic so it can still flex and flail about. Like many figures in this line, Beast Man has a push-button action feature on his back. Pressing this button will cause the figure to raise his right arm. Pressing repeatedly makes him swing the whip.

There was a second version of this figure that was exclusive to Kmart stores. The figure itself is exactly the same, but he was packed with a bonus trading card featuring original artwork.

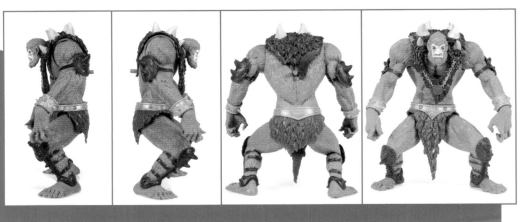

BEAST MAN (REPAINT)

First released 2003 • Member of the Evil Warriors

Accessory:
• Whip

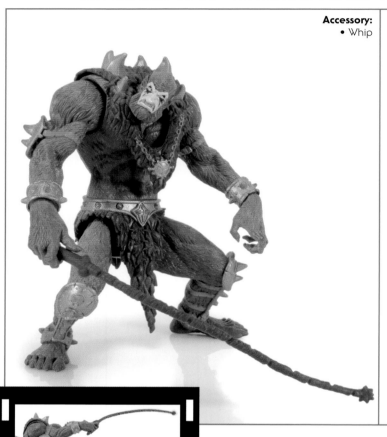

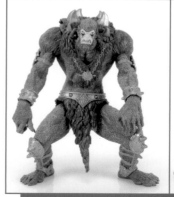

Repaints and reissues were extremely commonplace in this particular toy line, as Mattel wanted to try to keep a constant flow of these characters on store shelves.

This version of Beast Man features an all-new paint deco. The fur is a much dingier orange than before, and the loincloth and shoulder fur are now green instead of the usual brown.

Otherwise, the figure is exactly the same as the original release from 2002. He has joints at his neck, shoulders, wrists, waist, and hips, allowing for more posing options than with the original figures released in the 1980s.

Beast Man's classic whip is included as an accessory. The now-green whip is made out of a pliable plastic so it can still flex and flail about. Like many figures in this line, Beast Man has a push-button action feature on his back. Pressing this button will cause the figure to raise his right arm. Pressing repeatedly makes him swing the whip.

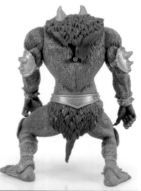

BUZZ-OFF

First released 2003 • Member of the Heroic Warriors

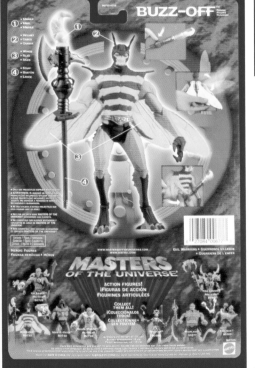

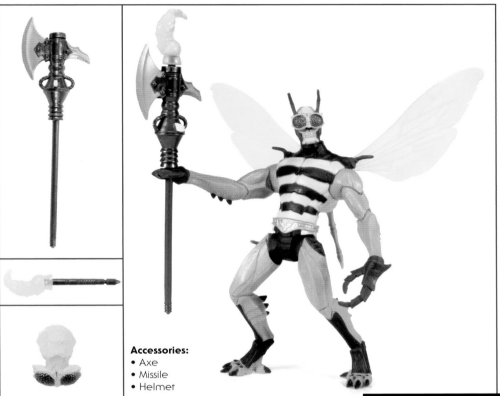

Accessories:
- Axe
- Missile
- Helmet

Buzz-Off might just be one of the more drastic redesigns for the new era of Masters of the Universe action figures, but it's one that makes a lot of sense.

Instead of the buff, muscular build that was the common look across the board for all of the original figures, Buzz-Off is now very slender—giving him a much more insectoid look. Even with the leaner body design, he still retains a lot of the elements straight off of the vintage toy.

His features include translucent yellow wings, this time on ball joints that allow for a wider range of movement. The bee stripes are still seen on his torso, and he even has claws in place of hands. And that signature Buzz-Off smile still rests upon his face.

Like all of the new figures in this lineup, Buzz-Off features more articulation than his vintage counterpart. In addition to those aforementioned ball-jointed wings, he also has joints at the neck, shoulders, wrists, and hips. Harking back to the original action figure, he also features a spring-loaded waist. By twisting the figure at his waist and releasing, he delivers a Power Punch!

His figure also comes with a removable helmet. This helmet fits the figure far better than the one included with the character's original figure from the 1980s. And his axe includes a rocket-firing missile on the top!

The action stance and skinny limbs on this figure have been known to cause balance issues, making him one of the harder figures to stand up on his own.

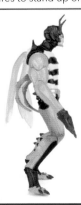
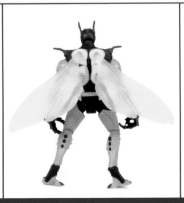
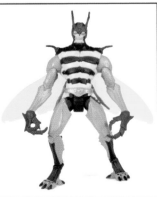

MOTU 2002

CASTLE GRAYSKULL

First released 2002 • Fortress of the Heroic Warriors

It's a new version of the fortress known as Castle Grayskull, one of the most iconic play sets of all time. This new version changes the look a bit and adds a lot of new action features.

The green brick motif is still present, as are many elements from the vintage play set. The top towers have a flag and a blaster, now with spring-loaded missiles to fire down at approaching enemies. The play set itself still folds up for easy transport and storage. When folded up, it's quite thin—much more so than the bulkier Castle Grayskull play set from the 1980s.

When opened, the inside has two levels of play. As another nod to the original play set, the weapons rack is again included—this time worked into the design of the wall. Several weapons are included and can be mounted to this weapons rack.

The big play feature revolves around the action chip that is included in all of the basic action figures released in the first year. This chip is embedded in the figure's foot, and triggers various electronic features throughout the castle. It's quite impressive, as the castle recognizes each of these characters by name and will react differently based on their alliance to good or evil.

1.0 Release

Accessories:
• Key
• Exclusive Sword of Power
• Two battle axes
• Three-piece dungeon cage
• Cannon
• Two missiles
• Trident
• Flag
• Three lasers
• Shackles
• Two daggers

1.0 Release

1.0 Release

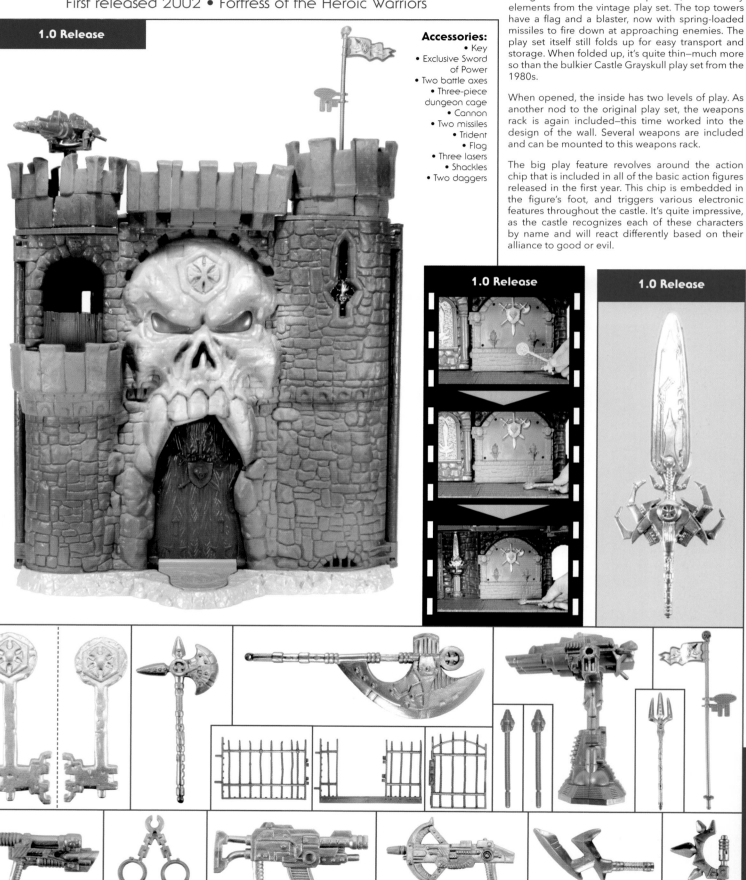

MOTU 2002

1.0 Release

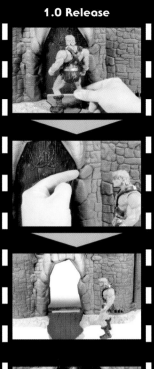

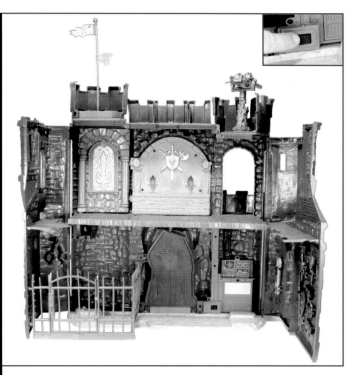

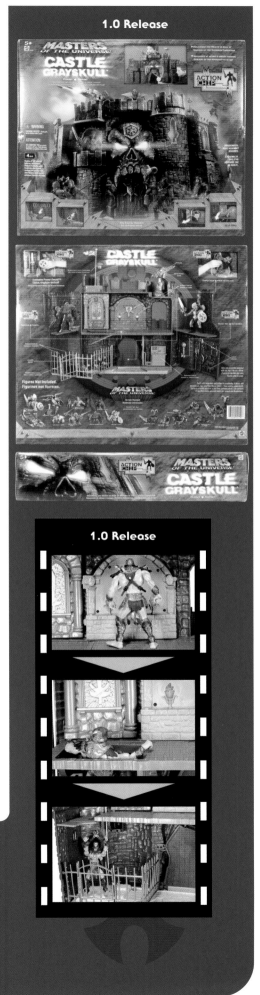

1.0 Release

One of these features occurs right at the Jaw Bridge. If you stand He-Man (or any of your Heroic Warriors) on the footprint on the front, the "Spirit of Grayskull" will speak. The eyes of the castle will glow red, and the voice will bellow out, "He-Man! Grayskull has awaited your return!" It will then instruct He-Man to step aside, and the castle will automatically throw the Jaw Bridge open so He-Man can enter.

If you attempt this with Skeletor (or any Evil Warrior with an action chip), the castle will let him know that he is not welcome, and the sound of thunder will crash. If Skeletor attempts to enter again, the castle will instruct him to stand right in front of the Jaw Bridge—which will then spring up and fall right on top of him, trapping him underneath!

Inside the castle on the second level lies the Hall of Secrets. If He-Man approaches the hall, the castle will welcome him and ask him to stand aside. A secret door will then spring up, revealing an exclusive silver Sword

1.0 Release

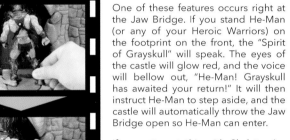

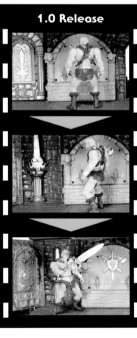

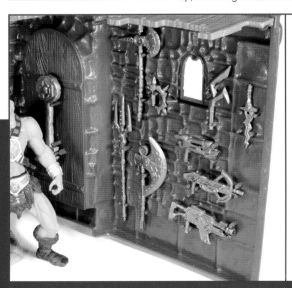

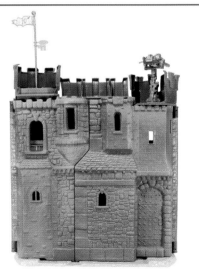

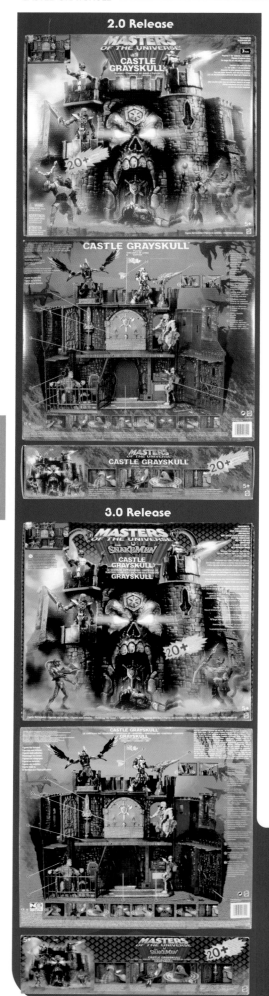

2.0 Release

CASTLE GRAYSKULL

3.0 Release

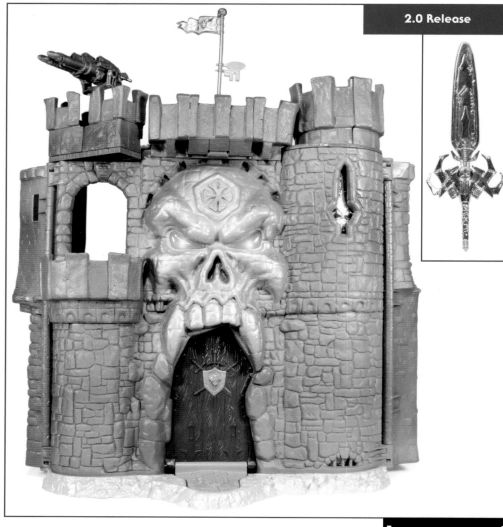

2.0 Release

of Power for He-Man to take. If Skeletor attempts to enter this hall, he will be instructed to "Stand upon the dragon." This is actually a trapdoor in the floor, which will then spring open and drop Skeletor into the dungeon cage below!

A gold key is also included with the castle. This also has an action chip inside and allows you to open the Jaw Bridge and Hall of Secrets without He-Man, if needed.

While the voice itself is rather corny sounding, it's a fun play feature that works incredibly well!

In the middle of the line, Mattel stopped including the action chip in the figures. This means Castle Grayskull does not recognize or interact with about half of the figures in the toy line. Eventually, Castle Grayskull 2.0 was released. The play set itself was mostly the same, though it featured new box art and a few updates to replace the action chip recognition feature.

One of the changes can be found outside of the castle below the Jawbridge. Whereas on 1.0 the door would come crashing down to trap any of your evil action figures, this new version features a trap in the ground to snatch them up!

2.0 Release

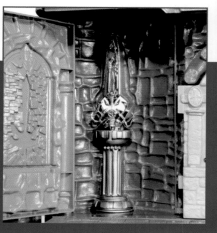

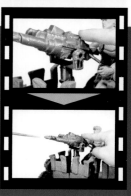

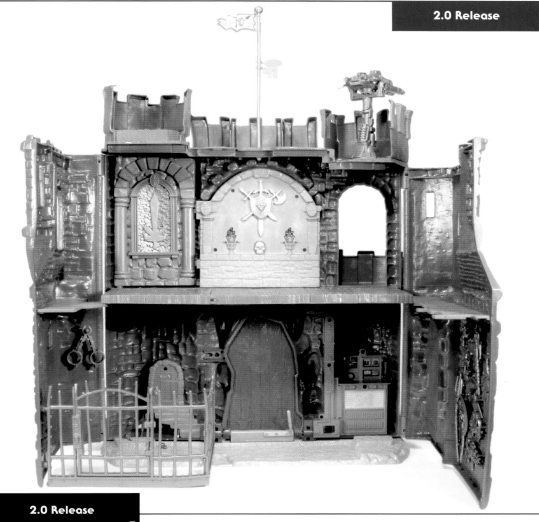

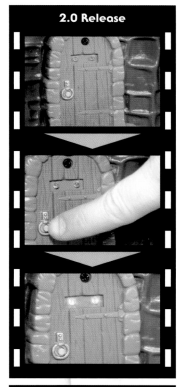

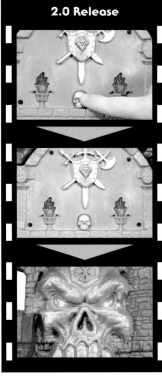

MOTU 2002

2.0 Release

The ground opens up to reveal teeth, ready to gobble up Skeletor or his minions!

Buttons on the computer and Hall of Secrets replace the action chip recognition from the first release. Now you can simply press these buttons to trigger the lights and sounds of the castle, including flickering flames inside and glowing eyes outside. Another memorable addition is the small button inside the prison cell. This button causes small red eyes to glow from within a door, accompanied by the sounds of a small creature lurking within!

This version also includes a vac-metalized gold sword instead of the silver version that came with the original release. All of these changes make both versions collectible for those looking to complete the line, because the differences are big enough to make them stand out.

While it's easy to try to immediately compare this Castle Grayskull play set to the iconic version of the 1980s, stepping back and looking at this play set on its own merits proves that there are a lot of fun elements and action features that could easily create hours of fun while playing with your action figures!

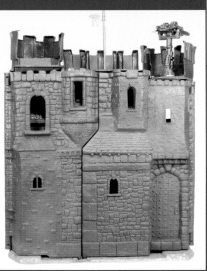

2.0 Release

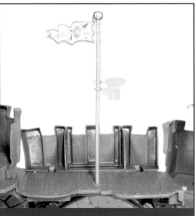

CLAW ATTACK STRATOS

First released 2004 • Member of the Heroic Warriors

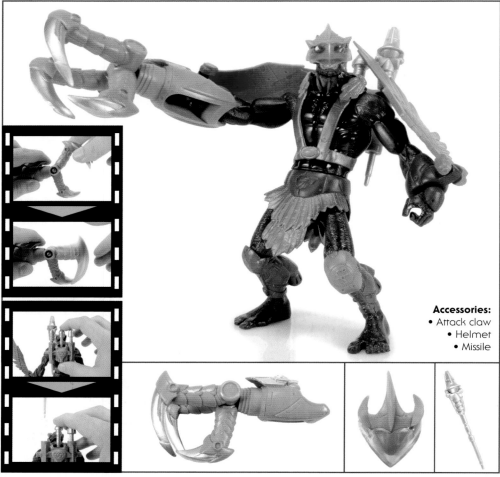

Accessories:
- Attack claw
- Helmet
- Missile

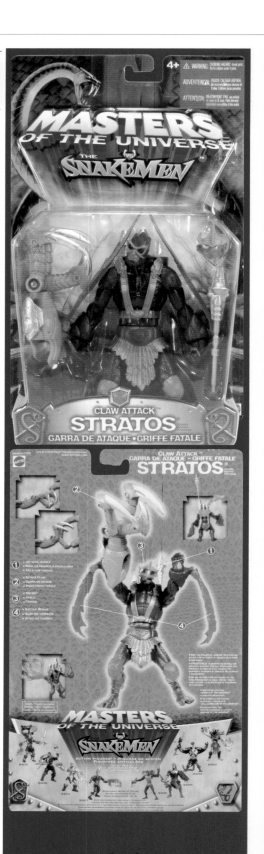

Released on the rebranded Masters of the Universe vs. the Snake Men green card package, this version of Stratos is a repaint of the original Stratos mold with some new accessories and key differences.

Many characters were reissued during this run and given new accessories for battling the evil Snake Men. Stratos has a giant attack claw that resembles the talon of a bird of prey. This slides over the figure's right arm and features a spring-loaded claw grip, allowing Stratos to grab his foes.

Stratos also has a new helmet with a blast shield shaped slightly like the beak of a bird. He can fire a missile from his jetpack, much like the first release. The sculpt itself is also the same as that first figure, with a new paint deco that is much brighter and features a more metallic green main color, as opposed to his typical blue.

The biggest difference is the removal of the "flapping" action in his arms! The original release had shoulders that did not allow his arms to move forward due to his flapping action feature. This makes Claw Attack Stratos better articulated for posing, which is favored by collectors.

Like many of the figures released at the end of the line on these green cards, Claw Attack Stratos saw limited distribution and is thus one of the harder figures to track down.

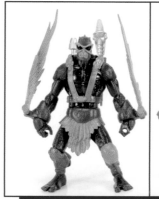

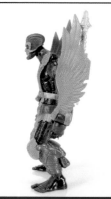
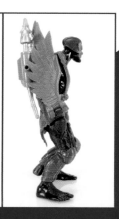

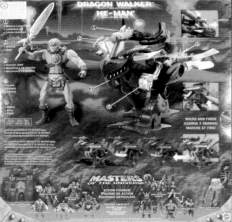

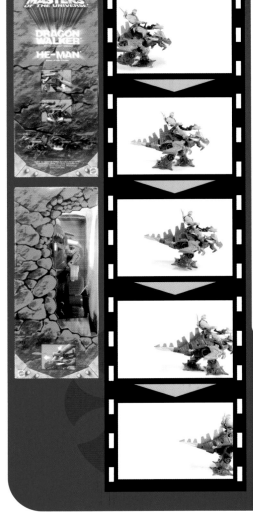

DRAGON WALKER

First released 2003 • Vehicle of the Heroic Warriors

Accessories:
• Missile
• He-Man figure

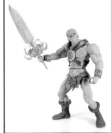

German Variant Figure

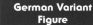

While it shares the name of one of the classic Masters of the Universe vehicles of the vintage toy line, that is where the similarities stop.

This new Dragon Walker has a completely different look. It's a metallic blue and gray in color, and it is much more animalistic in appearance than the original vehicle of the same name. While it's referred to as a dragon, the design is much more akin to a Tyrannosaurus rex, with its small, stubby arms and upright stance.

One figure can straddle the back of the Dragon Walker via a saddle to ride it into battle. It has a battery-operated walking feature that is quite impressive. The large round feet are designed to maintain balance while the vehicle is in motion. It moves quite fast, looking more like it's running rather than walking.

The Dragon Walker comes packaged with an exclusive He-Man action figure. The sculpt is the same as the standard release, but the color scheme is slightly different, with lighter brown used for the loincloth and chest harness.

There was a variant of this pack that was seemingly only released in Germany. On this version, the included He-Man action figure has a dragon tattoo on his arm and tattoo-like designs on his legs. This version is one of the rarer pieces, since it likely did not see release in North America.

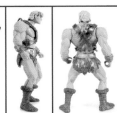

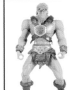

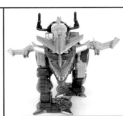

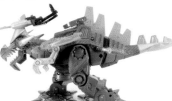

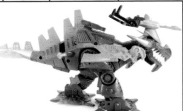

EVIL-LYN

First released 2003 • Member of the Evil Warriors

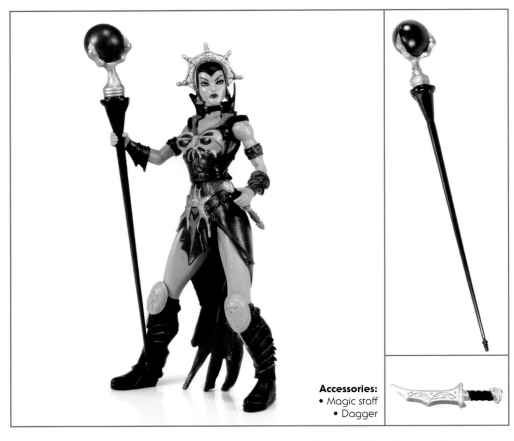

Accessories:
• Magic staff
• Dagger

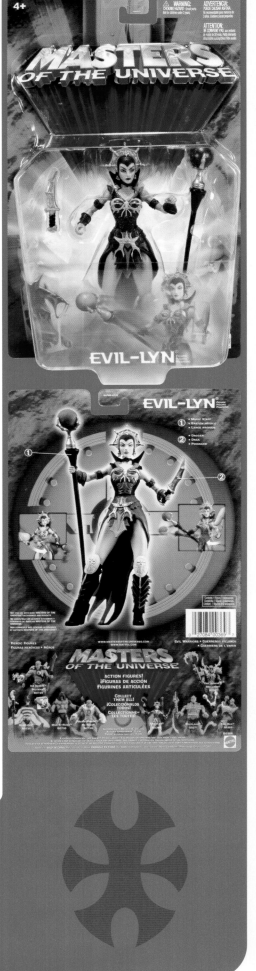

The evil sorceress known as Evil-Lyn is among the many characters from the original Masters of the Universe series to get an update in this new reimagining.

Maintaining many aspects of her classic look, such as her unique headdress and magic staff with the orb on top, the big differences lie in the colors used for the character's new design. While the original action figure from the 1980s was known for having a blue outfit and bright yellow skin, this new Evil-Lyn features a more pale skin tone and a purple color scheme with her outfit. This is quite reminiscent of her appearance in the Filmation cartoon series.

In addition to her magic staff, Evil-Lyn also comes packaged with a new weapon in the form of a small, detailed dagger. This dagger would end up becoming a standard accessory for Evil-Lyn figures in the years to come.

Like many of the action figures in this line, Evil-Lyn has more articulation than her original action figure. Joints at the neck, shoulders, wrists, waist, and hips allow for a decent range of posability. The waist also includes the classic Power Punch spring-loaded action feature. Twisting the waist and releasing it will cause Evil-Lyn to quickly swing her weapons for attack!

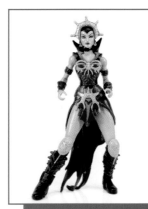
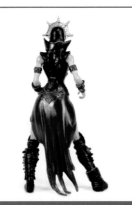
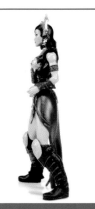
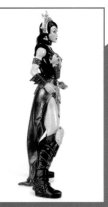

MOTU 2002

FAKER

First released 2003 • Member of the Evil Warriors

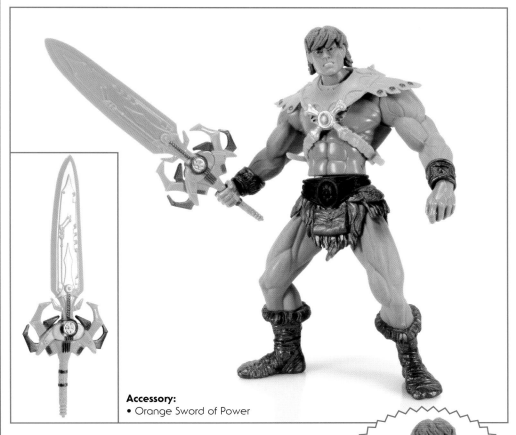

Accessory:
• Orange Sword of Power

The evil robotic version of He-Man is a fan favorite from the original Masters of the Universe toy line. He was brought to this new line via a mail-away offer from *Toyfare* magazine.

Just like with the original action figure of the 1980s, this new Faker figure recycles the same sculpt of He-Man with a new paint deco, reusing Skeletor's armor. While Faker is intended to be an evil clone of He-Man, the thing that always makes him stand out on his own is his signature bright blue skin, which is present again in this new figure.

Removing the bright orange armor reveals a small sticker on Faker's chest resembling a robotic control panel, another nod to the original action figure release. The only accessory included with this figure is the He-Man Sword of Power, painted in a bright orange color to match his armor.

This figure was a mail-away; instead of the standard blister card, he came packaged inside of a window box fully showcasing the action figure within. This box came inside of a white mailer box.

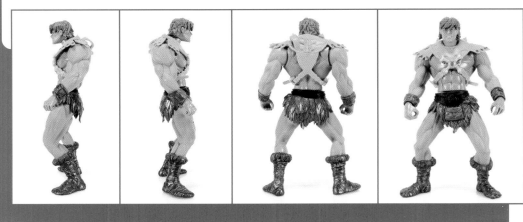

MOTU 2002

FIRE ARMOR SKELETOR

First released 2003 • Member of the Evil Warriors

Accessories:
• Two flaming swords
• Havoc Staff with flaming ram skull

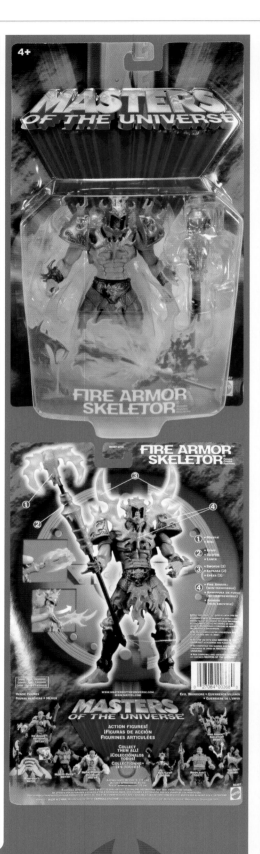

In the original Masters of the Universe toy line, it was common practice to release variations of both He-Man and Skeletor each year with various new gimmicks, to keep the main characters on store shelves. While the 2002 line is often criticized for including far too many He-Man and Skeletor variants, Fire Armor Skeletor is one of the fan favorites due to his design.

The armor has a bright copper appearance, with a flame-style motif. He wears nonremovable helmet on his head with flame-like horns on each side. The legs and arms are the same used on the standard Skeletor release, but he features a new torso with an interesting sculpt that gives his body an almost shell-like appearance, which might mean this was originally intended to be painted to match the flame armor.

Branching off his back are two large translucent yellow flames. These flames are removable and double as flaming swords that can be dual wielded by Skeletor! In addition, he also includes a new fire-themed version of his Havoc Staff. The ram skull on top is the same copper color as his armor, but now has translucent yellow flaming horns!

This staff now has an action feature as well. A small button on the staff triggers the spring-loaded missile feature, launching the flaming ram skull at Skeletor's foes!

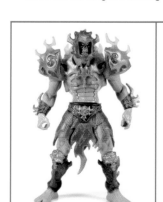
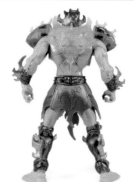

THE GENERAL

First released 2003 • Member of the Snake Men

Accessories:
• Snake staff
• Snake missile
• Tail

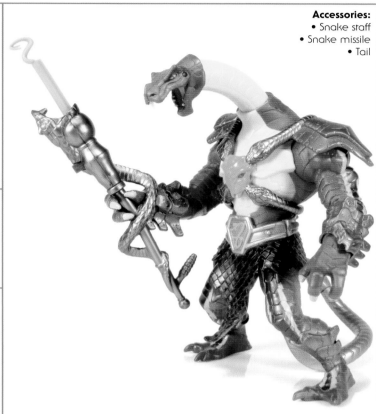

While the packaging might call this character The General, fans know that his true name is Rattlor. Known as General Rattlor in the Mike Young Productions animated series, due to a copyright issue Mattel had to rename the character when releasing him as an action figure.

Rattlor's new design bulked up the character, making him much larger, specifically in the upper body. New additions to the character included brand-new armor that looks like blue snakes wrapped around his torso, as well as a new loincloth that looked like it was made of snakeskin attached to a belt featuring the Snake Men logo. In the original toy line, Rattlor did not wear armor or a loincloth. As an added feature, Mattel made both of these items removable so that longtime fans had the option to display him without them if they wanted him to look more like his vintage counterpart.

Incorporating the original action features from the vintage toy line, General Rattlor has a small button on his back that, when pressed, triggers a spring mechanism in his neck, causing him to lunge forward for a bite attack. This version of Rattlor includes an articulated jaw, allowing you to open and close his mouth—a really nice addition. And of course, shaking the figure will allow you to hear a rattle due to small pieces of plastic being bounced around inside of the figure.

MOTU 2002

HE-MAN

First released 2002 • Member of the Heroic Warriors

Accessories:
• Sword of Power
• Battle-axe
• Shield

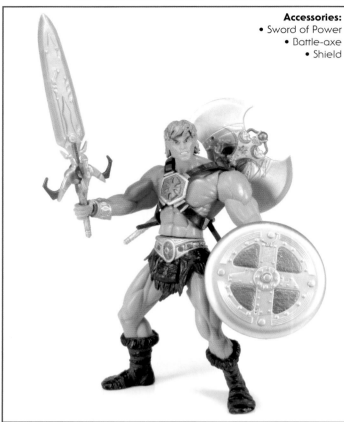
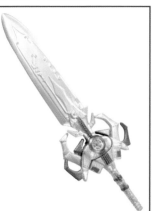
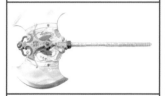

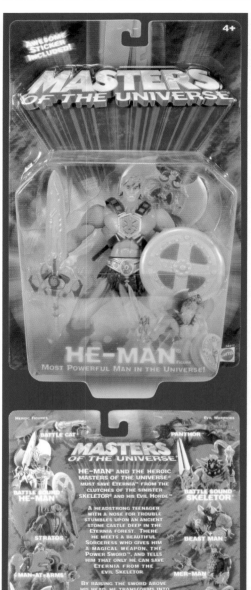

Updating the iconic He-Man for 2002 was not going to be an easy task. Luckily, Mattel relied on the help of the talented artists at Four Horsemen Toy Design to help.

The new look is leaner but still features a muscular build. Many classic elements were updated with this look, including the furry boots, loincloth, and the power harness that he wears on his chest. Everything was given much more detail this time around. He-Man's hair was first redesigned to be longer, but was ultimately changed to give him a shorter flared hairstyle based on what was popular in animation and toys at the time.

The Sword of Power has a completely new, more technology-based, look. The Four Horsemen had a new story idea for this particular sword in which Skeletor had finally stolen the original Sword of Power. As a result, Man-At-Arms had to build this new techno Sword of Power that the Sorceress imbued with the Power of Grayskull, enabling He-Man to fight to get the original sword back! Ultimately, this plan was scrapped by Mattel when they chose to reboot the story, but the new techno Sword of Power was kept. The classic shield and battle-axe also have a similar techno look. The sword has an action feature of its own. Twisting it causes the hilt to open up for battle. And as seen in the 2002 cartoon, the sword would open like this when Prince Adam would call on the Power of Grayskull.

Due to a running change in the toy line, Mattel opted to change the cross on his chest armor to a stylized *H* that looked more like an asterisk. This was done as a way to give He-Man his own symbol that Mattel could market. As a result, the cross version was phased out rather quickly. But prior to that, a rare cross symbol chase figure was released with a slightly different paint deco.

VARIANT

The earliest release of He-Man featured the classic iron cross on his power harness. This was quickly changed to a new asterisk-style symbol for future releases in an effort to create a defining logo for He-Man.

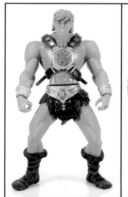
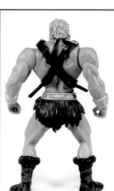
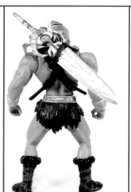
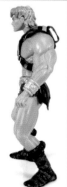
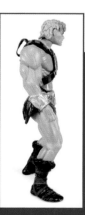

MOTU 2002

HE-MAN (ROTOCAST)

First released 2003 • Member of the Heroic Warriors

Accessory:
• Sword of Power

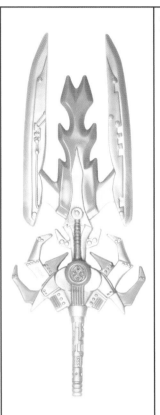

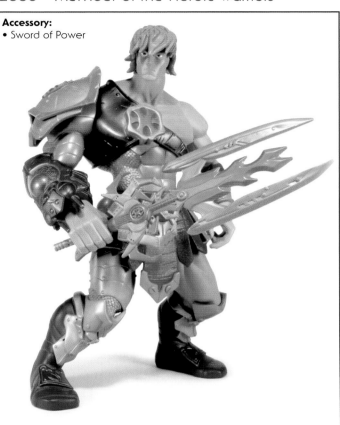

For the first time, both He-Man and Skeletor were officially released as larger-scale action figures from Mattel!

Standing roughly twelve inches tall, this version of He-Man is often referred to as "Rotocast He-Man." Rotocast refers to the molding process in which toys like this are made. As a result of the rotocasting process used to create a figure like this, He-Man is made of a hollow plastic that is quite sturdy yet not overly heavy. This allows the figure to display very nicely but also makes for a perfect lightweight toy that can still be bashed around by kids without worry of damage.

He-Man is presented in his snake armor as seen in the later episodes of the Mike Young Productions animated series. He is packaged with the accompanying version of the Sword of Power that is molded in the open position, allowing him to fire projectile blasts, another feature seen in conjunction with the snake armor in the cartoon. It's worth noting that this version of the toy sword does not actually close or fire projectiles.

The figure itself features ten points of articulation in the neck, shoulders, elbows, wrists, waist, and thighs. It's similar articulation to what is found in the smaller six inches version of Snake Armor He-Man without any of the action features. It's a very solid, well-made toy.

HE-MAN EAGLE FLIGHT-PAK

First released 2003 • Accessory of the Heroic Warriors

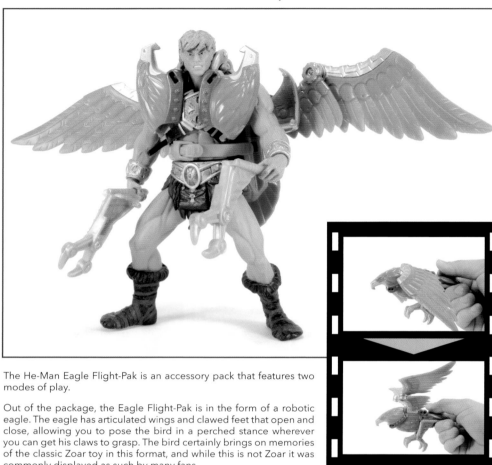

The He-Man Eagle Flight-Pak is an accessory pack that features two modes of play.

Out of the package, the Eagle Flight-Pak is in the form of a robotic eagle. The eagle has articulated wings and clawed feet that open and close, allowing you to pose the bird in a perched stance wherever you can get his claws to grasp. The bird certainly brings on memories of the classic Zoar toy in this format, and while this is not Zoar it was commonly displayed as such by many fans.

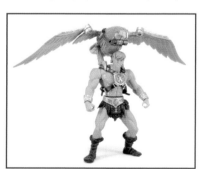

The eagle also has a transforming feature, allowing it to turn into the Flight-Pak for He-Man. By opening up the body and head, you can wrap the bird around He-Man's torso and snap it back together, creating armor for the hero with wings sprouting from his back for flight. The clawed feet can be removed and held by He-Man, now being utilized as clawed weapons.

The transformation feature is a bit clunky, but the end results are admittedly pretty cool. It's a fun play feature that makes for a unique way to both display and play with He-Man.

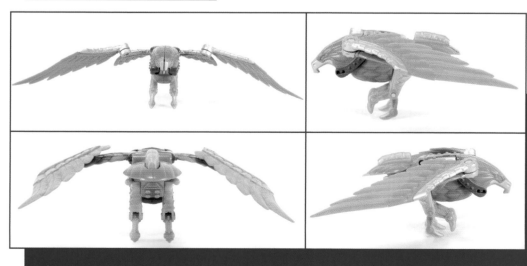

HE-MAN POWER SWORD
(ROLEPLAY)

First released 2002 • Accessory of the Heroic Warriors

This is one of the few times Mattel released their very own role-play Power Sword as part of the actual toy line!

This authentic Masters of the Universe Sword of Power is approximately twenty-five inches in length and features a push button on the hilt that activates flickering lights in the blade, as well as crashing thunder and battle sounds.

A small button on the handle of the Sword of Power activates sparring mode. In sparring mode, you can swing the sword to hear the sounds of battle!

The sword itself is quite large and hefty, but not too heavy. It's easy for a kid to swing around for play, and the action sounds are a really nice touch! Naturally, it is modeled after the new version of the Sword of Power introduced in the 2002 series.

ICE ARMOR HE-MAN

First released 2003 • Member of the Heroic Warriors

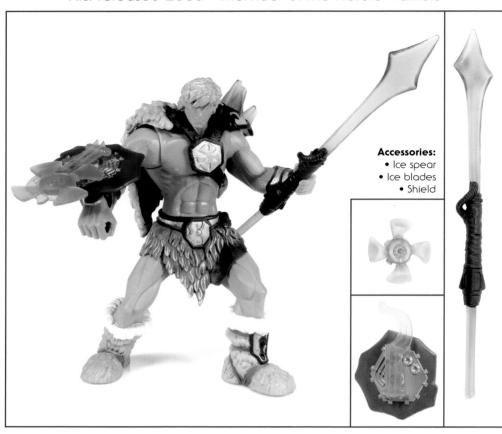

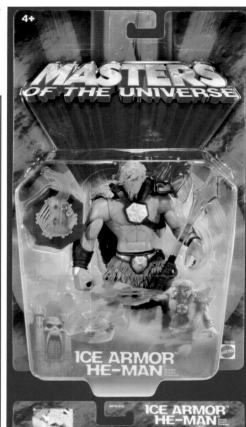

Accessories:
- Ice spear
- Ice blades
- Shield

Ice Armor He-Man is one of many costume variants in this line for our main hero, but one of the very few with the distinction of being featured in the accompanying animated series! It's also a favorite of many fans.

The sculpt is different from the original He-Man release, giving the figure a more battle-ready stance and a slightly chunkier overall build. The boots, loincloth, and cape hanging from his power harness all have an extra-fluffy sculpt to them, giving him the look of wearing a thicker pelt for journeying to areas with colder temperatures.

He is packaged with brand-new weapons as well. No Sword of Power is included with this release of He-Man. Instead, he has an ice spear. The blade portion is made of a translucent blue plastic to give it that icy feel. He also includes a new shield that can clip on his right wrist. This unique new shield has a slot on which you can rest one of the included translucent blue ice disks. This plays into his action feature.

In a modified version of the classic "Power Punch" feature found on many Masters of the Universe action figures, when He-Man's waist is twisted to the right it locks in place. A small button located on his hip unlocks the waist, flinging the figure back to his normal stance. If He-Man's shield arm is positioned out to his side and loaded with ice blade, this will cause him to hurl the blade toward his enemies!

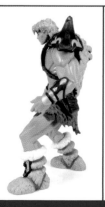
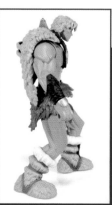

MOTU 2002

ICE ARMOR SKELETOR

First released 2004 • Member of the Evil Warriors

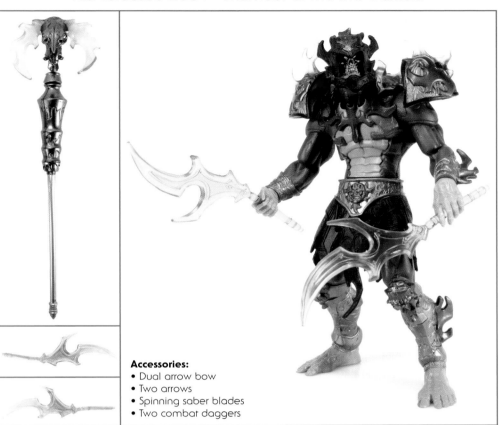

Accessories:
- Dual arrow bow
- Two arrows
- Spinning saber blades
- Two combat daggers

Unlike the original sculpt we got with Ice Armor He-Man, the Ice Armor version of Skeletor is merely a paint refresh of the earlier Fire Armor Skeletor. Nothing new was added to the sculpt to give him the more winterized look that He-Man sports. Instead, the figure was changed from a translucent orange color to a translucent blue color, with several shades of blue paint added.

The overall sculpt is still very effective, as it was on the Fire Armor version. He is packaged with the same unique Havoc Staff with rocket-firing skull at the press of a button. Also included are two "flame" blades that can be dual wielded. These can also be plugged into the slots on his back to be displayed as part of the overall look of his costume.

The flames themselves could now be considered icicles with this new paint deco—or maybe frozen flames. It's a bit odd to see the very heat-inspired sculpt turned frozen. But admittedly, the translucent blue works, making the look of Ice Armor Skeletor striking regardless of the oddity.

Ice Armor Skeletor was released near the end of the line on the "vs. the Snake Men" green card back, when strange repaints were commonplace.

JUNGLE ATTACK HE-MAN

First released 2002 • Member of the Heroic Warriors

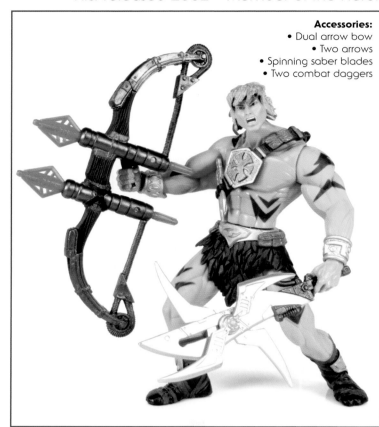

Accessories:
• Dual arrow bow
• Two arrows
• Spinning saber blades
• Two combat daggers

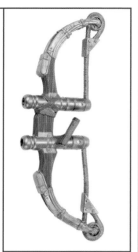

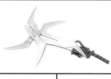

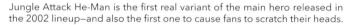

Jungle Attack He-Man is the first real variant of the main hero released in the 2002 lineup—and also the first one to cause fans to scratch their heads.

He-Man looks as though he is dressed for jungle combat, complete with a one-strap bandoleer instead of the usual power harness, camo body paint, and even a bandanna tied around his head—making him feel like he's jumped straight out of a macho 1980s action film!

The figure features a new sculpt and all-new accessories. The head has an angrier, yelling face and the legs are in an overly dynamic battle pose, which does cause a bit of an odd stance for the figure. Instead of the usual Sword of Power, he comes with a machete weapon with additional spinning blades. He is also equipped with an oversized green bow with two included red arrows that can be fired with the flick of your finger.

Two small daggers are also included, which can be holstered on the bandoleer on He-Man's chest. The large quantity of accessories with a place to store them all on the figure really is a huge positive for this version of the character. Regardless, it's certainly one of the stranger variants for He-Man, the jungle theme seeming a bit out of place for the character.

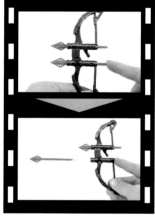

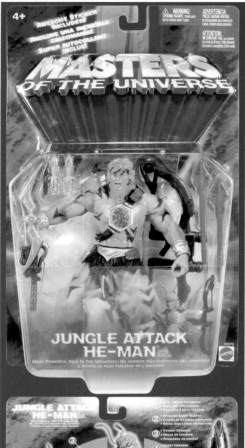

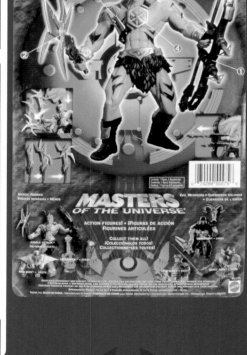

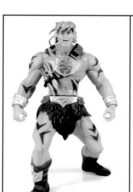
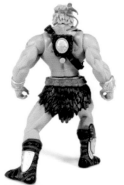
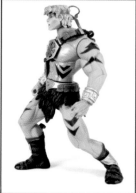
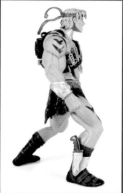

MOTU 2002

KELDOR

First released 2003 • Member of the Evil Warriors

Accessories:
• Snake staff
• Snake missile
• Shield

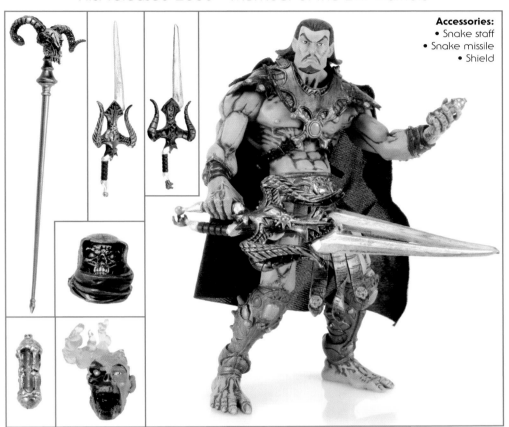

THE BIRTH OF SKELETOR!

INTERCHANGEABLE HEADS LET YOU GO FROM KELDOR TO SKELETOR AS TOLD IN THE PREMIERE EPISODE OF THE MASTERS OF THE UNIVERSE TELEVISION SHOW!

FUN FACTOIDS:

• While the retail line was aimed at kids first and collectors second, this version of Skeletor was made primarily for the collector fan base. With the extra accessories and top-notch paint deco, it truly delivered!

• Keldor later saw a limited release in Germany, where he came in a poly bag instead of his earlier packaging.

Released as a San Diego Comic-Con exclusive, the Keldor: The Birth of Skeletor box set seeks to re-create an iconic moment from the animated series and is a true collectors' figure in the 200X Masters of the Universe toy line.

The figure came inside of a special window box package that showed off the many accessories. This was housed inside of an outer mailer box, of which there are two variations. The original mailer box sold at SDCC was a black box, with gorgeous bright green artwork of the Keldor-to-Skeletor transformation. Later versions of the exclusive sold through fan site He-Man.org included a plain white mailer box instead.

The figure is exactly the same sculpt-as the standard Skeletor release; however, it includes a ton of extras. The paint deco is much different, featuring a heavy black wash giving the figure a more detailed and overall darker appearance. He also includes a cloth black cape—the only time in this line Skeletor was given a cape, despite the fact he was seen wearing it in the animated series often.

The Skeletor head is also removable on this figure, making this the only figure in the line with interchangeable heads. This allows you to use the Keldor head, allowing you to display him pretransformation to the Overlord of Evil. Or, you can display him midtransformation, with a grotesque sculpt featuring a half-burned face with a translucent green acid splash effect.

Along with those swappable heads, Keldor also comes with the usual double-bladed sword and Havoc Staff, both with a similar new paint wash to make them look darker and help bring out the details of their sculpts. A new accessory is the small green vial of acid that Keldor attempted to use against Randor in the infamous scene, ultimately resulting in his own transformation!

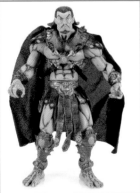

KING HSSSS

First released 2003 • Member of the Snake Men

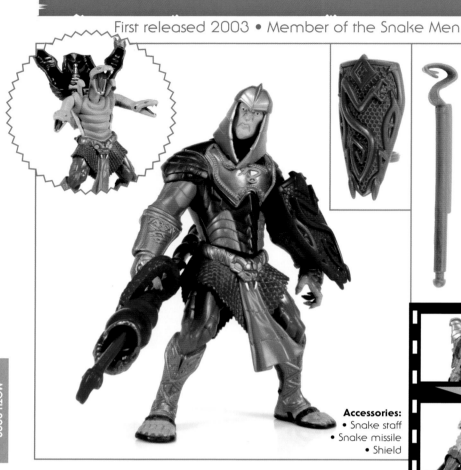

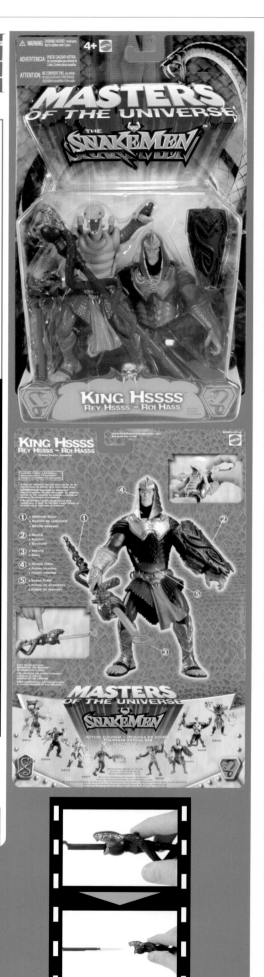

Accessories:
• Snake staff
• Snake missile
• Shield

The leader of the evil Snake Men faction was introduced as a main villain in the animated series, and thus was brought to the toy line with a brand-new refresh to the packaging that dubbed the line "Masters of the Universe vs. the Snake Men!"

King Hssss (note the new spelling) received a drastic overhaul to his look from the vintage toy, giving him an ancient Egyptian aesthetic. Among these changes are a headdress instead of the vintage hooded mask, and a greenish skin tone used on both the sandaled feet and hands.

The gimmick of the human body hiding a pile of snakes underneath returns, albeit in the form of a new action feature. Instead of the vintage removable clip-on pieces, the upper body and arms are one solid piece that folds upward via a spring-loaded mechanism to reveal the snake body within. This action feature is not the most effective, as when it's folded open to reveal the snake body, the shell is still attached. Also, when in human form the unarticulated arms are stuck in place, making it incredibly difficult to pose the figure with the included accessories.

King Hssss has a shield that can clip on to his wrist, and a snake staff that includes the now-common-for-the-line projectile action feature. However, because of the static arms he can only hold the staff pointing downward. Unfortunately, this is a figure where the included action feature greatly impacted the overall design in a negative way.

MOTU 2002

MAN-AT-ARMS

First released 2002 • Member of the Heroic Warriors

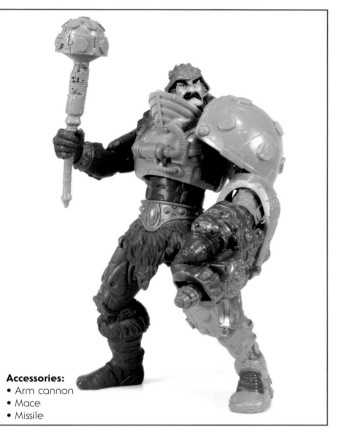

Accessories:
• Arm cannon
• Mace
• Missile

One of the original eight figures released in the original Masters of the Universe line, Man-At-Arms returns with a look that is very familiar but wonderfully updated to fit the aesthetic of the new toy line!

Man-At-Arms' traditional armor is slightly exaggerated this time around, featuring an oversized shoulder pauldron and a more tech-like sculpt on the green bodysuit. The colors are easily recognizable, matching what we saw on the vintage figure with the light orange, dark green, and the bright blue seen on the helmet. This is, however, the first Man-At-Arms action figure to include the mustache made famous for the character in the original Filmation cartoon.

In addition to his classic mace, Man-At-Arms is packaged with a brand-new weapon. This arm cannon fits over the figure's left hand and includes a spring-loaded missile that can be fired at the press of a button. This arm cannon was used regularly by the character in the Mike Young Productions cartoon series, and became a staple weapon for the character going forward.

FUN FACTOID: Like many of the figures in this toy line, Man-At-Arms also has an action feature triggered by a button on his back. Pressing this button will swing his right arm up and down, allowing him to bash the baddies with his mace!

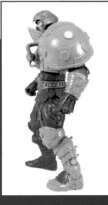

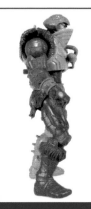

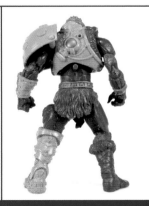

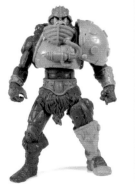

MOTU 2002

MAN-E-FACES

First released 2003 • Member of the Heroic Warriors

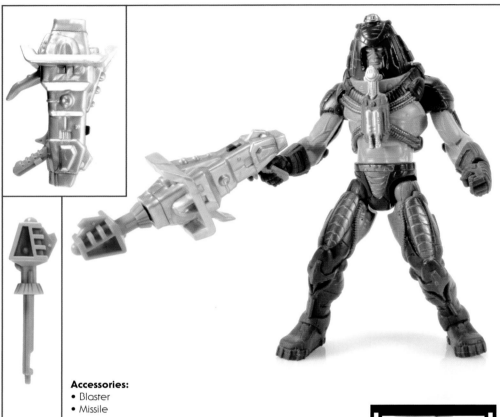

Accessories:
- Blaster
- Missile

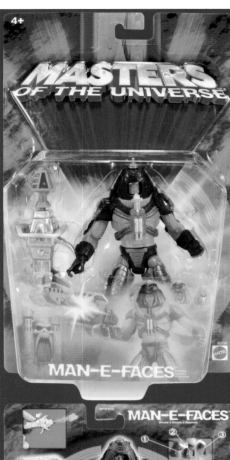

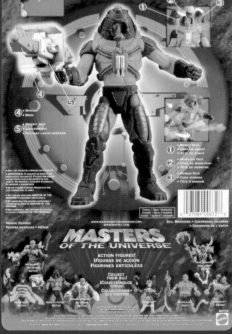

Man-E-Faces is another classic Masters of the Universe character updated for the new toy line in 2003. His look is very much in line with what we saw in the vintage line, with newly sculpted details adding more tech to the robotic-like armor that the character wears. This look suits a character like Man-E-Faces quite well, since he always looked as if he were based more in science fiction.

Of course, the action feature that Man-E-Faces is most known for is his ability to change between three different faces. This feature returns, and is handled exactly the same as on the vintage action figure. By turning the knob on the figure's head, you can rotate between his normal human face, a robot face, and a green monster face. It's worth noting that there are two variations of the standard figure, one featuring a small knob on his helmet, and one with a larger, easier-to-grip knob.

Also included is an oversized version of his classic laser blaster. This time around, it features a rocket-firing missile action feature. The inclusion of spring-loaded missiles in many of the weapons in this line often resulted in comically oversized accessories. This is one of the best examples of that, as the blaster is so large the figure can barely even hold on to it, as the weight often causes it to fall right out of the figure's grip.

FUN FACTOID: This was also one of the figures that had a rare chase variant. This chase figure features a slightly different paint deco on the figure's chest harness and a blaster that is more of a copper color than the standard silver. Otherwise, it is the same figure.

MOTU 2002

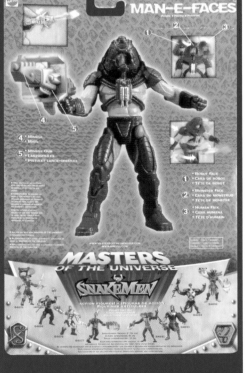

MAN-E-FACES (REPAINT)

First released 2004 • Member of the Heroic Warriors

Accessories:
• Blaster
• Missile

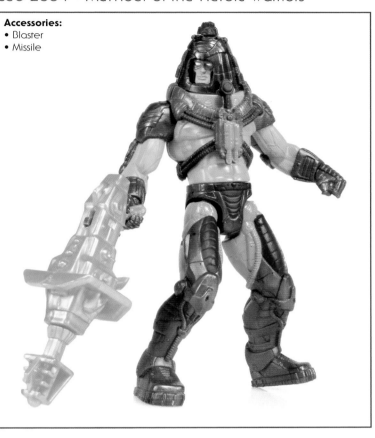

Toward the end of this Masters of the Universe toy line, several figures saw a brand-new release with a new paint deco in an attempt to keep the pegs filled with figures to buy while saving Mattel on tooling costs. Oftentimes, these new paint schemes were quite odd, usually with bright, garish colors that didn't make a lot of sense for the character.

Man-E-Faces here got a repaint in 2004. The figure itself is exactly the same as the original release, still featuring the rotating faces and the oversized blaster. This time around, the character is wearing a copper-colored suit of armor with bright, neon green details seen on the legs, chest, and on his weapon of choice.

Many of these oddly colored figures (which were not looked on fondly by fans) are a bit harder to track down now since they were released so late in the line's lifespan, when it was already becoming harder to find in stores.

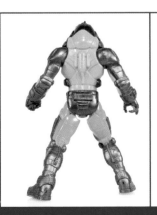
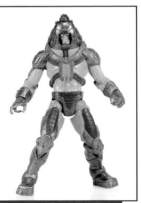

MOTU 2002

MARTIAL ARTS HE-MAN

First released 2003 • Member of the Heroic Warriors

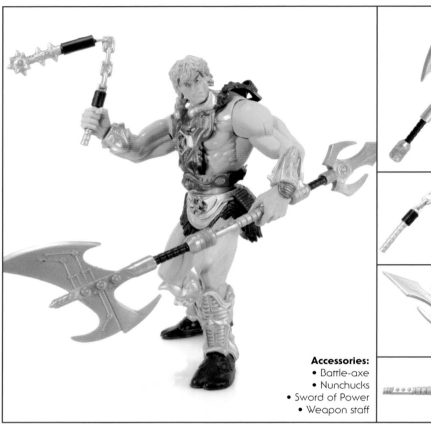

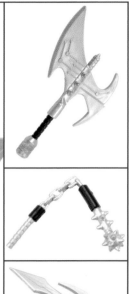

Accessories:
- Battle-axe
- Nunchucks
- Sword of Power
- Weapon staff

One of the many variations of the Most Powerful Man in the Universe, Martial Arts He-Man gives us a new sculpt for our main hero. Overall, he's still very recognizable, as the changes are not overly dramatic. He is still wearing a similar power harness over his chest, but this time around it has a dragon theme—colored a bright, metallic blue.

The weapons this time also have a more martial arts feel to tie in with the overall theme of the figure. He includes the Sword of Power and battle-axe, but they are much different looking than the standard weapons He-Man usually holds. In addition, these weapons have the ability to plug on to an included weapon staff, allowing you to turn them into a longer staff-like weapon. Also included was a pair of nunchucks with a sculpted chain. You can mix and match these parts with the weapon staff, allowing you to create a few different weapon designs. When not in use, they can also be stored on the back of He-Man's armor.

He-Man's right hand includes an action feature. A small button on his wrist allows the hand to spin around. This allows He-Man to twirl either the weapons staff or the nunchuks for battle!

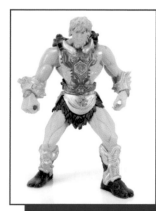
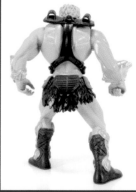
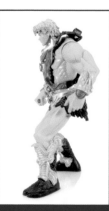

THE FOUR HORSEMEN

H. ERIC "CORNBOY" MAYSE, ERIC TREADAWAY, & JIM PREZIOSI

How did you get into toy design and sculpting?

H. Eric "Cornboy" Mayse: For me it was just dumb luck. I'd moved myself and my family to New Jersey from Indiana so I could go to the Joe Kubert School of Cartoon and Graphic Art so I could become a comic book artist. While going there and working part time in a machine shop I was told about a company nearby that "made toy trucks and dolls." They wanted me to come in for an interview and to see my portfolio, and I found out over the phone that it was actually McFarlane Toys. The "toy trucks" the guy was referring to was the Spawn Mobile and the "dolls" were the Spawn action figures! I was blown away to be given that kind of opportunity because I'd always seen on the back of toys that toys were "made in China" or "made in Taiwan," etc. I didn't know that the design work that I was really into was mostly done here in the US. Jim [Preziosi] and Eric [Treadaway] were both already working at McFarlane Toys, and that's how we met and eventually decided to go off and start our own business—Four Horsemen Toy Design. Eric and Jim have similar stories.

Eric Treadaway: I was going to an art college in Knoxville, Tennessee, and I'd already worked on a self-published comic when I was contacted by what was then called Todd Toys. I'd submitted a Violator sculpture and they really liked it and asked me to sculpt a bendy-style Violator action figure for them. That was my first (of many, many) sculptures for McFarlane Toys. Jim had already been in the toy design industry for a few years, mostly prototyping children's toys, and a friend of his asked him to come work for Todd Toys.

When did you first get into He-Man, and what were your favorite toys?

ET: He-Man and the Masters of the Universe was my first and greatest love when it came to action figures. Just the thought of characters that spanned almost every genre you could imagine, but that were still kind of grounded in the fantasy/sci-fi realm, just spoke to me. I loved G.I. Joe and Ninja Turtles and lots of other action figure lines when I was a kid, but to me there was nothing greater than He-Man. I used to carry my favorite Masters of the Universe characters (mostly the bad guys) around with me in a briefcase, which I still have. And my mom still has the coffee table that I used to lay under and draw He-Man and Batman characters on the bottom of. My favorite characters were always the bad guys. They always seemed so much cooler to me than the good guys. Webstor might be my favorite but there are quite a few that would run a *very* close second.

HEM: Although I loved the line when it came out, it came out at a time when I was getting into cars and girls, so I only bought a couple of characters that I liked the best, and then my oldest son bought a bunch of them at various garage sales a few years later. I was always a fan of the more monstrous characters. The guys you'd consider to be the brutes, like Beast Man and Whiplash. But characters like Spikor and Trap Jaw were always favorites of mine as well.

Jim Preziosi: He-Man came out after I'd really kind of gotten out of toys, and I had daughters, and even though I appreciated them from afar, I really didn't start getting into the whole line until we started doing them for Mattel. I was amazed at the amount of characters and history in the line that we could draw from. My favorite always has been and always will be Bow.

Can you talk about the genesis of the 200X line?

HEM: At a certain point the three of us had decided it was time to move on from McFarlane Toys and start our own business—Four Horsemen—so we were put in contact with some people at Mattel and they were very interested in talking with us. They were actually considering looking for an outside design team at the time and we just kind of came along at the exact right time, and we were interested in doing the exact same thing as they were, which was re-vamping and relaunching He-Man and the Masters of the Universe. It was really kismet and things just kind of all fell into place.

Early concepts for 200X He-Man look a bit more savage, although he ended up with a kind of pseudo-anime look. Can you talk about what drove some of those changes?

ET: Our original concept with the relaunch was that now Skeletor had both halves of the Sword of Power and had taken over Castle Grayskull. So He-Man and his crew were on the run and trying to come up with ways to get the Sword of Power and Castle Grayskull back from Skeletor. In the process of this, Man-At-Arms built He-Man a new, more mechanical-looking, sword, and the Sorceress imbued that sword with some of her own magic, in essence creating a new Sword of Power. Since they're forced to be kind of a nomadic troop and constantly on the run, He-Man and the rest ended up looking a little more barbaric and rough around the edges in our original concept, and the first sculpture we did of He-Man for the presentation in this idea, reflected that look.

HEM: Mattel seemed to like the idea, so their marketing department took all of that and ran it through some kid focus groups. Not only did those focus groups decide that they didn't care for our version of the continued story line as much as a whole new origin story, but they also seemed to prefer what Mattel referred to as more of an "angular anime" style. So we went back into the He-Man sculpture, and altered it to have that kind of look and the kind of mullet-looking haircut that they seemed to have preferred as well.

In 2002, the most recent previous reboot (the 1989 New Adventures line) of He-Man had been a pretty radical departure from the original designs. At the time you were working on 200X, did it feel like a return to form for He-Man?

ET: Somewhat, yes. At least in the fact that we were going back to utilizing all of the characters from the original cartoons. Even though some of them looked a bit different than they had in the original He-Man and the Masters of the Universe toy line and animated series, they were all still very recognizable as those characters.

Let's talk about that Sword of Power. It's completely different looking than the classic sword we all grew up with. As I understand it, you intended a specific story line for that sword that Mattel ultimately didn't use. Can you tell us about your idea for the sword?

JP: As we mentioned previously, in our concept the new sword was built by Man-At-Arms and the Sorceress in order to help He-Man gain control of the original Sword of Power and Castle Grayskull back from Skeletor. After having spoken to the focus groups, Mattel decided to make our "replacement sword" the actual new Sword of Power and they built a whole new origin story around that.

As I understand it, some characters, like Buzz-Off and Zodac, had some pretty out-there designs when you were first working on them, but the final toys were toned down significantly. Can you talk about that?

HEM: Buzz-Off's redesign was definitely a departure from the original, but it made it all the way through to toy form. With Zodac, we were considering him to be part of an intergalactic force that's been sworn to keep balance throughout the galaxy, so we decided to turn him into more of a "gray alien" looking character instead of giving him the original furry humanoid look. He'd still have all of the things that would make him recognizable as Zodac, but his overall proportions would be different. Before we got the chance to run our concept past Mattel, they came back with a Zodac design that looked nothing like the original character at all. It was now a helmetless black character with glowing white tattoos, blue armor that didn't resemble the original armor in the least, and his abilities would be based in martial arts. We asked them if it was okay if we tweaked their design a bit, and we brought the character they'd put together back around to looking much more like the original Zodac designs from the eighties with his red armor and a now-removable helmet that was very much inspired by the original one. Oh and they decided to call him "Zodak" now, instead of "Zodac."

What were your guiding design principles for 200X? What was the magic formula for taking a vintage character and turning it into a 200X design?

ET: It was really all about taking those original designs and tweaking them in a way that they looked more modern and updated, with different proportions and levels of detail, but still keeping them as recognizable as possible as the characters they originally were. We love the original toy designs from the eighties, so there was no way we wanted to go in, take those designs, and toss all of that out to create something new. We wanted to keep everything that we really loved the most about those designs and upgrade the characters in a way that they might attract a new audience.

Castle Grayskull was done in-house at Mattel. If you had been given the assignment to design it for the 200X line, what do you think it would have looked like?

HEM: Although we really would've loved to have had the chance to create the new 200X Castle Grayskull, there's not a whole lot we would've done differently than what the guys over at Mattel did with it. We might've stayed a little closer to the original design as far as the overall exterior look and shape, but other than that, I don't know that we would've altered much about it at all.

What aspects of the vintage line were most influential on the 200X designs? For example, 200X Mer-Man seems inspired by the card back art.

ET: Mer-Man definitely was inspired by the card art. I'd always been upset as a kid that the original Mer-Man figure didn't really look like the card art, but more like a repainted Stinkor. This was my first chance (but not my last) to try to rectify that by being able to sculpt Mer-Man in figure form so that he looked more like that original card back image I loved so much as a kid. But the designs of the original toys were absolutely influential as well. We wanted the 200X figures to be very reminiscent of the original MOTU figures, but to seem more current and up to date, so we went straight to the original source—the original toy line—for our main inspiration.

Were the 200X designs inspired by any material outside of MOTU?

HEM: Oh, of course. We're always inspired by artwork and toys around us. But even though we do take inspiration from other sources, we try to only be inspired by them and try to do something that's up to the level of whatever it was that inspired us in the first place, not rip them off and try to do what they're doing. At the time, we were really into the artwork and sculptures of Takayuki Takeya and Yasushi Nirasawa, and the phenomenal work they were putting out at the time really inspired us to try to create something at that level, but in action figure form. Eric and I even met Nirasawa at Comic-Con one year, shook his hand, and thanked him for all of the inspiration he'd provided to us over the years.

Can you talk a bit about the NECA station line and how that came about?

JP: It's funny that you and other people took to calling those "stactions," because that was really just a joke that someone made at Four Horsemen Studios about those mini figures. They said that they looked so much like the MOTU action figures we'd been doing, except for the fact that they were in

static poses, so they should be called "staction figures." Somehow the name got out there and it stuck, even though they were never officially named that.

HEM: Our run on the 200X action figure line at Mattel was coming to an end, and we were already sculpting MOTU busts and statues for NECA. NECA talked to us to see if we'd be interested in continuing to sculpt the 200X Masters of the Universe figures, but in mini-statue form that would be the same scale as the action figures. We loved the idea and we jumped at the chance, and NECA convinced Mattel to let them do it. We're really happy with the way those mini-statues came out, although we would've loved to have seen them continue for a few more waves.

How many of the original prototypes from the 200X line still exist?

ET: I'd imagine that Mattel still has all of the paint masters that we sent to them, but we only have a dozen or so at our studio. When we first started doing the line, we'd make two paint masters of every figure—one for Mattel and one for our studio—but that ended quickly because we just didn't have the time to produce the toys we needed to produce and create extra paint-master prototypes for the studio.

Are there any Easter eggs hiding within the 200X toys that the Four Horsemen worked on?

HEM: I'm not sure it would be considered an "Easter egg," but there is something going on with the Roboto figure that some might not have noticed. Rather than just having the turning gears that the original figure had, this new version of Roboto also has a mechanical heart and lungs moving around inside there.

ET: A couple other hidden gems are that the inside of Trapjaw's mouth has the remnants of a tongue, and the backs of Skeletor's legs have little bat symbols that are hints at his past with a certain other monstrously maniacal overlord—Hordak.

What characters did you not get a chance to work on for this line, but really wish you could have?

HEM: There were a few that came out in mini-statue form that we would've *loved* to have done as action figures. Clawful and Webstor were two of the ones that bothered us most that we never got to do as 200X action figures. Sorceress as well. So we were really happy that we at least got to do those and a few others later on as mini statues.

MECHA-BITE BATTLE CAT

First released 2004 • Steed of the Heroic Warriors

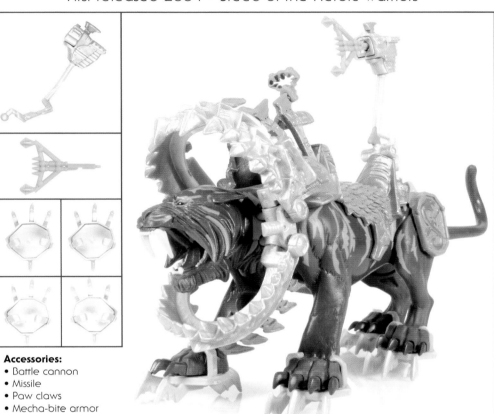

Accessories:
- Battle cannon
- Missile
- Paw claws
- Mecha-bite armor

This is the third variation of He-Man's companion in this Masters of the Universe line. The "mecha" variants for the cats gave them brand-new armor. The most striking piece of this new armor is the overexaggerated mechanical jaw that fits around Battle Cat's head instead of the usual helmet that covers his face. In normal position, this mechanical jaw filled with pointy teeth is open, showing Battle Cat's head within. Pressing the button on his back triggers the Mecha-Bite action, clamping the metal jaws shut on his enemies!

In addition to the large clamping jaw, Mecha-Bite Battle Cat also has a new battle cannon positioned behind the saddle on his back. This cannon is tall enough that it rises up above Battle Cat's rider, and can fire a spring-loaded missile at the touch of a button. On his feet are Paw Claws, silver-colored spiked armor pieces that sort of act like cleats. And since this was released during the "vs. the Snake Men" story arc, the large anti-Snake Men logo is positioned on his back legs.

It's certainly an odd-looking variation, with wild, over-the-top mechanical-like bits that this line had really become known for at this point.

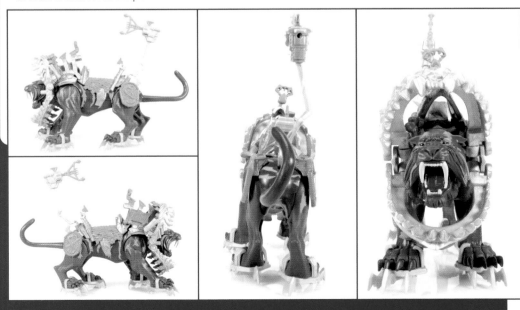

MOTU 2002

MECHA-BITE PANTHOR

First released 2004 • Steed of the Evil Warriors

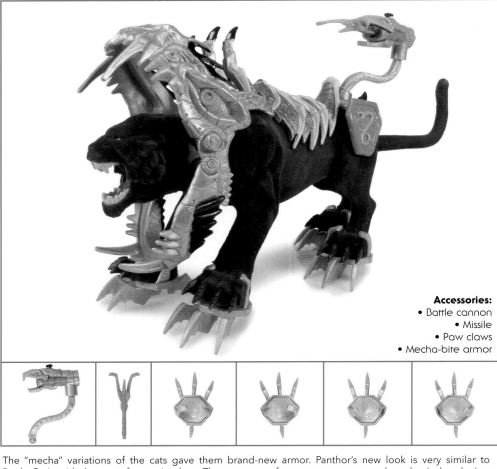

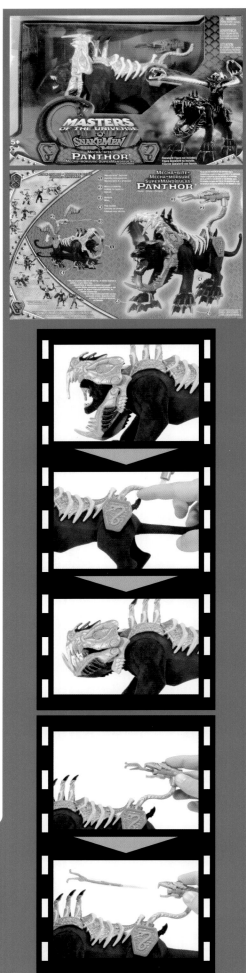

Accessories:
- Battle cannon
- Missile
- Paw claws
- Mecha-bite armor

The "mecha" variations of the cats gave them brand-new armor. Panthor's new look is very similar to Battle Cat's, with the same feature in place. The new armor features an exaggerated mechanical snake jaw positioned over Panthor's head. By pressing the button on his back, the snake jaws clamp shut over Panthor's head, allowing him to bite down in attack!

The entire armor piece is designed with a snake theme, showing allegiance to the evil Snake Men faction. Behind the saddle is a snake-themed battle cannon with a spring-loaded missile shaped sort of like a snake's tongue. The seat has a bright green, scaly theme. The back of the armor above the legs features the logo of the evil Snake Men. Panthor stands upon four Paw Claws—spiked cleats on the bottom of his feet.

Just like with Battle Cat, it's an odd-looking variation, but a welcome reissue of Skeletor's evil cat steed!

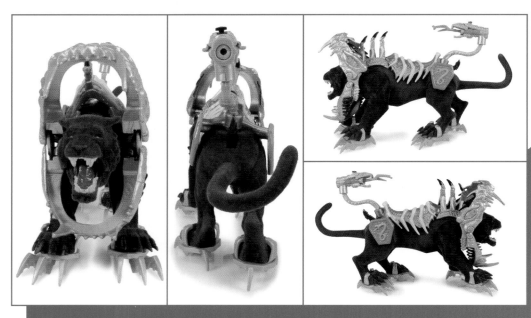

MOTU 2002

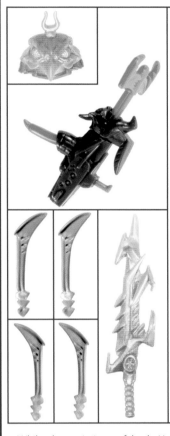

MECHA-BLADE HE-MAN

First released 2004 • Member of the Heroic Warriors

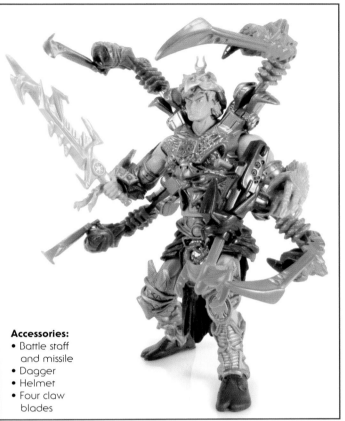

Accessories:
- Battle staff and missile
- Dagger
- Helmet
- Four claw blades

While the variations of both He-Man and Skeletor seemed endless in this Masters of the Universe toy line, some of them featured action features that really stood out as quite fun and interesting! The Mecha-Blade figures fit that bill.

Released as part of the "vs. the Snake Men" series at the end of the line, Mecha-Blade He-Man wears armor with the face of a falcon on his chest. Coming over his shoulders and around his torso from the back of the armor are four large clawed arms. They resemble the legs of a spider at first glance, but are actually designed to look like the talons of a bird.

Each arm has a blade that can be attached to it. A pull lever on He-Man's back will cause the clawed arms to grasp closed, either grabbing or slashing a potential enemy in front of him! This definitely adds to that spider-leg feel, but it's an oddly satisfying action feature!

In addition to the claw blades, Mecha-Blade He-Man also comes with a stylized golden sword and a spring-loaded missile blaster for extra ammo against his foes!

MOTU 2002

MECHA-BLADE SKELETOR

First released 2004 • Member of the Evil Warriors

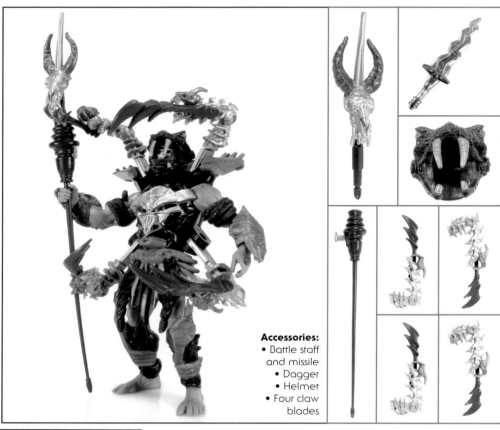

Accessories:
• Battle staff
 and missile
• Dagger
• Helmet
• Four claw
 blades

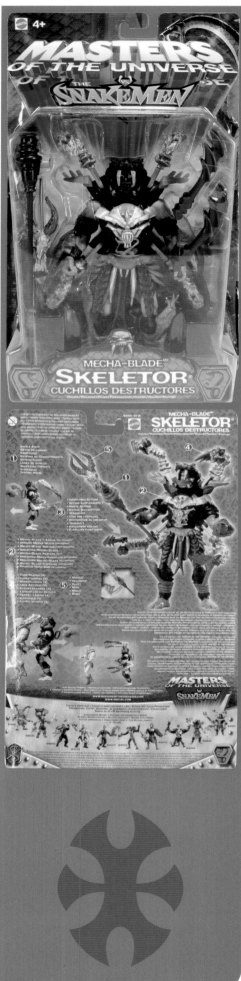

The Mecha-Blade version of Skeletor is designed quite similarly to Mecha-Blade He-Man. The action feature is the same, but the armor has a different look to it.

Since this is part of the "vs. the Snake Men" series at the end of the line, Skeletor's armor is snake-themed. The armor on his chest has a face on it that, interestingly, appears to resemble the leader of the Evil Horde, Hordak. This is noteworthy since Hordak does not appear in this toy line.

From the back of the armor are four large clawed arms stretching over his shoulders and around his torso. These arms are mechanical in look, sort of like a robotic spider, and feature blades jutting off the ends. By pulling a lever on Skeletor's back, the arms would fold forward, allowing Skeletor to trap an enemy in front of him. Like with the He-Man counterpart, this Mecha-Blade action feature works well and is remarkably satisfying.

In addition to the new armor, Skeletor features a new version of his Havoc Staff, called a "battle staff" on the box. This one features a button to the side that triggers a spring-loaded missile from the top.

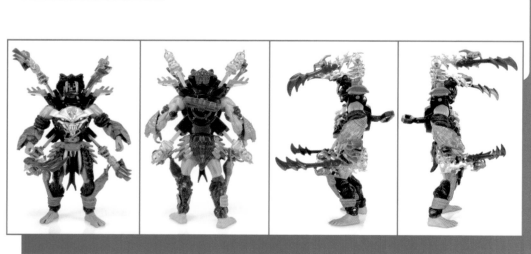

MOTU 2002

MEGA-PUNCH HE-MAN

First released 2003 • Member of the Heroic Warriors

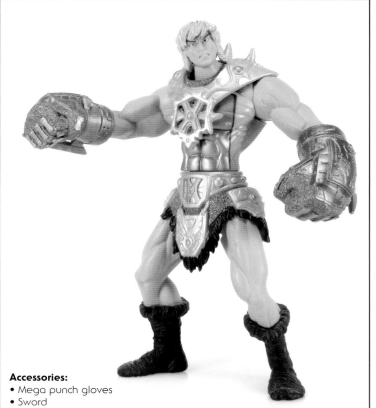

Accessories:
• Mega punch gloves
• Sword

This variation of He-Man is largely similar to the initial release, with a few new accessories to make him stand out a little.

The loincloth piece is different, featuring chain mail over the usual furry shorts and a large golden belt. The armor for this figure matches that silver-and-gold color scheme, and just sits over He-Man's shoulders rather than wrapping around his torso like his usual power harness. His chest has a silver painted stripe going right down the center. This certainly looks odd, as it's not clear if this is supposed to be part of his armor or just paint that He-Man is wearing on his chest and stomach.

To tie in to his Mega-Punch name, the key accessories are the Mega-Punch gloves that fit over He-Man's hands. These oversized gloves are sculpted to look like they are made of chain-mail and feature metallic red blades on the underside of the wrists. In addition, He-Man also comes with a new sword for battle without his gloves, which is styled to look like a mechanical katana.

This was always an odd choice for a He-Man variant, specifically since there is already a heroic character in the MOTU world who is known for having an oversized, metal hand. Many fans questioned why we didn't just get Fisto instead. Luckily, Mega-Punch He-Man did not keep Fisto from eventually seeing release (as "Battle Fist").

FUN FACTOID: The picture on the back of Mega-Punch He-Man's card depicts He-Man without the painted abdomen and with two-tone silver gloves.

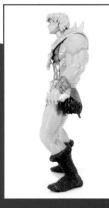

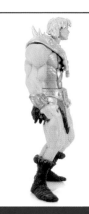

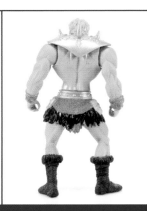

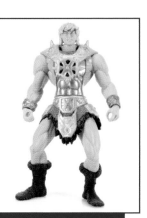

MEKANECK

First released 2002 • Member of the Heroic Warriors

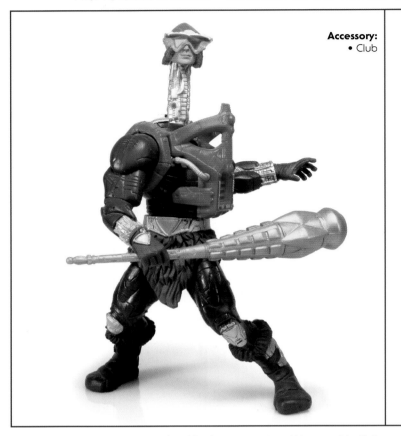

Accessory:
• Club

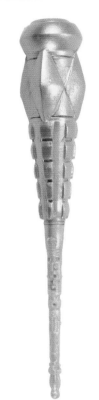

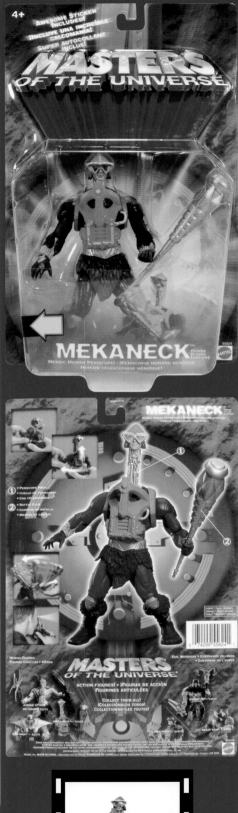

Another classic Heroic Warrior updated for this new version of Masters of the Universe, Mekaneck is instantly recognizable yet also features new details for this modern take. Like many of the new designs, he features a much more tech-like look with circuitry sculpted all over his body. This makes a lot of sense for a character who is essentially a cybernetically enhanced human, and works really well for the overall look!

The bright red armor is worked into the sculpt of the torso this time around, so it is not removable like it was on the vintage figure. However, he does retain the same neck-extending action feature straight out of that classic toy line! Operating exactly the same, twisting the figure at the waist causes Mekaneck to stretch his robotic neck upward! It's a fun, time-proven action feature and one that definitely feels right being included, but it's worth noting that this does cause some balance issues when trying to stand the figure with his neck outstretched. One of the improvements, however, is the ability to turn his head, thus allowing him to look left and right—an articulation point that was lacking on the vintage figure!

Another new added feature is the ability to look through the back of Mekaneck's head via a small hole to "see what he sees." His visor is made of a translucent green plastic, so essentially you just see the world with a green tint. Topping it all off, he also comes with a golden club that is modeled after the yellow club included with the vintage action figure.

Mekaneck is one of the figures who also had a rare chase figure released. The figure itself is exactly the same sculpt, but features small paint details that make him stand out. The chase version features green paint details on his silver belt, and has a clear visor instead of the usual green visor.

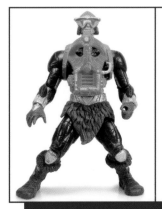

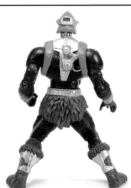

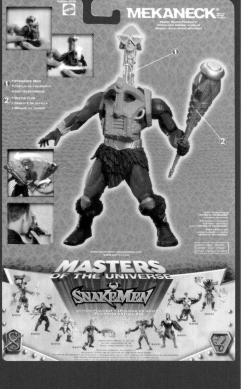

MEKANECK (REPAINT)

First released 2004 • Member of the Heroic Warriors

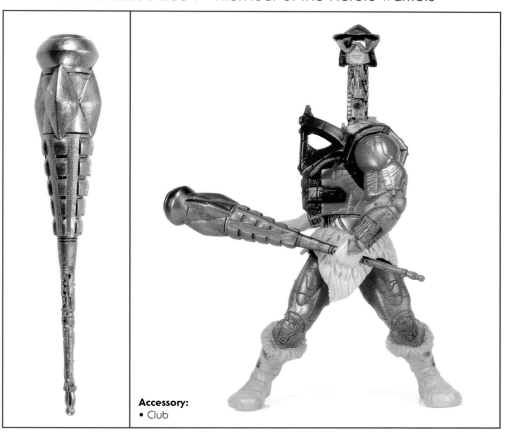

Accessory:
• Club

Toward the end of this Masters of the Universe toy line, several figures saw a brand-new release with a new paint deco in an attempt to keep the pegs filled with figures to buy while saving Mattel on tooling costs. Oftentimes, these new paint schemes were quite odd, usually with bright, garish colors that didn't make a lot of sense for the character.

Mekaneck's 2004 release is easily one of the ugliest. The figure itself is exactly the same as his initial release, featuring the same extending neck action feature and club accessory. The big difference with this version, aside from coming packaged on the new green "vs. the Snake Men" packaging, is the wild paint deco.

Mekaneck's color scheme is essentially reversed this time around, featuring a red bodysuit instead of the typical blue, and blue armor instead of the usual red. But where things get really odd are with his boots and loincloth, which are painted a flesh-tone color. The swapped red and blue are an interesting idea, but the whole look is really just thrown off by those flesh-colored clothing pieces.

MER-MAN

First released 2002 • Member of the Evil Warriors

Accessories:
• Sword
• Trident

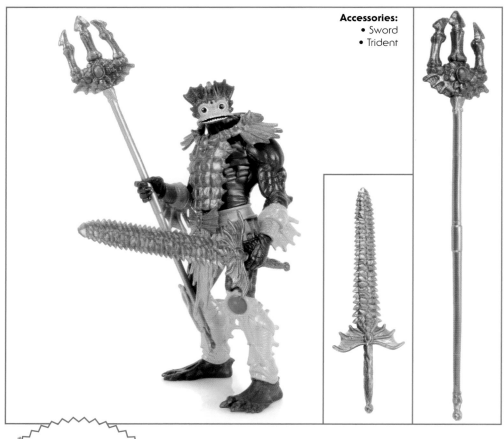

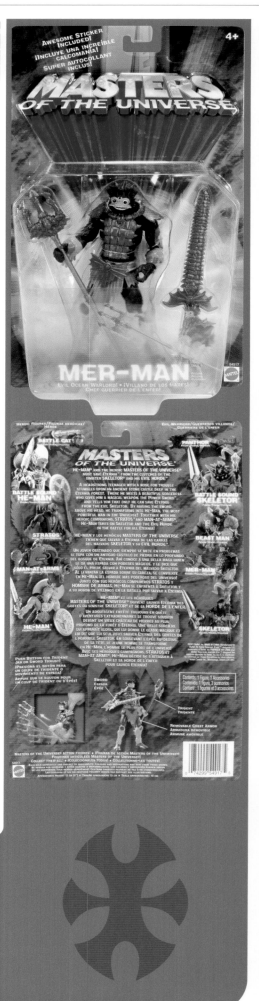

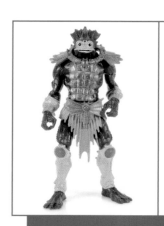

One of the original eight action figures released in the vintage Masters of the Universe toy line, Mer-Man's update for this new series is often considered one of the most effective in the lineup.

The original action figure was notorious for looking quite a bit different from the artwork featured on the back of the figure's packaging. The Four Horsemen, the toy sculptors responsible for most of the updated looks in this new line, made it a mission to rectify this by ensuring that this new version of Mer-Man looked much more like that original artwork seen on the vintage toy boxes. They did this quite masterfully, as a first glance at this figure is easily identifiable as Mer-Man. But standing him alongside the vintage figure really shows you the difference in the sculpts!

Included are two weapons for Mer-Man to wield: his classic sword and a brand-new trident, a perfect accessory for a sea-dwelling warrior! He also features a new action feature that works with his weapons. By pressing the button on Mer-Man's back, his right hand thrusts forward, allowing him to "stab" with either his sword or his trident accessory.

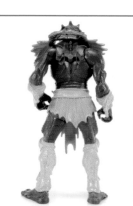

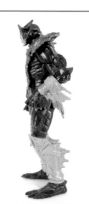

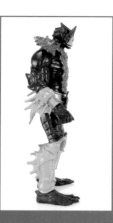

MOTU 2002

MER-MAN (REPAINT)

First released 2003 • Member of the Evil Warriors

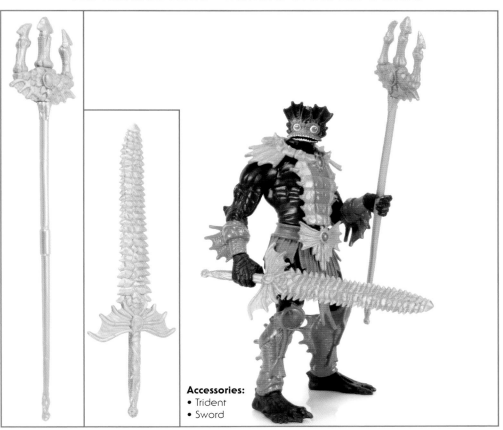

Accessories:
• Trident
• Sword

Repaints were certainly the name of the game in this Masters of the Universe toy line. It was a way for Mattel to utilize existing molds while keeping many of the main characters available for purchase. Sometimes this resulted in strange new paint schemes on the figures.

Mer-Man's repaint release is the same figure as the initial one, with the only difference being the colors used. He still includes his usual sword and trident accessory, and features the push-button stabbing action feature.

Mer-Man's new colors aren't too radically different from his normal release. His skin tone is still a dark shade of green, and while his armor is a little lighter in color, it's still mostly a familiar yellowish gold. The new additions are a reddish orange seen on his wrists and shins, and a new light green stripe on the front part of his chest armor.

The most standout elements of the new paint deco are the bright red eyes instead of the usual black, almost making Mer-Man look like he's possessed. While some of these paint choices seem a bit odd, this repainted version of Mer-Man is certainly one of the least controversial of all of the repaints released in this toy line.

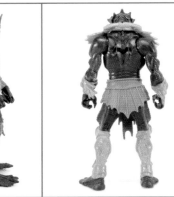
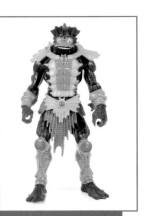

MINI FIGURES
HE-MAN / JUNGLE ATTACK HE-MAN / MAN-AT-ARMS / MEKANECK / MER-MAN / ORKO

First released 2002

 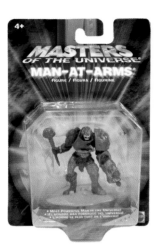

With the launch of the new Masters of the Universe toy line, Mattel opted to try something different by releasing multiple scales of the characters in toy form. While the fully articulated six-inch action figures would be the main line releases, the beginning of the line saw a small run of two-inch nonarticulated mini figures as well.

These mini figures were essentially small renditions of the larger action figures. It's obvious that the main action figures were the source of inspiration for these smaller releases, as they look nearly identical, just lacking articulation. Each mini figure is preposed and permanently attached to a small display base. The details are decent for such small figures, though the paint deco could definitely be hit or miss, especially on the faces.

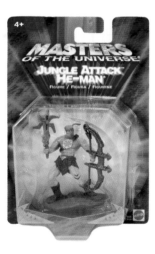 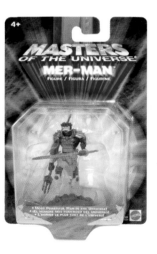

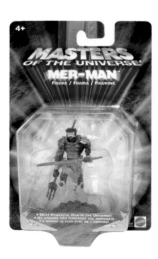 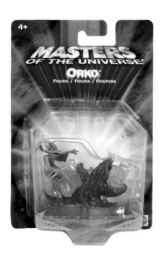

MINI FIGURES
SKELETOR / SNAKE ARMOR SKELETOR / STRATOS / TEELA / TRAPJAW / TRI-KLOPS

First released 2002

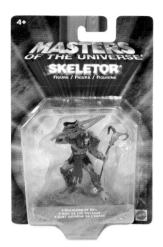

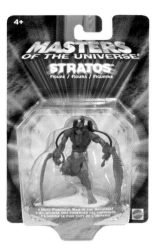

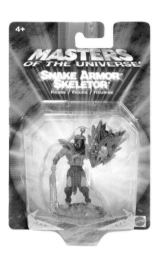

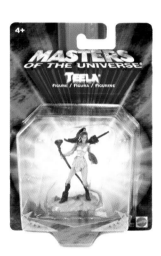

Each mini figure got a single carded release; however, there were also two gift packs released, each including four mini figures. These gift packs included three mini figures that were also released individually and one exclusive figure only available in the gift packs. Both of the exclusives, Ram Man and Beast Man, were considered major characters, so many fans were not happy that they might have to end up with doubles of other mini figures just to be able to add these two to their collections.

Much like the main line, the mini figures were also filled with variants of He-Man and Skeletor, giving us some of the odd variations, such as Jungle Attack He-Man and Snake Armor Skeletor—all versions that were not well received by fans.

The mini figure line was short lived, only lasting through the beginning of the Masters of the Universe relaunch in 2002.

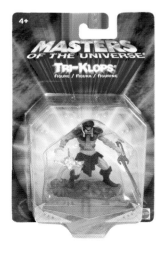

MINI FIGURES
GIFT PACK 1 & 2

First released 2002

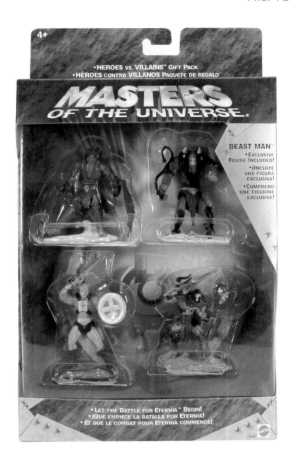

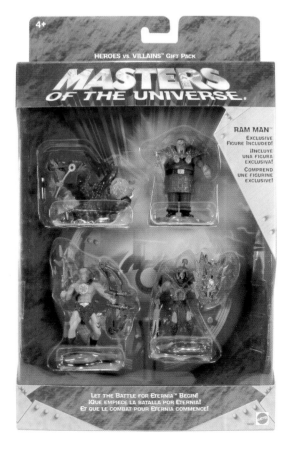

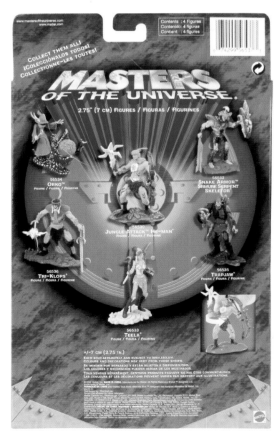

MOSS MAN

First released 2003 • Member of the Heroic Warriors

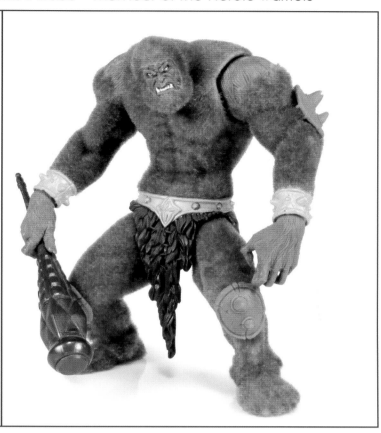

Moss Man was a mail-away exclusive from Mattel that you could send off for by collecting proofs of purchase from retail Masters of the Universe action figures.

The figure was shipped out in window box packaging, as opposed to the standard blister cards found in stores. The window box fully showcases the included action figure, with an image of the figure on the back. It was shipped in a white mailer box. This style of packaging would be typical of any exclusives offered throughout the line.

The figure itself followed the model of the vintage line—reusing the Beast Man action figure, but painting him green and covering him in flock. While on one hand it's fun to see Mattel following an old format for this release, it does not work particularly well for Moss Man as a character this time around. Since Beast Man was sculpted to be much bigger and more monstrous, this made for a quite hulking and angry-looking Moss Man action figure. This is especially odd, since it does not remotely match his appearance in the MYP animated series that accompanied this toy line, in which he had a completely different look from this toy.

Moss Man also came packaged with a brown version of Mekaneck's club. This isn't quite the same as the club that came with the vintage Moss Man, and it's obvious Mattel was just reusing existing parts anywhere they could to save on costs.

The entire figure feels phoned in and not on par with the other amazing sculpts and reimaginings found in this toy line. But it was a "free" promotion. So there's that!

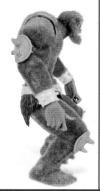
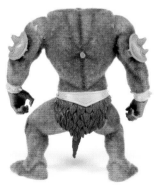
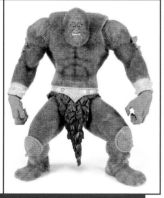

MUTANT SLIME PIT

First released 2003 • Lair of the Evil Warriors

Accessories:
- Mutant warrior
- Mutant guts
- Slime compound

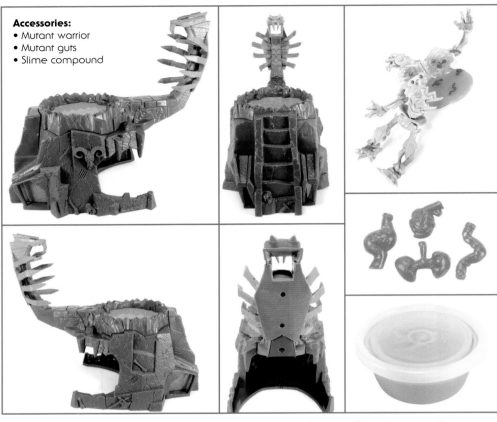

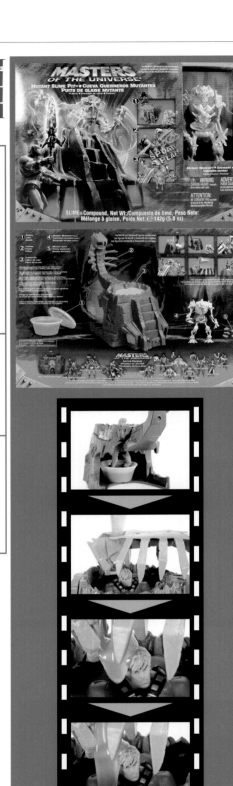

The Mutant Slime Pit is an interesting play set that attempts to bring elements of the MYP animated series into the toy line while also reimagining one of the more beloved play sets of the vintage toy line.

The overall design is meant to look like Skeletor's throne with a green pool of Slime at the base of it. It also includes a Mutant Warrior, a unique bone skeleton character that Skeletor summoned in the animated series to battle the Heroic Warriors. The Mutant Warrior is special in the sense that this is the first and only all-new character released as an action figure in the entire line with no attachment to the vintage toy line! The Mutant Warrior features a translucent chest that can be filled with the included red plastic "guts." The center of his torso is a push button, so that when it is punched by He-Man or any Heroic Warrior, the chest pops open and the guts spill out!

The play set itself has some interesting play features that admittedly don't work all that well. Skeletor doesn't really sit on his throne and instead straddles the "seat." After standing a figure on the pit directly in front of Skeletor, you can tilt his throne forward and the floor of the pit drops out, sending the figure crashing below. You can place the Slime compound jar underneath so that the figure falls into it. The problem here is that the figures are taller than the pit, so they land with only their feet in the Slime. There is also a small hole in the back of the snake head on Skeletor's throne to pour Slime through, but it doesn't work too well. Lastly, the doors of the pit can open upward by pressing up from underneath. This is one of the best features that allows you to have your Mutant Warrior rise out of the pit from below to re-create scenes from the cartoon.

The highlight is the included Mutant Warrior action figure, but the play features on the actual play set barely function. When compared to the iconic Slime Pit from the vintage line, the Mutant Slime Pit is a Slime Pit in name only.

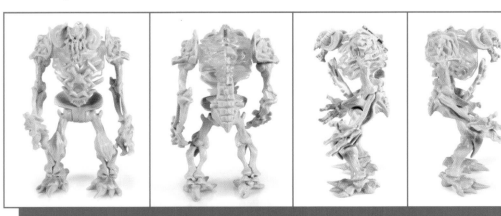

ORKO

First released 2003 • Member of the Heroic Warriors

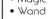

Accessories:
- Magic cloud
- Magic orb
- Wand

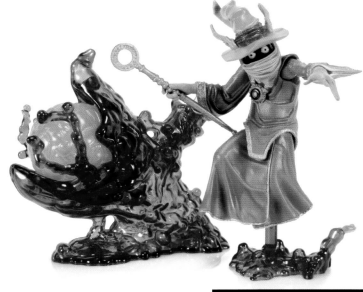

Orko played the role of comic relief in the original Masters of the Universe cartoon and toy line, making this new version one of the more drastic updates. While he is still instantly recognizable, the floating wizard has an overall darker, more serious tone this time around.

As is common in this line, the sculpt is much more detailed, featuring nice intricate designs on the robe. Replacing the large black O on the front of his robe is a golden medallion around his neck. His left arm is outstretched in a spell-casting pose, while his right hand holds on to a wand—a new accessory for an Orko action figure.

One of the most interesting design elements of this new sculpt can be found on the lower part of his robe. Orko is well known as a character who does not have any visible legs, hovering in the air. This figure is attached to a translucent base in the shape of a magic plume of smoke to pull off this hovering effect. However, his robe is designed to appear as if there is a bent knee under the robe. It's a really interesting design choice.

Also packed in with Orko is a large magic spell, made of the same translucent blue plastic of his base. This spell accessory is shaped like magic enveloping a large orange ball that can be fired at foes at the push of a button, with the idea being that it's a magical blast that Orko conjured up.

There's a chase figure for Orko as well, with the only difference being the color of plastic used on his base and magic spell accessory. The colors were reversed, making the magic a translucent orange and the ball a solid blue.

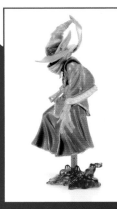

PANTHOR

First released 2002 • Steed of the Evil Warriors

Accessories:
- Two removable saddle rocket launchers
- Five-warhead missile
- Rocket

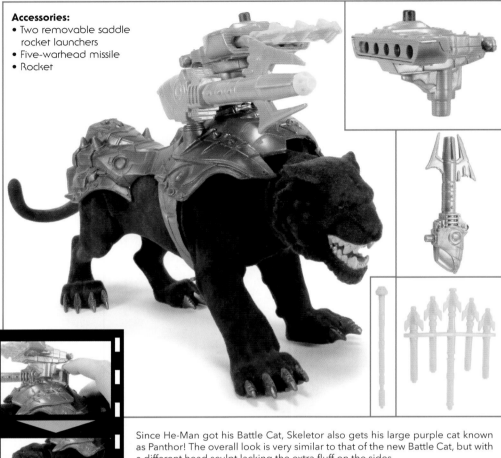

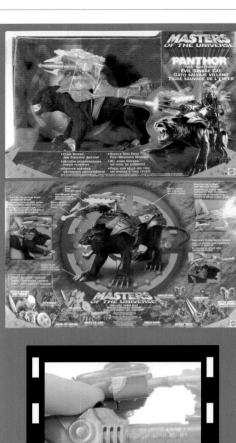

Since He-Man got his Battle Cat, Skeletor also gets his large purple cat known as Panthor! The overall look is very similar to that of the new Battle Cat, but with a different head sculpt lacking the extra fluff on the sides.

Of course the biggest difference here is that the entire sculpt is covered in purple flock, giving him a fuzzy look and feel. This is a direct nod to the vintage Panthor, the flocking having been a defining feature of that action figure.

Instead of being a solid, unarticulated sculpt like the original, we now get articulation in the legs. This is impressive, considering the flocked nature of the figure. It's done well, and there really aren't any present issues with the flocking peeling off by general movement of the legs. In addition, an action feature was included. Pressing a button on his back allows one of his paws to raise forward in a slash, and results in a chomping action with his mouth!

Skeletor can mount Panthor via the included saddle. Like with the new Battle Cat, we have the addition of large spring-loaded missile launchers that jut out of the sides of his saddle. These too are removable.

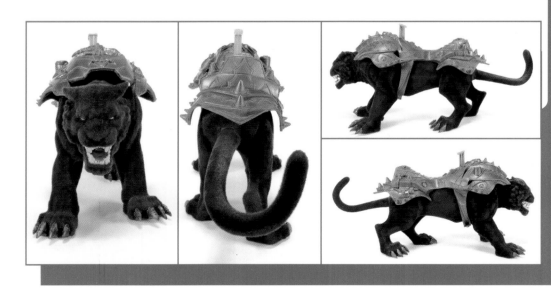

MOTU 2002

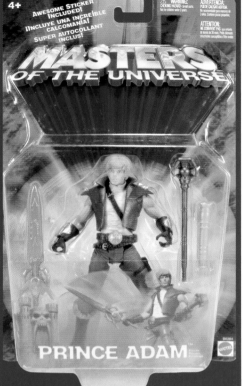

PRINCE ADAM

First released 2003 • Member of the Heroic Warriors

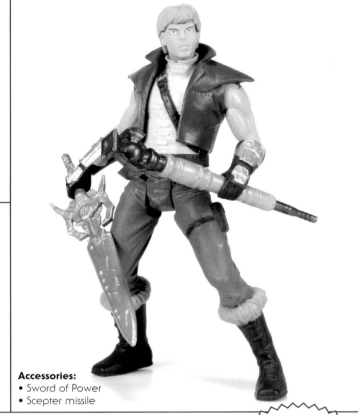

Accessories:
- Sword of Power
- Scepter missile

The secret identity of He-Man saw one of the more drastic changes with his new design in this new Masters of the Universe toy line, but it's one that truly makes a lot of sense. In the original series, the Prince Adam toy was a simple repaint of He-Man wearing a vest, so there wasn't any difference between the figure's build and that of He-Man. In this new series, Prince Adam is much smaller than He-Man!

Ditching the muscular look, this new Prince Adam is a skinnier figure with the appearance of a teenager. And although he does look different, at the same time he's still recognizable as the character. Like the vintage figure, this new Prince Adam is wearing a maroon vest with a white shirt underneath. He's sporting light blue pants, but gone is the furry loincloth. He is, however, still sporting fur-topped boots.

For accessories, Adam comes with a smaller version of the new mechanical Sword of Power. This gives off the impression that the sword itself also changes shape and size when the transformation to He-Man occurs, which was shown to happen in the tie-in animated series.

The Prince Adam figure also comes with a brand-new accessory for the character in the form of a royal scepter. This scepter is a weapon in disguise, as a spring mechanism allows it to blast at foes like a missile!

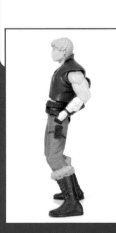

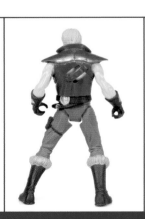
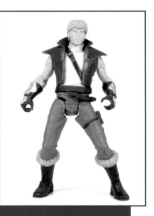

MOTU 2002

RAM MAN

First released 2002 • Member of the Heroic Warriors

MOTU 2002

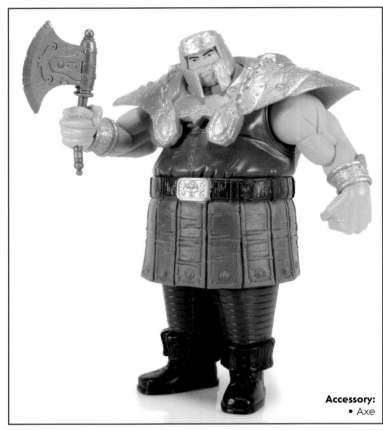

Accessory:
• Axe

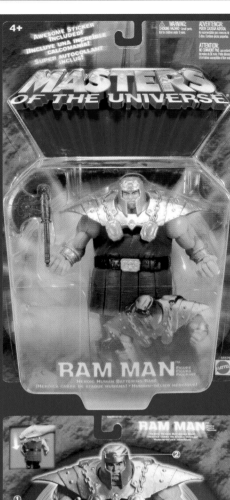

The Heroic Human Battering Ram was depicted as much larger in this new iteration of the brand than he was in the 1980s. While this new figure doesn't stand quite as large as he appears in the animated series, he's still a larger action figure.

Although he's taller, he's still instantly recognizable, featuring the same characteristic shoulder armor and helmet. Much of this figure's build is done in a very similar manner to the original action figure, right down to the action feature. Just like on that vintage toy, Ram Man's legs are not articulated, though they are molded as separate legs this time. They can be pressed up into his body and locked in place. Then, by pressing the small button on the back of his heel, the spring-loaded mechanism is triggered, launching the figure forward in a battering-ram motion.

Ram Man does feature more articulation this time around. While his legs are still pretty static as mentioned, he has joints at the shoulders, swivels at the wrist, and a joint at the neck—allowing for a much wider range of movement than we've ever seen for the character before.

Another similarity to the vintage action figure is his accessory, a single battle-axe that can be held in his right hand.

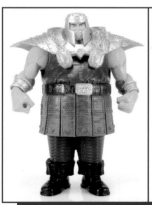

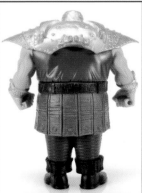

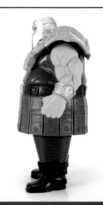

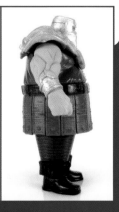

RAM MAN (REPAINT)

First released 2003 • Member of the Heroic Warriors

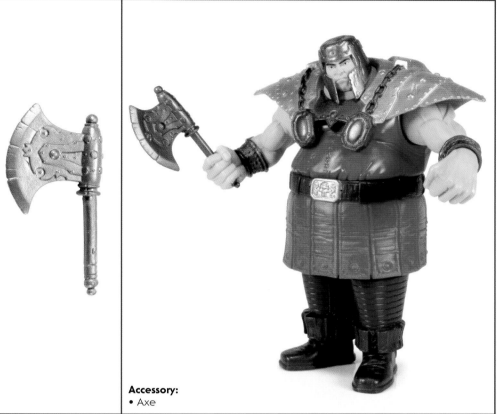

Accessory:
• Axe

As mentioned, many figures in this Masters of the Universe line were "refreshed" with a new paint deco in an effort to continue releases and keep many of the main characters on store shelves. Ram Man received this repaint treatment in 2003.

The figure itself is exactly the same as the standard release. He still features the same "battering ram" action feature. This is triggered by pressing Ram Man's torso downward, locking it in place. By pressing a small button on the back of his heel, Ram Man springs forward, attacking his foes with his armored head.

Also included is the same axe as seen on the standard release. The only difference you'll find here is with the colors used. Instead of his classic silver shoulder armor, Ram Man now has bright gold armor, although the helmet is still silver in color. In addition, the red and green of his clothes are much brighter than the first release of the character.

While it differs from the look we're all used to seeing for Ram Man, the colors actually work well—making for an effective addition to your collection, or a solid stand-in if you missed out on the first release.

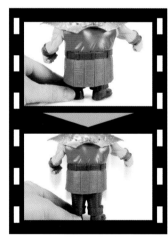

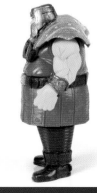

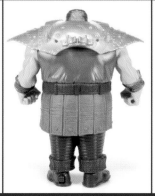

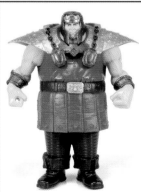

ROBOTO

First released 2003 • Member of the Heroic Warriors

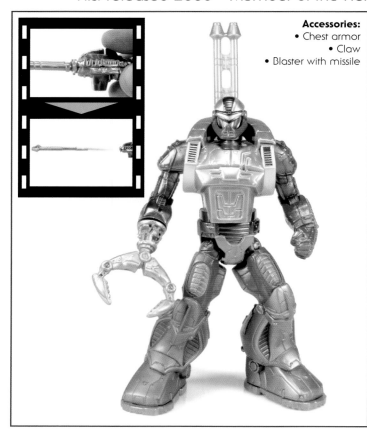

Accessories:
- Chest armor
- Claw
- Blaster with missile

As another classic character revamped for the new Masters of the Universe toy line, Roboto is a successful update for the modern era while simultaneously retaining everything that was memorable about him from the 1980s line.

This time around Roboto has a much more mechanical look to him, making him feel more like the robot that he is. Instead of using the same muscular legs and arms as any regular figure, Roboto now features arms with a more angular shape to their design, covered in circuitry. Meanwhile, he features new oversized feet that help to distinguish him from the standard human figures.

But even with these new design elements, he's still easily recognizable as the Roboto we all know and love. Bright blue and red adorn the figure, just like with the original. He also has an interchangeable right hand, allowing you to switch between an articulated robotic claw and a blaster, complete with a spring-loaded missile. This feels like a real upgrade to his classic action feature. Plus, you now even have the ability to store the extra arm attachment on his back.

Of course, the thing everyone really remembers Roboto for is the translucent chest that allows you to see his inner gears. At first glance, you might be wondering why that's missing from the new figure. But cleverly, this new version has removable silver chest armor that reveals the classic-style translucent chest, complete with small, colorful gears inside. And to top it all off, rotating the figure at the waist still causes those gears to spin and his face shield to move up and down—just like the vintage action figure!

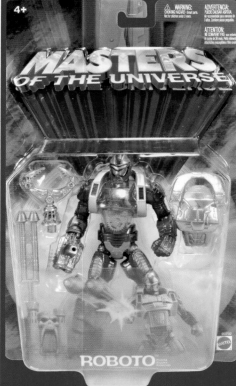
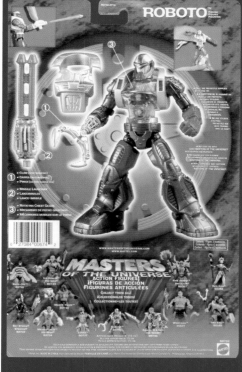

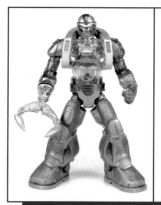
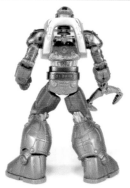
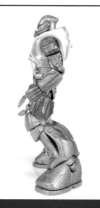
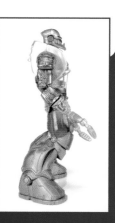

SAMURAI BATTLE CAT

First released 2003 • Steed of the Heroic Warriors

Accessories:
- Two missiles
- Sword
- Helmet
- Cannon

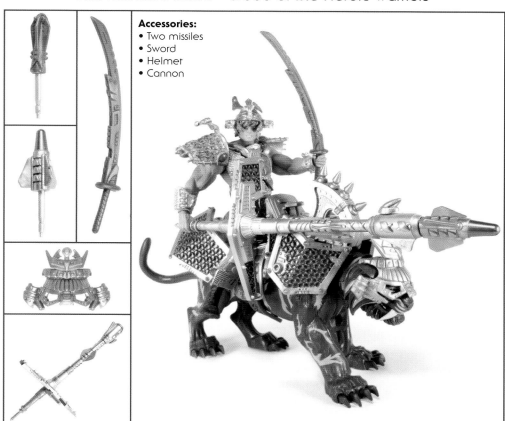

There was an entire series of Samurai variants as part of wave two in 2003. This gave us a few of our main characters in new tech-heavy samurai gear, along with two beasts, including Battle Cat here!

The Battle Cat action figure itself is the same as the standard Battle Cat that came out in 2002. The main difference is the included armor and gear, all made to fit in with that strange technofuturistic samurai look seen on all of the variants in this set.

Instead of the classic maroon armor we're used to, Samurai Battle Cat has a new silver helmet with a brand-new design, and a heavily armored silver saddle to seat He-Man on his back. This armored saddle includes spikes on the front, and a massive spring-loaded missile launcher on the side, as well as a spare missile store on the back. It even includes a new samurai sword for He-Man to wield, holstered on Battle Cat's side.

This marks the first time we were ever given a variant action figure for Battle Cat, allowing him to have a very different look.

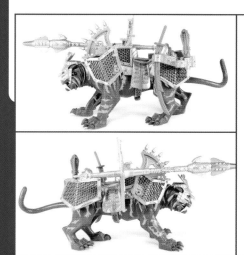

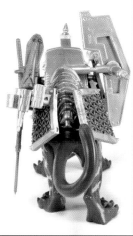

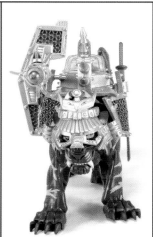

SAMURAI BATTLE RAPTOR

First released 2003 • Steed of the Evil Warriors

Accessories:
• Removable raptor claws
• Flame projectile

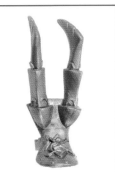

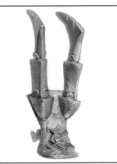

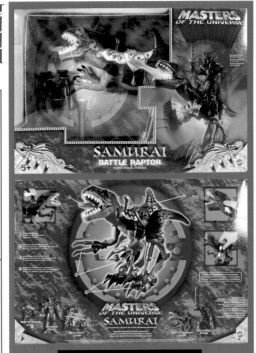

Now this is an interesting new addition to the lineup! As part of the Samurai set of variants, Skeletor was given a brand-new beast to ride. While Battle Cat was given the Samurai treatment, Panthor wasn't as lucky. Instead, Skeletor now has a purple pet dinosaur known as Battle Raptor!

The name is, honestly, hilarious—utilizing that classically overused "battle" adjective. But the figure is pretty great. It's hard not to love a dinosaur toy, and truth be told this isn't the first time we've seen dinosaurs involved in the Masters of the Universe property.

While Battle Raptor may lack much articulation, he makes up for it in action features. Pulling a lever unleashes his "claw slashing action." You can attach armored "raptor claws" to his hands, extending his reach and making the claw slash more effective. He also has what appears to be robotic pistons attached to his feet and legs. This is a spring-loaded mechanism. By pressing the figure downward, his legs bend. Releasing him will cause the figure to jump upward. A saddle on his back will allow Skeletor to ride him into battle. And of course, there's also a spring-loaded missile feature. This is in the form of "fire" that the dinosaur can blast at foes. It's a weird addition to the line, but it's a fun one too!

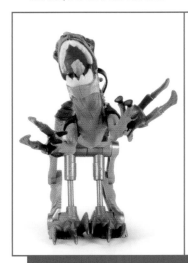

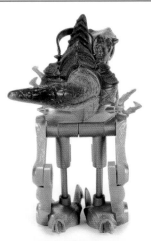

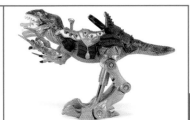

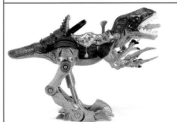

SAMURAI HE-MAN

First released 2003 • Member of the Heroic Warriors

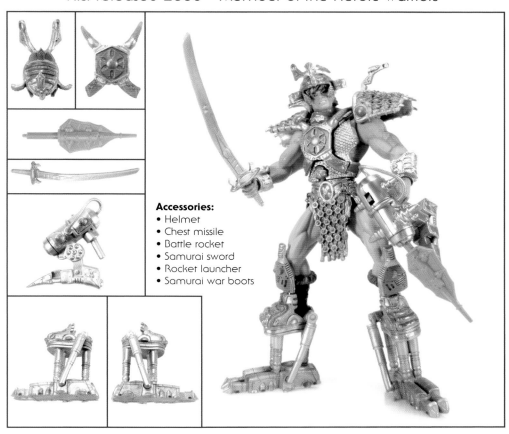

Accessories:
- Helmet
- Chest missile
- Battle rocket
- Samurai sword
- Rocket launcher
- Samurai war boots

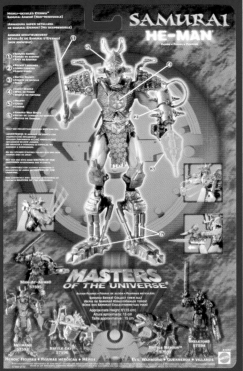

MOTU 2002

The variants of the main characters got a little wild in this particular line, and one of the earliest examples of that was certainly Samurai He-Man.

Part of an entire set of samurai-themed figures, He-Man comes with new samurai armor and accessories that have a futuristic-tech look to them. The figure itself looks much like your standard He-Man release, but there are some differences. For example, the torso piece is a new sculpt, featuring the new samurai armor as a nonremovable piece. One of the odd features of this figure includes a spring-loaded missile launcher in his chest! A chunk of the armor can blast off at He-Man's foes with the press of a button, leaving a hole in the center of his torso.

Aside from the chest missile, He-Man also has a handheld rocket launcher with its own spring-firing mechanism in case he needs more firepower than his armor can offer up. And instead of coming with his standard Sword of Power, he comes with a silver-and-gold samurai sword. A button on his back will cause his right hand to swing up and down for sword slashing or Power Punch action.

A removable helmet is included, that fits right over the figure's hair. But the accessories that might be the strangest are the samurai war boots—which are essentially stilts! These stilts can clip on to the bottom of the figure's feet, boosting his overall height. It's possible that these geta-esque attachments are a nod to an accessory from the vintage toy line called the Stilt Stalkers, but it is an odd inclusion here. It's a bit puzzling as to how these fit in with a samurai theme. Yet, these same samurai war boots can be found with all three of the samurai figures released.

 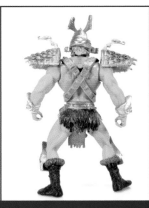 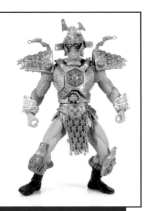

SAMURAI MAN-AT-ARMS

First released 2002 • Member of the Heroic Warriors

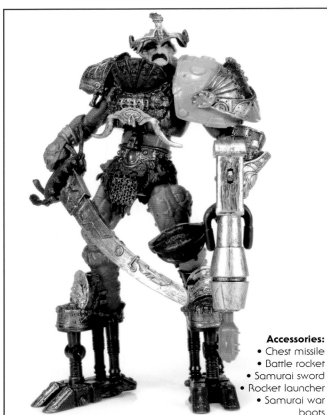

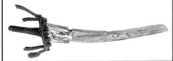

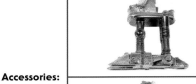

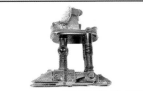

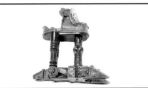

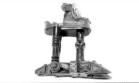

Accessories:
• Chest missile
• Battle rocket
• Samurai sword
• Rocket launcher
• Samurai war boots

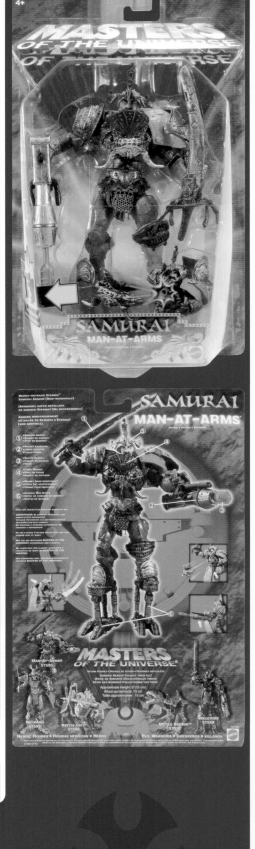

Joining in on the samurai fun, Man-At-Arms is one of five overall figures to be part of this samurai set from early 2003.

The deluxe figure comes with several accessories and brand-new armor. One thing that is humorous about this figure is how Duncan is wearing the samurai armor on top of his standard armor. There's a samurai helmet attached to his regular helmet, and there are several parts on the figure where you can see his usual orange armor peeking out from under the bluish samurai armor.

The accessories and action features are just like those included with Samurai He-Man, though the sculpts are different. Duncan here has his very own samurai sword and handheld rocket-firing missile launcher. And he even gets his very own chest missile that blasts out of his torso at the press of a button!

And of course, he also gets those stilts known as the samurai war boots. These clip on to the bottom of his feet to boost the figure's overall height. Perhaps these were an invention of Man-At-Arms himself.

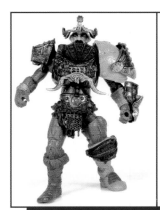

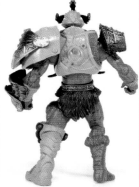

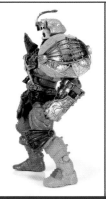

MOTU 2002

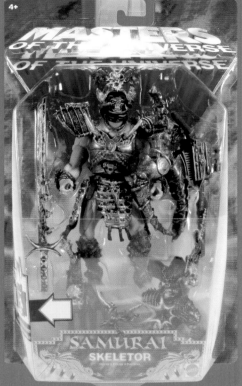

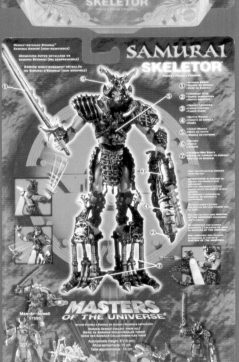

SAMURAI SKELETOR

First released 2003 • Member of the Evil Warriors

Accessories:
• Helmet
• Chest missile
• Samurai sword
• Battle missile
• Rocket launcher
• Samurai war boots

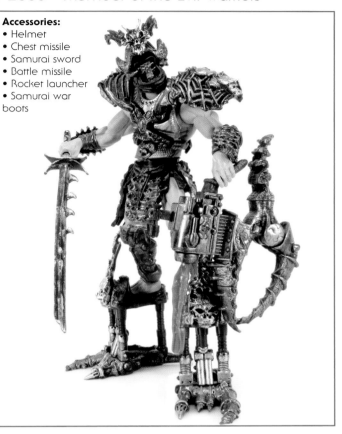

Skeletor is the last of the figures in the samurai set released in 2003, following a classic tradition of a matching Skeletor variant being released for every He-Man variant.

Interestingly, it seems that Skeletor got ahold of the samurai armor schematics, because aside from his armor looking a little more demonic, it's pretty much exactly the same as what we saw on He-Man and Man-At-Arms! The armor itself looks less polished and tech-heavy than the armor found on the heroes. It's a dark purple in color and features an overall much more evil tone, with little skulls and the like. It's honestly pretty striking armor, and out of all the samurai variants, this is the most fitting to the character.

Like with the others, Skeletor here has his very own samurai sword and handheld missile-firing rocket launcher. The small button on his stomach also allows him to blast a chest missile from his armor so he can return fire on He-Man.

He has his very own removable samurai helmet, complete with a little skull with bat wings on top that just clips to the top of his hood. And of course, he has his very own samurai war boots so that he can ensure he's the same height as He-Man and Man-At-Arms when he runs into battle.

In all honesty, even if you go without the boots and helmet attachment, this one stands alone as a pretty effective-looking armored Skeletor figure.

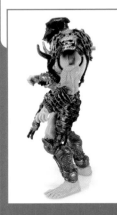
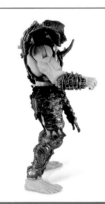
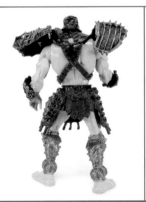
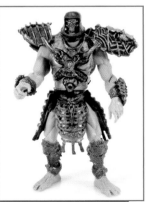

SERPENT CLAW MAN-AT-ARMS

First released 2003 • Member of the Heroic Warriors

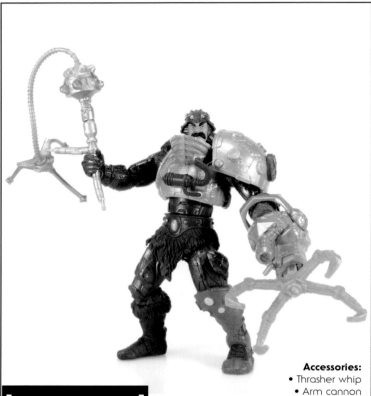

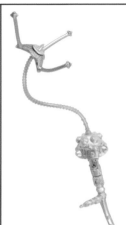

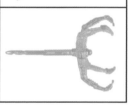

Accessories:
- Thrasher whip
- Arm cannon
- Serpent claw missile

When the Snake Men were introduced as a new threat to the heroes toward the end of the toy line, many of the characters got brand-new action figures with updated paint deco and new accessories. These were rethemed on new green packages as "Masters of the Universe vs. the Snake Men," and the heroic figures usually included a gimmick that was specifically themed as an anti-Snake Men weapon.

Serpent Claw Man-At-Arms is a repaint of the standard Man-At-Arms action figure with some new accessories to fit this theme. The new colors used on this one include a metallic green on his bodysuit, and silver on his armor—making for a pretty slick look for the character.

He comes with his standard club accessory; however, this time around there is a thrasher whip attached to the top. This is made of a softer, pliable plastic that allows it to whip around by pressing a button on the figure's back, moving his arm up and down.

In addition, he has a new version of his arm cannon. This time it comes equipped with the serpent claw missile that the figure is named for. This is a standard spring-loaded rocket launcher, but the missile itself is shaped like a claw intended to grapple the Snake Men foes.

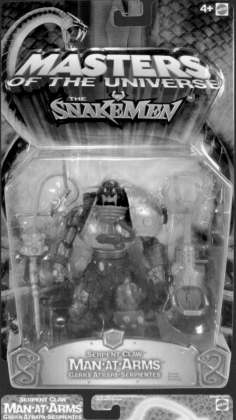

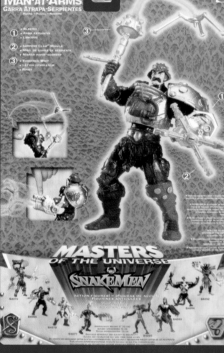

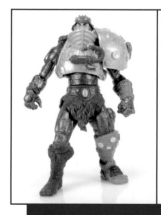

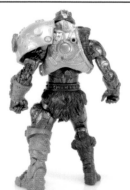

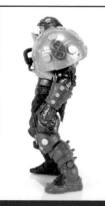

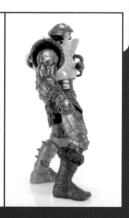

MOTU 2002

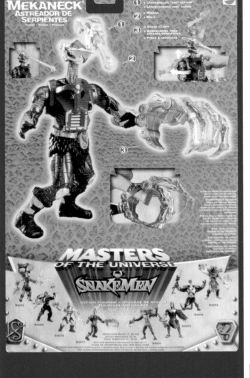

SERPENT TRACK MEKANECK

First released 2003 • Member of the Heroic Warriors

Accessories:
• Snake claw
• Missile
• Missile launcher

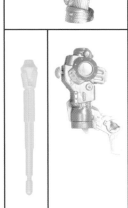

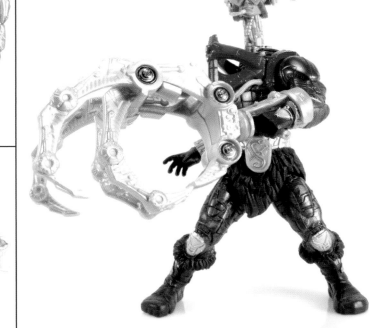

With the line being rebranded as Masters of the Universe vs. the Snake Men towards the end of the line, many of the heroes got rereleased with brand-new paint decos and accessories with the idea that they are now armed up specifically to fight off the threat of the evil Snake Men. This was a way to push the same figures back out on the shelves while only including some minor changes.

Mekaneck got this treatment with his Serpent Track release. The figure itself matches up with the standard release, but now features a new paint job. The colors are still similar to what you'd expect to see for the character, but the blue of his bodysuit has a metallic tone to it, and the red is much deeper in color. The translucent plastic used for his visor as well as his neck are now a bright green, tying in with the Snake Men theme.

For accessories, Mekaneck now has a large rocket-firing missile launcher attached to his head. This works like any other spring-loaded weapon in the line, though it is a bit strange seeing such a large accessory just sticking off the side of his head. He also has a large snake claw that attaches to his arm. This has the ability to open and grapple other figures, allowing him to better fight off those slithering snakes!

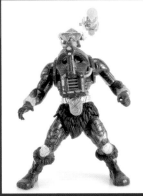

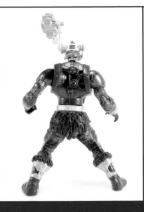

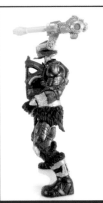

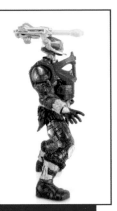

MOTU 2002

SHE-RA

First released 2004 • Member of the Heroic Warriors

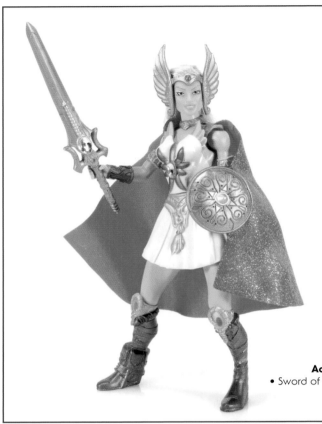

Accessories:
• Sword of Protection
• Shield
• Comb

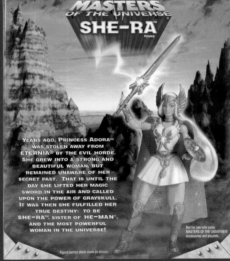

One of the later releases in the line, She-Ra was sold as a convention exclusive at the 2004 Wizard World Chicago event. Like the other exclusives in this line, the figure comes in a special window box instead of the typical blister card. The figure is mostly made up of preexisting parts with some new additions to make it stand out on its own.

The figure reuses the same female body seen on both Teela and Evil-Lyn. This is most noticeable in the arms and the legs, as the boots and arm pieces are clearly Teela's but repainted. The right boot even has the larger sculpt, which was originally done to include the Castle Grayskull Action Chip—a feature that was no longer being included in the figures at this point.

She-Ra was given a plastic skirt and new bodice piece to resemble her classic outfit, complete with a jewel embedded in the torso just like the vintage action figure. The head also has a strong resemblance to Teela, but the major difference is that She-Ra has rooted hair—a direct nod to the doll-like figures of the original Princess of Power toy line. The figure even came with a small red comb much like the one seen in the original lineup.

For accessories, she is packaged with a repaint of Teela's shield and a brand-new Sword of Protection! This new gold sword features a tech-heavy sculpt like many weapons in the 200X toy line, but the big difference is that this one looks much more similar to the classic Sword of Protection—something we did not see with He-Man's Sword of Power! It even includes a small gem embedded in it much like the classic toy and Filmation animated series swords.

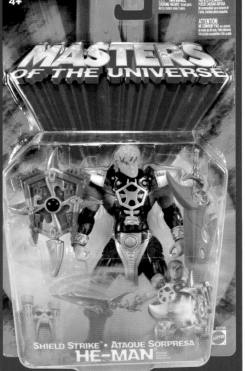

SHIELD STRIKE HE-MAN

First released 2003 • Member of the Heroic Warriors

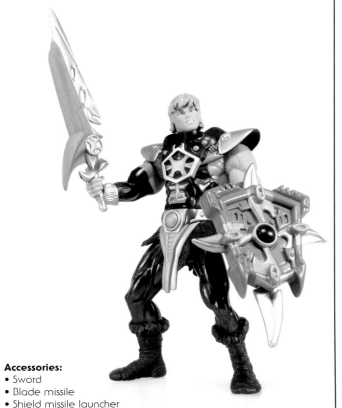

Accessories:
- Sword
- Blade missile
- Shield missile launcher

MOTU 2002

Shield Strike He-Man as a figure is essentially the same He-Man action figure sculpt, but with new accessories and armor additions, along with a new paint deco.

The armor this time has a very futuristic look to it. The figure has a new loincloth piece that includes some silver elements with a sci-fi vibe. The armor is similar, sitting atop his shoulders and featuring a more slick silver, gold, and dark blue color scheme. His legs are painted a dark blue to make it appear he is wearing pants, and his torso is painted the same color to look as though he is wearing a tank top under his armor. He even has some of that blue paint on his forearms, to look like half sleeves.

The sword is also redesigned, which was a common theme on many of the He-Man variants in the line. But the main gimmick lies in his shield, which is a large blue-and-gold contraption with a similar science-fiction feel. Each side of the shield has a large silver spike, but by pressing the button it is revealed that one of those spikes is actually a missile that can be fired at the enemy!

This figure almost has an "outer space" feel to it, making it seem like this is a 200X nod to the New Adventures of He-Man toys.

Shield Strike He-Man was later rereleased as Stealth Armor He-Man.

SKELETOR

First released 2002 • Member of the Evil Warriors

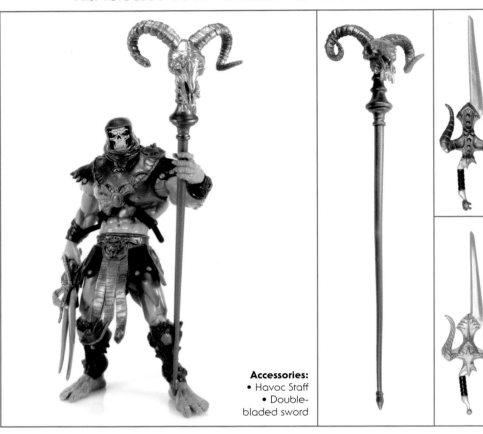

Accessories:
• Havoc Staff
• Double-bladed sword

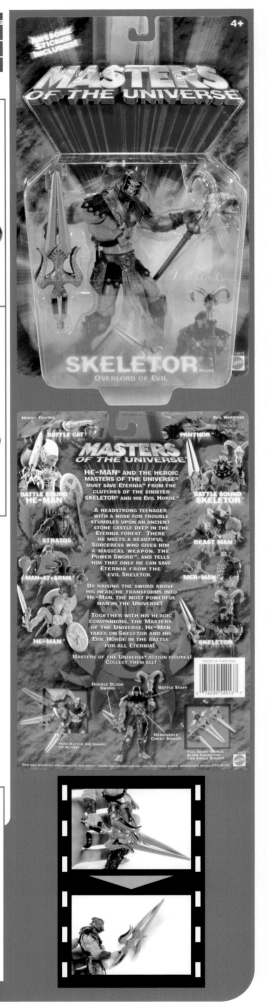

Updating the design of one of the most iconic bad guys of the 1980s must have been a stressful task. You want to make sure he's still recognizable to all of the fans who grew up loving him, but you also need him to appeal to a new audience. Four Horsemen Toy Design really nailed it, making this one of the most successful design updates with elements that have become a regular part of the character to this day.

While the original action figure of the vintage line shared the same beefed-up body design as He-Man, this new version really put more focus on the darker, creepier side of Skeletor. He's still muscular, sure. But he's a little leaner this time around, with a slightly contorted midsection. His fingers are sculpted with pointy nails, as are his toes on his now-exposed feet. The colors are still classic, with pale blue skin and purple armor—though they are all a bit more muted to help add to the dark nature of the character. And under his purple hood is the classic yellow skull face, this time with amazing sculpted details and a black wash that really brings out the small cracks and each tooth of his evil grin.

He comes packaged with his classic Havoc Staff accessory, as well as a brand-new dual-bladed sword. This sword has an interesting backstory. In the original concept idea pitched to Mattel by the Four Horsemen, this sword was actually the two halves of the original Sword of Power that Skeletor had now obtained for himself. This idea was ultimately scrapped, and this new sword became Skeletor's signature weapon in this line. The two halves of the sword are held together by small pegs and can be pulled apart to be wielded in each hand. A button protruding from Skeletor's back triggers a sword-slashing action feature in his right arm. Even though this arm is gimmicked, it's pretty easy to click it in place in multiple positions, still allowing for good posing.

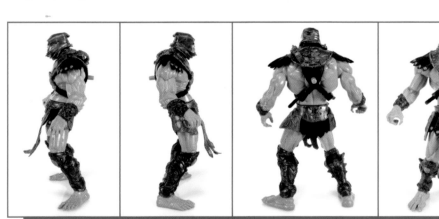

SKELETOR ("BLOOD" REPAINT)

First released 2004 • Member of the Evil Warriors

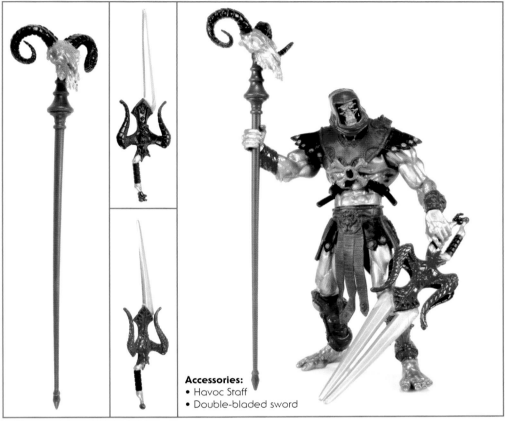

Accessories:
- Havoc Staff
- Double-bladed sword

Toward the end of the line, several repaints of many characters were released under the now-rebranded "Masters of the Universe vs. The Snake Men" series.

This figure is simply titled "Skeletor" on the packaging, but is often referred to by fans as "Blood Skeletor" in reference to the new red armor the figure is now wearing. Aside from the new armor color, Skeletor's skin tone has now been changed from the usual pale blue to a bright metallic blue in color.

Aside from the color differences, the figure itself is the same as the standard Skeletor release, including the same accessories in the double-bladed sword and the Havoc Staff, both of which also feature new colors to match the figure.

It's an odd one, but the colors are striking nevertheless. "Blood Skeletor" became a favorite among fans, and since he was released so close to the demise of the line he was a bit harder to find—likely because many stores had stopped stocking new MOTU figures at that time.

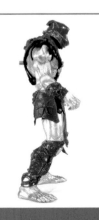
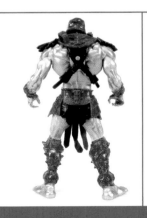
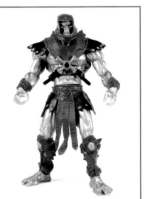

SKELETOR ("DISCO" REPAINT)

First released 2003 • Member of the Evil Warriors

Accessories:
• Havoc Staff
• Double-bladed sword

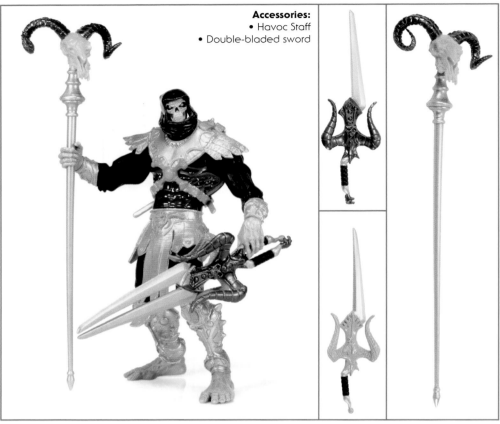

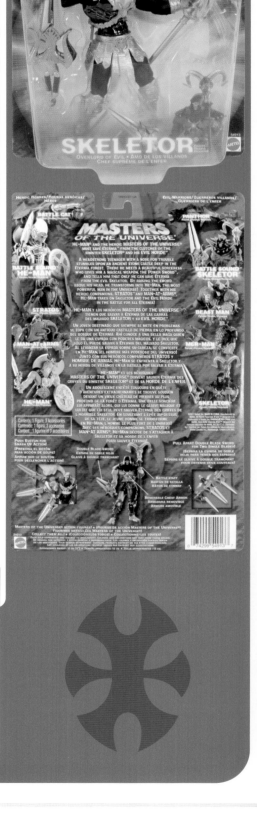

Of all of the repaints in the entire Masters of the Universe toy line, this one is easily the most notorious.

A simple reissue of the standard Skeletor action figure, this version was given one of the most bizarre paint jobs in the entire line. His hood, arms, and legs are all painted black, but his hands and feet are still the normal pale blue of Skeletor's skin. This leads us to believe he's wearing some sort of bodysuit. But all of his armor is metallic gold, while his face is pumpkin orange. And to top it all off, his torso is inexplicably a shiny, blue vac metal. This has to be one of the most gaudy-looking figures out there.

All of these strange colors inspired several strange nicknames for the figure among fans, including "Halloween Skeletor," due to his orange face. But the one name that really stuck and has become his unofficial name is "Disco Skeletor." Admittedly, the name is an odd choice, since these colors don't really evoke a disco vibe, but ask most fans what this figure's name is, and that's what they'll likely tell you.

Why Mattel decided to release Skeletor with such a bizarre paint deco is unknown, but Disco Skeletor has gained quite a reputation as a cult favorite simply due to his weirdness.

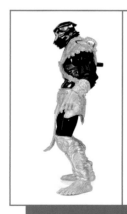
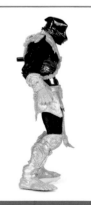
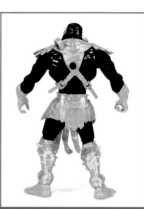
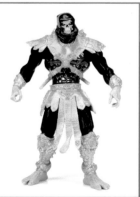

SKELETOR (ROTOCAST)

First released 2003 • Member of the Evil Warriors

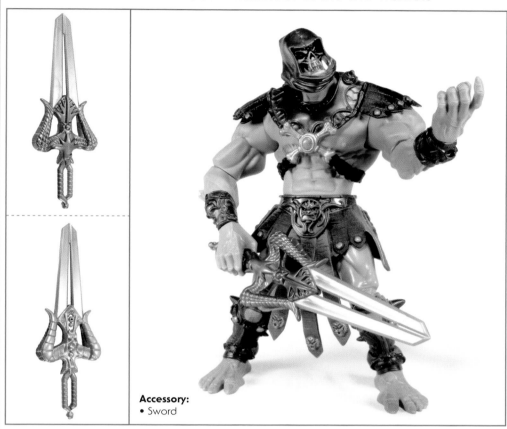

Accessory:
• Sword

For the first time, both He-Man and Skeletor were officially released as larger-scale action figures from Mattel!

Standing roughly twelve inches tall, this version of Skeletor is often referred to as Rotocast Skeletor. Rotocast refers to the molding process in which toys like this are made. As a result of the rotocasting process used to create a figure like this, Skeletor is made of a hollow plastic that is quite sturdy, yet still has a great weight. This allows the figure to display very nicely but also makes for a perfect lightweight toy that can still be bashed around by kids without worry of damage.

Rotocast Skeletor resembles the look of the smaller figure in the basic lineup, though he is a bit more squat in stature. It almost makes the proportions feel similar to the original five-and-a-half-inch figures of the vintage toy line. He includes the accompanying version of his dual-bladed sword, although the sword cannot be split in two like on the basic figure.

The figure itself features ten points of articulation in the neck, shoulders, elbows, wrists, waist, and thighs. It's similar articulation to what is found in the basic lineup without any of the action features.

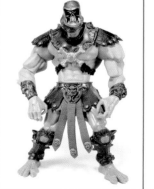

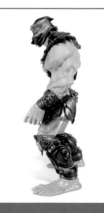
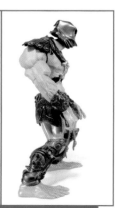

SKELETOR BAT FLIGHT-PAK

First released 2003 • Accessory of the Evil Warriors

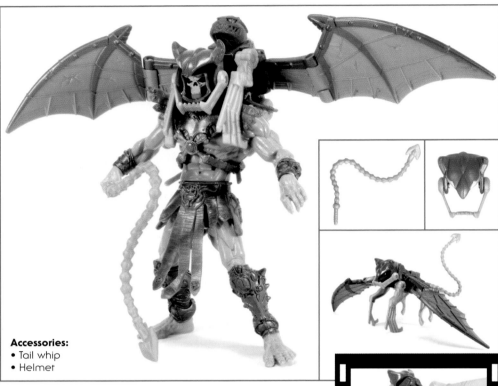

Accessories:
• Tail whip
• Helmet

The Bat Flight-Pak is an accessory pack that features two modes of play.

Out of the package, the Bat Flight-Pak is in the form of a robotic bat. The bat has articulated wings and clawed feet.

The bat also has a transforming feature, allowing it to turn into the Flight-Pak for Skeletor. By attaching the legs around Skeletor's shoulders and wrapping the body behind his torso, Skeletor wears the bat wings like a flying device. The helmet can also be removed from the head of the bat and placed over Skeletor's hood. The tail of the bat is also removable, doubling as a whip for Skeletor to use in battle.

The transformation feature works a bit better on this one than the Eagle Flight-Pak that was made for He-Man. The helmet and whip accessories add a lot to the overall presentation of this one, as it actually looks like a functional piece of tech that Skeletor could use in battle.

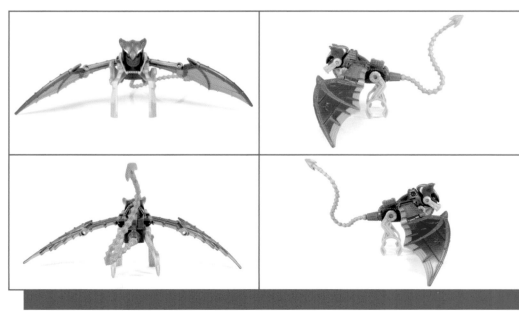

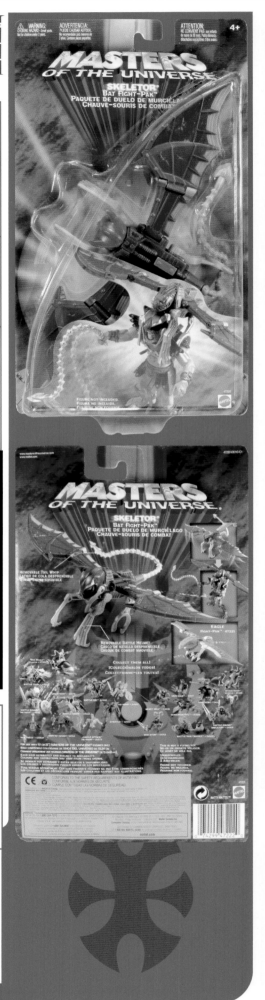

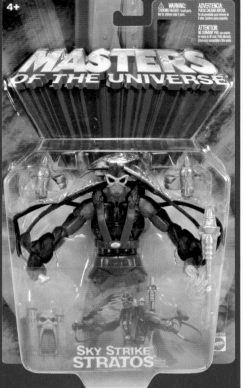

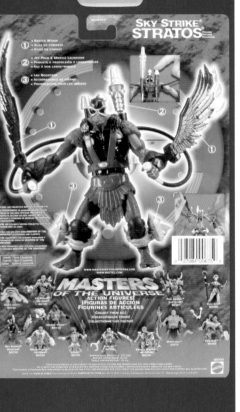

SKY STRIKE STRATOS

First released 2003 • Member of the Heroic Warriors

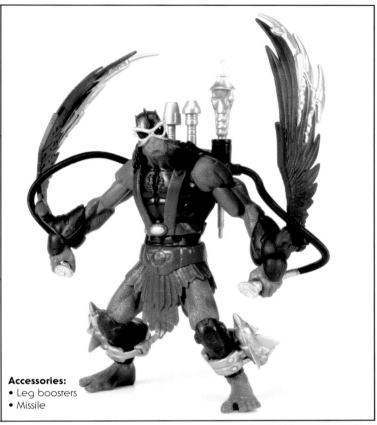

Accessories:
• Leg boosters
• Missile

Stratos was one of several characters to get a rerelease, in the form of Sky Strike Stratos. This figure looks much like the first release, with the most noticeable difference being the colors. While he is still wearing his signature blue and red on his harness and loincloth piece, the color of his body and wings are of a much darker tone than before. The wings especially make him feel quite different, since instead of the usual bright red they are more of a darker brown in color with silver wing tips.

In addition, he also includes removable leg boosters. These are small additional accessories that can be strapped around his ankles. He features a large missile that attaches to his jet pack. A button on the top of this pack triggers the spring mechanism, firing the missile.

However, there is one big difference with this figure that isn't very noticeable at first, but makes quite a difference. The original release has an arm flapping action feature, resulting in the arms lacking articulation. That feature has been removed from Sky Strike Stratos, replacing it with standard ball joints at the shoulders—thus allowing more better posability than the first Stratos release!

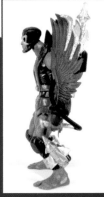 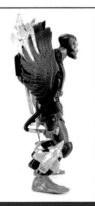 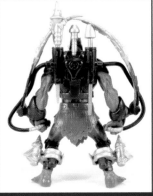 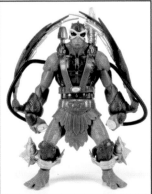

SMASH BLADE HE-MAN

First released 2003 • Member of the Heroic Warriors

Accessories:
• Sword of Power
• Smash blade
• Shield

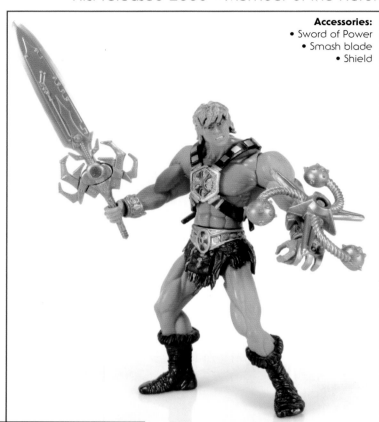
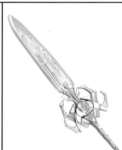
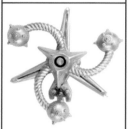
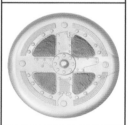
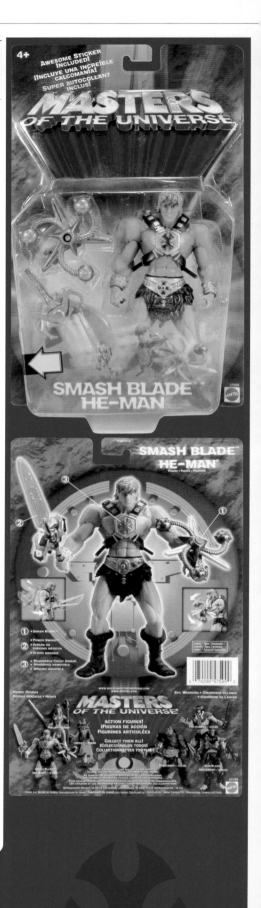

As one of the first variants of He-Man released in the new Masters of the Universe line, Smash Blade He-Man was also one of the most basic.

Essentially, Smash Blade He-Man is a straight reissue of the standard He-Man action figure, with a new color palette and one additional accessory. Instead of the usual browns on the figure, He-Man now wears a metallic blue harness and loincloth with metallic gold accents on the chest shield and arm bracers.

The Sword of Power and shield included are the same ones from the standard release, this time with more gold colors to match the new armor pieces. The one new addition to this figure is the Smash Blade accessory. This small weapon clips to He-Man's wrist and features three gold spiked balls that can be spun at the flick of your finger.

It's an adequate variant, but not too exciting. The color palette does look pretty striking with the gold accents. But this figure has quite the reputation. This figure, along with the matching Spin Blade Skeletor, was heavily overpacked upon initial shipment. Mattel grossly overestimated the demand for variants of the main characters such as this, and as a result the store shelves were flooded with Smash Blade He-Man action figures—making it difficult to find any other character. Many fans often point to this figure as the beginning of the end of the new Masters of the Universe toy line.

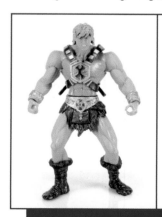
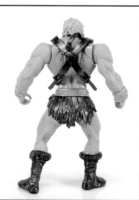
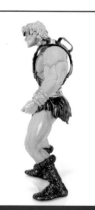
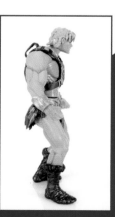

INTERVIEW WITH

JEREMY PADAWER

Tell me about how you came to work for Mattel.

I started at Mattel around 2000, I believe. I started out on Hot Wheels, which was a blast. But, my true passion was always in entertainment brands. When I was given the opportunity to switch to an entertainment brand and start working on Masters of the Universe, I was thrilled. It was an absolute blast.

One thing I did was I immediately started embracing collector communities. Val Staples was running He-Man.org, and I knew if we wanted to be legitimized in the eyes of collectors, we had to know who key players were. Val put us in touch with the key influences in the collector community. Being someone who embraced the fan community was an important part of my strategy.

It was the very beginning of social engagement with the fans. Companies, especially large companies, didn't take it very seriously. They would call you a nerd just because you were so engaged. But I just knew having engagement with core fans was one of the most important things we could do to be relevant with the collector community. I'm a collector myself, and I understand the value of collecting, and how to drive collectibles.

Was the intent to try to market to both kids and adult collectors?

It wasn't intentionally reaching out to adult collectors from a product segment standpoint. There wasn't a lot of thought about that. But for me it was a personal mission, it was absolutely about the collector. The product, though, was really geared toward a younger consumer.

There was a bit of disconnect though, if you look at the show. The 1980s version of He-Man was fun, uplifting, and humorous. The early 2000s version was more epic, not as funny, and had more of a story arc that went through many episodes. The 1980s cartoon was episodic and easier for younger viewers to follow.

To what extent were you able to interact with fans, and how did that affect the course of the line?

I think we were absolutely open to feedback. By the time Mattel figured it out it was a little too late. I've been waiting with bated breath for eighteen years for Mattel to come back and do it again.

Something crazy to think about. Now 2002 is approximately at the midpoint between the original line and today. If they relaunched today it would be approximately the same amount of time between 2002 and today as it was between vintage and 2002.

How did you get the responsibility for the MOTU relaunch? How did the whole thing start?

In 2000 Mattel had one of the first Comic-Con limited collectibles. It was the He-Man statue. That statue was so well regarded and popular, it sent people down a path of realizing how viable the collectible community was. Next year I was involved in the He-Man 1/1000 exclusive we did. We didn't have a real system to handle the amount of excitement from collectors. People were literally stampeding to get them.

In the beginning, what were your goals and expectations for the relaunch?

My hopes were that the entertainment would take off in a meaningful way. The problem Mattel had at the time was they had a Barbie mentality. Barbie makes up seventy percent of the assortment in her line, so some of the decision makers thought that He-Man should too. What He-Man should have been was a collection of all the different characters. If you're doing twelve different characters, each of them should be weighted evenly instead of giving He-Man disproportionate weighting.

That was my personal frustration. Later on I was able to implement the right strategy in terms of assortment on WWE, and they took off.

The 2002 line had a fairly different style compared to the original MOTU line. What was guiding the look and feel of 200X?

There's no doubt that anime made a big impression and impact. It was very, very hot at the time. You had *Dragon Ball Z* and *Pokémon* and lots of things making the landscape of entertainment drive folks toward an anime-influenced look. And that absolutely influenced the physical look. In retrospect it is a little silly we went in that direction. He-Man should not be anime.

I was coming in as a twenty-six-year-old kid, and hey, people seem very, very smart when they have so many years on you!

Were there times that you had to fight to get something made and lost? If so, what was it?

I would say that I lost the battle of having a variety in the assortment. The battle I lost was having a broad scope of characters. The company was very much about He-Man and Skeletor being the big heroes and that was the bulk of the line. Because of that we did the most undesirable variants you can imagine. Spin Blade Skeletor and Smash Blade He-Man—those are probably still on markdown after all these years.

What was the process like in getting a 200X toy produced, from the name on a piece of paper to the finished toy? How were the Four Horsemen involved?

The Four Horsemen did all the figures for sure. That relationship between Mattel and the Four Horsemen continues to this day.

Coming at it from a brand manager perspective, my process was, basically, the toys were meant to influence the entertainment. We put a big grid on the number of times we wanted the toys to show up in entertainment. You wanted to make sure that some of these crazy variants we were doing had some relevance in the program.

It was more of a how many He-Man and Skeletor figures can we put out there with a collection of the other characters. Today Mattel would do a much broader approach.

Midway through the line, there was a big shift to the Snake Men, and "vs. the Snake Men" variants. Can you talk about how that came about?

There had been other brands that had a new theme every year. The new theme was meant to excite retail. If you look at Power Rangers, Batman, they did that. It was just a tried-and-true thing. With He-Man, we were basically looking for themes that would allow entertainment to be wrapped around a new theme and keep things fresh.

If you were to manage He-Man again, what direction would you take the brand next?

I would immediately engage the collector community. I would take a list of every character that ever showed up and ask the fans about their intent to purchase. I would get a list back and identify how consumers felt about those characters, and I would put out the broadest line of He-Man collectibles of all time.

We would design a whole bunch of characters for the adult collectors, but then we would make a show for kids. That's what the adult collector wants—they want what they remember.

What are you most proud of in your tenure?

I would say, being at Comic-Con in the very early days of the collector-exclusive explosion at Comic-Con, and being one of the very first and having absolutely no plan to distribute characters appropriately. We opened the booth and heard what could only be called a stampede. This lady fell and screamed, "My leg!" And we all freaked out. By next year we had a full-on system. None of us knew how meaningfully important it would be. A lot of the collectors were there because I had meaningfully connected with the community.

What other toys have you managed?

WWE, Dragon Ball Z, Pokémon, Hot Wheels, Cabbage Patch Kids, and many others.

Anything else you can share?

It shaped my career. I learned so much from that experience. I recognized that He-Man could be a top action figure brand, but it needed to be managed with breadth and variety in mind.

SNAKE ARMOR

First released 2004 • Accessory of the Heroic Warriors

One of the very few Masters of the Universe role-play items actually released by Mattel, the Snake Armor is a really fun toy released to coincide with the "vs. the Snake Men" rebranding of the toy line and animated series.

This armor was made to resemble the armor He-Man wore on his arm in the animated series. It includes two pieces: an armor plate that covers your upper arm, and forearm armor that includes a hidden blade. The upper armor features "bicep action." By moving your arm, the armor pieces can move and bulge out, allowing kids to flex their muscles like He-Man.

Pressing the red button on the forearm armor, the hidden blade shoots out, accompanied by sound effects and lights. Swinging the blade and clashing it against objects in a sword fight will also trigger battle sounds!

While it likely didn't see much shelf life due to coming out at the end of the toy line, this is an amazingly fun toy that kids would no doubt have a great time with!

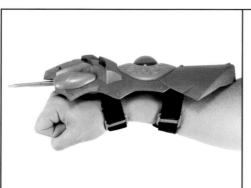

SNAKE ARMOR HE-MAN

First released 2004 • Member of the Heroic Warriors

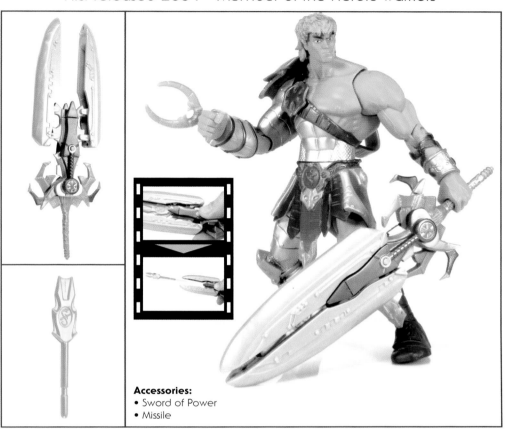

Accessories:
• Sword of Power
• Missile

When the toy line and animated series rebranded as "Masters of the Universe vs. the Snake Men," He-Man was given a redesign in an attempt to better appeal to kids of the modern era. This was explained in the show as an upgrade given by the Power of Grayskull in order to help combat the evil Snake Men.

This new action figure presented He-Man with his new armored-up look, with armor completely covering his right leg and arm and a large portion of his torso. His right arm includes a retractable claw in the forearm armor that can extend by pushing a button—a weapon he was seen using in the cartoon quite regularly at this point!

One of the big improvements that made waves with collectors was the addition of elbow articulation. Up until this point, elbow articulation was not normally included on the figures in this line. Many fans were hoping that this might lead to more articulated action figures going forward.

The Sword of Power included with Snake Armor He-Man was heavily gimmicked. The blade itself can open up, revealing a missile launcher inside! At the push of a button on the hilt, a green missile can be fired. As a result of this mechanism, the sword is way oversized. The combination of this with the odd stance that the figure is molded in makes it incredibly hard to keep the figure standing while holding his sword. He is far too top heavy while the sword is in his hand.

Nevertheless, overall this is an effective-looking action figure with some new features that proved popular, especially the added articulation.

MOTU 2002

SNAKE ARMOR SKELETOR

First released 2004 • Member of the Evil Warriors

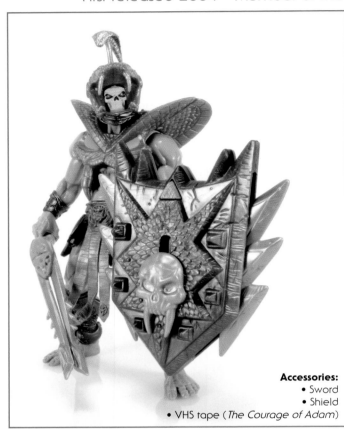

Accessories:
- Sword
- Shield
- VHS tape (*The Courage of Adam*)

Snake Armor Skeletor was featured as part of a two-pack alongside Wolf Armor He-Man. The two figures came inside of a large window box instead of the standard blister card packaging, and included a bonus pack-in VHS tape featuring an episode of the *Masters of the Universe* animated series by Mike Young Productions.

Snake Armor Skeletor is mostly the same figure as the standard release, but comes with new accessories. Among these, he has new copper-colored armor that resembles the head of a cobra. Over his usual purple hood, Skeletor also wears a helmet shaped like the head of a snake with an odd silver snake piece attached to the top.

Weapons include a snake sword with an interesting design. The handle is green and shaped like a snake, while the sword itself features two blades almost in a fork design. Because of the way the handle is shaped, Skeletor holds the sword a bit oddly as well.

The oversized shields were essentially the gimmick of this two-pack, and both He-Man and Skeletor include one. Skeletor's is purple in color with a silver skull on the front. By moving that skull, large silver spikes jut out of the sides of the shield!

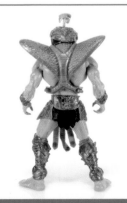

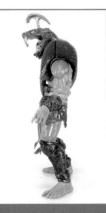

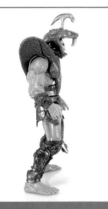

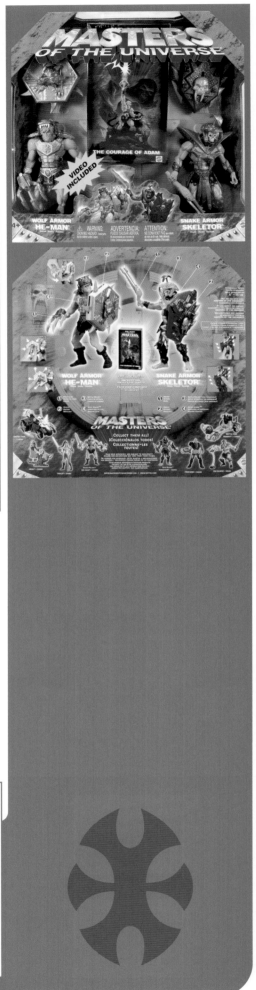

MOTU 2002

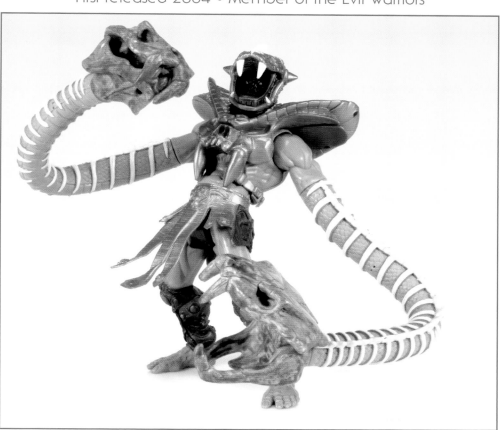

SNAKE CRUSH SKELETOR

First released 2004 • Member of the Evil Warriors

Released during the "Masters of the Universe vs. the Snake Men" rebranding, Skeletor joins in on the fun by donning his very own snake-themed armor.

He features large, green armor that is very similar to that found on the earlier Snake Armor Skeletor release, but this time with more of a skull shape to the front. The snake helmet on top of his head has large fangs that hang down in front of Skeletor's bone face and a bone-shaped mohawk on the top.

Of course, the big standout feature on this figure is Skeletor's elongated arms. His arms are made of a bendy plastic, allowing you to twist and mold them into various shapes. The arms have a scaly look with a bone theme that matches the helmet. In place of his hands, Skeletor has large snake skulls at the end of each arm! The skull on his right arm even features an articulated jaw.

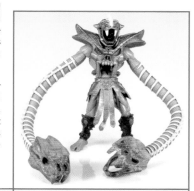

Many longtime fans would look at this and quickly realize that Skeletor swiped the action feature from a character who appears in the original toy line—one of the Snake Men named Sssqueeze. This is peculiar, especially since Sssqueeze was appearing in the animated series at the time this figure was released. Many fans were worried that this meant Sssqueeze might not be getting his own figure. Sadly, they were correct, as the line came to an end before he saw release.

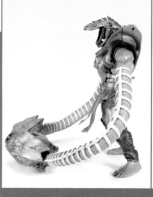
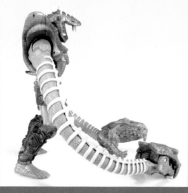

SNAKE HUNTER HE-MAN

First released 2003 • Member of the Heroic Warriors

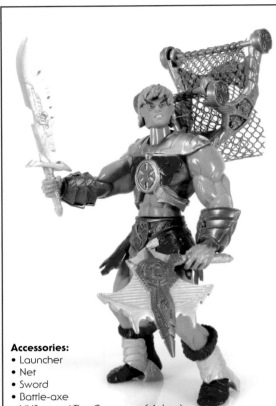

Accessories:
- Launcher
- Net
- Sword
- Battle-axe
- VHS tape (*The Courage of Adam*)

Released under the "Masters of the Universe vs. The Snake Men" banner, this version of He-Man is wearing special armor to help him combat the evil Snake Men!

Not to be confused with Snake Armor He-Man, Snake Hunter He-Man has a much more streamlined armor look. New armor on the chest and forearms features a red, gold, and silver color palette. Instead of the usual Sword of Power, Snake Hunter He-Man comes equipped with a unique silver sword and oddly shaped battle-axe for battle against the Snake Men.

You'll also notice some interesting silver armor attached to his boots, with large coverings extending down beyond the heels of his feet. These are there to help stabilize the figure for his action feature.

On the figure's back is a net that can be launched simply by pulling down on the little catapult and releasing. It's a very small net, but the catapult functions quite well. So even if it won't do a very good job of wrapping up any enemy action figures, it's still fun to throw!

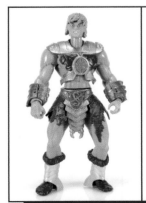

SNAKE TEELA

First released 2003 • Member of the Snake Men

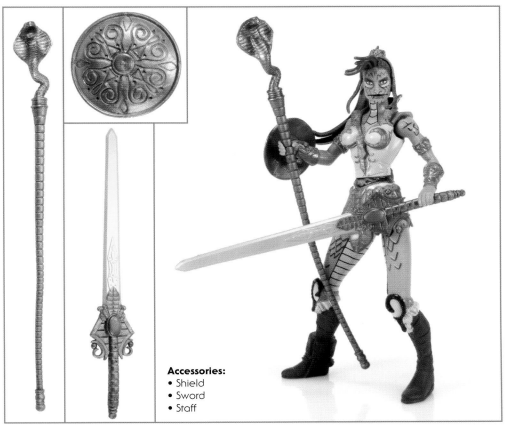

Accessories:
• Shield
• Sword
• Staff

Snake Teela was an exclusive mail-in figure made available through *ToyFare* magazine. Like many of the exclusive figures in this line, she came packaged in a window box instead of the standard blister card packaging. The box for this one was quite striking, as it featured the new green "vs. the Snake Men" theme, with a snake scale motif seen behind the figure inside of the box.

The figure is a simple repaint of the standard-release Teela action figure. She is based on an episode of the *Masters of the Universe* animated series by Mike Young Productions titled "Second Skin," in which several of the heroic masters, including Teela, are temporarily transformed into snake warriors by the evil Snake Men.

To pull off the look, the figure was given a green skin tone with details such as snake scales and fangs painted over the preexisting Teela sculpt. The colors of her outfit are normal, but her included weapons all got a new metallic green paint deco to match.

It's a simple repaint, sure. But stuff like this makes for the perfect mail-away item for a fun new addition to the line.

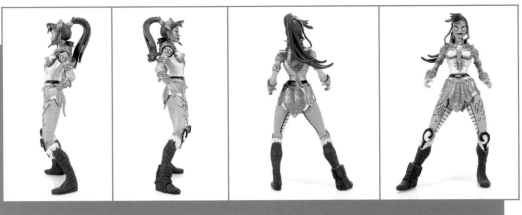

SPIN BLADE SKELETOR

First released 2003 • Member of the Evil Warriors

Accessories:
• Spin blade
• Double-bladed sword

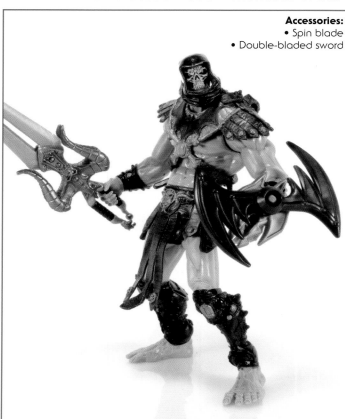

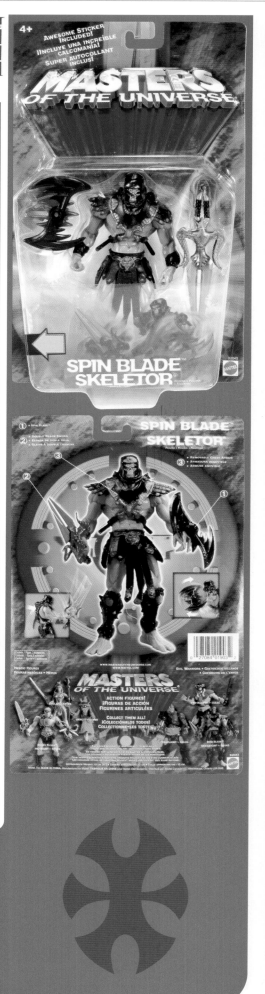

He's one of the first and also one of the most basic variants of Skeletor released in the new Masters of the Universe line.

Spin Blade Skeletor is a straight reissue of the standard action figure with a new color palette and one additional accessory. Skeletor is now wearing armor that is colored black and metallic red, which is actually an effective color palette that works quite nicely for the character.

He is lacking his signature Havoc Staff this time around, but still comes with a version of the double-bladed sword with new colors to match his armor. The new accessory included is the Spin Blade. This accessory clips on to Skeletor's wrist and features two black blades shaped like bat wings that spin at the flick of your finger.

It's an adequate variant, but there's not a lot to it unless you just prefer the new colors. This figure, along with the matching Smash Blade He-Man, was heavily overpacked upon initial shipment. Mattel grossly overestimated the demand for variants of the main characters such as this, and as a result the store shelves were flooded with these Spin Blade Skeletor action figures—making it difficult to find any other character.

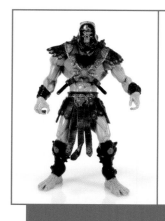

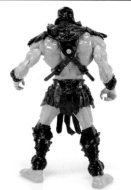

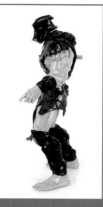

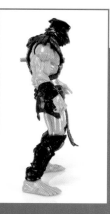

SPITBULL

First released 2003 • Vehicle of the Heroic Warriors

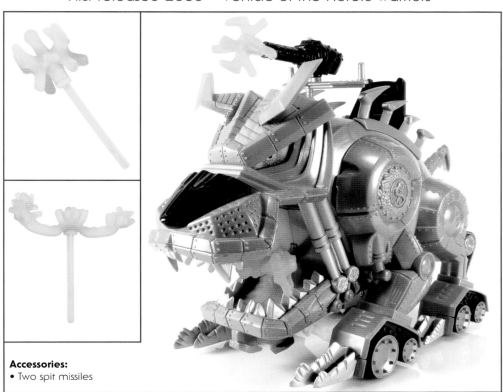

Accessories:
• Two spit missiles

Now this is an odd-looking vehicle that almost feels out of place. And yet, it's also an incredibly fun toy.

Despite his name, Spitbull more closely resembles a large mechanical English bulldog than he does a pit bull. The top includes a small cockpit with a chair and handlebars, allowing He-Man or any of your heroic action figures to drive the robotic beast into battle. The legs themselves do not move, but instead feature wheels allowing him to roll forward, more like a tank.

At the top near that cockpit is a missile launcher, where you can blast off one of the spit missiles at the push of the button. Why are these called spit missiles? Well, the ends of each included missile are made of a soft, squishy green plastic—resembling mucus. The purpose for that plays into the name and the other action feature.

When Spitbull's tail is lifted, his mouth opens up and blasts off another spit missile from inside of his mouth! In addition, by lowering the tail, Spitbull chomps his mouth shut, allowing him to take a bite out of the bad guys!

So yes—it's an odd design. But the action features are a lot of fun, and the strange, sticky missiles are sort of reminiscent of the classic Slime that once played a part in Masters of the Universe.

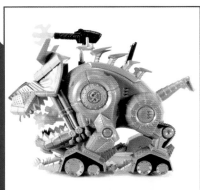
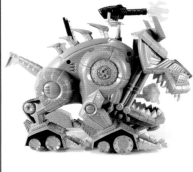

STRATOS

First released 2002 • Member of the Heroic Warriors

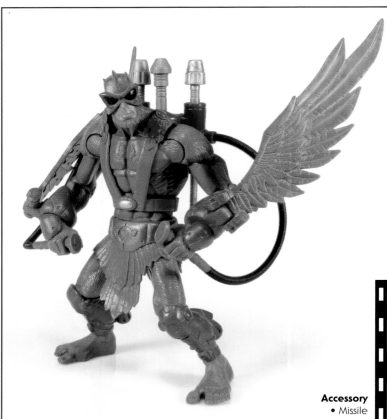

Accessory
• Missile

One of the original characters from the classic Masters of the Universe toy line, the winged warrior known as Stratos gets a fantastic new redesign for the modern toy line.

Staying true to the original design, Stratos has the appearance of a feathered simian species. He features his classic gray body with a furry sculpt, complete with large red-feathered wings attached to his arms, a red helmet on his head, and a blue jetpack strapped to his back. The design is a great upgrade, with a newly sculpted detail that might be easy to overlook unless you are very familiar with the vintage toy—this new Stratos actually has toes! The original figure had feet that looked as though he was wearing boots, even though he wasn't. So you can see why this is a big deal to longtime fans. It's the little things.

Adding to the jetpack, two cables extend from the back and attach to controls that Stratos holds in his hands. The back of the jetpack also has what looks like three missiles on the top—but two of these are cleverly disguised buttons! Pressing the far right missile activates the far left missile, blasting it via a spring-loaded mechanism!

The center missile is a disguised button that, when pressed repeatedly, causes Stratos's arms to flap up and down as if he is flying through the skies. The feature works well, but the downside here is that the inclusion of this flapping feature means that he does not have basic shoulder articulation. This keeps Stratos from being able to move his arms forward, which is the biggest downside to an otherwise beautiful update of a classic action figure.

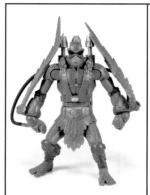

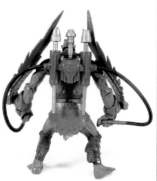

SY-KLONE

First released 2003 • Member of the Heroic Warriors

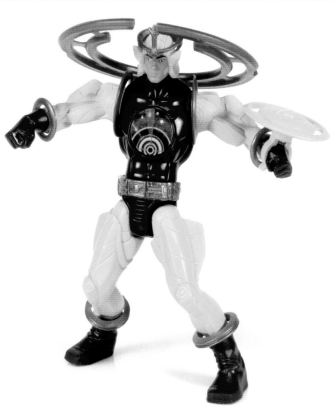

Accessories:
- Shield
- Blade ring

Sy-Klone is another example of Mattel giving a classic character a brand-new, updated sculpt while still remaining faithful to what made the original action figure memorable.

Sy-Klone is bright blue and yellow in color, much like his original 1980s counterpart. Leaning into the more sci-fi look of the character, his new design plays up the tech details by adding a lot of small line details carved throughout his arms and legs. Along with this are many details that make a return from the original design, including the bright red belt with the image of a ringed planet on it and the red rings around his wrists and boots.

Of course, there are two main things most fans probably remember about Sy-Klone, and both are present on this figure. He has the lenticular sticker radar screen on his chest, depicting a space scene that appears to move when the figure moves. He also includes his spinning tornado action feature, which works just as you'd expect. By turning the small dial on the back of Sy-Klone's belt, the upper body spins in circles. The shoulder articulation is loose, allowing the arms to fly out to their sides.

For accessories, he has his classic yellow shield that clips on his wrist. He also includes a new accessory in the form of a large red blade ring that is stored on his back. This ring can fold down and surround Sy-Klone's torso, adding a large blade weapon while he is spinning. It's worth noting that this accessory is removable, so if you decide that you don't want to display your figure with this new addition, it can easily be taken off.

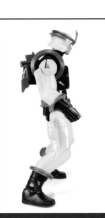
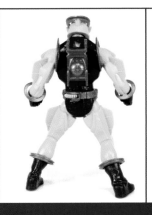
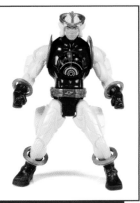

SY-KLONE (REPAINT)

First released 2004 • Member of the Heroic Warriors

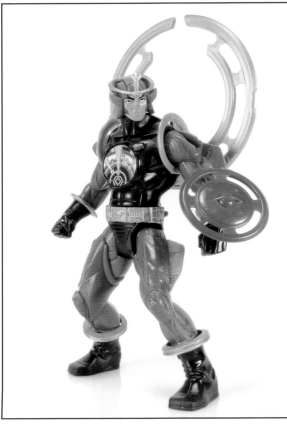

Accessories:
• Shield
• Blade ring

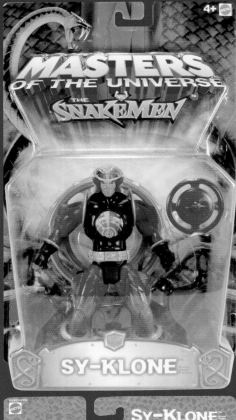

Toward the end of the Masters of the Universe toy line, many of the characters saw releases that often included a brand-new paint deco. Sometimes these updated colors looked pretty effective. Other times, they were questionable. This Sy-Klone repaint falls right in the middle.

The bright yellow colors we are used to seeing on Sy-Klone have been replaced with a deep red, and the usually bright blue is now a dark blue. This gives this new version of Sy-Klone a much darker tone—quite the opposite of the very bright character we usually see.

Aside from the new colors, the figure itself is exactly the same as before. He still includes the slip-on shield and the removable blade shield. And of course, by spinning the dial on the back of his belt, Sy-Klone performs a tornado spin.

It's certainly not the ugliest repaint in this line, but it's not the prettiest either.

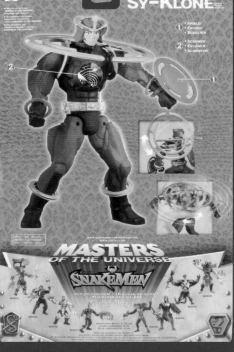

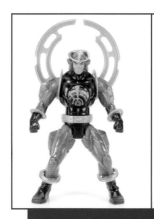

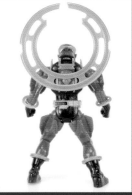

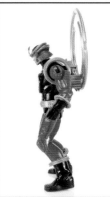

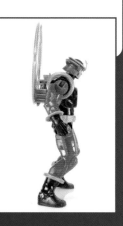

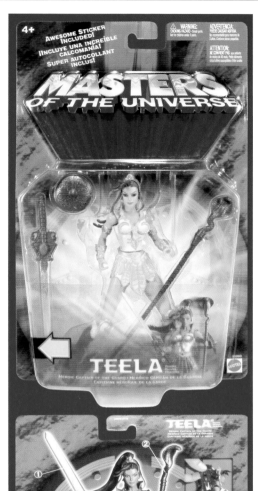

TEELA

First released 2003 • Member of the Heroic Warriors

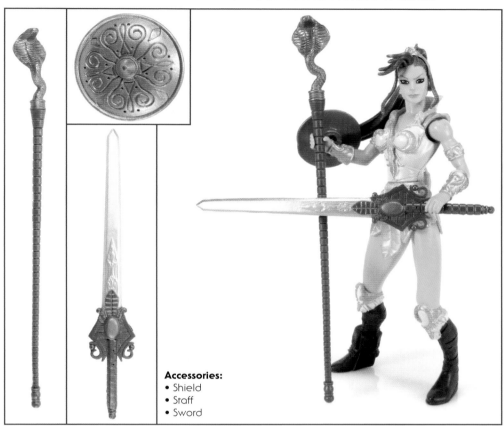

Accessories:
- Shield
- Staff
- Sword

One of the original eight characters, and the lone female Heroic Warrior, gets an update for this new Masters of the Universe toy line.

Teela was made to look a little younger for this new iteration, since like Adam she is meant to be in her late teens. This is most notable in one of the biggest changes to her design—the addition of a long, windswept ponytail in place of her classic bun hairdo.

Aside from the hair, much of her look is very similar to what she wore in the original line. Instead of a leotard-type outfit, it features a skirt design. However, the white, gold, and brown colors are all present, just as with her original design. The gold used this time around is brighter in color, but the overall design is easily recognizable.

Teela comes with a shield that clips on to her wrist and her classic snake staff. She is also given a brand-new accessory in the form of her own unique sword. One accessory that was completely scrapped for this new Teela is the snake armor, which was a normal part of the original action figure but never appeared in the Filmation cartoon series.

One of the noticeable oddities with Teela's sculpt that fans often pointed out was in her right boot, which has an odd design, making the ankle area of the boot quite oversized. The actual reason for this was so that the small Action Chip could be fitted inside the thinner sculpt of her legs. This chip feature works with Castle Grayskull, and was really only relevant for the figures near the early days of the line, as it was ultimately a scrapped concept. However, this bulky boot sculpt would go on to be used on the other female figures in the line, even after the chips were no longer being included in the figures.

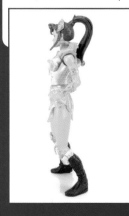
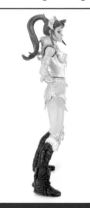
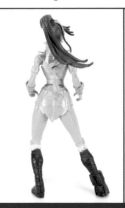
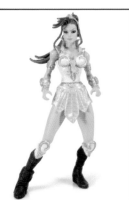

MOTU 2002

TERRORDACTYL

First released 2002 • Vehicle of the Evil Warriors

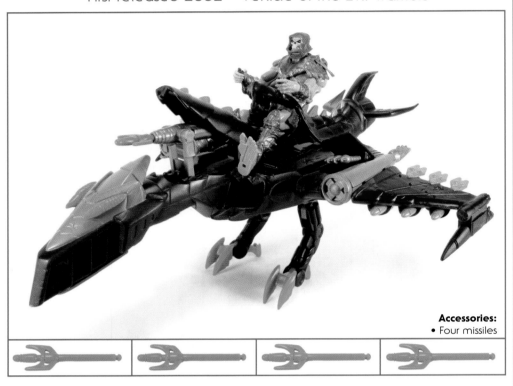

Accessories:
• Four missiles

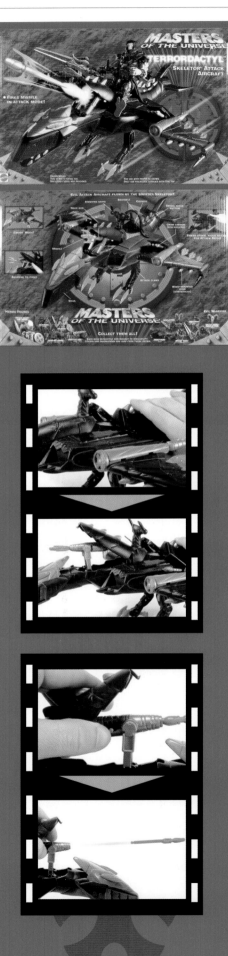

Following the animal theme found in many of the vehicles, the Terrordactyl is a jet-like vehicle for the Evil Warriors made to look like a mechanical pterodactyl.

Skeletor or any of your evil action figures can mount the Terrordactyl, complete with control sticks for the figure to grip on to and a seat belt to hold them in place. Pressing the spinal ridge button toward the back of the vehicle switches the Terrordactyl from cruise mode to attack mode. This reveals a spring-loaded cannon that fires green missiles on the back of the neck. Claw cannons, which are just small guns that don't actually fire, also pop up from the top of the wings.

The feet of the Terrordactyl feature large green attack claws. These feet also double as the landing gear for the vehicle, allowing it to stand.

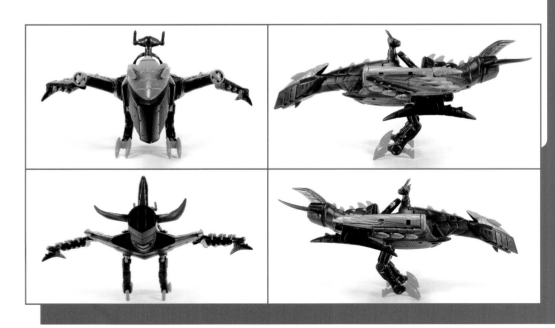

MOTU 2002

TRAP AND SMASH ORKO

First released 2004 • Member of the Heroic Warriors

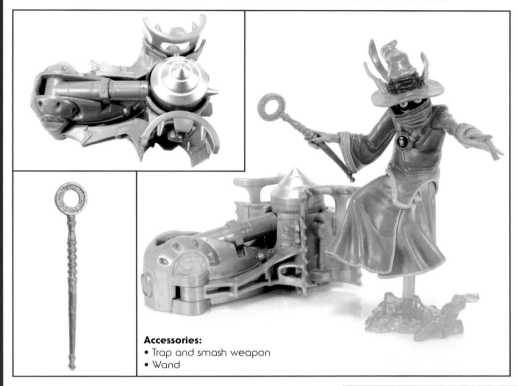

Accessories:
- Trap and smash weapon
- Wand

As part of the "Masters of the Universe vs. the Snake Men" rebranding toward the end of the line, many characters saw reissues with new paint decos and new accessories.

Trap and Smash Orko is the same figure as the standard Orko, but a new paint job gives the character a much brighter red color scheme. This makes him feel much closer to his appearance in the original Filmation cartoon series.

The big difference is with Orko's new accessory. Instead of the orb-blasting magic attack that came with the standard release, Orko now comes packaged with a strange-looking contraption that can trap his enemies. At the press of a button, the two green clamps fly forward to trap a figure in place, followed by a large, pointed hammer smashing the trapped figure in the head! This is very similar to the way the Bashin' Beetle vehicle works. It's a silly little contraption, but works incredibly well and is quite satisfying to play with.

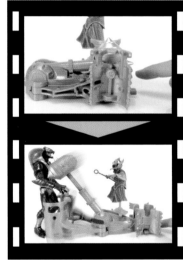

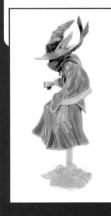
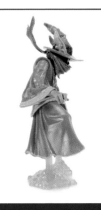
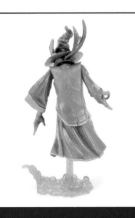
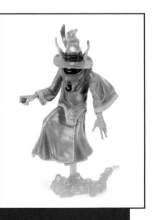

TRAPJAW

First released 2003 • Member of the Evil Warriors

Accessories:
- Claw attachment
- Blaster attachment
- Hook attachment

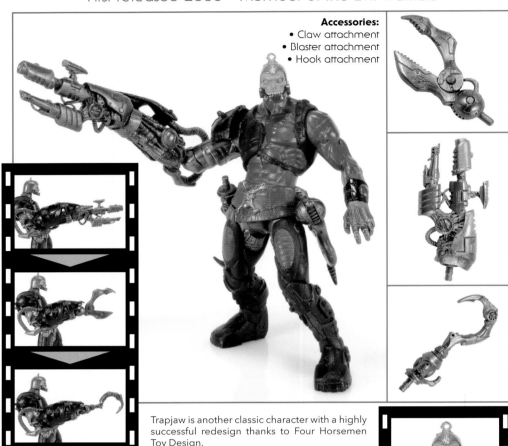

Trapjaw is another classic character with a highly successful redesign thanks to Four Horsemen Toy Design.

The new design gives Trapjaw a much more evil and monstrous look than before, with the intricate details that the Horsemen became known for delivering. His face is bright green and looks mangled, with sharp, pointy teeth on his upper jaw and his lower jaw being replaced by his signature red jaw. His torso has visible stitched scars, while his legs and especially his right arm have a very high tech look to them. He's an obvious mixture of monster and machine, giving him a strong Frankenstein vibe.

Small features straight from the vintage action figure are still present, including the articulated jaw and the small ring on top of his helmet for zipline action on a piece of string. His right arm also features the interchangeable arm attachments, but that arm is much larger this time around, featuring an overall heavier science-fiction influence, with exposed cables and wires and even elbow articulation this time around. That elbow also has a spring feature, which snaps the arm upwards.

The claw, blaster, and hook attachments come straight from the original action figure, but are also much larger and more exaggerated in design, just like the arm itself. They can easily plug into the end of the arm, and can also be stored on the sides of his belt. This figure is one of the best examples of the Four Horsemen staying true to what made the vintage action figure great while at the same time giving him an amazing, more detailed, and updated sculpt for a new generation.

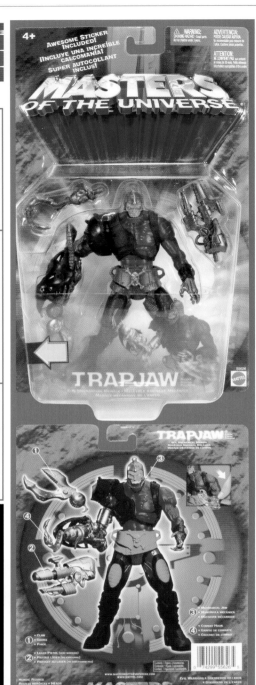

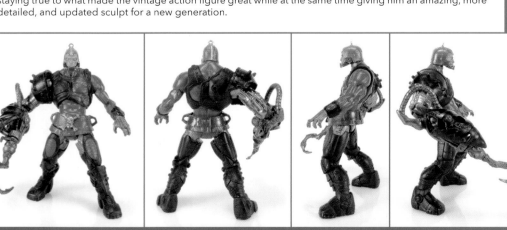

MOTU 2002

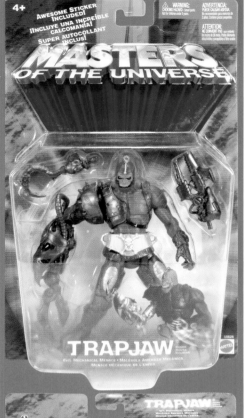

TRAPJAW (REPAINT)

First released 2003 • Member of the Evil Warriors

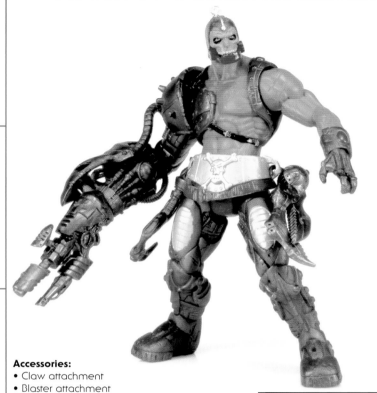

Accessories:
- Claw attachment
- Blaster attachment
- Hook attachment

While several characters were reissued with new paint decos throughout the life of this line, Trapjaw here is one of the more popular among fans.

The figure itself is the same as the standard release, featuring the same action features and still including the interchangeable claw, blaster, and hook attachments.

What makes this figure stand out is the new paint job, which removes the classic bright blue, green, and red colors and replaces them with a much paler green skin tone and gold accents on his gunmetal-gray robotic parts. While it's not an exact color match, many longtime fans saw this repaint as an homage to an early appearance of Trapjaw in the vintage Masters of the Universe minicomics, where his skin tone was a more yellow-green color. As a result, this repaint became one of the fan favorites.

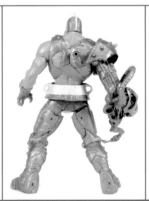
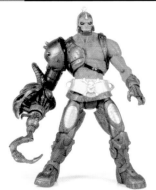

MOTU 2002

TRI-KLOPS

First released 2003 • Member of the Evil Warriors

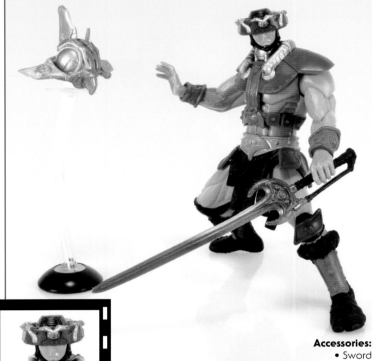

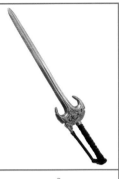

Accessories:
• Sword
• Remote spy robot (Doomseeker) and stand

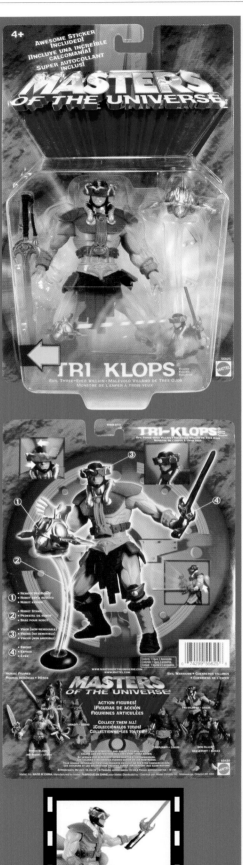

Another classic Evil Warrior, Tri-Klops, received a hugely successful redesign for this new iteration of Masters of the Universe. This is another case where many elements of the redesign were so well accepted that they became pretty standard for future versions.

This version of Tri-Klops is a little leaner, as opposed to the larger, chunky look of all of the figures from the vintage toy line. Like many of the new designs, some new tech elements were also added in the form of wires on his shoulders and around his visor, really playing into the mechanical eye action feature.

Speaking of this feature, much like on the vintage action figure you can rotate Tri-Klops's visor to display him with one of three different eyes. This time around, the visor incorporates a light-piping action feature. Each eye is a different color of translucent plastic—red, green, or blue—and by shining a light in the top of his head, the chosen eye will illuminate for a very striking effect.

For accessories, Tri-Klops comes with his classic sword that can be held in his left hand for combat. Pressing a button on the figure's back will swing his sword arm up and down. He also includes a brand-new accessory in the form of a remote spy robot which would go on to be called the Doomseeker in the tie-in animated series. This robot came with a clear flight stand, and would go on to be something that the character used regularly in the cartoon, and has since become one of the main characteristics Tri-Klops is recognized for among fans.

Probably the only thing that could be considered a downside for this figure is the dynamic stance. This is one of the only figures in the line which was given a battle-ready stance, with his legs squatting and his right arm outstretched with an open palm. While it looks effective, it results in limited poses for play and display.

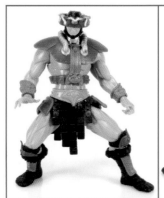

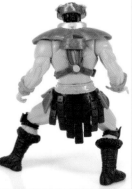

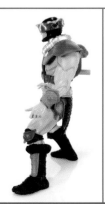

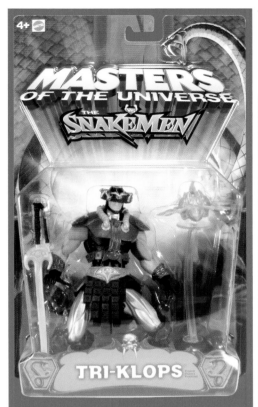

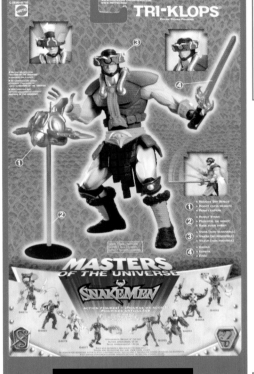

TRI-KLOPS (REPAINT)

First released 2003 • Member of the Evil Warriors

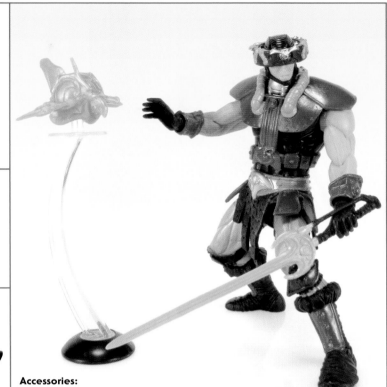

Accessories:
• Sword
• Remote spy robot (Doomseeker) and stand

Repaints were a very common way to reissue action figures throughout the 2000s Masters of the Universe toy line. Many of these repaints featured odd color choices that weren't considered very appealing visually. Unfortunately, Tri-Klops falls into that category.

The action figure itself is the same as the standard release, including the same accessories, the push-button sword-swinging action, and the rotating visor with the light-piping glowing feature.

The paint deco is all-new, with Tri-Klops now sporting neon green wires on his armor and visor where the silver color used to be. In addition, his included sword and Doomseeker are also this very bright, neon green—not a great color for a robotic device that is supposed to act as a spy.

His torso and hands are painted black, as if he is now wearing a shirt under his armor and a pair of gloves. And his legs are now painted silver, as if he has put on a pair of silver pants.

Unfortunately, the colors on this repaint clash, particularly with the neon green, making for a bizarre update to a classic character.

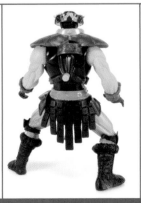

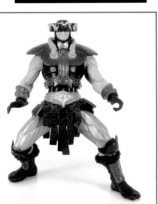

TWO BAD

First released 2003 • Member of the Evil Warriors

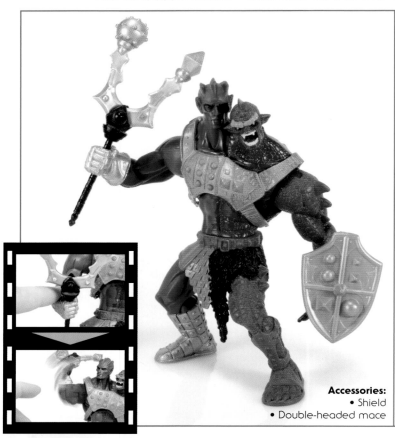

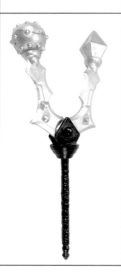

Accessories:
• Shield
• Double-headed mace

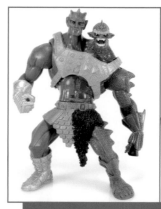

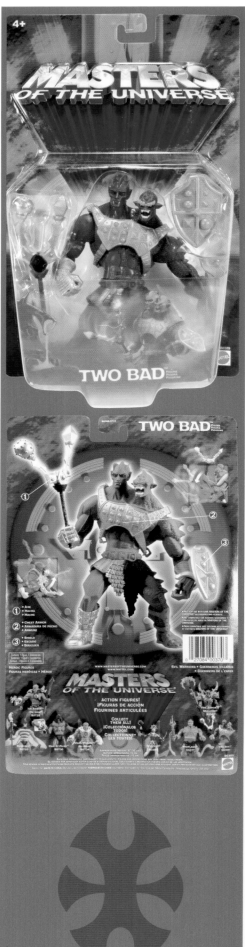

Two Bad's update for this new Masters of the Universe toy line is really well-done. The sculpt really gives off the idea that these are two separate characters that were melded together—a concept that was actually fleshed out in the tie-in animated series! As you can see, the blue half of Two Bad stands taller and more erect, with smooth skin. The purple half is shorter and more slouched, with scaly skin. It's another great example of Four Horsemen Design taking the concept of the original action figure and improving upon it.

There are some really great extra details that showcase the personality differences of each half. While the blue side wears sleek silver gloves and boots, the purple side is bare knuckled and wears a sandal on his foot. And one of the most effective design choices regards the two different sides of his loincloth, with one side being furry and the other side looking like a leather-type material.

Two Bad comes with a clip-on orange shield much like his vintage counterpart, but he is also given a brand-new accessory in the form of a double-headed mace. A great accessory for a character who himself has two heads, the mace ends are different from one another and are even articulated.

And this time around, Two Bad's arms are in a normal pose with actual articulation, allowing you to pose the figure without his hands constantly being in front of his faces like on the vintage toy.

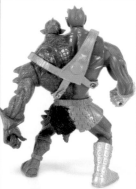

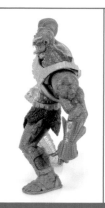

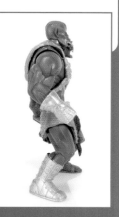

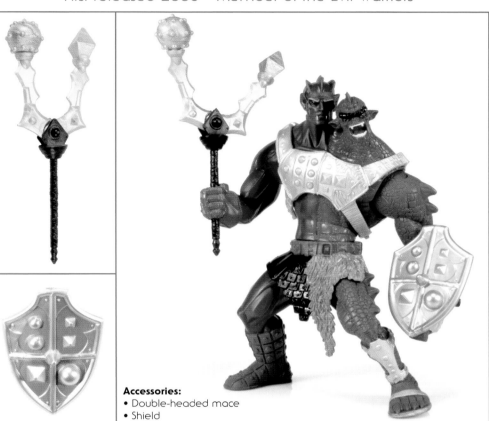

TWO BAD (REPAINT)

First released 2003 • Member of the Evil Warriors

Accessories:
- Double-headed mace
- Shield

Many figures were reissued throughout the life of this Masters of the Universe toy line with alternate paint jobs to differentiate them from their first release. Many of those paint decos were considered strange, sometimes leading to a bit of an ugly figure. Two Bad's reissue definitely has a strange paint job, but it's a surprisingly fun one!

Mattel opted to reissue Two Bad with his colors switched! The half that is typically blue is now purple, and vice versa. On top of this, all of the armor bits that we're used to seeing in an orange color are now a bright silver, and the mace that was silver before is now a bright gold in color. It really makes him feel like the exact opposite of the first release—quite an interesting concept for a reissue!

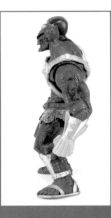

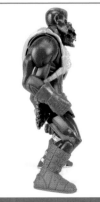

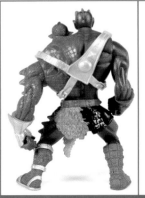

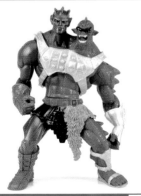

VENOM-SPITTING KHAN

First released 2003 • Member of the Snake Men

Accessories:
- Blaster
- Missile

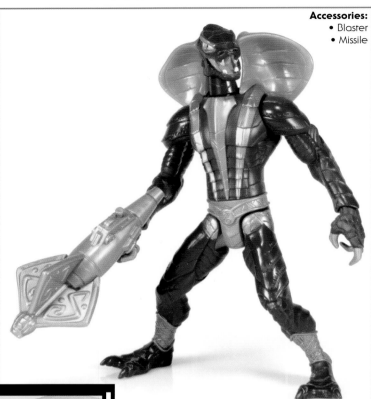

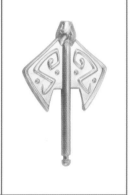

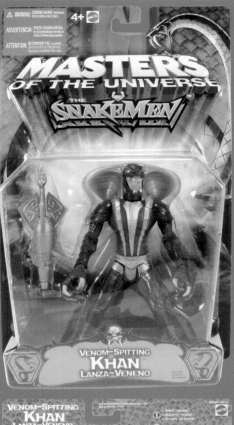

Introduced into the line during the "Masters of the Universe vs. the Snake Men" rebranding, Kobra Khan is a classic character that got quite the overhaul in his design. On top of that, due to more copyright issues, the character had to be named "Venom-Spitting Khan" on the toy packaging, although he was still referred to as Kobra Khan in the tie-in animated series.

This time around, the figure is very slender and much more snake-like than his vintage action figure counterpart. Even though each character had a unique sculpt in this new toy line, it was still unusual to see a character without a muscular build. He also has a cobra hood attached to his back that comes up to the sides of his head. This is a nonremovable piece, and creates quite a different look for the character, since his original figure lacked this.

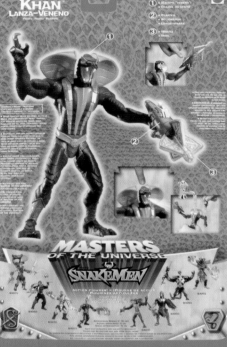

Khan still has a similar water-spitting action feature that works much the same way as the original. The head is removable so that you can fill his torso with water. By placing the head back on and pressing it down, the pump inside causes water to spray from the figure's mouth. Fans were pleased to see this classic action feature return, but with the hood needing to be designed so that it didn't hinder the action feature, it could look a bit odd at times.

Khan also comes with a blaster that looks similar to the one that came with his vintage action figure, but is quite oversized, like many of the weapons in this line, due to the addition of a spring-loaded missile feature.

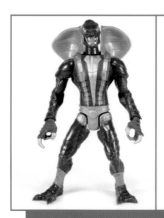

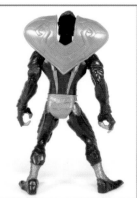

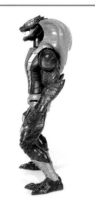

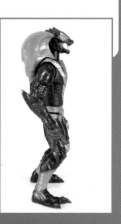

 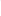

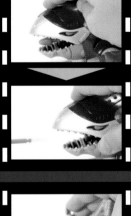

WAR WHALE

First released 1982 • Vehicle of the Heroic Warriors

Accessories:
• Six missiles

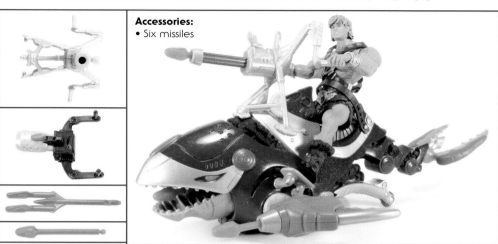

Following the animal theme found in many of the vehicles, the War Whale is a watercraft for the Heroic Warriors, made to resemble a mechanical whale.

A seat on the whale's back includes a seat belt so you can strap in He-Man or any of your Heroic Warriors. An oversized cannon attached to the handlebars includes a spring-loaded projectile that can be fired at the push of a button.

There are small wheels on the underside of the vehicle that trigger an additional action feature. While rolling the War Whale forward, his mouth opens and closes for jaw-crunching action. You'll also notice another missile launcher inside of his mouth. This can be fired by pressing the red button on the head.

The War Whale is meant to look similar to a Jet Ski–type watercraft. Even still, it seems a bit undersized with a figure riding on the back.

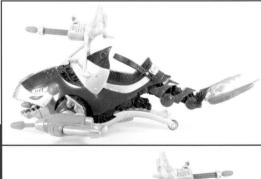

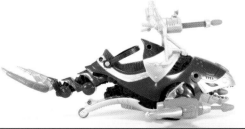

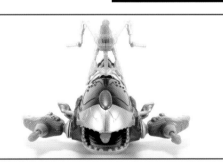

MOTU 2002

WHIPLASH

First released 2003 • Member of the Evil Warriors

Accessory:
• Trident-sword

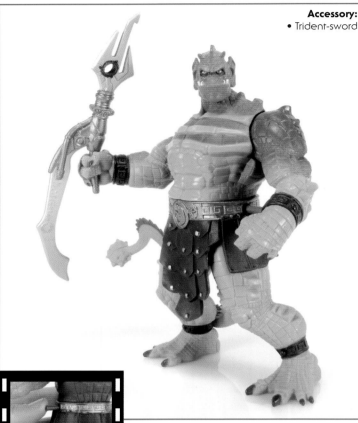

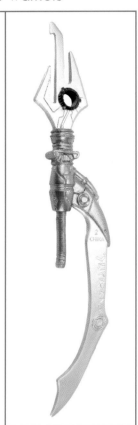

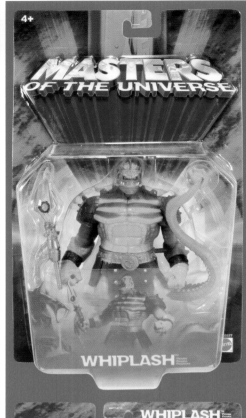

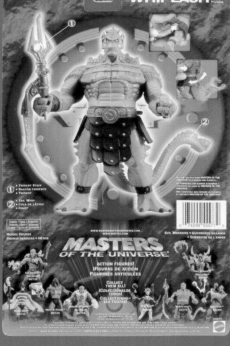

Whiplash was one of the classic characters to receive a more drastic overhaul in his design—perhaps the most drastic redesign in the line.

The character's build is of a much larger stature this time around. His presence is much larger, with a barrel chest and overall squat look. While the original figure's head was more elongated, the new head sculpt is much rounder, with a wider, stronger jawline and a much more reptilian nose.

In place of the long rubber tail that was attached to the back of the original action figure, this new Whiplash has a plastic tail with a spiked bone hammer at the end, much like you would see on an ankylosaurus. There's a large button sticking out of the left side of the figure's torso, which admittedly is a bit too obvious. Pressing this button repeatedly triggers his tail-whipping action, swinging the plastic tail from side to side to knock down his foes.

Whiplash also received a brand-new weapon. While the original action figure from the 1980s came with an orange spear, this new version comes with a unique sword-like weapon that has three prongs, much like a trident. This weapon can be held in his right hand.

Even though this was one of the more drastic departures from the original look, fans happily accepted it, and many even preferred Whiplash's new larger, more imposing presence. Whiplash also received a chase figure with a small paint difference. Most noticeable on this is the silver color used on both his belt insignia and the circle on the trident weapon.

FUN FACTOID:
With 200X, the Four Horsemen had a tremendous amount of freedom to reinterpret the characters, so with a character like Whiplash it was easy to make some strategic alterations and bring out the potential.

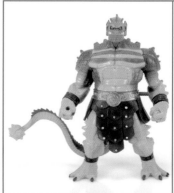

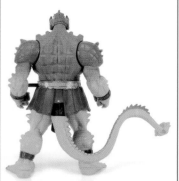

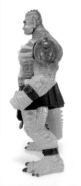

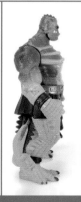

WOLF ARMOR HE-MAN

First released 2003 • Member of the Heroic Warriors

Accessories:
- Shield
- Wolf claw
- Battle helmet
- VHS tape

Wolf Armor He-Man was featured as part of a two-pack alongside Snake Armor Skeletor. The two figures came inside of a large window box instead of the standard blister card packaging, and came with a bonus pack-in VHS tape featuring an episode of the *He-Man and the Masters of the Universe* animated series by Mike Young Productions.

He-Man is mostly the same figure as the standard release, but comes with new accessories. Among these, he has new gold armor on his torso and a removable helmet that fits over his head. The helmet resembles the head of a wolf, with teeth hanging down in front of He-Man's face. Because it had to be sized to fit over his head, it's a bit bulky in appearance.

Instead of the Sword of Power, Wolf Armor He-Man includes a mechanical-looking wolf claw accessory that clips over his wrist. He also includes a unique shield accessory. The oversized shields were essentially the gimmick of this two-pack, and both He-Man and Skeletor come with one. He-Man's is silver in color with a copper wolf on the front. By moving that wolf head, large gold spikes jut out of the sides of the shield!

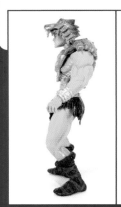
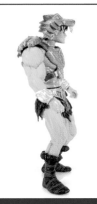
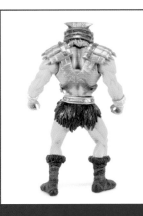
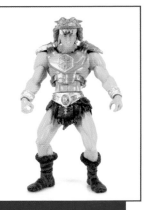

ZODAK

First released 2003 • Member of the Heroic Warriors

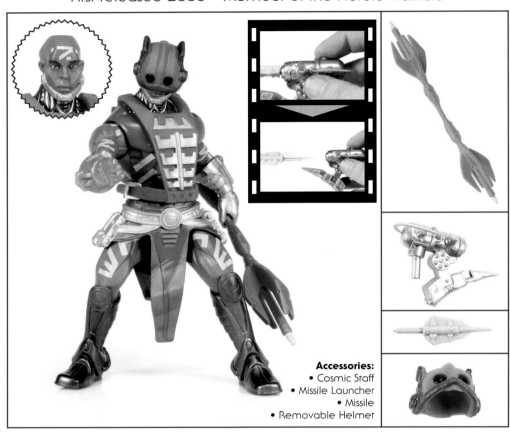

Accessories:
• Cosmic Staff
• Missile Launcher
• Missile
• Removable Helmet

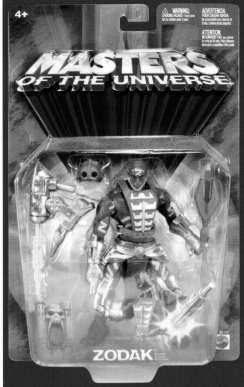

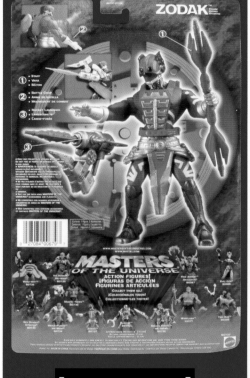

Zodak, based on one of the original eight Masters of the Universe characters from the vintage toy line, was given a lot of updates for his new release. For starters, his name is now spelled "Zodak" as opposed to the original "Zodac."

In the original toy line, there was some confusion over his allegiance. He was at times marketed as an Evil Warrior, as well as a neutral Cosmic Enforcer. While he is supposed to be playing the neutral role for this new toy line, he's definitely billed as being more heroic—with the new evil Snake Men as his enemy.

The new design gives him a more space-age science-fiction look. His boots are sleek and silver, with a futuristic flair. He now wears silver gloves and has light blue tattoos all over his body. He was also given an ethnicity change, now presented as a Black man.

The signature red armor and helmet, recognizable from the original action figure, are present, but with a new twist on the helmet. You can now remove the helmet to reveal Zodak's face! Additional accessories include a Cosmic Staff, which is designed in a similar fashion to the blaster held by his vintage action figure counterpart.

He also comes with a spring-loaded missile launcher, which was reused from Samurai He-Man. The only difference is that the missile is a light blue this time, which matches up with the color of Zodak's tattoos.

Similar to Tri-Klops, Zodak is in a bit of a preposed battle stance. His legs are wide apart, and his right hand is outstretched, with an open, pointing hand. This does tend to limit the posing and play options for the figure.

STACTIONS

First released 2006

With its 2002 Masters of the Universe line of action figures, Mattel sought to introduce the franchise to a new generation. This is why the characters were redesigned with such a stylized anime flair. This was a popular design element in animation at the time. Mattel was hoping this new look would catch the attention of a younger generation.

The redesigns were done by the team at Four Horsemen Design, a studio that Mattel hired to assist with the character designs and the sculpting on the new line of action figures. Many longtime fans of Masters of the Universe came to really admire the work of the Four Horsemen. Most of the classic characters were still recognizable, but they now had a new level of detail, never seen before.

Ultimately, the new Masters of the Universe toy line from Mattel did not catch on with kids in the way they were hoping and, unfortunately, came to an end much sooner than anyone likely expected. While the demographic Mattel desired didn't quite latch on, the new series certainly made an impact on the collector community. Fans were upset at the untimely demise of the action figures, worried that they'd be left with an incomplete collection. Several key characters were still missing.

 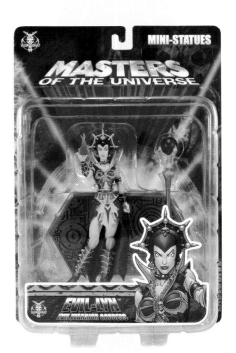 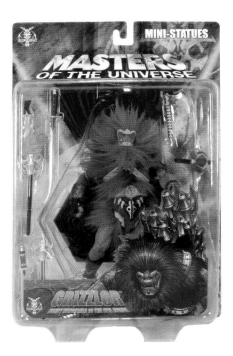

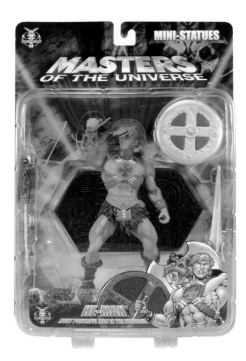
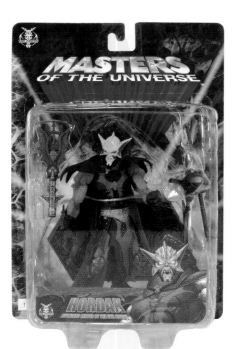

Luckily, Mattel struck a deal to license the Masters of the Universe property to the National Entertainment Collectibles Association (NECA), allowing them to create new product for the brand. As a company, NECA tends to appeal directly to the collector market, so this was a natural move for the brand. Now the line could continue on without anyone worrying about toys that kids would want to buy. Instead, the focus could be on delivering quality, highly detailed figures of the missing characters to help complete the collection.

There was a small caveat, however. Since Mattel was still in possession of the master toy license, they did not allow NECA to make articulated action figures. NECA and the Four Horsemen came up with a pretty brilliant idea: a line of mini statues that stood roughly six inches tall. They would be unarticulated, but roughly the same size as the action figures that fans already had in their collections. This would enable collectors to buy these mini statues and display them right alongside the figures, if they wished to do so!

The Four Horsemen continued sculpting and designing each mini statue, enabling them to fit right in with the existing toys. Even better, the Horsemen seemed to have a bit more artistic freedom this time around. This resulted in mini statues that were even more detailed than the action figures. In a sense, the characters were now being made exactly as the Four Horsemen intended them to look when they created these new designs.

While the official name of the line is Masters of the Universe Mini-Statues, the fan community called them by another name: Stactions. This term was first coined by the Four Horsemen, and was quickly adopted by collectors. The name combined the word "statue" with "action figure," and "stactions" has since become the name collectors use when referring to the line.

NECA released six waves, with three stactions per wave. In addition, there were five exclusives offered through various outlets. This brought the total count of the line to twenty-three Stactions.

When the line started out, it mostly focused on filling out the missing characters from the Mattel toy line. Giving fans the missing Snake Men and classic heroes and villains was exciting. One of the largest appeals, no doubt, was the release of characters from the Evil Horde. The animated series had just begun setting up for the Evil Horde's appearance when the show got canceled, leaving fans incredibly hungry for new Horde toys. The stactions line gave us Hordak and several core Evil Horde members!

While these pieces were scaled to fit in with the action figures, it's important to remember that they are still statues. They are made of a resin material, which means they are not durable. They are certainly not designed for play, and unfortunately, their fragile nature does lead to potential damage if not treated with care.

Some figures with smaller pieces have a tendency to break. The most notorious is Jitsu. He has a small, thin ponytail on the back of his head that is so fragile, it often snapped off even before the figure was removed from the blister card! It's pretty hard to find this particular staction figure today with the ponytail still intact.

While the majority of the main releases focused primarily on giving us the characters we never got from Mattel, NECA and the Horsemen did start having some fun with the exclusive releases. For example, an Evil-Lyn staction was released. She already had an action figure, yes. However, the main staction release was more detailed than the figure from Mattel, and an exclusive version presented the villainous witch with yellow skin and a blue outfit to match the vintage action figure!

He-Man even got a mini statue release, wearing his fan-favorite battle armor from the original toy line. But, even more exciting than that is the exclusive version of He-Man. This one was sculpted in a pose that fans had never been able to create with their action figures up to that point: with sword held aloft, as if he is calling on the Power of Grayskull!

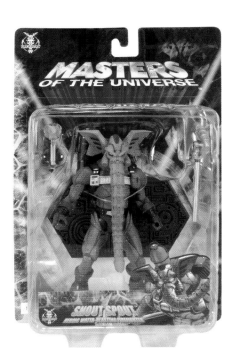

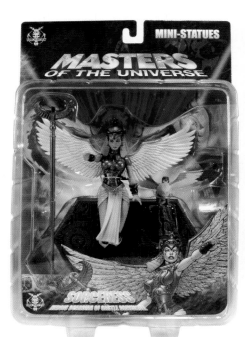

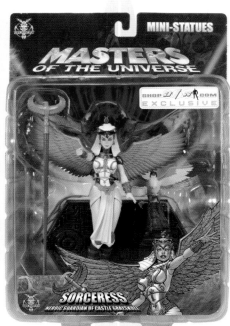

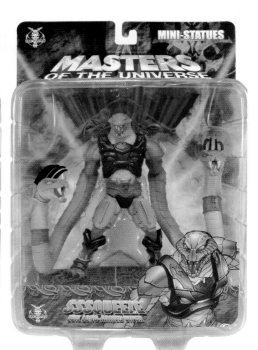

It's the Sword of Power on this particular release that got the most attention from the fans. You see, along with the redesigns for the new series, Mattel opted to completely change the iconic Sword of Power into a large, mechanical-looking new sword. This sword was always a point of contention in the fan community. While the new series had a lot of supporters, that new Sword of Power was often cited as one of the worst redesigns.

This Exclusive version of He-Man not only had an iconic pose, but he was also holding the original Sword of Power. It was an amazing acknowledgment that this line was being made specifically for the fans.

Alongside these six-inch mini statues, NECA also had the opportunity to produce larger statues and a line of character busts. Two more stactions were announced as an Action Figure Xpress exclusive two-pack: Kobra Khan and Faker. Sadly, the line came to an end before these final two got released. And with that, the NECA chapter of the Masters of the Universe story came to a close. While there were still plenty more characters that could have been done in this form, it's still pretty amazing that this happened at all. Mattel could have easily just closed everything up when the new toy line didn't perform in the way they had hoped. Instead, they threw the longtime fans a bone and allowed another company to give them something special.

Truly, the fans of Masters of the Universe have the power.

2002 PROMOTIONAL VARIANTS by Val Staples

The 2002 relaunch of Masters of the Universe did its best to make a splash in the world of action figures. In an effort to capitalize on sales, multiple promotional variants were created. Various big-box retail chains committed to carrying their own unique variant to draw in interest for the new toy line. This resulted in a number of fun variants that are valued by collectors today.

The line made its official debut on October 18, 2002, at an event that took place at the Toys"R"Us in Times Square. The Four Horsemen were on hand for signing as Mattel promoted this new era for He-Man. As a cherry on top, the figures sold at this event had a special gold Toys"R"Us Times Square sticker on the front. An estimated two hundred cases of figures, along with multiple cases of the first wave of vehicles and accessories, all got this sticker treatment. Many were purchased and opened. If you are lucky enough to find any of the surviving carded figures from this event, you'll discover many bear signatures from the Four Horsemen. Considering the initial six-figure case ratios were 3:2:1 (He-Man:Man-At-Arms:Stratos and Skeletor:Beast Man:Mer-Man), finding any of these figures is very difficult, especially Stratos, Mer-Man, and the vehicles and accessories.

Another type of promotional incentive first started with fan input. Mattel conducted a poll on He-Man.org for what the top five favorite Filmation MOTU episodes were among fans. The results of this poll went on to be used as promotional VHS releases, affixed to the carded figures, and most, if not all, were released at Walmart. As content from the upcoming cartoon was not ready when this promotion took place, Mattel opted to use episodes from the classic Filmation *He-Man and the Masters of the Universe* animated series as a temporary enticement and to bridge the gap for collectors between the old and the new. Those episodes were:

- Diamond Ray of Disappearance
- Dragon Invasion
- Into the Abyss
- The Problem with Power
- To Save Skeletor

It is not known how many were released, as the VHS tapes were bound to a wide assortment of different figures from the line and were also included with the Battle Sound figures. It's not uncommon to find the loose VHS tapes for sale on the aftermarket. And tapes didn't stop with classic Filmation episodes. As the new animated series hit Cartoon Network, three more VHS variants were released that focused on this new 2002 Mike Young Productions cartoon:

- Dragon's Brood (an episode of the new cartoon)
- The Courage of Adam (an episode of the new cartoon)
- The World of He-Man (a visual introduction to the new cartoon using content from the style guide and more)

Much like the Filmation episodes, these VHS tapes were also attached to many different carded figures.

Other promotional releases were found at different retailers. Kmart's initial release of the first wave of hero and villain action figures was packed with exclusive art cards produced by MVCreations. There are six to collect, consisting of He-Man, Man-At-Arms, Stratos, Skeletor, Beast Man, and Mer-Man. It is speculated a thousand of each existed. Target carried their own promotional exclusive. This was a two-pack of He-Man and Skeletor that contained a full-sized comic book. The comic had a cover by Neal Adams and the story was produced by MVCreations. Approximately five thousand of these were made.

Sam's Club and BJ's Wholesale Club each had a more expensive promotional item. Each released their own Castle Grayskull gift set. The sets at Sam's Club came with Castle Grayskull and four figures, housed in a red cardboard box. At least three different figure combinations are known. BJ's had a similar set, but it had only two figures instead of four. Multiple variations of their Castle Grayskull promotional gift set were released.

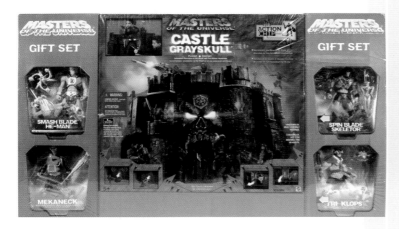

The 2002 line also had nine chase figures. These releases had slightly different paint applications and were released in various quantities. The rarest of them are He-Man and Skeletor, which were released first, and then Battle Fist, which was released last. Where eight of the chase figures had 1,000 to 1,500 made, Battle Fist is one of the rarest, because only 500 were reported to have been produced. As for He-Man and Skeletor, they weren't as limited. But fans were not made aware of the existence of the 200X chase figures until these figures had already been in the hands of the public. By that time, many of the He-Man and Skeletor chase figures had been opened, making it difficult to locate carded specimens. But all nine chase figures have a special place in the 200X collections of many fans.

Although short-lived, the 2002 MOTU toy line had a lot of great releases and a number of intriguing promotional items. And, even though this toy series existed during the height of action figure collecting, resulting in the preservation of most products released for the line, it still produced many rare items that fans can seek out to add to their collection.

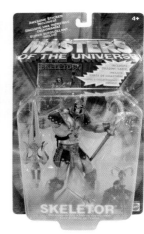

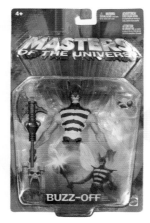

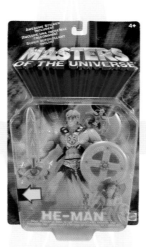

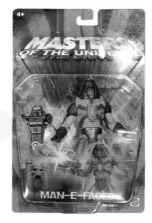

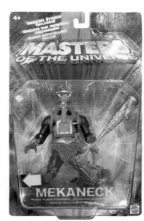

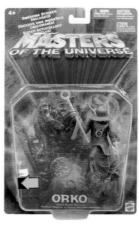

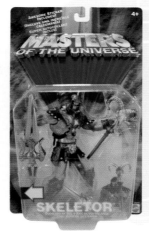

CHAPTER 6

SECTION 1

MASTERS OF THE UNIVERSE CLASSICS
COLLECTORS' CHOICE (2008)

BLURRING THE LINES
by Dan Eardley

For a long time now, I have wanted to see a book that collected and compiled each of the Masters of the Universe toy lines into an easy-reference guide for collectors. When I got the opportunity to write such a book, I was thrilled. But, when it came time to devise a road map of what should be included, I found the prospect a bit more complicated than expected.

Of course, the main line action figures, vehicles, and play sets needed to be in here, and that became the primary focus. But, what exactly counts as a "main line"? The decision was made to feature only the official action figure products from Mattel, in the traditional five-to-seven-inch scale, with a focus on USA packaging when it was available. The only exceptions are products released by Super7, the company that legitimately continued releasing action figures that extended the life of official Mattel lines. Therefore, this book covers all action figures, vehicles, and play sets from Masters of the Universe, Princess of Power, He-Man, Masters of the Universe (2002), and Masters of the Universe Classics (Collector's Choice and Club Grayskull).

But, as you flip through the pages of this book, you'll notice that some of these lines contain items that fall outside the realm of "action figure." For example, the 1989 He-Man line and the 2002 Masters of the Universe line both include role-play items such as the Sword of Power. These were released as part of the main line, and thus were included. Conversely, while the original 1982 Masters of the Universe line did indeed have role-play swords, shields, and more available in stores at the time, none of these items were actually produced by Mattel as part of the main line. They were all licensed items made by other manufacturers, and thus were not included in this book.

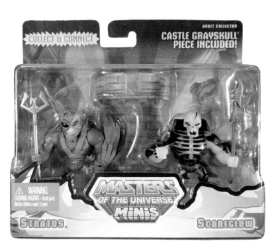

There were also some very cool additional pieces released alongside the main toy lines. During the 2002 line's run, Mattel released a He-Man and Skeletor-themed version of their classic Rock 'Em Sock 'Em fighting game. While this certainly feels like it could be counted as part of the action figure line, it qualifies as a game and was sold in the board game aisle of retail stores.

And then, there were the various spinoff lines of action figures released during the Masters of the Universe Classics era. The MOTU Giants were a Mattel line of oversized, jumbo versions of selected original Masters of the Universe action figures. On the opposite side of the scale were the MOTU Minis. This line of stylized action figures first launched as a San Diego Comic-Con set featuring three-inch He-Man and Skeletor action figures. This eventually led to a line of two-inch action figure two packs which showcased many more characters from the franchise.

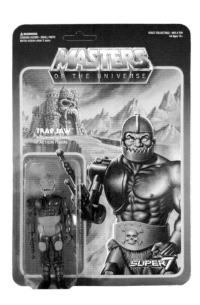

When Super7 took over from Mattel and continued the production of Masters of the Universe items, they also launched their M.O.T.U.S.C.L.E. (later as MOTU M.U.S.C.L.E.) series alongside the main toy lines. This was a mash-up of Masters of the Universe and M.U.S.C.L.E., which is another former Mattel property. Super7 also included MOTU in their popular ReAction toy line, which is a retro-inspired line of four-inch action figures done in a style once popularized by the toy company Kenner.

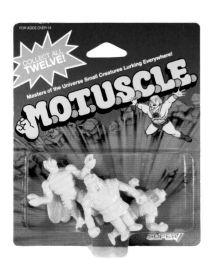

While all of these are certainly official action figure lines, they qualify more as spinoffs of the main lines featured here in this book, so the tough decision was made not to go into full detail with them. Not to mention, we easily hit the 700-page mark with just the main line action figures alone!

And then there was Baby Skeletor. This one-off was offered through Mattel during the run of the Masters of the Universe Classics line. It's meant to be a humorous piece, depicting Skeletor's head on a traditional baby-doll body. Even at the time of its release, fans felt that it was odd and questioned why it was made. It did sell out quickly, however, and never went on sale again, making it one of the harder-to-get Masters of the Universe items released in the modern era. Still, it's not technically part of the Masters of the Universe Classics line, which is why you won't see it in that section of this book. It's a shame, though. I bet I could have written a whole book about that one unique release.

ADORA
LEADER IN THE GREAT REBELLION

First released 2010 • Member of the Great Rebellion

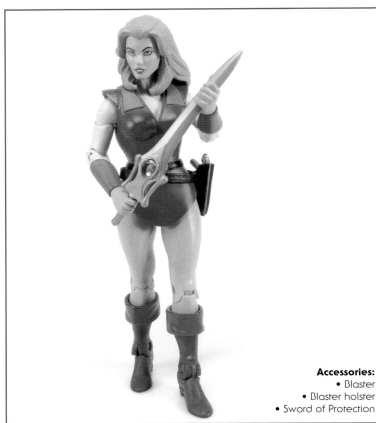

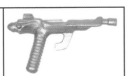

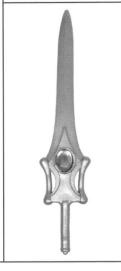

Accessories:
• Blaster
• Blaster holster
• Sword of Protection

ADORA

Adora, the alter ego of She-Ra, made her first-ever action figure appearance in the Masters of the Universe Classics toy line.

Since she did not have a figure in the vintage Princess of Power toy line, Adora broke the tradition of most of the early MOTU Classics action figures being based on their vintage toy counterparts. Instead, she is heavily based on her appearance in the Filmation *She-Ra* animated series. While her costume looks very much like what was seen in the cartoon, a notable difference is that instead of wearing a unitard outfit, Adora is wearing a skirt piece. This was addressed by Mattel as being the best way to handle the leg articulation so as not to hinder it.

Adora comes with the Sword of Protection, again modeled after what was seen in the animated series. This also marks the first time a toy version of the cartoon-style She-Ra sword was released. Adora is able to holster the sword on her back. She also comes with a blaster and a removable belt and holster. This allows fans to display Adora as Force Captain Adora, as she appeared in the beginning of the *Princess of Power* cartoon series.

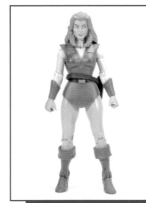 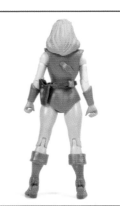

FUN FACTOID: The Four Horsemen said, "This figure was exciting for us to make not only because it was a foray into the Princess of Power universe, but it was also the first true-to-Filmation interpretation of Adora."

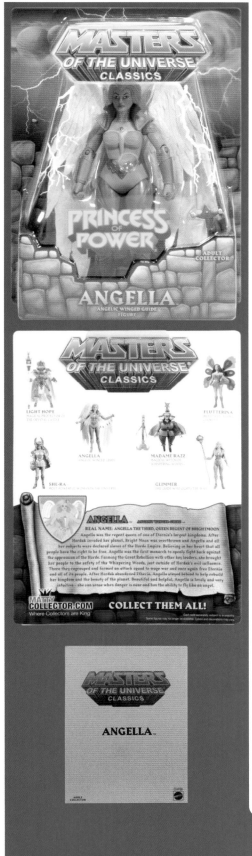

ANGELLA
ANGELIC WINGED GUIDE

First released 2015 • Member of the Great Rebellion

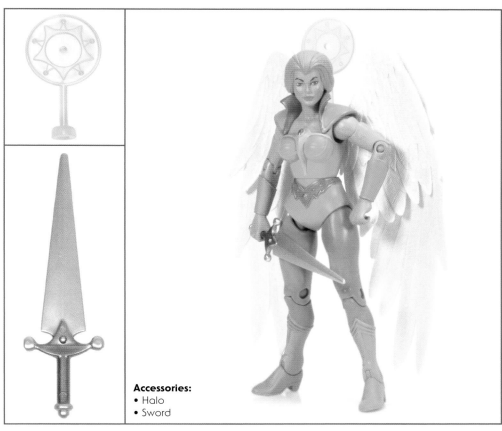

Accessories:
- Halo
- Sword

Like many of the Princess of Power characters, Queen Angella's overall design is mostly based on her appearance in the original She-Ra animated series by Filmation rather than her vintage Mattel action figure. However, while the colors of the outfit match the cartoon, there are a few additional details, like the ridges on her boots, that come straight off the design of that original action figure.

The figure comes with a small translucent pink halo accessory that can plug into the top of the wings on the figure's back. This is another nice nod to the vintage action figure, which featured this halo attached to the wings. It's removable, so you have the option to display the figure without this if you prefer. Angella is also packaged with a new sword accessory with which to do battle against the Evil Horde.

The standout addition to Queen Angella is the pair of beautiful large angel wings on her back. With sculpted feathers that feature a nice light blue wash, the wings are fully articulated. This allows you to pose Angella in-flight if preferred, with a nearly eighteen-inch wingspan!

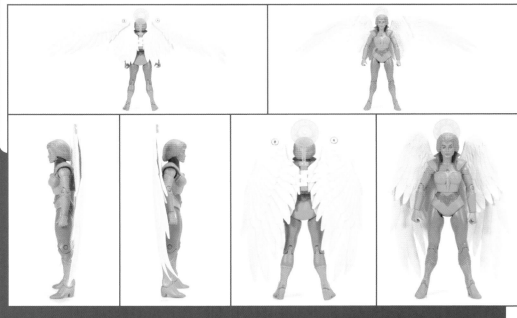

ANTI-ETERNIA HE-MAN
MOST EVIL MAN IN THE UNIVERSE

First released 2016 • Evil Doppelgänger

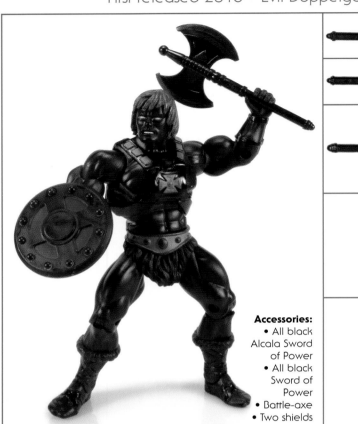

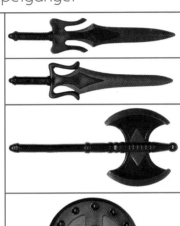

Accessories:
- All black Alcala Sword of Power
- All black Sword of Power
- Battle-axe
- Two shields

Anti-Eternia He-Man is a unique figure in the Classics toy line that really shows the depth of the character selection.

The figure reuses the standard He-Man mold, but features an incredibly striking black and red deco. His skin tone is painted with a dull black, while his power harness, loincloth, and more are all painted in a glossy black with bright red highlights. His hair is a dirty shade of red, while his eyes look as though they are glowing red with evil. It's a simple repaint of one of the very first figures in the lineup, yet it's also one of the most visually pleasing.

Even his packaging got a rare face-lift. While just about every single figure released in the Masters of the Universe Classics line came on the exact same blister card featuring the green bricks of Castle Grayskull, Anti-Eternia He-Man got a unique version of the card art that is colored the same shade of red and black as the figure within.

The concept of the character comes from Episode Eleven of the German audio plays. These audio plays were offered on cassette tapes exclusive to Germany, and featured brand-new stories for the characters of Eternia that many fans outside of the country never even knew existed. These audio stories played a massive role in the success of the franchise, which achieved levels of popularity there similar to those of the Filmation cartoon series in the US. As a result, the large Masters of the Universe fan base in Germany is fully aware of the Anti-Eternia version of He-Man and always hoped to see an action figure released.

This figure was one of a few chase figures offered by Mattel. It was not part of any of the annual subscriptions, but instead made available intermittently on Mattel's MattyCollector.com website.

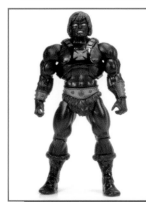

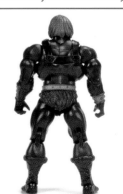

MOTUC - SECTION 1

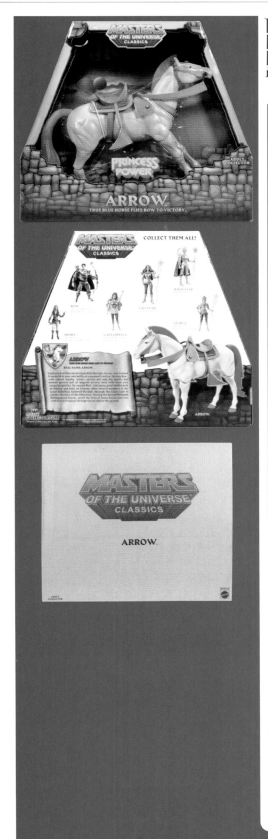

ARROW
TRUE BLUE HORSE FLIES BOW TO VICTORY

First released 2014 • Steed of the Great Rebellion

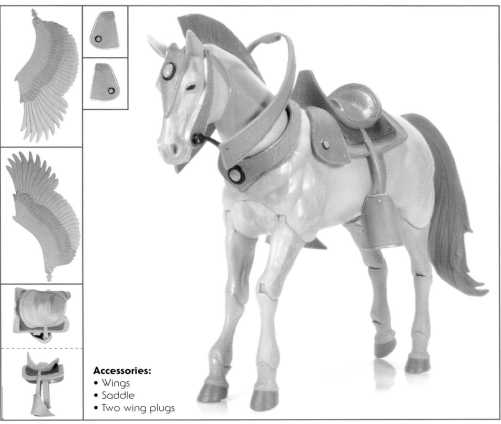

Accessories:
- Wings
- Saddle
- Two wing plugs

Just like in the original Princess of Power toy line, Masters of the Universe Classics saw many a steed for the various members of the Great Rebellion to ride. Arrow is the heroic horse of the mighty Bow!

The horse sculpt is reused from Swift Wind before him but has some new pieces that make him stand out. The mane on his head is styled more like a Mohawk. He also features two removable saddle bags that plug into the holes above his shoulder where the wings would attach. And if you want Arrow to have wings just like the vintage toy, these are also included and can easily pop into those same holes once the saddle bags have been removed.

While the vintage Arrow toy was a baby blue in color, the MOTU Classics version is modeled after the horse's appearance in the Filmation Princess of Power cartoon series. Most of the standard figures can mount Arrow's saddle with ease, and he even has stirrups for the figures' feet and a strap that fits in their hands.

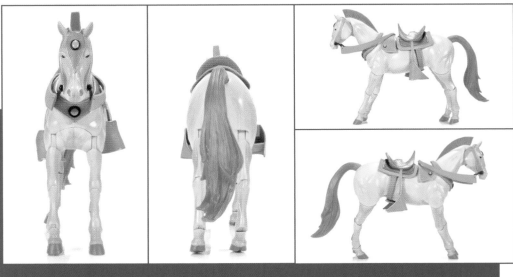

BATROS
EVIL MASTER OF THEFT

First released 2013 • Evil Villain

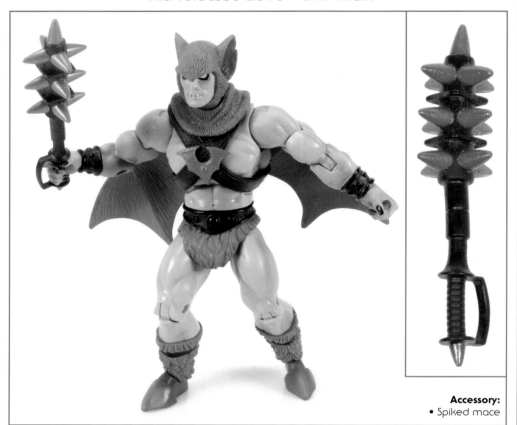

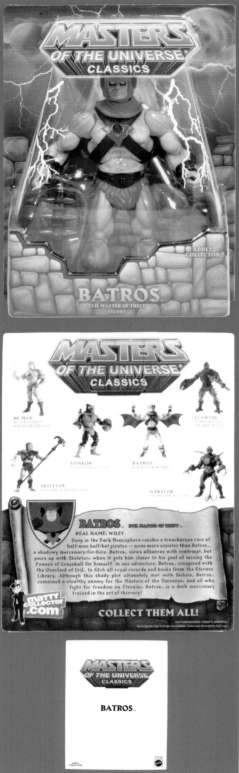

Accessory:
• Spiked mace

Batros is one of the villains that were created specifically for the original Filmation He-Man and the Masters of the Universe cartoon series. Until this figure, he had never been produced as a toy before! He was among the many Filmation characters that fans had hoped for years would someday make it to plastic.

The figure shares many of the same body elements as most of the standard MOTU Classics figures, but with some additional newly sculpted pieces to achieve the look of the character from the cartoon. Among those are the head, the boots, and the long-nailed fingers. He also has a unique neckpiece made to fit over the standard neck that adds to the look of his furry hood.

The most notable features are the new arms, which have small wings attached to the tricep area. This allows the figure to be posed with his wings out, but does not really hinder the arm movement. You can still easily place Batros's arms down at his side if you wish.

Batros did not have a signature weapon in the animated series, but Mattel still included something to arm him up. He has a red-and-black spiked mace, which is just a repaint of the same mace that was included with Spikor before him.

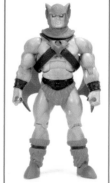
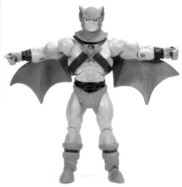
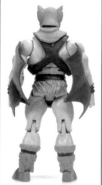
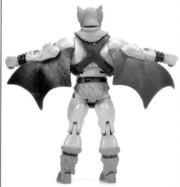

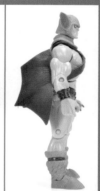

BATTLE ARMOR HE-MAN
MOST POWERFUL MAN IN THE UNIVERSE

First released 2010 • Member of the Heroic Warriors

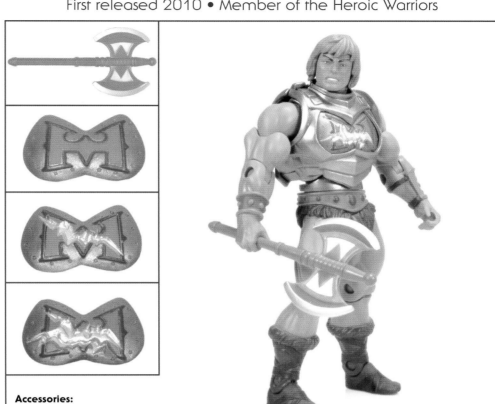

Accessories:
- Axe
- Battle armor and chest plates

Battle Armor He-Man was a fan-favorite variation of The Most Powerful Man in the Universe from the original Masters of the Universe toy line. So it was no surprise to see him turn up so quickly in the new MOTU Classics toy line with an updated look.

The figure itself is mostly the same body and head sculpt seen on the standard release. The biggest difference is that this time, he's wearing his bulky silver body armor rather than his standard power harness. Like most of the figures in the Classics toy line, the armor is made of a hard plastic and is removable. This completely eliminates the action feature of the vintage version of this figure, in which the chest had a rotating drum that would display various levels of damage on the armor when bumped.

In an effort to re-create this feature without actually incorporating a gimmick, Mattel included three interchangeable chest plates. These plates show the same various stages of damage as the vintage toy's drum mechanism, but instead you just remove the armor and place in whichever chest plate you desire.

Underneath that armor, He-Man's entire torso is painted a metallic silver. His ab piece is also lacking muscle definition. This is because the armor piece did not cover the entire torso, leaving the stomach area exposed in an effort to maintain as much articulation as possible. He was given this new flat ab piece to make it look like a continuation of the battle armor.

As far as accessories go, Battle Armor He-Man only includes his battle-axe this time around. Since the three additional armor plates were included to re-create the vintage action feature, Mattel opted not to include the shield or the Sword of Power.

FUN FACTOID: The Four Horsemen said, "After some of the wildly offbeat variations that we did for He-Man in the 200X line, it was nice to get back to basics with the original variant version!"

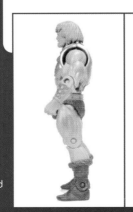
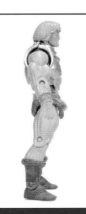
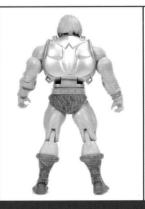
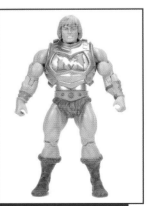

BATTLE ARMOR KING HSSSS
SLITHERING LEADER OF THE SNAKE MEN

First released 2015 • Member of the Snake Men

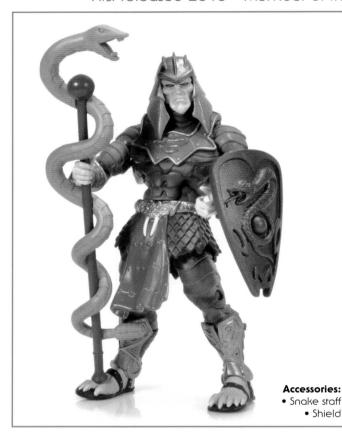

Accessories:
• Snake staff
• Shield

Battle Armor King Hssss came in a two-pack alongside Snake Armor He-Man.

This version of King Hssss is based on his appearance in the 200X Mike Young Productions animated series, which is a much different look from the version based on the vintage action figure that was released first. The face is longer, and much more angular. He has pale green skin and a scaly bodysuit. He almost has an Egyptian look to his design, with the helmet he wears on his head and overall design of his costume. He even has sandals with exposed feet featuring toes with long, pointy nails.

In a line where many figures reuse as many parts as possible, Battle Armor King Hssss is unique. He had to be, since his 200X look was so vastly different. He includes the usual Snake Men snake staff, but also comes with a brand-new shield modeled after the one that was included with his 2003 action figure.

You can remove his upper torso, which plugs into the legs via a single peg. This is so that you can plug on the King Hssss snake form. However, it is worth noting that the snake form was not included with this box set. Instead, it was later released with a new pair of legs under the name "Serpentine King Hssss." But the snake body from that one, as well as the snake body from the first release of King Hssss, both fit on these legs.

Shareable Accesories:

TORSO FROM SERPENTINE KING HSSSS

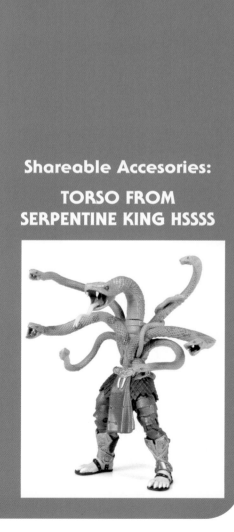

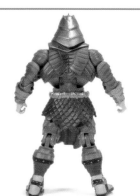
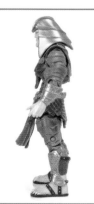
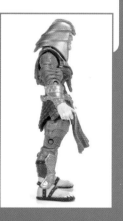

MOTUC - SECTION 1

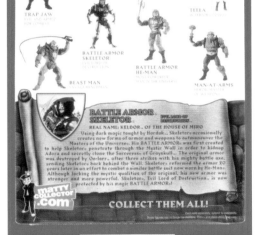

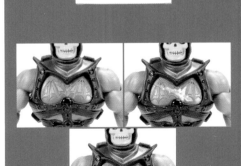

BATTLE ARMOR SKELETOR
EVIL LORD OF DESTRUCTION

First released 2011 • Member of the Evil Warriors

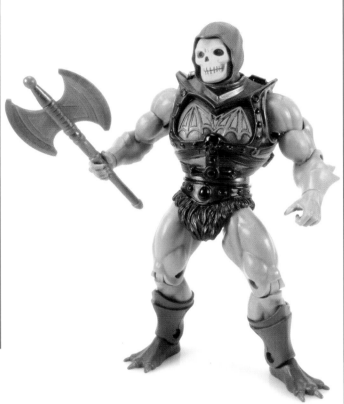

Accessories:
- Axe
- Battle armor and three chest plates

Battle Armor Skeletor was a fan-favorite variation of the Evil Lord of Destruction from the original Masters of the Universe toy line. So it was no surprise to see him turn up in the new MOTU Classics toy line with an updated look.

The figure itself is mostly the same body and head sculpt seen on the standard release of Skeletor, but there are several noticeable differences. First, the face this time around is painted a bright yellow with a light green color around the outside which is closer in appearance to the vintage figure. He also features a different loincloth, which is missing the extra Skeletor belt piece. His feet are also painted purple instead of looking like he's barefoot—another nod to the vintage toy.

Of course the biggest difference is the inclusion of his bulky body armor. Like most of the figures in the Classics toy line, the armor is removable. This completely eliminates the rotating-drum action feature of the vintage version. In an effort to re-create this feature without actually incorporating a gimmick, Mattel included three interchangeable chest plates that show the various stages of damage.

Under the armor Skeletor's entire torso is painted a metallic purple. His ab piece is also lacking muscle definition to make it look like a continuation of the battle armor.

As far as accessories go, Battle Armor Skeletor only includes a purple version of He-Man's axe. Since the three additional armor plates were included to re-create the vintage action feature, Mattel opted not to include Skeletor's Havoc Staff or sword.

MOTUC · SECTION 1

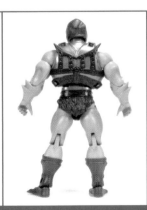

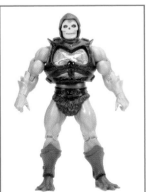

BATTLE CAT
FIGHTING TIGER

First released 2010 • Steed of the Heroic Warriors

Accessories:
• Helmet and armor

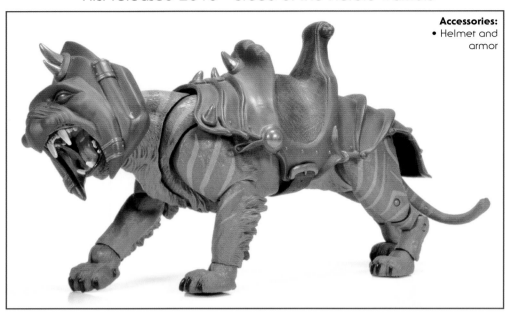

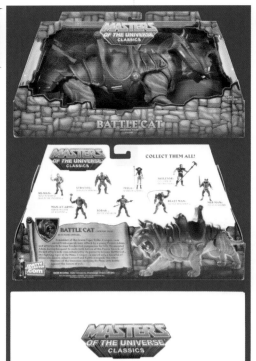

Battle Cat was the first beast figure released in the Masters of the Universe Classics toy line, and was a perfect example of just how massive this line would eventually become. Upon the line's launch, it was unknown if Mattel planned to release large-scale items such as this, but we just couldn't have He-Man without his trusted friend Battle Cat—and Mattel knew this!

The fighting tiger is an amazing update of the vintage toy. Unlike the original release from the 1980s, this version of Battle Cat is fully articulated, for the first time featuring several points of articulation that make him just as posable as the action figures in the line. The sculpt has tremendous detail, and since the helmet and armor are removable you can reveal a fierce, gorgeously sculpted feline face that brings Battle Cat to life better than ever before.

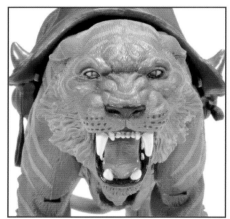

The armor has a saddle that perfectly seats He-Man or most of your other heroic action figures. The saddle sculpt even accommodates the sculpt of He-Man's loincloth, ensuring that there are no issues keeping He-Man posed upon his back. The armor also includes a small strap as part of the sculpt that is meant to hold He-Man's Sword of Power. This is an excellent inclusion, as it calls back to the vintage line, where the original figure was often shown being able to hold He-Man's sword in this way even though it actually could not! This allows fans to finally display their Battle Cat in such a way if desired.

FUN FACTOID: The Four Horsemen said, "This was a complex but deeply satisfying project for us. Taking such an iconic design and amping up the detail and articulation made for a great addition to the line. Although Battle Cat was a relatively early release he stands out as a highlight in the line for us."

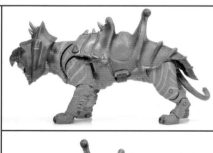

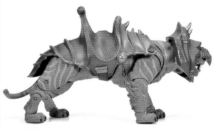

MOTUC - SECTION 1

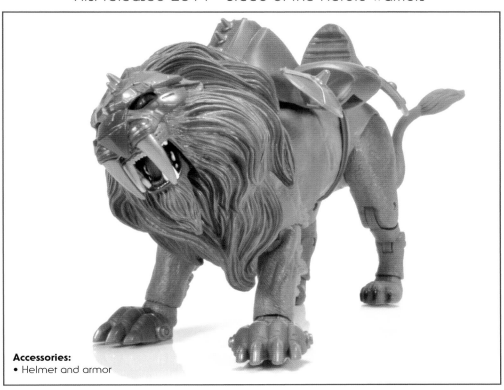

BATTLE LION
HEROIC STEED OF KING GRAYSKULL

First released 2014 • Steed of the Heroic Warriors

Accessories:
• Helmet and armor

Battle Lion was introduced in the 2002 animated series by Mike Young Productions as the heroic steed of King Grayskull. Although he was not officially named in the cartoon, fans coined the name "Battle Lion" to refer to the character, and this name was made official with the release of this toy. Since King Grayskull was the figure that launched the MOTU Classics toy line, many fans hoped they would see Battle Lion get his very first toy.

The action figure itself relies heavily on the same sculpt used for Battle Cat. There are some newly sculpted pieces included to make him stand out as his own beast. This works fine for the most part, but the most noteworthy downfall of the shared body is that Battle Lion was depicted as being much bigger than Battle Cat in the animated series. This brought him down to being roughly the same size.

The newly sculpted pieces include the new lion tail and the lion head, complete with a massive mane that does help him to feel a little bigger. The sculpt of the head is just as gorgeous and fierce as Battle Cat's before him. Battle Lion also gets brand-new armor, including armor that snaps on to his front paws. The armor has a gorgeous two-tone paint deco and a tech-inspired look, complete with a control panel at the saddle. It is also molded in such a way that King Grayskull or almost any of your heroic action figures can sit upon his back.

This armor and helmet are modeled after the look of the armor also worn by the redesigned Battle Cat in the 2002 toy line. As a fun hidden feature, all of this armor can be removed from Battle Lion and instead be placed on the previously released Battle Cat action figure, effectively allowing fans to create Battle Cat's 2002 appearance!

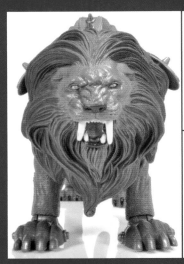

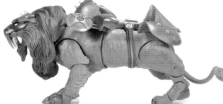

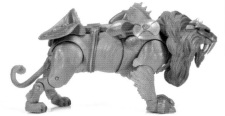

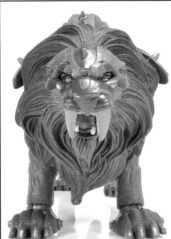

MOTUC - SECTION 1

BATTLE RAM
MOBILE LAUNCHER

First released 2014 • Vehicle of the Heroic Warriors

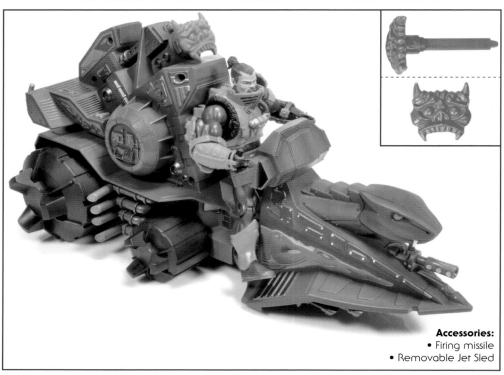

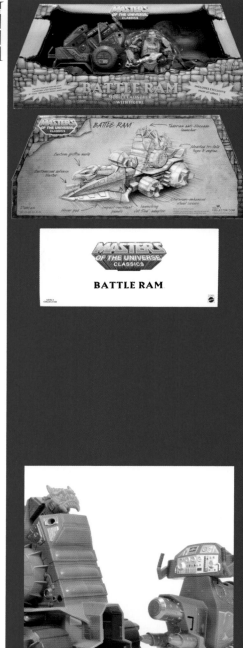

Accessories:
• Firing missile
• Removable Jet Sled

The Battle Ram is a fan-favorite vehicle from the original Masters of the Universe toy line. In 2014, it got a larger, more detailed remake fit for the updated Masters of the Universe Classics toy line.

This version beautifully re-creates the design of the original in a larger scale that reaches around fifteen inches in length. The details and paint deco are much more intricate this time, with all of the stickers décor from the vintage toy fully re-created as sculpted and painted details. The vehicle is able to carry up to two action figures, with one sitting on the front in the driver's position while a second figure can hang on to the back.

This new Battle Ram maintains many of the action features that the original 1980s toy had, including rolling wheels, a firing missile projectile, and even a removable Jet Sled on the front end. It's worth noting that the Jet Sled that comes with this particular Battle Ram does not feature the same griffin head sculpt of the original toy. Instead, it comes with a snake head design based on a version ridden by the Evil Warriors in the original Filmation animated series. This is because the griffin-themed Jet Sled was released as a standalone vehicle prior to the release of the Battle Ram. If you already have the Jet Sled from that standalone release, it can easily be placed onto the Battle Ram vehicle to fully re-create the classic look.

The vehicle also came packaged with an exclusive Man-At-Arms action figure, featuring newly sculpted parts that differentiate him from prior releases.

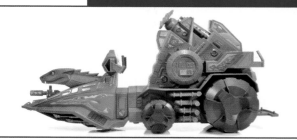

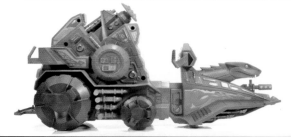

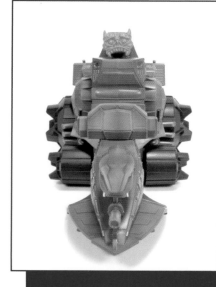

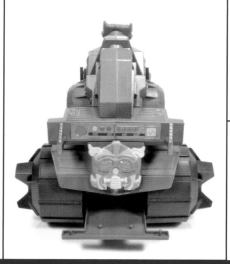

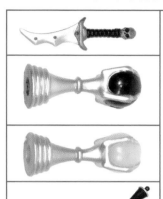

BATTLEGROUND EVIL-LYN
EVIL WITCH OF ETERNIA

First released 2011 • Member of the Evil Warriors

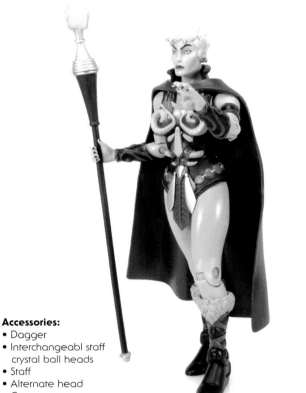

Accessories:
- Dagger
- Interchangeabl staff crystal ball heads
- Staff
- Alternate head
- Cape

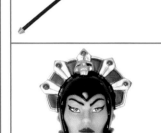

Battleground Evil-Lyn is the second action figure of the character released in the Masters of the Universe Classics line. While the first release was inspired by the yellow-skinned vintage action figure, this version is much more inspired by the character's appearance in the 2002 relaunch of the series.

The figure mostly reuses the same sculpt from the previous Evil-Lyn action figure. This time around, she has a much more natural, very pale skin tone and is wearing a black-and-purple outfit. She has been given a brand-new removable cape to help her stand out from that first figure even more. This cape is loose fitting and just rests on her shoulders around the neck.

Aside from that cape, there are two very distinct differences to the design thanks to newly sculpted pieces. Her left hand now utilizes an open, spell-casting hand sculpt that was first introduced with the Catra action figure. She also includes an interchangeable head, which allows you to display Evil-Lyn for the first time with her signature helmet removed, displaying her short, white hair.

This release was a smart reissue of a figure with mostly preexisting parts. Since every version of the Masters of the Universe property has its fans, this was a great way for Mattel to appeal to those who preferred this look for the character, while at the same time getting Evil-Lyn back out for purchase.

FUN FACTOID: The Four Horsemen said, "This was a simple refresh/repaint, but the results were extremely effective. Many wanted more of the Filmation cues, but we were more than happy with the wholly transformed figure that these few changes brought to Evil-Lyn."

MOTUC - SECTION 1

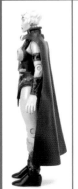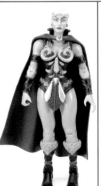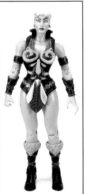

BATTLEGROUND TEELA
HEROIC HEIR TO THE SORCERESS

First released 2011 • Member of the Heroic Warriors

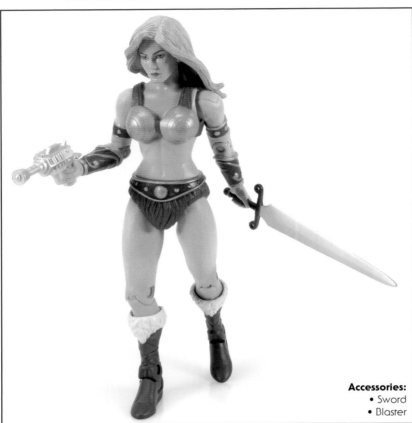

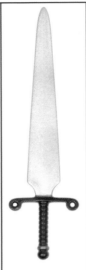

Accessories:
• Sword
• Blaster

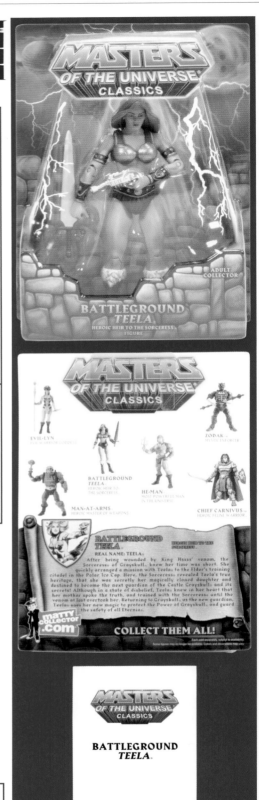

Battleground Teela introduced a very different look for one of the main characters. Based on her appearance in some of the early DC Comics, this version of Teela presents her with more of a barbarian warrior-type outfit similar to what we see He-Man wearing. The biggest difference here is that instead of the more familiar red hair pulled back in a bun, Battleground Teela has long blond hair.

The figure reuses some of the same parts from the standard Teela release, such as the arms and legs. But the torso and head are all-new sculpts, presenting Teela's earlier appearance for the very first time as an action figure.

Since the heads on most of the Masters of the Universe Classics action figures are swappable, this also allows you to place the new blond head on the standard Teela action figure that was previously released, allowing you to create yet another of her signature looks from the early minicomics. This figure is one of the great examples that show how Mattel was dedicated to presenting these characters in their many different forms, since Masters of the Universe is known to have many different story presentations via the comics, cartoons, and various toy lines.

FUN FACTOID: The Four Horsemen said, "Any time a figure required us to go back to the comic and minicomics roots of MOTU, we were always happy to do so. This one played up the barbarian aesthetic and also allowed us to add a new female torso assembly into the line."

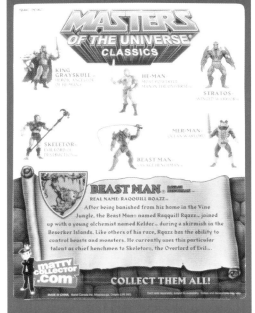

MAILER BOX CAME WITH REISSUE ONLY

FUN FACTOID: Beast Man was the first opportunity in the line to take advantage of modern tooling from a texture standpoint. The Four Horsemen said, "We were able to cover the figure in crisp fur detail, which couldn't really be done when the vintage line was around. Looking at the level of sculpting on the original figures, you can see that, if it wasn't for the technical limitations of the time, the figures would be even more amazing than they were."

BEAST MAN
SAVAGE HENCHMAN

First released 2008 • Member of the Evil Warriors

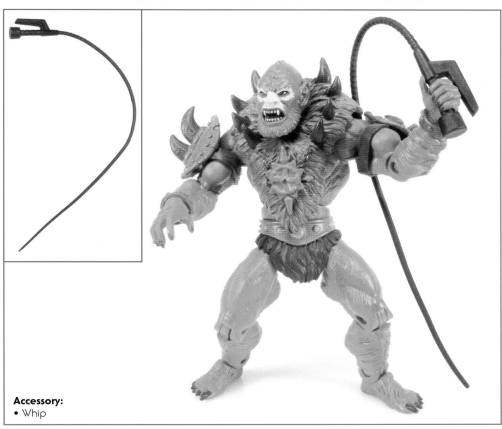

Accessory:
• Whip

Beast Man was among the first set of figures released in the Masters of the Universe Classics toy line. His figure introduced the furry body sculpt that would be reused multiple times, very much mimicking the way the figures in the vintage toy line often shared parts between one another.

The figure is strongly inspired by the original action figure from the 1980s, but with amazing new details that really make the character much more ferocious. While Beast Man appeared much larger in the recent 200X remake, this version shrunk him back down to being the same height as the other figures in the line. However, in an attempt to give him a more hunched, ape-like look, the design of the red armor piece is larger and sits on his shoulders to make it appear that his body is larger than it is. This type of clever sculpting of the armor and accessories would become a trademark of the line to make characters stand out even if they all utilize the same basic torso underneath.

Beast Man is packaged with his signature whip as an accessory, this time made of a soft, pliable plastic rather than a piece of string. He is able to hold this only in his left hand, as his right hand is molded open in a scratching pose, which pays homage to the open hands seen on the vintage action figure.

 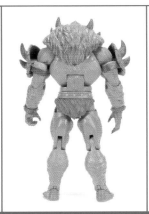 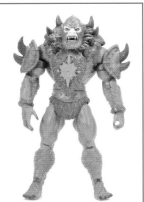

BEAST MAN
SAVAGE BLOOD-RED HENCHMAN

First released 2016 • Member of the Evil Warriors

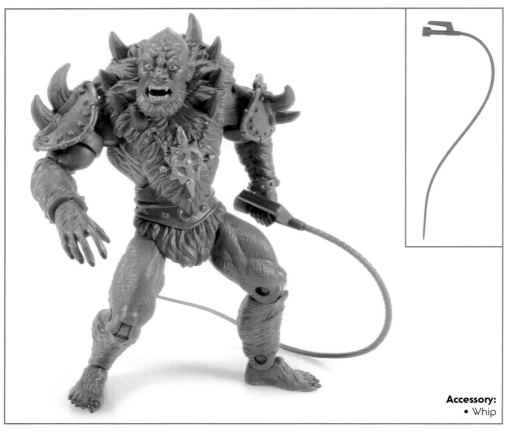

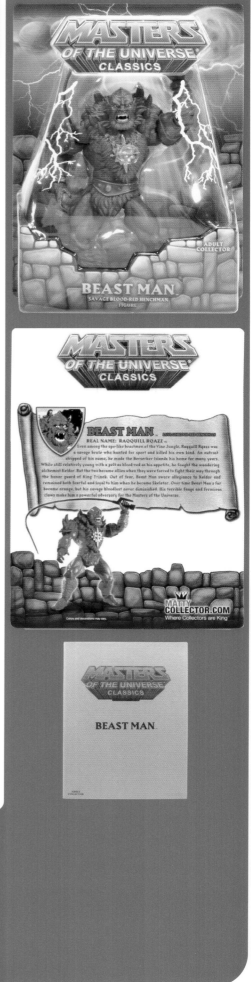

Accessory:
• Whip

Offered exclusively at Power-Con 2016, "Red Beast Man" is based on the way the character appeared in the vintage minicomic "He-Man and the Power Sword."

The figure itself features the exact same sculpt as the first Beast Man figure that came out in 2008. This time around, he only features a brand-new paint deco. While red is one of the only colors used, there is a nice black wash that helps to bring out all of the details, such as the sculpted fur.

While he's just a simple repaint of a figure that first debuted in the Classics line eight years prior, it's an effective repaint. Red Beast Man is one of those variations that fans had hoped to see get an action figure for many years, and is another example of how the Masters of the Universe Classics toy line was able to show representations from all forms of MOTU media.

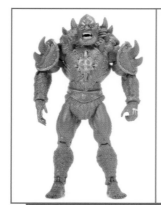
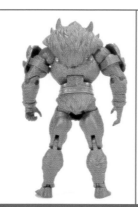

MOTUC - SECTION 1

BLADE
EVIL MASTER OF SWORDS

First released 2014 • Member of the Evil Warriors

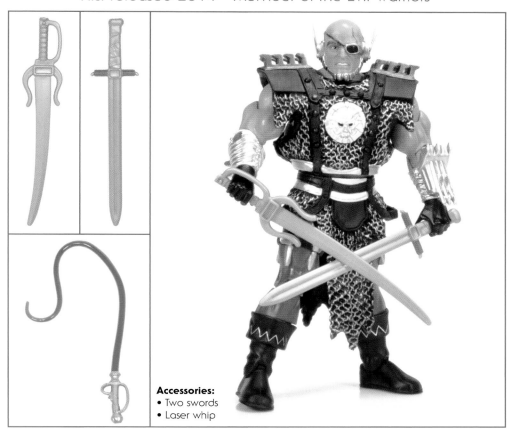

Accessories:
• Two swords
• Laser whip

A character created specifically for the 1987 Masters of the Universe motion picture, Blade is one of three movie characters who appeared in the vintage Masters of the Universe toy line. As a result, he was able to be brought to the new Classics line. Due to rights issues at the time, Mattel was only able to do these three characters in Classics since they had previous toys. As a result, this new figure of Blade looks more like the vintage action figure and does not bear the actor's likeness from the film.

Just as in the movie and the original toy, Blade includes two swords for combat. But since the swords in the movie look quite different from the swords that were included with the original action figure, Mattel opted to split the difference by including one of each version with this new Blade—giving him mismatched swords.

In addition to his signature swords, Blade also includes the laser whip for the very first time in toy form. This allows you to re-create one of the more memorable scenes from the film, in which Skeletor ordered Blade to punish He-Man.

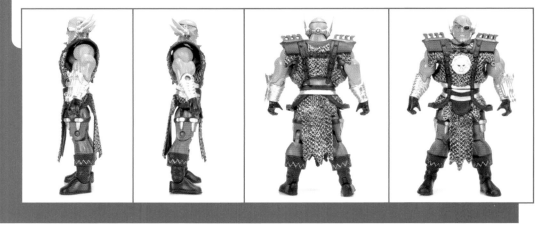

BLAST ATTAK
EVIL BLAST APART ROBOT

First released 2015 • Member of the Snake Men and the Evil Warriors

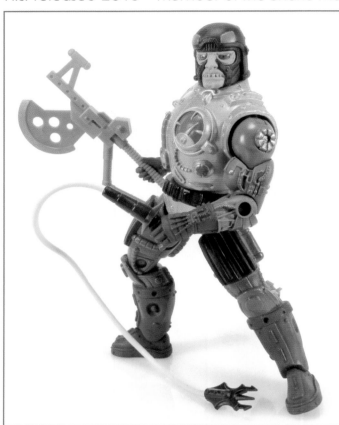

Accessories:
• Tech axe
• Cord whip

Blast Attak was a figure from the vintage toy line who relied heavily on his action feature. While pretty much all of the original figures had gimmicks, Blast Attak's was a big part of the figure, since he was essentially a character who was a walking time bomb, able to explode into two halves at the press of a button.

Since the Masters of the Universe Classics line rarely has action features, choosing to focus more on articulation and detailed sculpts, many fans wondered how this character would be approached. Mattel opted to nix the exploding action feature entirely, making Blast Attak a standard articulated action figure just like every other figure in this line.

There are still some fun nods to the vintage figure's action feature, however. One of the weapons included with this new Blast Attak is a whip that looks exactly like the plunger cord that you would attach to the original figure's back to trigger the explosion. The back of the armor also has a small rectangular slot that pays homage to the slot where that cord would plug in.

The figure is also notable for not having removable armor like most of the figures in the Classics line do. It had become standard practice to make an armor piece that fits over the standard torso, especially for characters who had unique appearances. Blast Attak's armor is still a separate piece that fits over the torso, but this time around it was glued on so that it could not be removed.

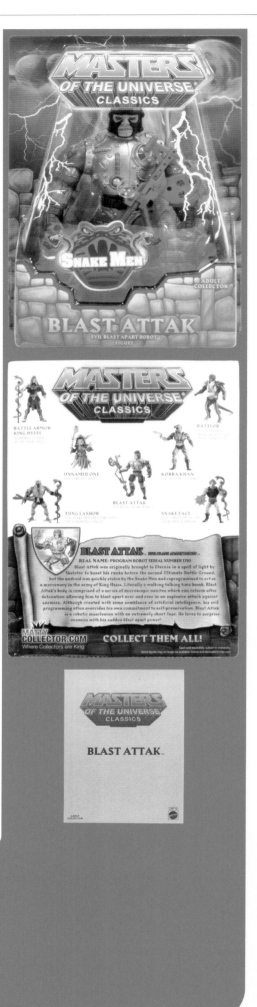

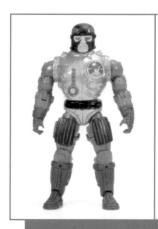

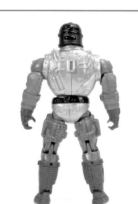

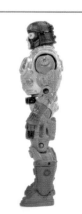

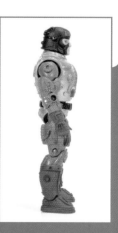

BOW
SPECIAL FRIEND WHO HELPS SHE-RA

First released 2011 • Member of the Great Rebellion

Accessories:
- Bow & arrow
- Chest emblems
- Harp
- Alternate head
- Cape & quiver

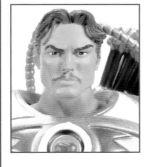

One of the great things about the Masters of the Universe Classics line is how inclusive it is, bringing together characters from many versions of the franchise, including Princess of Power. In the 1980s, Bow only existed in the She-Ra line of action figures, all of which had doll-like qualities. Those figures were much slimmer when compared to the beefed-out characters from He-Man's world.

Classics brings the characters of Etheria to the same scale and design as their Eternian counterparts. Mattel did a fantastic job of making Bow fit right in, while still holding true to his traditional design elements. This new figure was supplied with a ton of accessories, allowing fans to display the character in a number of ways. Two heads allowed you to swap between the mustached look seen in the original Filmation animated series and the clean-shaven, headband-wearing look that resembles the original action figure.

The small chest emblem in the center of his armor can also be changed between a red circle and a red heart —the latter also being a great homage to the "beating" heart action feature of that vintage toy. The armor on his chest is also attached to a long red cape and a quiver of arrows. Several arrows are sculpted into the quiver and are not removable, but one separate arrow is included. Bow has unique fingers that are molded in a way so that they can hold on to the back of the arrow as if he is preparing to fire at his foes. The bow itself does not include a string due to safety standards, but Mattel did leave little loops so that you can attach your own string if you desire.

FUN FACTOID: The Four Horsemen said, "The challenge for us with Bow was finding a way to visually integrate him into the line properly. Basically, 'How do we make a guy with a heart on his chest fit in the same line with a savage barbarian?' There seemed to be some fan prejudice against the character, so we really wanted to make sure that we did this right. It's long been our stance that anything goes in this line. Simply putting Bow on a Classics frame and matching up the level of detail with the rest of the line proved that to be the case."

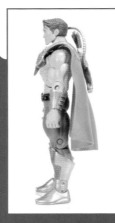 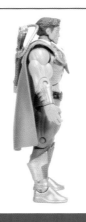 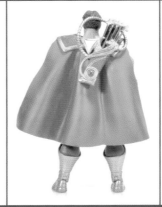 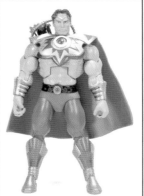

BROOM
HEROIC ALLY OF MADAME RAZZ

First released 2014 • Member of the Great Rebellion

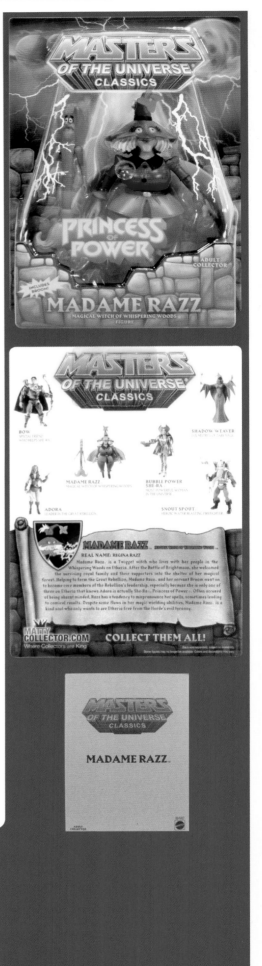

Broom was a pack-in figure included with the 2014 release of Madame Razz.

The figure is very basic but effectively manages to wonderfully capture the look of the character as he appeared in the She-Ra: Princess of Power animated series by Filmation. The only articulation is found in the arms. The bristles of the broom are sculpted to look like his feet; they are flat on the bottom, allowing him to stand on his own.

By stretching Broom's arms out to his side, you can pose Madame Razz holding on to him with her feet positioned in the curls of his bristles to re-create her using him to fly just like in the cartoon. They don't balance too well while in this pose, however. But still, it's a fun touch for a great-looking pair of characters getting their very first action figures.

MOTUC - SECTION 1

BUBBLE POWER SHE-RA
MOST POWERFUL WOMAN IN THE UNIVERSE

First released 2011 • Member of the Great Rebellion

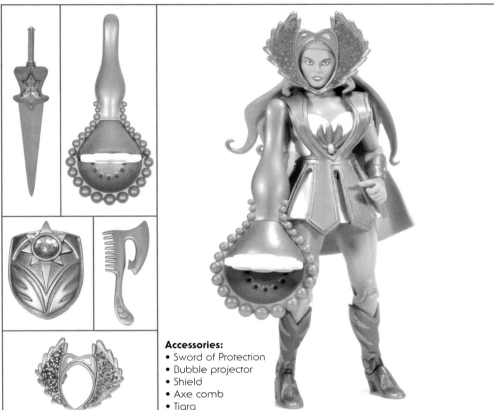

Accessories:
- Sword of Protection
- Bubble projector
- Shield
- Axe comb
- Tiara

Bubble Power She-Ra is based on one of the variants from the original Princess of Power toy line. This new version gives She-Ra a brand-new armor piece with a sparkly pink color scheme. The tiara on this one is also based on those that were included with the vintage toys rather than the Filmation-style tiara included on the first She-Ra release in Classics.

Also included is a new version of the Sword of Protection that matches the unique version included with the original Bubble Power She-Ra action figure. As another fun nod, she comes with the bubble projector. In the original Princess of Power toy line, this was an actual wand that you could fill with bubble solution for a bubble-blowing action feature.

Most notable on this figure is the design of the She-Ra body under the new Bubble Power armor. If you remove all of the new pink armor elements, you reveal a new version of the standard She-Ra outfit. This was referred to as "She-Ra 2.0," as many fan complaints were addressed with this new figure. There is now a waist cut joint, and slits in the skirt allow the legs a greater range of movement. Plus, more details were added to the design of the boots, arm guards, and outfit itself. Using this body with the standard She-Ra head from the first release allows fans to create a better detailed, more articulated She-Ra action figure.

FUN FACTOID: The Four Horsemen said, "This was a 'second chance' scenario that allowed us the chance to fix some of the shortcomings of the original version. Mainly the addition of the waist joint and the flexible skirt with slits in the side allowed She-Ra to ride Swift Wind in style and get into more dynamic poses."

 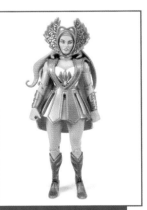

BUZZ-OFF
HEROIC SPY IN THE SKY

First released 2010 • Member of the Heroic Warriors

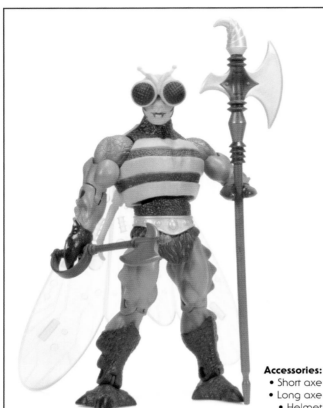

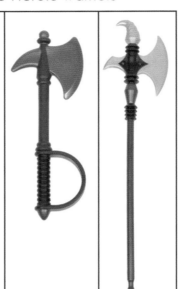

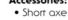

Accessories:
- Short axe
- Long axe
- Helmet

While the 200X version of Buzz-Off redesigned the character into a thinner, much more insect-like character, the new MOTU Classics figure brought him back to his chunkier roots. Much like the original figure from the 1980s, this new Buzz-Off uses the same arms and legs that are also seen on characters like Clawful, with the new torso piece that would also be used on Whiplash. This is an instance where Mattel essentially followed the exact same recipe from their original toy line in an effort to save on tooling costs.

The head even includes the same goofy smile on Buzz-Off's face that the original version is known for, and he has the oversized bee-eyed helmet that fits on top of his head and covers his eyes. The translucent yellow wings look very similar to those from the original action figure as well, but this time are connected via ball joints, allowing for better articulation and posing of the wings.

One small new addition to the figure does pay homage to the more insect-like design of the 200X-era by adding two small, ball-jointed insect appendages on his back under his wings. He also comes with the longer version of his axe seen in the 200X-era along with his shorter axe from the vintage era, allowing you to display him with whichever you choose.

FUN FACTOID: The Four Horsemen said, "After we made such a departure from the original line with the 200X version, it was surprisingly fun to return to the sillier side of Buzz-Off. We even kept his smile!"

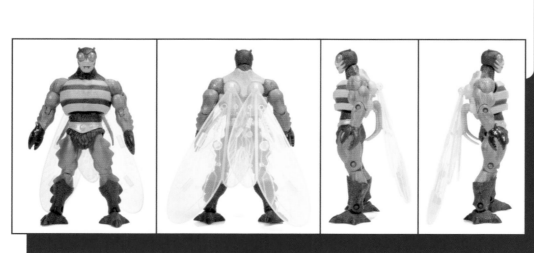

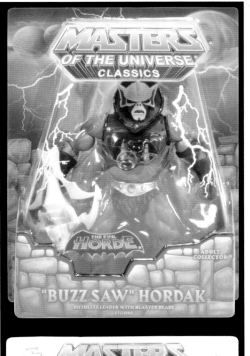

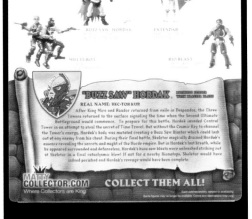

"BUZZ SAW" HORDAK
RUTHLESS LEADER WITH BLASTER BLADE

First released 2015 • Member of the Evil Horde

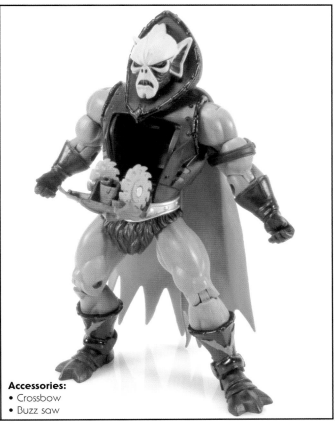

Accessories:
• Crossbow
• Buzz saw

"Buzz Saw" Hordak is based on a vintage variant of the ruthless leader of the Evil Horde. On that original action figure, Hordak was able to launch a spinning buzz saw weapon out of a hidden slot in his chest.

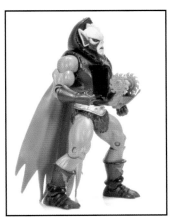

Since action features are mostly absent from the MOTU Classics toy line, the buzz saw does not shoot out of the torso as it did on that original figure. However, this figure does include a new hollow torso with a door in the front, allowing you to store the buzz saw accessory. The buzz saw is also designed so that Hordak can hold it in his hand.

Aside from that new torso piece, the rest of the figure looks very much like the first release of Hordak. Many of the parts used are exactly the same, as is the color scheme. One of the only other notable differences is with the included Horde crossbow accessory. While the crossbow that came with the first Hordak release was black, this new one is all white, which makes it match the vintage crossbow from the original toy line.

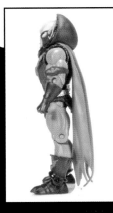

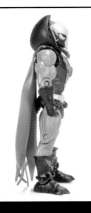

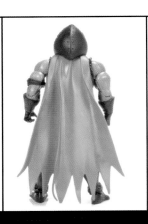

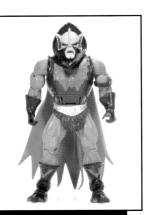

CALLIX
EVIL HORDE ROCK MAN

First released 2015 • Member of the Evil Horde

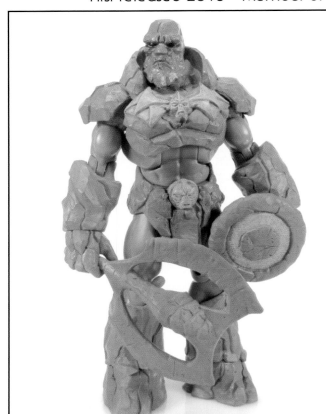

Accessories:
• Crossbow axe
• Shield

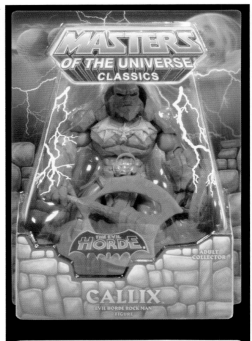

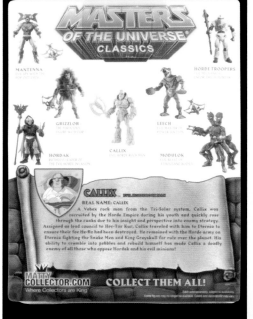

Callix is a member of the Evil Horde who appeared briefly in the 200X He-Man and the Masters of the Universe animated series by Mike Young Productions. Created specifically for that show, Callix had very little screen time, as he was quickly destroyed by his own leader, Hordak, in a display of power.

Regardless of his short appearance, the Masters of the Universe Classics line had become well known for including many characters from all eras of the franchise. Callix was one who often topped fans' "most wanted" lists, and Mattel listened.

The figure is unique, as he includes some brand-new rocky sculpted pieces all attached to the basic body, effectively creating his cracked-stone look. The rock-like pieces added to his feet give him a height boost, making him stand a bit taller than your standard figure. Even his axe accessory is quite creative, as it also doubles as a crossbow—the standard weapon of the Evil Horde!

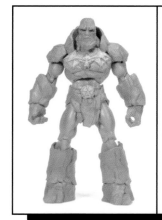
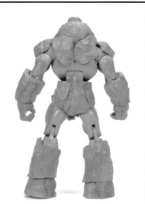

MOTUC · SECTION 1

CAMO KHAN
EVIL CAMOUFLAGED MASTER OF SNAKES

First released 2016 • Member of the Snake Men

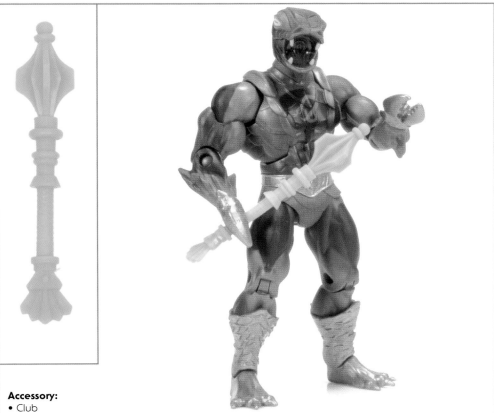

Accessory:
• Club

Sold exclusively at Power-Con 2016, Camo Khan is an interesting variant of Kobra Khan that is based on an incredibly rare foreign variant from the vintage Masters of the Universe toy line.

Only released in Argentina through Top Toys, under license by Mattel, the original Camo Khan depicted Kobra Khan with a new camouflage paint deco and the Snake Men insignia on his chest. Some versions of him also included the Buzz-Off clawed hands instead of the normal hands found on the US release of Kobra Khan.

This new version attempts to re-create that variant, all the way down to the golden claws for hands and the camouflage paint deco. This is the type of variant figure that makes for a great convention exclusive, because it's a relatively unknown variant outside of the die-hard fan base. But for those who are aware of the original release, this is a great way to get an official Camo Khan without breaking the bank trying to obtain the rare 1980s release.

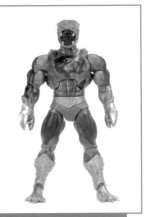

CAPTAIN GLENN
HEROIC GALACTIC ADVENTURER

First released 2011 • Member of the Heroic Warriors

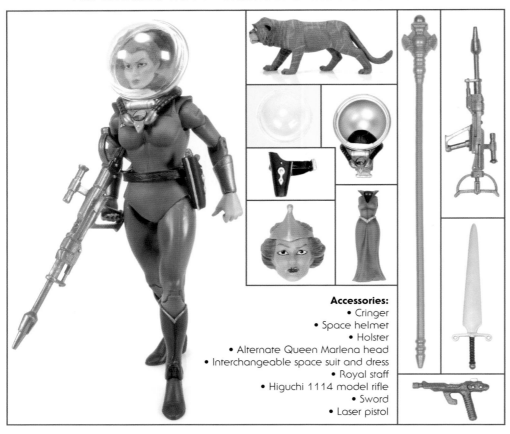

Accessories:
- Cringer
- Space helmet
- Holster
- Alternate Queen Marlena head
- Interchangeable space suit and dress
- Royal staff
- Higuchi 1114 model rifle
- Sword
- Laser pistol

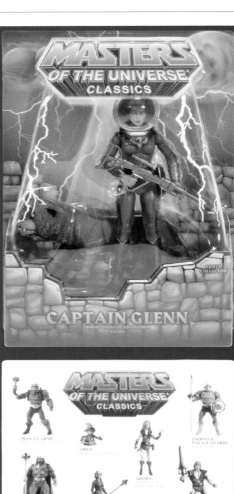

Captain Glenn is unique among Masters of the Universe Classics offerings, in that she comes with a costume change that makes her essentially two figures in one. Add the Cringer figure she comes packaged with, and you're getting three figures in one package. The other notable figure that came with a number of costume changes was Vykron.

The heroic galactic adventurer was packaged in two configurations. For those purchasing directly from Matty Collector, she was sold as Captain Glenn, and the Queen Marlena outfit was included in the box. As a San Diego Comic-Con exclusive, she was sold in a version that had her dressed as Queen Marlena, with her Captain Glenn costume change included in the box. Each packaging configuration featured a different bio: one detailing her past as a daring galactic adventurer, and the other detailing her reign as queen of Eternia.

Captain Glenn comes with quite a few accessories. There is the aforementioned costume change. She also comes with a royal scepter that is a great companion piece to the one that came with King Randor. Her rifle resembles the weapons carried by Skeletor's troopers in the 1987 Masters of the Universe movie. Her sword is a slight repaint of the one that came with Battleground Teela, and her pistol and holster are repaints of Adora's accessories. Her shoulders and biceps come from Adora, her boots come from She-Ra, and her legs, hands, and torso come from Teela. The Cringer figure looks very much like his animated counterpart, down to the snaggletooth. He is minimally articulated though, with swivel cuts at the head and tail only.

Captain Glenn's bio has a couple of Easter eggs. The Higuchi 1114 model rifle is actually a reference to Terry Higuchi, one of the designers on the Classics line. "Project Photog" is a reference to the character Fearless Photog, who would be released in the Classics line a year after Captain Glenn.

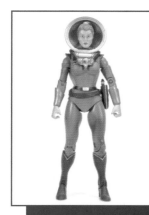

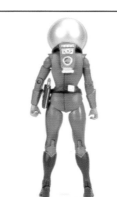

MOTUC - SECTION 1

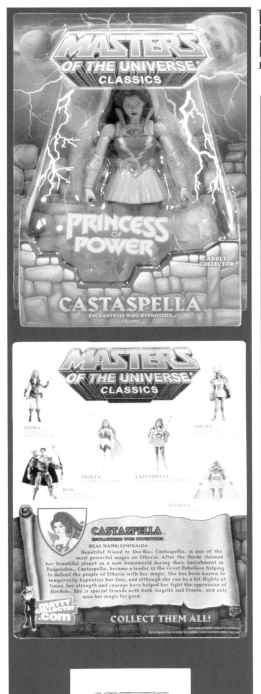

CASTASPELLA
ENCHANTRESS WHO HYPNOTIZES

First released 2013 • Member of the Great Rebellion

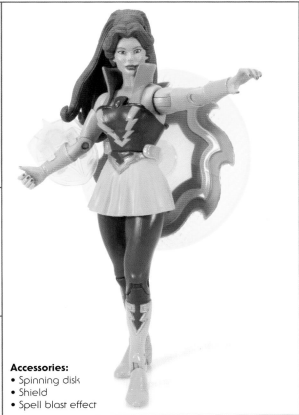

Accessories:
• Spinning disk
• Shield
• Spell blast effect

Like many of the Princess of Power characters to hit Masters of the Universe Classics, Castaspella is heavily inspired by her appearance in the original Filmation animated series rather than her vintage toy. This can mostly be seen in the design of her brightly colored blue-and-yellow costume, and the style of her hair. However, even though she is strongly Filmation inspired, elements of that classic toy are still included.

One accessory that is an homage directly to the 1980s action figure is the large spinning disk. On the vintage action figure, this wheel was attached to the figure's back and worked into her action feature. This time it's included as a removable accessory, allowing you to clip it to the figure's waist if you wish to display her with a similar look to her vintage counterpart. The wheel itself spins when you manually turn it, and is easily removed if you decide you'd prefer to keep her looking more as she appeared in the cartoon.

One of the best inclusions with this figure is the translucent yellow blast effect. This effect easily slides over her open spell-casting hand, allowing you to pose Castaspella as if she is firing off a magical spell toward her Evil Horde enemies!

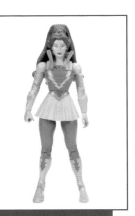

CASTLE GRAYSKULL
FORTRESS OF MYSTERY AND POWER FOR HE-MAN AND HIS FOES

First released 2013 • Fortress of the Heroic Warriors

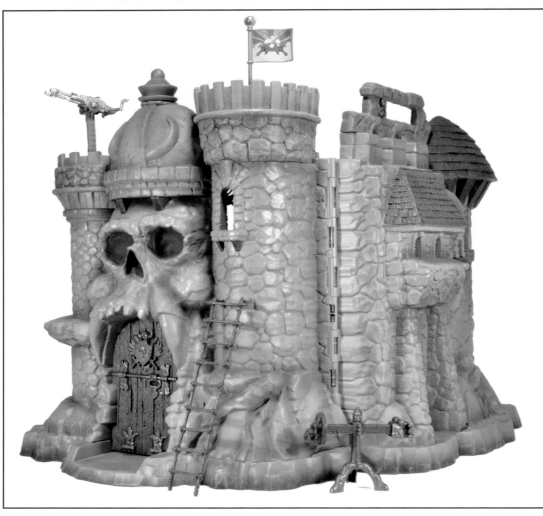

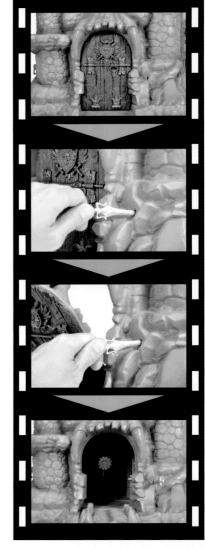

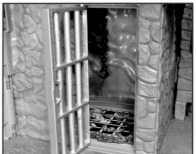

The iconic play set from the original Masters of the Universe toy line gets a full-blown collector-quality upgrade for Masters of the Universe Classics!

This brand-new sculpt is based primarily on the original 1982 play set, but also incorporates many elements only seen in the 1981 prototype as well as new elements added in! This new play set stands nearly two feet tall and re-creates many of the same memorable action features of the original. The castle retains the ability to fold open, revealing three levels on the inside. A new addition to this play set is a removable floor piece for the inside of the castle which also includes a slot specifically allowing you to attach the flight stand that was included with the Wind Raider vehicle, which was sold separately. This allows you to dock either the Wind Raider or the Sky Sled inside the castle when displayed in its open mode.

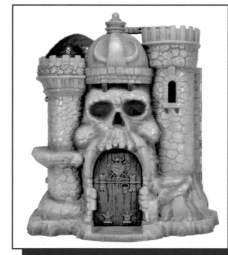

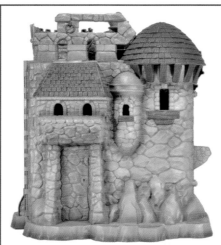

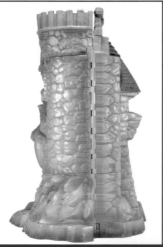

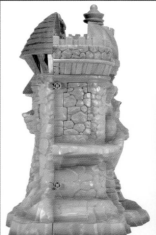

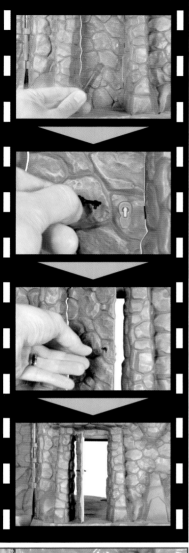

The included throne retains the ability to open up a hidden trapdoor to drop enemies to the floor below. A new prison cell was designed with a cage door and real metal chain shackles, allowing you to lock enemies away. On the floor inside of this prison cell is the dungeon grate sticker, a great throwback to one of the details of the original toy.

Many design elements that were just stickers and cardboard in the original play set were brought to life as fully sculpted pieces in this new version, including the control panel, monitor, the flag for the top tower, and the space-themed suit of armor. The training device from the original was given a new sculpt update that more closely matches the original prototype version, and the laser cannon for the top turret also returns.

The Jawbridge can open and close just like on the original play set, with the door standing about eight inches tall—tall enough for your seven inch Classics action figures to easily stand in the doorway. Similar to the feature of the original version, the Jawbridge can be locked. This can be done by sliding a small green stone that is on the side of the Jawbridge door.

There are a few other new additions that are specifically based on the original prototype designed by Mark Taylor in the early 1980s. Among these are the small skulls positioned at the top of the elevator posts, the bat-winged jetpack, and the minaret on the top of the castle's skull. This piece is also removable, so if you prefer to display the castle without this element you have the option to do so. Even the design of the external façade is based more closely on that early prototype, with the skull having an elongated jaw and face design and a new battle ledge that could support a figure.

There are even a few brand-new play features that tie in with the story being told in the bios from the back of the packaging in the Masters of the Universe Classics line. A hidden door can be found on the back of the castle. Next to this hidden door is a small keyhole, which is a reference to the tiny Grayskull key that was previously included with the Scare Glow action figure. The very top of the castle also has a small wooden door that opens to reveal a hidden chamber, complete with a small goblet that is designed to hold the Grayskull orb that was previously included with the King Grayskull action figure.

This really does feel like the ultimate version of the fortress of mystery and power. It truly encapsulates what the Classics line is all about by including elements from the original castle, the original prototype, and many new elements that tie in to various story elements from throughout the years. It's a massive play set with so many fantastic features, a gorgeous sculpt, and a solid, sturdy build—making for the perfect centerpiece to the Masters of the Universe Classics collection!

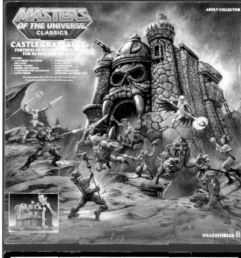

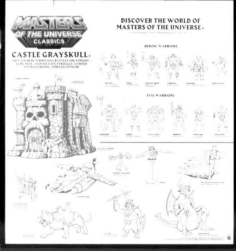

FUN FACTOID: Castle Grayskull was shipped along with the Masters of the Universe Checklist poster (see page 538).

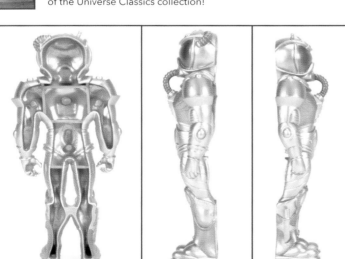

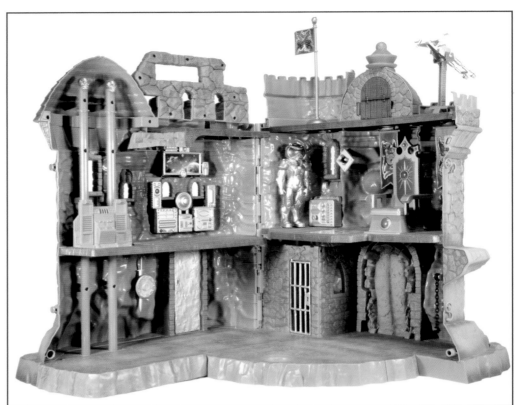

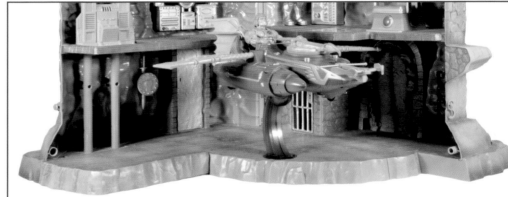

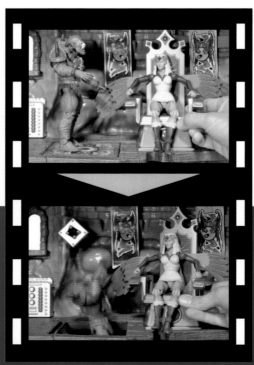

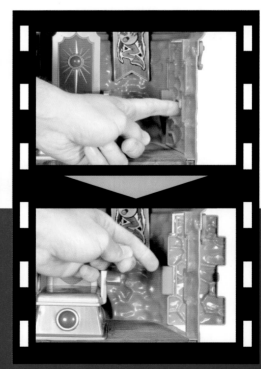

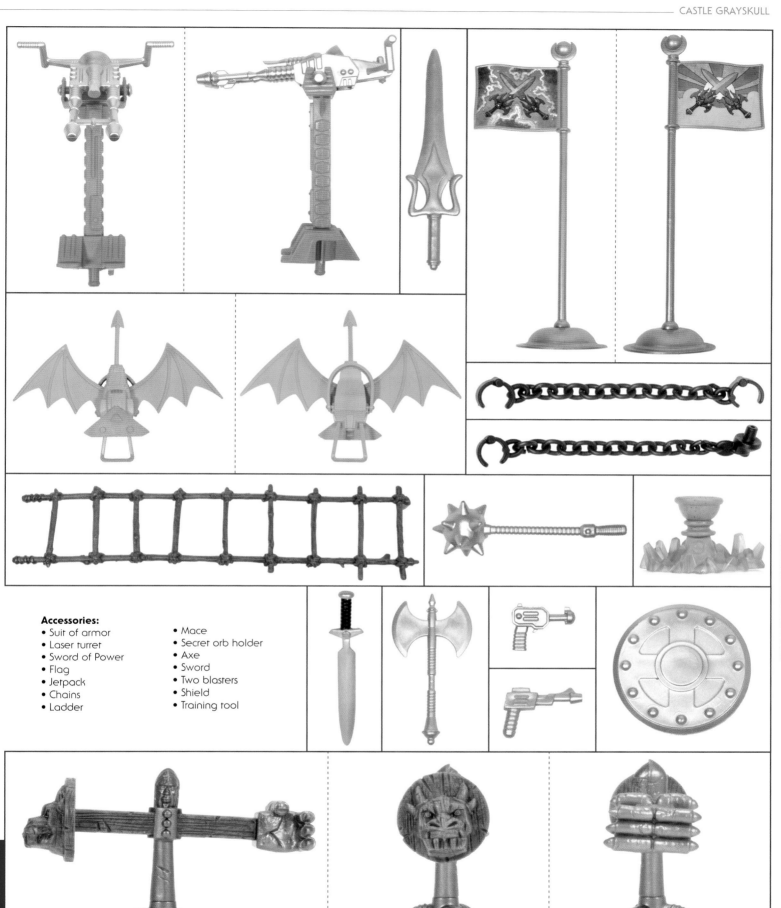

Accessories:
- Suit of armor
- Laser turret
- Sword of Power
- Flag
- Jetpack
- Chains
- Ladder
- Mace
- Secret orb holder
- Axe
- Sword
- Two blasters
- Shield
- Training tool

CASTLE GRAYSKULL STANDS
FOR 6-INCH FIGURES

First released 2010 • Accessory of the Heroic Warriors

x10

MASTERS OF THE UNIVERSE CLASSICS

CASTLE GRAYSKULL STANDS FOR 6" FIGURES

ADULT COLLECTOR

R6246

MATTEL

CONSUMER INFORMATION

Need Assistance? Visit service.mattel.com or call 1-800-524-8697 (US and Canada only).

SERVICE.MATTEL.COM

Contents: 5 Figure Stands

R6246

MATTEL

0 27084 83599 1

Accessories:
- Peg insertion tool
- Ten pegs
- Removable stone wall

The Castle Grayskull Stands came in a box of five and are designed to offer up a unique way to display your Masters of the Universe Classics action figures.

Each stand is a square plastic base designed to resemble the green bricks of Castle Grayskull. Each base has a staggered, brick-like design allowing you to position multiple bases alongside each other. Each base also has multiple peg holes and includes small removable pegs. These pegs can be plugged into any of the holes on the base and then used to snap into the bottom of a figure's feet to attach them to the base.

For additional decoration, a "wall" section is also included that can be attached to the base using those same pegs and peg holes.

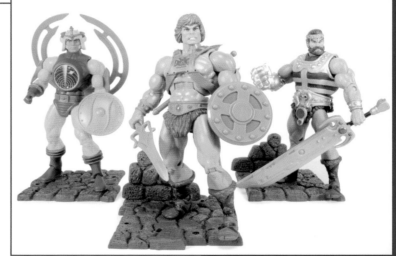

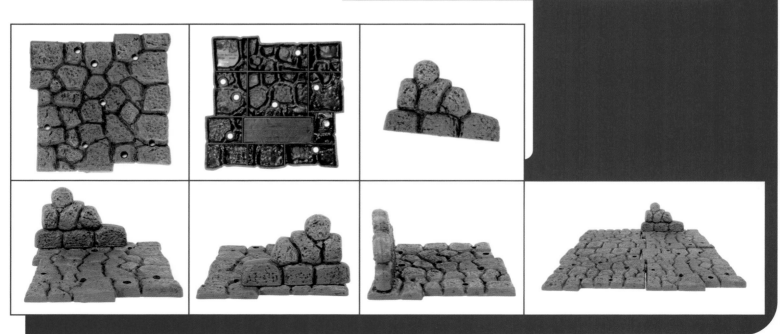

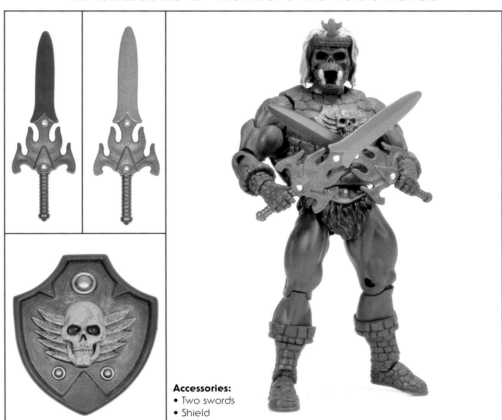

CASTLE GRAYSKULLMAN
HEROIC EMBODIMENT OF CASTLE GRAYSKULL

First released 2012 • Member of the Heroic Warriors

Accessories:
• Two swords
• Shield

In 2012, Mattel ran a Create a Character contest allowing fans to submit their own designs, with the winning design being turned into a real Masters of the Universe Classics action figure. The winner of this contest was Daniel Benedict for his design, Castle Grayskullman.

Castle Grayskullman was presented as a golem—the Heroic Embodiment of Castle Grayskull that would come to help protect the secrets of the castle if needed. The figure takes a lot of its design elements directly from the castle that it protects. Its armor, boots, and gloves are styled with the same familiar green brick design. The head is modeled after the skull face of the castle itself.

Even Castle Grayskullman's accessories have direct tie-ins to various accessories of the castle play set. The two swords, colored green and purple, are modeled after the swords seen on the two sides of the flag that sits atop the castle's tower. And the skull-adorned shield comes straight off of the shield emblem seen on the castle's Jawbridge.

MOTUC - SECTION 1

FUN FACTOID: The Four Horsemen said, "The winner of the fan Create a Character contest was Castle Grayskullman, who was created by Daniel Benedict. This character is such a perfect fit for MOTU in so many ways. The concept captures the simplicity that is inherent in so many of the line's characters, but the execution of the design and attention to clever details elevate it to a figure that feels at home in Classics. From our end anything and everything relating to Grayskull is a winner, so this project was a pleasure to work on."

 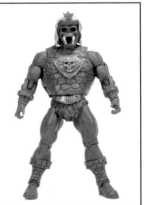

CATRA
JEALOUS BEAUTY

First released 2011 • Member of the Evil Horde

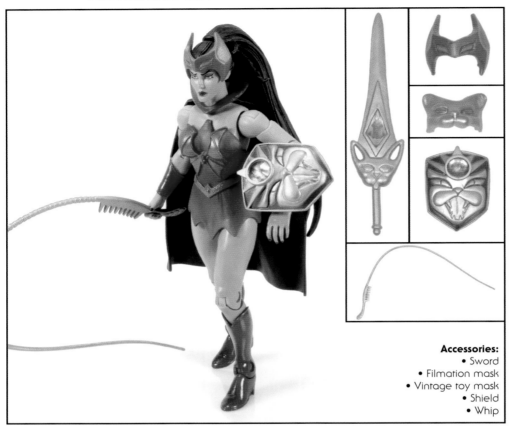

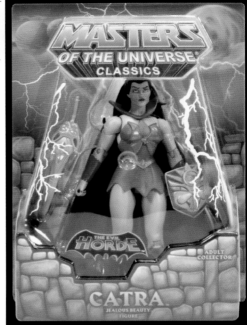

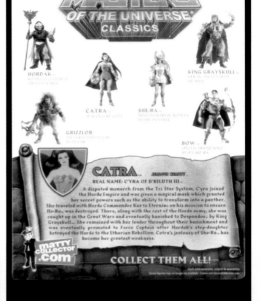

Accessories:
- Sword
- Filmation mask
- Vintage toy mask
- Shield
- Whip

Catra first appeared in the original Princess of Power toy line from Mattel in the 1980s, also appearing as one of the main members of the Evil Horde in the Filmation She-Ra animated series. Like many of the Princess of Power characters, the design in the cartoon was quite different from the design of the original action figure.

The Masters of the Universe Classics action figure's design is heavily inspired by Catra's appearance in the classic cartoon. She is wearing her red uniform, with a long purple cape down her back. Sitting on her forehead is the Filmation-style cat mask, complete with green eyes. In the series, Catra would lower this mask over her eyes in order to change into an actual panther. While the mask is removable, it unfortunately is not designed in a way that allows it to be lowered over her eyes.

While the figure mostly takes inspiration from the animated look, there are several included accessories that are direct nods to her classic toy. A silver cat mask matches the design of the mask that came with the vintage action figure. Unlike the red mask, this one is meant to clip over Catra's eyes. She also has her classic silver shield, complete with pink gem. She even has a pink sword modeled after the one that was included with the vintage variant known as Shower Power Catra. And humorously, she even has a new whip accessory that pays homage to the comb that came with the original action figure with the design of the handle.

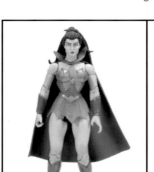

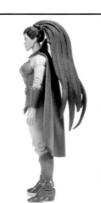
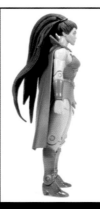

FUN FACTOID: The Four Horsemen said, "Like so many of the POP characters, this was an finally a chance to show Catra in her true Filmation look. Even though we technically didn't have the Filmation license at this point, the inspiration is unmistakable."

CERATUS
HEROIC LEADER OF SUB-TERNIA

First released 2015 • Member of the Heroic Warriors

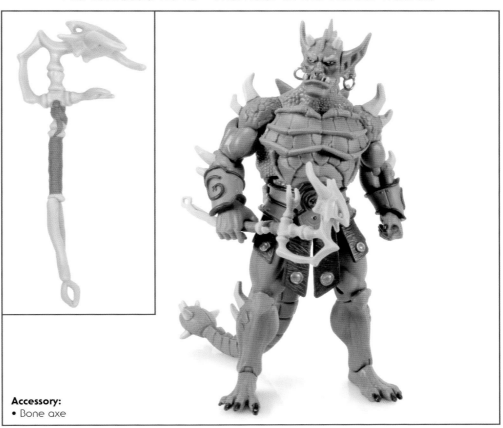

Accessory:
• Bone axe

Ceratus is the leader of the Caligar race of which Whiplash belongs. He is a heroic character that was first introduced in the 200X Mike Young Productions animated series, aligned with King Randor as part of his Eternian Council.

Unlike Whiplash before him, Ceratus's overall design is much more similar to the hyperdetailed look of the 200X-era. While he does feature some parts reuse from figures such as Whiplash, a large majority of the sculpt for this character's first-time figure is brand-new! The torso overlay is a new sculpt, featuring quite a bit more detail than the one used for Whiplash. He has a new loincloth piece, new arm pieces, and even a different tail than that seen on Whiplash. Mattel was well known for reusing a lot of parts in this line, so it's kind of nice to see just how much new tooling Ceratus got—which really makes him stand out as his own character.

The head sculpt features long, pointed ears that are even adorned with real metal hoop earrings. And the weapon given to Ceratus is unique, designed to be some sort of bone axe. Ceratus is a great example of the Masters of the Universe Classics toy line working at its best.

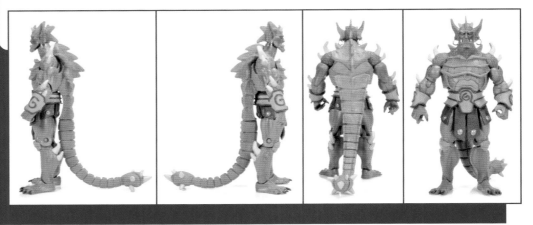

CHIEF CARNIVUS
HEROIC FELINE WARRIOR

First released 2010 • Member of the Heroic Warriors

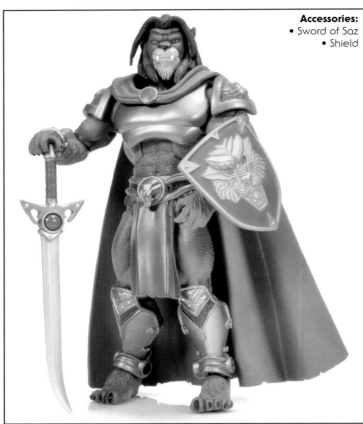

Accessories:
• Sword of Saz
• Shield

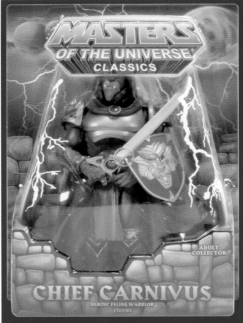

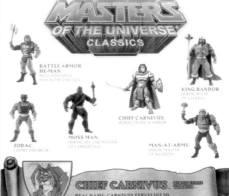

Introduced during the 200X animated series by Mike Young Productions, Chief Carnivus is the leader of a race of Eternian cat warriors known as the Qadians and is a member of King Randor's Eternian Council. This is the first time the character has ever been offered as an action figure.

Chief Carnivus was one of the earlier examples of Mattel introducing characters with first-time toy representation into the Classics toy line. As was standard practice for the line, the figure features a decent mixture of new and reused parts. The majority of the figure is reused from Beast Man, whose furry body sculpt works well for the cat creature. Brand-new armor, a cape, and of course a head sculpt were created to closely match his 200X animated series appearance while still allowing him to fit within the design of the rest of the MOTU Classics toy line.

Both of the figure's accessories were created specifically for this toy and are unique. The shield bears a cat emblem which was modeled after the cat head seen on the Central Tower of the vintage Eternia play set. And the new sword, referred to as the Sword of Saz in Matty Collector's ad copy, features a circular red gem at the center of the hilt, which is reminiscent of another famous sword that is also wielded by a cat warrior.

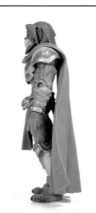

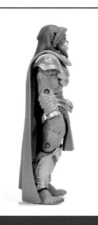

FUN FACTOID: The Four Horsemen said, "This figure is a good example of how the Classics parts reuse model came into play. He had a healthy mix of new parts with recombined existing parts, but he also had another important element, which was new parts that could be reused going forward. In this case it was the section between the knee and the top of the leg armor, which we knew we needed moving forward for Grizzlor."

CLAMP CHAMP
HEROIC MASTER OF CAPTURE

First released 2013 • Member of the Heroic Warriors

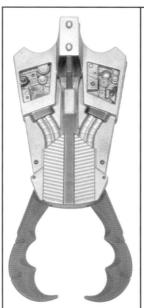

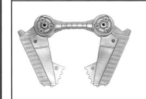

Accessories:
- Power clamp
- Mini power clamp

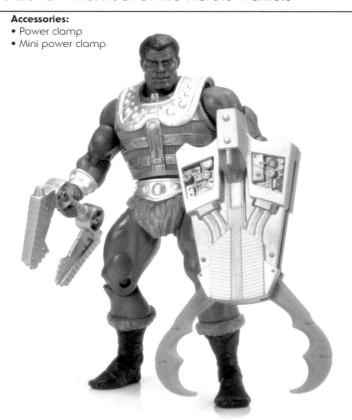

Clamp Champ comes straight out of the vintage Masters of the Universe toy line! While the original figure was a massive reuse of parts, this new figure still does an amazing job of bringing him to life with an updated look. The head, specifically, is a gorgeous new sculpt. The body itself is mostly reused from the standard He-Man buck, as expected, but Mattel did go the extra mile by giving him a brand-new armor piece with a detailed sculpt, even including some of the design elements first seen in the 200X redesign of the character.

Of course the biggest draw of the vintage action figure was his oversized clamp weapon. The new clamp looks a lot like the original, but it is updated with some better details. However, unlike the original, this new clamp does not feature the button-triggered clamping action feature. Instead, the two red claws are just articulated, allowing you to move them separately to grasp other figures.

The second accessory is a smaller mini clamp that can be held in his hand. This is also modeled after the 200X redesign. It's just a solid piece, so this one cannot clamp shut like the larger one.

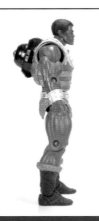

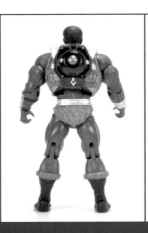

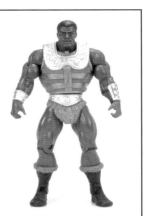

CLAWFUL
WARRIOR WITH THE GRIP OF EVIL

First released 2011 • Member of the Evil Warriors

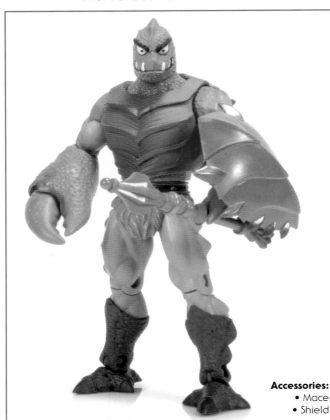

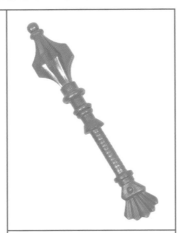

Accessories:
• Mace
• Shield

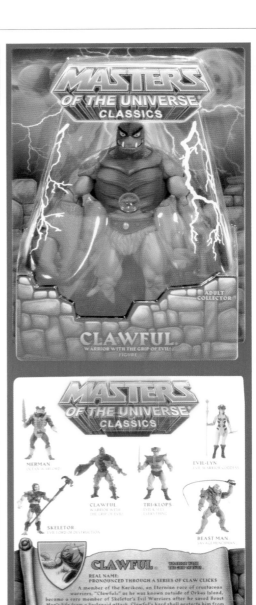

Many figures in the Masters of the Universe Classics line did a pretty good job of mixing and matching the various appearances of the characters from various media in an effort to make something that felt like a good mixture, almost making "ultimate" versions. Clawful had a pretty drastic redesign during the 200X-era cartoon, making him bigger and much meaner looking overall. But when it came time to bring the character to Classics, Mattel opted to go back to the look of his vintage action figure as inspiration.

This new figure looks like a perfect upgrade of that vintage toy, all the way down to the dopey look on his face with oversized, black eyebrows. His shell armor is nicely designed to fit over the standard Classics buck, which is very similar to how it was handled in the vintage toy line.

Since action features were typically removed from figures in the Classics toy line, this new version of Clawful does not feature the lever on the underside of his signature claw. However, you can still open the claw with your fingers, and it does still snap back in place when you let go—effectively leaving the action feature mostly still intact. It's just missing the lever.

For weapons, he comes with a green mace that is modeled after the weapon that was included with his original 1980s action figure, but also has a brand-new sheild that is sort of shaped like the shell on his back!

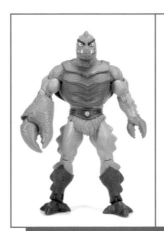

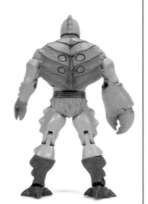

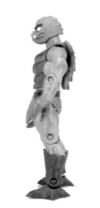

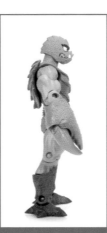

FUN FACTOID: The Four Horsemen said, "This was a much more controversial figure than we ever expected. We still stand by the classic look of his head, but many wanted a fiercer look than we provided. Luckily the 200X head pack came to the rescue and we had the opportunity to create a head that was much closer to some fans' expectations."

COMMANDER KARG
EVIL MASTER OF CRUELTY

First released 2020 • Member of the Evil Warriors

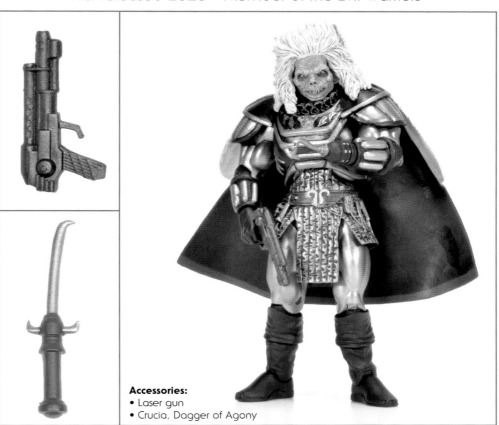

Accessories:
• Laser gun
• Crucia, Dagger of Agony

Karg received this second action figure release thanks to Super7's William Stout Collection. This series of four figures finally allowed for characters from the 1987 Masters of the Universe motion picture to be released, because they were based on the costume designs by William Stout.

While the figure is mostly the same as the previous release, this time around, the paint deco is far more accurate to what we saw in the film. Karg's skin is much paler, as opposed to being the bright green used previously, and his outfit is now a more metallic bronze. The one major difference in the sculpted details can be found with Karg's hook hand, which more accurately reflects the hook's onscreen appearance, as opposed to the comic story version from the previous release.

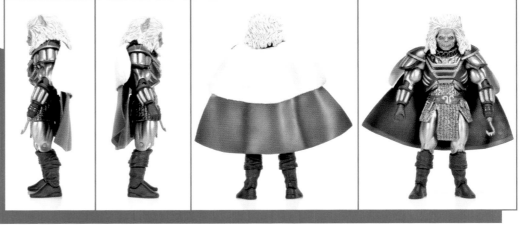

MOTUC - SECTION 1

COUNT MARZO
EVIL MASTER OF MAGIC

First released 2010 • Evil Villain

Accessories:
• Sword
• Amulet of Avarice

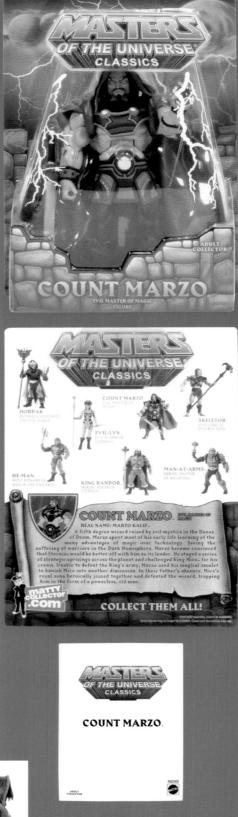

Count Marzo appeared as a standalone villain in both the Filmation cartoon series in the 1980s and again in the Mike Young Productions series of the 200X-era. This is the first time Marzo has appeared as an action figure, with this toy's design based on the character's redesign from the 200X series.

The figure mostly utilizes the now-standard Masters of the Universe Classics body but has some unique newly designed parts. Marzo is packaged with a new sword, as well as his signature amulet that was seen as the source of his power in the 200X animated series.

The new loincloth piece features a place to holster both his sword at his side and his signature amulet on the back! And if that wasn't enough, he also features a brand-new open hand sculpt that was designed specifically to hold on to that amulet, allowing you to re-create poses of Count Marzo holding out the amulet to cast evil spells toward his foes!

FUN FACTOID: The Four Horsemen said, "This figure came with a bit of controversy. We discovered quickly that the approach to the 200X figures needed to be more about including the design elements and less about incorporating any of the stylistic flourishes. This was the figure that sparked the term 'Hyper Anime Detail.'"

CRINGER
HEROIC "SECRET IDENTITY" OF BATTLE CAT

First released 2011 • Beast of the Heroic Warriors

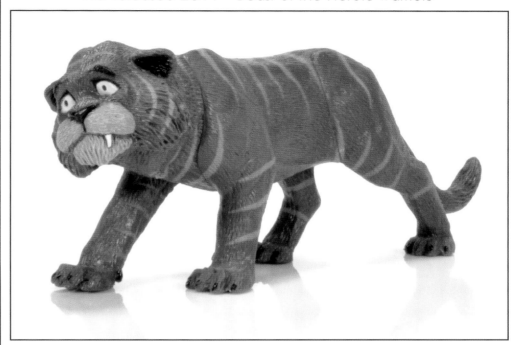

Cringer was a pack-in figure with Captain Glenn / Queen Marlena. This is a smaller figure that represents Battle Cat in his cowardly, untransformed state. Cringer features only two points of articulation—one for his head and one for his tail.

He is heavily inspired by the appearance of the character in the original Filmation cartoon series, complete with one snaggletooth and a very worried look on his face. He's much smaller than the Battle Cat figure released prior, and honestly may be a bit undersized compared to the Cringer that appeared in the cartoon. But at any rate, unless you count the vintage Battle Cat with his armor off, this marks the first time an official Cringer action figure has been released.

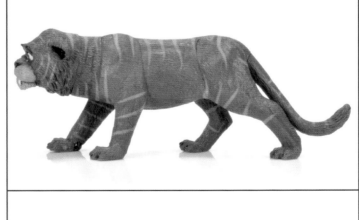

MOTUC - SECTION 1

CRITA
EVIL MUTANT BEAUTY

First released 2016 • Member of the Space Mutants

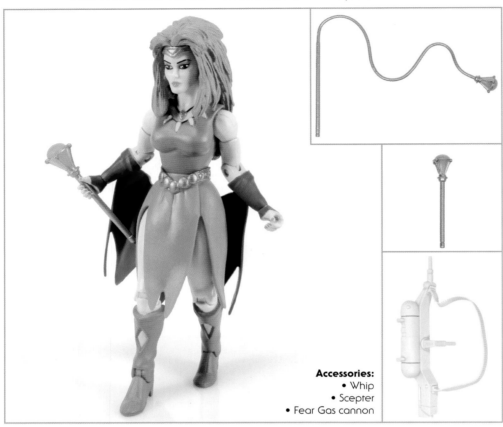

Accessories:
- Whip
- Scepter
- Fear Gas cannon

Crita is a character that had previously only been featured in the New Adventures of He-Man animated series. This is the first time she has appeared as an action figure.

The figure has a lot of newly sculpted parts, doing a great job of bringing Crita's eighties glam-rock design to life in plastic form. Her unique cape is made of a softer plastic and is permanently attached to the middle of her back as well as the back of both of her forearms. It looks great, but it is worth noting that it slightly hinders the posability of the arms, making it a bit hard to lift them outward.

For accessories, she includes a golden scepter with a red gem at the top. She also includes a whip which essentially is that same scepter, just extended and transformed into a whip. It's made of a more solid plastic, so it is not flexible. She also includes the Fear Gas cannon that can be wielded two handed, which comes straight out of the animated series.

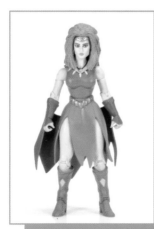

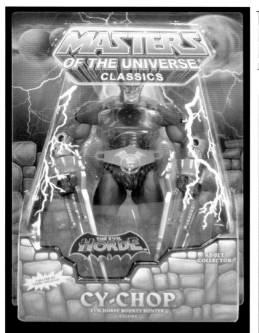

CY-CHOP
EVIL HORDE BOUNTY HUNTER

First released 2012 • Member of the Evil Horde

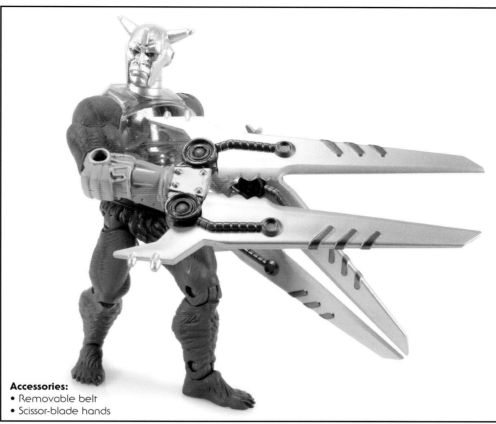

Accessories:
- Removable belt
- Scissor-blade hands

While Mattel was running the new Create a Character contest, they also introduced several original characters into the line that were created by various Mattel staff members. Cy-Chop is an all-original character created by Mattel designer Terry Higuchi.

He's quite the hodgepodge of preexisting parts, with a few new pieces that truly make this character stand out as something unique. Terry mentioned that while designing this character, he was going for a Japanese anime robot look—and that theme truly comes through. He utilizes the furry arms and legs sculpt from Beast Man with some of the robotic pieces, such as the translucent chest, of Roboto. Within that chest, instead of gears, you can see Cy-Chop's guts.

Instead of hands, Cy-Chop has scissor-like blades. The blades are quite large, almost the same length as the figure's torso. They are articulated, so you can pose them open or closed. The blades can also be removed, as they are just attached to the figure's arms using the same socket joint seen on other figures with arm attachments, such as Trap Jaw and Roboto. This means that you can attach any of those figures' arm attachments to Cy-Chop for mix-and-match customization.

FUN FACTOID: The Four Horsemen said, " This was the character creation submitted by the Mattel design team. Terry Higuchi was the specific designer who came up with Cy-Chop, who was a very cool and unique addition to the lineup. He not only serves as an evil match for Roboto, but he also adds to the ranks of the Evil Horde. We liked the combination of the clear torso with the bright silver head, as it reminded us of the old Time Travelers from Micronauts. This guy even had a built-in bonus item: his belt could be used to complement the extra Horde Prime head so that fans could be one step closer to creating the comic look of the character."

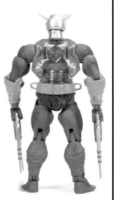
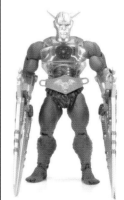

MOTUC - SECTION 1

DARIUS
LEADER OF THE GALACTIC PROTECTORS

First released 2016 • Member of the Galactic Guardians

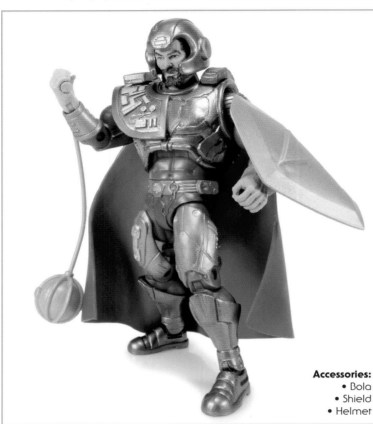

Accessories:
- Bola
- Shield
- Helmet

Darius was set to be released in the original 1989 He-Man toy line. Although he made it as far as being pictured on the card backs as an upcoming figure, the toy never actually saw release. As a result, he gained the status of being a fan-desired unreleased toy.

The character finally got an official toy release as part of the Masters of the Universe Classics toy line. He features new armor that gives off that great futuristic, tech-like vibe. The colors of Darius's uniform, matched up with the long blue cape, make him feel like a "space" version of King Randor—though he is a completely different character.

Most figures in the line that include a cape are usually made so that the cape itself is permanently attached to their armor. Darius stands out from the pack, as his cape is just attached to the shoulders of his armor by pegs and can easily be removed if desired. This allows you to pose Darius in his armor for battle without his cape.

He includes a shield that can be clipped to his wrist, and a bola weapon that can be held in his right hand, which is inspired by the weapon and wrist-spinning action feature that the vintage toy would have had if it had seen release.

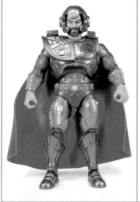 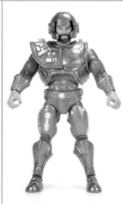 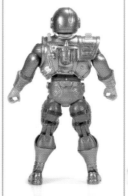 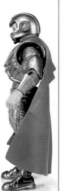 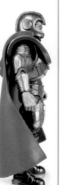

INTERVIEW WITH

SCOTT NEITLICH

Tell me about how you became brand manager for Masters of the Universe Classics at Mattel.

My first job at Mattel was a writer for Hot Wheels basic cars and sets. During my first year, Tim Kilpin (then general manager/SVP of boys) hosted an open Q&A with employees, and I asked, "Why don't we sell He-Man toys for adult collectors?" It was supposed to be a discussion about Hot Wheels packaging needs.

This led to a one-on-one meeting with Tim four months later, where I pitched the idea of what would become Matty Collector, namely that Mattel should take advantage of the growing adult collector market and sell products direct online. From there it was another year before we were up and running, but that was the start of it all!

In the beginning, what were your goals for the brand? What were your expectations?

The Justice League Unlimited Brand was really on fire at the time (this was 2007-ish) and with the common tooling and low deco, I had thought JLU would be the backbone of MattyCollector. The MOTUC figures were assumed to be a one-and-done series of six figures. But the fans supported the line and it took off.

Tooling for the Classics line was very conservative at first, focusing on toys that could share parts to save tooling dollars. Could you talk about that strategy and how it evolved over the course of the line?

Tooling is very expensive. It is the giant metal mold used to mass-produce toys in China. A figure with no shared parts costs close to $100,000 to tool. Whereas a shared-part figure that only needs armor, heads, and weapons could be done for closer to tens of thousands of dollars. Because both JLU and the vintage MOTU line used shared parts, they were great workhorses for Matty Collector, because we could do a ton of characters without breaking the bank and without compromising style.

As the brands and lines proved successful we were able to petition for more tooling dollars. Essentially the more money you make, the more tooling dollars you get assigned. It is a finite resource that needs to stretch to cover a year's worth of product. So a lot of work would go into finding ways to maximize tooling but still offer variety.

Throughout your tenure as brand manager, you acted as the public face of the brand, appearing on podcasts and other fan interviews and fielding fan questions. Obviously this wasn't something anyone was doing in the eighties. How do you feel this impacted the trajectory of the line?

A lot of this came out of the need to market the line and having very few resources to do so. Billion-dollar brands like Barbie and Hot Wheels get huge marketing budgets. Matty had a few coins. So if I could just snap a YouTube video in my cubicle and post it at almost no cost, it was a very effective way to market the line without funds (which for Matty were very limited).

Additionally, because MOTUC did not have content (i.e., a show or movie) I knew we could use "fan interaction," Q&As, forum posts, bios, and online interviews as content and a way to constantly keep people talking about the brand. My idea was the more people are talking, the more they are buying, so let's try to constantly engage with fans. Also, as a toy collector myself, I wanted to run the line the way I wished toy companies would run lines and talk to the customers. It was a bold move, and I think in the end it helped sales.

The adult collector market for action figures is obviously very niche and passionate. How do you feel that the Classics line compares to other competing lines aimed at the same demographic?

At the time I think we were cutting edge. A lot of the things we pioneered at Mattel are mainstream now. Things like the Hasbro Black Series Darth Vader Helmet and Sail Barge owe a lot to our Hoverboard, Ghost Trap, and Castle Grayskull. We broke a lot of ground as a team.

Were there times that you had to fight to get something made and lost? If so what was it?

I really wanted to do energy bursts and magic blasts packs. Our designer in the final year had worked on the 2002 line, which was considered a disaster. So he did not want to do anything that would hark back to this line, and I lost this battle. I had also wanted to keep Batzarro out of the DCU line for the reasons most fans objected (he was never asked for), but this designer also insisted, and I lost that fight.

What was the process like in getting a Classics toy produced, from the name on a piece of paper to the finished toy?

Every year it would start with a line plan based on the number of SKUs we were assigned and the tooling dollars (based on previous year's sales, to oversimplify). For things like MOTUC, I had a seven-year plan drawn up to ensure all the main characters were released and the fully tooled figures were sprinkled throughout the run, to not overburden one year on tooling costs.

From there we would need to present and re-present and re-present and re-present the line to management until they were happy with costs and we had justified and rejustifed every detail . Mattel is big on that.

Once things were approved from a financial point of view, we could move into creative, and design would create B-sheets of each character, showing which common parts to use, which new tools were needed, and how much tooling each figure was assigned.

From there (and again I am oversimplifying), it was off to the Four Horsemen to sculpt.

You had a roadmap for how you saw the line coming out over the years. How did that change over time?

About halfway through the line, costs started rising and fan reaction seemed to be that we were getting a little too obscure with the characters. Also, we gained rights to the Filmation characters about halfway through and those characters (like Batros) were not in the original rollout. So I made a lot of adjustments halfway through, but that was the only major tinkering. Otherwise it was about eighty-five percent from the original plan.

The Classics line is unique in that it included all eras of MOTU, from vintage MOTU to Princess of Power, New Adventures, and the 200X reboot, not to mention comic- and cartoon-inspired figures. Can you talk about the challenges of getting fans with niche interests to buy in to such a diverse line?

A lot of it was about sprinkling in the right amount of each type every year. By far, MOTU figures that had a vintage toy from 1982 to 1987 sold the best. In the end, the only way we would be able to "complete the line" was if each faction supported each other. They did. This line could not have happened if the fan community did not come together and support each other that way.

If you were to manage He-Man again, what direction would you take the brand next?

I would focus on toys for four-to-six-year-olds. I actually had an extensive plan to do this (in conjunction with the Filmation series to extend the six-inch line for adults). But Mattel pulled the plug, as they were terrified that if the line failed again at retail, it would never have a chance again (after three previous "failures" in Mattel's eye). They did not want to take a risk again without a movie/content. And I can't say I blame them at all!

Castle Grayskull is the one item that probably had the most publicity of all the toys produced for the Classics line. Can you talk about the process of getting that made? Most adult collector lines don't have anything quite that ambitious in the lineup.

Yeah, that was pretty much insane. It actually came about because a VP backed me in a corner in front of the company. After the success of the Hoverboard, I was asked by my VP to create another high-end item where one single SKU could do one to two million dollars in revenue. We talked about either a Proton Pack or Castle Grayskull, and settled on the castle since it was our intellectual property.

When I presented the castle as our "next big single item" (in front of two hundred people) to answer the "Hoverboard challenge", the VP very angrily yelled at me, "What are you talking about, Hoverboard challenge? Who in the world challenged you to do this?"

I felt like a deer in headlights because I was in front of the entire company. I meekly had to look her in the eye and say, "Ummm, you did."

She was so embarrassed by this that she had to greenlight the project on the spot in front of everyone, contingent that I could hit 5,000 preorders. If I hit that I could have the tooling dollars ($350,000). This was a challenge to the likes of Hercules's twelve labors. No one ever thought we would do it, so the offer was a bit of a dangling carrot just to shut me up and save face for this VP.

Then we hit 7,500 by the deadline and we got our tooling dollars.

What are you most proud of from your tenure as brand manager?

Finishing the vintage MOTU line in Classics. That was amazing. It has been thirty years and Hasbro still has not done the original Star Wars line in the modern era.

DARK DESPOT SKELETOR
EVIL TYRANT OF ETERNIA

First released 2020 • Member of the Evil Warriors

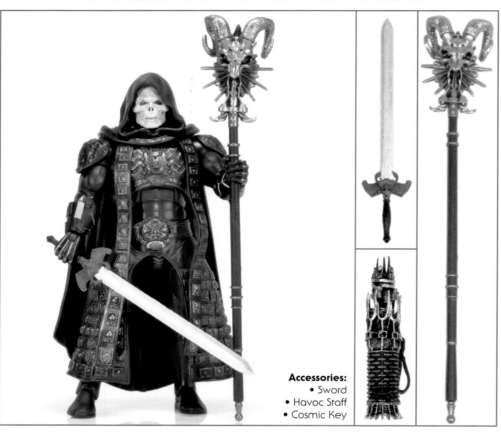

Accessories:
- Sword
- Havoc Staff
- Cosmic Key

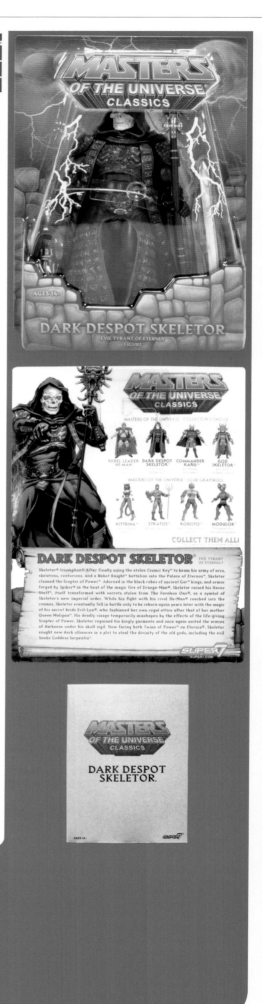

Once thought to be impossible for legal reasons, Super7 was finally able to release a Skeletor action figure based on the portrayal of the character by actor Frank Langella in the 1987 Masters of the Universe motion picture.

The figure was released as part of the William Stout Collection—four figures from the film based on the production art by legendary artist William Stout. Skeletor is depicted in his black robes, adorned with many sculpted bronze decorations to match those original designs. The figure's face reflects the heavy makeup seen in the movie. The white face, which appears to have lips, is quite a departure from the classic yellow-faced Skeletor, but it is iconic nonetheless for fans who grew up with that original film.

This version of Skeletor also comes with multiple unique accessories, including the Havoc Staff and Sword, both perfectly designed to resemble the props used onscreen. However, one of the best inclusions is the brand-new Cosmic Key. The Cosmic Key, of course, played a huge role in the film's story. While we've had a few variations of the Cosmic Key released with various figures in the Masters of the Universe Classics line, this is the first screen-accurate one.

MOTUC - SECTION 1

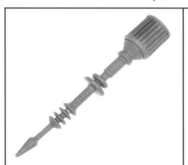
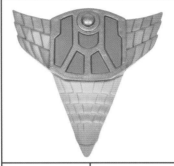

DAWG-O-TOR
HEROIC TALON FIGHTER PILOT

First released 2013 • Member of the Heroic Warriors, Evil Horde (formerly), and Fighting Foe Men (formerly)

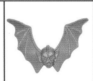
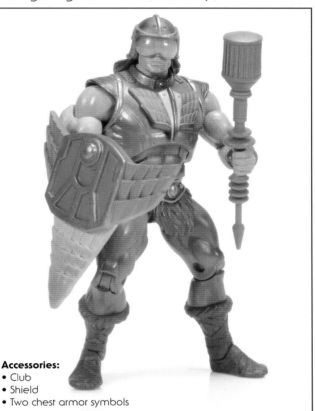

Accessories:
- Club
- Shield
- Two chest armor symbols

Dawg-O-Tor was one of three figures included in the Fighting Foe Men three-pack. This set is filled with nods to various aspects of Masters of the Universe and the folks behind the toy line. Firstly, the name "Fighting Foe Men" is a nod to one of the earliest names that the Masters of the Universe toy line almost went by.

Each of the figures is based on one of the unnamed vehicle drivers that were pictured on the box art for the Masters of the Universe vehicle model kits released in the 1980s by Monogram. Dawg-O-Tor is inspired by the character seen on the box art piloting the Talon Fighter. While the character in this artwork is mostly obscured by the vehicle itself, this new figure was designed as closely as possible to what is shown in the artwork. The insignia on his chest references the Talon Fighter vehicle. His weapons are also inspired by it, with his club essentially being one of the Talon Fighter's blasters, and his shield shaped just like a mini Talon Fighter ship!

The chest insignia can also be removed and replaced with an Evil Horde emblem if desired. This is in reference to the new bio that was written for the Fighting Foe Men in the Masters of the Universe Classics toy line, and allows you to add him to the ranks of your Evil Horde collection if desired. Later bios revealed that Dawg-O-Tor and Shield Maiden Sherrilyn repented of their evil ways and went on to join the good guys, giving collectors yet another display option.

All of the Fighting Foe Men action figures are also named after staff members of Four Horsemen Design —the team responsible for all of the MOTU Classics figure sculpts! Dawg-O-Tor is named in honor of Owen "O-Dawg" Oertling.

FUN FACTOIDS:
- Dawg-O-Tor's tagline and heroic affiliation came from his bio for Masters Mondays on He-Man.org.
- The tagline for the Fighting Foe Men three-pack was "Evil Eternian Pirate Clan."

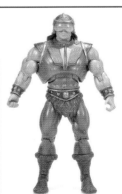

DEKKER
HEROIC TRAINER-OF-ARMS

First released 2012 • Member of the Heroic Warriors

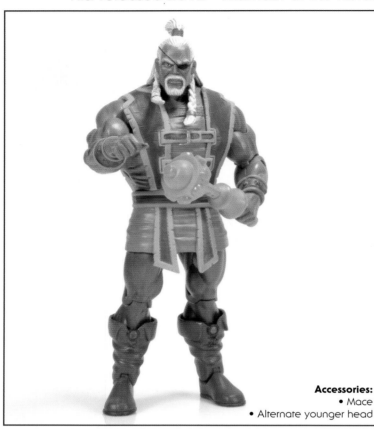

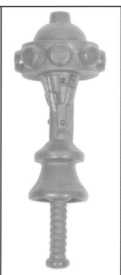

Accessories:
- Mace
- Alternate younger head

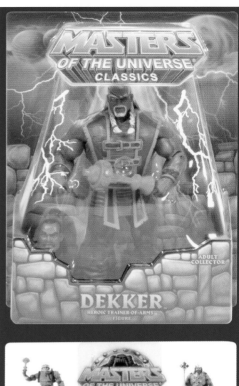

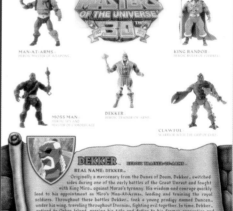

Dekker appeared in one episode of the 200X Mike Young Productions animated series and was introduced as the mentor of Man-At-Arms. This marks the very first appearance of this character in action figure form.

The figure does a great job of matching what we saw in the animated series while still fitting in with that Classics figure style. As an added bonus, the figure includes two heads that allow you to display Dekker as the older, more grizzled veteran we saw in the cartoon or as his younger self. It's a unique addition to the line, as the swappable heads typically allow you to display your figures with different design elements, but not usually as a de-aged version of themselves.

Certain elements of Dekker's design are a bit similar to that of Man-At-Arms, possibly showing where Duncan got some of his inspiration. Dekker has a similar mustache, and even uses the same style of orange mace for battle. While it does look a lot like Man-At-Arms's signature weapon, Dekker's mace is a brand-new sculpt.

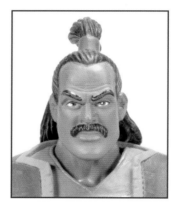

DEKKER

FUN FACTOID: The Four Horsemen wanted Classics to showcase supporting characters like Dekker who probably would never have made it to figure form in the vintage line.

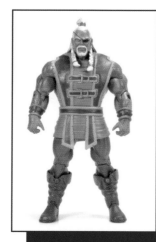
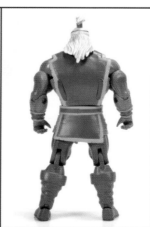
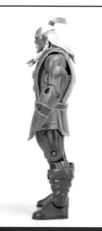
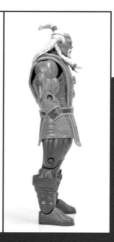

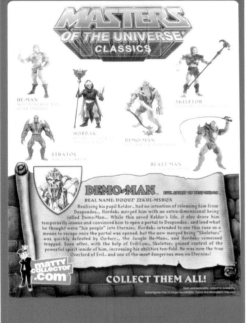

DEMO-MAN
EVIL SPIRIT OF DESPONDOS

First released 2011 • Member of the Evil Warriors

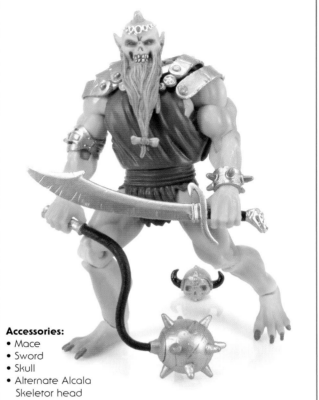

Accessories:
- Mace
- Sword
- Skull
- Alternate Alcala Skeletor head

Demo-Man is based on early artwork by Mark Taylor for a Masters of the Universe villain which was originally believed to be a concept for Skeletor. However, it was later revealed in interviews with Taylor that Demo-Man was meant to be a different character altogether. Little else was known about the character, so a new bio for Masters of the Universe Classics made him part of the official story line. The toy itself, of course, is an action figure of the Mark Taylor concept art.

He includes a cutlass-style sword and a spiked morning star mace, both of which come straight out of that original artwork. He also comes with a small skull wearing a Viking helmet. This is also seen in that original artwork, under Demo-Man's foot. While this was obviously thrown in as a fun accessory inspired by that art, Mattel actually made this skull so that it can fit on the ball joint of the figure's neck, allowing you to use this as an alternate head if desired.

But aside from that skull, Demo-Man also includes a brand-new head meant for your Skeletor action figure. This one is based on the artwork of Alfredo Alcala, seen in the first wave of Masters of the Universe minicomics that were packaged with the original action figures. This allows fans a new way to display the Skeletor action figure already in their collections!

Demo-Man is a great piece of Masters of the Universe history brought to life in action figure form for the first time, and he displays perfectly alongside Vikor—the figure based on early concept artwork for He-Man!

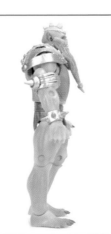
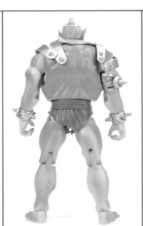
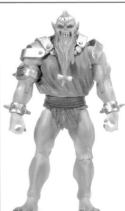

DESPARA
POWERFUL FORCE CAPTAIN OF THE EVIL HORDE
First released 2016 • Member of the Evil Horde

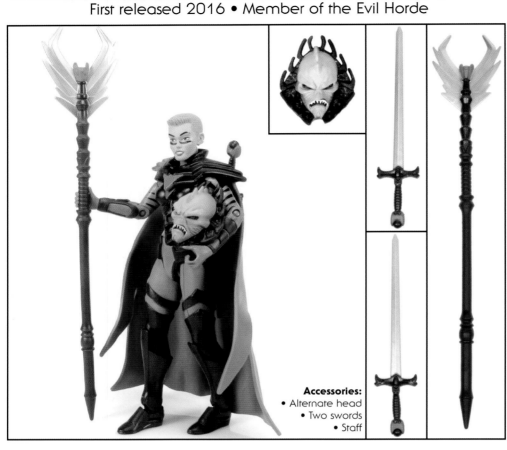

Accessories:
- Alternate head
- Two swords
- Staff

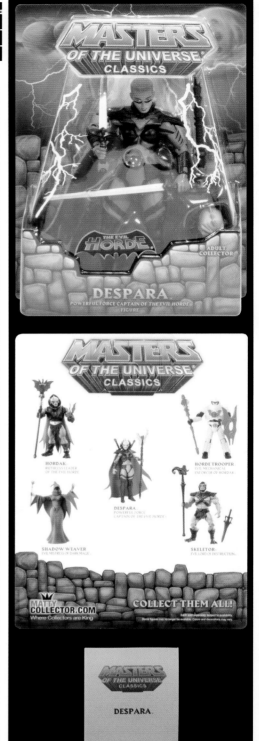

Despara was released as the 2016 Masters of the Universe Classics subscription-exclusive figure. She is based on a story line from the DC comics which was essentially a retelling of She-Ra's origin story, depicting Force Captain Adora in a much darker, grittier role prior to gaining the power of She-Ra.

The figure is modeled after the character's appearance in the comic series. She is wearing a new outfit that pays homage to the leader of the Evil Horde, Hordak. Her masked head even resembles Hordak himself. She also comes with an unmasked head that can be easily swapped onto the ball joint. This Adora head depicts the character with short hair and makeup smeared on her face, giving her a very different look from what we are used to.

Despara is packaged with two swords for doing battle. She can dual wield the blades, and can even holster them on her back when not in use. In addition, she also comes with a unique new Evil Horde–inspired staff.

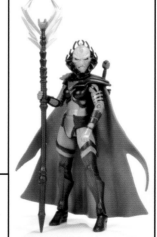

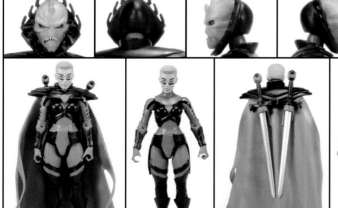

DITZTROYER
EVIL ROTON PILOT

First released 2013 • Member of the Evil Horde and Fighting Foe Men

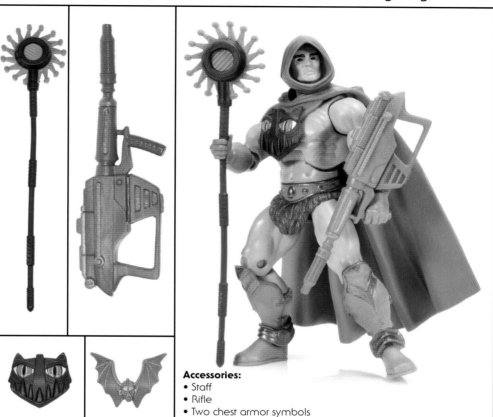

Accessories:
- Staff
- Rifle
- Two chest armor symbols

Ditztroyer was one of three figures included in the Fighting Foe Men three-pack. This set is filled with nods to various aspects of Masters of the Universe and the folks behind the toy line. Firstly, the name "Fighting Foe Men" is a nod to one of the earliest names that the Masters of the Universe toy line almost went by.

Each of the figures is based on one of the unnamed vehicle drivers that were pictured on the box art for the Masters of the Universe vehicle model kits released in the 1980s by Monogram. Ditztroyer is inspired by the character seen on the box art driving the Roton. While the character in this artwork is mostly obscured by the vehicle itself, this new figure was designed as closely as possible to what is shown in the artwork. The insignia on his chest references the Roton vehicle. His weapons are also inspired by it, with his blaster looking like it came straight off the vehicle, and his staff has the Roton shape on the top!

The chest insignia can also be removed and replaced with an Evil Horde emblem if desired. This is in reference to the new bio that was written for the Fighting Foe Men in the Masters of the Universe Classics toy line, and allows you to add him to the ranks of your Evil Horde collection if desired.

All of the Fighting Foe Men action figures are also named after staff members of Four Horsemen Design—the team responsible for all of the MOTU Classics figure sculpts! Ditztroyer is named in honor of Shane Ditzworth.

FUN FACTOID: Ditztroyer's tag line, "Evil Roton Pilot," was included on his unique bio for Masters Mondays on He-Man.org, while the tag line for the Fighting Foe Men as a whole was "Evil Eternian Pirate Clan."

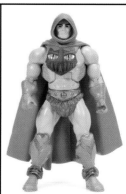

DOUBLE MISCHIEF
GLAMOROUS DOUBLE AGENT

First released 2014 • Member of the Great Rebellion

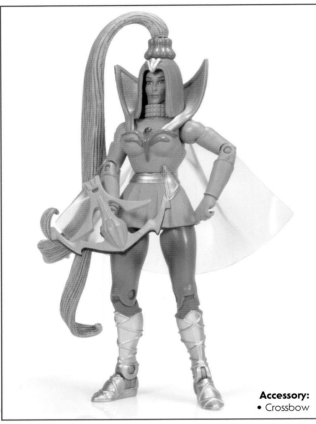

Accessory:
• Crossbow

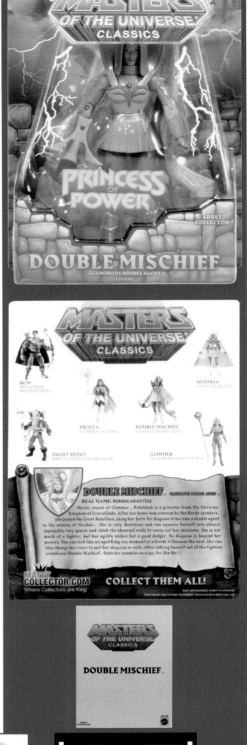

Known as "Double Trouble" in the original Princess of Power toy line, this character's name had to be changed to "Double Mischief" for the Masters of the Universe Classics release for copyright reasons.

Double Mischief works as a double agent for the Great Rebellion, doing work behind enemy lines of the Evil Horde. This concept plays directly into the figure's action feature, which in a rare case for MOTU Classics is intact and works much like it did on her vintage action figure. By turning the knob on top of her helmet, you can change Double Mischief's face from friendly to fierce!

Her overall design is based on her vintage action figure, since she did not appear in the Filmation She-Ra animated series. She includes a crossbow weapon, which has a changing action feature of its own! The front end can rotate, allowing it to switch from a green crossbow to an Evil Horde crossbow, enabling her to fit right in with the rest of the crossbow-wielding members of the Evil Horde!

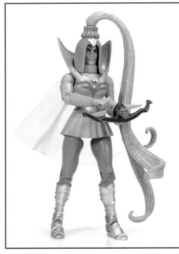

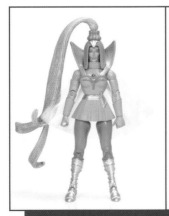

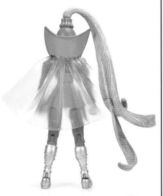

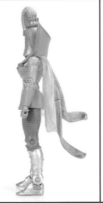

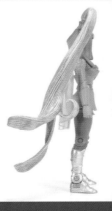

MOTUC - SECTION 1

DRAEGO-MAN
EVIL FIRE-BREATHING MENACE

First released 2012 • Member of the Evil Warriors

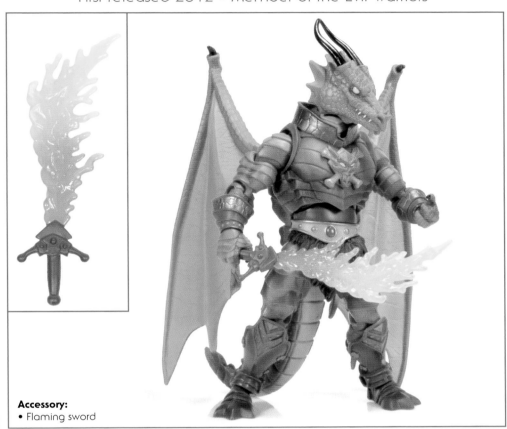

Accessory:
• Flaming sword

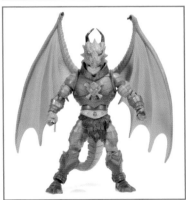

While Mattel was running the new Create a Character Contest, they also introduced several original characters into the line that were created by various Mattel staff members. Draego-Man is an all-original character created by Four Horsemen Toy Design, the team responsible for sculpting all of the MOTU Classics action figures.

Dragons have always had a place in the Masters of the Universe mythos, but until Draego-Man we have never had a humanoid dragon character in action figure form. The bright red creature cleverly reuses some preexisting parts, such as the arms and legs from King Hssss that perfectly work as a scaly reptilian skin. But the figure also has brand-new armor, a gorgeous new head sculpt, and massive, articulated dragon wings.

Draego-Man comes packaged with one brand-new accessory in the form of a flaming sword. The sword blade is made of a partially translucent plastic colored orange and yellow, giving off an amazing fiery effect. Draego-Man was originally planned to also come with a fire whip, but this was cut from the final release of the figure due to budgeting concerns. However, Mattel did find a way to eventually give fans the fire whip by releasing it as part of their third Weapons Pak.

FUN FACTOID: The Four Horsemen wanted the character to feel like it could have been an original eight back figure. As kids they all thought a character with some sort of bat or demon wings was missing.

 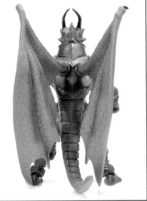 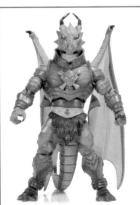

MOTUC - SECTION 1

DRAGON BLASTER SKELETOR
EVIL LEADER & HIS DREADFUL DRAGON WITH PARALYZING SPRAY!

First released 2012 • Member of the Evil Warriors

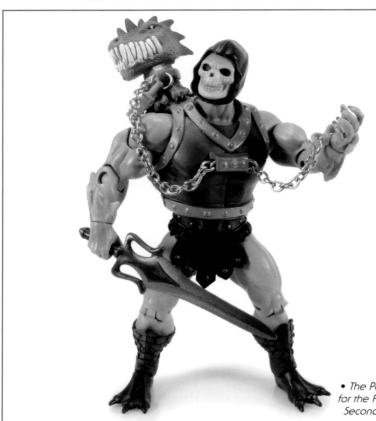

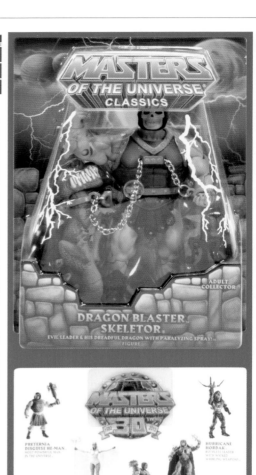

Accessories:
• Purple Sword of Power
• Removable armor with dragon

Minicomic:
• *The Powers of Grayskull: Battle for the Fate of the Universe! (The Second Ultimate Battleground!)*

The original Masters of the Universe toy line included many variants of the main villain, Skeletor, and all of those same variants eventually got updates for the Masters of the Universe Classics toy line.

With the vintage toy, the dragon sitting on Skeletor's back was essentially just the back part of his armor. It was able to be filled with water that it could then spray from its mouth by pressing down on the head. For Masters of the Universe Classics, the water-spitting gimmick has been removed and the dragon itself is a fully sculpted dragon figure that just clips on to the back of Skeletor's new armor via a peg. The dragon is mostly unarticulated with the exception of the head, which sits on a ball joint. Interestingly, this ball joint is the same used for most of the standard Masters of the Universe Classics heads, which means you can swap this dragon head onto a standard body.

The armor looks much like what was seen on that vintage action figure, complete with a real metal chain that attaches to Skeletor's wrist on one end and to the collar of the dragon on the other. Aside from this, Skeletor's only other accessory is his standard purple sword.

There are some changes to the actual Skeletor action figure on this release worth noting. For this version, Skeletor includes the "monster" forearms that were used earlier on figures such as Whiplash. He also has more detailed shin guards that were first used with Kobra Khan, as well as fully painted purple feet making it look as though he is wearing boots. These new parts are notable because if you remove the new Dragon Blaster armor and instead put on the standard Skeletor armor from the figure release, you can effectively re-create a more accurate update of the vintage Skeletor action figure, since it had the same type of forearms and boots.

FUN FACTOID: The Four Horsemen were happy with this update but missed the original figure's water spray feature, which was not possible in Classics.

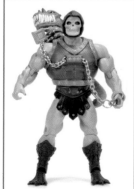

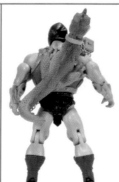

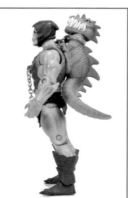

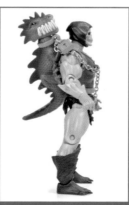

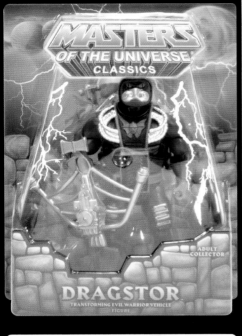

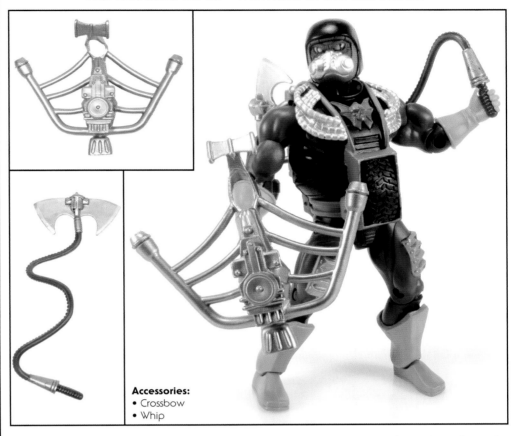

DRAGSTOR
TRANSFORMING EVIL WARRIOR VEHICLE

First released 2015 • Member of the Evil Horde

Accessories:
• Crossbow
• Whip

Dragstor was one of the characters released in the vintage toy line as a very action-feature-heavy figure. The concept of the toy was centered on the giant wheel embedded in the torso of the figure that allowed the character to roll across the floor with a pull of the included ripcord accessory.

Since Masters of the Universe Classics mostly omitted action features like this in favor of articulation and more detailed sculpts, Dragstor is left without the spinning wheel that was such a big part of his original look. This time around, Mattel opted to just make the wheel a part of the armor sculpt that is fitted over the standard buck used on most MOTU Classics action figures.

Even though the spinning wheel gimmick is absent, the figure itself does a great job of updating the unique design of the original action figure with the fantastic details the Classics line had come to be known for.

Just like the vintage figure, Dragstor comes with his signature Evil Horde crossbow. But brand-new to the figure is his secondary weapon. This weapon pays homage to the rip-cord accessory that came with the vintage toy, turning it into a bladed whip weapon that Dragstor can hold in either hand for battle.

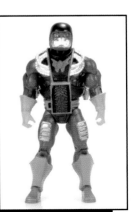

DYLAMUG
EVIL ROBOT WITH ENDLESS EXPRESSIONS

First released 2018 • Member of the Evil Horde

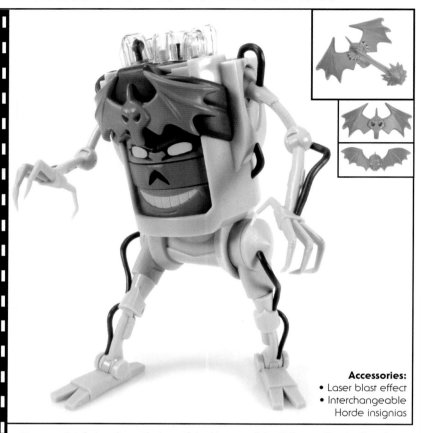

Accessories:
- Laser blast effect
- Interchangeable Horde insignias

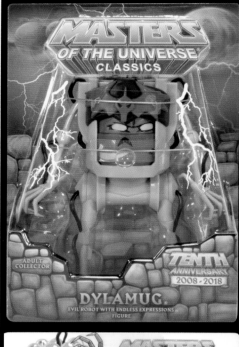

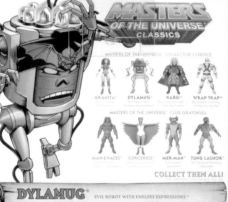

At one point during the early days of the Masters of the Universe Classics line, there was a formula that could be expected with the release of every action figure. Most of the figures shared the same parts and could oftentimes be repurposed for new characters. If a character had a unique look that would call for a one hundred percent newly tooled parts, they were usually off the table. Because of this, Dylamug was a character that many assumed would never make an appearance in this line, but that all changed in 2018.

A version of this character started as a concept illustration by Mattel designer Ted Mayer for an unmade vintage Masters of the Universe figure. Although he was never released as a toy in the eighties, Dylamug appeared in the original She-Ra: Princess of Power animated series as a member of the Evil Horde.

His robotic body is completely different from what you'd expect to see, since his torso also doubles as his face. In addition, he has skinny robotic arms and legs. Dylamug's face often changed expressions in the animated series, and this was captured perfectly in the form of the toy's action feature. The face is segmented into sections, allowing you to spin his eyes and mouth to create several combinations of facial features. He also includes two interchangeable Horde insignia for the top of his head: one that looks like the standard toy design and one like the Filmation cartoon design. Lastly, he also includes a small laser blast effect attached to a third Evil Horde insignia that can also be attached in case you want to display Dylamug firing on his foes!

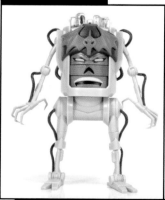

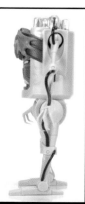

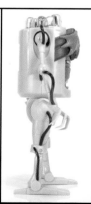

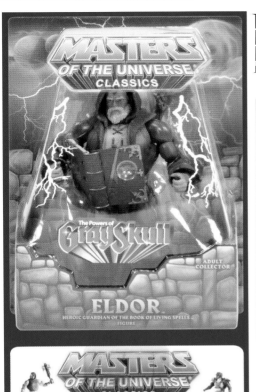

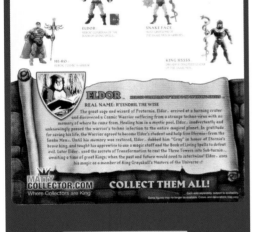

ELDOR
HEROIC GUARDIAN OF THE BOOK OF LIVING SPELLS

First released 2014 • Member of the Heroic Warriors

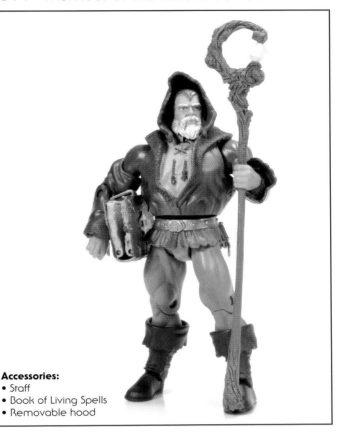

Accessories:
- Staff
- Book of Living Spells
- Removable hood

Eldor was designed to be a brand-new character for the canceled Powers of Grayskull toy line that was going to follow the original Masters of the Universe toy line. He made it as far as the prototype and first shot stages, but never saw release. Pictures of that never-released figure taunted fans for years. Now that Classics was thriving, Eldor could finally be given an official action figure release.

The new figure is heavily based on the design of that original prototype, although much more detailed to match the style of Masters of the Universe Classics. The original figure had a unique hooded tunic. This was brought to the new figure, but includes a removable hood piece that easily clips on to the tunic. This allows you to pose the figure without the hood, fully showing the details of the head sculpt.

The Book of Living Spells is included as an accessory. This large book was shown to be the included accessory with the original figure that never saw release. It was intended to have an action feature of some kind. While this new book does not have an action feature per se, it can be opened. The pages are blank, but it allows you to pose Eldor holding the book as if he is reading magic spells. The included staff containing the Eternian crystal comes from the Filmation He-Man and the Masters of the Universe cartoon episode "The Energy Beast."

 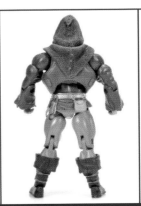 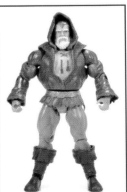

ENTRAPTA
TRICKY GOLDEN BEAUTY

First released 2014 • Member of the Evil Horde

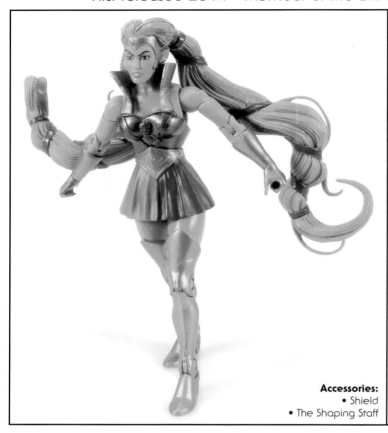

Accessories:
• Shield
• The Shaping Staff

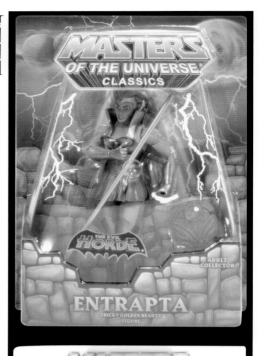

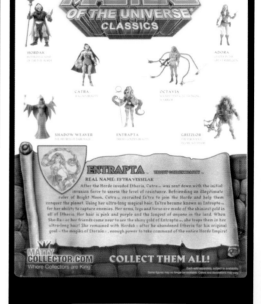

Entrapta combines more design elements from the vintage toy with the Filmation cartoon design than most of the other Princess of Power figures released in MOTU Classics. The Classics figure features the two-toned purple-and-pink skirt, and gold boots from the vintage toy, as well as the more magenta-colored hair. However, instead of the alternating magenta-and-purple hair from the vintage toy, this version features a purple ribbon running throughout the hair sculpt, much like in the Filmation cartoon. The Classics figure also features a solid purple color on the bodice and a more rigid collar design, which is a bit more reminiscent of the look from the cartoon. The eighties toy features a shiny golden vac-metalized body. While that is absent from this new release, the gold used on many parts of the figure does have a clean shine. There is one new addition to the outfit in the form of the small, red Evil Horde symbol on her bodice, showing her allegiance.

The gimmick of the original action feature was in the long, rooted pigtails that Entrapta would use to trap her foes. While the hair is sculpted rather than rooted on this new action figure, the look is still pulled off incredibly well. The braids even feature minimal articulation, allowing you to twist them around for different poses.

Entrapta comes with a shield, much like what we see with many of the Princess of Power characters. Her second accessory, however, isn't even really designed for her. This is the Shaping Staff, which was an artifact of importance in an episode of the original He-Man and the Masters of the Universe cartoon series, in which it was actually used by Evil-Lyn to cause trouble on Eternia. Including memorable artifacts such as this as a bonus would become a regular tradition for the Masters of the Universe Classics toy line.

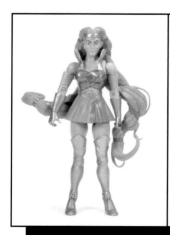 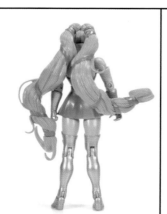

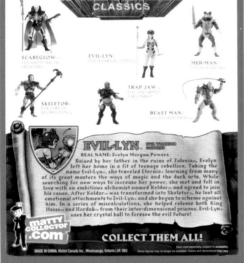

EVIL-LYN
EVIL WARRIOR GODDESS

First released 2010 • Member of the Evil Warriors

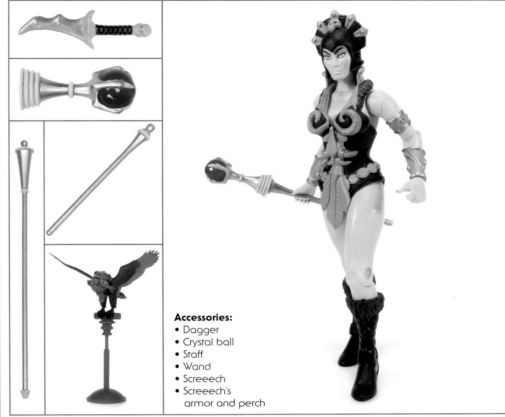

Accessories:
- Dagger
- Crystal ball
- Staff
- Wand
- Screeech
- Screeech's armor and perch

Evil-Lyn is heavily inspired by her original action figure release from the 1980s Masters of the Universe toy line. Though her appearance has changed through various forms of media, this version features the bright yellow skin and blue outfit seen on that original toy. Also like the vintage figure, this new Evil-Lyn reuses the body from Teela, only repainted and with a brand-new head sculpt.

Evil-Lyn is packaged with her wand accessory, but with a new twist. The orb on top is removable, allowing you to display Evil-Lyn with her shorter handheld wand seen on the vintage action figure, or with the longer staff version of the wand often seen in various Masters of the Universe media. In addition, she also comes with the small dagger that was introduced as one of her standard weapons during the 200X-era.

As a pack-in bonus, Evil-Lyn also comes with the evil falcon known as Screeech. Screeech appeared in the original toy line as a standalone, oversized bird. This time the bird is smaller in scale, much more the appropriate size of what you'd expect of a falcon. He's articulated at the wings and includes removable armor and a red perch to stand on.

FUN FACTOID: The Four Horsemen were impressed by how distinctively different Evil-Lyn looked from the Teela figure despite being mostly a repaint. They also liked getting back to her yellow-and-blue color scheme after changing it for 200X.

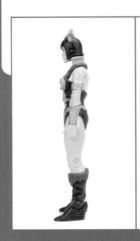

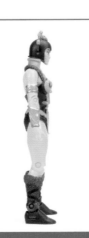

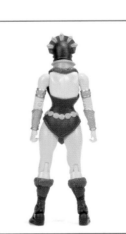

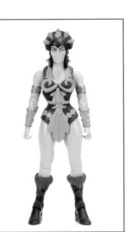

ETERNIAN PALACE GUARDS
HEROIC GUARDS

First released 2011 • Member of the Heroic Warriors

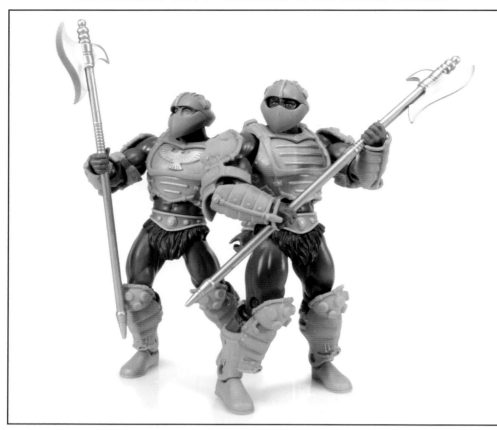

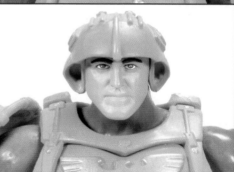

The Eternian Guards two-pack is one of the first instances of an army builder set in the Masters of the Universe Classics toy line. This set is inspired by the palace guards seen in the original He-Man and the Masters of the Universe cartoon series. Their armor is very similar to what we see Man-At-Arms wearing, but there are quite a few differences.

The idea here is that you could buy multiples of this set and build out an entire army of guards if you wanted. To help with this, the set includes four interchangeable heads: two human, one feline, and one reptilian. In addition, each head has a removable face mask that covers most of the face except for the eyes. This allows you to create multiple guards that all look different from one another.

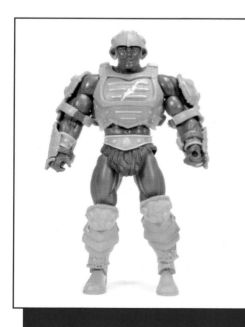
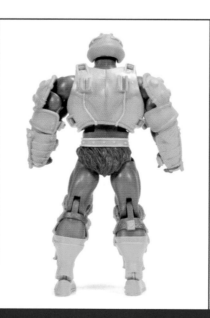
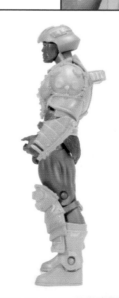
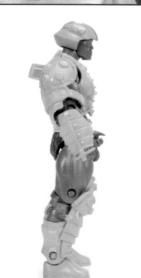

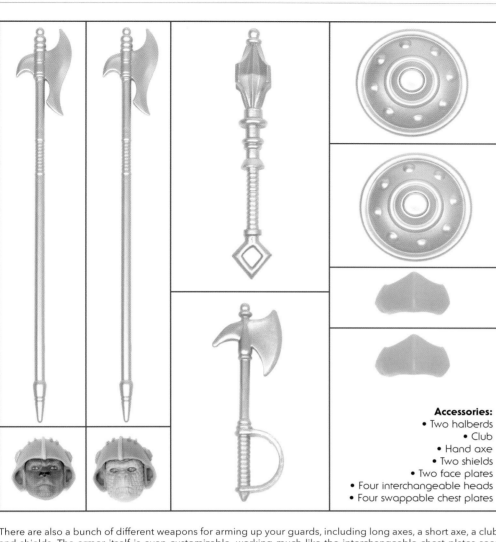

Accessories:
- Two halberds
- Club
- Hand axe
- Two shields
- Two face plates
- Four interchangeable heads
- Four swappable chest plates

There are also a bunch of different weapons for arming up your guards, including long axes, a short axe, a club, and shields. The armor itself is even customizable, working much like the interchangeable chest plates seen on the Battle Armor He-Man and Skeletor action figures. By removing the armor, you can swap chest plates to create different looks and ranks for your guards. Included are the Lt. Eagle insignia, private, private with battle damage, and private with double battle damage! There are many options to create unique guards to help you defend Eternos Palace!

FUN FACTOID: The Four Horsemen said, "One important aspect of these figures for us was to diversify the guards in a way that hadn't been seen before, so we wanted to go beyond human diversity and take it to the next level by including other Eternian races."

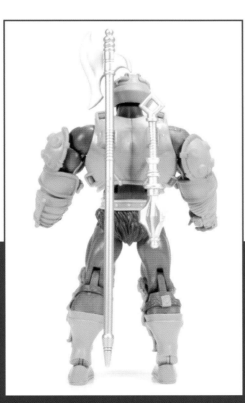

MOTUC - SECTION 1

EVIL SEED
EVIL MASTER OF PLANTS

First released 2015 • Evil Villain

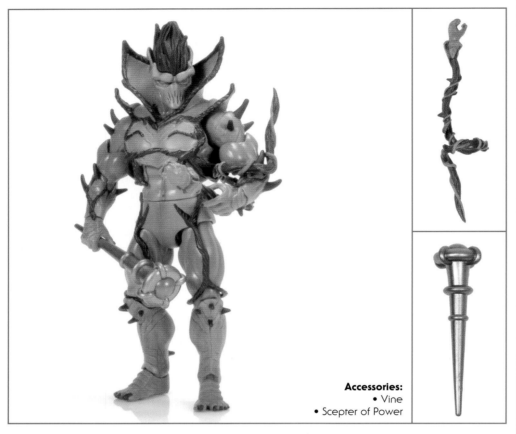

Accessories:
- Vine
- Scepter of Power

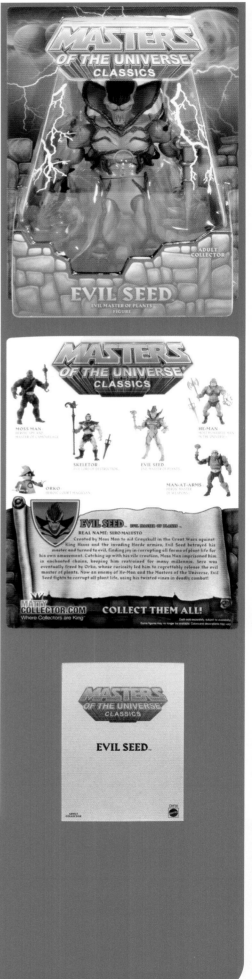

Evil Seed is a character who had never appeared as an action figure before this release. He was created as a standalone villain for the original Filmation He-Man and the Masters of the Universe animated series, and was later reimagined with a brand-new design for the 200X-era cartoon by Mike Young Productions. This figure is based on his look in the latter.

The evil, plant-based character has a lot of newly tooled pieces to create his vine-wrapped look. The new pelvis piece that fits over the standard buck has brown vines attached to that sculpt to come down his legs and wrap around just above the knees. This is quite clever, as it does not at all hinder the articulation of the figure. His arms also feature a lot of newly sculpted details, such as all of the spike-like vines poking out of his shoulders and forearms.

He is packaged with an accessory in the form of another vine that features a small Venus flytrap on the end. This is designed to wrap around his arm and be positioned in his hand, as if it is stretching out from him. In addition, he also includes the Scepter of Power—which isn't actually intended for Evil Seed. In fact, it's not even from the cartoon the figure is based on, but rather the original Filmation cartoon. This is an artifact intended to be displayed with your King Randor figure, another example of Mattel adding bonus accessories of memorable artifacts from various pieces of MOTU lore.

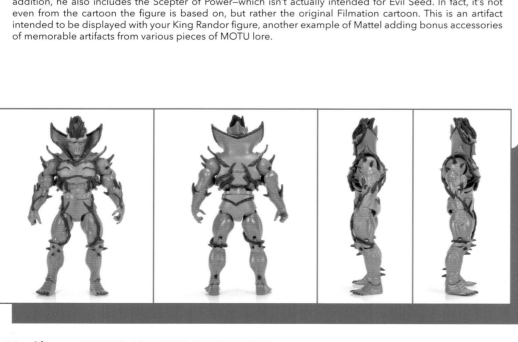

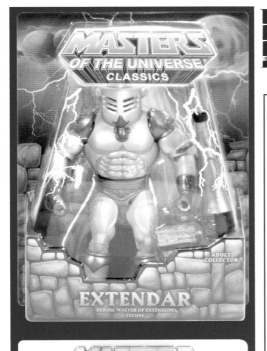

EXTENDAR
HEROIC MASTER OF EXTENSION

First released 2014 • Member of the Heroic Warriors

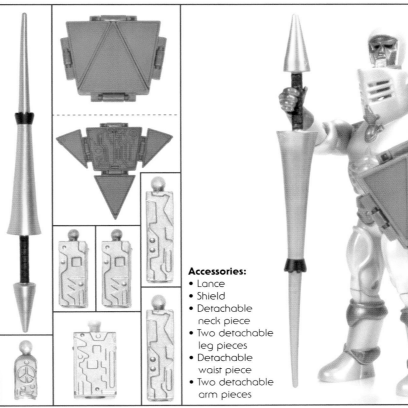

Accessories:
- Lance
- Shield
- Detachable neck piece
- Two detachable leg pieces
- Detachable waist piece
- Two detachable arm pieces

In the original Masters of the Universe toy line, Extendar was one of the characters that really stood out as something unique. Because of his action feature that allowed you to extend the arms, legs, torso, and neck to make the character taller, the figure was much bulkier than most other figures in the line and featured a unique sculpt.

This new version for Masters of the Universe Classics does a great job of updating the look, while maintaining the modern articulation expected of the line. As a result, the figure is handled quite a bit different from the vintage action figure. The extending action feature was removed, but since this character's identity was centered around his ability to extend and grow, the option to do this is still in place—just handled differently.

The figure now includes several detachable limbs, so extending the figure now works by detaching the figure at the arms, legs, torso, and neck and adding in these new extended pieces. They all attach via socket joints, and do a great job of allowing you to display Extendar in his fully extended form, or even mixing and matching pieces for various display modes.

Extendar comes with his classic red shield, which still maintains the ability to unfold into a larger shield, just as it did in the vintage toy line. He also gets a brand-new accessory in the form of a lance, which works so well for the character, seeing as he is depicted as a fully armored knight.

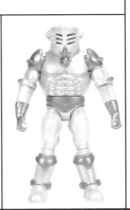

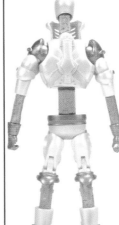

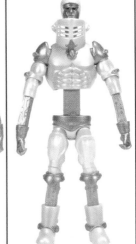

THE FACELESS ONE
ANCIENT LORD OF ZALESIA

First released 2011 • Ally of the Heroic Warriors

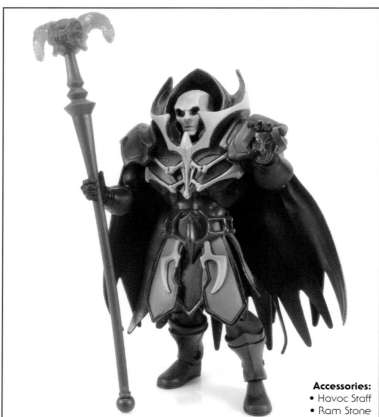

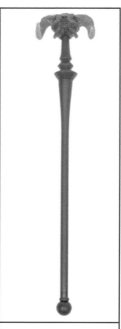

Accessories:
- Havoc Staff
- Ram Stone

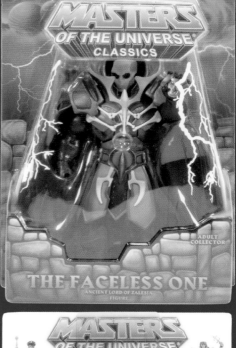

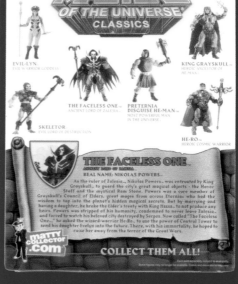

The Faceless One was introduced in the 200X-era animated series as the father of Evil-Lyn. He instantly became a fan favorite, and finally got his very first action figure in the Masters of the Universe Classics toy line.

In the cartoon, his face lacked any detail, with mostly just shadows where his facial features would normally be. This was accomplished in toy form with very minimal details being worked into the sculpt, with a paint deco that attempts to match the shadowing effect from the show.

He mostly utilizes the standard body seen on many MOTU Classics figures, but has a brand-new cape and an armor piece that sits over his shoulders, making him appear much larger and bulkier. His left hand is the same open-handed sculpt seen on other figures, such as Count Marzo, which allows him to properly hold on to his Ram Stone accessory. This Ram Stone played an important role to the character in the show, so it was a must to be included with the figure.

He also includes a brand-new version of Skeletor's Havoc Staff, featuring semitranslucent red plastic on the horns as if it is powered up for a magic blast. From the Faceless One's appearance in the cartoon, we learned that the Havoc Staff originally belonged to him before it was stolen by Skeletor. Thus, it makes sense to include it with this figure, but you can also pose it with your Skeletor, ready to blast his foes!

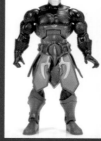

FUN FACTOID: The Faceless One's design was so distinctly 200X that it was hard to get the figure integrated into Classics. The Four Horsemen felt even with fewer details, he still looked very much like an MYP design.

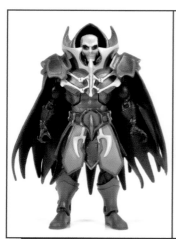

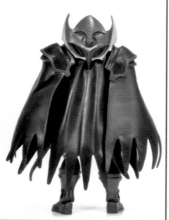

FAKER
EVIL ROBOT OF SKELETOR

First released 2009 • Member of the Evil Warriors

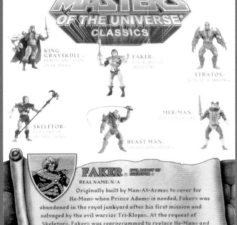

Accessories:
- Orange Sword of Power
- Orange Sword of Power half

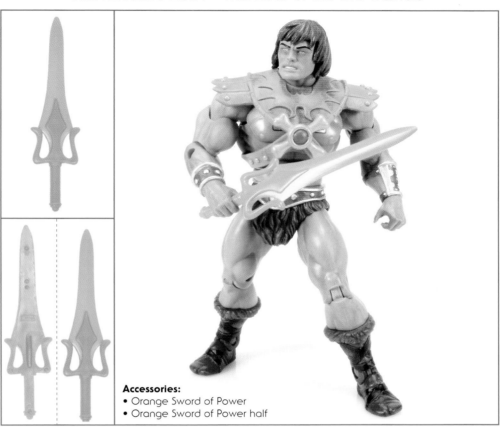

The evil robot version of He-Man known as Faker was nothing but a simple parts-swapped repaint in the vintage Masters of the Universe toy line, yet he quickly became a fan favorite. Since the new Masters of the Universe Classics toy line heavily relied on shared parts, especially in the early days, it was no surprise to see Faker released early on. But at the same time, he was a welcome addition.

Originally offered as an exclusive at the 2009 New York Comic-Con, Faker follows the exact same formula from the original toy line. He uses He-Man's body and head sculpt, this time in a bright blue color. And he reuses the armor from Skeletor, this time in a bright orange. The design is simple, but the paint is vibrant and quite detailed, making for a pretty impressive update to this classic character.

The original figure had a hidden sticker on his chest under the armor that looked like a robotic control panel. That control panel returns for this new update, but instead of a sticker it's been printed directly on to the figure this time.

He also comes with an orange version of He-Man's Sword of Power, as well as an orange version of the half sword. This utilizes the same sculpt as the half sword that was included with Skeletor, meaning it can fit together with He-Man's half—another nod to the original toy line.

MAILER BOX CAME WITH REISSUE ONLY

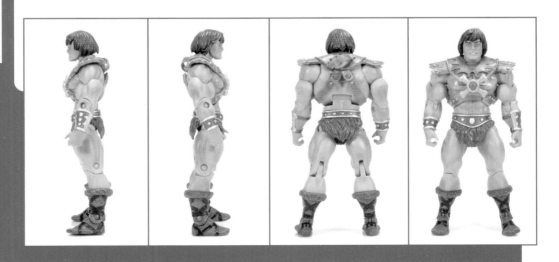

MOTUC - SECTION 1

FAKER (BATTLE ARMOR)
EVIL ARMORED HE-MAN IMPOSTER

First released 2011 • Member of the Evil Warriors

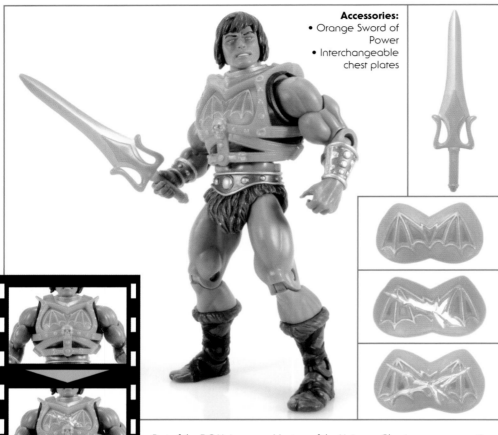

Accessories:
- Orange Sword of Power
- Interchangeable chest plates

Part of the DC Universe vs. Masters of the Universe Classics cross-promotion line-up, Faker was packaged with Bizarro and sold in limited numbers at the 2011 San Diego Comic-Con. As a result of the low sales numbers at the event, this is one of the harder sets to track down today.

The Faker figure included is mostly the same as the previously released version, but this time includes a fan-demanded new addition. Instead of the usual Skeletor armor, he now comes with an orange version of Skeletor's battle armor, complete with interchangeable chest plates that allow you to swap out for damaged versions of the armor. Aside from the battle armor, Faker also comes with the standard orange version of the Sword of Power.

FUN FACTOID: Battle Armor Faker's tagline did not come with his figure, but was featured on his bio for Masters Mondays at He-Man.org.

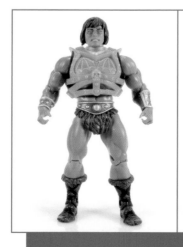
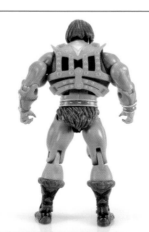
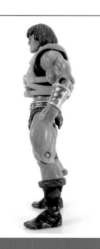
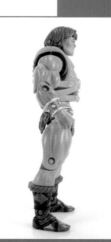

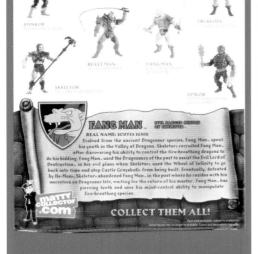

FANG MAN

FANG MAN
EVIL FANGED MINION OF SKELETOR

First released 2013 • Member of the Evil Warriors

Accessories:
- Sword of the Ancients
- Force field rod
- Wheel of Infinity

Fang Man was a villain who appeared in the original He-Man and the Masters of the Universe cartoon series by Filmation. He never appeared in the original line of action figures, making this his very first toy release.

Fang Man has a lot of newly tooled parts in order to pull off his unique look from the cartoon. For example, he still utilizes the standard body seen on most figures in the line, but he comes with a new neck extension piece that plugs onto the standard ball joint. His tunic also adds a bit of a hunch to his back. This allows the figure to look more hunched over with a longer, extended neck as seen in the show.

He also comes with a bunch of accessories, all of which are noteworthy. The two-pronged force field rod wasn't actually seen in the animated series, but was pictured with Fang Man in preproduction artwork. The Wheel of Infinity is an artifact that was used by Skeletor in the episode that featured Fang Man. The Sword of the Ancients is another artifact that was featured in a different episode of the Filmation cartoon series. It doesn't necessarily go with Fang Man, but it is included as a bonus to add another iconic artifact to the Classics line.

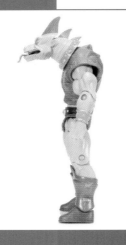

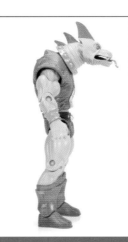

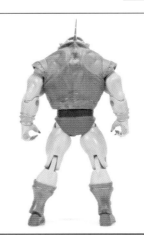

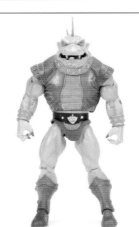

FANG-OR
FREAKISHLY-FANGED SNAKE MEN WARRIOR

First released 2018 • Member of the Snake Men

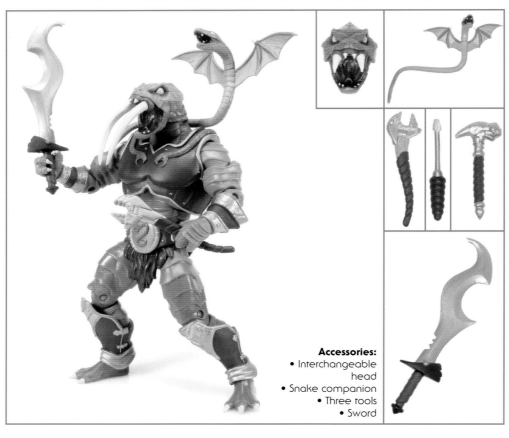

Accessories:
- Interchangeable head
- Snake companion
- Three tools
- Sword

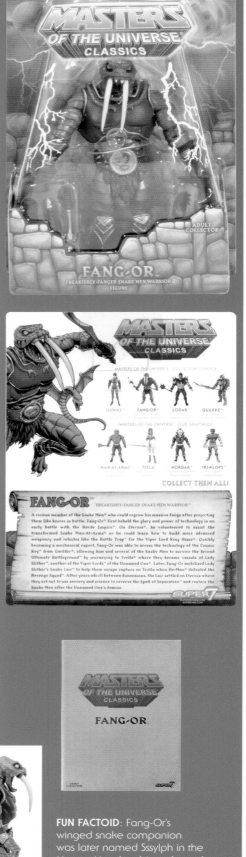

Fang-Or is a brand-new character that first appeared in the new minicomics in the Masters of the Universe Classics line.

This new Snake Man has details that make him feel like he fits right in with many of the redesigns seen during the 200X-era of Masters of the Universe. He features some new armor pieces, and a great design in which his open mouth has elongated fangs jutting out. He also includes a swappable head with shorter fangs if you would prefer to display him this way. The character was created with the mind set that if he had appeared in the vintage Masters of the Universe toy line, his action feature would have been extending fangs. The interchangeable heads are meant to mimic this without actually including the action feature.

Fang-Or is also a bit of a handyman, as he comes with several brand-new accessories in the form of snake-themed tools. A wrench, a hammer, and a screwdriver are all included and are uniquely designed!

FUN FACTOID: Fang-Or's winged snake companion was later named Sssylph in the Masters Mondays bios released on He-Man.org.

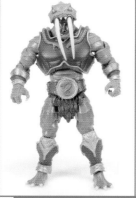
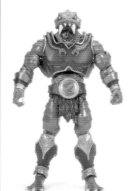
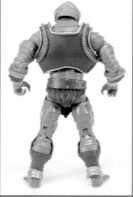
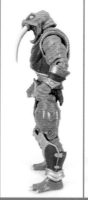
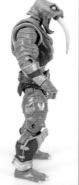

FEARLESS PHOTOG
HEROIC MASTER OF CAMERAS

First released 2012 • Member of the Heroic Warriors

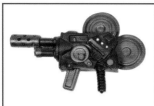

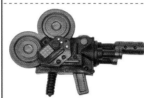

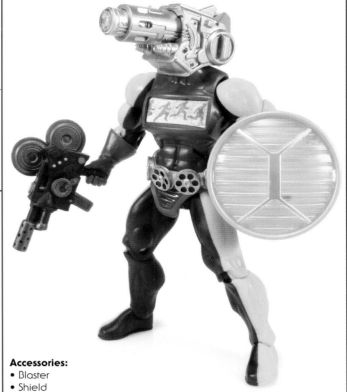

Accessories:
• Blaster
• Shield

MOTUC - SECTION 1

Fearless Photog was the winner of the original Create a Character contest that Mattel ran in the 1980s. The winning design was supposed to be turned into a real action figure, but it never happened. That is, until Masters of the Universe Classics came along and Mattel finally made good on their promise.

Created by contest winner Nathan Bitner, Fearless Photog is an interesting-looking robotic character with the features of a camera. He was originally depicted as having a screen on his chest with images of his subjects. This screen was brought to life on the new figure and given a distinctive lenticular sticker, so the image appears to show movement when the figure is moved from side to side.

The head has a very robotic look, resembling a mechanical camera. The lens even has the ability to slightly extend, as if he is zooming in. Adding to the overall film and photography feel, his belt resembles several film reels. His shield looks like a large camera flashbulb, and his blaster even looks like a classic movie camera.

It's a really bizarre design, even for Masters of the Universe. But he had become quite the legend in the fan community, so seeing Mattel finally make good on their promise by releasing him in figure form, as well as crediting Nathan as the contest winner, was certainly welcome.

FUN FACTOID: The Four Horsemen said, "It actually didn't take many new parts to make this character a reality, but the importance of finally following through with him was a historic moment for MOTU. It took decades, but the fan-created, contest-winning Photog finally became an official Masters of the Universe action figure!"

FISTO
HEROIC HAND-TO-HAND FIGHTER

First released 2012 • Member of the Heroic Warriors

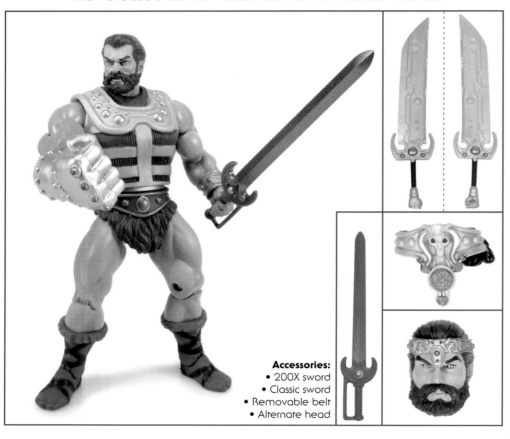

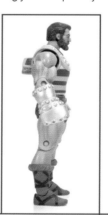

Accessories:
• 200X sword
• Classic sword
• Removable belt
• Alternate head

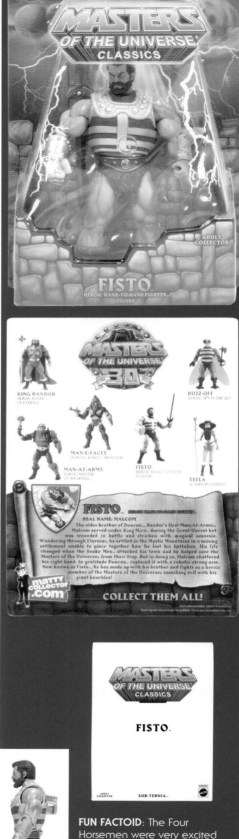

Fisto in Masters of the Universe Classics is one of the strongest examples of what this line can offer. A classic character from the vintage toy line, Fisto also appeared in the 200X-era with a slight redesign. All of the elements from both the classic toy and the update can be found in this new figure, allowing you multiple ways of display.

The sculpt is a great update of the original, with fantastic detailed sculpt work, specifically in the face. He features his signature oversized fist on the right hand, painted a nice shiny silver to give it a metallic look. And one of the most striking new details on the figure's sculpt is the larger, vein-popping bicep muscle on the right arm—giving the impression that his right arm is much stronger due to lugging around that huge metal fist!

He comes with two different heads, the only real difference between them being that one features the headband that was introduced to the character in the 200X-era, while the other is bare in the style of the vintage figure. He also has a removable belt, which helps complete his more modern look. And as far as weapons go, you have the option of arming him up with his classic purple sword or his oversized, stylized silver sword.

FUN FACTOID: The Four Horsemen were very excited about the inclusion of Fisto's never produced 200X sword. Although it was ridiculously huge and over the top for Classics, they were happy that the design could finally be seen and owned by the public.

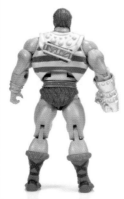

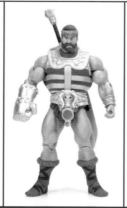

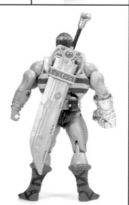

FLOGG
EVIL LEADER OF THE SPACE MUTANTS

First released 2014 • Member of the Space Mutants

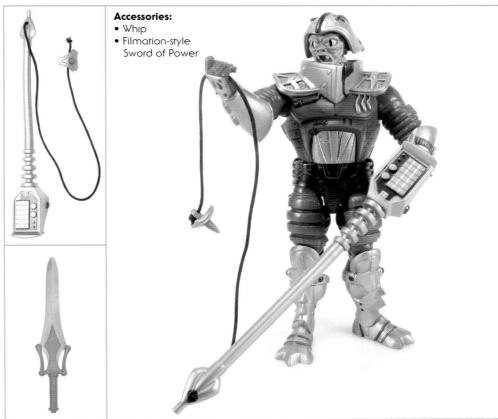

Accessories:
- Whip
- Filmation-style Sword of Power

Flogg was presented as the leader of the evil Space Mutants in the 1989 He-Man toy line—at least until Skeletor joined their ranks. The original action figures in what is often referred to as the "New Adventures of He-Man" toy line were much smaller in size than the vintage Masters of the Universe figures. Bringing a character like Flogg to Classics allows us a chance to have these characters fit in a little better with many of the more recognizable Masters of the Universe characters.

Flogg has a very futuristic look to his overall sculpt, featuring lots of new parts for his bright red and silver spacesuit. His head stands out, as it's a light shade of purple and has sort of a mutant reptile look to the design. Atop his head sits a silver helmet which appears to be a separate piece, but is in fact glued in place. This is interesting, considering the helmet was a removable accessory on the vintage toy. Typically, Classics did a good job of retaining many features like that from the original toys, so it's a bit odd that the new helmet cannot be removed.

For accessories, Flogg includes his unique whip weapon, complete with a real piece of black string, just as it was presented on the vintage action figure. He also comes with a bonus accessory that isn't actually meant for him. Instead, this weapon is intended for display with He-Man, as it's a newly sculpted version of the Sword of Power, styled more as it appeared in the original Filmation animated series!

FUN FACTOID: Flogg's "real name," Brakk, was based on his action figure's European release.

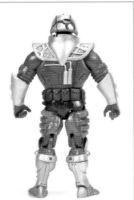

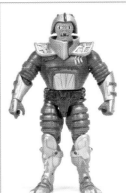

FLUTTERINA
BEAUTIFUL "FLYING" LOOKOUT

First released 2014 • Member of the Great Rebellion

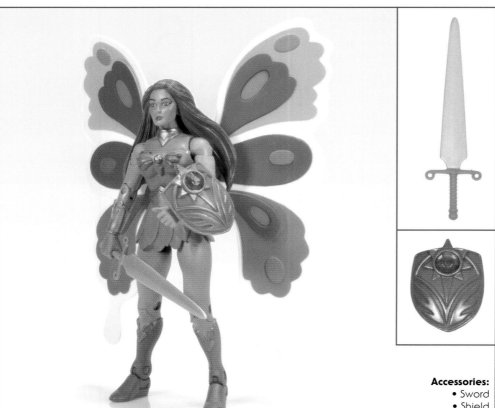

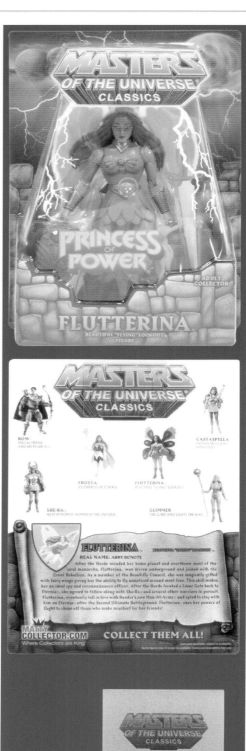

Accessories:
- Sword
- Shield

Like with many of the Princess of Power characters in the Masters of the Universe Classics toy line, this figure's design is very similar to how the character appeared in the She-Ra: Princess of Power cartoon from Filmation. But her original 1980s action figure was not too dissimilar in design, and many elements from that original figure's design are worked into the design of the new one.

The purple designs on her bodice are lifted straight off of the vintage action figure. And while the colorful patterns seen on her wings are similar to the cartoon, they too are actually based on the patterns seen on that original toy. Speaking of the wings, they have to be attached to the figure upon removing her from the packaging due to the large size. They plug into two ball sockets on her back, and are easily articulated. Her hair is cleverly designed to flow around her wings, thus hiding the ball joints.

Flutterina comes with an orange version of the gem-studded shield seen with many Princess of Power characters. And to give her more attack power, she also includes a sword. The sword design is the same as the one that was included with Battleground Teela, this time with a pink color to match up with Flutterina's outfit.

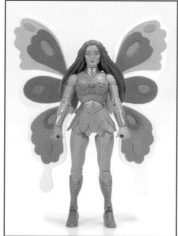

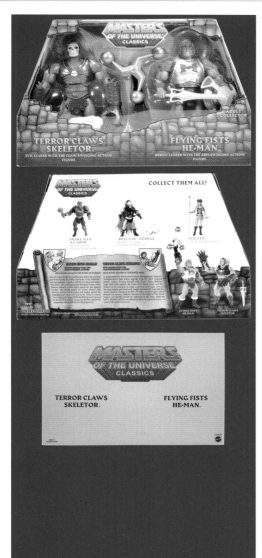

FLYING FISTS HE-MAN
HEROIC LEADER WITH THE ARM-SWINGING ACTION

First released 2015 • Member of the Heroic Warriors

Accessories:
- Spinning three-headed mace
- Rotating shield
- Sword of Power

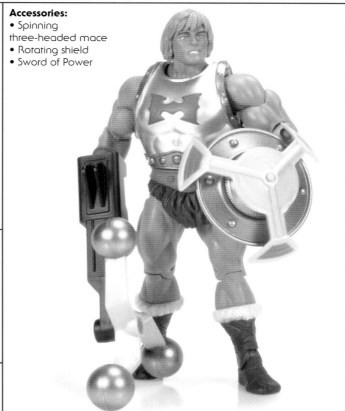

All of the He-Man variants from the vintage Masters of the Universe toy line got updated figures for Classics. However, many of those vintage variants had specific gimmicks. Oftentimes, these gimmicks are completely removed from the new figures, since Classics tends to strip away action features in favor of articulation.

The original figure would swing his arms, which would cause his special new mace and shield weapons to spin and rotate. While the new versions of the weapons retain the ability to spin, He-Man himself does not have an action feature to activate them.

Flying Fists He-Man is wearing silver armor just like the original figure. However, instead of the vac-metalized chrome-like look of the vintage action figure, this new one has a silver paint job that has a mild shine to it. The chrome look of the weapons is also not present time; instead they are made of a dull gray plastic. Admittedly, this makes them feel slightly less special than the originals, lacking that distinctive shine.

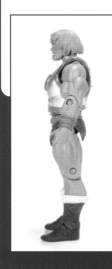

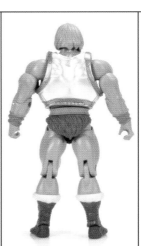

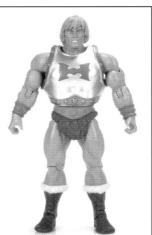

FLYING STANDS
1.0 & 2.0

First released 2012 • Second Release 2013

1.0

2.0

2.0

During the Masters of the Universe Classics line, Mattel offered up a pack of flight stands for purchase through their direct-to-consumer website Matty Collector. These stands were not officially marketed as part of the Masters of the Universe Classics toy line, but instead sold as a generic stand meant to fit with your six-to-seven-inch Mattel action figures, including MOTU Classics, DC Universe Classics, Ghostbusters, and more!

The first released, Flying Stands 1.0, featured a round, sturdy base. A semitransparent arm extended upward and had a C-clamp at the end on a hinge joint. This C-clamp would fit around the waist of your action figures, allowing you to pose your flying characters, such as Stratos, as if they were in flight! The C-clamp was interchangeable, with various sizes meant to fit DC and MOTUC action figures specifically.

The following year, Mattel released the upgraded Flying Stands 2.0. These new stands feature multiple parts of articulation on the arm, as well as the ability to extend. This allowed for more options, changing the height and angle of your posed in-flight figures. Just like with the first release, they also came with interchangeable C-clamps to fit various sizes of action figure.

1.0

FROSTA
ICE EMPRESS OF ETHERIA

First released 2012 • Member of the Great Rebellion

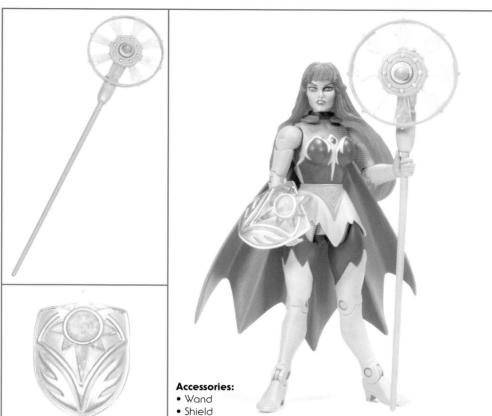

Accessories:
• Wand
• Shield

Frosta's Classics figure is heavily influenced by the character's appearance in the Filmation She-Ra: Princess of Power cartoon series. The design of her outfit features a little more detail to fit in with the overall MOTU Classics aesthetic, but otherwise looks much like what we saw on our television sets.

Her hair is made of a translucent blue plastic with a bit of white paint dry brushed over it. This gives it an icy look, though it does make it a slightly darker blue than what was seen in the cartoon. However, the vintage toy had a darker, shimmery blue hairstyle—so this might have been a unique new way to pay homage to that look.

Other nods to the vintage action figure can be found in her accessories. Her wand accessory is much like the one that was included with the original toy, complete with a spinning wheel at the top. She also comes with the Princess of Power gemstone shield, an accessory that is included with many of the figures of the ladies from Etheria.

FUN FACTOID: While the Four Horsemen corrected a lot of issues fans had with the first reveal of the figure, Frosta suffered in production when whites in her color scheme came out gray.

GELDOR
EVIL BARBARIAN OBSESSED WITH IMMORTALITY

First released 2013 • Evil Villain

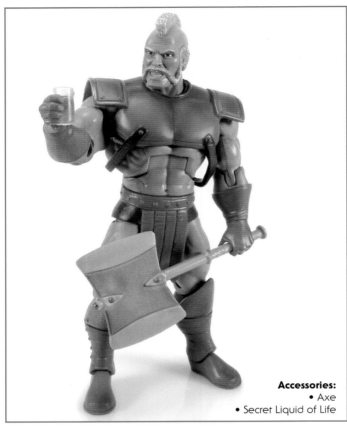

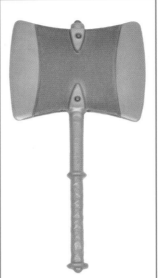

Accessories:
- Axe
- Secret Liquid of Life

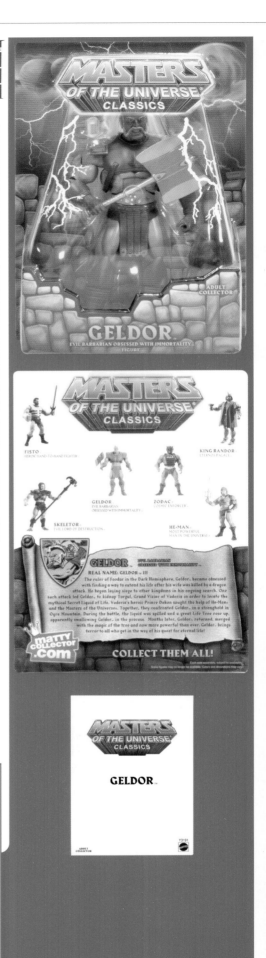

GELDOR

Geldor was a one-off villain featured in one of the Masters of the Universe minicomics included with the vintage action figures. Titled The Secret Liquid of Life!, this minicomic was always a fan favorite, with Geldor a much-desired action figure.

The figure is a great representation of how the character appeared in the comic. He includes brand-new armor, a new loincloth piece, and even new boots. For accessories, he comes packaged with his unique axe that he is seen using right on the cover of the minicomic.

And for a fantastic nonweapon accessory, Geldor includes a small glass he can hold in his hand. This glass is a representation of the Secret Liquid of Life itself, the subject of the story in which Geldor was featured.

Geldor was the winner of a Fan's Choice voting contest and was selected as a front-runner by the online German fan community. Ultimately, the character won the fan vote and was made into a figure.

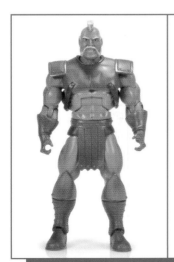

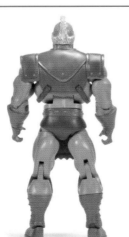

GENERAL SUNDAR
HEROIC FORMER HORDE GENERAL

First released 2016 • Member of the Evil Horde (formerly), and the Great Rebellion

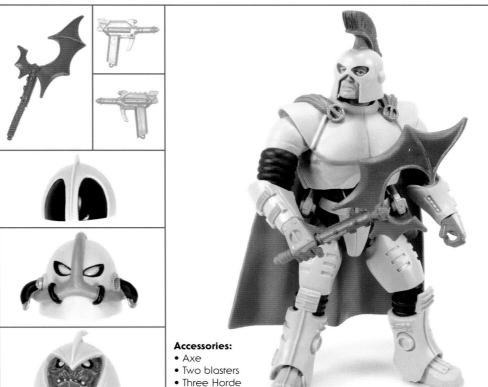

Accessories:
- Axe
- Two blasters
- Three Horde trooper heads

General Sundar was featured in the Filmation She-Ra: Princess of Power cartoon as a former Horde general who defected to the Great Rebellion. This marks the first time the character has ever appeared as an action figure.

He reuses many parts from the previously released Horde Troopers, which makes sense, since his armor is very similar. However, even the torso used under his armor is the same robotic body seen on the Horde Trooper figures, which is a bit odd since General Sundar is not a robot himself. The armor on his torso is all new though, and features a long red cape attached to the back.

He comes with two weapon accessories in the form of two silver hand blasters that can be dual wielded or holstered at his side. He also comes with a red axe with a unique blade shaped like the Horde bat emblem.

As a bonus, General Sundar also comes with three unique Horde Trooper heads that are meant for the Horde Trooper figures, allowing you to diversify your Horde army! Of these you get a navy trooper and an Eternian invasion trooper, both seen in the original Filmation cartoon. You also get one with an alien-like purple face that was featured in the modern run of Masters of the Universe books by DC Comics!

MOTUC - SECTION 1

GLIMMER
THE GUIDE WHO LIGHTS THE WAY

First released 2014 • Member of the Great Rebellion

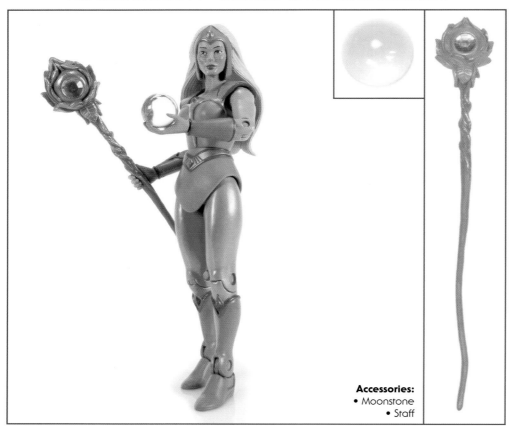

Accessories:
- Moonstone
- Staff

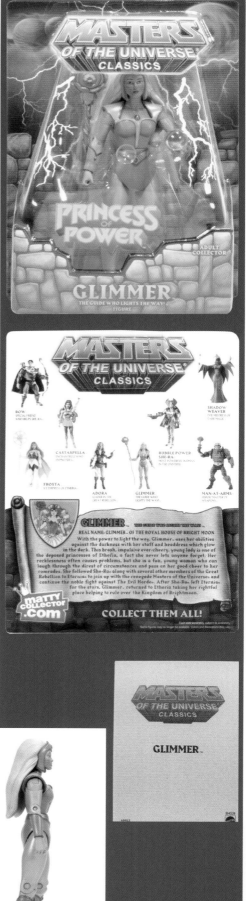

Glimmer is one of the Princess of Power characters whose vintage action figure and appearance in the Filmation cartoon series are quite different from each other. For her Masters of the Universe Classics release, Mattel opted to base her look primarily on her likely more recognizable animated appearance.

The colors used on the figure are blue and purple rather than the pink and silver of the original toy. However, one thing that ties the two looks together is the included staff accessory, which is inspired by the accessory that was included with the original action figure. Although the bio on her packaging makes reference to her staff glowing in the dark, it's worth noting that it does not actually include a glow-in-the-dark action feature.

Glimmer also comes with a small, clear marble-like orb which is meant to resemble the Moonstone from the Filmation She-Ra cartoon episode "Glimmer's Story." Her left hand is molded in an open position, allowing her to hold on to this easy-to-lose accessory.

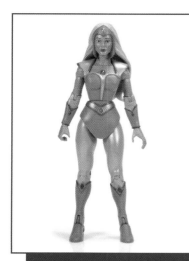
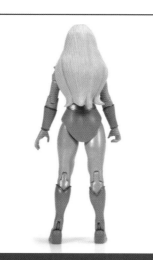

MOTUC - SECTION 1

MASTERS OF THE UNIVERSE CLASSICS

STAR SISTERS

JEWELSTAR STARLA TALLSTAR

GLORYBIRD
MAGICAL GUIDE OF THE STAR SISTERS
First released 2012 • Beast of the Great Rebellion

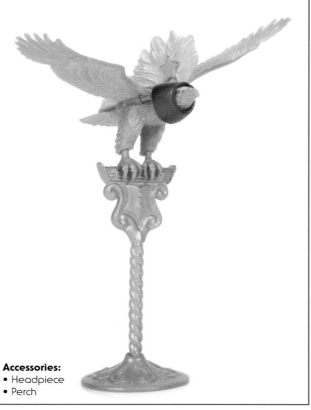

Accessories:
- Headpiece
- Perch

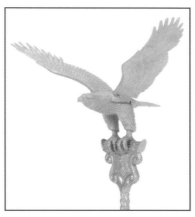

Glorybird was included with the Star Sisters three-pack. The small bird figure is based on a never-released action figure from the vintage Princess of Power toy line that would have reused the same bird sculpt as Zoar and Screeech for a new, pink bird character.

Following suit, Mattel reused the mold of the smaller Masters of the Universe Classics versions of Zoar and Screeech to finally release Glorybird officially alongside the Star Sisters, who were also based on unreleased vintage toys. Aside from the pink paint deco, Glorybird also includes a new tiara piece with pink feathers sprouting out of the top. This piece slides right over the figure's head to alter her appearance, making her stand out even more from Zoar and Screeech.

Glorybird also comes with a perch stand to allow for better display. While this is very similar to the red perch included with Zoar, the sculpt is unique and not just a simple repaint of the previous versions.

MOTUC - SECTION 1

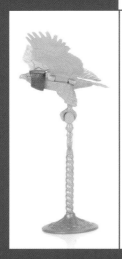

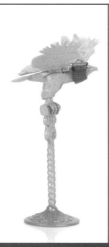

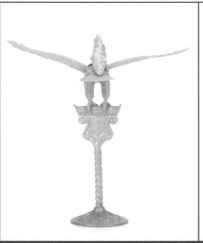

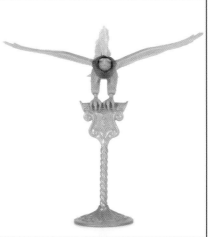

GOAT MAN
HORN-HEADED SERVANT OF BEAST MAN

First released 2014 • Member of the Evil Warriors

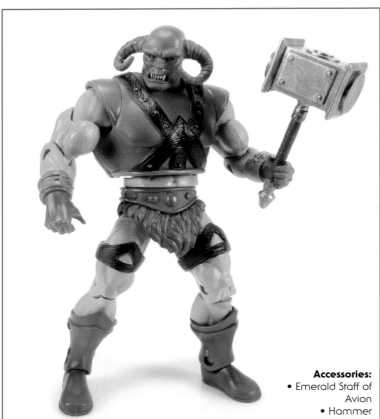

Accessories:
• Emerald Staff of Avion
• Hammer

Goat Man was a villain character whose only appearance was in a Masters of the Universe kids' storybook titled Secret of the Dragon's Egg from Golden Books. His design was memorable, and he became one of the characters that many fans pointed to as deserving an action figure.

The character was designed in such a way that he looked like he fit right in with the Masters of the Universe toy line, making his transition to action figure an easy one. He benefits from the reuse of many existing parts, but still features newly sculpted parts in his unique armor and new thighs with sculpted armor bits.

He comes with a large war hammer accessory for his weapon. He also includes a bonus accessory in the form of the Staff of Avion. This particular staff comes straight from the vintage minicomics, and is intended to be displayed with your Stratos action figure. The staff even has a handle which is specifically designed so your Stratos figure can hold on to it, since he is molded with two open hands.

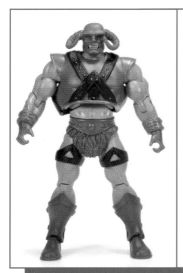

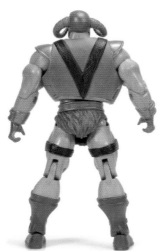

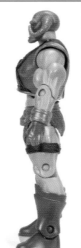

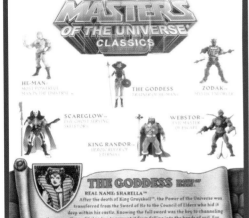

THE GODDESS
TRAINER OF HE-MAN

First released 2009 • Member of the Heroic Warriors

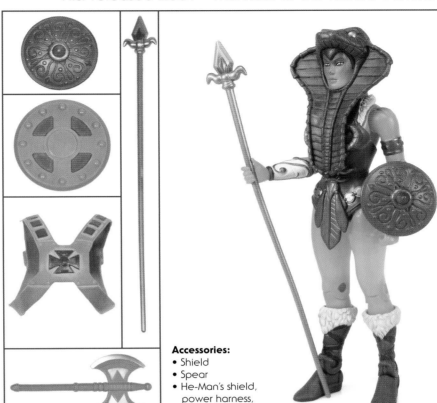

Accessories:
- Shield
- Spear
- He-Man's shield, power harness, and battle-axe

Often referred to by fans as "the Green Goddess," this character began as an early version of the Sorceress, appearing in the early Masters of the Universe minicomics, in which she recruited He-Man to defend Eternia. Although Mattel initially referred to the character as the Goddess, she was referred to as the Sorceress in the minicomics, before being significantly redesigned by Filmation into the more familiar Sorceress character. Given the drastic difference in her original appearance and name, fans came to consider the Goddess a separate character in her own right, and she was finally officially established as such with the release of this figure. As the first-ever Masters of the Universe minicomic featured her presenting He-Man with his armor, battle-axe, and shield, these are included as accessories with her action figure.

The figure is the same sculpt as Teela, which makes perfect sense, since the character was essentially an early concept of both Teela and The Sorceress; the original Teela figure was packaged with the Goddess's armor so the toy could be used as either character. She is made of a translucent green plastic, which makes for a very neat mystical look—however, the figure is notorious for breakage. The translucent plastic is apparently a bit weaker, causing potential cracking, usually around the hip joints.

She comes with the same removable snake armor and shield that were included with Teela; however, she features a brand-new staff. This staff is notable, as it matches an early staff design for Teela. This allows fans to do some mixing and matching by displaying this staff with Teela if they wish to do so.

FUN FACTOID: The Four Horsemen said, "Although she was basically just a Teela repaint, it was amazing to create this wonderfully mysterious character in figural form. The look of the final figure was great, but unfortunately she was plagued with quality control issues."

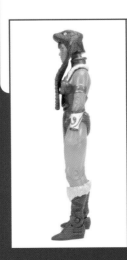
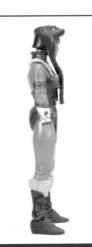
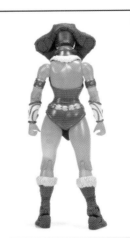
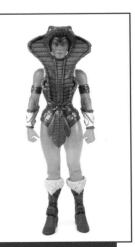

GOD SKELETOR
EVIL DEITY OF DESTRUCTION

First released 2020 • Member of the Evil Warriors

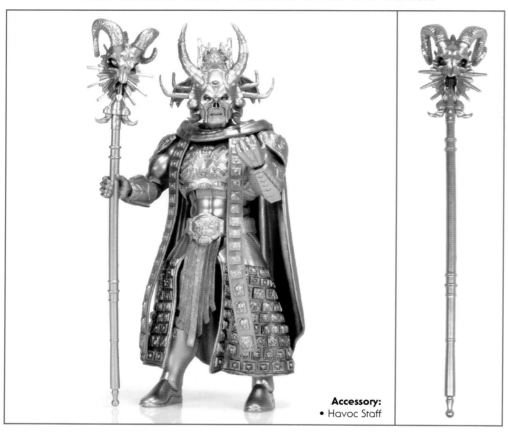

Accessory:
• Havoc Staff

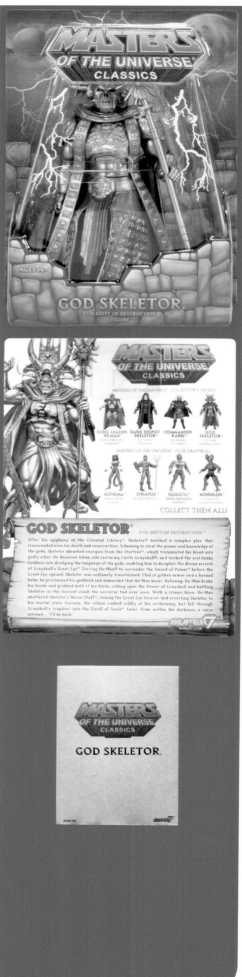

"Let this be our final battle!" Released as part of Super7's William Stout Collection, God Skeletor depicts the character as he appeared near the end of the 1987 Masters of the Universe motion picture—clad in gold with the full power of Grayskull.

The figure shares a lot of parts with the Dark Despot Skeletor release, matching up with the wardrobe worn by Frank Langella in the film, as designed by William Stout. The body is now painted a bright metallic gold and features a few additional details, such as the tassels hanging from the belt. The head is an all-new sculpt, and is adorned with the golden bat-shaped helmet from the film. Skeletor's mouth is exposed, with a scowl that differs slightly from the one on the face of the Dark Despot version of the character.

The only accessory included with this release is a golden version of the movie's Havoc Staff, possibly because this is the only weapon Skeletor uses while wearing this golden outfit in the film.

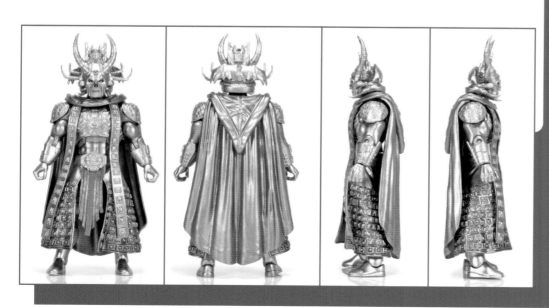

MOTUC - SECTION 1

GRANAMYR
GREAT MAGIC-WIELDING DRAGON

First released 2012 • Ally of the Heroic Warriors

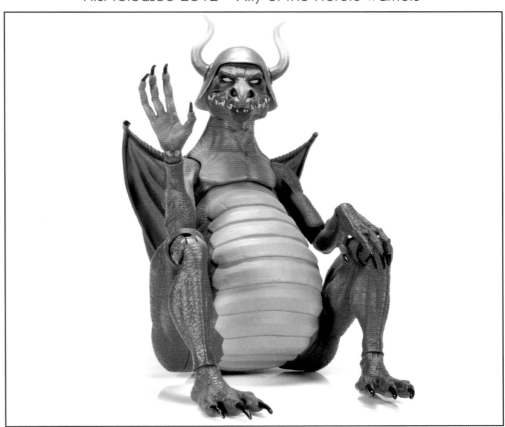

Granamyr appeared in both the original minicomics and the Filmation He-Man and the Masters of the Universe cartoon series, but had never appeared as a toy up until this point. The character was colored differently in the two forms of media. He was green in the comics, and red in the cartoon. Because of this, Mattel polled fans to see which color they would prefer the toy to be released in, with red winning the majority vote.

He comes in a fully enclosed box featuring brand-new artwork by Rudy Obrero, an artist who did box art for some of the original Masters of the Universe toy packages. Granamyr is one of the very few figures that requires assembly out of the box. Once assembled, Granamyr stands nearly twenty-two-inch-tall if stood up straight on his skinny legs. Although it's worth noting that the legs don't hold the weight too well. He's made to be posed in a sitting position, which is how the character appeared prominently in both the comics and the cartoon. While sitting, he still measures up to fourteen inches in height.

FUN FACTOIDS:
- Granamyr was so large the sculptors' hands literally hurt after long days of working on him.
- The original sculpture and prototype, described as the size of a newborn baby, were significantly larger than the final release.
- Granamyr was originally going to come with a large stack of books and a pile of golden treasure and weapons.

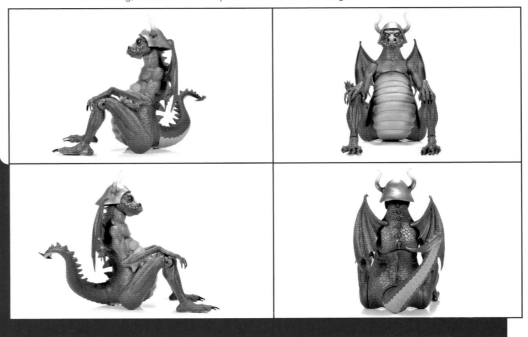

GRANAMYR
GREAT DRAGON LORD OF DARKSMOKE

First released 2016 • Ally of the Heroic Warriors

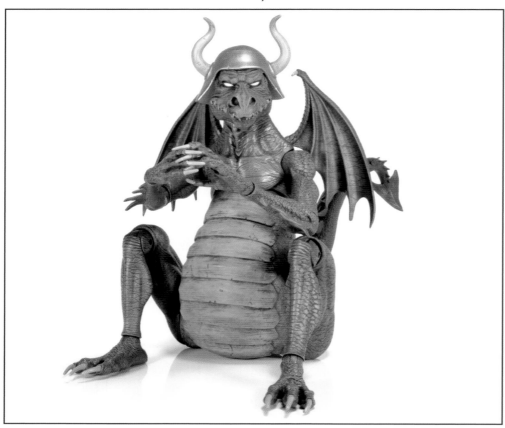

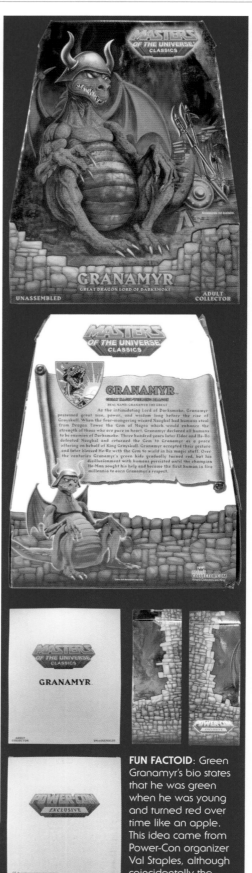

Offered as an exclusive at the 2016 Power-Con, this version of Granamyr presents the character with green skin as he appeared in the original Masters of the Universe minicomics.

The figure itself is identical in sculpt to the previously released red version. The box is also the same, although the artwork has been updated to present Granamyr with green skin, and a "Power-Con Exclusive" logo was added to the side. The figure still needs to be assembled out of the box the same as before. This new figure did run into some minor issues with the torso not snapping together as solidly as the red version before it. As a result, the figure is typically easy to take apart at the torso joint, whereas the red one locked together permanently once assembled.

The big difference is with the paint deco, which is now a bright green in color. It features a nice black wash that helps to add a bit of grit to the overall look, also bringing out all of the sculpted details of his scaly skin. He's just as massive as before, standing fourteen inches in height in sitting pose. While the red version of Granamyr won the original fan poll by Mattel, many fans were still hoping to get the green version at some point, making this a welcome addition to the collections of many fans.

FUN FACTOID: Green Granamyr's bio states that he was green when he was young and turned red over time like an apple. This idea came from Power-Con organizer Val Staples, although coincidentally the Preternia map rendered a younger Granamyr green as well.

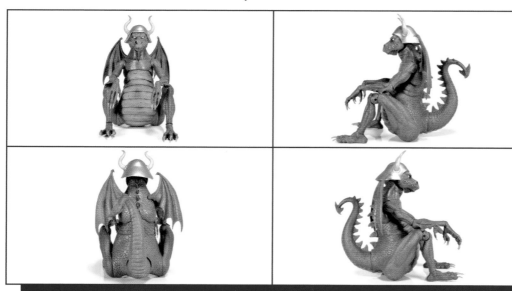

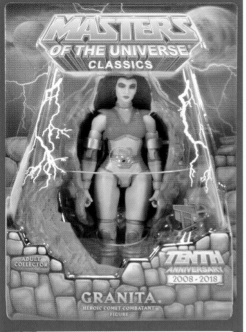

GRANITA
HEROIC COMET COMBATANT

First released 2018 • Member of the Comet Warriors,
the Heroic Warriors, and the Great Rebellion

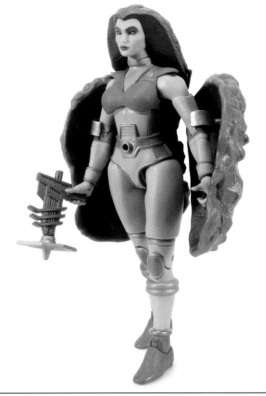

Accessory:
• Gun
• Removable back, arm,
 and leg shells

Granita appeared alongside her companions Rokkon and Stonedar in the original Filmation She-Ra: Princess of Power cartoon series. Unlike Rokkon and Stonedar, however, she did not appear as an action figure in the vintage Masters of the Universe toy line, making her a longtime fan-demanded character in action figure form.

While she did appear in the cartoon series, the figure is made with the more detailed style of the standard Masters of the Universe Classics toy line in an effort to make her fit in alongside the previously released Comet Warriors. While the original Comet Warriors action figures had a transforming action feature, this was handled with interchangeable rock parts in the Classics line. This exact same feature was incorporated with Granita.

The arm rock pieces clip on her biceps with small clips, and the leg pieces attach to the figure's thighs via similar clamps. The clamps tend to be a bit loose on Granita, causing the pieces to easily be bumped off the figure. Once these rock pieces are attached, you can also fold Granita forward and rest her on the larger included rock piece, making it look as though she has transformed into full comet form.

Her included blaster accessory has two ways to be displayed with the figure. She can hold it in her hand, but it also can be plugged into the small hole in her torso. This is to mimic the way the guns were stored on the vintage Comet Warriors when folded into their rock formations.

MOTUC - SECTION 1

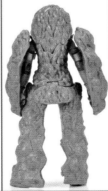

GRIFFIN
EVIL FLYING BEASTS

First released 2012 • Steed of the Evil Warriors

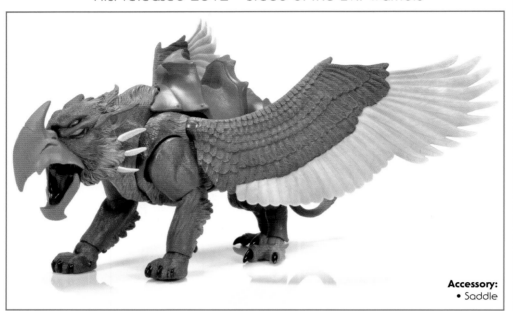

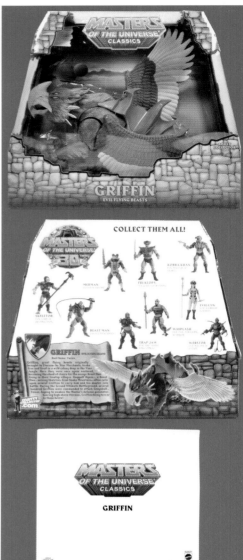

Accessory:
• Saddle

The Griffin is a beast featured regularly during the 200X-era He-Man and the Masters of the Universe cartoon series by Mike Young Productions. He was often ridden into battle by Beast Man.

This marks the first time the Griffin has been presented in action figure form. It's a clever reuse of the Battle Cat mold with new pieces, including bird-like back feet, a beaked head, and feathered wings much like what we saw on Swift Wind.

A saddle on his back allows Beast Man or any of your Evil Warriors to ride the beast into battle. He is quite a bit smaller than the large Griffin beasts seen in the animated series, but the figure still works quite well and matches up nicely with other mountable creatures in the MOTU Classics toy line.

FUN FACTOID: The Griffin allowed the Four Horsemen to carry their parts-sharing approach into the beast realm, as the cat body was created for the sole purpose of making cat characters, like Battle Cat and Panthor, but served as a perfect base body (with a vital assist coming from the Swift Wind wings) for the 200X Griffin.

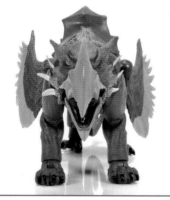

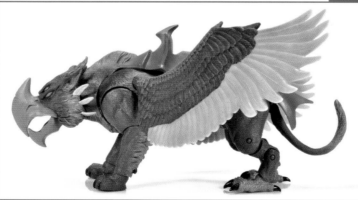

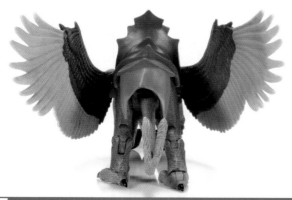

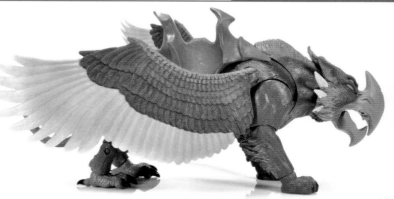

THE FOUR HORSEMEN

H. ERIC "CORNBOY" MAYSE, ERIC TREADAWAY, & JIM PREZIOSI

Can you talk about the genesis of the Masters of the Universe Classics line?

Eric Treadaway: We'd wrapped up the 200X version of Masters of the Universe, but we didn't want to let the property or the toy line just wither on the vine and die, so we started coming up with a new direction to take the line that we could introduce to Mattel, and hopefully they'd like it. We decided that we should try to bring back the proportions and look of the original Masters of the Universe line, but add in the articulation and technical updates of today.

H. Eric "Cornboy" Mayse: So, on our own time and without Mattel knowing we were doing it, we created a new He-Man action figure prototype that took the classic look and new articulation levels into account. We took it with us to the San Diego Comic-Con that year so we could present the idea and the prototype to the managers and designers at Mattel that we worked with at the time at a breakfast meeting that we have with them there every year. We were surprised that while most of the guys at the table loved the idea and the prototype, none were really interested in jumping in with another MOTU line so quickly. That is, until the manager of Mattel boys' toys at the time, David Voss, spoke up and said that he loved it and wanted us to place it into one of the Mattel display cases there at SDCC without saying anything about it, just to see what the reaction was. I guess you know by now that the response was overwhelmingly positive, and we released the SDCC-exclusive King Grayskull figure the next year, and MOTU Classics was off and running.

Quite a few of the Masters Classics figures seem to be primarily based on the vintage cross-sell art. That's not true of every figure, but it's especially true for figures like Mer-Man, Skeletor, Stratos, Teela, and so on. Can you talk about why you decided to go in that direction?

ET: All of that really came down to my love of the cross-sell art of the Mer-Man figure on the back of those original Masters of the Universe backer cards, and how the final figure was just a repainted Stinkor. That was a big letdown for me, and I'd always vowed that if I were ever to be allowed to redesign He-Man and the Masters of the Universe, that Mer-Man would look like that original cross-sell art rather than like a Stinkor knockoff. The cross-sell art on the backs of those packages was what drove me to the stores to hunt those figures down. They were so colorful and so beautifully done, and even as a kid I was a little disappointed when I'd get a new figure and it didn't exactly match the cross-sell artwork. This was my chance to correct that, so I took the opportunity while I could.

Was it a challenge for you to shift from the 200X designs you helped create back to a more "vintage" inspired design, especially in the beginning? Some of these characters, such as Clawful and Whiplash, had pretty different looks between the two lines.

Jim Preziosi: As much as we loved redesigning and relaunching He-Man and the Masters of the Universe when we did the 200X line, creating Masters of the Universe Classics just felt so much more authentic and true to what Masters of the Universe was meant to be. We've created a *lot* of different styles for a *lot* of different toy lines over the years, so changing from one style to another wasn't an issue, but creating the MOTU Classics line and trying to walk the tightrope of keeping things very classic looking while also updating the figures to today's standards was a bit of a challenge. We love challenges though.

Is there a formula in your head for creating a Classics figure, in terms of what to pay homage to from vintage material and what new spin you can subtly throw into it?

HEM: It really all depends on the characters. With He-Man himself it was simple. Take what made the original so great, and enhance that with the articulation and production levels that we're capable of today. With other characters, we also took into account the more popular aspects of their 200X counterparts and decided if there was a way to fit some of that in as well. Most of that happened with accessorization more than anything else. One often debated topic was the lack of play features in the MOTU Classics line when compared to the original toy line. We felt that with the added articulation, we'd already upped the ante on the playability of the line, and we've never liked action features that hinder the articulation of a figure or detract from the sculptural aesthetic of a figure, so we opted to leave those out, for the most part.

Extra heads and bonus accessories became standard throughout the line, sometimes even coming with new figures but specifically designed for figures that were released years prior. How did you guys decide upon what extra heads and accessories should be added to the line?

ET: To be honest, a lot of that was decided when costing out the figures for production. If we'd have had our way (Four Horsemen and Mattel) every figure would have come with alternate heads and extra accessories, but the head is often the most expensive part of an action figure to produce because of all of the paint applications. So we fit them in where we could and where we felt they were of the most value to collectors. The 200X-inspired MOTU Classics head pack was one of the most popular "accessories packs" that we'd ever done, and we'd love the chance to be able to do something like that again.

Some toys, like Wind Raider and Battle Ram, seem to take cues from the vintage box art by Rudy Obrero. Was the box art a big draw for you as a kid?

ET: It absolutely was! We *love* the depictions of the vehicles on the packaging and although we wanted the vehicles to be instantly recognizable as updates to the original toys, the final looks of the toy vehicles were heavily influenced by the images of the vehicles on the packaging.

Castle Grayskull was a huge project. Can you talk about what it took to put something like that together?

HEM: That was really out of control, but the results were even better than we'd expected. We first started with a frame that was kind of in the shape of Castle Grayskull and then sculpted on top of that to create the exterior details. The frame had to be separated into multiple parts so it could be sculpted on top of and then assembled for the final prototype. The molds for Castle Grayskull were some of the largest we've ever done. The framework and some of the interior accessories were originally done digitally, but all of that was eventually gone over and at least detailed a little more, if not completely redone to get everything up to the standards we expected of this monster. After all of the sculpting, fabrication, molding, and casting was done, then we had the daunting task of painting it. We just kind of stood there and stared at it a bit before finally diving into the paints. It took a lot of time, effort, and late nights, but we got it done and we're really proud of that play set.

JP: Altogether with all of the work that was done on it, I think we have somewhere between fifteen and twenty people all working in the studio on that and other projects at once, when normally we only have six or seven people in the studio at most. Hopefully someday we'll get to jump back into Snake Mountain. If you think Castle Grayskull's big? Then Snake Mountain is massive.

What source material were you inspired by when you were working on Castle Grayskull? Obviously the Mark Taylor prototype and the vintage play set were heavily in the mix.

ET: Obviously the toy had a huge influence because this was going to be another updated version of a classic toy.

Mark Taylor's prototype was a huge influence as well, and although we wanted to squeeze as much of that look into the castle as we could, we also, once again, didn't want to get too far away from the original look of the toy too much. We would've liked to have made more add-on parts later on, kind of like Point Dread. Maybe the large skeleton body coming out of the back of the castle that you caught a glimpse of in the original cartoon or something along those lines.

What's one figure in Classics that you put out that you didn't think would ever get made?

HEM: Fearless Photog! He's always seemed like kind of a goofy character from the drawings, but I'm really proud of the way that guy turned out. It's still goofy, but in a good MOTU kinda way.

ET: It absolutely has to be the Club Grayskull version of Clawful. First, that character always confused me as a kid. I loved the original toy, and I liked the Filmation cartoon version too, but the cartoon looked absolutely nothing like the toy. The Filmation version of Clawful looked more like a dinosaur than some sort of crab-like monster. Plus, we'd already done both the MOTU Classics and alternate 200X version in the MOTU Classics line, so I was happily surprised when I found out that we were going to be able to do a third version of him.

What Classics figure are you most pleased with in terms of how it came out?

ET: I mentioned it before, but Mer-Man was a true benchmark for the way I'd approach many of the other upcoming MOTU Classics figures as we moved forward. Seeing that character finally realized in three-dimensional form looking like a modernized representation of the original cross-sell art really inspired me to approach a lot of the other characters from that viewpoint as well.

HEM: I've always been a fan of gorillas, so mine has to be Gygor. I would never have imagined that I'd be into a character that had green skin and yellow fur, but it really works on that guy. Anytime a gorilla can be fit somewhere into a line of action figures, I'm down. Plus, he's a big bruiser type, and those are always my favorite kinds of characters.

JP: It's a tossup between three characters . . . Flutterina, Sweet Bee, and Angella. I love characters with wings, and one day I hope to have all three of those girls hanging from the ceiling in my office at the studio. I'll have to put a ceiling in my office at the studio first though. Ha!

If you were to travel back in time to the beginning of the Classics line, is there anything you would approach differently?

ET: I'd like to say that we'd have started it sooner, maybe even as far back as the point where we started the 200X line, but I'm not sure collectors would've been ready for the line back then. I'd have maybe looked into including soft goods with certain characters for things like capes and loincloths. If they were done correctly it would've been great, but I'd have been wary about how consistently good those soft-goods parts would've looked in a large production run.

HEM: I also would've liked to have had the chance to experiment with a bit more articulation, like double knees and double elbows. Either that or ball-joint elbows and knees. We've added some ball-joint wrists later in the series, but it would've been nice to have had those from the beginning. They say hindsight is twenty-twenty . . .

Are all of your prototypes sculpted by hand? Are you doing any digital work these days?

HEM: About ninety-nine percent of what we do now is done digitally. We're not yet doing the MOTU Vintage figures for Super7 digitally, but it may come to that just because of the speed and efficiency of doing things digitally. Like one of the simplest things to do used to be the hardest—if you have something, let's say a head, that's out of scale.

ET: Before you'd have to either completely resculpt the head or go through a molding and casting process to shrink it down to the size you need. Now you just go back into the computer and upsize it or downsize it by a percentage and just reprint it. No big deal. We no longer have to worry about whether a sculpture is going to get damaged or lost in shipping or if something might happen to it that would ruin it during the molding and casting process. You just send the parts via an FTP and you're good.

When you're designing figures, you obviously try to go with what is going to please the most fans. If you were going to make He-Man and Skeletor for yourself, based on your own preferred stylistic influences, what would they look like?

ET: If you mean that we didn't want them to look like MOTU Classics, then definitely more like the 200X stuff we did, but more along the lines of the first prototypes we showed Mattel for those—which were much more articulated and had less of that "anime angularity" that they had us add into it. They'd look much more realistic, monstrous and barbaric. Very cinematic in a sense.

Aside from Castle Grayskull, what was your most challenging project for Classics?

HEM: Snake Mountain by far. Even though most of the work that was done on that behemoth was done digitally rather than traditionally, we've gone back into the original parts two or three times from the beginning and tweaked, changed, and added a lot of stuff, and before we showed the paint master at the San Diego Comic-Con a few years ago, we were actually asked to figure out a way to shrink some of the proportions, but still retain the overall massive look of it. What we've ended up with is truly one of the best gem pieces that we've ever created here at Four Horsemen Studios. Now our fingers are just crossed that we ever get to see it produced and released to the public. Maybe someday . . .

How has the transition been from working with Mattel to working with Super7?

JP: At first it was a little worrisome, because we had no idea what to expect working with Super7. We'd known the guys over there for a few years, but we hadn't worked together yet at all. It turned out to be completely seamless on our end, and we've been having a great time working with them on various MOTU-related projects as well as some other cool things we've collaborated on. We hit some hiccups early on trying to build a 3D digital MOTU Classics library of parts to work from, and figuring out what would need to be done traditionally rather than digitally, but we've gotten those kinks ironed out and are having a blast continuing to crank out He-Man and the crew!

GRIZZLOR
THE FEROCIOUS FIGURE WITH FUR

First released 2010 • Member of the Evil Horde

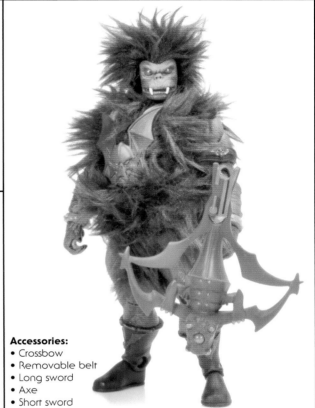

Accessories:
- Crossbow
- Removable belt
- Long sword
- Axe
- Short sword

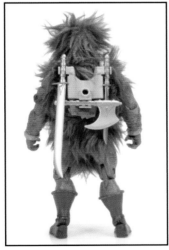

The original Grizzlor action figure was well known for his "real" fur body. This was brought back for this new version of Grizzlor.

The fur piece is positioned over the standard Masters of the Universe Classics buck, which makes the figure just as posable as the others even though he has this furry body piece. Much like with the original figure, he has his armor piece with the Horde insignia that fits over the fur body. New to this figure is the belt, which was introduced with the 200X-era redesign of the character. This is purposely removable, allowing fans who would prefer Grizzlor to look more like the vintage action figure to take it off if desired.

Along with the standard Horde crossbow accessory, he also comes with three new accessories in the form of two swords and a small axe. These weapons were also introduced to the character during the 200X-era. One of the most original features involving these new accessories is the ability to store them all on the back of Grizzlor's armor, allowing you to perfectly store each of his accessories on the figure.

FUN FACTOID: The Four Horsemen were pleased with the figure's balance between updating the vintage look while including optional 200X, inspired parts. The one part that could not be included, his 200X head, was eventually released in the Heads of Eternia pack.

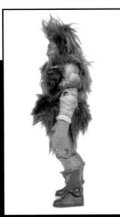
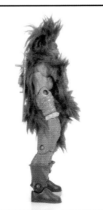
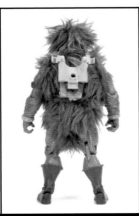
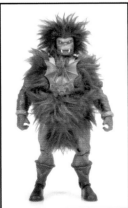

MOTUC - SECTION 1

GWILDOR
HEROIC CREATOR OF THE COSMIC KEY

First released 2014 • Member of the Heroic Warriors

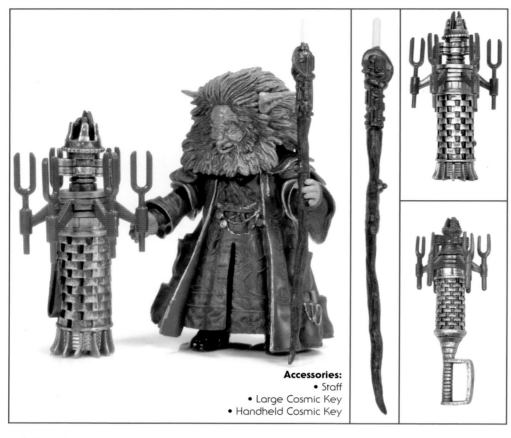

Accessories:
- Staff
- Large Cosmic Key
- Handheld Cosmic Key

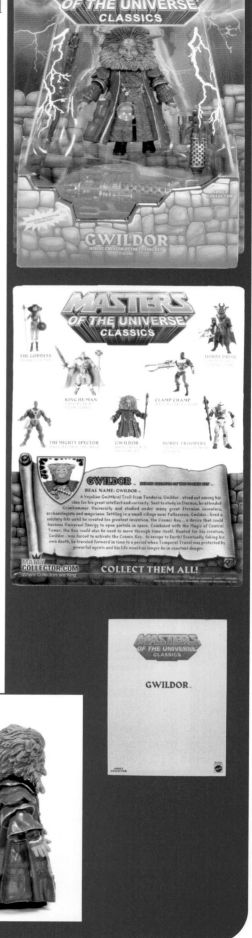

Only three characters from the original 1987 Masters of the Universe motion picture made it into the vintage action figure line. As a result, copyright permitted these same three characters to be produced for Masters of the Universe Classics. One of these was Gwildor.

Gwildor is heavily inspired by the original toy, more so than his appearance in the movie, which explains the bright blue and red colors used in the figure's outfit. However, his head sculpt is impressively detailed, and certainly has a likeness to Gwildor's appearance in the film, where he was played by actor Billy Barty.

He is packaged with a staff as an accessory, something that was not included with the vintage toy but was used by the character in the film. He also comes with two different versions of the Cosmic Key. Both are a hybrid of the way the key looked in the film and the original action figure. The bright red colors definitely tie in more closely to the original toy design. One version is smaller, with a handle on the bottom that allows Gwildor to hold it. This one is much more like the one included with the vintage toy. The other version is much larger, and quite oversized, but is intended as a closer representation of the one seen in the film—though still not entirely accurate.

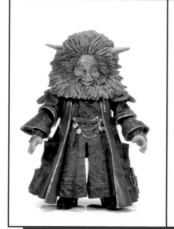

GYGOR
EVIL FIGHTING GORILLA

First released 2010 • Evil Villain

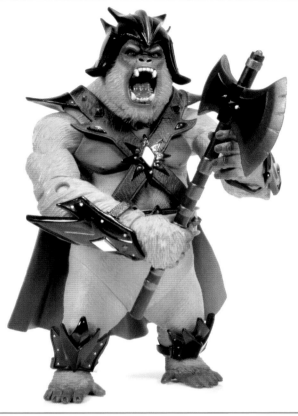

Accessories:
- Axe
- Removable armor, cape, and helmet

Back when the original Masters of the Universe toy line was coming together, Mattel reused several preexisting molds from some of their other toy lines, such as Big Jim, to come up with brand-new characters. This is how we ended up with figures like Zoar and Battle Cat. Another figure that was planned but never made it past the prototype stage was a reuse of the Big Jim gorilla, painted yellow and wearing armor. This would have been named Gygor, intended as a battle steed for He-Man.

Gygor was released in Classics as the first official release of this proposed character from the 1980s. Much like what was originally proposed, Gygor is a massive gorilla character with yellow and green fur, who wears black armor and a bright red cape. He comes with a large battle-axe to match up with his armor to do battle with the heroic Masters of the Universe (while he would have been a heroic character had he been made for the vintage line, the Classics bios redefined him as an evil beast).

The large gorilla body would also be used for the Shadow Beast in the Classics line, fitting right in with Mattel repurposing pieces as much as possible. He's an odd-looking character but at the same time is a true piece of Masters of the Universe history finally brought to life.

FUN FACTOID: The Four Horsemen said, "This figure was another example of pulling from MOTU's past. Gygor was an unproduced concept figure who'd gathered somewhat of a cult following. Classics was able to make another dream figure come to life while adding another new body type to the lineup and giving us a base body that we could use again for Shadow Beast."

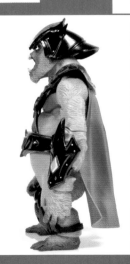
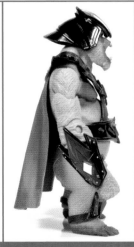
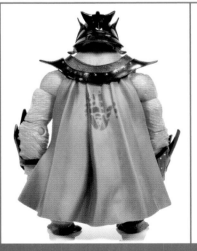
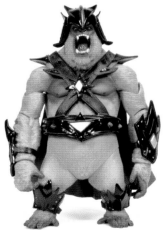

MOTUC - SECTION 1

HAWKE
HEROIC FEATHERED FIGHTER

First released 2018 • Member of the Heroic Warriors

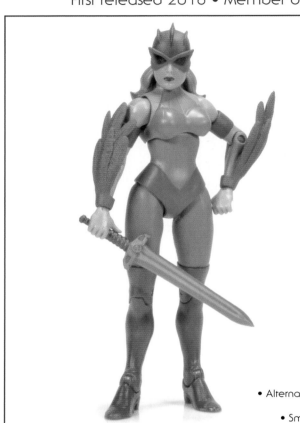

Accessories:
• Alternate Delora head
• Sword
• Smokescreen gun

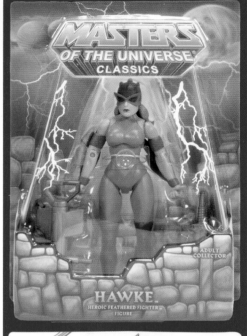

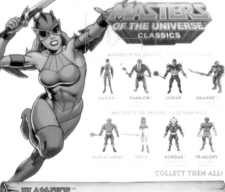

Hawke appeared in the original Filmation He-Man and the Masters of the Universe cartoon as a villainous Avionian woman who betrayed Stratos. The 200X cartoon by Mike Young Productions redefined her as a more likable character who fought alongside Stratos, while the MVCreations comics established her as his sister. Prior to the Classics line, she had never received an action figure.

The toy is heavily influenced by the character's appearance in the Filmation series, though she is given a few more details in the sculpt of her feathers and outfit to make her better fit in with the MOTU Classics style. She includes two accessories: a sword and the smokescreen gun. The gun comes straight out of the Filmation cartoon, and can be used by Hawke or your Stratos action figure. The strap on this gun isn't made of plastic, but rather a leather-like material.

Hawke also comes with an interchangeable head, allowing you to display her as Delora, an entirely different Avionian character also seen in the Filmation series! (Delora was portrayed as Stratos's sister in the Filmation show, but as his wife in other media, understandably leading to much confusion between the two characters).

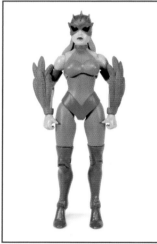

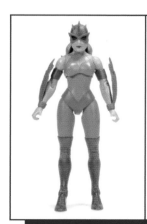
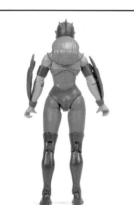
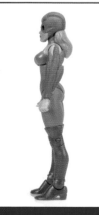

HEADS OF ETERNIA
ACCESSORY PACK

First released 2015

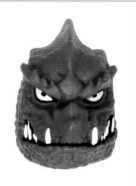

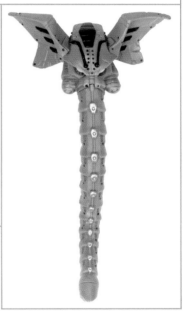

Many of the original Masters of the Universe characters received highly detailed, sometimes drastic redesigns when they were re-introduced to the world during the 200X-era toy line and cartoon. But when Masters of the Universe Classics rolled around, many of these characters reverted back to looks that more closely resembled their vintage action figures.

Many fans expressed interest in seeing an option introduced that allowed them to display several of these characters with their 200X-inspired designs, since the line already encouraged customization by having an interchangeable head feature. As a result, Mattel released this accessory pack that gave us six brand-new head sculpts meant to be used with previously released action figures.

Now fans could choose to swap for the more detailed versions of Sy-Klone, Roboto, Clawful, Snout Spout, Buzz-Off, and Grizzlor if they wanted to change up their display. Many of these heads look much like the 200X action figure designs but made to fit better with the body designs of Masters of the Universe Classics.

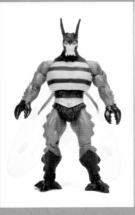

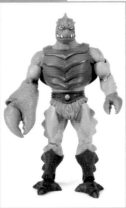

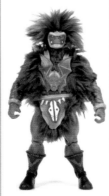

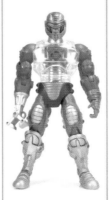

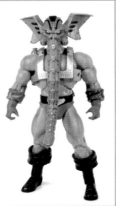

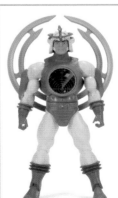

HE-MAN
MOST POWERFUL MAN IN THE UNIVERSE

First released 2008 • Member of the Heroic Warriors

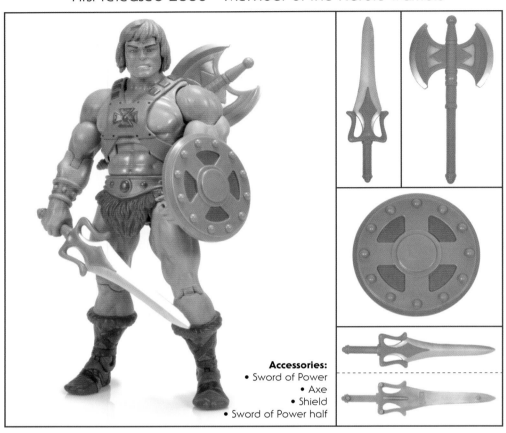

Accessories:
- Sword of Power
- Axe
- Shield
- Sword of Power half

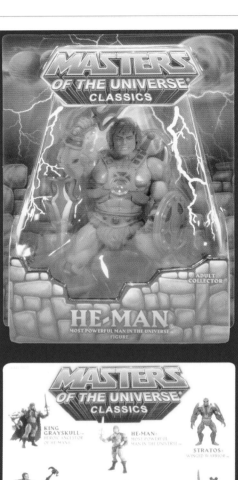

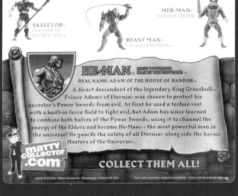

The Most Powerful Man in the Universe returns to the action figure world with a look that is much more reminiscent of the vintage figure that made him so popular in the first place.

Officially kicking off the Masters of the Universe Classics line after the previously released San Diego Comic-Con–exclusive King Grayskull, He-Man essentially gave us the mold and set the standard for what was to come. The figure is just as beefed-up as we remember his original toy being, but now with a lot of added articulation, allowing for better posing options. The head is removable, allowing for future interchangeability and to encourage simple customization by fans. Action features like the "Power Punch" found in the original toy line have now been completely removed in favor of a better sculpt and higher articulation count. Posability and collectibility were now the focus over play features.

He includes the same weapons as his original figure did in the form of the battle-axe, the shield, and the famous Sword of Power. He even comes with an alternate half Sword of Power that has the ability to clip together with Skeletor's half Sword of Power accessory, allowing you to re-create an action feature from the original toy line.

It's worth noting that this first release did have a quality-control issue. His shoulders were assembled opposite, meaning his left shoulder was on the right and vice versa. This didn't really cause any issues with posability, but the mistake is noticeable if you look closely at the sculpt of his muscles. This was corrected on later reissues of the figure.

MAILER BOX CAME WITH REISSUE ONLY

FUN FACTOID: This was the prototype for the line in every way. The idea was to take the look and proportions of the vintage figure and to simply articulate and modernize it. The result was a figure that captured the feel of the vintage while being something completely new.

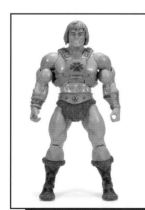 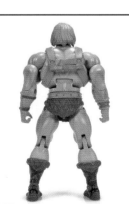 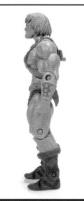

HE-MAN
BELOVED HERO OF ETERNIA

First released 2010 • Member of the Heroic Warriors

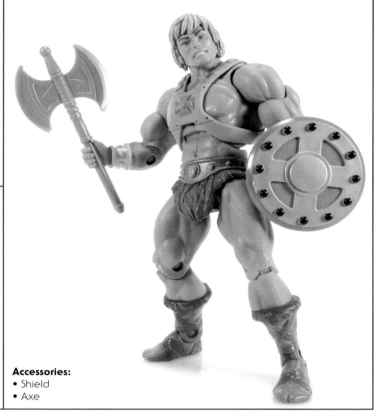

Accessories:
- Shield
- Axe

He-Man received a new toy line at the end of the 1980s (officially titled simply "He-Man" but often referred to as "The New Adventures of He-Man" due to the accompanying cartoon series) that saw him drastically redesigned and sent into outer space on a new mission. While the He-Man line is a lesser known and certainly less popular toy line, Masters of the Universe Classics was dedicated to bringing together all eras of MOTU into one cohesive toy line.

Galactic Protector He-Man was heavily based on his vintage toy counterpart, but this time beefed up to better match the proportions seen in the MOTU Classics toy line. He features his long blue pants and shiny gold boots, along with new versions of the shield and Sword of Power, both utilizing translucent yellow plastic just like the original New Adventures toy.

That original action figure has a removable helmet as well as removable body armor, allowing you multiple ways to display him. The Classics figure includes several interchangeable parts, allowing you to pull off these various looks. Instead of a removable helmet, he now has an interchangeable helmeted head. The full body armor can also be swapped out for the smaller harness, still allowing for multiple ways of display.

MOTUC - SECTION 1

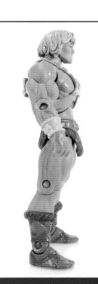
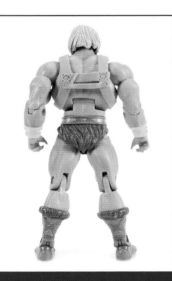
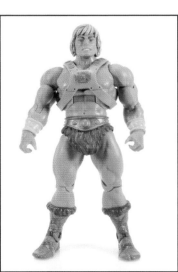

HE-MAN
GALACTIC PROTECTOR

First released 2013 • Member of the Galactic Guardians

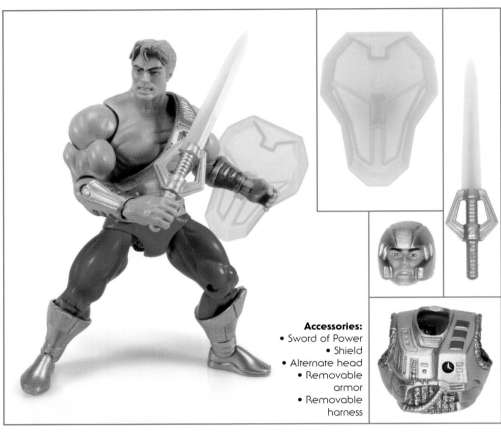

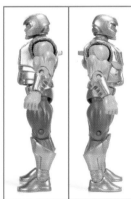

Accessories:
• Sword of Power
• Shield
• Alternate head
• Removable armor
• Removable harness

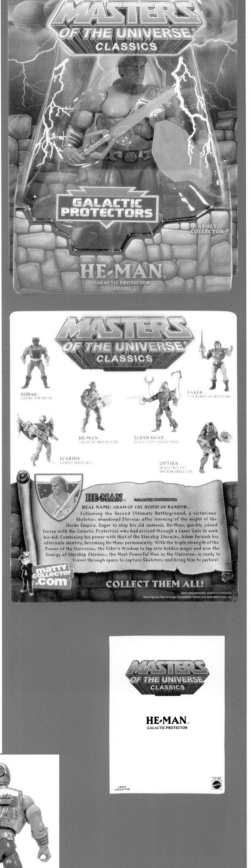

He-Man received a new toy line at the end of the 1980s (officially titled simply "He-Man" but often referred to as "The New Adventures of He-Man" due to the accompanying cartoon series) that saw him drastically redesigned and sent into outer space on a new mission. While the He-Man line is a lesser known and certainly less popular toy line, Masters of the Universe Classics was dedicated to bringing together all eras of MOTU into one cohesive toy line.

Galactic Protector He-Man was heavily based on his vintage toy counterpart, but this time beefed up to better match the proportions seen in the MOTU Classics toy line. He features his long blue pants and shiny gold boots, along with new versions of the shield and Sword of Power, both utilizing translucent yellow plastic just like the original New Adventures toy.

That original action figure has a removable helmet as well as removable body armor, allowing you multiple ways to display him. The Classics figure includes several interchangeable parts, allowing you to pull off these various looks. Instead of a removable helmet, he now has an interchangeable helmeted head. The full body armor can also be swapped out for the smaller harness, still allowing for multiple ways of display.

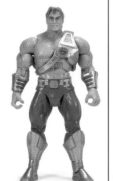
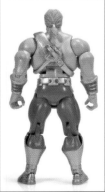
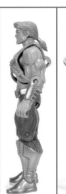
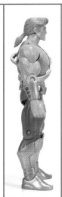
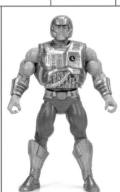
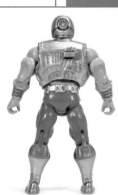

HE-RO
HEROIC COSMIC WARRIOR

First released 2009 • Member of the Heroic Warriors

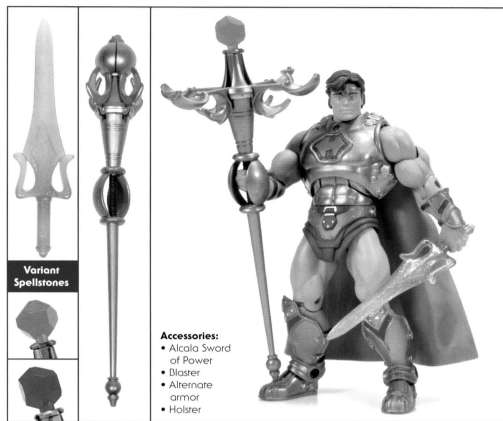

Variant Spellstones

Accessories:
- Alcala Sword of Power
- Blaster
- Alternate armor
- Holster

He-Ro was originally going to be released as part of the Powers of Grayskull toy line, which was intended as the follow-up to the original Masters of the Universe toy line, the story line serving as a prequel. He made it as far as the prototype stage before the plug was pulled on the new toy line. For years, he was one of the most storied unreleased toys in the MOTU world.

In 2009, Mattel finally released an official He-Ro action figure as part of the Masters of the Universe Classics toy line. The look of this new figure was modeled after the unproduced vintage toy. Instead of the shiny vac-metal gold armor seen on the vintage prototype, the new figure featured a much less shiny gold paint deco instead. His cape is made of a pliable plastic, rather than cloth—which became the standard for cape-wearing characters in MOTU Classics.

He includes his wizard's staff, which opens up to reveal a gemstone on top. There are actually three different gem colors available: green, purple, and red. The figure was packaged with the staff closed, so you were unsure which color gem your He-Ro figure would include until the figure was removed from the packaging and the staff was opened up.

He-Ro was first offered up at San Diego Comic-Con 2009 as an exclusive. The figure itself is identical to the version sold online, with one small difference. On the SDCC version, a small SDCC logo can be found on the figure's chest under the armor.

FUN FACTOID: This was a great example of what this line had to offer—fantasy fulfillment! This was a Holy Grail character for so many, and this release let people know that anything was possible with Classics.

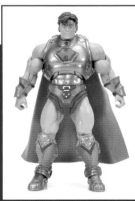

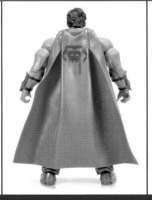

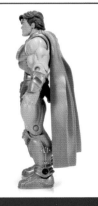

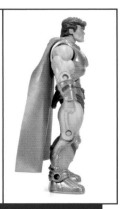

HE-RO II
HEROIC SON OF HE-MAN

First released 2015 • Member of the Heroic Warriors

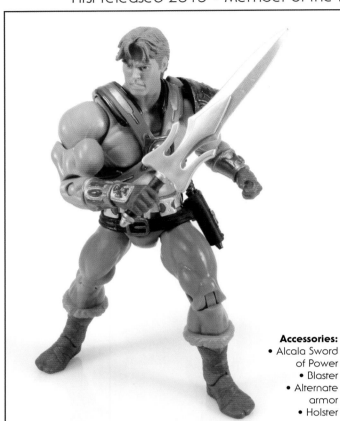

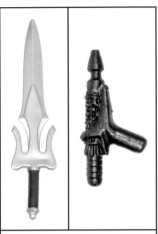

Accessories:
• Alcala Sword of Power
• Blaster
• Alternate armor
• Holster

There were two different pitches for a "He-Ro, Son of He-Man" animated series that was intended to follow the original Masters of the Universe toy line and cartoon. The first, pitched in the late eighties, ultimately became The New Adventures of He-Man, which shifted the focus back to He-Man himself rather than his future son. The second was pitched by Lou Scheimer in the midnineties, keeping the action on Eternia with the adopted son of He-Man and Teela having inherited the Sword of Power from his father. Both these pitches used the name "He-Ro" for He-Man's son, the name taken from the protagonist of the aborted Powers of Grayskull prequel line.

While there was never an official introduction of the son of He-Man, Mattel opted to include the character in the Masters of the Universe Classics line, making him part of the canon. Since there were two different pitches for the character, Mattel included several parts with this figure, allowing you to display him tied to either version. He has long blue pants much like Galactic Protector He-Man, and also includes removable sci-fi-themed armor that is quite similar to what we saw in the New Adventures line. He also includes a brand-new blue harness that you can use instead of the sci-fi armor that is much like the artwork seen in Lou Scheimer's series pitch. In addition, Mattel specifically designed this armor and He-Ro's head to be popped on to the Vykron body, allowing you to create a version of He-Ro that looks very close to the artwork of the son of He-Man in Scheimer's pitch!

As a bonus, the figure includes a new version of the Sword of Power that is based on the artwork seen in the original Masters of the Universe minicomics by Alfredo Alcala. This can be used with He-Ro, but of course can also be displayed with He-Man for fans who prefer this particular sword design.

FUN FACTOID: Many fans refer to this figure as "Dare" to distinguish him from the original He-Ro. Prince Dare is the character's name in his depowered form.

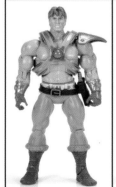

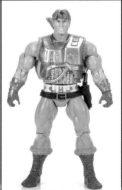
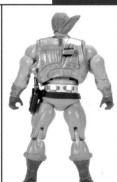

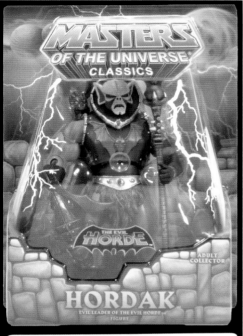

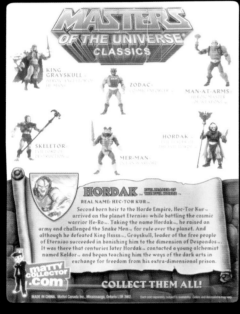

MAILER BOX CAME WITH REISSUE ONLY

FUN FACTOID: The Four Horsemen said, "The original figure was cool, but the head suffered because it was sculpted to be moldable. Being able to make the head and hood separate pieces allowed us to bring out all of the details that were implied on the original."

HORDAK
EVIL LEADER OF THE EVIL HORDE

First released 2009 • Member of the Evil Horde

Accessories:
- Staff
- Bat
- Crossbow

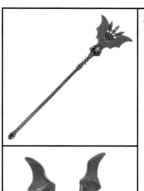

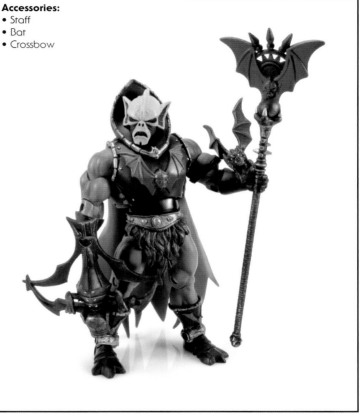

Hordak's release in the Masters of the Universe Classics toy line so early on was a big deal. He was a character who many fans wanted to see get an updated figure during the 200X-era, but never did. So Mattel opted to include him early on this time around. At this point, no one knew just how long the MOTU Classics toy line was going to last, so this was important.

The figure is strongly based on the look of the vintage action figure, but with more detailed sculpt work and the added articulation that was now known in the MOTU Classics toy line. The red cape on the back of his armor is made of plastic, and is much longer on this figure than it appeared on the original release. The head is also a clever sculpt as well, as the large collar he is wearing is a separate piece from the head itself. On the original toy, this was all one sculpt.

He is packaged with a brand-new staff accessory that was inspired by his appearance in the 200X-era. He also has the newly redesigned Horde Crossbow, although this time it's black rather than the white of the original toy. He also includes his little red bat companion. This is based off an accessory from the vintage toy line as well, although that bat was more like a shield that clipped to his arm. This time around, he's a fully sculpted bat creature that is able to perch on Hordak's arm, much in the same way the bat shield clipped to the original Hordak action figure.

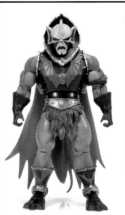

HORDAK
SPIRIT

First released 2013 • Member of the Evil Horde

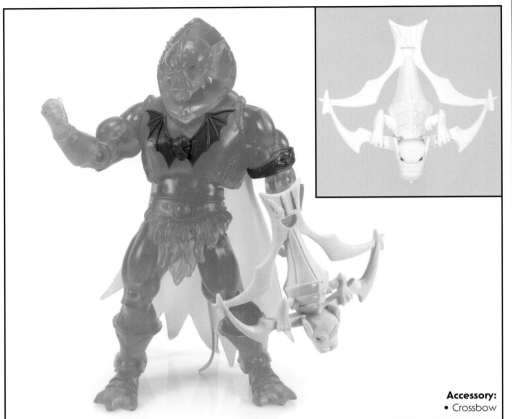

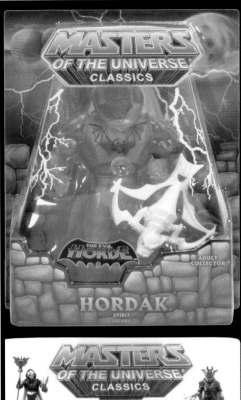

Accessory:
• Crossbow

The Spirit of Hordak is a reference to the MOTU Classics minicomics, in which Hordak would appear to Skeletor in red spectral form while he was still trapped in the dimension of Despondos. Mattel treated this like a chase figure, meaning that it randomly showed up for sale on their Matty Collector website with no warning at random times throughout the year. He was not part of the standard subscription service that most of the figures were sold through.

The Hordak figure sculpt is the same as the standard Hordak before him, but this time is made of a translucent red plastic. The only painted details on this figure include the Horde emblem on his chest, the armband, and his eyes, all of which are painted a solid red.

He includes one accessory in the form of his Horde crossbow, this time painted a solid, bright white. This is notable because the vintage Hordak action figure included a crossbow that was also white in color. This was added as a bit of a bonus, allowing fans to display this with their regular Hordak release in case they prefer the white crossbow from the vintage line.

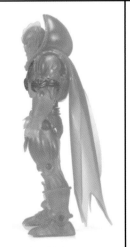

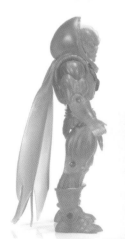

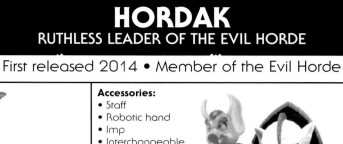

HORDAK
RUTHLESS LEADER OF THE EVIL HORDE

First released 2014 • Member of the Evil Horde

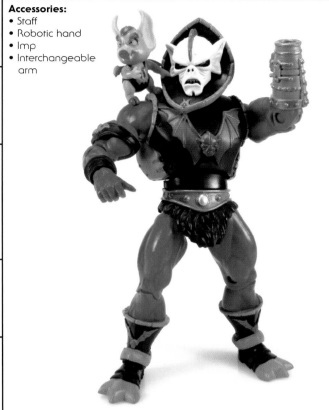

Accessories:
- Staff
- Robotic hand
- Imp
- Interchangeable arm

Sold as the 2014 San Diego Comic-Con exclusive, this version of Hordak is inspired by his appearance in the Filmation She-Ra: Princess of Power animated series.

The figure is mostly just a repaint of the standard Hordak action figure. This time around he has blue skin and a white face with a blue Mohawk, resembling his appearance in the animated series. The cowl this time comes from the Hurricane Hordak release, so there is no cape attached to it.

The biggest difference here is that his left arm is now interchangeable with a robotic arm. The arm just pops out of the socket at the shoulder, allowing you to easily swap in the new arm. This is another nod to the original cartoon series, in which Hordak often transformed his arm into a cannon. This robotic arm has a robotic hand plugged into the end that can also be removed, effectively creating that cannon.

He also comes packaged with Imp, his little sidekick character from the cartoon. Imp has limited articulation of his own; only his head and arms can be moved. Those who visited SDCC that year were given a bonus version of Imp in a small baggie, separate from the carded Hordak. This Imp was in the shape of a treasure chest, a nod to one of Imp's transformations from the classic cartoon.

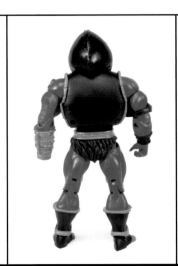
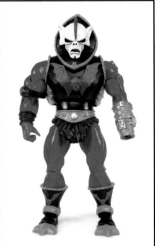

HORDE PRIME
SUPREME RULER OF THE HORDE EMPIRE

First released 2012 • Member of the Evil Horde

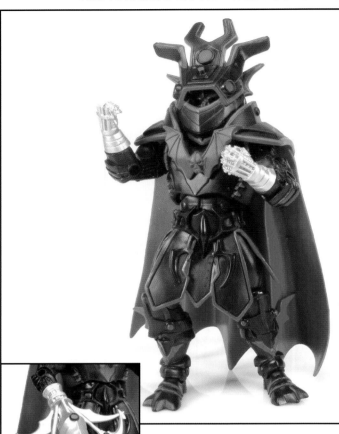

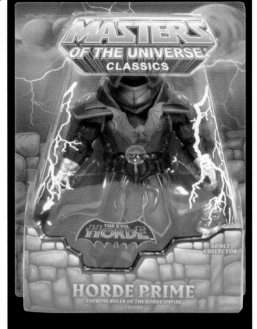

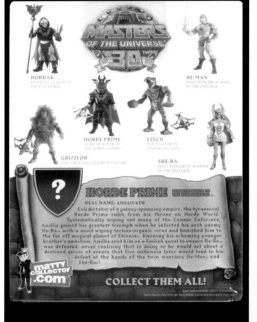

Accessories:
- Crossbow attachment
- Alternate head
- Replaceable hands
- Helmet

Horde Prime is the supreme ruler of the Evil Horde and appeared in the Filmation She-Ra cartoon as well as the UK comics published by London Editions. However, prior to the Classics line, he never had one true definitive look. In the She-Ra cartoon, he was permanently hidden behind a cloud of smoke, behind which only a faint form was distinguishable, with large robotic hands. The UK comics, meanwhile, gave him a physical form, but this did not match the little that was seen in the Filmation cartoon. This action figure in the Classics line marked the first time the character was given a definitive look.

Mattel attempted to keep Horde Prime's appearance under his helmet a surprise until the figure arrived in fans' hands. The helmet the figure is wearing is modeled after the design behind that cloud of smoke in the She-Ra cartoon. When you remove the helmet, there is a brand-new head sculpt that looks much like Hordak as he appeared in the 200X animated series, albeit with red-colored skin.

The figure's hands are sculpted to look a lot like the giant robotic hands seen in the She-Ra cartoon series. The hands are removable, and allow you to swap in the character's included Horde crossbow attachment in their place. The joints are the same, so you can also use previous hand attachments from figures like Roboto or Trap Jaw if you like.

Horde Prime also comes with a bonus secondary head. This head is inspired by Horde Prime's appearance in the UK London Editions comics, which is drastically different. This is a great added bonus that really allows MOTU Classics to do what it does best by paying homage to all forms of Masters of the Universe media.

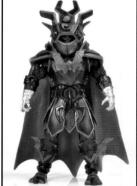

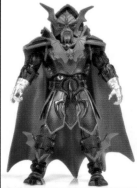

FUN FACTOID: The Four Horsemen said, "We did our best to interpret [the show's] silhouette into an armor design while including the hand design as well as some family resemblance to Hordak. We even gave him some extra height to at least give him a little size on the other characters."

MOTUC - SECTION 1

HORDE TROOPER
EVIL MECHANICAL ENFORCER OF HORDAK

First released 2017 • Member of the Evil Horde

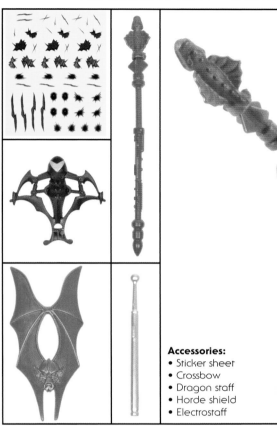

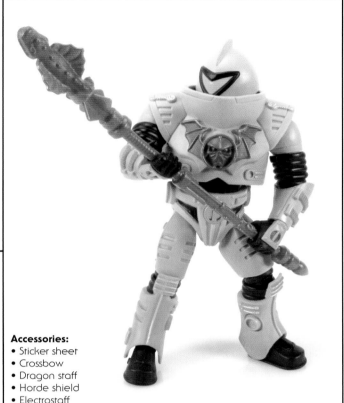

Accessories:
- Sticker sheet
- Crossbow
- Dragon staff
- Horde shield
- Electrostaff

Late in the Classics line's Mattel run, the Horde Trooper got a release as a single carded figure. This came a few years after the Horde Trooper was released in a two-pack, and was done to give fans the option to continue building their army of troops.

The figure is the same that was seen in that two pack, heavily inspired by his appearance in the vintage Masters of the Universe toy line. He also includes four accessories: the electrostaff from the Filmation cartoons, the dragon staff inspired by the vintage toy, a new Horde crossbow, and a new Horde insignia–shaped shield. A sticker sheet can be used to add battle damage. This large assortment of weapons allowed you to play in to the army-building design of the character so that you have multiple ways to arm up the figures for display.

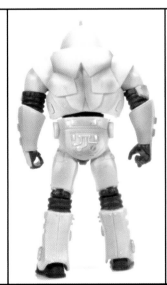

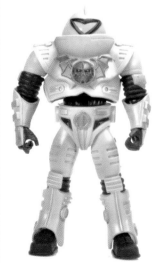

MOTUC - SECTION 1

HORDE TROOPERS
EVIL MECHANICAL ENFORCERS OF HORDAK

First released 2013 • Members of the Evil Horde

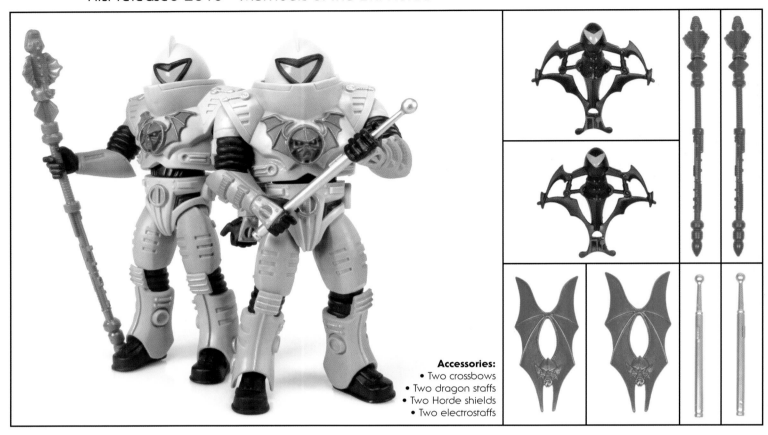

Accessories:
- Two crossbows
- Two dragon staffs
- Two Horde shields
- Two electrostaffs

Since the Horde Troopers were depicted as a large army of robotic warriors in the Filmation She-Ra: Princess of Power cartoon series, Mattel knew that fans would want to build armies with these particular characters. As a result, the Horde Troopers were released in two-packs with a ton of accessories to encourage the army-building concept.

The two figures inside are identical to one another, with the exception of one figure having "battle damage" in the form of blaster scuffs seen on his torso and helmet. The figures were heavily inspired by the vintage toy from the original Masters of the Universe toy line, but did have some elements of the Filmation design as well, specifically the shape of the eyes on the helmet. The original toy was far more detailed than the smooth appearance of the troops in the cartoon, and the new figures followed suit with a lot of robotic details worked into the sculpts.

The original action figure also had an action feature. When the large red button on the figure's chest was pressed, the robot would "explode" and crumple down. This action feature has been removed from these new figures, as was standard for MOTU Classics. However, the Horde insignia on the figure's chest is still circular, paying homage to that large button from the vintage toy.

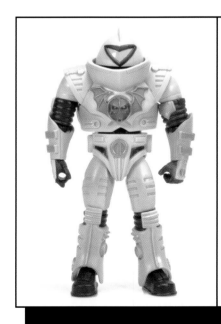
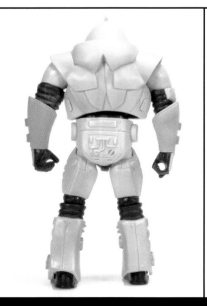
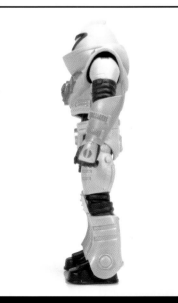
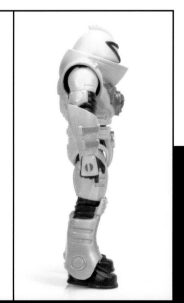

The figures contained a ton of newly sculpted parts. This was somewhat unique at this stage of the line, as many of the figures relied heavily on reusing body parts from preexisting figures. Even the torso on the Horde Troopers is brand-new under the armor. Instead of the usual, muscular torso piece, the Horde Troopers have a new robotic body design, which even includes painted details in the form of small red wires that look as though they are running up to the figure's helmet.

The heads are still swappable on these figures, just as with most of the Masters of the Universe Classics figures. This plays even more into the idea of buying multiple figures, as you can re-create scenes from the cartoon. Placing Hordak's head or He-Man's head on a Horde Trooper body will re-create moments in the series of them wearing the Horde Trooper armor. Or you can use the extra Horde Trooper heads that came with the later General Sundar action figure to make Horde Trooper variations.

A slew of weapons were included with these figures to play even more into that army-building concept. The electrostaff comes straight out of the Filmation cartoon, while the dragon staff is inspired by the weapon that came with the vintage action figure. Brand-new weapons included are a unique version of the Horde crossbow and a new Horde insignia–shaped shield. You get two of each of these weapons, really allowing you to mix and match parts to display a massive army of Hordesmen.

Shareable Accessories: GENERAL SUNDAR

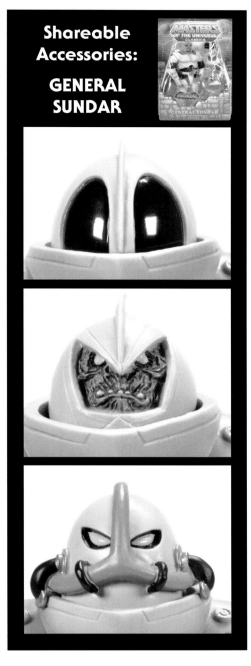

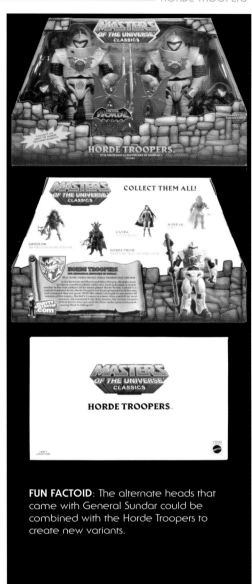

FUN FACTOID: The alternate heads that came with General Sundar could be combined with the Horde Troopers to create new variants.

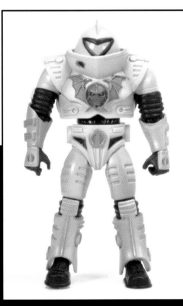

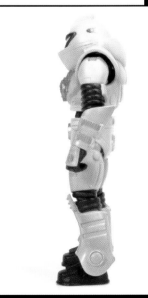
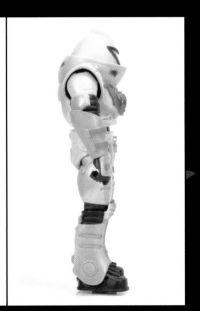

MOTUC - SECTION 1

HORDE WRAITH
SORCERER FOR THE EVIL HORDE

First released 2016 • Member of the Evil Horde

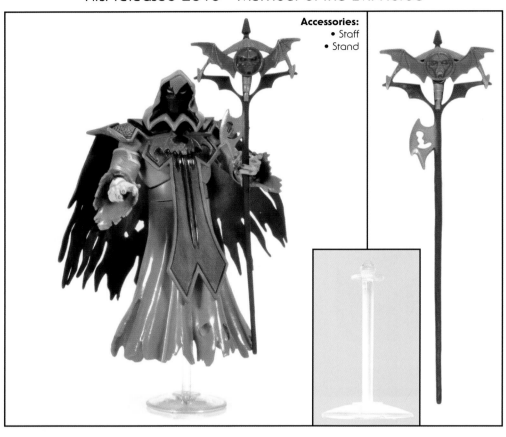

Accessories:
- Staff
- Stand

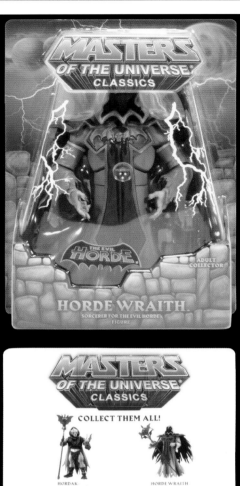

The Horde Wraith showed up briefly in the 200X-era cartoon series by Mike Young Productions. There was an army of these characters accompanying the Evil Horde as spell-casters, so essentially this is a nameless army-building figure.

The figure is unique in the fact that he does not actually contain any legs. Under the robes you will find a transparent flight stand, making it look like the robed wizard is floating above the ground. As a result, the figure stands nearly eight inches tall, making him hover nearly a full head taller than most figures in the MOTU Classics toy line.

His hands are sculpted open as if he is casting spells. He does include one accessory in the form of a Horde staff. Because his hands are open, there is a special way for him to hold on to the accessory. A little extra piece is attached to the side of the staff with finger holes shaped to fit his open right hand.

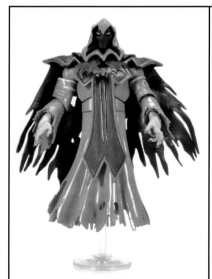

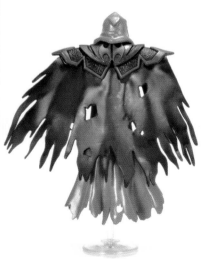

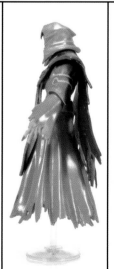

HORDE ZOMBIE HE-MAN
MIND-CONTROLLED MONSTER OF THE EVIL HORDE

First released 2019 • Member of the Evil Horde

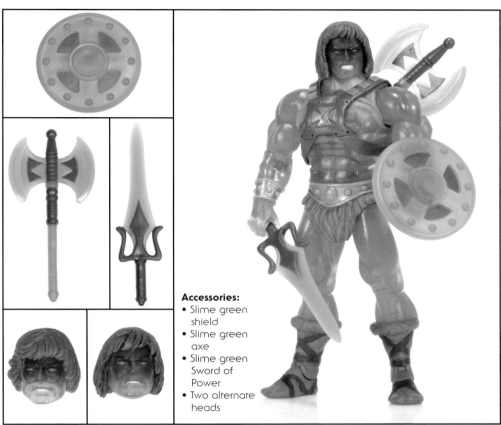

Accessories:
- Slime green shield
- Slime green axe
- Slime green Sword of Power
- Two alternate heads

Released as a Power-Con exclusive in 2019, Horde Zombie He-Man had long been a fan-demanded action figure variant. Given the official name Horde Zombie He-Man, this all-green He-Man is the result of being turned into a Slime Pit zombie by the Evil Horde. Because of this, the fan community referred to this character as "Slime Pit He-Man" for many years prior to the figure's release.

Utilizing the same basic body seen on most of the He-Man variations in the MOTU Classics toy line, this version is molded in a translucent green plastic. He includes three different He-Man heads that can be swapped out, each of which had been previously released throughout the life of the Classics line. Now molded in the same translucent green plastic as the body, and with bright red eyes, the three heads allow you to display Horde Zombie He-Man according to your preference: original MOTU Classics head, Alcala minicomics-inspired head, or vintage toy-inspired head.

In addition to the three heads, Horde Zombie He-Man also comes with the classic He-Man weapons—the shield, axe, and Sword of Power—all of which are also molded in the same translucent green plastic as the figure itself.

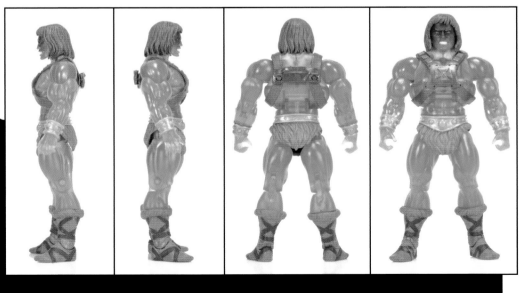

HOVER ROBOTS
EVIL MINDLESS ROBOT GOONS

First released 2015 • Members of the Evil Warriors

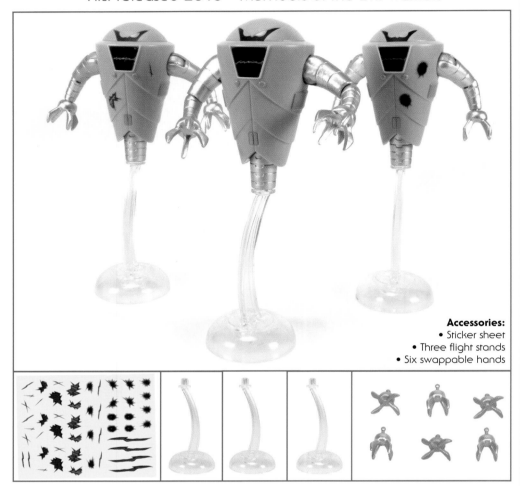

Accessories:
• Sticker sheet
• Three flight stands
• Six swappable hands

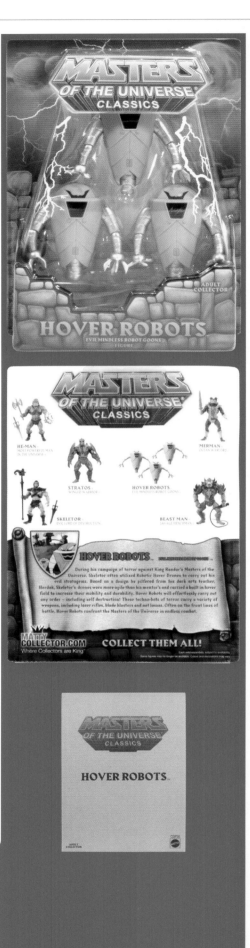

The Hover Robots appeared in the original Filmation He-Man and the Masters of the Universe cartoon as a mindless army controlled by Skeletor. These had never been offered in toy form until the Classics line. Sculpted by frequent Four Horsemen collaborator Joe Amaro, the Hover Robots were released in MOTU Classics as the 2015 traveling convention exclusive, meaning they showed up for sale at multiple conventions throughout the year.

The robots came in a three-pack and were heavily inspired by their original cartoon appearance. There is a lenticular sticker on the body that appears to move when you turn the figure. This is meant to look like the wavy line when the robots spoke in the cartoon. Each one also includes a removable flight stand to make it look as though they are hovering. It's worth noting that the figures do not really stand without those flight stands attached.

The hands are interchangeable. Each one has standard three-fingered hands. But all of those can be replaced with bladed hands if desired. There is also a sheet of decal stickers allowing you to apply battle damage to the Hover Robots if you wish. The stickers look like blaster burns, scratches, and cracks and allow you to really modify the overall look the way you wish. This also plays into the army-building aspect of these figures, encouraging you to differentiate them from one another.

MOTUC - SECTION 1

HUNTARA
COURAGEOUS SILAXIAN WARRIOR

First released 2015 • Member of the Great Rebellion

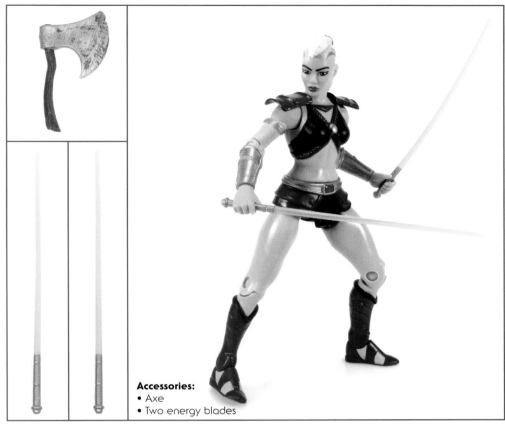

Accessories:
- Axe
- Two energy blades

Huntara appeared in the Filmation She-Ra: Princess of Power cartoon series as a standalone character. She was a fan-choice figure, voted on by the fans to appear in the Masters of the Universe Classics toy line.

The figure is unique, with a lot of new pieces to closely match up with how she appeared in the cartoon series. She includes her two signature energy blades for weapons. She can dual wield these in her hands for combat, but can also store them on her back when not in battle.

She also includes an axe weapon, but as it turns out this axe does not actually belong to this action figure. Mattel stated at the time that there was a slip-up at the factory that resulted in this axe mistakenly being packaged with Huntara. In fact, it was designed for Oo-Larr. So if you have Oo-Larr, you can treat this as a bonus accessory and give it to him. But of course, there's nothing stopping you from posing it with Huntara if you wish.

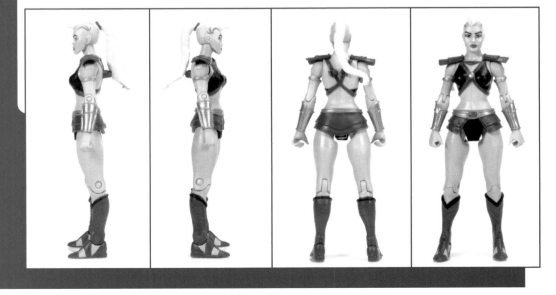

MOTUC - SECTION 1

HURRICANE HORDAK
RUTHLESS LEADER WITH WICKED WHIRLING WEAPONS

First released 2011 • Member of the Evil Horde

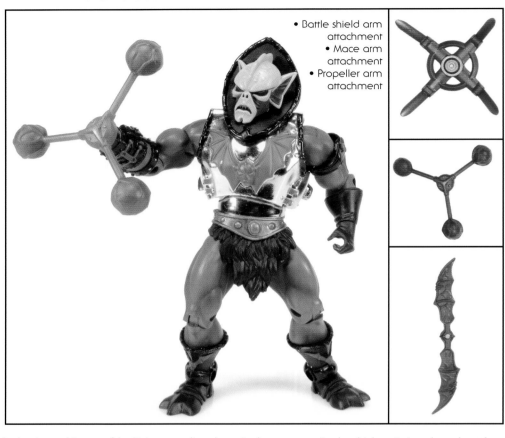

- Battle shield arm attachment
- Mace arm attachment
- Propeller arm attachment

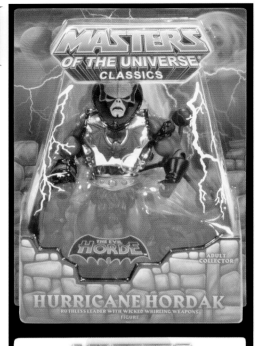

In the vintage Masters of the Universe toy line, the main characters received multiple variations throughout the years. This included Hordak, for whom Hurricane Hordak was the first variant.

While action features are mostly missing from the MOTU Classics toy line in favor of higher articulation and better detailed sculpts, Mattel still included a lot of unique additions here to make Hurricane Hordak feel very similar to his original release. The figure is mostly a reuse of the sculpt from the standard Hordak; however, he does have newly sculpted pieces. One of those is the cowl around his head, which this time does not have the long red cape attached to it. He also has a new cannon arm on the right. This arm allows you to swap between the three included arm attachments. They do not have a spinning feature on this figure like they did on the original, but they still work very well for displaying the figure with one of the new weapons attached.

The torso and the armor over it are vac metalized to accomplish the shiny gold look of the vintage toy. The armor is made of a softer, pliable plastic instead of the harder plastic typically seen on vac-metal toys. As a result, flexing the armor around can result in the gold cracking and flaking off fairly easily.

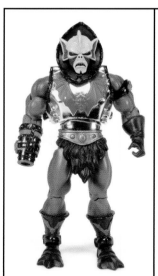

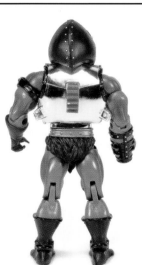

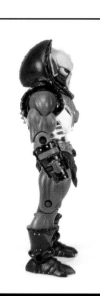

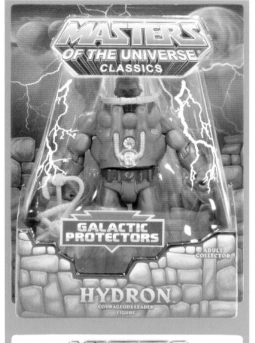

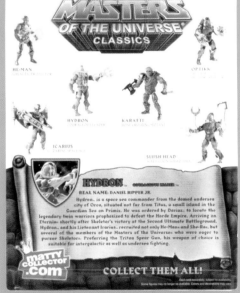

HYDRON
COURAGEOUS LEADER

First released 2014 • Member of the Galactic Guardians

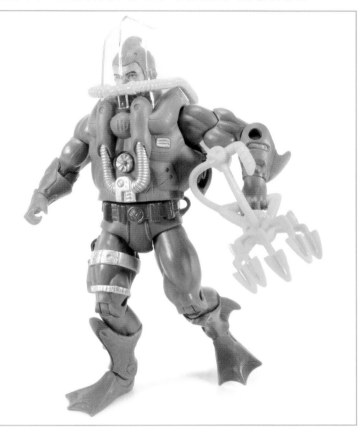

Accessories:
• Trident blaster
• Helmet

Hydron was introduced in the New Adventures of He-Man line in 1989. Presented as one of the leaders of the Galactic Protectors, this character has always seemed odd in that he wears a full-on water-diving suit while fighting his battles primarily in outer space.

The character was updated for the Masters of the Universe Classics toy line. While the original New Adventures toy line was smaller in scale compared to the vintage Masters of the Universe line, Hydron was made to fit in with the style of the line by being bulked up with the same muscular body seen on most figures. His armor and many of the parts on his arms and legs are newly sculpted bits to pull off the look of his unique diving suit. The large sculpt of his armor over his muscular body does result in his torso looking extra puffy.

The helmet is a transparent plastic dome. It can be removed, and is attached to the armor with a connecting plastic yellow hose. Hydron also comes with his unique trident blaster, which closely resembles the same odd weapon that came with his vintage toy counterpart.

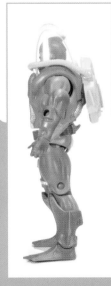

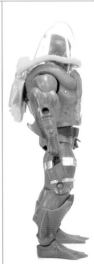

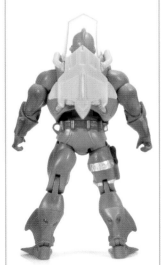

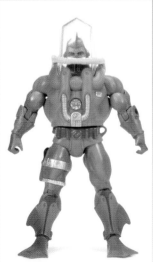

ICARIUS
DARING SPACE ACE

First released 2011 • Member of the Galactic Guardians

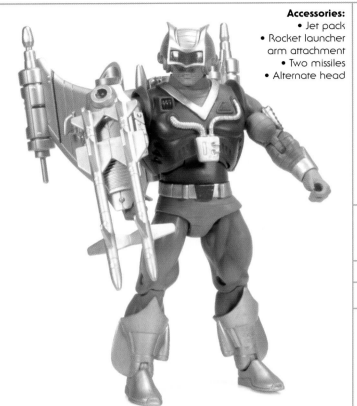

Accessories:
• Jet pack
• Rocket launcher arm attachment
• Two missiles
• Alternate head

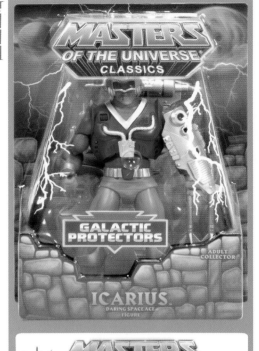

Icarius was better known in the US under the name "Flipshot." A part of the New Adventures of He-Man toy line, he was known as "Icarius" outside of the US. This name had to be used in the MOTU Classics toy line due to trademark issues with the name Flipshot.

Icarius includes a winged jetpack much like the one packaged with his vintage action figure. It's larger and more detailed for this new rendition, and even features articulation at the wings, allowing them to slightly move back and forth for flight poses. The missiles at the end of the wings are removable, but don't actually fire.

The rocket launcher arm attachment accessory clips on to the figure's wrist. Much like the jetpack, there is no rocket-firing action feature, but the missiles are removable from the attachment. The visor on Icarius's helmeted head can be raised and lowered. Or if you prefer to display him sans helmet, he includes an interchangeable nonhelmeted head. For a figure that doesn't have any actual action features, he does have multiple display features!

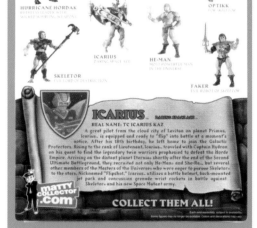

FUN FACTOID: Icarius was the first hero from New Adventures made in Classics.

ICARIUS

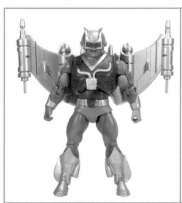
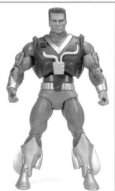
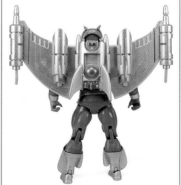
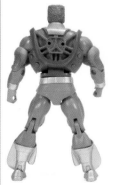

ICER
EVIL MASTER OF COLD

First released 2013 • Member of the Evil Warriors

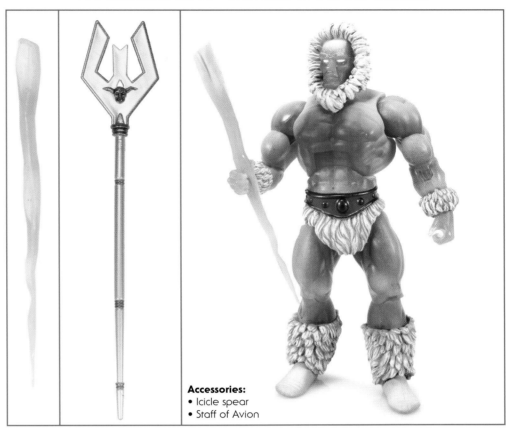

Accessories:
- Icicle spear
- Staff of Avion

Icer appeared as a standalone villain in the Filmation He-Man and the Masters of the Universe cartoon series. He had never appeared as an action figure before the MOTU Classics toy line.

The figure's look is based on his appearance in the cartoon series, but with a more detailed sculpt to better fit in with the style of the Classics line. The figure is made of a translucent blue plastic with a nice white dry brushing to give him a frosted, icy look. He comes with a large icicle spear-like weapon that can be held in his hand for battle.

The second accessory is a bonus. This is the Staff of Avion as it appeared in the Filmation cartoon series. This is actually meant for your Stratos action figure. Introducing recognizable relics from the Filmation series would become standard practice for the Classics line.

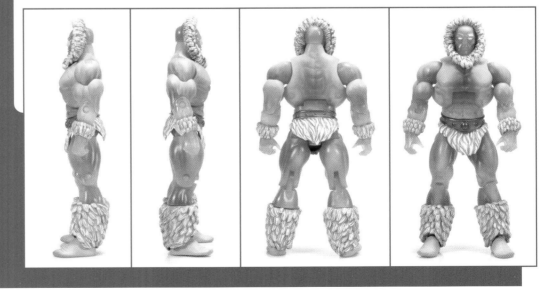

IMP
MINIATURE MUTATING MINION OF HORDAK
First released 2014 • Member of the Evil Horde

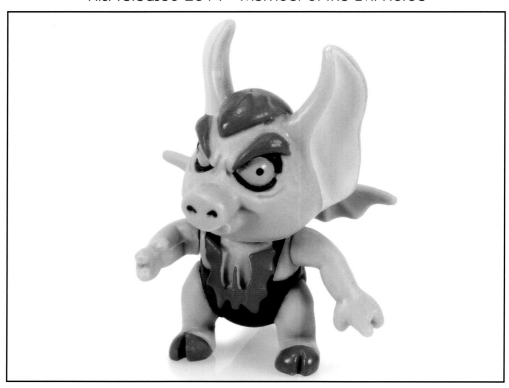

Imp appeared as the sidekick of Hordak in the Filmation She-Ra: Princess of Power cartoon series. He was offered as an action figure for the very first time when he came as a pack-in bonus with the San Diego Comic-Con 2014 exclusive Hordak figure.

Imp is modeled directly after his appearance in the cartoon. He has limited articulation—only his head and arms move. He's a very small figure, only standing around one inch tall.

Those who visited SDCC that year were given a bonus version of Imp in a small baggie, separate from the carded Hordak. This Imp was in the shape of a treasure chest, a nod to one of his transformations in the classic cartoon. The toy featured a lid that could actually open.

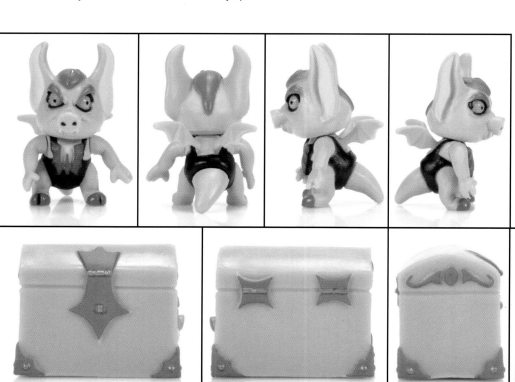

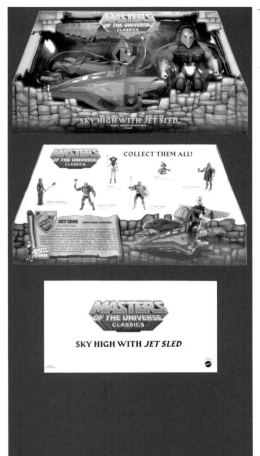

JET SLED

First released 2013 • Vehicle of the Heroic Warriors

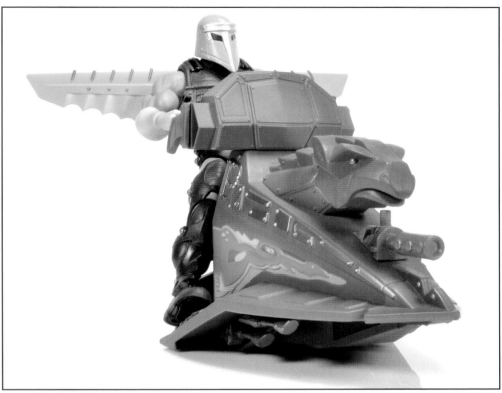

Originally named the Sky Sled in the vintage Masters of the Universe toy line, the Jet Sled is a small standalone flying vehicle used by the Heroic Warriors. It's better known as the front half of the Battle Ram vehicle. On the original toy, it could be detached to become its own mini vehicle, and was often seen in this form in the Filmation cartoon series.

At the time of its release, Mattel did not know if they would be able to release a vehicle as large as the full Battle Ram. Instead, they opted to just release the front piece as the Jet Sled and pack it with a brand-new action figure named Sky High. The Jet Sled follows the look of the vintage toy, but with some newly sculpted details. For example, all of the areas that were merely adorned with stickers on the original toy now have fully sculpted and painted design work. This can be seen most prominently in the green dragon design on the side of the craft.

A figure could mount the vehicle on the back end and hold on to the handlebars. It was also designed so that it could be plugged in to a future Battle Ram release just in case—which paid off, as Mattel ultimately did release the full Battle Ram vehicle in Masters of the Universe Classics.

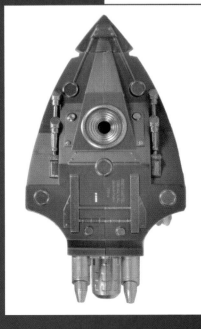

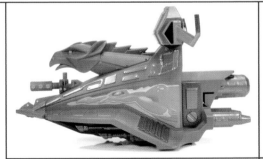

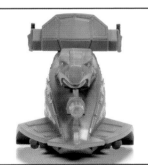

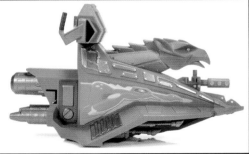

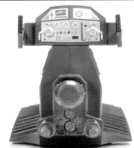

MOTUC - SECTION 1

JEWELSTAR
HIDDEN BEAUTY

First released 2012 • Member of the Great Rebellion

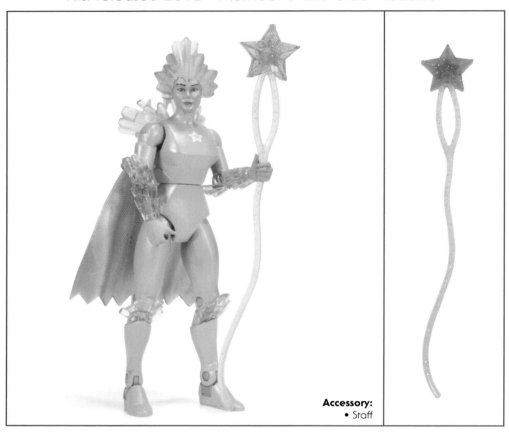

Accessory:
• Staff

The Star Sisters appeared briefly in the Filmation She-Ra: Princess of Power animated series and were also prototyped to be released as figures in the vintage She-Ra toy line, but never saw release. Masters of the Universe Classics finally brought them to action figure form with the Star Sisters three-pack.

Like the other Star Sisters in the MOTU Classics line, Jewelstar's appearance was closely based on her depiction in a poster and illustrated story from issue 6 of the Princess of Power magazine from 1987. These designs are closer in appearance to the Star Sisters' look in the Filmation She-Ra cartoon than to their prototype designs..

If released in the vintage toy line, the figure would have been made entirely out of translucent pink plastic. In Classics, the crystal formations found on Jewelstar's headdress, arms, and legs are all made of a translucent pink plastic, while the rest of the figure is painted a shimmery pink. Her cape has a pearlescent look to it as well. Like with the rest of the Star Sisters, Jewelstar also comes with her own Star Staff as an accessory.

The Star Sisters three-pack is another great example of the Masters of the Universe Classics line honoring the many different forms of media by bringing to life figures that were merely unreleased prototypes before.

FUN FACTOID: Jewelstar was part of the Star Sisters three-pack based on vintage prototypes that were not released in the original She-Ra line.

JITSU
EVIL MASTER OF MARTIAL ARTS

First released 2013 • Member of the Evil Warriors

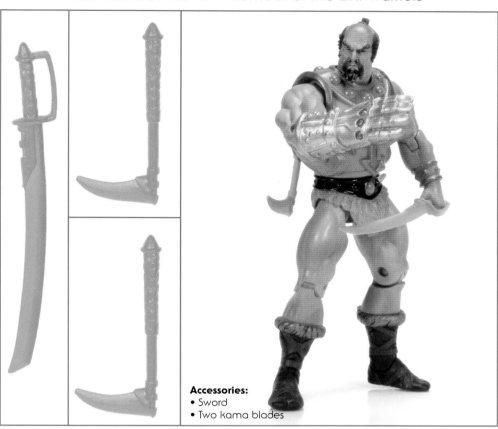

Accessories:
- Sword
- Two kama blades

Shareable Accesory!
Belt came Ninja Warrior

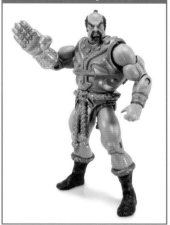

Jitsu is another character from the vintage Masters of the Universe toy line returning for MOTU Classics. While the figure is mostly taking direction from the look of the vintage action figure, there are certainly some new elements here that make him stand out on his own.

Many of the figures in this line that are based on original toys follow the design very closely, just with an updated, modern sculpt. Jitsu seems to take that a step further, as his face sculpt is much more stylized rather than a straight update of the vintage head. His armor is also brand-new, and unlike the vintage toy is not a shared design with King Randor.

The right hand is his signature enlarged golden chopping hand. Unlike with the vintage toy, this one is not made of a shiny vac-metal but rather just painted gold. He carries his orange sword, just like the vintage figure, but also has two additional kama sickle blades inspired by his redesign from the 200X-era. The back of his armor is even designed to store all of these weapons when not in use.

JITSU

FUN FACTOIDS:
- The Four Horsemen said, "This was a very faithful update of the vintage design, which just goes to show how solid the source material was in the first place. Once again a couple of 200X callbacks give the option to deck your figure out even more."
- Jitsu's 200X-inspired belt came with the Ninja Warrior figure in Classics, but the belt could be placed on Jitsu to re-create his 200X staction appearance.

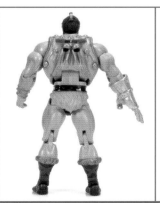
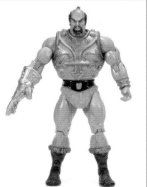

KARATTI
BONE BASHING MUTANT

First released 2013 • Member of the Space Mutants

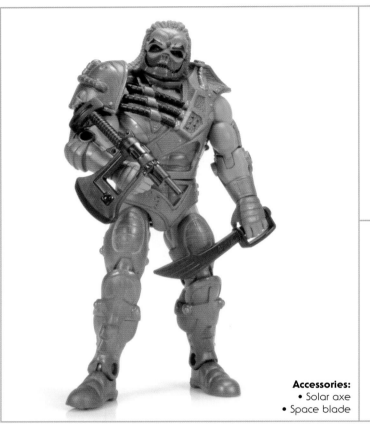

Accessories:
• Solar axe
• Space blade

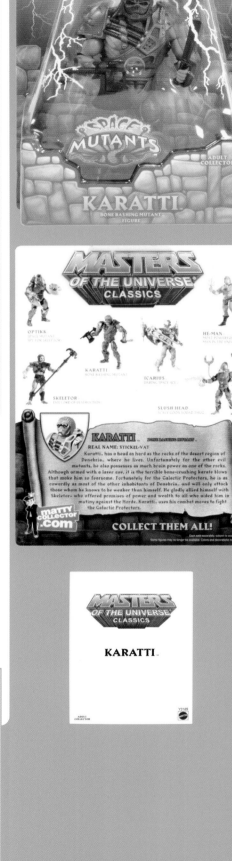

Karatti first appeared as one of the villainous Space Mutants in the New Adventures of He-Man toy line. Since all of the figures in that line were much smaller in scale, Karatti needed to be updated to the chunkier, more muscular look of Masters of the Universe Classics by using the standard body.

Many parts on this figure are reused from previous releases. Most notably, the arms and legs were used on many figures, including Man-E-Faces, Trap Jaw, Optikk, and Roboto. These parts got reused quite a bit, and almost became standard for the outer space creatures such as the evil Space Mutants.

Karatti does feature brand-new armor, that updates the look of the original action figure with more detailed sculpting. His included weapons also come from the vintage toy line, and are nearly identical, as they are just made of solid-colored, unpainted black plastic. The sword can be held in his right hand, while his Solar Axe can double as either an axe weapon or a blaster.

KARG
EVIL INQUISITOR WITH A HORRIBLE HOOK

First released 2018 • Member of the Evil Warriors

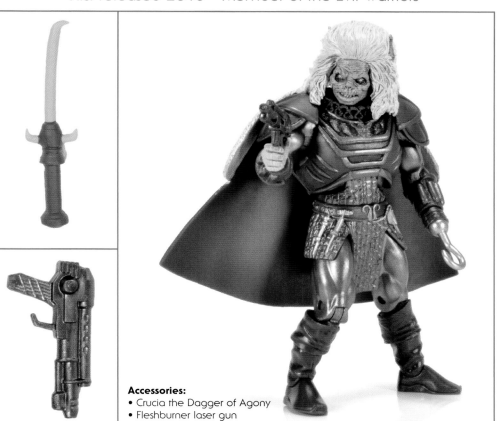

Accessories:
- Crucia the Dagger of Agony
- Fleshburner laser gun

Introduced in the 1987 Masters of the Universe motion picture, Karg never received a figure in the vintage line. With this 2018 toy release, he became the first character from the movie previously unproduced in toy form to be made for the Classics line. For many years, licensing kept Classics from including any character from the film outside of Blade, Saurod, and Gwildor. But a clever workaround eventually permitted Karg to be made for Classics. This involved basing his appearance on his depiction in a comic from Masters of the Universe magazine issue 11 from 1987 rather than the movie itself—which is why the color scheme of this toy is drastically different from his appearance in the movie.

Regardless of the fact that his color scheme is comic based, the sculpt is still highly detailed and otherwise matches the way the character appeared in the movie itself. He has a hook for a left hand and unique boots that come up above the knees. His torso is the standard muscular body used for most MOTU Classics figures, with new armor fitted over it, making him look a bit bulky. It's worth noting that the armor is not removable on this figure, as it is glued in place.

Karg comes with two accessories, a dagger and a blaster, the latter inspired by the film. Since he only has one hand, he can only hold one of these accessories at a time, and he does not have anywhere to store them on his body.

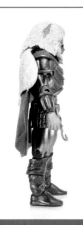
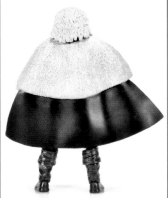
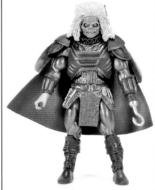

KELDOR
APPRENTICE OF HORDAK

First released 2010 • Member of the Evil Warriors

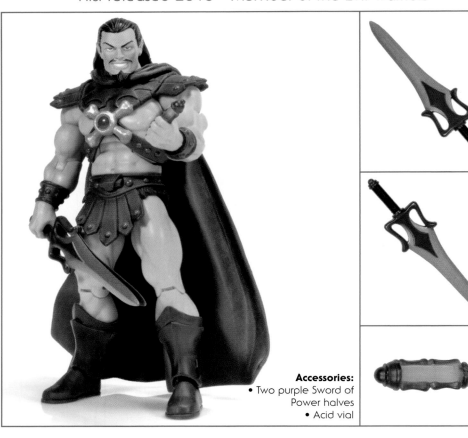

Accessories:
• Two purple Sword of Power halves
• Acid vial

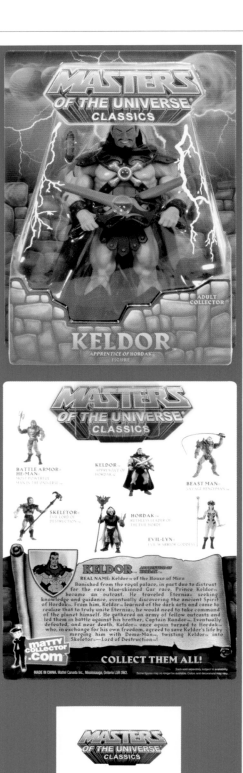

Keldor first appeared in the 200X-era cartoon series as the pretransformation Skeletor. This figure is heavily based on his appearance in that cartoon series.

Many parts are reused here from previously released figures such as Skeletor, including the armor, with a new paint job. His body uses the more standard buck seen on figures like He-Man, so it's more human and missing the monster-like details of the finned arms. He also features brand-new boots on his feet, as well as a new purple cape. This cape is a nice addition, as it allowed fans to also place this cape on the Skeletor figure to re-create a signature look for the character that had seldom been seen in toy form.

For accessories, he has the small vial of acid that ultimately caused his face to be disfigured into the yellow skull visage we all know. He also carries both halves of the classic Sword of Power in purple, allowing them to be split in half for dual-wielding sword posing. This is in reference to Skeletor's dual swords in the 200X-era, although those had a very different look.

Eventually, Mattel would hear the request of the fans and offer a new dual-bladed sword for Keldor that actually matched the unique look from the 200X-era. It was offered as part of the third Weapons Pak, released in 2012. There was also an individually bagged version that was given out to fans for free at Power-Con 2012. However, due to a factory error, this version was unable to separate into two.

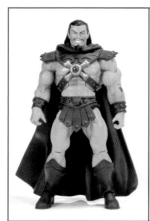 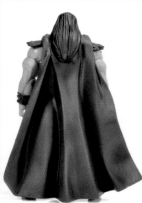 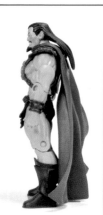 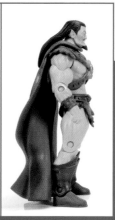

MOTUC - SECTION 1

KING CHOOBLAH
HEROIC KING OF THE KULATAKS

First released 2015 • Member of the Heroic Warriors

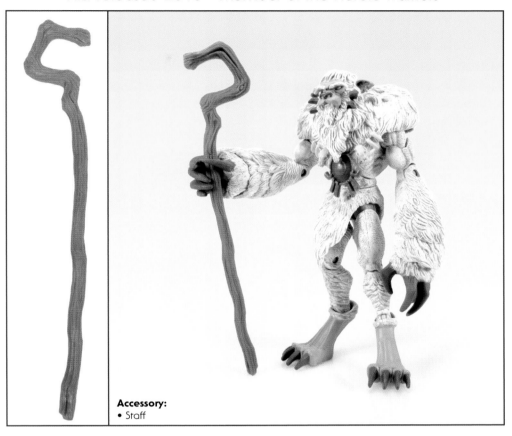

Accessory:
• Staff

King Chooblah was a character who appeared in the 200X-era cartoon series by Mike Young Productions. Although he was unnamed in the show, he was given the name King Chooblah for the Classics line. This is one of the figures that really seem to break the mold set by Masters of the Universe Classics, because it has a lot of new parts in order to create the larger, yeti-like look of the Kulatak race.

The torso and upper legs are the same furry parts used on previous figures like Beast Man. However, the new massive forearms and unique lower leg sculpts do an amazing job of making the figure both taller and considerably different in appearance from your standard MOTU Classics action figures. The upper body piece sits over the shoulder of the torso, making it appear as if he has a large, hunched back. It is truly a clever mix of existing and new parts.

King Chooblah only comes with one accessory in the form of his large staff, which can be held in his right hand. But with all of the unique pieces on this figure, it's easy to see why he wasn't packed with a lot of weapons.

MOTUC - SECTION 1

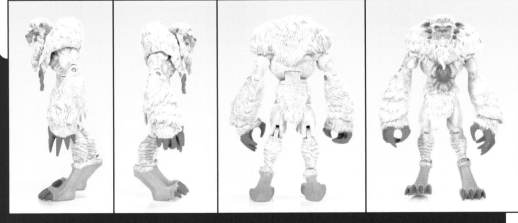

KING GRAYSKULL

First released 2008 • Ancestor of the Heroic Warriors

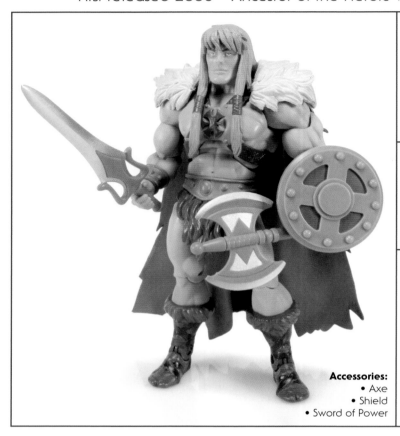

Accessories:
- Axe
- Shield
- Sword of Power

At San Diego Comic-Con 2008, Mattel launched their brand-new Masters of the Universe Classics toy line with a show exclusive. This exclusive was King Grayskull, a character who was introduced as the ancestor of He-Man in the 200X-era cartoon series by Mike Young Productions. Until this figure, King Grayskull had never been released in toy form.

This figure was notable for giving us a new character in toy form while also ushering in a brand-new era for Masters of the Universe in the form of a line of action figures aimed specifically at the collector market. The new body design, articulated and highly detailed, would become the standard for the line, reused over and over again for a variety of future action figures.

The figure bridged the gap between the 200X toy line that ended a few years earlier and the Classics toy line, which would return to the brand's roots with many of the design elements. For example, the Sword of Power included with King Grayskull was not the 200X-style sword, but rather was modeled after the original Sword of Power seen in the vintage toy line. The same was done with both the battle-axe and the shield included with the figure.

King Grayskull also had unique packaging, since he was a SDCC exclusive. The box could be unfolded and displayed as a model of Castle Grayskull. The jaw-bridge door on the front could be opened up, revealing the King Grayskull action figure within. When this door was opened, the voice of King Grayskull from the animated series would shout, "I have the power!" and be accompanied by flashing lights within the box and the sound of thunder crashing. Truly a special presentation and quite a way to hype the return of the Most Powerful Man in the Universe.

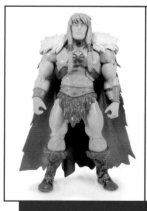

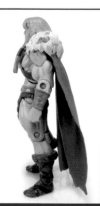

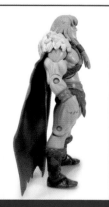

FUN FACTOID: Although the first figure sculpted for Classics was He-Man, King Grayskull was the first release. Ironically, a 200X character was the one to introduce MOTU Classics to the world.

MOTUC · SECTION 1

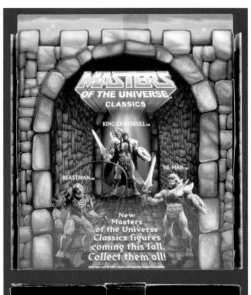

Long before PRINCE ADAM™ held the Sword of Power to become HE-MAN™, his ancestor, KING GRAYSKULL™ defended Eternia™ from evil. Heroically mastering the secret power of his sword, Grayskull fought side-by-side with the cosmic warrior HE-RO™ against both the evil HORDAK™ and KING HISS™.

Although Grayskull eventually fell before Hordak's magic, he was able to preserve his powers inside the sword, so that one day his descendents could reclaim the power and call upon Grayskull's name whenever evil threatens the peace of Eternia. To this day, Grayskull's spirit remains hidden away deep inside the castle which will forever bear his name.

KING GRAYSKULL
ENCHANTED HEROIC AVATAR OF GRAYSKULL

First released 2008 • Monument of Heroic Ancestor

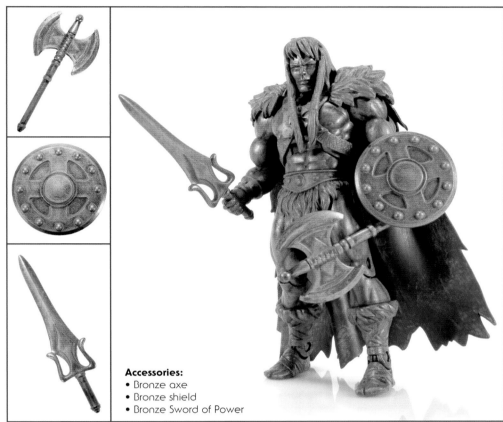

Accessories:
- Bronze axe
- Bronze shield
- Bronze Sword of Power

When King Grayskull was released at the 2008 San Diego Comic-Con, a small number of chase figures were also released. This version had a bronze paint deco to mimic the look of a statue of King Grayskull. It was unknown to fans if they would end up with this version when they bought their King Grayskull action figure, as the only way to know who was in the box was to open the Jaw Bridge on the package, revealing the figure within.

In addition to this bronze chase figure, there were also a handful of translucent blue King Grayskull figures made, dubbed "Spirit of King Grayskull." Only two of these were made for the public—one was given away as a raffle prize at SDCC, and the other was raffled off for charity. The other twenty-nine translucent figures were given to Mattel employees who worked on the line. As a result, this spirit figure isn't officially considered part of the toy line, but rather a bonus "employee" figure.

MOTUC - SECTION 1

KING GRAYSKULL
HEROIC ANCESTOR OF HE-MAN

First released 2010 • Ancestor of the Heroic Warriors

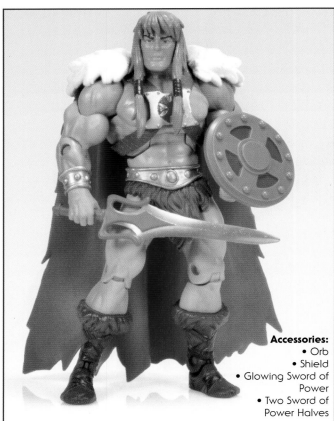

Accessories:
- Orb
- Shield
- Glowing Sword of Power
- Two Sword of Power Halves

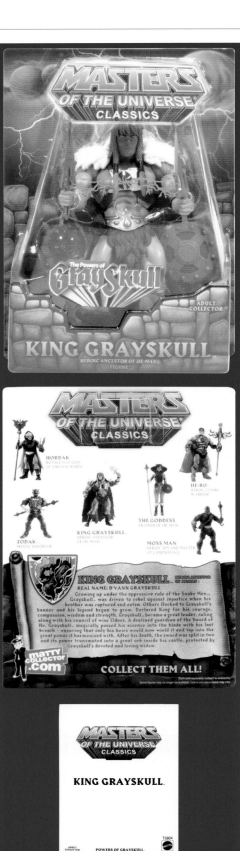

Since the King Grayskull action figure that kicked off the Masters of the Universe toy line was exclusive to the 2008 San Diego Comic-Con, many fans missed out on the figure, especially those who came into the line later. Because of this, Mattel opted to reissue King Grayskull with some updates and new accessories.

The figure's sculpt is exactly the same as the previous release's; however the paint job is different. The biggest difference is in the cape, which is now bright red with white flocked fur at the top. He comes with the same standard shield, but the Sword of Power now has a translucent blue tip, as if he is transferring the Power of Grayskull energy from the blade.

Also included is a sparkly blue orb. This orb is the receptacle that Grayskull transferred his power into. The Castle Grayskull play set in the Classics line has a hidden chamber to store this orb in. Lastly, King Grayskull comes with another, silver, Sword of Power that can be split in two. All of these elements are part of the story of King Grayskull transferring the power to the orb inside Castle Grayskull, and then splitting the Sword of Power into two parts–later to be reunited by He-Man.

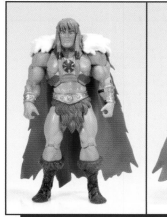

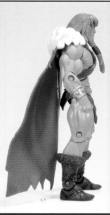

MOTUC - SECTION 1

KING HE-MAN

KING HE-MAN
HEROIC RULER OF FUTURE ETERNIA

First released 2013 • Member of the Heroic Warriors

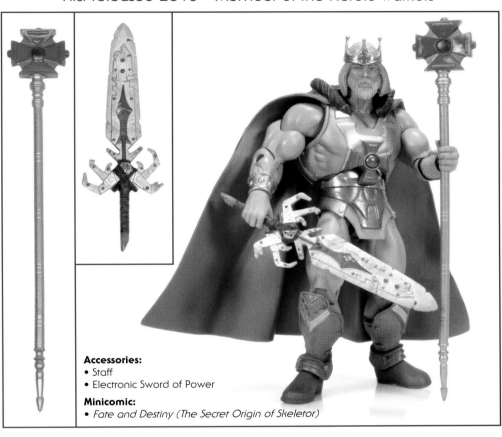

Accessories:
- Staff
- Electronic Sword of Power

Minicomic:
- *Fate and Destiny (The Secret Origin of Skeletor)*

This is best described as a "what if" figure, looking into the future to show us an older He-Man as the king of Eternia.

The design of this character seems to blend together many aspects of what we've seen through the years on Eternia. The boots and loincloth piece are quite reminiscent of what was worn by He-Ro before him. The long blue cape and crown upon his head, as well as the bushy beard, all remind us of his father, King Randor.

This is a grizzled, battle-worn He-Man, as we can see by the large scar across the left side of his face. Since in this era, the Sword of Power has been handed down to his son, also named He-Ro, this King He-Man figure has a new version of the electronic Sword of Power. This sword is now very beat up and rusted. The all-new sculpt shows the sword with dents, scrapes, and even a new bone handle strapped on.

FUN FACTOID: King He-Man was shipped with the Subternia map as the 2013 Club Eternia exclusive (see page 537).

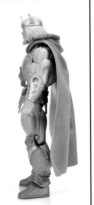

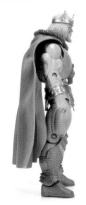

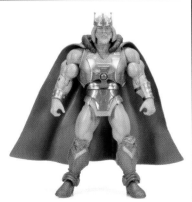

MOTUC - SECTION 1

KING HSSSS
DREADFUL DISGUISED LEADER OF THE SNAKE MEN

First released 2011 • Member of the Snake Men

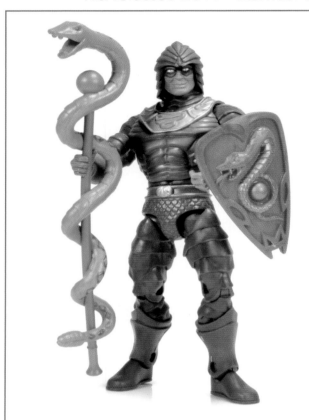

Accessories:
• Shield of Ka
• Snake staff
• Alternate snake form

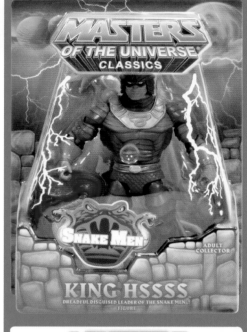

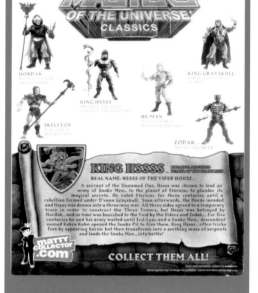

KING HSSSS.

King Hssss is a character who had a drastic redesign in the 200X-era, but the Masters of the Universe Classics figure returns his look back to the design of the vintage toy.

The vintage action figure had the feature of removable arms and torso armor, which acted as a disguise to cover up the character's true snake form underneath. Rather than having removable pieces, Mattel opted to make the entire upper body removable at the waist, allowing you to replace that with the snake form. This allowed the humanoid body to retain all of the articulation that the MOTU Classics line was now known for.

The snake body was similar to that of the vintage line in look, but was now made of a softer plastic with a bendable wire inside, allowing you to twist the snakes around a bit. The mouth even has a hinged jaw, so you can open and close it.

FUN FACTOID: In trying to adhere to the look of the vintage line, the Four Horsemen felt they took things a bit too literally and ended up with a snake form that just wasn't updated enough.

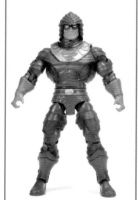

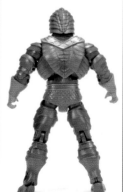

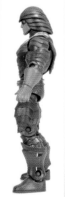

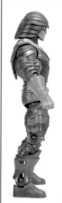

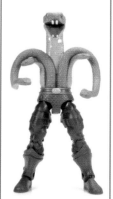

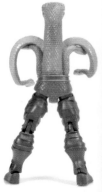

MOTUC - SECTION 1

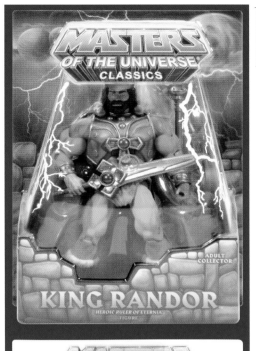

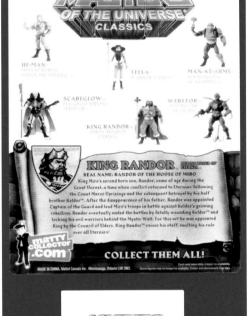

FUN FACTOID: The Four Horsemen tried to make Randor look less like the Burger King than did the original release.

KING RANDOR
HEROIC RULER OF ETERNIA

First released 2009 • Member of the Heroic Warriors

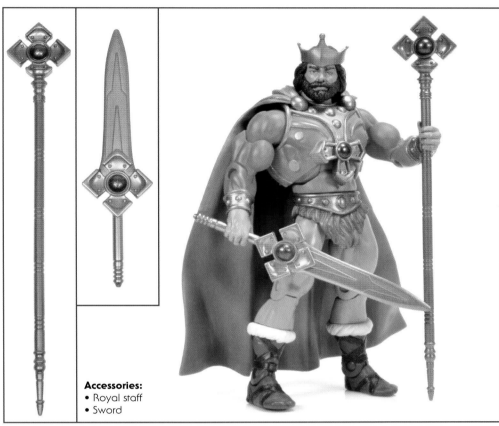

Accessories:
• Royal staff
• Sword

King Randor has had many looks over the years in various forms of media, such as the cartoons and comic books. The first King Randor figure release in the Masters of the Universe Classics toy line is based on his appearance in the vintage toy line.

Much like his original figure, Randor shares parts with preexisting figures. He has the standard muscular body, but the upper body is painted red, and the legs are painted orange to look like pants. He has new red and gold armor with a long blue plastic cape attached to the back.

While the majority of this figure is based on the look of the vintage toy, his accessories are actually inspired by his 200X-era redesign. Instead of the spear that came with his original action figure, he now wields a royal staff and the Sword of Eternos to do battle against the villains of Eternia!

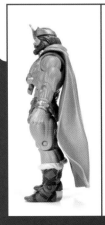
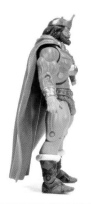
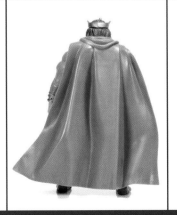
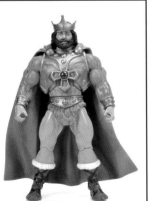

KING RANDOR
ETERNOS PALACE

First released 2012 • Member of the Heroic Warriors

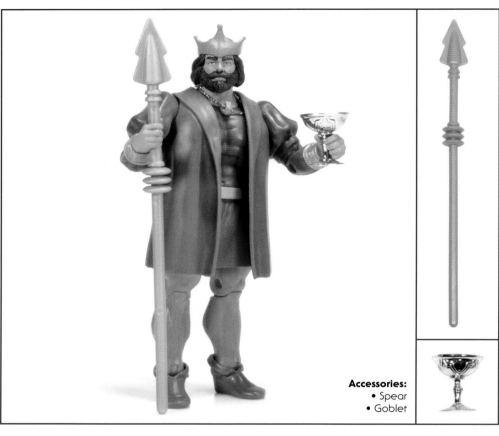

Accessories:
- Spear
- Goblet

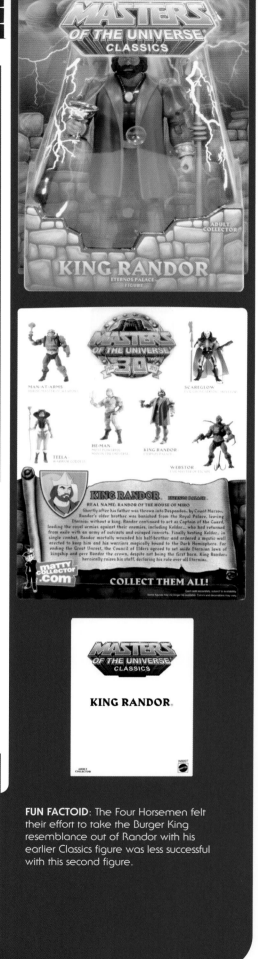

The second King Randor figure to be released in the Masters of the Universe Classics toy line, this version is much more reminiscent of the way he appeared in the Filmation cartoon series.

The head sculpt is the same as the first release figure's. Instead of the armor, this time he is wearing a much more kingly robe with arms sculpted to look like the sleeves of his new outfit. And while this version of the king is not armored for battle like the previous release, he does have a gold spear for an accessory. This is a direct nod to the accessory included with the vintage King Randor action figure.

The second accessory is incredibly fun. It's a metallic gold goblet, complete with sculpted red liquid inside. The king can hold this goblet in his hands, ready to celebrate the defeat of Skeletor's forces!

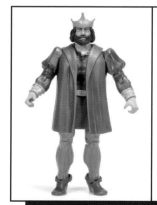

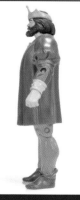
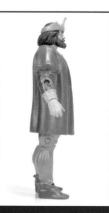

FUN FACTOID: The Four Horsemen felt their effort to take the Burger King resemblance out of Randor with his earlier Classics figure was less successful with this second figure.

MOTUC - SECTION 1

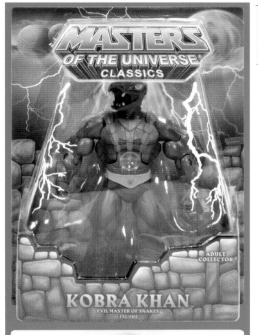

KOBRA KHAN
EVIL MASTER OF SNAKES

First released 2012 • Member of the Evil Warriors and Snake Men

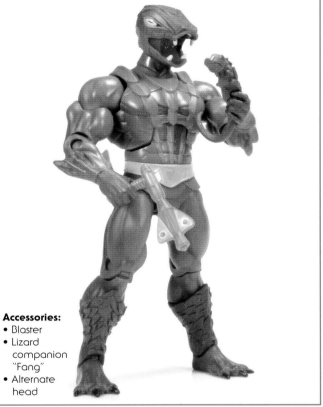

Accessories:
• Blaster
• Lizard companion "Fang"
• Alternate head

Based on the original figure that appeared in the vintage Masters of the Universe toy line, Kobra Khan's Classics figure also incorporates many elements from his redesign in the 200X-era.

The skin itself is much scalier than that of the figure of the 1980s, and he includes a lot of newly tooled pieces, including a new torso and new boot details that more closely resemble the parts used on the original toy—sculpted details we had not yet seen in the MOTU Classics line!

The vintage figure had hollow body and a water-squirting action feature in the head. Since action features have been removed, the head sculpt is modified so that it didn't necessarily resemble the squirt-gun-shaped mouth of the vintage—though it still has an open mouth, similar in shape. The figure also includes an interchangeable head with a cobra hood, a detail that was seen in the 200X figure of the character.

He comes with his classic blaster, similar to the one included with the original toy. He also has a new accessory in the form of a small lizard companion, a character introduced during the 200X-era cartoon from Mike Young Productions. This little lizard, sometimes referred to as "Pixel," is sculpted in such a way that he rests perfectly on the shoulder of Kobra Khan for display.

FUN FACTOID: The Four Horsemen felt the sculpture on the vintage figure seemed forced around the mechanism, and they wanted to give him a fully detailed mouth as well as a less rotund torso.

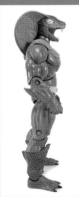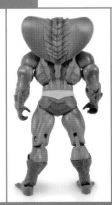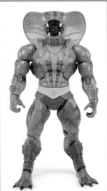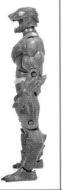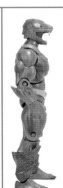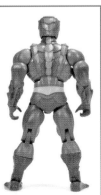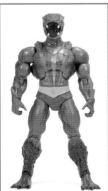

KOWL
THE KNOW-IT-OWL

First released 2013 • Member of the Great Rebellion

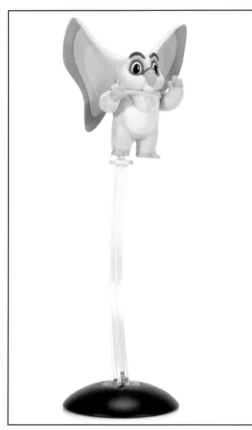

Kowl has been released twice in the Masters of the Universe Classics toy line. His first appearance was as part of the 2013 Weapons Pak as a pack-in bonus figure. This version is sculpted to look much like how the character appeared in the Filmation She-Ra: Princess of Power cartoon series, but his yellow color actually matches the look of the vintage action figure.

Here, Kowl is much smaller than the vintage figure, matching the scale of the character from the cartoon. He has minimal articulation, and is small enough to sit on the shoulder of your Bow action figure, much like he often did in the cartoon.

The same Kowl figure was released again in 2014 as part of the Loo-Kee and Kowl two-pack. The sculpt is the same, but this time his orange color matches up with his appearance in the cartoon. He also now has a flight stand that plugs into the bottom of his foot, allowing you to pose Kowl hovering above the ground.

MOTUC - SECTION 1

LASER LIGHT SKELETOR
EVIL MASTER OF LIGHT ENERGY

First released 2015 • Member of the Evil Warriors

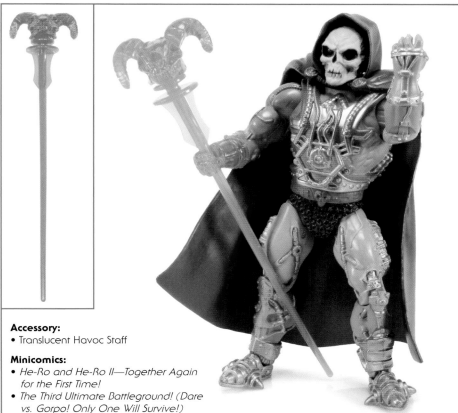

Accessory:
• Translucent Havoc Staff

Minicomics:
• *He-Ro and He-Ro II—Together Again for the First Time!*
• *The Third Ultimate Battleground! (Dare vs. Gorpo! Only One Will Survive!)*

Laser Light Skeletor was released in a two-pack with his heroic counterpart, Laser Power He-Man. He has a unique head sculpt with large goblin-like eyes. He is covered from head to toe with visible wires and electronic parts sculpted to his body. In many ways he resembles Intergalactic Skeletor, albeit with a different color scheme and a more intricately-designed costume.

As with his vintage 1988 counterpart, the figure's eyes and right hand and forearm light up. Rather than activating this feature by raising the figure's right arm (as was the case with the 1988 figure), the 2015 release's feature is activated by a push button on his backpack. Pushing and releasing the button will make the eyes and hand glow steadily, but pushing and holding the button will cause the lights to pulsate rapidly. The LEDs shut off by themselves after several seconds to conserve the batteries. The figure is powered by three button cell batteries, rather than the single AA battery used on the vintage figure.

Laser Light Skeletor comes with a removable soft plastic hood and cape, rather than the cloth cape and hood of the vintage figure. This version of Skeletor reuses several parts from the 2014 Intergalactic Skeletor figure, including the upper thighs, shoulders, feet, and left bicep. Due to his action feature, he does not have bicep or elbow articulation on his right arm. Additionally, his chest armor and backpack are sculpted to the torso, and he lacks ab-crunch articulation. Due to the unique design of his boots, he also lacks boot-cut articulation. Unlike most figures, his head is not removable due to the two LEDs mounted in his eyes.

Compared to the vintage figure, the 2015 Laser Light Skeletor looks much taller and more commanding. The vintage Laser Light Skeletor had an extreme leg bend to help compensate for the weight of his backpack. The design of the 2015 version is mostly based on the original 1988 release, although the details of some of the figure's cybernetic parts are different due to the reuse of parts from Intergalactic Skeletor.

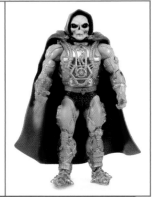

MOTUC - SECTION 1

LASER POWER HE-MAN
HEROIC MASTER OF LIGHT ENERGY

First released 2015 • Member of the Heroic Warriors

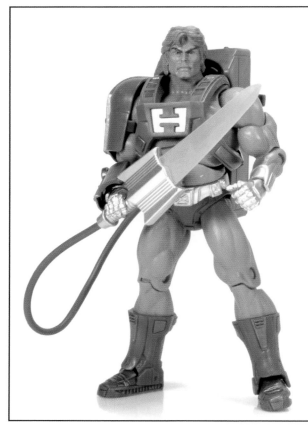

Accessory:
• Light-Up Sword of Power

Minicomics:
• He-Ro and He-Ro II—Together Again for the First Time!
• The Third Ultimate Battleground! (Dare vs. Gorpo! Only One Will Survive!)

Laser Power He-Man was released in a two-pack with his evil counterpart, Laser Light Skeletor. He has a unique head sculpt that is based on the Italian release of the vintage Laser Power He-Man. The Classics version of the figure, however, brings many sculpted details to the forefront of his costume, ones that were only hinted at in the vintage figure. Unlike most versions of He-Man, this version is not baring his teeth and sports a more neutral expression.

As with his vintage 1988 counterpart, the figure's sword lights up. Rather than activating this feature by raising the figure's right arm (as was the case with the 1988 figure), the 2015 release's glowing sword is activated by a push button on his backpack. Pushing and releasing the button will make the sword glow steadily, but pushing and holding the button will cause the light to pulsate rapidly. The LEDs shut off by themselves after several seconds to conserve the batteries. The figure is powered by three button cell batteries, rather than the single AA battery used on the vintage figure.

This version of He-Man reuses several parts from the 2008 King Grayskull figure, including the shins, thighs, torso, shoulders, and biceps. He has unique, space-age boots, belt, and gloves and features hinge articulation on his wrists. Unlike the original 1988 Laser Power He-Man, the 2015 version's backpack can be used to holster the sword.

Laser Power He-Man is one of the few Classics figures to retain (more or less) the same action feature that the original vintage figure had, making him stand out as rather special in the line.

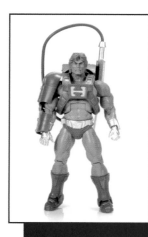

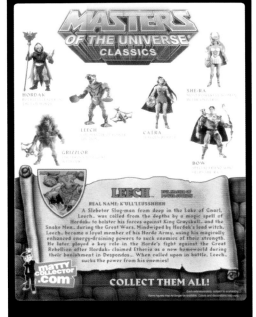

LEECH
EVIL MASTER OF POWER SUCTION

First released 2011 • Member of the Evil Horde

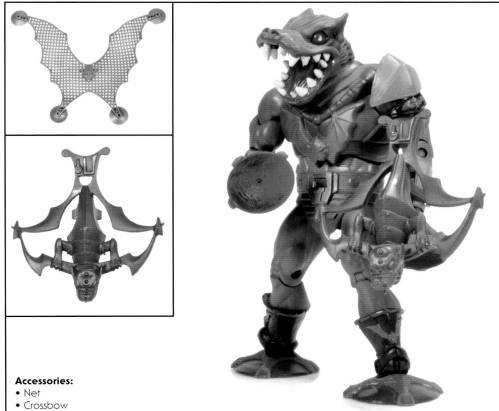

Accessories:
- Net
- Crossbow

One of the original members of the Evil Horde in the vintage Masters of the Universe toy line, Leech comes to MOTU Classics with newly sculpted details.

His look is based on the original toy, but with all of the added articulation that the Classics line has come to be known for. The original figure was unique in that it had a larger torso in order to house the action feature, which was a giant suction cup for a mouth that could be activated by pressing the button on his back. The new figure removes the action feature in favor of sculpt and articulation, but he does have a wider torso sculpt to match his unique appearance. Also, since the vintage figure just had a suction cup for a mouth, Mattel had to give us a newly sculpted head with an open mouth full of teeth!

Leech comes with his very own Horde crossbow, but also with a new accessory in the form of a net shaped like the Evil Horde bat insignia. To pay homage to the vintage toy's suction-cup feature, this net has little suction cups on the back—allowing you to stick the net to a flat surface.

FUN FACTOID: The Four Horsemen said, "The major challenge with Leech was to use the standard classics body to create the thicker build that he had on the vintage figure. It was accomplished primarily with a new torso and loincloth, which was surprising to us. Going in we thought that he might have required all new tooling. This was also one of the vintage figures that were sculpted in such a way that form heavily followed function. It was great to finally see Leech with a mouth that wasn't built around a suction cup!"

 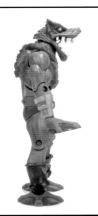 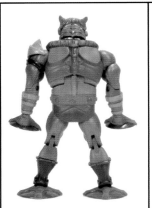 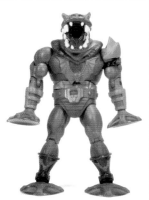

LIGHT HOPE
MAGICAL PROTECTOR OF THE CRYSTAL CASTLE

First released 2014 • Member of the Great Rebellion

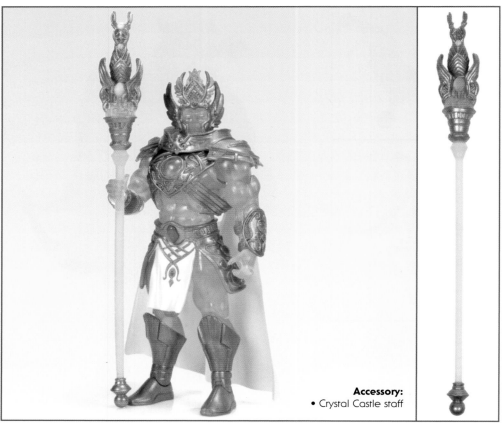

Accessory:
• Crystal Castle staff

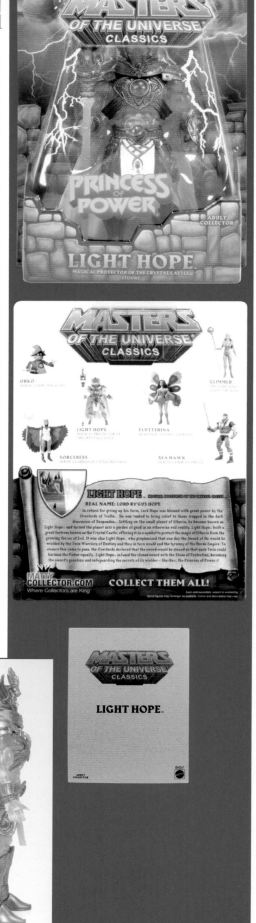

Designed by Nate Baertsch, Light Hope is a corporeal interpretation of the formless spirit that dwelled in the Crystal Castle in Filmation's She-Ra: Princess of Power series. Since Light Hope didn't have a specific shape in the cartoon, the figure's costume and staff pay homage to both the animated and toy versions of the Crystal Castle. His armor also has subtle triangular design nods to the floor where Light Hope appeared in the cartoon. In a sense, Light Hope functions as a kind of counterpart to Castle Grayskullman, given his strong design similarities to the Crystal Castle.

Light Hope is cast in a translucent pinkish plastic to replicate the hue of his appearance as a beam of light in the cartoon. Light Hope reuses the basic King Grayskull buck, as well as the boots from Bow. His forearms, loincloth, armor, head, cape, and staff are all newly tooled pieces. Light Hope has a regal, kingly look, and his transparent body allows collectors to get creative in their display options and shelf lighting.

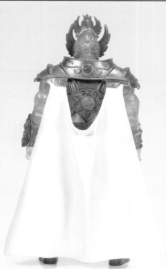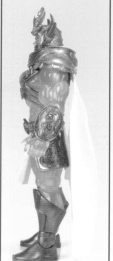

INTERVIEW WITH

BILL BENECKE

What's your origin story? How did you get into the toy business?

I was an illustration major who was working as a concept artist/ storyboard artist / character designer when one of my best friends, who was at a toy company, said they had two spots open on his team, and would I and our other close friend be interested? I thought about it for, like, three seconds, and found out I just needed to be able to draw and could learn the practical part of the job (a.k.a. the other ninty percent) on the job. Off I went to work on Universal Classic Monsters and Van Helsing.

A move to Mattel in 2008 led to working on DC Universe Classics, Action League, Brave and the Bold, every Batman "evergreen" line, Dark Knight, Batman v. Superman, Suicide Squad, Wonder Woman, Justice League, Aquaman, Green Lantern, Teen Titans Go, Multiverse, Justice League Action, Ghostbusters, and WWE.

What toys inspired you when you were a kid?

Growing up in the early eighties, all the usual suspects you'd expect. Graduating from cars and trucks, Man-E-Faces was the first action figure I recall seeing at a store (in Mexico) and thinking, "I *have* to have that!" He opened the door to Stratos, then Mer-Man, then a lot of Masters of the Universe over the next year. I was big into Transformers and G.I. Joe (really driven by the file cards and tech specs).

When Super Powers and Secret Wars hit, though, that was it. Superhero figures and Legos from that point onward to this day, and I've been lucky to have spent the majority of my career working on both.

Taking the long view, the two figures that have had the greatest influence on me were Man-E-Faces and Super Powers Flash. I still have my originals today.

What were the first projects you worked on at Mattel?

I was lucky to come onto DCU Classics, picking up on wave 4. More than ten years later, and under a few different line names, I'm still working on it!

Along with DCUC, I worked on Brave and the Bold, Ghostbusters, a little bit of Dark Knight Movie Masters, and I got a chance to do a stint on MOTU Classics!

What was your role in regard to He-Man-related toys?

I was the designer on MOTU Classics from Count Marzo to Man- E- Faces. (After a reorganization on the design team. I asked to stay on MOTU until *after* Man-E-Faces. I wasn't going to let *that* opportunity slip past!)

I was already working closely with the impossibly talented Four Horsemen on DCUC, so MOTU was a very natural addition. My role involved creating concept sheets for the characters chosen, figuring out some of the things they'd come with (like Clawful's shield, Man-E-Faces' alt head, and Panthor's helmet), and talking through how we might want to handle a character (like what style of head for Leech or giving King Hssss an interchangeable torso rather than a removable shell). We were always on the same page in our shared love of the eight-back designs, so that provided an easy "North Star" to follow on some characters.

Then the most important part: having the good sense to get out of the way and let the Horsemen do what they do so well! Their love of these characters and passion for everything they work on made every project (no exaggeration, and it's been hundreds now) an absolute delight! It was always a joy to get in the fast casts of the sculpts and see the surprises the guys had added: new extra heads, weapons, etc. [It was] like Christmas every time!

After they delivered the casts, I'd work with our engineering partner and the team in China to make sure everything made it through

successfully, and add some fun touches for production (like spinning gears on Roboto, color change on Orko, etc.).

Another fun part of the job was working with Scott Neitlich. Since we came from a similar love of the characters and worked hand in hand on DCUC, we would spend a lot of time discussing our plans for the characters, and how we could deliver something cool for the fans.

We were all a very tight team of friends working within a huge company, with everyone running flat out with this opportunity to play with these toys and create the best stuff we could! Except for Roboto's shoulders. I face planted that one, I gotta say.

What's the most challenging thing about producing He-Man toys?

To paraphrase: "With great fun comes great responsibility"! It's an incredible honor to get a chance to work on these toys, but at the same time, you realize the responsibility of trying to do justice to the legacy when you get your chance to put your brick into this massive wall, and you want to deliver the toy you think / hope all the other fans will want.

Plus, there are a *lot* of unexpected challenges from all different corners along the way, and you have to stay focused on "the mission" to shepherd your project through and not disappoint.

If you were going to reimagine a He-Man line from the ground up, what would it look like?

This is a short question that deserves a lengthy answer, but in the interest of brevity, my favorite part of the mythology hands down is the first four minicomics. Whatever the details of scale, articulation, and even character designs, I'd draw heavily from the spirit of those comics, the early concept art—that slightly darker, slightly more Frazetta vibe. *Fire and Ice* meets Jack Kirby would be the elevator pitch.

What are the He-Man toys you worked on that you're most proud of, and why?

This is probably a surprise out of left field, but, Man-E-Faces from MOTU Classics. That vintage figure put me on a journey that I'm still on thirty-five years later, more than fifteen of which have been spent making toys. To bring the circle around, and to do it in conjunction with the Horsemen . . . Wow. *Much* cooler than winning the lottery every week for the rest of my life, in my book.

He-Man has had a lot of different looks, from vintage to New Adventures to 200X to the Minis, Classics, Super7 ReAction-style figures, Filmation-style figures, and more. What's your favorite incarnation, and why?

I developed the first two Minis (He-Man and Skeletor for SDCC) with the Horsemen as a concept, which they brought amazing life to. When they showed us the sculpts they'd worked up over breakfast at Comic-Con one year, I was floored. I recognized my drawings, but they were so, so much better, like watching Spielberg create his version of your student film. So I have a lot of fondness there, and I think when Brandon Sopinsky took over and really built that line, I loved where he took them. He did a beautiful job. But they're a little too close to me to fully love as a pure fan, so I'd say MOTU Classics for delivering everything I'd ever wanted from the eight-back illustrations and the vintage line, followed by the vintage line itself, driven by all that incredible painted art. I'm an absolute nut for the vehicles and play sets because of that world of mystery and power in the paintings!

If you had the chance to work on He-Man again, would you do it?

In a heartbeat, without a second's hesitation!

LIZARD MAN
HEROIC COLD BLOODED ALLY

First released 2015 • Member of the Heroic Warriors

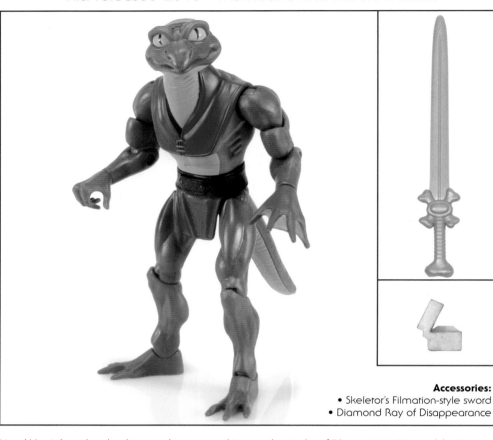

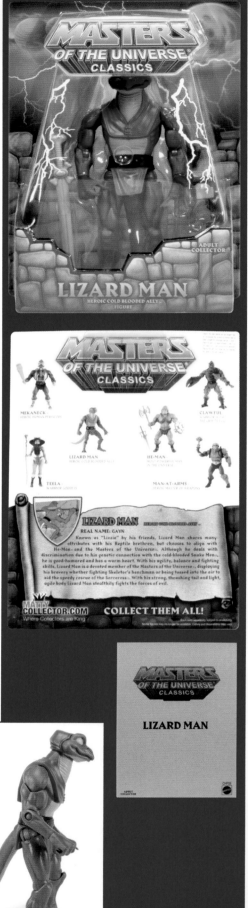

Accessories:
- Skeletor's Filmation-style sword
- Diamond Ray of Disappearance

Lizard Man is based on the character that appeared in several episodes of Filmation's He-Man and the Masters of the Universe. Befitting his cartoon origins, he comes with two accessories actually intended for Skeletor, as they appeared in the show: Skeletor's crossbones sword and his Diamond Ray of Disappearance.

Lizard Man actually originates from a concept from Mattel that would eventually evolve into the Evil Warrior Whiplash. Whiplash's early working name was Lizard Man, and early concept designs for the figure were later modified by Filmation into a much friendlier-looking character, as Mattel independently took the Whiplash design in a different direction. The 2015 release is the first time Lizard Man was released as a figure.

Lizard Man reuses thighs, forearms, biceps, and shoulders from Modulok. His tail would later be reused for Saurod. He has a much slighter build than most male Masters of the Universe Classics figures, befitting his agile lizard nature. He also features translucent webbing on his hands, an effect achieved by casting his hands in translucent green plastic and applying paint to the nonwebbed areas.

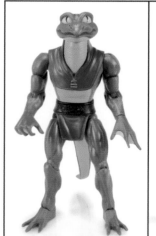

LODAR
EVIL MASTER OF CELESTIAL MAGIC
First released 2017 • Evil Villain

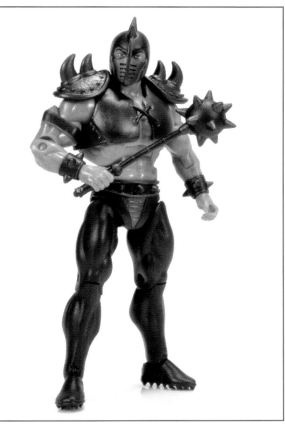

Accessories:
- Chain
- Morning Star Mace

Lodar is based on the villain from the minicomic Slave City! Originally, the character's name in the story was Draca, which was then changed to Zodak, because the team working on the comic had been instructed to include the character from the toy line in the minicomic. However, the comic's artist, Larry Houston, was not aware that Zodak already had a specific look and therefore created his own look for the character. When the art was presented to Mattel, they asked why the character did not resemble his toy counterpart, and the misunderstanding became clear. To avoid confusing toy buyers, editor Lee Nordling altered the Z and K in Zodak's name to create the name Lodar, consequently creating a brand-new character.

Lodar comes with the mace he used in the minicomic and the chains he used to keep He-Man captive. Lodar uses the standard King Grayskull buck, with shins taken from Demo-Man and shoulder pads taken from Beast Man's bicep armor. He also features hinged articulation on his wrists, with hands borrowed from the Filmation-style Club Grayskull He-Man release.

Lodar looks something like a villain out of Mad Max, with spikes all over his costume and a mask over his face. He is more monochromatic than most characters in the Classics line, but he certainly fits right in next to figures like Spikor or Webstor.

 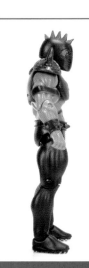 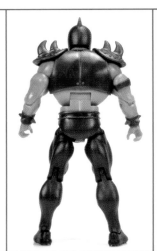 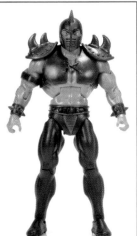

LOO-KEE
HIDES AND SEES ALL IN ETHERIA

First released 2014 • Member of the Great Rebellion

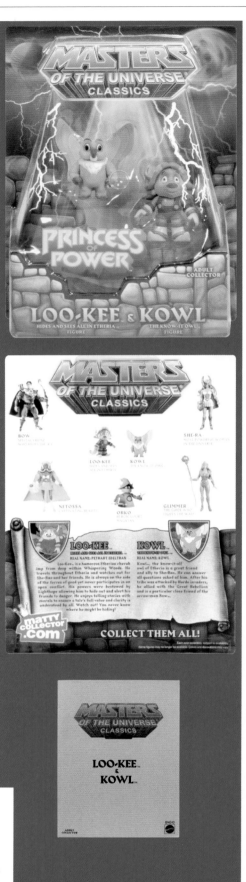

Loo-Kee came packaged with the orange version of Kowl and is based on his appearance in Filmation's She-Ra: Princess of Power cartoon. The figure is much shorter than most Masters of the Universe Classics characters, standing at about three inches. His articulation is limited, given his small size—he has swivel joints at the head, tail, and arms. He reuses no parts from any previous figures. Unlike the vintage Loo-Kee figure, the Classics version has no action feature but looks much more like his animated appearance than his 1987 counterpart did.

In the show, Loo-Kee would hide somewhere in a scene of the cartoon. Observant viewers would be on the lookout for Loo-Kee during the show. At the end of each episode, Loo-Kee would appear, let the viewers know where he had been hiding, and then deliver the moral of the story. Loo-Kee has a very bright, cartoonish color scheme, with three-colored wristbands and leg warmers that unmistakably represent the zeitgeist of 1980s children's animation.

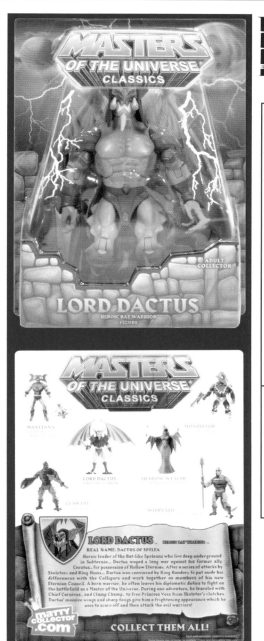

LORD DACTUS
HEROIC BAT WARRIOR

First released 2013 • Member of the Heroic Warriors

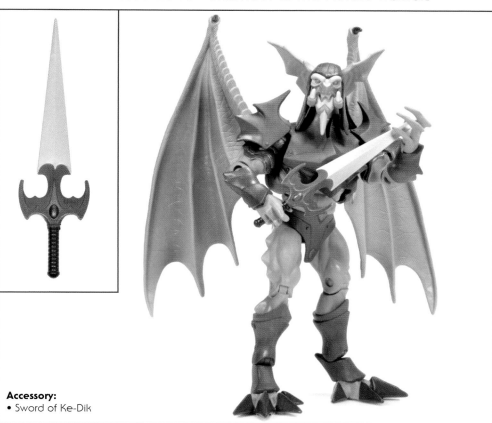

Accessory:
• Sword of Ke-Dik

Lord Dactus is based on the character that appeared in the 2002 Mike Young Productions He-Man and the Masters of the Universe cartoon. His first appearance was in the fourteenth episode of the series, "Underworld", which first aired in December of 2002.

Dactus reuses thighs and upper shins from Whiplash, wings and shoulders from Draego-Man, boot tops and forearms from Skeletor, biceps from Mosquitor, and the standard He-Man torso. He is overlaid with new armor pieces and extensions that make him taller and scarier than most Masters of the Universe Classics figures. Dactus features hands and feet with large talons. He has a bat-like head that looks fearsome but somehow not evil.

Dactus's design language is quintessentially 200X—he's all sharp lines and overlapping armor segments. He fits in well with any of the other 200X-inspired figures, and his menacing appearance makes him a unique addition to the Heroic Warriors.

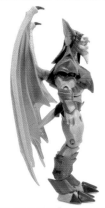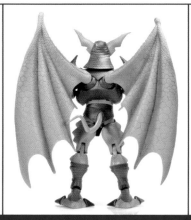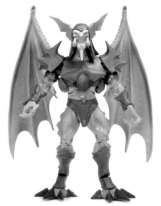

LORD GR'ASP
VENOMOUS VIPER WITH A CRUSHING CLAW

First released 2017 • Member of the Snake Men

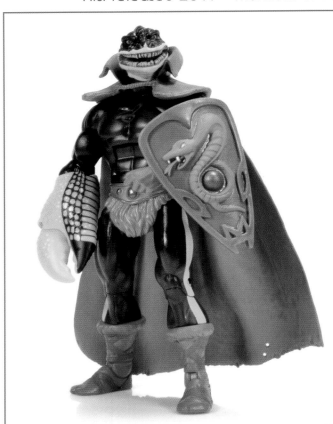

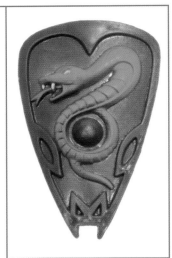

Accessory:
• Shield

Lord Gr'Asp was released in an exclusive Power-Con three-pack, along with Terroar and Plasmar. The character was discovered in a group of unused figure packaging art pieces created by Errol McCarthy. He was one of several planned but unproduced figures from the vintage line that would have been made entirely from parts recycled from previous figures.

In terms of Masters of the Universe Classics parts, Lord Gr'Asp reuses the boots, legs, chest, shoulders and biceps from King Grayskull and the loincloth from He-Man. He has the left forearm and hand of Skeletor, the right forearm and claw of Clawful, the cape of Scare Glow, the head of Sssqueeze, and the shield of King Hssss. It's not known what the vintage Lord Gr'Asp's color scheme would have been, but the Classics version has a vibrant orange, yellow, and green color scheme over a black body.

Lord Gr'Asp is one of the more audacious-looking characters in the Classics line, with his somewhat goofy lizard face and his inexplicable giant claw. The specific color choices on his costume make him stand out, as the shades used are uncommon in the Classics line (the metallic Persian green in particular). They are emphasized by his mostly jet-black body.

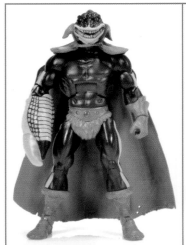

LORD MASQUE
EVIL SERVANT OF SHOKOTI

First released 2016 • Evil Villain

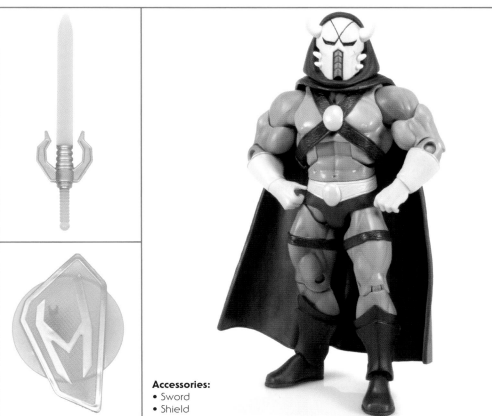

Accessories:
- Sword
- Shield

Lord Masque is based on the Filmation character that appeared in the episode "House of Shokoti Part 1." In the story, Masque is a servant of the evil sorceress Shokoti. Masque's primary job seems to be to keep outsiders away from Shokoti's temple. To this end he teams up with Trap Jaw to thwart Melaktha's attempt to discover the House of Darkness. In the end he is defeated by Orko and He-Man. Orko removes the villain's mask, which seems to be the source of his powers, and He-Man cuts it in half with his Sword of Power, causing Masque to disintegrate into a cloud of black smoke.

Lord Masque is made from mostly reused parts, including the lower legs, chest, shoulders, and biceps from King Grayskull. He takes his upper boots from Skeletor, his feet from Keldor, and his gloved forearms from Hordak. His weapons are actually based on the 1992 New Adventures Thunder Punch He-Man variant and are meant to be used with the Galactic Protector He-Man variant.

Masque is one of the darker and more sinister looking of the many one-off villains created by Filmation Studios and is an important addition to anyone's Filmation-themed shelf.

MOTUC - SECTION 1

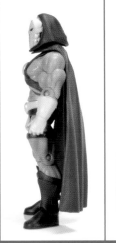

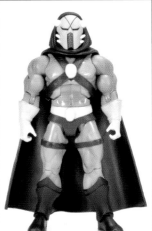

MADAME RAZZ
MAGICAL WITCH OF WHISPERING WOODS

First released 2014 • Member of the Great Rebellion

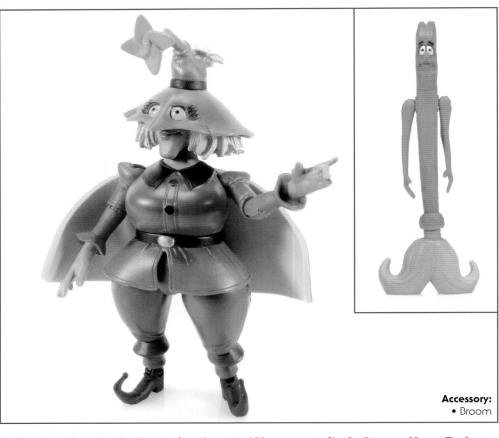

Accessory:
• Broom

Madame Razz is based on the character from the original Filmation series She-Ra: Princess of Power. The figure is a note-for-note re-creation of the Filmation design, down to the floral hat and the tiny curled boots. This is Razz's first incarnation in plastic, as no figure was made of the character in the vintage Princess of Power line.

Madame Razz's only accessory is Broom, the anthropomorphic talking broom that Razz rode around in the series. Both Razz and Broom have somewhat limited articulation, given their small size and particular design challenges, but it's certainly sufficient to get them nicely posed in the manner of your favorite scene from the 1980s cartoon. Neither figure reuses any previously existing parts.

Razz seems to share certain themes in common with Orko in terms of both color scheme and the role she played in the story. It's a testament to the diversity of the Masters of the Universe Classics line that a bright and cartoonish character like Madame Razz works just fine alongside darker and more sinister-looking characters like Hordak and Modulok.

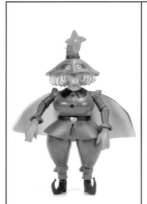

MOTUC - SECTION 1

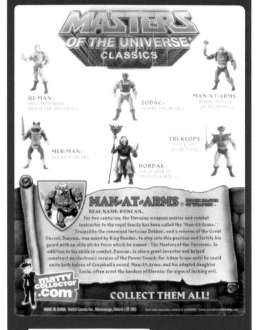

MAN-AT-ARMS
HEROIC MASTER OF WEAPONS

First released 2009 • Member of the Heroic Warriors

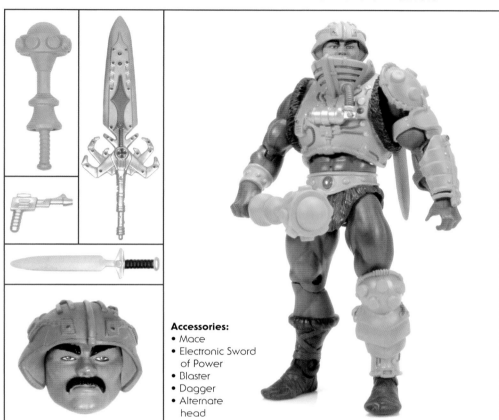

Accessories:
- Mace
- Electronic Sword of Power
- Blaster
- Dagger
- Alternate head

Man-At-Arms was first released as one of the original eight action figures in the vintage Masters of the Universe toy line. The new version was released early in the MOTU Classics line and features a highly detailed update to the classic figure's look.

The overall design matches up with what we remember from the original toy, but the armor is much more detailed, with a lot of technical wires and hoses, with multiple paint applications to bring out all of those details nicely. He has several accessories, including his signature orange mace. He also comes with a small silver blaster and a short silver dagger, both of which pay homage to weapons that came with the vintage Castle Grayskull play set. Man-At-Arms plays into his name with all of these weapons, and even has a mini weapons rack built into the back of his armor that allows him to store all of these weapons when not in battle!

An important addition to this figure is the swappable heads, finally allowing fans the option of displaying Man-At-Arms without a mustache, like his vintage action figure, or with his mustache from the various cartoons! He also comes with a bonus accessory in the form of what the Classics line began referring to as the electronic Sword of Power. This is the 200X-era design of the Sword of Power, allowing fans the option to display it with their He-Man figure if they prefer this specific style.

MAILER BOX CAME WITH REISSUE ONLY

FUN FACTOID: The Four Horsemen felt the vintage figure had a tough and bulky look like the fantasy version of a football player, and they wanted to capture that idea in his Classics figure as well.

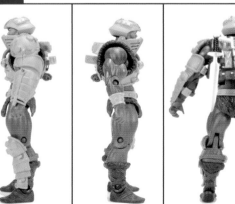

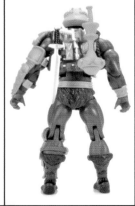

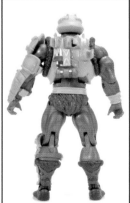

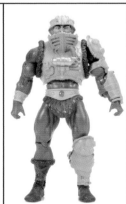

MOTUC - SECTION 1

MAN-AT-ARMS
HEROIC RESURRECTED MASTER OF WEAPONS

First released 2014 • Member of the Heroic Warriors

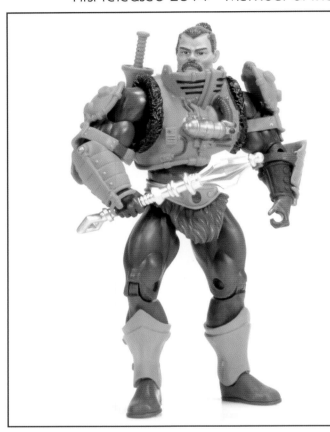

Accessory:
• Mace

The Battle Ram vehicle was packaged with a bonus Man-At-Arms action figure upon release. This version of Man-At-Arms features new pieces that allow fans to create many different versions of the character by mixing and matching parts with their other Man-At-Arms figures.

First of all, this version of Man-At-Arms is not wearing his helmet, marking the first time we've ever received this character in toy form without a helmet on. He has a small ponytail, which is based on his helmetless appearance in the 200X cartoon by Mike Young Productions.

He is also now wearing armor on both arms instead of just one, which is actually how he was depicted in the Filmation He-Man and the Masters of the Universe cartoon series. His boots also more closely resemble the Filmation look. So essentially, you can swap this head for the standard helmeted head with the mustache from your original release and create a Man-At-Arms that is closer to how he looked in the original cartoon!

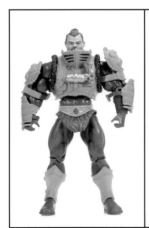
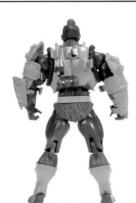
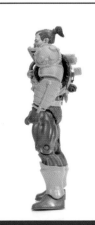
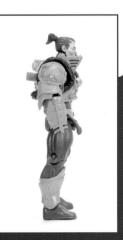

MOTUC - SECTION 1

FUN FACTOID: The figure was heavily inspired by the vintage cross-sell art, which was visually different from the vintage figure. A fan vote for the final color scheme chose a hybrid of the card back version and the vintage toy.

MAN-E-FACES
HUMAN...ROBOT...MONSTER!

First released 2011 • Member of the Heroic Warriors

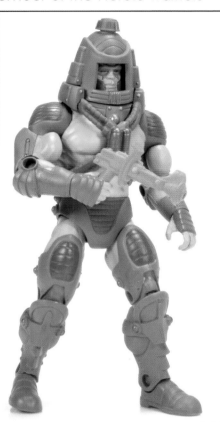

Accessories:
- Laser gun
- Alternate head

Man-E-Faces, the warrior with interchangeable faces, is closely based on the original 1983 cross-sell artwork for the figure, rather than the vintage figure itself. The one concession to the vintage figure design is that the purple parts of Man-E-Faces' costume are a reddish-purple, rather than the bluish purple of the artwork.

Man-E-Faces comes with his classic orange blaster, as well as a second head, an extra feature that was kept secret until the figure actually started shipping. The figure's main head has the classic mix of human, robot, and monster faces. The second head features the faces of He-Man, Skeletor, and Orko. The Four Horsemen had wanted to included Beast Man as one of the faces on the second head (a reference to a Filmation episode where Man-E-Faces impersonates Beast Man) but couldn't get him looking quite right, and so they opted for He-Man's face instead.

Man-E-Faces is one of the most popular characters in the Masters of the Universe line, and one of the few Classics figures to retain its vintage action feature. Man-E-Faces' helmet pops off to allow the user to change out the rotating head drums.

Man-E-Faces reuses several parts from the 2010 Trap Jaw release, including legs, biceps, forearms, and hands. His pelvis area comes from Optikk.

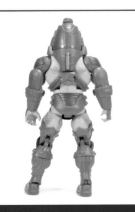
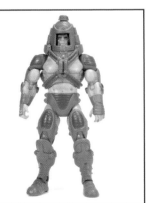

MANTENNA
EVIL SPY WITH THE POP-OUT EYES
First released 2013 • Member of the Evil Horde

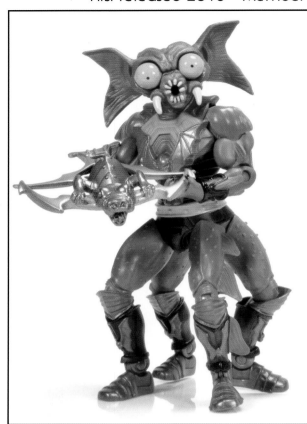

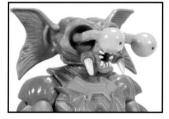

Accessories:
• Alternate eyes
• Horde crossbow

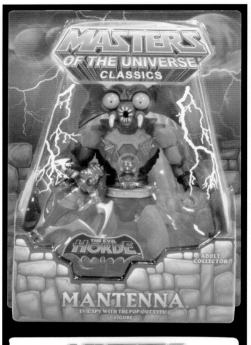

Mantenna is perhaps one of the strangest and creepiest figures in the Masters of the Universe Classics line. Unlike the original 1985 figure, the Classics Mantenna has four fully separate and articulated legs (the legs were fused into pairs on the vintage figure). The figure is mainly based on the vintage toy design, although it has some details that recall the 2006 NECA mini statue. Those influences are primarily evident in the exaggerated points on the figure's ears, and the choice to go with yellow eyes rather than bloodshot eyes. The yellow eyes were also a design element on the animated version of the character in the 1980s She-Ra: Princess of Power series.

Mantenna does not retain the action feature of the original 1985 toy, but the effect can be replicated by changing the eyes out for the extra set of eyes with extended eyestalks. These extended eyes are pushed out forward rather than upward, which is another subtle nod to the animated version of the character, whose eyes also popped out forward. To facilitate the changing of the eyes, Mantenna's mouth can also be removed.

The only parts that Mantenna reuses are Skeletor's hands. Otherwise, he is a completely new sculpt, and one of the most impressive of the Evil Horde figures in the Classics line.

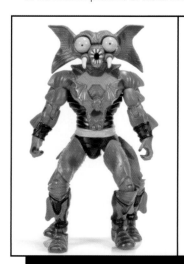

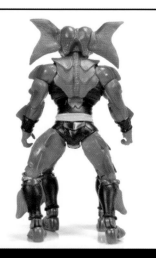

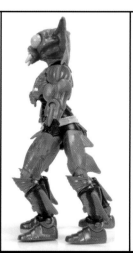

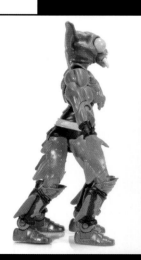

MAP OF CASTLE GRAYSKULL

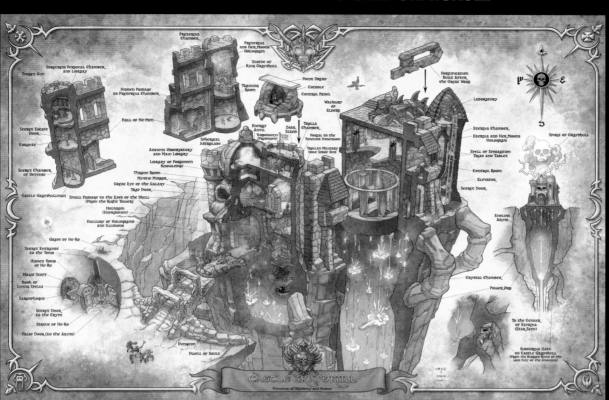

The Map of Castle Grayskull poster was released in 2015. It was shipped with Oo-Larr as the Club Eternia subscription bonus, sent to fans who paid for the full year's figure-subscription service. This poster features new artwork that dissects Castle Grayskull and maps out many of the details found within!

MAP OF ETERNIA

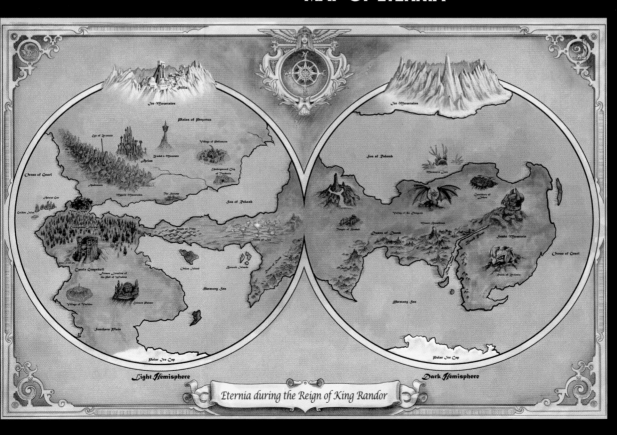

The Map of Eternia poster was released in 2010. It was shipped with Wun-Dar as the Club Eternia subscription bonus. This poster features brand-new artwork of the planet of Eternia, mapping out many of the locations from stories found in the cartoons, comics, and more!

The Map of Etheria Poster was released in 2011. It shipped with Preternia Disguise He-Man as that year's
Bonus for fans who subscribed to the full year of action figures. This poster features brand-new artwork of th
out several locations from the stories of the cartoons, comics, and more!

MAP OF PRETERNIA

The Map of Preternia was released in 2012. It shipped with Shadow Weaver as that year's Club Eternia Sub
poster features brand-new artwork of Preternia—Eternia during ancient times! It maps out many new elemer

MAP OF SUBTERNIA

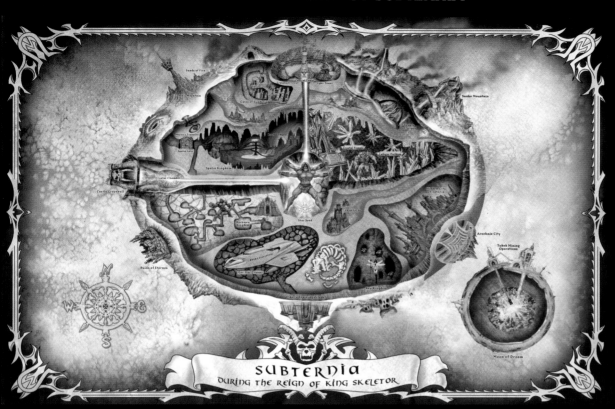

The Map of Subternia poster was released in 2013. It shipped with King He-Man as part of the Club Eternia subscription bonus for fans who subscribed to the full year's worth of action figures. It features brand-new artwork of Subternia, the hidden land beneath the surface of Eternia. It maps out many locations from various Masters of the Universe stories found in the cartoons, minicomics, and more!

MAP OF THE HORDE EMPIRE

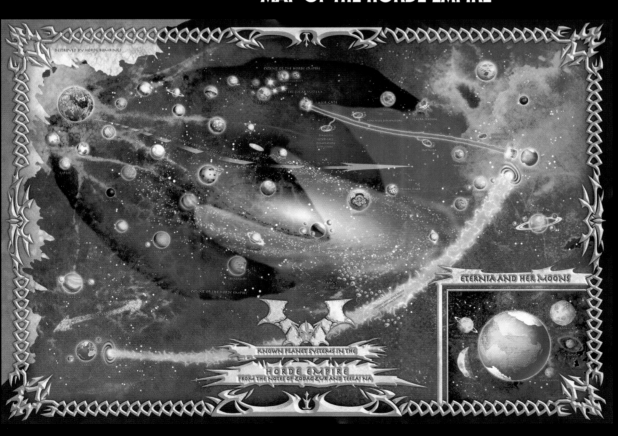

The Map of the Horde Empire poster was released in 2014. It shipped with the Unnamed One as part of the Club Eternia subscription bonus. This poster features brand-new, original artwork showing the part of the galaxy under the occupation of the Evil Horde Empire!

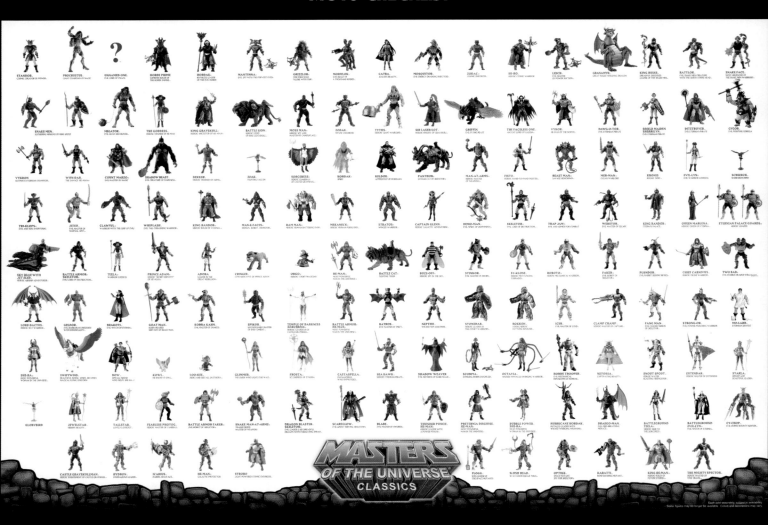

This Masters of the Universe Classics checklist poster was a 2013 bonus exclusive sent to those who preordered Castle Grayskull. It was also offered to fans at the 2014 San Diego Comic-Con. It features all of the figures in the line released up to that point. Since this line has lasted beyond the year 2014, this checklist poster is far from complete. There has not yet been another checklist poster released.

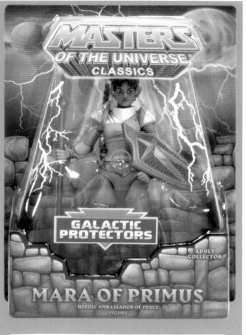

MARA OF PRIMUS
HEROIC AMBASSADOR OF PEACE

First released 2015 • Member of the Galactic Guardians

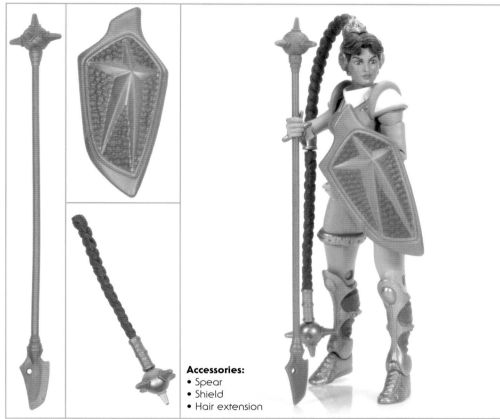

Accessories:
- Spear
- Shield
- Hair extension

Mara of Primus was a character featured on the 1989 New Adventures of He-Man animated series. Although Mattel went so far as to create a prototype figure for the New Adventures line, it was never released in stores.

The Classics figure is the first time the character has been realized in plastic. It is believed that the original figure would have had an action feature where her waist would turn and whip around her long braid, which terminated in a spiked mace. The Classics version of the figure does not have that action feature, but her long braid is cast in flexible plastic that allows it to be whipped around manually. This can be enhanced with an included braid extension, which doubles the length of her braid and mace weapon.

Mara reuses shoulders and biceps from Adora, and hands and thighs from the original Teela release. Like many female figures, she lacks ab-crunch and boot cut-articulation, but otherwise has the same range of movement and posability as most Masters of the Universe figures.

Like many of the New Adventures-style figures, Mara's costume is dominated by metallic colors—in her case, gold. Her boots, bracers, and shield have hits of purple as well, and the rest of her costume is blue and white.

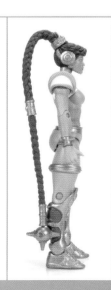
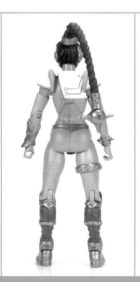
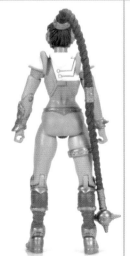
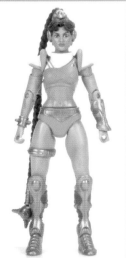

MEGATOR
EVIL GIANT DESTROYER

First released 2011 • Member of the Evil Horde, the Snake Men, and the Evil Warriors

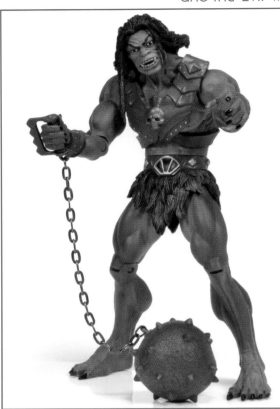

Accessories:
• Flail
• Alternate "zombie" head

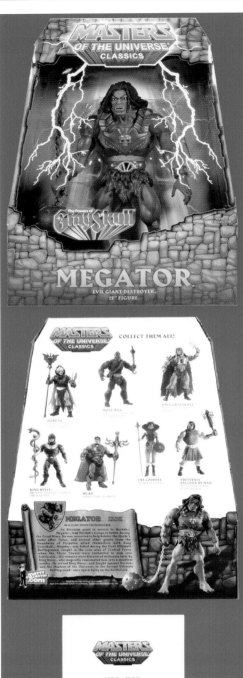

MEGATOR

Megator is one of the few Masters of the Universe Classics figures that is actually a few inches smaller than his vintage counterpart. To keep costs down, the 2011 release of Megator was produced in a twelve-inch scale a hollow rotocast body. He also has reduced articulation compared to a typical figure, lacking bicep cut, ab-crunch, and ball-jointed shoulders.

Despite being smaller than the 1988 version of Megator, the Classics version still towers over most other figures and has a wonderfully brutal and savage appearance. His armor is cast from soft plastic and has a realistic leather texture. Subtle touches of gold paint brighten up an otherwise muted green, brown, and black color scheme.

Megator reuses thighs and upper arms from Tytus, but was otherwise created using newly sculpted parts. Megator comes with his flail (with real metal chain), patterned after the vintage accessory. His zombie head accessory is meant to represent the story created in Megator's bio, where he is raised from the dead to serve King Hssss. The zombie head has actual rooted hair, in a nod to the vintage figure. This second head was actually kept secret and only revealed once the figure started shipping. Megator is the only figure in the Masters of the Universe Classics line to feature rooted hair.

FUN FACTOID: Megator was the second giant in the MOTUC line. Having two characters now at this size really helped to establish the giants as as a fleshed-out new scale.

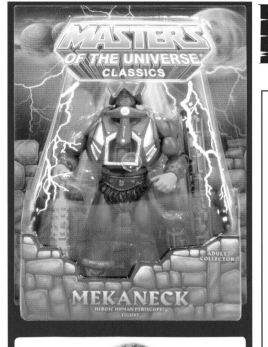

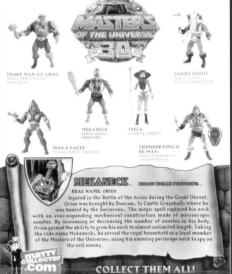

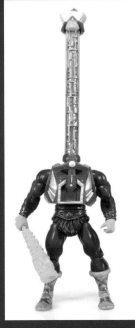

MEKANECK
HEROIC HUMAN PERISCOPE

First released 2012 • Member of the Heroic Warriors

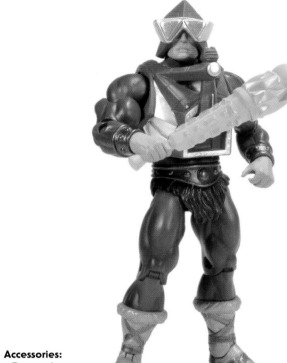

Accessories:
- Two neck extensions
- War club

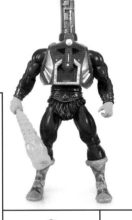

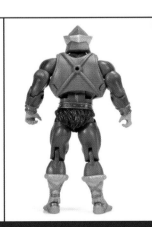

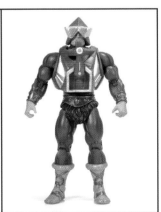

Mekaneck is very closely based on his vintage 1984 action figure, with no discernible nods to either the Filmation cartoon or to the 200X version. Unlike the original figure, the Classics Mekaneck has no action feature. To simulate the telescoping neck, Mattel included two neck extensions. The first takes his head up slightly higher than the vintage figure's neck could go. The second extension is so long that it effectively doubles the figure's height!

Mekaneck reuses the entire body from King Grayskull, except for his left forearm, which comes from Tri-Klops. His loincloth is reused from He-Man, and his armor is reused from Stinkor, who was released earlier in 2012. Only his head, neck extensions, and club are newly-sculpted pieces.

Mekaneck is one of the most colorful figures in the line. His classic superhero colors of blue and red are accented with contrasting hits of green, silver, and yellow. Mekaneck's abilities might not seem to be all that practical, but he's a sharp and fun-looking figure who looks great fighting alongside Buzz-Off, a frequent collaborator in comic book stories and animation.

MER-MAN
OCEAN WARLORD

First released 2009 • Member of the Evil Warriors

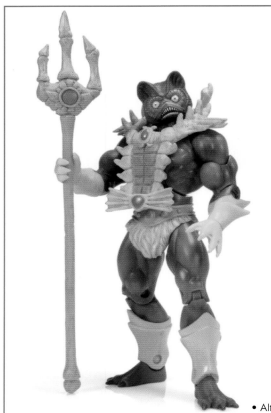

Accessories:
- Sword
- Trident
- Alternate head

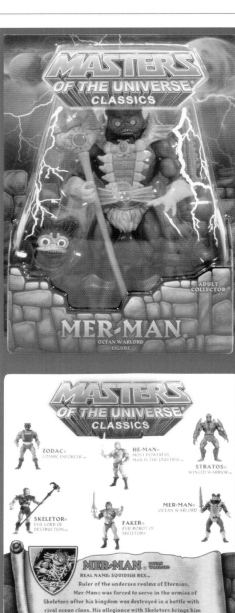

One of the original eight figures from the vintage Masters of the Universe toy line, Mer-Man joined the ranks of MOTU Classics in the first full year with fantastic new details.

Many fans are aware of how the vintage Mer-Man action figure did not quite match up with the artwork of the character that was seen on the back of the vintage toy packages. Four Horsemen Toy Design, the sculptors behind the MOTU Classics action figures, wanted to right this wrong by making sure the new figure finally looked like the toy shown in that original eight-back cross-sell!

To accomplish this, he has a new head sculpt that looks just like that original artwork. There's also a clever new additional piece that fits over the standard torso's neck to give Mer-Man a gilled look. Everything else, from the colors of the figure to the pose of his hands, is made to match that original art.

For fans who prefer the vintage toy's head, Mattel also included an interchangeable head that allows fans to display him whichever way they prefer. He also comes with his classic sword as well as the trident accessory that we first saw with the 200X-era action figure.

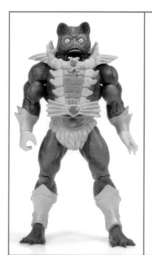

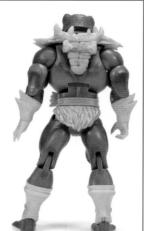

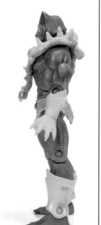

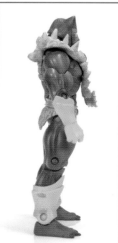

MAILER BOX CAME WITH REISSUE ONLY

FUN FACTOID: After paying tribute to the never-released look of the vintage card back with the 200X version of Mer-Man, the Four Horsemen were also able to faithfully re-create the toy's head for Classics.

MOTUC - SECTION 1

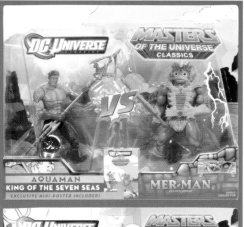

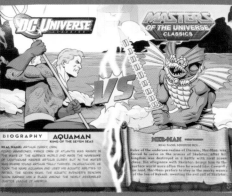

FUN FACTOID: This Mer-Man's light blue skin tone more closely resembles his appearance in the early vintage minicomics.

MER-MAN
EVIL UNDERSEA TYRANT

First released 2010 • Member of the Evil Warriors

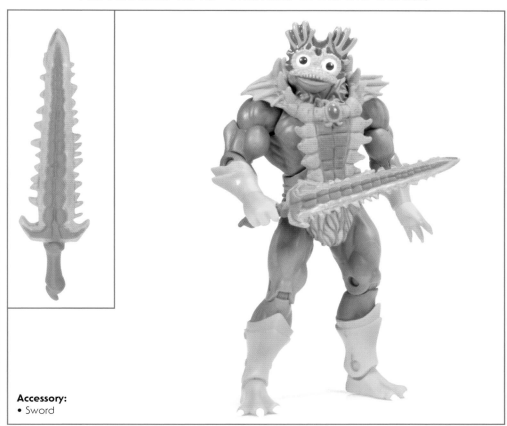

Accessory:
• Sword

In 2011, Mattel released a series of retail-exclusive two-packs merging two of their popular collector figure lines: Masters of the Universe Classics and DC Universe Classics.

Packaged with the DCUC Aquaman figure was a new variation of MOTU Classics Mer-Man. The figure is exactly the same sculpt as the original Matty Collector release. However, this version features bright blue skin instead of the usual green. This is a reference to Mer-Man appearing with bluish skin in some of the original minicomics.

This version only comes with a sword as an accessory, which also has a new paint job to reflect the blue color of the figure. These two-packs were a great way to offer some variants for MOTU Classics fans while also introducing the general public to the usually online-only toy line through retail outlets.

MOTUC - SECTION 1

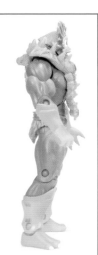
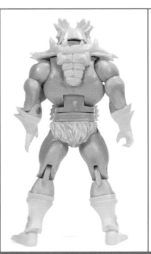
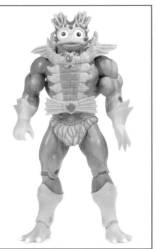

MERMISTA
MERMAID FRIEND OF SHE-RA

First released 2014 • Member of the Great Rebellion

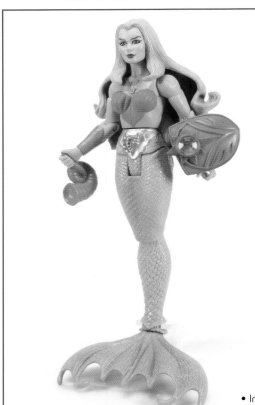

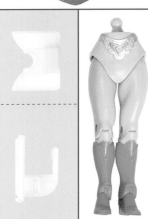

Accessories:
- Seashell
- Shield
- Figure stand
- Interchangeable mermaid tail and legs

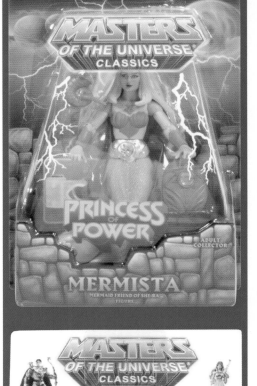

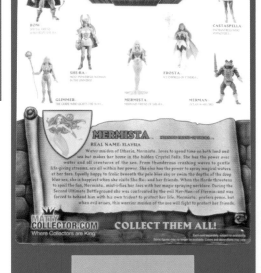

Mermista is the only mermaid in the Masters of the Universe Classics line, but one of many aquatic-themed characters. She has flowing blue hair, and her fish tail is cast in a glittery blue plastic that, combined with the intricately sculpted scales, makes for quite a stunning effect. In many cases there is a dramatic difference between Princess of Power characters as they appeared on the She-Ra cartoon and their vintage figure look. In this case both looks are roughly the same, with the exception of Mermista's human legs. The vintage doll had bare legs and green boots, while the animated version had blue leggings. The Classics figure takes its cues from the vintage toy in the design of her legs and bracers.

Like King Hssss, Mermista's upper half separates from her lower half. This allows her to be posed either with her mermaid's fish tail (as she is displayed in the package) or with her alternative set of human legs. On the original 1986 figure, the fish tail was actually made of cloth and could slip over her human legs.

The seashell accessory on the vintage figure (called a "backpack" on the vintage packaging) was actually used to spray water through a hole in the toy's back and out through her necklace. It doesn't have that function on the Classics figure, but it is included along with her shield.

Mermista reuses boots from Netossa, biceps and shoulders from Adora, shield from She-Ra, and thighs from Teela.

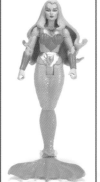

THE MIGHTY SPECTOR
HEROIC MASTER OF TIME TRAVEL

First released 2012 • Ally of the Heroic Warriors

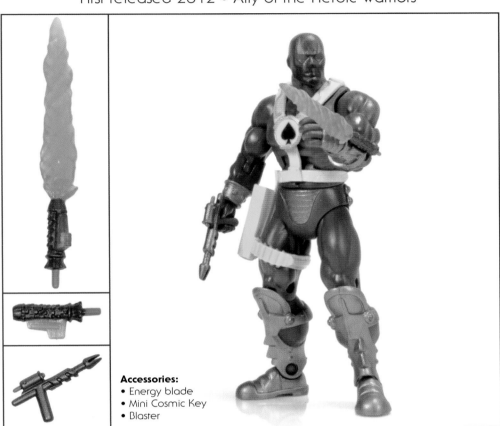

Accessories:
• Energy blade
• Mini Cosmic Key
• Blaster

During Mattel's new Create a Character Contest, they also allowed several members of Mattel's staff to create characters of their own. The Mighty Spector is the creation of MOTU Classics brand manager Scott Neitlich.

The Mighty Spector is based on a character that Scott actually drew as a kid and entered into the original Masters of the Universe Create a Character Contest. This purple-clad hero is dressed like a comic book superhero. He wears a bright yellow harness with a spade emblazoned on his chest.

His left arm has a device attached that looks like a small version of the Cosmic Key from the Masters of the Universe motion picture. This device is used for time travel by the character but can also double as a weapon by emitting energy blades. You can take the small device off the figure's wrist and replace it with a version that has a green energy blade extended for battle.

MOTUC - SECTION 1

FUN FACTOID: Although Mighty Spector had a bit more of a superhero look to his design than other characters, little details like the Cosmic Key inspired wrist attachment helped to connect him to the rest of the line.

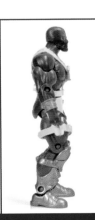
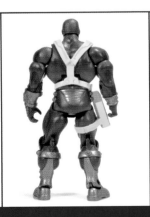
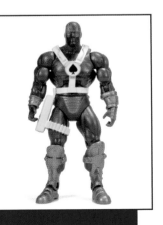

MODULOK
EVIL BEAST OF A THOUSAND BODIES

First released 2014 • Member of the Evil Horde

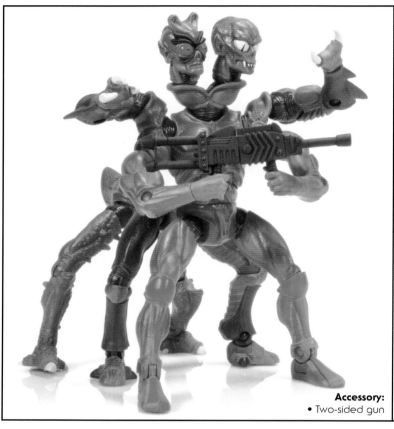

Accessory:
• Two-sided gun

Modulok is one of the few Masters of the Universe Classics figures whose action feature translated almost unchanged from his initial 1980s release to his incarnation in the Classics line. Modulok can separate into twenty-one different pieces. The parts are arranged a little differently compared to the vintage figure—the vintage figure didn't have individual neck pieces as the Classics figure does, but it had more connector pieces. Also, the 2014 Modulok figure's pelvis piece cannot be separated from the torso, unlike his vintage counterpart.

But, generally, the Classics figure can be built into most of the same configurations as the 1985 release. Modulok is fully articulated and can be contorted into a number of bizarre and disturbing poses. Even his gun can separate into two pieces. He stands alongside Mantenna as one of the weirdest and creepiest figures in the Classics lineup.

Modulok is made up of entirely new pieces, except for his hands, which are borrowed from Skeletor. His look is very closely based on his vintage toy look, but with enhanced details and paint applications. His parts can be combined with Multi-Bot to create Megabeast, also known as Ultrabeast.

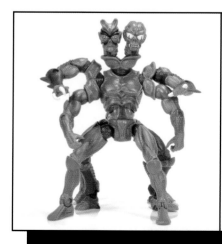

MO-LARR
ETERNIAN DENTIST

First released 2010 • Enforcer of Dental Hygiene

Accessories:
- Extraction forceps with tooth
- Dental mirror
- Dental pick
- Drill
- Dental floss

Mo-Larr originates from a Robot Chicken sketch where Skeletor is suffering from an impacted wisdom tooth and must suffer the ministrations of Mo-Larr, Eternian dentist. Mo-Larr was sold in a two-pack with a toothless version of Skeletor as a way to pay homage to the sketch. The sketch was animated using models based on vintage five-and-a-half-inch style figures, but of course the Classics interpretation of toothless Skeletor was made in the larger Classics scale.

Mo-Larr reuses the basic King Grayskull body (as well as He-Man's loincloth, hidden under his dentist's coat), but borrows his gloves from Hordak. He comes with a number of dental instruments that have a nice vac-metal chrome finish to them. Looking like the world's buffest family dentist (complete with dentist jacket with torn-off sleeves), Mo-Larr is the perfect foe to terrorize all Heroic and Evil Warriors who dare to bare their teeth in his presence.

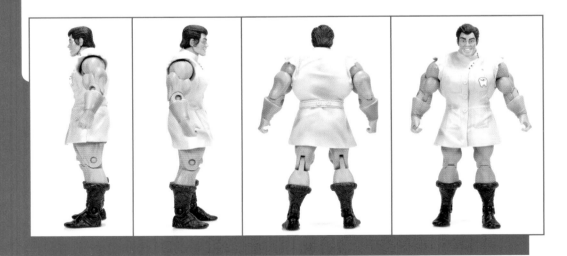

MOSQUITOR
EVIL ENERGY-DRAINING INSECTOID

First released 2012 • Member of the Evil Horde

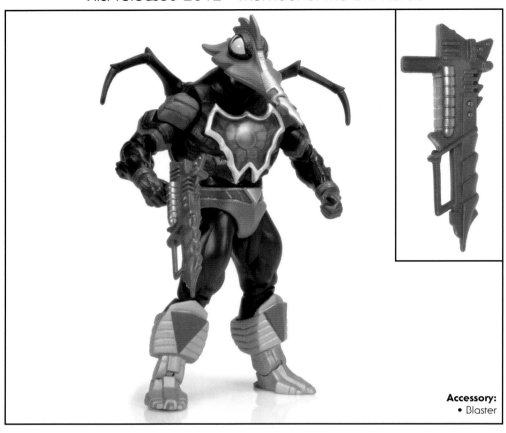

Accessory:
• Blaster

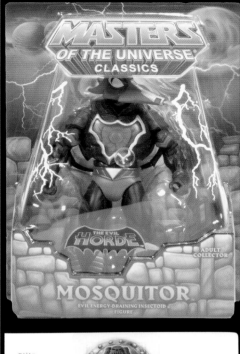

Mosquitor appeared in the original Masters of the Universe toy line as one of the action-feature-heavy members of the Evil Horde. That original figure had a torso filled with red liquid that could be seen through a clear window. Pushing a button on his back would pump this liquid "blood" to make it look as though he were sucking it from his foes like a vampire.

Since the MOTU Classics line typically ditches action features in favor of articulation, this blood window needed to be handled completely differently. The new figure uses the standard male torso, and instead has a new armor piece that captures the unique shape of the vintage figure's torso, complete with the "blood" window. Instead of showing actual liquid, this time the transparent window is tinted red and features sculpting inside that creates the appearance of blood showing within his chest.

In the 200X-era, Mosquitor's redesign gave him a skinnier, much more insect-like look with extra insect appendages. As a nod to this, Mosquitor also has two small insect legs protruding from the back of his armor. These are ball jointed and are also removable in case you would prefer to display Mosquitor without them.

 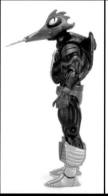 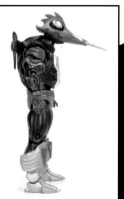

FUN FACTOID: In the absence of the original figure's blood-dripping action feature, the Four Horsemen added details in the chest cavity as well as additional appendages on his back similar to their 200X staction design.

MOSS MAN
HEROIC SPY AND MASTER OF CAMOUFLAGE

First released 2010 • Member of the Heroic Warriors

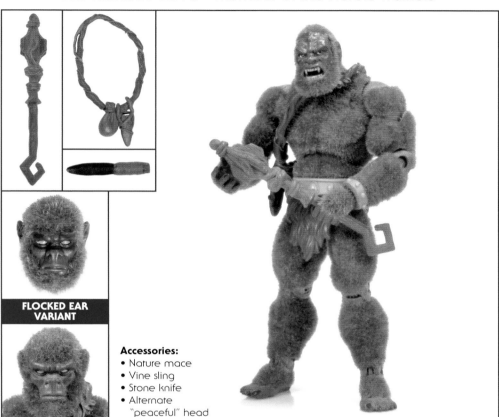

FLOCKED EAR VARIANT

Accessories:
• Nature mace
• Vine sling
• Stone knife
• Alternate "peaceful" head

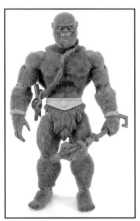

Like his vintage counterpart, Moss Man is largely a reuse of Beast Man's head and body, but cast in green with added flocking. The vintage figure had a subtle pine scent, which is also re-created in the Classics release. Because the Classics version of Beast Man was left handed (which was done to re-create the look of the vintage cross-sell art), Classics Moss Man is also left handed. Moss Man reuses the longer loincloth of King Grayskull, rather than the shorter Beast Man loincloth.

Unlike the vintage figure, the 2010 release has several extras and upgrades. Moss Man's mace is sculpted to resemble worn wood with vines wrapped around it. He also has a second, "peaceful," head that recalls concept art for the 200X version of Moss Man. In addition, he comes with a small stone knife that fits neatly into a removable vine sling.

Initially Moss Man was released with flocked ears. Most fans weren't happy with that, so subsequent versions were released without the flocking covering the ears. As a result, Moss Man with flocked ears is rare and more expensive on the secondary market.

Moss Man, as the master of camouflage, is well suited to posing in and around houseplants, as he waits to pounce on unsuspecting Evil Warriors.

FUN FACTOIDS:
• All of the moving parts on the new version created areas where the flocking rubbed off.
• Moss Man's new head was meant to establish him as a more peaceful looking forest creature.

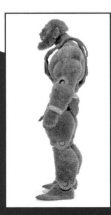 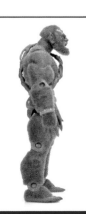 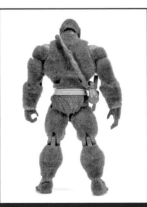 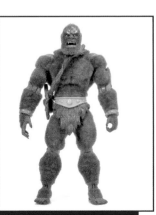

MOTUC - SECTION 1

MOTUC CARDED FIGURE PROTECTORS

First released 2013

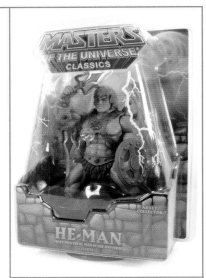

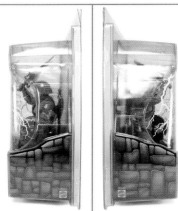

MOTUC CARDED FIGURE PROTECTORS

Y4331

ADULT COLLECTOR

P1

Sold in packages of four, the MOTUC Carded Figure Protectors were offered as a way to protect carded Masters of the Universe Classics figures. The front of the protector is perfectly formed to the shape of a standard Masters of the Universe Classics blister card, and the back piece (with an embossed MOTUC logo) seals the carded figure in securely.

A cutout at the top allows the users to hang their carded figures on their walls. Figures inside the protectors can also be displayed on a shelf without falling over.

CONFORMS TO THE SAFETY REQUIREMENTS OF ASTM F963.

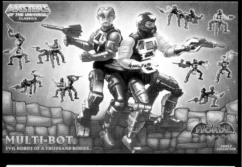

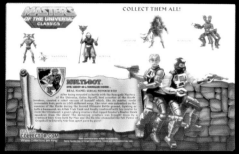

MULTI-BOT
EVIL ROBOT OF A THOUSAND BODIES
First released 2015 • Member of the Evil Horde

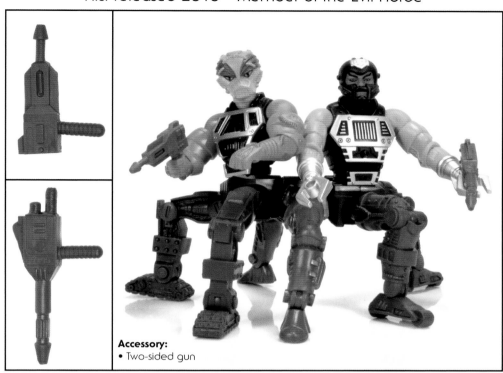

Accessory:
• Two-sided gun

Like Modulok, Multi-Bot's gimmick is that all of his body parts are removable and interchangeable, allowing the user to reconfigure the toy into a number of different looks. Unlike Modulok, Multi-Bot's torsos can be detached from the pelvis pieces. Like the vintage toy, Classics Multi-Bot comes with two torsos, allowing you to more easily split the figure up into separate figures. Multi-Bot is also compatible with Modulok, and the two can be combined to create Megabeast, also known as Ultrabeast.

Multi-Bot is closely patterned after his original 1986 action figure. Like the vintage figure, Multi-Bot doesn't reuse any previously existing parts.

Multi-Bot is a fun and colorful character that adds some unique color tones to the line, including forest green and plum purple. He lacks some of the creepiness factor of Modulok because his parts are robotic rather than organic (with the exception of his black-helmeted head, of course), but he's a great representation of the more mechanical side of the Evil Horde.

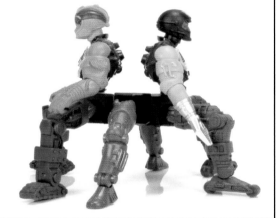

NEPTHU
WICKED SUN SORCERER

First released 2013 • Evil Villain

Accessories:
• Crystal Zoar
• Sun Scarab ankh

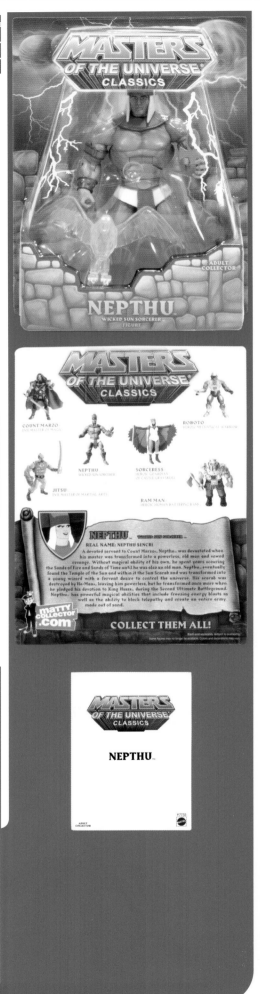

Nepthu is based on the character who appeared in "Temple of the Sun," the fiftieth episode of the Filmation He-Man and the Masters of the Universe series. In the episode, Nepthu discovers the Sun Scarab (included with the figure) hidden in the Temple of the Sun. He uses its power to try to gain control of Eternia, and in the process turns the Sorceress (in her form of Zoar, the falcon) into crystal.

Nepthu's costume has strong ancient Egyptian overtones, seen in his headdress, collar, and loincloth. He has a fairly simple and streamlined design, which isn't surprising given his animated origins. The orange, blue, and green elements of his costume include a mixture of metallic and flat paint applications to give the overall look some additional depth. Nepthu reuses the basic King Grayskull body, with a left forearm borrowed from Tri-Klops, left hand taken from Count Marzo, and boots borrowed from Bow. Zoar is cast in clear plastic with sharp, crystalline lines, and does not share any parts with previous releases of Zoar.

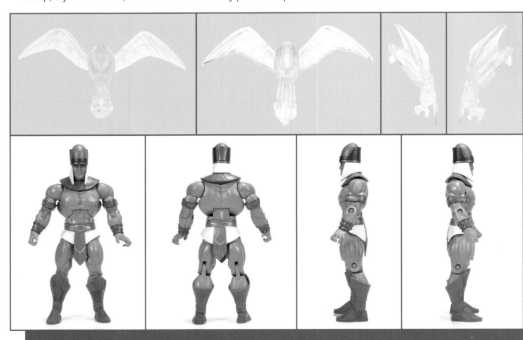

MOTUC - SECTION 1

NETOSSA
CAPTIVATING BEAUTY

First released 2013 • Member of the Great Rebellion

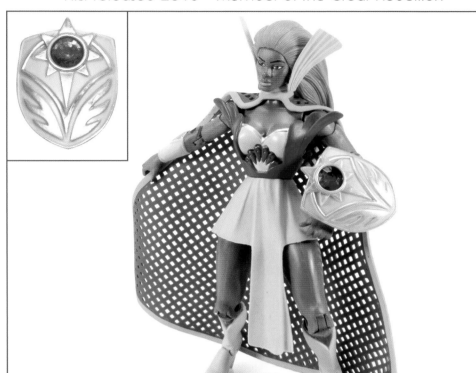

Accessories:
• Power Shield
• Cape

Netossa is among the most beautiful of the Princess of Power figures in the line, featuring an elegant blue-and-white costume complete with detachable net cape. The vintage figure's cape had a drawstring feature that could be used to capture another figure. The Classics version lacks that ability, and the soft plastic cape is simply a part of her costume. Since Netossa's cape is supposed to be her main weapon, her only other accessory is her shield, which has some striking silver paint highlights and a deep blue jewel inset at the top.

Netossa reuses the shoulders and biceps from Adora, the shield from She-Ra, and the hands and thighs from Teela. All of her other parts are newly sculpted. Her design seems slightly more influenced by the Filmation She-Ra cartoon, than the somewhat busier design of the vintage doll. The white elements of her costume are given metallic silver highlights, which help to emphasize her almost regal appearance.

FUN FACTOID: The Four Horsemen were nervous about Netossa's cape, since they weren't using soft goods in the line and making a molded cape that worked as both a net and a cape was challenging.

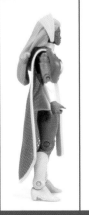

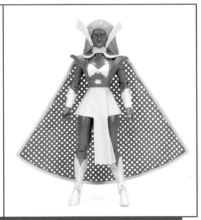

NIGHT STALKER
EVIL ARMORED BATTLE STEED

First released 2016 • Steed of the Evil Warriors

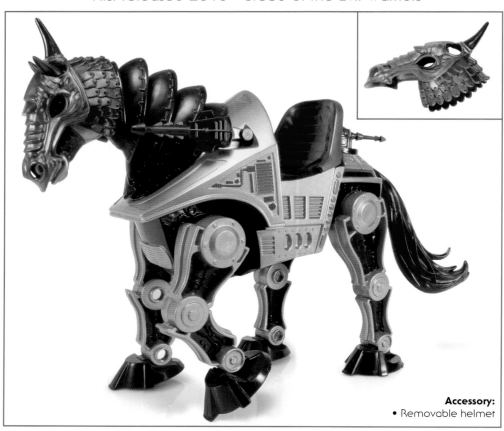

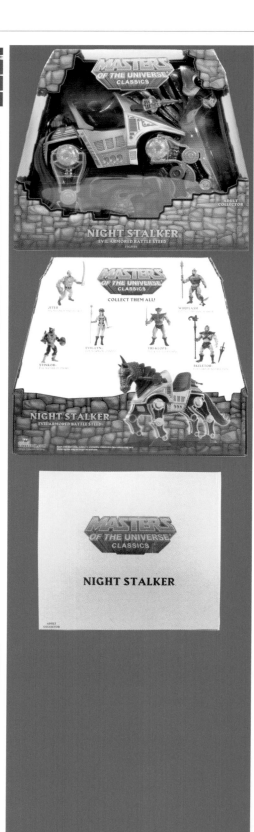

Accessory:
• Removable helmet

Night Stalker is the evil counterpart to Stridor. The robotic steed is often associated with Jitsu, since the vintage Night Stalker was offered in a gift set with Jitsu, as well as individually.

Classics Night Stalker (unlike his 1985 predecessor) has fully articulated legs and a multijointed neck that allows him full range of articulation. The evil mount is bristling with guns and features a roomy seat for one rider. He has a striking black, gold, and purple color scheme—a somewhat unusual combination of colors within the Masters of the Universe line. As is usually the case with the large-scale Classics toys, sticker details in the vintage toy have been translated to fully sculpted details in the Classics toy. None of the parts used to create Night Stalker were reused from any previously existing toys.

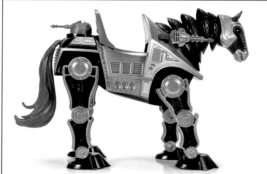

Some versions of the vintage Night Stalker came with a purple repaint of Stridor's helmet. The Classics version takes it a step further and includes a much more sinister-looking helmet that seems to include design elements inspired by Skeletor's costume. The modern Night Stalker was designed by Nate Baertsch, a frequent collaborator of the Four Horsemen.

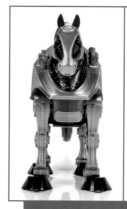
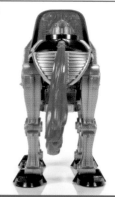
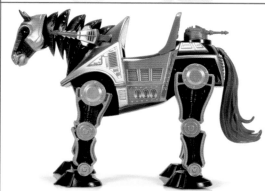

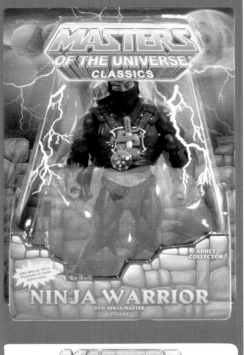

NINJA WARRIOR
EVIL NINJA MASTER

First released 2015 • Member of the Evil Warriors

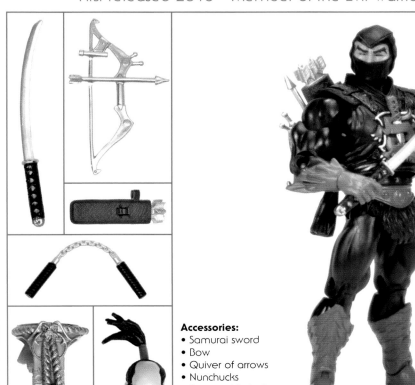

Accessories:
- Samurai sword
- Bow
- Quiver of arrows
- Nunchucks
- Removable belt
- Alternate unmasked head

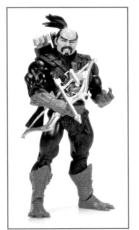

The character known as Ninja Warrior was originally released in 1987 as Ninjor. Unfortunately the trademark for the original Ninjor had long since expired, and by the time Mattel was ready to release the Classics version, another company had copyrighted the name. Something similar happened in the 200X line, when Fisto had to be released under the name "Battle Fist."

Ninjor has highly detailed sculpted armor, with parts that resemble black leather and worn black fabric. He is also given demonic-looking red eyes that help drive home the point (in case it wasn't clear from his clawed feet) that Ninjor is not exactly human. He comes with a second, unmasked, head. The vintage figure had a cloth mask that was removable, and the second head on the 2015 Ninjor helps replicate that effect.

Ninjor reuses the standard King Grayskull body, with forearms from Whiplash, boot tops from Kobra Khan, loincloth from He-Man, and hands and feet from Skeletor. The vintage figure reused Jitsu's sword; however, the Classics version has been given his own unique sword. Ninjor's bow design is based on the vintage toy design, which was in turn reused from an accessory that came with the Eternia play set. Ninjor's removable belt is actually meant to be used with Jitsu, and helps give Jitsu more of a 200X look.

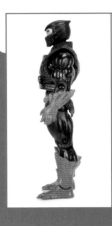

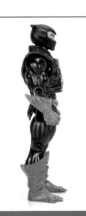

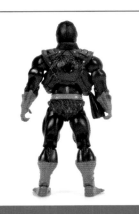

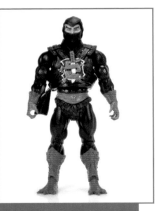

OCTAVIA
EVIL TENTACLE-SWINGING WARRIOR

First released 2013 • Member of the Evil Horde

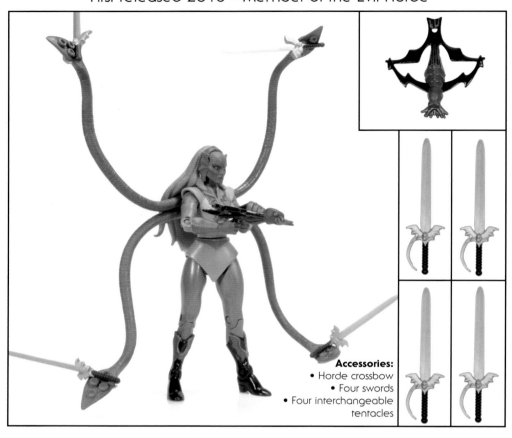

Accessories:
- Horde crossbow
- Four swords
- Four interchangeable tentacles

Octavia is closely designed after the character in the 1980s She-Ra cartoon who appeared in "Treasure of the First Ones" and "She-Ra Makes a Promise." Octavia is a formidable foe, often posing a very credible threat to She-Ra and Sea Hawk.

Octavia's four tentacles plug into her back and feature a ball-and-hinge joint. The tentacles themselves are intricately sculpted with creases, folds, and realistic-looking suction cups. They are not flexible, but still posable. Octavia's skin is a sickly green, and she sports fishy-looking fins on the sides of her face. She wears the Horde logo on both her boots and chest. Due to her long tentacles, she's quite an imposing figure and is well suited for dramatic battle poses. Octavia's swords are based on her weapons used in the cartoon, but her crossbow is an all-new design, featuring a creepy Cthulhuesque design on the front.

Octavia reuses feet from She-Ra shoulders and biceps from Adora, while her thighs and hands come from Teela.

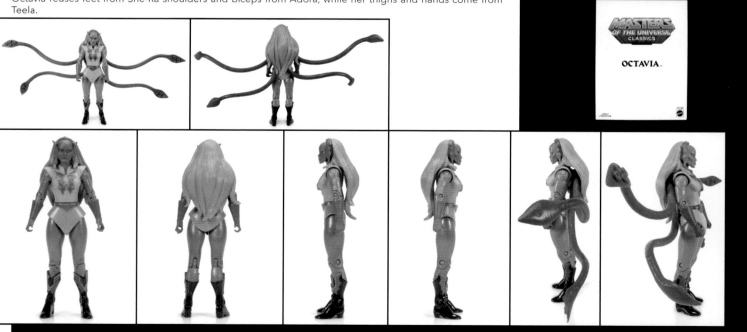

FUN FACTOID: Oo-Larr was shipped with the map of Castle Grayskull as the 2015 Club Eternia exclusive (see page 535).

OO-LARR
THE JUNGLE HE-MAN

First released 2015 • Ally of the Heroic Warriors

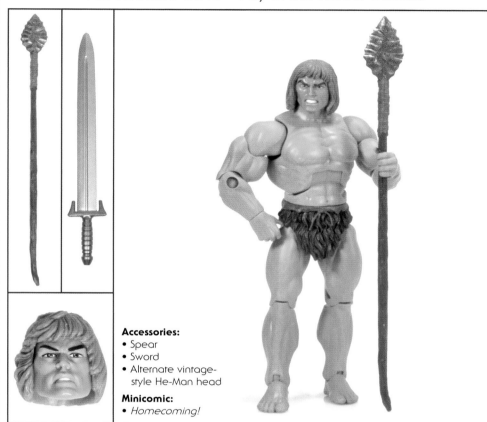

Accessories:
- Spear
- Sword
- Alternate vintage-style He-Man head

Minicomic:
- *Homecoming!*

Oo-Larr is based on the first minicomic appearance of He-Man in He-Man and the Power Sword. In the Masters of the Universe Classics story line, there are multiple He-Men, a trope used to integrate the various contradictory stories told about He-Man during the 1980s. In He-Man's first appearance, he is a jungle warrior who is gifted fantastic weapons by the Goddess. Oo-Larr represents He-Man's look before he is given those weapons and dons the familiar He-Man costume. He definitely has a wild and savage look.

Oo-Larr is unique among the human-like figures in Classics, in that he has neither boots nor chest armor. His only clothing is a ragged loincloth, as befits his jungle origins. He has a fantastically detailed rough-hewn spear, which is the first weapon he holds in the minicomic. Also included is a sword from the set of weapons and equipment given to him by the Goddess. A short-handled axe that appeared in another scene in the minicomic was intended to come with Oo-Larr, but it was included with Huntara by mistake. Oo-Larr's main head has long, shaggy hair, again taken straight from the early minicomics.

Oo-Larr also includes a second head that is a much closer representation of the 1982 He-Man head sculpt than the one included with the 2008 Classics version. The updated vintage-style head has the strong facial features and the windswept hair of the original He-Man.

Oo-Larr reuses most of the original King Grayskull body, but with new, smooth forearms and bare feet. He also reuses Demo-Man's shins, which means he has no boot-cut articulation.

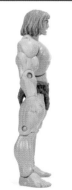
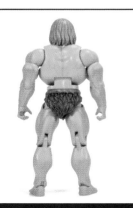
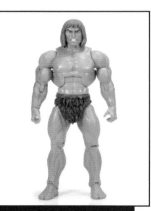

OPTIKK
SPACE MUTANT SPY FOR SKELETOR

First released 2011 • Member of the Space Mutants

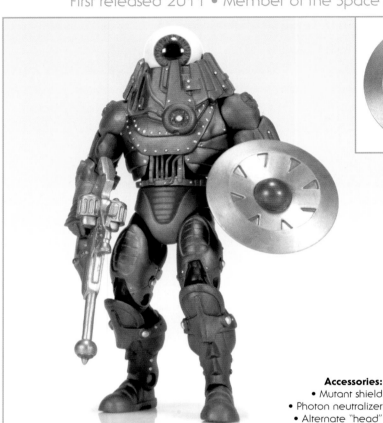

Accessories:
- Mutant shield
- Photon neutralizer
- Alternate "head"

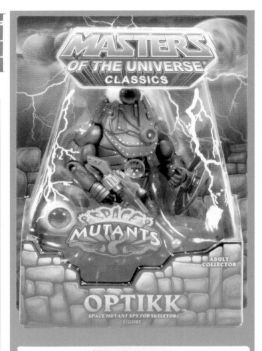

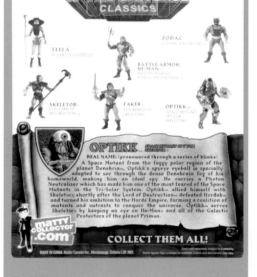

OPTIKK.

Optikk was the first New Adventures figure released in the Classics line. Because he came early in the line, when the reuse of parts was an important aspect of its strategy, Optikk is more reliant on parts reuse than other New Adventures figures that followed later. He was also designed specifically to share parts with Man-E-Faces, who came out the following year. Accordingly, Optikk's legs and left arm comes from Trap Jaw's mold, and his right arm and pelvis piece were later used for Man-E-Faces. His torso comes from King Grayskull, but is well hidden behind removable armor and an additional piece that covers his abdomen.

The vintage Optikk figure had a unique sculpt, with chains around his boots and lots of heavy industrial design touches and irregularities. Some of that is toned down in the Classics figure for the purposes of sharing parts with Trap Jaw and Man-E-Faces, but Optikk's extras help make up for it. He includes the photon neutralizer that was included with the vintage figure and a newly designed shield that resembles an eye. He also comes with an alternative eye "head" that is colored orange to match the vintage card artwork. Optikk is a striking, unique figure, and probably one of the most popular of the New Adventures designs.

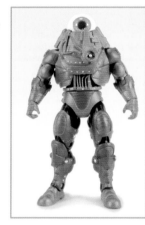

FUN FACTOID:
- Optikk was the first New Adventures character in the line!
- The Four Horsemen were pleased by how the NA designs translated to Classics' bulkier frames, even when removed from the long and lean proportions of the NA line.

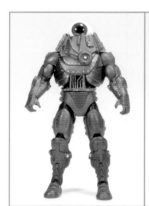
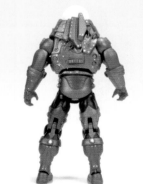
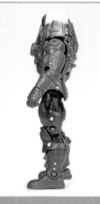

ORKO
HEROIC COURT MAGICIAN

First released 2010 • Member of the Heroic Warriors

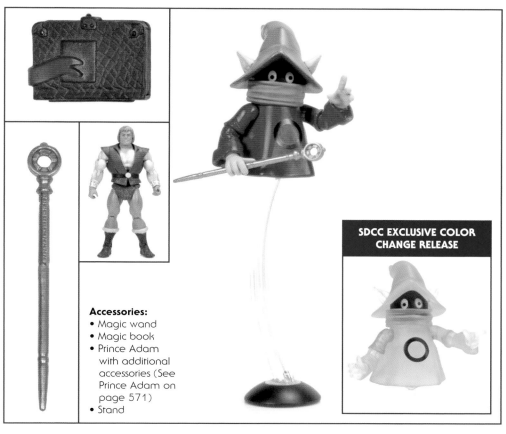

SDCC EXCLUSIVE COLOR CHANGE RELEASE

Accessories:
- Magic wand
- Magic book
- Prince Adam with additional accessories (See Prince Adam on page 571)
- Stand

Orko was released in a standard-sized package along with Prince Adam. In an amusing reversal of expectations, Prince Adam was packaged lying down at the bottom, as if he were Orko's accessory or sidekick.

The Classics release of Orko is a flawless recreation of Orko as he was depicted in the Filmation He-Man cartoon. The vintage 1984 figure, by comparison, was a bit out of scale (no doubt the result of Orko's ripcord-pull action feature) and a bit crude looking.

Orko comes with a gold magic wand that is shaped like the old ripcord that came with the vintage figure (the 200X version of Orko had a similar accessory). Orko comes with a magic book and a stand that allows him to "hover" at about the chest level of the other Classics figures. His arms are fully articulated, and his head and scarf are removable.

An alternative color-changing version of Orko was also made available as a 2010 San Diego Comic-Con exclusive variant. When this semitranslucent figure is exposed to heat (warm water or air), the plastic turns completely translucent, with the exception of the black and yellow areas. This is a fun re-creation of Orko's disappearing trick that he performed so frequently in the Filmation cartoon. Likewise, if the variant's magic book is exposed to heat, the SDCC logo appears on the cover.

FUN FACTOID: The Four Horsemen liked that Classics finally delivered a properly sized, fully articulated, fully accessorized (and Filmation accurate) version of Orko.

PANTHOR
SAVAGE CAT OF SKELETOR

First released 2011 • Beast of the Evil Warriors

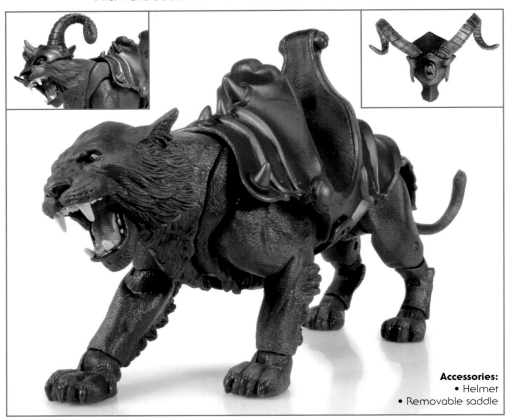

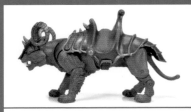

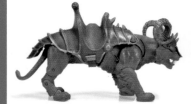

Accessories:
• Helmet
• Removable saddle

FUN FACTOID: The Four Horsemen ditched the flocking and instead took inspiration from its haunting box art.

The Masters of the Universe Classics Panthor is in some ways a departure from the vintage 1983 toy he's based on. The most noticeable difference is that the 2011 release lacks the characteristic purple flock covering that the original had. The lack of flocking does allow for the sculpted fur texture to come through, as well as the paint shading. Classics Panthor also features a newly sculpted original helmet design inspired by the look of Skeletor's Havoc Staff, complete with curled ram's horns. Panthor's saddle also features some impressive metallic green highlights.

The vintage Panthor was a simple repaint of Battle Cat. Classics kicks things up a notch with the previously mentioned helmet, as well as a brand-new head sculpt that seems directly inspired by the vintage Panthor box art. The rest of the body, as well as the saddle, is reused from Battle Cat.

Panthor is a fearsome mount for Skeletor, or any other Evil Warrior that dares try to ride him. His combination of impeccable sculpt work and striking colors makes him stand out among all the beasts of the Classics line.

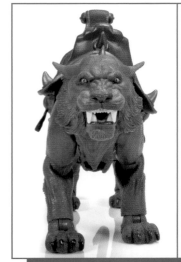

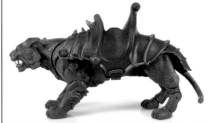

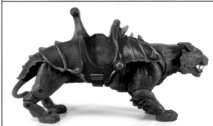

INTERVIEW WITH
TERRY HIGUCHI

Tell me how you got into the toy design business.

I got a job working at JAKKS Pacific toys. I was originally going to work on packaging art, since I was an illustration / graphic design major. I had a love for toys, and luckily, they let me move into the product design department. I learned all of the technical toy development information on the job.

You've been a project designer at Mattel for some time. What does the role entail?

As a project designer, I am able to design toys as well as take on a little more responsibility in handling projects on my own. It's a fun position where I don't need to manage other people, and I can focus my time on new concepts and seeing my projects go through the process of becoming toys.

How did you become involved in the Masters of the Universe Classics line?

I was lucky enough to be given this project as one of my first projects at Mattel. Fortunately, my boss at the time was Martin Arriola. He worked on Masters of the Universe back in the day, and he introduced me to many of the people who had worked on the original line and the fun stories of what it was like working there, and how toys were produced back then.

Who else did you meet (aside from Martin) who worked on the original He-Man line? Do you remember any of the stories they shared?

I met several engineers and master model makers that worked on the original He-Man line. I learned that model makers used to carve molds out of wood. One engineer showed me his 1:1 scale mechanical drawings he did on vellum. They were beautiful, perfect drawings to show the mechanisms of the figures and vehicles like the Land Shark. Back in the day, molds and mechanical drawings for the toys were done by hand. It is pretty much a lost art now that most things have converted to digital. The one thing that has not changed, however, is the symphony of people it takes to get a toy produced. One person alone cannot take ownership and credit for a toy that Mattel makes. It was true back then, and it is still true today.

The craziest story I heard about Mattel back in the day had to do with a bunch of MOTU paintings being thrown out in the trash. I guess when the Mattel offices moved, someone did some office cleaning and thought that those paintings weren't worth keeping. Luckily, some people found out and dug them out and saved them. Can you imagine dumpster diving and finding original William George MOTU paintings? I heard a similar story from the prop master at Sony Pictures when I was working on the Ghostbusters figures. The proton packs I was studying for the toy were saved from the dumpster as well. I guess sometimes there really are some treasures in the trash!

For the thirtieth anniversary of He-Man, you got to design your own figure, Cy-Chop, a cyborg figure with a clear chest and massive scissor hands. Can you talk about what inspired your design?

As a kid growing up in Hawaii, I watched a lot of Japanese shows like *Kikaida*, *Kamen Rider V3*, *Goranger* (original *Power Rangers*), and *Ultraman*. I also played with a lot of Japanese toys like Microman and Popy die-cast robots, since those were available at the stores in town. You can see the Microman influence in Cy-Chop, with the silver head and translucent *henshin* cyborg chest. The scissors hands come from one of my favorite *Kamen Rider V3* villains, Hasami Jaguar "scissors jaguar." He also had the horns on his head and the Shocker belt that all the villains had. I also drew from the character Overdog from the 1983 movie *Spacehunter: Adventures in the Forbidden Zone*. Take a look at those awesome claw hands! I remember watching that movie as a kid. Originally, I wanted to name the figure Sci-Zor, but I guess the name wouldn't clear because it was too close to a Pokémon name.

Were you into He-Man as a kid?

I was into He-Man as a kid, but I didn't own too many of the toys. I always watched the cartoons after school. My favorite figures were Trap Jaw and Webstor.

What are some of the projects that stand out most to you on the MOTU Classics line?

Since Trap Jaw was my favorite figure, it was great to work on the Classics version. My favorite part of that figure is his tongue inside the jaw. The Wind Raider was also memorable because I remember having to work out a solution to the rotating mechanism and figuring out how to do the big graphic on the sides of the ship. When I first started on the Classics line, the armor wasn't removable, so I remember having to fix that as well. It was also fun to redraw Faker's "reel-to-reel" chest deco while the original designer (Martin Arriola) was sitting just a cubicle away.

What are some of the challenges you faced in your work on the Classics line?

The most challenging part of the MOTU Classics line for me was staying on budget. As a collector myself, I would want to keep all the nice deco on the figures. It was hard for me to take stuff off. There are also production issues that you run into with materials not matching colors, parts shrinking in weird ways, getting the deco to look right, safety issues, etc. These are the day-to-day challenges a toy designer faces as a toy goes through the production process.

If you were to reboot He-Man again in a new action figure format, what would it look like?

Personally, I am a collector of twelve-inch-scale figures. I enjoy seeing the type of detail that can be achieved at that scale. So if I were to reboot He-Man for myself, I would go to a scale around eight inches so I could get more detail and size over the standard six-and-a-half-inch figure.

Were there any figures you worked on that didn't come out quite the way you wanted?

Most of the time, the Classics figures did not have all of the deco I wanted. The paint masters that came from the Four Horsemen were usually pretty good in having a good amount of deco, but not going over. However, I remember Man-At-Arms and Icarius in particular being way over cost. There were a lot of rivets on Man-At-Arms' armor and Icarius's wings. I just could not afford to paint them all.

What, in your opinion, makes a great action figure, regardless of style or specific toy line?

A great action figure or toy needs to stand the test of time. The greatest toys can transport you back to your childhood. I see it all the time when we dig out old toys. Someone would be walking by and then just stop in their tracks and say something like, "Oh, I had that when I was a kid! I played with it all the time!" Years down the road, will someone remember the toys you worked on? This is the question that all toy designers should be asking themselves as they are designing their own products.

PEEKABLUE
WATCHFUL FEATHERED FRIEND

First released 2015 • Member of the Great Rebellion

Accessories:
- Shield
- Fighting fan
- Removable tail

Peekablue is one of the most colorful and eye catching of the Princess of Power faction in Masters of the Universe Classics. The eye is instantly drawn to her dramatic peacock's tail, which is covered with eye designs that allow Peekablue to actually see in all directions. The tail can be collapsed like a fan. Peekablue's hair is almost neon green, and the rest of her costume consists of simple primary colors.

Peekablue is patterned after her appearance in the She-Ra cartoon rather than the vintage figure. The cartoon design was much more streamlined, with a simplified color scheme, but otherwise had a similar overall design when compared to the original doll.

Peekablue reuses She-Ra's shield, Adora's biceps and shoulders, Netossa's boots and forearms, and Teela's thighs and hands. She comes with a newly sculpted fan weapon that suits her character to a tee.

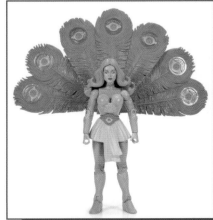

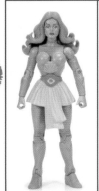

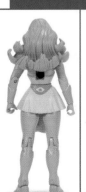

PERFUMA
SCENT-SATIONAL FLOWER MAIDEN

First released 2015 • Member of the Great Rebellion

Accessories:
- Flower gun
- Shield
- Flower hat

Perfuma is like a walking florist's shop, with a flower hat and flower gun and a vivid pink-and-green color scheme. Like Moss Man and Stinkor, Perfuma is scented, with a quite strong rose aroma right out of the package. The vintage Perfuma had a backpack with a pop-up "blooming" flower action feature. That backpack has been translated into a flower gun for the Classics release. Perfuma also comes with a flower hat (recalling the design of the animated character) and a shield.

Perfuma's overall design is a cross between the vintage figure and her appearance in the animated series. Her boots, belt, shield, and bracers are straight from the 1986 doll, while the floral hat and bodice come from the Filmation design.

Perfuma reuses She-Ra's shield; Adora's shoulders and biceps; Teela's thighs, right hand, and feet; and Battleground Evil-Lyn's left hand.

MOTUC - SECTION 1

PLASMAR
HEROIC MASTER OF PLASMA-BLAST POWER

First released 2017 • Member of the Heroic Warriors

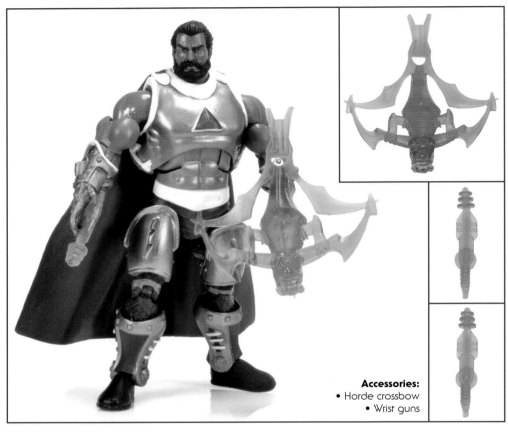

Accessories:
- Horde crossbow
- Wrist guns

Plasmar was released in an exclusive Power-Con three-pack with Terroar and Lord Gr'Asp. The character was discovered in a group of unused figure packaging art by artist Errol McCarthy. He was one of several planned but unproduced figures from the vintage line that would have been made entirely from parts recycled from previous figures.

Plasmar's armor has quite an interesting metallic mint green color not seen before in previous MOTU figures. He reuses Fisto's head; King Grayskull's torso, shoulders, and upper arms; Rio Blast's forearms and hands; Sssqueeze's legs and pelvis; Rio Blast's wrist guns; and Grizzlor's crossbow. The unproduced vintage figure was actually supposed to use armor from He-Ro's chest (another concept character that was never made in the vintage line but was produced in the Classics line), but Plasmar uses Sir Laser-Lot's armor instead.

Despite his mishmash of parts, Plasmar really does look like a brand-new figure design, which is probably due to the color choices and eclectic mix of parts and accessories.

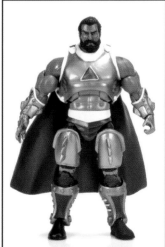

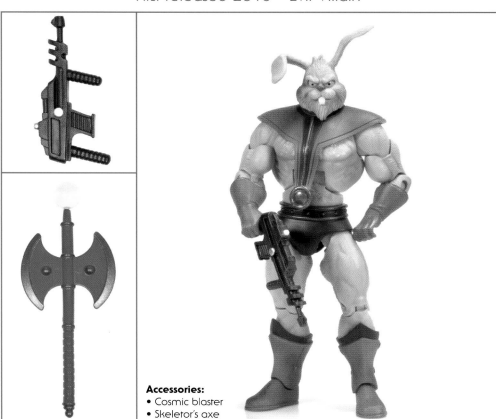

PLUNDOR
EVIL RABBIT SEEKING RICHES

First released 2013 • Evil Villain

Accessories:
• Cosmic blaster
• Skeletor's axe

Plundor is the main villain from the Filmation He-Man episode "Quest for He-Man." Plundor is the ruler of the planet Trannis, a place filled with bizarrely cartoonish animals and characters. Despite being a rather silly-looking six-foot-tall purple rabbit man, Plundor is a formidable villain who is bent on stripping Trannis of all its resources and life.

Plundor here is much more detailed than the character as he appeared in the cartoon, with nicely sculpted fur and new decorative details on his costume. Plundor's axe is actually intended for Skeletor, and comes from the Filmation He-Man episode "Diamond Ray of Disappearance."

Plundor reuses the torso, thighs, shoulders, and biceps from Beast Man. His upper shins come from Stinkor, his boot tops come from Skeletor, his feet are from Keldor, his hands come from He-Man, and his blaster comes from Webstor. Plundor adds some much-needed pastels to the Classics color palette, and also doubles as an Easter basket decoration.

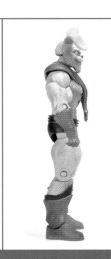
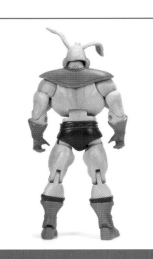
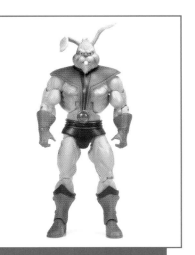

MOTUC - SECTION 1

POWER SWORD
LEGACY OF HE-MAN

First released 2012 • Artifact of the Heroic Warriors

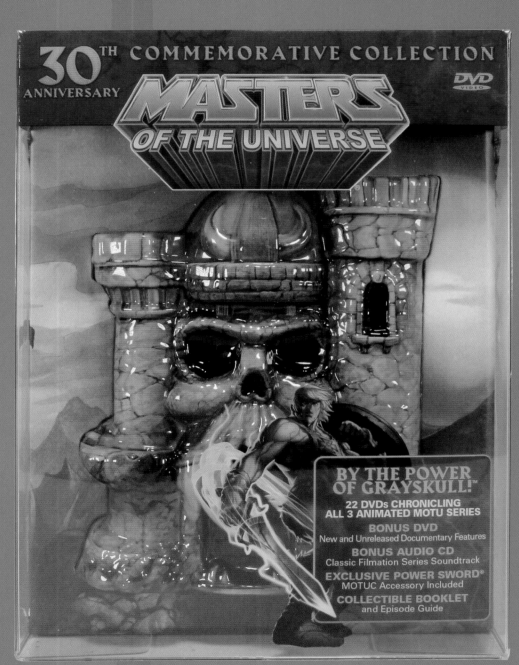

The 30th Anniversary Commemorative Collection DVD set came with a two-tone gold Masters of the Universe Classics Sword of Power, which was packaged in a sealed bag within the set. The plastic case for the set features a three-dimensional Castle Grayskull on the front, which has the distinctive look of the prototype vintage castle sculpted by Mark Taylor. The DVD set included the entire Filmation *He-Man* series, as well as twenty selected episodes from *The New Adventures of He-Man*, the entire Mike Young Productions 2002 *He-Man* series, selections from the Filmation *He-Man* soundtrack, a documentary featurette, and an episode guide booklet.

PRAHVUS
EVIL MASTER OF DOOM
First released 2015 • Evil Villain

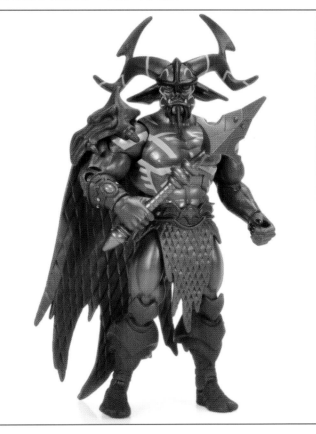

Accessories:
- Mace
- Magic lamp

Part of the Club 200X subscription, Prahvus is based on an independent villain from the 2002 He-Man and the Masters of the Universe series who first appeared in the episode "Out of the Past." In the story, Prahvus plays a part in the Sorceress's origin tale. As a young woman living in the village, she manages to fend off the invading warlord Prahvus and his evil minions using magic.

Prahvus is a dramatic and imposing character, with huge horns and a bull-like face. His chest is covered with light blue markings resembling tattoos. He wears a ragged purple cape with a dragon skull perched on his shoulder, and carries a weapon that looks like a cross between a mace and a spear.

Prahvus reuses King Grayskull's torso, right hand, thighs, upper shins, shoulders, biceps, and feet, as well as Oo-Larr's left forearm. He also reuses Fang Man's left hand. Prahvus's boot tops are technically new, but they make use of He-Man's boot tops as the basis for the design, with some newly sculpted areas near the top that run up to his knees.

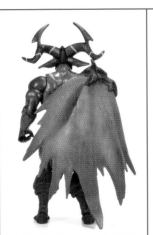

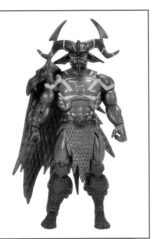

POINT DREAD
MYSTERIOUS COSMIC FRONTIER OUTPOST

First released 2015 • Outpost of the Heroic Warriors

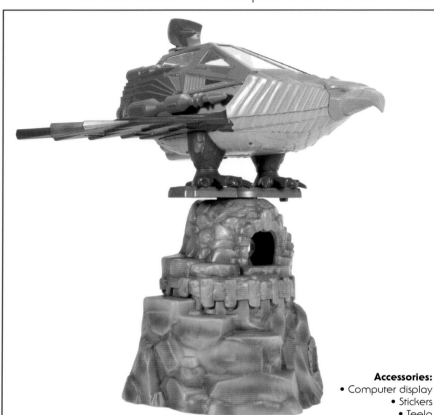

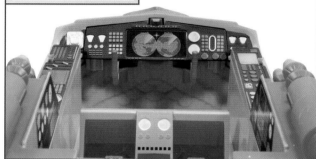

Accessories:
- Computer display
- Stickers
- Teela

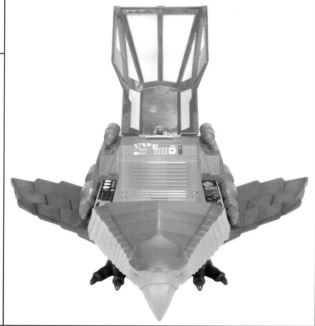

Point Dread & Talon Fighter is one of the largest and most impressive items produced to date for Masters of the Universe. The set includes the two-piece Point Dread play set, the Talon Fighter vehicle, a removable computer display for Point Dread, and a Filmation-style Teela figure with an alternative helmeted head.

Talon Fighter is mainly based on the vintage 1983 Mattel vehicle, although the guns on its sides (just above the wings) are actually based on the guns that came with the Monogram Talon Fighter model kit. The Classics Talon Fighter, like the vintage vehicle, has two seats, one in front and another in back. However, the Classics Talon Fighter is much larger in scale relative to the Classics figures than the vintage vehicle was relative to the vintage figures. Another change is that the vehicle's talons stick straight out rather than curving down, allowing the vehicle to sit on a flat surface. Several of the stickers from the interior of the vintage vehicle have been translated into fully sculpted control panels, although some stickers are still present in the 2015 Talon Fighter. Another added detail is that the modern Talon Fighter has clear plastic windows, whereas the vintage version just had empty cutouts for windows.

Point Dread is in two separate pieces, just like the vintage play set. The top half can be removed from the bottom half and affixed to the tallest turret on Castle Grayskull, allowing the Talon Fighter to perch on top of the castle. The Classics Point Dread has a number of new details not present on the vintage play set. It has a sculpted interior floor with faux wood paneling, a sculpted second window on the bottom section and a fully sculpted computer display (rather than the cardboard piece used in the vintage toy), and it is much taller relative to Classics figures

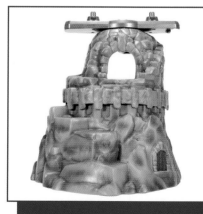
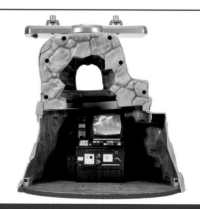
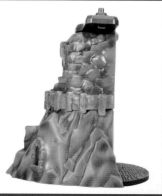

& TALON FIGHTER
LEGENDARY FLYING VEHICLE

First released 2015 • Vehicle of the Heroic Warriors

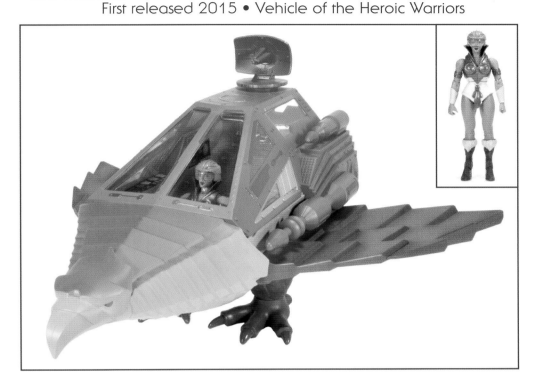

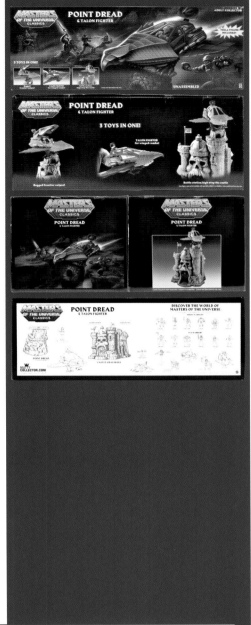

than the vintage toy was relative to vintage figures. At the top of the play set is a perch that the Talon Fighter is meant to sit on. The Talon Fighter locks into place on the perch, but a button allows you to remove the vehicle.

Teela is meant to resemble the character as she appeared in the Filmation He-Man cartoon, although she is more detailed than the Club Grayskull version of Teela, which is more Filmation accurate. Teela comes with her cartoon sword and shield, as well as an extra pilot head with a helmet that looks like a cross between those worn by Man-At-Arms and Dawg-O-Tor. Teela reuses the thighs, upper shins, boot tops, shoulders, upper arms, and hands of the first Classics Teela figure. Her feet and forearms are reused from She-Ra.

The packaging art for Point Dread & Talon Fighter was illustrated by Rudy Obrero, who has done all the front box art for large Classics items, including Castle Grayskull, Granamyr, Wind Raider, and Roton. Rudy illustrated the early box art for the vintage MOTU line as well, although he did not illustrate the vintage Point Dread packaging.

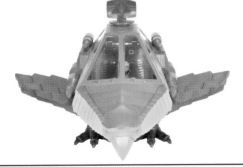
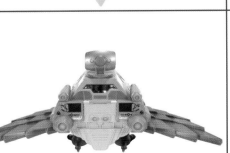
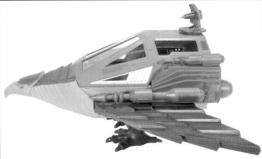
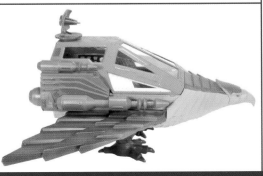
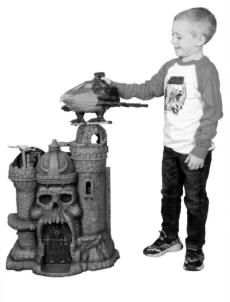

PRETERNIA DISGUISE HE-MAN
MOST POWERFUL MAN IN THE UNIVERSE

First released 2011 • Member of the Heroic Warriors

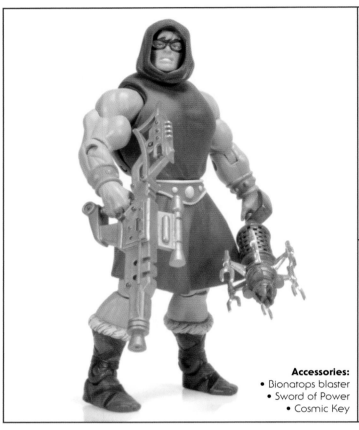

Accessories:
- Bionatops blaster
- Sword of Power
- Cosmic Key

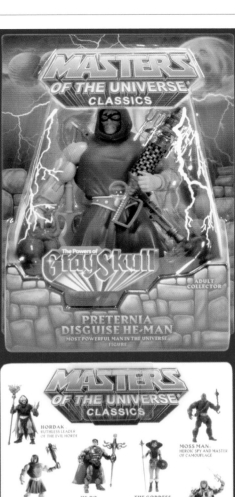

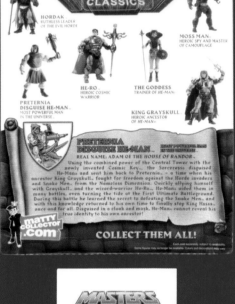

Available as the Club Eternia subscriber exclusive for 2011, Preternia Disguise He-Man is based on his look in the final minicomic of the vintage MOTU line, The Powers of Grayskull: The Legend Begins! The comic was meant to introduce the new Powers of Grayskull toy line, which unfortunately fizzled out before the actual associated action figures (He-Ro and Eldor) could be released. In the story, the Sorceress takes He-Man back in time and discovers that Skeletor has also gone back in time to meddle with events of the past. The Sorceress gives He-Man a disguise so Skeletor won't recognize him.

Preternia Disguise He-Man reuses the lower torso from Battle Armor He-Man; the upper torso, shoulders, biceps, hands, right forearm, legs, and boots from King Grayskull; and the left forearm from Tri-Klops. The Cosmic Key he comes with was mentioned in the minicomic, but is better known as the time-travel device from the 1987 Masters of the Universe live-action movie. The design here is based on the key as it appeared in action figure format with the 1987 Gwildor figure, but uses the blue-and-gold color scheme from the movie.

The big blaster is based on the guns that were mounted on top of the vintage Bionatops figure, which He-Man rides in the minicomic. Bionatops has not, at the time of this writing, been released in the Classics line.

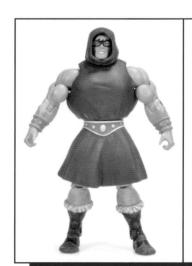

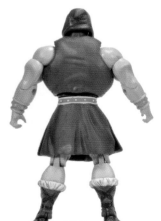

FUN FACTOID: Preternia Disguise He-Man came with first of several Cosmic Key accessories in the Classics line. He also came with a bonus planet Etheria map drawn by Rudy Obrero, who painted the very first set of box art for Masters of the Universe.

MOTUC - SECTION 1

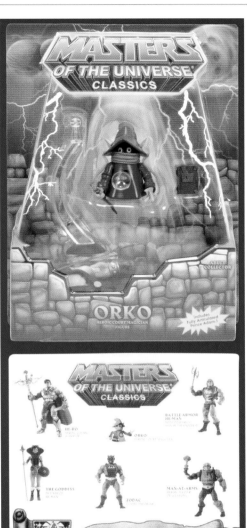

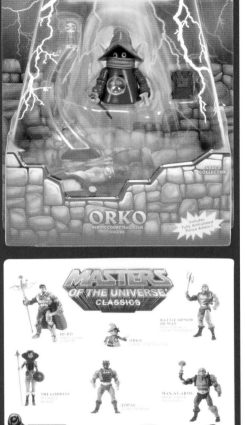

PRINCE ADAM
HEROIC DEFENDER OF THE SECRETS OF CASTLE GRAYSKULL

First released 2010 • Member of the Heroic Warriors

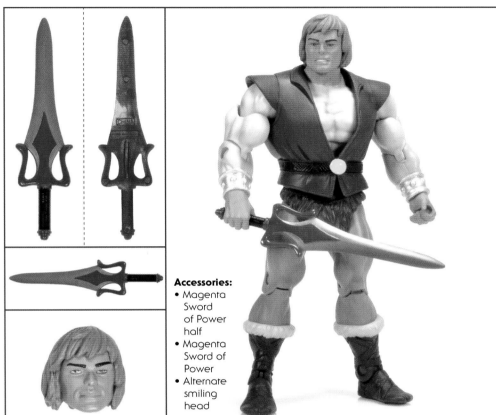

Accessories:
- Magenta Sword of Power half
- Magenta Sword of Power
- Alternate smiling head

Prince Adam was humorously released as Orko's "accessory", lying down at the bottom of Orko's package. Adam's design is based on the 1984 vintage figure. The biggest difference between the vintage figure and the cartoon version of the character was vest color. The figure had a maroon-colored vest, while the cartoon gave him a pink vest. Prince Adam comes with a second head that has a more relaxed expression. It doesn't exactly look Filmation accurate, but it looks more in keeping with the character of the happy-go-lucky prince. He also comes with a maroon version of the Sword of Power and a maroon half sword.

Prince Adam reuses the entire body of the 2008 King Grayskull release, but with Tri-Klops's left forearm. He also reuses the head and loincloth from the 2008 release of He-Man, along with He-Man's sword and half sword. Only the smiling head and soft plastic vest were newly tooled for this figure. He's a colorful character that makes a great "accessory" for Orko.

This release of Prince Adam didn't get a bio on the package itself, but an official bio for him was later released digitally via the "Masters Mondays" MOTU Classics bio series on He-Man.org.

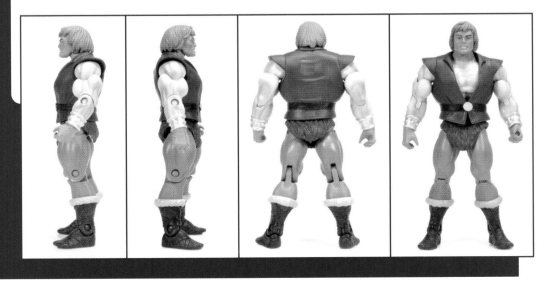

MOTUC - SECTION 1

PRINCE ADAM
HEROIC "SECRET IDENTITY" OF HE-MAN

First released 2017 • Member of the Heroic Warriors

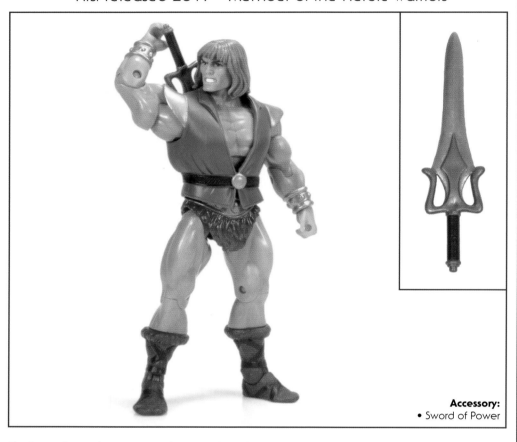

Accessory:
• Sword of Power

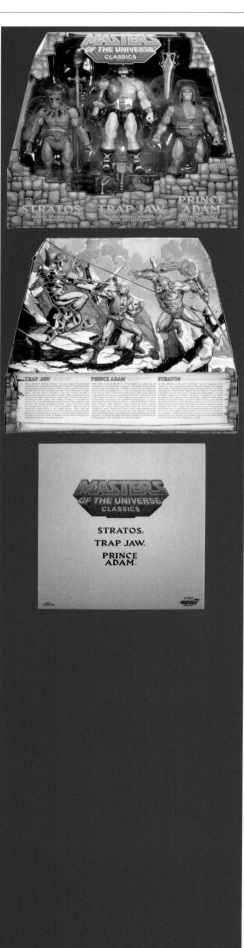

The Power-Con exclusive Prince Adam was released in a minicomic-themed three-pack, along with Stratos and Trap Jaw minicomic variants. The look for this Prince Adam is closest to the way he looked in He-Man and the Insect People. Prince Adam actually had quite a number of different costumes in early DC and Mattel minicomics, so there was plenty of source material to choose from. The look they chose here is also similar to the way he appeared in "To Tempt the Gods," published by DC Comics.

Prince Adam reuses the entire body of the 2008 King Grayskull release, but with Tri-Klops's left forearm and He-Man's loincloth. His head comes from Oo-Larr, and his sword (in the style of early Alfredo Alcala–illustrated minicomics) is from He-Ro II. His vest is reused from the 2010 release of Prince Adam, although with one difference—he has a sword holder on the back of his vest. The 2010 Prince Adam was actually supposed to have one as well, but it was left off by mistake.

This Prince Adam is a much tougher-looking version of the character, befitting his "savage" origins. He is equally at home in the palace as he is in the local tavern, flirting with barmaids and fighting the local drunkards.

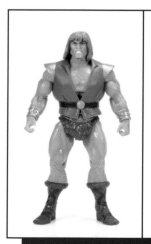
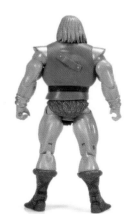

PROCRUSTUS
GIANT GUARDIAN OF MAGIC

First released 2012 • Ally of the Heroic Warriors

Accessory:
• Star Seed

Procrustus is a character that appeared in the 1983 minicomic The Magic Stealer! In the story, Skeletor creates a device that steals all of the magic out of Eternia. Procrustus, "the god who holds the inner world together with his many arms," is lured out from under the ground by Skeletor's device, but He-Man knocks him back into the ground using the Attak Trak.

Procrustus has slightly better articulation than the giants that came before him (Tytus and Megator), in that he has articulation cuts between the shoulders and biceps of his four arms. His extra two arms mount on his back and can be swiveled around in a number of different poses. Procrustus is cast in a light sandy-brown color, with medium brown paint highlights that bring out the craggy details in his sculpt. He reuses the legs and left hand from Megator, but otherwise he is an entirely new sculpt.

Procrustus's only accessory is the Star Seed, a large yellow orb. It wasn't an element in The Magic Stealer! but it was a magical artifact from the Filmation He-Man cartoon. The Star Seed was a leftover remnant from the explosion that created the universe. It is located deep underground at the center of Eternia, which is the very center of the universe. Anyone possessing the Star Seed would have unlimited power. Because it was an artifact located deep under Eternia, it made sense to give it to Procrustus as his accessory.

FUN FACTOID: Procrustus was a fan requested giant who came from Eternian mythology in the original minicomics.

QUAKKE
EVIL METEOR SMASHING MUTANT

First released 2017 • Member of the Space Mutants

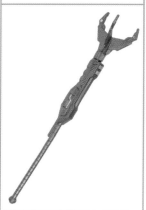

Accessories:
• Meteor
• Grabatron Meteormace

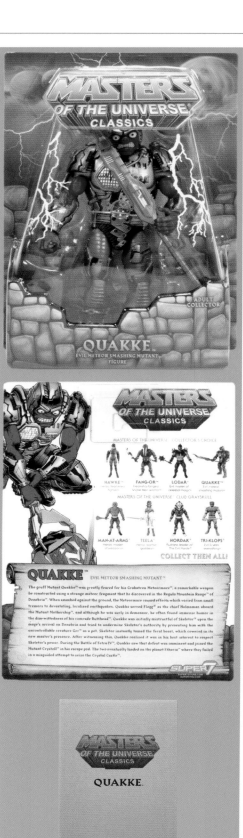

Quakke is an awesomely bizarre and quirky-looking member of the Evil Mutants faction. As befits his power to cause earthquakes using his Grabatron Meteormace, Quakke's costume is fractured with fault lines. He has a seismograph affixed to his chest, presumably to measure the force of his earthquake attacks.

Quakke's weapon is essentially a long pole with a detachable meteor at the end that can split in two. In the vintage 1991 Quakke figure, a lever on the back could be pushed to raise the figure's arms (with weapon in hand), and releasing it would send the weapon smashing down to the ground, breaking the meteor in two. The Classics version's meteor also splits in two, but of course without the lever on the back of the figure. The 2017 release ups the ante by including some sculpted electronic parts inside of the meteor.

Quakke reuses the shoulders from Man-E-Faces, the biceps from King Grayskull, the boot tops from Intergalactic Skeletor, the feet from Blast-Attak, the right hand from Demo-Man, and the left hand from Fang-Man.

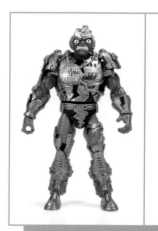

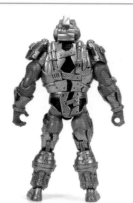

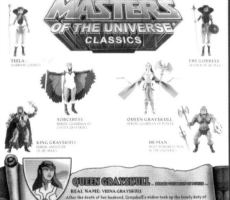

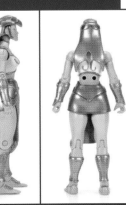

QUEEN GRAYSKULL
HEROIC GUARDIAN OF POWER

First released 2015 • Ancestor of the Heroic Warriors

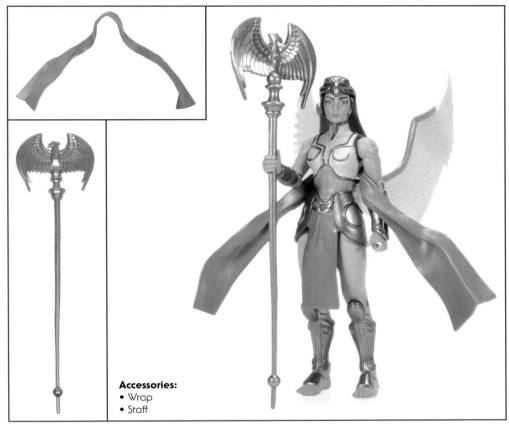

Accessories:
• Wrap
• Staff

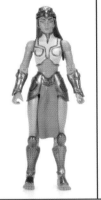

Queen Grayskull was released as a part of the Club 200X subscription. In the 2002 He-Man and the Masters of the Universe cartoon, Queen Grayskull (or Veena) was the wife of King Grayskull and appeared in the episode "The Power of Grayskull." She had the ability to transform into a falcon and served as the first Sorceress of Castle Grayskull after the death of King Grayskull.

The figure is a spot-on representation of the animated character, with dramatic white wings mounted on her lower back. She has a unique wrap that goes around her back and in front of her forearms and is sculpted to look as if it's being blown about by the wind. She also comes with a gold falcon staff befitting her role and powers.

Queen Grayskull reuses Adora's shoulders and biceps, and Teela's thighs and hands. Otherwise, she is a completely original sculpt, and remains one of the most beautiful figures in the Classics line.

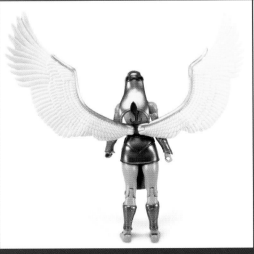
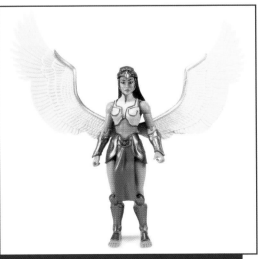

QUEEN MARLENA
HEROIC QUEEN OF ETERNIA

First released 2011 • Member of the Heroic Warriors

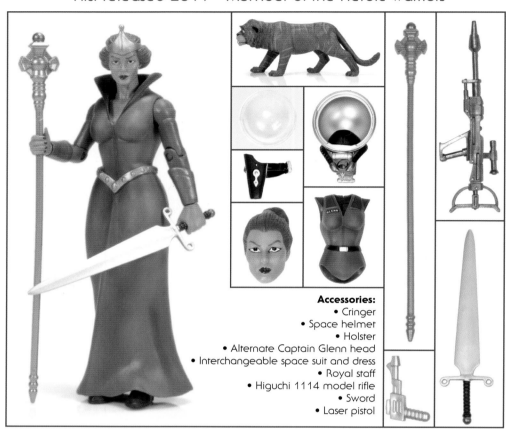

Accessories:
- Cringer
- Space helmet
- Holster
- Alternate Captain Glenn head
- Interchangeable space suit and dress
- Royal staff
- Higuchi 1114 model rifle
- Sword
- Laser pistol

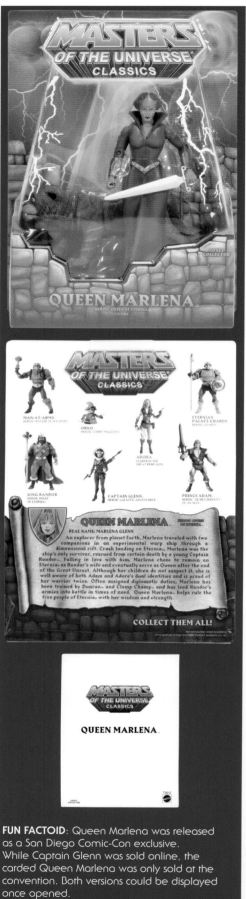

Queen Marlena is unique among Masters of the Universe Classics offerings, in that she comes with a costume change that makes her essentially two figures in one. Add the Cringer figure she comes packaged with, and you're getting three figures in one package. The other notable figure that came with a number of costume changes was Vykron.

The heroic queen of Eternia was packaged in two configurations. As a San Diego Comic-Con exclusive, she was sold in a package that had her dressed as Queen Marlena, with her Captain Glenn costume change included in the box. For those purchasing directly from Matty Collector, she was sold as Captain Glenn, and the Queen Marlena outfit was included in the box. Each packaging configuration featured a different bio: one detailing her past as a daring galactic adventurer and the other detailing her reign as queen of Eternia.

Marlena comes with quite a few accessories. There is the aforementioned costume change. She also comes with a royal scepter that is a great companion piece to the one that came with King Randor. Her rifle resembles the weapons carried by Skeletor's troopers in the 1987 Masters of the Universe movie. Her sword is a slight repaint of the one that came with Battleground Teela, and her pistol and holster are repaints of Adora's accessories. Her shoulders and biceps come from Adora, her boots come from She-Ra, and her legs, hands, and torso come from Teela. The Cringer figure looks very much like his animated counterpart, down to the snaggletooth. He is, however, minimally articulated, with swivel cuts at the head and tail only.

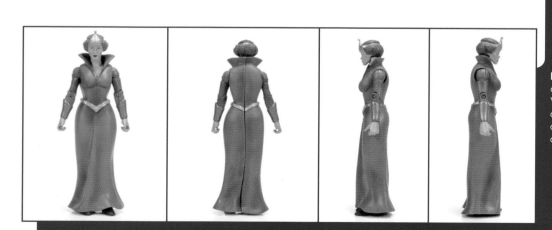

FUN FACTOID: Queen Marlena was released as a San Diego Comic-Con exclusive. While Captain Glenn was sold online, the carded Queen Marlena was only sold at the convention. Both versions could be displayed once opened.

RAM MAN
HEROIC HUMAN BATTERING RAM

First released 2013 • Member of the Heroic Warriors

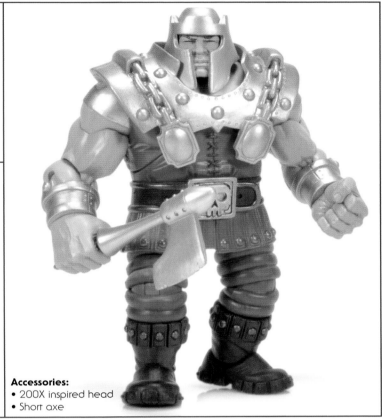

Accessories:
- 200X inspired head
- Short axe

Ram Man is one of the heaviest and stoutest figures in the Classics line, especially for his height. Standing at about the same height as He-Man, Ram Man is at least twice as thick.

Ram Man is closely based on the vintage cross-sell art in terms of his sculpt. This is especially evident in the shape of his shoulder armor and axe, as well as his expression, with tightly closed eyes as if he were about to ram something. His red-and-green color scheme, however, is based on his vintage 1983 action figure. The vintage figure had spring-loaded legs that, when held in place, would cause his upper half to ram forward at the push of a button on his boot. The Classics figure doesn't have that action feature, but it does have a second, unhelmeted, head, inspired by scenes from the 2002 He-Man cartoon.

Ram Man does not use any previously existing pieces from other figures. He includes a great deal of enhanced detail, including some sculpted skull designs hidden on the bottom of his feet. His armor is adorned with tiny rivets, and his arms and face have a great deal of sculpted detail, including veins, tendons, and wrinkles. This differentiates him all the more from his 1983 counterpart, which had a rather soft sculpt that was light on details.

Thanks to the absence of the action feature, this is the first Ram Man figure with actual leg articulation. Each of his legs can be moved independently, and he even has hidden knee joints which enable the knees to bend.

Ram Man's axe can be stored on a clip on the back of his armor, a feature he shares with the 200X version of the figure.

FUN FACTOID: For the first time, Ram Man was a fully articulated figure that matched the rest of the line in its articulation scheme.

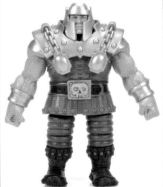

RATTLOR
EVIL SNAKE MEN CREATURE WITH THE QUICK-STRIKE HEAD
First released 2012 • Member of the Snake Men

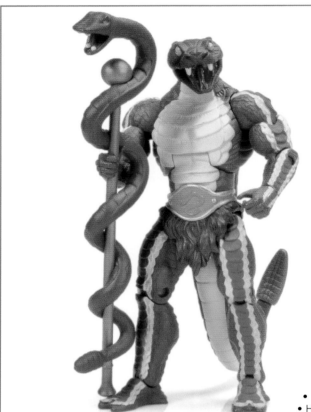

Accessories:
- Snake staff
- Neck extension
- Horde armband

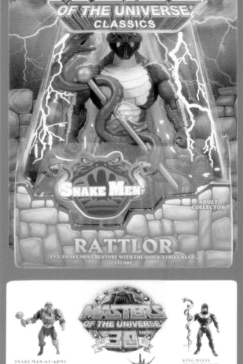

RATTLOR

Rattlor is one of the most intricately-detailed of the Snake Men figures, due to his painstakingly sculpted scales and striking color scheme.

The vintage Rattlor had a rather dramatic quick-strike-head action feature. With a push of a button (hidden under his tail), Rattlor's neck would extend out quickly, simulating a snake strike. The Classics version lacks that action feature, but the look can be replicated with a neck extension that can be attached between the upper torso and head. This is a feature he shares with Mekaneck, Tallstar, Extendar, and Terroar. Compared to the vintage toy, Classics Rattlor has longer legs and a shorter torso. He features an extended loincloth, the one nod in this figure to the 200X Rattlor figure (which was actually called "The General" due to trademark issues).

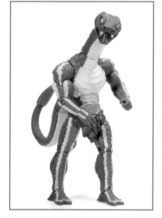

Rattlor also comes with a removable Horde armband. In the She-Ra cartoon, Rattlor was a member of the Evil Horde, and the armband helps to identify him as such if you choose to equip him with it.

Rattlor reuses the shoulders, biceps, forearms, hands, thighs, shins, and feet from the orange Snake Man that came in the Snake Men two-pack. He also reuses King Hssss's snake staff, just as the vintage Rattlor did.

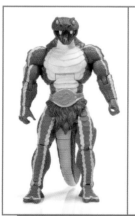

FUN FACTOID: One pet peeve that the Four Horsemen had with the original vintage figure was the lack of detail on the neck. They were able to correct this in Classics with a fully painted and textured neck extension.

REBEL LEADER HE-MAN
HEROIC DEFENDER OF ETERNIA

First released 2020 • Member of the Heroic Warriors

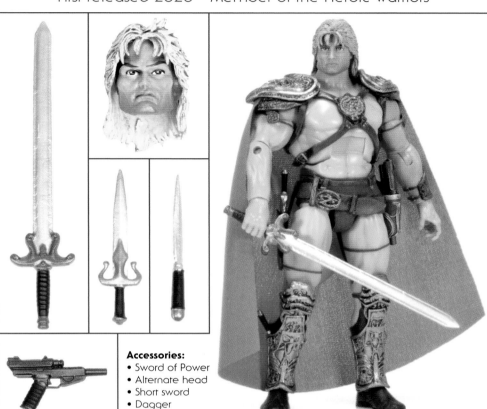

Accessories:
- Sword of Power
- Alternate head
- Short sword
- Dagger
- Laser gun

Released as part of Super7's William Stout Collection, Rebel Leader He-Man gave us, for the first time, an official action figure release of the main hero as he appeared in the 1987 Masters of the Universe motion picture.

Based on the wardrobe and prop designs by William Stout, this new figure includes highly detailed new armor pieces and the long red cape He-Man was seen wearing in the film. It also features the likeness of actor Dolph Lundgren, who portrayed the Most Powerful Man in the Universe onscreen. An alternate head is also included with the figure that appears to be more generic, based on the William Stout designs rather than the actor.

He-Man can choose from several accessories seen in the film. The new version of the Sword of Power is based on the actual prop from the movie. In addition, he also comes with the blaster he is seen using onscreen. This can be held or holstered at his hip. A small dagger can be sheathed in his boot, and a short sword that resembles the design of the classic toy Sword of Power is also included.

As a bonus display option for He-Man, you can pose him with the movie-inspired blaster rifle accessory that came with the MOTU Classics Queen Marlena figure.

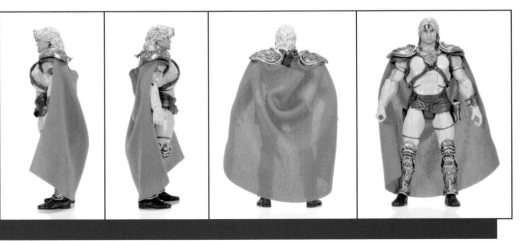

RIO BLAST
HEROIC TRANSFORMING GUNSLINGER

First released 2014 • Member of the Heroic Warriors

Accessories:
* Blasterpak with swiveling blasters
* Snap-on chest, knee, and wrist guns

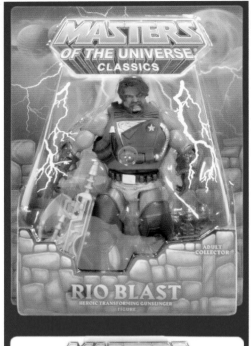

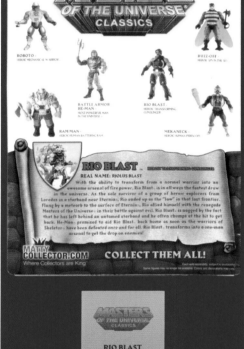

Rio Blast is for the most part based on the look of the vintage 1986 version of the character, albeit with a more overgrown horseshoe mustache and longer hair than his eighties counterpart. Positively bristling with ammunition, Rio Blast features guns that snap onto his wrists, knees, and chest. The guns on his backpack (called a "blasterpak" on the original 1986 packaging) swivel forward and also bring a targeting display over the figure's eyes, just as with the original figure.

In an oblique nod to the 200X Rio Blast NECA statue, the Classics figure also comes with some tubing that snakes around from the backpack to the gloves, presumably to deliver ammo or power. On the vintage figure these tubes were sculpted onto his arms. Like Fisto, Rio Blast has been given some interesting new details around the back, with a whip and a green pouch sculpted at the back of his belt. Rio Blast reuses the torso, shoulders, biceps, and thighs from King Grayskull, but is otherwise a newly sculpted figure.

In a line filled with monsters, barbarians, knights, robots, ninjas, princesses, wizards, mermaids, alien mutants, ghosts, and cyborgs, a cybernetically-enhanced cowboy doesn't feel too out of place, even though the western theme is not well developed in Masters of the Universe generally.

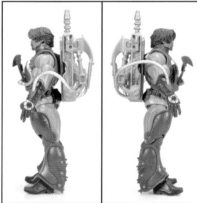

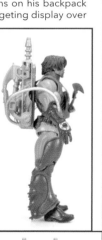

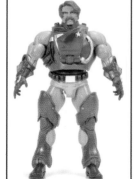

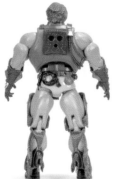

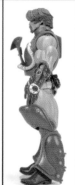

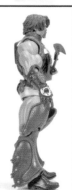

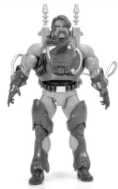

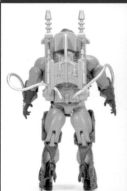

MOTUC - SECTION 1

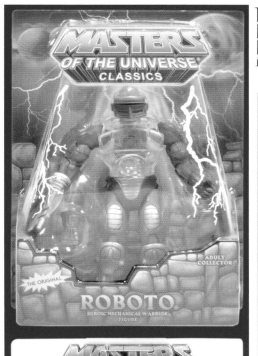

FUN FACTOID: The original intention was that Roboto's gears were to be static, but Cornboy made them like they worked anyway. In the end that was for the best, since Mattel opted to make them a functioning feature.

ROBOTO
HEROIC MECHANICAL WARRIOR

First released 2010 • Member of the Heroic Warriors

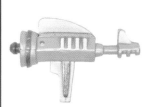
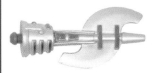
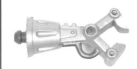

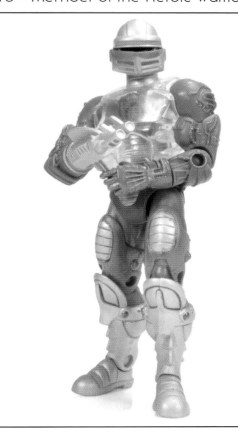

Accessories:
- Blaster attachment
- Axe attachment
- Claw attachment
- Hand attachment

Roboto is closely based on his vintage 1985 counterpart, down to the working internal chest gears. As with the original toy, Roboto's gears turn as his waist is rotated; however, unlike the vintage version, this motion does not cause his jaw to open and close automatically.

Roboto comes with his three vintage-accurate interchangeable weapons, as well as a newly created detachable right hand to match the left one. His silver accessories have some smart-looking blue paint applications, and his chest looks less boxy and more anatomically human than his vintage counterpart's. Like his eighties incarnation, he has a red heart hidden behind his gears.

Roboto reuses the legs from Trap Jaw and the pelvis from Optikk, both released earlier in 2010. Due to his chest construction, he lacks the usual ab-crunch articulation. Unfortunately, due to a factory error, Roboto's shoulders were assembled backward, with the left and right pieces switched.

Roboto is a classic and colorful character, and one of the few figures in the Classics line whose action feature survives more or less intact.

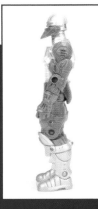
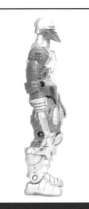
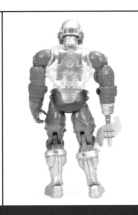
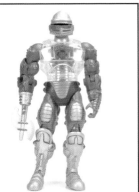

ROKKON
YOUNG HEROIC BATTLING BOULDER

First released 2013 • Member of the Comet Warriors and the Heroic Warriors

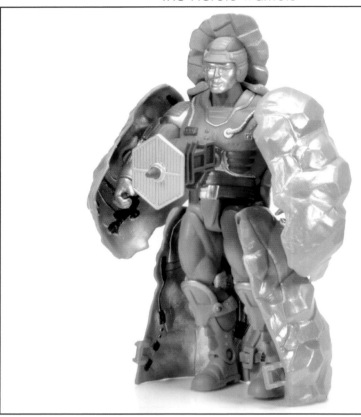

Accessories:
• Light blazer gun
• Removable back, arm, and leg shells

Rokkon was released in a two-pack with his comet comrade, Stonedar. Rokkon is closely based on the vintage 1986 figure, although unlike his vintage counterpart his comet "shell" is removable, aside from the part sculpted onto his head. He also has a hinged area on the lower part of his back shell that helps cover his bottom when he transforms into comet mode. His rocky shell features a bright silvery-blue color scheme, suggesting an almost crystalline structure.

Unlike most Classics figures, Rokkon's loincloth does not cover the upper areas of his thighs. This gives the figure greater flexibility and aids in his transformation. The vintage Rokkon figure was quite short compared to other Masters of the Universe figures. In his Classics incarnation, he is the same height as most other figures, so in comet or rock mode he is actually much more impressive than his vintage counterpart.

Rokkon reuses King Grayskull's hands, torso, and thighs. He borrows Trap Jaw's boots, feet, biceps, and forearms, as well as Man-E-Faces' shoulders.

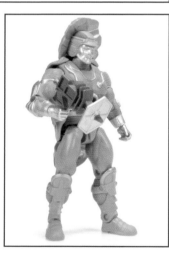

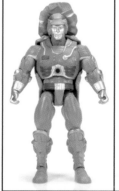
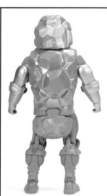
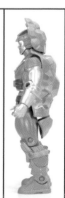
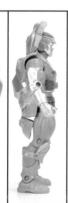
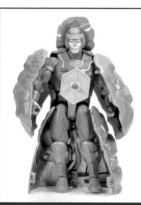

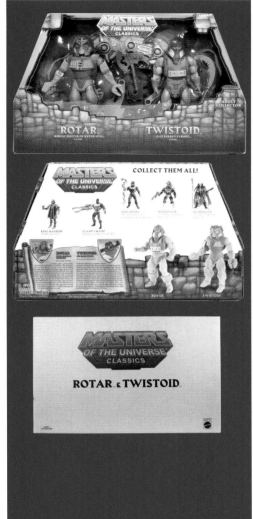

ROTAR
HEROIC MASTER OF HYPER-SPIN

First released 2015 • Member of the Heroic Warriors

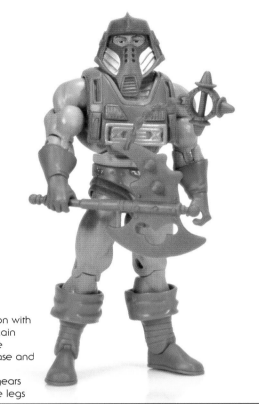

Accessories:
- Axe weapon with ball and chain
- Removable spinning base and pedestal
- Roto-pod gears
- Removable legs

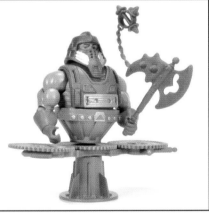

Rotar was packaged in a gift set with his evil spinning nemesis, Twistoid, and offered as an exclusive for the 2015 San Diego Comic-Con. He is closely based on the original 1987 spinning-top figure. Unlike the vintage toy, the Classics Rotar is not a functioning top, nor does it include the gear-firing action feature on his "roto-pod." However, as an added bonus, he comes with a set of removable legs so you can display him as he was before the injury that turned him into a spinning top of justice.

Like the original 1987 figure, Rotar is somewhat rare and hard to find on the secondary market, but is an essential acquisition for MOTU Classics completists.

Rotar reuses King Grayskull's torso, shoulders, biceps, hands, thighs, and upper legs. He also makes use of Keldor's feet, Snout Spout's boot tops, Hordak's gloves, and He-Ro's loincloth.

In a packaging error, Rotar's name appeared underneath Twistoid and vice versa. Twistoid is also mistakenly referred to as a cyborg in his tag line, when it is actually Rotar who is the cyborg.

 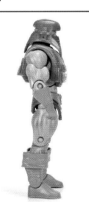 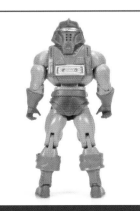 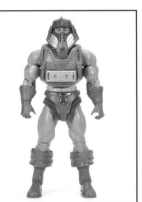

MOTUC - SECTION 1

ROTON
EVIL ASSAULT VEHICLE

First released 2016 • Vehicle of the Evil Warriors

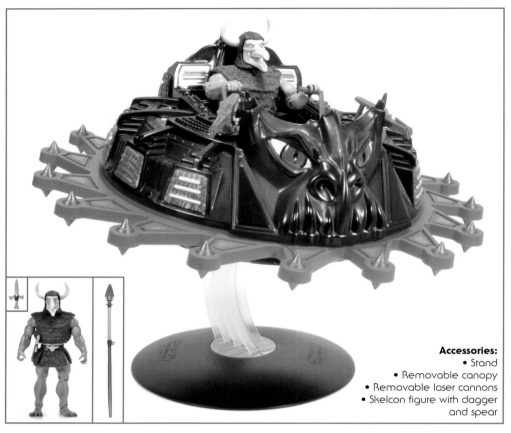

Accessories:
- Stand
- Removable canopy
- Removable laser cannons
- Skelcon figure with dagger and spear

Roton is mainly patterned after the vintage 1984 vehicle, although it also features some influence from the Roton model kit by Monogram, like a removable canopy and laser cannons with handles on them. Roton's face looks a bit more organic compared to either of the 1980s versions, and the back of the vehicle in particular has been given quite a lot of new scaly and spiny detail.

The various panels along the sides and in the cockpit that were decorated with stickers on the vintage toy are realized in fully painted 3D sculpts on the Classics version. The cannons can be positioned in four different places on the vehicle and can also be removed and used as accessories for a figure.

The Classics Roton retains the action feature of the original toy, in that the blades spin as the vehicle is rolled forward and backward. Unlike the vintage vehicle, the 2016 Roton also comes with a flight stand, allowing it to be posed in various flying positions. It's also larger relative to the size of the figures, making it a much more imposing presence.

This incarnation of the vehicle was designed by Nate Baertsch, a frequent collaborator of the Four Horsemen. Rudy Obrero painted the box art for this piece (the vintage box art was painted by the late William George).

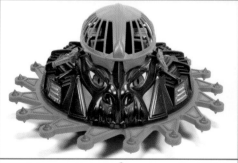

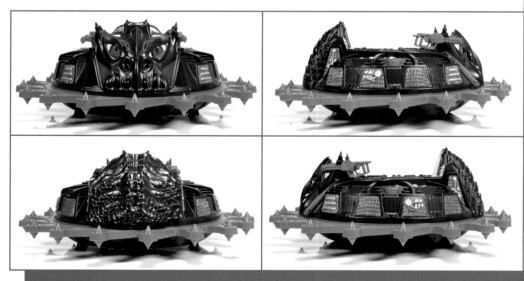

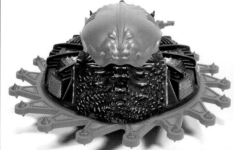

SAUROD
EVIL SPARK SHOOTING REPTILE

First released 2015 • Member of the Evil Warriors

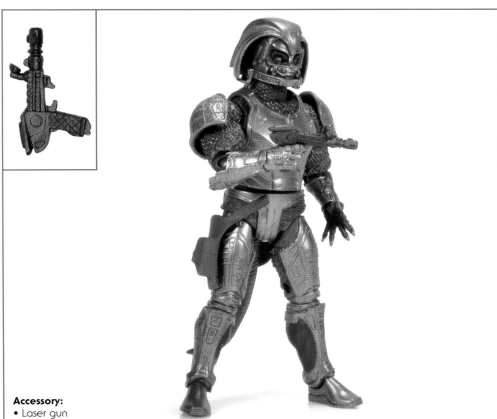

Accessory:
• Laser gun

Saurod is based more closely on the character in the 1987 Masters of the Universe Movie than he is on the vintage action figure. Classics Saurod features the holster from the movie design and hints of green skin around the legs. Like the vintage action figure, it features blue chain mail around the arms and chest, as well as blue skin around the eyes.

Saurod's armor is intricately sculpted and even includes a bit of battle damage across the chest. His shoulder armor includes some realistic sculpted pitting. All in all he features some of the most detailed sculpting of the Classics line.

The original figure had a lever in the back that caused sparks to shoot out of the toy's mouth, hence the "spark shooting reptile" epithet. That feature is not built into the Classics incarnation; however, the exquisitely detailed costume and fine paint work more than make up for it.

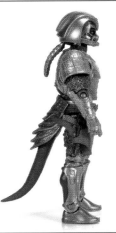

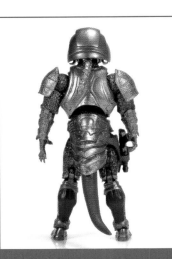

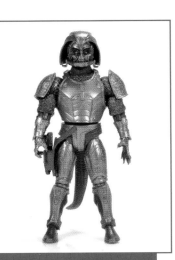

SCAREGLOW
EVIL GHOST SERVING SKELETOR

First released 2009 • Member of the Evil Warriors

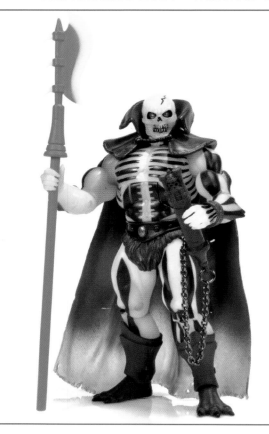

Accessories:
- Scythe of Doom
- Cursed Castle Grayskull reliquary with castle key

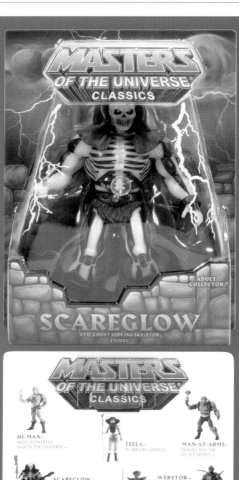

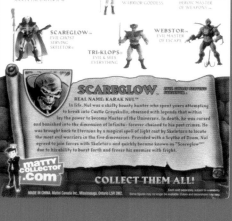

A fan favorite in the vintage Masters of the Universe toy line, Scareglow got a release early in the first full year of the MOTU Classics toy line. He's one of the characters who did not see a release during the 200X-era, making this only the second time he's been seen in action figure form.

Much like the vintage action figure, Scareglow's Classics figure reuses many of the tooled parts previously used for Skeletor, but is made of glow-in-the-dark plastic with a painted-on skeleton design. Thus, he retains the glowing action feature of the original toy.

Instead of a cloth cape, this time Scareglow has a plastic cape with added details. The bottom looks tattered, and it even fades to a translucent purple color toward the bottom. He comes with his bright green scythe, much like the vintage toy. But he also gets a brand-new accessory. This reliquary has a small Castle Grayskull on the top and a real metal chain that hooks to Scareglow's wrist. You can pop the Castle Grayskull off the top, revealing a small key inside that is meant to be a key to a hidden door on the side of the castle!

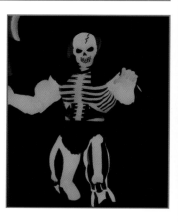

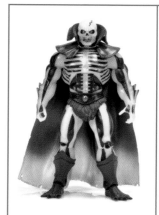

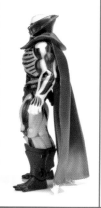

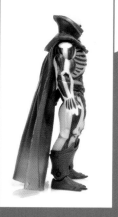

FUN FACTOID: The Four Horsemen included a Grayskull reliquary, which contained a secret key to Castle Grayskull. For the Grayskull play set years later, they gave the castle a secret door which could be opened with Scareglow's key.

MOTUC - SECTION 1

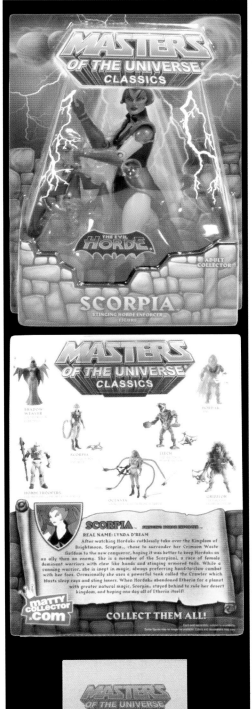

SCORPIA
STINGING HORDE ENFORCER

First released 2014 • Member of the Evil Horde

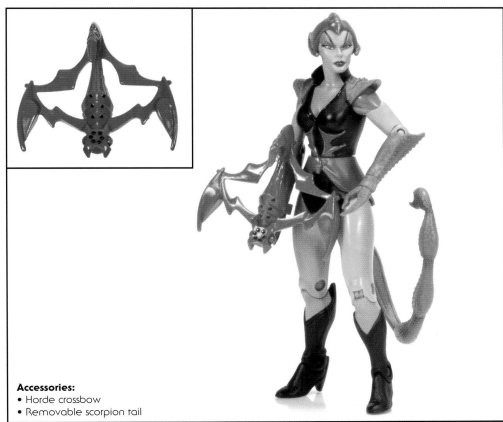

Accessories:
• Horde crossbow
• Removable scorpion tail

Scorpia is directly based on her appearance in the 1985 She-Ra: Princess of Power cartoon, as she was never released as a toy prior to 2014. Scorpia has some additional sculpted detail that goes beyond the cartoon source material. This is most evident in her tail, claws, and shoulders, which are covered in realistic bumps that recall the look of actual scorpion exoskeletons.

Scorpia's tail is removable and has a single swivel joint for articulation. She comes with a unique scorpion-themed Horde crossbow that was designed by the Four Horsemen for the figure. She has a severe expression that perfectly captures the look of the animated character. Scorpia reuses Teela's thighs and Adora's biceps but is otherwise a newly sculpted toy.

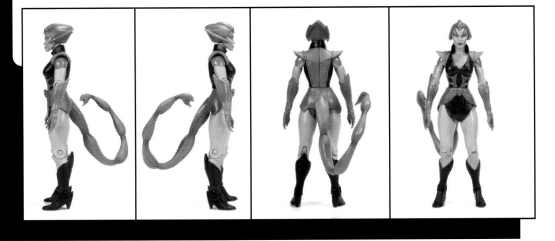

SCREEECH
EVIL BARBARIAN BIRD

First released 2010 • Beast of the Evil Warriors

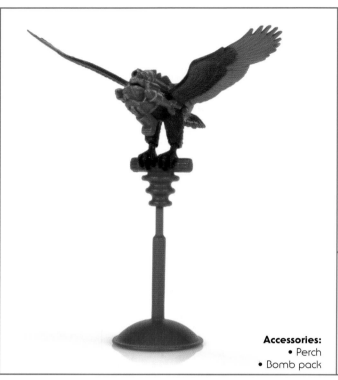

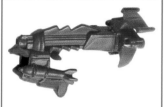

Accessories:
• Perch
• Bomb pack

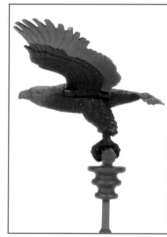

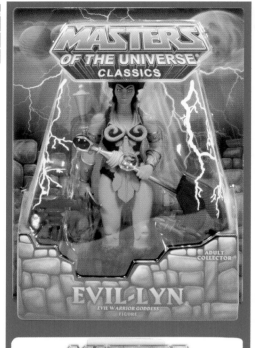

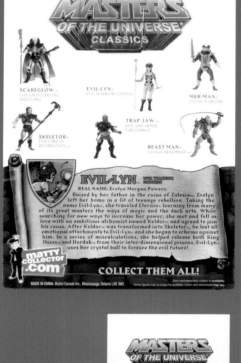

Screeech was released as an accessory for the 2010 Evil-Lyn release. The barbarian bird is closely based on the design of the 1983 toy; however, it is much smaller in scale. The original Screeech reused an old Big Jim mold, and so was actually in scale with ten-to-twelve-inch figures. Classics Screeech is a proportionally sized bird of prey, albeit with an exotic purple-and-blue color scheme. His "bomb pack" features highly detailed bombs (not removable) and a tail fin with jet engines to allow him to swoop down toward the heroes at great speed.

Screeech lacks the wing-flapping action feature of the original. However, he does have articulated feet, and his wings can be moved on hinge joints. As with his vintage incarnation, Screeech shares all of his parts with Zoar but is cast in a different color.

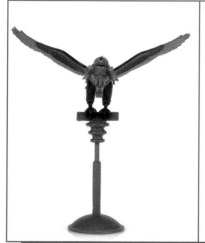
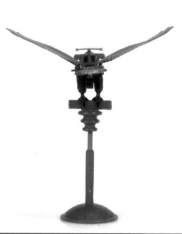
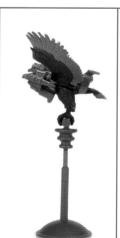
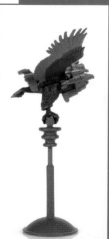

MOTUC - SECTION 1

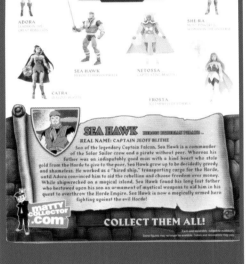

SEA HAWK
HEROIC ETHERIAN PIRATE

First released 2013 • Member of the Great Rebellion

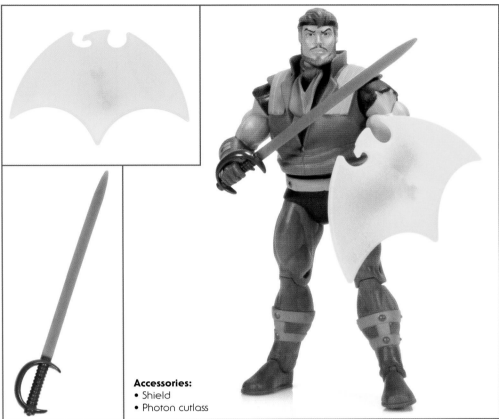

Accessories:
• Shield
• Photon cutlass

Sea Hawk's Classics figure is closely based on the character as he appeared in the 1985 She-Ra: Princess of Power series. Specifically, he has the red photon cutlass, seven-league boots, and shield generated by the impact ring (sculpted on the figure's left hand) that all belonged to his father, the Falcon. Sea Hawk acquired these items from his father in the episode "Anchors Aloft Part 2." Prior to this he had a slightly different look, with plain black boots and a less powerful yellow laser rapier.

Sea Hawk reuses King Grayskull's torso, biceps, right hand, thighs, and upper shins. His feet come from Keldor, and his other parts are new for the figure.

Sea Hawk has a dashing, devil-may-care appearance, a bit like Errol Flynn with red hair and a beard. Befitting his animated origins, he's a fairly colorful character, but he's detailed enough to look at home standing next to just about any of the other Classics figures.

MOTUC - SECTION 1

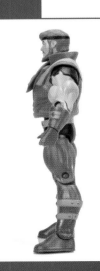
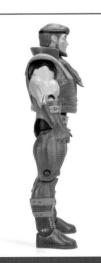
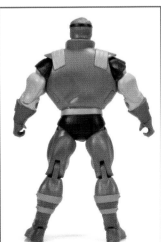
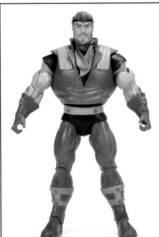

SERPENTINE KING HSSSS
EVIL DISGUISED LEADER OF THE SNAKE MEN

First released 2016 • Member of the Snake Men

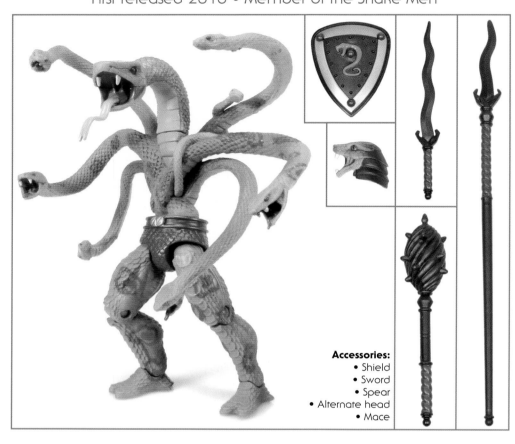

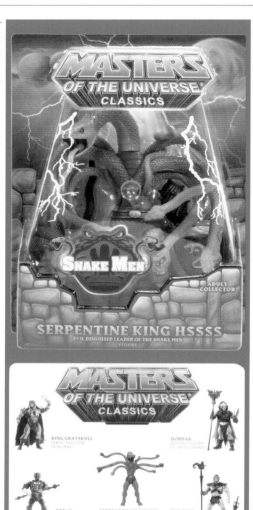

Accessories:
- Shield
- Sword
- Spear
- Alternate head
- Mace

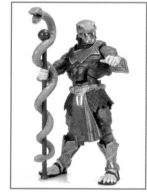

Serpentine King Hssss is the third incarnation of the character in the Masters of the Universe Classics line, and can be mixed and matched with both the original King Hssss (2011) and Battle Armor King Hssss (2015). The top half of Serpentine King Hssss was actually originally supposed to be included with Battle Armor King Hssss (who is based on the character's 200X look). However, the snake form had to be cut for cost reasons. Serpentine King Hssss was a way for Mattel to get the much desired snake form out to fans, in the form of a brand-new variant.

The 200X inspired snake form has more writhing snakes than the 2011 release, which was based on the vintage 1986 action figure. Serpentine King Hssss's top half can be paired with Battle Armor King Hssss for a transformed 200X look, or with the original King Hssss for a look that is close to the way the character was portrayed in poster artwork by Earl Norem.

The figure's bottom half is bare reptilian legs. King Hssss reuses legs and accessories from the Snake Men two-pack, as well as the pelvis from the 2011 King Hssss. His shield, sword, mace, and spear are recycled from the Snake Men two-pack, and a new midtransformation head goes well on the 2011 King Hssss release.

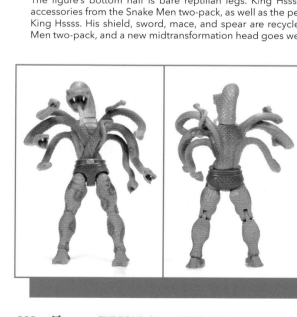

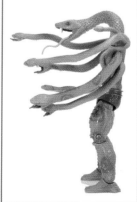

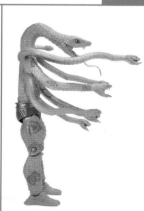

SHADOW BEAST
EVIL CREATURE OF DARKNESS

First released 2011 • Beast of the Evil Warriors

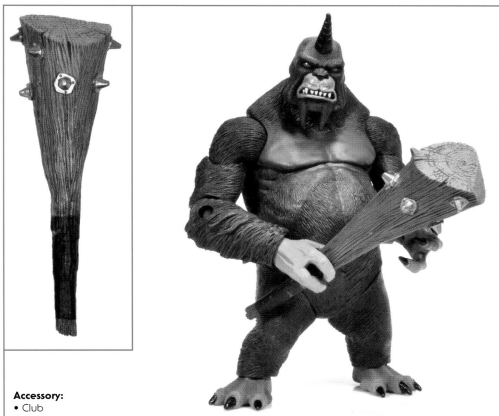

Accessory:
• Club

Shadow Beasts appeared in both the 1983 He-Man cartoon and the 2002 He-Man cartoon. The Classics version is modeled after the Filmation Shadow Beast, with its single horn and three-fingered hands and feet. However, its coloration is closer to the 2002 version (the Filmation Shadow Beasts were dark purple, while the 2002 beasts were black).

Shadow Beast reuses the torso, arms, and legs from Gygor. His head, hands, feet, and club are newly-sculpted for the figure. He has a hollow torso with no waist or ab-crunch articulation. His legs have only simple swivel joints at the hips and feet, but his arms have the usual amount of articulation present in most Masters of the Universe Classics figures.

Shadow Beast remains one of the biggest and bulkiest toys in the Classics lineup. With his fierce facial expression and menacing posture, this is not a beast you would wish to meet alone in the Vine Jungle at night!

FUN FACTOID: The Shadow Beast made good reuse of the larger gorilla buck previously used for Gygor, which added to the range of figure sizes for the line.

MOTUC - SECTION 1

SHADOW WEAVER
EVIL MISTRESS OF DARK MAGIC

First released 2012 • Member of the Evil Horde

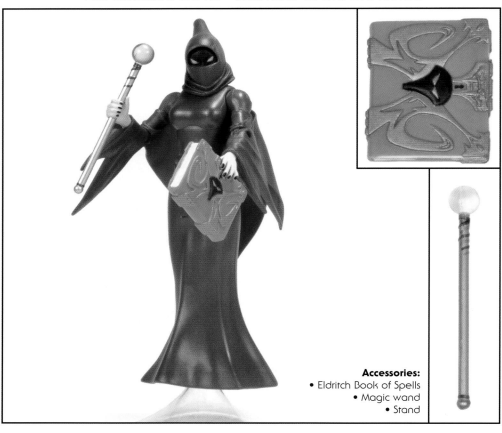

Accessories:
- Eldritch Book of Spells
- Magic wand
- Stand

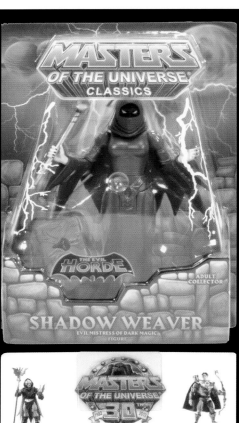

The character of Shadow Weaver was created by Filmation to be to Hordak what Evil-Lyn is to Skeletor. In 2012 the first official version of the character in action figure format was released. Shadow Weaver was released as the 2012 subscription-exclusive figure, meaning that only those who had subscribed for the year's worth of figures could obtain her. That makes Shadow Weaver one of the most expensive and sought-after MOTU Classics figures on the market today.

Shadow Weaver's ragged cloak is cleverly engineered, with part of it molded onto the forearms of the figure, and the central part connecting across the figure's biceps and back. She is molded mostly in a dark wine-red color, with plenty of shading that adds to her sinister look. The figure does not have sculpted legs under the dress, but it does have a hinge joint below the pelvis that allows some forward and backward posing of the lower body, along with the usual joint at the waist allowing the upper half of the body to turn left and right.

Shadow Weaver's accessories include the Eldritch Book of Spells (from the episode "The Eldritch Mist"), a wand (featured in "The Caregiver"), a stand that gives the appearance that she is slightly hovering over the ground, and a Preternia map.

Shadow Weaver borrows her left hand from Battleground Evil-Lyn and her shoulders from Adora but is otherwise a brand-new sculpt.

SHADOW WEAVER

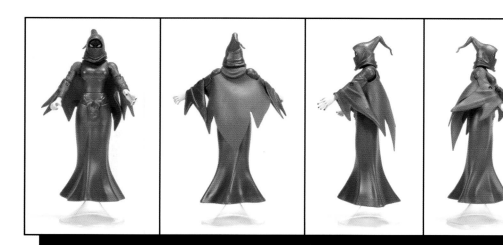

FUN FACTOIDS:
- Shadow Weaver replaced Horde Prime as the planned 2012 subscription exclusive for the line.
- She was the first previously unavailable Filmation original character revealed for the line.
- She was shipped with the Preternia map as the 2012 Club Eternia exclusive (see page 536).

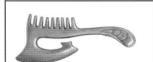

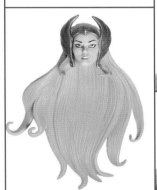

SHE-RA
MOST POWERFUL WOMAN IN THE UNIVERSE

First released 2010 • Member of the Great Rebellion

Accessories:
- Sword of Protection
- Axe comb
- Shield
- Alternate head
- Mask tiara

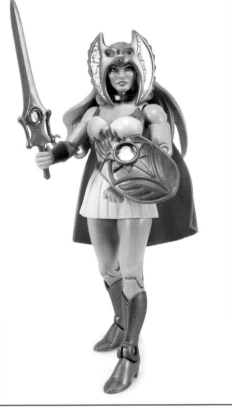

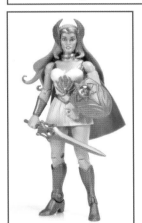

FUN FACTOID: This was the first action figure of She-Ra that mainly resembled her animated series design, although she came with her toy tiara displayed on the card.

She-Ra is a powerful-looking figure with a bold design that brings to mind Greek goddesses. Adorned in white and gold with a red cape, She-Ra is truly the Most Powerful Woman in the Universe!

This She-Ra is largely based on the character as she appeared in her eponymous 1985 cartoon series, and not on the toy released the same year. Her costume, certainly, is entirely based on the cartoon, as is the shape of her sword (however, her sword is golden, a nod to her vintage toy's sword). Her shield is based on her vintage figure's accessory. The vintage figure also came with a pink comb, which in the Classics version is reenvisioned as an axe that doubles as a comb. One of her heads features a slot to hold her mask, which is based on the vintage toy. Her other head is closely modeled after She-Ra's cartoon look.

She-Ra reuses the sword, shoulders, and biceps from Adora, and her hands and legs (minus the boots) come from Teela.

A silver version of the figure was created for San Diego Comic-Con and was offered as a raffle giveaway to celebrate She-Ra's twenty-fifth anniversary. Only two of the chromed figures were made, and they featured the figure's Filmation-style head, as well as her sword and shield. Because these silver She-Ras were custom made and not officially released, they are not considered part of the Classics line.

MOTUC - SECTION 1

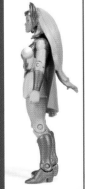
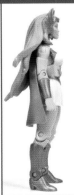

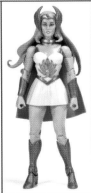

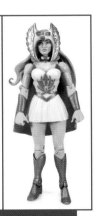

SHE-RA
HEROIC CHAMPION OF THE OPPRESSED

First released 2011 • Member of the Great Rebellion

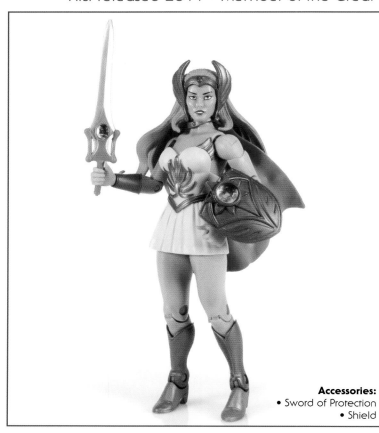

Accessories:
- Sword of Protection
- Shield

This release of She-Ra is essentially a rerelease of the 2010 figure, but without her toy-based head, mask, and axe comb. Her sword is a cartoon-accurate silver color, and her gold costume accents are somewhat more muted, but otherwise she is very close to the previous year's release. She came packed with a DC Universe Supergirl figure.

The slight changes to this release make her essentially a cartoon-accurate version of the character, with the exception of her shield, which is still based on the 1985 figure's accessory. She-Ra reuses the sword, shoulders, and biceps from Adora, and her hands and legs (minus the boots) come from Teela.

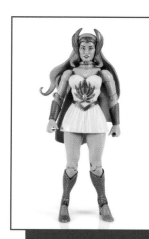
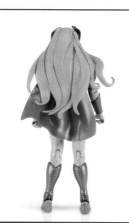
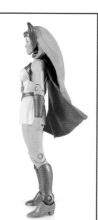
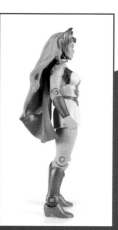

MOTUC - SECTION 1

SHE-RA
GALACTIC PROTECTOR

First released 2014 • Member of the Galactic Guardians

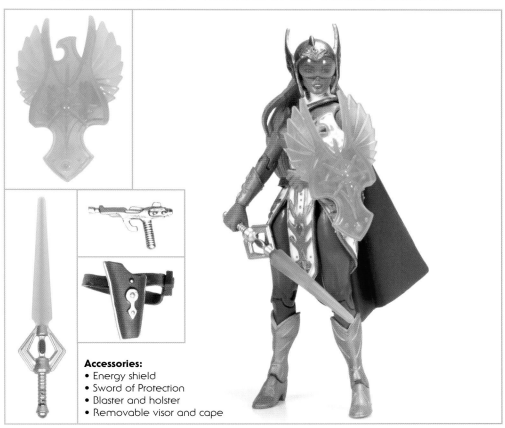

Accessories:
- Energy shield
- Sword of Protection
- Blaster and holster
- Removable visor and cape

The Galactic Protector variant of She-Ra was created to work as a counterpart to the New Adventures–style Galactic Protector He-Man. To that end, she's been given a futuristic costume dominated by blue and silver. Her new Sword of Protection has a translucent green blade, with a blue jewel in the handle. Her energy shield is also translucent green and in the shape of a falcon. Her futuristic He-Man counterpart has similar translucent accessories, although his shield has a much simpler design.

She-Ra also includes a Flash Gordon-style laser pistol, which can be stored in a holster that sits at her hip. The decoration at the chest of She-Ra's costume is actually based on the original 1985 She-Ra figure, and most of the other details on her elegant and futuristic costume are variations on that theme.

She looks every bit a counterpart to her Galactic Protector brother, He-Man. The figure was designed by Nate Baertsch.

She-Ra reuses the thighs and hands from Teela, the forearms from Shield Maiden Sherrilyn, the boots from Bubble Power She-Ra, and the shoulders and biceps from Adora.

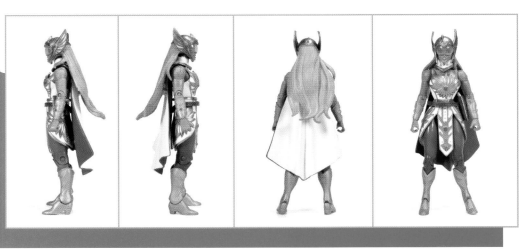

SHIELD MAIDEN SHERRILYN
HEROIC ATTAK TRAK PILOT

First released 2013 • Member of the Heroic Warriors, Evil Horde, and Fighting Foe Men

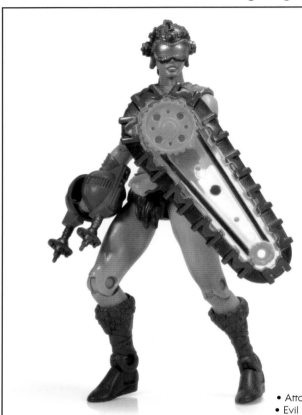

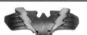

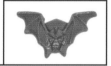

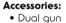

Accessories:
• Dual gun
• Attak Trak shield
• Attak Trak chest piece
• Evil Horde chest piece

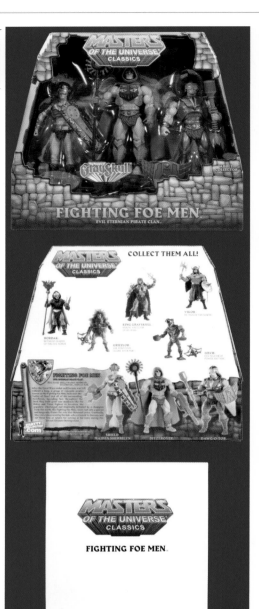

Shield Maiden Sherrilyn is based on the vehicle driver created by Larry Elmore for the artwork for the vintage Monogram Attak Trak model kit. The driver in the artwork was actually a male, but his appearance was also mostly obscured by the canopy. The Four Horsemen opted to make the driver a woman to bring a little more diversity into the MOTUC line. The figure was named after Sherri Lynn Cook, a talented painter who works at Four Horsemen studios.

Sherrilyn's costume and accessories are adorned with little nods to the vintage Attak Trak, and especially the Monogram kit version. Her shield is in the shape of the model kit's treads, her gun is in the shape of the model kit's blasters, and her default chest piece is based on a sticker on the vintage toy. She comes with a swappable Horde chest piece to match with her bio, which has her defecting to the Evil Horde at some point, although a later bio reveals that she and Dawg-O-Tor repent and go on to join with the Heroic Warriors.

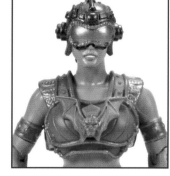

Sherrilyn reuses the boots, lower legs, hands, shoulders, and biceps from the original Teela release. Her torso and thighs come from Battleground Teela.

FUN FACTOID: The tagline for the Fighting Foe Men three-pack was "Evil Eternian Pirate Clan."

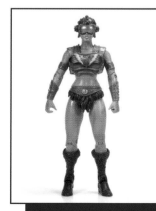

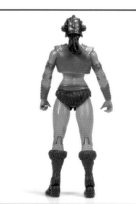

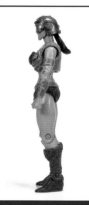

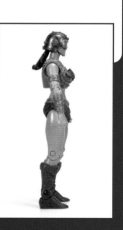

MOTUC - SECTION 1

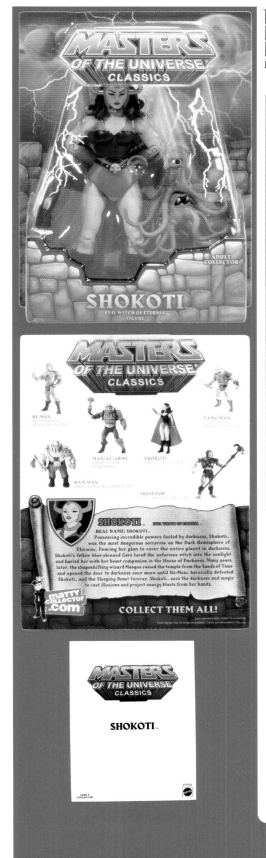

SHOKOTI
EVIL WITCH OF ETERNIA

First released 2013 • Evil Villain

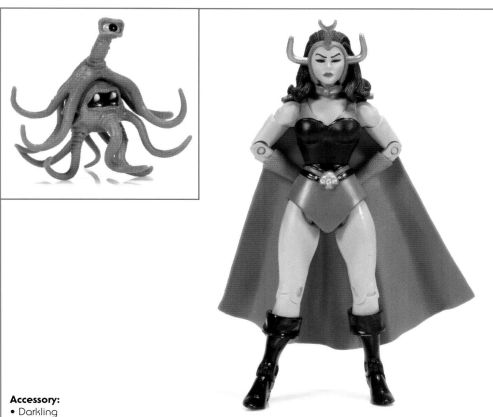

Accessory:
• Darkling

Shokoti is based on the Filmation character that appears mainly in the "House of Shokoti Part 2" episode of the 1980s He-Man and the Masters of the Universe series. She is an evil witch who was imprisoned in a pyramid-shaped temple, which was raised from beneath the desert by her servant, Lord Masque, in part 1 of the story. Shokoti lures Melaktha's apprentice Stanlan into the risen temple, and He-Man and Ram Man must rescue the boy from the dark witch and the Lovecraftian horrors she summons.

Shokoti is a brightly colored figure, with light blue skin and a red cape. Her blacked-out eyes and skull belt are the primary visual cues that let you know she is a villain. Her only accessory is a Darkling, one of the tentacled creatures she summons in the story to capture He-Man and Ram Man. She has a somewhat simplistic animation look, but there are just enough added sculpted and paint details to elevate her beyond her two-dimensional origins.

Shokoti reuses Teela's legs and hands, as well as Adora's feet, biceps, and shoulders.

SIR LASER-LOT
HEROIC KNIGHT OF GRAYSKULL

First released 2012 • Member of the Heroic Warriors

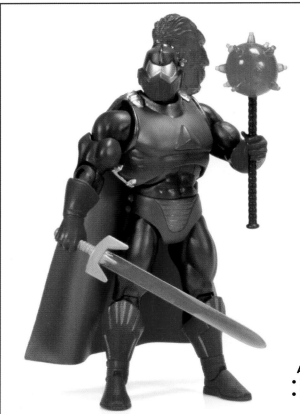

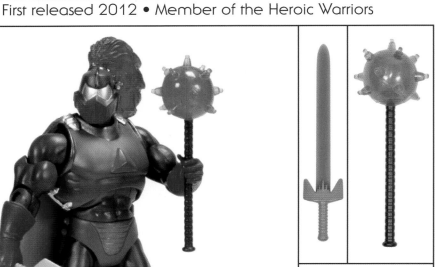

Accessories:
• Laser sword
• Laser mace
• Shield

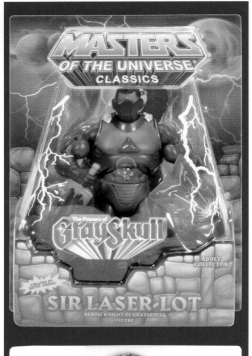

Sir Laser-Lot, a part of the thirtieth-anniversary mini subscription, was created by Geoff Johns, then chief creative officer at DC Comics. The character was based on something Johns designed as a child, when he was playing with and collecting He-Man figures. Sir Laser-Lot features a bright, classic blue-and-red color scheme, reminiscent of Mekaneck, but with a knight theme. His sword and mace are cast in translucent laser red, as is the plume on his helmet.

Sir Laser-Lot makes his first modern story appearance in the first digital comic issue of Masters of the Universe, released in 2012, and is shown in the background in several other modern MOTU comic book issues. Sir Laser-Lot fits in well with Extendar, another figure with a futuristic knight theme.

Sir Laser-Lot reuses King Grayskull's torso, legs, shoulders, biceps, and hands. His boots come from Bow, his pelvis comes from Optikk, and his gloves are from Hordak.

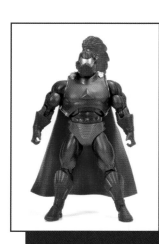

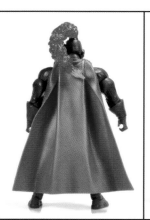

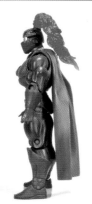

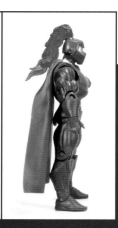

FUN FACTOID: Sir Laser-Lot was created by DC CCO Geoff Johns for Classics. Mattel was in the middle of the long running DC Universe Classics at the time, and there was a growing synergy between Mattel and DC. This figure constituted a kind of "crossover", and was part of the hype of the create-a-character wave. The figure showed some of Johns' superhero leanings while adhering to the Classics aesthetic.

SKELCON
EVIL DEMONIC MINIONS OF SKELETOR

First released 2016 • Member of the Evil Warriors

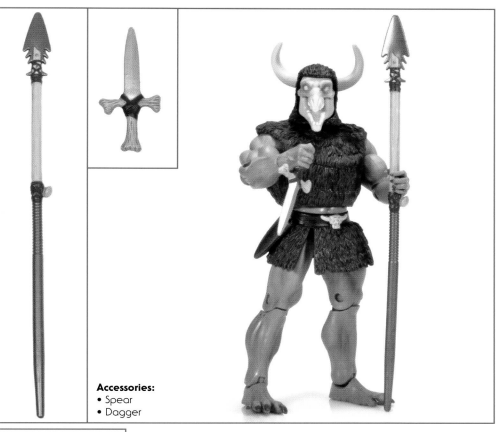

Accessories:
• Spear
• Dagger

Skelcons originate in the series of Masters of the Universe books published by Ladybird in the UK, such as Wings of Doom and The Iron Master. The Skelcons were generic minions of Skeletor that served as both soldiers and servants.

The Skelcon figure, which came packaged with the Roton vehicle, is a close representation of the illustrated characters, except that its face and horns are bone yellow rather than the white or blue color usually depicted in the storybooks. The figure has a furry purple outfit and blue skin, and almost looks like a crude imitation of Skeletor himself. The Skelcon looks a bit cartoonish, but that's offset by some realistically sculpted bone and fur details on the figure.

The Skelcon reuses King Grayskull's torso, shoulders, thighs, and biceps. His shins and feet come from Demo-Man, his forearms come from Oo-Larr, and his hands come from Skeletor.

SKELETOR
EVIL LORD OF DESTRUCTION

First released 2009 • Member of the Evil Warriors

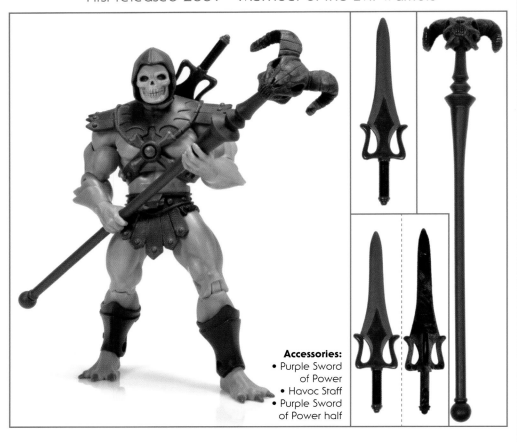

Accessories:
- Purple Sword of Power
- Havoc Staff
- Purple Sword of Power half

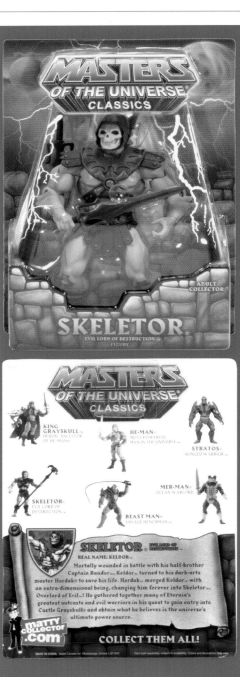

MAILER BOX CAME WITH REISSUE ONLY

Overlord of evil, and the bad guy that everyone loves to boo! Skeletor joined the Masters of the Universe Classics toy line early in the first full year of the line.

As was standard for many of the characters early on, Skeletor is specifically modeled after the original toy line's figure. The head is more rounded like the vintage figure's rather than the smaller, scarier design of the 200X-era. He has the same muscular torso as characters such as He-Man, but he does have new forearms and shins, as well as bare monster-like feet.

He comes with his signature Havoc Staff accessory, which is all purple in color, much like that of the vintage toy. He also includes a purple version of the He-Man-style Sword of Power, which is another nod to the accessories of the original line. Like He-Man, Skeletor also includes a half-version of the Sword of Power. This can be combined with He-Man's half, paying homage to the original story line of the vintage toy line, in which the Sword of Power was split into two halves and needed to be united in order to open up Castle Grayskull!

The left hand of the original release of the figure was much more open, making it hard for him to hold accessories in his hand. When Skeletor was eventually reissued, his left hand was more closed, allowing for a much better grip on accessories.

FUN FACTOID: The Four Horsemen took inspiration from the vintage card back cross-sell art, particularly for his feet and arms. More faithful adaptations of the original toy's feet and boots would follow.

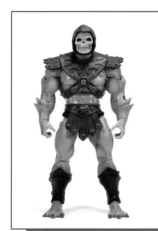

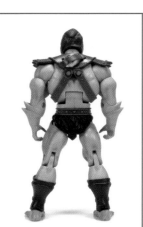

SKELETOR
REVILED VILLAIN OF ETERNIA

First released 2010 • Member of the Evil Warriors

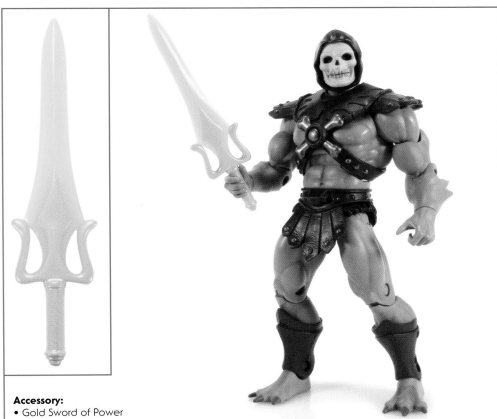

Accessory:
• Gold Sword of Power

In 2010 Mattel released several two-packs to retail stores that combined two of their popular collector figure lines: Masters of the Universe Classics and DC Universe Classics.

Packaged with Lex Luthor was a new version of Skeletor. The figure itself shares the same sculpt as the figure already released through the Matty Collector website. This version features a new paint deco, with a bright yellow face and brighter purple used on the armor.

This Skeletor only comes with one accessory: a new yellow version of the He-Man Sword of Power. These two-packs were a great way to offer some variants for MOTU Classics fans while also introducing the general public to the usually online-only toy line through retail outlets.

MOTUC · SECTION 1

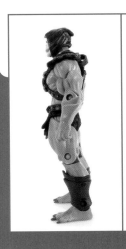
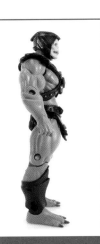
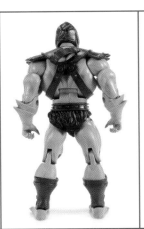
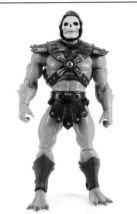

INTERVIEW WITH
BRANDON SOPINSKY

How did you get into toy design?

I actually went to school for it! I went to Otis College of Art and Design, and they actually offered it as a major. It wasn't something that I was expecting, but once I saw the program and the variety of skills that it taught I really thought it was amazing. Getting to learn all the aspects of what goes into designing, producing, and marketing a great toy was really exciting, and it also was a ton of fun. The "toy kids" were always the most rambunctious and crazy group of people at school. I guess because we were all just big kids at heart.

What was your role at Mattel in regard to the MOTU Classics line?

I took over design on all of the Matty Collector brands toward the end of 2014. I helped finish the 2015 MOTU Classics line and then created all of the 2016 line, and even most of the planning for the 2017 line that Super7 has been producing. At this point it was near the end of Matty Collector, so my job was really trying to keep the whole thing afloat and make sure that there were still passionate people seeing the product through to the end.

What were the first projects you got to work on for the MOTU Classics line?

The first figure I worked on was actually Gwildor, which had so many complications to deal with. This was my first real introduction to all the complicated issues tied to the MOTU brand, and all the licensing rights that are scattered all over the place. Gwildor was a challenge because at the time we were told that we only had the rights to do figures from the 1987 live-action movie if we had also produced it as a toy. On top of that, if we did re-create those figures, it would have to be based on the styling of the original toy and not be film authentic.

The problem was the figure was sculpted to be authentic to the movie look, and also came with props from the movie, and all of this was started before I came onboard. So, it was handed to me along with all these issues of basically needing to be fixed to resemble the vintage figure, but with no time to do it. Ultimately we were able to paint it to resemble the vintage figure's paint scheme, and kit bash some existing accessories together to look like what he came with in the eighties. It seems so simple now, but the number of headaches and meetings that figure caused was absurd.

Can you take us through the process from start to finish on figure design? Where did the Four Horsemen leave off and Mattel come in?

The process of working on a figure for MOTU Classics is a bit different than working on a figure for another line, mainly because the majority of the design is handled by the Four Horsemen. When I came onto the brand it was a pretty well-established process, so I stuck to it since it was what was working. The basic process is design and marketing will work together to come up with what the full line looks like for the year, we figure out all the main line figure selections, any special items like large figures, vehicles, and play sets and then see where we might have opportunities to throw in some crazy, innovative items.

After that we will work with our product engineering team to evaluate the amount of tooling we will need for all the items, and then we will go back and forth to work out the line so that it fits what our budget is for the year.

This is when the Four Horsemen are brought in; we will also work with them on the character selection to get their insight and make sure it's a good balance of fan-demanded characters and ones that we want to see. The Four Horsemen would then create tooling breakdowns of every part that would be used in the figure, which ones are existing reused parts, and which are brand-new parts.

Once we are all approved on the Mattel side for what each figure will be composed of, we give the green light for the Four Horsemen to start sculpting. Unless we have very specific design direction, we pretty much let the Four Horsemen have free rein on what the figure looks like and the design of the accessories. Within a couple weeks we will start to receive all the newly sculpted parts in fast-cast resin, which we will review with our development team, and then send over to our Hong Kong design and development team for them to start the process of creating the first test models.

We will then receive the tooling models, which are the handmade full figure with all existing parts and new parts to review. At this stage we need to make any comments on aesthetic or functional issues. This process may take a couple of rounds if there are big issues. Once the figure is approved, the factories will begin to cut the steel molds. Any changes after this will cause delays in production and increased cost, so we really try to make sure everything has been addressed before we cut steel.

At the same time, we will start receiving paint masters from the Four Horsemen. These are the fully assembled figures painted to look exactly like what we want in the final product. We usually receive three copies: two to send to China and one to keep for review later. These usually also serve as our photo models, which we would use for PR and also to showcase at SDCC or any other events like Toy Fair or Power-Con. The paint masters are also what our China team will use to figure out all the paint applications that will be needed and what it will cost. This is usually where design and development have to work together to get the figure on cost, which most often means removing paint applications. Cost reduction is something that every designer has to do and is also the hardest part, but if done right, you can still produce a great figure. The last thing you want is a great-looking figure that is too expensive and ultimately costs more to produce than we will make on it.

Once we get the cost to meet the target, and everyone is happy with the final look, we will start to get different stages of samples to review.

First shots are the very first time the plastic is shot into the steel molds, and it's our first look at the plastic figure. At this point the figures are all kinds of crazy colors and just made with whatever scrap plastic the plant has excess of. These are also what tend to end up on eBay if they're not scrapped or turned into regrind plastic. After this each model will get closer and closer to the final look of what will ship, and it's really just refining it to make sure it matches the paint master and what we want for the final product. Basically it's a lot of reviews of samples until they look exactly right, and even after all that, you can still get errors in the full production line.

Any other toy line has all of the same steps for production, but for design it would all be done internally. The design team will brainstorm all the concepts, create full turnover packets that include details for everything the figure does,

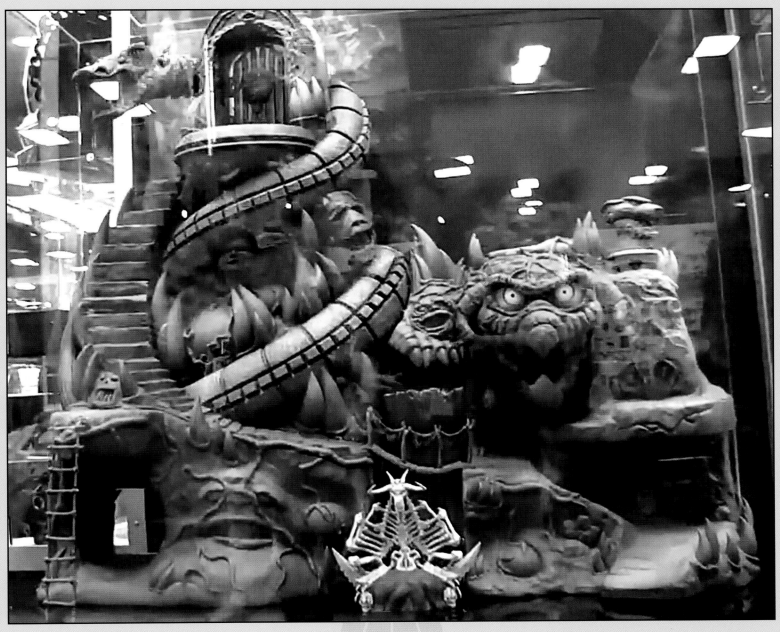

how it looks, and everything it comes with. We will start to build working breadboards for mechanisms, work with the internal sculpting team to get everything created, and we will have many internal review meetings until it is on cost and approved by upper management.

At that point it is turned over to China, and the tooling process begins. This doesn't even include all the meetings we will have with all the sales and marketing teams, who then have to go out and pitch the toy line to all the different retailers in order to get it placed on the shelf. Sometimes you spend months on lines that just get cut or trimmed down because either there isn't enough shelf space or the buyers just don't want it. Especially now with Toys"R"Us gone, those couple of shelves at Walmart or Target have become even tougher battlegrounds for placement.

Did the Classics line present any special challenges compared to other Mattel products?

I would say the main challenge was just making the fans happy and really trying to be able to react to requests to make the line better. We work so far in advance and by the time the public would see what is coming, there's only so much we could do to react to it. The other challenge was just getting the factories to give as much care and attention to our small line as they would to a big mass-production line. They often prioritize larger lines with bigger production runs. Another challenge was just keeping the brand going within Mattel. Usually the company is so focused on what is coming next from our big licensed partners, that there isn't as much focus on our core heritage brands. (This is changing for the better.) It was always a struggle to keep it going without some big form of content, like a movie or TV show, to support the line. Ultimately that is why we partnered with Super7 to keep things going. It made sense for them as a smaller company who could do the smaller runs of product. We still work very closely with them on everything that comes out.

Hopefully soon something big will be coming from Mattel and bring Masters of the Universe back onto the toy shelves!

What's the one MOTU Classics toy you worked on that you're most proud of?

Well, there were a lot, but the two that I really enjoyed working on were Snake Mountain and Anti-Eternia He-Man. Snake Mountain was really challenging and would have been such a rad play set, so that was a huge bummer that we had to stop working on it once Matty Collector shut down. I hope one day we can do some sort of crowd funding and get it made either by us or with Super7. [Editor's Note: See page 614.]

Anti-Eternia He-Man was the other one. Even though it was a simple repaint of He-Man, it was really enjoyable to work on. It was really cool to be able to offer the first official design of the character, which was so obscure to begin with.

There was a lot of freedom in what we could do with the design. We actually tried to create a really cool "shadow effect" by mixing opaque black plastic with translucent black plastic. This gives you a cool swirl effect. The test shots we got were really cool, as it made him look like he was made of black smoke, but ultimately the factory could never get it right and could not keep the effect consistent. It was also fun playing with the packaging so that it had the dark "Anti" look to the normal Grayskull bricks. I think it was the first time the packaging was changed to match the figure, and I think we could have had a lot more fun with the packaging on some of the past stuff.

SKELETOR
VS MO-LARR

First released 2010 • Member of the Evil Warriors

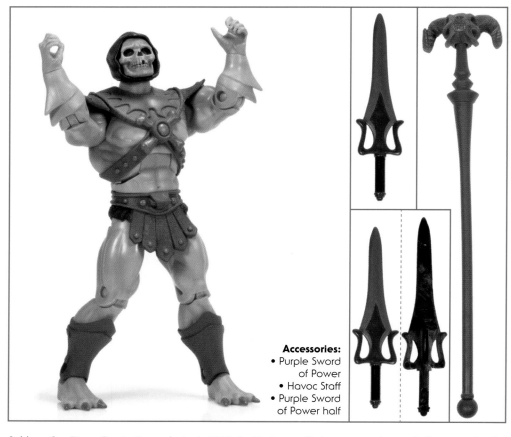

Accessories:
• Purple Sword of Power
• Havoc Staff
• Purple Sword of Power half

Sold as a San Diego Comic-Con exclusive in 2010, the Mo-Larr vs. Skeletor two-pack payed tribute to a sketch on the comedy series Robot Chicken. This set saw a character created for that sketch, Mo-Larr, the Eternian Dentist, extracting a tooth from Skeletor!

The Skeletor figure included with this set is the same as the second version issued of the standard Skeletor, with the exception of the head sculpt. He now features a new face that looks a little worried, and has a missing tooth—just extracted by the dentist!

Aside from this, his weapons are also exactly the same as those in the standard release. He has the Havoc Staff, the purple version of the Sword of Power, and even the half Sword of Power.

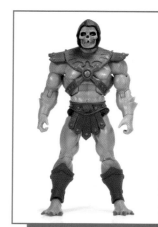
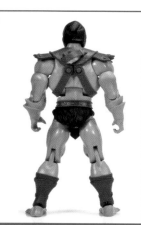

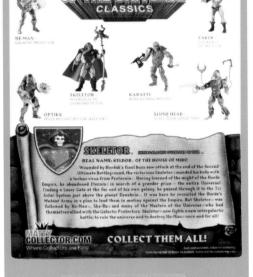

SKELETOR
INTERGALACTIC OVERLORD OF EVIL

First released 2014 • Member of the Space Mutants

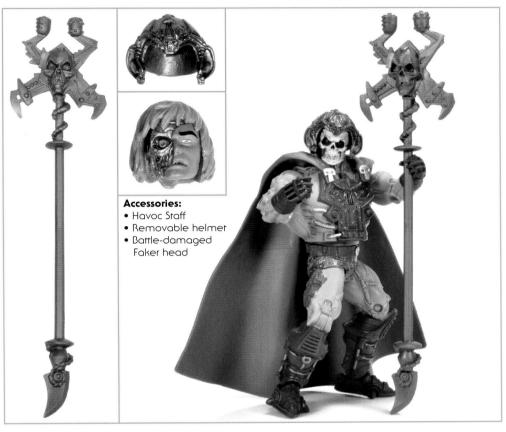

Accessories:
- Havoc Staff
- Removable helmet
- Battle-damaged Faker head

Based on his appearance in the New Adventures of He-Man toy line comes Intergalactic Skeletor! This version of Skeletor saw a new look, with cybernetic parts and wires now attached to his body.

The sculpted detail of this MOTU Classics version is really well done, showing all of the small wires, hoses, and circuitry that covers Skeletor's body. The original figure no longer wore armor, but rather had armor pieces attached to his torso. To accomplish this in MOTU Classics, Mattel used the standard muscular torso but made a new "armor" piece that fit over it to resemble Skeletor's cybernetic body. The new piece is highly detailed, but it does cause the figure to look much bulkier than he should, and sometimes you can see the stomach of the torso underneath showing at the bottom—which sort of ruins the illusion.

The figure has a removable helmet, as did the vintage toy. Taking that helmet off reveals cybernetic pieces attached to the back of Skeletor's skull. He also comes with a staff accessory based on the version that came with the classic toy.

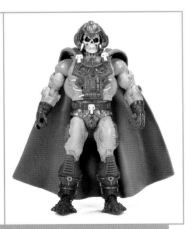

SKY HIGH
HEROIC AIRSHIP ADVENTURER

First released 2013 • Member of the Heroic Warriors

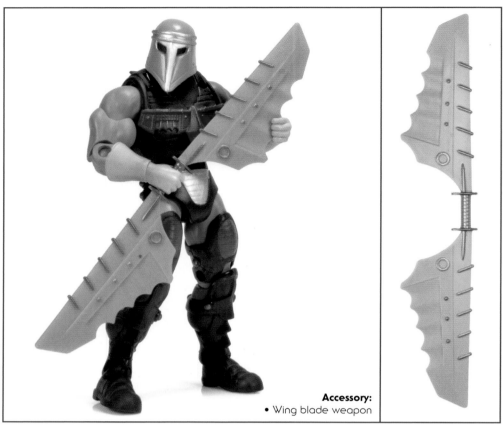

Accessory:
• Wing blade weapon

Sky High is based on a character first shown in a 1984 Masters of the Universe poster by William George. In the poster, a helmeted pilot is seen flying in the Wind Raider. Sky High was packaged with the Jet Sled (which in the vintage line was called the Sky Sled, also known as the front half of the Battle Ram), but he does have a blade weapon that closely resembles the wings on the Wind Raider.

Sky High is mainly made up of preexisting parts. His stomach comes from Battle Armor He-Man, and his chest, shoulders, biceps, and hands come from King Grayskull. His gloves are from Hordak, his pelvis comes from Optikk, and his legs are borrowed from Trap Jaw. Only his head, armor, and weapon are newly sculpted pieces. Despite that fact, he looks like a pretty fresh design and can function well as either a generic pilot or a Heroic Warrior in his own right.

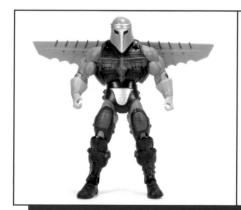
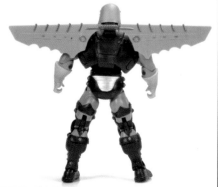
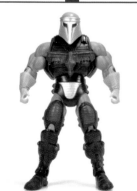

SLAMURAI
HEROIC MASTER OF MARTIAL ARTS

First released 2019 • Member of the Heroic Warriors

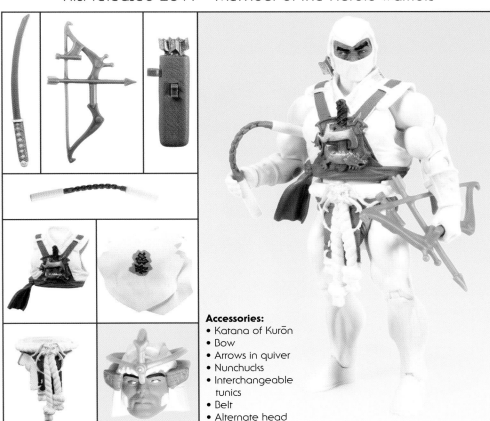

Accessories:
- Katana of Kurōn
- Bow
- Arrows in quiver
- Nunchucks
- Interchangeable tunics
- Belt
- Alternate head

Slamurai was released as a Power-Con exclusive in 2019 and came as part of a three-pack with two Snake Trooper action figures. He is based on an unused character design from the vintage Masters of the Universe toy line—part of an unreleased final wave of action figures. Until this release, the character did not have a name and was often referred to by the fan community simply as "White Ninja."

The design of the figure is based upon unused card back artwork by Errol McCarthy. Most of the figure reuses parts from the previously released Ninjor action figure. The shins, boots, and forearms, do not come from Ninjor, although they are reused pieces from other MOTU Classics figures. Slamurai also comes with the same accessories as Ninjor—the 200X Jitsu belt, katana sword, bow, and arrow quiver, all with new colors to match Slamurai's costume.

The pieces that truly make Slamurai stand out from Ninjor are the additional accessories which allow for alternate methods of display. He includes an alternate head which is a repaint of the 200X-inspired Sy-Klone head, previously released in the line. This head has been repainted to now look like an unmasked head for Slamurai, who is wearing a samurai-style helmet. He also has an alternate cloth tunic—something totally unique in the MOTU Classics line. This allows you to remove the plastic armor the figure is packaged with and replace it with this cloth tunic and belt. This is very similar to the cloth tunic used on the vintage Ninjor action figure and makes Slamurai stand out as a completely unique-looking figure in the Classics lineup. Furthermore, the cloth tunic is emblazoned with a faux kanji symbol which is different from Ninjor's, and which more accurately reflects the one seen in the character's unused vintage action figure artwork.

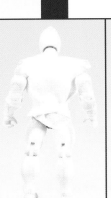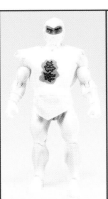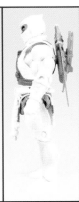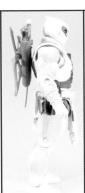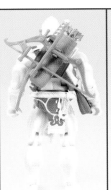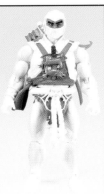

SLUSH HEAD
SCALY GOON SQUAD THUG

First released 2012 • Member of the Space Mutants

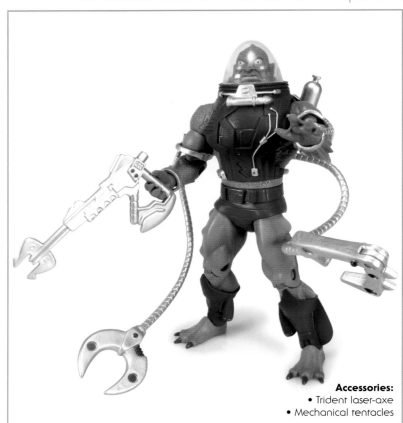

Accessories:
• Trident laser-axe
• Mechanical tentacles

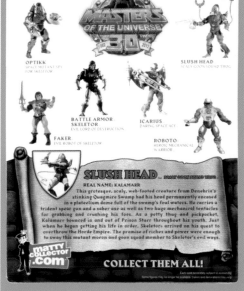

Slush Head is based on the 1989 Mattel New Adventures Space Mutant figure. He is something of a kit bash—the Four Horsemen used quite a number of existing parts to get a decent representation of the vintage figure. He borrows the torso, shoulders, forearms, and legs from Whiplash, feet from Skeletor, hands from Mer-Man, biceps from King Grayskull, and shin guards from Icarius. Only his head, armor, and accessories are newly sculpted pieces.

Slush Head does not have head articulation, it is possible to fill his clear helmet with water, replicating the liquid-filled helmet from the vintage 1989 figure. Like the original toy, his mechanical tentacles are static pieces that may be removed from his armor, but they do look rather menacing.

The real name in Slush Head's bio, "Kalamarr," was actually the name of the figure used on European packaging. Slush Head's "trident laser-axe" may be held at either end, allowing it to work like a gun or an axe. He has a strong retrofuturistic vibe about him, like an alien creature from a fifties B movie, and makes a great addition to the ranks of the Space Mutants.

SLUSH HEAD

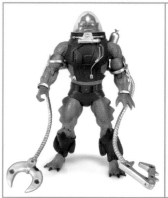

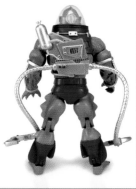

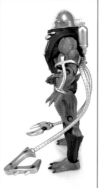

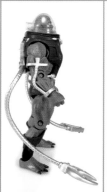

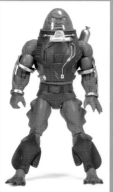

FUN FACTOID: It actually took very few new parts to assemble this guy. But when those few new pieces were combined with the growing library of existing parts, the result was a pretty seamless update of an already striking character.

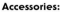

SNAKE ARMOR HE-MAN
MOST POWERFUL SNAKE HUNTER IN THE UNIVERSE

First released 2015 • Member of the Heroic Warriors

Accessories:
- Electronic Sword of Power
- Mechanical claw

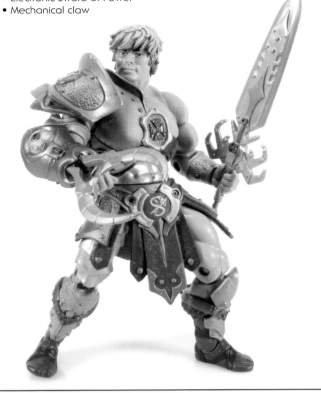

Snake Armor He-Man is based on the 2004 Mattel He-Man variant of the same name. The gladiator-style armor that he's wearing is supposed to help him in his fight against the Snake Men, and He-Man is shown in this costume for most of the second season of the Mike Young Productions He-Man and the Masters of the Universe series.

This version of He-Man is intricately-detailed, with a number of overlapping costume elements and even some mild weathering on the armor. He features a removable claw that plugs into his right gauntlet, which is supposed to allow him to capture snakes. Unlike the 200X source material, this He-Man features his original 1982 cross design on his armor. Otherwise he is a faithful reproduction of the 200X variant in the Classics style.

Snake Armor He-Man reuses the torso, left shoulder, left bicep, hands, left thigh, upper shins, and feet from King Grayskull. His right shoulder, right bicep, and right leg (minus the boots) are borrowed from King Hssss. His sword was first included as an accessory that came with Man-At-Arms in the Classics line, but is also based on the 200X design. He features an all-new head sculpt that combines the anime-style hair of the original figure with the more realistic facial features of the Classics line.

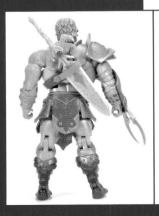

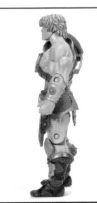

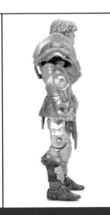

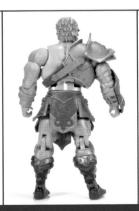

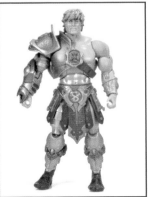

MOTUC - SECTION 1

SNAKE FACE
MOST GRUESOME OF THE SNAKE MEN WARRIORS
First released 2013 • Member of the Snake Men

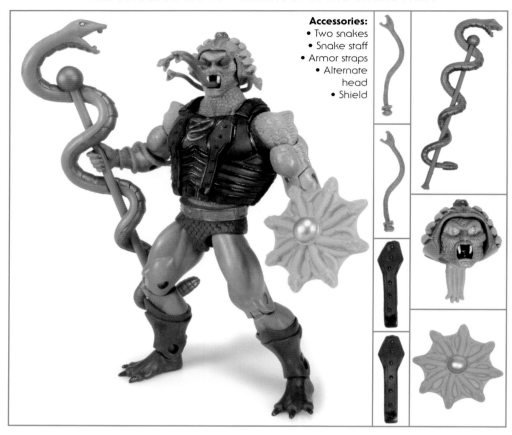

Accessories:
- Two snakes
- Snake staff
- Armor straps
- Alternate head
- Shield

Snake Face is closely based on the vintage 1987 Snake Face figure. While the original had an action feature that made snakes pop out of his eyes, mouth, shoulders, and torso (similar to Mantenna's pop-up eyes, but on steroids), the Classics version of the figure achieves the same effect with an alternative "popped-out" head as well as removable armor straps and snakes. Like the vintage toy, he is a gruesome figure covered with scales, bumps, and snakes.

He is like a male version of Medusa, but much more monstrous. In fact, an early working name for the vintage concept was "Medusa Man." Like Medusa, Snake Face's snakes are supposed to be able to turn his enemies to stone. Unlike some Snake Men characters, like Rattlor and King Hssss, who are clearly anthropomorphic snakes, Snake Face is more of a monster who has somehow bonded with snakes and uses them as mystical weapons.

Snake Face reuses the staff from King Hssss, the boots and hands from Skeletor, and the legs and torso from King Grayskull.

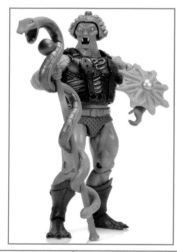

 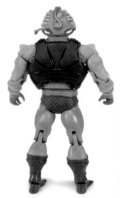 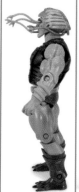 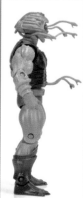 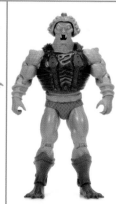 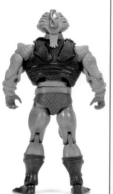

SNAKE MAN-AT-ARMS
TRANSFORMED MASTER OF WEAPONS

First released 2012 • Member of the Snake Men

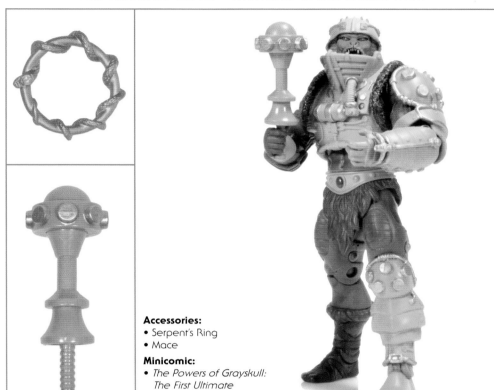

Accessories:
- Serpent's Ring
- Mace

Minicomic:
- *The Powers of Grayskull: The First Ultimate Battleground (He-Ro Unleashed!)*

Snake Man-At-Arms is Duncan after he has been transformed into a Snake Man by King Hssss's Serpent's Ring, as depicted in the 2002 He-Man and the Masters of the Universe cartoon series episode "Second Skin." In the animated story, the transformation is reversed soon after, but it made for a memorable episode.

Originally Snake Man-At-Arms was going to be mostly a simple repaint of the 2009 Man-At-Arms, but in colors reminiscent of the 1982 version of the figure instead of the cross-sell art. However, due to fan feedback, the Four Horsemen opted to give the figure a more mechanical-looking body, in line with the highly technological suit worn by Man-At-Arms in the 200X line.

To that end, he reuses the thighs, forearms, and left hand from Trap Jaw; shoulders from Man-E-Faces; biceps from Roboto; left boot from Keldor; torso, right hand, right boot and loincloth from King Grayskull. He reuses the armor from the 2009 Man-At-Arms, although it is a paler orange.

He has the monstrous green snake face from the cartoon, which can be swapped for the mustachioed head from the 2009 release, or the unhelmeted head of the Man-At-Arms that came packed with the Battle Ram, for a pretty solid 200X-style Man-At-Arms.

MOTUC - SECTION 1

SNAKE MEN
SLITHERING MINIONS OF KING HSSSS

First released 2012 • Members of the Snake Men

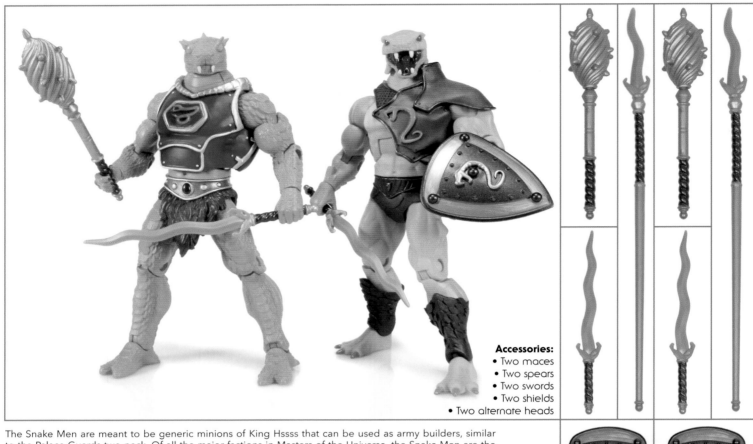

Accessories:
- Two maces
- Two spears
- Two swords
- Two shields
- Two alternate heads

The Snake Men are meant to be generic minions of King Hssss that can be used as army builders, similar to the Palace Guards two-pack. Of all the major factions in Masters of the Universe, the Snake Men are the smallest, so they, more than anyone, needed some army builders to fill out their ranks.

The design for the Snake Men is roughly based on some of the generic background snake warriors featured in the 2002 Mike Young Productions He-Man cartoon. The biggest elements from the cartoon are evident in the look of the removable chest armor and in the enlarged neck overlay pieces. The costumes have a blue, brown, and silver color scheme, so each piece of chest armor works equally well on either figure. In this way the costumes can be varied and changed around for those collectors who have four or more Snake Men on display. The set is also packed with enough weapons to further diversify an army builder display.

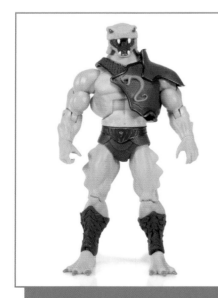
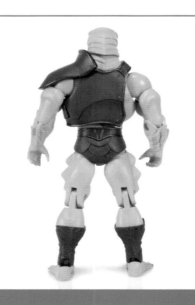
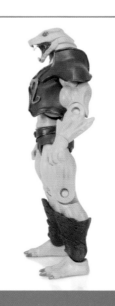
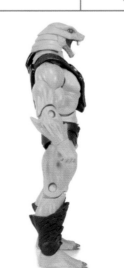

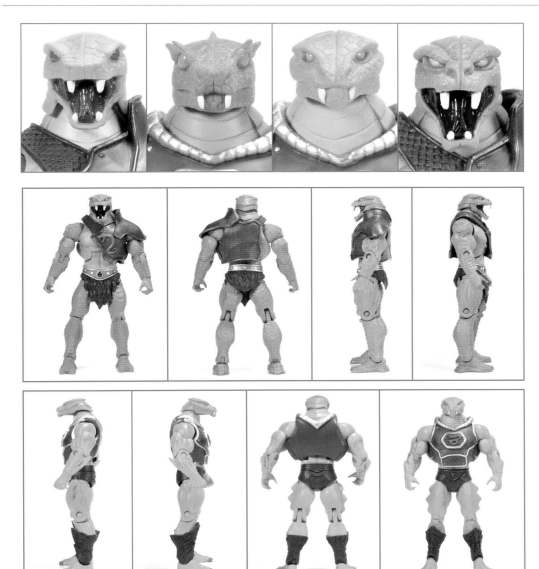

FUN FACTOID: This set included as many interchangeable parts as possible so that multiple purchases reward the buyer by giving them the ability to mix and match the parts to create a diverse Snake Men army.

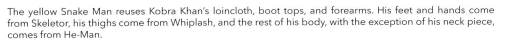

The yellow Snake Man reuses Kobra Khan's loincloth, boot tops, and forearms. His feet and hands come from Skeletor, his thighs come from Whiplash, and the rest of his body, with the exception of his neck piece, comes from He-Man.

The orange Snake Man reuses King Grayskull's loincloth and torso. The rest of his body was actually designed with the intention of being reused for Rattlor, who was released two months later. These figures help fill out the ranks of the Snake Men faction, which is one of the smaller factions in the MOTU galaxy of heroes and rogues.

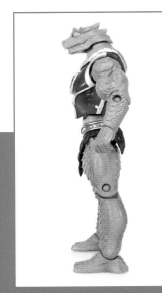
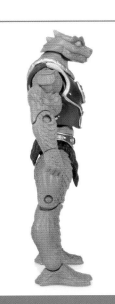
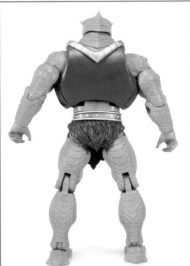
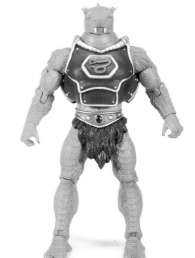

MOTUC - SECTION 1

SNAKE MOUNTAIN
EVIL STRONGHOLD OF SKELETOR

First released 2020 • Fortress of the Evil Warriors

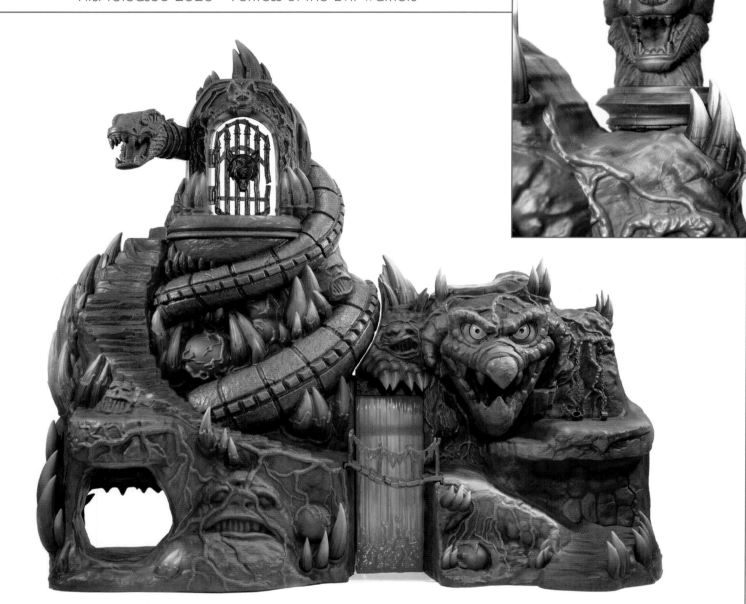

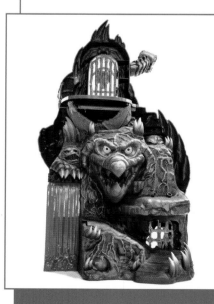

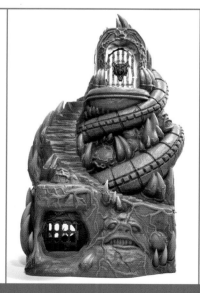

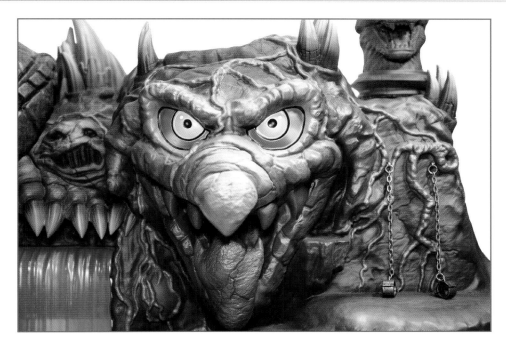

The long-awaited companion piece to the Masters of the Universe Classics Castle Grayskull play set was finally released in 2020, thanks to Super7.

This massive play set was designed and sculpted by Four Horsemen Design, much like Castle Grayskull, guaranteeing that it will fit right in with the rest of the collection. The play set measures thirty-six inches in height and forty-eight inches across when fully opened, making this much larger than the already-huge Castle Grayskull!

The design is a bit of an amalgamation of the vintage Mattel play set from the 1980s and the stronghold as it appeared in the Filmation He-Man and the Masters of the Universe animated series. On the right side, you'll notice the familiar demon face seen on the classic toy, while on the left, we have the larger mountain spire with a snake wrapped around it. In the center is Blood Falls, a bright reddish-orange lava fall.

As with Castle Grayskull before it, the team at Four Horsemen Design took a lot of inspiration from the vintage play set, sculpting in all of the weird, creepy faces seen in the original toy's façade. Notably, they detailed the inside a little better. The vintage play set was mostly a hollow shell on the inside, but this version has much more detailed and pronounced faces on the walls. Also, what was once just a sticker on the play set floor has been brought to life as a group of horrifying three-dimensional creatures emerging from the swamp below!

Some of the classic features from the original play set make an appearance here. The tall mountain spire has the same opening gate on top, complete with a trapdoor in the floor that drops unsuspecting action figures into a net below. Real metal chains can be used to shackle heroes to the ledge outside. There's even a brand-new breakaway wall, revealing a hidden entrance! The play set can also be folded up, much like the vintage one.

The wolf head column was used as a microphone on the original toy. There is no "voice of Snake Mountain" action feature this time around, but the column can still be removed, allowing fans to decide if it should or shouldn't be included in their Snake Mountain display. In the base of the column, there's also a door that can be opened, allowing you to store items within if you so choose.

Some of the new accessories inside take cues from several of the more popular aspects of the Filmation version of Snake Mountain. Specifically, we now have Skeletor's scrying table! Scenes from the series can be re-created with our villains gathered around the table as Skeletor explains his plans for attack on Castle Grayskull.

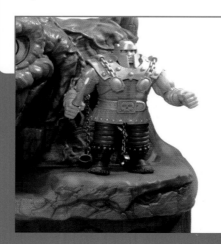

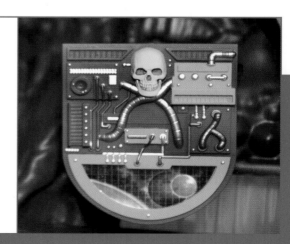

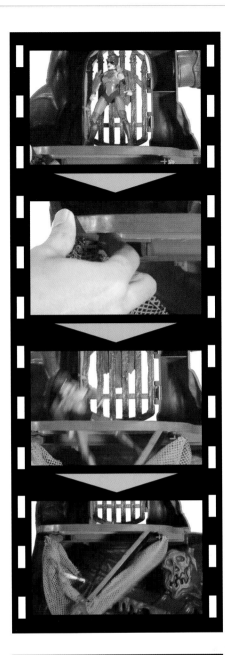

Arguably, the most exciting addition is the Bone Throne. For the first time ever, Skeletor has his iconic chair, as seen in the Filmation animated series! This is truly a throne befitting the Overlord of Evil and future ruler of Eternia.

As of this writing, Snake Mountain is set to be the final release in the Masters of the Universe Classics toy line. The line has lasted twelve years, giving us an impressive lineup of action figures, vehicles, and play sets. It'll go down in toy history as one of the most comprehensive collector lines of all time. Capping things off with the massive Snake Mountain is a fitting way to end such an epic toy line.

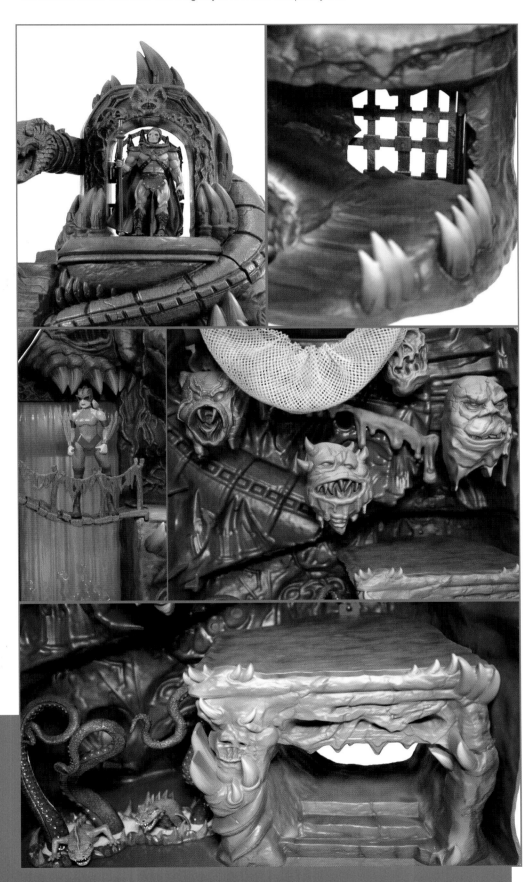

MOTUC - SECTION 1

MOTUC · SECTION 1

Accessories:
- Bone Throne
- Dungeon creatures
- Ladder
- Bridge
- Scrying table
- Wolf head column
- Two metal chains

SNAKE MOUNTAIN™ STANDS

W8906

ADULT COLLECTOR ZALESIA™

CONSUMER INFORMATION
Need Assistance? Visit service.mattel.com or call 1-800-524-8697 (US and Canada only).
SERVICE.MATTEL.COM

W8906

7 46775 08630 5

SNAKE MOUNTAIN STANDS

First released 2012 • Accessory of the Evil Warriors

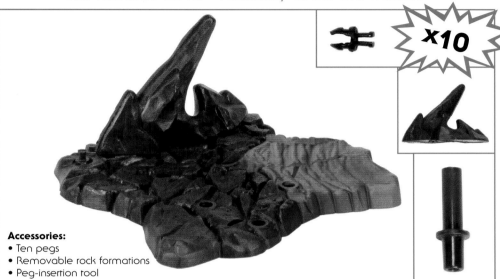

X10

Accessories:
• Ten pegs
• Removable rock formations
• Peg-insertion tool

Each package of Snake Mountain Stands includes five identical stands, five removable rock formations, a peg-insertion tool, and a number of loose pegs. The stands themselves are sculpted to resemble black volcanic rock with just a hint of purple dry brushing, with a section of red lava on each of them. There are a number of holes on the stands, and pegs can be inserted into any of them, either to hold up a figure (Classics figures feature a hole on the bottom of each foot so they can work with pegs) or to install one of the rock formations.

The stands can be arranged together so that there appear to be small rivers of running lava. They work to enhance a shelf display while at the same time making it less likely that figures will fall over.

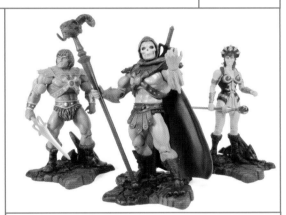

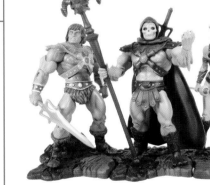

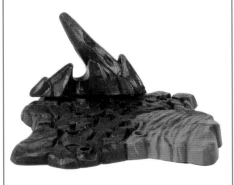

SNAKE TROOPERS
SLITHERING CYBORGS OF THE SNAKE MEN

First released 2019 • Members of the Snake Men and the Evil Horde

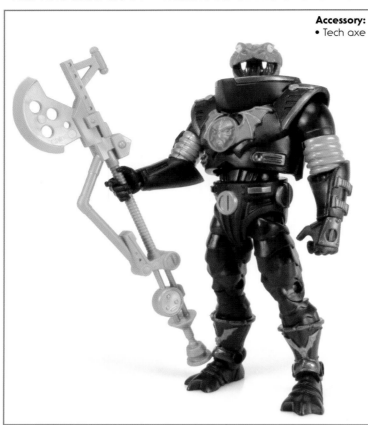

Accessory:
• Tech axe

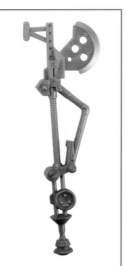

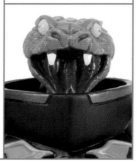

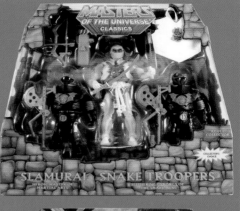

**SLAMURAI,
SNAKE TROOPERS**

The Snake Troopers were released as a Power-Con exclusive in 2019 and came as part of a three-pack that included two Snake Troopers and Slamurai. They are based on unused character designs from the vintage Masters of the Universe toy line—part of an unreleased final wave of action figures.

The design of the Snake Troopers is based upon unused card back artwork by Errol McCarthy. The figures themselves are composed entirely of reused parts from other figures released throughout the MOTU Classics toy line. If these figures had been released in the vintage toy line as intended, they too would have been wholly made up of preexisting parts from other figures in the line.

Utilizing the Horde Trooper body armor with the snake head from Rattlor, these zombie-like troops are wearing black armor with the red Evil Horde emblem emblazoned across their chests. The only distinguishing feature between the two figures is the slight color variation of the snake heads. Otherwise, the two figures are the same, and meant to be built up into an army of troops for your Horde or Snake Men display. Their only accessories are two identical, reused Blast-Attak tech axes, now molded in a golden color to match some of the bits of the Snake Troopers' armor.

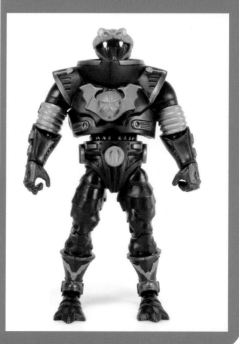

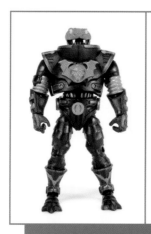

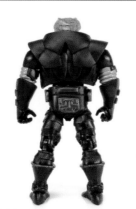

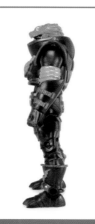

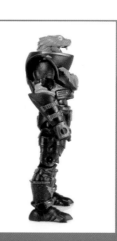

SNOUT SPOUT
HEROIC WATER BLASTING FIREFIGHTER

First released 2012 • Member of the Great Rebellion, the Heroic Warriors, and the Galactic Protectors

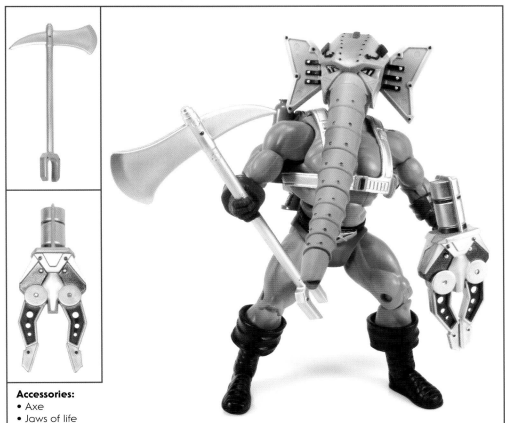

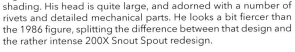

Accessories:
- Axe
- Jaws of life

Snout Spout is closely based on the 1986 action figure, complete with firefighter axe and long rubbery trunk. The original could spray water out of his trunk, via a push button on his backpack. His water supply was also refilled from his backpack.

In lieu of that action feature, the Classics version has a soft trunk that can be articulated in various poses, thanks to internal bendable wires. He has a bright orange costume that is toned down somewhat with generous paint

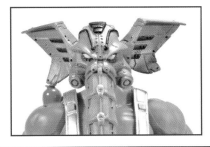

shading. His head is quite large, and adorned with a number of rivets and detailed mechanical parts. He looks a bit fiercer than the 1986 figure, splitting the difference between that design and the rather intense 200X Snout Spout redesign.

In addition to his vintage-style fire axe, Snout Spout comes with a jaws of life accessory, which could come in handy in case there's a fire at Castle Grayskull and He-Man is not around with his Sword of Power to open the jaw-bridge. Snout Spout reuses the torso, shoulders, biceps, and legs (minus the boots) from King Grayskull.

FUN FACTOID: Snout Spout's figure was hurt by quality-control issues with the trunk. The 200X Heads of Eternia pack not only gave fans the opportunity to get a second look with the more aggressive head, but also a replacement head for those who had a damaged figure.

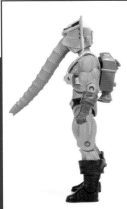
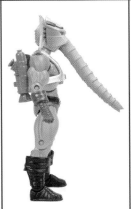
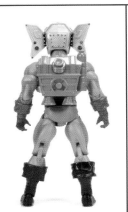
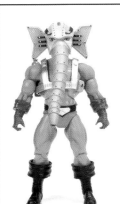

SORCERESS
HEROIC GUARDIAN OF CASTLE GRAYSKULL

First released 2012 • Member of the Heroic Warriors

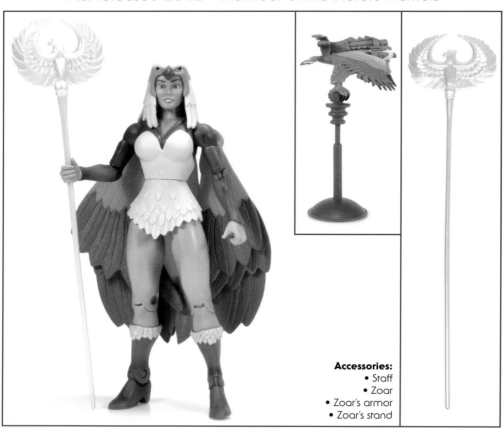

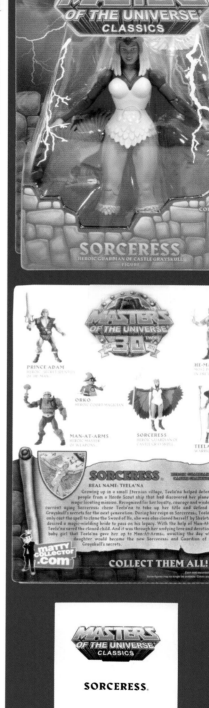

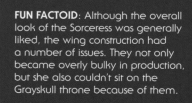

Accessories:
- Staff
- Zoar
- Zoar's armor
- Zoar's stand

The Sorceress is perhaps one of the most beautiful figures in the Masters of the Universe Classics line. She is most closely based on the character as she appeared in the 1983 He-Man and the Masters of the Universe cartoon, especially in regard to her face and costume. She does have two nods to the vintage 1987 action figure, which are her staff and the ability to extend her wings outward. The vintage figure had wings that could pop out by pulling her tail. On the Classics version this is accomplished by raising her arms up from her sides.

The Sorceress differs slightly in her color scheme from both the animated and the vintage toy versions of the character. She features blue coloring at the tips of her wings (inside and out), while in 1980s depictions of the character, only the outside of the wingtips had the blue coloring.

The Sorceress comes with a repaint of the Zoar figure that came with Teela. Teela's Zoar had colors based on the vintage cross-sell art for Zoar, while the Sorceress's Zoar has the orange, blue, and white color scheme of both the vintage toy and the animated version. Zoar comes with armor and a stand based on the vintage toy, but her size is in scale with Zoar as she appeared in the cartoon. Zoar has the same modified coloration on her wings that the Sorceress has.

The Sorceress reuses shoulders, biceps, and feet from She-Ra, and hands, thighs, and upper shins from Teela.

FUN FACTOID: Although the overall look of the Sorceress was generally liked, the wing construction had a number of issues. They not only became overly bulky in production, but she also couldn't sit on the Grayskull throne because of them.

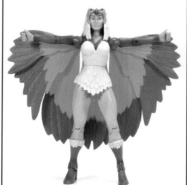

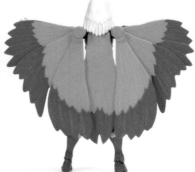

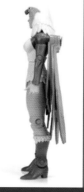

SPACE ACE
STELLAR "STARMAN"

First released 2012 • Heroic Warrior

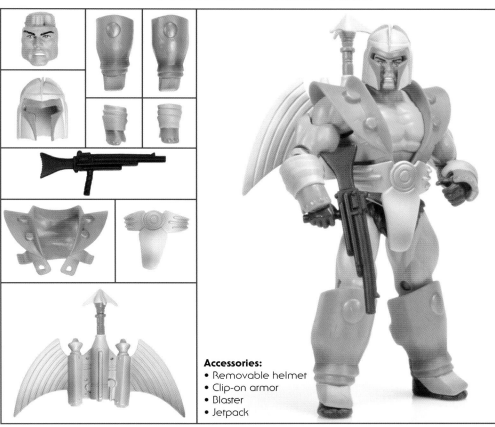

Accessories:
• Removable helmet
• Clip-on armor
• Blaster
• Jetpack

Released as the 2012 San Diego Comic-Con Exclusive, the Vykron pack was meant to pay homage to the Roger Sweet prototypes from when the original Masters of the Universe toy line was being pitched. Roger's idea included a character that could be three different things: a barbarian, a military man, or a sci-fi fighter! This three-pack comes with one action figure and three different outfits, allowing you to swap the armor around to create these three different concepts that were originally pitched for the line.

Space Ace is the name given to the sci-fi themed character. He has shin guards, a belt, armor, a jetpack, and a removable helmet. Since the original prototype of this character actually utilized parts from an existing Star Wars action figure, some of these pieces needed to be modified for the figure's release—but the nods to the character's roots are still quite present in the design, specifically of the helmet.

The packs were released with the figure wearing one of the outfits, chosen at random. That means some of these feature Space Ace in the center of the packaging.

FUN FACTOID: The Four Horsemen said, "When there is a line with this many figures there are bound to be some that are more successful than others. Whereas concept characters like Gy-Gor and Demo-Man translated smoothly into Classics figures, Vykron still felt a little clunky and dated. A major contributing factor was the aesthetic concessions made in the interchangeable armor and accessories. The slip on armor (along with the original design itself) had a blocky feel that didn't quite mesh with the Classics look. Also, the Boba Fett homage sticks out no matter how you address it."

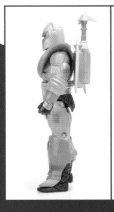
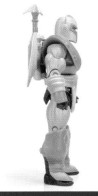
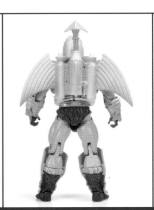
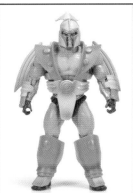

MOTUC - SECTION 1

SPIKOR
UNTOUCHABLE MASTER OF EVIL COMBAT
First released 2012 • Member of the Evil Warriors

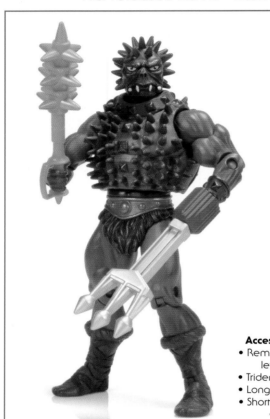

Accessories:
• Removable left hand
• Trident base
• Long trident
• Short trident
• Mace

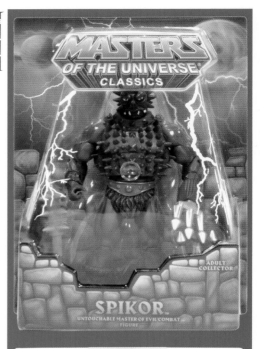

SPIKOR

Spikor is one of the most distinctive-looking Masters of the Universe characters. His upper body is bristling with deadly purple spikes, he carries a bright orange spiked mace, and he has a spiky trident for a hand.

Spikor is closely based on his vintage 1985 counterpart. Unlike the vintage toy, however, he can be displayed either with a trident for a left hand, or with an intact left hand. In some appearances in the Filmation He-Man cartoon, as well as in some comic book appearances, Spikor was portrayed with two intact hands. The vintage toy had a trident left hand that could slide in and out of his arm. To simulate that feature, the Classics version comes with a long and a short trident that can be swapped on his arm.

Spikor reuses most of the body from King Grayskull, including the torso, legs, boots, shoulders, and biceps. His hands come from Skeletor (specifically the second release of Skeletor with the closed left hand), and his loincloth comes from He-Man.

In his bio, Spikor is said to come from the village of Nordling. The village of Nordling appeared in the minicomic that came with Spikor's vintage figure, and was a reference to Lee Nordling, one of the editors who worked on vintage Masters of the Universe minicomics for Mattel.

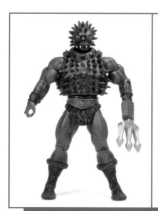 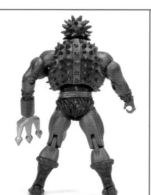

FUN FACTOID: When creating the prototype, each one of the spikes was hand turned on a lathe and then glued on one by one onto the clay sculpture. Once the spikes were attached, each and every spike had to be backfilled with more clay so that it was moldable and maintained a clean, seamless look!

SPINNERELLA
DIZZYING DEFENDER

First released 2014 • Member of the Great Rebellion

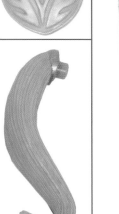

Accessories:
- Shield
- Spear
- Two removable hairpieces

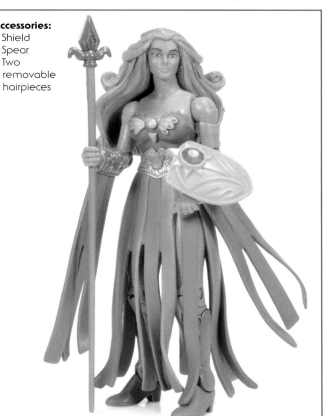

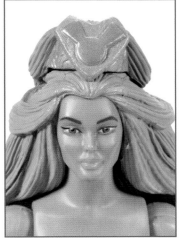

Spinnerella is an even mix of influences from her incredibly hard-to-find 1987 figure and her animated appearance in the Filmation She-Ra cartoon. Her colors are mainly based on the vintage version, with alternating blue and purple color hits on her costume. Her tassels are somewhat simpler than the ones on the toy and hang straight like the cartoon version. She also comes with two removable hairpieces that let you re-create the vintage toy version with the tiara on top, or the simpler cartoon version.

Spinnerella comes with a repaint of She-Ra's shield, just as the vintage doll did. She doesn't include a comb, but she does have a repaint of the spear that came with the Goddess.

The original toy included a stand. Spinnerella could be placed on the stand and made to spin via a lever, which would make her tassels move outward due to centrifugal force. The Classics version doesn't include the stand, and her tassels are made of flexible plastic rather than fabric. However, the spinning effect can be somewhat replicated depending on how the figure is posed.

Spinnerella reuses She-Ra's feet, shoulders, and biceps, and Teela's thighs and hands.

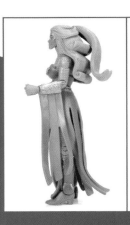
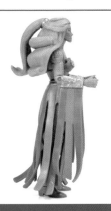

MOTUC - SECTION 1

SPIRIT OF GRAYSKULL
HEROIC GUARDIAN OF POWER

First released 2015 • Spirit of Heroic Warriors

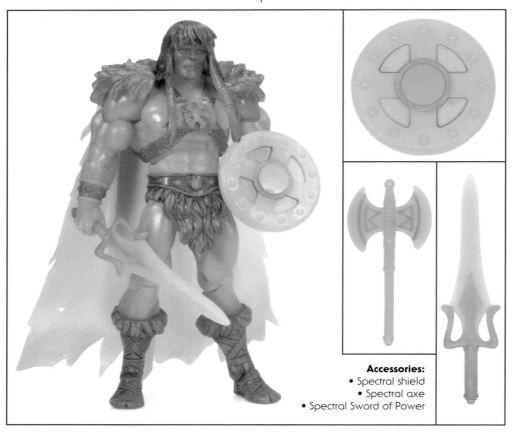

Accessories:
- Spectral shield
- Spectral axe
- Spectral Sword of Power

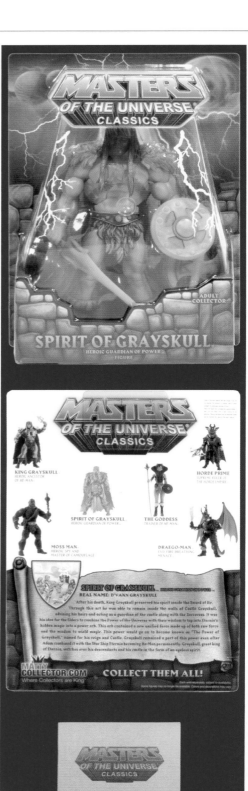

The Spirit of Grayskull is a repainted version of the original King Grayskull, the first figure of the Classics line released in 2008. This version is actually the ghost of King Grayskull. As such he is cast in translucent green glow-in-the-dark plastic, with a wash of darker green paint applied judiciously to bring out the details of his sculpt. Unlike the original King Grayskull, the Spirit of Grayskull's cape is not removable. The figure's luminescent material glows quite brightly with only a short "charge" in the light.

The Spirit of Grayskull is actually the second "Spirit" variant of the character. In 2008, Mattel produced a few versions of the figure cast in translucent blue. One was given away as a raffle prize at San Diego Comic-Con, and another was raffled off for charity. The other twenty-nine translucent figures were given to Mattel employees who worked on the line. As a result, the 2008 Spirit figure isn't officially considered part of the toy line by Mattel, but rather a bonus "employee" figure. The 2015 figure is considered the official release of the Spirit of Grayskull.

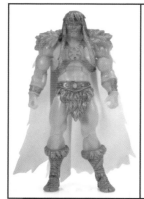

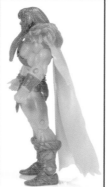
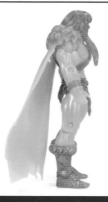

MOTUC - SECTION 1

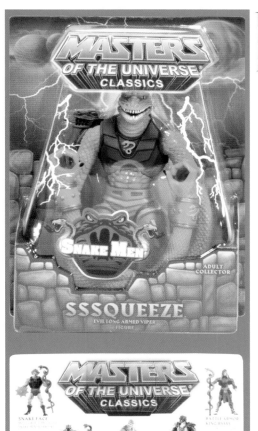

SSSQUEEZE
EVIL LONG ARMED VIPER

First released 2015 • Member of the Snake Men

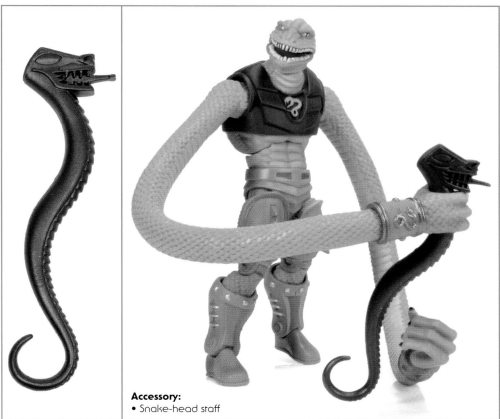

Accessory:
• Snake-head staff

Sssqueeze is closely modeled after his vintage 1987 counterpart. The original had long rubber arms that could bend and hold their shape due to internal bendable metal wires. The Classics version has the same feature, while also featuring the usual Classics articulation at the shoulders and wrists.

Sssqueeze is a vivid green color with a purple-and-orange costume. He carries a purple snake staff that has been somewhat redesigned compared to the vintage source material. The vintage accessory was actually more of a "pet snake" that wrapped around Sssqueeze's arm. This version has a relatively straighter body and can only be held in the figure's hand.

Sssqueeze is one of several Snake Men that don't actually have a snake-like head. His head instead looks more like that of a lizard or a dinosaur. He seems to fit into the Snake Men faction mainly on the strength of his long snake-like arms.

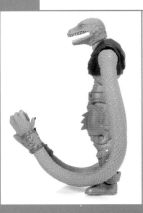
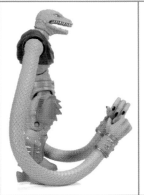

MOTUC - SECTION 1

STACKABLE STANDS

First released 2013

Stackable Stands are figure stands that feature staggered structures resembling an awards platform for displaying Masters of the Universe Classics figures. They are painted and sculpted to resemble the floor of Castle Grayskull. Like previous stands, the set includes a peg-insertion tool and a number of removable pegs. The stands (packaged three to a box) can be nested together in various ways to create different configurations for displaying figures.

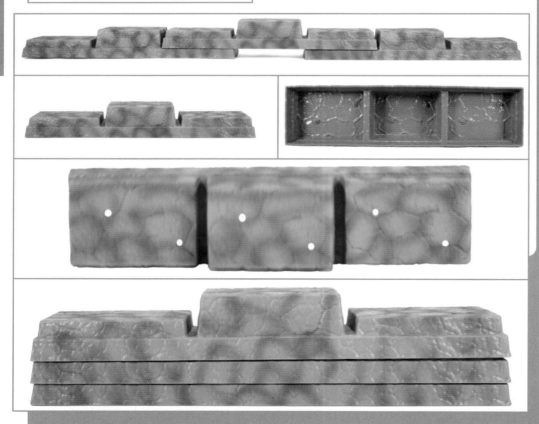

MASTERS OF THE UNIVERSE CLASSICS

STACKABLE STANDS

FITS MOST MASTERS OF THE UNIVERSE ACTION FIGURES.

TRY THESE COMBINATIONS!

ADULT COLLECTOR

CONTENTS: 3 stands & 19 pegs

STANDOR

First released 2013 • Ally of the Heroic Warriors

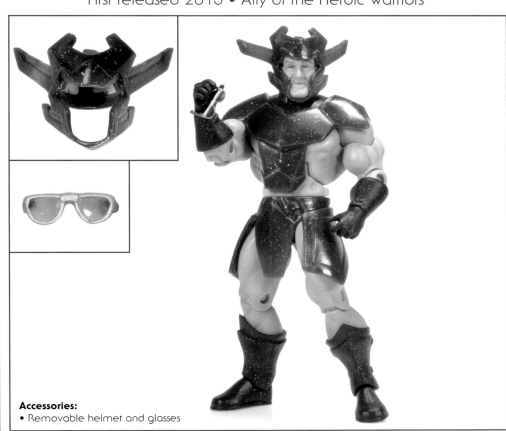

Accessories:
• Removable helmet and glasses

Standor was an exclusive figure created to celebrate the partnership between Mattel and POW! Entertainment, Stan Lee's media company. Standor has a head sculpted in the likeness of Lee himself, but with grayish blue skin. The figure's cosmic armor is molded in black plastic with white speckles that bring to mind stars against the blackness of space.

Both his helmet and his blue-tinted Solar Goggles (modeled after Lee's glasses) are removable. The helmet makes it difficult to tell that the head is based on Stan Lee, but once removed the resemblance is obvious. Just as the legendary late comic figure was a titan of the comic book industry, Standor is a titan among the stars in the world of Masters of the Universe.

Standor reuses King Grayskull's torso, shoulders, biceps, hands, and legs. His gloves come from Hordak, his boot tops come from Skeletor, and his feet come from Keldor.

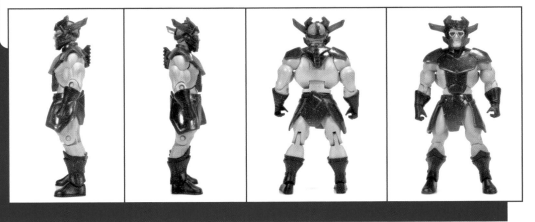

MOTUC - SECTION 1

STARLA
BRIGHT AND BEAUTIFUL LEADER

First released 2012 • Member of the Great Rebellion

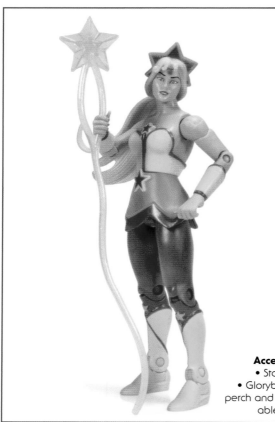

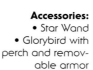

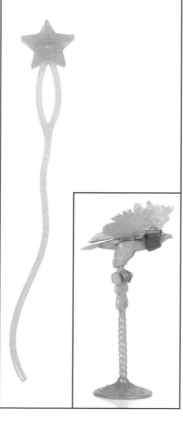

Accessories:
• Star Wand
• Glorybird with perch and removable armor

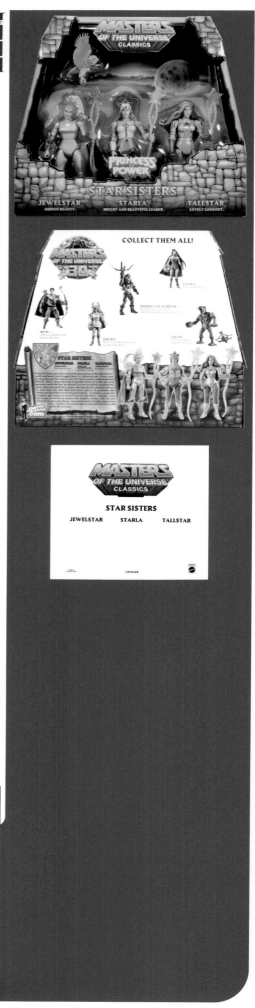

Starla is based on one of three unreleased vintage prototypes known as the Star Sisters. More accurately, she is based on a poster version of the figure, which is a rather more streamlined and Filmation-like interpretation of the character.

Starla has a bold yellow-and-red color scheme, with a star on her head that gives her something of a Statue of Liberty look. Her costume is adorned with stars. She is the most human-like of the three sisters, without the stretching limbs or crystalline body of her siblings. Her Star Wand is cast in glittering translucent yellow.

Starla reuses shoulders and biceps from She-Ra, forearms from Adora, and hands, thighs, and feet from Teela. Glorybird is a repaint of Zoar, but the accompanying perch and armor are newly-created pieces.

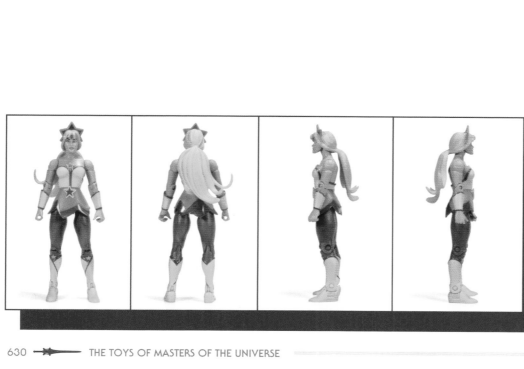

MOTUC - SECTION 1

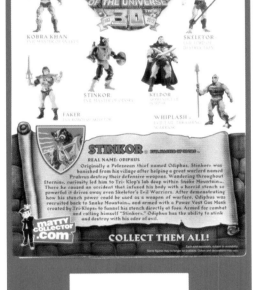

STINKOR
EVIL MASTER OF ODORS

First released 2012 • Member of the Evil Warriors

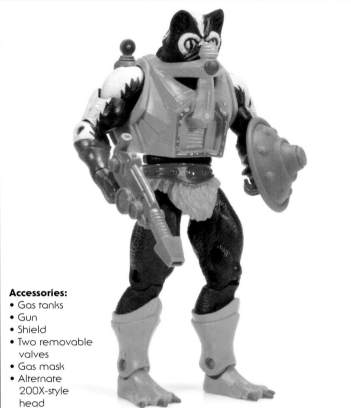

Accessories:
- Gas tanks
- Gun
- Shield
- Two removable valves
- Gas mask
- Alternate 200X-style head

Stinkor was always one of those characters that rode the line between hilarious and wickedly awesome, and the Classics version is perhaps the ultimate incarnation of the Evil Master of Odors. Stinkor is bursting with accessories that let you achieve both his vintage 1985 look and his 200X look. For the vintage look, he can use his default head (a repaint of Mer-Man's toy-look head) and his shield.

For the 200X look, he can be equipped with his alternative head, gun, gas tank, gas mask, and removable gas valve. Like the vintage toy, Stinkor's plastic is mixed with patchouli to give him a distinctive "skunky" odor.

While the vintage Stinkor was a simple Mer-Man repaint, Classics Stinkor has a fur-textured body, befitting his skunky biology. Stinkor reuses Beast Man's torso, shoulders, biceps, and thighs. His upper shins are from Chief Carnivus, his loincloth is from He-Man, his shield is from the Eternian Palace Guards, and his boots and hands are from Skeletor.

FUN FACTOID: While the vintage figure was 100 percent reused parts, the Classics figure was able to ratchet up the accessory count so that he not only had a faithful vintage look but also a convincing 200X motif.

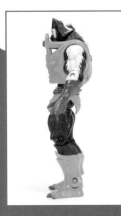

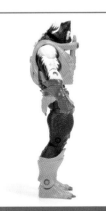

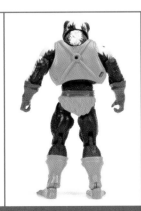

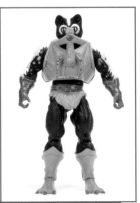

MOTUC - SECTION 1

STONEDAR
HEROIC LEADER OF THE COMET WARRIORS

First released 2013 • Member of the Comet Warriors and
the Heroic Warriors

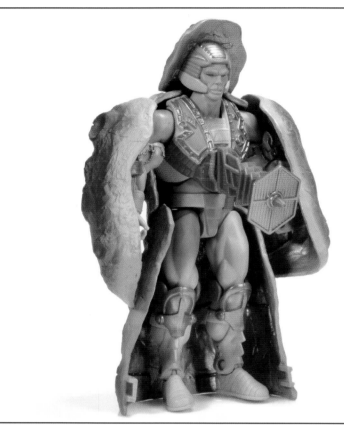

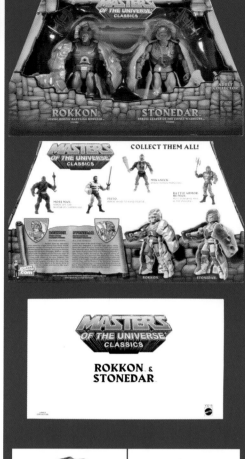

Accessories:
• Light blazer gun
• Removable back, arm,
and leg shells

Stonedar was released in a two-pack with his comet compatriot, Rokkon. Stonedar is closely based on the vintage 1986 figure, although unlike his vintage counterpart, his comet shell is removable, aside from the part sculpted onto his head. He also has a hinged area on the lower part of his back shell that helps cover his bottom when he transforms into comet mode.

Unlike most Classics figures, Stonedar's loincloth does not cover the upper areas of his thighs. This gives the figure greater flexibility and aids in his transformation. The vintage Stonedar figure was quite short compared to other Masters of the Universe figures. In his Classics incarnation, he is the same height as most other figures, so in comet or rock mode he is actually much more impressive than his vintage equivalent.

Stonedar reuses King Grayskull's hands, chest, shoulders, and thighs. He borrows Battle Armor He-Man's abdomen, Trap Jaw's boots and forearms, Snout Spout's feet, and Roboto's biceps. His rocky shell features a blue-and-gray color scheme, pockmarked with craters like the surface of a moon or asteroid.

Notably, the red leg bands of the original Stonedar figure are absent on the Classics version of the character. Although these bands were sculpted, and even appear in a back-of-the-package photo, they did not make it onto the final figure.

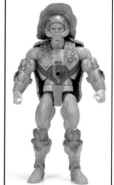
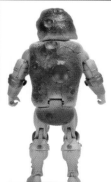
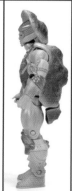
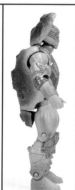
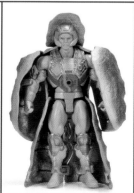

MOTUC - SECTION 1

FUN FACTOID: Stratos' Classics figure was very true to the original, but the look of the hands and feet was more in line with the card back.

STRATOS
WINGED WARRIOR

First released 2009 • Member of the Heroic Warriors

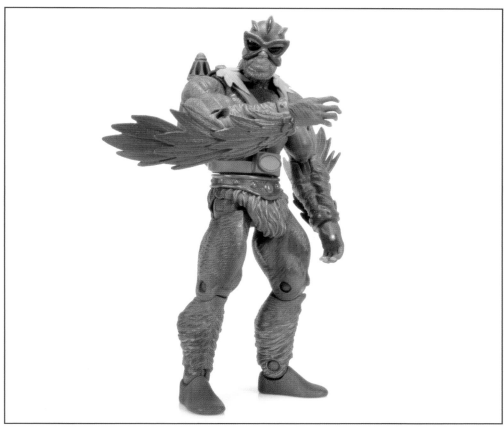

Stratos was one of the original eight characters released in the vintage Masters of the Universe toy line. He saw an updated release early in the first full year of Masters of the Universe Classics.

The new figure holds quite true to the look of the vintage action figure. The articulation and details are up to the standard of the Classics toy line, but Mattel held true to the original toy's release by not including anything above and beyond. For example, the figure still has feet with no sculpted details, making it look as though he is wearing boots, even though he is not. His hands are also both molded open, since he is a character who can fly.

Despite the fact that his hands are open, he has nothing to hold, since the figure does not come with any accessories. This was done simply because the vintage toy did not include weapons, and early on in MOTU Classics, Mattel was following the exact same format as their original line.

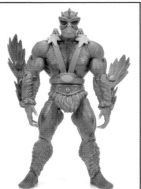

STRATOS
WINGED LEADER OF AVION

First released 2010 • Member of the Heroic Warriors

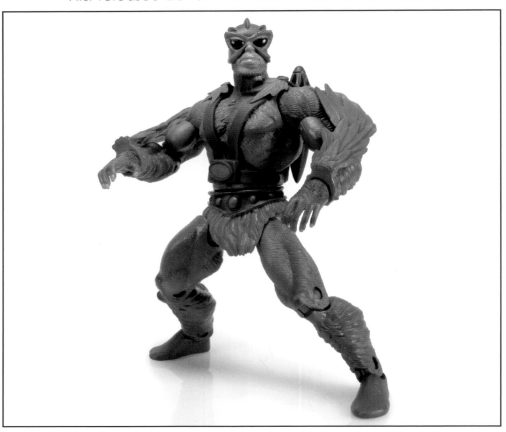

In 2011 Mattel released several two-packs to retail stores that combined two of their popular collector figure lines: Masters of the Universe Classics and DC Universe Classics.

Packaged with Hawkman was a new version of Stratos. The figure itself shares the same sculpt as the figure already released through the Matty Collector website. This version features a new paint deco, swapping the colors of the wings and jetpack. This is an homage to the vintage Masters of the Universe toy line, as Stratos was released with both red and blue wings. Now fans have the option of having both versions of Stratos in their MOTU Classics collection.

These two-packs were a great way to provide some variants for MOTU Classics fans while also introducing the general public to the usually online-only toy line through retail outlets.

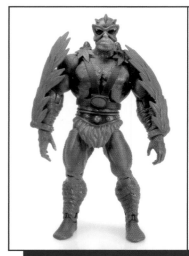
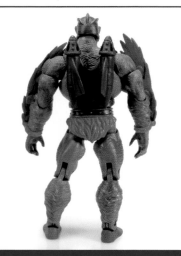
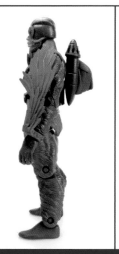
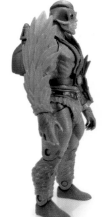

STRATOS
HEROIC LEADER OF THE BIRD PEOPLE

First released 2017 • Member of the Heroic Warriors

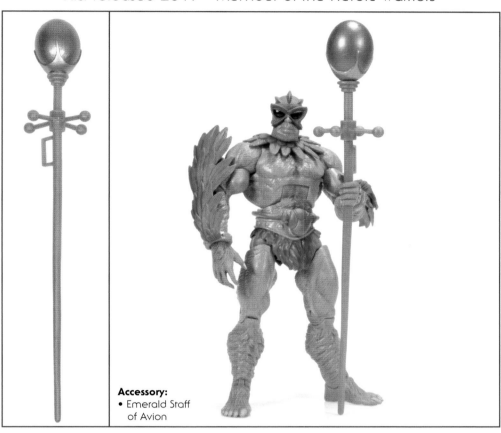

Accessory:
• Emerald Staff
of Avion

Released exclusively at the 2017 Power-Con, this three-pack features new versions of existing characters as they appeared in the original Masters of the Universe minicomics that preceded the Filmation show.

Stratos is mostly the same sculpt seen on his original release, but there are lots of new updates added to the figure. This time around, his feathers are a flesh-tone color rather than gray. It's an odd look, but this is how he was sometimes colored in the earliest mini comics. He comes with a new belt piece and a new neckpiece of red feathers around his neck, to help round out his minicomic look.

Other updates include a new gripping hand on the left, which now allows Stratos to better hold on to accessories. The feet on this figure are also detailed, reusing the bare Beast Man foot sculpts. For an accessory, he comes with a newly colored version of the Staff of Avion as it appeared in those original minicomics that came packaged with the vintage action figures!

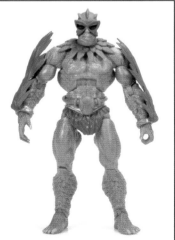

STRIDOR
HEROIC ARMORED WAR HORSE

First released 2019 • Steed of the Heroic Warriors

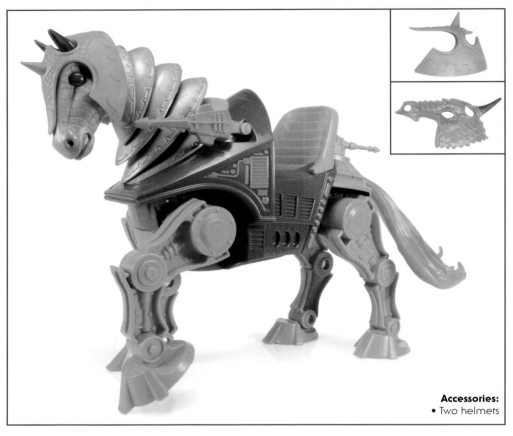

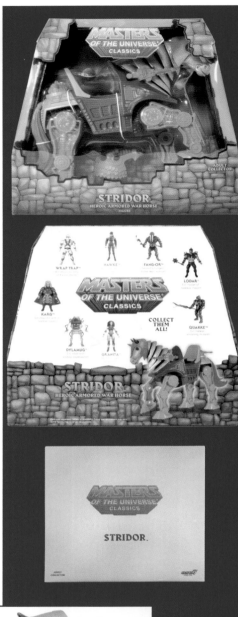

Accessories:
• Two helmets

Stridor is the heroic counterpart to the evil Night Stalker. The robotic steed is often associated with Fisto, since the vintage Stridor figure was once offered in a gift set with the Fisto action figure.

Unlike in the vintage toy line, Night Stalker was released first in MOTU Classics. When Mattel seemingly closed the doors on MattyCollector and put an early end to MOTU Classics, many fans thought Stridor would be one of the original vintage action figures/beasts that would not get an updated action figure. Luckily with Super7 taking the reins, Stridor eventually got his release in 2018!

Just like with the original Masters of the Universe toy line, Stridor and Night Stalker share the exact same sculpt. The main difference is the color scheme: while Night Stalker was a striking gold and black, Stridor is a silver, brown, and orange color combination.

Stridor has the same helmet as Night Stalker now in orange to match his color scheme. However, Stridor also has a second helmet that matches the style of the one included with his vintage counterpart.

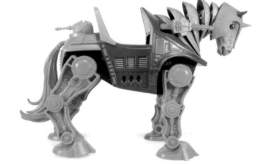

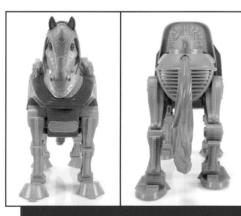

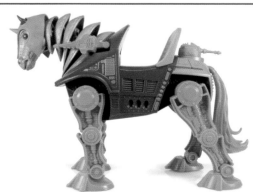

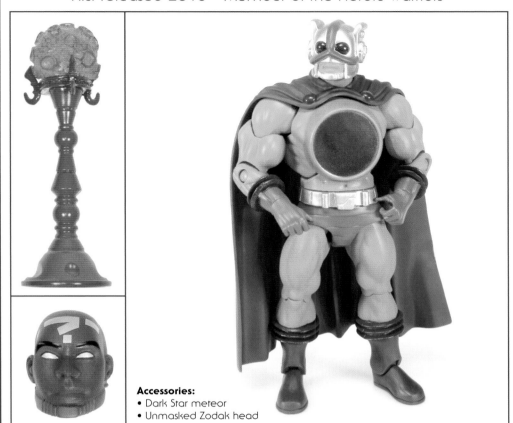

STROBO
LIGHT-POWERED COSMIC ENFORCER

First released 2013 • Member of the Heroic Warriors

Accessories:
• Dark Star meteor
• Unmasked Zodak head

Strobo made a single appearance in the fall 1988 issue of Masters of the Universe Magazine. He was planned as a part of a series of figures made up entirely of preexisting parts, but that series was never released in the vintage line.

Strobo's gimmick was that he could spin in circles (reusing Sy-Klone's action feature) while reflecting light from a mirrored sticker on his chest. The Classics figure doesn't have the spinning action feature, but he does have a mirrored sticker on the center of his chest.

Strobo comes with an artifact from the story he appeared in—a Dark Star meteor fragment that has the power to enslave, so long as it is not exposed to light. He was slated to come with a strobe rifle, but that piece costed out and was released separately with Weapons Pak #4 (End of Wars Assortment). Strobo also comes with an alternate, unmasked, head intended to be used with Zodak.

Strobo reuses Sy-Klone's chest, forearms and boots; Zodac's head; Icarius's trunks; and King Grayskull's thighs, upper shins, shoulders, biceps, and hands.

STRONG-OR
EVIL POWER-PUNCHING WARRIOR

First released 2013 • Member of the Evil Warriors

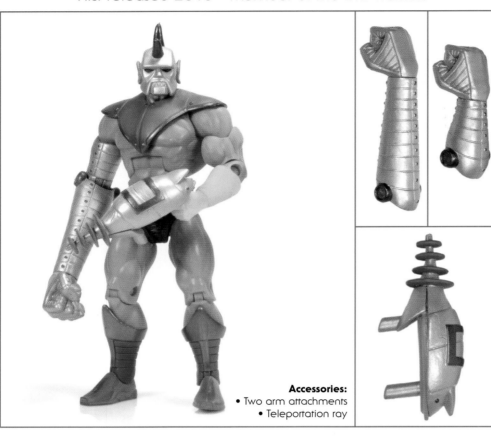

Accessories:
- Two arm attachments
- Teleportation ray

Strong-Or is based on the character of Strongarm, who appeared in the episode "She-Demon of Phantos" in Filmation's He-Man and the Masters of the Universe series. Unfortunately, at the time the figure was being prepared for production, the name "Strongarm" had been trademarked by another company, so this figure was released as "Strong-Or." Mattel never produced a Strongarm figure in the vintage line, but the concept was further developed and eventually released as Jitsu.

Strong-Or comes with two removable arm attachments, simulating his power to extend the length of his arm, as shown in the episode. He also comes with the teleportation ray that Skeletor used in the episode "Teela's Triumph." Despite his colorful costume, Strong-Or is a formidable-looking evil warrior with a mean right hook.

Strong-Or reuses the torso, shoulders, left bicep, left hand, thighs, and upper shins of King Grayskull. His left glove reused from Hordak, and his feet are borrowed from Bow.

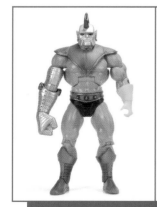
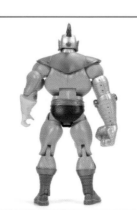

MOTUC - SECTION 1

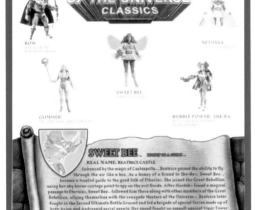

SWEET BEE
HONEY OF A GUIDE

First released 2014 • Member of the Great Rebellion

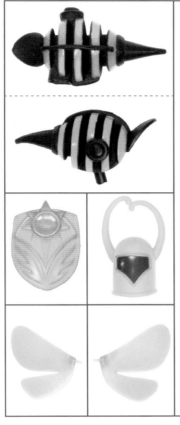

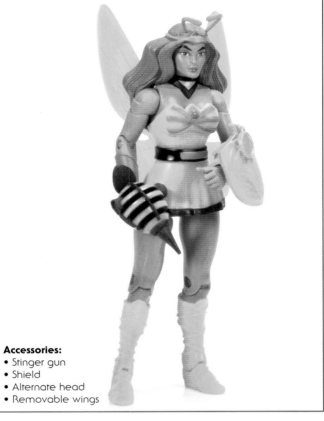

Accessories:
• Stinger gun
• Shield
• Alternate head
• Removable wings

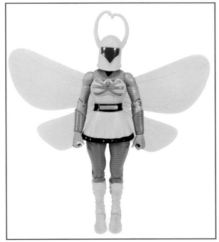

Sweet Bee is the second bee-themed figure released in the Masters of the Universe Classics line, after Buzz-Off. Unlike Buzz-Off, she is entirely human, other than her pink wings. Both the vintage 1986 figure and the animated version of the character had roughly the same design, other than perhaps the size of the antennae on her headband and the detail on her boots. In that regard Classics Sweet Bee splits the difference with a Filmation-style headband and vintage figure-style boots. Sweet Bee has a youthful face and wears a sporty costume.

Sweet Bee comes with a "stinger" gun, removable wings, a shield, and an alternative head. The helmeted head comes from the episode "Sweet Bee's Home." In the episode, Sweet Bee comes to Etheria in a ship from another world. Her spaceship is shot down by the Evil Horde, and she is wearing the helmet when she is rescued by the heroes. Sweet Bee reuses Double Mischief's boots, She-Ra's arms and shield, and Teela's thighs and hands.

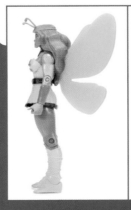

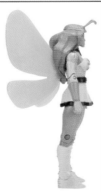

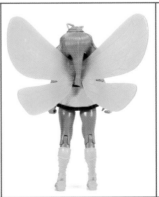

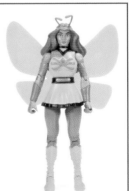

MOTUC - SECTION 1

SWIFTWIND
BEAUTIFUL HORSE, SPIRIT, BECOMES MAGICAL FLYING UNICORN
First released 2011 • Beast of the Great Rebellion

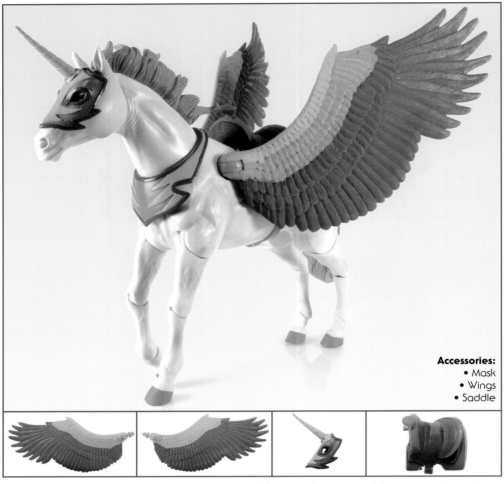

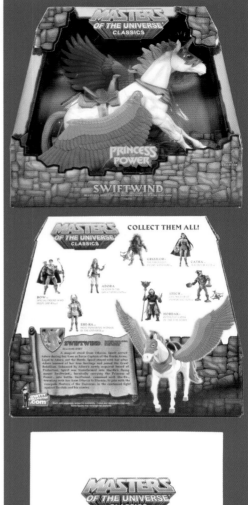

Accessories:
- Mask
- Wings
- Saddle

Swiftwind is one of the largest and most impressive steed figures in the Masters of the Universe Classics line. She-Ra's winged unicorn mount is an entirely new sculpt, with intricate feathered wings and a design that is detailed enough to include sculpted veins along the horse's body.

Swiftwind is based on the animated version of the character, rather than the vintage toy, which had a pink, gold, and white color scheme. Swiftwind has fully-articulated legs, tail, head, and neck, allowing the figure to assume a number of dynamic poses. The unicorn horn is sculpted to the removable mask, which can be affixed to the figure by means of a strong internal magnet. The saddle and wings are also removable, although the collar is not. With the wings and mask removed, the figure makes for a passable interpretation of Spirit, who is the Princess of Power equivalent to Cringer.

Many of Swiftwind's sculpted parts would later be reused for Bow's horse, Arrow.

FUN FACTOID: According to the Four Horsemen, horse anatomy is tough to translate into an articulated action figure, and Swift Wind was no exception.

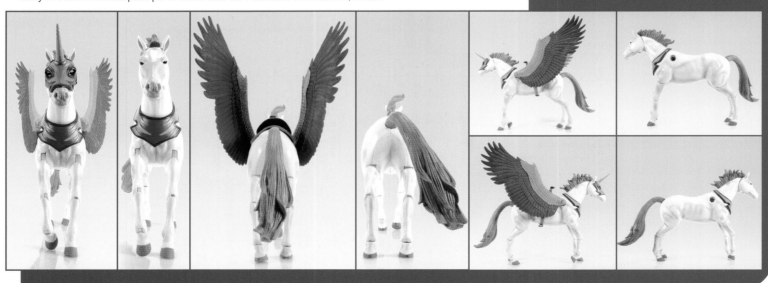

SY-KLONE
HEROIC FIST-FLINGING TORNADO

First released 2011 • Member of the Heroic Warriors

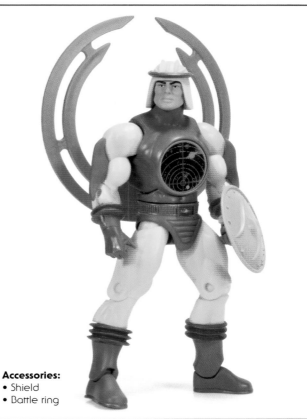

Accessories:
• Shield
• Battle ring

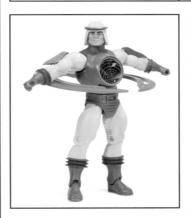

Sy-Klone is one of the most colorful characters in the Masters of the Universe Classics lineup, with a vivid yellow, blue, and red color scheme and a lenticular radar sticker affixed to his chest. The figure is almost entirely based on the original 1985 toy. The lenticular sticker is of course carried over. It looks like a radar screen with a cosmic background. As the figure is tilted from side to side, the radar swipes across the "screen." His entire design has something of a Jetsons feel to it, with red, Saturn-like rings around his helmet, gloves, and boots.

The vintage figure had a spinning-waist action feature, which was activated by spinning a wheel on the back of the figure's belt. That action feature wasn't carried over to Classics, but a simulated wheel appears on the Classics figure nevertheless.

Sy-Klone has quite a number of new parts, but he does carry over a few pieces from previous figures, including hands from Hordak, shoulders and legs from King Grayskull, and feet from Keldor. He comes with his vintage-inspired shield as well as a slight nod to the 200X figure: a red battle ring that can be attached to his back, either vertically or horizontally, like a spinning hula hoop of doom.

FUN FACTOID: The Four Horsemen said, "After such a departure in the 200X line it was fun to return to the original look in all of his lenticular glory. Again we were lucky enough to later do a 200X head, which combined with the giant ring on his back, gave him a convincing modern look."

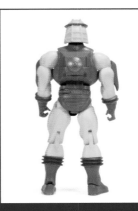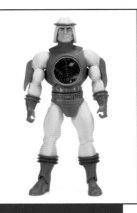

MOTUC - SECTION 1

TALLSTAR

TALLSTAR
LOVELY LOOKOUT

First released 2012 • Member of the Great Rebellion

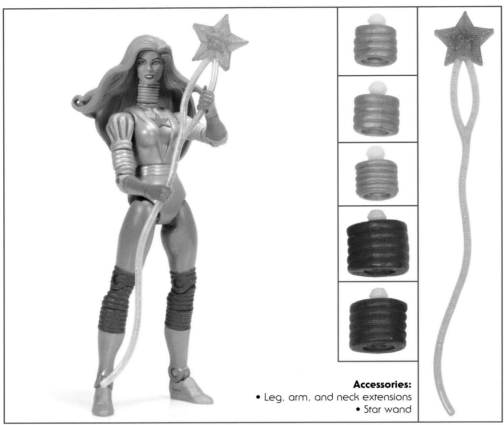

Accessories:
- Leg, arm, and neck extensions
- Star wand

Tallstar is based on one of three unreleased vintage prototypes known as the Star Sisters. Her design cues are taken from a poster version of the figure, which is a rather more streamlined and Filmation-like interpretation of the character.

The prototype figure had accordion-like sections on her legs, arms, and neck which would allow each of those parts to be stretched out. As with Mekaneck, Rattlor, and Terroar, this extending action feature is approximated with the use of removable extensions that make the figure taller and longer limbed.

Tallstar shares the same wand as Starla and Jewelstar, except cast in translucent, sparkling orange. She has long pink hair and a flashy orange, blue, and metallic purple costume. She reuses hands and feet from Teela but otherwise is constructed of newly created parts.

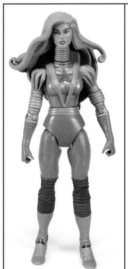
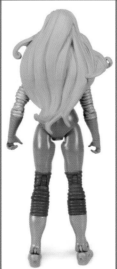
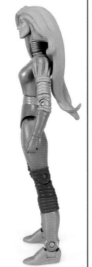

642 THE TOYS OF MASTERS OF THE UNIVERSE

MOTUC - SECTION 1

TANK TOP
ARMORED GLADIATOR

First released 2012 • Heroic Warrior

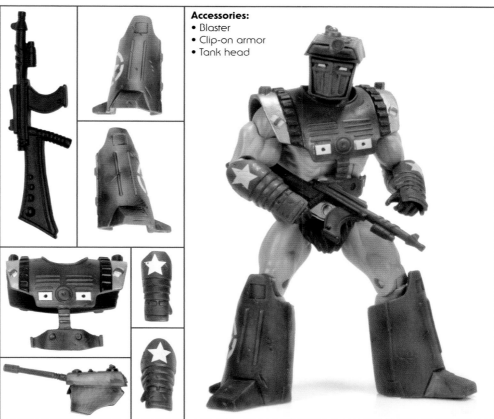

Accessories:
- Blaster
- Clip-on armor
- Tank head

Released as the 2012 San Diego Comic-Con Exclusive, the Vykron pack paid homage to the Roger Sweet prototypes from when the original Masters of the Universe toy line was being pitched. Roger's idea included a character that could be three different things: a barbarian, a military man, or a sci-fi fighter! This three-pack comes with one action figure and three different outfits, allowing you to swap the armor around to create these three different concepts that Roger originally pitched for the line.

Tank Top is the name given to the military-themed character. He includes a belt, clip-on boots, armor, clip-on arm guards, and an interchangeable head that looks like a tank. The design of the character is quite odd, as he essentially has a gun for a face. But the weird design of that original prototype is brought to life officially with this figure.

The packs were released with the figure wearing one of the outfits, selected at random, meaning some of these feature Tank Top in the center of the packaging.

MOTUC - SECTION 1

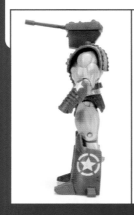
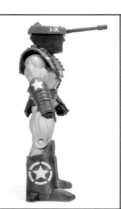
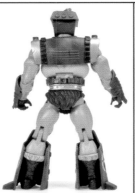
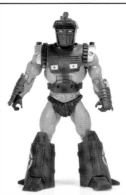

TEELA
WARRIOR GODDESS

First released 2009 • Member of the Heroic Warriors

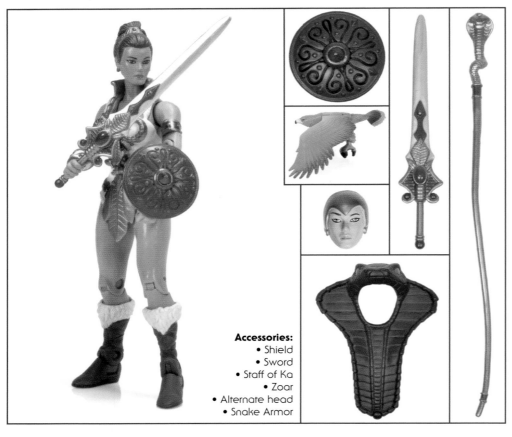

Accessories:
- Shield
- Sword
- Staff of Ka
- Zoar
- Alternate head
- Snake Armor

Teela was one of the original eight action figures released in the vintage Masters of the Universe toy line. She was released early in the first full year of Masters of the Universe Classics as the first female figure of the line, and she's also among the figures with the most accessories, allowing for many ways to display the figure.

Teela heavily benefits from the updated sculpt. The original action figure had removable Snake Armor, although the character was rarely depicted wearing this in most MOTU story media. Many fans were much more familiar with how Teela appeared in the Filmation cartoon series. This action figure includes the option to display her both ways, as her figure is packaged with an additional head wearing a golden helmet, which the included Snake Armor perfectly fits over. But she also has a swappable unhelmeted head that features the red hair tied back in a short ponytail that is much closer to the cartoon's look.

Like the vintage toy, she also comes with her snake staff, Ka, and a shield that clips on her wrist just as it did on the original toy. She also includes a new sword, modeled after the sword that was included with the 200X version of the character.

And as an added bonus, Teela is also packaged with Zoar the falcon. This falcon is based on the look of the bird from the vintage toy line, but this time scaled down to a more appropriate size. The bird features articulated wings and even has removable red armor and a perch to stand on, all modeled after the original toy!

 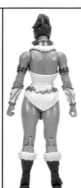 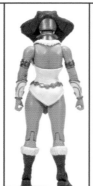 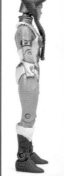

FUN FACTOID: The Four Horsemen used the cardback art (along with the original Mark Taylor designs) to punch up the detail, but mainly they felt her original figure has stood the test of time as a true classic.

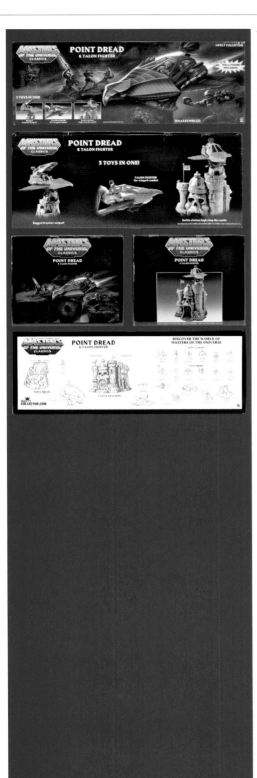

TEELA
HEROIC CAPTAIN OF THE ROYAL GUARD

First released 2015 • Member of the Heroic Warriors

Accessories:
- Shield
- Sword
- Alternate head

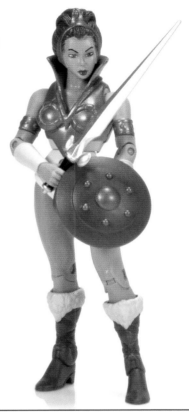

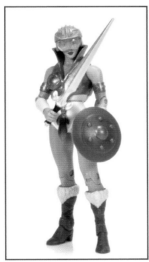

A brand-new Teela action figure was included as a bonus with the Point Dread and Talon Fighter box set. This version is meant to look more like the way she was depicted in the Filmation He-Man and the Masters of the Universe cartoon series.

The outfit is a little less detailed, and is modeled after the cartoon look, with the lighter color. She also features a brand-new head sculpt that also is designed to look like the cartoon version. She comes with the usual shield and a new sword, which is inspired by the weapon she typically used in the cartoon.

She also comes with an interchangeable head wearing a pilot helmet, which is intended for piloting the Talon Fighter that she is included with.

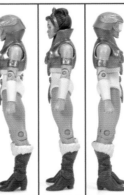
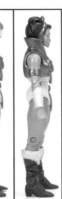
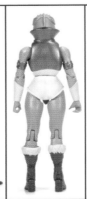

TEMPLE OF DARKNESS SORCERESS
HEROIC GUARDIAN OF CASTLE GRAYSKULL

First released 2012 • Member of the Heroic Warriors

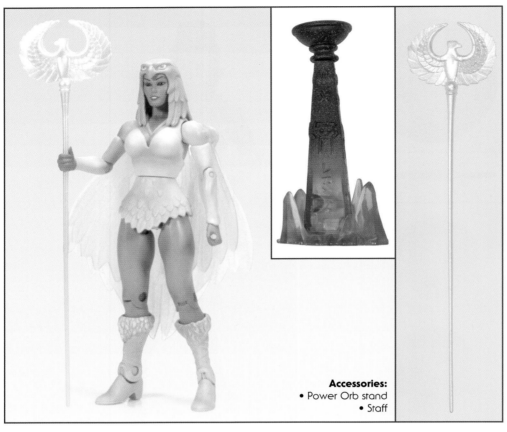

Accessories:
• Power Orb stand
• Staff

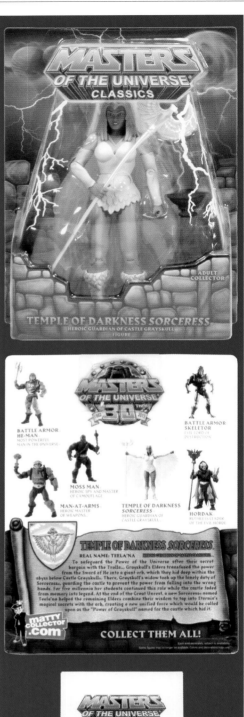

Temple of Darkness Sorceress is more or less a repaint of the standard orange-and-blue Sorceress figure released earlier in 2012. In this release, her costume is varying shades of white. Rather than Zoar, Temple of Darkness Sorceress comes with an orb stand designed to hold the orb that comes with King Grayskull. She also includes her classic bird-staff weapon. She shares the same sculpture as the previous Sorceress, with the exception of her boot tops, which are borrowed from Teela.

The white costume and name are a reference to the 1984 minicomic Temple of Darkness! where the Sorceress is depicted all in white. She also is colored this way in other vintage minicomics, including The Obelisk and Masks of Power.

The orb stand she comes with is cast in a translucent blue, with a speckled gray overspray at the top. The design is reminiscent of internal elements of Castle Grayskull as it appeared in the 2002 Mike Young Productions cartoon. It also features symbols for He-Ro, King Grayskull, and the Sorceress along the sides.

Temple of Darkness Sorceress reuses shoulders, biceps, and feet from She-Ra, and hands, thighs, shins, and boots from Teela.

FUN FACTOID: This was a traveling exclusive that Mattel took to a few conventions and eventually sold online. An ideal choice for an exclusive, it came from a single appearance in a minicomic and was easily attainable despite being an exclusive.

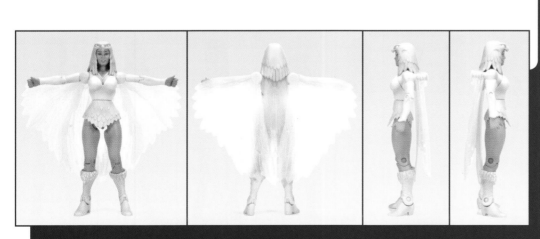

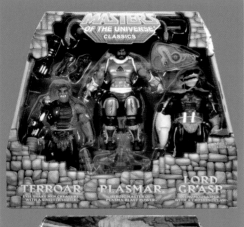

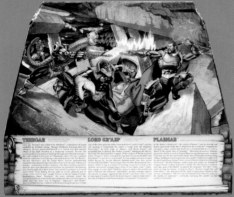

TERROAR
EVIL SNAKE MEN CREATURE WITH A SINISTER SHRIEK

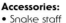

First released 2017 • Member of the Snake Men

Accessories:
- Snake staff
- Laser attachment
- Hook attachment
- Neck extension
- Claw attachment

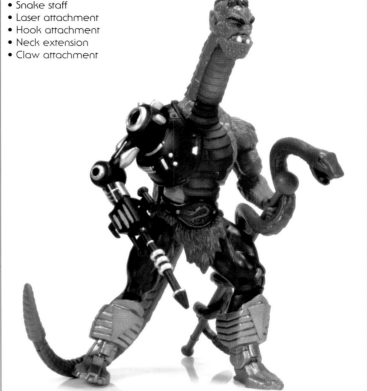

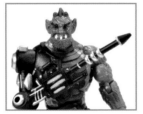

Terroar was released in an exclusive Power-Con three-pack, along with Lord Gr'Asp and Plasmar. The character was discovered in a group of unused figure packaging art done by artist Errol McCarthy. He was one of several planned but unproduced figures from the vintage line that would have been made entirely from parts recycled from previous figures.

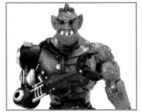

Terroar reuses Whiplash's head; Rattlor's neck extension, torso, left arm, tail, and loincloth; Trap Jaw's right arm, attachments, and chest armor; King Grayskull's legs; and Mosquitor's boots. It's not known what the vintage Terroar's color scheme would have been, but the Classics version has a two-tone purple color scheme with a silver-and-black costume. The color scheme serves to somewhat obscure the fact that all of his parts have been recycled from previous characters. Terroar helps to round out the Snake Men faction while at the same time expanding its color palette.

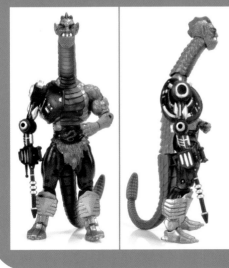

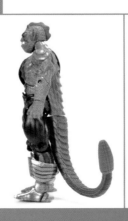

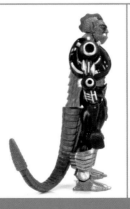

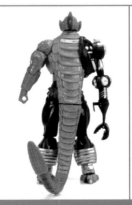

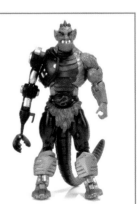

TERROR CLAWS SKELETOR
EVIL LEADER WITH THE CLAW-SWINGING ACTION!

First released 2015 • Member of the Evil Warriors

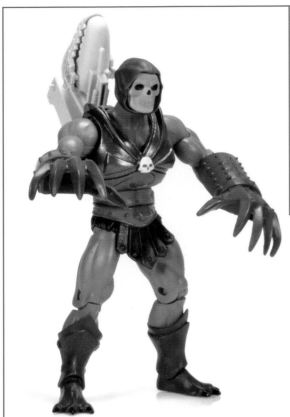

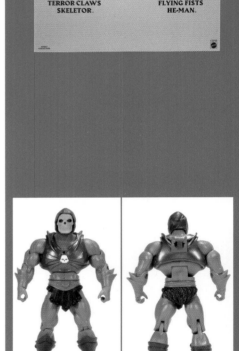

Accessories:
- Skull weapon
- Terror Claws

Terror Claws Skeletor was released in a gift set with his heroic counterpart, Flying Fists He-Man. He is based on the vintage 1986 figure, with a few key differences. The vintage figure had unique arm and leg sculpts (his feet were especially different from previous releases), while the Classics version opts to reuse the arms and legs (and indeed the whole body) from the 2009 Skeletor release. The vintage figure also lacked the Roman-style balteus belt from the 1982 Skeletor, but the Classics Terror Claws Skeletor includes that detail. The Classics figure is cast in a slightly darker blue color, which seems to be a homage to the vintage cross-sell artwork.

Terror Claws Skeletor includes the newly sculpted Terror Claws and skull weapon, as well as removable metallic-purple armor. As with the vintage figure, there is a clip in the back that can be used to store the skull weapon, which, like its vintage counterpart, has an articulated jaw.

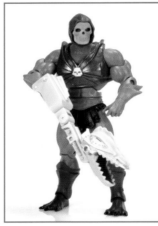

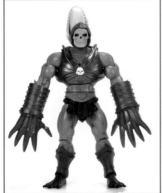

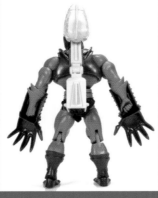

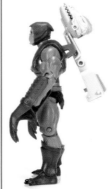

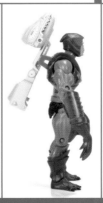

MOTUC - SECTION 1

THUNDER PUNCH HE-MAN
HEROIC LEADER WITH A POWER PUNCH

First released 2012 • Member of the Heroic Warriors

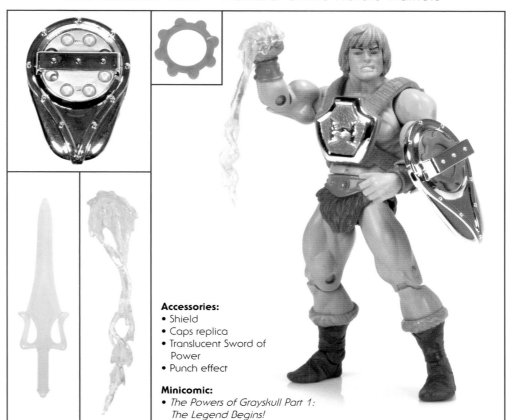

Accessories:
- Shield
- Caps replica
- Translucent Sword of Power
- Punch effect

Minicomic:
- *The Powers of Grayskull Part 1: The Legend Begins!*

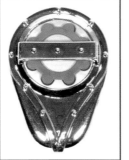

Thunder Punch He-Man is a pretty close re-creation of the vintage 1985 figure, down to a replica set of caps that really fit in his backpack. The figure of course lacks the cap-blasting action feature of the original, but it certainly conjures the feeling of playing with the original.

Thunder Punch He-Man's caps can be placed in either the backpack or in his vac-metal shield, as in the original. He features a translucent yellow version of the Sword of Power, and as an added bonus comes with a blast effect that fits on his right fist, simulating the power of his "Thunder Punch."

He-Man's right fist is newly sculpted for the figure, and quite well detailed. His armor (which includes vac metal detail), shield, and caps replica are new as well. Everything else is reused from previous figures. He-Man's body is borrowed from King Grayskull, and his head is from the original 2008 He-Man release. His left forearm comes from Tri-Klops.

FUN FACTOID: In this pretty straightforward update, Thunder Punch He-Man's new fist and unique accessories were enough to make up for his lack of the vintage action feature.

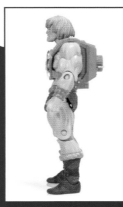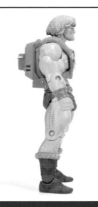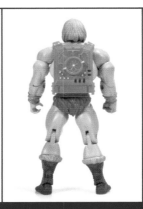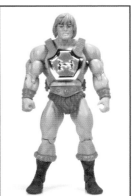

MOTUC - SECTION 1

TRAP JAW
EVIL AND ARMED FOR COMBAT

First released 2010 • Member of the Evil Warriors

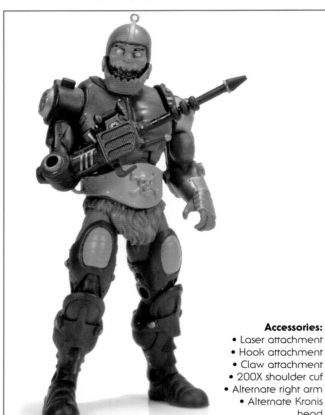

Accessories:
• Laser attachment
• Hook attachment
• Claw attachment
• 200X shoulder cuf
• Alternate right arm
• Alternate Kronis head

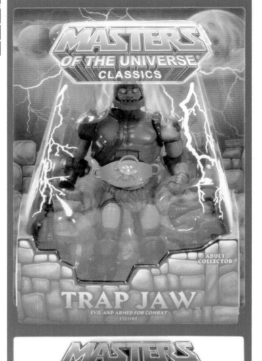

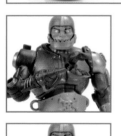

Trap Jaw is absolutely brimming with accessories and options for display. His two primary modes of display are as vintage-style Trap Jaw, and as Kronis, his name before his right arm and jaw were replaced with mechanical prosthetics. The Kronis backstory (which is referred to in Trap Jaw's bio) originates from the 200X series of comics. To that end, Trap Jaw comes with his intact Kronis head and right arm, which can be popped on in place of the more familiar iron-jawed head and robotic arm. His left arm is also removable, allowing you to take off, if you wish, a shoulder cuff that recalls the 200X Trap Jaw figure.

As with the vintage version, Trap Jaw includes a removable belt and three attachments for his robotic arm. All of his black accessories have a bit of metallic blue detailing not present on the 1983 figure. His arms also have additional metallic blue hits, whereas the vintage counterpart was cast in solid blue with just a bit of green detail.

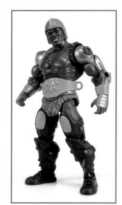

FUN FACTOID: Trap Jaw, a favorite of the Four Horsemen, was the first figure in the line to push the limits of what accessories could be included with a single figure.

Trap Jaw comes with quite a number of newly created parts, which would get a lot of reuse over the life of the Masters of the Universe Classics line. His chest (not including some of the inner connecting parts) is borrowed from King Grayskull, and his loincloth comes from He-Man.

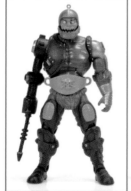 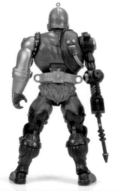 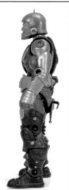 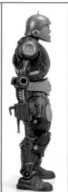 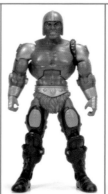 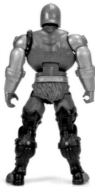 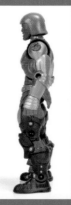 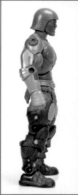

MOTUC - SECTION 1

TRAP JAW
EVIL CYBORG CRIMINAL WITH AN "IRON JAW"

First released 2017 • Member of the Evil Warriors

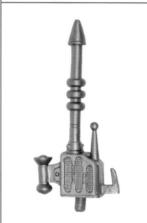

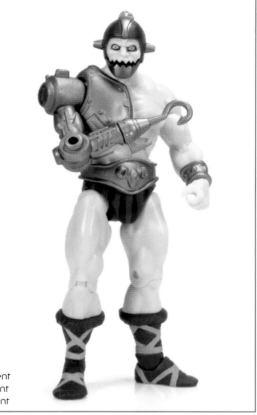

Accessories:
- Hook attachment
- Claw attachment
- Laser attachment

The three-pack Power-Con exclusive Trap Jaw is a refresh of the character, based on his appearance in the vintage minicomic The Menace of Trap-Jaw! Following the general design from the story, Trap Jaw has pale green skin, dark mechanical parts, and red He-Man-style boots.

The figure includes a couple of newly sculpted pieces, most notably his belt/loincloth and head. His jaw isn't articulated (unlike the 2010 Trap Jaw release), but his new head is slimmer, and recolored, after the look of the minicomic (which was in turn based on early concept art for the character).

Trap Jaw's cybernetic parts are reused from the 2010 Trap Jaw figure, while the rest of his body comes from King Grayskull. His left forearm is reused from Tri-Klops.

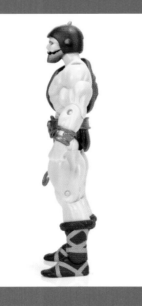

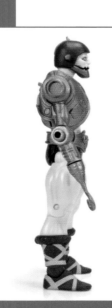

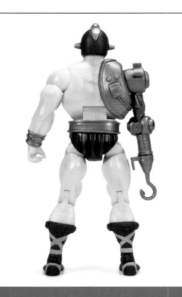

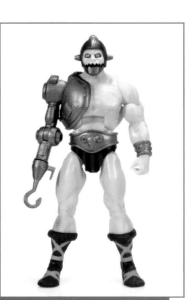

TRI-KLOPS
EVIL & SEES EVERYTHING

First released 2009 • Member of the Evil Warriors

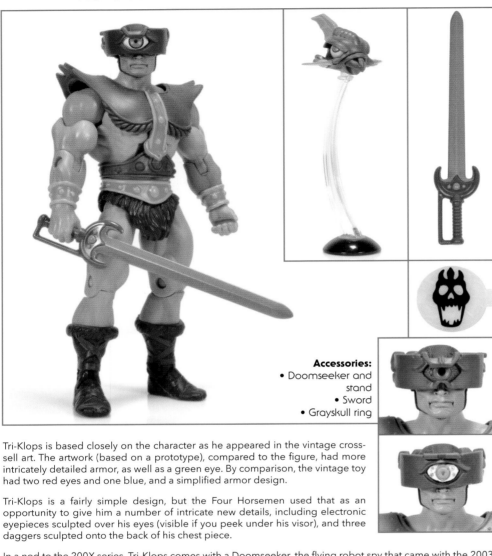

Accessories:
- Doomseeker and stand
- Sword
- Grayskull ring

Tri-Klops is based closely on the character as he appeared in the vintage cross-sell art. The artwork (based on a prototype), compared to the figure, had more intricately detailed armor, as well as a green eye. By comparison, the vintage toy had two red eyes and one blue, and a simplified armor design.

Tri-Klops is a fairly simple design, but the Four Horsemen used that as an opportunity to give him a number of intricate new details, including electronic eyepieces sculpted over his eyes (visible if you peek under his visor), and three daggers sculpted onto the back of his chest piece.

In a nod to the 200X series, Tri-Klops comes with a Doomseeker, the flying robot spy that came with the 2003 figure. This version is of course larger, and also painted in green and orange, to match Tri-Klops's costume. He also comes with a glow-in-the-dark Grayskull ring. The ring originally came in specially marked packages of the 1983 Tri-Klops figure (as well as Trap Jaw). This version is very closely modeled on the original version, but scaled to fit an adult.

Tri-Klops' body is largely reused from pieces first used for King Grayskull and He-Man. However, he has a newly created symmetrical left bracer, which would be reused for a number of figures that came after him.

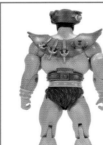
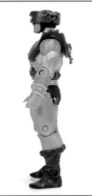
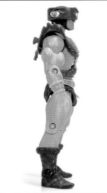

FUN FACTOID: Though the sculptors were faithful to the vintage card back art for Tri-Klops, they were able to add some hidden elements, such as the details under his visor.

MOTUC - SECTION 1

TUNG LASHOR
EVIL SNAKE MEN CREATURE WITH THE VENOMOUS TONGUE

First released 2014 • Member of the Snake Men

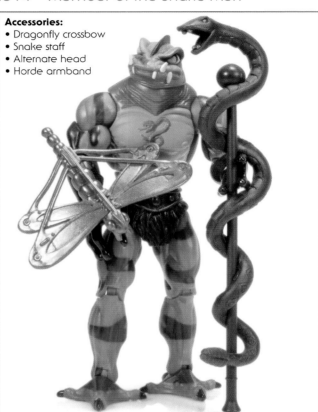

Accessories:
- Dragonfly crossbow
- Snake staff
- Alternate head
- Horde armband

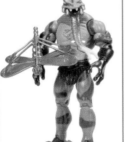

Tung Lashor is one of the most bright and colorful characters in the Snake Men faction. His Classics action figure is largely based on the original 1986 toy, but there are a few nods to his 200X design as well. The 200X influence is mostly present in the black claws on his feet, and in the "teeth" on the extended tongue on his alternate head. The original 1986 figure had a wheel on its back that could be used to extend and retract a thin plastic tongue. That feature is simulated with the inclusion of two heads, one with and one without an extended tongue.

Tung Lashor has a vivid pink, purple, and orange color scheme. He looks a bit more like a poison dart frog than a snake, but the Snake Men faction seems to be open to just about any cold-blooded creature. He comes armed with the same weapons the vintage figure had: a purple repaint of King Hssss's staff and a unique dragonfly crossbow that somewhat recalls the weapons used by the Evil Horde.

Speaking of the Evil Horde, Tung Lashor comes with a removable Evil Horde armband, should you wish to use him in that faction. He was aligned with the Horde in the Filmation She-Ra cartoon series.

Tung Lashor has quite a few unique pieces, but like most Classics figures, he does reuse some previous parts. As previously mentioned, he reuses King Hsss' snake staff. He also recycles King Grayskull's shoulders, biceps, and thighs; Demo Man's shins; and He-Man's loincloth.

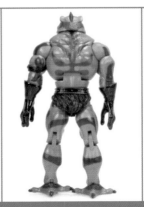

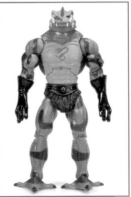

TUSKADOR
MIGHTY TUSKED GALACTIC GUARDIAN

First released 2016 • Member of the Galactic Guardians

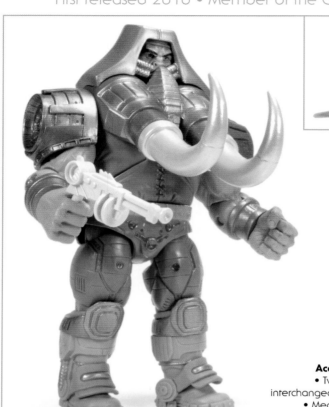

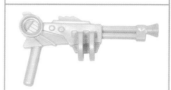

Accessories:
• Two sets of interchangeable tusks
• Mega Blaster
• Removable helmet

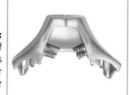

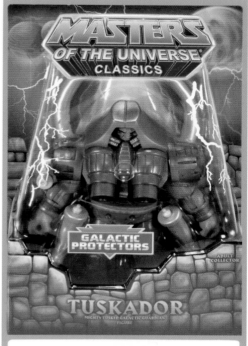

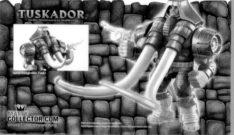

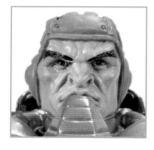

Tuskador is one of the standout heroic figures from the Galactic Guardians faction of the Masters of the Universe Classics line. Most of his compatriots wear fairly conventional futuristic costumes, but Tuskador looks like a space-age elephant.

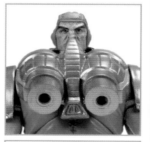

Tuskador reuses the torso, arms, hands, and feet from the 2013 Ram Man release. Despite this reuse, the figure is a pretty accurate reproduction of the 1991 figure, albeit beefed up dramatically. The original Tuskador wasn't really any larger than the other figures released in 1991, but Mattel opted to make his Classics figure a real bruiser.

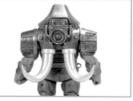

Tuskador's costume is dominated by metallic gold and blue. Removing his helmet reveals a weather-beaten face, with one of the more detailed sculpts of the Classics line. He comes with long and short tusks. The short tusks give the figure a more cartoonish look, while the longer ones help him achieve his vintage action figure bull elephant stance. His Mega Blaster is cast in the same ivory white as his tusks.

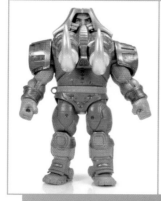

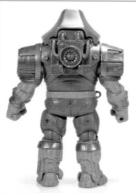

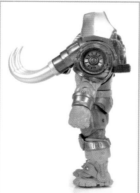

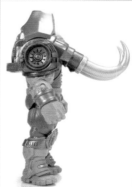

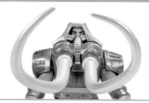

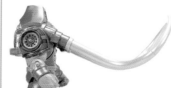

MOTUC - SECTION 1

TWISTOID
EVIL ENERGY CYBORG

First released 2015 • Member of the Evil Warriors

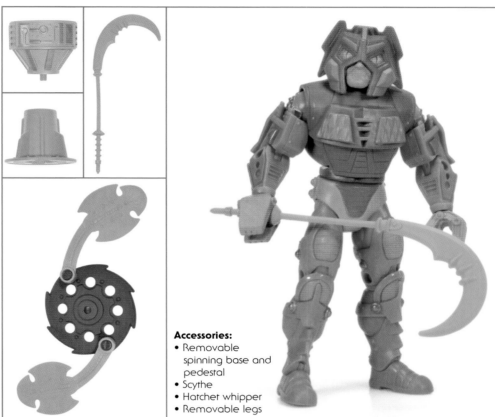

Accessories:
- Removable spinning base and pedestal
- Scythe
- Hatchet whipper
- Removable legs

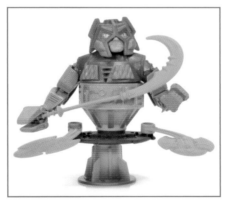

Twistoid was packaged in a gift set with his heroic spinning nemesis Rotar and offered as an exclusive for the 2015 San Diego Comic-Con. He is closely based on the original 1987 spinning-top figure. Unlike the vintage toy, the Classics Twistoid is not a functioning top. However, as an added bonus, he comes with a set of removable legs so you can display him as a more regular-looking warrior.

Twistoid has a very colorful purple, blue, and green color scheme. He has a fairly clunky robotic design, giving him something of a retrofuturistic look. Like the original 1987 toy, Twistoid is somewhat rare and hard to find on the secondary market but is an essential acquisition for MOTU Classics completists.

Twistoid reuses King Grayskull's torso, Roboto's shoulders, Trap Jaw's legs and feet, and Optikk's loincloth.

In a packaging error, Twistoid's name appeared underneath Rotar and vice versa. Twistoid is also mistakenly referred to as a cyborg in his tagline, when it is actually Rotar who is the cyborg.

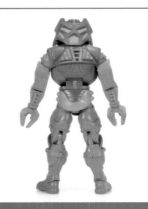
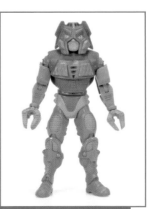

MOTUC - SECTION 1

TWO BAD
DOUBLE-HEADED EVIL STRATEGIST
First released 2014 • Member of the Evil Warriors

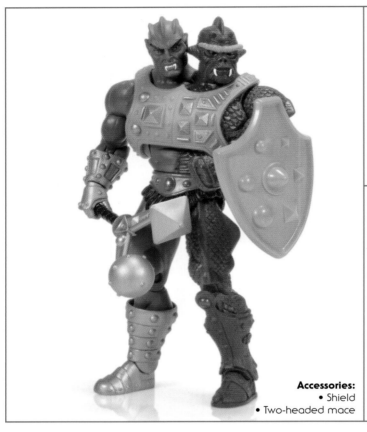

Accessories:
• Shield
• Two-headed mace

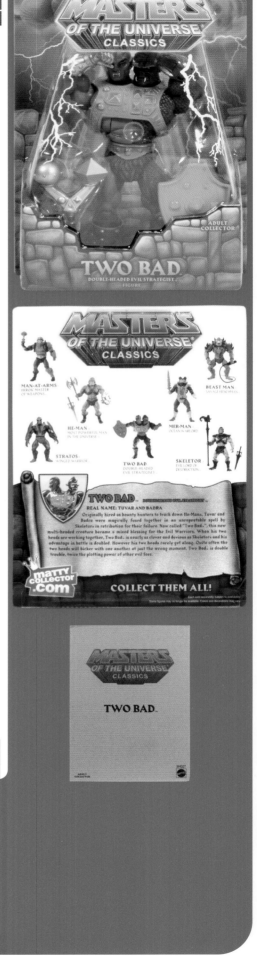

Two Bad was one of the most anticipated figures of the Masters of the Universe Classics line. Based mostly on the vintage 1985 figure, Two Bad has a great deal of sculpted and painted detail, from the minute scales on the purple half of the figure to the textured leather apparel and metallic orange hits on his armor.

The figure departs slightly from the vintage and 200X versions of the character, in that his purple and blue sides are split cleanly down the middle. He includes his vintage shield as well as his 200X-style double-headed mace. He sports quite a slim profile compared to the vintage toy, which had dual spring-loaded arms permanently cocked at a ninety-degree angle to the torso.

Two Bad sports quite a few newly sculpted pieces. His only reused parts are He-Man's loincloth and King Grayskull's right leg, shoulder, and bicep.

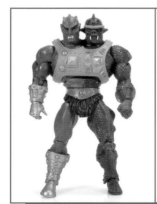

MOTUC - SECTION 1

TYTUS
HEROIC GIANT WARLORD

First released 2010 • Member of the Heroic Warriors

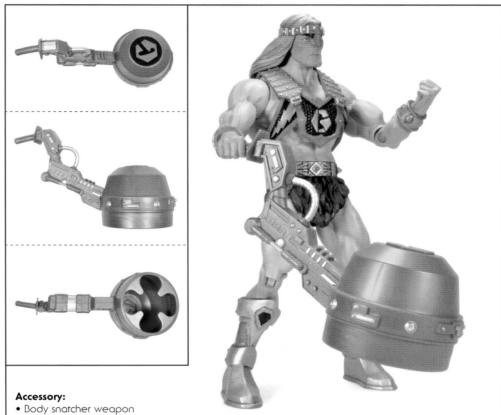

Accessory:
• Body snatcher weapon

Tytus is based on the rare giant action figure released in 1988 and available only in Europe. Like most Masters of the Universe Classics figures, Tytus ramps up the details compared to the source material, including sculpted hair rather than rooted hair. Unlike most Classics figures, Tytus is actually a few inches shorter than his vintage counterpart, for cost reasons.

Tytus retains his vintage "body snatcher" weapon, which is shaped so that it can pick up and hold other action figures by their head. Tytus was intended for the abandoned Powers of Grayskull line. He has a classic barbarian look, with the exception of his weapon, which is adorned with technological design flourishes. The Classics version is the first time the figure has been reissued in any form.

FUN FACTOID: The first giant in Classics, Tytus helped build out a physically diverse toy line.

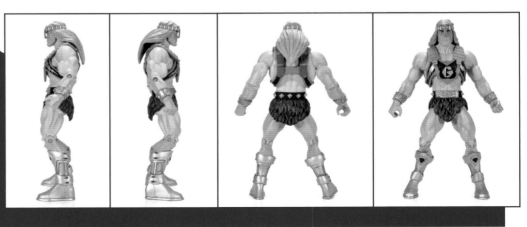

MOTUC · SECTION 1

UNNAMED ONE
THE LORD OF CHAOS

First released 2014 • Evil Trollan Served by the Snake Men

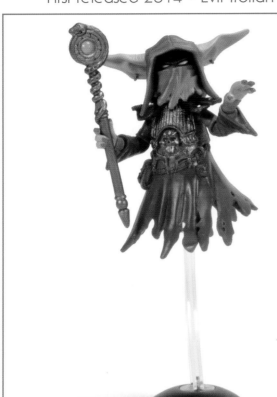

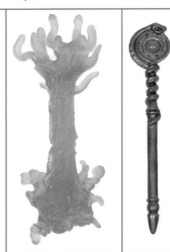

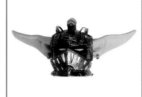

Accessories:
• Magical blast
• Wand
• Alternate head
• Stand

Minicomic:
• A New Era Begins (He-Man vs. Skeletor! Their Final Battle!)

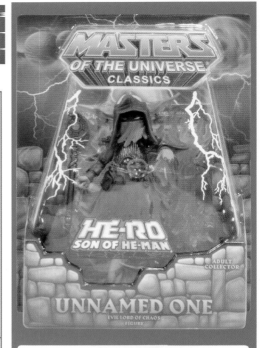

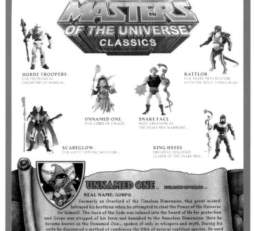

The Unnamed One is an evil Trollan figure, meaning that, like Orko, he has blue skin, pointed ears, and travels by floating. The physical similarities end there. A villain in the He-Ro, Son of He-Man faction, the Unnamed One has a highly detailed costume with chest armor, a skull decoration, chains, and a torn and tattered robe. He has oversized blue ears with earrings and malevolent yellow eyes. Some of his design elements, as conceived by frequent Four Horsemen collaborator Nate Baertsch, somewhat recall the 200X series. He comes with an alternative helmeted head for battle, which has a fittingly intimidating design.

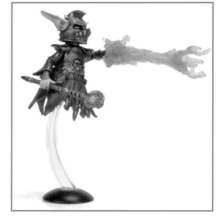

The Unnamed One's real name, Gorpo, was actually an early working name for Orko. The name "Unnamed One" was first mentioned in the vintage minicomic, The Powers of Grayskull: The Legend Begins! This mysterious character was the ultimate leader of the Snake Men, but his identity was never revealed. The Classics line fleshed out the idea of this character, making him an evil Trollan. To that end, the Classics figure comes with a wand somewhat reminiscent of Orko's, but with a snake design. His magical blast is green, presumably a visual nod to the idea that he created and controls the Snake Men.

FUN FACTOID: He was shipped with the Map of the Horde Empire as the 2014 Club Eternia exclusive (see page 537).

VIKOR
HE-MAN OF THE NORTH

First released 2011 • Ancestor of the Heroic Warriors

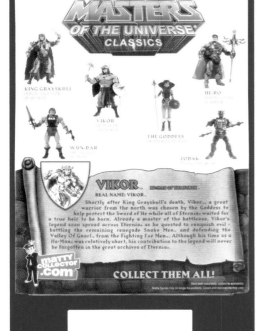

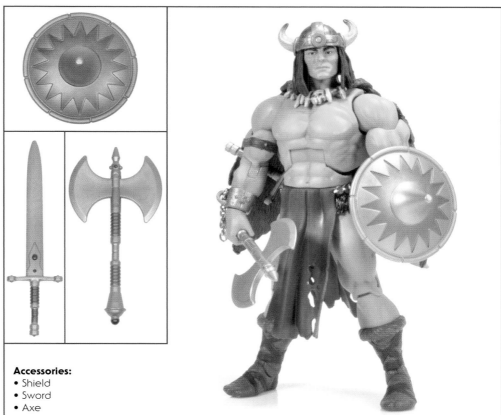

Accessories:
- Shield
- Sword
- Axe

Vikor is essentially an action figure of an early concept for He-Man. Designed by Mark Taylor, this original barbarian character that eventually became He-Man had a bit more of a Viking look, with a horned helmet and fur cape. This design was honored by being turned into a full-fledged new character for Masters of the Universe Classics.

The figure is essentially Mark Taylor's original artwork brought to life. All of the details of that original sketch, from the fur cape to the bone necklace, are seen on this brand-new action figure. Real metal chains hang from the shackles on the figure's wrists. He uses the same basic body as many figures in the line, but he has so many new little details that he truly feels unique and different.

The figure includes a new sword, axe, and shield—all of which are based on the original artwork, just like the figure itself. There's even a loop hanging from the back of his belt that allows you to store the sword behind the figure when not in use for battle.

You can treat him as a brand-new character or as a concept figure. Either way, Vikor is a great piece of Masters of the Universe history brought to life in action figure form for the first time, and he displays perfectly alongside Demo-Man, a villain who was once believed to have been an early concept for Skeletor.

FUN FACTOID: Vikor was based on one of Mark Taylor's concept designs for the original line. The Four Horsemen were eager to honor the barbarian concept by making him an official part of the line.

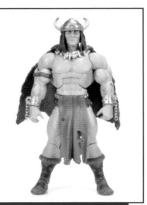

VULTAK
EVIL FLYING ZOOKEEPER

First released 2016 • Member of the Evil Horde

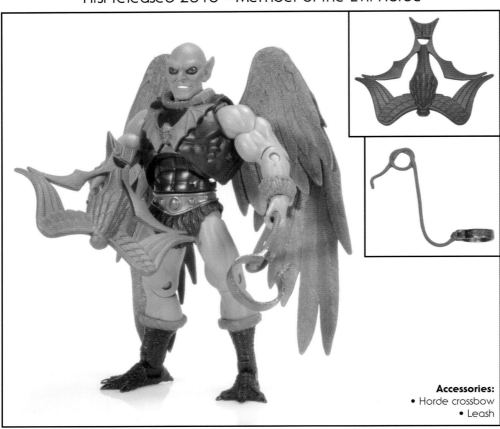

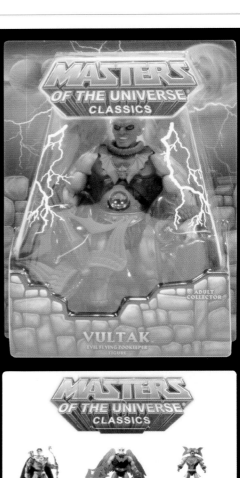

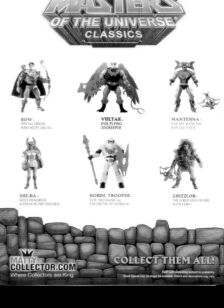

Accessories:
• Horde crossbow
• Leash

Vultak is based on the animated character from Filmation's She-Ra series. He's got quite a striking look, with huge bird-like eyes, a demonic-looking face, and articulated gray wings. Vultak reuses quite a number of existing parts, including King Grayskull's torso, legs, shoulders, and biceps, Angella's wings, He-Man's trunks, Icer's forearms, and Skeletor and Zodac's hands. For all of that he still looks unique and matches well with his animated source material. His boots are distinctive, looking something like a cross between He-Man's furry boots and Skeletor's three-toed boots, but with sculpted scales.

Vultak's Horde crossbow is a unique piece, with sculpted feather decorations befitting his character design. He also comes with a leash that fits around Kowl, which can be used to replicate a scene from the She-Ra animated series. His armor is fairly simple, a black vest with a bright red Horde symbol, but it certainly is effective at communicating what he represents.

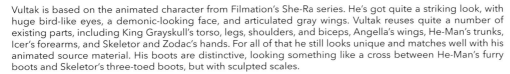

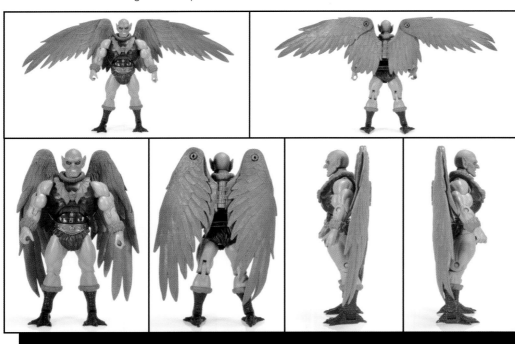

MOTUC - SECTION 1

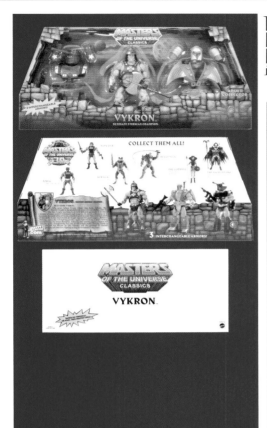

VYKRON
ULTIMATE ETERNIAN CHAMPION

First released 2012 • Heroic Warrior

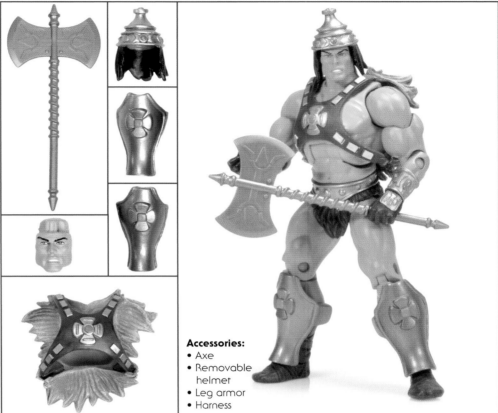

Accessories:
- Axe
- Removable helmet
- Leg armor
- Harness

Released as the 2012 San Diego Comic-Con Exclusive, the Vykron pack was intended to pay homage to the Roger Sweet prototypes from when the original Masters of the Universe toy line was being pitched. Roger's idea included a character that could be three different things: a barbarian, a military man, or a sci-fi fighter! This three-pack comes with one action figure and three different outfits, allowing you to swap the armor around to create these three different concepts that Roger originally pitched for the line.

Vykron is the name given to the barbarian-themed character. He includes shin guards, a power harness for his torso, a battle axe, and a removable helmet which has black hair attached to it. The original prototype is the one that most closely resembles what would eventually go on to be known as He-Man, and is obviously the route that Mattel took when they ultimately released the Masters of the Universe toy line. That makes Vykron here a pretty important piece of MOTU history.

The packs were randomly released with the figure wearing only one of the three outfits at random. That means some of these feature Vykron in the center of the packaging.

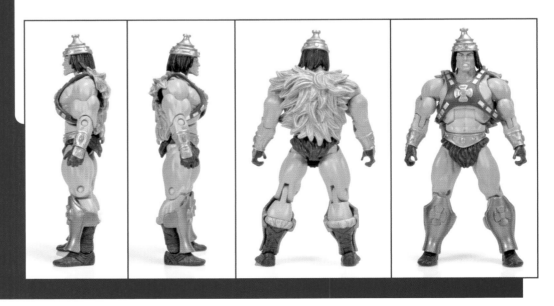

WALL DISPLAY SYSTEM

First released 2014

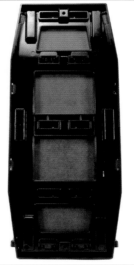

These wall-mounted display stands can accommodate up to six figures in a number of different scales. The sets come with two frames and six platforms that can be placed on various locations up and down the frames.

They also have swappable backgrounds: a yellow-orange burst pattern and a MOTUC Grayskull brick pattern.

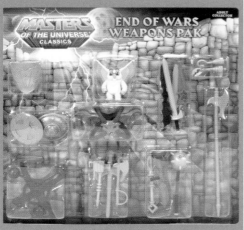

**END OF WARS
WEAPONS PAK**

FUN FACTOID: Getting these into the Classics line was not only a nod to the vintage line but also an effective way to meet fan requests and correct missed opportunities on already released figures.

WEAPONS PAK: END OF WARS
VICTORY OF THE GREAT REBELLION

First released 2013

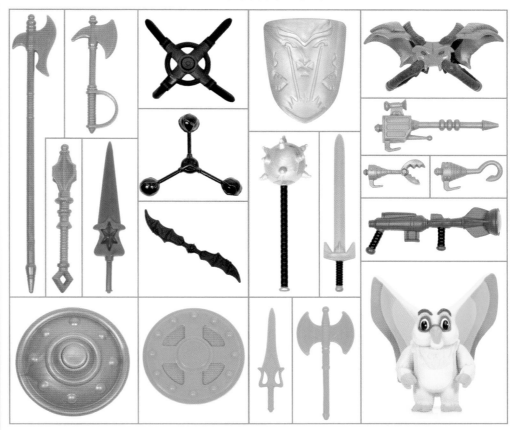

The 2013 End of Wars Weapons Pak is in the tradition of the first MOTU Weapons Pak, released in 1984 with a number of recolored figure weapons. The 2013 collection includes:

- Halberd, shield, axe, and club in gold
- Hurricane Hordak's attachments in black for Trap Jaw
- Sir Laser-Lot's sword, shield, and mace in gray
- Blue sword for Netossa
- Rattlor's 200X inspired armor
- Trap Jaw's arm attachments in gray for Roboto
- Strobo's blaster
- King Grayskull's Sword of Power, axe, and shield in green
- Kowl in vintage toy colors

MOTUC - SECTION 1

SHAREABLE ACCESSORIES

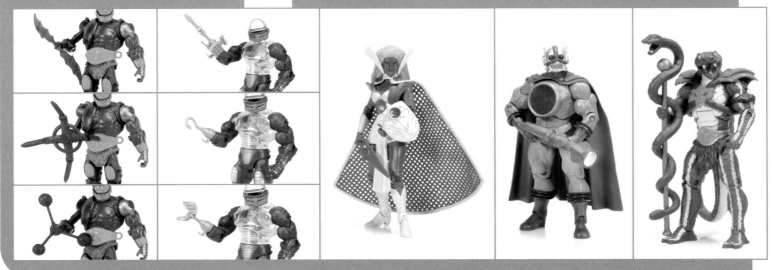

WEAPONS PAK: GREAT UNREST
FIGHT FOR THE CROWN OF ETERNIA

First released 2012

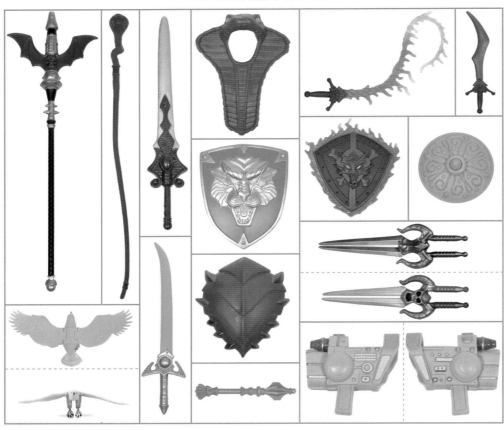

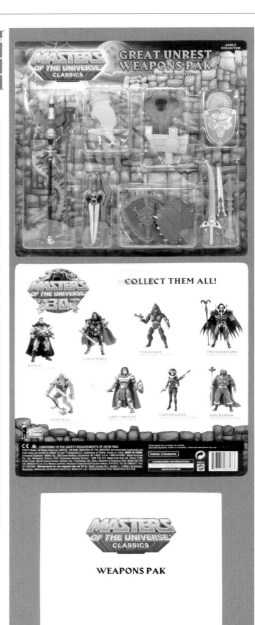

The 2012 Great Unrest Weapons Pak is in the tradition of the first MOTU Weapons Pak, released in 1984 with a number of recolored figure weapons. The 2012 collection includes:

- Staff for Horde Prime
- Teela's cobra armor, staff, and sword in red (vintage figure colors)
- Draego Man's purple sword, shield, and fire whip
- Chief Carnivus's sword and shield, in blue and silver (Eternia play set colors)
- Teela shield in blue (Evil-Lyn colors)
- Keldor's swords
- Zoar in white (for Temple of Darkness Sorceress)
- Clawful's mace and shield in green
- Man-At-Arms's arm cannon (200X-style)

SHAREABLE ACCESSORIES

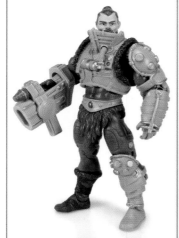

WEAPONS PAK: GREAT WARS
EPIC BATTLE OF PRETERNIA

First released 2010

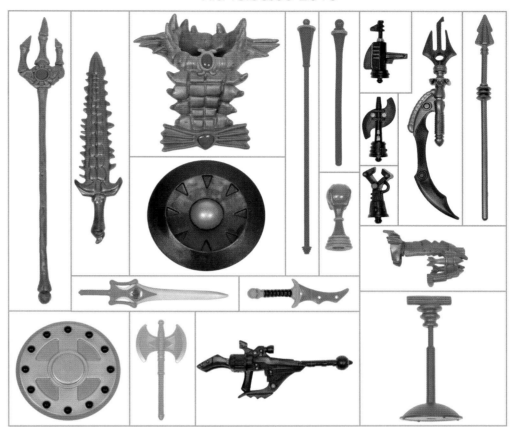

The 2010 Great Wars Weapons Pak is in the tradition of the first MOTU Weapons Pak, released in 1984 with a number of recolored figure weapons. The 2010 collection includes:

- Mer-Man's armor and weapons in gold (200X colors)
- Evil-Lyn's staff, wand, and knife in purple (200X colors)
- Three Roboto arm attachments in black (for Trap Jaw)
- Whiplash's spear in gold (for King Randor)
- Whiplash's electro shocker in gold (200X colors)
- Optikk's shield and blaster in black
- She-Ra's Sword of Protection in silver (cartoon colors)
- King Grayskull's axe and shield in orange (for Faker)
- Zoar's armor and stand in green (vintage cross-sell colors)

SHAREABLE ACCESSORIES

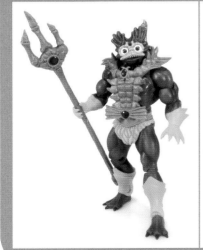

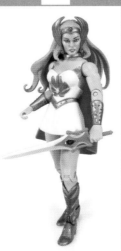

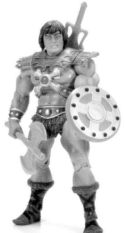

MOTUC - SECTION 1

WEAPONS PAK: ULTIMATE BATTLEGROUND
THE CONFLICT FOR ANCIENT ETERNIA

First released 2010

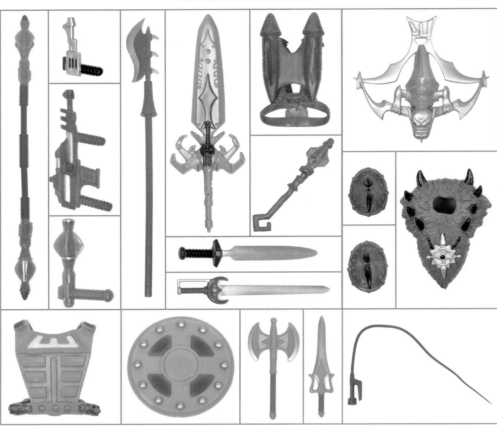

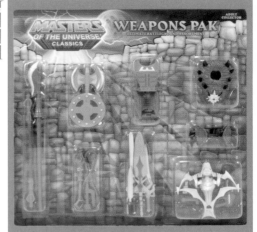

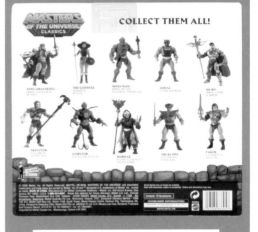

The 2009 Ultimate Battleground Weapons Pak is in the tradition of the first MOTU Weapons Pak, released in 1984 with a number of recolored figure weapons. The 2009 collection includes:

- Zodak's staff in pink
- Man-At-Arms's short sword and pistol in silver, with blue accents
- Scare Glow's halberd in gray (vintage Weapons Pak colors)
- The 200X style Sword of Power with green accents (200X colors)
- Stratos's backpack in red
- Silver Hordak crossbow
- Webstor's rifle in gray (vintage Weapons Pak colors)
- Moss Man's club in gray (vintage Weapons Pak colors)
- Beast Man's chest and arm armor in yellow (vintage Weapons Pak colors)
- Tri-Klops's sword in silver and gold (vintage cross-sell colors)
- Zodac's armor and gun in pink
- King Grayskull's Sword of Power, shield, and axe in blue (vintage Weapons Pak colors)
- Beast Man's whip in red

SHAREABLE ACCESSORIES

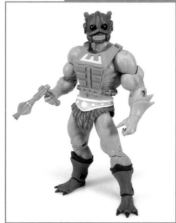

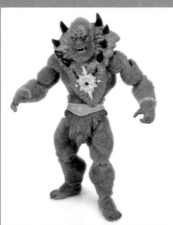

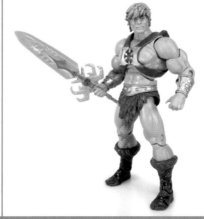

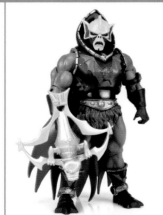

WEAPONS RACK
FORGOTTEN LEGEND OF CASTLE GRAYSKULL

First released 2011 • Accessory of the Heroic Warriors

WEAPONS RACK

FUN FACTOID: The Weapons Rack was an early taste of what could be done with Castle Grayskull in Classics.

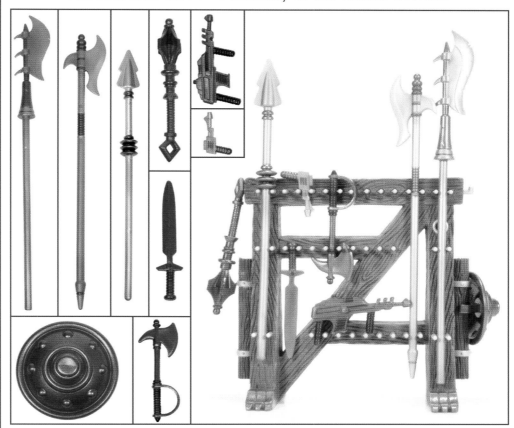

Inspired by the weapons rack and various armaments that came with the original 1982 Castle Grayskull, the Classics Weapons Rack ups the detail considerably compared to the source material. The rack itself is sculpted with a realistic wood texture, with plenty of pegs on either side for hanging just about any weapon in the Classics line.

The weapons included are the same eight weapons that were included with the vintage Castle Grayskull, but of course larger in size and with greater detail. Some have the original gray look (in this case with metallic paint and hits of rust overspray), and others have the maroon color of the weapons that came with some versions of the vintage Man-E-Faces figure. The Weapons Rack was released a couple of years before the Classics version of Castle Grayskull, but it's an essential piece to display with the castle and a great way to store some of the extra weapons that inevitably clutter up any serious collection.

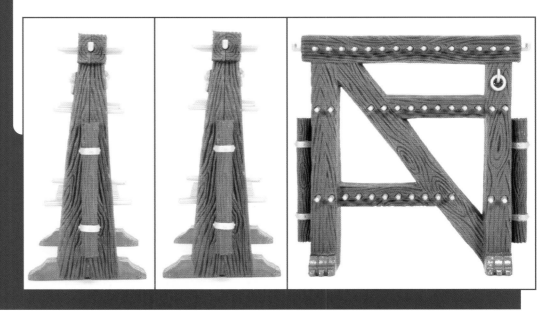

WEBSTOR
EVIL MASTER OF ESCAPE

First released 2009 • Member of the Evil Warriors

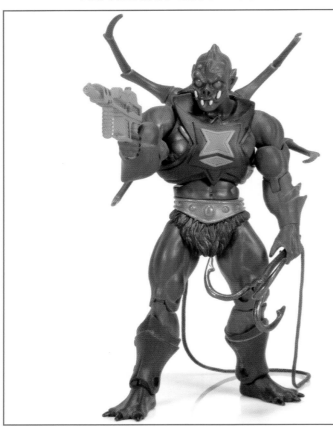

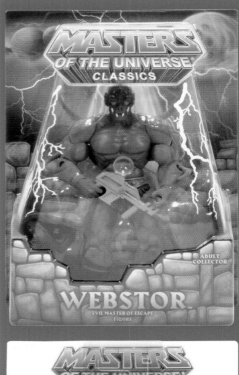

Accessories:
• Power blaster
• Grappling hook

Webstor is primarily based on the vintage 1984 action figure, but with a healthy dose of 200X influence as well. Most of the figure's body parts are actually reused from existing figures like King Grayskull, He-Man, Skeletor, and Zodac. His head is a new sculpt, and it has quite a menacing face, featuring six eyes (a nod to his 200X design) rather than the four on the vintage figure. His signature orange blaster is decked out with hits of red and metallic orange paint. His backpack has four 200X-style spider legs coming off it to give him a much creepier vibe than he would otherwise have. The legs are not removable but can be tucked down so they're mostly hidden from the front.

Webstor also comes with his classic grappling hook and string. The vintage figure had a pulley system in the backpack, allowing him to climb up the string as you pulled downward on the other end. The pulley was notoriously fussy and prone to internal tangles. For the Classics version, Mattel opted to pass the string through the backpack rather than try to replicate the original.

Webstor is quite a dark and menacing figure, the perfect foil to the heroic insectoid Buzz-Off.

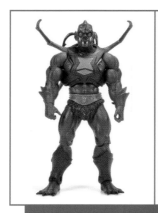
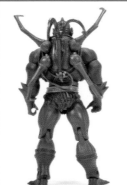
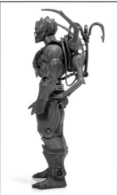
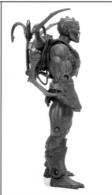

FUN FACTOID: The Four Horsemen wanted to maintain his stealthy and sinister look, and they also included the extra spider legs on his backpack from the 200X design to play up his design theme.

WHIPLASH
EVIL TAIL-THRASHING WARRIOR

First released 2010 • Member of the Evil Warriors

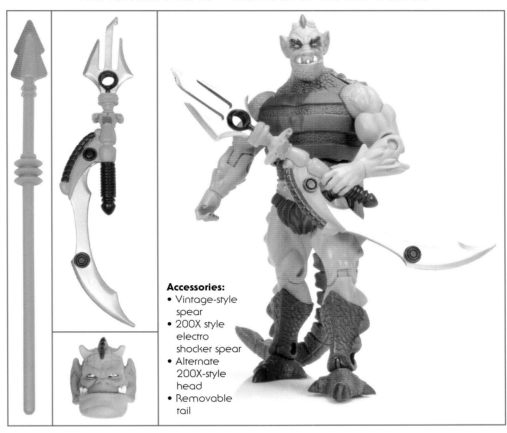

Accessories:
- Vintage-style spear
- 200X style electro shocker spear
- Alternate 200X-style head
- Removable tail

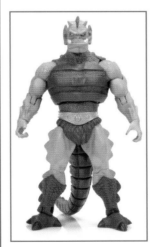

Whiplash is one of the most versatile of the Classics figures, in that he can be configured to represent the vintage version of the character, the 200X version, or something in between. Whiplash comes with an extra 200X-style head and electro shocker spear. The latter is meant to be held in his more open left hand, while his vintage-style spear fits in his right hand. His vintage style head has been updated to look more menacing. It also fixes the design of his center tooth by moving it downward (in the vintage figure, the tooth seems to be coming from his nose).

Whiplash introduces a different type of textured torso with a crocodilian tail affixed to his back to complete the look. The removable tail attaches to his back by way of two pegs. Whiplash also features newly sculpted forearms, thighs, and boots, which would be reused for a number of different figures down the line. The forearms, based on the arms used on many of the vintage figures, really accentuate details that were only hinted at in the 1980s line.

Whiplash reuses only a few parts—biceps from King Grayskull, hands from Skeletor, and trunks from He-Man. He's quite a striking figure with his two-tone green color scheme with orange and blue accents, and he looks much fiercer than the original 1984 figure.

FUN FACTOID: The Four Horsemen had to stick closer to the original vintage design than they did in 200X. It was surprising to them how it only took a few small changes to transform him into one of the best prototype-to-production translations in the line.

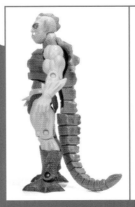 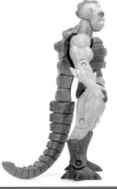 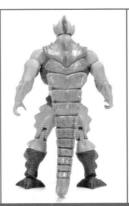 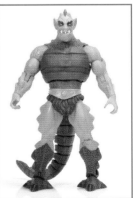

MOTUC - SECTION 1

WIND RAIDER
ASSAULT LANDER

First released 2011 • Vehicle of the Heroic Warriors

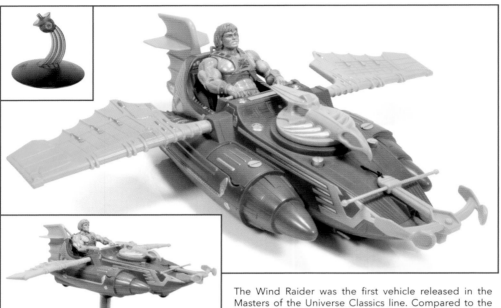

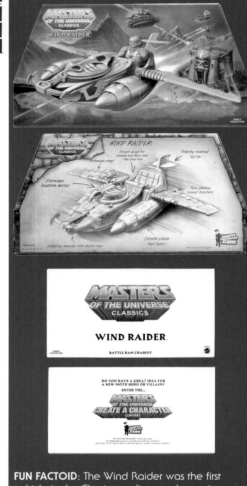

The Wind Raider was the first vehicle released in the Masters of the Universe Classics line. Compared to the original 1982 Wind Raider, it is far more detailed and larger in scale relative to the figures that it was made for. The Classics Wind Raider is closely based on the vintage box art for the vehicle by Rudy Obrero, which was much sleeker and more finely detailed than the vintage toy.

The Wind Raider features fully-sculpted and painted fuselage decorations and control panels, rather than the stickers used in the vintage vehicle. The wings attach to the body via hexagonal pegs in ratchet joints, allowing the wings to be posed at preset angles. The vehicle features the same anchor and string feature that the original had, but you can actually fire the anchor forward via a gold button that releases a spring-loaded launching mechanism. The anchor can be rewound by raising and rotating the figurehead on the front of the vehicle.

The Four Horsemen went the extra mile and added panels at the top of both engines that can be opened to reveal mechanical parts and bombs. There are wheels underneath the vehicle to allow it to roll on the ground, and it comes with a two-piece articulated stand to allow the user to display the Wind Raider in flight.

Rudy Obrero was brought in to illustrate the box art on the front of the package, just as he had done for the vintage vehicle. The Classics box art depicts an air battle between the Wind Raider (piloted by He-Man) and three Rotons (piloted by Skeletor, Evil-Lyn, and Beast Man).

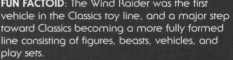

FUN FACTOID: The Wind Raider was the first vehicle in the Classics toy line, and a major step toward Classics becoming a more fully formed line consisting of figures, beasts, vehicles, and play sets.

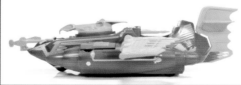

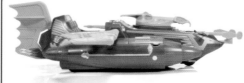

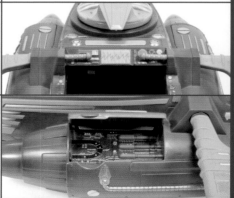

MOTUC - SECTION 1

WRAP TRAP
MONSTROUS MUMMY OF THE EVIL HORDE
First released 2018 • Member of the Evil Horde

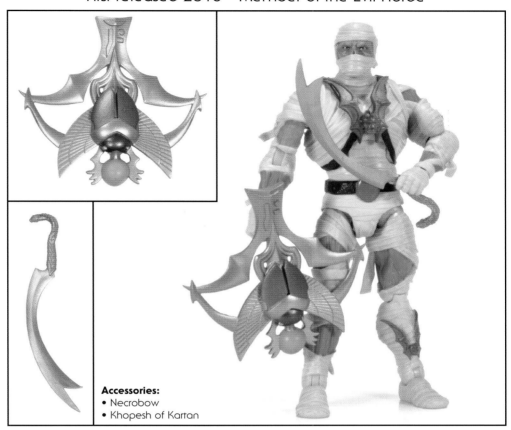

Accessories:
- Necrobow
- Khopesh of Kartan

Wrap Trap was long a fan-demanded character for Masters of the Universe Classics. The figure is based on a previously unused Horde mummy design by Ted Mayer, one of the visual designers on the original Masters of the Universe toy line. Wrap Trap is a faithful re-creation of Ted's concept art, but the attention to detail is taken to the next level.

Because of Wrap Trap's very distinctive design, he reuses no previously existing parts from other figures. His bandages are in various shades of white, with a realistically dirty-looking wash to give them the appearance of age. Several of the bandages are hanging loose from the figure. His exposed flesh is painted in various shades of green, and he has piercing red eyes. Like many other Evil Horde characters, he has red Horde symbols on his chest and left arm, as well as one on his shin.

Wrap Trap includes two weapons newly created for him. One is the Khopesh of Kartan, an ornate sword with a golden hilt in the shape of a cobra. The other is a Necrobow, which has the general shape of many of the Horde crossbows but a unique design influenced by ancient Egypt depicting a scarab beetle with feathered wings.

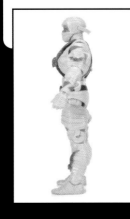 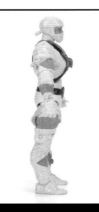 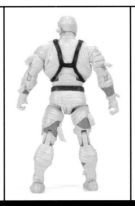 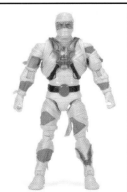

MOTUC - SECTION 1

WUN-DAR
THE SAVAGE HE-MAN

First released 2010 • Ancestor of the Heroic Warriors

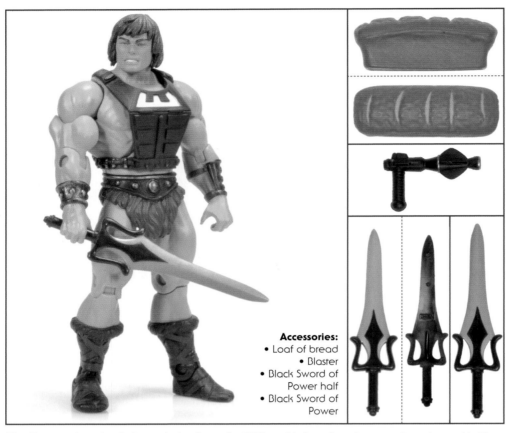

Accessories:
• Loaf of bread
• Blaster
• Black Sword of Power half
• Black Sword of Power

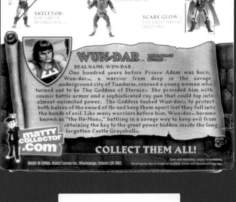

Wun-Dar was the subscription-exclusive figure for 2010, and is based on the mysterious vintage He-Man figure known as "Wonder Bread He-Man." The figure got that name because of a fan rumor that it was given away in a joint promotion between Mattel and Wonder Bread. It turns out there is no evidence that Wonder Bread was ever involved with the figure, but the name stuck. Its origins remain mysterious to this day, but it does appear to be an authentic Mattel figure. It was, in essence, a He-Man toy with brown hair, black boots, and brown trunks. The vintage figure likely came without any armor, but has often been displayed with the black Weapons Pak repaint of Zodac's armor. The figure is also often associated with the series of maroon Castle Grayskull weapons that came with some Man-E-Faces figures, although it's not known for sure what weapons, if any, Wonder Bread He-Man came with. The two most commonly associated with him are the maroon sword and axe.

The Classics version diverts somewhat from the vintage source material, in that it doesn't come with any of those maroon weapons. Instead, it comes with a black version of Zodac's gun, black-and-silver versions of He-Man's Sword of Power and half sword, and a loaf of bread, a joke referencing the Wonder Bread rumor. There is even a circular area on the back of the figure's armor that features coloration that brings to mind the Wonder Bread logo.

Wun-Dar is the first official reissue of the mysterious vintage figure, with his bio establishing him as a separate character from He-Man in his own right. Because this figure was a subscription exclusive, it can be somewhat expensive to acquire on the secondary market.

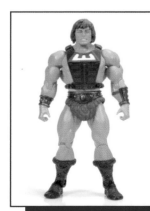
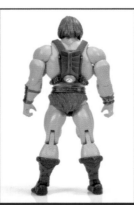

FUN FACTOIDS:
• Wun-Dar is based on the Wonder Bread He-Man. His harness contains an easter egg in the form of a sticker with the colorful Wunder Bread logo.
• As the first subscription exclusive, Wun-Dar was shipped with the Eternia map as the 2010 Club Eternia exclusive (see page 535).

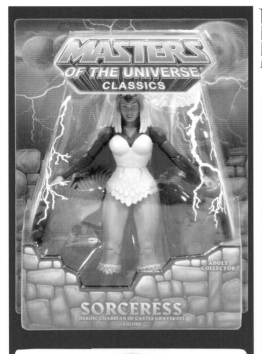

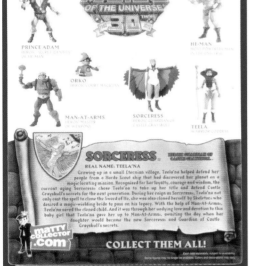

ZOAR
FIGHTING FALCON

Multiple releases • Beast of the Heroic Warriors

Accessories:
- Armor
- Perch

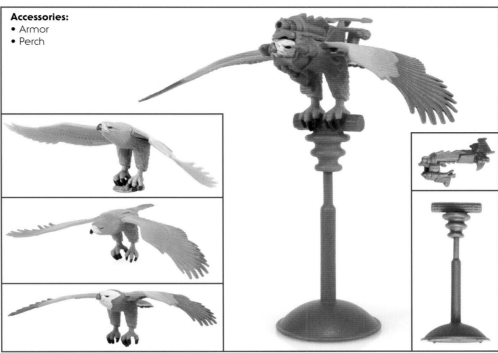

Zoar has been released multiple times in the Masters of the Universe Classics line, in various colors and styles based on different source material. The vintage 1983 Zoar was actually a giant bird with a wingspan larger than most of the figures, but the Classics Zoar in all its forms is much smaller, in scale with Zoar as depicted in the Filmation cartoon. Most versions feature outstretched wings that articulate on a hinge joint, as well as feet that can articulate left and right.

Zoar was first released with Teela, painted based on the cross-sell artwork included on the back of some vintage minicomics. In the art, Zoar is orange with no blue highlights and has green armor. Teela's Zoar lacks the armor and perch, but they were included with the second Weapons Pak release (Great Wars assortment).

The next Zoar to be released in the Classics line came with the first Sorceress release, and comes in the orange, blue, and white colors based on the vintage toy as well as the Filmation cartoon. This version of Zoar comes with the toy-accurate red armor and perch, but of course it's much smaller.

The next Zoar was released with the Great Unrest Weapons Pak and is cast in white with subtle blue highlights. This version of Zoar is intended to go with Temple of Darkness Sorceress, who has a white costume and is based on the character's appearance in the vintage minicomic, Temple of Darkness!

A crystalline version of Zoar was included with Nepthu. Zoar is cast in clear plastic and has a brand-new sculpt with sharper lines, to replicate a scene from the Filmation cartoon where Zoar is turned to crystal by Nepthu. This version of Zoar is not articulated.

Finally, Zoar was released with the 2018 Club Grayskull Sorceress. This version of Zoar is the first to have wings that are folded rather than outstretched. Because it's based on Zoar's animated look, it does not include armor, but it does include a red perch.

ZODAC
COSMIC ENFORCER

First released 2009 • Ally of the Heroic Warriors

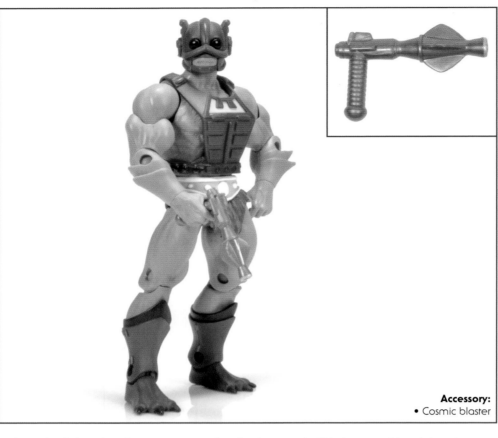

Accessory:
• Cosmic blaster

MAILER BOX CAME WITH REISSUE ONLY

Zodac is closely based on the vintage cross-sell art for the original 1982 character, although his colors are closer to the vintage toy. The differences are subtle—compared to the vintage figure, Zodac has smoother-textured boots and his forearms have an almost gloved look, compared to the more organic direction of the toy. Zodac is a relatively simple figure, but he has plenty of shading across his body and his armor to give him additional depth.

Zodac includes a number of cartridges around the sides of his armor, which are given metallic red paint hits for additional realism. The eyes on his helmet have glossy black paint to give them the appearance of dark glass. Like the vintage figure, Zodac is mainly made up from a mixture of reused parts, including Beast Man's hairy chest; Skeletor's boots; Skeletor's forearms and right hand; King Grayskull's legs, shoulders and biceps; and He-Man's loincloth. Despite his being a simple and deceptively plain figure, Zodac's paint applications and smart sculpt work make him a standout in the line.

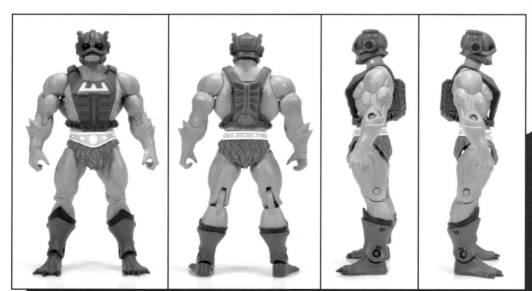

FUN FACTOID: The Four Horsemen said, "This character is so true to the original that he sometimes flies under the radar, which is a shame because we feel like he was a really solid update."

MOTUC - SECTION 1

FUN FACTOID: This was mostly a refresh of the Zodac figure, but with the new parts and altered deco Zodac became a wholly new and meaningful addition to the line.

ZODAC
HEROIC MASTER OF THE COSMOS

First released 2011 • Ally of the Heroic Warriors

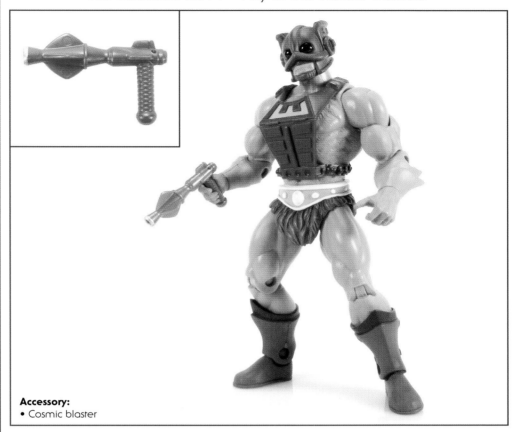

Accessory:
• Cosmic blaster

Zodac was rereleased in a gift set with a DC Universe Classics Green Lantern figure. For the set, Zodac was given a slightly different paint job and sculpture, with gray gloves and human feet (borrowed from Keldor), to make him look closer to the character as he appeared in the Filmation cartoon. Aside from those differences, this release of Zodac omits some of the white paint hits on the circular decorations on the belt that were present on the first Zodac release.

To cut costs, some of the shading on the body of this Zodac release was reduced compared to the first release. However, he does retain the metallic red paint hits to the cartridges around the sides of his armor.

Zodac's packaging includes a poster depicting Zodac battling the Green Lantern. Curiously, in the artwork Zodac holds the 200X-inspired version of his staff, which was included with Zodak (note the different spelling).

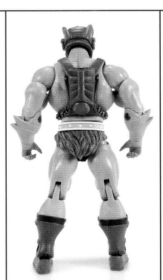
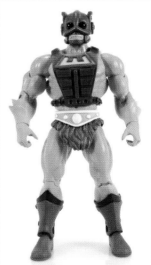

ZODAK
MYSTIC ENFORCER

First released 2009 • Ally of the Heroic Warriors

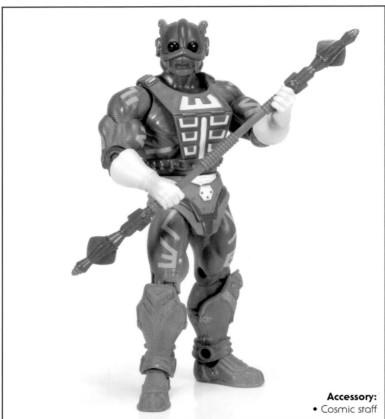

Accessory:
• Cosmic staff

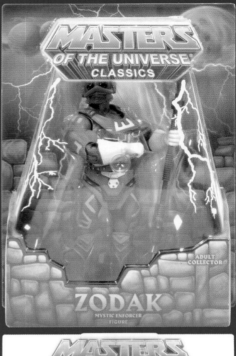

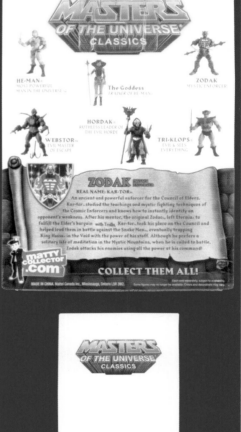

Zodak is based on the 2003 figure, which was a fairly substantial redesign of the original 1982 Zodac. He features glow-in-the-dark blue tattoos across his body, darker skin, and a much more futuristic costume design compared to Zodac. His staff weapon is based on the 200X accessory, but toned down a bit. The ends look very much like Zodac's blasters, attached to a staff. He reuses the trunks and boots from He-Ro, which actually match up very well with the corresponding parts on the 2003 figure. His head and armor (repainted) are borrowed from the 2009 Zodac figure, while his torso, arms, and legs come from King Grayskull. His gloves are reused from Hordak.

Despite sharing a name (almost) and a head sculpt with Zodac, Zodak looks like a completely different character and doesn't look odd sharing a shelf with his older cousin. Indeed, the bio accompanying the figure separates him from Zodac, establishing him as a different character in his own right. The intricate costume and detailed paint design of the figure make him stand out among the Cosmic Enforcers.

Shareable Accessory:
EXTRA HEAD FROM STROBO

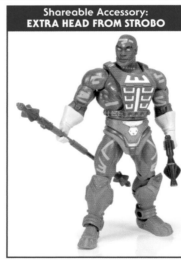

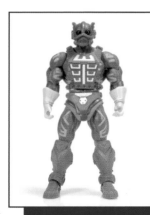

SECTION 2
MASTERS OF THE UNIVERSE CLASSICS
CLUB GRAYSKULL (2016)

BEAST MAN

First released 2016 • Member of the Evil Warriors

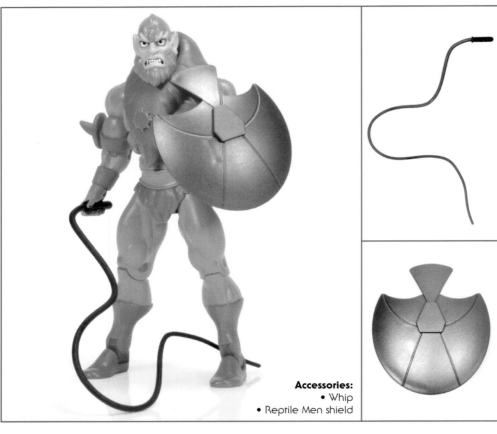

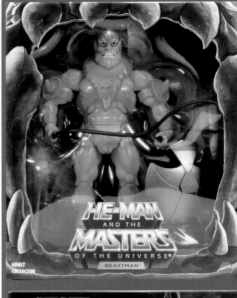

Accessories:
- Whip
- Reptile Men shield

Beast Man is a bright and colorful departure from the snarling beast first released in the Classics line in 2008. Meticulously patterned after the Filmation design, Beast Man trades in his gnarly clawed feet for red boots. Instead of a furry body, he has a smooth, seamless coat of orange. The spikes on his arms are reduced to just one per arm, with a simplified, rounded base. The furry armor around his neck has no spikes at all, and he's given a cartoon-accurate face, complete with pale skin-tone ears.

Beast Man reuses the basic male buck, including chest, shoulders, biceps, and legs from King Grayskull. His feet, trunks, and forearms are reused from the Club Grayskull He-Man release, and his hands are reused from Club Grayskull Skeletor. His whip is a new piece, and he also has a new shield, which was seen in the hands of the Reptile Men in the Filmation He-Man episode "House of Shokoti Part 1."

Club Grayskull's Beast Man is definitely less feral-looking than his Classics counterpart, but he's still a mean-looking figure, and his bright orange-and-red color scheme looks absolutely smashing on the shelf, especially posed next to his master, Skeletor.

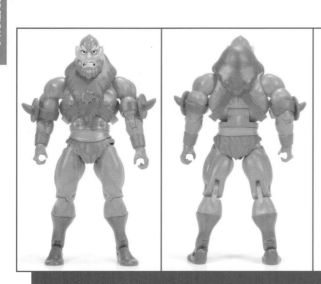

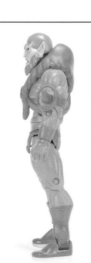

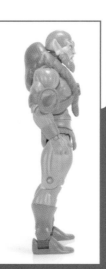

Chopper*, the silent, stocky member of the Evil Warriors*, was present during the acquisition by Skeletor* of the Dragon Pearl* and subsequent attempt to overthrow Castle Grayskull*. Aside from having above average strength, Chopper's main attribute lies on his large right hand, which is immensely powerful. In battle Chopper could fell an opponent with a single chop. Despite his brute strength, Chopper was rarely utilized by Skeletor, with the Evil Lord of Destruction* relying on his more familiar henchmen.

CHOPPER

First released 2018 • Member of the Evil Warriors

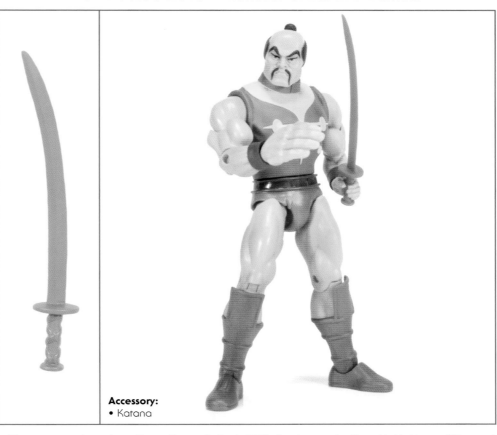

Accessory:
• Katana

Chopper was released as a Power-Con exclusive in 2018. For those unfamiliar with his history, "Chopper" was the working name for Jitsu used in Filmation scripts. The Filmation design for Chopper was quite a bit different from the vintage toy design, so Chopper almost feels like another figure entirely compared to the more toy-based 2013 Jitsu Classics release.

Chopper features brand-new boots with a samurai-style design, rather than the typical furry boots. He has the familiar enlarged right chopping hand, but with this version of the character it's an actual bare hand rather than a metal glove. Chopper features a new armor piece on a slim torso design, allowing his arms to rest easily at his sides. His head sculpt is new, larger and simplified compared to Jitsu's. He reuses some basic parts, legs, shoulders, and biceps from King Grayskull. His left hand and forearm are borrowed from Club Grayskull He-Man.

Chopper comes with a red katana blade that appears to be inspired by the weapon included with the vintage Jitsu figure, although that one was cast in orange. Overall he has a more obvious samurai look than the 2013 Jitsu figure, mainly owing to his boot design.

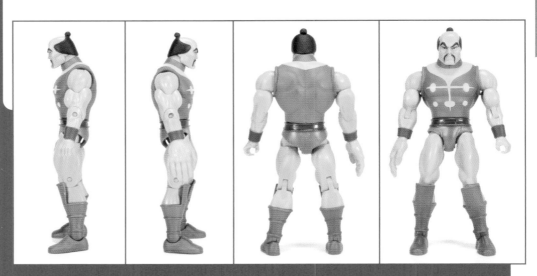

MOTUC - SECTION 2

CLAWFUL

First released 2016 • Member of the Evil Warriors

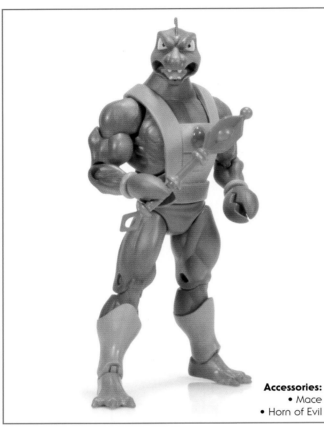

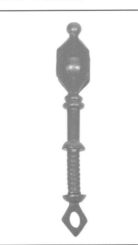

Accessories:
• Mace
• Horn of Evil

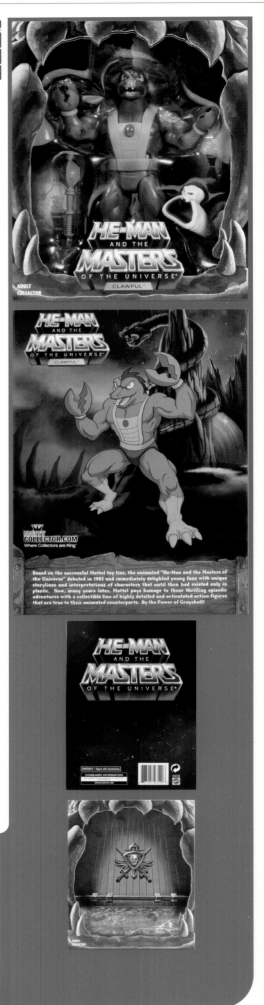

Clawful in the Filmation He-Man cartoon looked worlds away from his vintage action figure counterpart, making him an excellent candidate for the Club Grayskull line. The Filmation incarnation of the character probably represents an early concept look for Clawful, which ended up going through several revisions before hitting the shelves in 1984.

Compared to the 2011 release, Clawful has a much more simplified costume, with orange-yellow armor and boots, and smoothed-out trunks. He has two symmetrical small claws (both new pieces) rather than the giant claw from the first release. His head is large and cartoonish, with an open mouth and visible tongue.

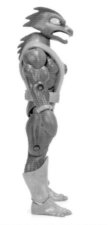

Clawful includes a green mace, which appears to be a "Filmationized" version of the mace that came with the vintage toy. He also comes with the Horn of Evil, an artifact from the Filmation episode "Dree Elle's Return," which featured Clawful as a primary villain.

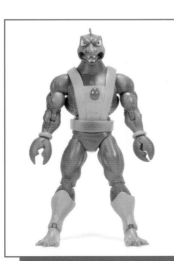

DREE ELLE

First released 2018 • Member of the Heroic Warriors

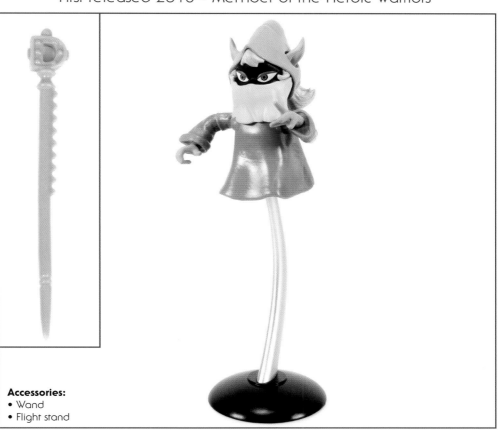

Accessories:
• Wand
• Flight stand

Dree Elle was released in a two-pack with a fellow Trollan, Uncle Montork. Dree Elle was an occasionally recurring character on the Filmation He-Man and She-Ra cartoons, and the love interest of Orko.

Dree Elle is similar in size and shape to the 2010 Orko release. She appears to reuse Orko's hands, but the rest of her sculpt is new. She features a magic wand similar in shape to Orko's, but with a letter D at the top of it. She also comes with a flight stand, which has a wider and more stable base than the one that came with Orko.

Like all Trollans, Dree Elle keeps her face covered, only revealing it to her true love. Female Trollans seem to use a veil for that purpose, while male Trollans like Orko and Uncle Montork use a scarf. She's an elegant-looking little figure, and she looks like she floated right out of the TV screen and onto the toy shelf.

EVIL-LYN

First released 2016 • Member of the Evil Warriors

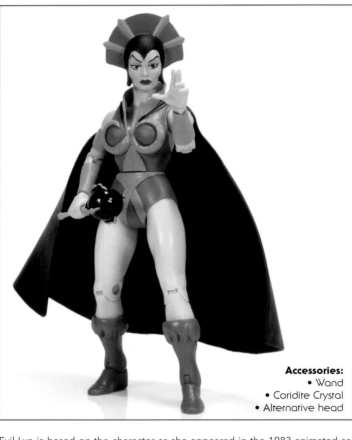

Accessories:
- Wand
- Coridite Crystal
- Alternative head

Evil-Lyn is based on the character as she appeared in the 1983 animated series, He-Man and the Masters of the Universe. There are quite a few differences between this figure and the one released in 2010. One of the most obvious differences is her skin tone—while the 2010 release was based on the vintage figure, with its lurid yellow skin, the Club Grayskull version has a more realistic skin tone. Her costume is similar, but has been greatly simplified and modified in the design on her lower half. It is purple with blue highlights, rather than the two-tone blue of the 2010 figure. Finally, she has a simplified headdress and a black cape to pull together the Filmation look.

Evil-Lyn comes with an alternative helmetless head, a callback to the episode "The Witch and the Warrior," in which she takes off her helmet, revealing short white hair. She has her cartoon-accurate short wand, as well as a piece of Coridite Crystal, a powerful mineral that Evil-Lyn tries to steal from the Widgets in the cartoon series.

Evil-Lyn reuses legs from Teela and shoulders from Adora, but otherwise is mostly made up from newly sculpted pieces.

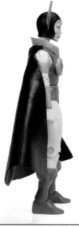

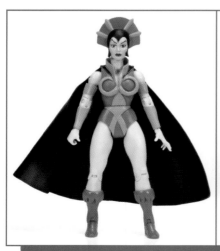

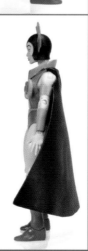

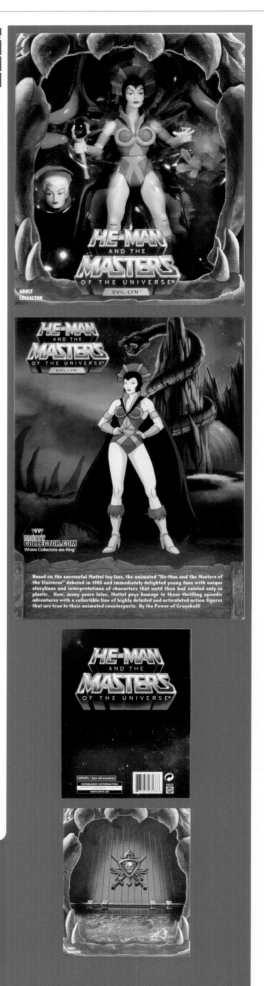

EVIL SEED

First released 2016 • Evil Villain

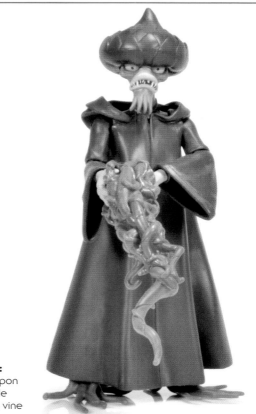

Accessories:
- Vine weapon
- Extendable wrapping vine

Evil Seed was the exclusive figure for the 2016 He-Man and the Masters of the Universe Club Grayskull subscription. In terms of design, he is a million miles away from the first Evil Seed figure released in 2015. While that figure was based on the evil plant creature from the Mike Young Productions 2002 He-Man and the Masters of the Universe cartoon, the Club Grayskull release is based on Evil Seed as he appeared in the original 1980s animated series.

Owing to his unique design, Evil Seed shares no parts with any previous Classics or Club Grayskull figures. A faithful recreation of the animated character, he wears a brown robe that obscures most of his body. He has fairly hum-an-like hands, but his feet are just a tangle of vines. He has a rather large artichoke-shaped head, and a mouth full of nasty-looking teeth.

Due to his unique design, he lacks some of the usual points of articulation, like an ab rocker or bicep swivels. He does however come with two great vine accessories. He can hold one of them as if he is shooting vines out of his hand. The other vine accessory can be placed around another Classics or Club Grayskull figure, allowing Evil Seed to "capture" the figure.

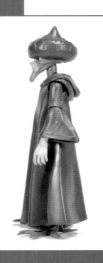

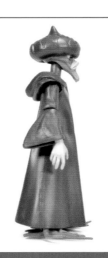

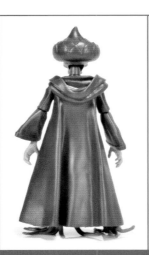

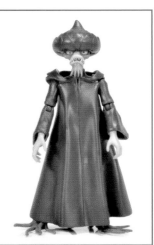

MOTUC · SECTION 2

FISTO

First released 2019 • Member of the Heroic Warriors

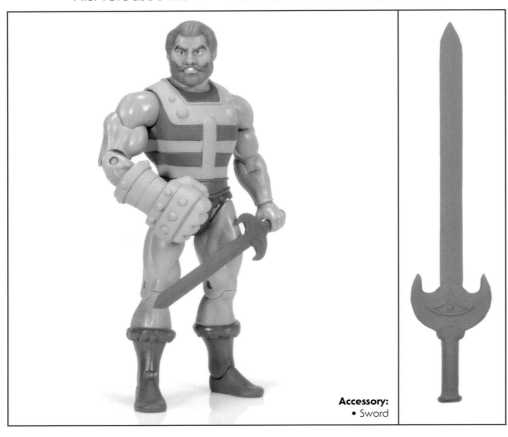

Accessory:
• Sword

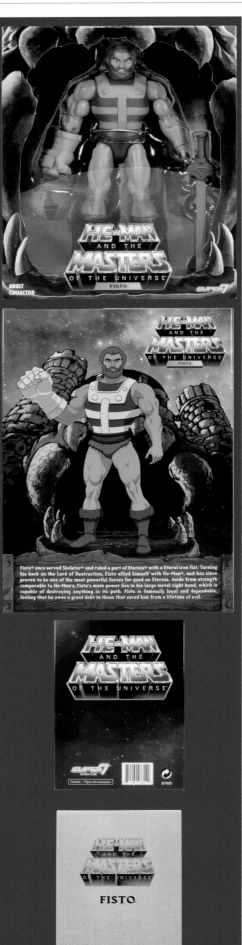

This version of Fisto is based on his appearance in the Filmation He-Man and the Masters of the Universe animated series. This marks the first time an action figure of Fisto was made specifically from the animated design.

While the cartoon's design of the character was based on the vintage Fisto action figure, the details are a little less intricate. The figure features a new torso sculpt of Fisto's armor. This differs from the practice typically seen throughout the Masters of the Universe toy line of the figures having removable armor over a standard torso.

Fisto's signature enlarged fist is also a new sculpt to better match the animation. It is painted a flat gray color, as opposed to the shinier silver that is often seen on Fisto action figures. He also comes with a purple sword for an accessory. This sword looks very much like the one that was included with the vintage Fisto action figure, this time painted with a flat purple color to better match the simpler color scheme of the figure.

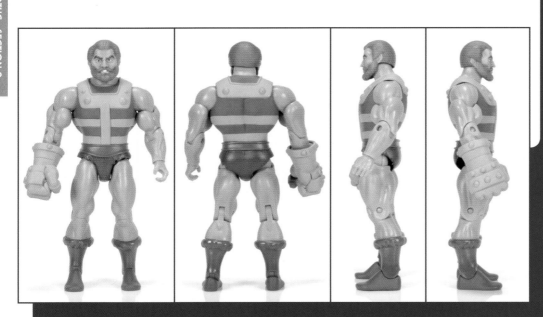

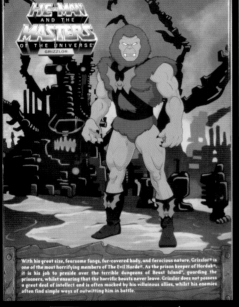

GRIZZLOR

First released 2019 • Member of the Evil Horde

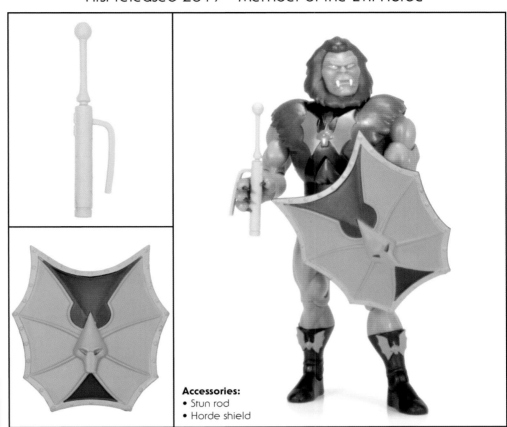

Accessories:
• Stun rod
• Horde shield

For the first time ever, Grizzlor gets an action figure release that is based on his appearance in the original She-Ra: Princess of Power animated series by Filmation!

This figure noticeably stands out from all previous Grizzlor toy releases in that it is the first one with fully sculpted fur details. The previous releases always used a faux fur material instead. This gives this new action figure a very different look for the character. Like many of the Filmation-inspired figures, many of the sculpted parts for this figure are brand-new and unique to the character, such as his large clawed paws for hands.

He comes with two accessories. The electric shock rod is much like the ones typically used by the Horde Troopers. It has an extra handle that allows it to be held in Grizzlor's paws. The shield is shaped like the Evil Horde insignia, featuring a bright red bat.

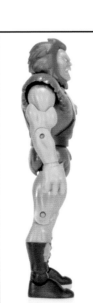

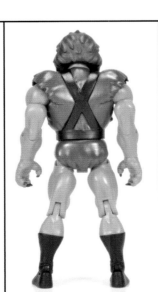

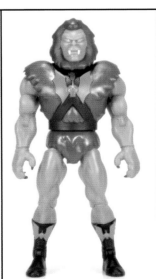

HE-MAN

First released 2016 • Member of the Heroic Warriors

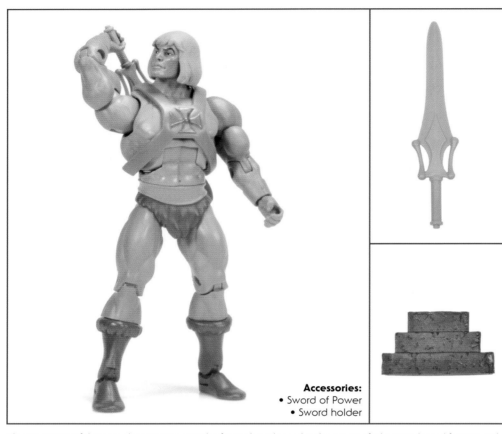

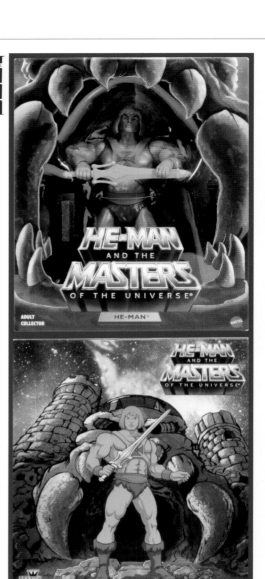

Accessories:
- Sword of Power
- Sword holder

The Most Powerful Man in the Universe was the first to be released in the series of Filmation-based figures and variants known as the Club Grayskull line.

The Filmation He-Man head seems to be quite challenging to render into 3D form, given all the semi-successful attempts that have been made at it over the years, but the Club Grayskull version seems to have just about nailed it. The bone structure on the face is pretty similar to the toy-inspired head that was included with Oo-Larr, but the details are subtly softened, and he is given a more friendly expression. The hair especially is key to achieving the Filmation look, which has a Prince Valiant–like pageboy haircut, as opposed to the tousled Luke Skywalker hair of the original toy design.

He-Man's Filmation details of course go further than that. He has the cleaner Filmation harness, with its rectangular pieces removed and the central cross enlarged and simplified. His belt and bracers are very simple plain bands, without the ornamentation of the 2008 release. The sculpt of He-Man's trunks and boots is also quite simplified, with minimal detail, as per the cartoon source material. The boots feature rocker joints at the ankles that are effective at allowing him to assume a number of dynamic poses.

He-Man includes the Filmation-style Sword of Power that was originally released with Flogg, and his harness includes a sheath in the back to hold it. Aside from the sword, He-Man also reuses the torso, shoulders, biceps, and legs from the 2008 King Grayskull figure. He-Man comes with a stack of gray bricks, with slots designed to hold the Sword of Power and She-Ra's Sword of Protection (not included).

He-Man looks as if he's stepped right out of the 1983 cartoon, something many fans had been wanting for a number of years.

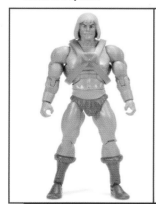

HOLIDAY HE-MAN

First released 2018 • Member of the Heroic Warriors

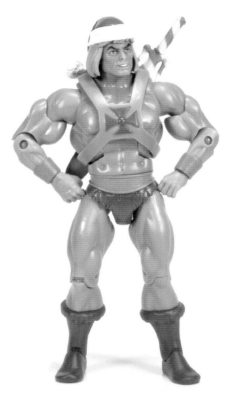

Accessory:
• Holiday Sword of Power

Holiday He-Man is a festive variant of the Filmation-styled figure originally released in 2016. The most obvious changes to his appearance are his new head and repainted sword. His head features an open-mouthed, smiling expression, and he's wearing a Santa hat which is permanently attached to his head. His Sword of Power, which was first released as an accessory with Flogg, is repainted in a festive candy cane color scheme.

Holiday He-Man has a few more subtle changes from the 2016 model as well. Borrowing from Club Grayskull Tung Lashor, his trunks have been redesigned so that they are more like briefs, rather than the short loincloth design of the previous version. His boots have been reworked as well, removing the rocker joint on the ankles but improving the appearance of the boots by tightening up the gap in the joints and slightly widening the ankles.

Holiday He-Man reuses the hands that were released with the laughing Prince Adam, which are similar to the 2016 He-Man release, but with modified hinge joints. The rest of his body has the same parts that were used in the 2016 release, albeit in a slightly glossier, lighter-colored plastic.

Holiday He-Man comes wrapped in a reproduction of the vintage Masters of the Universe holiday wrapping paper, originally illustrated by Earl Norem. His also comes in a festive Club Grayskull box, which features snow around the Castle Grayskull illustration and a snowman that looks like it was built by Orko, judging by what it's wearing.

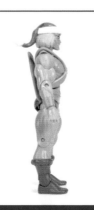

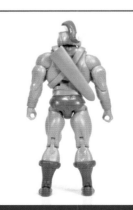

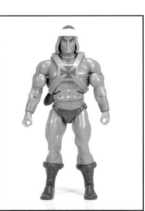

HORDAK

First released 2018 • Member of the Evil Horde

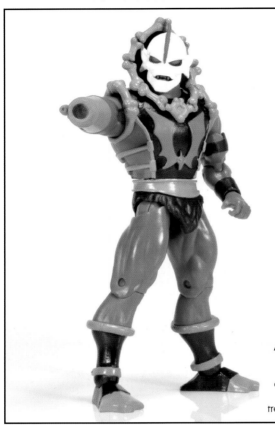

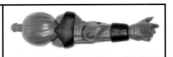

Accessories:
• Imp
• Alternate cannon arm
• Imp as treasure chest

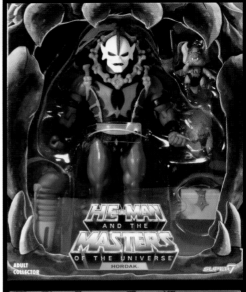

Under the watchful eye of Horde Prime®, Hordak® rose through the ranks of the Evil Horde®. He favored science over sorcery, and soon gained the ability to transform his physical form into a plethora of offensive weaponry. Despite failing to overthrow Eternia®, Hordak effortlessly conquered the planet of Etheria®. But the appearance of She-Ra® has seen Hordak's dominance of the planet stall. Yet, with an endless army at his disposal, Hordak believes it is only a matter of time before even the Princess of Power® bows to him.

The Super7 Club Grayskull Hordak release is actually the second attempt at a Filmation-style Hordak in the Classics line. The first attempt came in 2014. It was essentially a repaint of the 2009 vintage toy–style Hordak, but in Filmation colors, with a few extras, like Imp and a new interchangeable robotic arm.

The Club Grayskull release is much closer to the look of Hordak from the cartoon. The most notable differences are the face sculpt, which looks more mechanical than organic in this release, and the bone cowl, which in this version has larger, more cartoonish bones.

The design of Hordak's armor, particularly around the Horde emblem, is much more stylized this time around. He also includes a new alternative cannon arm that can be swapped with his regular arm. He is accompanied by both versions of Imp that were previously released (standard and Imp as treasure chest). His feet and loincloth are also much more cartoon accurate than the 2014 release.

Hordak reuses shoulders, biceps, and legs from King Grayskull. His trunks are borrowed from Club Grayskull He-Man, and his hands from Club Grayskull Skeletor. He's a vivid and striking villain, a fitting tribute to the snorting nemesis of She-Ra from the old animated adventures.

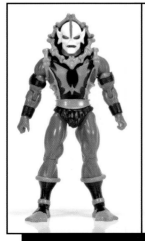

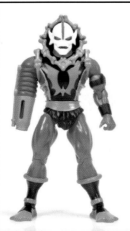

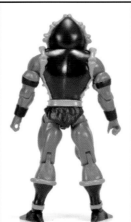

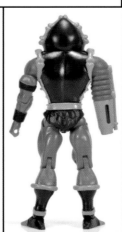

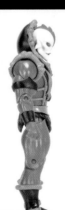

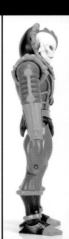

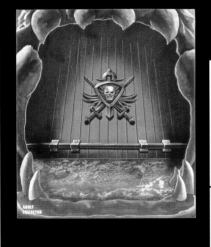

IMP

First released 2018 • Member of the Evil Horde

Imp was offered as a pack-in figure with the 2018 release of Club Grayskull Hordak.

As Imp was the onscreen sidekick of Hordak in the Filmation She-Ra: Princess of Power animated series, it made perfect sense to include him with this release of Hordak. Imp was previously released as an action figure in the Masters of the Universe Classics toy line. This version is very similar, but does have a few distinct differences.

The overall sculpt appears to be similar, but this new version appears to have a more slender head. The colors are also much more vibrant, and a little more accurate in representing the character's animated look. While the previously released Imp figure was articulated at both the neck and shoulders, this version lacks arm movement. He is only articulated at the neck.

In addition, Club Grayskull Hordak also included the treasure chest version of Imp. This is a bit special, as that version of Imp was previously only made available to those who attended San Diego Comic-Con in 2014. This version is the same mold, but does not have the ability to open like that previous release.

MOTUC - SECTION 2

KITTRINA

First released 2020 • Member of the Heroic Warriors

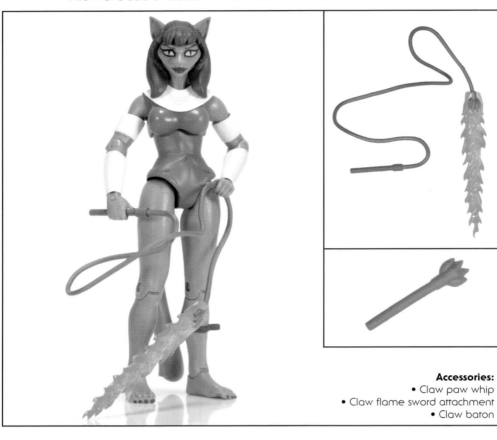

Accessories:
• Claw paw whip
• Claw flame sword attachment
• Claw baton

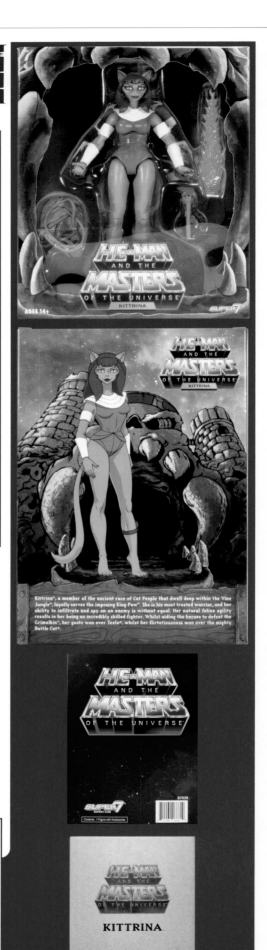

Kittrina is a character created for the Filmation He-Man and the Masters of the Universe animated series. Appearing in the episode "The Cat and the Spider," Kittrina had never before been released as an action figure. Even though she only had one appearance in the show, it was a standout episode which made Kittrina a memorable character for fans of the series. As a result, she was often included on lists of characters that fans wanted to see in figure form.

Kittrina's overall design is distinct enough that she most likely wouldn't have been able to follow the vintage formula of sharing parts with other figures from the toy line. Although the character was originally slated for release in MOTU Classics Collector's Choice, the modern Club Grayskull line ended up being a perfect place for her to finally get made, as this line featured far less parts sharing and allowed for more uniquely sculpted pieces.

Kittrina comes packaged with a few episode-specific accessories. The Claw baton can be holstered at her left calf, or held in either hand. To prepare her for battle, a translucent flame attachment plugs into the end of the baton to create a Flame Sword—an effect seen in the episode! She also has a separate Claw whip, made of a softer, more pliable plastic to allow the whip to hang or flail around.

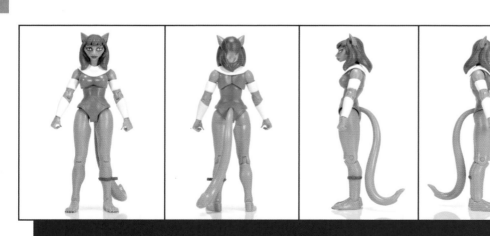

MAN-AT-ARMS

First released 2018 • Member of the Heroic Warriors

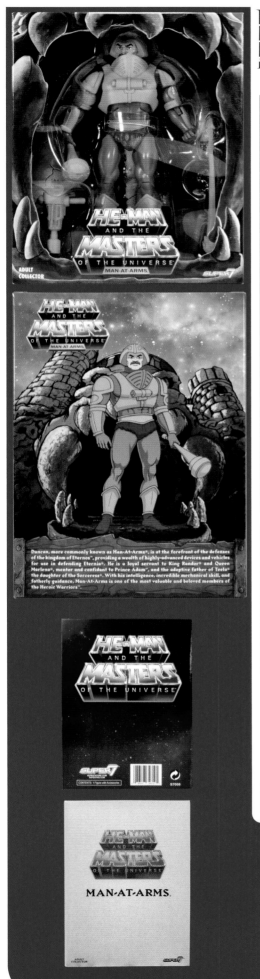

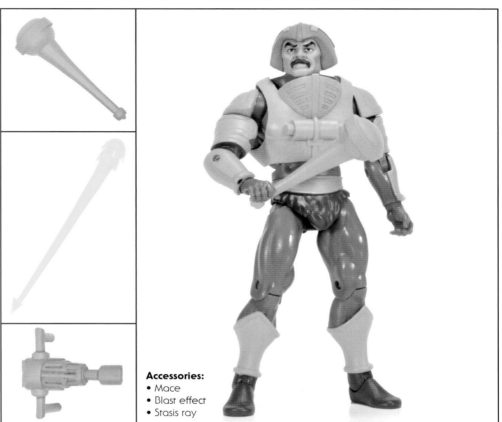

Accessories:
- Mace
- Blast effect
- Stasis ray

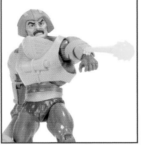

Man-At-Arms has been released in a number of variants in the Classics line, but his Filmation-style Club Grayskull release is perhaps the most distinctive of all the Man-At-Arms variants to date. Unlike previous versions of the character, his arm armor is a part of the sculpt of his body, rather than a removable piece, giving him a slimmer profile and a cartoon-accurate look. He has symmetrical orange shin guards covering brown boots, as per the animated source material. His armor is greatly simplified compared to previous versions.

This is actually not the first attempt at a Filmation-style Man-At-Arms in the Classics form factor. In 2014 a figure of Man-At-Arms was released with the Battle Ram, which featured a Classics-style likeness of Filmation Man-At-Arms, with the vintage toy styling but symmetrical armor and roughly Filmation-style boots.

Man-At-Arms comes with his Filmation-style club (rarely seen in the cartoon), a blast effect that can be attached to his wrist armor to simulate him firing his weapon, and the stasis ray, an artifact that appeared in "The Dragon Invasion."

Man-At-Arms features a lot of newly sculpted pieces, but he does reuse the King Grayskull torso and legs, as well as the 2016 Club Grayskull He-Man trunks.

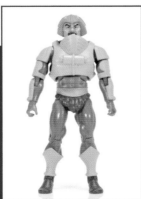

MAN-E-FACES

First released 2018 • Member of the Heroic Warriors

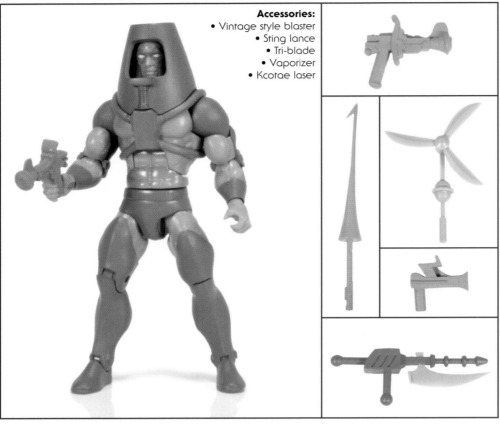

Accessories:
- Vintage style blaster
- Sting lance
- Tri-blade
- Vaporizer
- Kcotae laser

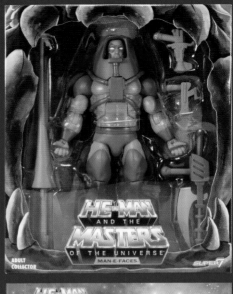

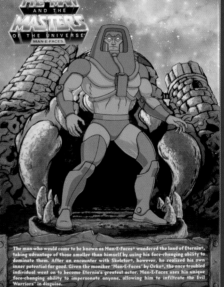

The man who would come to be known as Man-E-Faces® wandered the land of Eternia®, taking advantage of those smaller than himself by using his face-changing ability to dominate them. After an encounter with Skeletor®, however, he realized his own inner potential for good. Given the moniker "Man-E-Faces" by Orko®, the once troubled individual went on to become Eternia's greatest actor. Man-E-Faces uses his unique face-changing ability to impersonate anyone, allowing him to infiltrate the Evil Warriors® in disguise.

In his Filmation form, Man-E-Faces is quite a departure from the 2011 Classics figure. As with most Filmation-style figures, he has less sculpted detail. In terms of his faces, he is actually a closer representation of the vintage toy than the previous 2011 release, because this version, in spite of deviating from the overall toy design, remains faithful in the designs of the character's three faces.

Man-E-Faces has tall, streamlined blue boots, and a fairly minimal design on his costume. He still has enough detail, however, so that he doesn't look out of place alongside many figures in the Classics line. He retains his rotating-face feature, although this version lacks the knob on the top of the helmet, so the faces need to be turned by manually pushing them through the helmet. Man-E-Faces is made up of mostly new parts, but he does reuse the hands from the Club Grayskull Man-At-Arms, as well as King Grayskull's abdomen.

Man-E-Faces comes with a wide variety of Filmation-style weapons, perhaps as an oblique nod to the vintage limited-offer "free weapons" Man-E-Faces (commonly called "Man-E-Weapons"), who came with a number of repainted Castle Grayskull armaments.

Man-E-Faces is packaged with a vintage toy style gun. He also has a tri-blade, which appeared in "She-Demon of Phantos"; a sting lance, which Buzz-Off used in "Disappearing Dragons"; a vaporizer, which appeared in "The Once and Future Duke"; and finally a "Kcotae lazer" (which is Eatock spelled backward, a reference to Filmation historian James Eatock), which appeared in "She-Demon of Phantos."

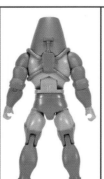
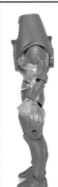

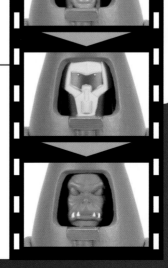

MANTENNA

First released 2019 • Member of the Evil Horde

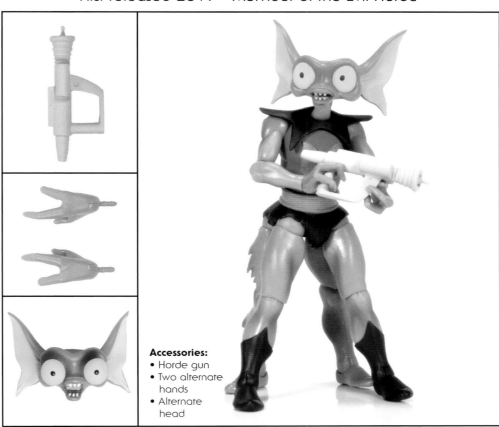

Accessories:
- Horde gun
- Two alternate hands
- Alternate head

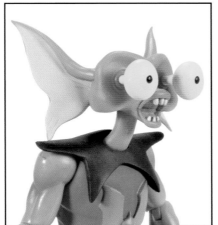

For the first time ever, Mantenna is presented as an action figure based upon his appearance in the Filmation She-Ra: Princess of Power animated series!

When compared to the previous Masters of the Universe Classics releases, this version of Mantenna is a bit smaller and thinner in appearance. The details are also not quite as intricate, in an effort to better match the animation from the show.

Mantenna is unique in that he is a character with four legs. All four legs are fully articulated exactly as you would expect any two-legged character's to be, with the same ball-hinge joints at the thighs, bends at the knees, and joints at the ankles.

Also included is an interchangeable head. Mantenna's head pops right off of the ball joint of his unique neck peg so that you can easily swap on the alternate head. This second head features the eyes of Mantenna's eyes bugging out of his face.

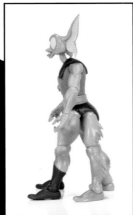
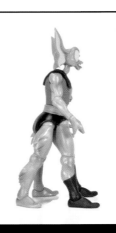
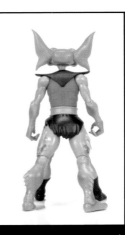
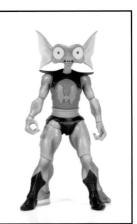

Mantenna®, who is by far the most bizarre-looking member of The Evil Horde®, has the ability to telescope his eyes from their sockets. Once extended, his eyes have the ability to shoot a variety of beams that can overpower an enemy in mere seconds. Although Hordak® takes great pleasure in mistreating Mantenna, his shrill-voiced underling has often proven himself capable of leading patrols of Horde Troopers® against the oppressed people of Etheria®. It is in these moments of dominance that Mantenna's cruelty shines through.

MANTENNA

MOTUC - SECTION 2

MER-MAN

First released 2018 • Member of the Evil Warriors

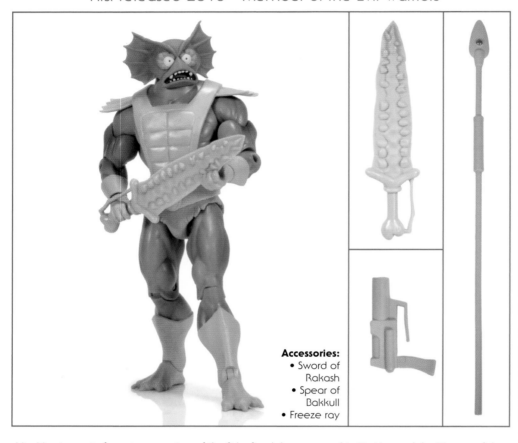

Accessories:
• Sword of Rakash
• Spear of Bakkull
• Freeze ray

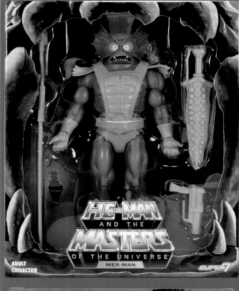

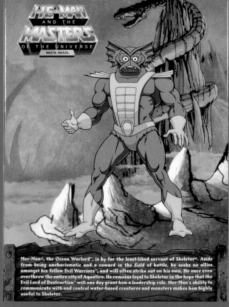

Mer-Man is a note-for-note re-creation of the fishy fiend that appeared in He-Man and the Masters of the Universe.

Compared to the 2009 Classics Mer-Man figure, the Club Grayskull version is greatly streamlined but still unmistakably Mer-Man. The 2018 release has a larger head, with enlarged, sideways-facing fins and angry-looking eyes. His armor is greatly simplified, and includes a blue-painted section that surrounds his neck, simulating a bulkier neck without the need for a new upper torso piece. He reuses a number of previously existing parts, including upper boots from Club Grayskull Clawful, feet from Classics Skeletor, trunks from Club Grayskull Spikor, hands from Club Grayskull Man-At-Arms, and torso, shoulders, biceps, and legs from King Grayskull.

Mer-Man comes with the Sword of Rakash, which is very closely modeled on the sword that came with the original 1982 Mer-Man action figure. He also comes with the Spear of Bakkull (containing the Crimson Pearl) for summoning the giant aquatic monster of the same name, and a Filmation-style freeze ray.

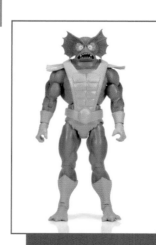
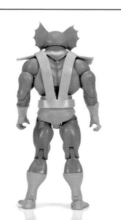
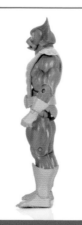
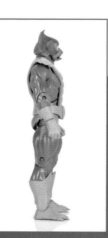

MOTUC - SECTION 2

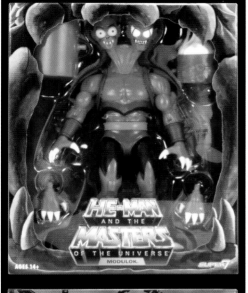

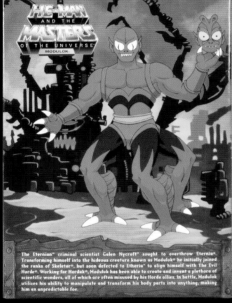

The Eternian criminal scientist Galen Nycroft sought to overthrow Eternia. Transforming himself into the hideous creature known as Modulok he initially joined the ranks of Skeletor, but soon defected to Etheria to align himself with The Evil Horde. Working for Hordak, Modulok has been able to create and invent a plethora of scientific wonders, all of which are often misused by his Horde allies. In battle, Modulok utilizes his ability to manipulate and transform his body parts into anything, making him an unpredictable foe.

MODULOK

First released 2020 • Member of the Evil Horde

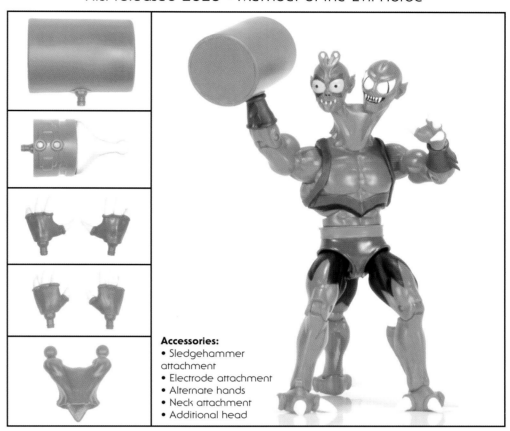

Accessories:
- Sledgehammer attachment
- Electrode attachment
- Alternate hands
- Neck attachment
- Additional head

Modulok was one of the characters from the original Masters of the Universe toy line who had multiple appearances in both the He-Man and She-Ra animated series from Filmation. While the character did a decent job of resembling the original 1985 action figure, there were elements of the on-screen character that differed. This made Modulok a perfect candidate for the Filmation-inspired Club Grayskull line of action figures.

The gimmick of the original action figure allowed you to pull the figure apart at all of the joints, enabling you to build your own beast with multiple legs, arms, or heads. The version of Modulok depicted in the cartoons was a mad scientist of sorts. There was less focus on him being a monster who could shape shift into strange forms, and more emphasis on the science aspect. Modulok did attempt to build a second head for himself, stealing the brain power of Man-At-Arms to fill it.

This new action figure has three legs, but they do not pop off like the ones on the former release. Instead, much of the articulation of the figure matches that of a standard figure in the Club Grayskull line. He does come with the alternate head featured in the series, and this can either replace his main head or be added to the neck attachment accessory to display Modulok with both heads. Modulok can also be displayed holding the second head in his hand, as he is seen doing in the fan-favorite poster of the Evil Horde by artist Earl Norem. The hands are also swappable, allowing him to have either opened or closed hands. You can also remove his hands and, instead, attach a sledgehammer or electrode in their place.

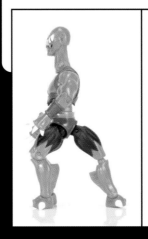

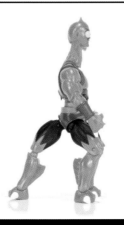

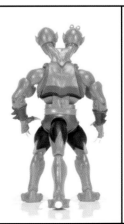

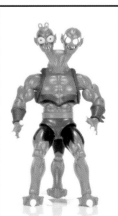

PRINCE ADAM

First released 2020 • Member of the Heroic Warriors

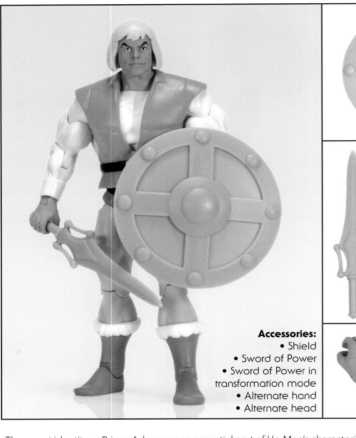

Accessories:
- Shield
- Sword of Power
- Sword of Power in transformation mode
- Alternate hand
- Alternate head

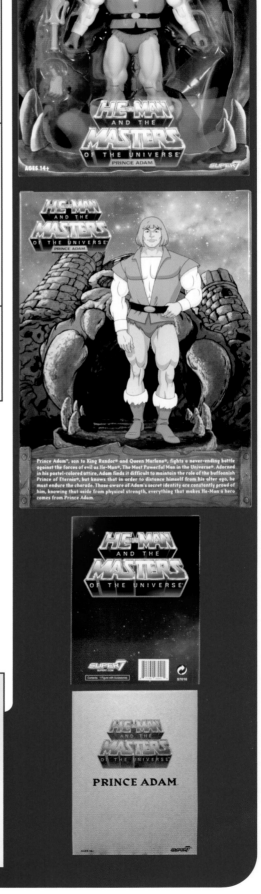

Prince Adam™, son to King Randor® and Queen Marlena®, fights a never-ending battle against the forces of evil as He-Man®, The Most Powerful Man in the Universe®. Adorned in his pastel-colored attire, Adam finds it difficult to maintain the role of the buffoonish Prince of Eternia®, but knows that in order to distance himself from his alter-ego, he must endure the charade. Those aware of Adam's secret identity are constantly proud of him, knowing that aside from physical strength, everything that makes He-Man a hero comes from Prince Adam.

The secret identity as Prince Adam was an essential part of He-Man's characterization in the Filmation He-Man and the Masters of the Universe animated series. While he did have an action figure in the original toy line, the more cartoon-accurate Club Grayskull line was a perfect excuse to finally bring us a Prince Adam action figure with a vest in the correct shade of pink!

And that vest is the best example of what makes this particular Prince Adam action figure more representative of his appearance in animation. Prior to this release, Super7 sold the laughing Prince Adam as an exclusive at San Diego Comic-Con. That version was inspired by the popular internet meme. It did not include a normal, non-laughing Adam head. It also reused the minicomic Prince Adam vest, which is not cartoon accurate. This new figure fixed that, in addition to giving us a standard Adam head.

The accessories included with Prince Adam are some of the most fun. Of course, he comes with the Sword of Power. But, in addition, he also has a version of the Sword of Power in transformation mode! This version of the sword is a bit narrower and pointed, and it includes a removable burst of lightning that is made of glow-in-the-dark plastic. This allows for an amazing pose that comes straight out of the original animated series, with Adam holding his magic sword aloft as it explodes with the Power of Grayskull.

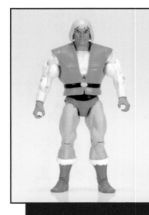

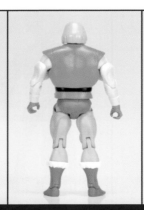

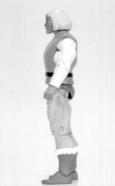

PRINCE ADAM (LAUGHING)

First released 2018 • Member of the Heroic Warriors

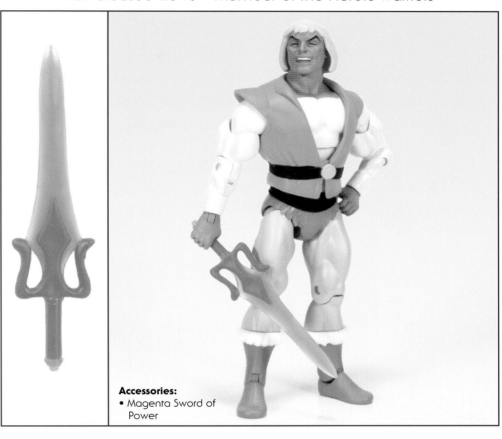

Accessories:
• Magenta Sword of Power

The Club Grayskull laughing Prince Adam is an homage to the old viral internet parody video that first appeared in 2005, featuring Prince Adam and other characters from the He-Man and the Masters of the Universe cartoon singing a disco cover of "What's Up?" by 4 Non Blonds. One of the most famous scenes from the video features Prince Adam laughing in front of a sparkling rainbow background. To that end, this Prince Adam comes packaged in a unique Club Grayskull package, featuring a rainbow-tinted, sparkling Castle Grayskull as the illustration.

Prince Adam has a new laughing head sculpt, and borrows boots from Club Grayskull Spikor and loincloth from Club Grayskull Tung Lashor. His shoulders, biceps, and legs come from King Grayskull. His hands are borrowed from Club Grayskull Man-At-Arms, and his chest comes from Club Grayskull Tri-Klops. His vest seems to derive from the Classics Prince Adam release, but it has been shrunk down a bit to fit laughing Prince Adam's narrower chest.

Laughing Prince Adam's only accessory is the original Classics Sword of Power, which has been cast in pink for this release.

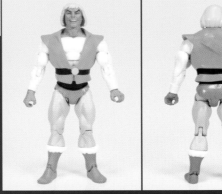
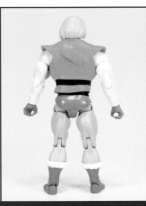
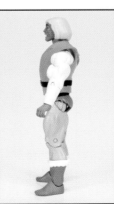
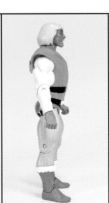

ROBOTO

First released 2020 • Member of the Heroic Warriors

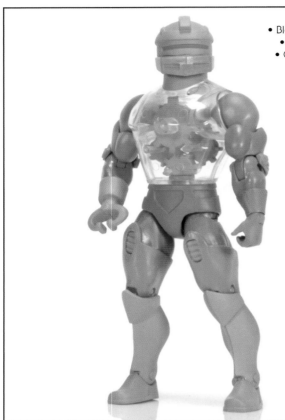

Accessories:
- Blaster attachment
- Axe attachment
- Claw attachment

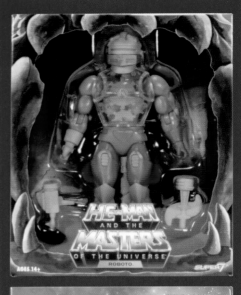

Roboto is another character from the original Masters of the Universe toy line who appeared in the Filmation animated series. He looked a lot like his toy counterpart, but was a little less detailed.

Following suit, the Club Grayskull action figure features fewer details than the previously released Roboto figure seen in the MOTU Classics line. Aside from the more simplistic design, he also has a brighter color palette and feels a little more rounded in shape, overall. He does feature his signature translucent chest with bright, colorful gears inside. Unlike the original action figure, this version does not include a rotating-gear action feature.

All of Roboto's accessories will feel quite familiar to longtime fans. Roboto's right hand can be removed at the wrist joint and can then be replaced with one of three arm attachments: a claw, an axe, or a blaster.

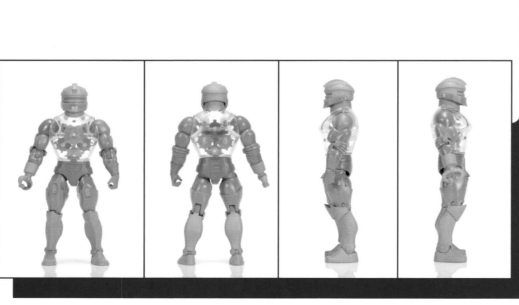

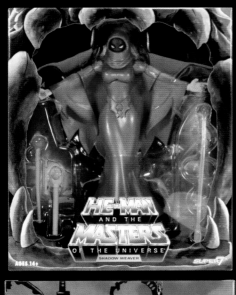

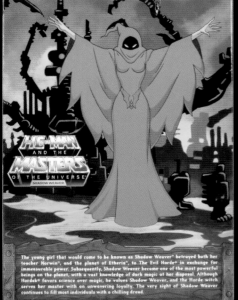

The young girl that would come to be known as Shadow Weaver™ betrayed both her teacher Norwin™, and the planet of Etheria™, to The Evil Horde® in exchange for immeasurable power. Subsequently, Shadow Weaver became one of the most powerful beings on the planet, with a vast knowledge of dark magic at her disposal. Although Hordak® favors science over magic, he values Shadow Weaver, and the Horde witch serves her master with an unwavering loyalty. The very sight of Shadow Weaver continues to fill most individuals with a chilling dread.

SHADOW WEAVER

SHADOW WEAVER

First released 2020 • Member of the Evil Horde

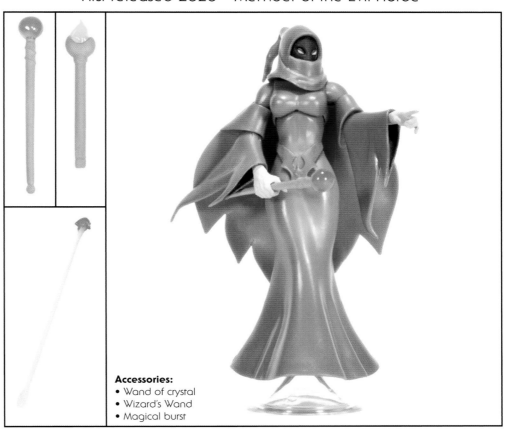

Accessories:
- Wand of crystal
- Wizard's Wand
- Magical burst

Before this Club Grayskull release, Shadow Weaver had only been offered as a seven-inch action figure one other time. That release, part of the Masters of the Universe Classics line, was exclusively sold only to those who bought the full-year subscription of action figures in 2012. This made the figure a bit harder to come by, and it was sought after by many fans who missed out on the original exclusive sale.

Therefore, this Club Grayskull release was extra appealing. Fans who were still lacking a proper Shadow Weaver action figure in their seven-inch-scale MOTU or POP collection finally had the chance to purchase one. This version is completely different from the previous release. The figure more accurately reflects the character's appearance in the She-Ra: Princess of Power animated series, with brighter robes and a simpler design for the Evil Horde emblem on her belt.

She includes several accessories. There is a translucent figure stand that allows you to display the figure as if she's hovering above the ground. Two wands that come straight out of the animation, the Wand of Crystal and the Wizard's Wand, are also included. The most baffling accessory is the blast effect. This would have been a great additional accessory if it actually worked. However, a production error resulted in a hole that should have been open on the end of the piece getting filled in with plastic. This made it impossible to plug the blast onto Shadow Weaver's finger, as intended!

MOTUC - SECTION 2

SHE-RA

First released 2019 • Member of the Great Rebellion

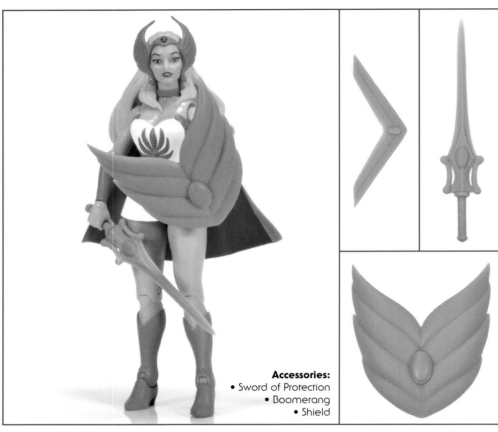

Accessories:
• Sword of Protection
• Boomerang
• Shield

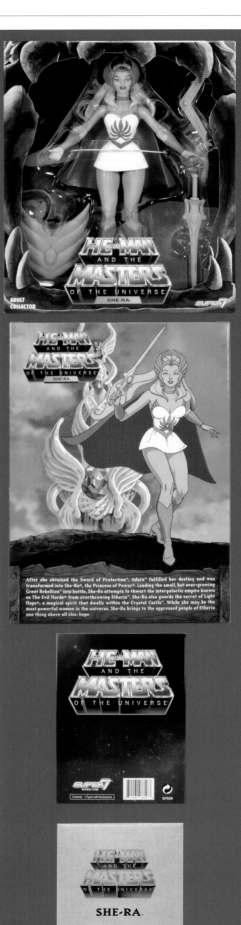

While previous releases of She-Ra in the Masters of the Universe Classics toy line featured elements of the animated She-Ra, this new Club Grayskull version is the first She-Ra figure in the line that is completely based upon her animated appearance in the original Filmation She-Ra: Princess of Power cartoon.

Like many of the Filmation-inspired action figures, the colors used are much brighter and more flat in an effort to make She-Ra appear more like her animated counterpart. There is also much less detail in the sculpt than seen on previous versions of She-Ra. While the sculpt does a great job of re-creating that original animated look, there is a notable paint flaw that appeared on many of these She-Ra figures, where the eyes are painted slightly off from the eye sculpt, making them a bit further apart than they should be.

She-Ra comes with multiple accessories. The most prominent is her Sword of Protection, also styled to appear as it did in the popular cartoon series. Brand-new to this She-Ra action figure are versions of the Sword of Protection transformed into other objects (as it regularly did in the cartoon series): a shield and a boomerang.

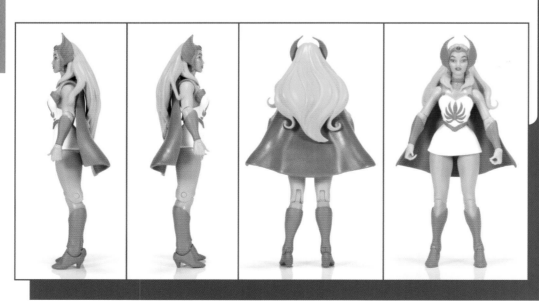

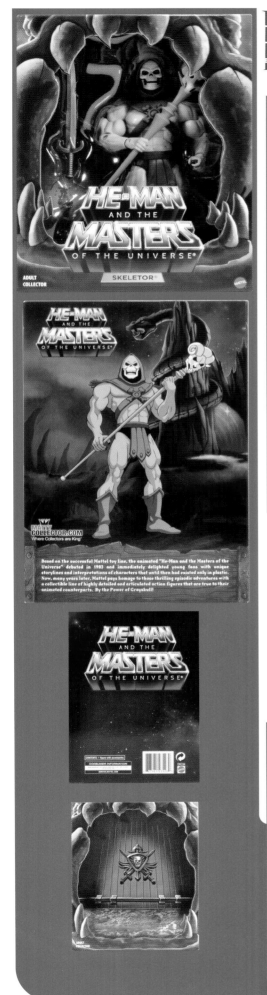

SKELETOR

First released 2016 • Member of the Evil Warriors

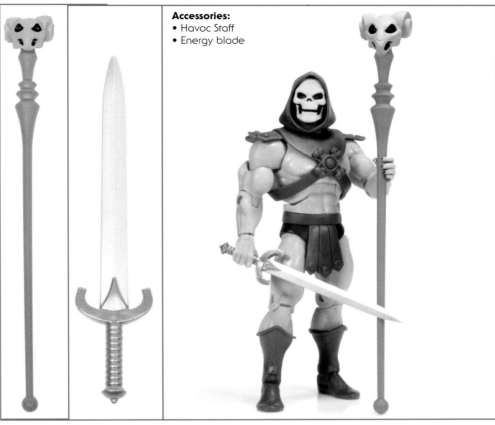

Accessories:
• Havoc Staff
• Energy blade

Club Grayskull Skeletor is based on the character as he appeared in the classic 1983 cartoon series, He-Man and the Masters of the Universe. As the primary villain in the show, Skeletor's animated visage was burned into the brains of millions of children in the eighties, and this figure brings that image to life in vivid 3D.

Club Grayskull Skeletor isn't too radically different from the original 2009 Classics release, but the most striking difference is the head sculpt. The animated version features larger, more evil-looking eyes and a partially open mouth. There's more negative space in the design, giving his features a distinctive look. His hood is also larger and looser compared to the 2009 release.

Skeletor's costume follows the animated look to a tee, with simplified chest armor and belt, booted human feet in place of the three-toed feet of the older release, and smoothed-out human forearms that look like they were borrowed and modified from the Oo-Larr figure.

Speaking of reuse, Skeletor recycles the torso, shoulders, biceps, and legs from King Grayskull. His feet are shared with Club Grayskull He-Man, but his boot tops are new. He has a new cartoon-accurate Havoc Staff, and also the energy blade that Skeletor often used in the first few minicomics released in the 1980s toy line.

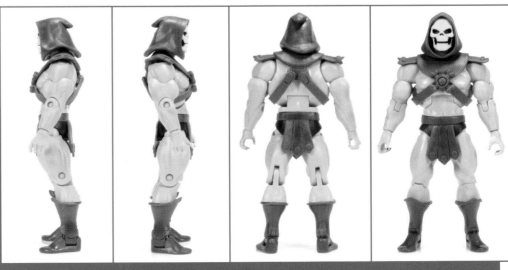

SORCERESS

First released 2018 • Member of the Heroic Warriors

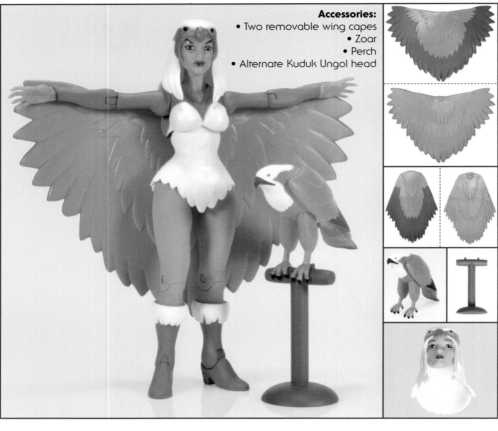

Accessories:
- Two removable wing capes
- Zoar
- Perch
- Alternate Kuduk Ungol head

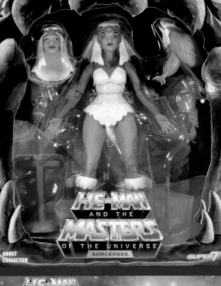

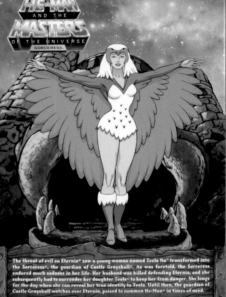

The threat of evil on Eternia® saw a young woman named Teela Na® transformed into the Sorceress, the guardian of Castle Grayskull®. As was foretold, the Sorceress endured much sadness in her life. Her husband was killed defending Eternia, and she subsequently had to surrender her daughter Teela® to keep her from danger. She longs for the day when she can reveal her true identity to Teela. Until then, the guardian of Castle Grayskull watches over Eternia, poised to summon He-Man® in times of need.

Club Grayskull Sorceress is probably the closest in appearance to her Classics counterpart, because both were based on the character as she appeared in the Filmation He-Man and She-Ra cartoons. While the 2012 release was a Classics-style interpretation of the design, the Club Grayskull version is a much more faithful re-creation.

Rather than the folding wing plates used on the 2012 release, the Sorceress includes two removable wing capes, one extended outward and the other retracted. The sculpting on the feathers of her cape is much less detailed than the previous release, but also better follows the Filmation color scheme.

The Sorceress comes with an alternative head—that of Kuduk Ungol, the person who guarded Castle Grayskull as the Sorceress before Teela Na. She also comes with a new version of Zoar (the Sorceress in bird form), who is sculpted in a sitting position with her wings folded. Because she is based on Zoar's animated look, she does not include armor, but she does come with a red perch.

The Sorceress reuses the legs and feet from Club Grayskull Teela, but otherwise is made up of mostly newly tooled parts. Like the 2012 release, she's a beautiful figure, and a watchful protector for any and all Castle Grayskull play sets you might own.

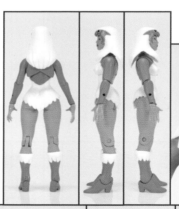

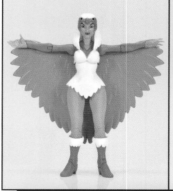

SPIKOR

First released 2018 • Member of the Evil Warriors

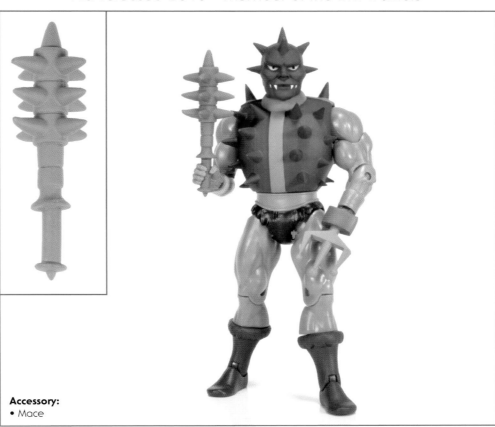

Accessory:
• Mace

Spikor was released as a 2018 Power-Con exclusive. Based on his (infrequent) appearances in the Filmation He-Man cartoon, Spikor is mean, lean, and covered with deadly spikes. His spikes are actually quite sharp, so care should be taken when handling this figure!

In some of his appearances in the cartoon, Spikor had two human-like hands, and in others he had a trident for a left hand. This version is based on the latter. Spikor features a brand-new head sculpt, armor, trident, mace, and boots. His shoulders, biceps and legs are reused from King Grayskull; his right hand is reused from Club Grayskull Man-At-Arms; his trunks come from Club Grayskull Tung Lashor; and his forearms come from Club Grayskull He-Man.

Spikor has a somewhat goofy appearance, mainly due to his face, but that's certainly a match for the bumbling henchman that he was portrayed as in the cartoon.

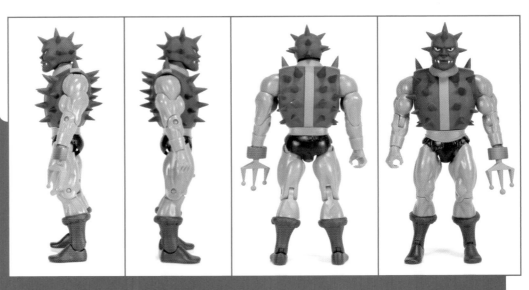

STRATOS

First released 2020 • Member of the Heroic Warriors

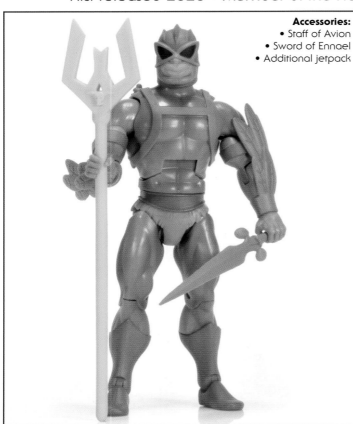

Accessories:
- Staff of Avion
- Sword of Ennael
- Additional jetpack

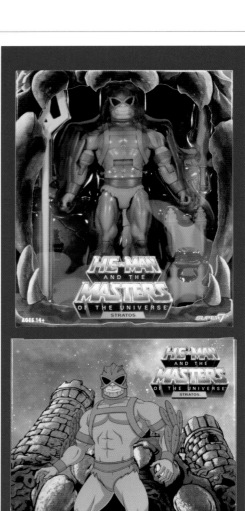

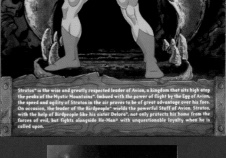

Stratos was one of the original eight action figures released in the vintage Masters of the Universe toy line. He made his way to the Filmation He-Man and the Masters of the Universe animated series, ultimately inspiring one of the final Club Grayskull action figures.

Since this figure is based on how Stratos appeared in the animation, the overall design is much smoother and more simplistic, featuring a lot less detail than the 2008 Masters of the Universe Classics action figure. As a result, he doesn't have the fur sculpting on his body that the original action figure is known for, and the wings on his arms are much smaller.

In most of his action figure releases, Stratos doesn't typically tend to include weapons or accessories. This Club Grayskull version, however, comes with two. He's packed with the Staff of Avion, as it appeared in the animated series. This is an accessory that did see release in the MOTU Classics toy line, but this one is newly sculpted and painted with a bright yellow color scheme that is more representative of its look in the cartoon. Also included is the Sword of Ennael. This item never appeared in the animation, and is essentially just a red version of the same sword that came with the Club Grayskull Teela. It was included specifically to give Stratos a weapon for combat—something we do not usually see him wield.

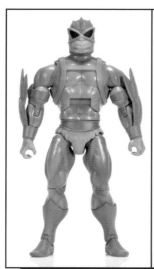

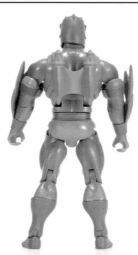

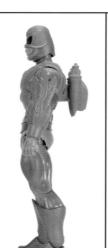

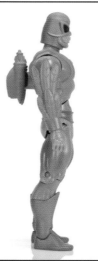

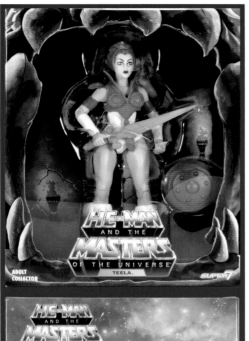

TEELA

First released 2018 • Member of the Heroic Warriors

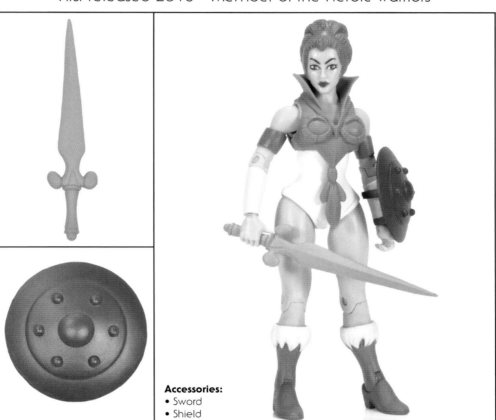

Accessories:
• Sword
• Shield

The captain of the guard returns to Eternia in the 2018 Club Grayskull release of Teela. This was actually the second attempt at a Filmation-style Teela. The first came in 2015, packed with Point Dread and the Talon Fighter. That version split the difference between Classics details and a Filmation-accurate look, but was unfortunately marred by a defective head sculpt from the factory. The 2018 release, while not 100 percent spot on, gets fans much closer to a toontastic Teela.

Teela comes with her cartoon weapons, a sword and a shield. These are very similar looking to the 2015 release, but subtly different and with a toned-down paint job. Teela borrows the boot tops from Evil-Lyn, but she is largely made up of brand-new parts. She's actually significantly shorter than Club Grayskull Evil-Lyn, particularly from the waist up. She is, however, about the same height as her mother, the Sorceress. Overall, Teela is a great-looking figure, and a fitting representation of the adopted daughter of Duncan as she appeared in the cartoon.

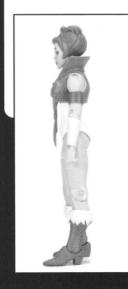
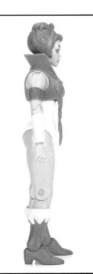
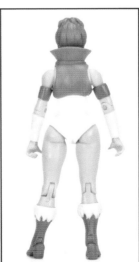
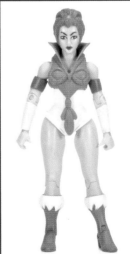

MOTUC - SECTION 2

TRAP JAW

First released 2016 • Member of the Evil Warriors

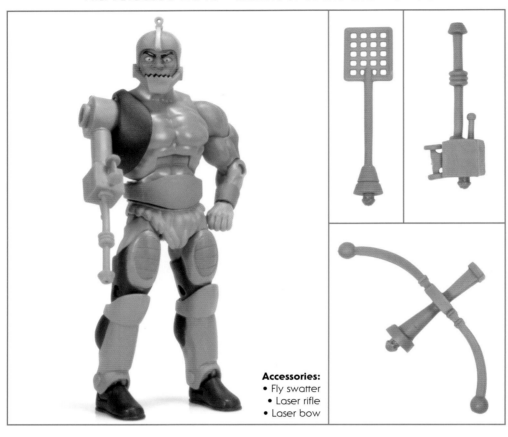

Accessories:
• Fly swatter
• Laser rifle
• Laser bow

Trap Jaw gets a Filmation-style makeover in the second release of the Club Grayskull line. Trap Jaw was always an impressive-looking character, but he gets a lot more color in this release, with the mechanical arm, trunks, and boots getting the same pinkish-red color as his helmet.

Trap Jaw has less sculpted mechanical detail on his costume than the 2010 Classics release. He does feature an articulated jaw and three attachments for his mechanical arm. The laser rifle attachment is quite similar to the one included in the previous release, but his laser bow and comical fly swatter are unique to this release and come straight out of the cartoon.

Trap Jaw is very faithful to the animated design, with the exception of his mechanical arm. In the cartoon, Trap Jaw's attachments would connect right up to the artificial shoulder. The Club Grayskull release is slightly more like the vintage toy, in that there is a length of mechanical arm coming from the shoulder, and the attachments connect to the end of it.

Trap Jaw reuses the torso, left shoulder, and left bicep from King Grayskull, and the left forearm and hand from Club Grayskull He-Man.

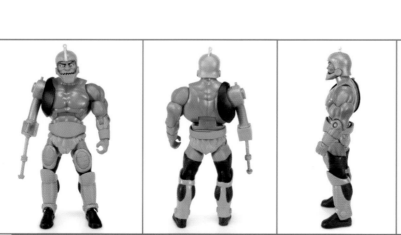

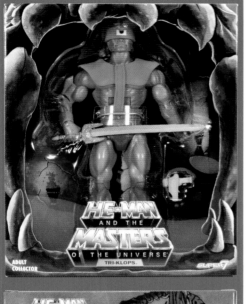

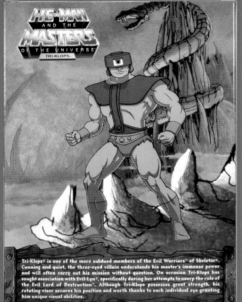

TRI-KLOPS

First released 2018 • Member of the Evil Warriors

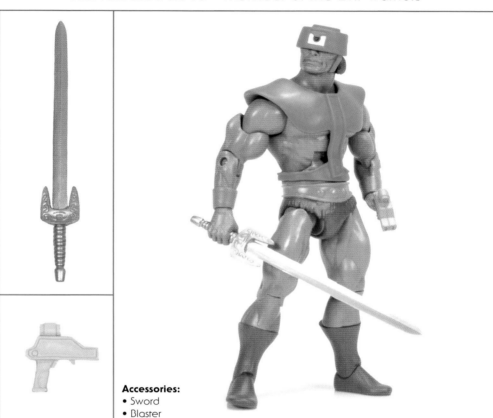

Accessories:
• Sword
• Blaster

Tri-Klops helps to round out the group of core Filmation-style Evil Warriors in the Club Grayskull line. Compared to the 2009 release, he is greatly simplified, but that is of course usually the case with animated designs. One of the most obvious differences is in the head sculpt. The Club Grayskull version has a much simpler visor, with eyes in simple geometric shapes and a relatively unadorned helmet design.

Tri-Klops borrows the boot tops from Club Grayskull Beast Man, the hands and feet from Club Grayskull Man-At-Arms, the forearms from Club Grayskull He-Man, and the shoulders, biceps, and legs from King Grayskull. His torso is a new design, taller and narrower than the usual Classics male chest. He of course has a newly-sculpted head and accessories as well. His bright green armor is based on his original model sheet colors. Sometimes the color would come across much darker in broadcasts, depending on your location.

As for accessories, Tri-Klops comes with the decidedly non-Filmation cross-sell-art-inspired sword, which works well with the 2009 Tri-Klops, whose design was also based on that artwork. The figure also comes with a small Filmation-style blaster.

For the initial release, Tri-Klops' visor was glued in place. This was a factory mistake, as the visor was always intended to rotate like previous versions of the character. To rectify this, Super7 mailed out a free corrected head to everyone who ordered the figure.

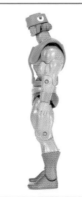

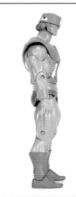

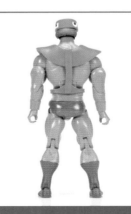

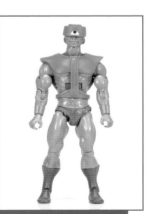

TUNG LASHOR

First released 2018 • Member of the Evil Horde

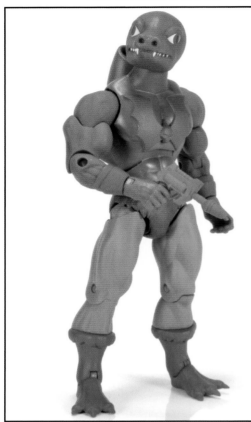

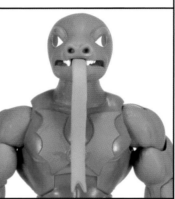

Accessories:
- Gun
- Jetpack
- Alternate head

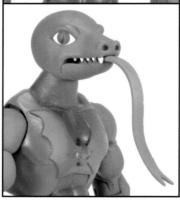

Of all the Club Grayskull figures, Tung Lashor is perhaps the most different from his Classics release. Tung Lashor's appearance in the Filmation cartoon was actually based on an early concept design for the figure. By the time the figure went to market in 1986, the character's design had been radically changed, meaning the animated character's look was almost unrecognizable as the action figure.

Tung Lashor is a simple-looking figure, with a bulbous head, cartoony face, and rather basic color scheme. He comes with an alternative head that shows his tongue extended, a removable backpack, and a laser gun. Tung Lashor features a number of newly-sculpted pieces, including his heads, chest, and forearms. He also reuses some of the typical parts, including shoulders, biceps, and legs from King Grayskull and feet from the 2009 Skeletor release.

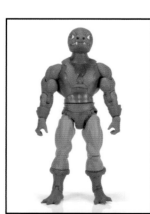

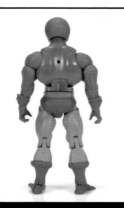

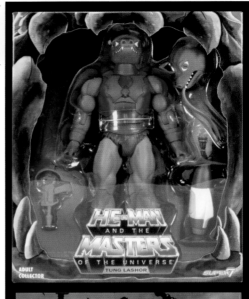

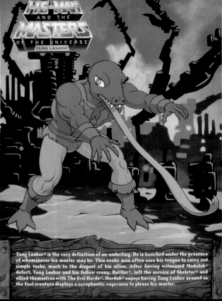

UNCLE MONTORK

First released 2018 • Member of the Heroic Warriors

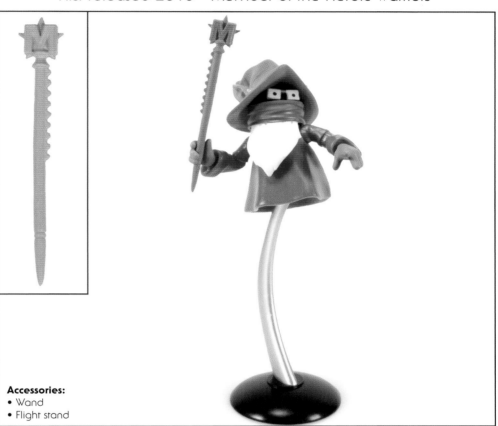

Accessories:
• Wand
• Flight stand

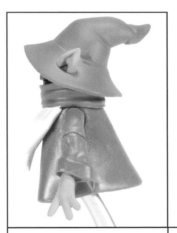

Uncle Montork was released in a two-pack with his fellow Trollan, Dree Elle. Uncle Montork was an occasional recurring character on the Filmation He-Man and She-Ra cartoons, and the uncle and mentor of Orko.

Uncle Montork's arms and body are closely based on the 2010 Orko release, with some apparent slight differences on sections of the arms. He includes a new head sculpt with long white beard, and he comes with a magic wand similar to Orko's, but with a letter M sculpted at the top. Montork also comes with a flight stand, which has a wider and more stable base than the one that came with Orko.

Montork looks very much like a bearded, bespectacled Orko, which makes sense, considering they are family. Together with Dree Elle he helps to round out the Trollan characters in the Masters of the Universe lineup.

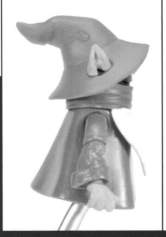

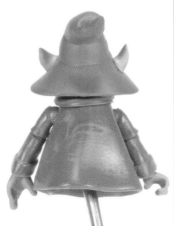

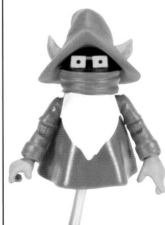

MOTUC - SECTION 2

ZOAR

First released 2018 • Beast of the Heroic Warriors

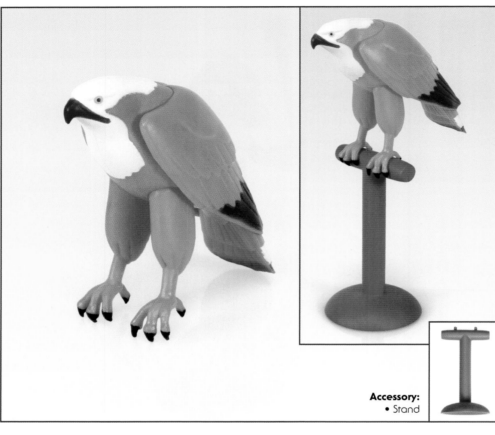

Accessory:
• Stand

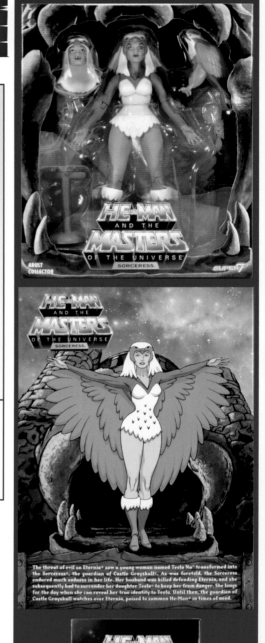

Zoar was included as a pack-in with the 2018 release of the Sorceress in the Club Grayskull lineup.

Although Zoar was released a few times in the Masters of the Universe Classics toy line, those versions were based much more on the design of the original Zoar from the 1982 Masters of the Universe toy line.

This version fully embraces the design aesthetic of Club Grayskull by finally giving us a toy of Zoar as she appeared in the He-Man and the Masters of the Universe animated series. This figure does not have any articulation, but does include a red perch. The perch has two pegs that plug into the bottom of the bird's feet in order to fasten her to the stand for display.

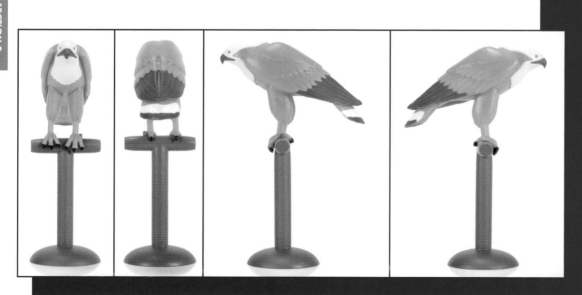

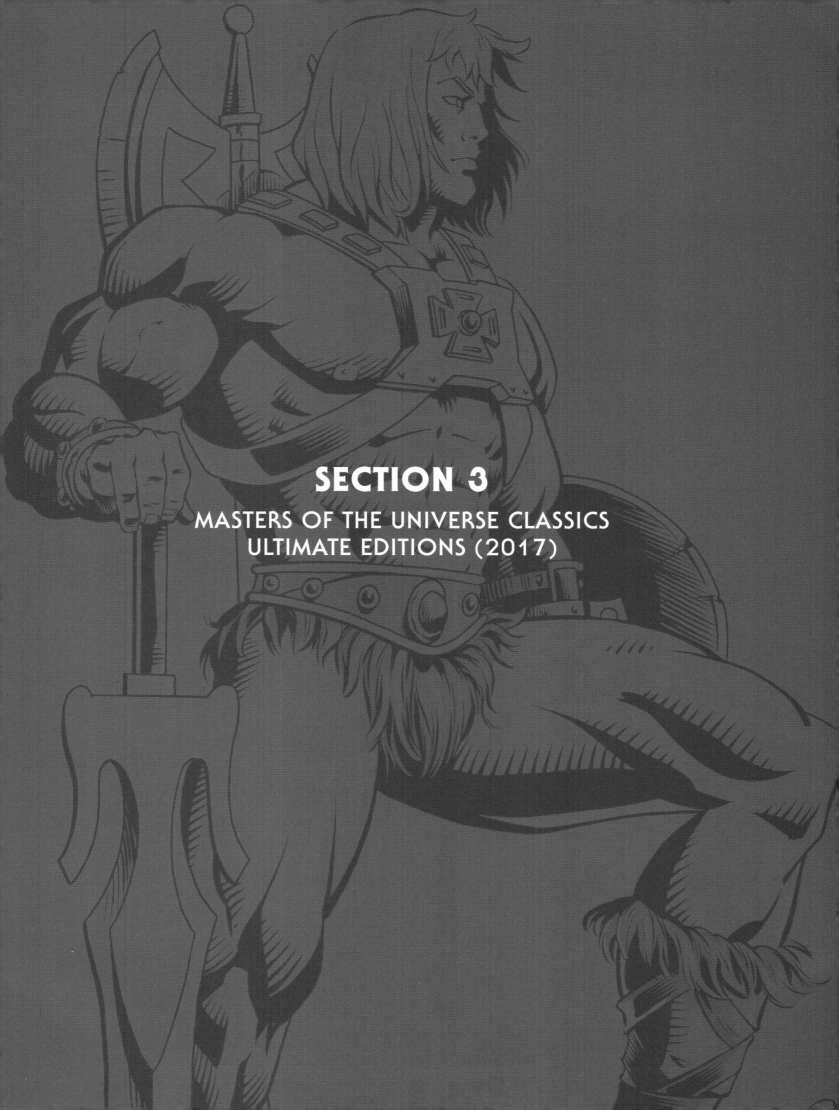

SECTION 3

MASTERS OF THE UNIVERSE CLASSICS
ULTIMATE EDITIONS (2017)

FAKER (ULTIMATE EDITION)
EVIL ROBOT OF SKELETOR

First released 2017 • Member of the Evil Warriors

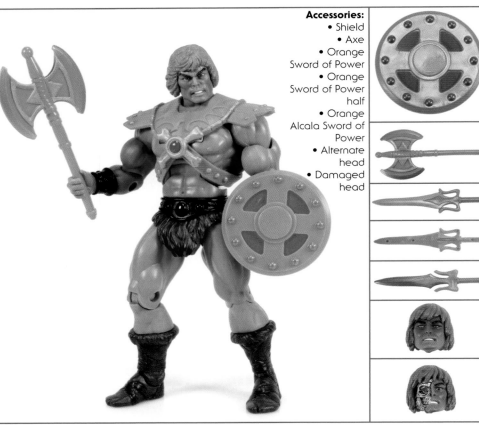

Accessories:
- Shield
- Axe
- Orange Sword of Power
- Orange Sword of Power half
- Orange Alcala Sword of Power
- Alternate head
- Damaged head

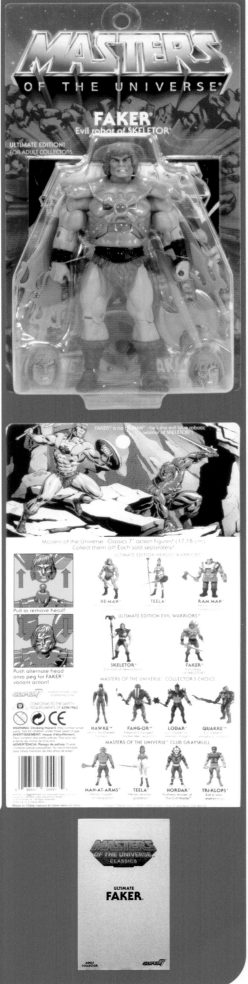

The Ultimate Edition of Faker includes quite a few fan-demanded upgrades to his first release in 2009. Faker comes with the original head and accessories from that first release (which were in turn borrowed from King Grayskull, He-Man, and Skeletor), but he also has some fun extras.

Faker comes with the extra head included with Intergalactic Skeletor, which shows half of his synthetic face devoid of skin, revealing the robotic skeleton underneath. Faker also includes, repainted in blue and orange, the extra vintage toy–style He-Man head that was included with Oo-Larr. He has an orange repaint of the minicomic-style Sword of Power that first shipped with He-Ro II, as well as the He-Man axe in orange that originally shipped with King Grayskull.

In terms of paint applications, there are few key differences between Ultimate Faker and his first 2009 release. Rather than silver and black belt and bracers, Ultimate Faker features a gloss black finish, which is more in keeping with the color scheme of the vintage 1983 action figure. Ultimate Faker also features bright orange hair that matches his armor, as opposed to the dark red hair of the first release. Like the previous version, he has a control panel tampographed to his chest, patterned after the sticker included on the vintage toy.

HE-MAN (ULTIMATE EDITION)
MOST POWERFUL MAN IN THE UNIVERSE!

First released 2017 • Member of the Heroic Warriors

Accessories:
- Shield
- Axe
- Sword of Power
- Sword of Power half
- Alcala Sword of Power
- Two Alternate heads

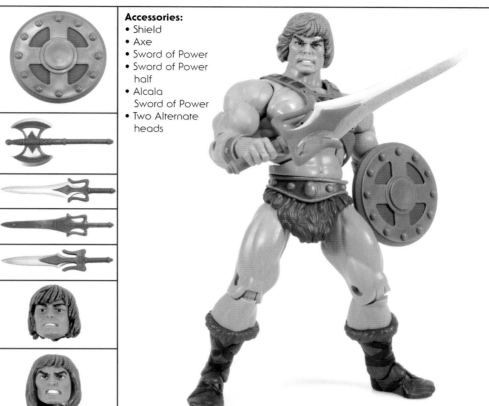

The Most Powerful Man in the Universe makes for a very powerful-looking figure indeed. Ultimate Edition He-Man is a rerelease of the 2008 Classics figure, but with extra accessories for some additional display options.

The figure includes the head that came with the 2008 He-Man, which in design terms seems to split the difference between the 1982 figure and the 2002 He-Man, which had a younger, anime-inspired face. He also includes both heads that came with Oo-Larr, one of which resembles He-Man in the vintage minicomics illustrated by Alfredo Alcala, and the other of which looks like the original 1982 action figure.

As with the 2008 release, He-Man's weapons are sleeker than their vintage counterparts: his shield is flatter, his axe has a smoother handle, and his Sword of Power looks like a mash-up between the vintage toy and the vintage cross-sell artwork. He-Man also comes with a half sword, which can be combined with Skeletor's half sword to make a full sword. He also comes with the minicomics-inspired Sword of Power that came with He-Ro II, but this time with a two-tone sword blade. Much of the paint deco on Ultimate He-Man is darker than the 2008 release, particularly around the belt and bracers. His hair has a darker wash on it as well.

Ultimate He-Man was sold on a vintage-inspired card, complete with the red burst pattern familiar to anyone who grew up with the original 1980s line. Behind the figure is a faux minicomic cover, and the back of the card features new vintage-style art. The artwork was done by Axel Giménez, with colors by Val Staples and inks by Jason Moore.

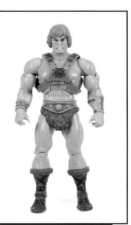

HE-MAN (CLUB GRAYSKULL)
MOST POWERFUL MAN IN THE UNIVERSE!

First released 2019 • Member of the Heroic Warriors

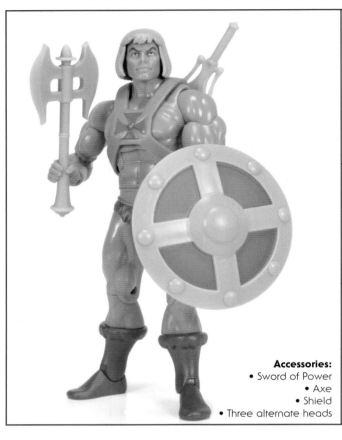

Accessories:
- Sword of Power
- Axe
- Shield
- Three alternate heads

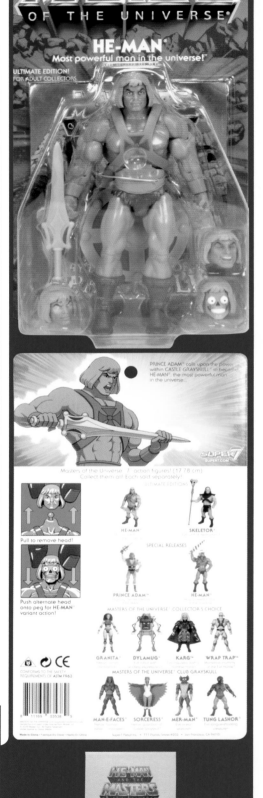

Several years after the first Filmation-style He-Man action figure was released, a new Ultimate version was offered from Super7. This allowed fans who might have missed out on the original release to finally add the cartoon version of He-Man to their toy shelves.

This new version came on special blister card packaging modeled after the vintage Mattel Masters of the Universe toy line. The figure itself also differs from the original Mattel release. While the overall sculpt looks similar, there are small changes to areas such as the ankle joints. The right wrist joint has also been changed, meaning He-Man can no longer hold the sword aloft in a proper transformation pose.

Several new accessories are included with this new version of He-Man that did not come with the original Club Grayskull release. Along with the usual Sword of Power, He-Man now comes with an animation-style battle axe and shield. There are also several swappable heads. A laughing head allows fans to re-create scenes from the cartoon series, while a robot-faced head is included so the figure can be displayed as the He-Man robot from the episode "Disappearing Act", and a head with glowing white eyes is also included so he can be displayed as the Filmation version of Faker.

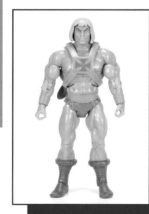
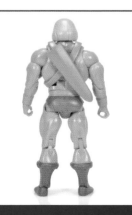
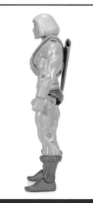
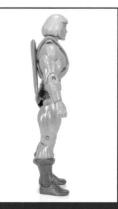

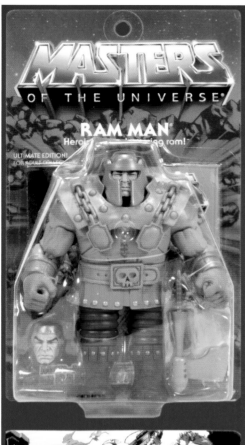

MASTERS OF THE UNIVERSE®

RAM MAN
Heroic ...ng ram!

ULTIMATE EDITION!

Use the iron-like body of RAM MAN as a battering ram!

Pull to remove head!

Push alternate head onto peg for RAM MAN variant action!

MASTERS OF THE UNIVERSE CLASSICS

ULTIMATE RAM MAN.

RAM MAN (ULTIMATE EDITION)
HEROIC HUMAN BATTERING RAM!

First released 2017 • Member of the Heroic Warriors

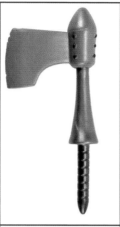

Accessories:
- Short axe
- Alternate 200X inspired head

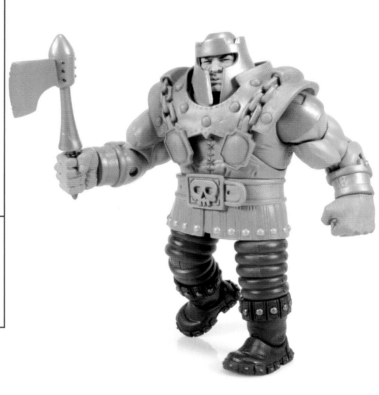

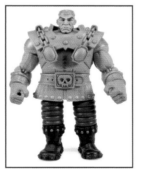

The Ultimate edition of Ram Man, unlike the other Ultimate figures, includes only the same accessories that were included with the first release of the figure in 2013.

As with the first release, Ultimate Ram Man is closely based on the vintage cross-sell art in terms of his sculpt. This is especially evident in the shape of his shoulder armor and axe, as well as his expression, with tightly closed eyes as if he were about to ram something. Unlike the first release, his color scheme also follows the look of the cross-sell art, with brown boots, red pants, and an orange tunic.

Ram Man comes with his axe, which can be stored on a clip on his back. His second, unhelmeted, head is inspired by scenes from the 2002 He-Man cartoon.

As with the first release, Ultimate Ram Man includes a great deal of detail, including some sculpted skull designs hidden on the bottom of his feet. His armor is adorned with tiny rivets, and his arms and face have a great deal of sculpted detail, including veins, tendons, and wrinkles. This differentiates him all the more from his 1983 counterpart, which had a rather soft sculpt that was light on details.

Ram Man is one of the heaviest and stoutest figures in the Classics line, especially for his height. Standing at about the same height as He-Man, Ram Man is at least twice as thick around.

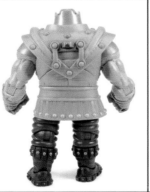
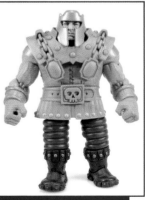

MOTUC - SECTION 3

SKELETOR (ULTIMATE EDITION)
EVIL LORD OF DESTRUCTION

First released 2017 • Member of the Evil Warriors

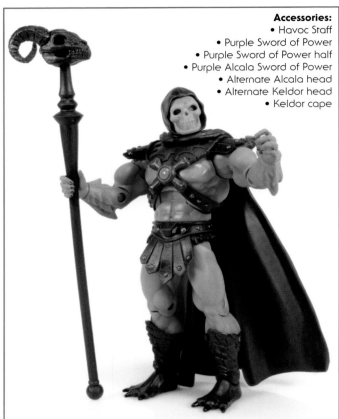

Accessories:
- Havoc Staff
- Purple Sword of Power
- Purple Sword of Power half
- Purple Alcala Sword of Power
- Alternate Alcala head
- Alternate Keldor head
- Keldor cape

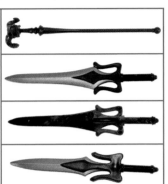

As the big bad of the Masters of the Universe Classics universe, Skeletor had a lot to live up to, and he doesn't disappoint. The Ultimates version kicks it up a notch by allowing the Evil Lord of Destruction to be displayed as two different characters, and as at least two different incarnations of Skeletor.

Whereas the 2009 release of Skeletor was closely based on the vintage cross-sell artwork, the Ultimates version is more closely based on the design of the 1982 figure, particularly in the look of the boots and forearms, which in this case are borrowed from Kobra Khan and Whiplash, respectively. The original 2009 accessories and head are included in this release.

Also included is the minicomic-inspired Skeletor head (originally released with Demo-Man) that was based on the rather ghoulish-looking Skeletor that appears in minicomics illustrated by Alfredo Alcala. To round out the look, a two-tone purple repaint of the minicomic-inspired Sword of Power (originally released with He-Ro II) is also included.

Ultimate Skeletor also comes with Keldor's head and cape. The character of Keldor was first mentioned in the vintage minicomic The Search for Keldor, which hinted that Skeletor was originally Keldor, the missing brother of King Randor. The character was fleshed out in the 200X animated series. The familial connection was finally made fully official in the Classics bios, in which we learned that Keldor was King Randor's half-brother, who lost his fleshy face in an attempted acid attack that backfired badly, and thus became known as Skeletor. Keldor's cape, as included with this figure, matches well with Skeletor's armor and can be used in concert with any of the heads.

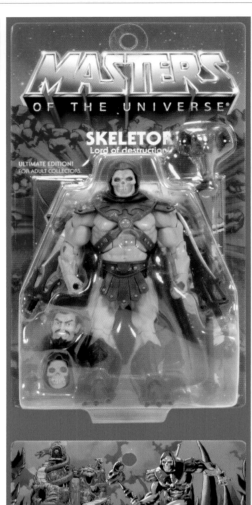

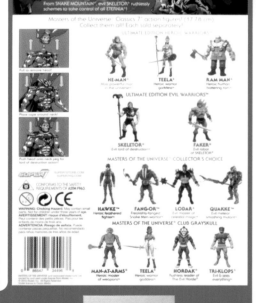

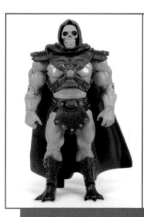

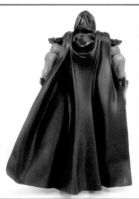

SKELETOR (CLUB GRAYSKULL)
LORD OF DESTRUCTION!

First released 2019 • Member of the Evil Warriors

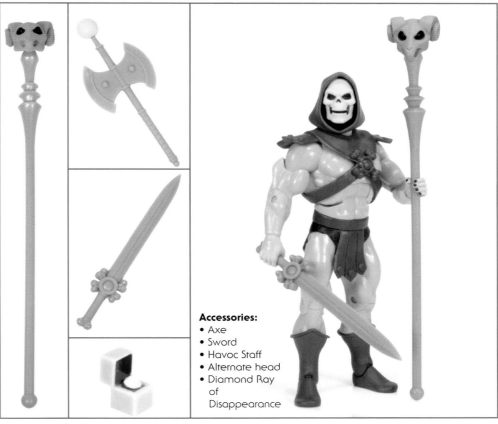

Accessories:
- Axe
- Sword
- Havoc Staff
- Alternate head
- Diamond Ray of Disappearance

Skeletor joined He-Man for the Ultimate reissue treatment from Super7, so that fans who missed out on this cartoon-styled Skeletor action figure the first time around were allowed a second chance to add him to their collections.

Skeletor comes in special blister card packaging styled after Mattel's original Masters of the Universe toy line. The figure inside is very similar to the original Club Grayskull Skeletor released by Mattel a few years earlier. The most notable difference is the color, as this new "Ultimate" version is much brighter than the previous release, giving him a more cartoon-accurate look.

This new Ultimate figure also includes some new accessories that were not released with the previous version. He still includes the usual Havoc Staff, but in addition he also comes with a sword featuring a crossbones hilt—a weapon seen in the cartoon series. Also included is the Diamond Ray of Disappearance—a relic used by Skeletor in the pilot episode of the Filmation series.

Finally, Skeletor now includes one alternate head. This head can be swapped by popping the current head off of the ball joint at the neck. This alternate head depicts Skeletor with a wide-open mouth as if he is laughing maniacally—a common occurrence in the He-Man and the Masters of the Universe cartoon.

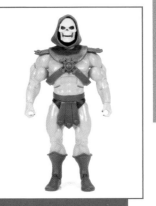

TEELA (ULTIMATE EDITION)
WARRIOR GODDESS

First released 2017 • Member of the Heroic Warriors

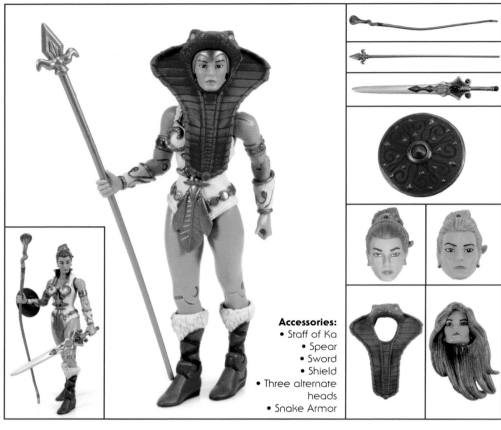

Accessories:
- Staff of Ka
- Spear
- Sword
- Shield
- Three alternate heads
- Snake Armor

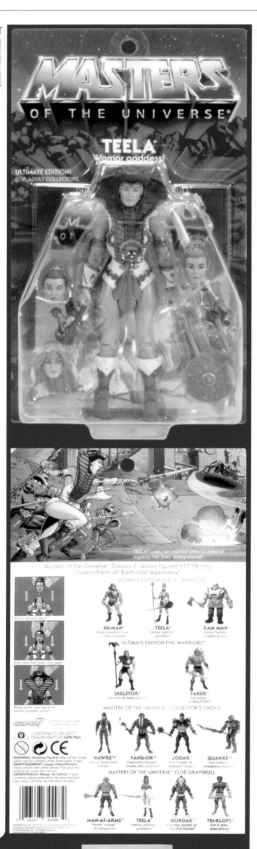

Ultimate Edition Teela is one of the most accessory-laden figures in the line, and also one of the most versatile, with three extra heads and a number of different options for display.

Teela comes with everything that was included in her 2009 release, except for the Zoar figure. That is to say, she has the helmeted head, the red-ponytail head, the 200X-inspired sword, the staff, and the shield. She also includes the spear from the Goddess, the head from Battleground Teela, and another version of her ponytail head with blond hair. Ultimate Teela borrows her bracers from Battleground Evil-Lyn, who had extra articulation points to allow them to rotate freely.

Unlike the 2009 Teela, Ultimate Teela has red boots and red Snake armor instead of brown. The 2009 version's brown costume was based on the coloring of her cross-sell artwork, while the red costume of Ultimate Teela is more closely based on the 1982 action figure. Color changes notwithstanding, Teela's sculpt is still closely based on her vintage cross-sell-art look, as opposed to her vintage toy look. Comparatively, the cross-sell artwork was much more detailed than the actual figure.

Teela's extra heads allow her to assume a number of different looks. Depending on the head and accessories chosen, she can look like several different blond minicomic versions of Teela, the vintage toy version of Teela, or the Sorceress as depicted in several vintage comic books published by DC Comics.

Teela technically has waist articulation, although the plastic on her outfit is too stiff to allow her waist to actually twist. Teela reuses no previously existing parts, although every piece used in her construction would eventually find its way into one or more other figures released later.

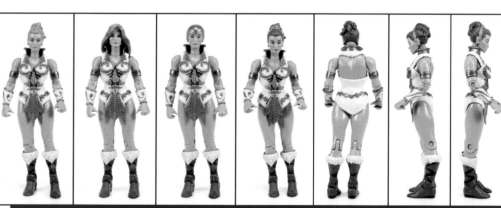

CHAPTER 7

Masters of the Universe (2016)

BEAST MAN
SAVAGE HECHMAN!

First released 2019 • Member of the Evil Warriors

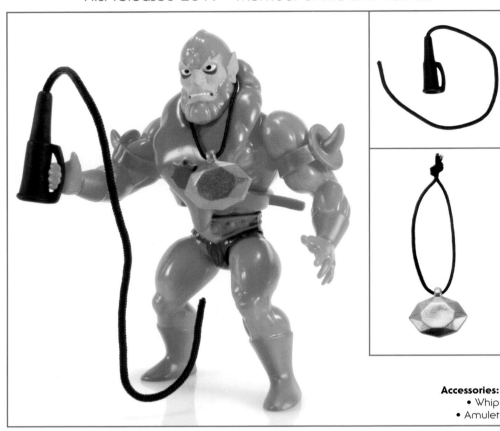

Accessories:
• Whip
• Amulet

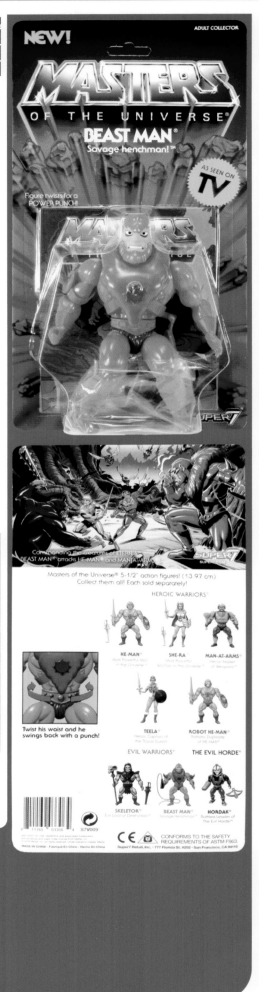

In 2019, Super7 relaunched the original Masters of the Universe toy line under license from Mattel. The figures were done in a retro style, meant to mimic the squat five-and-a-half-inch action figures of the 1980s. The difference is that this new line would be inspired by the way the characters appeared in the Filmation He-Man and She-Ra animated series!

You can really see this with Beast Man. Sure, he still has the muscular body with the bent legs much like he did in that original toy line. But he now features brighter colors and a smoother sculpt to make him appear more like his animated counterpart. On top of that, this time, the head is modeled after his cartoon appearance rather than the meaner, most beastly head of the vintage action figure.

He comes with two accessories. First up is his classic whip, which is very similar to the one included with his original action figure. But he also has one other accessory that comes straight out of the original animated series! The golden amulet comes from the episode "Orko's Return," and has a real string that allows you to place the amulet around the neck of any of your action figures!

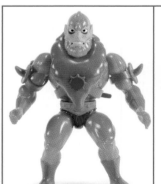

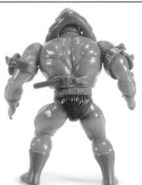

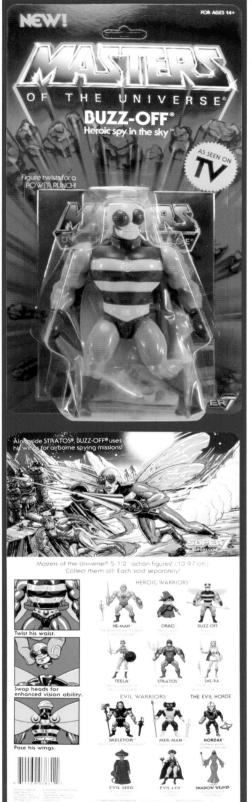

BUZZ-OFF
HEROIC SPY IN THE SKY

First released 2019 • Member of the Heroic Warriors

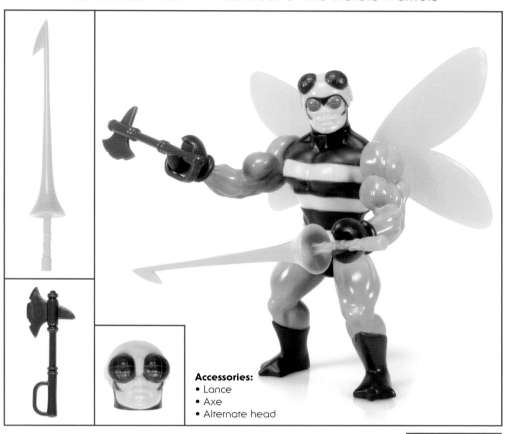

Accessories:
• Lance
• Axe
• Alternate head

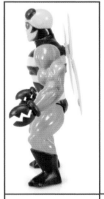

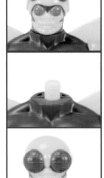

Since the original He-Man and the Masters of the Universe cartoon characters were modeled after the original toys, details often had to be simplified for the animation process. This resulted in some characters in the show looking similar to the toys, but also distinctly different at the same time. This is why revisiting these original action figures with a cartoon theme is such a fun idea!

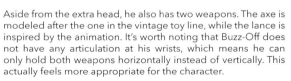

Buzz-Off is one such character. The wings are much different on this version when compared to his vintage action figure counterpart. They now plug into his back and have the ability to swivel. He's also the only figure in this line that features an interchangeable head. The alternate head has Buzz-Off's helmet sitting higher up, revealing his actual eyes underneath. The original action figure had a removable helmet to achieve this look instead.

Aside from the extra head, he also has two weapons. The axe is modeled after the one in the vintage toy line, while the lance is inspired by the animation. It's worth noting that Buzz-Off does not have any articulation at his wrists, which means he can only hold both weapons horizontally instead of vertically. This actually feels more appropriate for the character.

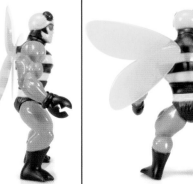

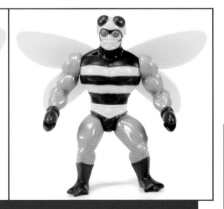

CRYSTAL MAN-AT-ARMS
CRYSTAL STATUE OF MAN-AT-ARMS

First released 2019 • Member of the Heroic Warriors

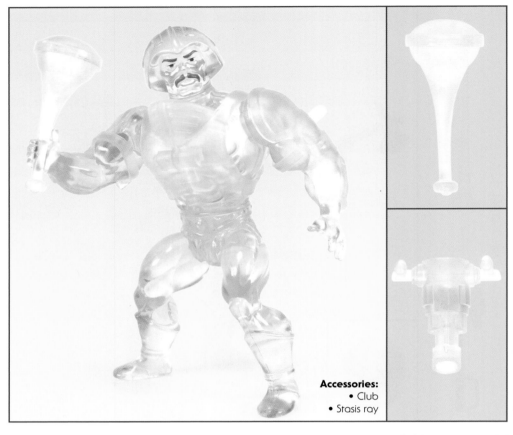

Accessories:
- Club
- Stasis ray

This line of retro-inspired figures from Super7 also included some variants of main characters that were based on specific episodes of the original animated series. Crystal Man-At-Arms comes from the episode "The Dragon's Gift," in which Duncan was turned into a crystal statue by the villains.

The figure is exactly the same as the standard Man-At-Arms action figure released in this line, with the only exception being that he is now made of a crystal-clear plastic. The plastic on the figure's body is completely translucent, while the armor pieces have a foggy look, making for a nice contrast. The only paint applications found on the figure are on his face, where his eyes and mustache are painted black.

He even comes with the same two accessories in the form of the club and the stasis ray, both of which are also made from the same clear plastic.

ELDOR
HEROIC GUARDIAN OF THE BOOK OF LIVING SPELLS

First released 2019 • Ally of the Heroic Warriors

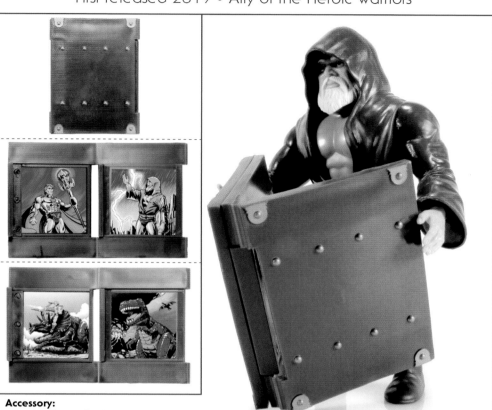

Accessory:
• Book of Living Spells

Eldor is one of two action figures in Super7's retro-inspired line not to be based on the Filmation animated series. Instead, Eldor comes from "The Powers of Grayskull," an unreleased line of action figures that was originally planned as a spinoff from the classic Masters of the Universe toy line. Photos of prototypes of two figures, He-Ro and Eldor, have been floating around for years. Fans have always wanted to add these two mystery characters to their vintage collections, and now, Eldor and He-Ro are a reality!

Eldor is a brand-new sculpt, but he is based very closely on the photos of the original unreleased prototype. Even the packaging is nearly identical to what we would have seen had this figure been released in the 1980s, as originally planned.

Eldor's one accessory is unique. The Book of Living Spells includes a sticker sheet with stickers that you need to apply to the pages of the book yourself. Once applied, the book essentially works like a simple magic trick. It has a trifold mechanism that makes it look as if the pages are magically changing simply by opening it up in alternating directions. It's an oversized accessory, and very hard for the figure to hold, but it's still quite fun!

Eldor and He-Ro are are two of the most exciting figures to come out of this line of retro action figures, simply for the fact that fans can finally own a piece of toy history they never thought they'd have.

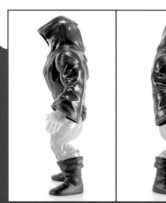
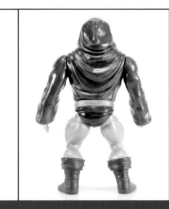
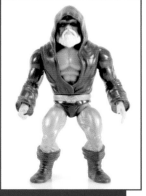

EVIL-LYN
EVIL WARRIOR GODDESS

First released 2019 • Member of the Evil Warriors

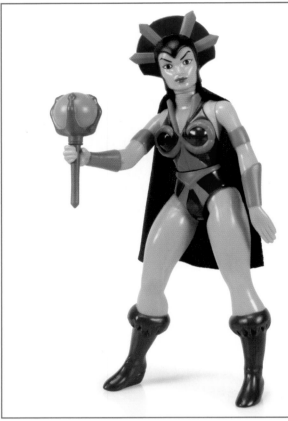

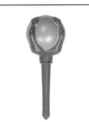

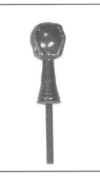

Accessories:
• Gray wand
• Blue wand
• Coridite Crystal

Evil-Lyn is one example of a character who had very different looks between the original action figure and the animated series. The original toy had bright yellow skin, while the cartoon had a much paler skin tone. If you were a kid who wondered why your toy didn't match what you saw on TV, then this action figure is for you!

Aside from the colors, this new figure also has a larger headdress and a cloth cape to match up with her onscreen look. The style of the figure itself is very similar to that of the vintage figure, with the left hand open and straight, and the right hand in a gripping pose.

For accessories, she has two versions of her signature wand. One is gray in color to more closely resemble the onscreen version, while the other is blue to match up with what we saw on her original action figure release. In addition, she has an all-new accessory straight out of the animated series: the Coridite Crystal!

Getting a vintage-style action figure that looks much more like the character many fell in love with in the cartoon is pretty wild, and exactly the kind of thing this particular line delivers well!

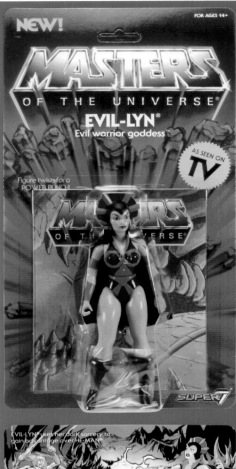

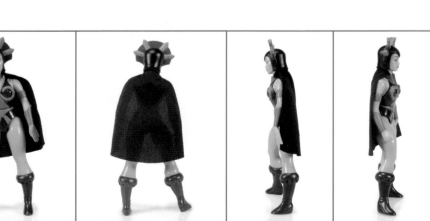

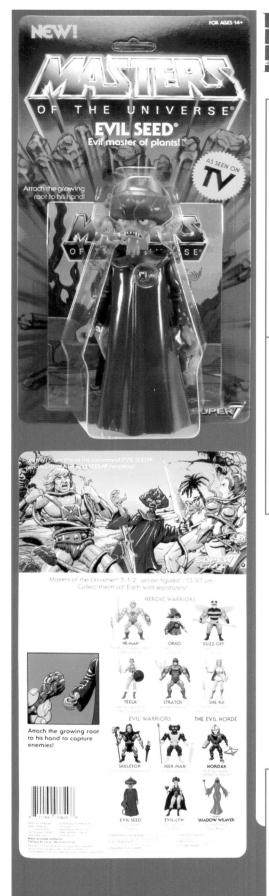

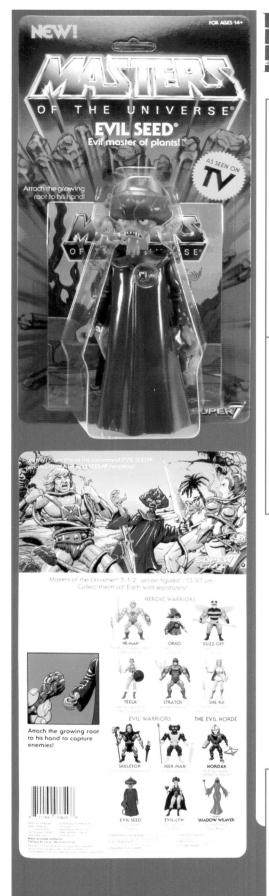

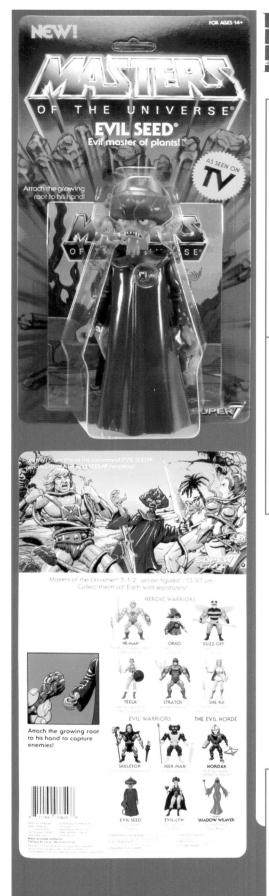

EVIL SEED
EVIL MASTER OF PLANTS!

First released 2019 • Evil Villain

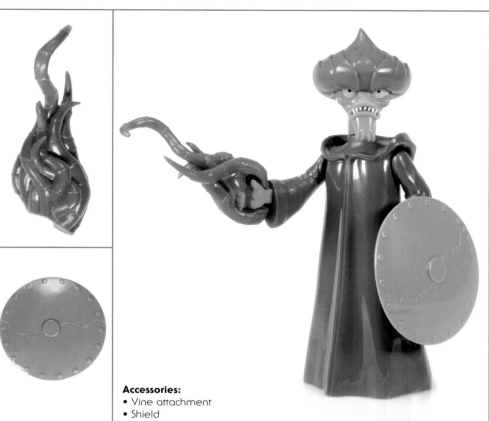

Accessories:
- Vine attachment
- Shield

The original He-Man and the Masters of the Universe animated series often featured one-off villains that never appeared as action figures, but many of them left an impression on the viewers. Evil Seed is one of those villains.

Because he did not appear first in the original toy line, his design does not follow the frequently-used muscular build. Instead, he's slender, wearing a full robe that hides his body of vines. Bringing this character to the retro style makes for a figure that truly stands out among the rest.

Evil Seed's appearance is almost extra-cartoony. He has a large, bulbous head with bright yellow eyes. Because of the robes, his body is a solid sculpt. This limits his articulation when compared to the rest of the line, since the figure doesn't have any legs.

For accessories, Evil Seed has a shield that can be held in his left hand. He also has an attachment that fits over his right hand, making it look as though he has transformed his hand into several twisted vines.

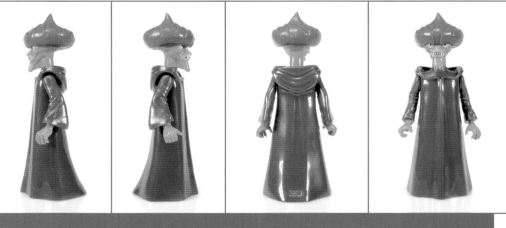

FROZEN TEELA
ICE STATUE OF TEELA

First released 2019 • Member of the Heroic Warriors

Accessories:
• Sword
• Shield

Frozen Teela is another variant of a main character in this lineup that is inspired by one specific episode of the original He-Man and the Masters of the Universe animated series.

From the episode "The Ice Age Cometh," this frozen statue of Teela is the same figure as the standard Teela release from this line. The difference is that she is now made of a translucent blue plastic to give her an icy look. The only paint applications found on the figure are on her face, where her eyes and mouth are white in color.

She comes with the same two accessories as her standard release: the sword and shield. She can hold the sword in her right hand, while the shield clips onto her left wrist.

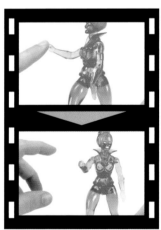

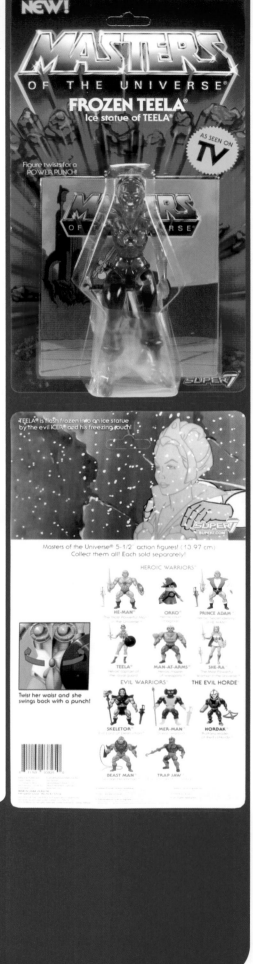

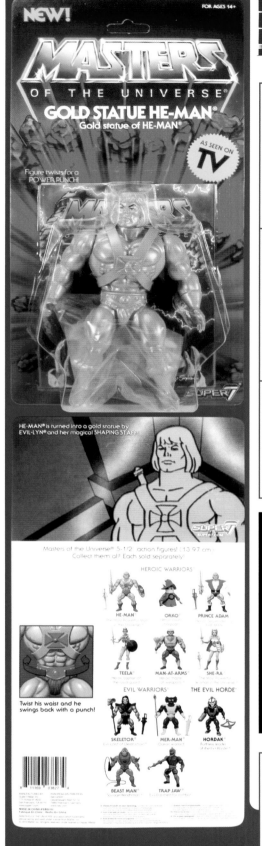

GOLDEN STATUE HE-MAN
GOLD STATUE OF HE-MAN

First released 2019 • Member of the Heroic Warriors

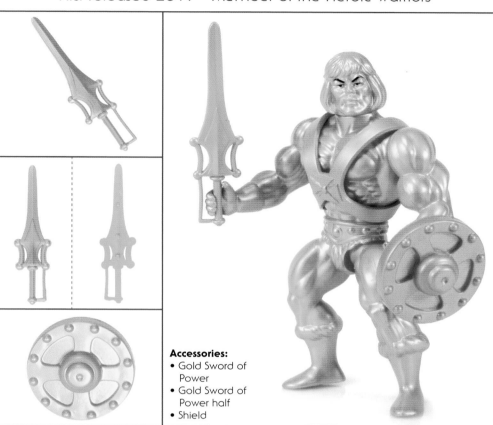

Accessories:
- Gold Sword of Power
- Gold Sword of Power half
- Shield

Gold Statue He-Man is yet another variant of a main character released in this line that is based on the happenings within a specific episode of the original He-Man and the Masters of the Universe animated series.

In the episode "The Shaping Staff," Evil-Lyn uses an artifact to turn He-Man into a solid gold statue. This action figure is exactly the same as the standard He-Man release from this line, with the only difference being that he is now painted a shiny gold to capture that gold-statue look from the episode.

The figure includes the same accessories as well: the Sword of Power, the half Sword of Power, and the shield. Of course, these are also painted a shiny gold to match the rest of the action figure.

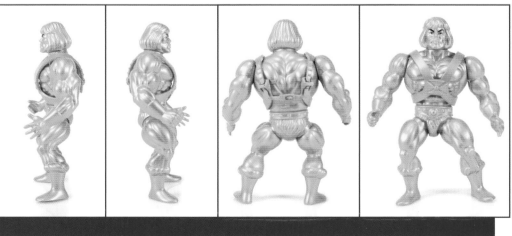

HE-MAN
MOST POWERFUL MAN IN THE UNIVERSE!

First released 2018 • Member of the Heroic Warriors

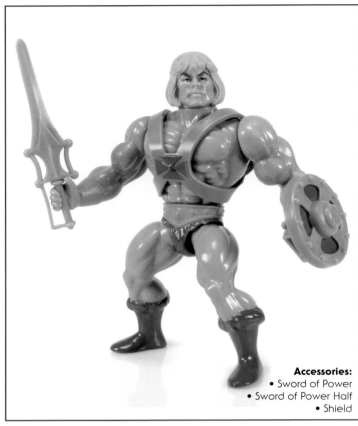

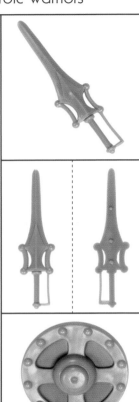

Accessories:
- Sword of Power
- Sword of Power Half
- Shield

Super7 brings Masters of the Universe back to its original five-and-a-half-inch roots with a line of action figures done in the vintage style! This He-Man action figure is styled just like the original 1980s action figure, but the look is meant to match up with how the character appeared in the Filmation cartoon series.

The plastic used is a bit glossier than Mattel's original Masters of the Universe action figure, but the overall style is quite similar. The figure matches the same muscular, squat pose that those original action figures are known for. The details are a little more simplistic, specifically on the harness on the figure's chest. This was done to match the animated appearance, which had a smoother, less detailed look than the original figure.

He-Man's new head sculpt is an interesting mesh of the vintage toy and his appearance in the Filmation cartoon series. It's certainly not full-cartoon, but it has elements that better match up with what we saw on that show. He-Man comes with a shield that is styled much like the vintage toy's, but his Sword of Power is a slightly different sculpt from that of the original action figure. This time it's a little slimmer, matching the appearance of the sword from the cartoon. Much like with Masters of the Universe Classics, the figure also comes with a half Sword of Power that can fit together with the half that comes with Skeletor, paying homage to the gimmick of the original toy line.

The legs are slightly different. The original line used rubber bands to hold the legs to the hips. This caused the legs to sometimes end up loose and wobbly. This new He-Man has a hinge joint at the thighs, which results in tighter leg joints, so the figure can stand on his own much better. It's worth noting that early releases of this figure, specifically the version that came packaged in the exclusive two-pack with Skeletor, had issues with the leg joints that resulted in easy breakage.

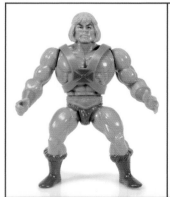

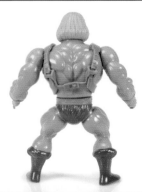

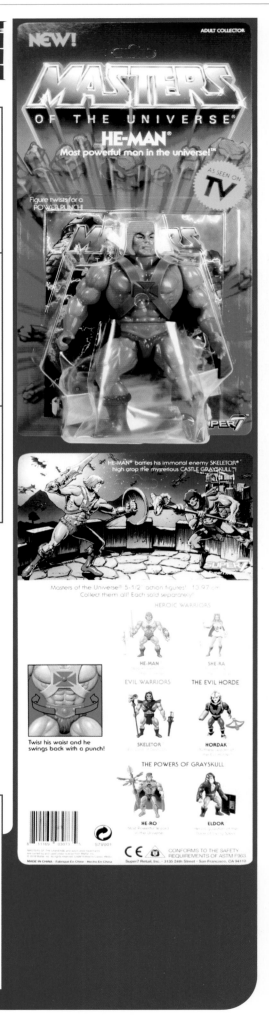

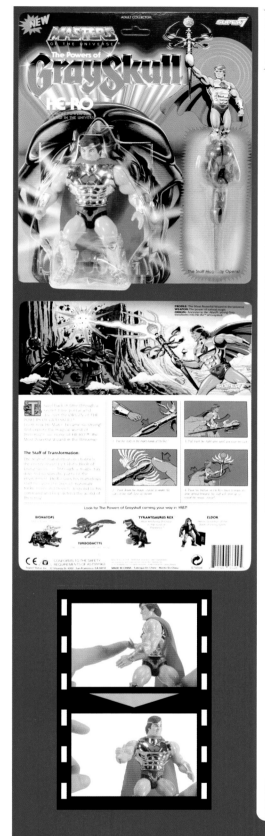

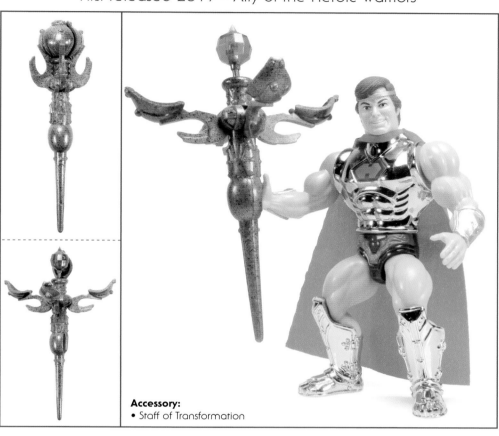

HE-RO
THE MOST POWERFUL WIZARD IN THE UNIVERSE

First released 2019 • Ally of the Heroic Warriors

Accessory:
• Staff of Transformation

He-Ro, along with Eldor, is one of two non-Filmation characters released in this retro-inspired line from Super7. Instead, He-Ro has roots in the original Masters of the Universe toy line. At one point, he was set to take over as the main character in a spinoff line called "The Powers of Grayskull," He-Ro was the Most Powerful Wizard in the Universe. Set in prehistoric Preternia, 'The Powers of Grayskull' was going to serve as a sort of prequel to Masters of the Universe.

He-Ro and Eldor made it to the prototype stage, but were never released. Pictures of the prototypes have floated around within the fandom for years—making them quite desired! They were the lost figures of the original Masters of the Universe toy line.

Super7 did a great job of finally bringing this figure to life. It's an entirely new sculpt but is closely modeled on those early prototype photos, all the way down to the shiny vac-metal torso and boots!

He-Ro includes one accessory: the Staff of Transformation. Much like what was shown on the original prototype images, the staff opens to reveal a green gem placed at the top. He-Ro can hold this staff in his right hand.

This figure is truly one of the standouts of Super7's modern retro line, as it gave longtime fans the chance to add a figure that they never thought they'd get to their vintage collections.

HORDAK
RUTHLESS LEADER OF THE EVIL HORDE

First released 2018 • Member of the Evil Horde

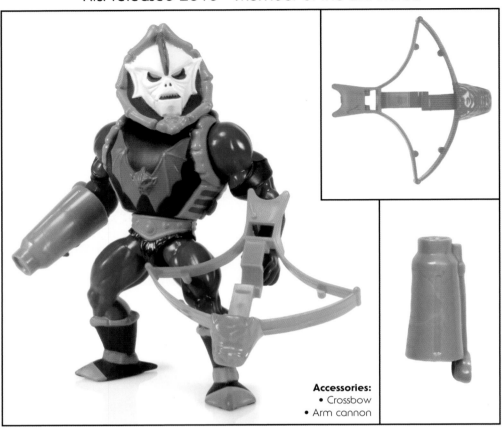

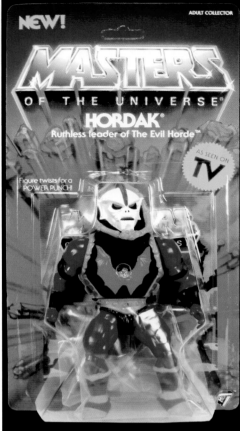

Accessories:
- Crossbow
- Arm cannon

This Hordak action figure is designed to look like he fits right in with the original 1980s toy line while having a closer resemblance to how the character appeared in the She-Ra: Princess of Power cartoon series.

The plastic used is a bit glossier than Mattel's original Masters of the Universe action figure, but the overall style is quite similar. Hordak's sculpt almost looks identical to that of his vintage counterpart. However, the colors used are much more accurate to how he appeared in animation. He now has dark blue skin and a bright white face.

Just like with his vintage action figure, he comes with a Horde Crossbow. This time around, the plastic is a bright red. It otherwise functions just like the original one. For a brand-new accessory, he has a clip-on arm cannon. This fits over his right arm and is meant to mimic Hordak's ability to transform his arm—a power he used often in the cartoons.

The legs are slightly different. The original line used rubber bands to hold the legs to the hips. This caused the legs to end up loose and wobbly. This new Hordak has a hinge joint at the thighs, which results in tighter leg joints, so the figure can stand on his own much better. It's worth noting that early releases of this figure, specifically the version that came packaged in the exclusive two-pack with She-Ra, had issues with the leg joints that resulted in easy breakage.

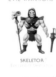

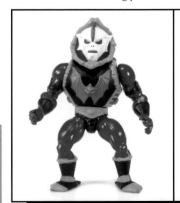

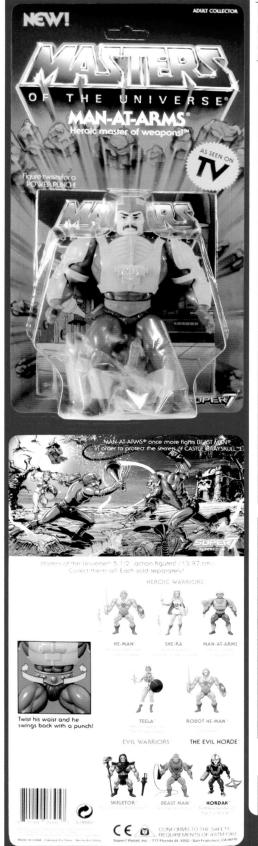

MAN-AT-ARMS
HEROIC MASTER OF WEAPONS!

First released 2019 • Member of the Heroic Warriors

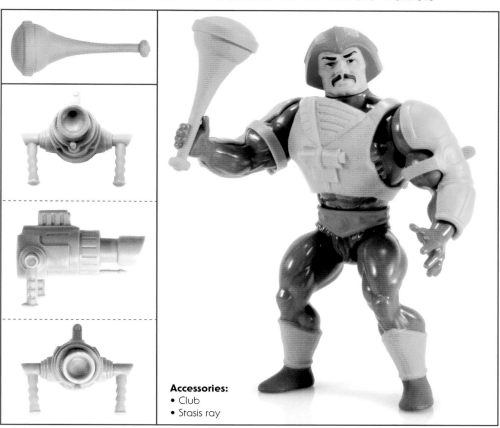

Accessories:
• Club
• Stasis ray

When you compare your original Man-At-Arms action figure to what was seen on your television set, what's the one major difference you notice? Why, it's that sweet mustache, of course!

Since this version of Man-At-Arms is based on his appearance in the original He-Man and the Masters of the Universe animated series, he now finally sports that mustache. Much like the other figures in this line, his design is also more simplistic. The armor pieces on his torso, arms, and legs are smooth and brightly colored.

He comes with two accessories. The first is his classic club. While very similar to the one that was included with the original toy release, this one is a bit larger to match the version seen in the animation. His second accessory is inspired directly by the Filmation show: the stasis ray! It's certainly a bonus to get accessories that, until now, had only appeared in the cartoon, but it's worth noting that Man-At-Arms can't even hold both handles due to the basic articulation found on this vintage-inspired action figure.

MER-MAN
OCEAN WARLORD!

First released 2019 • Member of the Evil Warriors

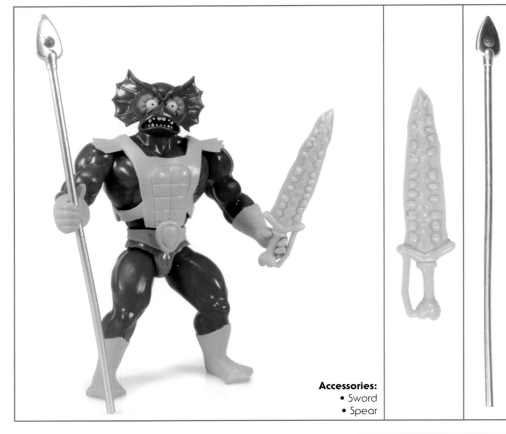

Accessories:
- Sword
- Spear

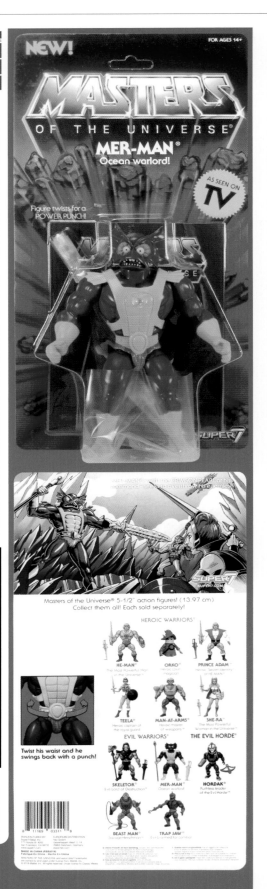

Mer-Man is one of the characters from the original Masters of the Universe toy line that had a drastically different look in animation.

This action figure presents Mer-Man with the larger head that has fin-like ears sticking off the sides. The blank expression on his face does a great job of matching up with what we saw in that original cartoon series. He includes two accessories. His sword is inspired by the one from the original action figure release, while the silver spear weapon is based on an artifact from Filmation's He-Man and the Masters of the Universe cartoon.

Since the original Mer-Man action figure didn't match up with the cross-sell artwork on his own packaging, the addition of the distinctive cartoon design gave Mer-Man three unique looks in the 1980s! With the release of this new figure in 2019, fans can now have two of those versions in their vintage figure displays.

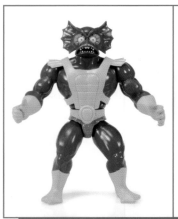

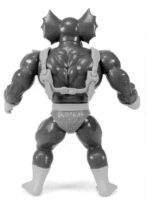

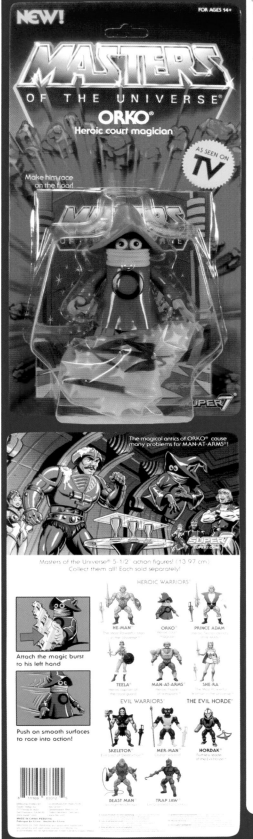

ORKO
HEROIC COURT MAGICIAN

First released 2019 • Member of the Heroic Warriors

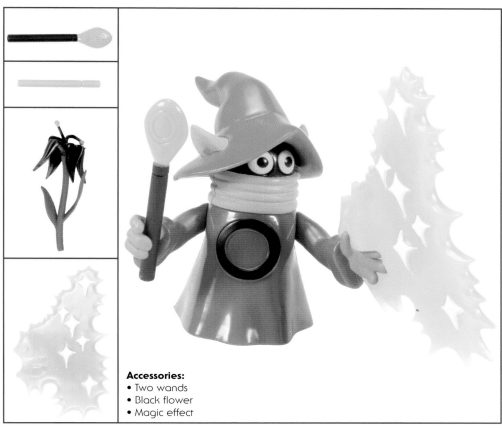

Accessories:
- Two wands
- Black flower
- Magic effect

Orko is a bit unique, since he appeared first in the Filmation He-Man and the Masters of the Universe animated series before being made into an action figure in the original toy line. While this version is done in the vintage style of that classic line of action figures, this Orko looks much more like the character onscreen.

He's much shorter and more squat in stature, with his robe sculpted to look a little more straight, like in the animation, rather than with the billowing look of the classic toy. Although the character was always seen hovering in the show, this figure, unfortunately, does not include any sort of flight stand. Instead, Orko has small wheels on the underside, allowing him to glide across smooth surfaces.

He comes with several accessories. He has two different styles of magic wand, both inspired by the cartoon shows. Orko can hold either wand in his right hand. He also comes with a black flower, an item used by the villainous Count Marzo in the Filmation animated series.

Finally, Orko comes with a magical effect that can clip onto his left hand, making it look as though he is casting a spell!

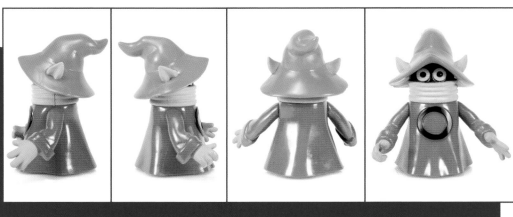

POSSESSED SKELETOR
EVIL LORD OF DESTRUCTION

First released 2016 • Member of the Evil Warriors

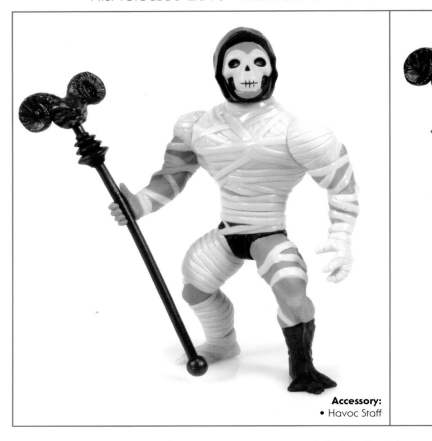

Accessory:
• Havoc Staff

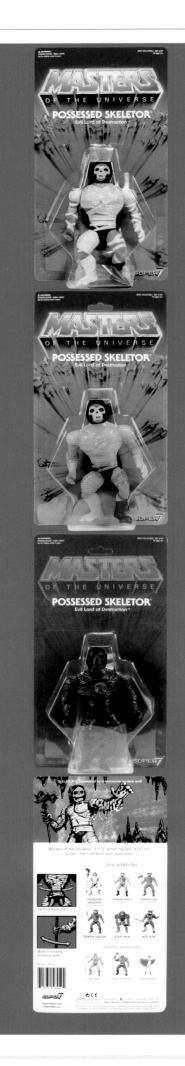

In 2016, Super7 brought Masters of the Universe back to its roots with the first officially licensed new characters in the five-and-a-half-inch style since the 1980s. These figures even came packaged on blister cards that match the iconic red-and-blue packaging of the original toy line that started it all.

Possessed Skeletor is based on a character in "The Curse of the Three Terrors," a new piece of animation that tells a Filmation-style Masters of the Universe story. This cartoon premiered during San Diego Comic-Con 2016 alongside the release of this series of action figures.

Skeletor was essentially possessed by a new villain in the short, resulting in the mummy-wrapped looks of this new action figure. The figure is an all-new sculpt, but is done in the style of those original Masters of the Universe action figures. Details such as Skeletor's head sculpt and feet are all very similar to that original toy.

The figure retains the spring-loaded, waist-twisting "Power Punch" action feature of the original toys. He also has the same style of rubber bands holding the legs to the hips, though they do feel a bit looser on these new figures. Skeletor also comes with his classic Havoc Staff as an accessory, which looks very much like the one included in the original toy line.

There were two variants of Possessed Skeletor also released by Super7. In the debut year, Super7 sold a glow-in-the-dark version at San Diego Comic-Con in which all of the mummy wraps on the figure were made of glow-in-the-dark plastic. In 2017 there was also an all-black version of the figure, sold on an all-black version of the vintage Masters of the Universe packaging exclusively at San Diego Comic-Con.

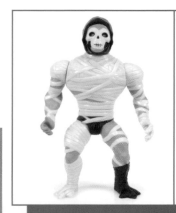
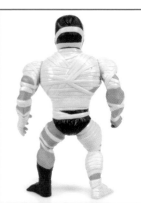

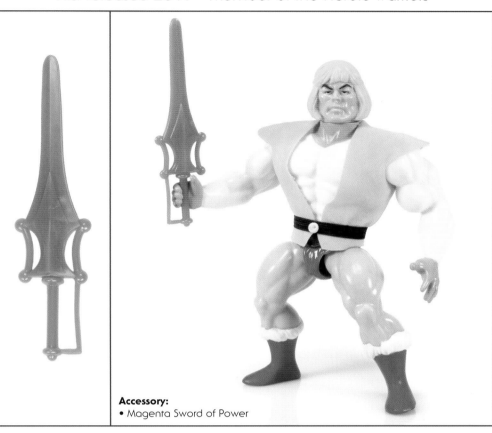

PRINCE ADAM
HEROIC "SECRET IDENTITY" OF HE-MAN

First released 2019 • Member of the Heroic Warriors

Accessory:
• Magenta Sword of Power

Much like Orko, Prince Adam appeared in the original He-Man and the Masters of the Universe animated series before showing up in the original toy line. That figure looked similar to what we saw onscreen, although the toy version of Adam was outfitted with a maroon vest instead of the pink one from the show.

This new figure is handled in a very similar manner to the original. He reuses the same He-Man figure from this lineup, but is repainted with a white shirt and purple leggings. However, the fabric vest is now a bright pink color—just like we saw in the cartoon!

He only has one accessory, a pink Sword of Power. It's clear the color was chosen because that's the color of the sword included with the vintage Prince Adam action figure. In the series, though, the sword was always silver. Fortunately, you can always pose him with He-Man's accessory if you want the overall look to be more accurate.

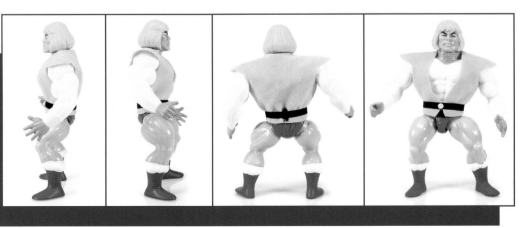

ROBOT HE-MAN
ROBOTIC DUPLICATE OF HE-MAN

First released 2019 • Member of the Heroic Warriors

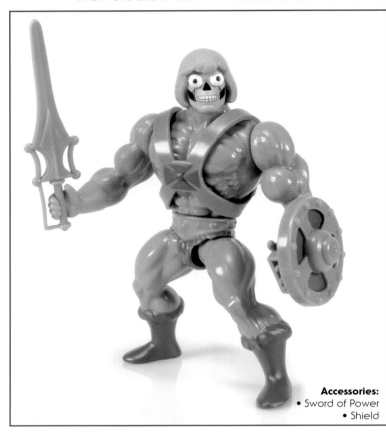

Accessories:
• Sword of Power
• Shield

This is a really fun variant of He-Man, released for the first time as part of Super7's line of retro-inspired action figures. While this character might be mistaken for Faker, it's actually a representation of the robotic He-Man double created by Man-At-Arms in the Filmation He-Man and the Masters of the Universe episode "Disappearing Act." Many children were forever scarred by the uncanny vision of a robotic skull with bulging eyeballs underneath the He-Man faceplate.

This figure uses the same He-Man body from this lineup, but gives us a new robotic head sculpt to match its appearance in the episode.

Robot He-Man also includes the same Sword of Power and shield from the basic He-Man, so there aren't a lot of new things here. However, that new robot head is enough to excite those who fondly remember this episode of the series.

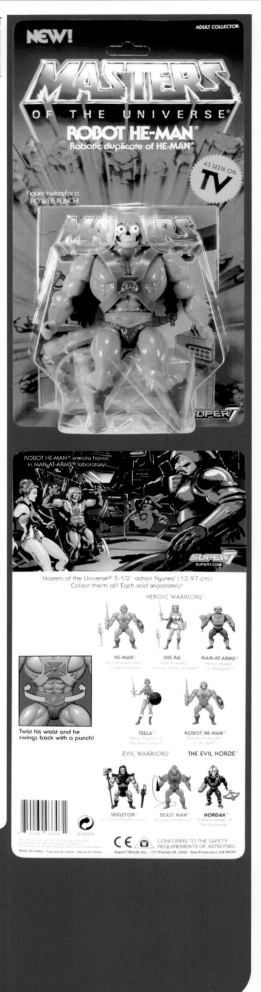

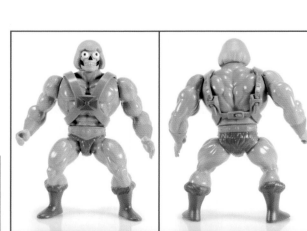

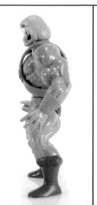

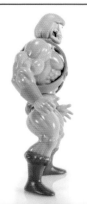

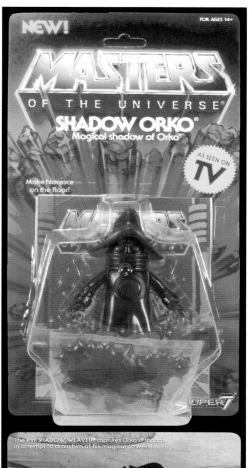

Attach the magic burst to his left hand

Push on smooth surfaces to race into action!

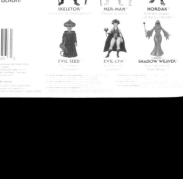

SHADOW ORKO
MAGICIAL SHADOW OF ORKO

First released 2019 • Servant of the Evil Horde

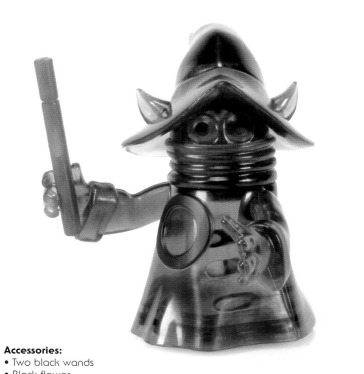

Accessories:
- Two black wands
- Black flower
- Black magic effect

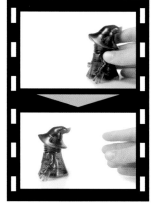

Several of the main characters in Super7's neovintage line received variants based on specific incidents that occurred in the original He-Man and the Masters of the Universe and She-Ra: Princess of Power animated series.

Based on the She-Ra episode "Shades of Orko," where Shadow Weaver stole Orko's shadow in an attempt to drain him of his magic, this figure is exactly the same as the standard Orko release in the lineup. The only difference is that the figure is now made of a smoky, translucent black plastic in order to make him look like Orko's shadow.

The figure comes with all of the same accessories, including both wands, the black flower, and even the clip-on magical effect. However, all of those accessories are cast in the same translucent black color as the shadowy figure.

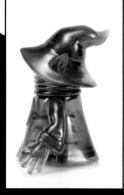

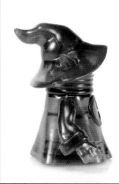

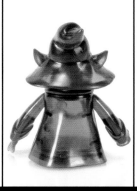

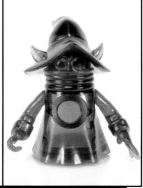

SHADOW WEAVER
EVIL MISTRESS OF DARK MAGIC!

First released 2019 • Member of the Evil Horde

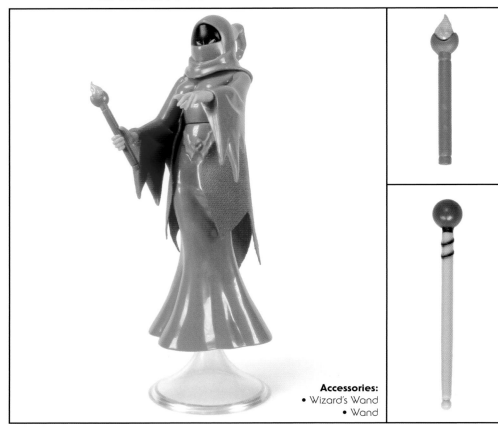

Accessories:
• Wizard's Wand
• Wand

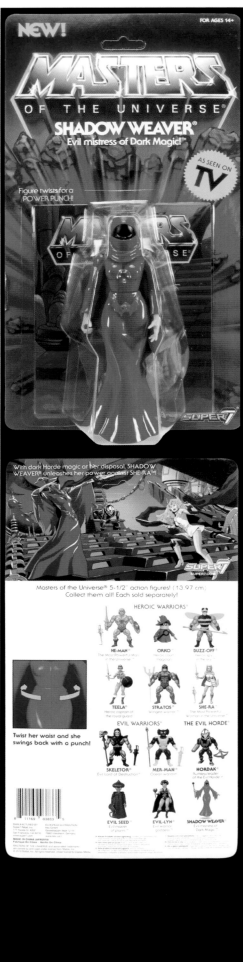

Shadow Weaver is a fan-favorite character from the Filmation She-Ra: Princess of Power animated series that, sadly, did not make an appearance in the original toy line. This figure aims to rectify that injustice.

This release takes some cues from the Teela and Evil-Lyn figures in the vintage Masters of the Universe toy line, as seen by the position of her arms. But, since Shadow Weaver has a unique, robed look, the body is quite different. She also includes a clear flight stand plugged into the bottom of the robe to make it look as though she is hovering slightly above the floor, much like she did in the cartoon series.

Shadow Weaver comes packed with two different wands, both of which come straight out of the Filmation shows. These can be held only in her right hand, since her left hand is open.

She's quite impressive, doing a wonderful job of looking how Shadow Weaver may have actually appeared if she had been released in the 1980s!

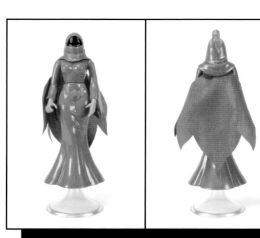

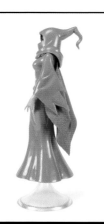

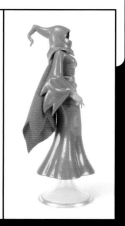

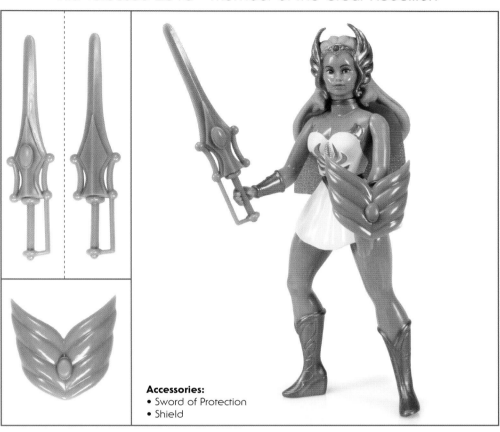

SHE-RA
MOST POWERFUL WOMAN IN THE UNIVERSE!

First released 2018 • Member of the Great Rebellion

Accessories:
• Sword of Protection
• Shield

This She-Ra action figure could be seen as answering the question of "What if She-Ra had been released in the original Masters of the Universe toy line instead of having her own doll/figure hybrid?"

The plastic used is a bit glossier than Mattel's original Masters of the Universe action figure, but the overall style is quite similar. While the vintage She-Ra action figure had rooted hair much like a doll, this new version essentially uses a body similar to Teela's. This is likely how a She-Ra figure would have looked if it had been part of the Masters of the Universe line, since the line's only two females in its early stages—Teela and Evil-Lyn—both used this body.

She-Ra's hair is now fully sculpted plastic rather than rooted hair. The design of her outfit is also based on the Filmation cartoon series rather than the vintage toy, which had a different design to it. She also comes with a brand-new Sword of Protection weapon that looks as it did in the cartoon. This version of the sword has never been made at this scale before! She also includes a shield, which is actually her sword transformed into a shield—something that she was able to do in the animated series.

The articulation now matches up with what we saw with figures such as Teela; however, the legs now use a hinge joint rather than the classic rubber bands. This does allow the legs to be more sturdy than many vintage MOTU action figures. It's worth noting that early releases of this figure, specifically the version that came packaged in the two-pack with Hordak, had issues with the leg joints that resulted in easy breakage.

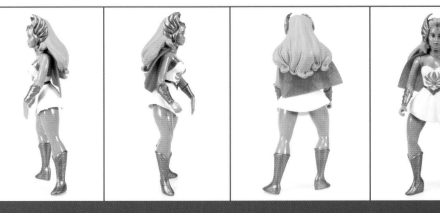

SKELETOR
EVIL LORD OF DESTRUCTION!

First released 2018 • Member of the Evil Warriors

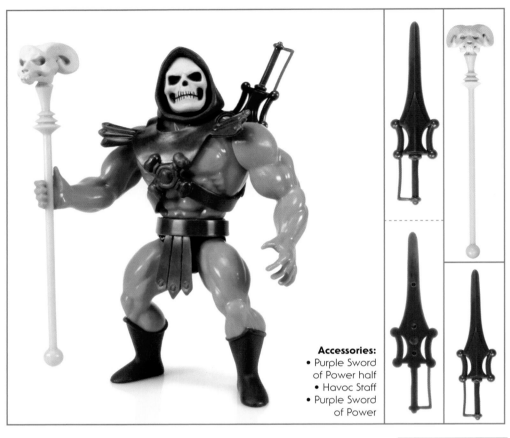

Accessories:
- Purple Sword of Power half
- Havoc Staff
- Purple Sword of Power

This Skeletor action figure is styled just like the original 1980s action figure, but the look is altered to match up with how the character appeared in the Filmation cartoon series.

The plastic used is a bit glossier than Mattel's original Masters of the Universe action figure, but the overall style is quite similar. The armor has a much simpler design, which is meant to match the smoother, less detailed look of his animated counterpart. The colors are also much brighter than the original Skeletor action figure.

His head sculpt has a larger, more pronounced hood than the vintage action figure. The face is also a very light yellow with no shading or green details in the skull. The sculpt of the face is a pretty impressive re-creation of the character's onscreen appearance. He comes packaged with his Havoc Staff, also sculpted and painted to match the version from the cartoon. This looks considerably different from the one included with the vintage toy. He also comes with a purple version of He-Man's Sword of Power, along with a half version that can be fitted together with the half that is included with He-Man.

The legs are slightly different. The original line used rubber bands to hold the legs to the hips. This caused the legs to become loose and wobbly over time. This new Skeletor has a hinge joint at the thighs, creating tighter leg joints so the figure can stand on his own much better. It's worth noting that early releases of this figure, specifically the version that came packaged in the exclusive two-pack with He-Man, had issues with the leg joints that resulted in easy breakage.

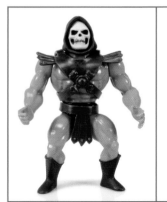

STRATOS
WINGED WARRIOR!

First released 2019 • Member of the Heroic Warriors

Accessories:
• Staff of Avion (Filmation)
• Staff of Avion (minicomics)

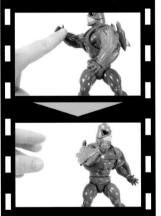

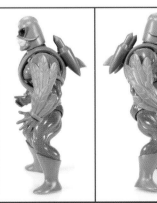

Stratos is a character that doesn't look too terribly different when his vintage toy is compared to his design in the original He-Man and the Masters of the Universe animated series.

The biggest difference with this figure is that he has far fewer sculpted details. Instead of the furry body seen in the sculpt of the vintage toy, this one has a much smoother look to match how he appeared on-screen. He also has a head that is more rounded, with a fluffy beard that almost makes it look as if he doesn't have much of a neck.

The wings are much smaller on this version. They loosely clip onto the arms, and are easily removable. In addition, he comes with two different versions of the Staff of Avion. The yellow version is how the staff appeared in the animated series, while the green staff with the egg-like gem on top was how the staff appeared in the original minicomics included with the vintage figures. This allows you to display him with whichever version you prefer!

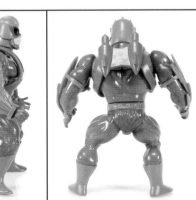

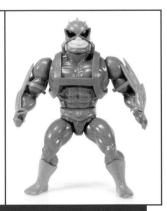

TEELA
HEROIC CAPTAIN OF THE ROYAL GUARD!

First released 2019 • Member of the Heroic Warriors

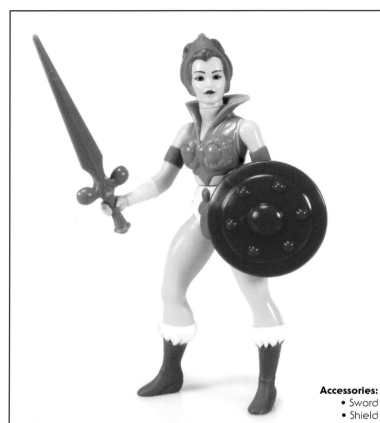

Accessories:
- Sword
- Shield

Teela is a great candidate for this line. While the character's appearance in animation wasn't too far off from what we saw in the original toy, there's no doubt that this particular characterization is what made many viewers into fans of Teela.

The figure is done much in the same style as her vintage figure counterpart, and is sculpted in the same stance, with the same arm placement. Gone, however, is the Snake Armor and snake staff of that vintage toy. Now, Teela has her bright red hair as seen on TV, as well as a much more screen-accurate outfit.

The Captain of the Guard also comes with two accessories in order to do battle against Skeletor and his evil henchmen. She has a sword that can be held in her right hand and a shield that clips onto her left wrist.

Seeing this Filmation version of Teela released as if she had been a part of the vintage toy line is quite exciting!

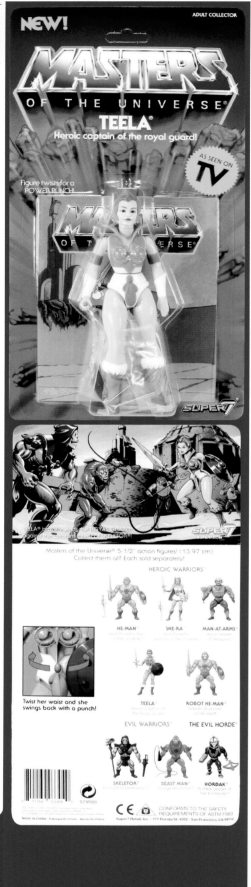

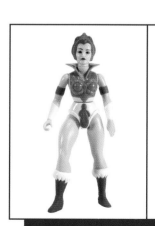
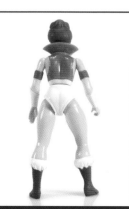
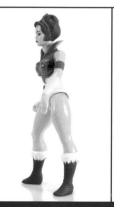

TERROR BAT
SHRIEKING UNDEAD WARRIOR

First released 2016 • Evil Villain

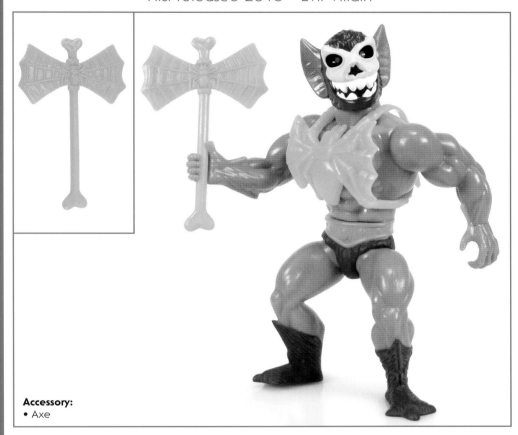

Accessory:
• Axe

Terror Bat is one of three brand-new characters introduced in "The Curse of the Three Terrors," an animated short that tells a new Filmation-style Masters of the Universe story. This cartoon premiered during San Diego Comic-Con 2016 alongside the release of this new series of action figures.

Terror Bat's body design is very similar to the vintage Skeletor action figure. This fits right in, as most of the figures in the original Masters of the Universe toy line shared parts like this. He has new, bright green armor featuring a large spider on the chest. This armor is shared across all three Terror figures. The head is a new sculpt, depicting a bat-shaped creature with a skull-like face. The head is slightly oversized when compared to most of the vintage MOTU action figures.

The figure retains the spring-loaded, waist-twisting "Power Punch" action feature of the original toys. He also has the same style rubber bands holding the legs to the hips, though they do feel a bit looser on these new figures. Terror Bat comes packaged with a brand-new bright green axe weapon that he can wield in his right hand.

There was an additional variant of Terror Bat released by Super7. In the debut year, Super7 sold a glow-in-the-dark version at San Diego Comic-Con, in which the figure's body was molded in a glow-in-the-dark white plastic.

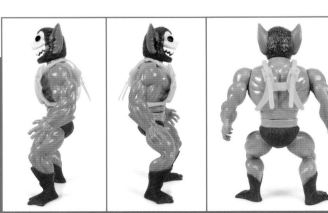

TERROR JAGUAR
SNARLING UNDEAD WARRIOR

First released 2016 • Evil Villain

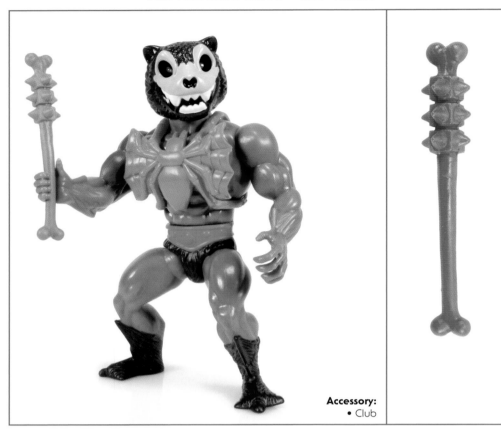

Accessory:
• Club

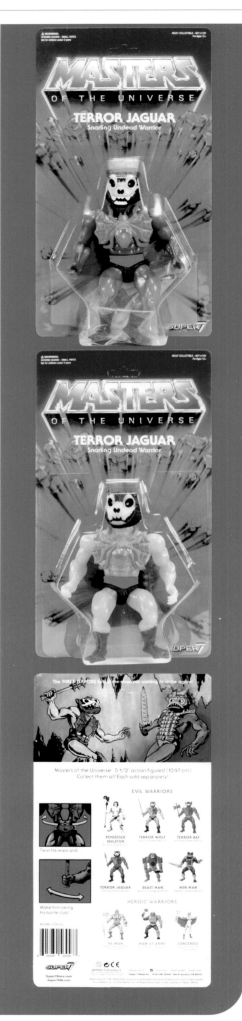

Terror Jaguar is one of three brand-new characters introduced in "The Curse of the Three Terrors," an animated short that tells a new Filmation-style Masters of the Universe story. This cartoon premiered during San Diego Comic-Con 2016 alongside the release of this new series of action figures.

Terror Jaguar's body design is very similar to the vintage Skeletor action figure. This fits right in, as most of the figures in the original Masters of the Universe toy line shared parts like this. He has brand-new bright red armor featuring a large spider on the chest. The head is a new sculpt, depicting a cat-shaped creature with a skull-like face. The head is slightly oversized when compared to most of the vintage MOTU action figures.

The figure retains the spring-loaded, waist-twisting "Power Punch" action feature of the original toys. He also has the same style of rubber bands holding the legs to the hips, though they do feel a bit looser on these new figures. Terror Jaguar comes packaged with a brand-new bright red spiked club weapon that he can wield in his right hand.

There was an additional variant of Terror Jaguar. In the debut year, Super7 sold a glow-in-the-dark version at San Diego Comic-Con, in which the figure's body was molded in a glow-in-the-dark white plastic.

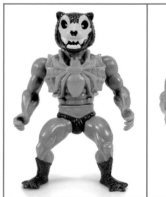

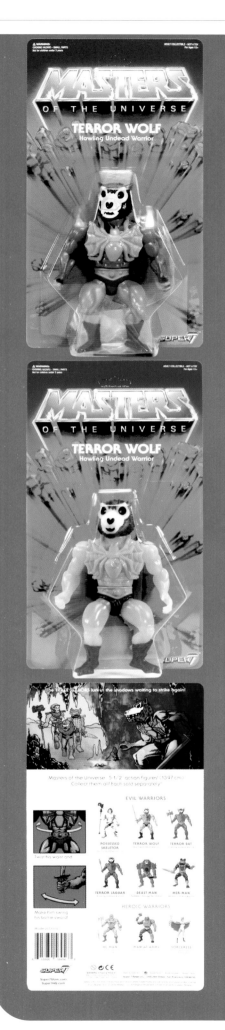

TERROR WOLF
HOWLING UNDEAD WARRIOR

First released 2016 • Evil Villain

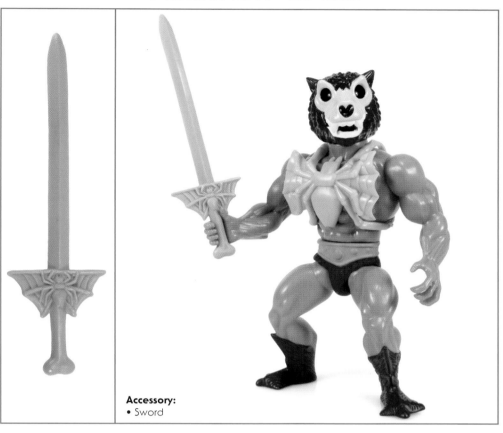

Accessory:
• Sword

Terror Wolf is one of three brand-new characters introduced in "The Curse of the Three Terrors," an animated short that tells a new Filmation-style Masters of the Universe story. This cartoon premiered during San Diego Comic-Con 2016 alongside the release of this new series of action figures.

Terror Wolf's body design is very similar to the vintage Skeletor action figure. This fits right in, as most of the figures in the original Masters of the Universe toy line shared parts like this. He has brand-new bright blue armor featuring a large spider on the chest. This same armor is shared across all three Terror figures. The head is a new sculpt, depicting a wolf creature with a skull-like face. The head is slightly oversized when compared to most of the vintage MOTU action figures.

The figure retains the spring-loaded, waist-twisting "Power Punch" action feature of the original toys. He also has the same style of rubber bands holding the legs to the hips, though they do feel a bit looser on these new figures. Terror Wolf comes packaged with a new bright blue long sword that he can wield in his right hand.

There was an additional variant of Terror Wolf. In the debut year, Super7 sold a glow-in-the-dark version at San Diego Comic-Con, in which the figure's body was molded in a glow-in-the-dark white plastic.

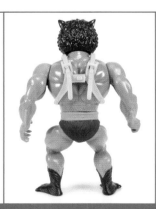
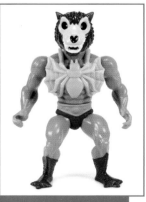

TRANSFORMING HE-MAN
THE MOST POWERFUL MAN IN THE UNIVERSE

First released 2019 • Member of the Heroic Warriors

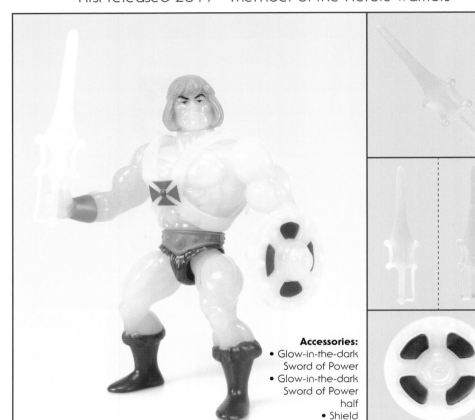

Accessories:
• Glow-in-the-dark Sword of Power
• Glow-in-the-dark Sword of Power half
• Shield

Another variation of the standard He-Man action figure released in this lineup, Transforming He-Man has an odd look but a really fun gimmick!

The idea here is that this is He-Man in midtransformation. He even has unique packaging that looks like the lightning storm that surrounds Adam as he calls out, "By the Power of Grayskull!"

The figure itself is a pale white plastic, which admittedly looks a bit odd in normal light. But the reason for this coloring is that he is made of glow-in-the-dark plastic! Charge him up under some light, then put him in a dark room to see the figure brightly glowing with the Power of Grayskull.

He comes with the same accessories as the standard He-Man release, but they too are all made of glow-in-the-dark plastic. The glow feature, combined with the unique packaging, really does make this a fun variant.

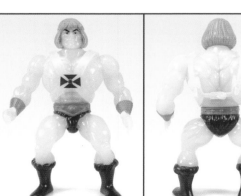

TRAP JAW
EVIL & ARMED FOR COMBAT!

First released 2019 • Member of the Evil Warriors

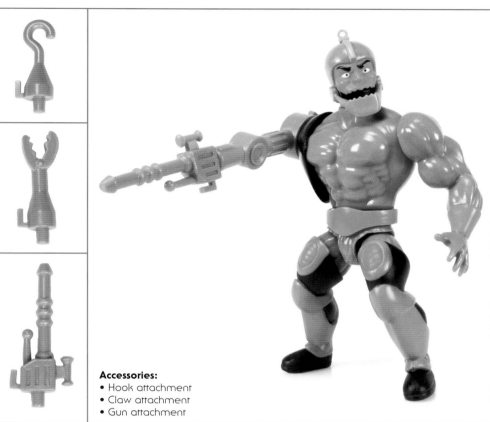

Accessories:
- Hook attachment
- Claw attachment
- Gun attachment

Trap Jaw is a classic Skeletor henchman who was quite prominent in the original He-Man and the Masters of the Universe animated series. It could be argued that he is one character whose appearance onscreen wasn't too far off from the original toy.

He has a new head sculpt that more accurately reflects the look of the character as he appeared in the show. The biggest difference, aside from that, can be seen in the colors. This version of Trap Jaw has more maroon on his robotic arm and on his legs, whereas those parts of the vintage action figure were black.

The robotic arm works very much like the one on the original toy, with interchangeable parts such as a claw, a hook, and a blaster gun. There are even little hooks on the attachments, but unlike the vintage toy, there are no loops on his belt to hang those parts.

These are minor differences, maybe, but this Trap Jaw is more cartoon accurate.

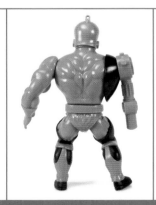
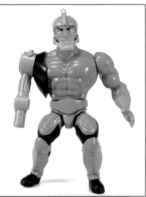

GLOSSARY by Dan Eardley & Four Horsemen Studios

200X • Pronounced "two thousand X," this is an abbreviation used to identify the rebooted Masters of the Universe toy line that launched in 2002. Since the toy line, and then the NECA "staction" line, ran from 2002 to 2007, the X was adopted as a stand-in for the year.

2-up • An action figure prototype, usually hand sculpted, that is twice the size of the mass-produced toy. This size allows the sculptors the ability to add as much detail as possible before it is scaled down for production.

3D print • A physical model created by a 3D printer using digital files created by a sculptor.

3D printer • A device that constructs a three-dimensional object from a digital file.

Ab crunch • A hinged joint in the midtorso which allows the figure to bend forward and backward.

ABS • Acrylonitrile butadiene styrene. A rigid plastic often used for the torso and crotch portions of an action figure.

Accessory • Refers to an item included with an action figure that is intended to be used with the action figure. This is typically a weapon associated with the character.

Action feature • A function worked into an action figure or toy that is designed to encourage play. Examples of action features may include spring-loaded missile-launching weapons or draw-back-and-release punches activated by turning a figure's waist. Also referred to as a "gimmick."

Airbrush • The process of using a tool called an airbrush to apply a mist of paint onto an object using compressed air. This allows for subtle gradations and paint fades. This process is often used to shade and define the muscular anatomy of an action figure. Sometimes a form-fitting stencil or mask is used to isolate a specific area or shape on the surface of the plastic prior to airbrushing.

Ankle rocker • A joint which allows side-to-side movement at the ankle. This is used in combination with a standard ankle joint, which gives a front-to-back positioning. Also called "pivot joint."

Army builder • A term used by collectors that refers to a character within a line of action figures that can be purchased multiple times to build a squad of fighters. For example, the Horde Trooper from Masters of the Universe was typically shown in large numbers whenever it appeared in media. As a result, some fans enjoy building an army of Horde Troopers by purchasing many of the same Horde Trooper action figure.

Articulation • An industry term referring to the joints worked into the design of an action figure which allow for movement. These joints are often referred to as the points of articulation (POA).

Assortment • The breakdown of the figures released in a case. As an example, the initial wave of 200X heroes had different case assortments. One case assortment comprised of three He-Man, two Man-At-Arms, and one Stratos. A second case assortment was made up of four He-Man and two Man-At-Arms, while a third case assortment consisted of six He-Man figures. Assortments vary based on what a toy company feels they can sell and are adjusted in the future based on sales reports. Also, if a big retail account is buying a large-enough quantity, they can request a specific assortment.

Ball-and-socket joint • A ball joint where a ball-shaped joint uses a friction fit to pop into a socket. This is often seen on a neck joint.

Ball joint • A spherical joint that allows a piece to move in multiple directions using a single joint.

Bio • The story typically found printed on the back of an action figure's card back packaging. This is meant to introduce the character to the customer and tell a story that may aid in play value.

Blister • The plastic attached to a card back that houses the action figure. It is sometimes referred to by action figure collectors as the "bubble" and is a shaped pocket of plastic that is formed to contain the action figure and create a design that complements the product.

Blister insert • This is the card that is inserted directly behind the plastic blister and is usually in front of the enclosed product. This insert may display the name and other information about the product contained inside the package.

Bootleg • Refers to an unofficial action figure release. Bootlegs are often kitbashed replicas of figures from one or more official toy lines. Historically, bootleg products were cheaper versions of official toy lines that were produced by an overseas factory without permission. Bootlegs were known for usually having lower-quality materials, lackluster paint applications, and subpar detailing in the casting. In modern times, a bootleg may be a boutique product produced by an artist in extremely low production runs that pays homage to something well known, such as a famous toy or pop culture icon.

Buck • This is a working armature or blank base body that is used as the starting point for a new figure. From a sculpting standpoint this would be something that a sculptor would sculpt on top of. From a production standpoint, this would refer to a previously tooled body where parts of that body are used repeatedly throughout a line by adding new parts, such as heads and armor to create a new character. See also Refresh.

Butterfly joint • A joint in the shoulders that allows the shoulders to move forward and backward. It allows for a wider range of motion in the chest, reminiscent of flapping wings.

Card back • The cardboard backing of an action figure's packaging. The back usually features artwork and a cross sell of other figures included within the toy line.

Case • A carton of toys shipped to stores from the factory, typically containing figures from that season's product wave. A case can contain various quantities, and the size of the case is usually dictated by the size and weight of the product inside.

Castaline • A popular wax/clay hybrid sculpting material which can be heated into a soft, malleable form and cooled into a more wax-like rigid form.

Casting • The process of pouring or injecting material into a mold to create multiple copies of an object.

Chase figure • An action figure that is usually almost identical to the standard release within a wave of figures but has a slight difference, such as a different accessory or paint deco. Chase figures are purposely released in much smaller quantities and are meant to be "hunted" for by fans.

Cherry picker • A term used to identify a customer or collector who only purchases select products from a toy line.

Clamshell • A style of packaging for an action figure that replaces the typical card back with a full PVC plastic package. This PVC packaging has a hinge on one end, allowing it to open like a clam.

Clay • Malleable material used to sculpt objects or figures.

Complete • A term used by collectors that typically refers to an action figure removed from its packaging that includes all its original items and accessories.

Completist • A term used to identify a customer or collector who seeks to purchase all products released for a toy line, including exclusives. There are different types of completists. Some only seek all official releases from a toy line, while others also want all variants of those products.

Control drawing • Highly refined drawings of a project which often depict multiple views of a character or object, usually front, back, and both sides. Vehicles and play sets may also require top and bottom control drawings. These illustrations tend to include vital details regarding size, articulation, and features. Control drawings are sometimes referred to as "turnarounds."

Cross sell • Typically found on the back of an action figure package. These photographs or illustrations show other products available for purchase within the toy line.

Crotch • The hip piece, which, for action figures, usually comes in two versions. First is the T-crotch, where the legs attach perpendicularly to the crotch piece. Second is the Y-crotch, where the legs attach to the crotch at an angle. The Y-crotch tends to allow the legs to spread further apart than the T-crotch does.

Custom • Refers to an action figure that has somehow been altered by a collector or customizer and is not a mass-produced item. This could be as simple as a custom paint job applied to an existing action figure or as complicated as an entirely new figure made from the parts of other action figure, or from brand-new sculpted parts. As toy collecting has become mainstream since the 2000s, customs have grown immensely in popularity and are desired as unique art pieces. A custom tends to be one of a kind, even if multiple versions were made. This is because each custom is hand-crafted. Some customs even go up in value if a customizer becomes popular for their work.

Deco • A common industry abbreviation referring to the painted decoration or paint application on a toy or action figure.

Die cut • A process in which a manufactured piece of metal called a die, reminiscent of a cookie cutter, is used to cut a specific shape out of another type of material. For action figure packaging, dies are often used to cut specific shapes out of cardboard for the corners, windows, or hang hole.

Double elbow (or knee) joint • This type of joint combines two hinge joints to allow elbows and knees to bend further than they do with a single joint.

Drybrush • A painting process in which paint is applied using a dry paintbrush to lightly graze the high points of a sculpted surface. This paint is usually a lighter color or a different color than what is already on the surface. The paint touches the only high points of the surface, therefore enhancing the details of the piece.

Dumbbell joint • Similar to a ball joint, but with less range. This is typically two balls attached via a peg, with each end of the ball plugging into the limb or torso of the action figure.

Elastic band • A type of ball joint that is facilitated by using an elastic band that creates resistance and allows for a wide range of movement. This was often in the crotch on vintage Masters of the Universe action figures.

Exclusive • Refers to a toy produced for a special event or retailer. Exclusives are often produced in lower numbers, which can make it harder to obtain them on the aftermarket. Exclusives can be offered in several ways: They can be at a convention. They can be available from only one retailer. Or they can be offered online via a specific website.

Face seal blister • A blister that is sealed directly to the card. This requires the plastic blister to be peeled off the card back to gain access to the product inside. The vintage Masters of the Universe line used this method for most of the action figures.

Fabrication • The process in which an item is made using hard materials, often with the aid of machinery. It is like sculpting but with the use of nonmalleable materials. This process is generally used to achieve a hard-edged or mechanical look and is most often used to create items like weapons or vehicles.

Factory error • A mishap at the factory that affects the final toy. Sometimes the result is a faulty product. Other times, the result is a color or material variation that becomes collectible.

Fine cut • Final hard copy of the product which is created by the factory and includes all the final engineering for articulation and more. These offer one last chance to review the figure before it enters the tooling stage.

Flocking • The process of applying small fibers directly onto plastic which has been coated with an adhesive. For action figures, this is typically done to create a faux fur or velvety surface. For example, in the original Masters of the Universe toy line, the character Moss Man is flocked.

Foot • a piece of plastic extending off the bottom of the blister that allows the package to stand upright on a shelf without the need of a retail display hook.

Full card blister • A type of packaging in which the card back is the same size as the blister. But instead of the blister being sealed to the card back, the blister has flanges that wrap around the card back so the card can be removed and reinserted into the blister. Mythic Legions is a toy line that uses this type of packaging.

G-code • Generation code. See SKU.

Gimmick • See Action Feature.

GITD • Glow in the dark. This is a feature found on action figures where parts of the toy are cast in photoluminescent plastic or covered with a photoluminescent paint deco. The material absorbs and stores particles of light (photons). This energy is then released light, making the figure visible in the dark.

Hang hole • The die-cut hole at the top of a package typically used to hang a carded product from a retail display hook. It comes in various shapes, including the "standard" or "round" hole, which is a small circle; the "osha," which looks like a flattened triangle with rounded corners; and the "inverted T" or "sombrero," which looks like a rounded rectangle with a little half circle at the top. The inverted T hang hole was used frequently on the vintage Masters of the Universe action figures.

Hard copy • The casted copy of an object. This is the result of the molding and casting process.

Hinge joint • A joint that allows something like a limb to bend back and forth in an area like an elbow or knee.

Hunt • Usually referred to as "the hunt," it is what collectors have done for decades when collecting toy lines released in retail stores. The process involves visiting various retail stores, at the right time either by planning or by luck, to locate toys missing from their collection. This tends to center around newly released items that are in high demand, or products that are limited in an assortment and can prove difficult to find. The hunt is both loved and hated by collectors.

Injection molding • The production process of injecting molten material into a mold. In the case of toys, molten plastics are injected into steel tools.

Joint • The meeting of two body parts on a figure which allows for movement.

Kitbashing • Originally a method by which customizers would take various pieces from model kits and reassemble them to make a new vehicle or object, kitbashing went on to include custom molding that recasts existing pieces of toys or other products. These pieces are recast using silicone molds and are replicated to match the original piece or transformed into something else with the use of different casting materials or paint decos. Where mass-produced toy lines rely on durable steel tooling molds that will last years and produce countless pieces, a kitbashed silicone mold tends to produce a small number of parts before the mold is damaged. Kitbashing is a common practice in both customizing and boutique bootleg production.

Lenticular • A printing technology in which lenticular lenses are used to produce printed images that give the illusion of motion. For example, in the vintage Masters of the Universe toy line, the action figure Sy-Klone has a lenticular sticker on his chest that resembles a radar image of a star field.

Loose • A term used by collectors that refers to an open action figure that no longer includes its original packaging.

Mail-away • This is a special incentive product that can only be obtained by responding to a mail-in offer from a company and adhering to certain conditions. In the 1980s, this was commonly done using a coupon, proof-of-purchase clippings off toy packaging, partial payment, and/or a receipt. In exchange for mailing in this information, an exclusive toy product would be mailed back to the recipient.

Mailer box • This is a special cardboard package placed around the packaged toy to help protect and conceal it during mailing. These boxes were usually plain in appearance. Mailer boxes were common in the 1980s for things like mail-away incentives.

Minicomic • Refers to the small pack-in comic books included with many Masters of the Universe and Princess of Power action figures of the 1980s.

Mint condition • A term used primarily by collectors that refers to the current quality of a toy or action figure. Saying that a figure is in mint condition means that it is pristine and as close as possible to how it was originally shipped from the factory.

MIB • Mint in box. A term used by collectors meaning that an action figure or toy is in the original box packaging, but that packaging has usually been opened to verify that all contents are present.

MISB • Mint in sealed box. A term used by collectors meaning that an action figure or toy is still sealed in the original box packaging and has never been opened, with extra emphasis on the fact that the box is still sealed. MISB tends to be more valuable than MIB if provenance can be proven. Without provenance, MISB items with no viewing window can be a risky purchase, because at some point in the history of the item, an unscrupulous reseller may have replaced the contents.

MOC • Mint on card. A term used by collectors meaning that an action figure is still sealed on the original card back packaging and has never been opened. The figure must be in mint condition, but the card may not be. Collectors seeking a package and toy that are both in mint condition would look for MOMC (mint on mint card).

Mold • Typically made from steel when used for mass-produced items, the mold is what the factories inject with plastic to create the parts needed to assemble a toy or action figure. The mold is part of the tooling.

Molding • The process of creating a mold or shell around a sculpture or object.

MOTU (MotU) • Masters of the Universe.

MOTUC (MotUC) • Masters of the Universe Classics.

NA • An abbreviation for the cartoon *The New Adventures for He-Man*. Also used to refer to the associated 1989 He-Man toy line.

NIB • New in box. A term used by collectors that refers to an action figure or toy in the original box packaging, which may or may not be sealed. The toy itself has never been used or handled, except to carefully inspect its condition.

OBJ file • A commonly used 3D image format used in the digital sculpting and printing processes, across multiple applications. The OBJ format includes the geometry of the object along with color and texture data for the surface of the object.

Opener • A term used to identify a customer or collector who prefers to remove a toy from the packaging so it can then be displayed. Openers sometimes store the packaging for future use or resale, or they display parts of the packaging behind the toy.

Pack-in • Refers to any extra item packaged along with the action figure, such as an accessory or minicomic.

Paint master • A hand-painted casting of a prototype or, less often, the original prototype, if it has made it to its final approved form. It is used for promotional photography or event display. Afterwards, it is sent to the factory as a guide on how to paint the final figure. Sometimes, more than one paint master is made of the same figure.

Peg warmer • An action figure that is usually less popular, or was overproduced, and thus does not sell swiftly. This results in a customer seeing multiples of the same action figure hanging on the pegs of the store shelves, along with an absence of other action figures from the same wave. A peg warmer is sometimes referred to as a "shelf warmer."

POM • Polyoxymethylene. A hard plastic used when there is need for strength and low friction. This is often used for the articulation disks inside of certain joints on an action figure.

POP (PoP) • Princess of Power.

Proof of purchase • This is usually a small label found on the packaging of a toy. This label states it is the proof of purchase and is generally used as a marketing tactic by companies to encourage purchasing more of their products through special incentives that utilize the proof of purchase.

Prototype • This is the original sculpted design of an action figure. Articulation and paint decos are not necessarily considered during the prototyping phase. A prototype can go through many changes due to intercompany feedback that results in revisions to the previous design.

PVC • Polyvinyl chloride. A flexible and resilient plastic often used for limbs and heads of action figures.

Ratchet joint • A joint that has teeth like a gear that allows the joint to lock into place in various increments. This joint can offer more support for a figure where weight on the lower joints is an issue, but it can also limit posing options.

Reference • Images and materials used to help guide creators through the figure-making process.

Refresh • The process of a toy company reusing preexisting parts from one action figure to create a new version of the same figure or to create an entirely new character. A refresh may also include a minimal amount of additional tooling, as opposed to all-new tooling for a new figure. This is a common cost-saving practice across many Masters of the Universe toy lines. Also referred to as a "retool."

Reissue • The process of a toy company rereleasing a previous action figure. Sometimes this is done to meet demand or to keep a main character available for purchase over the course of a toy line.

Repaint • The process of a toy company rereleasing an action figure that is identical to a prior release with the only difference being a new paint deco. A repaint is a type of toy refresh.

Reseller • More commonly known by the less polite term "scalper," a reseller is an individual who buys a limited or popular item to then resell for a profit while demand is still strong.

Rooted hair • Strands of artificial fiber that simulate the look and feel of real hair. Rooted hair is sewn into the plastic (often a softer silicone material) in small bundles or plugs with the use of a rooting machine. These plugs can then be further cut or styled to give the desired look.

Rotocast • Refers to an action figure that was made using the process of rotocasting or rotomolding. This method of production results in a toy that is sturdy, hollow, and lightweight. This is commonly used for larger action figures within a toy line. While rotocasting is cost efficient, injection molding is cheaper for smaller action figures due to their many complex parts, bulk production, and a need for a broader range of plastics.

Rotocasting • Rotational casting. A molding process in which material is added into a mold that is slowly rotated on multiple axes. The material sticks to the walls of the mold, creating a hollow object. This process is often used for doll and action figure heads. Also called "rotomolding."

Scale • The height of the action figures in a toy line. Action figures in a toy line tend to have similar height unless they are a deluxe figure or are using different bucks. This keeps the entire line within a similar scale. The scale ratio of a humanoid action figure is done in relation to a human height of seventy-two inches. For example, action figures that measure between five inches and six inches tall are typically referred to as being in the 1:12 scale. This applies to most Masters of the Universe toy lines.

Short pack • Refers to an action figure in a wave that may not have had as many units produced and is included in smaller numbers within a case assortment. An action figure may be short packed if a company feels other figures in the line will be better sellers. But if a line is popular, this often leads to the short-packed figure being harder to find, and sometimes drives up its value on the aftermarket.

Single elbow (or knee) joint • A single hinge joint used in either a knee or an elbow.

SKU • Stock keeping unit. This is a number created and assigned by a company for their own stock-keeping and internal purposes. A SKU can be any combination of letters and numbers. This code can usually be found somewhere on the package. It is sometimes confused with the UPC.

Vintage Masters of the Universe had a specific SKU system.

An example of a vintage MOTU SKU is: 7015-0910-G1

The first four numbers of the SKU were also used frequently in the UPC code. They are also the product ID that you see on the front of the package, in the lower right corner, and in the proof-of-purchase box on the back.

The second four numbers indicate the country where the figure was to be sold. Most often, 0910 is for product sold in the USA, 0810 is for product in Canada, and 0610 is for product in France. However, this is different on figures released in 1983, such as Man-E-Faces and Trap Jaw, where the USA code is 0810, and Canada is 0710.

At the end is the G-code, which signifies the production run, as numerous products from vintage MOTU went back into production multiple times. Some products do not have a G-code, which usually indicates it is the earliest production run.

This SKU system was not used by all countries that released Masters of the Universe figures.

Soft goods • The use of tailored fabrics on a toy rather than molded fabric. In the action figure world, soft goods are often used for capes.

Spring action • This is where a spring is used within the engineered pieces of a figure to perform an action. The spring usually serves to make part of the toy move in one direction, then return to its original position. In the vintage Masters of the Universe line, spring action was used in the waist of some figures, where the toy could be twisted and then released to provide the "power punch."

Spring loaded • This is where a projectile is inserted (or loaded) into a chamber that contains a spring placed further inside. The spring is compressed until the projectile locks into place. When the button or trigger is pressed and the projectile is unlocked, the compressed spring forces the projectile out of the chamber.

Staction • A term coined by Four Horsemen Studios to describe a statue produced in a style and scale to compliment existing action figures.

STL file • A common 3D image format used in the digital sculpting and printing processes, across multiple applications. The STL format includes the geometry of the object but does not include any colors or textures. Instead, the objects are shown as plain, grayscale sculpts.

Swivel hinge • A ball joint that utilizes a plastic disk hinge joint along with a perpendicular swivel joint to create a ball joint movement. This is mostly used on shoulder joints.

Swivel joint • Also sometimes called a cut joint, this creates lateral movement on a figure in an area like a thigh swivel.

Tampo printing • A printing process that allows for the transfer of a 2D image to a 3D surface. This is often used in place of stickers, which are hard to adhere and wear off quickly. Two great examples of a tampo print are the robot panel on the chest of Faker in the Masters of the Universe Classics toy line, and the lightning bolts on the front of the Masters of the Universe Classics blister.

Test shot • An early sample of a figure that uses random plastics at the factory which are injected into the molds to test the tooling and engineering. These shots are then sent to the toy company so they can either approve the current state of the tooling or send them back to the factory with requests for changes.

Tooling • The steel molds that are used for the injection molding process are part of the tooling. Tooling is a broad term that stands for all the components that make up the device that works with the injection molding, like fixtures, pins, bars, plates, the mold into which the plastic is injected, and more. These steel tools tend to be large, are extremely durable, and offer precision detail during casting. As a result of their size, multiple action figure pieces can often be created inside of a single tooling mold. But also because of their size, storage can be costly, and steel tools are often melted down and reused to make new tooling at the end of a toy line, unless a company is certain those tools will prove valuable in the future.

Tooling pattern • This is the final version of a figure's sculpt that is sent to the factory. Traditionally this would be an engineered urethane casting of the figure, but more recently this could also refer to a 3D print or even a digital file.

Translucent • A term that refers to an action figure that is partially or entirely made from semitransparent parts. They are sometimes referred to as "gummy figures" due to their common use of bright colors and the fact that light passes through them.

Under rib • A ball joint found under the rib cage which allows the figure a full range of midtorso motion.

Unpunched • Describes a card back whose hang hole was die cut, but the cut piece of cardboard was left inside of the card back instead of being "punched" (pushed) out. This small piece of cardboard is referred to as the chad. This type of hang hole is not as common with modern action figures but was frequently used in the 1980s. Because many hang holes lost their chad when the action figure was pushed onto the retail display hook, unpunched card backs are rare and are considered very desirable by some collectors.

UPC • Universal product code. The UPC is a twelve-digit numeric code that is accompanied by a barcode. This is a cataloging system often used by retail stores for inventory and for customer checkout.

Vac metal • Vacuum metallization. This is a process used to apply a metallic shine to plastic action figures. Metal is heated until it is liquid and is then passed into a vacuum chamber, where it vaporizes. This vapor is then allowed to settle on and adhere to the plastic action figure components inside the vacuum.

Variant • A production difference for a given action figure. For example, one figure may be released with two different paint jobs. While variants were typically the result of a factory error in older toy lines, a lot of modern toy lines do this on purpose to create something special for collectors. In most cases, the version that is harder to find is considered the variant. A secondary use describes a significant change in design for the same character. For example, Battle Armor He-Man is often described by collectors as a variant of He-Man. But such releases are technically a refresh and not a variant.

Vintage • A term that refers to action figures and toys that are no longer actively sold in retail stores. The era for what is considered vintage often depends on the age of the collector. Sometimes the term is used to refer to toys from an adult's childhood, but it can also be used to refer to toys that were released as little as five years ago.

Wash • The painting process in which watered-down paint is applied to a piece. The "wash" tends to settle into the low points of the surface, which enhances the deeply sculpted areas, adding depth.

Wave • A series of action figures released at the same time, typically part of the same case when shipped to stores. The frequency of waves depends on the company. But when it comes to action figures, waves tend to be released on a quarterly or seasonal schedule. A wave is sometimes referred to as a "series."

Wax • Rigid sculpting material that can be heated into a liquid and cooled into a workable form.

Window box • Packaging style that uses an enclosed cardboard box which includes a transparent plastic "window" to show off the product inside. Often used for larger items like oversized figures, vehicles, and even play sets.

Yellowing • A common occurrence with older toys and packaging. While yellowing is most common in white or clear plastic, yellowing can occur in a number of colored plastics where color shifts are noticeable. Unstable polymers and dyes in much older plastics may cause them to age. But the biggest offenders for yellowing are environmental conditions, with UV radiation being one of the primary culprits.

THE FANS BEHIND THE GUIDE

Putting together a guide of this magnitude would not have happened without the kindness of fans. We offer our thanks to the generous collectors who allowed us into their homes to photograph their collections. And in many cases, an extra special thanks to the collectors who stayed up late with us to help us meet our goals on a very tight schedule. And it wasn't just access to collections that made this guide a reality. It was a team of people who wrote entries, took photos, edited images, and more!

This gallery doesn't feature everyone. So please check out the credits at the beginning of the book to see everyone who offered up a lot of time and effort to produce what we think you will agree is a great look into the action figures that have made He-Man and She-Ra an important part of toy history.

NATHAN BLU

AIDAN CROSS

JUSTIN CURY

CARSTEN DE MUYNCK

DAVID FOWLER

DANIELLE GELEHRTER

LEANNE HANNAH

DARAH HERRON

ERIC MARSHALL

JOHN MCREYNOLDS

JOHN MEDAGLIA

NICK MURRAY

FREDERIC OUDOUL

MIKE PETRUK

DANIEL QUINTERO

SANTIAGO SALVADOR

BRENT SCARANO

BROCK SNYDER & JOE TEAGUE

CURTIS TONE

KYLE WOLFE

CHRISTA VAN FLEET

AFTERWORD
by Val Staples

I am a lifelong fan of He-Man and She-Ra. For almost twenty years, I have been the owner of He-Man.Org, the world's largest Masters of the Universe and Princess of Power fan site. I established and have worked hard to help grow Power-Con, the He-Man and She-Ra fan convention. When it comes to MOTU and POP, I produced comics for 200X, I have worked on packaging and promotional art for Mattel and licensees, I helped develop content for DVDs, I have worked on all the Dark Horse books in some capacity… the list goes on and on.

So, I think it is safe to say that I know a thing or two about MOTU and POP. And one thing I knew fans wanted and needed was an official toy guide. But not just any guide. A guide that cataloged the history from when it all began in 1982, up until today.

This guide went through a long journey. But in the end, the fine folks at Dark Horse helped bring it to life so you would have it to enjoy. From the beginning, there was only one other fan I knew needed to be with me on this adventure, and that is "Pixel Dan" Eardley. Many people know Dan from his YouTube reviews, something at which he excels, but Dan is also a massive MOTU and POP fan. I have known for a long time that it was his dream to help produce an official toy guide, so with a lot of effort, and a little bit of luck, we pushed forward to make that dream happen.

The books in this series from Dark Horse are nothing to scoff at. It takes a year or two of tireless work to create the content within. And this book was no exception. Dan and I flew to the homes of many fans and spent entire weekends photographing collections, which enabled us to piece together everything you have seen in these pages. And after each trip, we would return home and spend nearly all our free time working on this guide.

We could not have done it alone. Like with past Dark Horse books, we were joined by a crew of passionate and talented fans to restore, write, edit, and more. Especially noteworthy are fans like Daniel Quintero who probably needs a long vacation after the restoration miracles he pulled off, or Adam McCombs and Darah Herron, who both wrote a substantial number of the

entries, or Peter Wilura who photographed the majority of the MOTU Classics toys, or Aidan Cross and Danielle Gelehrter who proof-checked and edited text at the drop of a hat. But outside of Dan and myself, the king of long hours is Eric Marshall. If it were not for Eric's layout and assembly skills, there would be no book to speak of. Outside of the many moments he probably wanted to murder me for having him constantly make changes, he would always deliver on what was needed. So, from both Dan and I, thank you to everyone who helped make this guide happen.

Amidst the grind required to create the content before you, one thing I did not anticipate was the joy we would discover when we got to photograph these toys. It not only brought back memories, but both of us got to hold toys that we had never seen before. Something that seems interesting in images online takes on a much different perspective when you have it in your hands. We got to marvel at the box art and the design that went into crafting the packaging. And even more enjoyable than that was getting to play with the toys. We felt like kids again, drifting back to carefree moments of our past when these toys and our imaginations were all we needed to make an afternoon memorable.

One thing that stood out to both of us was the play value of many of these toys, especially underappreciated lines like the space-themed He-Man toy line. It is so easy to get caught up in how something new might depart visually from a previous design aesthetic that one can miss out on what a toy has to offer. A toy line like He-Man, especially its vehicles and play sets, is a lot of fun, and this sentiment held true for all the different lines released over the years. It was great to remind myself once more why MOTU and POP have endured in the hearts of fans. If you have considered collecting, or want to add to your collection, I encourage you to do so. Pictures are great but owning these toys to display and do with as you please will always be a far superior experience. While the cartoons, comics, and licensed items are fantastic, the toys are truly what define Masters of the Universe and Princess of Power.

THE ART OF HE-MAN AND THE MASTERS OF THE UNIVERSE

Tim Seeley and Steve Seeley

In 1982, the world was introduced to *He-Man and the Masters of the Universe*, creating a cultural sensation that changed the landscape of children's entertainment forever! This comprehensive retrospective chronicles He-Man's decades-long, epic journey, including rarely seen images of concept sketches, prototypes, restored art from master illustrator Earl Norem, and more from Mattel's archives! Featuring interviews with Dolph Lundgren, Paul Dini, Erika Scheimer, and many more!

ISBN (Standard) 978-1-61655-592-4 | $39.99
ISBN (Ltd. Ed.) 978-1-61655-730-0 | $129.99

HE-MAN AND THE MASTERS OF THE UNIVERSE MINICOMIC COLLECTION

Bruce Timm, Tim Seeley, Mark Texeira, Robert Kirkman, and others

This oversized hardcover collection features sixty-eight minicomics from the Masters of the Universe, Princess of Power, and He-Man action figure lines, plus an introduction to the minicomics in the current Masters of the Universe Classics toy line.

ISBN 978-1-61655-877-2 | $29.99

HE-MAN AND SHE-RA: A COMPLETE GUIDE TO THE CLASSIC ANIMATED ADVENTURES

James Eatock

The official companion to the *He-Man and the Masters of the Universe* and *She-Ra: Princess of Power* animated series, featuring story synopses, animation processes, and trivia for every episode!

ISBN 978-1-50670-064-9 | $39.99

HE-MAN AND THE MASTERS OF THE UNIVERSE: THE NEWSPAPER COMIC STRIPS

James Shull, Gérald Forton, Karen Willson, and others

Masters of the Universe had its own newspaper comic strip, continuing the tales from the Filmation cartoon and bridging the saga to the space-themed New Adventures of He-Man cartoon relaunch. The comic strip only ran in selected newspapers and was never reprinted, so most fans have never read it . . . until now!

ISBN 978-1-50670-073-1 | $29.99

HE-MAN AND THE MASTERS OF THE UNIVERSE: A CHARACTER GUIDE AND WORLD COMPENDIUM

Val Staples, Josh de Lioncourt, James Eatock, and Danielle Gelehrter

This is the most comprehensive MOTU guide ever published, covering all things Masters of the Universe and Princess of Power from 1982 through today!

ISBN (standard) 978-1-50670-142-4 | $49.99

AVAILABLE AT YOUR LOCAL COMICS SHOP OR BOOKSTORE
TO FIND A COMICS SHOP IN YOUR AREA, VISIT COMICSHOPLOCATOR.COM

DARK HORSE BOOKS
DarkHorse.com

For more information or to order direct, visit DarkHorse.com or call 1-800-862-0052

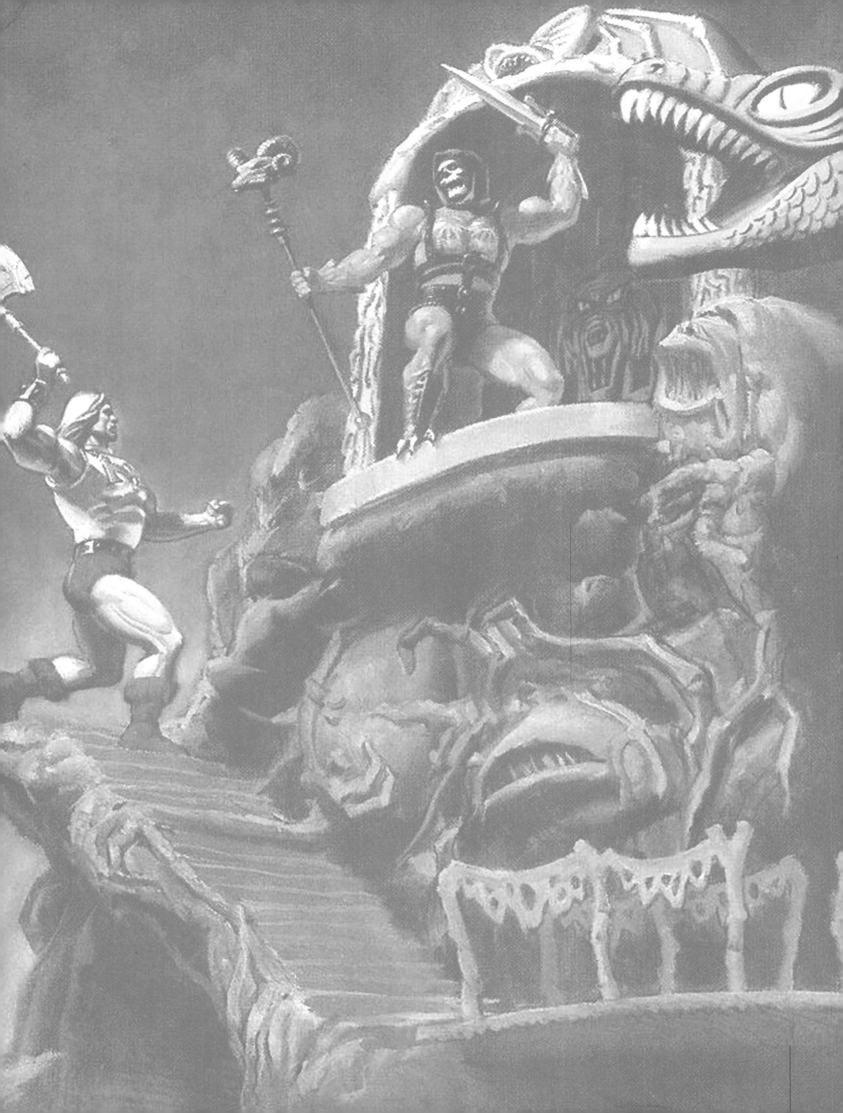